PRAISE FOR

# IDEAS

"A thoughtful, source-fi[...] religion, literature, time, and money are among [...]dable yet lengthy text." —[...] and Bill Eichenberger, *Columbus Dispatch*

"Watson transmits tricky things in a palatable way. . . . It's bit of a whirlwind tour of the best brains ever. . . . Stiff drink required, but your brain will be bigger after you've read it." [...]ount, *The Spectator*

"Given the contraction of intellectual life in certain parts of the world at the moment, a book like this one is to be highly valued and thoroughly read. Watson is an authoritative and unobtrusive guide, gentling pointing towards where the future of ideas may go, namely to the unraveling of the misconception of the 'inner' self." —Beth Pearson, *The Herald* (Glasgow)

"If you read and comprehend this one, you are guaranteed to significantly increase your brain power. Watson takes you on a world tour through the history of great ideas and the thinkers who came up with them." —Vick Mickunas, *Dayton Daily News*

"Ranging freely across time and space, his survey includes some enlightening vignettes of Chinese and Indian thought, and he gives a useful account of Vedic traditions in which human individuality is regarded as an illusion." —John Gray, Professor of European Thought at the London School of Economics, *The New Statesman*

"The undeniable strength of the book lies in its bracing enthusiasm for the life of the mind, and its insistence that intellectual history is unintelligible in isolation from technology, and its global scope." —*London Times*

"This is a monumental work. . . .Watson, a renowned researcher at Cambridge University, is to be commended for this unprecedented one-man encyclopedia." —Larry Cox, *Tucson Citizen*

Sue Adler

## *About the Author*

PETER WATSON was educated at the universities of Durham, London, and Rome. He is the author of thirteen books, which have been translated into seventeen languages, and has presented several television programs about the arts. Since 1998 he has been a Research Associate at the McDonald Institute for Archaeological Research at the University of Cambridge. He is the author of *The Modern Mind: An Intellectual History of the Twentieth Century*. He lives in London.

# IDEAS

*A History of Thought and Invention,*

*from Fire to Freud*

# PETER WATSON

HARPER ● PERENNIAL

NEW YORK ● LONDON ● TORONTO ● SYDNEY

HARPER ● PERENNIAL

First published with the title *Ideas: A History from Fire to Freud* in Great Britain in 2005 by Weidenfeld & Nicolson.

A hardcover edition of this book was published in 2005 by HarperCollins Publishers.

HarperCollins books may be purchased for educational, business, or sales promotional use. For information please write: Special Markets Department, HarperCollins Publishers, 10 East 53rd Street, New York, NY 10022.

FIRST HARPER PERENNIAL EDITION PUBLISHED 2006.

The Library of Congress has catalogued the hardcover edition as follows:
Watson, Peter.
    Ideas : a history of thought and invention, from fire to Freud / Peter Watson.—
1st ed.
        p.   cm.
    ISBN-10: 0-06-621064-X
    ISBN-13: 978-0-06-621064-3
    Includes bibliographical references and indexes.
    1. Civilization—History. 2. Intellectual life—History. I. Title.
CB69.W38   2005
909—dc22                                                          2005050255

ISBN-10: 0-06-093564-2 (pbk.)
ISBN-13: 978-0-06-093564-1 (pbk.)

06 07 08 09 10   UK/RRD   10 9 8 7 6 5 4 3 2 1

*For Bébé*

*There are no whole truths;*
*All truths are half-truths.*
*It is trying to treat them as*
*Whole truths that plays the devil.*

—ALFRED NORTH WHITEHEAD, *DIALOGUES* (1953)

*While it may be hard to live with generalizations,*
*it is inconceivable to live without them.*

—PETER GAY, *SCHNITZLER'S CENTURY* (2002)

# Contents

**PART TWO: ISAIAH TO ZHU XI**
**The Romance of the Soul**

*thoughts on the soul – the attack on Jesus – the attack on prophecy – Hobbes – Hume – Bayle – Vanini the first modern atheist – the attack on the Old Testament – the attack on Genesis – the attack on biblical chronology*

## PART FIVE: VICO TO FREUD
### Parallel Truths: The Modern Incoherence

# Author's Note

In the acknowledgements to his book *The Joys of Yiddish*, published in 1970, Leo Rosten thanks a friend of his who, in making a critique of the manuscript, brought to bear 'his singular acquaintanceship with ancient history, Latin, Greek, German, Italian, Hebrew, Aramaic and Sanskrit'. It is that last touch I liked – Aramaic and Sanskrit. To be able to speak English, German and Italian is impressive enough; add on Latin, Greek and Hebrew and that marks you out as a linguist of unusual distinction; but Aramaic (the language of Jesus) and Sanskrit? Such an individual can only be what Rosten himself identifies elsewhere in his book as a great scholar, a *chachem*, 'a clever, wise or learned man or woman'. In a work such as *Ideas* it is comforting to think of learning and wisdom as one and the same but Rosten immediately punctures any such hope. 'A bright young *chachem* told his grandmother that he was going to be a Doctor of Philosophy. She smiled proudly: "Wonderful. But what kind of disease is philosophy?" '

I could have done with any number of friends like Rosten's in the course of writing this book, which ranges over material conceived in many languages, Aramaic and Sanskrit among them. But multi-multi-lingual *mavin* (Yiddish for experts, connoisseurs) are not as thick on the ground as once they were. However, I have been no less fortunate in that a number of eminent scholars, who liked the plan for a history of ideas aimed at a general readership, agreed to read either parts or all of the typescript, and to give me the benefit of their expertise. Before I thank them, I hasten to make the usual disclaimer, that such errors, omissions and solecisms as remain in the text are my responsibility and mine alone. That said, I extend my gratitude to: John Arnold, Peter J. Bowler, Peter Burke, Christopher Chippendale, Alan Esterson, Charles Freeman, Dominick Geppert, P. M. Harman, Robert Johnston, John Keay, Gwendolyn Leick, Paul Mellars, Brian Moynahan, Francis Robinson, James Sackett, Chris Scarre, Hagen Schulze, Robert Segal, Chandak Sengoopta, Roger Smith, Wang Tao, Francis Watson and Zhang Haiyan. For editorial and other input, I am also indebted to: Walter Alva, Neil Brodie, Cass Canfield Jr., Dilip Chakrabati, Ian Drury, Vivien Duffield, Hugh van Dusen, Francesco d'Errico, Israel Finkelstein, Ruth and Harry Fitzgibbons, David Gill, Eva Hajdu, Diana and Philip Harari, Jane Henderson, David Henn, Ilona Jasiewicz, Raz Kletter, David Landes, Constance Lowenthal, Fiona McKenzie, Alexander Marshack, John and Patricia Menzies, Oscar Muscarella, Andrew Nurnberg, Joan Oates, Kathrine Palmer, Colin Renfrew, John Russell, Jocelyn Stevens, Cecilia Todeschini, Randall White and Keith Whitelam. The book could not have been written without the help of the staffs of three libraries: the Haddon Library of Anthropology and Archaeology,

Cambridge, England; the London Library; the library of the School of Oriental and African Studies, in the University of London. I am most grateful for their help.

At the end of this book there are roughly 3,550 references spread over 58 pages. However, I would like here to draw attention to those titles on which I am especially reliant. One of the very real pleasures of researching and writing *Ideas* has been making the acquaintance of so many works that, though they may never be bestsellers, are masterpieces of erudition, insight and scholarship. Not a few of the titles mentioned below are classics of their kind, and were this book not so long already I would have liked to have attempted a bibliographical essay describing the contents, approach and attractions of many of the following works. As it is, I will merely say that the list which follows contains books that are, quite simply, indispensable for anyone who wishes to consider himself or herself informed about the history of ideas and that my gratitude to the following authors knows no bounds. The pleasure these volumes have given me is immeasurable.

Alphabetically by author/editor, they are: Harry Elmer Barnes, *An Intellectual and Cultural History of the Western World*; Isaiah Berlin, *The Sense of Reality*; Malcolm Bradbury and James McFarlane (editors), *Modernism: A Guide to European Literature, 1890–1930*; Jacob Bronowski and Bruce Mazlish, *The Western Intellectual Tradition*; Edwin Bryant, *The Quest for the Origins of Vedic Culture*; James Buchan, *The Capital of the Mind*; Peter Burke, *Culture and Society in Renaissance Italy*; J. W. Burrow, *The Crisis of Reason: European Thought, 1848–1914*; Norman Cantor, *The Civilisation of the Middle Ages*; Ernst Cassirer, *The Philosophy of the Enlightenment*; Jacques Cauvin, *The Birth of the Gods and the Origins of Agriculture*; Owen Chadwick, *The Secularisation of European Thought in the Nineteenth Century*; Marcia Colish, *Medieval Foundations of the Western Intellectual Tradition, 400–1400*; Henry Steel Commager, *The Empire of Reason*; Alfred W. Crosby, *The Measure of Reality: Quantification and Western Society*; Georges Duby, *The Age of the Cathedrals*; Mircea Eliade, *A History of Religious Ideas*; Henri F. Ellenberger, *The Discovery of the Unconscious*; J. H. Elliott, *The Old World and the New*; Lucien Febvre and Henri-Jean Martin, *The Coming of the Book*; Valerie Flint, *The Imaginative Landscape of Christopher Columbus*; Robin Lane Fox, *The Unauthorised Version*; Paula Fredericksen, *From Jesus to Christ*; Charles Freeman, *The Closing of the Western Mind*; Jacques Gernet, *A History of Chinese Civilisation*; Marija Gimbutas, *The Gods and Goddesses of Old Europe: 6500 to 3500 BC*; Edward Grant, *God and Reason in the Middle Ages*; Peter Hall, *Cities in Civilisation*; David Harris (editor), *The Origins and Spread of Agriculture and Pastoralism in Eurasia*; Alvin M. Josephy (editor), *America in 1492*; John Keay, *India: A History*; William Kerrigan and Gordon Braden, *The Idea of the Renaissance*; Paul Kriwaczek, *In Search of Zarathustra*; Thomas Kuhn, *The Copernican Revolution*; Donald F. Lach, *Asia in the Making of Europe*; David Landes, *The Wealth and Poverty of Nations*; David Levine, *At the Dawn of Modernity*; David C. Lindberg, *The Beginnings of Western Science*; A. O. Lovejoy, *The Great Chain of Being*; Ernst Mayr, *The Growth of Biological Thought*; Louis Menand, *The Metaphysical Club: A Story of Ideas in America*; Steven Mithen, *The Prehistory of the Mind*; Joseph Needham, *The Great Titration*; Joseph Needham *et al.*, *Science and Civilisation in China*; Hans J. Nissen, *The Early History of the Ancient Near East*; Anthony Pagden, *The Fall of Natural Man* and *People and Empires*; J. H. Parry, *The Age of Reconnaissance*; L. D. Reynolds and N. G. Wilson, *Scribes and Scholars*; E. G. Richards, *Mapping Time: The Calendar and*

*Its History*; Richard Rudgley, *The Lost Civilisations of the Stone Age*; H. W. F. Saggs, *Before Greece and Rome*; Harold C. Schonberg, *Lives of the Composers*; Raymond Schwab, *The Oriental Renaissance*; Roger Smith, *The Fontana History of the Human Sciences*; Richard Tarnas, *The Passion of the Western Mind*; Ian Tattersall, *The Fossil Trail*; Peter S. Wells, *The Barbarians Speak*; Keith Whitelam, *The Invention of Ancient Israel*; G. J. Whitrow, *Time in History*; Endymion Wilkinson, *Chinese History: A Manual*.

I would also like to draw attention to the sponsors and editors of the various university presses around the world. Many of the most interesting and important books discussed in the following pages were never going to be commercial propositions; but university presses exist, at least in part, to see that new ideas get into print: we are all in their debt. Nor should we forget the translators (some anonymous, some long-departed) of so many of the works described in this book. As Leo Rosten acknowledged, linguistic skills ought not to be taken for granted.

In the chapters on China I have used the Pinyin system of transliteration as opposed to Wade-Giles, except for certain words where the Wade-Giles format is well-known even to non-specialists (Pinyin dispenses with all apostrophes and hyphens in Chinese words). In transcribing other scripts (for example, Arabic, Greek, Sanskrit) I have omitted virtually all diacritical marks, on the grounds that most readers will not know how, for example, å or ę modifies the sound. Marks are included only where essential – for example, to distinguish the Russian prehistoric site of Mal'ta from the Mediterranean island of Malta. For the most part I have referred to the books of the Hebrew Bible as scriptures. Occasionally, for the sake of variety, I have used Old Testament.

My greatest debt, as always, is to Kathrine.

# Introduction

## *The Most Important Ideas in History*
## *Some Candidates*

In 1936, a collection of papers by Sir Isaac Newton, the British physicist and natural philosopher, which had been considered to be 'of no scientific value' when offered to Cambridge University some fifty years earlier, came up for auction at Sotheby's, the international salesroom, in London. The papers were bought by another Cambridge man, the distinguished economist John Maynard Keynes (later Lord Keynes). He spent several years studying the documents – mainly manuscripts and notebooks – and in 1942, in the midst of the Second World War, delivered a lecture to the Royal Society Club in London in which he presented an entirely new view of 'history's most renowned and exalted scientist'. 'In the eighteenth century and since,' Keynes told the club, 'Newton came to be thought of as the first and greatest of the modern age of scientists, a rationalist, one who taught us to think on the lines of cold and untinctured reason. I do not see him in this light. I do not think that anyone who has pored over the contents of that box which he packed up when he left Cambridge in 1696 and which, though partly dispersed, have come down to us, can see him like that. Newton was not the first of the age of reason. He was the last of the magicians, the last of the Babylonians and Sumerians, the last great mind which looked out on the visible and intellectual world with the same eyes as those who began to build our intellectual inheritance rather less than 10,000 years ago.'[1]

Newton is still known to us, first and foremost, as the man who conceived the modern notion of the universe, as held together by gravity. But, in the decades since Keynes spoke to the Royal Society, a second – and very different – Newton has emerged: a man who spent years involved in the shadowy world of alchemy, in the occult search for the philosopher's stone, who studied the chronology of the Bible because he believed it would help predict the apocalypse that was to come. He was a near-mystic who was fascinated by Rosicrucianism, astrology and numerology. Newton believed that Moses was well aware of the heliocentric theory of Copernicus and his own doctrine of gravity. A generation after the appearance of his famous book *Principia Mathematica*, Newton was still striving to uncover the exact plan of Solomon's Temple, which he considered 'the best guide to the topography of heaven'.[2] Perhaps most surprising of all, the latest scholarship suggests that Newton's world-changing discoveries in science might never have been made but for his researches in alchemy.[3]

The paradox of Newton is a useful corrective with which to begin this book. A history

of ideas might be expected to show a smooth progression in mankind's intellectual development, from primitive notions in the very beginning, when early man was still using stone tools, through the gestation of the world's great religions, down to the unprecedented flowering of the arts in Renaissance times, the birth of modern science, the industrial revolution, the devastating insights of evolution and the technological wizardry that marks our own day, with which we are all familiar and on which so many are dependent.

But the great scientist's career reminds us that the situation is more complex. There *has* been a general development, a steady progress much of the time (the idea of progress is discussed more fully in Chapter 26). But by no means all of the time. Throughout history certain countries and civilisations have glittered for a while, then for one reason or another been eclipsed. Intellectual history is very far from being a straight line – that is part of its attraction. In his book, *The Great Titration* (1969), the Cambridge historian of science Joseph Needham set out to answer what he thought was one of the most fascinating puzzles in history: why the Chinese civilisation, which developed paper, gunpowder, woodblock printing, porcelain and the idea of the competitive written examination for public servants, and led the world intellectually for many centuries, never developed mature science or modern business methods – capitalism – and therefore, after the Middle Ages, allowed itself to be overtaken by the West and then dropped further and further behind (his answer is discussed on pages 323–324).[4] The same might be said about Islam. Baghdad in the ninth century led the Mediterranean world intellectually: it was here that the great classics of the ancient civilisations were translated, where the hospital was conceived, where *al-jabr*, or algebra, was developed, and major advances made in *falsafah*. By the eleventh century, thanks to the rigours of fundamentalism, it had disappeared. Charles Freeman, in his recent book *The Closing of the Western Mind*, describes many instances of the way intellectual life withered in the early Middle Ages, the years of Christian fundamentalism.[5] In the fourth century Lactantius wrote: 'What purpose does knowledge serve – for as to knowledge of natural causes, what blessing is there for me if I should know where the Nile rises, or whatever else under the heavens the "scientists" rave about?'[6] Epilepsy, which Hippocrates described as a natural illness as early as the fifth century BC, was, in the Middle Ages, placed under the care of St Christopher. John of Gaddesden, an English physician, recommended as a cure the reading of the Gospel over the epileptic while simultaneously placing on him the hair of a white dog.[7]

This is perhaps the most important lesson we can learn from a history of ideas: that intellectual life – arguably the most important, satisfying and characteristic dimension to our existence – is a fragile thing, easily destroyed or wasted. In the last chapter some conclusions will be attempted, in an effort to assess what has and has not been achieved in this realm. This Introduction, however, shows how this history differs from other histories, and in so doing helps explain what a history of ideas *is*. The discussion will be confined to an exploration of the various ways the material for an intellectual history may be organised. A history of ideas clearly touches on a vast amount of material and ways must be found to make this array manageable.

For some reason, numerous figures in the past have viewed intellectual history as a tripartite system – organised around three grand ideas, ages or principles. Joachim of Fiore

(*c.* 1135–1202) argued – heretically – that there have been three epochs, presided over by God the Father, God the Son and God the Holy Spirit respectively, during which the Old Testament, the New Testament and a 'spiritual eternal Gospel' will be in force.[8] Jean Bodin (*c.* 1530–1596), the French political philosopher, divided history into three periods – the history of Oriental peoples, the history of Mediterranean peoples, and the history of northern peoples.[9] In 1620 Francis Bacon identified three discoveries that set his age apart from ancient times.[10] 'It is well to observe the force and virtue and consequences of discoveries. These are to be seen nowhere more conspicuously than in those three which were unknown to the ancients, and of which the origin, though recent, is obscure and inglorious; namely, printing, gunpowder, and the magnet. For these three have changed the whole face and state of things throughout the world, the first in literature, the second in warfare, the third in navigation; whence have followed innumerable changes; insomuch that no empire, no sect, no star, seems to have exerted greater power and influence in human affairs than these mechanical discoveries.'[11] The origins of each of these discoveries have been identified since Bacon's time but that does not change the force of his arguments.

Thomas Hobbes (1588–1679), Bacon's amanuensis, argued that three branches of knowledge outweighed all others in explanatory power: physics, which studies natural objects; psychology, which studies man as an individual; and politics, which deals with artificial and social groupings of mankind. Giambattista Vico (1668–1744) distinguished the age of the gods, the heroic age and the human age (though he borrowed some of these ideas from Herodotus and Varro). In fact, Vico tended to think in threes: he distinguished three 'instincts' which, he said, shaped history, and three 'punishments' that shaped civilisation.[12] The three instincts were a belief in Providence, the recognition of parenthood, and the instinct to bury the dead, which gave mankind the institutions of religion, family and sepulture.[13] The three punishments were shame, curiosity and the need to work.[14] The French statesman Anne Robert Jacques Turgot (1727–1781) argued that civilisation is the product of geographical, biological and psychological factors (Saint-Simon agreed). Marie Jean Antoine Nicolas Caritat, marquis de Condorcet (1743–1794), who thought that the French Revolution was the dividing line between the past and a 'glorious future', believed there were three outstanding issues in history – the destruction of inequality between nations, the progress of equality within one and the same nation, and the perfecting of mankind. William Godwin (1756–1836), the English anarchist, thought that the three chief ideas that would produce the all-important goal in life – the triumph of reason and truth – were literature, education and (political) justice. Thomas Carlyle (1795–1881) noted 'the three greatest elements of modern civilisation [are] gunpowder, printing and the Protestant religion', while Auguste Comte (1798–1857) idealised three stages of history – theological, metaphysical and scientific, later expanded to theological-military, metaphysical-legalistic, and scientific-industrial.[15] Later still in the nineteenth century the anthropologist Sir James Frazer distinguished the ages of magic, religion and science, while Lewis Morgan, in his *Ancient Society*, divided history into the stages of savagery, barbarism and civilisation, and thought that the main organising ideas of civilisation were the growth of government, the growth of ideas about the family, and the growth of ideas about property.

Not everyone has fallen into this tripartite way of looking at history. Condorcet thought

there had been ten stages of progress, Johann Gottfried Herder divided history into five periods, Georg Wilhelm Hegel divided it into four, and Immanuel Kant believed that progress had gone through nine stages.

Nevertheless, W. A. Dunlap, writing in 1905, used the word 'triposis' to describe this tendency to divide intellectual history into three, while Ernest Gellner in 1988 favoured the term 'trinitarian'.[16] In recent years we have had J. H. Denison's *Emotions as the Basis of Civilisation* (1932), which divided societies into the patriarchal, the fratriarchal and the democratic. In 1937, in his *Intellectual and Cultural History of the Western World*, Harry Elmer Barnes described three great changes in 'sensibility' in history – the arrival of 'ethical monotheism' in the Axial Age (700–400 BC), the advent of individualism in the Renaissance, when the present world became an end in itself instead of a preparation for the shadowy afterlife, and the Darwinian revolution of the nineteenth century.[17]

Economists have often thought in threes. In *The Wealth of Nations* (1776), Adam Smith (1723–1790) offered a pioneering analysis of the fundamental division of income into rents, wages and the profits of stock, identifying their respective owners as the landlord, the wage-earner and the capitalist, the 'three great, original and constituent orders of every civilised society'.[18] Even Marxism can be reduced to three: an age when man knows neither surplus nor exploitation, when both surplus and exploitation are pervasive, and when surplus remains but exploitation is ended.[19] And Karl Polanyi, in *The Great Transformation* (1944), distinguished three great economic epochs – reciprocity, redistribution and the market. Two years later, in *The Idea of History*, R. G. Collingwood described 'three great crises' that have occurred in the history of European historiography. The first occurred in the fifth century BC, when the idea of history as a science came into being; the second took place in the fourth and fifth centuries AD, with the advent of Christianity, which viewed history as the working out of God's purpose, not man's; and the third came in the eighteenth century with a general denial of innate ideas and intuitionism or revelation. In 1951, in *Ideas and Men*, Crane Brinton, professor of ancient and modern history at Harvard, identified humanism, Protestantism and rationalism as the three great ideas making the modern world. Carlo Cipolla published *Guns and Sails in the Early Phase of European Expansion, 1400–1700* in 1965, in which he argued that nationalism, guns and navigation accounted for the European conquests which created the modern world. The rising nationalism in Europe, as a result of the Reformation, led to a new round of war, which promoted the growth of metallurgy, and ever more efficient – and brutal – weapons. These far outstripped anything available in the East (in contrast to the situation in 1453, when the Turks sacked Constantinople), while the developments in navigation, fuelled by ambitions of empire, enabled European ships to reach both the far east (the 'Vasco da Gama' era) and, eventually, the Americas.[20]

In Ernest Gellner's *Plough, Sword and Book* (1988), he argued that there have been three great phases in history – hunting/gathering, agrarian production and industrial production – and that these fitted with the three great classes of human activity – production, coercion and cognition. In 1991, Richard Tarnas, in *The Passion of the Western Mind*, argued that philosophy, in the West at any rate, can be divided into three great epochs – as largely autonomous during the classical period, as subordinate to religion during the dominant years of Christianity, and as subordinate to science ever since.[21]

In his book *Fire and Civilisation* (1992), Johan Goudsblom argued that man's control of fire produced the first transformation in human life. Early man was now no longer a predator: control of fire enabled him to corral animals and to clear land. Without this, agriculture – the second transformation – would not have been possible. Control over fire also introduced the possibility of cooking, which distinguished man from the animals and may be regarded as the origins of science. (The use of smoke may also have been the first form of communication.) Control over fire, of course, also led to baking, ceramics and smelting (the 'pyrotechnic cultures'), which enabled metal daggers and then swords to be constructed. But the third great transformation, and the most important, after agriculture, Goudsblom said, was industrialisation, the union of fire with water, to produce in the first instance steam, harnessing a new form of energy which enabled machines of unprecedented size and power to perform certain routine skills much better and much faster than was possible by hand.[22]

Isaiah Berlin, the Oxford political philosopher, thought there had been three great political/psychological turning-points in history. The first came after the death of Aristotle, when the philosophical schools of Athens 'ceased to conceive of individuals as intelligible only in the context of social life, ceased to discuss the questions connected with public and political life that had preoccupied the Academy and the Lyceum, as if these questions were no longer central . . . and suddenly spoke of men purely in terms of inner experience and individual salvation'.[23] A second turning-point was inaugurated by Machiavelli, which involved the recognition that there is a division 'between the natural and the moral virtues, the assumption that political values are not merely different from, but may in principle be incompatible with, Christian ethics.' The third turning-point – which Berlin says is the greatest yet – was the advent of romanticism. These changes are discussed in Chapter 30.

Finally, in 1997, in *Guns, Germs and Steel*, Jared Diamond picked up where Cipolla left off: his concern was to explain the way the world developed before modern times and why Europe discovered (and conquered) America rather than vice versa. His answer had three broad themes. Eurasia, he pointed out, is mainly an east–west landmass, whereas the Americas are north–south. The exigencies of geography, he said, mean that the migration of domesticated animals and plants is by definition easier along latitudes than it is along longitudes, which meant that cultural evolution was likewise easier, and therefore faster, in Eurasia than it was in the Americas. Second, Eurasia had more mammals capable of domestication than in the Americas (fifteen, as opposed to two), and this also helped civilisations evolve. In particular, the domestication of the horse, in Eurasia, transformed warfare, which encouraged the development of the sword, which helped the evolution of metallurgy, meaning that European weapons far outstripped their equivalents in the New World. Third, domestication of many animals meant that European humans evolved immunity to the diseases which those animals carried and which, when they were introduced into the New World, devastated the population.[24]

It is encouraging that there is a measure of overlap here. Agriculture, weapons, science, industrialisation, and printing, for example, are each selected by more than one author. These arguments and ideas certainly help us begin to find our way about a massive field but, as will become clear later in this Introduction, and then throughout the book, though

I think that all these ideas and innovations are important, my own candidates are very different.

Of course, this is by no means the only way of looking at the development of ideas – by identifying the most influential innovations and abstractions of all time. In their book, *The Western Intellectual Tradition*, Jacob Bronowski and Bruce Mazlish identify three 'realms' of intellectual activity, an approach that I have found very useful. There is first the realm of truth: the effort to inquire into truth is the concern of religion, science, philosophy where, in an ideal world, agreement would be total and involuntary – i.e., inevitable in a logical, mathematical or syllogistical sense. Next, there is the search for what is right: this is the concern of law, ethics and politics, where agreement, largely voluntary, need not be total but in order to work still needs to be widespread. And thirdly there is the realm of taste, which is largely the business of the arts, where agreement is not necessary at all and where disagreement may be fruitful. Of course, there is again a measure of overlap between these realms (artists search for the truth, or say that they do, religion is concerned with what is right as well as with what is true) but the distinction *is* worth bearing in mind throughout this book. The Greeks early on recognised an important distinction between natural law and human law.[25]

Of course, there is nothing sacred or inevitable about 'the rule of three'. An alternative approach has been to stress the continuity of 'big' thoughts. Many books, for instance, have been written on such overwhelming topics as 'Progress', 'Nature', 'Civilisation', 'Individualism', 'Power', what is and what is not 'Modern'. A number of scholars – political historians and moral philosophers in particular – have seen the most important intellectual strand running through the past as a moral saga revolving around the twin issues of freedom and individuality. Immanuel Kant was just one who viewed history as the narrative of man's moral progress. Isaiah Berlin also devoted his energies to defining and refining different concepts of freedom, to explaining the way freedom has been conceived under different political and intellectual regimes, and at different times in history. The study of individualism has grown immensely in recent years, with many historians seeing it as a defining aspect of modernity and capitalism. Daniel Dennett, in his recent title *Freedom Evolves*, described the growth of individualism throughout history and the various ways that freedom has increased and benefited mankind. Freedom is both an idea in itself and a psychological/political condition especially favourable to the instigation of ideas.

Each of these approaches to intellectual history has something to be said for it and each of the books and essays referred to above is warmly recommended. In the event, however, I have given this book a tripartite structure, in the manner of Francis Bacon, Thomas Carlyle, Giambattista Vico, Carlo Cipolla, Ernest Gellner, Jared Diamond and others. Not merely to ape them (though one could do worse than follow this array of distinguished minds) but because the three particular ideas I have settled on, as the most important, do, I believe, concisely summarise my argument about what has happened in history and describe where we are today.

All of the forms of organisation mentioned above are recognisable in the following pages, but the three ideas I have settled on as the most important, and which determine

the book's ultimate structure and thesis, are these: the soul, Europe, and the experiment. I do not intend to rehearse the argument of the book in this Introduction but, if I may anticipate some criticisms, I trust it will become clear why I think the soul is a more important concept than the idea of God, why Europe is as much an idea as it is a place on the map, and why the humble experiment has had such profound consequences. I also think that these three ideas are responsible for our present predicament – but that too will emerge in the following pages.

I should perhaps expand a little on what I mean by 'idea'. I do not have any magic formula according to which ideas have been chosen for inclusion in this book. I include abstract ideas and I include inventions which I think are or were important. According to some palaeontologists man's first abstract idea occurred around 700,000 years ago, when stone hand-axes became standardised to the same proportions. This, the scientists say, shows that early man had an 'idea' inside his head of what a hand-axe should be. I report this debate and discuss its implications on pages 26–27. But I also treat the invention of the first hand-axes – 2.5 million years ago, before they became standardised – as evidence for an 'idea', after early man realised that a sharp stone would break through animal hide when his own fingernails or teeth wouldn't. Writing is an idea, a very important idea, which was invented before 3000 BC. Today, however, we tend not to regard letters or words as inventions, as we do computers or mobile phones, because they have been so long with us. But inventions are evidence of ideas. I have treated language as an idea, because language reflects the way that people think, and the ways in which languages differ characterise the social and intellectual history of different populations. In addition, most ideas are conceived in language. Thus I consider the history and structure of the world's most intellectually influential languages: Chinese, Sanskrit, Arabic, Latin, French and English.

The first person to conceive of intellectual history was, perhaps, Francis Bacon (1561–1626). He certainly argued that the most interesting form of history is the history of ideas, that without taking into account the dominating ideas of any age, 'history is blind'.[26] Voltaire (1694–1778) spoke of the philosophy of history, by which he meant that history was to be looked at as what interests a *philosophe* (rather than a soldier-politician, say). He argued that culture and civilisation, and progress on that score, were susceptible of secular, critical and empirical enquiry.[27] The French *Annales* school, with its interest in *mentalités*, some of the less tangible aspects of history – for example, the everyday intellectual climate at various points in the past (how time was understood, or what, say, medieval notions of privacy were) – also comprised a form of the history of ideas, though it was hardly systematic.

But in modern times, the person who did more than anyone else to create an interest in the history of ideas was Arthur O. Lovejoy, professor of philosophy at Johns Hopkins University, in Baltimore in the United States. He was one of the founders of the History of Ideas Club at Johns Hopkins and gave a series of lectures, the William James Lectures on Philosophy and Psychology, at Harvard University, in spring 1933. The topic of the series was what Professor Lovejoy called *the* most 'potent and persistent presupposition' in Western thought. This was 'The Great Chain of Being', published as a book of that title in

1936 and which, by 2001, had been reprinted twenty-one times. The Great Chain of Being, Lovejoy said, was for 2,400 years the most influential way of understanding the universe and implied a certain conception of the nature of God. Without acquaintance with this idea, he insisted, 'no understanding of the movement of thought in [the West] ... is possible.'[28] At its most simple, the notion underlying The Great Chain of Being, as identified in the first instance by Plato, is that the universe is essentially a rational place, in which all organisms are linked in a great chain, not on one scale of low to high (for Plato could see that even 'lowly' creatures were perfectly 'adapted', as we would say, to their niches in the scheme of things) but that there was in general terms a hierarchy which ranged from nothingness through the inanimate world, into the realm of plants, on up through animals and then humans, and above that through angels and other 'immaterial and intellectual' entities, reaching at the top a superior or supreme being, a terminus or Absolute.[29] Besides implying a rational universe, Lovejoy said, the chain also implied an 'otherworldliness' of certain phenomena, not just the Absolute (or God) but, in particular, 'supersensible' and 'permanent entities', namely 'ideas' and 'souls'.

The chain further implied that the higher up the hierarchy one went the greater the 'perfection' of these entities. This was the notion of 'becoming', improving, approaching perfection, and from this arose the idea of the 'good', what it is to be good, and the identification of the Absolute, God, with the good. 'The bliss which God unchangingly enjoys in his never-ending self-contemplation is the Good after which all other things yearn and, in their various measures and manners, strive.'[30] The conception of the eternal world of ideas also gave rise to two further questions: *why* is there any world of becoming in addition to the eternal world of ideas or, indeed, the one Supreme Being – why, in effect, is there something rather than nothing? And second, what principle determines the number of kinds of beings that make up the sensible and temporal world? Why is there plenitude? Is that evidence of the underlying goodness of God?

Lovejoy went on to trace the vicissitudes of this idea, in particular in the medieval world, the Renaissance and in the eighteenth and nineteenth centuries. He showed, for instance that Copernicus' *De revolutionibus orbium*, which introduced the idea that the earth went round the sun, rather than vice versa, was understood by many of the time as a new way to contemplate the heavens as 'the highest good', as closer to what God intended mankind's understanding to be.[31] For example, Cardinal Bellarmino, whom we shall meet in Chapter 25 as the leader of the Catholic Church's resistance to Copernicus, also said: 'God wills that man should in some measure know him through his creatures, and because no single created thing could fitly represent the infinite perfection of the Creator, he multiplied creatures, and bestowed on each a certain degree of goodness and perfection, that from these we might form some idea of the goodness and perfection of the Creator, who, in one most simple and perfect essence, contains infinite perfections.'[32] On this reading, Copernicus' breakthrough was an infinitesimal increase in man's ascent to God.

Rousseau, in *Émile*, said: 'O Man! Confine thine existence within thyself, and thou wilt no longer be miserable. Remain in the place which Nature has assigned to Thee in the chain of beings ...'[33] For Pope: 'Know thy own point; this kind, this due degree, / Of Blindness, weakness, Heaven bestows on thee.'[34] The writers of the *Encyclopédie*, in France in the eighteenth century, thought this approach would advance knowledge: 'Since "every-

thing in nature is linked together", since "beings are connected with one another by a chain of which we perceive some parts as continuous, though in the greater number of points the continuity escapes us", the "art of the philosopher consists in adding new links to the separated parts, in order to reduce the distance between them as much as possible".'[35] Even Kant spoke of 'the famous law of the continuous scale of created beings . . .'[36]

Influential though it was, Lovejoy felt that the idea of the great chain had failed. In fact, he said, it had to fail: it implied a static universe. But that had little to do with its influence.*

Lovejoy was by all accounts an impressive man. He read English, German, French, Greek, Latin, Italian and Spanish and his students joked that on his sabbatical year from Johns Hopkins he occupied himself by 'reading the few books in the British Museum Library that he had not yet read'.[38] Nonetheless, he was criticised for treating ideas as 'units' – underlying and unchanging entities, like the elements in chemistry – whereas his critics saw them as far more fluid.[39]

But Lovejoy certainly started the ball rolling in that he became the first editor of the *Journal of the History of Ideas*, founded in 1940. (Among the contributors to that volume were Bertrand Russell and Paul O. Kristeller.) In the first issue, Lovejoy set out the *Journal*'s aims as: to explore the influence of classical ideas on modern thought, the influence of European ideas on American thought, the influence of science on 'standards of taste and morality and educational theories and models' and the influence of certain 'pervasive and widely ramifying ideas or doctrines', such as evolution, progress, primitivism, determinism, individualism, collectivism, nationalism and racism. He argued that the history of thought is not 'an exclusively logical progress in which objective truth progressively unfolds itself in a rational order'. Instead, he said, it revealed a sort of 'oscillation' between intellectualism and anti-intellectualism, between romanticism and enlightenment, arising from non-rational factors. This, he thought, was an alternative model to 'progress'. In an essay elsewhere, he identified the subject matter of a history of ideas as: the history of philosophy, of science, of religion and theology, of the arts, of education, of sociology, of language, of folklore and ethnography, of economics and politics, of literature, of societies.

In the years since then, the *Journal of the History of Ideas* has continued to explore the subtle ways in which one idea in history leads to another. Here are some recent articles: Plato's effects on Calvin, Nietzsche's admiration for Socrates, Buddhism and nineteenth-century German thought, a pre-Freudian psychologist of the unconscious (Israel Salanter, 1810–1883), the link between Newton and Adam Smith, between Emerson and Hinduism, Bayle's anticipation of Karl Popper, the parallels between late antiquity and Renaissance Florence. Perhaps the most substantial spin-off of the *Journal* was the *Dictionary of the History of Ideas*, published in 1973 and edited by Philip P. Wiener, who had followed Lovejoy as editor-in-chief. This massive work, in four volumes, of 2,600 pages, had 254 contributors, seven associate editors, including Isaiah Berlin and Ernest Nagel, and seven

* Here is something else to bear in mind – that to be influential an idea does not have to be *right*. The critic Paul Robinson made the same point about Sigmund Freud in the twentieth century: 'The dominant intellectual presence of our century was, for the most part, wrong.'[37]

contributing editors, among whom were E. H. Gombrich, Paul O. Kristeller, Peter B. Medawar and Meyer Schapiro.[40] The dictionary identified nine core areas – these were: ideas about the external order of nature; ideas about human nature; literature and aesthetics; ideas about history; economic, legal and political ideas and institutions; religion and philosophy; formal logical mathematical and linguistic ideas. As one reviewer remarked, 'it is a vast intellectual Golconda'.

In an essay in the *Journal*, to mark fifty years of publication, one contributor singled out three failures worthy of note. One was the failure of historians to come up with any understanding of what one big modern idea really means – this was 'secularisation'; another was the widespread disappointment felt about 'psychohistory' when so many figures – Erasmus, Luther, Rousseau, Newton, Descartes, Vico, Goethe, Emerson, Nietzsche – cry out for a deep psychological understanding; and the third was the failure among both historians and scientists to get to grips with 'imagination' as a dimension in life generally and in particular so far as the production of ideas is concerned. These alleged failures are something worth bearing in mind as this history proceeds.[41]

In the pages of the *Journal of the History of Ideas* a distinction is often made between 'the history of ideas' (an English language, and mainly American, usage), and several German terms – *Begriffsgeschichte* (the history of concepts), *Geistesgeschichte* (history of the human spirit), *Ideengeschichte* (history of ideas), *Wörtegeschichte* (history of individual words) and *Verzeitlichung* (the anachronistic disposition to insert modern concepts into historical processes). These are useful terms for scholars, for refining the subject. The general reader, however, needs only to be aware that this deeper level of analysis is there, should they wish to take their interest further.

In this Introduction, by discussing the theories and arguments of others, I have tried to give a flavour of what a history of ideas is and can be. But perhaps another, altogether simpler way of looking at this book is as an alternative to more conventional history – as history with the kings and emperors and dynasties and generals left out, with the military campaigns, the empire-building conquests and the peace treaties and truces omitted. There is no shortage of such histories and I assume here that readers will know the bare bones of historical chronology. But although I do not explore particular military campaigns, or the deeds of this or that king or emperor, I do discuss advances in military tactics, the invention of new and influential weapons, theories of kingship and the intellectual battles between kings and popes for the minds of men. I do not discuss in any detail the actual conquest of America but I do dwell on the thinking that led to the discovery of the New World and the ways in which that discovery changed how Europeans and Muslims (for example) thought. I do not describe the build-up of empires but I do discuss the idea of empire, and of colonialism. I explore 'The imperial mind', how for example the British changed Indian thinking and vice versa. Ideas about race haven't always been as contentious as they are now and that, in itself, is a matter of interest and importance.

One set of arguments I make space for is the alternative to Lovejoy's 'Great Chain' thesis, as epitomised by James Thrower's excellent, if little-known, *The Alternative Tradition*.[42] This is a fascinating exploration of naturalistic views of the past, in other words ideas

which seek to explain the world – its existence and order – without recourse to God or the gods. In my view this tradition has not had the attention it merits (and is needed now more than ever). Thrower's book is discussed in Chapter 25.

I have introduced many 'little' ideas that I found fascinating but are rarely included in more conventional histories, despite being indispensable: who had the idea to divide time into BC and AD and when? Why do we divide a circle into 360 degrees? When and where were the 'plus' and 'minus' signs (+ and −) introduced into mathematics? We live in an age of suicide bombers, who do what they do because they believe they will earn an honoured place in paradise – where does this strange notion, paradise, come from? Who discovered the Ice Age and how and why did it come about? My aim throughout has been to identify and discuss those ideas and inventions that have had a long-term influence on the way we live or have lived and think. I do not expect everyone to agree with my choice, but this is a long book and I urge any reader who thinks I have made serious omissions to write to me. I also urge the reader to consult the notes at the back of the book. Many aspects of the past are the subject of fascinating dispute among scholars. To have laid out these disagreements fully in the main text would have held up the narrative unreasonably, but I do make space for the more important intellectual sword-fights in the notes.

# Prologue

## *The Discovery of Time*

On the evening of Wednesday, 1 May 1859, John Evans, a British archaeologist, crossed the English Channel by steamer from Folkestone to Boulogne. He took the train to Abbeville where he was met by Joseph Prestwich, a renowned British geologist. Next morning they were collected at seven o'clock by Jacques Boucher de Crèvecoeur de Perthes, chief customs officer in the town but also an amateur archaeologist. Evans and Prestwich were in France to investigate certain discoveries of their host.

Since 1835 workmen quarrying gravel from the river on the outskirts of Abbeville had been turning up ancient animal bones alongside different types of stone implements. These stone tools had convinced Boucher de Perthes that mankind was much more ancient than it said in the Bible. According to a number of ecclesiastical authorities, basing their calculations on the genealogies in Genesis, mankind was created between 6,000 and 4,000 years before Christ. Boucher de Perthes had been confirmed in his very different view when, in the course of excavations made for a new hospital in the Abbeville area, three stone hand-axes had been found alongside the molar tooth of a species of elephant long since extinct in France.

Nonetheless, he had great difficulty convincing his fellow Frenchmen that his 'evidence' proved that man dated back hundreds of thousands of years. There was no shortage of expertise in France at that time – Laplace in astronomy, Cuvier, Lartet and Scrope in geology and natural history, Picard in palaeontology. But in the latter discipline the experts tended to be 'amateurs' in the true sense of the word, lovers of the subject who were scattered about the country, digging in their own localities only, and divorced from the high-profile publication outlets, such as the French Academy. Furthermore, in Boucher de Perthes' case his credibility was a particular problem because he had taken up archaeology only in his fifties, and had before that authored several five-act plays, plus works on political, social and metaphysical subjects, filling no fewer than sixty-nine heavy volumes. He was seen in some circles as a jack-of-all-trades. It didn't help either that he presented his discoveries as part of a fantastic theory that early man had been completely wiped out by a worldwide catastrophe and later on created anew. The British were more sympathetic, not because their scientists were better than the French – they were not – but because similar discoveries had been made north of the Channel – in Suffolk, in Devon, and in Yorkshire. In 1797, John Frere, a local antiquary, found at Hoxne, near Diss in Suffolk, a number of hand-axes associated with extinct animals in a natural stratum about eleven feet below the surface. In 1825, a Catholic priest, Father John MacEnery, excavating Kent's

Cavern, near Torquay in Devon, found 'an unmistakeable flint implement' in association with a tooth of an extinct rhinoceros – both lying in a level securely sealed beneath a layer of stalagmite.[1] Then, in 1858, quarrying above Brixham harbour, not far away and also in Devon, exposed a number of small caves, and a distinguished committee was set up by the Royal Society and the Geographical Society to sponsor a scientific excavation. Fossilised bones of mammoth, lion, rhinoceros, reindeer and other extinct Pleistocene animals were found embedded in a layer of stalagmite and, beneath that, 'flints unmistakably shaped by man'.[2] That same year, Dr Hugh Falconer, a distinguished British palaeontologist, and a member of the committee which sponsored the Brixham excavations, happened to call on Boucher de Perthes on his way to Sicily. Struck by what he saw, Falconer persuaded Prestwich and Evans, as members of the professional disciplines most closely involved, to see for themselves what had been unearthed at Abbeville.

The two Englishmen spent just a day and a half in France. On Thursday morning they looked at the gravel pits in Abbeville. There, according to the account in Evans' diary: 'We proceeded to the pit where sure enough the edge of an axe was visible in an entirely undisturbed bed of gravel and eleven feet from the surface . . . One of the most remarkable features of the case is that nearly all if not quite all of the animals whose bones are found in the same beds as the axes are extinct. There is the mammoth, the rhinoceros, the Urus – a tiger, etc. etc.' Evans and Prestwich photographed a hand-axe *in situ* before returning to London. By the end of May Prestwich had addressed the Royal Society in London, explaining how the recent discoveries in both Britain and France had convinced him of the 'immense antiquity' of man and, in the following month, Evans addressed the Society of Antiquaries, advocating the same conclusion. Several other prominent academics also announced their conversion to this new view about the early origins of mankind.[3]

It is from these events that the modern conception of time dates, with a sense of the hitherto unimagined antiquity of mankind gradually replacing the traditional chronology laid down in the Bible.[4] That change was intimately bound up with the study of stone tools.

This is not to say that Boucher de Perthes was the first person to doubt the picture painted in the Old Testament. Flint axes had been known since at least the fifth century BC, when a Thracian princess had formed a collection of them and had them buried with her, possibly for good luck.[5] The widespread occurrence of these strange objects led to many fanciful explanations for stone tools. One popular theory, shared by Pliny among others, held them to be 'petrified thunderbolts', another had it that they were 'fairy arrows'. Aldrovandus, in the mid-seventeenth century, argued that stone tools were due to 'an admixture of a certain exhalation of thunder and lightning with metallic matter, chiefly in dark clouds, which is coagulated by the circumfused moisture and conglutinated into a mass (like flour with water) and subsequently indurated with heat, like a brick'.[6]

Beginning in the age of exploration, however, in the sixteenth and seventeenth centuries, mariners began encountering hunter-gatherer tribes in America, Africa and the Pacific, and some of these still used stone tools. Mainly as a result of this, the Italian geologist Georgius Agricola (1490–1555) was one of the first to express the view that stone tools found in Europe were probably of human origin. So too did Michel Mercati (1541–1593)

who, as superintendent of the Vatican botanical gardens and physician to Pope Clement VII, was familiar with stone tools from the New World that had been sent to Rome as gifts.[7] Another was Isaac La Peyrère, a French Calvinist librarian who, in 1655, wrote one of the first books to challenge the biblical account of creation. Others, such as Edward Lhwyd, were beginning to say much the same, but Peyrère's book proved very popular – an indication that he was saying something that ordinary people were willing to hear – and it was translated into several languages. In English it was called *A Theological Systeme upon that presupposition that Men were before Adam.* He identified 'thunderstones' as the weapons of what he called a 'pre-Adamite' race of humans, which he claimed had existed before the creation of the first Hebrews, in particular Assyrians and Egyptians. As a result, he said that Adam and Eve were the founding couple only of the Jews. Gentiles were older – pre-Adam. Peyrère's book was denounced, as 'profane and impious', he himself was seized by the Inquisition, imprisoned, and his book burned on the streets of Paris. He was forced to renounce both his 'pre-Adamite' arguments and even his Calvinism, and died in a convent, 'mentally battered'.[8]

Despite this treatment of Peyrère, the idea of man's great antiquity refused to die, reinforced – as we have seen – by fresh discoveries. However, none of these finds had quite the impact they deserved, for at the time geology, the discipline that formed the background to the discovery of stone implements, was itself deeply divided. The surprising fact remains that until the late eighteenth century the age of the earth was not the chief area of interest among geologists. What concerned them most was whether or not the geological record could be reconciled with the account of the earth's history in Genesis. As we shall see in more detail in Chapter 31, geologists were divided over this into catastrophists and uniformitarians. 'Catastrophists' – or 'Diluvialists' – were the traditionalists who, in sticking to the biblical view of creation, the oldest written record then available to Europeans, explained the past as a series of catastrophes (floods mainly, hence 'Diluvialists') that repeatedly wiped out all life forms, which were then recreated, in improved versions, by God. On this basis, the story of Noah's Flood, in Genesis, is an historical record of the most recent of these destructions.[9] The Diluvialists had the whole weight of the church behind them and resisted rival interpretations of the evidence for many decades. For example, it was believed at one stage that the first five days of the biblical account of the creation referred allegorically to geological epochs that each took a thousand years or more to unfold. This meant that the creation of humans 'on the sixth day' occurred about 4000 BC, with the deluge of Noah following some 1,100 years later.

The traditionalist argument was also supported – albeit indirectly – by the great achievements of nineteenth-century archaeology in the Middle East, in particular at Nineveh and at Ur-of-the-Chaldees, the mythical home of Abraham. The discoveries of the actual names in cuneiform of biblical kings like Sennacherib, and kings of Judah, like Hezekiah, fitted with the Old Testament chronology and added greatly to the credibility of the Bible as a historical document. As the museums of London and Paris began to fill with these relics, people started to refer to 'scriptural geology'.[10]

Against this view, the arguments of the so-called uniformitarians began to gain support. They argued the opposing notion, that the geological record was continuous and continuing, that there had been no great catastrophes, and that the earth we see about us was

formed by natural processes that are exactly the same now as in the past and that we can still observe: rivers cutting valleys and gorges through rocks, carrying silt to the sea and laying it down as sediment, occasional volcanic eruptions, and earthquakes. But these processes were and are very slow and so for the uniformitarians the earth had to be much older than it said in the Bible. Rather more important in this regard than Peyrère was Benoît de Maillet. His *Telliamed*, published in 1748 but very likely written around the turn of the century, outlined a history of the earth that made no attempt to reconcile its narrative with Genesis. (Because of this, de Maillet presented his book as a fantastic tale and as the work of an Indian philosopher, Telliamed, his own name spelled backwards.) De Maillet argued that the world was originally covered to a great depth by water. Mountains were formed by powerful currents in the water and as the waters receded they were exposed by erosion and laid down debris on the seabed to form sedimentary rocks.[11] De Maillet thought that the oceans were still retreating in his day, by small amounts every year, but his most significant points were the absence of a recent flood in his chronology, and his argument that, with the earth starting in the way that he said it did, vast tracts of time must have elapsed before human civilisation appeared. He thought that life must have begun in the oceans and that each terrestrial form of being had its equivalent marine form (dogs, for example, were the terrestrial form of seals). Like Peyrère, he thought that humans existed before Adam.

Later, but still in France, the comte de Buffon, the great naturalist, calculated (in 1779) that the age of the earth was 75,000 years, which he later amended to 168,000 years, though his private opinion, never published in his lifetime, was that it was nearer half a million years old. He too sweetened his radical views by arguing that there had been seven 'epochs' in the formation of the earth – this allowed more orthodox Christians to imagine that these seven epochs were analogous to the seven days of creation in Genesis.

Such views were less fanciful at the time than they seem now. The classic summing up of the 'uniformitarian' argument was published by Charles Lyell in his *Principles of Geology*, three volumes released between 1830 and 1833. This used many of Lyell's own observations made on Mount Etna in Sicily, but also drew on the work of other geologists he had met on mainland Europe, such people as Étienne Serres and Paul Tournal. In *Principles*, Lyell set out, in great detail, his conclusion that the past was one long uninterrupted period, the result of the same geological processes acting at roughly the same rate that they act today. This new view of the geological past also suggested that the question about man's own antiquity was capable of an empirical answer.[12] Among the avid readers of Lyell's book, and much influenced by it, was Charles Darwin.

If the gradual triumph of uniformitarianism proved the very great antiquity of the earth, it still did not necessarily mean that man was particularly old. Lyell himself was just one who for many years accepted the antiquity of the earth but not of man. Genesis might be wrong but in what way and by how much? Here the work of the French anatomist and palaeontologist Georges Cuvier was seminal. His study of the comparative anatomy of living animals, especially vertebrates, taught him to reconstruct the form of entire creatures based on just a few bones. When fossil bones came to be much studied in the late eighteenth century, Cuvier's technique turned out to be very useful. When this new knowledge was

put together with the way the fossil bones were spread through the rocks, it emerged that the animals at deeper levels were (a) very different from anything alive today and (b) no longer extant. For a time it was believed that these unusual creatures might still be found, alive, in undiscovered parts of the world, but such a hope soon faded and the view gained ground that there has been *a series* of creations and extinctions throughout history. This was uniformitarianism applied to biology as well as geology and, once again, it was nothing like Genesis. The evidence of the rocks showed that these creations and extinctions took place over very long periods of time, and when the mummified bodies of Egyptian pharaohs were brought back to France as part of the Napoleonic conquests, and showed humans to have been *unchanged* for thousands of years, the great antiquity of man seemed more and more likely.

Then, in 1844, Robert Chambers, an Edinburgh publisher and polymath, released (anonymously) his *Vestiges of the Natural History of Creation*. As James Secord has recently shown, this book produced a sensation in Victorian Britain because it was Chambers (and not Darwin) who introduced the general idea of evolution to the wider public. Chambers had no idea *how* evolution worked, how natural selection caused new species to arise, but his book argued in great and convincing detail for an ancient solar system which had begun in a 'fire-mist', coalesced under gravity and cooled, with geological processes, tremendous and violent to begin with, gradually getting smaller but still taking aeons to produce their effects. Chambers envisaged an entirely natural and material origin of life and argued openly that human nature 'did not stem from a spiritual quality marking him off from the animals but was a direct extension of faculties that had been developing throughout the evolutionary process'.[13] And this was the single most important sentence in the book: 'The idea, then, which I form of the progress of organic life upon the globe – and the hypothesis is applicable to all similar theatres of vital being – is, *that the simplest and most primitive type, under a law to which that of like production is subordinate, gave birth to the type next above it, that this again produced the next higher, and so on to the very highest*, the stages of advance being in all cases very small – namely, from one species to another; so that the phenomenon has always been of a simple and modest character.'[14]

By this time too there had been parallel developments in another new discipline, archaeology. Although the early nineteenth century saw some spectacular excavations, mainly in the Middle East, antiquarianism, an interest in the past, had remained strong since the Renaissance, especially in the seventeenth century.[15] In particular there had been the introduction of the tripartite classification scheme – Stone Age, Bronze Age and Iron Age – that we now take so much for granted. It occurred first in Scandinavia, owing to an unusual set of historical factors.

In 1622, Christian IV of Denmark issued an edict protecting antiquities, while in Sweden a 'State Office of Antiquities' was founded in 1630. Sweden established a College of Antiquities in that year and Ole Worm, in Denmark, founded the Museum Wormianum in Copenhagen.[16] At the very beginning of the nineteenth century, there was a period of growing nationalism in Denmark. This owed a lot to its battles with Germany over Schleswig-Holstein, and to the fact that the British – fighting Napoleon and his reluctant continental allies – annihilated most of the Danish navy in Copenhagen harbour in 1801,

and attacked the Danish capital again in 1807. One effect of these confrontations, and the surge in nationalism which followed, was to encourage the study of the kingdom's own past 'as a source of consolation and encouragement to face the future'.[17] It so happens that Denmark is rich in prehistoric sites, in particular megalithic monuments, so the country was particularly well suited to the exploration of its more remote national past.

The key figure here was Christian Jürgensen Thomsen, who originally trained as a numismatist. Antiquarianism had first been stimulated by the Renaissance rediscovery of classical Greece and Rome and one aspect of it, collecting coins, had become particularly popular in the eighteenth century. From their inscriptions and dates it was possible to arrange coins into sequence, showing the sweep of history, and stylistic changes could be matched with specific dates. In 1806, Rasmus Nyerup, librarian at the University of Copenhagen, published a book advocating the setting up of a National Museum of Antiquity in Denmark modelled on the Museum of French Monuments established in Paris after the Revolution. The following year the Danish government announced a Royal Committee for the Preservation and Collection of National Antiquities which did indeed include provision for just such a national museum. Thomsen was the first curator, and when its doors were opened to the public, in 1819, all the objects were assigned either to the Stone, Brass (Bronze) or Iron Age in an organised chronological sequence. This division had been used before – it went back to Lucretius – but this was the first time anyone had addressed the idea practically, by arranging objects accordingly. By then the Danish collection of antiquities was one of the largest in Europe, and Thomsen used this fact to produce not only a chronology but a procession of styles of decoration that enabled him to explore how one stage led to another.[18]

Though the museum opened in 1819, Thomsen did not publish his research and theories until 1836, and then only in Danish. This, a *Guide Book to Northern Antiquities*, was translated into German the following year and appeared in English in 1848, four years after Chambers had published *Vestiges*. Thus the three-age system gradually spread across Europe, radiating out from Scandinavia. The idea of cultural evolution paralleled that of biological evolution.

At much the same time, scholars such as François de Jouannet became aware of a difference in stone tools, between chipped implements found associated with extinct animals, and more polished examples, found in more recent local barrows, well after the age of extinct animals. These observations eventually gave rise to the four-age chronology: old Stone Age, new Stone Age, Bronze Age, and Iron Age.

And so, by May 1859, when Evans and Prestwich returned from their visit with Boucher de Perthes in Abbeville, the purpose, importance and relevance of stone hand-axes could no longer be denied, or misinterpreted. Palaeontologists, archaeologists and geologists across Europe had helped build up this picture. There was still much confusion, however. Édouard Lartet, Cuvier's successor in Paris, was convinced about the antiquity of man, as was Prestwich. But Lyell, as we have seen, opposed the idea for years (he sent a famous letter to Charles Darwin in which he apologised for his unwillingness 'to go the whole orang'). And Darwin's main aim, when he published *On the Origin of Species by Means of Natural Selection or the Preservation of Favoured Races in the Struggle for Life*, in the same

year that Prestwich and Evans returned from France, was *not* to prove the antiquity of man: it was to show how one species could transform into another, thus building on Chambers and destroying the need for a Creator. But, in completing the revolution in evolutionary thinking that had begun with Peyrère and de Maillet, and had been popularised so much by Chambers, the *Origin* confirmed how slowly natural selection worked. Therefore, though it wasn't Darwin's main aim, his book underlined the fact that man must be much older than it said in the Bible. Among the many things natural selection explained were the changes in the palaeontological record. The very great antiquity of man was established.

Once this was accepted, ideas moved forward rapidly. In 1864, an Anglo-French team led by Edouard Lartet and Henry Christy, a London banker-antiquary, excavated a number of rock shelters in Perigord in France, and this led, among other things, to the discovery of an engraved mammoth tusk at La Madeleine, showing a drawing of a woolly mammoth. This piece 'served to remove any lingering doubts that humankind had coexisted with extinct Pleistocene animals'.[19]

What was now the four-age system served as the basis for organising the great archaeological exhibition at the Paris Exposition Universelle in 1867, where visitors could promenade room by room through the pre-history of Europe. Scientific archaeology had replaced the antiquarian tradition. 'One could now envisage a cultural history independent of the written record, reaching back to Palaeolithic times by way of the iron-age cemeteries of France and Britain, the Bronze-Age lake dwellings of Switzerland, and the Neolithic kitchen middens of Denmark...'[20] When Charles Lyell finally came round to the new view, in his *Geological Evidences for the Antiquity of Man* (1863), his book sold 4,000 copies in the first weeks and two new editions appeared in the same year.

Since then, as we shall see in Chapter 1, ancient stone tools have been found all over the world, and their distribution and variation enable us to recreate a great deal about our distant past and the first ideas and thoughts of ancient humankind. In the century and a half since Prestwich and Evans confirmed de Perthes' discoveries, the dating of the original manufacture of stone tools has been pushed back further and further, to the point where this book properly starts: the Gona river in Ethiopia 2.7 million years ago.

# PART ONE

# LUCY TO GILGAMESH
## The Evolution of Imagination

# 1

## *Ideas Before Language*

George Schaller, director of the Wildlife Conservation Division of the New York Zoological Society, is known to his fellow biologists as a meticulous observer of wild animals. In a long and distinguished career he has made many systematic studies of lions, tigers, cheetahs, leopards, wild dogs, mountain gorillas and hyenas. His book, *The Last Panda*, published in 1993, recorded many new and striking facts about the animal the Chinese call the 'bear-cat'. He found that on one occasion a sick panda had gone freely to a human family in the Wolong area, where it was fed sugar and rice porridge for three days, until it recovered and returned to the forest.[1]

In the late 1960s Schaller and a colleague spent a few days on the Serengeti plain in Tanzania, East Africa, where they made a simple observation which had escaped everyone else. In the course of those few days, they stumbled across quite a lot of dead meat 'just lying around'. They found dead buffalo, the butchered remains of lion kills, and they also came across a few incapacitated animals that would have been easy prey for carnivores. Smaller deer (like Thompson's gazelles) remained uneaten for barely a day but larger animals, such as adult buffalo, 'persisted as significant food resources' for about four days.[2] Schaller concluded from this that early humans could have survived quite easily on the Serengeti simply by scavenging, that there was enough 'ruin' in the bush for them to live on without going hunting. Other colleagues subsequently pointed out that even today the Hadza, a hunter-gathering tribe who live in northern Tanzania, sometimes scavenge by creeping up on lions who have made a kill and then creating a loud din. The lions are frightened away.

This outline of man's earliest lifestyle is conjectural.[3] And to dignify the practice as an 'idea' is surely an exaggeration: this was instinct at work. But scavenging, unromantic as it sounds, may not be such a bad starting-point. It may even be that the open African savannah was the type of environment which favoured animals who were generalists, as much as specialists, like a hippopotamus, for example, or a giraffe, and it is this which stimulated mankind's intelligence in the first place. The scavenging hypothesis has, however, found recent support from a study of the marks made on bones excavated at palaeontological sites: animals killed by carnivores do show tool marks but fewer than those butchered by humans. It is important to stress that meat-eating in early humans does not, in and of itself, imply hunting.[4]

There are two candidates for humankind's first idea, one rather more hypothetical than the other. The more hypothetical relates to bipedalism. For a long time, ever since the

publication of *The Descent of Man* by Charles Darwin in 1871, the matter of bipedalism was felt to be a non-issue. Following Darwin, everyone assumed that man's early ancestors descended from the trees and began to walk upright because of changes in the climate, which made rainforest scarcer and open savannah more common. (Between 6.5 million and 5 million years ago, the Antarctic ice-cap sucked so much water from the oceans that the Mediterranean was drained dry.) This dating agrees well with the genetic evidence. It is now known that the basic mutation rate in DNA is 0.71 per cent per million years. Working back from the present difference between chimpanzee and human DNA, we arrive at a figure of 6.6 million years ago for the chimpanzee–human divergence.[5]

Several species of bipedal ape have now been discovered in Africa, all the way back to *Sahelanthropus*, who lived six to seven million years ago in the Djurab desert of Chad and was close to the common ancestor for chimpanzees and humans.[6] But the human ancestor which illustrates bipedalism best is *Australopithecus afarensis*, better known as 'Lucy', because on the night she was discovered the Beatles' song 'Lucy in the Sky with Diamonds' was playing in the palaeontologists' camp. Enough of Lucy's skeleton survives to put beyond doubt the fact that, by 3.4 to 2.9 million years ago, early humans were bipedal.

It is now believed that the first and most important spurt in the brain size of man's direct ancestors was associated with the evolution of bipedalism. (Most important because it was the largest; there is evidence that our brains are, relative to our bodies, slightly smaller now than in the past.)[7] In the new, open, savannah-type environment, so it is argued, walking upright freed the arms and hands to transport food to the more widely scattered trees where other group members were living. It was bipedalism which also freed the hands to make stone tools, which helped early man change his diet to a carnivorous one which, in providing much more calorie-rich food, enabled further brain growth. But there was a second important consequence: the upright posture also made possible the descent of the larynx, which lies much lower in the throat of humans than in the apes.[8] At its new level, the larynx was in a much better position to form vowels and consonants. In addition, bipedalism also changed the pattern of breathing, which improved the quality of sound. Finally, meat, as well as being more nutritious, was easier to chew than tough plant material, and this helped modify the structure of the jaw, encouraging fine muscles to develop which, among other things, enabled subtler movements of the tongue, necessary for the varied range of sounds used in speech. Cutting-tools also supplemented teeth which may therefore have become smaller, helpful in the development of speech. None of this was 'intended', of course; it was a 'spin-off' as a result of bipedalism and meat-eating. A final consequence of bipedalism was that females could only give birth to relatively small-brained offspring – because mothers needed relatively narrow pelvises to be able to walk efficiently. From this it followed that the infants would be dependent on their mothers for a considerable period, which in turn stimulated the division of labour between males and females, males being required to bring back food for their mates and offspring. Over time this arrangement would have facilitated the development of the nuclear family, making the social structure of the cognitive group more complex. This complex structure, in which people were required to predict the behaviour of others in social situations, is generally regarded as the mechanism by which consciousness evolved. In predicting the behaviour of others, an individual would have acquired a sense of self.

This is all very neat. Too neat, as it turns out. Whereas early humans began walking upright six million years ago, the oldest stone tools are about 2.5 to 2.7 million years old (and maybe even three million years old) – too long a time-lag for the developments to be directly linked. Second, modern experiments have shown that bipedalism does not increase energy efficiency, and as more fossils have been found we now recognise that early bipedal apes lived in environments where trees were plentiful.[9] In these circumstances, Nina Jablonski and George Chaplin, of the California Academy of Sciences, have suggested that the real reason humans became bipedal was as a way to appear bigger and more threatening in contests with other animals, and in so doing avoid punishing conflicts and gain access to food. The idea behind this is taken from observations of gorilla and chimpanzee behaviour in the wild. Both types of ape stand upright, swagger, wave their arms about and beat their chests when threatening others in contests over food or sexual partners. Such displays are not always effective but they are often enough for Jablonski and Chaplin to suggest that 'individuals who learned to defuse tense situations with bipedal displays could have reduced their risk of injury or death and thus, by definition, improved their reproductive chances'. On this scenario, then, bipedalism, though a physical change to the body frame of early humans, developed because it had behavioural – psychological – consequences of an evolutionary kind. Almost certainly, however, it too had a large instinctive element, and for that reason can at best be called a proto-idea.[10]

The second candidate for man's earliest idea is much better documented. This is the emergence of stone tools. As we shall see, the manufacture of stone tools went through at least five major phases in pre-history, as early man's handling of raw stone became more sophisticated. The most important dates to remember, when major changes in technology occurred, are 2.5 million years ago, 1.7 million, 1.4 million, 700,000, and 50,000–40,000 years ago.[11] The oldest artefacts yet discovered come from the area of the river Gona in Ethiopia. They consist mainly of selected volcanic pebbles from ancient streambeds and are often difficult to distinguish from naturally-occurring rocks. At some point, about 2.5 million years ago, ancient man learned that if he struck one stone against another in a particular way, a thin, keen-edged flake could be knocked off which was sharp enough to pierce the hide of a dead zebra, say, or a gazelle. To the untutored eye, a primitive stone axe from Gona looks little different from any pebble in the area. Archaeologists have noticed, however, that when a flake is deliberately manufactured by another rock being struck against it, it usually produces a distinctive swelling, known as a 'bulb of percussion' immediately next to the point of impact. This is used by professionals to distinguish human artefacts from mere broken stones arising from natural 'collisions' as a result, for example, of water action.[12]

Although a cultural artefact, the link between stone tools and man's later *biological* development was momentous. This is because, until 2.5 million years ago, early man's diet was vegetarian. The invention of stone tools, however, enabled him to eat meat – to get at the muscles and internal organs of big and small game – and this had major consequences for the development of the brain. All mammals – primates, and especially humans – are highly encephalised: they have brains that are large when compared with their body mass. Compared with reptiles of the same size, for example, mammals have brains that are, roughly, four times as big.[13] In modern humans, the brain comprises only 2 per cent of

body weight, but it consumes 20 per cent of the body's metabolic resources. As we shall see, each major change in stone technology appears to have been accompanied by an increase in brain size, though later increases were nowhere near as large as the first spurt.[14]

That some major change in brain structure – in size and/or organisation – occurred about 2.5 million years ago is not in doubt. At one stage it was thought that tool-making was a defining characteristic of 'humanity' but that was before Jane Goodall in the 1960s observed chimpanzees pulling the leaves off twigs so they could insert the twigs into termite mounds, and then withdraw them – by now suitably coated with termites – to be eaten at leisure. Chimpanzees have also been observed cracking open nuts using stones as 'hammers' and, in Uganda, using leafy twigs as fans, to keep insects away. However, palaeontologists recognise two important ways in which early hominid stone tools differ from the tools produced by other primates. The first is that some of the stone tools were produced to manufacture *other* tools – such as flakes to sharpen a stick. And second, the early hominids needed to be able to 'see' that a certain type of tool could be 'extracted' from a certain type of rough rock lying around. The archaeologist Nicholas Toth of Indiana University spent many hours trying to teach a very bright bonobo (a form of pygmy chimpanzee), called Kanzi, to make stone tools. Kanzi did manage it, but not in the typical human fashion, by striking one stone against another. Instead, Kanzi would hurl the stones against the concrete floor of his cage. He just didn't possess the mental equipment to 'see' the tool 'inside' the stone.[15]

Early stone tools similar to those found on the Gona river have also been found at Omo in southern Ethiopia, at Koobi Fora, on lake Turkana just across the border in Kenya and, controversially, in the Riwat area of northern Pakistan. In some circles these tools are referred to as the Omo Industrial Complex. The Omo industry is followed by the second type of stone tool, called Oldowan, after the Olduvai gorge, and dating to between 2.0 and 1.5 million years ago. Olduvai, in Tanzania, near the southern edge of the Serengeti plain, is probably the most famous location in palaeontology, providing many pioneering discoveries.

Stone tools, in general, do not occur in isolation. At several sites in Olduvai, which have been dated to about 1.75 million years ago, the tools were found associated with bones and, in one case, with larger stones which appear to be fashioned into a rough semi-circle. The feeling among some palaeontologists is that these large stones formed a primitive wind-break (man's second idea?), offering shelter while animals were butchered with the early hand-axes. The stone tools in use 1.7 million years ago were already subtly different from the very earliest kinds. Louis and Mary Leakey, the famous 'first family' of palae-ontologists, who excavated for many years at Olduvai gorge, carefully studied Oldowan technology and although by later standards the stone tools were very primitive, the Leakeys and their colleagues were able to distinguish four 'types' – heavy duty choppers, light duty flakes, used pieces and what is known as *débitage*, the material left over after the tools have been produced. There is still much discussion as to whether the early hominids at Olduvai were passive scavengers, or confrontational scavengers, as the Hadza are today.[16]

Who made these early tools? Nothing of the kind has ever been found associated with *A. afarensis* remains. By the time tools appear, various species of hominid co-existed in

Africa, two or three of which are given the family name *Paranthropus* ('alongside man'), also known as *A. robustus* and *A. boisei*, with the others belonging to *Homo* – these are *H. habilis* ('Handy man'), *H. rudolfensis* and *H. ergaster*. These different hominids varied in interesting ways that make the exact line of descent to ourselves difficult to fathom. All had bigger brains than 'Lucy' (500–800 cc, as compared with 400–500 cc), but whereas *H. habilis* had an ape-type body with more human-like face and teeth, *H. rudolfensis* was the other way round – a human-type body and more ape-like face and teeth.[17] In theory, any of these species could have produced the tools but two reasons seem to rule out *Paranthropus*. The first reason relates to the thumb of primitive man. The anthropologist Randall Susman has noticed that chimpanzees have very different thumbs from human beings. Chimps have curved, narrow-tipped fingers and short thumbs – ideal for grasping tree limbs. Humans, on the other hand, have shorter, straighter fingers with squat tips, and larger, stouter thumbs. This is a better arrangement for grasping things like stones. On examination, it turns out that *A. afarensis* had chimpanzee-like thumbs and so, probably, did *Paranthropus*. A second reason is that, if *Paranthropus* had manufactured tools, in addition to the *Homo* family, we should almost certainly find two separate tool traditions in the fossil record. We don't.

Steven Mithen, an archaeologist at the University of Reading, in Britain, has conceived the primitive mind as consisting of three entities: a technical intelligence (producing stone tools), a natural history intelligence (understanding the landscape and wildlife around him/her), and a social intelligence (the skills needed to live in groups). At the level of *H. habilis*, says Mithen, there is no evidence that social intelligence was integrated with the other two. The stone tools are associated with animal bones – the victims of early hunters. But from the evidence so far obtained there is no social separation of tools and food, no evidence at all of organised group activity – the earliest archaeological sites are just a jumble of tools and bones.[18]

From this faltering beginning, a major step forward was taken some time between 1.8 and 1.6 million years ago, with the appearance of another new species, *Homo erectus* – upright man – found first at Koobi Fora and then in Java. With his 'sad, wary face and flat nose', *H. erectus* was the first human to leave Africa, other remains having been found in Dmanisi in Georgia, and in mainland Asia: in October 2004 stone tools believed to have been made by *H. erectus* were reported as having been found in Majuangou, west of Beijing, and dated to 1.66 million years ago.[19] He or she shows a further increase in brain size, the second-most sizeable jump – but perhaps the most important of all – to 750–1,250 cc, though the skulls were also marked by robust brow ridges.[20] After what we may call a 'technology lag' of about 400,000 years, we find that at around 1.4 million years ago, the earliest true hand-axes appear. These, the third type of hand-axe, are 'true' in the sense that they are now symmetrical, formed by knocking flakes off the core alternately from either side, to produce an elegant long point and a stone with a pear shape. These are known to professionals as Acheulian because they were first discovered by French archaeologists in the Amiens suburb of St Acheul. (Much stone-age terminology is based on the place names of French sites – Cro-Magnon, Mousterian, Levallois – where French archaeologists were the first to make the discoveries.) These hand-axes appear abruptly in the archaeological record in Africa, Europe and parts of Asia (though much less so in

south-west Asia and not at all in south-east or east Asia). Some palaeontologists believe that *H. erectus* was a hunter, the first true hunter, rather than a scavenger, and that his better tools enabled him to spread across Eurasia, what is sometimes called the Old World.

*Homo erectus* may also have invented cooking. This is inferred because, although he was 60 per cent larger than his predecessors, he had a smaller gut and teeth. This could be accounted for by cooking which, in breaking down the indigestible fibre of plants into energy-giving carbohydrate, puts fewer demands on the teeth and alimentary canal. For this reason, the most interesting *H. erectus* site is probably Zhoukoudien (literally 'Dragon Bone Hill'), a cave situated about twenty-five miles south-west of Beijing in a range of limestone hills. In a series of excavations carried out mainly in the 1930s, the site was dated to about 400,000–300,000 years ago. The significance of Zhoukoudien is that it appears to have been a base camp from which *H. erectus* hunted and brought back their kills to be cooked and eaten. But were the animals (again, large mammals such as elephants, rhinoceros, boars and horses) actually cooked? A quantity of hackberry seeds was found at Zhoukoudien, making them the earliest plant remains known, and they probably survived only because they had been burnt. The consensus now appears to be that this *wasn't* the purposeful use of fire, as we would understand it, but the issue – like so much else at that period – remains unresolved.[21]

Claims have been made for the use of fire as far back as 1.42 million years ago. At least thirteen African sites provide evidence, the earliest being Chesowanja in Kenya, which contained animal bones alongside Oldowan tools and burnt clay. As many as fifty pieces of burnt clay were found and, to some palaeontologists, the layout of certain stones suggested a hearth. Tantalisingly, no burnt clay was found outside this narrow area and tests on the clay itself showed it to have been fired to about 400°, roughly typical of campfires.[22] Stone tools have been found in association with burnt animal remains at several sites in China dating from before one million years ago. Johan Goudsblom has pointed out that no animal species controls fire, as humans do. Some prehistorians believe that early humans may have followed fire, because roasted animal flesh is better preserved (chimpanzees have been observed searching for afzelia beans after bush fires; normally too tough to eat, after a fire they crumble easily).[23] The archaeologist C. K. Brain advanced the idea that it was man's control of fire which helped convert him from being the prey of the big cats to being a predator – fire offered protection that earlier man lacked. And in Spain there is evidence of the use of fire as a way to corral elephants into a bog, where they were butchered. Later, keeping a fire alive continuously would have encouraged social organisation.[24] The latest evidence reports a campfire, with burnt flint fragments, in tiny clusters, suggesting hearths, dated to 790,000 years ago, at Gesher Benot Ya'aqov in northern Israel. The control and use of fire may therefore count as one of primitive man's three earliest ideas.

From such ancient skulls as have been unearthed, we may conclude that there were two early spurts in brain growth, the first being the larger, each of which was associated with a change in stone technology: these were the first tools, associated with *H. habilis*, and bifacial Acheulian tools, associated with *H. erectus*. After this, apart from the use of fire, only one thing seems to have happened for nearly a million years. This was the 'standardisation' of the hand-axe, around 700,000 years ago. Allowing for individuality,

and for the fact that, about a million years ago, *H. erectus* spread out over much of Eurasia (i.e., not the northern latitudes, Australia or the Americas) – and therefore had to deal with very different forms of stone – hand-axes everywhere nevertheless began to show an extraordinary degree of uniformity. Thousands of hand-axes have now been examined by palaeontologists from all over the world, and they have shown that, although of different sizes, most axes are constructed in almost identical proportions. This is not chance, say the experts. V. Gordon Childe, the eminent Australian archaeologist, actually went so far as to say that the standardised tool was 'a fossil idea' and that it needed a certain capacity for abstract thought on the part of *H. erectus*. In order to produce a standardised tool, Childe argued, early man needed some sort of image of tools in general. Others have gone further. 'Hand-axes from many . . . sites, show that . . . the mental apparatus already existed for [early man to make] basic mathematical transformations without the benefit of pen, paper or ruler. It was essentially the same operation as Euclid was to formalise hundreds of thousands of years later.'[25]

A third spurt in brain size occurred around 500,000–300,000 years ago, with a jump from 750–1,250 cc (for *H. erectus*), to 1,100–1,400 cc. In Africa, this new, larger-brained individual is known as archaic *H. sapiens*, and it would later give rise to the Neanderthals. After another 'technology lag', and beginning around 250,000 years ago, we see the introduction of the fourth type of stone tool, produced now by the so-called Levallois technique. Crude hand-axes die out at this point, to be replaced by stone nodules much more carefully prepared. Levallois-Perret is a suburb of Paris and it was during an excavation in the French capital that archaeologists first recognised that, instead of relying on chance, which involved striking a stone to produce a flake, early man of 250,000 years ago knew enough about stone fracture dynamics ('early physics') to be able to predict the shape of the tool he was producing. Pebbles about the size of a hand were selected, vertical flakes were knocked off the edges until a crown was produced roughly the size of the palm of a hand. Then, with a swift horizontal blow, a bevelled flake was dislodged, with a sharp edge all around. As a result of this, stone tools took many different forms (up to sixty-three different types, according to one expert), and could even be hafted, to become spear points. Not surprisingly, the technique spread quickly throughout Africa, Asia and Europe.

At much the same time, possibly earlier, around 420,000 years ago, the first hunting spears appear. What is almost certainly one of the oldest wooden artefacts ever found is the Clacton spear point, unearthed at Clacton, Essex in England in 1911 and dated to between 420,000 and 360,000 years ago. Even more impressive were three javelin-like spears found in a coal mine at Schöningen, south-west of Hanover in Germany, which date back 400,000 years. The longest is 2.3 metres (7 feet, 7 inches) in length. They are shaped like a modern javelin (with a swelling towards the front), meaning they were throwing rather than thrusting spears.[26] Ochre was also used for the first time around then. The Wonderwerk cave in South Africa may have been the earliest mine we have evidence of, for lying among the many hand-axes found in the cave are pieces of ochre chipped off local rock.[27] At Terra Amata, in the south of France – a site dated to 380,000 years ago – ochre has again been found associated with Acheulian tools, and this time the lumps show signs of wear. Does this mean they were used as 'crayons' and does that imply

symbolic behaviour on the part of early man? Tantalising, but there are tribal peoples alive today who use ochre either as a way to treat animal skins or else as an insect repellent, to staunch bleeding, or as protection from the sun. Ochre may have been the first medicament.[28]

Moving forward, to 350,000–300,000 years ago, we find at the Bilzingsleben site, near Halle in Germany, three round dwelling places, each comprising, mainly, piles of stones and bones though there is also evidence for the existence of hearths, and special tool-making areas. These early workshops still had 'anvil' stones in place.[29] In 2003 it was announced that the skulls of two *Homo sapiens* adults and a child, unearthed at the village of Herto, 140 miles north-east of Addis Ababa, had enigmatic cut-marks made with stone tools, suggesting that flesh was stripped away from their heads after death. Was this a funerary ritual of some kind?

The first signs of undisputed intentional burial date to 120,000 to 90,000 years ago, at the Qafzeh and Skhul caves in Israel.[30] The bones contained in these 'graves' were very similar to modern humans but here the picture becomes complicated by the arrival of the Neanderthals. From about 70,000 years ago, both the Neanderthals (whose remains have never been found in Africa or the Americas) and *Homo sapiens* were, at least sometimes, burying their dead. This of course is a very significant development, perhaps the next purely abstract idea after the standardisation of tools. This is because intentional burial may indicate an early concern with the afterlife, and a primitive form of religion.

The old image of the Neanderthals as brutish and primitive is now much outmoded. Quite a lot is known about their intellectual life and although it was simple compared with our own, the advance it represented on life forms that went before is clear. While they were alive, the Neanderthals developed more or less in parallel with modern humans. The latest excavations in Spain show that Neanderthals for example knew enough to 'settle' in areas of greatest biotic diversity.[31] The picture is, however, muddied by the emergence of anatomically modern humans, who seem to have arisen in Africa between 200,000 and 100,000 years ago and then spread out across the globe. They are believed to be descended from archaic *H. sapiens*, or *H. heidelbergensis*, with smaller teeth, no brow ridges, and a brain size of between 1,200 and 1,700 cc. And so from then, until around 31,000 years ago, when we find the last traces of the Neanderthals, these two forms of humanity lived side-by-side, and such artefacts as remain could belong to either. The French palaeontologist, Francesco d'Errico, concludes that both Neanderthals and *H. sapiens* showed evidence of 'modern behaviour'.[32]

Until about 60,000 years ago, for example, we find thick ash deposits, burnt bone and charcoal becoming very common in both open and cave sites.[33] Middle Palaeolithic people had fire, it appears, but they did not yet build elaborate hearths. (Middle Palaeolithic applies to the period of the Neanderthals and the fifth kind of stone hand-axe – blade tools, dating to 250,000–60,000 BP – years before the present.) Only at around 60,000 years ago do we find controlled fire, proper hearths – at Vilas Ruivas in Portugal and at Molodova on the Dnestr river in Russia – significantly associated with windbreaks made from mammoth bones. In fact, it seems that here the first undisputed use of fire may have been less for cooking, but rather for defrosting the huge carcasses of large mammals frozen in winter, and which other scavengers, like hyenas, would have been unable to touch.[34]

Some of the Neanderthal sites, especially in the Middle East, seem to show individuals who have been buried, and one was associated with flower pollen. This is disputed, however, and it is not at all clear whether these are ritual burials. In these so-called Neanderthal graves, more than one individual lies with his or her head resting on his or her arm, so in theory these people could have died in their sleep and just have been left where they were (though the practice has not been found among earlier hominids). Other burials have been accompanied by the remains of red ochre, or with goat horns stuck into the ground nearby. Though many archaeologists favour naturalistic explanations of these discoveries – i.e., the apparent association is accidental – it is quite possible that the Neanderthals did bury their dead with an associated ritual that implies some form of early religion. Certainly, at this time there is a sudden increase in the recovery of complete or nearly complete skeletons, which is also suggestive.[35]

In assessing the significance of these burials it is important to say first that the sample size consists of about sixty graves only and so, given the time-frame involved, we are talking about an average of two burials per thousand years. With that qualification in mind, there are three further factors worth discussing. One is the age and sex of the bodies buried. Many were children or juveniles, enough to suggest that there was a 'cult of the dead', in particular of children, who were buried with more ceremony than adults, designed perhaps to ensure their rebirth. At the same time, more males than females were buried, hinting that males enjoyed higher status than females. A third factor is that in one case of a Neanderthal discovered in the Shanidar caves in northern Iraq the man was blind, suffered from arthritis and had his right arm amputated just above the elbow. This individual lived till he was forty, when he was killed by a rock fall; so until this point, his colleagues had evidently looked after him.[36] The amputation of his arm also implies some medical knowledge, and this idea was further fuelled by the discovery of a second individual at Shanidar, dated to around 60,000 BP, who had been buried with no fewer than seven species of flower, all of which had medicinal properties. These included woody horsetail (*Ephedra*), which has a long history of use in Asia to treat coughs and respiratory disorders, and as a stimulant to promote endurance on protracted hunting forays.[37] Were these medicinal herbs/flowers placed in the graves as substances to help the dead on their journey to the next world, or were they, as critics claim, simply used as bedding, or, even more prosaically, blown into the caves by the wind, or buried by rodents?

The consensus now among palaeontologists and archaeologists is that, prior to about 60,000–40,000 years ago, archaic *H. sapiens* and *H. neanderthalensis* did *not* show symbolic behaviour and had a fairly limited capacity to plan ahead. Paul Mellars, of Cambridge, distinguishes three major changes at the transition to the Upper Palaeolithic. There was first a distinct shift in stone technology – in the Middle Palaeolithic 'tools do not appear to have been produced with clearly defined preconceived "mental templates" about the final, overall form of the finished tools', whereas in contrast the Upper Palaeolithic tools, the fifth kind, besides being smaller and better controlled, are far more standardised, their shapes conforming to 'clearly preconceived morphological "norms".'[38] Mellars also distinguished a change in bone technology, from the use of random fragments to the shaping of bone. And, third, from unstructured to highly structured – even rectangular – settlements. He argues that all this amounted almost to a 'culture' with 'norms' of

behaviour. By and large, he says, these changes reflect the growth of long-term planning, strategic behaviour on the part of early humans of this period, in which individuals are anticipating behaviour *in the future*.[39] He says that he does not think this could have been accomplished without language.

Other palaeontologists believe that the emergence of complicated tool-making is, in brain terms, analogous to speech and that the two activities emerged at the same time. In modern experiments, for example, James Steele and his colleagues found that, on average, 301 strikes were needed to form Acheulian biface hand-axes (the third kind, associated with *H. erectus*), taking 24 minutes. Such a sequence, they argue, is like constructing sentences, and they point out that damage to Broca's area in the brain results in impairment to both language and hand and arm gestures.[40] Language is considered more fully in the next chapter.

The period we have been covering, say 400,000–50,000 years ago, has been identified by Merlin Donald, professor of psychology at Queen's University in Toronto, as possibly the most momentous stage in history. Donald has identified four stages in the development of the modern mind, involving three transitions. The first mode he calls 'episodic' thinking, as is shown in the great apes. Their behaviour, he says, consists of short-term responses to the environment, their lives are lived 'entirely in the present', as a series of concrete episodes, with a memory for specific events in a specific context.[41] The second form of thinking/behaving, typified by *H. erectus*, is 'mimetic'. For Donald, the world of *H. erectus* is *qualitatively* different from all that went before and this is what makes it so important. *Erectus* lived in a 'society where cooperation and social coordination of action were central to the species' survival strategy'.[42] Without language, *Erectus* nonetheless slowly developed a culture based on mimetics – intentional mime and imitation, facial expression, mimicry of sounds, gestures etc. This was a qualitative change, says Donald, because it allowed for intentionality, creativity, reference, co-ordination and, perhaps above all, pedagogy, the acculturation of the young. It was a momentous change also because minds/individuals were no longer isolated. 'Even highly sophisticated animals, such as apes, have no choice but to approach the world solipsistically because they cannot share ideas and thoughts in any detail. Each ape learns only what it learns for itself. Every generation starts afresh because the old die with their wisdom sealed forever in their brains ... There are no shortcuts for an isolated mind.'[43] Even so, mimesis was slow – it probably took *Erectus* half a million years to domesticate fire and three-quarters of a million to adapt to the cold.[44] But Donald is in no doubt that many cultural artefacts had been produced by *Erectus* before language and the next transition, to 'mythic' thinking, which necessitates language. The shift to mimesis was the great divide in history, Donald says – it was, as he puts it, 'The Great Hominid escape from the nervous system.'[45] The later transitions are considered below.

The re-creation of the first ideas of early man, inferring his mental life from the meagre remains of crude stone tools and assorted remains, is itself an intellectual achievement of the first order by palaeontologists of our own day. The remains tell – or have been made to tell – a consistent story. At about 60,000–40,000 years ago, however, the agreement

breaks down. According to one set of palaeontologists and archaeologists, at around this time we no longer need to rely on unpropitious lumps of stone and bone fragments to infer the behaviour of our ancient ancestors. In the space of a (relatively) short amount of time, we have a quite fantastic richness of material which together amply justify historian John Pfeiffer's characterisation of this period as a 'creative explosion'.[46]

In the other camp are the 'gradualists', who believe there was no real explosion at all but that man's intellectual abilities steadily expanded – as is confirmed, they say, by the evidence. The most striking artefact in this debate is the so-called Berekhat Ram figurine. During excavations at Berekhat Ram in Israel, in 1981, Naama Goren-Inbar, of the Hebrew University in Jerusalem, found a small, yellowish-brown 'pebble' 3.5 centimetres long. The natural shape of the pebble is reminiscent of the female form but microscopic analysis by independent scholars has shown that the form of the figure has been enhanced by artificial grooves.[47] The age of the pebble has been put at 233,000 BP but its status as an art object has been seriously questioned. It was the only such object found among 6,800 artefacts excavated at the site, and sceptical archaeologists say that all it represents is some 'doodling' by ancient man 'on a wet Wednesday'.[48] The gradualists, on the other hand, put the Berekhat Ram figurine alongside the spears found at Schöningen (400,000 BP), a bone 'dagger' found at a riverside site in the Zemliki valley in Zaire, dated to 174,000–82,000 BP, some perforated and ochred *Glycymeris* shells found at Qafzeh in Israel (100,000 BP), some ostrich shell perforated beads found in the Loiyangalani river valley in Tanzania (110,000–45,000 BP), a carved warthog tusk, recovered from Border cave, in South Africa, and dated to 80,000 BP, and some mollusc beads from Blombos cave, also in South Africa, dated to between 80,000 and 75,000 BP (the beads were brought from twenty kilometres away and appear to have ochre inside them). These show, they say, that early humans' mental skills developed gradually – and perhaps not in Europe. They imply that Europe is 'the cradle of civilisation' only because it has well-developed archaeological services, which have produced many discoveries, and that if African or Asian countries had the same facilities, these admittedly meagre discoveries would be multiplied and a different picture would emerge.

The debate has switch-backed more than once. The gradualists certainly suffered a setback in regard to one other important piece of evidence, the so-called Slovenian 'flute'. This was unveiled in 1995, amid much fanfare, as the world's oldest musical instrument. Dated to 54,000 years ago, it consisted of a tubular piece of bone, found at Divje Babe near Reke in western Slovenia, containing two complete holes, and two incomplete ones, in a straight line. It comprised the femur of a young bear and was the only femur among 600 found in the same cave that was pierced in this way. What drew the archaeologists' attention was the discovery that the holes were roughly 1 centimetre across and 2.5 centimetres apart, a configuration that comfortably fits the dimensions of the human hand. According to some scholars, the instrument was capable of playing 'the entire seven-note scale on which Western music is based.'[49] However, Francesco d'Errico and a group of colleagues at the Centre Nationale de la Recherche Scientifique (CNRS) in Bordeaux were able to show that this suggestive arrangement was in fact an entirely natural occurrence, the result of the bone being gnawed by other carnivores, possibly cave bears. Similar puncture holes were discovered on bones in several caves in the Basque region of Spain.[50]

Over the last few years, however, the gradualists have been making a strong comeback. Stephen Oppenheimer, of Green College, Oxford, has collected the evidence in his book, *Out of Eden: The Peopling of the World*.[51] There, he shows that 'Mode 3' hand-axes, capable of being hafted, were produced in Africa by archaic *H. sapiens* from 300,000 years ago. These early humans were also producing bone tools looking like harpoon tips, were quarrying for pigment at 280,000 years ago, used perforated shell pendants in South Africa at 130,000–105,000 years ago, and crafted haematite 'pencils' at 100,000 years ago. Figure 1

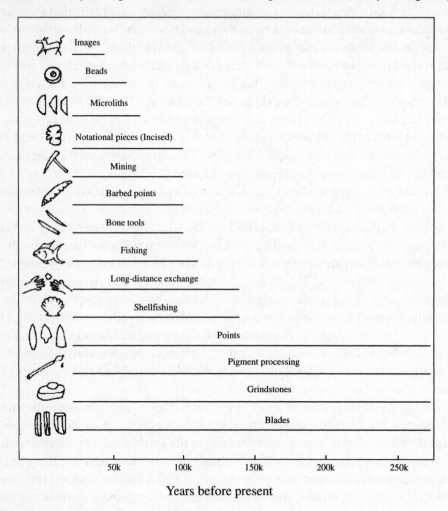

***Figure 1: The chronology of early cognitive skills***
[Source: Stephen Oppenheimer, *Out of Eden: The Peopling of the World*, London: Constable, 2003, page 123]

shows his chronology for the advent of various cognitive advances. Oppenheimer concludes that, by 140,000 years ago, 'half of the important clues to cognitive skills and behaviour which underpinned those that eventually took us to the Moon were already present'.[52]

Despite this strong showing recently by the gradualists, it remains true that it is the sudden appearance, around 40,000 years ago, of very beautiful, very accomplished, and very modern-looking *art* that captures the imagination of all who encounter it. This art takes three main forms – the famous cave paintings, predominantly but not exclusively found in Europe, the so-called Venus figurines, found in a broad swathe across western and eastern Europe, and multi-coloured beads, which in some respects are the most important evidence of all. What stands out is the sudden appearance of this art, its abundance and its sophistication. In northern Spain the art consists mainly of engravings but the paintings extend from south-west France to Australia. When the first cave art was discovered in the nineteenth century, it took many years before it was accepted as truly ancient because so many of the images were realistic and lifelike, and modern-looking. It was felt they must be forgeries. But it is now generally accepted (there *are* still doubters) that, with the paintings spread so far across Eurasia, and with the dating being so consistent, something very important was going on around 40,000 years ago (although this art should probably not be treated as a single phenomenon). This, the Middle/Upper Palaeolithic transition, as it is known to professionals, is probably the most exciting area of study in palaeontology now, and for three reasons.

The advent of art is so sudden (in palaeontological terms), and so widespread, that many scientists think it must reflect an important change in the development of early man's mental state. It is, as Steven Mithen puts it, 'when the final major re-design of the mind took place'.[53] Once again there was a time lag, between the appearance of anatomically modern humans, around 150,000–100,000 years ago, and the creative explosion, at 60,000–40,000 years ago. One explanation is the climate. As the glaciers expanded and retreated, the available game changed in response, and a greater variety of equipment was needed. Also needed was a record of the animals available and their seasonal movement. Perhaps this is, again, too neat. A second – and more controversial – climatic explanation is that the eruption of the Mount Toba volcano at 71,000 years ago led to a worldwide volcanic winter, lasting ten thousand years and drastically reducing both the human and animal population. This would have been followed by a period of severe competition for resources, resulting in rapid development among very disparate groups, fuelling innovation. Another explanation for the 'creative explosion' derives from the art itself. In north-eastern Spain and south-western France (but not elsewhere) much is contained in highly inaccessible caves, where the superimposition of one image over another implies that these sub-terranean niches and crevices were returned to time and again – over centuries, over thousands of years. The suspicion is, therefore, that cave art is in fact to be understood as writing as much as art, a secret and sacred recording of the animals which early man relied upon for food. (This is an idea supported by the fact that many contemporary tribes who create rock paintings have no word for art in their language.[54]) The cave paintings and engravings were in effect a record, possibly of what animals were in the area, when, in what numbers, and showed what routes they followed. These records, which may have been kept outside to begin with, would have been transferred to inaccessible places partly out of concerns for security – so rivals would never find them – and partly out of ritual. The animals may have been worshipped – because life depended on them and their abundance – and reflect what early man knew about their movements, a record, in effect,

of his ability to plan ahead. The caves may also have been ritual temples, chosen not only for inaccessibility but because they were thought to be in some sense gateways to and from the underworld. According to the French prehistorian André Leroi-Gourhan, the cave art of Europe comprises a 'single ideological system', a 'religion of the caves'.[55]

There are two important questions to be asked of this art. Why, in the first place, did it emerge 'fully formed', as it were, why was there no primitive version? And what does it mean? One reason it emerged 'fully formed' may simply be that early versions were produced on perishable materials, which have been lost. Steven Mithen, however, has a 'deeper' reason for why this art emerged fully formed. He believes that the three different types of intelligence that evolved in man's primitive brain – the natural history intelligence, the technical intelligence, and the social intelligence – finally came together some time between 100,000 and 40,000 years ago, to form the modern brain as we know it. Indeed, he says that the very fact that early art shows so much technical skill, and is so full of emotive power, is itself the strongest argument for this latest restructuring of the mind. This is speculative, of course; there is no other evidence to support Mithen's view.

Richard Klein, professor of anthropological sciences at Stanford University in California, offers a different theory. He believes that humanity's cultural revolution began with one or more genetic mutations that 'transformed the ability to communicate'.[56] Professor Klein argues that 'a suite of language and creativity genes, perhaps as few as ten or as many as 1,000, developed as a result of random mutation', giving rise to a new pattern of human culture. He cites as an example the gene FOXP2, which was discovered in 2001 among the fifteen members of a large London family (the 'KE' family), three generations of which have severe speech and language impediments. Researchers have since shown that the human version of this gene differs by only three molecules, out of 715, from the version carried by mice, and by just two molecules from the version carried by chimpanzees. The German researchers who identified the mutation say that it occurred about 200,000 years ago and spread rapidly, in 500–1,000 human generations, or 10,000–20,000 years. 'A sweep that rapid indicates to biologists that the new version of the gene must have conferred a significant evolutionary advantage on the human ancestors lucky enough to inherit it.'[57] Another explanation of the cultural explosion arises from demography. Until around 70,000 years ago, the population density of humanity was fairly thin. We know this because the main animals used as food were both adults of the species and examples of species that took a long time to mature (tortoises, for example). After that, there was a switch to deer etc., which replaced themselves more quickly. This increased competition may well have stimulated both new forms of hand-axe and the efflorescence of art, to be understood as secret records of game movements.[58] There was also a switch to marine foods at this time.

The gradualists say this is all illusion, that art and other symbolic behaviour was developing for perhaps 100,000 to 250,000 years before the apparent 'explosion' but has either perished or is still waiting to be found. This, they say, explains why the art is 'fully formed' in the European caves – there had been generations for techniques to improve. They also point out that art appeared in Australia fully formed as soon as early humans arrived there. It stands to reason, on this account, that the *ability* to produce such art had already evolved before the migrants left Africa.[59]

The meaning of the art is more complex. Between 40,000 and 30,000 years ago we see a

huge number of developments – not just the striking cave paintings of Lascaux, Altamira and Chauvet that have become famous, but the first production of items for personal decoration such as beads, pendants and perforated animal teeth, carved ivories which have the body of a man and the head of different animals, such as lion and bison, and scores of V-shaped signs etched on rocks. There is little doubt among palaeontologists that these images are intentional, conveying information of one kind or another. Among contemporary Australian tribes, for example, a simple circle can – in different circumstances – be held to represent a fire, a mountain, a campsite, waterholes, women's breasts, or eggs. So it may never prove possible to recover completely the meaning of ancient art. Yet we can decipher in a broad sense the idea of art as stored information.[60] Many of the new bone and antler tools found in the Upper Palaeolithic are decorated and John Pfeiffer has called these, together with the cave paintings, 'tribal encyclopaedias'. The basic fact to remember, perhaps (since nothing is certain in this field), is that most Palaeolithic art was created in the last ice age, when environmental conditions were extremely harsh. Therefore the art must, at least in part, have been a response to this, which should help us understand its meaning.[61] We may draw some inference, for example, from the fact that, while many animals were painted in profile, so far as their bodies were concerned, their hooves were painted full on, which suggests that the shape of the hooves was being memorised for later, or being used to instruct children.[62] Even today, among the Wopkaimin hunter-gatherers of New Guinea, they display the bones of the animals they catch against the rear wall of their houses – with the remains arranged as a 'map' so as to aid the recall of animal behaviour.[63]

The widespread depiction of the female form in Palaeolithic art also needs some explanation and comment. There are the so-called 'Venus pebbles', inscribed stones, which appear to show breasts and skirts, found in Korea and dated to 12,165 BP; there is the 'Venus of Galgenberg', found near Krems in Lower Austria, showing a large-breasted woman who appears to be dancing, and dated to 31,000 years ago; most important of all there are the 'Venus figurines', found in a shallow arc stretching from France to Siberia, the majority of which belong to the Gravettian period – around 25,000 years ago. There has been, inevitably perhaps, much controversy about these figures. Many of them (but by no means all) are buxom, with large breasts and bellies, possibly indicating they are pregnant. Many (but not all) have distended vulvas, indicating they are about to give birth. Many (but not all) are naked. Many (but not all) lack faces but show elaborate coiffures. Many (but not all) are incomplete, lacking feet or arms, as if the creator had been intent on rendering only the sexual characteristics of these figures. Some, but not all, were originally covered in red ochre – was that meant to symbolise (menstrual) blood? Some critics, such as the archaeologist Paul Bahn, have argued that we should be careful in reading too much sex into these figures, that it tells us more about modern palaeontologists than it does about ancient humans. Nevertheless, other early art works do suggest sexual themes. There is a natural cavity in the Cougnac cave at Quercy in France which suggests (to the modern eye) the shape of a vulva, a similarity which appears to have been apparent also to ancient man, for they stained the cave with red ochre 'to symbolise the menstrual flow'.[64] Among the images found in 1980 in the Ignateva cave in the southern Urals of Russia is a female figure with twenty-eight red dots between her legs, very likely a reference

to the menstrual cycle.[65] At Mal'ta, in Siberia, Soviet archaeologists discovered houses divided into two halves. In one half only objects of masculine use were found, in the other half female statuettes were located. Does this mean the homes were ritually divided according to gender?[66]

Whether some of these early 'sexual images' have been over-interpreted, it nonetheless remains true that sex *is* one of the main images in early art, and that the depiction of female sex organs is far more widespread than the depiction of male organs. In fact, there are *no* depictions of males in the Gravettian period (25,000 years ago) and this would therefore seem to support the claims of the distinguished Lithuanian archaeologist, Marija Gimbutas (discussed in detail in Chapter 3), that early humans worshipped a 'Great Goddess', rather than a male god. The development of such beliefs possibly had something to do with what at that time would have been the great mystery of birth, the wonder of breastfeeding, and the disturbing occurrence of menstruation. Randall White, professor of anthropology at New York University, adds the intriguing thought that these figures date from a time (and such a time must surely have existed) when early man had yet to make the link between sexual intercourse and birth. At that time, birth would have been truly miraculous, and early man may have thought that, in order to give birth, women received some spirit, say from animals (hence the animal heads). Until the link was made between sexual intercourse and birth, woman would have seemed mysterious and miraculous creatures, far more so than men.

Olga Soffer, of the University of Illinois, also points out that some of the Venus figurines appear to be wearing caps that are woven. She thinks that textiles were invented very early on: she has, she says, identified impressions of netting on fragments of clay from Upper Palaeolithic sites in Moravia and Russia that suggest the possibility of net hunting. She also believes that cordage – ropes made of plant fibres – extends back 60,000 years and helped early humans construct sailing vessels, with the aid of which they colonised Australia.[67]

Beads first appeared at Blombos cave in South Africa 80,000–75,000 years ago. They are common by 18,000 years ago, but their most dramatic arrival is seen towards the end of the 'creative explosion' in a series of burials in the 28,000-year-old site at Sungir in Russia. Randall White, the archaeologist who has studied these beads, reports on three burials – a sixty-year-old man, a small boy and a girl. The figures were adorned with, respectively, 2,936, 4,903 and 5,274 beads plus, in the case of the adult, a beaded cap with fox teeth and twenty-five mammoth-ivory bracelets. Each bead, according to experiments White carried out, would have taken between an hour and three hours to produce – 13,000–39,000 hours in total (somewhere between eighteen and fifty-four months). So the word 'decoration' hardly applies and we need to ask whether these beads are evidence of something more important – social distinctions, maybe, or even primitive religion. White certainly thinks social divisions were already in existence 28,000 years ago; for one thing, it is unlikely that at Sungir everyone was buried with thousands of beads that took so long to make – there would hardly have been time for real work. It is possible, therefore, that the people who were buried with beads were themselves religious figures of some kind. The differences in decoration between individuals also imply that early humans were acquiring a sense of 'self'.[68]

The very presence of grave goods, of whatever kind, suggests that ancient people believed at least in the possibility of an afterlife, and this in turn would have implied a belief in supernatural beings. Anthropologists distinguish three requirements for religion: that a non-physical component of an individual can survive after death (the 'soul'); that certain individuals within a society are particularly likely to receive direct inspiration from supernatural agencies; and that certain rituals can bring about changes in the present world.[69] The beads at Sungir strongly suggest that people believed in an afterlife, though we have no way of knowing how this 'soul' was conceived. The remote caves decorated with so many splendid paintings were surely centres of ritual (they were lit by primitive lamps, several examples of which have been found, burning moss wicks in animal fat, another use of fire). At the caves of Les Trois-Frères in Ariège in southern France, near the Spanish border, there is what appears to be an upright human figure wearing a herbivore skin on its back, a horse's tail and a set of antlers – in other words, a shaman. At the end of 2003 it was announced that several figures carved in mammoth ivory had been found in a cave, near Shelklingen in the Jura mountains in Bavaria. These included a *Löwenmensch*, a 'lion-person', half-man, half-animal, dating to 33,000–31,000 years ago, suggesting a shamanistic magical or religious belief system of some sophistication.

David Lewis-Williams is convinced of the shamanistic nature of the first religions and their link to the layout of cave art. He puts together the idea that, with the emergence of language, early humans would have been able to share the experience of two and possibly three altered states of consciousness: dreams, drug-induced hallucinations, and trance. These, he says, would have convinced early humans that there was a 'spirit world' elsewhere, with caves – leading to a mysterious underworld – as the only practical location for this other world. He thinks that some of the lines and squiggles associated with cave art are what he calls 'entoptic', caused by people actually 'seeing' the structures of their brains (between the retina and the visual cortex) under the influence of drugs.[70] No less important, he notes that many paintings and engravings in the caves make use of naturally-occurring forms or features, suggesting, say, a horse's head or a bison. The art, he suggests, was designed to 'release' the forms which were 'imprisoned' in the rock. By the same token, the 'finger flutings', marks made on the soft rock, and the famous hand prints, were a kind of primitive 'laying on of hands', designed again to release the forms locked in the rock.[71] He also notes a form of organisation in the caves. Probably, he thinks, the general population would have gathered at the mouth of the cave, the entrance to the underworld, perhaps using forms of symbolic representation that have been lost. Only a select few would have been allowed into the caves proper. In these main chambers Lewis-Williams reports that the resonant ones have more images than the non-resonant ones, so there may have been a 'musical' element, either by tapping stalactites, or by means of primitive 'flutes', remains of which have been found, or drums.[72] Finally, the most inaccessible regions of the caves would have been accessed only by the shamans. Some of these areas have been shown to contain high concentrations of $CO_2$, an atmosphere which may, in itself, have produced an altered state of consciousness. Either way, in these confined spaces, shamans would have sought their visions. Some drugs induce a sensation of pricking, or being stabbed, which fits with some of the images found in caves, where figures are covered in short lines. This, combined with the shamans' need for a new persona every so often

(as is confirmed today, among 'stone age' tribes), could be the origin of the idea of death and rebirth, and of sacrifice which, as we shall see, looms large in later religious beliefs.[73]

Lewis-Williams' ideas are tantalising, but still speculative. What we *can* be certain of, however, is that none of the complex art, and the ancient ceremonies that surrounded the painted caves, could have been accomplished without language. For Merlin Donald the transition to mimetic cognition and communication was the all-important transformation in history, but the arrival of spoken language was hardly less of a breakthrough.

It is too soon to say whether the picture given above needs to be changed radically as a result of the discovery of *Homo floresiensis*, on the Indonesian island of Flores, and announced in October 2004. This new species of *Homo*, whose closest relative appears to be *H. erectus*, lived until 13,000 years ago, was barely one metre tall, and had a brain capacity of only 380 cc. Yet it appears to have walked upright, to have produced fairly sophisticated stone tools, may have controlled fire, and its predecessors must have reached Flores by rafting, since there is no evidence that the island was ever attached to the mainland of Asia. The new species' small size is presumably explained by adaptation to an island environment, where there were no large predators. But, on the face of it, *H. floresiensis* shows that brain size and intelligence may not be as intimately linked in early species of man as previous scholarship had suggested.[74]

# 2

# The Emergence of Language and the Conquest of Cold

The acquisition of language is perhaps *the* most controversial and interesting aspect of early humans' intellectual life. It is, so far as we know, and together with mimetic cognition (if Merlin Donald is right), the most important characteristic that separates *Homo sapiens* from other animals. Since the vast majority of the ideas considered in the rest of this book were expressed in words (as opposed to painting, or music, or architecture, say), an understanding of the invention and evolution of language is fundamental.

Before we come to language itself, though, we need to consider why it developed. And this is where we return to the significance of meat-eating. As was outlined in Chapter 1, the brain size of *Homo habilis* showed a marked increase over what went before, and this was associated with an advance in stone tool technology. Important in the context of this chapter is the discovery of stone tools up to ten kilometres from the raw material source, which implies that, beginning with *H. habilis*, early man was capable of 'mental maps', planning ahead, predicting where game would be and transporting tools to those sites, presumably in advance. This is intellectual behaviour already far beyond the capacities of other primates. But we also know, from the archaeological remains at sites, that early man ate antelope, zebra, and hippopotamus. Searching for large animal prey would have pitted early humans against hyenas when scavenging, and against the prey itself when hunting. Some palaeontologists argue that this could not have been accomplished as solitary individuals or even, perhaps, as small groups. A relationship has been observed by some zoologists between brain volume and the average size of social groups among primates. There is even a view that brain size is correlated with what Steven Mithen calls social intelligence. According to one estimate, the australopithecines lived in groups with an average size of sixty–seventy individuals, whereas *H. habilis* groups averaged around eighty.[1] These provided the basic 'cognitive group' of early man, the group he had to deal with on an everyday basis, and the increasing size of this cognitive group would, say the palaeontologists, have stimulated the growth of man's social intelligence. Distinguishing one group member from another, and one's own kin within this wider group, would have become much easier once language had developed, and easier still once beads and pendants and other items of bodily adornment had been created, with which people could emphasise their individuality. Against this, George Schaller, who was mentioned at the beginning of Chapter 1, points out that lions hunt quite successfully in groups without language.

We do also see a marked change in technology in the Upper Palaeolithic, and in hunting technique, both of them changes that are difficult to imagine without language. In Europe at least a whole range of tools appear – including hafted tools, harpoons and spear throwers made of shaped antler and bone (the first 'plastics'); at the same time we see the development of blades, produced as 'standardised blanks' that could be turned into burins, scrapers, awls or needles as required.[2]

In southern Africa we see a very different picture when comparing the remains excavated at Klasies River Mouth (120,000–60,000 BP) with the much younger Nelson Bay cave (20,000 BP). The latter contains more bones of large dangerous prey, like buffalo and wild pigs, and far fewer eland. By this time too, people had developed projectiles such as the bow and arrow that allowed them to attack prey at a distance. And there is an equivalent difference between the seal remains at Klasies and Nelson Bay. The age of the seals at Klasies indicates that ancient humans lived on the coast all through the year 'including times when [food] resources were probably more abundant in the interior'.[3] At Nelson Bay, however, the inhabitants timed their coastal visits to late winter/early spring when they could catch the infant seals on the beach, and then moved inland when it was more productive to do so.[4] There is a final difference in these two sites as regards fishing. There are no fish among the debris at Klasies, while fish predominate at Nelson Bay. As we saw above, by now harpoons had been invented. Could such co-operation have been achieved without language? Could the concept of the harpoon barb be passed on without a word for it?

Still more deductions can be made about the origin of language from examination of the sudden appearance of early humans in difficult environments, in particular the very cold parts of the world, notably Siberia. Siberia is important because the conquest of cold was man's greatest achievement before the invention of agriculture, and because it was the jumping-off point for what turned out to be the greatest natural experiment in mankind's history – the peopling of America. And, we may ask, would any of this been possible without language? Many sites in greater Siberia have been dated to at least 200,000 years ago and their very existence raises the question of fire (again) and of clothing. The climate was so harsh that many palaeontologists feel that the land could not have been occupied without man wearing 'tailored' clothing. However rough this tailoring would have been, it nevertheless implies the invention of the needle very early on, though nothing has ever been found. In 2004 it was reported by biologists at the Max Planck Institute for Evolutionary Anthropology at Leipzig, in Germany, that body lice are different from hair lice. Mark Stoneking and his colleagues infer that body lice 'probably evolved from hair lice when a new ecological niche – clothing – became available'. Based on the rate of mutation, they date this to 75,000 BP.[5]

To conquer Siberia and Australia, early humans would have needed not only needles, to make clothes, but in the case of Australia rafting vessels, and in both places an elaborate social structure, involving kin and not-kin (and an appreciation of the differences). All of which would have required elaborate communication between individuals – i.e., language.[6] Experiments show that group decision-making grows less effective in assemblies of more than six. Larger groups can therefore exist only with a hierarchy and this too implies

language. By 'communication', we mean proto-languages, which probably lacked both tenses and subordinate clauses, where the action and thought is displaced from the face-to-face here-and-now.[7]

Some time between 25,000 and 10,000 years ago, the area of sea that now separates Siberia from America – the Bering Strait – was land, and ancient man was able to walk from Eurasia to Alaska. In fact, during the last ice age that part of the world was configured quite differently from the way it is now. Not only was the land that is now submerged above water but Alaska and parts of what is now Yukon and the Northwest Territories, in Canada, were separated from the rest of the Americas by two gigantic ice sheets. Beringia, as this area is known to palaeontologists and archaeologists, stretched as an unbroken landmass from deepest Siberia across the strait and for three or four hundred miles into north America. Then, around 10,000 BP (though it was of course a very gradual process), the seas rose again as the world warmed up and the glaciers melted, and what we now call the Old World was cut off from the New and from Australia. Earth was effectively divided into two huge landmasses – Eurasia and Africa on the one hand, the Americas on the other. Early man then set about developing on the two landmasses, each for the most part unaware of the other's existence. The similarities and the differences in the course of that independent existence tell us a great deal about humanity's fundamental nature.

Mys Dezhneva (or Uelen), the easternmost point of Siberia, is 8,250 miles from the Olduvai Gorge, as the crow flies. The route taken by early man was anything but straight, however, and a journey of 12,000 miles would be nearer the mark. It is a very long way to walk. Such archaeological and palaeontological remains as have been found place *H. erectus* in Asia from 800,000–700,000 years ago, associated with primitive tools of the Oldowan kind and, from 400,000–350,000 years ago, with the use of fire. *H. erectus* cave sites contained many charred bones of animals – deer, sheep, horses, pigs, rhinoceros – showing that s/he used fire for cooking as well as warmth. What is less clear is whether *H. erectus* knew how to start fires, or only preserved naturally-occurring flames, though there are sites with deep charcoal deposits, which do suggest that hearths were kept burning continuously.

The latest evidence suggests that modern humans left Africa twice, first around 90,000 years ago, through Sinai into the Levant, an exodus which petered out. The second exodus occurred around 45,000 years later, along a route across the mouth of the Red Sea at the 'Gate of Grief' in Ethiopia. Humans reached the Middle East and Europe via the valleys of Mesopotamia, and south-east Asia by 'beachcombing' along the coasts. (This cannot quite be squared with the most recent evidence that early humans reached Australia around 60,000–50,000 BP.)[8]

Studies of *H. erectus* skulls found in China show around a dozen tantalising – and highly controversial – similarities with those of Mongoloids and native Americans. These similarities include a midline ridge along the top of the skull, a growth of the lower jaw which is especially common among Eskimos, and similar shovel-shaped incisors. Taken together, these traits suggest that Chinese *H. erectus* contributed some genes to later Asian and native American *Homo sapiens*, though this evidence is very controversial.[9] At the same time, it is important to stress that no trace of *H. erectus* or *H. neanderthalensis* has ever been found in America or, for that matter, above the 53° north parallel. This suggests

that only *H. sapiens* successfully adapted to very cold weather. Mongoloid people are adapted to cold, with double upper eyelids, smaller noses, shorter limbs, and extra fat on their faces. Charles Darwin, in his travels, encountered people at Tierra del Fuego who didn't need much clothing.[10]

Excavations by Russian (Soviet) archaeologists tell us a little about what *Homo sapiens* was capable of at that time. Some Asian scholars claim that s/he was in the region as early as 70,000–60,000 years ago and that modern humans evolved independently and separately in Asia. However, the fossil evidence for both claims is very thin.[11] Most likely, modern humans arrived in Siberia between 40,000 and 30,000 years ago, after evolving in Africa. Certainly, traces of human settlement do not occur in north-east Siberia until around 35,000 years ago, when there is an 'explosion' of sites which record their presence. This may have had something to do with the changing climate.[12]

All over the world, and not just in Siberia, more sophisticated artefacts began to occur after about 35,000 years ago – new stone tools, harpoons, spear points and, most important perhaps, needles, for making sewn and therefore tailored garments.[13] In Europe, north Africa and western Asia, Neanderthals made and used some sixty types of stone tools.[14] These are referred to collectively as the Mousterian industry (after the site of Le Moustier in south-west France). Levallois-Mousterian tools have been found in Siberia but very few north of 50° and none at all above 54°. This could mean that during the time the Neanderthals were alive the climate was worse than later, or that they never managed to conquer the cold (or of course that their sites, which exist, have simply not been found). If they never managed to conquer the cold, whereas modern man did, this could be due to the invention of the needle, which resulted in tailored clothing, possibly similar to the modern Eskimo parka. (Three of the women depicted on Siberian art are shown wearing clothing which suggests this garment.) Bone needles have been dated back as far as 19,000 BP at least in Europe, and to 22,000–27,000 BP at the Sungir site near Moscow, where the decorations on the clothing, which had not disintegrated to the same extent as the skin on the remains, allowed archaeologists to reconstruct the shirts, jackets, trousers and moccasins that these people wore.

*Homo sapiens'* move into Siberia may have had something to do with a change in climate: as was mentioned above, it was much drier in the last ice age, producing vast expanses of steppe-tundra (treeless plains with arctic vegetation) in the north, and taiga, or coniferous forest, in the south. This move to the north and east appears to have followed an explosion of sites in eastern Europe and the Russian plain, along three great rivers – the Dnestr, the Don and the Dnepr, and was associated with an increase in big game hunting. The migration reflected the development of portable blade blanks, artefacts that were light enough to transport over large distances and were then turned into tools of whatever kind were needed – knives, borers, spear heads as the case might be. At first these people lived in depressions scooped out of the soil but, around 18,000–14,000 years ago, they began to build more elaborate structures with mammoth bones as foundations, topped with hides and saplings. They decorated the mammoth bones with red ochre and carved stylised human and geometric designs on them. Many of the camp sites, most of which are in locations sheltered from the prevailing northern winds, were relatively permanent, which shows, say some palaeontologists, that these primitive societies could resolve disputes

and had an emerging social stratification.[15] The settlements, such as they were, supported populations in the thirty to one hundred range and, quite clearly, must have had language.

The taiga – the coniferous forest of Siberia – may have been so dense as to prevent human penetration, which would mean that *Homo sapiens* reached the Bering Strait by either a very northerly or a far more southerly trek.[16] In the more northerly route, such sites as have been found, Mal'ta and Afontova Gora, for example, cover about 600 square metres and consist of semi-subterranean houses. Mal'ta was probably a winter base camp with houses built of large animal bones interlaced with reindeer antlers. Its ivory carvings depict mammoth, wildfowl and women. Arctic foxes were buried in large numbers, after skinning, which may indicate a possible ritual.[17]

The dominant culture of the area, however, appears to be that known as the Dyukhtai, first discovered in 1967 at a site close to the floodplain of the river Aldan (around the modern town of Yakutsk, 3,000 miles east of Moscow). Here were found the remains of large mammals, associated with distinctive bifacially flaked spear points, and with burins and blades made from characteristic wedge-shaped cores. Other very similar sites were found, first along the river valley, dated to between 35,000 and 12,000 years ago, though most scholars prefer a date of 18,000 years ago for the beginnings of this culture. Later, most exciting of all, Dyukhtai sites were found *across* the Bering Strait in Alaska and as far south as British Columbia. Many scholars believe that early man from Dyukhtai followed mammoths and other mammals across the (dry) strait into the New World. Berelekh, 71 degrees north, near the mouth of the Indigirka river, on the East Siberian Sea, is the northernmost Dyukhtai site. It is known for its mammoth 'cemetery', with more than 140 well-preserved mammoths which drowned in spring floods. Early man may have followed the river from Berelekh to the sea, then turned east along the coast.[18]

So far as we can tell, the land bridge between what is now Russia and Alaska was open between 20,000 and 12,000 years ago, after which the seas again rose and it was submerged.[19] When it was exposed, however, it comprised arid steppe-tundra, covered by grasses, sedges, and wormwood, and littered with scattered shallow ponds. There would have been few trees but, especially in summer, this would have been attractive territory for grazing herbivores, and large mammals like mammoth and bison. Fossil insects found in Alaska and Siberia are those associated with hoofed animals.[20] The ponds would have been linked by large rivers in whose waters fish and shellfish would have been plentiful. A legend among the Netsi Kutchiri Indians of the Brooks range, in Canada's Yukon Territory, has it that in the 'original land' there were 'no trees', only low willows.

Of course, early man may have sailed across the straits. No artefacts have actually been recovered from the land under the water, but mammoth bones have been brought up. We know that 60,000–55,000 years ago Australia was discovered, and that must have involved sailing or rafting over distances of about fifty miles, roughly the width of the Bering Strait. The general consensus is, however, that this far north, in very inhospitable waters, open ocean sailing would have been very unlikely. Coastal sailing, to the strait itself, and then across the land bridge, is more likely, if only because man would have followed the game. And the fauna is identical on both sides of the strait, proving that animals walked across. Naturally, early man did not realise that Beringia would eventually be submerged. As was

mentioned earlier, there were at the time two huge ice sheets covering much of north America, the Laurentide and the Cordilleran, extending as far west as what is now the border between the Yukon and the Northwest Territories. To early man, the landmass to the west of the ice would have been one continuous area. Indeed, some archaeologists and palaeontologists say Beringia was 'a cultural province unto itself', showing a biotic unity, and that it may have had a higher population then than now.[21]

The evidence for a migration across the strait falls into what we may call the geological, the zoological, the biological or medical, the archaeological, and the linguistic. On both sides of the present strait there are identical features, such as raised beaches now some miles inland, showing that the two continents share a similar geological history. Zoologically, it has long been observed that the tropical animals and plants of the Old World and the New have very little in common, but that the nearer the strait one gets, the greater the similarities. Biologically, native Americans are closest to the Mongoloid people of Asia. This shows in the visible physical characteristics they share, from their coarse, straight black hair, relatively hairless faces and bodies, brown eyes and a similar brown shading to the skin, high cheek bones and a high frequency of shovel-shaped incisor teeth. Such people are known to biologists as sinodonts (meaning their teeth have Chinese characteristics, which separates them from sundadonts, who do not). Teeth found in the skulls of ancient man from western Asia and Europe do not display sinodonty (which is mainly a hollowing out of the incisors, developed for the dentally demanding vegetation in northern Asia).[22] All native Americans show sinodonty. Finally, on the biological front, it has been found by physical anthropologists that the blood proteins of native Americans and Asians are very close. In fact, we can go further and say that native American blood proteins, as well as sharing similarities with Asians, fall into three dominant groups. These correspond to the palaeo-Indians of north, central and southern America, the Eskimo-Aleut populations, and the Athabaskans (Apache and Navaho Indians, situated in New Mexico). This, according to some scholars, may underlie other evidence, from linguistics and DNA studies, which indicate not one but three and even four migrations of early man into the New World. Some scholars argue that there was an 'early arrival' of the Amerinds (perhaps as early as 34,000–26,000 BP), a later arrival (12,000–10,000 BP) of the Amerinds, and a third wave (10,000–7000 BP) of the Eskimos and the Na-Dene speakers. But the awkward fact remains that there is no direct archaeological evidence to support these earlier dates. The remains of only thirty-seven individuals had been found in America by AD 2000 which dated to earlier than 11,000 BP.[23]

The archaeological evidence for early man in the Americas suffers further because there are no *securely* dated sites in Alaska earlier than the Bluefish caves in the eastern Yukon Territory, which date to between 15,000 and 12,000 years ago.[24] Nevertheless, there is little doubt that there are many features common to both sides of the Beringia area. One element is the 'Northwest Microblade' tradition, a particular type of microblade, which was wedge-shaped and made from a distinctive core, found all over Beringia.[25] These cores have been associated with one site in particular, Denali, which, according to F. Hadleigh West, is the eastern outpost of Dyukhtai culture, with at least twenty locations in Alaska. (Denali is situated in and around Tangle Lakes in Alaska.) Dyukhtai culture is no older than 18,000 years ago and Denali was gone by 8000 BP.[26] That early man crossed the Bering land bridge

between 18,000 and 12,000 years ago is also supported by details from the Meadowcroft rock shelter in western Pennsylvania, where remains have been calculated, on eight separate occasions, to between 17,000 and 11,000 BC. And by the fact that the presence of early man at Tierra del Fuego, 'the end of the road' at the southern tip of South America, has been dated to about 9000 BC. However, there are still doubts about the dating of Meadowcroft, where the remains are corrupted by the presence of coal, which may make it seem older than it is.

Early man's discovery of the New World may not seem, on the face of it, to fall into the category of 'ideas'. But there are three reasons for including it. One is because the conquest of cold was a major advance in early humans' capabilities. Second, in being cut off for so long, and from such an early date (say 15,000 BP to AD 1492, 14,500 years, and ignoring the possibility of Norse contacts, which were abortive) the parallel development of the Old World and the New provides a neat natural experiment, to compare how and in what order different ideas developed. Third, as we shall now see, this separation throws crucial light on the development of language.

George Schaller, as mentioned before, has pointed out that lions hunt game in groups – fairly successfully – without the benefit of language. We cannot say, therefore, that as man turned to the hunting of big game he necessarily had more than the rudiments of language. On the other hand, it would seem highly unlikely that he could manufacture standardised tools, or cave paintings, or beads, without language. But these are all inferential forms of evidence. Is there anything more direct?

We have to remember that many of the skulls of ancient men and women, on which these studies are based, have been in the ground for as much as 2 million years, with rock and earth bearing down on them. Their present-day configuration, therefore, may owe as much to those millennia of pressure as to their original form. Nevertheless, with this (all-important) proviso in mind, we may say as follows. Modern studies, of people living today, show that two areas of the brain are chiefly responsible for language – what are called Broca's area, and Wernicke's area. Broca's area is located in the left hemisphere, towards the front of the brain, and about half-way up. Individuals with damage to that area generally lose some of their facility with words. Wernicke's area, slightly larger than Broca's area, is also in the left hemisphere, but behind it, also about half-way up. Damage to Wernicke's area affects comprehension.[27] There is much more to the brain than this, of course, in relation to language. However, studies of the skulls of *H. habilis* show that Broca's area was present with the earliest of the hominids but not with the aus-tralopithecines. Pongids (apes), who lack Broca's area, cannot produce any human speech sounds and they further appear to lack *intentional* voluntary control of vocal signals: for example, they cannot suppress food-barks even when it is in their best interest to do so.[28] On the other hand, several experiments in the late twentieth century show that chimps possess a *nascent* language ability in that, although they couldn't speak, they could learn American Sign Language. This suggests (to some) that language ability is very old.[29]

In line with such reasoning, each of the skulls unearthed at Skhul and Qafzeh in Israel and dated to 95,000–90,000 BP, had a completely modern supra-laryngeal vocal tract: 'These fossil hominids probably had modern speech and language.'[30] Palaeontological

anatomists also find no reason why early humans should not have had modern syntax.[31] This suggests that *H. habilis* had a form of language, more sophisticated than the half-dozen or so calls that may be distinguished among chimpanzees and gorillas, but still not a full language in our sense of the term.

The only hyoid bone (important in speech, linked by muscle to the mandible, or lower jaw) to be found on a palaeontological site was discovered in the summer of 1983 in the Kebara cave on Mount Carmel in Haifa, Israel. The skeleton discovered there was dated to 60,000 BP and was labelled Mousterian – i.e., Neanderthal. According to B. Arensburg, of Tel Aviv University, the hyoid bone of this creature 'resembles that of modern man in configuration and size' and 'casts a totally new light on the speech capability of [Neanderthals] . . . Viewed in anatomical terms, it would seem that Mousterian man from Kebara was just as capable of speech as modern man.'[32] Neanderthal ear bones recovered in 2004 from excavations in Spain showed that 'their hearing was attuned to pick up the same frequency as those used in human speech'.

There are a number of other inferences that may be made about early thought, stemming from the inspection of tools and the behaviour of early man and of primates and other mammals. One is the standardisation of stone tools. Is it possible for this to have happened, say some palaeontologists, without language? Language would have been needed, they argue, for the teacher to impress upon the student what the exact form the new tool should be. In the same way, the development of elaborate kin systems would also have required the development of words, to describe the relationships between various relatives. Some primates, such as chimpanzees and gorillas, have rudimentary kin systems: brothers occasionally recognise each other, and mothers their offspring. But this is not highly developed, is inconsistent and unreliable. Gorilla 'family units', for example, are not kin groups as we would recognise them.

One very different piece of evidence was unveiled in 2002 (this was mentioned earlier, in a different context). A team led by Svante Paabo at the Max Planck Institute for Evolutionary Anthropology in Leipzig, Germany, announced in August that year that it had identified two critical mutations which appeared approximately 200,000 years ago in a gene linked to language, and then swept through the population at roughly the same time anatomically modern humans spread out and began to dominate the planet. This change may thus have played a central role in the development of modern humans' ability to speak.[33] The mutant gene, said the Leipzig researchers, conferred on early humans a finer degree of control over the muscles of the face, mouth and throat, 'possibly giving those ancestors a rich new palette of sounds that could serve as the foundation of language'. The researchers did not know exactly what role the gene, known as FOXP2, plays in the body, but all mammals have versions, suggesting it serves one or more crucial functions, possibly in foetal development.[34] In a paper published in *Nature*, the researchers reported that the mutation that distinguishes humans from chimpanzees occurred quite recently in evolution and then spread rapidly, entirely replacing the more primitive version within 500 to 1,000 human generations – 10,000 to 20,000 years. Such rapid expansion suggests that the advantages offered by the new gene were very considerable.

Even more controversial than the debate over when language began have been the attempts

to recreate early languages. At first sight, this is an extraordinary idea (how can words survive in the archaeological record before writing?) and many linguists agree. However, this has not deterred other colleagues from pushing ahead, with results that, whatever their scientific status, make riveting reading.

One view is that language emerged in the click sounds of certain tribes in southern Africa (the San, for example, or the Hadzabe), clicks being used because they enabled the hunters to exchange information without frightening away their prey on the open savannah. Another view is that language emerged 300,000–400,000 years ago, and even 1.75 million years ago, when early man would sing or hum in a rhythmical way. Initially, these sounds were 'distance calls', by which males from one group attracted females from another group (as happens with some species of chimpanzee), but then the rhythmic chanting acted as a form of social bonding, to distinguish one tribe from another.

From such other anthropological evidence as exists, from contemporary hunter-gatherer tribes, we find that there is about one language for every thousand or two thousand people (there were around 270 Aboriginal languages in Australia when that continent was discovered by Europeans).[35] This means that, at the time man crossed from Siberia to Alaska, when the world population was roughly 10 million,[36] there may have been as many languages in existence then as there are today, which is – according to William Sutherland, of the University of East Anglia – 6,809.[37] Despite this seeming handicap, some linguists think that it is possible to work back from the similarities between languages of today to create – with a knowledge of pre-history – what the original languages sounded like. The most striking attempt is the work of the American Joseph Greenberg who distinguishes within the many native American languages just three basic groupings, known as Eskimo-Aleut, Na-Dene and Amerind. His investigations are particularly noteworthy when put alongside the evidence, mentioned earlier, that there were three migrations into the Americas from Asia.[38]* The latest DNA evidence, however, suggests there were not three but five waves of migration from Siberia into America, one of which may have been along the coast.[40] This evidence suggests that the first Americans may have entered as early as 25,000 years ago – i.e., before the Ice Age, and meaning that these pioneers *sailed* across the Bering Strait.

More controversial still is the work of the Danish linguist Holger Pederson and the Russians Vladislav Illich-Svitych and Aron Dolgopolsky, who believe that all languages of Europe and Asia and even north Africa – the so-called Indo-European tongues, Semitic, Uralic, Altaic and even the Eskimo-Aleut languages across the Bering Strait in Canada – were descended from a remote 'ancestor', called Nostratic, from the Latin adjective *nostras*, meaning 'of our country, native'.[41] (And meaning that, of 6 billion people in the world today, 4 billion speak Nostratic languages.[42]) This act of 'linguistic palaeontology' takes us back, they say, some 12,000–15,000 years. It has an even more controversial relationship with an equally contentious entity, known as Dene-Sino-Caucasian, which includes languages as diverse as Basque, Chinese, Sumerian and Haida (spoken in British Columbia and Alaska). The relationship between Chinese and Na-Dene has been recognised since the 1920s but, besides being further proof of the links between New World peoples and

---

* There is other evidence that the art of the early Americans also falls into three separate styles.[39]

those of eastern Asia, it raises an even more controversial possibility. This is that, perhaps, proto-Dene-Sino-Caucasian was spoken by the *original inhabitants* of Eurasia, and the people who moved into the Americas, but then the earliest farmers, who spoke proto-Nostratic, overcame them, and displaced them and their language.[43] This theory is supported by the very latest evidence, which finds a particular mutation of mitochondrial DNA shared between India, Pakistan, central Asia and Europe.[44]

This is highly speculative (at best), as – inevitably – are the claims of some linguists, Merritt Ruhlen chief among them, who claim to be able to distinguish a Proto-Global or Proto-World language. While Dolgopolsky has published etymologies of 115 proto-Nostratic words, Ruhlen and his colleagues have published 45 'global etymologies' of words which, they believe, indicate a connection between all the world's languages. Here are three of the etymologies – the reader may judge their credibility.[45]

MANO, meaning man. This is found as follows: Ancient Egyptian, *Min*, the name of a phallic god; Somali, *mun* = male; Tama, an East Sudan language, *ma* = male; Tamil, *mantar* = people, men; Gondi, *manja* = man, person; Austric, whose people call themselves *man* or *mun*; Squamish (a native Canadian language), *man* = husband; Wanana (South American), *meno* = man; Kaliana, *mino* = man, person; Guahibo, *amona* = husband; Indo-European, including English, *man*.
TIK, meaning finger or one. Gur (Africa), *dike* = 1; Dinka (African), *tok* = 1; Hausa (African), (*daya*)*tak* = only one; Korean, *teki* = 1; Japanese, *te* = hand; Turkish, *tek* = only; Greenland-Eskimo, *tik* = index finger; Aleut, *tik* = middle finger; Tlingit, *tek* = 1; Amerind (Karok, *tik* = finger, hand; Mangue, *tike* = 1; Katembri, *tika* = toe); Boven Mbian (New Guinea), *tek* = fingernail; Latin, *dig(-itus)* = finger, *decem* = 10.
AQ'WA meaning water. Nyimang (Africa), *kwe* = water; Kwama (Africa), *uuku* = water; Janjero (Africa), *ak(k)a* = water; Japanese, *aka* = bilge water; Ainu, *wakka* = water; Amerind (Allentaic, *aka* = water; Culino, *yaku* = water and *waka* = river; Koraveka, *ako* = drink; Fulnio, *waka* = lake); Indo-European (Latin, *aqua*, Italian *aqua* = water).

Dolgopolsky's construction of the actual words in proto-Nostratic shows, he says, that the speakers of the language 'were not familiar with agriculture, animal husbandry and pottery' but his claims that they used 'bows and arrows and fishing nets' were attacked by fellow linguists.[46] He was also able to reconstruct what foods were available (eggs, fish, honey), a variety of tools (flint knives, hooks, poles), leather footwear, parts of the body (spleen, the neck), kinship terms (father, mother, in-laws, members of the clan) and supernatural entities (casting of spells, magic).[47] He found no word for a large body of water and so, partly for this reason, located the original homeland of Nostratic speakers inland in southwest Asia.[48]

Attempts have also been made to reconstruct the way and order in which languages formed. An experiment published in 2003 reported that a chimpanzee in Atlanta had suddenly started 'talking', in that he had made up four 'words', or stable sounds, standing for 'grapes', 'bananas', 'juice' and 'yes'. Among humans, according to Gyula Décsy, of Indiana University, in Bloomington, Indiana, the various features of language developed as follows:

H and e, the first vocal sounds, and the sounds made by Neanderthals, say 100,000
　　years ago

'Timbric sounds' (nasal) – u, i, a, j, w = 25,000 years ago

w, m, p, b = 15,000 years ago

t/d, k/g = 12,000 years ago

I/you, here/there, stay/go, good/bad = 10,000 years ago

Third person = 9,000 years ago.[49]

Some may feel that this speculation has been taken as far as it can go, the more so as other scholars have recently emphasised the levels of disagreement in this area. For example, Steven Pinker, the Harvard psychologist who specialises in linguistics, argues that language began 'two to four million years ago', and Robin Dunbar attracted a great deal of interest in the mid-1990s with his theory that speech developed from grooming in chimpanzees. In effect, sounds allowed early humans to 'groom' more than one person at a time.[50]

No less intriguing and controversial than the emergence of language is the emergence of consciousness. The two were presumably related but, according to Richard Alexander, a zoologist from the University of Michigan, the key factor here would have been the development of early humans' social intelligence. We have seen that one consequence of bipedalism was an increase in the division of labour between males and females, leading to the nuclear family. This in itself, say some palaeontologists, might have been enough to stimulate an awareness of human differences, between men and women and between self and not-self, at the least a rudimentary form of consciousness. Then, as humans came to live in larger groups, co-operating with each other and competing against other groups, the appreciation of human differences would have been all-important in developing a sense of self, and the prediction of the future – what other groups might do in certain circumstances – would have highlighted the present and how it should be organised. The recognition of kin would also have been significant in evolving a sense of self, as would the development of techniques of deception in one's own self-interest.[51] Alexander believes that these two factors – self/not-self and present/future – were the basis not just of consciousness but of morality (the rules by which we live) and that the scenario-building (as he puts it) which was required helped to evolve such social/intellectual activities as humour, art, music, myth, religion, drama and literature.[52] It would have also been the basis for primitive politics.[53] This is another field where speculation is running ahead of the evidence.

Merlin Donald, mentioned in the last chapter, has a different view. It will be recalled that, for him, the first two modes of thought were 'episodic' (in apes), and 'mimetic' (in *H. erectus*). His second transition, to the third mode, was to 'mythic' thought. To begin with, he says (and this is based on an analysis of present-day 'stone age' tribes), language was first used to create conceptual models of the universe, grand unifying syntheses, as individual and group self-consciousness emerged with language. Language may eventually have been used in many other ways, he says, but this was its first use and purpose.[54]

　　For Donald, the final transition was to theoretic thinking or culture. This is shown in

the inventions and artefacts that suggest the existence of apparently analytic thought skills that contain germinal elements 'leading to later theoretic developments'.[55] Examples he gives include fired ceramics at 25,000 BP, boomerangs at 15,000 BP, needles, tailored clothing, the bow and arrow, lunar records, rope, bricks at about 12,000 BP – and of course the domestication of plants and animals.[56] The final phase in the demythologising of thought came with the development of natural philosophy, or science, in classical Greece.

Many of the discoveries described above are piecemeal and fragmentary. Nevertheless, taken together they show the gradual development of rudimentary ideas, when and (in some cases) where they were first tried out. It is a picture full of gaps but in recent years some palaeontologists and archaeologists have begun to build a synthesis. Inevitably, this too involves speculation.

One aspect of this synthesis is to say that 'civilisation', which has traditionally been held to develop in western Asia around 5,000 years ago, can now be held to have begun much earlier. Many researchers have noticed that in the Upper Palaeolithic there are regional variations in stone tools – as if local 'cultures' were developing.[57] Cave art, Venus figurines, the existence of grinding stones at 47,000 BP and textiles at 20,000+ BP, together with various forms of notation, in fact amount to civilisation, they say.

One of the most important examples of early notation has recently been re-evaluated in a potentially significant way. This is the 'La Marche antler'. Discovered in the cave of La Marche, in the Vienne department of western France, in 1938, this shows an engraving of two horses, with several rows of marks above them. The antler first came to prominence in 1972 when it was analysed by Alexander Marshack, who concluded that it was a record of lunar notation, accumulated over seven-and-a-half months.[58] In the 1990s, it was re-examined by Francesco d'Errico, referred to earlier in connection with the Berekhat Ram figurine and the so-called Slovenian flute. D'Errico examined the notches on the La Marche antler under a powerful microscope. He concluded that the marks had all been made at the same time, not accumulated over months, and that they had nothing to do with a lunar cycle. He wasn't sure what, exactly, the notches represented, or measured, but he noted that they were not dissimilar from the notches used in cuneiform writing. Since, as we shall see in Chapter 4, cuneiform began as a way to record commercial transactions (counting bales of hay, or pitchers of wine, for example), d'Errico suggests that perhaps the La Marche antler may be understood in a similar fashion, as proto-writing.[59]

Paul Bahn goes further. He has suggested that there appears to be a link between the decorated caves of the Pyrenees and eastern Cantabria and the many thermal and mineral springs in the vicinity of these sites. Perhaps, he says, these centres played a role in the mythology of Palaeolithic times. The widespread occurrence of serpentine and zig-zag lines, almost invariably associated with water, is no accident and, he speculates, may be associated with a mother-goddess cult. The zig-zag is a common motif, often associated with fish, and a human-like figure at Les Eyzies in France, a site dating back 30,000 years, shows a zig-zag inscribed on the figure's torso.[60] A bone fragment discovered in 1970 at Bacho Kiro in Bulgaria suggests this sign may go back to the time of the Neanderthals. The same applies to M-shaped and V-shaped carvings, which recall feminine symbols,

such as the uterus and vulva. These symbols were repeated well into the Bronze Age on water vessels.

Many specialists claim that carved or notched bones are tallies of hunters, others say that the signs can be divided into male (lines and dots) and female (ovals and triangles) and that Ice Age humans really were on the brink of an alphabet. This may be going too far but what does seem clear is that, in covering bones with carved images alongside a series of dots, in rows and columns, early humans were constructing what anthropologists call Artificial Memory Systems – and that, after all, is what writing is. Embryonic writing

| | |
|---|---|
| Franco-Cantabrian signs in cave art | *(rows of cave art signs)* |
| Hieroglyphics | a *(signs)* |
| Sumerian | b *(signs)* |
| Indus valley | c *(signs)* |
| Linear A | d *(signs)* |
| Linear B | e *(signs)* |
| Phoenician | h *(signs)* |
| Etruscan | i *(signs)* |
| Greek | k *(signs)* |
| Runic | m *(signs)* |
| Signs on Chinese oracle bones | *(signs)* |

*Figure 2: Similar signs among early forms of writing and proto-writing*
[Source: Richard Rudgley, *The Lost Civilisations of the Stone Age*, New York, The Free Press, 1999, page 78]

is perhaps the best description. The essential similarity of these signs is particularly intriguing, so much so that some archaeologists now believe that 'a considerable number of the deliberate marks found on both parietal and mobile art from the Franco-Cantabrian region are remarkably similar to numerous characters in ancient written languages, extending from the Mediterranean to China'.[61] (See Figure 2.) In rebuttal, it might be said that there are only so many signs the human mind can invent. But even if this is true, the similarities would still amount to something, implying that there is perhaps a genetically determined limit to our imagination in this field. At present we just do not know, although in 2005 a study of 115 different alphabets found that most languages average three strokes a character. This is no coincidence, says Mark Changizi, the researcher concerned. 'Three happens to be the biggest number our brains can recognise without having to count.'[62]

For archaeologists, the term 'civilisation' generally implies four characteristics – writing, cities with monumental architecture, organised religion and specialised occupations. We cannot say that Palaeolithic humans got there fully – cities, for example, lay some way in the future. But the study of language, and writing, in civilisation – advanced though it now is – may still have some way to go. Merlin Donald, for example, has highlighted certain important stages in language development, in particular rhetoric, logic (dialectic) and grammar.[63] As he also points out, these comprised the medieval *trivium* in Christendom, which separated these basic skills, these rules of thinking, from the *quadrivium* – mathematics, astronomy, geometry and music, which were specific subjects.

In so far as ideographic, hieroglyphic and alphabetical systems of writing vary in their rhetorical, logistical and grammatical possibilities, does this difference help account for the different trajectories of the disparate civilisations around the world? Does the physical form of writing affect thinking in a fundamental way? The *trivium* was based on the idea that dispute – argument – was a trainable skill. Was it this which, at base, would provide the crucial difference between the West and the rest, which is the subject of Parts Three, Four and Five of this book, and did it encourage the assault on religious authority, the all-important break with mythic thinking? It is something to keep in the back of one's mind as we proceed.

# 3

## *The Birth of the Gods, the Evolution of House and Home*

As we have seen, for Merlin Donald the great transformation in human history was the change from episodic thinking to mimetic, because it allowed the development of culture, 'the great escape from the nervous system'. Before this book reaches its conclusion we shall have encountered many other candidates for the single most important idea in history: the soul, the experiment, the One True God, the heliocentric universe, evolution – each of them has passionate supporters. Some of these ideas are highly abstract concepts. For most archaeologists, however, humans' 'greatest idea' is a far more down-to-earth practical notion. For them, the domestication of plants and animals – the invention of agriculture – was easily the greatest idea because it produced what was by far the most profound transformation in the way that humans have lived.

The domestication of plants and animals took place some time between 14,000 and 6,500 years ago and it is one of the most heavily studied ideas in pre-history. Its origins at that time in history are intimately related to the climatological record of the earth. Until, roughly speaking, 12,000 years ago, the average temperature of the earth was both much colder and more variable than it is now. Temperature might vary by as much as 7° in less than a decade, compared with 3° in a century now.[1] Around 12,000 years ago, however, the earth warmed up considerably, as the last ice age finally ended and, no less important, the climate stabilised. This warming and stabilisation marks the transition between the two major periods in earth's history, the Pleistocene and the Holocene. This was in effect the 'big trigger' in history and made our world possible.[2]

It is safe to say that while we are now fairly clear about where agriculture began, how it began, and with what plants and animals, there is no general agreement, even today, about *why* this momentous change occurred. The theories, as we shall see, fall into two types. On the one hand, there are the environmental/economic theories, of which there are several; and there are the religious theories, of which at the moment there is only one.

The domestication of plants and animals (in that order) occurred independently in two areas of the world that we can be certain about, and perhaps in seven. These areas are: first, south-west Asia – the Middle East – in particular the 'fertile crescent' that stretches from the Jordan valley in Israel, up into Lebanon and Syria, taking in a corner of south-east Turkey, and round via the Zagros mountains into modern Iraq and Iran, the area known in antiquity as Mesopotamia. The second area of undoubted independent

domestication lies in Mesoamerica, between what is now Panama and the northern reaches of Mexico. In addition, there are five other areas of the world where domestication also occurred but where we cannot be certain whether it was independent, or derived from earlier developments in the Middle East and Mesoamerica. These areas are the highlands of New Guinea; China, where the domestication of rice seems to have had its own history; a narrow band of sub-Saharan Africa running from what is now the Ivory Coast, Ghana and Nigeria across to the Sudan and Ethiopia; the Andes/Amazon region, where the unusual geography may have prompted domestication independently; and the eastern United States.[3]

One reason for the distribution about the globe of these areas has been provided by Andrew Sherratt, from the Ashmolean Museum in Oxford. His theory is that three of these areas – the Middle East, Mesoamerica and the south-east Asian island chain – are what he calls 'hot spots': geologically and geographically they have been regions of constant change, where incredible pressures generated by tectonic plates moving over the surface of the earth created in these three places narrow isthmuses, producing a conjunction of special characteristics that are not seen elsewhere on earth. These special characteristics were, first, a sharp juxtaposition of hills, desert and alluvium (deposits of sand or mud formed by flowing water) and, second, narrow strips of land which caused a build-up of population so that the isthmus could not support traditional hunter-gathering.[4] These 'hot spots' therefore became 'nuclear areas' where the prevailing conditions made it more urgent for early man in those regions to develop a different mode of subsistence.

Whatever the truth of this attractively simple theory, or in regard to the number of times agriculture was 'invented', there is little doubt that the very first time, chronologically speaking, that plants and animals were domesticated, was in the 'fertile crescent' of south-west Asia. To understand fully what we are talking about we need to grasp the nature of the evidence about domestication, which means in the first instance understanding the relatively new science of palynology, or pollen analysis. Plants – especially the wind-pollinated tree species – each produce thousands of pollen grains every year, the outer skins of which are very tough, and very resistant to decay. Pollen varies in shape and size and, being organic, can be carbon-dated. Its age and genus, if not its species, can therefore often be determined and this has enabled archaeo-botanists (a relatively new specialism) to reconstruct the surface vegetation of the earth at different periods in the past.

Plant remains (i.e., not just pollen) have now been identified and radio-carbon dated from hundreds of sites in the Middle East and, according to the Israeli geneticist Daniel Zohary, the picture is more or less clear. First, there were three cereals which formed the principal 'founder crops' of Neolithic agriculture. In order of importance, these were: emmer wheat (*Triticum turgidum*, subspecies *dicoccum*), barley (*Hordeum vulgare*) and einkorn wheat (*Triticum monococcum*). They first appeared in the tenth and ninth millennia B P. Second, the domestication of these cereals was accompanied by the cultivation of several 'companion plants', in particular the pea (*Pisum sativum*), the lentil (*Lens culaniris*), the chickpea (*Cicer arietinum*), bitter vetch (*Vicia ervilia*) and flax (*Linum usitatissimum*).[5] In each case, the original wild variety, from which the domestic crop evolved, has now been identified; this enables us to see what advantages the domestic variants had over their wild cousins. In the case of einkorn wheat, for example, the

main distinguishing trait between wild and cultivated varieties lies in the biology of seed dispersal. Wild einkorn has brittle ears, and the individual spikelets break up at maturity to disperse the seed. In the cultivated wheat, on the other hand, the mature ear is less brittle, stays intact, and will break only when threshed. In other words, to survive it needs to be reaped, and then sown. The same is true for the other crops: the domesticated varieties were less brittle than the wild types, so that the seeds are spread only once the plant has been reaped, thereby putting it under man's control. Comparison of the DNA of the various wheats all over the fertile crescent shows that they are fundamentally identical, much less varied than the DNA of wild wheats. This suggests that in each case domestication occurred only once. 'The plants with which food production started in the South West Asia "nuclear area" were transported (already as domesticated crops) to initiate agriculture all over these vast territories.'[6]

A number of specific sites have been identified where domestication may have first occurred. Among these are Tell Abu Hureyra and Tell Aswad in Syria, which date back to 10,000 years ago, Karacadağ in Turkey, Netiv Hagdud, Gilgal and Jericho, in the Jordan valley, and Aswan in the Damascus basin, also in Syria, which date back even further, to 12,000–10,500 BP. An alternative theory – still speculative – is that man's increasing control of fire enabled him to burn huge tracts of forest, and that the tender grasses and shoots that would have grown up amid the burnt remains would themselves have been, in effect, domesticated plants *and* would have attracted herbivorous game.[7] This would have needed a knowledge of 'slash and burn' technology and tools sufficient to cut down large trees – to create fire-breaks. It is by no means certain that early humans had such tools.

In the case of animal domestication the type of evidence is somewhat different. In the first place we should note that the general history of the earth helped somewhat: after the last ice age most species of mammal were smaller than hitherto.[8] One or more of three criteria are generally taken as evidence of domestication: a change in species abundance – a sudden increase in the proportion of a species within the sequence of one site; a change in size – most wild species are larger than their domestic relatives, because humans found it easier to control smaller animals; and a change in population structure – in a domestic herd or flock, the age and sex structure is manipulated by its owners to maximise outputs, usually by the conservation of females and the selection of sub-adult males. Using these criteria, the chronology of animal domestication appears to begin shortly after 9000 BP – that is, about 1,000 years after plant domestication. The sites where these processes occurred are all in the Middle East, indeed in the fertile crescent, at locations which are not identical to, but overlap with those for plant domestication. They include Abu Hureyra, at 9400 BP, Ganj Dareh in Iran, at 9000–8450 BP, Gritille in Turkey, at 8600–7770 BP, and Tell Aswad, Jericho, Ramad, 'Ain Ghazal, Beida and Basta, all just post-dating 9000 BP. In most cases, the sequence of domestication is generally taken to be: goats then sheep, to be closely followed by pigs and cattle. 'The transformation from a hunting and collecting economy, perhaps beginning with the *cultivation* of wild cereals, to the establishment of permanent villages and a mixed agricultural economy with fully domesticated races of plants and animals, took place over at least 3,000 years.' There was no radical break; for many years people simply tended 'wild gardens' rather than neat smallholdings or farms as we would recognise them. There was a transition period where hunter-gatherers culled

smaller animals. Pigs do not adjust to the nomadic way of life, so their domestication implies sedentism.[9]

So far as animal domestication is concerned, it first took place in the hilly/mountainous region where modern-day Iran, Iraq and Turkey meet, the most likely reason for this being that, in a situation where most wild species were not naturally domesticable, hilly regions (with a variety of altitudes and therefore of vegetation) would have produced the greatest range of animal species, and the greatest variation of individuals within species. Such an environment would have been the most likely to have produced smaller types, more amenable to control.

For the Old World, then, the location and timing of agriculture is understood, as are the plants and animals on which it was based. Further, there is a general agreement among palaeobiologists that domestication was invented only once and then spread to western Europe and India. Whether it also spread as far afield as south-east Asia and central Africa is still a moot point, and the most recent genetic evidence of farmers (as opposed to their plants) is not as conclusive as it might be. It shows that modern-day Greeks share 85–100 per cent of their (relevant) genes with Middle Easterners (from Baghdad, Ankara and Damascus), whereas Parisians share only 15–30 per cent. Some archaeologists have suggested that this means that it wasn't the *idea* that spread, but people practising the idea, but not everyone accepts this.[10]

Much more controversial, however, are the reasons for *why* agriculture developed, why it developed then, and why it developed where it did. This is clearly of major importance in understanding mankind's mental development. It is also an even more interesting question than it looks when you consider the fact that the hunter-gathering mode is actually quite an efficient way of leading one's life. Ethnographic evidence among hunter-gatherer tribes still in existence shows that they typically need to 'work' only three or four or five hours a day in order to provide for themselves and their kin. Skeletal remains of Stone Age farmers reveal more signs of malnutrition, infectious diseases and dental decay than those of their hunter-gatherer predecessors. Why, therefore, would one change such a set of circumstances for something different where one has to work far harder? In addition, reliance on grain imposed a far more monotonous diet on early humans than they had been used to in the time of hunting and gathering. In any case, when people first domesticated crops, these remained a minor part of the diet for centuries, possibly more than a thousand years. Again, why the change?

One theory is that the switch to agriculture was made for ritualistic or social reasons, because the new foods were rare luxuries, which gradually spread, the way designer goods do in our own day. Lentils, for example, grow just two per wild plant and would hardly have staunched the hunger of a Stone Age family. Yet lentils are among the first crops of the Near East. Some palaeontologists feel beer was the most important end-product of these grains, the importance of alcohol in a ritual feast being obvious.

But the most basic of the economic arguments stems from the fact that, as has already been mentioned, some time between 14,000 and 10,000 BP, the world suffered a major climatic change. This was partly a result of the end of the Ice Age which had the twin effects of raising sea levels and, in the warmer climate, encouraging the spread of forests.

These two factors ensured that the amount of open land shrank quite dramatically, 'segmenting formerly open ranges into smaller units and arranging the niches for different species by altitude and type of vegetation ... Sedentism and the reduction of open range encouraged territoriality. People began to protect and propagate local herds, a pre-domestication practice that can be referred to as food resource management.'[11] A further aspect of this set of changes was that the climate became increasingly arid, and the seasons became more pronounced, a circumstance which encouraged the spread of wild cereal grasses and the movement of peoples from one environment to the next, in search of both plants and animal flesh. There was more climatic variety in areas which had mountains, coastal plains, higher plains and rivers. This accounts for the importance of the fertile crescent. Grasses were naturally prevalent in this Near Eastern region (wild stands of emmer and einkorn wheat, and barley, exist there to this day). But it is not difficult to work out what happened. 'The harvested batch of seeds would be selected in favour of non-shattering and uniform maturation. As soon as humans began to sow the seeds they had harvested, they automatically – even if unintentionally – initiated a process of selection in favour of the non-shattering genotype.'[12]

Mark Nathan Cohen is the most prominent advocate of the theory that there was a population crisis in pre-history and that it was this which precipitated the evolution of agriculture. Among the evidence he marshals to support his argument is the fact that agriculture is not easier than hunter-gathering, that there is a 'global coincidence' in the simultaneous extinction of mega-fauna, the big mammals which provided so much protein for early humans, a further coincidence that domestication emerged at the end of the Pleistocene Age, when the world warmed up and people became much more mobile, and that the cultivation of wild species, before agriculture proper, encouraged the birth of more children. It is well known, for instance, that nomads and hunter-gatherers control the number of children by not weaning them for two years. This limits the size of a group that is continually on the move. After the development of sedentism, however, this was no longer necessary, and resulted, says Cohen, in a major population explosion. Cohen also claims that evidence for a population crisis in antiquity can be inferred from the number of new zones exploited for food, the change in diet, from plants which need less preparation to those which need more, the change in diet from larger animals to smaller (because larger ones were extinct), the increasing proportion of remains of people who are malnourished, the specialisation of artefacts which had evolved to deal with rarer and rarer animals and plants, the increased use of fire, for cooking otherwise inedible foodstuffs, the increased use of aquatic resources, the fact that many plants, though available as food in deep antiquity, were not harvested until around 12,000 BP, that grass (cereals) is a low priority in food terms, and so on and so on, all of which Cohen contends is corroborated by archaeological excavation. For him, therefore, the agricultural revolution was not, in and of itself, a liberation for early humans. It was instead a holding action to cope with the crisis of overpopulation. Far from being an inferior form of life, the hunter-gatherers had been so successful they had filled up the world, insofar as their lifestyle allowed, and there was no place to turn.[13]

It is another attractively simple hypothesis but there are problems with it. One of the strongest criticisms comes from Les Groube, who is the advocate of a rival theory.

According to Groube, who is based in France, it is simply not true that the world of deep antiquity was in a population crisis, or certainly not a crisis of overpopulation. His argument is the opposite, that the relatively late colonisation of Europe and the Americas argues for a fairly thinly populated Earth. For Groube, as man moved out of Africa into colder environments, there would have been fewer problems with disease, simply because, from a microbial point of view, the colder regions were safer, healthier. For many thousands of years, therefore, early man would have suffered fewer diseases in such places as Europe and Siberia, as compared with Africa. But then, around 20,000 years ago, an important coincidence took place. The world started to warm up, and man reached the end of the Old World – meaning that, in effect, the known world was 'full' of people. There was still plenty of food but, as the world warmed up, many of the parasites on man were also able to move out of Africa. In short, what had previously been tropical diseases became temperate diseases as well. The diseases Groube mentions include malaria, schistosomiasis and hookworm, 'a terrible trinity'. A second coincidence also occurred. This was the hunting to extinction of the mega-fauna, which were all mammals, and therefore to a large extent biologically similar to man. All of a sudden (sudden in evolutionary terms), there were far fewer mammals for the microbial predators to feast on – and they were driven to man.[14]

In other words, sometime after 20,000 years ago, there was a health crisis in the world, an explosion of disease that threatened man's very existence. According to Groube's admittedly slightly quirky theory, early humans, faced with this onslaught of disease, realised that the migrant pattern of life, which limited childbirth to once every three years or so, was insufficient to maintain population levels. The change to sedentism, therefore, was made because it allowed people to breed more often, increase numbers, and avoid extinction.

One thing that recommends Groube's theory is that it divorces sedentism from agriculture. This discovery is one of the more important insights to have been gained since the Second World War. In 1941, when the archaeologist Gordon Childe coined the phrase 'The Neolithic Revolution', he argued that the invention of agriculture had brought about the development of the first villages and that this new sedentary way of life had in turn led to the invention of pottery, metallurgy and, in the course of only a few thousand years, the blossoming of the first civilisations.[15] This neat idea has now been overturned, for it is quite clear that sedentism, the transfer from a hunter-gathering lifestyle to villages, was already well under way by the time the agricultural revolution took place. This has transformed our understanding of early man and his thinking.

Although present-day 'stone age' tribes are by no means a perfect analogue of ancient hunter-gatherers (for one thing, they tend to occupy marginal areas), it has become clear that 'primitive' peoples do have an intimate knowledge of the natural world in which they live. And, although they may not practise full-scale agriculture, they certainly *cultivate* both plants and animals, in the sense of clearing areas and planting grasses or vegetables or fruits. They sow, drain and irrigate, they practise rough herding and 'free range movement'. They keep pet mammals and birds and are fully aware of the medicinal qualities of certain herbs. This is surely a half-way stage between the old idea of hunter-gatherers and

full-blown agriculture. By the same token, 'there is now a considerable body of evidence in support of the view that some resource-rich locations in the Levant were occupied year-round during the terminal Pleistocene (more specifically in the Natufian and Khiamian periods: *c.* 10,500–8300 BC) by "sedentary foragers" who developed ... techniques of plant exploitation, including storage and possibly small-scale cultivation ... and who lived year round in settlements of up to half a hectare in area'.[16]

The fact that sedentism *preceded* agriculture has stimulated the French archaeologist Jacques Cauvin to produce a wide-ranging review of the archaeology of the Middle East, which enables him to reconcile many developments, most notably the origins of religion and the idea of the home, with far-reaching implications for the development of both our basic and our more speculative/philosophical innovations. If tools and the control of fire were the first ideas, clothing and shelter soon followed.

Cauvin, late director of research emeritus at the Institut de Préhistoire Orientale at Jalés in Ardèche, France (between Lyons and Marseilles), starts from a detailed examination of the pre-agricultural villages of the Near East. These begin, he says, between 15,500 and 12,500 BC, at Kharaneh in Jordan, with 'base camps' up to 2,000 square metres in extent and which consist of circular depressions in open air sites. Between 12,500 and 10,000 BC, however, the so-called Natufian culture extended over almost all of the Levant, from the Euphrates to Sinai (the Natufian takes its name from a site at Wadi an-Natuf in Israel). Excavations at Eynan-Mallaha, in the Jordan valley, north of the Sea of Galilee, identified the presence of storage pits, suggesting 'that these villages should be defined not only as the first sedentary communities in the Levant, but as "harvesters of cereals" '.[17]

The Natufian culture also boasted houses. These were grouped together (about six in number), as villages, and were semi-subterranean, built in shallow circular pits 'whose sides were supported by dry-stone retaining walls; they had one or two hearths and traces of concentric circles of posts – evidence of substantial construction'. Their stone tools were not just for hunting but for grinding and pounding, and there were many bone implements too. Single or collective burials were interred under the houses or grouped in 'genuine cemeteries'.[18] Some burials, including those of dogs, may have been ceremonial, since they were decorated with shells and polished stones. Mainly bone art works were found in these villages, usually depicting animals.

At Abu Hureyra, between 11,000 and 10,000 BC, the Natufians intensively harvested wild cereals but towards the end of that period the cereals became much rarer (the world was becoming drier) and they switched to knot grass and vetch. In other words, there was as yet no phenomenon of deliberate specialisation. Analysis of the microblades from these sites shows they were used both for harvesting wild cereals and for cutting reeds, still more evidence for the absence of specialisation.

Cauvin next turned to the so-called Khiamian phase. This, named after the Khiam site, west of the northern end of the Dead Sea, was significant for three reasons: for the fact that there were new forms of weapons, for the fact that the round houses came completely out of the ground for the first time, implying the use of clay as a building material, and, most important of all, for a 'revolution in symbols'.[19] Natufian art was essentially zoomorphic, whereas in the Khiamian period female human figurines begin to appear. They were schematic initially, but became increasingly realistic. Around 10,000 BC the

skulls and horns of aurochs (a now-extinct form of wild ox or bison) are found buried in houses, with the horns sometimes embedded in the walls, an arrangement which suggests they already have some symbolic function. Then, around 9,500 BC, according to Cauvin, we see dawning in the Levant '*in a still unchanged economic context of hunting and gathering*' (italics added), the development of two dominant symbolic figures, the Woman and the Bull. The Woman was the supreme figure, he says, often shown as giving birth to a Bull.

Cauvin sees in this the true origin of religion. His main point is that this is the first time humans have been represented as gods, that the female and male principle are both represented, and that this marked a change in mentality *before* the domestication of plants and animals took place. It is easier to see why the female should be chosen rather than the male. The female form is a symbol of fertility. At a time when child mortality was high, true fertility would have been highly prized. Such worship was designed to ensure the well-being of the tribe or family unit.

But Cauvin's second important point, over and above the fact that recognisable religion as we know it emerged in the Levant around 9500 BC, is that this all took place after cultivation and sedentism had begun, but before domestication/agriculture proper.

He turns next to the Mureybetian culture. This is named for Tell Mureybet, near the Euphrates, in what is now Syria. Here the houses are already more sophisticated, with special sleeping areas, raised, separate hearths and storage areas, with flat mud roofs supported by jointed joists. Between the houses, communal open spaces contained several large 'fire-pits'. These pits were of a type frequently encountered in the Near Eastern Neolithic: they were basin-shaped, and were often found packed full of pebbles. So they may have functioned on the model of the present-day Polynesian oven, where the pebbles store the heat of a fire lit on their surface, and then give off that heat over a long period. The fire-pits of Mureybet are generally surrounded with animal bones that are to a greater or lesser degree charred. 'Their utilisation for the communal cooking of meat seems reasonably probable.'[20] What most excited Cauvin, however, was an important change in architecture that began to occur at Mureybet after 9000 BC. 'It is at this point that the first rectangular constructions known in the Near East, or in the world, appear.' Both houses and storage areas become rectangular (though some houses had rounded corners). These constructions were built out of chalk blocks 'chipped into cigar shapes' and bonded with mortar. Rectangular houses allowed more to be gathered into small spaces and Cauvin speculates as to whether the reason for this was defence.

Another important innovation at Mureybet was the use of baked clay for the manufacture of female figurines. 'It [clay] is also used for very small receptacles, although we are still a millennium and a half ahead of the general use of pottery in the Near East . . . It follows that the action of fire in consolidating these modelled objects was well known and intentionally practised by the people of Mureybet from 9500 BC.'[21]

Cauvin's central point, then (and there are others who share his general view), is that at places such as Mureybet, the development of domestication was not a sudden event owing to penury, or some other economic threat. Instead, sedentism long preceded domestication, houses had already changed from the primitive round structures, half underground, to rectangular buildings above ground, and that bricks and symbolic artefacts were already being produced. From this, he says, we may infer that early man, roughly

12,000–10,000 years ago, underwent a profound psychological change, essentially a religious revolution, and that this *preceded* domestication of animals and plants. (This argument is reminiscent of Merlin Donald's, that the first use of language was for myth, not more 'practical' purposes.) This religious revolution, Cauvin says, is essentially the change from animal or spirit worship to the worship of something that is essentially what we recognise today. That is to say, the human female goddess, flanked by her male partner (the bull), is worshipped as a supreme being. He points to carvings of this period in which the 'faithful' have their arms raised, as if in prayer or supplication. For the first time, he says, there is 'an entirely new relationship of subordination between god and man'.[22] From now on, says Cauvin, there is a divine force, with the gods 'above' and everyday humanity 'below'.

The bull, he says, symbolises not only the male principle but also the untameability of nature, the cosmic forces unleashed in storms, for example. Batons of polished stone are common throughout the Mureybetian culture, which Cauvin says are phallic symbols. Moreover, Cauvin discerns in the Middle East a clear-cut evolution. 'The first bucrania of the Khiamian or Mureybetian remained buried within the thickness of the walls of buildings, not visible therefore to their occupants. Perhaps they only metaphorically wanted to ensure the resistance of the building to all forms of destruction by appealing to this new symbolism for an initial consecration [i.e., when the houses were built]. The time had not yet come for direct confrontation with the animal.'[23] After that, however, bovine symbolism diffused throughout the Levant and Anatolia and at 'Ain Ghazal we see the first explicit allusions, around 8000 BC, to the bull-fighting act, in which man himself features.[24] Man's virility is being celebrated here, says Cauvin, and it is this concern with virility that links the agricultural revolution and the religious revolution: they were both attempts to satisfy 'the desire for domination over the animal kingdom'.[25] This, he argues, was a psychological change, a change in 'mentality' rather than an economic change, as has been the conventional wisdom.

On this reading, the all-important innovation in ideas is not so much the domestication of plants and animals, but the *cultivation* of wild species of cereals that grew in abundance in the Levant and allowed sedentism to occur. It was sedentism which allowed the interval between births to be reduced, boosting population, as a result of which villages grew, social organisation became more complicated and, perhaps, a new concept of religion was invented, which in some ways reflected the village situation, where leaders and subordinates would have emerged. Once these changes were set in train, domesticated plants at least would have developed almost unconsciously as people 'selected' wild cereals which were amenable to this new lifestyle.

These early cultures, with the newly-domesticated plants and animals, are generally known as Neolithic and this practice spread steadily, first throughout the fertile crescent, then further, to Anatolia and then Europe in the west, and to Iran and the Caucasus in the east, gradually, as we shall see, extending across all of the Old World. In addition to farming and religion, however, a third idea was included in this spread: the rectangular house. Foundations showing different variations have been found, in Anatolia, at Nevali Cori in Iran, and in the southern Levant, but the evolution of circular houses into rectangular ones with rectangular rooms appears to be a response to the consequences of domestication

and farming. There was now more need for storage space, for larger families and, possibly, for defence (with sedentism the number of material possessions grows and there is more to envy/steal). Rectangular rooms and houses fit together more efficiently, are easier to vary in size, allow more 'interior' rooms, and make more use of shared walls.[26]

We have here then not so much a renaissance as a naissance, a highly innovative time – relatively short – when three of our most basic ideas were laid down: agriculture, religion, the rectangular house. The mix of abstract and practical down-to-earth ideas would not have been recognised by early humans. Religion would have suffused the other two ideas as each activity spilled over into the other.

When Jericho was excavated by the British archaeologist Dorothy Garrod in the 1930s she made three discoveries of interest in the context of this chapter. First, the settlement consisted of about seventy buildings, housing perhaps as many as a thousand people: Jericho was a 'town'. Second, she found a tower, eight metres high, nine metres in diameter at the base, with an internal staircase of twenty-two steps. Such architecture was unprecedented – it would have needed a hundred men working for a hundred days to build such an edifice.[27] Garrod's third discovery, unearthed at Terrace B, was a good example of a Natufian baking/cooking unit. 'This terrace seems to be provided with all the equipment required for the processes: the pavement, partly preserved, would be suitable for hand-threshing and husking; the cup basins and the numerous stone mortars would be suitable for the grinding or milling of the grain; the one larger basin would serve for mixing the ground grits or rough "flour" with water; and all this was found not far from ovens.'[28]

There was no clay. All tools and personal accessories of the Natufians were produced by the meticulous grinding of stone on stone, or stone on bone.[29] The first use of clay in the Middle East is documented at Jericho (ninth millennium BC), at Jarmo (eighth) and at Hacilar (seventh), where it was found mixed with straw and chaff and husks – in effect the by-products of threshing – used to bind bricks. At both Jericho and Jarmo depressions were discovered in the clay floors.[30] 'Whether used as basins for household activities, or as bins, or as ovens with "boiling stones", the main interest lies in the fact that these immovable receptacles are located together with the ovens and hearths in the courtyards, the working spaces of the houses. We may now conclude ... that some accidental firing, due to the proximity of the various acts of preparing-cooking-baking the ground wheat or barley in the immovable basins and the oven, was the cause of the transformation of the mud clay into pottery.'[31] Johan Goudsblom speculates as to whether the preservation of fire became a specialisation in early villages, giving the specialists a particular power.[32]

Among archaeologists there has been some debate that the earliest forms of pottery have never been found, because what has been found is too good, too well made to represent 'fumbling beginnings'.[33] So perhaps pottery was invented there earlier, even much earlier. This would fit with the fact that the very first pottery was made in Japan, as part of the Jomon culture, as early as 14500 BC, among people who were full-time hunter-gatherers.[34] The Jomon Japanese were extremely creative, with very sophisticated hand-axes, and they also invented lacquer. However, no one knows exactly why Jomon pottery was invented or what it was used for (it has even been suggested that large numbers were smashed, in some form of ceremony). The full development of pottery, as one of the

'cultures of fire', is better illustrated through its development in the Middle East.

At the early Neolithic site of Çatal Hüyük in Turkey (seventh millennium BC), two types of oven were found built next to one another. 'One is the normal vaulted type of baking oven. The second is different in that it has a fire chamber divided into two compartments by a half brick some 15cm high below the main chamber. The front part of these ovens and kilns, which evidently protruded into the room, was destroyed, and was evidently removed to take out whatever was baked in them, whether pots or bread. With the next firing/baking, the front part would be covered over again, which is of course easily done in mud.'[35] It appears from shards found at Jarmo, Jericho and Çatal Hüyük that pots were made from coils of clay laid in rings and then smoothed over. Dung and grasses were the fuel used, rather than wood.[36]

At a village like Teleilat al Ghassul, near the northern edge of the Dead Sea, in Jordan, we see both stone tools and early pottery, as this important transition occurs. Frederic Matson found during his excavations at Tepe Sarab, near Kermanshah in western Iran (a site roughly contemporaneous with Jarmo), that there were but three principal diameters of the vessels. Does this suggest three functions? He found that, once invented, the technology of pottery quickly improved. For example, methods were found to lower the porosity of the clay, using burnishing or more intensive firing and, sometimes, the impregnation of organic materials. Vessels that were too porous lost water too quickly; but vessels needed to be a little porous so that some water evaporated, helping to cool what remained.[37]

Some early pots were left plain, but decoration soon appeared. Red slip was the first type of decoration used, together with incising, using the fingers. 'The discovery that the brown earth will fire to a bright red colour might have come from camp fires.'[38] The most common pot shapes at the earliest sites are globular (for rodent-free storage), part of which was underground, and open bowls, probably used for gruel or mush made from the seeds of wild and cultivated plants.[39] After the first pots – blackened, brown or reddened as the case might be – creams and mottled grey began to appear (in Anatolia, for instance).[40] Cream-ware especially lent itself to decoration. The earliest decorations were made by hand, then by pressing such things as shells into the clay before firing.[41] Lids, spouts and flaring rims also evolve, and from here on the shape and decorations of pottery become one of the defining characteristics of a civilisation, early forms of knowledge for archaeologists for what they reveal about ancient societies.

The Woman and the Bull, identified by Cauvin as the first true gods, as abstract entities rather than animal spirits, found echoes elsewhere, at least in Europe in the Neolithic period. They occurred in very different contexts and cultures, together with a symbolism that itself differed from place to place. But this evidence confirms that sedentism and the discovery of agriculture *did* alter early humans' way of thinking about religion.

Between – roughly speaking – 5000 BC and 3500 BC, we find the development of megaliths. Megaliths – the word means 'large stones' – have been found all over the world but they are most concentrated, and most studied, in Europe, where they appear to be associated with the extreme western end of the continent – Spain, Portugal, France, Ireland, Britain and Denmark, though the Mediterranean island of Malta also has some of the best megalithic monuments. Invariably associated with (sometimes vast) underground burial

chambers, some of these stones are sixty feet high and weigh as much as 280 tons. They comprise three categories of structure. The original terms for these were, first, the menhir (from the Breton *men* = stone and *hir* = long), usually a large stone set vertically into the ground. The cromlech (*crom* = circle, curve and *lech* = place) describes a group of menhirs set in a circle or half-circle (for example, Stonehenge, near Salisbury in England). And third, the dolmen (*dol* = table and *men* = stone), where there is usually an immense capstone supported by several upright stones arranged to form an enclosure or chamber.[42] The practice now is to use plain terms such as 'circular alignment' for cromlech.

Most of the graves were originally under enormous mounds and could contain hundreds of dead. They were used for collective burial, on successive occasions, and the grave goods were in general unimpressive. Very rarely the chambers have a central pillar and traces of painting can be seen. As Mircea Eliade has said, all this 'testifies to a very important cult of the dead': the houses where the peasants of this culture lived have not stood the test of time, whereas the chamber tombs are the longest-surviving structures in the history of the world. Perhaps the most impressive structures of all are the stone temples of Malta, which some archaeologists consider may have been a sacred island in pre-history. The most striking, according to Colin Renfrew, is at Ggantija on Gozo, the more northerly of the Maltese archipelago. 'In front of the Ggantija is a spacious terrace, some forty metres wide; supported by a great retaining wall, the façade, perhaps the earliest architecturally conceived exterior in the world, is memorably imposing. Large slabs of coralline limestone, set alternately end-on and sideways-on, rise to a height of eight metres; these slabs are up to four metres high for the first course, and above this six courses of megalithic blocks still survive. A small temple model of the period suggests that originally the façade may have been as high as sixteen metres.'[43] In one of the other Maltese temples, Tarxien, on Malta itself, relief carvings of spirals were found, together with friezes of animals and, most surprising of all, 'a large fragment of a colossal statue of a seated woman. Originally she must have attained a height of two metres in the seated position. This must be the earliest colossal statue in the world.'[44] Several smaller stone structures have also been found, most of them 'fat ladies', 'splendidly plump personages in stone'.[45] The basic idea, of a seated goddess, possibly pregnant, certainly recalls the Natufian figures discussed by Cauvin.

What ideas lay behind the worship in these temples? Renfrew's researches on the island of Arran, in Scotland, have shown that the tombs there are closely related to the distribution of arable land and it therefore seems that these tomb/temples were somehow linked to the worship of a great fertility goddess, which developed as a cult as a result of the introduction of farming, and the closer inspection of nature that this would have entailed. We can, however, say a little more about this set of beliefs. Although it is very variable, megalithic sites are often sited so that 'the countryside falls into certain patterns around them. The classic megalithic site is on a platform part-way down a spur which runs from higher ground behind. From the site itself, a bowl or valley in the land will be noticeable below, while the horizon will be surrounded by ridges of hills which wrap around behind the spur.'[46] These sitings are believed to relate to ancient beliefs about sacred landscape – geomancy. 'The happy site is almost always sheltered by the hills, slightly elevated within them, and connected to them by land through which the geodic currents flow. In the angle formed by the junction of such hills, the geomancer looked for a "little hollow or little

mound", from which the chain of hills around can be seen to form "a complete horseshoe" with one side open, and streams that run away gently rather than steeply.'[47] From about 1930 onwards, modern dowsers have explored megalithic sites and picked up very powerful reactions in their vicinity. One dowser, Guy Underwood, published in 1969 a map of primary dowsing lines under Stonehenge which showed that twenty lines converged on the site.[48] Some, but by no means all megalithic sites are also grouped in straight lines that, when connected on a map, link several places which, in England, have names that end in the syllable 'ley'. (These are called leylines.) Whether there is anything to this, it does seem to be true that several megalithic circular alignments were prehistoric astronomical observatories. Knowledge of the sun's cycle was clearly important for an agricultural community, in particular the midwinter solstice when the sun ceases to recede and begins to head north again. From the mound, features on the horizon could be noted where the midwinter solstice occurred (for example), and stones erected so that, on subsequent years, the moment could be anticipated, and celebrated. Sun observatories were initiated round 4000 BC but moon ones not until 2800 BC. Tombs usually faced east. Chris Scarre, of Cambridge, argues that many of these huge stones are taken from sacred parts of the landscape, 'places of power' – waterfalls, for example, or cliffs, which have special acoustic or sensory properties, such as unusual colours or texture, and are taken to form shrines in areas that are important for hunting or domestication. This, he says, explains why these stones are transported sometimes over vast distances but are otherwise not modified in any way.[49]

There may however be a further layer of meaning on top of all this. A number of carvings have been found associated with megalithic temples and observatories – in particular, spirals, whorls and what are called cup-and-ring marks, in effect a series of concentric Cs.[50] Elsewhere in Europe, as we shall see in just a moment, these designs are related to what some prehistorians have referred to as the Great Goddess, the symbol of fertility and regeneration (not everyone accepts this interpretation). In Germany and Denmark, pottery found associated with megaliths is also decorated with double circles and these too are associated with the Great Goddess. Given the fact that, in the very earliest times, the fertility of women must have been the greatest mystery and greatest miracle known to mankind, before the male function was discovered, and given the fact that menhirs almost by definition resemble the male organ, it is certainly possible that the megalithic cromlechs were observatory/temples celebrating man's new-found understanding. The sexual meaning of menhirs is not simply another case of archaeologists reading too much into the evidence. In the Bible, for example, Jeremiah (2:27) refers to those who say to a stone: 'You have begotten me.' Belief in the fertilising virtues of menhirs was still common among European peasants at the beginning of the twentieth century. 'In France, in order to have children, young women performed the *glissade* (letting themselves slide along a stone) and the *friction* (sitting on monoliths or rubbing their abdomen along certain rocks)'.[51]

It is not difficult to understand the symbolism. The midwinter solstice was the point at which the sun was reborn. When it appeared that day, the standing stones were arranged so that the first shaft of light entered a slit in the centre of the circular alignment, the centre of the world in the sacred landscape, which helped to regenerate the whole community, gathered there to welcome it. A good example of this is Newgrange in Ireland.

One final word on megaliths. While Orkney and Malta cannot really be called part of the same early culture, there are signs in both that there was a special caste of people, apart from the general population, in sizeable megalithic communities. 'In Malta, the skeletons of those associated with the temples after 3500 BC indicate a lightly-muscled people, who ate a special diet which wore down their teeth very little for Neolithic times.' The bones of animals slaughtered at an uneconomically early age, associated with inhabitants who lived in houses luxurious for the time, suggests that there was already in existence a social division between people with, at the top, a special caste, a combination of ruler, priest and scientist.[52]

At much the same time as megalithic ideas were proliferating, but in a different part of Europe, a different form of worship of essentially the same principles was evolving. This part of the continent is generally referred to as 'Old Europe', and includes Greece and the Aegean, the Balkans, southern Italy and Sicily and the lower Danube basin and Ukraine. Here the ancient gods have been studied by the Lithuanian scholar, Marija Gimbutas.

She finds a complex iconography grouped around four main entities. These are the Great Goddess, the Bird or Snake Goddess, the Vegetation Goddess, and the Male God. The snake, bird, egg and fish gods played their part in creation myths, while the Great Goddess was the creative principle itself, the most important idea of all. As Gimbutas puts it, 'The Great Goddess emerges miraculously out of death, out of the sacrificial bull, and in her body the new life begins. She is not the Earth, but a female human, capable of transforming herself into many living shapes, a doe, dog, toad, bee, butterfly, tree or pillar.'[53] She goes on: '. . . the Great Goddess is associated with moon crescents, quadripartite designs and bull's horns, symbols of continuous creation and change . . . with the inception of agriculture'.[54] The central theme was the birth of an infant in a pantheon dominated by the mother. The 'birth-giving Goddess', with parted legs and pubic triangle, became a form of shorthand, with the capital letter M as 'the ideogram of the Great Goddess'.[55]

Gimbutas' extensive survey of many figurines, shrines and early pottery produced some fascinating insights – such as the fact that the vegetation goddesses were in general nude until the sixth millennium BC and clothed thereafter, and that many inscriptions on the figurines were an early form of linear proto-writing, thousands of years before true writing, and with a religious rather than an economic meaning. By no means everyone accepts Gimbutas' ideas about proto-writing but her main point was the development of the Great Goddess, with a complicated iconography, yet at root a human form, though capable of transformation into other animals and, on occasion, trees and stones.[56] There *is* a link here, back to Lewis-Williams' ideas of the mind in the cave, 'releasing' living forms from the rock surfaces.

At this point, then, say around 4000 BC, there is a small constellation of ideas underlying primitive religion, all woven together. We have the Great Goddess and the Bull. The Great Goddess, emerging via the Venus figurines, symbolises the mystery of birth, the female principle, and the regeneration of nature each year, with the return of the sun. This marked a time when the biological rhythms of humans and the astronomical rhythms of the world had been observed but not yet understood. The Bull and stones represent the male principle but also suggest, via the decorated caves of the Palaeolithic age, the idea of a sacred

landscape, special locations in man's environment where significant occurrences take place (having mainly to do, first, with hunting, then with agriculture). These are early humans' most basic religious ideas.[57]

There was another reason why stones and the landscape should become sacred, and it had nothing to do with astronomy. At some point after 4000 BC, early humans experienced the apparently magical transformation by which solid rock, when treated in a certain way through heat, can produce molten metal, sometimes of a very different colour.

Pottery, as we have seen, was the first of five new substances – the 'cultures of fire' – which laid the basis for what would later be called civilisation. The other four were metals, glass, terra-cotta and cement. Here we shall concentrate on metals but the other pyrotechnological substances underline the continuing importance of fire in antiquity, and show how sophisticated early humans became in their understanding, and manipulation, of heat and flame.

Although archaeologists now order the 'ages' of man into the Stone, Copper, Bronze and Iron Ages, in that order, the first use of a metallic substance was almost certainly iron, around 300,000 years ago, when ochre found favour as decoration. Haematite in particular was popular, possibly because of its colour – red, the colour of blood and life. By Neolithic times (8000–6000 BC), there appear to have been special workshops in places like Çatal Hüyük to produce red ochre and green malachite in cakelike lumps, as a storage technique.[58] In pre-pottery Jericho three life-size plaster figures thought to portray divinities were covered in ochre. But houses too were painted red at other sites in the Middle East. As pottery developed, ochre continued as the favoured colour, though blue-green took over as the colour considered most beneficial to the dead.[59]

If the colour, lustre and even the weight of metals made their impact on early humans, it was as raw rocks, or in the beds of rivers and streams that they first encountered them. From this, they would have discovered that some rocks, such as flints and cherts, became easier to work with on heating and that others, like native copper, were easier to hammer into serviceable tools. Gradually, therefore, as time passed, the advantages of metals over stone, wood and bone would have become apparent. However, when we think of metallurgy in antiquity we mainly mean one thing – smelting, the apparently magical transformation by which solid rock can be transformed into a molten metal. One can easily imagine the awesome impact this would have had on early humans.

Copper ores are found all over the fertile crescent region but invariably in hilly and mountainous regions. Archaeologists are inclined therefore to think this is where metallurgy began, rather than in river valleys. The area favoured nowadays is a region 'whose inhabitants, in addition to possessing ore and fuel, had adopted some form of settled life and were enjoying a chalcolithic culture'.[60] This area, between the Elburz mountains and the Caspian Sea, is the front-runner for the origin of metallurgy, though the Hindu Kush and other areas have their adherents too. 'That the discovery was fortuitously made can hardly be doubted, for it is inconceivable that men, simply by taking thought, would have realised the relationship existing between malachite – a rich-blue, friable stone – and the red, malleable substance, which we call copper.'[61] Because such a link was regarded then as magical, the early copper-smiths were believed to have superhuman powers.

At one stage it was believed that 'the camp-fire was the original smelting furnace'. No more. Quite simply, the hearths at around 4000 BC were not hot enough. Without a forced draught, 'a camp fire, though giving enough heat to cook the food and to warm the feet ... would not produce a temperature much higher than about 600° or 650°. Such copper ores as malachite, the easiest to deal with, are not reduced at temperatures lower than 700° to 800°C, and metallic copper does not melt below 1083°C.' It is not only the temperature that acts against campfires. Not being enclosed, the atmosphere would not have been conducive to 'reducing' (separation).[62] On the other hand, well before the discovery of smelting, much higher temperatures would have been obtained in some pottery kilns. Two-chambered kilns, with the fire down below and the pots above, had been evolved by the fifth millennium, temperatures as high as 1200°C being obtained, for example, at Susa (Iran) and Tepe Gawra (near Mosul, in Iraq).[63] The atmosphere in these baking chambers would have been of a strongly reducing character and modern experiments have confirmed that a spongy copper could be smelted in this way. The accident may have happened when ancient potters used malachite to colour pottery – 'and then got the shock of their lives, when the colour delivered was very different from that anticipated'.[64]

By placing the invention of two-tiered pottery kilns – towards the end of the fifth millennium – next to the archaeological observation that certain copper objects were discovered at Susa, Al 'Ubaid, Nineveh and Ur, we can conclude that smelting was discovered about 4300 BC. We know that by 4000 BC knowledge of the process had spread to a number of regions in western Asia and that, by 3800 BC, copper smelting was being practised 'comparatively widely' in the ancient world.[65] 'By the early years of the third millennium BC, the people of Sumer had created the first important civilisation known to us in which metals played a conspicuous role.' (The oldest known stock of metal tools dates from 2900 BC.) From these dates onward copper was the dominant metal in western Asia and north Africa until after 2000 BC.[66]

Insofar as early metallurgy was concerned, after the discovery of smelting two advances were crucial. These were the discovery first of bronze and second of iron. There are two mysteries surrounding the advent of the Bronze Age, certainly so far as the Middle East is concerned, where it occurred first. One mystery lies in the fact that tin, the alloy with copper that makes it much harder, as bronze, is relatively rare in nature. How did this particular alloy, therefore, come to be made for the first time? And second, why, despite this, were advances so rapid, with the result that, between about 3000 BC and 2600 BC, all the important advances in metallurgical history, save for the hardening of steel, were introduced?[67]

In one sense, we should call the early Bronze Age the alloy age. This is because for many years, either side of 2000 BC, and despite what was said above, objects that might be called bronze had a very varied chemical make-up. Alloyed with copper, and ranging from less than 1 per cent to 15 per cent, there could be found tin, lead, iron and arsenic, suggesting that although early man had some idea of what made copper harder, more malleable and gave its tools and weapons a better edge, he wasn't entirely comfortable with the precise details of the process. The exact composition of bronze also varied from area to area – between Cyprus, Sumer and Crete, for example. The all-important change-over from copper to real bronze occurred in the first quarter of the second millennium BC. 'Tin

differs from copper – and the precious metals – in that it is never found in nature in a pure state. Instead, it is always in chemical combination. It must therefore have been smelted, though (and this is another mystery) hardly any metallic tin has ever been found in excavations by archaeologists. (In fact, only one piece of pure tin older than 1500 BC has ever been found.)'[68]

Though the exact origins of bronze are obscure, its attractions over copper were real enough, once its method of production could be stabilised, and its increasing popularity brought about considerable changes in the economy of the ancient world. Whereas copper was found in a fairly large number of localities, this was not the case with bronze for, as was said above, in neither Asia nor Europe is tin ore widely distributed. This limitation meant that the places where tin was mined grew considerably in importance and, since they were situated almost entirely in Europe, that continent had advantages denied to Asia and Africa. The fact that bronze was much more fluid than copper made it far more suitable for casting while its widespread use in weapons and tools simply reflects the fact that, provided tin content could be kept at 9–10 per cent, hammered bronze is usually a good 70 per cent stronger than hammered copper. The edges of bronze tools were at least twice as hard as copper.[69]

This final fact about bronze was very important. The sheer hardness of bronze meant that the edges of daggers became as important as their points, encouraging the development of swords. Moreover, this development coincided with the domestication of the horse in the steppe countries of Europe, and the wheel in Sumer. Warfare was therefore suddenly transformed – in fact, it changed more rapidly than at any other time until gunpowder was used in anger in China in the tenth century AD.[70]

The Bronze Age reached its peak around 1400 BC. It was a time when iron was scarce and valuable. Tutankhamun reigned for only a very few years as a pharaoh in Egypt, and died about 1350 BC, but his tomb, famously discovered and excavated by Lord Carnarvon and Howard Carter in 1922, contained – besides vast quantities of gold, jewels and fabulous ornaments – a dagger, headrest and bracelet all made of iron.[71] There were also some very small models of tools, barely an inch long, also made of iron. In all cases this was smelted iron, not meteoric.

The earliest iron instruments date from, roughly, 5000 BC, in northern Iraq, Iran and Egypt. But only one of these was smelted, the others being fashioned from meteoric iron. Another early instrument comes from Ur and dates to the early part of the third millennium BC. However, it seems likely that when iron was produced as early as this it had not been recognised as a new metal, or even as a metal at all.[72] Iron needs higher temperatures than copper (1100°–1150°) in order to be separated from its ore, and it needs a larger furnace, so that the particles of iron can drop away from the smelting zone and accumulate below, collecting into a lump usually called a 'bloom'.[73] Such a procedure seems to have first been developed and practised within the territory of the Hittite confederacy. The Hittites established a state in central Turkey and northern Syria, 1450–1200 BC, where for a while they successfully challenged the Assyrians and Egyptians.[74] According to Theodore Wertime, the first deliberately smelted iron seems to have been produced when bronze products had reached perfection and where copper, lead and iron ores were in abundance:

northern Anatolia along the shores of the Black Sea.[75] In other words, the success of bronze, the rarity of tin and the abundance of iron induced the Hittites to experiment. The technique appears to have been a closely-guarded secret for several hundred years, with the craftsmen keeping the vital details within their families and charging a very high price for their wares. To begin with it was looked upon as a truly precious metal, more valuable than gold according to ancient records; only ornaments were made of it and the secrets of iron were probably not known outside the Hittite sphere of influence before 1400 BC.[76] (It is likely that the iron dagger found in King Tutankhamun's tomb had been made under Hittite supervision.) By the middle of the thirteenth century, however, the Hittite confederation had encountered troubled times and, by 1200 BC, the cat was out of the bag, and full knowledge of iron-making spread to other parts of Asia.[77] The Iron Age truly dates from when the metal ceased to be precious.[78]

Besides its other attractions, iron smelting was less complicated than copper production. Provided there were bellows sufficiently strong to provide a current of air, a single-tier furnace was enough, as compared with the elaborate two-tier, kiln-type furnace which was needed for copper ore to be reduced in crucibles. Furnaces of quite simple design were used during the first thousand years of iron smelting – therefore, once the secret was out, almost anyone could make iron, though naturally smelting tended to be conducted where the ores could easily be mined and where charcoal was readily available. Like tin, iron differs from copper and gold in never being found free in nature, except as the very rare meteorites that fall to earth. Like copper, none of its ores were found in the great river valleys, but in many nearby areas they were to be found in abundance. The most important mining and smelting enterprises of the later years of the second millennium were established in the neighbourhood of the Taurus and Caucasian mountains, and in Armenia.

The crucial process in iron production – carburisation, by which iron is converted into steel – was probably developed in the two centuries after 1200 BC on the coastal areas of the eastern Mediterranean. To carburise iron, it is heated 'in intimate contact' with charcoal for a long period, a discovery that must have been accidental (uncarburised iron is not as strong as bronze).[79] Mount Adir in north Israel is one site of early carburised iron, Taanach and Hazorea in Palestine are others.[80] In the *Odyssey*, Homer shows some awareness that the quenching of carburised iron also enhances its hardness.

Given its versatility, hardness, and low cost, one might have thought that the new metal would be rapidly adopted. Bowl-shaped ingots were certainly being traded in the late Bronze Age.[81] Nevertheless, the earliest collection of iron tools that has been found in Egypt dates only from about 700 BC, a millennium and a half after its use by the Hittites.[82] In *Works and Days*, Hesiod refers to the men of his own era as a 'race of iron'.[83]

Metallurgy was quite sophisticated from early on. Welding, nails and rivets were early inventions, in use from 3000 BC. Gold plating began as early as the third millennium, soon followed by the lost-wax technique, for making bronze sculptures.[84] In terms of ideas, three uses to which metals were put seem to have been most profound. These were the dagger, as was mentioned earlier, the mirror, and coins. Mirrors were particularly popular among the Chinese, and the Romans excelled at making them, finding that an alloy of

23–28 per cent tin, 5–7 per cent lead, and the rest copper, served best. Reflections were later considered to be linked to man's soul.[85]

Money does not occur in nature, says the historian Jack Weatherford. Jules Renard, the nineteenth-century French writer, put it another way: 'I finally know what distinguishes man from the other beasts: financial worries.' The first forms of money were commodity money, ranging from salt to tobacco, coconuts to rice, reindeer to buffaloes. The English word 'salary' derives from the Latin *salarius*, meaning 'of salt'. (Roman soldiers were perhaps paid in salt, to flavour their otherwise bland food.[86]) The *as*, a Roman coin, represented the value of one hundredth of a cow. The English word 'cattle' is derived from the same Latin root as the word 'capital'. As early as the third millennium BC, however, the inhabitants of Mesopotamia began using ingots of precious metals in exchange for goods. The ingots, of gold or silver and of uniform weight, were called *minas* or *shekels* or *talents*.[87]

The transition from proto-money to coins proper took place in Lydia, in what is now Turkey, some time between 640 and 630 BC. The very first coins were made of electrum, a naturally-occurring mixture of gold and silver, and they were about the size of a thumb nail, and almost as thick as a thumb, like a small ingot. They were stamped with a lion's head, to ensure their authenticity, and the stamping had the effect of flattening them, making them more like the coins that we use today.[88] Whether the first coins were used exactly as we use money now is open to doubt. The first coins would have been *so* valuable they could never have been anything like 'change'. The main breakthrough, to commodification, probably came with the introduction of bimetallic coinages, gold and silver and/or copper. This may have been introduced in the third or second centuries BC, when they were used to pay people in Greece who had been selected for political office by ballot (see Chapter 6).

But the eventual change in life that the invention of money brought about was momentous. It was in a Lydian city, Sardis, that the first retail market was introduced, when anyone could come to the market and sell, for money, whatever they had. In the archaeological record the oldest traded material is obsidian, a very fine, jet-black and shiny volcanic glass, which was mined at a single source in southern Turkey but was found all over the Middle East, where its transparent, reflective, super-cutting properties made it magical and much sought after.[89] But all sorts of new activities were sparked by the invention of money. At Sardis, for instance, the first known brothels were built, and gambling was also born.[90] More fundamentally, the advent of money enabled people to break out from their kin group. Money became the link between people, creating a nexus that had not been possible under the barter system. In the same way, money weakened traditional ties and that, in time, had profound political implications. Work and human labour became a commodity, with a coin-related value attached, and therefore time too could be measured in the same way.

In Greece, near to Lydia, and therefore quickly influenced by this new development, money encouraged the democratisation of politics. Under Solon, the old privileges were abolished and eligibility for public office became based on (landed) wealth.[91] Democracy arose in cities with market economies and strong currencies. Furthermore, the wealth generated by such commerce allowed for greater leisure time, out of which the Greek elite

built its pre-eminence in philosophy, sport, the arts, in politics itself. Counting had existed before money, but the emergence of the market, and a money economy, encouraged rational and logical thinking, in particular the Greek advances in mathematics that we shall be exploring in a later chapter. The German economic historian Georg Simmel observed in his book *The Philosophy of Money*, 'the idea that life is essentially based on intellect, and that intellect is accepted in practical life as the most valuable of our mental energies, goes hand in hand with the growth of a money economy'.[92] He added, 'those professional classes whose productivity lies outside the economy proper have emerged only in the money economy – those concerned with specific intellectual activity such as teachers and literary people, artists, physicians, scholars and state officials'. This is over-stating the case somewhat (teachers and doctors existed before money), but the point has validity.

Money also vastly promoted international trade. This, more than anything, helped the spread of ideas around the globe. After Sardis, the great urban centres of the world were as likely to be market towns as places of worship, or the homes of kings.

# 4

## *Cities of Wisdom*

In 1927 the British archaeologist Leonard Woolley began to dig at Ur of Chaldea (Chaldea is an alternative name for Babylon). Ur, the home of Abraham according to the Bible, had first been identified in 1854–1855 but it was Woolley's sensational excavations that revealed its wider importance in mankind's history. Among his discoveries was the unearthing of the so-called mosaic standard of Ur, which featured a cluster of chariots, showing that it was the Sumerians (inhabiting what is now the southernmost reaches of Iraq from *c.* 3400 BC), who may well have conceived the wheel and introduced this device into warfare. Woolley also discovered a practice that royalty in Babylon was not buried alone. Alongside the king and queen, in one chamber, lay a company of soldiers (copper helmets and spears were found next to their bones) and in another chamber were the skeletons of nine ladies of the court, still wearing their elaborate headdresses. Now these were very grisly practices, and quite important enough in themselves, for what they revealed about ancient beliefs. But what particularly attracted Woolley's attention was that *no text had ever hinted at this collective burial.* He therefore drew the conclusion that the interment had taken place before writing had been invented to record the event.

According to the historian H. W. F. Saggs, 'No invention has been more important for human progress than writing', and Petr Charvát has called it 'the invention of inventions'.[1] So here we have another major idea, to put alongside farming as 'the greatest ever'. In fact, more important, more fundamental even than writing in the history of progress, is that happy coincidence that the Sumerians also invented the chariot. For once you start making a list of the 'firsts' achieved by this formidable people, it is difficult to know where to stop. For example, in 1946 the American scholar Samuel Noah Kramer began to publish his translations of Sumerian clay tablets and in doing so he identified no fewer than twenty-seven 'historical firsts' discovered or achieved or recorded by the early Iraqis. Among them were the first schools, the first historian, the first pharmacopoeia, the first clocks, the first arch, the first legal code, the first library, the first farmer's almanac, and the first bicameral congress. The Sumerians were the first to use gardens to provide shade, they recorded the first proverbs and fables, they had the first epic literature and the first love songs. The reason for this remarkable burst of creativity is not hard to find: civilisation, as we now call it, occurred only after early man had begun to live in cities. Cities were far more competitive, experimental environments than anything that had gone before. The city is the cradle of culture, the birthplace of nearly all our most cherished ideas.

*

In the classical definition, civilisation consists of three or more of the following: cities, writing, the specialisation of occupations, monumental architecture, the formation of capital.[2] But this, while not wrong, ignores the underlying principle. Sometime in the late fourth millennium BC, people came together to live in large cities. The transition transformed human experience for the new conditions required men and women to *co-operate* in ways they never had before. It was this close contiguity, this new face-to-face style of cohabitation, that explained the proliferation of new ideas, particularly in the basic tools for living together – writing, law, bureaucracy, specialised occupations, education, weights and measures.

According to research published in the autumn of 2004, the first urban sites were Tell Brak and Tell Hamoukar in northern Mesopotamia, on the Iraq–Syria border, dated to just before 4000 BC. They had rows of brick ovens for preparing food on an industrial scale and numerous 'seal stamps' used to keep track of goods and to 'lock' doors. But they were relatively small – Hamoukar was twelve hectares – and the first cities proper emerged further south in Mesopotamia about 3400 BC. These sites included Eridu, Uruk, Ur, Umma, Lagash and Shuruppak (more or less in that order). By the end of the third millennium BC, 90 per cent of southern Mesopotamia was living in urban areas.[3] These cities were very large: Uruk, for example, had a population of 50,000. Why did they develop and what was the experience like? Several reasons have been put forward for the development of cities, the most obvious of which is security. But this argument can no longer be supported, and for three reasons. In the first place, there are some large ancient cities – notably in West Africa (such as in Mali) – that never developed walls. Second, even in the Middle East, where city walls were sometimes vast and very elaborate, the walls came *after* the initial settlement. At Uruk, for example, the city had been largely formed around 3200 BC, but the walls were not built until roughly 2900 BC. (On the other hand, Uru means a walled area.[4]) Finally, there is a much more convincing explanation, with a great deal of empirical support.

What appears to have happened is that, in the middle of the fourth millennium BC, in Mesopotamia, there was a slight but noticeable change of climate, leading to cooler and dryer average conditions. Until that point, agriculture had flourished between the Tigris and the Euphrates for thousands of years. Because of these rivers, the area was relatively secure and irrigation was well developed.[5] 'The climatic changes documented for the middle of the fourth millennium seem, within a space of two to three hundred years, to have stemmed the floods that regularly covered large tracts of land and to have drained such large areas that in a relatively short period of time, large parts of Babylonia became attractive for new permanent settlements.'[6] Excavations show that, associated with this climate variation, there was a sudden change in settlement pattern, from very scattered and fairly small individual settlements to dense settlements of a much larger kind never seen before.[7] These geographical conditions appear to have favoured the development of *communal* irrigation systems – systems that were not elaborate, not at that stage, but which nonetheless brought about marked improvements in the yield of barley (which now evolved from the two-row to the six-row mutant), and at the same time taught people the advantages of co-operation. In other words, it was the particular climatic conditions of Mesopotamia – where irrigation could markedly improve crop yields and where there was

enough water available (but in the wrong place) to allow this development fairly easily and obviously. The crucial point was that though the land was now habitable, there was still so much water available that nearly every arable plot had easy and direct access to it. 'This fact ... must have produced a "paradise", with multiple, high-yield harvests each year.'[8] An added factor was that the southern alluvial plains of Mesopotamia were lacking in other commodities, such as timber, stone, minerals and metals. The food surplus of this 'paradise' could be traded for these commodities, making for a dense network of contacts, and provided conditions for the development of specialist workers in the cities themselves. This may have been a factor leading to the diverse populations that were such a feature of early city life, going beyond simple kin groups. This was an exciting advance: for the first time people could become involved in activities not directly linked with food production. Yet this development would have raised anxiety levels: citizens had to rely on others, not their kin, for essentials. This underlying anxiety may well explain the vast, unprecedented schemes and projects which fostered a community spirit – monumental, labour-intensive architectural undertakings. For these same reasons, religion may well have become more important in cities than in previous configurations.

The first city is generally held to have been Eridu, a site just over a hundred miles inland from the Persian Gulf and now called Aby Shahrein. Its actual location was unique, in that it occupied a transitional zone between sea and land. It was near an alluvial plain and close to marshes, which meant that it could easily benefit from three ecological systems – the alluvium, the desert and the marshes, and so profit from three different modes of subsistence: farming, nomadic pastoralism, and fishing.[9] But there was also a religious reason for Eridu. The city was located on a small hill ringed by a depression, in which subterranean water collected. This surrounding area was never less than a swamp and in the rainy season formed a sizeable lake.[10] It was thus a configuration that conformed neatly to Mesopotamian ideas of the Cosmos, which pictured the earth as a disc surrounded by a huge body of water. In mirroring this configuration, Eridu became a sacred spot. Petr Charvát says that Eridu was believed to contain the source of all wisdom and that it was the seat of the god of knowledge. He says the 'first intelligible universal religion seems to have been born' in Eridu, in which worship involved the use of a triad of colours in the local pottery. Earthly existence was affirmed by the use of red, death by the use of black, and eternal life (and purity) through white.[11]

In general, towns are defined by archaeologists as occupying 30 hectares or less, whereas cities are 31 hectares and more. In the case of Uruk, by the time its wall was built, it occupied about 5.5 square kilometres, roughly 2.5 kilometres by 3.0 kilometres at its most extended points but in a rough diamond shape. With a population density of around 100–200 inhabitants per 1,000 square metres, this would give a total head-count of 27,500–55,000. The built-up area of Ur occupied 100 acres (roughly 41 hectares) with perhaps 24,000 inhabitants. Its surrounding territory of 4 square miles 'may have been occupied by half a million people ... Girsu, a site adjacent to and apparently part of Lagash, is said to have had 36,000 males which means a population of 80,000–100,000.'[12] All this compares favourably with Athens, *c.* 500 BC, which covered an area of 2.5 square kilometres, or Jerusalem at the time of Christ which was but 1 square kilometre. Rome at the time of Hadrian was only twice as large as Uruk had been three thousand years earlier.[13] A measure

of the rapidity of the change at this time can be had from the survey reported by Hans Nissen which shows that at the end of the fourth millennium rural settlements outnumbered urban ones by the ratio of 4:1. Six hundred years later – i.e., the middle of the third millennium – that ratio had reversed completely and was now 9:1 in favour of the larger urban sites.[14] By this time Uruk was the centre of a 'hinterland', an essentially rural area under its influence, which extended roughly 12–15 kilometres around it. Next to this was an area some 2–3 kilometres wide which showed no influence, and then began the hinterland of the next city, in this case Umma.[15] There were at least twenty cities of this kind in Mesopotamia.

The achievements of these cities and city-states were astonishing and endured for some twenty-six centuries, with a remarkable number of innovations being introduced which created much of the world as we know it and live it. It was in Babylonia that music, medicine and mathematics were developed, where the first libraries were created, the first maps drawn, where chemistry, botany and zoology were conceived. At least, we assume that is so. Babylon is the home of so many 'firsts' because it is also the place where writing was invented and therefore we *know* about Babylon in a way that we do not know history before then.

Excavations have shown that these early urban areas were usually divided into three. There was an inner city with its own walls, inside which were found the temples of the city's gods, plus the palace of the ruler/administrator/religious leader and a number of private houses. The suburbs consisted of much smaller houses, communal gardens and cattle pens, providing day-to-day produce and support for the citizens. Finally, there was a commercial centre. Though called the 'harbour', this area was where overland commerce was handled and where foreign as well as native merchants lived. The very names of cities are believed in many cases to have referred to their visual appearance.[16]

In these first cities, much life revolved around the temple. People associated with the cult were the most prominent members of society.[17] At Eridu and Uruk the existence of temple platforms shows that there was already sufficient communal organisation to construct such buildings – after the megaliths these are the next great examples of monumental architecture.[18] As time went by, these platforms were raised ever higher, eventually becoming stepped or terraced towers crowned by shrines. These are known as ziggurats, a word based on the Assyrian, and probably on an earlier Akkadian term, *zigguaratu*, meaning summit or mountain top.[19] This increasingly elaborate structure had to be maintained, which required a highly organised cult.

The temples were so important – and so large – that they played a central role in the economic life of the early cities. Records from the temple of Baba (or Bau), a goddess of Lagash, show that shortly before 2400 BC the temple estates were more than a square mile in extent. The land was used for every kind of agricultural use and supported as many as 1,200 people in the service of the temple. There were specialist bakers, brewers, wool workers, spinners and weavers, as well as slaves and an administrative staff.[20] The tenant farmers were not slaves exactly; instead, their relation to the temple seems to have been an early form of feudalism.[21] In addition to the new specialisations already mentioned, we may include the barber, the jeweller or metal-worker, the costumier and cloth merchant,

the laundryman, the brick makers, the ornamental gardener, the ferryman, the 'sellers of songs' and the artist. From our point of view the most important specialist was the scribe.

The origin of writing is a contentious issue at the moment, for there are three possibilities. For many years it was assumed that the cuneiform script of Mesopotamia was the earliest true writing, but it was associated with a problem. Cuneiform consists of more or less abstract signs, whereas many people thought that writing proper would show a stronger link with paintings, or pictographs – symbols that were part pictures of objects and part symbols. This is where the work of archaeologist Denise Schmandt-Besserat comes in.

In the late 1960s she noticed that thousands of 'rather mundane clay objects' had been found throughout the ancient Near East and regarded as insignificant by most archaeologists. Schmandt-Besserat thought otherwise, that they might have formed an ancient system that had been overlooked. She therefore visited various collections of these 'tokens', as she called them, in the Near East, North Africa, Europe and America.[22] In the course of her study, she found that the tokens were sometimes geometrical in form – spheres, tetrahedrons, cylinders – while others were in the shape of animals, tools or vessels. She came to realise that they were the first clay objects to have been hardened by fire. Whatever they were, a lot of effort had gone into their manufacture. Whatever they were, they were not mundane. Eventually, she came across an account of a hollow tablet found at Nuzi, a site in northern Iraq and dated to the second millennium BC. The cuneiform inscription said: 'Counters representing small cattle: 21 ewes that lamb, 6 female lambs, 8 full-grown male sheep . . .' and so on. When the tablet had been opened, inside were found forty-nine counters, exactly the number of cattle in the written list.[23] For Schmandt-Besserat, this was 'like a Rosetta stone'. For the next fifteen years she examined more than 10,000 tokens, and came to the conclusion that they comprised a primitive accounting system and one which led to the creation of writing. Words, in a sense, began with numbers. This is, after all, what writing is, a form of communication which allows the two communicating parties to be spatially and temporally separated.

The first tokens dated to 8000–4300 BC and were fairly plain and not very varied. They were found in such sites as Tepe Asiab in Iran (*c.* 7900–7700 BC), where the people still lived mainly by hunting and gathering. Beginning around 4400 BC, more complex tokens appeared, mainly in connection with temple activity. The different types represented different objects: for example, cones appear to have represented grain, an ovoid stood for a jar of oil, while cylinders stood for domestic animals.[24] The tokens caught on because they removed the need to remember certain things, and they removed the need for a spoken language, so for that reason could be used between people who spoke different tongues. They came into use because of a change in social and economic structure. As trade increased between villages, the headman would have needed to keep a record of who had produced what.

The complex tokens appear to have been introduced into Susa, the main city of Elam (southern Iran), and Uruk, and seem to have been a result of the need to account for goods produced in the city's workshops (most were found in public rather than private buildings). The tokens also provided a new and more accurate way to assess and record taxes. They were kept together in one of two ways. They were either strung together or, more

importantly from our point of view, enclosed in clay envelopes. It was on the outside of these envelopes that marks were made, to record what was inside and who was involved. And although this chronology has recently been queried by French scholars, this still seems to be the best explanation for how cuneiform script came about. Of course, the new system quickly made the tokens themselves redundant, with the result that the impressions in the clay had replaced the old system by about 3500–3100 BC. The envelopes became tablets and the way was open for the development of full-blown cuneiform.[25]

A system of marks, of more or less geometric lines, whorls and squiggles, has been found on a number of tablets, figurines, pottery, and amulets in south-east Europe, in Romania and Bulgaria in what is known as the Vinca culture. Associated with undoubted picto-graphs – goats, animal heads, ears of corn – these were found in burial and apparently sacrificial contexts, dating from *c.* 4000 BC. The Gradesnica Plaque, discovered in Vratsa in western Bulgaria in 1969, is even older, dating to 7,000–6,000 years ago.[26] The signs associated with this Vinca culture have been analysed according to which type of artefact they appear on – amulets or pottery, for example. The analysis has shown that their distribution is consistent. There is a corpus of 210 signs, forming just five core groups: straight lines, crosses, chevrons, dots and curves. But these nowhere form texts. Instead, they seem to be symbolic designs, no doubt with religious rather than economic meanings. They comprise a form of proto-writing.

Some scholars believe that the users of these 'Old European' scripts (to use Marija Gimbutas' phrase) were forced out of their native lands by invading Indo-Europeans. Harald Haarman, of the University of Helsinki, is one of those who believes that the Old Europeans may have been driven to places like Crete. There, at Knossos and elsewhere, in the early twentieth century, Sir Arthur Evans and his colleagues uncovered a major civilisation – the Minoan, with Bull and Snake worship among its common features. But the Minoans also produced two scripts, known to us as Linear A and Linear B. The use of the term 'Linear' was originally Gimbutas' idea, to stress the mainly linear (as opposed to pictographic) qualities of the Vinca signs. But while Linear B was famously deciphered by the English amateur, Michael Ventris, in the 1950s, and shown to be a form of Greek, Linear A has never been deciphered. Haarman suggests that this is because Linear A is not an Indo-European language at all but an 'Old European' one. Haarman says he has found fifty signs in Linear A that are identical with Old European (see Figure 3, opposite).

The most recent candidate for the birth of writing takes us to India. There, traditionally, the earliest major civilisation was known as the Indus civilisation, the capitals of which were Harappa and Mohenjo-Daro, dating back to 2300–1750 BC. In May 1999 it was announced that a tablet, 5,500 years old, and bearing an inscription, had been discovered at Harappa. A month later, another announcement claimed that the script had been deciphered. This script consisted of a double M, a Y, a lozenge with a dot at its centre, a second lozenge, somewhat deformed, and a V. According to Drs Jha and Rajaram, this means 'It irrigates the sacred land.' The language is allegedly 'pre-Harappan', much more primitive than other Indus seals. Four other examples have been found in the region. The Indian scholars believe that this script, like other primitive scripts elsewhere, does not use vowels, though in this case the use of double consonants, as in the double M, is meant to

*Figure 3: Signs common to Old
European script and Linear A*
[Source: Richard Rudgley, *Lost
Civilisations of the Stone Age*, New
York, The Free Press, 1999, page 70]

indicate vowels. In other words, it shows early writing in the course of evolution. Scholars associated with the discovery believe this is enough to move the 'cradle of civilisation' from Mesopotamia to the Indus region.[27] These are the latest researches, and in time they may well change the way we think about origins. For the present, however, the Vinca markings do not comprise full-blown scripts, while the tablets discovered in and around the Indus region are only a handful of examples. While undoubtedly intriguing, even promising, we must await further discoveries before abandoning Mesopotamia – and cuneiform – as the earliest example of true writing.

Cuneiform script has been known about since the late seventeenth century. Partially successful attempts to decipher it were made in 1802 and again in 1846. But a complete

understanding of Babylonian culture was only possible after the discoveries of a 'footloose young Englishman', a newly-qualified solicitor, Austin Henry Layard. On his way overland to Ceylon (as Sri Lanka then was), he stopped off in the Middle East and got no further than western Persia (now Iran). 'After undertaking some unofficial intelligence work for the British Ambassador in Istanbul, he won his backing for a period of excavation in Iraq, where he chose a huge mound called Nimrud, twenty miles south of Mosul.'[28] Though he was not a trained archaeologist (hardly anybody was in those days), Layard was blessed with luck. He discovered a series of huge slabs, great limestone bulls up to fourteen feet high, images so striking that his account of his researches became a best-seller. But Layard also found many examples of what appeared to be wedge-shaped inscriptions on stone, and the dating of the site – 3500–3000 BC – made this the earliest known form of writing. Sumerian was not finally understood until the twentieth century but once it was, the discoveries came thick and fast.[29]

Our new understanding shows that there were in Mesopotamia several forms of 'proto-writing' in use before writing proper. Of these, stone cylinder seals were both more permanent and at the same time more flexible versions of the clay 'envelopes' examined by Schmandt-Besserat. The seal itself took the form of a hollow cylinder, on which was inscribed a set of engravings. The cylindrical seal would be rolled over wet clay, which therefore reproduced the engraved inscription as a reversed, embossed image.[30] The clay seals were used everywhere: they could be moulded over the knot of a rope tied around a bundle; or over the rope fastening of a door. The idea was that the seal should bear a clear mark, identifying its owner.[31] Like the clay envelopes studied by Schmandt-Besserat, seals were instruments of economic control, guaranteeing the supervision of proceedings, or confirming that a transaction had taken place. In practice, the Sumerians produced some very imaginative devices with which to identify owners: worshipping at a temple, processions of boats, prisoners before a ruler, the feeding of animals. They were, in effect, pictographical signatures.[32] Later, a new type of seal emerged, produced by cutting machines. This clearly suggests that trade was increasing and that the need for identifying marks was likewise growing.

So much for proto-writing. But cuneiform actually developed out of the archaic Uruk pictographic system, which took over many of the signs used with the earlier tokens, such as the sign for sheep, and wavy lines for water. The birth of writing proper is clearly shown by the use the first scribes made of the so-called 'bevel-rimmed' bowls of Uruk. These were cheap, coarse and very porous. They could not have been made to hold water and yet they were so common that, at some sites, they made up three-quarters of the pottery found. The fact that they were so porous – suitable only for containing solid matter – and were all the same size, provides a key to their use. Texts that have been deciphered tell us that the workers of Uruk, at least the workers on the large temple projects, were paid in kind – i.e., with a daily ration of food. Since the bulk of the workers' rations would have been grain, it stands to reason that these were the 'standard' bowls by which the workers were paid.[33]

Shown in Figure 4, opposite, is the very ancient sign for 'eat'. This quite clearly shows a head, with an open mouth, receiving food from one of these 'bevel-rimmed bowls'. It was, in other words, a picture, or pictograph. Many other words began as pictographs, too (see Figure 5, opposite).

**Figure 4: A bevel-rimmed bowl and the early sign for 'to eat' (left); as it begins to be represented in early cuneiform (right)[34]**
[Source: Hans J. Nissen, *The Early History of the Ancient Near East: 9000–2000 BC*, translated by Elizabeth Lutzeier with Kenneth J. Northcott. © 1988 by the University of Chicago]

This was only the beginning. Just as cylinder seals became simpler and easier to mass-produce – to cope with busy life – so too did writing evolve. Writing on moist clay made it awkward to draw these images clearly and quickly (a problem which the Egyptians never had, with their smooth, dry surfaces, which is why they stuck with hieroglyphics), and so signs, words, became more abstract, fewer, aligned much more in the same direction, all developments that enabled the speed of writing to be increased. Figure 6 on page 82 shows how a few words changed in appearance, over a millennium and more, from the earliest

**Figure 5: Early pictographs: (a) a group of reeds; (b) an ear of corn; (c) a fish; (d) a goat; (e) a bird; (f) a human head; (g) a form of pot; (h) a palm tree; (i) a ziggurat[35]**
[Source: H. W. F. Saggs, *Civilisation Before Greece and Rome*, London: B. T. Batsford, 1989, page 62]

days in Uruk, to the height of Ur's power, that is, between *c.* 3800–3200 and *c.* 2800–2100 BC. We still don't know why the images were turned through ninety degrees, but this would surely have made the images less legible and that in turn may have provoked a more simple way of writing. Circular and curved marks were always more difficult to produce in wet clay and this is why cuneiform emerged as a system of simple strokes and wedges. The repertoire of signs was reduced and homogenised by the first third of the third millennium.

| Late Uruk Period ca. 3100 | Jamdet Nasr Period ca. 3000 | Early Dyn. III Period ca. 2400 | Ur III Period ca. 2000 | Meaning |
|---|---|---|---|---|
| | | | | SAG  'Head' |
| | | | | NINDA 'Bread' |
| | | | | KU  'to eat' |
| | | | | AB  'Cow' |
| | | | | '1' |

*Figure 6: The development of pictographs into Babylonian cuneiform script*[36]
[Source: Hans J. Nissen, *The Early History of the Ancient Near East: 9000–2000 BC*, translated by Elizabeth Lutzeier with Kenneth J. Northcott. © 1988 by the University of Chicago]

In these early phases, the uses of writing were limited and, because of its basis in trade, consisted just as much of numbers as of words. Among the signs, for example, there was one which had a D-shape: there was a straight edge which was deep-cut and a round end which was much shallower, reducing to nothing. What gave the game away was that these Ds were grouped into clusters, ranging from one to nine. Here then was the making of a decimal system. In some cases, a circular punchhole, formed by means of a cylindrical reed pressed into the clay, was associated with the Ds. 'It is a reasonable assumption that these "round holes" represent tens.'[37] It was common for the early tablets to have a list of things on one side, and the total on the other.[38] This helped decipherment.

A system of signs was one thing. But, as we have seen in examples from elsewhere, such a system does not fully amount to writing as we know it. For that, three other developments were necessary: personal names, grammar, and an alphabet.

Personal identification was a problem and a necessity from the moment that economic organisation went beyond the extended family, where everyone knew each other and property was owned communally. Certain names would have been easy, 'Lionheart' say.[39] But how would one render an abstract name, such as 'Loved-by-God'? Pictographs would have been developed, much as the heart shape, ♥, has come to mean 'love' in our time. In this way, multiple meanings overlapped: the sun, ☀, for example, might mean 'day', 'bright', or 'white', while a star, ✳, might mean 'god' or 'sky', depending on context. The 'doctrine of the name' was important in Babylon, where thought worked mainly by analogy, rather than by inductive or deductive processes as we use in the modern world.[40]

For both the Babylonians and the Egyptians the name of an object or a person blended in with its essential nature.[41] Therefore, a 'good' name would produce a 'good' person. For the same reason, people were named after the gods and that was also the case with streets ('May the enemy never tread it') and canals and city walls and gates ('Bel hath built it, Bel hath shown it favour'). To cap it all, the practice evolved to adopt a certain tone when uttering proper names. This was especially true when speaking gods' names and it is still true today, to a certain extent, when people use a different tone of voice when praying out loud.[42]

To begin with, there was no grammar. Words – nouns mainly, but a few verbs – could be placed next to one another in a random fashion. One reason for this was that at Uruk the writing, or proto-writing, was not read, as we would understand reading. It was an artificial memory system that could be understood by people who spoke different languages.

Writing and reading as we know it appears to have been developed at Shuruppak in southern Mesopotamia, and the language was Sumerian. No one knows who the Sumerians were, or where they originated, and it is possible that their writing was carried out in an 'official' language, like Sanskrit and Latin many thousands of years later, its use confined only to the learned.[43] This next stage in the development of writing occurred when one sound, corresponding to a known object, was generalised to conform to that sound in other words or contexts. An English example might be a drawing of a striped insect to mean a 'bee'. Then it would be adapted, to be used in such words as 'be-lieve'. This happened, for example, with the Sumerian word for water, *a*, the sign for which was two parallel wavy lines. The context made it clear whether *a* meant water or the sound. This was when the signs were turned through ninety degrees, to make them easier to write in a hurry, and when the signs became more abstract. This form of writing spread quickly from Shuruppak to other cities in southern Mesopotamia. Trade was still the main reason for writing but it was now that its use was extended to religion, politics and history/myth – the beginnings of imaginative literature.

Such a transformation didn't happen overnight. In the early schools for scribes, we find lexical lists – lists of words – and lists of proverbs. This is probably how they were taught to write, and it was through well-known proverbs and incantations, even magic spells, that abstract signs for syntactical and grammatical elements became established (the proverbs had a simple, familiar form). And it was in this way that writing changed from being a purely symbolic system of information-recording and exchange, to a *representation of speech*.

Although the first texts which contain grammatical elements come from Shuruppak, word order was still highly variable. The breakthrough to writing in the actual order of speech seems to have occurred first when Eannatum was king of Lagash (*c.* 2500 BC). It was only now that writing was able to convert all aspects of language to written form.[44] The acquisition of such literacy was arduous and was aided by encyclopaedic and other lists.[45] People – in the Bible and elsewhere – were described as 'knowing the words' for things, such as birds or fishes, which meant they could, to that extent, read. Some lists were king lists, and these produced another advance when texts began to go beyond mere lists, to offer comment and evaluation on rulers, their conflicts, the laws they introduced:

history was for the first time being written down.[46] The list about the date-palm, for instance, includes hundreds of entries, not just the many parts of the palm, from bark to crown, but words for types of decay and the uses to which the wood could be put. In other words, this is how the first forms of knowledge were arranged and recorded. At Shuruppak the lists included: bovines, fish, birds, containers, textiles, metal objects, professions and crafts.[47] There were also lists of deities, mathematical and economic terms. (In the names for gods, females still predominate.)

Lists made possible new kinds of intellectual activity. They encouraged comparison and criticism. The items in a list were removed from the context that gave them meaning in the oral world and in that sense became abstractions. They could be separated and sorted in ways never conceived before, giving rise to questions never asked in an oral culture. For example, the astronomical lists made clear the intricate patterns of the celestial bodies, marking the beginning of mathematical astronomy and astrology.[48]

The texts repeatedly mention other cities, with which Shuruppak had contact: Lagash, Nippur, Umma and Uruk among them. The very first idea, apart from economic tablets and proper names, that we can decipher among the earliest writing is that of the battle between 'kings' and 'priests'. At one stage it was believed that all of a city's inhabitants and all of its land 'belonged' to the supreme city god and that the high priest or priestess administered the city on behalf of this deity, but such a view is no longer tenable: land holding was much more complex than this. The high priest or priestess was known as the *en*, or *ensi*. Normally, and to begin with, the *en* or *ensi* was the most powerful figure, but there was another, the *lugal* – literally speaking, the 'great man'. He was in effect the military commander, the fortress commander, who ran the city in its disputes with foreign powers. It does not take much imagination to envisage conflict between these two sources of power. The view preferred now is that Mesopotamian cities are better understood not as religious but as corporate entities – municipalities – in which people were treated equally. Their chief characteristic was economic: goods and produce were jointly owned and redistributed, both among the citizens themselves but also to foreigners who provided in exchange goods and commodities which the cities lacked. This is inferred from the writing on seals, references to 'rations', the fact that everyone was buried in the same way, certainly to begin with, and the discovery of locks by which goods were sequestered in warehouses. To begin with, the *en* administered this system though, as we shall see, that changed.[49]

Apart from lists, the other major development in writing was the switch from a pictographic system to a syllabary and then to a full alphabet. Just as it was in the busy trading cities of Sumer that writing began, because it was needed, so the alphabet was invented, not in Mesopotamia but further west where the Semitic languages lent themselves to such a change. A pictographic system is limited because hundreds if not thousands of 'words' need to be remembered (as with Chinese today). In syllabaries, where a 'word' corresponds to a syllable, only around eighty to a hundred entities need to be remembered. But alphabets are even better.

Hebrew and Arabic are the best-known Semitic languages today but in the second millennium BC the main tongue was Canaanite, of which both Phoenician and Hebrew are descendants. What made the Semitic languages suitable for alphabetisation was that

most nouns and verbs were composed of three consonants, fleshed out by vowels which vary according to the context, but which are generally self-evident. (Professor Saggs gives this English equivalent: *th wmn ws cryng* and *th wmn wr cryng*. Most readers have no difficulty in deciphering either phrase.[50])

The earliest alphabet so far found was discovered in excavations made at Ras Shamra ('Fennel Head') near Alexandretta, the north-east corner of the Mediterranean that lies between Syria and Asia Minor. Here, on a hill above a small harbour was an ancient site excavated in 1929, which in antiquity was known as Ugarit. A library was discovered at the site, situated between two temples devoted to Baal and Dagon. The library belonged to the high priest and consisted mainly of tablets in writing in a cuneiform style but which comprised only twenty-nine signs. It was, therefore, an alphabet. The scholars making the excavation guessed that the language was probably related to Canaanite or Phoenician or Hebrew and they were right: the script was rapidly deciphered. Many of the events portrayed, as we shall see, prefigure stories in the Old Testament.[51] This system appears to have been deliberately invented, with no real precursors. As Figure 7 shows, the signs fit into five groups, with patterns of increasing complexity, indicating an order for the letters.

**Figure 7: Signs of the Ugaritic alphabet[52]**
[Source: H. W. F. Saggs, *Civilisation Before Greece and Rome*, London: B. T. Batsford, 1989, page 81]

Although the first alphabet occurred at Ugarit, it was restricted mainly to north Syria and a few Palestinian sites. After the twelfth century BC, it died out and the future lay with descendants of the proto-Canaanite language. This alphabet took time to stabilise, with the letters facing either way, and the writing often taking the boustrophedon form.* However, shortly before 1000 BC, proto-Canaanite did become stabilised into what is generally referred to as the Phoenician alphabet (the earliest inscriptions occur at Byblos – now Jublai, north of Beirut in Lebanon – many on bronze arrow heads, saying who the head belonged to). By this time the number of letters was reduced to twenty-two and all the signs had become linear, with no traces of pictographs. The direction of writing had

---

* Boustrophedon means the lines follow the route of a plough: if the first line is right to left, the second is left to right, the third right to left, and so on.

also stabilised, consistently horizontal from right to left. By common tradition, it was the Phoenician alphabet which was imported into classical Greece.

In both Mesopotamia and Egypt literacy was held in high esteem. Shulgi, a Sumerian king around 2100 BC, boasted that

> As a youth, I studied the scribal art in the Tablet-House, from the tablets of Sumer and
>   Akkad;
> No one of noble birth could write a tablet as I could.[53]

Scribes were trained in Ur since at least the second quarter of the third millennium.[54] When they signed documents, they often added the names and positions of their fathers, which confirms that they were usually the sons of city governors, temple administrators, army officers, or priests: literacy was confined to scribes and administrators. Anyone in authority probably received some sort of scribal education and it has even been suggested that the Sumerian term *dub.sar*, literally 'scribe', was the equivalent of Esquire, or BA, applied to any educated man.[55]

Two schools, perhaps the first in the world, were founded by King Shulgi at Nippur and at Ur in the last century of the third millennium BC, but he referred to them without any elaboration, so they may have been established well before this. The Babylonian term for school or scribal academy was *edubba*, literally 'Tablet-House'. The headmaster was called 'Father of the Tablet-House', and in one inscription a pupil says this: 'You have opened my eyes as though I were a puppy; you have formed humanity within me.'[56] There were specialist masters for language, mathematics ('scribe of counting') and surveying ('scribe of the field') but day-to-day teaching was conducted by someone called, literally, 'Big Brother', who was probably a senior pupil.

Cuneiform extracts have been found in several cities which show that there were already 'standard texts' used in instruction. For example, there are tablets with the same text written out in different hands, others with literary texts on one side, maths exercises on the reverse, still others with the teacher's text on one side, the pupil's on the other, together with corrections. On one tablet, a pupil describes his workload:

> This is the monthly scheme of my school attendance:
> My free days are three each month;
> My religious holidays are three each month;
> For twenty-four days each month
> I must be in school. How long they are![57]

Scribes had to learn their own trade, too – they needed to know how to prepare clay for writing and how to bake the texts that were to be preserved in libraries. Limestone could be added to make the surface of the clay smoother, and the wedges clearer.[58] Besides clay, boards of wood or ivory were often coated with wax, sometimes hinged in several leaves. The wax could be wiped clean and the boards reused.[59]

The scribal tradition spread far beyond Mesopotamia, and as it did so it expanded.[60]

The Egyptians were the first to write with reed brushes on pieces of old pottery; next they introduced slabs of sycamore which were coated with gypsum plaster, which could be rubbed off to allow re-use.[61] Papyrus was the most expensive writing material of all and was available only to the most accomplished, and therefore least wasteful, scribes. Scribal training could take as long as for a modern PhD.

Not all writing had to do with business. The early, more literary texts of Sumer, naturally enough perhaps, include the first religious literature, hymns in particular. In Uruk there was a popular account of the king's love affair with the goddess Inanna (Ishtar in Babylon, Astarte in Greece). Other texts included a father's instructions to his son on how to lead a useful and rewarding life, accounts of battles and conquests, records of building activity, cosmogonies, and a vast corpus to do with magic. By the time Ashur flourished, roughly 1900–1200 BC, there were many private archives, in addition to the public ones, some of which contained as many as 4,000 texts. By now, the most prestigious form of learning was astronomy/astrology, omen literature, and magic. These helped establish Ashur's reputation as *al nemeqi*, 'City of Wisdom'.[62]

We should never forget that in antiquity, before writing, people performed prodigious feats of memory. It was by no means unknown for thousands of lines of poetry to be memorised: this is how literature was preserved and disseminated. Once writing had evolved, however, two early forms of written literature may be singled out. There was in the first place a number of stories that prefigured narratives which appeared later in the Bible. Given the influence of that book, its origins are important. For example, Sargon, king of Akkad, emerged from complete obscurity to become 'king of the world'. His ancestry was elaborated from popular tales, which tell of his mother, a priestess, concealing the fact that she had given birth to him by placing him in a wicker basket, sealed with bitumen, and casting him adrift on a river. He was later found by a water drawer who brought Sargon up as his adopted son. Sargon first became a gardener ... and then king. The parallels with the Moses story are plain. Sumerian literature also boasts a number of 'primal kings' with improbably long reigns. This too anticipates the Old Testament. In the Bible, for example, Adam begot his son Seth at age 130 and is said to have lived for 800 more years. Between Adam and the Deluge there were ten kings who lived to very great ages. In Sumer, there were eight such kings, who between them reigned for 241,200 years, an average of 30,400 years per king. The texts unearthed at Ras Shamra/Ugarit speak of the god Baal fighting with Lotan, 'the sinuous serpent, the mighty one with seven heads', which anticipates the Old Testament Leviathan. Then there is the flood literature. We shall encounter one version of the flood story in the epic of Gilgamesh, which is discussed immediately below. In that poem, the flood-hero was known as Utnapishtim, 'Who Found [Eternal] Life', though he was also known in similar legends as Ziusudra or Atra-hasis. In all the stories the flood is sent by the gods as a punishment.[63]

The very name, Mesopotamia, between the rivers, suggests that floods were a common occurrence in the area. But the idea of a Great Flood seems to have been deeply embedded in the consciousness of the ancient Middle East.[64] There are three possibilities. One is that the Tigris and Euphrates flooded together, creating a large area of water. According to Leonard Woolley's excavations at Ur, referred to at the beginning of this chapter, the flood

revealed in the silt he found there could have meant an inundation twenty-five feet deep that was 300 miles long and 100 miles across.[65] This has been called into question because Uruk, fifteen miles from Ur, and situated lower, shows no trace of flood. A second possibility, discussed in more detail in the next chapter, is that a terrible earthquake hit the Indus valley area of India in about 1900 BC and caused the diversion of the river Sarasvati. This, the mighty river of the ancient Hindu scripture, the *Rig Veda*, was ten kilometres wide in places but is now no more. The event that triggered this great catastrophe must have caused huge floods over a very wide area. The last possibility is the so-called Black Sea flood. According to this theory, published in 1997, the Black Sea was formed only after the last Ice Age, when the level of the Mediterranean rose, around 8,000 years ago, sluicing water through the Bosporus and flooding a vast area, 630 miles from east to west, and 330 miles from north to south.[66]

The greatest literary creation of Babylon, the first imaginative masterpiece in the world, was the epic of Gilgamesh, or 'He Who Saw Everything to the Ends of the World', as the title of the poem has it. Almost certainly, Gilgamesh ruled in Uruk around 2900 BC, so some of the episodes in his epic are rooted in fact.[67] His adventures are complicated, often fantastic and difficult to follow. In some respects, they recall the labours of Hercules and, as we shall see, are echoed in the Bible. In the poem, he himself is two-thirds god and one-third man. In the first verses, we learn how Gilgamesh has to overcome the resistance of the people of Uruk and push through 'a wondrous feat', namely the building of the city wall. This, 9.5 kilometres long, boasted, it is said, at least 900 semi-circular towers. Some of this part of the story may be based on fact, for excavations have identified semi-circular structures in the Early Dynastic period (i.e., around 2900 BC) using a new type of curved brick.[68] Gilgamesh is a hard taskmaster, so much so that his subjects appeal to the gods to create a counterforce, who will take on Gilgamesh and let the citizens have a quiet life. Sympathetic, the gods create Enkidu, a 'hairy wild man'. But here the plot twists and Enkidu and Gilgamesh become firm friends and from then on undertake their adventures as companions.[69] The two return to Mesopotamia where the goddess Inanna falls in love with Gilgamesh. He spurns her attentions and in retaliation she sends the awesome 'bull of heaven . . . which even a hundred men could not control' to kill him.[70] But Enkidu joins forces with Gilgamesh and together they defeat the bull by tearing off its limbs.

This early part of the poem is in general positive, but it then turns darker. Enlil, the god of the air and of the earth, decides that Enkidu must die for some of the heroic killings he has performed. The loss of Enkidu affects Gilgamesh badly:

> All day and all night have I wept over him
> and would not have him buried –
> my friend yet might rise up at my (loud) cries,
> for seven days and nights –
> until a maggot dropped from his nose.
> Since he is gone, I can no comfort find,
> keep roaming like a hunter in the plains.[71]

Until this point, Gilgamesh has given little thought to death. From now on, however, his

sole aim is to find everlasting life. He recalls the legend that, at the end of the world, beyond 'the waters of death', lives an ancestor of his, Utnapishtim, who is immortal and therefore must know the secret. Alone now, Gilgamesh sets out to reach the end of the world, beyond the mountains where the sun sets. He finds the dark passage through which the sun disappears at night, and eventually arrives on the shore of a wide sea.[72] There, he meets Utnapishtim's boatman, who agrees to ferry him over the waters of death, 'a single drop of which means certain destruction'.[73] When, finally, Gilgamesh reaches Utnapishtim he is disappointed. The ancestor's immortality, he tells Gilgamesh, is due to unique circumstances that will never be repeated. He confides that, in an earlier age, the gods had decided to destroy mankind and had caused a flood. Utnapishtim and his wife were the only ones allowed to survive: they were forewarned and built a large boat, in which they stored pairs of all living things. After the storm had lashed the boat for six days and nights, and when all was quiet, Utnapishtim opened a window, and saw that his boat was beached on an island, which was in fact the top of a mountain. He waited for another six days, then sent out a dove, followed by a swallow. Both returned. Finally, he let loose a crow, which did not come back.[74] Later on, Utnapishtim reports, Enlil regretted his rash decision and rewarded Utnapishtim with immortality for saving life on earth. But the gods will never repeat this act.

The first libraries were installed in Mesopotamia, though to begin with they were more like archives than libraries proper. They contained records of the practical, day-to-day activities of the Mesopotamian city-states. This is true whether the library was in Nippur, in the middle of the third millennium BC, or Ebla, where two thousand clay tablets were found in 1980, dating to roughly 2250 BC, or to later libraries. We have to remember that in most cases the libraries served the purposes of the priests and that in Mesopotamian cities, where the temple cult owned huge estates, practical archives – recording trans-actions, contracts and deliveries – were as much part of the cult as were ritual texts for the sacred services. But the propagandistic needs of the cult and the emerging royal elite – hymns, inscriptions – provoked a more modern form of literacy. Texts such as the epic of Gilgamesh, or the epic of Creation, may therefore have been used in ritual. But these works, which involved some form of mental activity beyond flat records of transactions, appear first in the texts at Nippur in the middle of the third millennium. The next advance occurred at Ebla, Ur and Nippur.[75] Each of these later libraries boasted a new, more scholarly entity: catalogues of the holdings, in which works of the imagination, and/or religious works, were listed separately. Later still, there was a further innovation: several lines of writing, added at the end of the text on the back surface, identifying what the text contained, more or less as a table of contents does today. This acquired the term colophon, derived from the Greek *kolophon*, meaning 'finishing touch'. One, for example, was written thus: 'Eighth tablet of the Dupaduparsa Festival, words of Silalluhi and Kuwatalla, the temple-priestess. Written by the hand of Lu, son of Nugissar, in the presence of Anuwanza, the overseer.' The colophons were numbered, and recorded how many tablets the text was comprised of. Some of the catalogues went beyond the detail in the colophons, so that the scribes could tell from perusing just this document what was in the library. The ordering of the list was still pretty haphazard, however, for alphabetisation was not introduced for

more than 1,500 years.[76] As time went by, the number of religious titles began to grow. By the time of Tiglath-Pileser I, one of Assyria's greatest rulers (1115–1077 BC), the biggest component of the texts dealt with the movements of the heavens, and prediction of the future based on a variety of omens. There were some hymns and a catalogue of musical compositions ('5 Sumerian psalms comprising one liturgy, for the *adapa* [possibly a tambourine]'). Ashurbanipal, Assyria's last important ruler (668–627 BC), also had a fine library and was himself literate. Here too the mass of archival material comprised the bulk of the library; next in number came the omen texts; next largest were the lists, words and names, dictionaries for translating; and finally literary works, such as the epic of Gilgamesh. In all there were about 1,500 separate titles.[77] A curse was inscribed on many Assyrian tablets to deter people from stealing them.[78]

Libraries undoubtedly existed in ancient Egypt, but because they wrote on papyrus (the 'bullrushes' in which the infant Moses was supposed to have been sequestered), little has survived. In describing the building complex of Ramses II (1279–1213 BC), the Greek historian Diodorus says that it included a sacred library which bore the inscription 'Clinic for the Soul'.

In the early cities there were two types of authority. There was first the high priest, known as the *en*. He (and sometimes she) administered the corporate entity, or municipality, interceding with the gods to guarantee the continued fertility of enough land to provide everyone with food/income, and the *en* also administered its redistribution, both among the citizens and for foreign trade. The *en*'s consort was *nin* and, in Petr Charvát's words, they comprised the 'pontifical couple'.[79] The second form of authority was the *lugal* – the overseer, fortress commander, literally the 'great man', who administered military matters, foreign affairs as we would say, relations with outsiders. We should not make too much of this division, however: not every city had two types of leader – some had *ens* and others had *lugals*, and in any case where there were two types of authority the military leaders would have sought the backing of the religious elite for all of their military exploits. But this early arrangement changed, for the records show that, at some point, *nin* detached herself from *en* and realigned herself with the *lugal*.[80] At the same time, the role of the *ens* shrank, to become more and more ceremonial, whereas the *lugal* and the *nin* took on the functions of what we would call kings and queens. There now developed a greater division between temporal and spiritual power, and more of an emphasis on masculinity,[81] a change that may have been brought about by war, which was now more of a threat and for two reasons. First, in an area that was circumscribed between two mighty rivers there would have been growing competition among rival cities, rivalry for land and for water, as population expanded; and second, with increasing prosperity and the accumulation of material possessions, produced by increasing numbers of specialists, there would have been more to gain from successful plunder. In war, a warrior was his own master, much more so than in peacetime, and the charisma and success of a clever *lugal* would have had a forceful impact on his fellow citizens. It would have been natural, following the victory of one city over another, for the *lugal* to have administered both territories: it was he who had achieved the victory, and in any case the gods of the rival city might well be different from those in his native city. The *en* from city A, therefore, would have little or no authority

in city B. In this way, *lugals* began to overtake *ens* as the all-powerful figures in Sumerian society. Petr Charvát notes that the worship of the same god in different Sumerian cities did begin to grow, confirming this change. The growing power of the *lugals* was recognised in the practice whereby they acquired the prerogative to control systems of measurement (perhaps a relic of building defences) and the right to leave written records of their deeds. This was part-propaganda, part-history, so that people would remember who had done what and how.[82] Thus the more-or-less modern idea of kingship grew up in Mesopotamia and, parallel with it, the idea of the state. *Lugals* who became kings administered more than one city, and the territory in between. The first supra-regional political entity in the ancient Middle East was the Akkadian state, which began with Sargon, *c.* 2340–2284 BC, the first king in the sense that we still use the term.

Kingship, then, was forged in part by war. War, or the institutionalisation of war, was the crucible or the forcing house for a number of other ideas.

The wheel may or may not have been invented in Mesopotamia. The first vehicles – sledges – were used by early hunter-fisher societies in near-Arctic northern Europe by 7000 BC, presumably pulled by dogs.[83] 'Vehicle' signs occur in the pictographic script of Uruk in the late fourth millennium BC, and actual remains of an axle-and-wheel unit were found at a similar date at a site in Zurich in Switzerland. These vehicles had solid wheels, made from either one or three pieces of wood. From archaeological remains at sites before 2000 BC, these so-called disc wheels stretch from Denmark to Persia, with the greatest density in the area immediately north of the Black Sea.[84] So this may indicate where the wheel was first introduced. Oxen and donkeys appear to have been used at first.

These (four-wheeled) wagons were very slow – 3.2 kph, on one estimate. The (two-wheeled) chariot, however, was a good bit faster – 12–14 kph when trotting, 17–20 kph when galloping. In the cuneiform texts, Sumerian refers to the 'equid of the desert', meaning an ass or donkey, and to the 'equid of the mountains', meaning horse.[85] Three words were used for wheeled vehicles: *mar-gid-da*, for four-wheeled wagons, *gigir*, for two-wheeled vehicles, and *narkabtu* which, as time went by, came to mean chariot. With *narkabtu*, says archaeologist Stuart Piggott, 'We come to the beginning of one of the great chapters of ancient history: the development of the light two-wheeled chariot drawn by paired horses as a piece of technology and as an institution within the social order as an emblem of power and prestige.'[86] After the first solid wheels were invented, the spoked wheel was conceived. This had to be built under tension, with shaped wood, but its lightness made much greater speeds possible.[87] Chariot warfare flourished between 1700 and 1200 BC – i.e., at the end of the Bronze Age and in the Iron Age.

A word about the equid of the mountains. It is fair to say that, just now, no one knows exactly where or when the horse was domesticated and when or where the idea of riding was conceived. Until recently, it was assumed that settlement of the Eurasian steppe depended on the domestication of the horse, and that the steppe pioneers were 'pastoral horsemen of warlike disposition'. Among archaeologists, the earliest example of horse domestication was for many years attributed to Dereivka, 300 kilometres north of the Black Sea, and now in Ukraine, and which formed part of the Sredny Stog culture – i.e., much the same location as where the wheel may have been invented. This site, dated to

between 4570 and 3098 BC, is located on the right bank of the river Omelnik, a tributary of the Dnepr. The evidence for this interpretation came from the presence of horse bones in human burials, the remains of pre-molar teeth apparently worn down by bits, perforated antler tines interpreted as cheek pieces, and the preponderance of male horse bones at ancient sites, suggesting that they were preferred in a traction and riding context. There is also the indirect evidence of the emergence of horse-headed sceptres, made of bone, which indicate a horse cult, if not, strictly speaking, riding.[88]

Reanalysis of the material in the past few years has by and large vitiated these conclusions. The so-called cheek pieces have never been found in place on a horse's skull and are only rarely associated with horse remains at all. The wear of the pre-molars on wild horses turns out to be no different from that on so-called domesticated animals, and the profile of bones found at ancient sites, both inside and outside tombs, is no different from wild populations (which are known to exist, for example, in 'bachelor groups'). We now know that the only area where changes in bone structure are incontrovertibly brought about by domestication, in this case by riding, is to the mid-backbone of a horse, where the rider would sit. Vertebrae of ancient horses that undoubtedly were ridden characteristically show minute stress lesions (cracks) on their epiphyses, the outer harder parts. Such lesions are completely absent in wild horses. So far, these lesions on ancient horses have been traced back no earlier than the fifth century BC.[89] The earliest unambiguous dateable textual and artistic evidence for horse domestication goes back to the end of the third millennium BC. Evidence of horse graves, accompanied by artefacts unambiguously associated with riding or traction, is even more recent, dating to probably no later than the end of the second millennium BC, when horses were widely used to pull chariots in both the Near East, the Eurasian steppe and in Greece. There is thus no reliable textual or artistic evidence for horse-riding earlier than the end of the second millennium BC.[90]

The Latin poet Ovid was just one author in antiquity who was convinced there had once been a primeval golden age, free of aggression and rancour: 'With no one to impose punishment, without any laws, men kept faith and did what was right ... The people passed their lives in security and peace, without need for armies.'[91]

If only ... In 1959 Raymond Dart published an analysis of an Australopithecine chin and concluded that 'it was bashed in by a formidable blow from the front and delivered with great accuracy just to the left of the point of the jaw'. The instrument, in his view, was an antelope humerus.[92] In the proto-Neolithic period, four 'staggeringly powerful' new weapons appeared 'that would dominate warfare down to the present millennium: the bow, the sling, the dagger and the mace'.[93] Cave paintings from Spain show warriors carrying bows and arrows, the leader marked out by a more fancy headdress. Other paintings show archers arrayed into a firing line. 'The appearance of the column and line, which imply command and organisation, is synonymous with the invention of tactics.'[94] Other paintings depict what appears to be protective clothing – armour – over the warriors' knees, genitals and shoulders. Slings are shown being used at Çatal Hüyük and the spread of fortified sites took place all over the Middle East from 8000–4000 BC.[95] There was no golden age of peace.

By the time of the New Kingdom in Egypt, the pharaohs could put armies of up to

20,000 in the field. This implied vast organisation and logistical support. For comparison, at Agincourt (1415) 6,000–7,000 Englishmen defeated a French force of 25,000 and in the battle of New Orleans (1815) 4,000 Americans defeated 9,000 British troops. The introduction of the chariot meant that rapid reaction was more necessary than ever, which in turn provoked the idea of standing armies. In Egypt the army comprised professional soldiers, foreign mercenaries (Nubians, in this case) and, sometimes, conscripts. The title, 'overseer of soldiers' was equivalent to our term 'general', of whom, at any one time, there were about fifteen.[96] Conscripts were recruited by special officers who toured the country and were empowered to take one in a hundred men. Assyria's awesome power as a fighting nation was due to two factors over and above the chariot: iron and cavalry. Iron, in particular the Assyrians' discovery of how to introduce carbon into red-hot iron to produce carburised, or steel-like, iron favoured the development of the sword – with a sharp edge – as opposed to the dagger, with a point.[97]

Given that the horse was not indigenous to Assyria, the measures they adopted to acquire animals was extraordinary. This was revealed in 1974 by Nicholas Postgate, a professor at Cambridge, in his *Taxation and Conscription in the Assyrian Empire*. He showed that around 2,000 'horse reports' were written daily, addressed to the king, who had two men in every province specifically searching out horses and transporting them to the capital. Collectively, these agents, or *musarkisus*, sent around one hundred animals *per day* to Nineveh over a period of three months. Nearly three thousand animals are mentioned in the Horse Reports, of which 1,840 are 'yoke' or chariot horses, and 787 are riding or cavalry horses. 'Though the Assyrians were the classic charioteers of all time, the more mobile cavalry would soon displace them, and from around 1200 BC formed the elite of the world's armies until the arrival of the tank in the First World War, in 1918.'[98]

One of the duties of the king in Mesopotamia was the administration of justice. (In the early cities, injustice was considered an offence against the gods.[99]) For centuries, it was thought that the most ancient laws in the world were those of the Old Testament, concerning Moses. At the start of the twentieth century, however, this idea was overturned, when French archaeologists excavating at Susa in south-west Iran in 1901 and 1902 unearthed a black basalt stele over eight feet high (now in the Louvre), which proved to be inscribed with the law code of the Babylonian king, Hammurabi, who ruled early in the second millennium. The upper section showed the king praying to a god, either Marduk, the sun-god, or Shamash, the god of justice, seated on a throne. The rest of the stone, front and back, was carved with horizontal columns of the most beautiful cuneiform.[100] Since the French discovery, the origins of law have been pushed back a number of times but it suits us to consider this sequence in reverse order because the evolution of legal concepts becomes clearer.

Hammurabi (1792–1750 BC) was an adventurous and successful king. His capital was at Babylon, where he centralised the local cults in the worship of Marduk.[101] As part of this he simplified and unified the bureaucracy throughout his realm, including the legal system. Altogether, nearly three hundred laws are now known from Hammurabi's code, sandwiched between a prologue and an epilogue. They are arranged in this way: offences against property (twenty sections), trade and commercial transactions (nearly forty

sections), the family (sixty-eight sections, covering adultery, concubinage, desertion, divorce, incest, adoption, inheritance), wages and rates of hire (ten sections), ownership of slaves (five sections). Hammurabi's laws, as H. W. Saggs tells us, take one of two forms, apodictic and casuistic. Apodictic laws are absolute prohibitions, such as 'Thou shalt not kill.' Casuistic laws are of the type: 'If a man delivers to his neighbour money or goods to keep, and it is stolen out of the man's house, then, if the thief is found, he shall pay double.' The prologue makes it plain that Hammurabi's laws were intended to be exhibited in public, where citizens could read them, or have them read out.[102] They are not what we would understand as statutes: they are royal decisions, a range of typical examples rather than a formal statement of principles. Hammurabi meant the code to apply across all of Babylonia, replacing earlier local laws that differed from area to area.

From the code we can see that, legally speaking, Babylonian society was split into three classes: free men (*awelu*), *mushkenu*, and slaves (*wardu*). The *mushkenum* were privileged, in that some military or civilian duty was performed in exchange for certain advantages. For instance, the fee for a life-saving operation was set at ten shekels of silver for an *awelum*, five for a *mushkenum* and two for a slave (§§ 215–217). Similarly, 'if a man has pierced the eye of an *awelum*, they shall pierce his eye', but 'if he has pierced the eye or broken the bone of a *mushkenum*, he shall pay one mina of silver' (§§ 196–198). Punishments were cruel by our standards but the objectives were not so different. Family law was designed to protect women and children from arbitrary treatment and to prevent poverty and neglect. Thus, although a wife's adultery was punishable by death, her husband could always pardon her and the king could pardon her lover. This saved them 'from being bound together and thrown into the river' (§ 129).[103] Just as many Sumerian and Babylonian literary narratives prefigured those in the Bible, so did Hammurabi's laws anticipate Moses'. For example: Hammurabi's Laws, § 117 reads: 'If a debt has brought about the seizure of a man and he has delivered his wife or his son or his daughter for silver, or has delivered them as persons distrained for debt, for three years they shall serve in the house of the buyer or distrainer; in the fourth year their freedom shall be established.' Compare that with Deuteronomy 15:12, 18: 'If your brother, a Hebrew man, or a Hebrew woman, is sold to you, he shall serve you six years, and in the seventh year you shall let him go from you.'

In places the Hammurabi code refers to judges and discusses the conditions under which they could be disqualified. This sounds as though they were professionals, who were paid by the state. They worked either in the temples or at the gates, in particular those dedicated to the god of justice, Shamash. However, the king was always the court of appeal, and intervened whenever he wanted to. The Babylonians were less concerned with an abstract theory of justice, and more with finding an acceptable solution that did not disrupt society. For example, the two parties in a case were required to swear they were satisfied with the verdicts and would not pursue vendetta.[104] When a case came before the judges, there was no advocacy, and no cross-examination. The court first examined any relevant documents and then heard statements by the accuser, the accused and any witnesses. Anyone giving evidence took an oath by the gods and if a conflict of testimony arose, it was settled by recourse to the ordeal – that is, the rival witnesses were forced to jump into the river, the idea being that the fear of divine wrath would pressure the lying

party to confess. It seems to have worked, since the practice of ordeal was still in use in biblical times where it is mentioned in Numbers.[105]

This all sounds very well organised and carefully thought out. It is important to add, therefore, that there is no direct evidence that Hammurabi's code was ever adopted, and that no extant legal rulings of the period refer to his system.

But Hammurabi's famous code is no longer the oldest set of laws we have. In the 1940s an earlier code, written in Sumerian, was discovered.[106] This had been set down by Lipit-Ishtar (1934–1924 BC) of Isin, a city which was prominent in southern Mesopotamia after the fall of Ur. It too contains a prologue which speaks of the gods raising Lipit-Ishtar to power 'to establish justice in the land ... to bring well-being to the people of Sumer and Akkad'. The two dozen or so laws are more limited in scope than Hammurabi's, covering ownership of land, including theft from or damage to an orchard, runaway slaves, inheritance, betrothal and marriage, injury to hired animals. Land ownership brought privileges but also responsibilities. For example, § 11 reads: 'If next to a man's estate, another man's uncultivated land lies waste and the householder has told the owner of the uncultivated land, "Because your land lies waste someone may break into my estate; safeguard your estate", and this agreement is confirmed by him, the owner of the uncultivated land shall make good to the owner of the estate any of his property that is lost.'[107]

In the 1950s and 1960s even earlier laws were discovered, deriving from Ur-Nammu, who founded the Third Dynasty of Ur at about 2100 BC. The fragment discovered deals with abuses in taxation and setting up standard weights and measures, but it also has a strong statement of principle, in this case to block the exploitation of the economically weak by the strong: 'The orphan was not given over to the rich man; the widow not given over to the powerful man; the man of one shekel was not given over to the man of one mina.'[108] The laws of Ur-Nammu make no attempt at being a systematic code, governed by abstract legal principles. They are based on actual cases. Also, unlike the laws of Hammurabi and the Bible, there is no idea of the *lex talionis*, the principle of an eye for an eye or a tooth for a tooth, as punishment for causing bodily injury.[109] Talion seems to have been a more primitive form of law, despite its presence in the Bible (a relatively late document, legally speaking). In the Hittite laws (*c.* 1700–1600 BC), for example, the penalty for stealing a beehive was 'exposure to a bee sting', but this was replaced later by a fine.[110]

But again, all this may make ancient justice sound more organised, and more modern, than it really was. The earliest 'code' we now have is that of Uruinimgina of Lagash but he, like the others, may simply have attempted to alleviate the traditional injustices of ancient society, which were always threatening to get out of hand. Uruinimgina's reforms, like the others, may have been as much royal propaganda as real. Kingships emerged in societies that were changing rapidly and were very competitive. Kings themselves liked to interfere in the administration of justice – it was one of the ways they showed their power. Justice was probably nowhere near as clearly organised as the idealised codes make it appear.

There is evidence of a development in abstract thought in the Mesopotamian cities. To begin with, for example, early counting systems applied only to specific commodities – i.e., the symbol for 'three sheep' applied only to sheep and was different from that for 'three cows'. There was no symbol for '3' in and of itself (in Umberto Eco's well-known

phrase, 'There were no nude names in Uruk times').[111] The same was true of measuring. Later, however, words for abstract qualities – such as number, the measurement of volume in abstract units (hollow spaces), and geometrical shapes (such as triangularity) – emerged. So too did the use of the word *LU*, to mean 'human being, individual of the human species'.[112] Hardly less momentous was the development of the concept of private property, as evidenced by extra-mural cemeteries which, it seems, were confined to individuals from particular communities.[113] Yet another important 'first' of the Babylonians.

It was thus in these first cities that *LU*, human beings, discovered a genius for art, literature, trade, law – and many other new things. We call it civilisation and we are apt to think of it as reflected in the physical remains of temples, castles and palaces that we see about us. But it was far more than that. It was a great experiment in living together, which sparked a whole new psychological experience, one that, even today, continues to excite many more of us than the alternatives. Cities have been the forcing houses of ideas, of thought, of innovation, in almost all the ways that have pushed life forward.

# PART TWO

# ISAIAH TO ZHU XI
The Romance of the Soul

# 5

# *Sacrifice, Soul, Saviour:*
# *'the Spiritual Breakthrough'*

In 1975 the British archaeologist Peter Warren excavated a small building that formed part of the Knossos complex in Crete. Knossos was the main site of the Minoan, bull-worshipping civilisation, dating to 2000 BC, which was discovered by Sir Arthur Evans in 1900. The building excavated by Warren had at some stage been the victim of an earthquake, making it more difficult than usual to 'read' the rubble. Despite this, he soon came across the scattered bones of four children aged between eight and twelve. Many of the bone fragments bore the tell-tale knife marks that resulted from de-fleshing of the bones. More children's bones were found in an adjoining room, 'one of them a vertebra bearing a knife-cut pathologists associate with slitting of the throat'.[1] Warren concluded that the remains were those of children who had been sacrificed to avert a great disaster – perhaps the very earthquake that was so soon upon them.

Of all the beliefs and practices in ancient religion, sacrifice – both animal and human, and even of kings – is the most striking, certainly from a modern standpoint. In our examination of the origins of religion, among the Palaeolithic painted caves and Venus figurines, and around the time that worship of the Great Goddess and the Bull began, we find no traces of sacrifice. However, by the time of the first great civilisations – in Sumer, Egypt, Mohenjo-Daro and China – it was widely practised and proved very durable: human sacrifice was abolished in parts of India only in the nineteenth century AD.*[2] Surveys of ancient texts, decorations on temple and palace walls, on pottery and mosaics, together with anthropological surveys among nineteenth- and twentieth-century tribes across the world, have confirmed the widespread variety of sacrificial practices (the difference between religious sacrifice and magical sacrifice is discussed in the notes). In Mexico children were sacrificed so that their tears would encourage rain.[3] In other cultures people with physical abnormalities were selected for sacrifice. A not-uncommon form of sacrifice is for a pig to be slaughtered. This sends a message to the gods, who are deemed to have replied according to the state of the pig's liver. (The liver is the bloodiest organ and blood was often identified with the life force.)

---

* A case of 'suttee', a widow sacrificing herself following the death of her husband, was reported from northern India in the summer of 2002. An account of the nineteenth-century human sacrifice among the Khonds of Bengal is given in the notes.

If we can say that the ideas of the Great Goddess, the Bull and sacred stones are the earliest core ideas of many religions, they were followed by a second constellation of beliefs that were all in place before the great faiths that are still dominant today were conceived. Sacrifice was the most striking of this second set of ideas.

A sacrifice is, at its most basic, two things. It is a gift and it is the link between man and the spiritual world. It is an attempt either to coerce the gods, so they will behave as we wish them to behave, or to propitiate them, to defuse their anger, to get, get rid of, to atone. This much is easy to understand. What requires a fuller explanation is the actual form that sacrifice takes, and has taken in the past. Why must animals or humans be killed? Why is it that blood must be shed? How did such an ostensibly cruel practice take root and become widespread? Did ancient people *see* sacrifice as cruel?

Sacrifice originated at a time when ancient man regarded all that he experienced – even the rocks, rivers and mountains as a form of life. In India hair was sacred because it continued to grow after a person's death and so was judged to have a life of its own.[4] Vedic Aryans regarded the actual leaping fire as a living thing, swallowing oblations.[5] Most important, perhaps, sacrifice dates from an era when the rhythms of the world were observed but not understood. It was these rhythms, the very notion of periodicity, that were the basis of religion: such patterns were the expression of mysterious forces.

As the first great civilisations developed in various parts of the world, in Sumer, Egypt and India, for example, the core symbolism – of the Great Goddess, the Bull, and sacred stones – developed and proliferated, taking on many different forms. Among early Indian gods, for example, Indra was constantly compared to a bull.[6] In Iran the sacrifice of bulls was frequent.[7] Bull gods were also worshipped in parts of Africa and Asia. In the Akkadian religion in early Mesopotamia the bull was a symbol of power and at Tel Khafaje (near modern Baghdad) the image of a bull was found next to that of the 'Goddess Mother'.[8] The main god of the early Phoenician religion was known as *shor* ('bull') and as *El* ('merciful bull'). According to Mircea Eliade 'the bull and Great Goddess was one of the elements that united all the proto-historic religions of Europe, Africa and Asia.'[9] Among the Dravidian tribes of central India, there developed a custom whereby the heir of a man who had just died had to place by his tomb, within four days, a vast stone, nine or ten feet high. The stone was intended to 'fasten down' the dead man's soul.[10] In many cultures of the Pacific, stones represent either gods, heroes or 'the petrified spirits of ancestors'. The Khasis of Assam believed that cromlechs, circular alignments, were 'female' stones, representing the Great Mother of the clan and that the menhirs, standing stones, were the 'male' variety.

Sacrifice may also have begun in a less cruel way, beginning at a time when grain was the main diet, and meat-eating still relatively rare. Animals may have been worshipped, and eating one was a way of incorporating the god's powers. This is inferred from the Greek word *thusia*, which has three overlapping meanings: violent, excited motion; smoke; and sacrifice.[11] But sowing and reaping are the focal points of the agricultural drama, and these are invariably associated with ritual.[12] In many cultures, for example, the first seeds are not sown but thrown down alongside the furrow as an offering to the gods.[13] By the same token, the last few fruits were never taken from the tree, a few tufts of wool were always left on the sheep and the farmer, when drawing water from a well, would always put back a few drops 'so that it will not dry up'.[14]

Already, we have here the concept of self-denial, of sacrificing part of one's share, in order to nourish, or propitiate, the gods. Elsewhere (and this is a practice that stretches from Norway to the Balkans) the last ears of wheat were fashioned into a human figure: sometimes this would be thrown into the next field to be harvested, sometimes it would be kept until the following year, when it would be burned and the ashes thrown on the ground before sowing, to ensure fertility.[15] Records show that human sacrifice was offered for the harvest by certain peoples of central and north America, some parts of Africa, a few Pacific islands, and a number of Dravidian tribes of India.[16] Apart from the Khonds, the Aztecs of Mexico showed the process most clearly, for a young girl was beheaded at the temple of the maize god in a ceremony performed when the crop was just ripe. Only after the ceremony was performed could the maize be reaped and eaten – before that it was sacred and couldn't be touched. One can imagine why sacrifice, which began in holding back a few ears of corn, should grow increasingly elaborate, and seemingly cruel. Each time the harvest failed, and famine ensued, primitive peoples would have imagined the gods were displeased, unpropitiated, and so they would have redoubled their efforts, adding to their customs, increasing the amount of self-denial, in an attempt to redress the balance.[17]

After sacrifice, the next important addition to core beliefs, the most widespread new idea which had emerged since early Neolithic times, was the concept of the 'sky god'. This is not hard to understand either, though many modern scholars now rather downplay this aspect. By day, the apparent movement of the sun, its constant 'death' and 'rebirth', and its role in helping shape the seasons and make things grow, would have been as self-evident as it was mysterious to everyone. By night, the sheer multitude of stars, and the even more curious behaviour of the moon, waxing and waning, disappearing and reappearing, its link with the tides and the female cycle, would have been possibly more mysterious. In Mesopotamia (where there were 3,300 names for gods), the Sumerian word for divinity, *dingir*, meant 'bright, shining'; the same was true in Akkadian. Dieus, god of the light sky, was common to all Aryan tribes.[18] The Indian god Dyaus, the Roman Jupiter and the Greek Zeus all evolved from a primitive sky divinity, and in several languages the word for light was also the word for divinity (as the English word 'day' is related to the Latin word *deus*). In India in Vedic times, the most important sky god was Varuna, and in Greece Uranus *was* the sky.[19] His place was eventually taken by Zeus, which is probably the same word as Dieus and Dyaus, meaning both 'brightness', 'shine', and 'day'. The existence of sky gods is responsible for the concept of 'ascension'. In several ancient languages the verb 'to die' involved associations with climbing mountains, or taking a road into the hills.[20] Ethnological studies show that all across the world, heaven is a place 'above', reached by means of a rope, tree or ladder, and there are many ascension rites in, for example, ancient Vedic, Mithraic, and Thracian religions.[21] Ascension plays an important part in Christianity.

Moon symbolism appears to be associated with early notions of time (see Genesis 1:14–19).[22] The fact that the moon at times has a crescent shape induced early people to see in this an echo of the horns of the bull, so that like the sun the moon was also on occasions compared to this divinity. Finally, like the sun, the death and rebirth of the moon meant

that it was associated with fertility. The existence of the menstrual cycle convinced certain early peoples that the moon was 'the master of women' and in some cases 'the first mate'.[23]

The sky gods also played a role in another core idea: the afterlife. We know that from Palaeolithic times early man had a rudimentary notion of the 'afterlife', because even then some people were buried with grave goods which, it was imagined, would be needed in the next world. Looking about them, early humans would have found plenty of evidence for an afterlife, or death and rebirth. The sun and the moon both routinely disappeared and reappeared. Many trees lost their leaves each year but grew new ones when spring came. An afterlife clearly implies some sort of post-mortem existence and this introduces a further core belief, what the historian S. G. Brandon has called humanity's 'most fundamental concept': the soul. It is, he says, a relatively modern idea (compared with the afterlife) and even now is far from universal (though his colleague E. B. Tylor thought it the core to all religions).[24] A very common belief is that only special human beings have souls. Some primitive peoples ascribe souls to men and not to women, others the reverse. In Greenland there was a belief that only women who had died in childbirth had souls and enjoyed life thereafter. According to some peoples, the soul is contained in different parts of the body: the eye, the hair, the shadow, the stomach, the blood, the liver, the breath, above all the heart. For some primitive peoples, the soul leaves the body via the top of the head, for which reason trepanning has always been a common religious ritual.[25] Similarly in Hindu the soul is not the heart but, 'being "the size of a thumb" (at death)', it lives *in* the heart. The *Rig Veda* recognised the soul as 'a light in the heart'. The Gnostics and the Greeks saw the soul as the 'spark' or 'fire' of life.[26]

But there was also a widespread feeling that the soul is an alternative version of the self.[27] Anthropologists such as Tylor put this down to primitive man's experience of dreams, 'that in sleep they seemed to be able to leave their bodies and go on journeys and sometimes see those who were dead.'[28] Reflecting on such things, primitive peoples would naturally have concluded that a kind of inner self or soul dwelt in the body during life, departing from it temporarily during sleep and permanently at death.[29]

For the ancient Egyptians, there were two other entities that existed besides the body, the *ka* and the *ba*. 'The former was regarded as a kind of double of the living person and acted as a protective genius: it was represented by a hieroglyphic sign of two arms upstretching in a gesture of protection.' Provision had to be made for it at death and the tomb was called the *het ka*, or 'house of death'.[30] 'Of what substance it was thought to be compounded is unknown.'[31] The *ba*, the second entity, is usually described as the 'soul' in modern works on ancient Egyptian culture, and was depicted in art as a human-headed bird. This was almost certainly meant to suggest it was free-moving, not weighed down by the physical limitations of the body. In the illustrations to the *Book of the Dead*, dating from about 1450 BC, the *ba* is often shown perched on the door of the tomb, or watching the fateful post-mortem weighing of the heart. 'But the concept was left somewhat vague and the *ba* does not seem to have been conceived as the essential self or the animating principle.'[32]

The Egyptians conceived individuals as psycho-physical organisms, 'no constituent part being more essential than the other'. The elaborate burial rites that were practised in Egypt for three millennia all reflected the fact that a person was expected to be 'reconstituted'

after death. This explains the long process of embalmment, to prevent the decomposition of the corpse, and the subsequent ceremony of the 'Opening of the Mouth', designed to revivify the body's ability to take nourishment. 'The after-life was never etherealised in the Egyptian imagination, as it was in some quarters, but we do find that as soon as man could set down his thoughts in writing, the idea that man is more than flesh and blood is there.'[33]

In Mesopotamia the situation was different. They believed that the gods had withheld immortality from humans – that's what made them human – but man was still regarded as a psycho-physical organism. Unlike the Egyptians, however, they regarded the psychical part as a single entity. This was called the *napistu*, which, originally meaning 'throat', was extended to denote 'breath', 'life' and 'soul'. This *napistu*, however, was not thought of as the inner essential self, but the animating life principle and what became of the *napistu* at death isn't clear. Although they didn't believe in immortality, the ancient Mesopotamians did believe in a kind of post-mortem survival, a contradiction in terms in a way.[34] Death, they believed, wrought a terrible change in a person – he was transformed into an *etimmu*. 'The *etimmu* needed to be nourished by mortuary offerings, and it had the power to torment the living, if it were neglected … among the most feared of Mesopotamia's demonology were the *etimmus* of those who had died unknown and received no proper burial rites. But, even when well provided for, the afterlife was grim. They dwelt in *kur-nu-gi-a*, the land of no return, where dust is their food and clay their substance … where they see no light and dwell in darkness.'[35]

The origins of the Hindu religion are far more problematical than any of the other major faiths. After Sir William Jones, a British judge living and working in India in the late eighteenth century, first drew attention to the similarity of Sanskrit to various European languages, scholars have hypothesised the existence of an early proto-European language, from which all others evolved, and a proto-Indo-Aryan people, who spoke the 'proto-language' and helped in its dispersal. In its neatest form, this theory proposes that these people were the first to domesticate the horse, an advantage which helped their mobility and gave them a power over others.

Because of their link to the horse, the proto-Indo-Aryans are variously said to have come from the steppe land between the Black Sea and the Caspian, between the Caspian and the Aral Sea, or from other locations in central Asia. The most recent research locates the homeland in the Abashevo culture on the lower Volga and in the Sintashta-Arkaim culture in the southern Urals. From there, according to Asko Parpola, a Finnish professor of Indology, 'the domesticated horse and the Indo-Aryan language seem to have entered south Asia in the Gandhara grave culture of north Pakistan around 1600 BC'. The most important aspect of their migration is held to have been in north-west India, around the Indus valley, where the great early civilisation of Harappa and Mohenjo-Daro suffered a mysterious decline in the second millennium BC, for which the Indo-Aryans are held responsible. It is the Indo-Aryans who are held to have composed the *Rig Veda*. Their place of origin, and their migration, are said to be reflected in the fact that the Finno-Ugaric language shows a number of words borrowed from what became Sanskrit, that the Andronovo tribes of the steppes show a culture similar to that described in the *Rig Veda*, and that they left a trail of names, chiefly of rivers (words which are known to be very stable),

as they moved across central Asia. They also introduced the chariot (and therefore the horse) into India, and iron – again, items mentioned in the *Rig Veda*.[36] Finally, the general setting of the *Rig Veda* is pastoral, not urban, meaning it was written down before the Indo-Aryans arrived in the mainly urban world of the Indus valley.

This view has been severely criticised in recent years, not least by Indian scholars, who argue that this 'migrationist' theory is 'racist', developed by Western academics who couldn't believe that India generated the *Rig Veda* all by herself. They argue that there is no real evidence to suggest that the Indo-Aryans came from outside and they point out that the heartland of the *Rig Veda* more or less corresponds to the present-day Punjab. Traditionally, this presented a problem because that name, Punjab, based on the Sanskrit, *panca-ap*, means 'five rivers', whereas the *Rig Veda* refers to an area of 'seven rivers' with the Sarasvati as the most majestic.[37] For many years no one could identify the Sarasvati among today's rivers, and it was therefore regarded by some as a 'celestial' entity. However, in 1989, archaeologists discovered the bed of a once-massive, now dried-up river, six miles wide in places, and this was subsequently confirmed by satellite photographs.[38] Along this dried river bed (and a major tributary, making seven rivers in all in the Punjab) are located no fewer than 300 archaeological sites. This thus confirms, for the indigenists at least, not only that the area of the *Rig Veda* was inside India, but that the drying-up of the river helps explain the collapse of the Indus valley civilisation.[39] They also point to recent research on the astronomical events in the *Rig Veda* which, they say, confirm that these scriptures are much older than the 1900–1200 BC date traditionally ascribed. They argue that the astronomy, and the associated mathematics, show that the Indo-Aryans were indigenous to north-west India, that that is where the Indo-European languages began, and that Indian mathematics were much in advance of those elsewhere. While this debate is inconclusive at the moment (there are serious intellectual holes in both the migrationist and the indigenous theories), it remains true that Indian mathematics *was* very strong historically, and that, as was discussed in the last chapter, a very old script – perhaps the oldest yet discovered – was unearthed recently in India.

In Vedic thought, man's life fell into two phases. His earthly life was seen as the more desirable. The hymns of the *Rig Veda* speak of a people living life to the full – valuing good health, eating and drinking, material luxuries, children.[40] But there was a post-mortem phase, the quality of which was, to an extent, determined by one's piety on earth. However, the two phases were definitive: there was no idea whatsoever that the soul might return to live again on earth – that was a later invention. In the early stage, when Vedic bodies were buried, the dead were imagined as living in an underworld, presided over by Yama, the death-god.[41] The dead were buried with personal articles and even food, though what part of a person was thought to survive is not clear.[42] The Indo-Aryans thought of an individual as composed of three entities – the body, the *asu*, and the *manas*. The *asu* was in essence the 'life principle', equivalent to the Greek *psyche*, while the *manas* were the seat of the mind, the will and the emotions, equivalent to the Greek *thymos*. There appears to have been no word, and no idea, for the soul as an 'essential self'. Why there was a change from burial to cremation isn't clear either.

If one accepts the existence of souls, it follows that there is a need for a place where they

can go, after death. This raises the question of where a whole constellation of associated ideas came from – the afterlife, resurrection, and heaven and hell.

The first thing to say is that heaven, hell and the immortal soul were relative latecomers in the ancient world.[43] The modern concept of the immortal soul is a Greek idea, which owes much to Pythagoras. Before that, most ancient civilisations thought that man had two kinds of soul. There was the 'free-soul', which represented the individual personality. And there were a number of 'body-souls' which endowed the body with life and consciousness.[44] For the early Greeks, for example, human nature was composed of three entities: the body, the *psyche*, identified with the life principle and located in the head; and the *thymos*, 'mind' or 'consciousness', located in the *phrenes*, or lungs.[45] During life, the *thymos* was regarded as more important but it didn't survive death, whereas the *psyche* became the *eidolon*, a shadowy form of the body.

This distinction was not maintained beyond the sixth century BC, when the *psyche* came to be thought of as both the essential self, the seat of consciousness and the life principle. Pindar thought the *psyche* was of divine origin and therefore immortal.[46] In developing the idea of the immortal soul Pythagoras was joined by Parmenides and Empedocles, other Greeks living alongside him in southern Italy and Sicily. They were associated with a mystical and puritanical sect known as the Orphics, who at times were 'fanatical vegetarians'. This appears to have been part of a revolt over sacrifice and the sect used mind-altering drugs – hashish, hemp and cannabis (though here the scholarship is very controversial). These ideas and practices are said to have come from the Scythians, whose homeland was north of the Black Sea (and was visited by Homer). They boasted a curious cult, surrounding a number of individuals suffering a chronic physical disease, possibly haemochromatosis, and possibly brought on by rich iron deposits in the area. This condition culminates in total impotence and eunuchism. There are a number of accounts of cross-dressing in the area and these individuals may have led the funerary ceremonies in Scythia, at which ecstasy-inducing drugs were used.[47] Was this cult the foundation for Orphism and were the trances and hallucinations induced by drugs the mechanism whereby the Greeks conceived the idea of the soul and, associated with it, reincarnation? Pythagoras, Empedocles and Plato all believed in reincarnation and in metempsychosis – the idea that souls could come back in other animals and even in plants. The Orphics believed that the actual form the soul took on reincarnation was a penalty for some 'original sin'.[48] Both Socrates and Plato shared Pindar's idea of the divine origin of the soul and it is here that the vision took root that the soul was in fact more precious than the body. This was not, it should be said, the majority view of Athenians, who mainly thought of souls as unpleasant things who were hostile to the living. Many Greeks did not believe that there was life after death.*

Among those Greeks who did believe in some form of afterlife, the dead went straight to the underworld which, in the *Iliad*, was guarded by canine Cerberus. The soul could reach this 'mirthless place' only by crossing the river Styx. The underworld was called Hades, which derives from a root word meaning invisible, unseen.[49] Death seems to have been regarded then as unavoidable. Athena tells Odysseus' son Telemachus that 'death is

---

* The English word 'soul' is derived from the Germanic *saiwalo*.

common to all men, and not even the gods can keep it off a man they love . . .'[50] By the later parts of the *Odyssey*, however, there has been a change. For example, Proteus tells Menelaus that he will be sent 'to the Elysian plain at the ends of the earth'. The name Elysion is pre-Greek and so this idea may have begun elsewhere. By the time of Hesiod's *Works and Days* (late eighth century BC) we hear of the Islands of the Blessed, to which many heroes will be sent after their lives on earth are over. At much the same time, in epic poems, we hear for the first time of Charon, the ferryman of the dead. In the fifth century, there began in Greece the practice of burying the deceased with an *obol*, a small coin to pay Charon.[51] Around 432 BC, on an official war monument, the souls of dead Athenians are described as being received by the *aither*, 'the upper air', though their bodies will remain on earth. In Plato and in many Greek tragedies we learn that the Athenians did not seem to believe in rewards and punishments after death. 'In fact, they do not seem to have expected very much at all. "After death every man is earth and shadow: nothing goes to nothing".' (This is a character in one of Euripides' plays.) In Plato's *Phaedo*, Simmias betrays his worry that at his death his soul will be scattered 'and this is their end'.[52]

Paradise – the word, at least – is much better documented. It is based on an old Median word, *pari* = around, and *daeza* = wall. (The Medes were a civilisation in Iran in the sixth century BC.) The word *paridaeza* came variously to mean a vineyard, a grove of date palms, a place were bricks were made and even, on one occasion, the 'red-light' quarter of Samos. But its most probable association was with royal hunting forests, or simply the lush, shaded gardens that were the prerogative of the aristocracy. This could be allied to the belief, considered below, that only kings and aristocrats could go to paradise, and all others went to hell. There are some indications in Pythagoras' writings that his idea of the afterlife, and the immortal soul, was reserved for the aristocracy, so this may have been an idea that was born as a way of preserving upper-class privileges at a time when that class was being marginalised, as cities (and merchants) grew more important.

For the Israelites, the soul was never developed as a sophisticated idea. The God of Israel formed Adam from the '*adamah*, the clay, and then breathed 'the breath of life into him', so that he became a *nephesh*, or 'living soul'.[53] This is similar to the Akkadian word *napistu*, and is associated with blood, the 'life substance', which drains away at death.[54] The Hebrews never had a word for the 'essential self' that survived death. We should not forget that the entire book of Job in the Hebrew scriptures is concerned with the problem of faith and suffering and inequality in a life where there is no hereafter (all the rewards promised to the Jews by their God are worldly). Even with the advent of Messianism in Judaism, there is still no concept of the soul. There was the concept of Sheol, but this is more akin to the English word 'grave' than Hades, which is how it was often translated. 'Sheol was located beneath the earth (*Psalm* 63.10), filled with worms and dust (*Isaiah*, 14.11) and impossible to escape from (*Job*, 7.9f.).' It was only after the exile in Babylon that good and bad departments of Sheol were envisaged, and it became associated with Gehenna, a valley south of Jerusalem where it was at first believed that punishments would be handed out after the Last Judgement. Soon after, it became the name for the fiery hell.[55]

The final – and conceivably the most important – aspect of this constellation of core beliefs is the simple fact that, around the time of the rise of the first great civilisations, the main

gods changed sex, as the Great Goddess, or a raft of smaller goddesses, were demoted and male gods took their place. Once again, it is not hard to see why this transformation occurred. Predominantly agricultural societies, grouped around the home, were at the very least egalitarian and very probably matriarchal societies, with the mother at the centre of most activities. City life, on the other hand, as was discussed in the previous chapter, was much more male-orientated. The greater need for standing armies favoured men, who could leave home. The greater career specialities – potters, smiths, soldiers, scribes, and not least priests – also favoured men, for women were left at home to look after the children. And with men fulfilling several occupations, they would have had a greater range of self-interest than housewives, and therefore felt a more urgent need to partake in politics. In such a background, it was only natural for the leaders to be males too, so that kings took precedence over queens. Male priests ran the temples and, in certain cases, conferred godlike status on their kings. The effect that this change has had on history has been incalculable. It was first pointed out in the nineteenth century by Johann Jakob Bachofen in *The Law of the Mothers*, or *Mother Right*.

Analysis of early religions can seem at times like numerology. There are so many of them, and they are so varied, that they can be made to fit any theory. Nevertheless, insofar as the world's religions *can* be reduced to core elements, then those elements are: a belief in the Great Goddess, in the Bull, in the main sky gods (the sun and the moon), in sacred stones, in the efficacy of sacrifice, in an afterlife, and in a soul of some sort which survives death and inhabits a blessed spot. These elements describe many religions in some of the less developed parts of the world even today. Among the great civilisations, however, this picture is no longer true and the reason for that state of affairs is without question one of the greatest mysteries in the history of ideas. For during the period 750–350 BC, the world underwent a great intellectual sea-change. In that relatively short time, most of the world's great faiths came into being.

The first man to point this out was the German philosopher Karl Jaspers, in 1949, in his book *The Origin and Goal of History*. He called this period the 'Axial Age' and he characterised it as a time when 'we meet with the most deep cut dividing line in history. Man, as we know him today, came into being ... The most extraordinary events are concentrated in this period. Confucius and Lao-tse were living in China, all the schools of Chinese philosophy came into being, including those of Mo-ti, Chuang-tse, Leh-tsu and a host of others; India produced the Upanishads and Buddha and, like China, ran the whole gamut of philosophical possibilities down to scepticism, to materialism, sophism and nihilism; in Iran Zarathustra taught a challenging view of the world as a struggle between good and evil; in Palestine the prophets made their appearance, from Elijah, by way of Isaiah and Jeremiah to Deutero-Isaiah; Greece witnessed the appearance of Homer, of the philosophers – Parmenides, Heraclitus and Plato – of the tragedians, Thucydides and Archimedes. Everything implied by these names developed during these few centuries almost simultaneously in China, India, and the West, without any one of these regions knowing of the others.'[56]

Jaspers saw man as somehow becoming 'more human' at this time. He says that reflection and philosophy appeared, that there was a 'spiritual breakthrough' and that the Chinese, Indians, Iranians, Jews and Greeks between them created modern psychology, in which

man's relation to God is as an individual seeking an 'inner' goal rather than having a relationship with a number of gods 'out there', in the skies, in the landscape around, or among our ancestors. Not all the faiths created were, strictly speaking, monotheisms, but they did all centre around one individual, whether that man (always a man) was a god, or the person through whom god spoke, or else someone who had a particular vision or approach to life which appealed to vast numbers of people. Arguably, this is the most momentous change in the history of ideas.

We start with the religion of Israel, not because it came first (it didn't, as we shall see), but because, as Grant Allen says, 'It is the peculiar glory of Israel to have *evolved God*.'[57] In Israel's case, this evolution is especially clear.

The name of the Jewish God, Yahweh, which was disclosed to Moses, appears to have originated in northern Mesopotamia. We have known this only since the 1930s, with the discovery of a set of clay texts at Nuzu, a site situated between modern Baghdad and Nimrud in Iraq. Dating from the fifteenth and fourteenth centuries BC, these texts do not identify any biblical individuals by name but they do outline a set of laws, and describe a society that is recognisably that to which Jacob, son of Isaac, fled (in Mesopotamia, according to the Bible) after tricking his father into blessing him, instead of his brother Esau. For example, in the Bible Jacob purchases from Esau his 'birthright', which means title to the position of firstborn. The Nuzu tablets make clear that inheritance prospects there are negotiable. Jacob's grandfather, Abraham, although he was born in Ur, later spent time in Haran, which is also in northern Mesopotamia. This general area was a meeting ground of various peoples, most importantly the Amorites, Arameans and the Hurrians. The divine name Yahweh appears not infrequently in Amorite personal names.[58]

However, until a relatively late period of Jewish history the Israelites had a 'considerable' number of divinities. 'According to the number of thy cities are thy gods, O Judah,' says the prophet Jeremiah, writing in the sixth century BC.[59] When Israelite religion first appears, in the Hebrew scriptures, we find no fewer than three main forms of worship. There is the worship of *teraphim* or family gods, the worship of sacred stones, and the worship of certain great gods, partly native, partly perhaps borrowed. Some of these gods take the form of animals, others of sky gods, the sun in particular. There are many biblical references to these gods. For example, when Jacob flees from Laban, we hear how Rachel stole her father's teraphim: when the furious chieftain finally catches up with the fugitives, one of his first questions is to ask why they stole his domestic gods.[60] Hosea refers to teraphim as 'stocks of wood', while Zechariah dismisses them as 'idols that speak lies to the people'.[61] It is clear that the teraphim were preserved in each household with reverential care, that they were sacrificed to by the family at stated intervals, and that they were consulted on all occasions of doubt or difficulty by 'a domestic priest "clad in an ephod". In all this the Israelites were little different from the surrounding peoples.'[62]

Stone-worship also played an important part in the primitive Semitic religion. For the early Hebrews a sacred stone was a 'Beth-el', a place where gods dwelt.[63] In the legend of Jacob's dream we get an example where the sacred stone is anointed and a promise is made to it of a tenth of the speaker's substance as an offering. In other places women pray to phallic-shaped stones so that they might be blessed with children.[64] Yahweh is referred to

as a rock in Deuteronomy, and in the second book of Samuel. References to other great gods are equally numerous. The terms Baal and Molech are general terms in the Hebrew scriptures, referring mainly to local gods in the Semitic region, and sometimes to sacred stones. A god in the form of a young bull was worshipped at Dan and Bethel, when the Israelites made themselves a 'golden calf' in the wilderness at the time of the Exodus.[65] Grant Allen says explicitly that Yahweh was originally worshipped in the shape of a young bull. In other words, the Israelite religion was polytheistic for centuries, with the worship of Baal, Molech, the bull and the serpent going on side-by-side with worship of Yahweh 'without conscious rivalry'.[66] But then it all began to change, with enormous consequences for humankind.

There are two aspects to that change. The first is that the early Yahweh was a god of increase, fruitfulness and fertility. In the Bible Yahweh promises to Abraham 'I will multiply thee exceedingly', 'thou shalt be a father of many nations', 'I will make thee exceedingly fruitful'. He says the same thing to Isaac.[67] One of the best-known practices of Judaism, circumcision, is a fairly obvious fertility rite concerning the male principle and also confirms the dominance of male gods over female ones.

The early Yahweh was also a god of light and fire. The story of the burning bush is well known but in addition Zechariah says 'Yahweh will make lightnings', while Isaiah describes him this way: 'The light of Israel shall be for a fire, And his holy one for a flame ... His lips are full of indignation, And his tongue is as a devouring fire.'[68] It is not so very far from here to Yahweh being 'a consuming fire, a jealous god'.[69] Several aspects of lunar worship were also incorporated into early Judaism. For example, the Sabbath (*shabbatum*, the 'full-moon day' in Babylon) was originally the unlucky day dedicated to the malign god Kewan or Saturn, when it was undesirable to do any kind of work. The division of the lunar month into four weeks of seven days, dedicated in turn to the gods of the seven planets, is self-evident in its references.

When you look for them, the biblical verses linking early Judaism to even earlier pagan religions, showing all the core beliefs we have identified, are clear-cut. Far from being an ethereal, omnipotent and omniscient presence, the God of the early Hebrew scriptures lived in an ark. Otherwise, why was it sacrosanct, why the despair when the Philistines captured it? What now needs to be explained is two things: why Yahweh emerged as one god; and why he was such a jealous god, intolerant of other deities.

First, there are the particular circumstances of the Israelites in Palestine.[70] They were a small tribe, surrounded by powerful enemies. They were continually fighting, their numbers always threatened. The ark of Yahweh (the portable altar), in its house at Shiloh, seems to have formed the general meeting-place for Hebrew patriotism. Containing the golden calf (i.e., the bull), the ark was always carried before the Hebrew army. There was thus just one god in the ark, and although Solomon (tenth century BC) built temples dedicated to other Hebrew gods, which remained in existence for some centuries, Yahweh became in this way the main deity.[71] For generations the two tiny Israelite kingdoms maintained a precarious independence between the great empires of Egypt and Meso-potamia. Beginning in the eighth century BC, however, this balancing act broke down and they were defeated in battle, first by the Assyrians, then by the Babylonians. The very

existence of Israel was at stake and, in response, 'there broke out an ecstasy of enthusiasm' for Yahweh. In this way was generated the 'Age of the Prophets', which produced the earliest masterpieces of Hebrew literature, designed to shock the sinful Israelites into compliance with the wishes of their god, Yahweh who, by the end of this period, had become supreme. 'Prophet' is a Greek word, meaning one who speaks before the sacred cave of an oracle.[72]

There are two issues here, one of which will be considered now, the other in a later chapter. These are, first, the message and impact of the prophets and, second, the compilation of the Hebrew scriptures which, far from being the divinely-inspired word of God, are, like all holy writings, clearly a set of documents produced by human hands with a specific aim.[73]

The Hebrew prophets fulfilled a role that has been called unique in the history of humanity, but if so it was not so much prophecy in itself that marked them out as their loud and repeated denunciations of an evil and hypocritical people, and their bitter predictions of the doom that must follow this continued estrangement from God. To a man, the prophets were opposed to sacrifice, idolatry and to the traditional priesthood, not so much on principle as for the fact that 'men were going through the motions of formally honouring God while their everyday action proved they had none of the love of God that alone gives sacrifice a meaning'.[74] The prophets' main concern was Israel's internal spirituality. Their aim was to turn Yahweh-worship away from idolatry (the idol in the ark), so that the faithful would reflect instead on their own behaviour, their feelings and failings. This concentration on the inner life suggests that the prophets were concerned with an urban religion, that they were faced with the problem of living together in close proximity. This may explain why, in their efforts to shock the Israelites into improving their morality, the prophets built up the idea of revelation.[75]

Just when ecstatic prophecy began in Israel is uncertain. Moses not only talked to God and performed miracles, but he carried out magic – rods were turned into snakes, for example. The earliest prophets wore magicians' clothes – we read of 'charismatic mantles' worn by Elijah ('the greatest wonder-worker since Moses') and inherited by Elisha.[76] According to the book of Kings (1 Kings 18:19ff), prophecy was a practice common among the Canaanites, so the Israelites probably borrowed the idea from them.[77] The central – the dominating – role in Israelite prophecy was an insistence on the 'interior spirit' of religion. 'What gives Israelite prophetism its distinctly moral tone almost if not quite from the very beginning, is the distinctly moral character of Israelitic religion. The prophets stand out in history because Israel stands out in history ... Religion is by nature moral only if the gods are deemed moral, and this was hardly the rule among the ancients. The difference was made in Israel by the moral nature of the God who had revealed himself.'[78] The prophets also introduced a degree of rationalism into religion. As Paul Johnson has pointed out, if there *is* a supernatural power, why should it be confined only to certain sacred rocks, or rivers, or planets, or animals? Why should this power be expressed only in an arbitrary array of gods? Isn't the idea of a god of limited power a contradiction in terms? 'God is not just bigger, but infinitely bigger and therefore the idea of representing him is absurd, and to try to make an image of him is insulting.'[79]

Although the prophets differed greatly in character and background, they were united in their condemnation of what they saw as the moral corruption of Israel, its turning

away from Yahweh, its over-zealous love of empty sacrifice, especially on the part of the priesthood. They were agreed that a time of punishment was coming, due to the widespread corruption, but that Israel would eventually be saved by a 'remnant' which would survive. Almost certainly, this reflected a period of great social and political change, when Israel was transformed from a tribal society to a state with a powerful king and court, where the priests were salaried and therefore dependent on the royal house, and where a new breed of wealthy merchant was emerging, keen and able to buy privileges for itself and its offspring and for whom, in all probability, religion took second place. All this at a time when the threat from outside was especially difficult.

The first prophets, Elijah and Elisha, introduced the idea of the individual conscience. Elijah was critical of the royal household because some of its members were corrupt and worshipped Baal.[80] God spoke to him, he famously said, in 'a still, small voice'. Amos was appalled at the bribery he saw around him, and at temple prostitution, a relic of ancient fertility rites.[81] It was he who developed the concept of 'election', that Israel had been selected by Yahweh, to be his chosen people, that he would protect them provided they abided by their covenant with him, to worship him and only him (but see below, page 113). For Amos, if Israel failed in this sacred marriage with Yahweh, Yahweh would intervene in history and 'settle accounts'.[82] Hosea refined the covenant still further. He believed in a Yahweh who was master of all history, who had 'irresistible designs' for all the world. He too opposed corrupt kingship and the cult of the temple, expressly branding as idolatry the worship of the golden bulls which had been instituted in the royal sanctuaries (1 Kings 12:25–30); he also conceived the idea of a messiah who would redeem Israel.[83] It was Hosea who first introduced a religion of the heart, divorced from place. This was reinforced when Jerusalem survived a siege by the Assyrian King Sennacherib, in 701 BC. The Israelites triumphed thanks to bubonic plague, transmitted by mice, but to them this only confirmed that their fate was linked to Yahweh and their own moral behaviour.[84]

Isaiah, without question the most skilful wordsmith and the most moving writer among the prophets (and indeed of the entire Hebrew canon), began his mission, according to his own account, in the year that King Uzziah died – around 740 BC. By tradition he was the nephew of King Amaziah of Judah and was well-connected to the politicians of his day.[85] But he got out among the people and had a sizeable following – a popularity that endured, as may be gauged from the fact that, among the texts found at Qumran after the Second World War was a leather scroll, twenty-three feet long, giving the whole of Isaiah in fifty columns of Hebrew. As a result of his pressure on Hezekiah, the king at the time, the Temple in Jerusalem turned back to Yahweh-worship and the sanctuaries in the provinces were closed and public worship centralised in the capital.[86] Isaiah condemned Judah as a land of unbridled, irresponsible luxury, a sensual society without concern for the spirit, divine or human.[87] He explicitly singled out for condemnation the monopoly in land that had 'borne such evil fruit in Judah'.[88] Isaiah was pushing the Israelite religion to a new spirituality and a new interiority, still more divorced from time and place than Hosea had imagined, more and more a religion of conscience, when men are thrown back on themselves as the only way to achieve social justice. Men and women, he was saying, must turn away from the pursuit of wealth as the chief aim in life. 'Woe unto them that join house to house, that lay field to field, till there be no place.'[89]

But there was another side to Isaiah, and equally important. In his religion, sacrifice is not enough but repentance is always possible, the Lord is always forgiving and, if enough people repent, he foresees an age of peace, when men and women 'shall beat swords into ploughshares, and their spears into pruning-hooks: nation shall not lift up sword against nation, neither shall they learn war anymore'. This, as many scholars have noted, for the first time gives history a linear quality. God gives history a direction and here Isaiah introduces an even more radical idea: 'Behold a young woman shall conceive and bear a son, and shall call his name Immanuel.' This special son shall advance the age of peace: 'The wolf shall also dwell with the lamb, and the leopard shall lie down with the kid; and the calf and the young lion and fatling together; and a little child shall lead them.' But he will also be a great ruler: 'For unto us a child is born, unto us a son is given; and the government shall be upon his shoulder: and his name shall be called Wonderful, Counsellor, The Mighty God, the Everlasting Father, the Prince of Peace.' Christians attach more to this passage than Jews do. Matthew saw this as a prophecy of Jesus; Jews do not interpret Isaiah messianically.[90] The book of Isaiah is above all concerned with the individual soul – though that is not the right word. For Isaiah, each of us has the 'still small voice' of conscience, and that marks out Judaism. The Jews had no real belief in the afterlife, so the nearest they could come to a soul was the conscience.

In the last days before Jerusalem finally fell, Isaiah was followed by Jeremiah, who could not have been more different. Equally critical of the establishment, equally blunt and perhaps even more acid, Jeremiah became an outcast, forbidden to enter – or even to go near – the Temple. He was probably as unstable as he was unpopular: his family turned against him and no woman would marry him.[91] (He did, however, have and keep a secretary. When others went into exile he remained for a while in Mizpah, a modest town north of Jerusalem.) Yet his writings were preserved – for his prophecies of doom came true. In 597 BC and again in 586 BC, the Babylonians besieged Jerusalem, and after the second siege the Temple and the walls of the city were destroyed and most of the rest of the city was set ablaze. Jeremiah was among those who fled but thousands of Israelites were carried off into exile in Babylon. Traumatic as it was, exile would prove invigorating for the transformation of Judaism.

The Israelites remained in exile in Babylon from 586 BC to 539 BC. While they were there, they found that their captors practised Zoroastrianism, which was the major belief system in the Middle East before Islam. The origins of this faith are obscure. According to Zoroastrian tradition, Zarathustra made his first conversion '258 years before Alexander', which would put it at 588 BC, and therefore right in the middle of the Axial Age. But this cannot be correct. One reason is that the language of Zoroastrian scriptures, the Gathas, the liturgical hymns which make up the *Avesta*, the Zoroastrian canon, is very similar to the oldest layer of Sanskrit, the language of the Vedas, the sacred texts of the Hindus (see below, page 115). The two languages are so close that they are 'little more than dialects of one tongue', and not many centuries can have separated them from their common origins.[92] Since the Vedas date to between 1900 and 1200 BC, at least, the Gathas cannot be very much younger.

However, while the Vedas were still set in the heroic age, with many gods, often acting

'with the same nature as men', and sometimes with great cruelty, Zoroastrianism was very different.[93] Zoroastrianism has one origin in the third millennium BC with the migration of the peoples known to archaeologists, pre-historians and philologists as the Indo-Aryans. As was mentioned above, there has been much debate as to where these people originated: from the region between the Black Sea and the Caspian Sea, between the Caspian Sea and the Aral Sea, in the lands around the Oxus river, north of Persia, as Iran then was, the so-called BMAC complex (Bactria Margiana Archaeological Complex, essentially northern Afghanistan), even the Indus valley. What seems more certain is that they split into two groups, one – further east – giving rise to the Vedic religion, which developed into Hinduism (see below, page 115); and the second, further west, giving rise to Zoroastrianism.

Certain aspects of Zoroastrianism appear to have developed from the cult of Mithras. Mithras, said to have been born out of a rock and often associated with bull sacrifice, appears first in the historical record on an inscription found at Boghazköy in eastern Anatolia, and dating from the fourteenth century BC. The inscription commemorates a treaty between the Hittites (whom we have already encountered, in an earlier chapter) and the Mitanni (a tribe with Aryan chiefs, across the Euphrates from what is now Syria) and mentions a number of deities who later appear in the *Rig Veda*, the Hindu scriptures. These deities include Mithra, Varuna and Indra.[94] Mithra, be it noted, is the old Persian word for contract, which is interesting for at least three reasons. One, and this is speculative, a god of contract recalls the Israelite idea of the covenant, which is essentially a contract with God – is this where the idea originally came from? Two, a god of contract also suggests an urban, or urbanising, culture, with a growing merchant class; but third, and arguably the most important reason is that contract stood for fairness, and therefore justice.[95] And here, for the first time, we have a god who is an abstract concept – this was Zarathustra's achievement. He broke with the tradition of a pantheon of gods.

Tradition variously puts Zarathustra's birthplace in Rhages, the ancient town of Rayy, now on the outskirts of Tehran, or in Afghanistan or even as far away as Kazakhstan. By the time he was about thirty, however, Zarathustra had found his way to the court of King Gushtasp, the ruler of a tribe of people in the north of Iran, possibly the ancient site north-west of Kabul known as Balkh. There, he won over the king, and then the people, and his beliefs became the official religion.

The crucial importance – and the mystery – of Zoroastrianism lies partly in its intro-duction of abstract concepts as gods, and partly in its other features, some of which find echoes in Buddhism and Confucianism, and some of which appear to have helped form Judaism, and therefore Christianity and Islam. According to Friedrich Nietzsche, Zara-thustra was the source of the 'profoundest error in human history – namely the invention of morality'.[96] Zarathustra envisaged three types of soul: the *urvany*, that part of the individual which survived the body's death; *fravashi*, who 'live the earth since the time of their death'; and *daena*, the conscience.[97] Either way, Zoroastrianism may well have been the fundamental set of ideas that helped shape the world's major faiths as we know them today.

The society into which Zarathustra addressed his ideas was a people who venerated fire and worshipped the familiar gods of earth and sky, plus a host of *daevas*, spirits and demons.[98] Zoroastrians believe that Zarathustra received a revelation direct from the one

true god, Ahura Mazda. In accepting the revelation, he imitated the primordial act of god – the choice of good. This is a crucial aspect of Zoroastrianism: man is invited to follow the path of the Lord, but he is free in that choice – he is not a slave or a servant.[99] Ahura Mazda was also the father of a set of twins, Spenta Mainyu, the Good Spirit, and Angra Mainyu, the Destroying Spirit. These twins respectively choose *Asha*, justice, and *Druj*, deceit.[100]

Zarathustra referred to himself several times as a 'saviour' and this helped to shape his idea of heaven and the soul. In the religion of the day, which Zarathustra was born into, only priests and aristocrats were understood to have immortal souls, only they could go to heaven, whereas the laity were consigned to hell.[101] He changed all that. He condemned the sacrifice of cattle as cruel and denounced the priestly cult of Haoma, which may have been a hallucinogenic plant related to the Soma mentioned in Hindu scriptures, and possibly cannabis or hemp, which Herodotus records as being used in rituals by the steppe nomads.[102] At the same time, there is some evidence that early Zoroastrianism was itself an ecstatic religion, with even Zarathustra using *bhang* (hemp).[103] The name of paradise in the new religion was *garo demana*, or 'House of Song', and there are ancient accounts of shamans reaching ecstasy by singing for long periods of time. The House of Song was in theory open to all in Zoroastrianism, but only the righteous actually got there. The road to the beyond passed over the Cinvat Bridge where the just and the wicked were divided, sinners remaining for ever in the House of Evil.[104] The idea of a river dividing this world from the next is found in many faiths, while the idea of a Judgement became a major feature of Judaism, Christianity and Islam. In fact, life after death, resurrection, judgement, heaven and paradise were all Zoroastrian ideas first, as were hell and the devil.[105] One verse of the Gathas says that the soul remains close to a person's body after death, but after three days a wind arises. For the righteous it is a perfumed wind which quickly transports the soul to 'the lights without beginning, paradise', but for others it is a cold north wind, which drives the sinner to the zone of darkness.[106] Note the delay of three days.

The Israelites had been taken into captivity in 586 BC, by the Babylonians under Nebuchadnezzer. In 539, however, Babylon was captured by Cyrus, a Persian king who had also defeated the Medes and the Lydians. He and his followers spread Zoroastrianism throughout the Middle East. Cyrus freed the Jews and allowed them back to their homeland. It is no accident, therefore, that he is one of only two foreign kings to be treated with respect in the Hebrew scriptures (the other is Abimelech, in Genesis 21). It is no accident that Judaism, and therefore Christianity and Islam, share many features of Zoroastrianism.

The Buddha was not a god and he was not really a prophet. But the way of life that he came to advocate *was* the result of his dissatisfaction with the development of a new merchant class in the towns, their materialism and greed, and with the local priesthood, their obsession with sacrifice and tradition. His answer was to ask men to look deep inside themselves to find a higher purpose in life. In that, conditions in India in the sixth–fifth century BC paralleled those in Israel.

Siddhartha Gautama was by all accounts a pessimist anyway, constitutionally inclined to look on the grimmer side of life. Nevertheless, the social and religious ideas in India were changing fundamentally at the time he was alive. Hinduism is a Muslim word for the

traditional religion of India, and dates only from 1200 AD, when the Islamic invaders wished to distinguish the Indian faith from their own. (Hindu is in fact the Persian word for Indian – see Chapter 33 below.) Traditional Hinduism has been described as more a way of living than a way of thought.[107] It has no founder, no prophet, no creed and no ecclesiastical structure. Instead, Hindus speak of 'eternal teaching' or 'eternal law'. The first record of these beliefs come from excavations at Harappa and Mohenjo-Daro, the twin capitals of the civilisation, about 400 miles apart, on the banks of the Indus river and dating to about 2300–1750 BC. A ritual purity appears to have been one of the central rites (as it is today), with prominent places for ceremonial ablutions.[108] In addition there were many figurines of the mother goddess, which either showed her pregnant, or emphasised her breasts. Each village had its own goddess, embodiments of the female principle, though there was also a male god, with horns and three faces, known as *Trimurti*, which later found expression in Brahma, Vishnu and Shiva. Fertility symbols were also found, in particular the *lingam* and the *yoni*, representing, again, the female and male sex organs. Besides purification, the holy men of Harappa and the Indus valley practised yoga and renunciation of the world.

The first change Hinduism went through occurred around 1700 BC, when India was invaded by the Aryan peoples. The Aryans arrived from Iran, as their name implies, but their exact origins have been one of the great mysteries of archaeology.\* The Aryan impact on India was profound. Even today, northern Indians are taller and paler than their Dravidian compatriots in the southern part of the subcontinent. The Aryan language developed in India into what is now called Sanskrit, related to Greek, Latin and the other Indo-European languages which were discussed in Chapter 2. Their religion may have had links with that of Homer's Greece, insofar as there are parallels among the gods, which are mainly forces of nature. They practised sacrifice and performed their ceremonies around the fire, where they cast butter, grain and spice into the flames. They also are known to have used the drug, *soma*, which induced trances, by means of which the Vedas were 'revealed' to them. The fact that sacred fire was so important in their religion hints that they originally came from a northern (cold) region. Unlike the proto-Hindus, the Aryans did have a sacred text. This, written down about 800 BC, is known as the *Rig Veda* ('Songs of Knowledge'; *vid* = 'knowledge' or 'wisdom'). Many of these religious hymns may have been composed before the Aryans arrived in India, though by later times they were considered to be a revelation from Brahman, the ultimate source of all being.[109] More than a thousand hymns (20,000 verses) make up the *Rig Veda*, and they are addressed to scores of different deities. The most important gods, however, are Indra, conceived as a warrior who overcomes evil and brings everything into being; Agni, who personifies the sacred fire (Latin = *ignis*), which links heaven and earth by carrying the sacrifice upwards; and Varuna (the Greek god Uranus), a sky god but also the chief of the gods, and the guardian of cosmic order.

As it developed, the *Veda* posited a world soul. This is a mystical entity, quite unlike anything else: it is envisaged both as a sacrifice and as a form of body, which gives the world order. The creator brought the world into existence by sacrifice – even the gods,

---

\* See above, pages 103–104, for the scholarly disagreements on this subject.

their very existence, depended on continued sacrifice. The mouth of the world soul is made up of the priests (called Brahmans, to reflect their relationship to the fundamental source, Brahman: before the Vedas were written down, it was the Brahmans' responsibility to memorise and preserve them, father to son); the arms comprised the rulers, the thighs make up the commercial classes – landowners, farmers, bankers and merchants – and the feet are the artisans and peasants. To begin with, the four different classes were not hereditary but in time they became so, probably led by the Brahmans, whose task of memorising the Vedas was more easily achieved if fathers could begin teaching their sons early on. It was the Brahmans too who knew how to perform the elaborate sacrificial rites by means of which the whole world was kept in existence.[110] The kings and nobles funded the sacrifices and the landowners bred the cattle that were killed. Thus three of the four classes had a vested interest in maintaining the status quo.

This is the traditional picture. By the time of Gautama, however, there was widespread change in India, both social and spiritual. Towns and cities were on the increase and the power partnership of king and temple was breaking down as merchants and a market economy undermined the status quo. A new urban class was emerging which was ambitious for itself and impatient with the old ways. The new Iron Age technology played a role here, too, in helping farmers clear the dense forests.[111] This opened up more and more land to cultivation and changed the economy from stockbreeding to agricultural crops. Though this helped expand population, it also changed attitudes to sacrifice, now seen as more and more out of place.

Kapilavatthu, where Gautama lived, typified these changes. In any case shortly before his birth there was a religious rebellion in India. Dissatisfied with the old Vedic faith, the sages of the day began to compose a new series of texts which they passed secretly between themselves. These new texts became known as the Upanishads, which derived from a Sanskrit term, *apa-ni-sad*, which means 'to sit near', and reflected the unorthodox way that these new, reinterpreted verses, were begun. In a way the Upanishads had parallels with the teaching of the Israeli prophets, in that they made the old Vedas more spiritual and gave them an interiorised aspect.[112] By dint of the Upanishad disciplines, a practitioner would find that Brahman was present in the core of his own being. 'Salvation lay not in sacrifice but in the realisation that absolute, eternal reality that is higher even than the gods, was identical to one's own deepest self (*atman*).' In the Upanishads, salvation is not just salvation from sin, but from the human condition itself.[113] This really marked the beginning of the religion that we now call Hinduism, and the parallels with the Judaism of the prophets are clear.

Just where the idea of reincarnation came from is not so clear. However, in the *Asva-layana-Grkyasutra*, one of the Vedas, there is an idea that 'The eye must enter the sun, the soul the wind; go into the heaven and go into the earth according to destiny; or go into the water, if that be assigned to thee, or dwell with thy limbs in the plants.'[114] Though primitive, this passage in many ways heralds the idea, in the Upanishads, that, after cremation, the dead, according to their life on earth, would go 'the way of God' (*devayana*), which led to Brahman, or to 'the way of the fathers' (*pitrayana*) which went via darkness and gloom to the abode of the ancestors and then back to earth for a new cycle.[115] It was in the Upanishads that the twin doctrines of *samsara* and *karma* appear. *Samsara* is rebirth,

*karma* is the life force but its character determines the form of someone's next incarnation. The subject of the twin processes was the *atman*, the soul, a word derived from *an*, to breathe, meaning that for Hindus too the soul was equivalent to the animating principle.[116] In order to be at one with Brahman and achieve *moksa*, and to succeed to the 'way of the gods', salvation, the *atman* had to overcome *avidya*, a profound ignorance, of which the most important aspect was *maya*, taking the phenomenal world for reality and regarding the self as a separate entity. The overlap here between Hinduism on the one hand, and Plato on the other, is apparent and will become more so.

This then was the background out of which Siddhartha Gautama – the Buddha – appeared. His life is nowhere near as well documented as the Israelite prophets, say, or that of Jesus. Narrative biographies have been written, but the earliest dates from the third century AD, and though they were based on an earlier account, written down around a hundred years after his death in 483 BC, that text has been lost, and we can have little idea of the accuracy of the extant biographies. But it would appear that Gautama was about twenty-nine when, *c.* 538 BC, he suddenly left his wife, child and very well-to-do family and embarked on his search for enlightenment. It is said that he sneaked upstairs for one last look at his sleeping wife and son, but then left without saying goodbye. Part of him at least was not sorry to go: he had nicknamed the little boy Rahula, which means 'fetter', and the baby certainly symbolised the fact that Gautama felt shackled to a way of life he found abhorrent. He had a yearning for what he saw as a cleaner, more spiritual life, and so he did what many holy men did in India at the time: he turned his back on his family and possessions, put on the yellow robe of an itinerant, and lived by begging, which was an accepted form of life in India at the time.

For six years he listened to what other sages had to say, but it was not until he put himself into a trance one night that his world was changed. 'The whole cosmos rejoiced, the earth rocked, flowers fell from heaven, fragrant breezes blew and the gods in their various heavens rejoiced … There was a new hope of liberation from suffering and the attainment of nirvana, the end of pain. Gautama had become the Buddha, the Enlightened One.'[117] Buddha 'believed' in the gods that were familiar to him. But he shared with the Israelite prophets the idea that the ultimate reality lay beyond these gods. From his experience of them, or his understanding of them, according to Hinduism, they too were caught up in the vicissitudes of pain and change, in the cycle of birth and rebirth. Instead, Gautama believed that all life was *dukkha* – suffering, flux – and that *dharma*, 'the truth about right living', brought one to *nirvana*, the ultimate reality, freedom from pain.[118] Buddha's insight was that, in fact, this state had nothing to do with the gods – it was 'beyond them'. The state of *nirvana* was natural to humanity, if people only knew how to look. Gautama claimed not to have 'invented' his approach but to have 'discovered' it, and therefore other people could too, if they looked within themselves. As with the Israelites in the age of the prophets, the truth lay *within*. More specifically, the Buddha believed that man's first step was to realise that something was wrong. In the pagan world this realisation had led to ideas of heaven and paradise, but Buddha's idea was that we can gain release from *dukkha* on this earth by 'living a life of compassion for all living beings, speaking and behaving gently, kindly and accurately and by refraining from anything like drugs or intoxicants that cloud the mind.'[119] The Buddha had no conception of heaven. He thought

such questions were 'inappropriate'. He thought that language was ill-equipped to deal with these ideas, that they could only be experienced.

But Buddhism, as we shall see, did develop notions of salvation very similar to Christianity (so similar that early missionaries thought that Buddhism was a counterfeit faith created by the devil). Buddhism developed a concept (and a word, *parimucyeran*) for being set free from life's ills, and three names for saviour, *Avalokitresvara*, *Tara* and *Amitabha*, who all belonged to the same family.

The Greeks are generally known for their rationalism, but this tends to obscure the fact that Plato (427–346 BC), one of their greatest thinkers, was also a confirmed mystic. The main influences on him were Socrates, who had questioned the old myths and festivals of the traditional religion, and Pythagoras, who, as we have seen, had decided ideas about the soul, and who, in addition, may have been influenced by ideas from India, by way of Egypt and Persia.

Pythagoras believed that souls were fallen, defiled gods, now imprisoned in the body 'as in a tomb and doomed to a perpetual cycle of rebirth'.[120] Pythagoras, and the Orphics, thought that the soul could only be liberated through ritual purification, but Plato went further. To him there was another level of reality, an unchanging realm of the divine, which was beyond the senses. He accepted that the soul was a fallen divinity but believed that it could be liberated and even regain its divine status through his own form of purification – reason. He thought that, in this higher unchanging plane, there were eternal realities – forms or ideas, as he put it – fuller, more permanent and more effective than anything we find on earth, and they could only be fully understood or apprehended in the mind. For Plato there was an ideal form which corresponded to every general idea we have – justice, say, or love. The most important of the forms were Beauty and Good. He didn't dwell much on god, or the nature of god. The world of the forms was unchanging and static and these forms were not 'out there', as the traditional gods were, but could only be found within the self.[121]

His own ideas, outlined in *The Symposium* and elsewhere, were to show how love of a particular beautiful body, for example, could be 'purified and transformed' into an ecstatic contemplation (*theoria*) of ideal Beauty. Plato thought that the ideal forms were somehow hidden in the mind and that it was the task of thinking to discover and reveal these forms, that they could be recollected or apprehended if one considered them long enough. Human beings, remember, were fallen divinities (an idea resurrected by Christianity in the Middle Ages) and so the divine was within them in some way, if only it could be 'touched' by reason, reason understood as an intuitive grasp of the eternal realm within. Plato didn't use the word *nirvana* but his pattern of belief is recognisably similar to that of the Buddha, leading men back within themselves. Like Zarathustra, for Plato the object of the spiritual life was concentration on abstract entities. Some have called this the birth of the very idea of abstraction.

The ideas of Aristotle (384–322 BC) were no less mystical, even though he was a much harder-headed scientist and natural philosopher (aspects of his thought which will be considered in the next chapter). He realised there was an emotional basis of religious belief, even though he thought of himself as a rationalist. This is why, for example, Greek

theatre, in particular its tragedies, started life as part of religious festivals: theatrical tragedy was for Aristotle a form of purification (he called it *katharsis*) whereby the emotions of terror and pity were experienced and controlled. Whereas Plato had proposed a single divine realm, to which we have access via contemplation, Aristotle thought there was a hierarchy of realities, at the top of which was the Unmoved Mover – immortal, immobile, in essence pure thought though he was at one and the same time the thinker *and* the thought.[122] He caused all the change and flux in the universe, all of which stemmed from a single source. Under this scheme, human beings were privileged, in that the human soul has the gift of intellect, a divine entity, which puts man above the animals and plants. The object of thought, for Aristotle, was immortality, a kind of salvation. As with Plato, thought was itself a form of purification but again *theoria*, contemplation, did not consist only of logical reasoning, but of 'disciplined intuition resulting in an ecstatic self-transcendence'.[123]

Confucius (Kongfuzi, 551–479 BC) was by far the least mystical of all the prophets/religious teachers/moral philosophers to emerge in the Axial Age. He was deeply religious in a traditional sense, showing reverence toward heaven and an omnipresent spiritual world, but he was cool towards the supernatural and does not seem to have believed in either a personal god or the afterlife. The creed he developed was in reality an adaptation of traditional ideas and practices, and was very worldly, addressed to the problems of his own times. That said, there are uncanny parallels between the teachings of Confucius, Buddha, Plato and the Israelite prophets. They stem from a similarity in the wider social and political context.

Even by the time of Confucius' birth, the Chinese were already an ancient people. From the middle of the second millennium BC, the Shang dynasty was firmly established and, according to excavations, appears to have comprised a supreme king, an upper ruling class of related families, and a lower level of people tied to the land. It was a very violent society, characterised, according to one historian, by 'sacrifice, warfare and hunting'. As with ancient Hindu ideas, sacrifice underlay all beliefs in early China. 'Hunting provided sacrificial animals, warfare sacrificial captives.'[124] Warfare was itself considered a religious activity and before battle there took place a ritual of divination, prayers and oaths.

In early China there were two kinds of deities – ancestors and sky gods. Everyone worshipped their ancestors, whose souls were believed to animate living humans. But the aristocracy also worshipped Shang Di, the supreme god who ruled from on high, together with the gods of the sun, moon, stars, rain and thunder. Shang Di was identified with the founder-ancestor of the race and all noble families traced their descent from him.[125] The hallmark was eating meat. There were three forms of religious functionary: the *shih*, or priest-scribes, whose duty was to record and interpret significant events, which were regarded as omens for government; the *chu*, or 'invokers', scholars who composed the prayers used in the sacrificial ceremonies – they became 'masters of ritual', making sure that the correct form of sacrifice was preserved (just like the Brahmans in the Buddha's India); the third group of religious figures were the experts in divination, the *wu*, whose duty was to communicate with the ancestor spirits, usually by way of the so-called 'Dragon bones'.[126] This practice – 'scapulimancy' – was not discovered until the end of the nineteenth century, but some 100,000 bones have now been collected. The *wu* would apply a

hot metal point to the shoulder blades (*scapulae*) of a variety of animals, and interpret the resulting cracks as advice from the ancestors. The soul was represented on these bones either by *kuei*, a man with a large head, or a cicada, which became the accepted symbol of immortality and rebirth. Around the time of Confucius, the idea developed that everything there is, is the product of two eternal and alternating principles, *yin* and *yang*, and that within each person there are two souls, the *yin*-soul and the *yang*-soul, one deriving from heaven, the other from earth.[127] The *yin* was identified with *kuei*, in other words the body; the *yang* was the life principle and the personality. The aim of Chinese philosophy was to reconcile the two.

Confucius was born near Shantung at a time of great warfare but also of great social change, and he was shaped by both processes. Cities were growing in size (up to 100,000 inhabitants, according to some sources), coinage had been introduced, and commercial progress was so marked that certain areas were already well known for particular products (silk and lacquer in Shantung, iron mining in Szechuan). Most particular to China was the class known as *shih* (inflected differently from the *shih*, priest-scribes, mentioned above): these were families of noble descent who had slipped down the social scale and become commoners. They were not merchants but scholars, educated but dispossessed of their former cachet. Confucius was of this class.

Bright enough to be educated at a school for the aristocracy, his first job was as a clerk in the state granaries. He was married at nineteen but little is known about his wife and family.[128] He was greatly influenced by Zi Zhaan, the prime minister of Cheng, who died in 522 BC, when Confucius was twenty-nine. Zi Zhaan introduced the first law code in China, the text for which he ordered to be inscribed on bronzes and displayed publicly, so that all would know what rules they were expected to obey.[129] A final influence on Confucius was the prevalent scepticism which the Chinese then felt towards religion. There had been so much war that no one any longer believed in the power of the gods to aid kings, with the result that many temples – historically the most prominent buildings in the cities – had been destroyed. The fact that prayer and sacrifice had failed so dismally created circumstances for a rise in rationalism, of which Confucius was the finest fruit.

He and his most important followers, Motzu (*c.* 480–390 BC) and Mengtzu (Mencius, 372–289 BC), were members of an important group of thinkers, the so-called 'hundred schools' (= a great many). Confucius' learning gradually established him a reputation, and he was given a government job, along with several of his students. But he resigned, and journeyed on the road for ten years, after which he set up a school – the first in Chinese history – taking students from all classes of society, and where he could begin to broadcast his ideas more effectively. His main concern was an ethical life, facing the problem of how men can live together. This reflected China's transition to an urban society. Like the Buddha, like Plato and like Aristotle, he looked beyond the gods, and taught that the answer to an ethical life lies *within* man himself, that universal order and harmony can only be achieved if people show a wider sense of community and obligation than their own and their family's self-interest.[130] He thought that scholarship and learning were the surest way to harmony and order and that the natural aristocrats in the sort of society he wanted were the sages.

There were three key elements in his thought. The first was *tao*, The Way. He never

defined this too closely – like Plato he believed that intuition served a role here. But the Chinese character *tao* originally meant a path or a road, the way to a destination. Confucius meant to emphasise that there is a path which one *ought* to follow in life, to produce wisdom, harmony and 'right conduct'. He implied that we intuitively know what this is, but often, for narrow, selfish reasons, pretend we don't. The second concept was *jen*. This is a form of goodness (again, echoes of Plato's ideal forms), the highest perfection normally only achieved by mythical heroes. Confucius believed that an individual's nature was pre-ordained by heaven (a word he used widely in place of an anthropomorphised god) but, importantly, he thought that man can work on his nature, to improve himself: he can *cultivate* morality, hard work, love towards others, the continued effort to be good.[131] One should be (as the Buddha also said) gentle, polite, considerate always, in conformity with *li*, the mores of polite society. This inner harmony of mind, he thought, could be helped by the study of music. The third concept was *I*, righteousness or justice. Again, Confucius was wary of defining this idea too closely, but he affirmed that men can learn to recognise justice from everyday experience (as Plato said we can learn to recognise Beauty and Goodness), and that this should always be their guide.

The Taoist religion is in many ways the opposite of Confucianism, though it still shares many similarities with Aristotle and the Buddha. Some believe that the founder of Taoism, Laotzu, was an older contemporary of Confucius. Others contend that he never existed: the words *lao tzu* mean 'old man' and, say the doubters, the *Lao tzu*, the book – the most-frequently translated work in Chinese – is an anthology compiled by various authors. Whatever the truth of this, whereas Confucianism seeks to perfect men and women within the world, Taoism is a turning away from the world, its aim being to transcend the (limited) conditions of human existence in an effort to attain immortality, salvation, the perpetual union of several different soul-elements. Underlying Taoism is a search for freedom – from the world, from the body, from the mind, from nature. It fostered the so-called 'mystical arts': alchemy, yoga, drugs and even levitation. Its main concern is *tao*, the way, though that name is not really applicable because language is not adequate for such a purpose (as with *nirvana* in Buddhism). The *tao* is conceived of as responsible both for the creation of the universe and its continued support (as with the primal sacrifice in the Vedas). The way can only be apprehended by intuition. Submission is preferable to action, ignorance to knowledge. *Tao* is the sum of all things that change, and this ceaseless flux of life is its unifying idea. Taoism stands against the very idea of civilisation; its view of God, as the Greeks said, was that he was essentially unknowable, 'except by the *via negativa*, by what he is not'.[132] To think one can improve on nature is a profanity. Desire is hell.[133] God cannot be understood, only experienced. 'The aim is to be like a drop of water in the ocean, complete and at one with the larger significant entity.' Laotzu speaks of sages who have attained immortality and, like the Greeks, inhabit the Isles of the Blessed. Later, these ideas were ridiculed by Zhuangtzu, a great rationalist.[134]

In all cases, then, we have, centring on the sixth century BC, but extending 150 years either side, a turning away from a pantheon of many traditional 'little' gods, and a great turning inward, the emphasis put on man himself, his own psychology, his moral sense or con-science, his intuition and his individuality. Now that large cities were a fact of life, men

and women were more concerned with living together in close proximity, and realised that the traditional gods of an agricultural world had not proved adequate to this task. Not only was this a major divorce from what had gone before, separating late antiquity from 'deep' antiquity, it also marked the first split that would, in centuries to come, divide the West from the East. In all the new ethical systems of the Axial Age, the Israelite solution stands out. They, as we shall see, developed the idea of one true God, and that history has a direction, whereas with the Greeks and in particular with Buddhism, Confucianism and Taoism, the gods stood in a different relation to humans as compared with the West. In the East the divine and the human came much closer together, the Eastern religions being commonly more inclined to mysticism than Western ones are. In the West, more than the East, the yearning to become divine is sacrilege.

# 6

# *The Origins of Science, Philosophy and the Humanities*

When Allan Bloom, a professor at the University of Chicago, published his book *The Closing of the American Mind* in 1987, he had no idea he was about to become notorious. Incensed by the 'dumbing down' that he saw everywhere about him, he pugnaciously advanced his view that the study of 'high culture' has to be the main aim of education. Above all, he said, we must pay attention to ancient Greece, because it provided 'the models for modern achievement'. Bloom believed that the philosophers and poets of the classical world are those from whom we have most to learn, because the big issues they raised have not changed as the years have passed. They still have the power to inform and transform us, he said, to move us, and 'to make us wise'.[1]

His book provoked a storm of controversy. It became a best-seller on both sides of the Atlantic and Bloom was himself transformed into a celebrity and a rich man. At the same time he was vilified. At a conference of academics at Chapel Hill, the campus of the University of North Carolina, about a year after his book appeared, called to consider the future of liberal education, 'speaker after speaker' denounced Bloom and other 'cultural conservatives' like him. According to the *New York Times*, these academics saw Bloom's book as an attempt to foist the 'elitist views of dead, white, European males' on a generation of students who were now living in a different world, where the preoccupations of small city-states 2,500 years ago were long out of date.

These 'culture wars' are not so sharp as once they were but it is still necessary to highlight why the history of a small European country, thousands of years ago, is so important. In his book *The Greeks*, H. D. F. Kitto opens with these words: 'The reader is asked, for the moment, to accept this as a reasonable statement of fact, that in a part of the world that had for centuries been civilised, and quite highly civilised, there gradually emerged a people, not very numerous, not very powerful, not very well organised, who had a totally new conception of what human life was for, and showed for the first time what the human mind was for.'[2] Or, as Sir Peter Hall puts it, in a chapter on ancient Athens which he calls 'The fountainhead': 'The crucial point about Athens is that it was first. And first in no small sense: first in so many of the things that have mattered, ever since, to western civilisation and its meaning. Athens in the fifth century BCE gave us democracy, in a form as pure as we are likely to see; ... It gave us philosophy, including political philosophy, in a form so rounded, so complete, that hardly anyone added anything of moment to it for

well over a millennium. It gave us the world's first systematic written history. It systematised medical and scientific knowledge, and for the first time began to base them on generalisations from empirical observation. It gave us the first lyric poetry and then comedy and tragedy, all again at so completely an extraordinary pitch of sophistication and maturity, such that they might have been germinating under the Greek sun for hundreds of years. It left us the first naturalistic art; for the first time, human beings caught and registered for ever the breath of a wind, the quality of a smile. It single-handedly invented the principles and the norms of architecture . . .'[3]

A new conception of what human life is for. The fountainhead. First in so many ways that have mattered. *That* is why ancient Greece is so important, even today. The ancient Greeks may be long dead, were indeed overwhelmingly white, and, yes, by modern standards, unforgiveably male. Yet in discovering what the historian (and Librarian of Congress) Daniel Boorstin calls 'the wondrous instrument within' – the courageous human brain and its powers of observation and reason – the Greeks left us far more than any other comparable group. Their legacy is the greatest the world has yet known.[4]

There are two principal aspects to that legacy. One is that the Greeks were the first to truly understand that the world may be known, that knowledge can be acquired by systematic observation, without aid from the gods, that there is an order to the world and the universe which goes beyond the myths of our ancestors. And second, that there is a difference between nature – which operates according to invariable laws – and the affairs of men, which have no such order, but where order is imposed or agreed and can take various forms and is mutable. Compared with the idea that the world could be known only through or in relation to God, or even could be known not at all, this was a massive transformation.

The first farmers appear to have settled around Thessalonika, in the north of Greece, about 6500 BC. The Greek language is believed to have been brought to the area not before 2500 BC, possibly by invading Aryan-type people from the Russian steppes. (In other words, similar people to those who invaded northern India at much the same time.) Until at least 2000 BC, the prosperous towns of Greece were still unfortified, though bronze daggers began to lengthen into swords.[5]

Greece is a very broken-up country, with many islands and several peninsulas, which may have influenced the development there of the city-state. Kingship, and the aristocratic hero culture, which in Homer is the universal political arrangement, had vanished from most cities by the dawn of history (roughly 700 BC). The experience of Athens shows why – and how – monarchy was abolished.[6] The first encroachment on the royal prerogative took place when the nobles elected a separate war chief, the Archon, because the priestly king of the time was not a fighter. This was followed by the promotion of the Archon over the king. According to tradition, the first Archon was Medon, who held office for life, and his family after him. The king lost power but he continued to be the city's chief priest. Legal duties were divided: the Archon took cases concerning property, whereas the king tried religious cases and homicide. Thus there are parallels here with what was happening in Mesopotamia.[7]

War was also the background to a set of stories that became central to Greek self-

consciousness, and the first written masterpieces of Western literature. They concerned the Achaean (i.e., Mycenean) expedition to Troy, a city in Asia Minor (now Turkey). Homer's two great epics, the *Iliad* and the *Odyssey*, are often described as the earliest literature, the 'primary source' from which all European literature derives, the 'gateway' to new avenues of thought. Between them they contain around 28,000 lines and preceding their appearance and for hundreds of years following them, 'there is nothing remotely resembling these amazing achievements'. Homer's genius was recognised in Greece from the very beginning. Athenians referred to his books the way devout Christians nowadays refer to the Bible, or Muslims to the Qur'an. Socrates quoted lines from the *Iliad* when he was on trial for his life.[8]

One important thing to say about these achievements is how very different they are from the early biblical narratives, which most scholars now accept as having been composed at more or less the same time. The Hebrew Bible, as we shall see in the next chapter, is the fruit of many hands but concerns itself with one theme: the history of the Israelites and what that reveals about God's purpose. It is a history of ordinary mortals, essentially small, everyday people, trying to understand the divine will. Other nations, other peoples, worship different gods and that puts them in the wrong: they deserve – and receive – no sympathy. In strong contrast, Homer's epics do not concern ordinary people so much as heroes and the gods themselves, who enshrine excellence in one form or another. But the stories are not really histories. They are more like modern novels which take an episode and examine it in detail for what it reveals about human nature. In Horace's words, Homer plunges in, *in medias res*, in the middle of things. But in Homer the gods are not 'unknowable'. They are in fact all too human, with human problems and failings. No less significantly, in Homer, the heroes' enemies are themselves heroes, treated with sympathy at times, allowed their own dignity and honour. In composing his epics, Homer drew upon a vast number of poems and songs that had been transmitted orally for generations. They depended on myths and *mythos*, in Greek, from which the English word 'myth' derives, actually meant 'word', in the sense of 'the last word', a final pronouncement. This contrasted with *logos*, which also meant 'word' but in the sense of a truth which can be argued and maybe changed (as in, 'what's the word on …?'). Unlike *logoi*, which were written in prose, myths were recorded in verse.

The stories of Homer are in some ways the first 'modern' narratives. His characters are fully rounded, three-dimensional, with weaknesses as well as strengths, with differing motives and emotions, courageous at one moment, hesitant the next, more like real people than gods. Women are treated as sympathetically – and as fully – as men: for example, in Helen we see that beauty can be a curse as much as a blessing. Above all, as the story unfolds, Odysseus learns – his character develops – making him more interesting, and more dignified, than the deities. Odysseus shows himself as capable of rational thought, independent of the gods.

The same rationalising process that finds its first expression in Homer was brought to bear on communal life, with momentous consequences for mankind. As in the *Iliad* and the *Odyssey*, war played a part.

One of the inventions in that area of the world, among the Lydians – as we have

seen – was coins. This spread quickly among the Greeks and the growing use of money enabled wealth to grow and more men acquired land. This land needed defending and, in conjunction with new weapons, in the seventh century BC a new sort of warrior, and a new sort of warfare, appeared. This was the development of the 'hoplite' infantry, boasting bronze helmets, spears and shields (*hoplon* is Greek for shield). Earlier fighting had mainly consisted of single combat: now, in the hoplite formations, men advanced (mainly in the valleys, to protect or attack the crops grown there) in disciplined masses, in careful formation of eight rows, with each man protected on his right-hand side by the shield of his comrade. If he fell the man in the row behind him took his place.[9] As more men shared military experience, this had two consequences. One, power slipped from the old aristocracies, and two, a big gap opened up between rich and poor. (The hoplites had to provide their own armour, so they came mainly from middling to rich peasants.)

This gap opened up because land in Attica was poor, certainly so far as growing grain was concerned. Therefore, in bad years the poorer farmers had to borrow from their richer neighbours. With the invention of coins, however, instead of borrowing a *sack* of corn in the old way, to be repaid by a sack, the farmer now borrowed the *price* of a sack. But this sack was bought when corn was scarce – and therefore relatively expensive – and was generally repaid in times of plenty, in other words when corn was cheap. This caused debt to grow and in Attica the law allowed for creditors to seize an insolvent debtor and take him and his family into slavery. This 'rich man's law' was bad enough, but the spread of writing, when the laws were set down, under the supervision of Dracon, made it worse, encouraging people to enforce their written rights. 'Draconian law', it was said, was written in blood.[10]

Dissatisfaction spread, so much so that the Athenians took what for us would be an unthinkable step. They appointed a tyrant to mediate. Originally, when it was first used in the Near East, tyrant was not a pejorative word. It was an informal title, equivalent to 'boss' or 'chief', and tyrants usually arose after a war, when their most important function was the equitable distribution of the enemy's lands among the victorious troops. In Athens, Solon was chosen as tyrant because of his wide experience. A distant descendant of the kings, he had also written poems attacking the rich for their greed. He took office in 594 or 592 BC and his first move was to abolish enslavement for debt, and at the same time he cancelled all debts outstanding. He embargoed the export of all agricultural produce, except olive oil, in which Athens was swimming, arguing that the big landowners could not sell their produce in richer markets while fellow Athenians went hungry. His other move was to change the constitution. Until his period in office Athens had been governed by a tripartite system. By this time, there were the nine Archons at the top; next came the Council of Best Men, or *aristoi*, who met to discuss all major questions; and finally the Assembly of the People (*ekklesia*, from which we take the French word *église*, church). Solon transformed the Assembly, extending membership to tradespeople, and not just landowners, and also widened the eligibility for election to Archon. More than that, Archons had to account for their year in office before the Assembly and only those judged a success were eligible for the Council of Best Men. Thus the whole system became a good deal fairer and more open than it had been in the past, and the power of the Assembly was much enhanced. (This somewhat oversimplifies Athenian democracy but it does at least

make clear that what we regard as democracy in the twenty-first century is actually elective oligarchy.[11])

Athenian democracy, however, cannot be understood without a full appreciation of what a *polis* was, and without taking on board how small – by modern standards – Greek city-states were. Both Plato and Aristotle thought that the ideal *polis* should have around 5,000 citizens and in fact very few had more than 20,000. 'Citizen' here means free males, so to these figures should be added women, children, foreigners and slaves. Peter Jones calculates that in 431 BC the total population of Athens was 325,000 and in 317 BC it was 185,000. In general, Greek *poleis* were roughly the size of a small English county and the *polis* owed a lot to Greece's geography – with many islands and peninsulas, and with the country broken up into many smaller, self-contained geographical entities. But the *polis* also owed something to Greek nature. Whereas it originally meant 'citadel', it came to mean 'the whole communal life of the people, political, cultural, moral . . .'[12] Greeks came to regard the *polis* as a form of life that enabled each individual to live life to the full, to realise his true potential. They tried hard not to forget what politics was *for*.[13]

Democracy was introduced into Athens in 507 BC by Cleisthenes and, by the time of Pericles (*c.* 495–429) – Athens' so-called golden age – the Assembly was supreme, and with good reason. Though he had no shortage of enemies, Pericles was one of Greece's greatest generals, among its finest orators and an exceptional leader. He installed state pay for jurors and council members, completed the city walls, which made Athens all but impregnable and, unusually for a military man and a politician (though this was the Athenian ideal), took a great interest in philosophical, artistic and scientific matters. His friends included Protagoras, Anaxagoras and Phidias, all of whom we shall meet shortly, while Socrates himself was close to both Alcibiades, Pericles' ward, and Aspasia, his morganatic wife. Pericles rebuilt the Parthenon, which provided employment for countless craftsmen and helped to kick-start Athens' golden age.

Under him, the Assembly now comprised every adult male who had not been disenfranchised by some serious offence. It was the sole legislative body and had complete control of both the administration and the judiciary. It met once a month, any citizen could speak and anyone could propose anything. But, with Assemblies of 5,000 and more, there was need of a committee to prepare business. This council was called the *boule* and it was scarcely less cumbersome, consisting of 500 citizens, not elected but chosen by ballot, the point being that in this way it never developed a corporate identity which might have corrupted and distorted the business of the Assembly. There were no professional lawyers. 'The principle was preserved that the aggrieved man appealed directly to his fellow citizens for justice.'[14] The jury was a selection of the Assembly and could vary from 101 to 1,001, according to the importance of the case. There was no appeal. If the offence did not carry a specific penalty then the prosecutor, if he won the case, would propose one penalty, while the accused proposed another. The jury then chose between the two. 'To the Athenian, the responsibility of taking his own decisions, carrying them out, and accepting the consequences, was a necessary part of the life of a free man.'[15]

Given the size of Athens, democracy there was a remarkable – a unique – achievement. Not everyone liked it – Plato for one condemned it – and the arrangement was nothing like, say, parliamentary democracy in our own day. (To repeat Peter Jones' point: modern

democracies are elective oligarchies.) And this is one reason why another Greek idea, rhetoric, has not survived. Rhetoric was a way of speaking, arguing, persuading, that was necessary in a democracy where the assemblies were large, where there were no microphones, and where it was necessary to sway others in debate. Rhetoric developed its own rules and it encouraged great feats of eloquence and memory, which had a profound influence on the evolution of classical literature. In elective oligarchies, however, where the political etiquette is more intimate, and more cynical, rhetoric has no real place: to the modern ear it sounds forced and artificial.

If politics – democracy – is the most famous Greek idea that has come down to us, it is closely followed by science (*scientia* = knowledge, originally). This most profitable area of human activity is generally reckoned to have begun at Ionia, the western fringe of Asia Minor (modern Turkey) and the islands off the coast. According to Erwin Schrödinger, there are three main reasons why science began there. First, the region did not belong to a powerful state, which are usually hostile to free thinking. Second, the Ionians were a sea-faring people, interposed between East and West, with strong trading links. Mercantile exchange is always the principal force in the exchange of ideas, which often stem from the solving of practical problems – navigation, means of transport, water supply, handicraft techniques. Third, the area was not 'priest-ridden'; there was not, as in Babylon or Egypt, a hereditary, privileged, priestly caste with a vested interest in the status quo.[16] In their comparison of early science in ancient Greece and China, Geoffrey Lloyd and Nathan Sivin argue that the Greek philosopher/scientists enjoyed much less patronage than their contemporaries in China, who were employed by the emperor, and often charged with looking after the calendar, which was a state concern. This had the effect of making Chinese scientists much more circumspect in their views, and in embracing new concepts: they had much more to lose than in Greece, and they seldom argued as the Greeks argued. Instead, new ideas in China were invariably incorporated into existing theories, producing a 'cascade' of meanings; new notions never had to battle it out with old ones.[17] In Greece on the other hand there was a 'competition in wisdom', just as in sports contests (sport was itself seen as a form of wisdom).[18] Lloyd argues that there are far more first-person-singular statements in Greek science than in Chinese, much more egotism, individuals describe their mistakes more often, their uncertainties, and criticise themselves more.[19] Greek plays poked fun at scientists and even this served a useful purpose.[20]

What these Ionians grasped was that the world was something that could be understood, if one took the trouble to observe it properly. It was not a playground of the gods who acted arbitrarily on the spur of the moment, moved by grand passions of love, wrath or revenge. The Ionians were astonished by this and, as Schrödinger also remarked, 'this was a complete novelty'.[21] The Babylonians and the Egyptians knew a lot about the orbits of the heavenly bodies but regarded them as religious secrets.

The very first scientist, in the sixth century BC, was Thales of Miletus, a city on the Ionian coast. However, science is a modern word first used as we use it in the early nineteenth century, and the ancient Greeks would not have recognised it; they knew no boundaries between science and other fields of knowledge, and in fact they asked the questions out of which both science and philosophy emerged.[22] Thales was not the first

ancient figure to speculate about the origin and nature of the universe but he was the first 'who expressed his ideas in logical and not mythological terms'.[23] As a merchant who had travelled to Egypt, he had picked up enough mathematics and Babylonian astronomy to be able to predict a total eclipse of the sun in the year 585 BC, which duly occurred, on the day we call 29 May. (For Aristotle, writing two centuries later, this was the moment when Greek philosophy began.)[24] But Thales is more often remembered for the basic scientific-philosophical question that he asked: *what is the world made of ?* The answer he gave – water – was wrong, but the very act of asking so fundamental a question was itself an innovation. His answer was also new because it implied that the world consists not of many things (as it so obviously does) but, underneath it all, of one thing. In other words, the universe is not only rational, and therefore knowable, but also simple.[25] Before Thales, the world was made by the gods, whose purpose could only be known indirectly, through myths, or – if the Jews were to be believed – not at all. This was an epochal change in thought (though to begin with it affected only a tiny number of people).

Thales' immediate successor was another Ionian, Anaximander. He argued that the ultimate physical reality of the universe cannot be a recognisable physical substance (a concept not so far from the truth, as it turned out much later). Instead of water, he substituted an 'undefined something' with no chemical properties as we would recognise them, though he did identify what he called 'oppositions' – hotness and coldness, wetness and dryness, for example. This could be seen as a step towards the general concept of 'matter'. Anaximander also had a theory of evolution. He rejected the idea that human beings had derived indirectly from the gods and the Titans (the children of Uranus, a family of giants) but thought that all living creatures arose first in the water, 'covered with spiny shells'. Then, as part of the sea dried up, some of these creatures emerged on land, their shells cracked and released new kinds of animal. In this way, Anaximander thought 'that man was originally a fish.'[26] Here too it is difficult to overstate the epochal change in thinking that was taking place – the rejection of gods and myths as ways to explain everything (or anything) and the beginnings of observation as a basis for reason. That man should be descended from other animals, not gods, was as great a break with past thinking as could be imagined.

For Anaximenes, the third of the Ionians, *aer* was the primary substance, which varied in interesting ways. It was a form of mist whose density varied. 'When most uniform,' he said, 'it is invisible to the eye … Winds arise when the *aer* is dense, and moves under pressure. When it becomes denser still, clouds are formed, and so it changes into water. Hail occurs when the water descending from the clouds solidifies, and snow when it solidifies in a wetter condition.'[27] There is not much wrong with this reasoning, which was to lead, a hundred years later, to the atomic theory of Democritus.

Before Democritus, however, came Pythagoras, another Ionian. He grew up on Samos, an island to the north of Miletus, off the Turkish coast, but emigrated to Croton, in Greek Italy, because, it is said, the pirate king, Polycrates, despite luring poets and artists to Samos, and building impressive walls, headed a dissolute court that Pythagoras, a deeply religious – not to say mystical – man, hated. All his life, Pythagoras was a paradoxical soul. He taught a wide number of superstitions – for example, that you do not poke a fire with a knife (you might hurt the fire, which would seek revenge). But Pythagoras' fame rests

on the theorem named after him. This particular theorem (about how to obtain a right angle), we should never forget, was not merely an abstraction: obtaining an absolute upright was essential in building. This interest in mathematics led on to a fascination with music and with number. It was Pythagoras who discovered that, by stopping a lyre-string at three-quarters, two-thirds or half its length, the fourth, fifth and octave of a note may be obtained, and that these notes, suitably arranged, 'may move us to tears'.[28] This phenomenon convinced Pythagoras that numbers held the secret of the universe, that number – rather than water or any other substance – was the basic 'element'. This mystical concern with harmony persuaded Pythagoras and his followers that there was a beauty in numbers, and this led, among other things, to the idea we call 'square numbers' – those that can be represented as squares:

But this fascination also led Pythagoras to what we now call numerology, a belief in the mystical meaning of numbers. This was an elaborate dead-end.

The Pythagoreans also knew that the earth was a sphere and were possibly the first to draw this conclusion, their reasoning based on the outline of the shadow during eclipses of the moon (which they also knew had no light of its own). They thought that the earth always presented the same face to the 'Central Fire' of the universe (not the sun), rather as the moon always presents the same face to the earth. For this reason they imagined that half the earth was uninhabitable. It was the varying brightness of Mercury and Venus which persuaded Heraclitus (who was very close to the later Pythagoreans) that they changed their distance from earth. These orbits added to the complexity of the heavens and confirmed the planets as 'wanderers' (the original meaning of the word).[29]

This quest for what the universe was made of was continued by the two main 'atomists', Leucippus of Miletus (fl. 440 BC), and Democritus of Abdera (fl. 410 BC).[30] They argued that the world consisted of 'an infinity' of tiny atoms moving randomly in 'an infinite void'. These atoms, solid corpuscles too small to be seen, exist in all manner of shapes and it is their 'motions, collisions, and transient configurations' that account for the great variety of substances and the different phenomena that we experience. In other words, reality is a lifeless piece of machinery, in which everything that occurs is the outcome of inert, material atoms moving according to their nature. 'No mind and no divinity intrude into this world ... There is no room for purpose or freedom.'[31]

Anaxagoras of Clazomenae was partially convinced by the atomists. There must be some fundamental particle, he thought: 'How can hair come from what is not hair, or flesh from what is not flesh?'[32] But he also felt that none of the familiar forms of matter – hair or flesh, say – was quite pure, that everything was made up of a mixture, which had arisen from the 'primordial chaos'. He reserved a special place for mind, which for him was a substance: mind could not have arisen from something that was not mind. Mind

alone was pure, in the sense that it was not mixed with anything. In 468–467 BC, a huge meteorite fell to earth in the Gallipoli peninsula and this seems to have given Anaxagoras new ideas about the heavens. He proposed that the sun was 'another such mass of incandescent stone', 'larger than the Peloponnese', and the same went for the stars, which were so far away that we do not feel their heat. He thought that the moon was made of the same material as the earth 'with plains and rough ground in it'.[33]

The arguments of the atomists were strikingly near the mark, as experiments confirmed more than two thousand years later. (As a theory it was, as Schrödinger put it, the most beautiful of all 'sleeping beauties'.[34]) But, inevitably perhaps, not everyone at the time accepted their ideas. Empedocles of Acragas (fl. 450), a rough contemporary of Leucippus, identified four elements or 'roots' (as he called them) of all material things: fire, air, earth and water (introduced in mythological garb as Zeus, Hera, Aidoneus and Nestis). From these four roots, Empedocles wrote, 'sprang all things that were and are and shall be, trees and men and women, beasts and birds and water-bred fishes, and the long-lived gods too, most mighty in their prerogatives . . . For there are these things alone, and running through one another they assume many a shape.' But he also thought that material ingredients by themselves could not explain motion and change. He therefore introduced two additional, immaterial principles: love and strife, which 'induce the four roots to congregate and separate'.[35]

As ever, we do well not to make more of Ionian positivism than is there. Pythagoras had such an immense reputation that he was credited with many things he may not have been responsible for – even his famous theorem, which may have been the work of later followers. And these first 'scientists' have been compared to a 'flotilla' of small boats headed in all directions and united only by a fascination for uncharted waters.

In the *Iliad* and the *Odyssey*, plague is attributed to divine intervention (an idea that was to be resurrected more than a millennium later by Christianity), but in the reports of the battles themselves the treatment of wounds is carefully described and Homer makes it clear that this was already a specialist skill. Asclepius, referred to by him as a great healer, was subsequently deified in the Greek manner and a cult in his honour was established. Archaeologists have identified at least a hundred temples to Asclepius, to which the sick would flock in search of a cure.[36]

In the fifth and fourth centuries, a new and more secular traditional grew up, associated with the name of Hippocrates of Cos (about 460–377 BC), who was a meticulous observer. (Celsus recognised Hippocrates as the man who detached medicine from philosophy.[37]) One of his treatises examined the effects of climate and environment on physique and psychology, another – entitled *The Sacred Disease* – was an investigation of epilepsy. Hippocrates discounted divine intervention and attributed this malady to 'natural causes . . . men think it divine because they do not understand it . . . all diseases alike are divine, and all are human; all have their antecedent causes'. His own theory was that epilepsy was caused by a blockage (by phlegm) of the veins in the brain.

Probably under the influence of Empedocles, Hippocrates' school adopted the theory of the Four Humours: phlegm, blood, yellow bile and black bile 'which reflect in the body the four elements [or "roots"] of the cosmos, fire, air, water and earth, and each of which

is associated with the basic qualities of hot, dry, cold and moist. Phlegm, for example, which is cold, increases in quantity in the winter, and therefore during the winter phlegmatic ailments are more common. Their proper balance in the body is the cause of good health, imbalance causes pain, and temperaments differ according to which humour predominates (phlegmatic, sanguine, choleric and melancholic).' Purging the body, through blood-letting or laxatives, for example, was the right way to restore balance and therefore health.[38] As the historian Andrew Burn points out, 'This theory was to exercise a thoroughly deleterious influence on medicine for 2,000 years; *because* under it one could account for anything, it blocked the way to further inquiry based on observation.' (Hippocrates' method for treating dislocation of the jaw was still being used in France in the nineteenth century.[39]) Hippocrates also taught that the careful observation of symptoms was an important part of medicine – examination of the body, posture, breathing, sleep, urine and stools, sputum, whether or not the patient is coughing, sneezing, has flatulence or lesions, and so on. Treatment did not only include diet, but might also entail bathing or massage, and many herbal remedies, including emetics, to promote vomiting, and expectorants to produce coughing. But Hippocrates was probably even more famous for his oath, which was taken on adoption into his school. The chief features of the oath were to always put the patient first, never to give poison or procure abortion, or to use one's position of authority to seduce 'male or female, slave or free'. The oath covers patient–client confidentiality in such detail that it has secured a high status for doctors for most of history.

It does not take much imagination to see how shocking all this would have been for people to whom the heavenly bodies and winds were gods, or agents of the gods. Moves were made against these 'advanced' intellectuals, as holy men sought to impeach them and Aristophanes famously lampooned them in *The Clouds*. But the new ideas were part of an evolving culture in the Greek *poleis*. Geoffrey Lloyd has shown, for instance, that a word like 'witness', as used in the Athenian courts, was also the root for 'evidence' as used by early scientists, and the term 'cross-examination' likewise was adapted to describe the testing of a hypothesis.[40]

The birth of reflection in Ionia, what some modern scholars call Ionian Positivism, or the Ionian Enlightenment, occurred in a dual form: science and philosophy. Thales, Anaximander and Anaximenes can all be regarded as the earliest philosophers as well as the earliest scientists. Both science and philosophy stemmed from the idea that there was a *kosmos* that was logical, part of a natural order that could, given time, be understood. Geoffrey Lloyd and Nathan Sivin say that the Greek philosophers invented the very concept of nature 'to underline their superiority over poets and religious leaders'.[41]

Thales and his immediate followers had sought answers to these questions by observation, but it was Parmenides, born *c.* 515 BC in Elea (Velia) in southern Italy, then part of *Magna Graecia*, who first invented a recognisably 'philosophical' method, as we would understand that term today. His achievement is difficult to gauge because only about 160 lines of a poem, *On Nature*, have survived. But he was a great sceptic, in particular about the unity of reality and the method of observation as a way to understand it. Instead, he preferred to work things through by means of raw thought, purely mental processes, what

he called *noema*. In believing that this was a viable alternative to scientific observation, he established a division in mental life that exists to this day.[42]

Parmenides became known as a sophist. To begin with, this essentially meant a wise man (*sophos*), or lover of wisdom (*philo-sophos*), but our modern term, philosopher, conceals the very practical nature of the sophists in ancient Greece. As classicist Michael Grant tells it, sophists were the first form of higher education – in the Western world at least – developing into teachers who travelled around giving instruction in return for a fee. Such instruction varied from rhetoric (so that pupils could be articulate in political discussion in the Assembly, a quality much admired in Greece), to mathematics, logic, grammar, politics, and astronomy. Because they travelled around, and had many different pupils, in differing circumstances, the sophists became adept at arguing different points of view, and in time this bred a scepticism about their approach. It wasn't helped by the sophists' continued stress on the difference between *physis*, nature, and *nomos*, the laws of Greece. (It was in their interests to stress this division because the laws of nature were inflexible, whereas the laws of the land could be modified and improved by educated people – i.e., the very students they taught, and received income from.) Thus sophistry, which began as a love of wisdom and knowledge, came to embody 'cunning reason, designed to put bad arguments in a good light'.[43]

The most renowned of the Greek sophists was Protagoras of Abdera in Thrace (*c.* 490/485–after 421/411 BC). His scepticism extended even to the gods. 'I know nothing about the gods, either that they are or they are not, or what are their shapes.'[44] (Xenophanes had also been sceptical: he asked why the gods should have human form. On that basis, horses would worship horse gods. He thought there might just as easily be one god as many.[45]) Protagoras is probably best remembered, however, for another statement, that 'the human being is the measure of all things: of things that are, that they are; and things that are not, that they are not.'

This is how philosophy started, but there are three great Greek philosophers whose names everyone knows – Socrates, Plato and Aristotle. In his book on Protagoras, Plato described Socrates (*c.* 470–399 BC) making fun of the sophists who he said were more interested in verbal pyrotechnics than genuine learning. But, like Parmenides and Protagoras, Socrates also turned away from scientific observation and concentrated more on what might be achieved by raw thought. However, he never wrote any books and what we know about him is largely due to Plato and to Aristophanes who portrayed Socrates, unflatteringly, in two plays. He is remembered now primarily for three reasons: his conviction that there is an eternal and unchanging 'absolute standard' as to what is good and right, the belief that all nature works towards a purpose, which is the apprehension of this 'standard'; that to discover this standard one must above all know oneself; and his 'Socratic method' of questioning everything and everyone he came across ('the unexamined life is not worth living'). Socrates played more than word games, though; he believed he had a mission from the gods to make people think and so he played *mental* games to provoke people into questioning all that they took for granted. His aim was to help people lead a good and fulfilling life but his mischievous methods led eventually to his trial on charges of mocking democracy and public morality, and of corrupting the youth, by teaching them to disobey their parents. When he was found guilty, he was allowed by law to suggest

the penalty. Had he chosen exile this would surely have been granted. But, contentious as ever, he said that what he really deserved was maintenance for life as a public benefactor but that he would agree to a fine. The jury was insulted and ordered him – by a larger majority than had convicted him – to commit suicide. After a delay when, according to Plato, he spoke eloquently on the soul, he drank hemlock at sundown.[46]

Plato, who was born *c.* 429 BC, originally wanted to be a poet but around 407 he met Socrates, was inspired by the older man and decided to devote himself to philosophy. He travelled a lot, in southern Italy and Sicily, and is reported to have had a number of adventures, in one of which he may have been detained at Aegina, and released only after paying a ransom. Returning to Athens, he founded his famous Academy, about a kilometre outside the city, beyond the Dipylon gate, named in honour of the hero Academus, whose tomb was nearby. (There would be four prominent schools in Athens: the Academy, the Lyceum, the Stoa – home of the Stoics – and the Garden of Epicurus.) Apart from his championing, and reporting, of Socrates' views, Plato shows all the strengths and weaknesses of the 'raw thought' approach to understanding the world. He had a fantastic range and, unlike Socrates, he wrote many books. In the *Phaedo*, he defends his theory that the soul is immortal (discussed in the last chapter); in the *Timaeus* (an astronomer) he explores his famous theory of the origins of life, recounted as the myth of the imaginary continent of Atlantis and how the Athenians defeated the invasion of the bull-worshipping seapower. Plato then lapses into his familiar mystical intuitionism when he says that Timaeus introduced God as the intelligent, effective cause of the whole world and its moral order, but ruling at times in ways that we can never know.[47] The *Timaeus* would find echoes in Christianity (see below, Chapter 8).

With great inventiveness, Plato also contemplated the mathematicisation of nature. The cosmos, he said, was the handiwork of a benevolent craftsman, a rational god, the Demiurge, the personification of reason. He it was who had created order out of chaos and, taking over Empedocles' idea of the four roots – earth, water, air and fire – and under Pythagoras' influence also, Plato reduced everything to triangles. Equilateral triangles were the basic entity of the world, he said. This 'geometrical atomisation' explained both stability and change. It was already known in Plato's day that there are only five regular geometrical solids: the tetrahedron, the octahedron, the icosahedron (twenty equilateral triangles), the cube, and the dodecahedron (twelve pentagons). Plato linked each of these with the roots: fire = tetrahedron; air = octahedron; water = icosahedron; earth (the most stable) = cube. The dodecahedron, he said, was identified with the cosmos as a whole. What matters here is not the slippery way Plato links the five shapes with the four roots, and ropes in the cosmos to even up the numbers, or the way he conveniently ignores the fact that a cube is not composed of equilateral triangles; instead, Plato's proposal that each of these solids (the 'Platonic solids') could be decomposed into triangles and resurrected in different ways, to produce different substances, develops and refines the ideas of a basic material in the universe, beneath appearances, which accounts for stability and change at the same time. This is not so very different from the view we have now.[48]

But the heart of Plato's doctrine, where he is at his most influential but also his most mystical, was the theory of 'ideas'. This word, which really means 'forms', was first used by

Democritus to designate atoms, but Plato gave it an entirely new twist. Plato seems to have believed that he was building on both Socrates and the Pythagoreans: Socrates had argued that virtue existed in and of itself, independently of virtuous people; the Pythagoreans had revealed abstract order, the pattern of numbers underlying the universe. To this Plato added his own contribution, first and foremost related to beauty. He conceived it possible to proceed from contemplation of one beautiful body to another, and another, to the notion that there existed, *in another realm*, ideal beauty, the idea in its purest form. The pure essence of the Beautiful (and other forms, like Goodness and Truth) became available to the initiated through study, self-knowledge, intuition, and love. For Plato, the world of being was organised at four levels: shadows, perceptible objects, mathematical objects and ideas. In the same way, knowledge existed in four states: illusion, belief, mathematical knowledge, and dialectic (inquiry, discussion, study, criticism) – which eventually provided access to 'the supreme world of ideas'.[49]

This all-embracing theory even encompassed politics as Plato tried to imagine the ideal city. In the *Republic*, he dismissed the four 'impure' forms of government (timocracy, oligarchy, democracy and tyranny) and in their place imagined a system where the specific aim was to produce ideal governors. Initially, men must be free to develop themselves as Socrates had indicated, so women and children were held in common. This freed men to pursue a strict system of education: gymnastics (from the age of seventeen to twenty); the theory of numbers (twenty to thirty years); and finally the theory of ideas (thirty to thirty-five years). The graduate of this system would thus be fit to fulfil office between the ages of thirty-five and fifty, when he would retire to his studies.[50] In the *Laws* Plato carried his theories much further. Here too he envisaged an early form of communism of possessions, women and children. The main aim now was to protect the individual from 'the tumultuous attractions of his instincts' and so regulations were rampant. Education, heavily weighted to mathematics, was the prerogative of the state. Liberty all but disappeared: women inspectors could enter young households at will. Pederasty was proscribed (a great innovation this), as were journeys abroad for those under the age of fifty. At the same time, religion was compulsory – unbelievers were shut up in a 'house of correction' for five years, until they saw reason. Those judged incorrigible were put to death.[51]

To the modern reader, the mystical intuitionism of Plato is as maddening as his energy, consistency and breadth of interests are impressive. His writing embraced everything from psychology and eschatology to ethics and politics. His importance lies in his influence, in particular the attempts in Alexandria in the first century AD, by Philo and the Fathers of the Church, to marry the Old Testament and Plato into a new wisdom which, it was believed, Christianity 'brought to completion' (see Chapter 8, below). Plato's intuition, about hidden worlds, the immortality of the soul, and his idea that the soul was a separate substance, were elaborated by Christian Neoplatonists down the ages.[52] That same intuition would irritate later philosophers (such as Karl Popper) who thought its inherent anti-scientific approach did as much harm as good. This issue is discussed in the Conclusion.

'Aristotle is the colossus whose works both illuminate and cast a shadow on European thought in the next two thousand years.'[53] And, as Daniel Boorstin also says, 'Who would

have guessed that Plato's most famous disciple would become (in words attributed to Plato) "the foal that kicks its mother"?'

Aristotle (384–322) was a very practical man who had little time for Plato's more intuitive and mystical side. Nor was he enamoured of the emphasis at the Academy on mathematics. (Over the entrance, so legend has it, was the inscription: 'Only geometers may enter.') He came from a family of doctors and his father, Nicomachus, was the personal physician to the king of Macedonia, Amyntas, who was the father of Philip of Macedon and grandfather of Alexander the Great. After he was orphaned, Aristotle was sent to Athens for his education, where he arrived in 367 BC, when he was seventeen. He joined Plato's academy but all his life he was an outsider. As a 'metic', a resident foreigner, he could not own real estate in Athens.[54] He remained at the Academy for more than twenty years (no fees were charged and a scholar could remain for as long as he was able to support himself), leaving only at Plato's death in 347 BC. Fortune then smiled on him, however, for at that time Philip of Macedon was looking for a tutor for his son, Alexander. 'It was an encounter that should have sparked more consequences than it did: the West's most influential philosopher in close contact with the future conqueror of vast stretches of the Middle East, the largest empire of the West before Roman times.' In fact, Aristotle got more out of it than did Alexander the Great. Bertrand Russell thought that the young Alexander 'must have been bored by the prosy old pedant set over him by his father to keep him out of mischief'.[55] For his part, Aristotle was doubly rewarded by the Macedonians. He was well paid (dying a rich man), and they aided his researches into natural history by having the royal gamekeepers tag the wild animals of the area so he could follow their movements. In Macedonia, Aristotle also forged a friendship with the general Antipater that would prove decisive later on.

After Alexander acceded to the throne in Macedonia, in 336 BC, Aristotle returned to Athens. It was now more than ten years since Plato had died and the Academy was much changed. But Aristotle was by then rich enough to set up his own teaching centre in the Lyceum, a grove and gymnasium about a kilometre from the Agora of Athens. There it became the practice for Aristotle to stroll on the public walkway (*peripatos*) talking philosophy with his students 'until it was time for their rubbing with oil'. Like the Academy, the Lyceum had a number of lecture rooms but it also had a library: according to tradition, Aristotle put together the first systematically-arranged collection of books. (He may well have believed that all knowledge could fit into a coherent whole, though the present arrangement of his books was made by the Romans in the first century AD.) In the mornings he gave lectures for serious scholars, but the evenings were open to anyone. The day was completed by *Symposia*, or festive dinners, conducted according to rules that Aristotle himself drew up.[56] These dinners were an Athens institution, the equivalent of clubs in later ages. There were rules/fashions governing even the way the couches were arranged and how the wine was served.

Aristotle spent more than a decade at the Lyceum. During that time he wrote and lectured on a vast repertoire of subjects, no less impressive than Plato's in its range, reaching from logic and politics to poetry and biology. His attempt to classify everything, and to count what he could, also made him our first encyclopaedist. The irony is that Aristotle's 'published' works (as we would say) have not survived. What has come down

to us are his morning lectures, added to and annotated by his students.[57] Aristotle was forced to leave Athens when, in the summer of 323 BC, news arrived of the death of Alexander. The Athenian Assembly immediately declared war on Antipater, Aristotle's former friend and patron, who was by now the general in charge in Macedonia. Aristotle, the 'metic', was seen as a Macedonian and so was immediately suspect and he fled to Chalcis, a Macedonian stronghold. This at least had the effect, as Aristotle himself aptly observed, of preventing the Athenians from 'sinning twice against philosophy'.[58] He died a year later, aged sixty-three, still in Chalcis.

Bertrand Russell thought that Aristotle was 'the first [philosopher] to write like a professor . . . a professional teacher, not an inspired prophet'. In place of Plato's mysticism, Aristotle substituted a shrewd common sense.[59] The most striking contrast to Plato's approach came in politics. Instead of Plato's intuitive outline of an ideal commonwealth, Aristotle's theories were solidly founded on research – for example, his assistant's descriptions of 158 different political systems, covering the Mediterranean world from Marseilles to Cyprus. His survey convinced him that the ideal city did not exist, could not exist. No constitution was perfect, governments were bound to differ 'on climate, geographical conditions and historical precedents'. He himself preferred a form of democracy open only to educated men.[60]

His aptitude for classifying the natural world, though imaginative, also acted as a straitjacket for later generations, especially in biology. He subscribed to the view that there was an underlying unity in nature. 'The observed facts show that nature is not a series of episodes, like a bad tragedy' (*Metaphysics*).[61] But at the same time he thought that nature was constantly changing. 'So, goodbye to the Forms. They are idle prattle, and if they do exist are wholly irrelevant.' In fact, Aristotle turned Plato upside-down. For example, for him the existence of musicians did not depend on some Idea called Music. Abstractions don't really exist, in the way that trees or animals do. They exist only in the mind. 'Musicianship cannot exist unless there are musicians.'[62]

If he had a mystical side, it lay in his tendency to see purpose everywhere; he thought for instance that every species of animal fulfilled some special purpose, that it existed for a reason: 'Nature does nothing in vain.' But for the most part he strained to be logical – indeed, he can claim to be the founder of logic. He called it analytics but either way he was the first to explain deductive reasoning, the science of drawing conclusions from premises in formal syllogisms. He thought this was a basic tool for understanding any subject.[63] Logic led his thinking about animals, and in two ways. With the help of those Macedonian gamekeepers he described (in meticulous detail) and classified more than 400 species of animal. For example:

*The eight 'great categories' of the animal kingdom according to Aristotle*

---

**I    Animals with red blood**
    1       Viviparous (mammalians and cetaceans)
            Two species: bipeds and quadrupeds
    2–4    Oviparous:    2    Birds: eight species
                          3    Reptiles
                          4    Fish

**II    Animals with white blood**
         5          with soft bodies (cephalpoda)
         6          with soft bodies covered by scales (crustaceans)
         7          with soft bodies covered with a shell (gasteropoda)
         8          insects (nine species) and worms.

Logic (not to mention common sense) also led him to dissect animals, because this would enable him to describe their internal anatomy. This reinforced his view that life was a unity; he showed that, inside, animals were not that different from man, or from each other.[64]

His view of being – existence – was also fairly commonsensical. It had ten aspects: substance, quantity, quality, relation, place, time, position, possession, action, passion. The only mystical element related to substance which had two sides to it: *action*, 'when its form was realised'; and *potential*, before realisation had occurred. When a sculptor turned raw bronze into the finished piece, he 'realised' the substance.[65] This too reflected Aristotle's obsession with purpose.

Change and purpose applied to humans and animals. His idea of God was the opposite. Amid all this change, over and above and around it, he proclaimed an *unmoved mover* which was God. God, he said, was pure thought, pure action, 'without matter, accident or development'. Everything in the universe aspired to this state, which he said equated to true beauty, intelligence and harmony. This harmony was the aim of learning and here he was, perhaps, closest to Plato.[66] The collection of lectures in which these views appear was called by Aristotle himself 'first' or 'primary' philosophy. Later editors, however, placed this material after another collection on *Physics* and they became known as *Meta ta physika*. This is where our word 'metaphysics' comes from.[67]

Nowhere is Aristotle's common sense more in evidence than in his treatise on ethics. Everyone wanted happiness, he said, but it was a mistake to look for it in pleasure, wealth and respect, as most citizens understood it. Happiness, harmony – virtue – came from behaviour that was consistent with the nature of man, in other words in behaving reasonably. Happiness involved control over the passions; one should always seek in life an average position, half-way between opposing excesses. As Pierre Leveque says, Aristotle was later accused of being 'dry' (writing like a professor, as Russell put it) but even if this is true (and all we have are his notebooks, remember), his ability to stay close to the real, the particular, and the commonsensical far outweigh any shortcomings on this score. For him, humans were born with potential and, given the use of reason and the right upbringing/education, could be ethically good. This was the very opposite of what would become the Christian view under St Augustine and the notion of original sin.

The very same preoccupations of philosophy were a major concern of tragic drama, a unique and particular glory of Athens. 'Other cities under democracies had developed comedy, but tragedy was the invention of Athens alone.'[68] 'This tragic poetry, even though the music and dancing which were essential to its performance are lost, remains one of the decisive theatrical and literary innovations and achievements of all time. It was designed to express the deepest thoughts of which men and women are capable, and in particular, to examine and assess their relationships with the divine powers.'[69]

Though the plays of Aeschylus, Sophocles and Euripides – the only tragic authors whose works have survived – are classics to us, to the Athenians of ancient Greece they were brand new, exploiting and reflecting the new realities of democracy, science and military tactics. The new wisdom had put man into a new relation, both with the gods and with his fellow men. In classical tragedy, human nature is pitted against the nature of the gods, free will set against destiny. Though man always loses – killed or banished through his ignorance or defiance of the gods, or his *hubris*, his arrogant self-confidence – death is used in tragedy as a device to concentrate the mind, to provoke thought and reflection as to why it comes about. Though direct links between tragedy and contemporary politics are hard to discern, they are there. The drama in Athens exemplifies a stage in the evolution of man's self-consciousness: is self-confidence, as reflected in the advances in science and philosophy and politics and law the same as arrogance? What is the true place for the gods, amid all this new knowledge?

The development of Athenian theatre was a direct effect of a long period of prosperity. We infer there was prosperity in Athens because this was a time that saw the planting of many olive trees. Since olive trees do not produce their fruit for about thirty years, their planting indicates that people were, at the least, optimistic about the future. The growth in the export of olive oil also encouraged the development of pottery, in which the oil was transported. About 535 BC came the invention of red-figure vase painting. Hitherto, black figures had been painted on vases, with the details incised. Now the whole surface was blackened, with figures picked out in the natural red. This allowed much more variety and realism.[70] But the prosperity brought about by the international trade in olive oil spread to the peasants and it was their rituals, with choral song and mimic dancing, celebrating Dionysus, god of the vine, whose blood was shed for the service of men, that formed the basis of early theatre. When Dionysus was worshipped, the usual sacrifice was a goat and the ritual itself was known as the *trag-odia*, or Goat-Song. Thus there is a direct link between sacrifice and tragedy: this primitive ritual lives on in our most powerful form of theatre. In the beginning, *trag-odia* was a purely religious celebration, with a single celebrant, called the Responder, who narrated the Birth of the Divine Child and 'the calculations of his enemies'. In between episodes, a chorus sang and danced (it was their role to highlight issues raised by the Responder for general contemplation).[71] Before long, innovations proliferated. Narratives were taken from gods other than Dionysus, and dialogue was introduced, usually between the Responder and the leader of the chorus. Around 534 BC, Thespis introduced a further change: the solo voice, or *hypokrites*, now made successive entries, each time changing his costume and mask in the dressing tent, or *skēnē* (our word scene). In this way the solo voice represented different characters, adding to the complexity of the narrative, and his speeches were delivered accompanied by the music of a double flute. The chorus, which still occupied the stage most of the time, sang or danced the emotions evoked by the developing story.

There was an annual festival of Dionysus at Athens, held in the shadow of the Acropolis and here the tragic drama became established as a regular occurrence. Prizes were offered for the best plays and for technical innovation: Thespis was an early winner, for his *skēnē*, and Phrynichus also won for introducing roles for women (though the characters were always played by men). In their explorations of character, plot and counter-plot, it became

the custom for playwrights to compose tetralogies, which comprised three tragedies and a satire.[72]

The first of the three great Athenian tragedians was Aeschylus (525/524–456 BC), with his 'rich and pregnant' language. He introduced a second actor, which made dialogue less stilted, more realistic, adding to the tension, and he was also alive to the dramatic possibilities in delay.[73] The early plays had not much drama, or revelation, or excitement, as we would understand the terms. Usually, the central dilemma was given early on and the rest of the play revolved around the reactions of the characters. But in *The Persians*, for example, Aeschylus delays the main development for 300 lines. Even so the climax occurs before the play has reached its mid-point.[74] Seventy-two tragedies by Aeschylus are recorded in one catalogue, but only seven have come down to us.

Sophocles (*c.* 496–406 BC) was the son of Sophilus, a successful arms manufacturer from Colonus outside Athens. He may have studied under Aeschylus and knew Pericles, who saw to it that Sophocles was given a number of important posts: collector of tribute, general, priest, ambassador. When he turned to writing he was no less fortunate: his 120 plays won twenty-four awards and it is a tragedy in itself that – again – only seven survive.[75] But his plays introduced two innovations over and above those of Aeschylus. First he allowed a third actor to appear, adding complexity and depth to his plotting. No less important, his plots used myths that were very familiar to his audiences. This allowed him to develop and refine the technique of 'tragic irony' – when the audience knows what will happen but the characters do not. This stimulated tension and encouraged reflection in his audiences as they compared the human view of predicaments with the established perspective of the gods and destiny. Such ambiguity was part of the attraction and still appeals, even today. Aristotle saw *Oedipus Rex* as the greatest play of all for its concern with self-knowledge and ignorance and for its dramatic tension; and of course its influence is felt in our own day, thanks to Freud and the Oedipus complex. Sophocles' main point, however, was that man is often trapped by forces greater than he. Heroes can fail.

Euripides (485/480–406 BC), the third of the great tragedians, was more colloquial, more strident. He came from a family of hereditary priests and in Athens was much more of an outsider than Sophocles: his ninety or so plays won few prizes. The best known is *Medea*, a work that deals with a novel theme in Greek drama: the terrible passions that can transform a woman who has been dealt a great wrong. His aim is less to show the difference between *hubris* and other emotions than to show how human personality can deteriorate in response to vengeance and retribution. Euripides is more interested in the calculated venalities of humans than the more arbitrary and wayward power of the gods. Love, and the victims of love, especially women, are a major preoccupation. As a result, under Euripides the individual assumes larger importance than before and psychology takes centre-stage over destiny.[76] (Medea was not Greek, but an outsider from the Black Sea, so in this play there may also have been references to 'barbarian' behaviour. See Chapter 10 below.)

The works of Homer, and the great tragedians, were based on myth. There was a fair measure of real history included, but no one knew just how much. It is, however, also to

the Greeks' credit that they invented history proper, an emancipation from myth if still not quite history as we know it today.

Herodotus (*c.* 480–425) is generally described as 'the father of history' though he probably loved a good story too much to be completely reliable. He came from a family of poets at Halicarnassus, now Bodrum in Turkey, on the Aegean coast. He set himself the task of writing about the wars of Greece, first the battles between Athens and Sparta, then the invasions of the Greek mainland by the forces of the Persian kings, Darius I (490) and Xerxes I (480–479). Herodotus chose these for the simple reason that he believed they were the most important events that had ever taken place. Apart from his basic idea, of writing history as opposed to myth, his work stands out for three reasons. There was his research method (the original meaning of *historia* was 'research'): he travelled widely, consulting archives and eyewitnesses where he could, checking land surveys (to get the names right, and the shapes of battlefields) and literary sources. There was his approach, distilled from Homer, of conceding that *both* sides had stories worth telling, with their own heroes, skilful commanders, clever weapons and tactics. And third, he was obsessed – as were Homer and the tragedians – by *hubris*. He thought that all men who 'soared high' must be tainted by an arrogance that would provoke the gods.[77] This, and his belief in divine intervention, invalidated many of his arguments about the causes and outcomes of battles. But this accorded more or less with the understanding of his readers and his lucid style (and sheer hard work) ensured that his book was extremely popular.

Thucydides (*c.* 460/455–*c.* 400) made two more innovations. He selected a war theme also but he chose a battle of his own time: in effect, he invented contemporary history. He too thought that the Peloponnesian War (431–404, between Athens and Sparta) was the most important thing that had ever happened. He did not have Herodotus' eye for anecdote but – and this was his second innovation – he allowed little or no place for the gods in war. 'Unlike Herodotus, Thucydides attached primary importance in military affairs to intelligence. The word *gnome*, meaning understanding or judgement, appears more than three hundred times in the book and intelligent men are singled out for praise time and again, notably Themistocles, Pericles and Theramenes.'[78] This allowed Thucydides to achieve the penetrating insight that the war had two sets of origins, the proximate causes and the underlying ones, which he identified as Sparta's fear of Athenian expansion. Such a distinction, between immediate causes and basic realities, ignoring the gods, was a major advance in political thinking. 'In this sense Thucydides has also been called the founder of political history.'[79]

Just as prosperity was a factor in Greek drama, so peace helped create the golden age of classical art. By 450 BC, roughly speaking, Athens was secure again after a period of war. She had managed this by putting herself at the head of a confederacy in which the other city-states paid her tribute in return for her navy defending them against any attack from outside, in particular from the Persians. In 454 Pericles, the great Athenian general and leader, set aside a proportion of this tribute for extensive rebuilding after the ravages of earlier wars: his aim was to make Athens a show-place for Greece.[80] She would never look so splendid again.

In art and architecture, a number of purely pragmatic or technical advances had been

made at the end of the sixth century/beginning of the fifth: the triangular pediment had been invented, together with square metopes, various forms of distinctive column, caryatids (female figures acting as supports for the pediments), town-planning, and red figures on pottery. And, as happened at other times in history (the High Renaissance, for example), a greater than usual number of talents were alive at more or less the same time: Euphronius, Euthymides, Myron, Phidias, Polyclitus, Polygnotus, the Berlin, Niobid and Achilles Painters (whose actual names are not known, but who are named for their most distinguished works). This happy set of circumstances resulted in a golden age for art, the very world that we now revere as 'classical'. It produced the *telesterion* at Eleusis, the temples of Poseidon at Sounium and of Nemesis at Rhamnus, the famous temple of Zeus at Olympia and its statue, the bronze charioteer from Delphi, the temple of Apollo at Bassae, but above all in Athens the Odeon (the original, not the one there now) and the temples of Hephaestus and Dionysus, not to mention a completely new arrangement for the sacred hill of the acropolis, which we know as the Parthenon. These temples, of course, are not one work of art each, but very many.

The great temple of the Parthenon was built on a site that had always been dedicated to Athena, the guardian goddess of the city (full name Athena Polias. The name Athena Parthenos meant she had been later amalgamated with the ancient virgin fertility goddess). Its architect, Ictinus, and master-builder, Callicrates, devised a number of optical illusions in their design to make the temple more striking (for example, the columns lean slightly inward and are laid in a shallow convex line, to make the lines seem longer). They combined the more robust Doric colonnades with more slender, elegant Ionic friezes and so arranged the main temple and entrance (the Propylaea) for maximum visual effect. The success of the Parthenon, with the 'Critian Boy' statue and the Erechtheum, and the Greek style in general, may be judged from the fact that it is by far the most imitated style the world over.

Phidias, the sculptor who masterminded the reliefs for the friezes and the free-standing figures in the temple, was only the first of three who made mid-century statuary famous in Athens – the others were Myron and Polyclitus. Phidias' frieze (which he designed and then had as many as seventy other sculptors execute) was originally 520 feet long – 420 of which survive, mainly in the British Museum in London. It depicts Athens' most famous festival, the Great Panathenaea in which, every four years, the new robe of the great goddess, woven by the citizens' daughters, was brought to the Acropolis. The two pediments of the temple show the birth of Athena and her conflict with Poseidon, the sea god, for control of Attica. But Phidias' masterpiece was the free-standing Athena Parthenos, forty feet tall and made (perhaps the first of its kind) of gold and ivory (*chryselephantinon*). Like so much else, she has been lost but is known from Pausanias' description, small copies, and coins. About her shoulders she wears her miracle-working short goatskin cloak, her *aegis*. Phidias depicted himself on her shield (as a bald man), a bad case of *hubris* forcing him to flee to Olympia where he designed a second gold and ivory statue, of Zeus. This was later removed to Constantinople, where it burned in a fire. But again we know what it looked like from coins and replicas. Its expression was so sublime and gentle, it was said, 'that it could console the deepest sorrow' and was regarded as one of the seven wonders of the world.[81]

At its highest, classical statuary represents 'ideal realism', beauty that *ought* to exist. Its two main forms are the male nude (*kouros*) and the draped female, usually a deity (*kore*). The male nude appears to have originated from Naxos and Paros, islands rich in limestone and marble, which enabled the creation of large-scale images. The female figure developed in Athens but only after the flight of Ionians to the city following the Persian invasion of 546 BC.[82] The tradition of the *kouros* starts from the fact that, in ancient Greece, athletic contests were a form of worship: in taking part in the games, Greek athletes were competing in a religious ceremony. There was thus a mystical aspect to competition but, more important from an artistic point of view, bodies – athletic male bodies in particular – were seen in a religious light. The perfectly formed body was viewed as a virtue, an attribute of someone with godlike powers. Artists therefore sought to show bodies as real as possible, in the way in which the muscles and hair and genitals or feet or eyes were represented; but at the same time they combined the best parts of different people, to create humans who were also, in effect, superhuman in their beauty – gods. This clearly owed a lot to Plato's theory of forms. The most famous is Myron's 'Discus Thrower' (*Discobolus*) which was probably part of a group and also survives only in Roman copies. The tense moment before the athlete explodes into action is beautifully caught. In rational Athens it was a virtue to have one's passions under control, as the gods did. Likewise the statues.[83]

Red-figure vases seem to have been introduced in Athens around 530 BC. The colour scheme is the exact opposite of what went before: instead of a black figure on a red ground (the fine Ceramicus clay in Attica was rich in iron, which gave it its colour), we have a red figure on a black ground. At the same time, the brush replaced the incisor. This enabled far more detail to be included and a greater flexibility in subject matter, poses, and comment.[84] Greek vases were popular all over the ancient Mediterranean world: their subject matter was partly myth, but also, partly, scenes of everyday life – weddings, burials, love scenes, athletic games, people gossiping at the well. They show what earrings people wore, how they bound up their penises, prior to athletic combat, what musical instruments were played, what hairstyles were fashionable. In the fifth century, the Athenian poet Critias listed the most distinguished products of the different states: the furniture of Chios and Miletus, the gold cups and decorative bronzes of Etruria, the chariots of Thebes, the alphabet of the Phoenicians, and from Athens the potter's wheel and 'the child of the clay and oven, the finest pottery, the household's blessing'.[85]

The development of Greek painting can perhaps be seen best in the evolution of vase decoration, from the 'pioneer' style of Euphronius, through the Niobid Painter, to the Berlin Painter and his pupil the Achilles Painter. Drawing and subject matter become ever freer and more varied, never quite losing their tenderness and restrained ambience. Although often very beautiful, these objects are documents before they are works of art. No ancient people has given us such an intimate account of themselves as the Greeks did in their vase painting. It may be the first form of popular art.

Sir John Boardman has also made the point that, for the Greeks, the experience of art was not as our own. There was a uniformity in classical Greece that we would find taxing, 'as if all twenty-first-century cities were comprised of art nouveau buildings'. On the other hand, all the art of Greece was finished to a high degree – there was nothing 'shoddy or

cheap' about the experience of art in Greece. Probably, much public art was taken for granted: the mythological stories were well known, literacy was low, and so sculpture in particular would be a form of ever-present, pre-Herodotus history.[86]

In classical art, two things go together. There is first the sheer observation of the natural world, from the finest points of anatomy and musculature to the arrangement of flowers in a nosegay, the expressions of horror, lust or slyness, the movement of dogs, horses or musicians, much of it not lacking a sense of humour either. There was a down-to-earth quality about all this, and a growing mastery over the materials used. This is most clearly shown in the way drapery is handled in sculpture. Greek sculptors became masters in the way they represented clothing in stone, the way it fell, so as to both conceal and reveal the human form underneath. (The figure of a woman touching her sandal from the temple of Athena Nike, in the Acropolis, is a superb example.) But, beneath and beyond this observation and realism, there was a restrained quality, a serene harmony of the figures, a 'bridled passion' which the Greeks valued because it epitomised their achievement – the discovery of the intellect, or reason, as a way forward.[87] This restraint is sometimes misconceived as an emotional coldness and, certainly, in the centuries which followed, 'classicism' and 'romanticism' have often been contrasted, as opposing forms of sensibility. But this is to misconceive the Greeks, and classicism. They made a distinction between *techne*, what artists knew, and *sophia*, what poets and musicians knew, but they were not passionless. One of Phrynichus' plays, *The Taking of Miletus*, made the Athenians weep so much that it had to be banned.[88] The Greeks valued calm because they knew where passion could lead. (Plato wanted to 'silence' emotion because it interfered with cool, rational thought.) *This* is what classicism is all about.

Many gods in classical Greece were female – not least Athena herself. But ideas about women, sex and gender were very different from now and women played almost no role in public life. They were not full citizens, so had no direct part in politics, they owned no property, and they belonged to their fathers until marriage, after which they were the property of their husbands. If a woman's father died, she became the property of his next male kin. When a husband went out at night to attend *symposia* – fashionable dinners with serious conversation – his wife stayed at home: female company was provided by *hetairai*, cultured women brought in expressly. Aristotle was only one ancient Greek who believed that women were inferior to men.[89] One scholar has claimed that the Greek masculine world was nervous about women, as 'a defiling element' who, in the plays of Aeschylus, Sophocles, Euripides and Aristophanes, are put there to 'subvert the orderliness of male society'.[90] In recent years there has been a vast amount of scholarship on gender in ancient Greece. The overall message appears to be that there was a tension between the idea of the home-loving, child-bearing woman and the wild, unrestrained emotional woman (like Medea).

The sculptor Praxiteles (middle of the fourth century BC) introduced the female nude into Western art – what was to become, probably, the single most popular subject of all time. In the process he refined the technique of marble carving, producing smooth planes that depicted skin, female skin especially, with great realism and the hint, more than the hint, of eroticism. Praxiteles' statue of Aphrodite for Cnidus, *c.* 364/361, on the Turkish

coast, was described by the Elder Pliny as 'the finest statue ever made anywhere in the world'.[91] It was certainly one of the most influential, although it is now lost.

Whatever the reason for the classical Greek attitude to women, male homosexuality in Greece was far more common, more so than now. Right across the country, and not just in Athens, male partnerships between an older man and his younger beloved were regarded as the norm (which is another reason why classical sculpture consists of so many male nudes, or *kouroi*). Plato has Phaedrus argue that 'the most formidable army in the world' would comprise pairs of male lovers and, indeed, in the fourth century BC, something just like this was actually established – the Theban Sacred Band – and won the battle of Leuctra. 'A whole educational philosophy was built around such relationships.'[92] As with gender studies, there has been an explosion of scholarship in this area.

Given the importance of the Greek legacy, it is perhaps necessary to point out here that, three times recently, scholars have claimed that the Greeks themselves were heavily influenced from outside. The first time was in 1984 when the German historian Walter Burkhart identified a number of specific areas of Greek life and thought that had been shaped by Middle Eastern civilisations. He argued, for instance, that the Hebrew and Assyrian names for Greeks, respectively *Jawan* and *Iawan*, or Ionian, showed unmistakable contact between specific areas. In the *Odyssey* Homer mentioned *Phoinikes*, men of Sidon, as producers of costly metal vessels. The hoplite weaponry is closely linked to Assyrian arms. The Greek names for the letters of the alphabet (*alpha, beta, gamma*), are Semitic words, as are many loan words: *chrysos* (= gold), *chiton* (= garment, related to cotton). The Akkadian unit of weight, *mena*, became the Greek *mna*, and *harasu*, to scratch or incise, became *charaxai*, which eventually became the English word 'character', an incised letter. The idea of the Hippocratic oath was derived from Babylonian magicians, says Burkhart, as well as the practice of interring guardian figures under buildings (which, as we have seen, began in the Natufian culture). More controversially, Asclepius may be *Az(u)gallat(u)*, 'the great physician' in Akkadian, while Lamia may be *Lamashtu*, the Near Eastern demoness. Finally (though Burkhart gives rafts of other examples), he finds parallels between the *Odyssey* and the *Iliad*, on the one hand, and *Gilgamesh* on the other.[93]

More recently, and even more controversially, Martin Bernal, a professor of government at Columbia University in New York, has argued, in *Black Athena*, that northern Africa, in particular ancient Egypt – several dynasties of whom were black – was the predominant influence on classical Greece. He argued that the bull cult started in Egypt before transferring to Crete in the Minoan civilisation. He too looked at loan words and at parallels between, for example, Egyptian writing and Aeschylus' *The Supplicants*. Kephisos, the name for rivers and streams all over Greece, he derives from Kbh, 'a common Egyptian river name, "fresh".' In a chapter on Athens, he argues that the name is derived from the Egyptian HtNt: 'In antiquity, Athena was constantly identified with the Egyptian goddess, Nt or Neit. Both were virgin divinities of water, weaving and wisdom.' And so on into pottery styles, military terms and the meaning of sphinxes.[94] Bernal was even more heavily criticised than Allan Bloom was, for poor scholarship and faulty interpretation of dates and data, and for not delivering later volumes as promised.

The third time that outside influence on Greece has been advanced comes from M. L.

West, in *The East Face of Helicon: West Asiatic Elements in Greek Poetry and Myth* (1997). West confirms a heavy overlap between, for example, Gilgamesh and the *Iliad*, between Gilgamesh and Odysseus, and between Sappho and Babylonian poems.[95] This is not to diminish the Greek achievement, just to place it in sensible context, and to reaffirm, *pace* Bernal, that on balance the traditional view of Greece, that it owes more to the Middle East and the Balkans than to north Africa, still prevails. Such a background is a necessary perspective, to show where Greek ideas may have originated, but it does nothing to change the importance of those ideas.

Aristotle died in 322 BC. In 1962 Isaiah Berlin, the Oxford historian of ideas, gave a series of lectures at Yale, later published in book form, in which he noted that a great change came over Greece in the wake of Aristotle's death. 'Some sixteen years or so later, Epicurus began to teach in Athens, and after him Zeno, a Phoenician from Kition in Cyprus. Within a few years theirs are the dominant philosophical schools in Athens. It is as if political philosophy had suddenly vanished away. There is nothing about the city, the education of citizens to perform their tasks within it . . . [T]he notion of fulfilment as necessarily social and public disappears without a trace. Within twenty years or less we find, in place of hierarchy, equality; in place of emphasis on the superiority of specialists, the doctrine that any man can discover the truth for himself and live the good life as well as any other man; in place of emphasis on intellectual gifts . . . there is now stress upon the will, moral qualities, character; . . . in the place of the outer life, the inner life; in place of political commitment . . . we now have a notion of individual self-sufficiency, praise of austerity, a puritanical emphasis on duty . . . stress on the fact that the highest of all values is peace of soul, individual salvation, obtained not by knowledge of the accumulating kind, not by the gradual increase of scientific information (as Aristotle taught) . . . but by sudden conversion – a shining of the inner light. Men are distinguished into the converted and the unconverted.'[96]

    This is, says Berlin, the birth of Greek individualism, one of the three great turning points in Western political theory (we shall come across the other two in due course). In Greece's classical period, Berlin says, it was a commonplace that human beings were conceived in essentially social terms. It is taken for granted by all – philosophers, dramatists, historians – that 'the natural life of men is the institutionalised life of the *polis*'. 'One should say not that a citizen belongs to himself,' says Aristotle, in the *Politics*, 'but that all belong to the *polis*: for the individual is a part of the *polis*.'[97] Epicurus, on the other hand, says something very different, 'Man is not by nature adapted for living in civic communities.'[98] Nothing, he adds, is an end in itself except individual happiness. Justice, taxes, voting – these have no value in themselves, other than their utilitarian value for what happiness they bring the individual. Independence is everything. In the same way, the Stoics, after Zeno, sought *apathia*, passionlessness – their ideal was to be impassive, dry, detached and invulnerable. 'Man is a dog tied to a cart; if he is wise he will run with it.'[99] Zeno, a mathematician as well as a Stoic, told men to look into themselves, because there was nowhere else to look, and to obey the laws of *physis*, nature, but none other. Society was a fundamental hindrance to the all-important aim in life – which was self-sufficiency. He and his supporters advocated extreme social freedom: sexual promiscuity, homosexuality,

incest, the eating of human flesh. Human law is irrational, 'nothing to the wise man'.[100]

Berlin thought that the consequences of this break in thought were immense. 'For the first time the idea gains ground that politics is a squalid occupation, not worthy of the wise and the good. The division of ethics and politics is made absolute; ... Not public order but personal salvation is all that matters.'[101] Most historians, he acknowledged, agree that this change came about because of Philip of Macedon and his son Alexander the Great's destruction of so many city-states in their conquests, as a result of which the *polis* became insignificant. With the old, familiar landmarks gone, and with man surrounded by a vast empire, a concern with personal salvation made sense. Men retreated into themselves.[102]

Berlin didn't agree. He thought it all happened too quickly. Furthermore, the *poleis* were not destroyed by Alexander – in fact, new ones were created.[103] Instead, Berlin saw the origin of the new ideas beginning in Antiphon, a sophist at the end of the fifth century, and in Diogenes, who reacted against the *polis* with a belief that only the truly independent man was free, 'and freedom alone makes happy'. Only the construction of a private life can satisfy the deepest needs of man, who can attain to happiness and dignity only by following nature, which means ignoring artificial arrangements.[104] Berlin in fact wonders if this was not an idea imported from the Orient, since Zeno came from the Phoenician colony of Cyprus, Diogenes from Babylon, and others of like mind from Sidon, Syria and the Bosporus. ('Not a single Stoic was born in old Greece.')

Whatever its origin, the revolution in ideas consisted of five core elements. One, politics and ethics were divorced. 'The natural unit is now no longer the group ... but the individual. His needs, his purposes, his solutions, his fate are what matter.' Two, the only genuine life is the inner life – the outer life is expendable. Three, ethics are the ethics of the individual, leading to a new value on privacy, in turn leading to one of the main ideas of freedom by which we now live, that frontiers must be drawn, beyond which the State is not entitled to venture. Four, politics was degraded, as unworthy of a truly gifted man. And fifth, there grew up a fundamental division, between the view that there is a common bond among people, a unity to life, and that all men are islands. This has surely been a fundamental political difference between people ever since.

'Classical' is itself an idea. In the twenty-first century, it confirms a measure of excellence and a certain taste: classical music; classic rock; this or that publisher's list of 'the classics' – books we all ought to be familiar with from whatever era; even classic cars, an established category in auction house sales. When we describe something as 'a classic' we mean that it is the best of its kind, good enough to endure as a standard in the future. But when we speak about classical Greece, we are talking about Greece in general, and Athens in particular, in the fifth century BC, the names and ideas addressed in this chapter.[105] Ideas and practices which were all new but have stood the test of time since, as Allan Bloom insisted. We shall see in Chapter 9 that it was the Roman reverence for the Greek way of life that gave rise to the notion of the 'classics', the idea that the best that has been thought and written and carved and painted in the past is worth preserving and profiting from. We have a lot to thank the Romans for, but here is perhaps the best answer to those who attacked Allan Bloom and his like for championing the achievements of 'dead, white,

European males' in a small city-state 2,500 years ago. These are the words of the German historian of science Theodor Gomperz: 'Nearly our entire intellectual education originates from the Greeks. A thorough knowledge of their origin is the indisputable prerequisite for *freeing* ourselves from their overwhelming influence.'[106]

# 7

## The Ideas of Israel, the Idea of Jesus

In 597 BC, the disaster that had always threatened to engulf Israel finally overwhelmed her. Led by King Nebuchadnezzer, the Babylonians besieged Jerusalem, captured the king and appointed their own governor. According to the second book of Kings, 'all Jerusalem, and all the princes, and all the mighty men of valour, *even* ten thousand captives, and all the craftsmen and all the smiths', were removed, with only the poorest people of the land remaining.[1] Worse, the ruler appointed proved so unpopular that uprisings went on and the city was again besieged. When, eventually, the starving city fell a second time, in 586 BC, the Babylonians wreaked terrible havoc, sacking everything, including the Temple. Those who could, escaped, but another batch of captives was taken into exile. 'From that date on, more Jews would live outside Palestine than within her borders.'[2]

Just how many people were involved is far from certain. Although the book of Kings refers to 10,000, figures in Jeremiah are more modest, around 4,600 in all, only 832 of them in 586. On the other hand, these figures may refer only to adult males: if they do, we are probably talking about 20,000 overall. Either way, it was a small group, a fact of some importance because it made it easier for the Jews in exile to retain their cohesiveness.

For them, this misfortune was in many ways cataclysmic. As Paula Fredericksen has observed, one conclusion the Jews could have drawn from their predicament, 'and perhaps the most realistic', might have been that their God was in fact much less powerful than the gods of their neighbours. Instead, the Jews drew the diametrically opposite conclusion: her misfortune confirmed what the prophets had foretold, that she had strayed too far from her covenant with Yahweh, and was being punished. This implied that a major change in Jewish behaviour was needed, and exile provided just such a breathing space.[3]

It was in exile that much of Judaism came into being, though present-day Judaism*s* have evolved as much as, say, Christianity has developed beyond its early days. (The Judaism that we know today didn't become stabilised until roughly AD 200.) The most important change was that, lacking a territory of their own, or a political or spiritual leader, the Jews were forced to look for a new way to preserve their identity and their unique relation with their God. The answer lay in their writings. There was no Old Testament, or Hebrew Bible, as we know it, as the Jews went into exile. Instead, they had a collection of scrolls containing civil law, they had a tradition of the Ten Commandments, they had a book of other religious laws, said to have been compiled by Moses, they had such scrolls as the Book of

Wars, and they had the sayings of their prophets and their psalms, which had been sung in the Temple.[4]

In the past, the scribes had not been especially prestigious. Now, as the book became more central to the faith, so the status of the scribes improved. For a time, in fact, they became more important than the priests, as they were financed by wealthy merchants to write down material that would establish traditions and keep the people together. Also, many of their fellow-Israelites looked upon writing as a near-magical activity, possibly of divine origin. As well as writing, of course, the scribes could read. In Mesopotamia, they came across the many writings of Sumerians, Assyrians and Babylonians and, in time, translated their texts. In this way they came under the influence of other cultures, including other religious beliefs.

But it was not only written traditions that were consolidated in exile. It was now that certain dietary laws were first insisted upon, and circumcision, 'to distinguish Jews irrevocably from pagans'.[5] (Other peoples in antiquity, such as the Egyptians, practised circumcision, and the Syrians abstained from eating fish.) Babylonian astronomy was considerably more sophisticated than that of the Jews and so they used this fact to update their liturgical year, devising a cycle of regular festivals: Passover (the Angel of the Lord passing over the Israelites as they crossed the Red Sea into the Promised Land – therefore the founding of the state); Pentecost – the giving of the Laws, the founding of the religion; and the Day of Atonement – anticipation of the Day of Judgement. It was only now that the Sabbath, which had been referred to in Isaiah, took on a new significance (this is inferred because records show that the most popular new name at this time was 'Shabbetai'). *Shabbatum*, as was mentioned in an earlier chapter, was originally a Babylonian word and custom, meaning 'full moon day', when no work was done.[6] There is even some evidence that the idea of a 'Covenant' with God derives from this time of exile. It is reminiscent of an old idea in Zoroastrianism and, as we shall see, the man who eventually freed the Jews from exile, Cyrus the Great, was a Zoroastrian.

Exile lasted from 586 to 538 BC, not even half a century. Yet its influence on Jewish ideas was profound. According to the books of Jeremiah and Ezekiel, most of the exiles were moved to the southern half of Mesopotamia, near Babylon itself. They were free to build houses and to run farms, and were free to practise their religion, though no Jewish temple has ever been found in Babylon. Many seem to have been successful traders and, in the commercial cuneiform tablets of the day, there is a growth of Jewish names.[7]

If exile itself was far from onerous, the situation of the Jews improved immeasurably when, in 539 BC, an alliance of Persians and Medes, put together by Cyrus the Great, founder of the Achaemenid (greater Persian) empire, conquered the Babylonians. Besides being a Zoroastrian, Cyrus was very tolerant of other religions and had no desire to keep the Jews captive. In 538 they were released (though many refused to go, Babylon remaining a centre of Jewish culture for a millennium and a half).[8]

The Hebrew scriptures tell us that the return of the first batch of captives proved a great deal harder than exile. The descendants of the poorer Israelites, whom the Babylonians had not bothered to remove earlier, were scarcely welcoming and saw no need for the expense of new city walls. A second, larger group of exiles, left Babylon in 520, more than

42,000 we are told in the Bible, and perhaps twice the number that had originally been taken captive. This group had the support of Cyrus' son, Darius, but even so the rebuilding of Jerusalem did not recommence until 445 BC. This was when Nehemiah arrived. He was a wealthy Jew, highly placed in the Persian court, who had heard about the sorry state of affairs in Jerusalem. He rebuilt the walls and the Temple, and he introduced changes that helped the poor. But, as Robin Lane Fox says, 'although he appears to have assumed a broad awareness of Moses' law among the people, nowhere does he allude to written scripture'.[9]

This first and all-important reference is generally agreed to have been made by Ezra, a priest well-connected in Babylon. He too had been an official at the Persian court in Mesopotamia and he arrived in Jerusalem in 398 BC, 'with a royal letter of support, some splendid gifts for the Temple and a copy of the law of Moses'.[10] It is only now, according to scholars like Lane Fox, that 'we find for the first time "an appeal to what is written" '. We conclude from this that an unknown editor had begun to amalgamate all the different scrolls and scriptures into a single narrative and law. Whereas there was an agreed form of Homer in Greece by, roughly speaking, 300 BC, the Hebrew scriptures (the Old Testament for Christians) was not fully formed in Israel until about 200 BC, when figures such as Ben Sira, the author of Ecclesiasticus and the first Jewish author that we know by name, refers to the 'book of the covenant of the most high god, the law which Moses commanded'.[11] As was mentioned earlier, the idea of a covenant with God, such a central element in Judaism, may have been adapted from Zoroastrian beliefs in Mesopotamia. After exile, the covenant that dominated Jewish life the most was with the book, which in turn meant that great effort was made to ensure there was strict agreement on what went into it and what was left out. The Jews had to establish a canon. So began the first steps toward the compilation of the Bible, arguably the most influential book of all time.

Originally, the word 'canon' was Sumerian – it meant 'reed', something straight and upright. Both the Akkadians and the Egyptians had canons. It was particularly important in Egypt where the Nile flooded regularly and inundated properties, changing the land and obliterating boundaries. Precise records were therefore invaluable, and this was the primary meaning of the canon. At the same time, the vizier, who was in charge of the archives, was also in charge of the judiciary – and this is how use of the word spread, to mean a traditional, unvariable standard.[12] In Greek, the word *kanon* also meant a straight rod or ruler, and it too expanded, to mean an abstract standard (a 'yardstick', as we would say), and even the rules by which poetry or music should be composed.[13] Plato's ideas about ideal form easily lent themselves to the idea of a canon: great works enshrined these traditional rules. In classical Greece, therefore, canon could apply either to single works or entire collections. Polyclitus wrote a canon about the human form. But it was the Jews who first applied the word to scripture. To be included in their canon, writings must have been divinely inspired.

The development of the scriptures had an effect on the Jews which set them apart from, say, the Greeks and, later, the Romans. In Greece, the fifth, fourth and third centuries BC saw the development, as we have seen, of philosophy, critical thinking, tragic drama, history writing, and a trend to less and less religious belief. In Israel it was the opposite: as people learned to read, and to take pleasure in the book, they made more and more of it.

Since so much of it was prophecy, rather than mythology, or observation (as in Greece), there was huge scope for interpreting what, exactly, the prophets had meant. Bible commentaries proliferated and with them a general level of confusion as to the real meaning of the scriptures. Many scrolls of scripture were regarded as sacred, especially the early ones that contained the name of God, YHWH. Later texts excluded this name, for fear that gentiles might use it in spells. Not mentioning the name also implied that God could not be defined or limited.[14]

Josephus, a Jewish leader born around AD 37, who later became a Roman citizen, wrote two famous histories about the Jews, *The Jewish War* and *The Jewish Antiquities*. He identified twenty-two scriptural books, though there were many other non-canonical ones. These twenty-two, he said, 'are justly accredited and contain the record of all time'. He identified five books of law, thirteen books of history, all written, he said, by prophets, and four 'books of hymns to God and precepts for human conduct' (Psalms, Proverbs, the Song of Songs and Ecclesiastes).[15] Twenty-two may have been chosen because it was the number of letters in the Hebrew alphabet – numerology again. Yet, in Jesus' lifetime, there appears to have been no idea that the canon of scriptures was closed, there was no 'authorised version' as we would say. The wording and the length could both vary (there were long and short versions of some books, such as Ezekiel), and great disagreement on what their meaning was.[16]

What Christians call the Old Testament is for Jews the Tanakh, actually an acronym which derives from the three types of holy writing: *Torah* (law), *Neviim* (prophets) and *Ketuvim* (writings). The five books that make up the Torah were known in early Greek versions of the Bible as the Pentateuch.[17] The division of the scriptures into verses and chapters was not in the minds of the original authors, but were later innovations. Verses were introduced in the ninth century, and chapters in the thirteenth. The order of the books of the Hebrew Bible differs from that of the Christian Old Testament, while the Catholic OT has inter-testamental books and the Protestant OT does not.[18]

There is now an immense amount of scholarship relating to the writing of the Old Testament, analysis which has 'revealed', among other things, when the scriptures were first set down, by how many authors, and in some cases where they were written. For example, scholars now believe that the Torah was made up of four 'layers', compiled towards the end of the fourth century BC (i.e., post-exile). This is deduced because, although the book of Genesis comes first in the Bible's scheme of things, the earliest books of the prophets, set in the mid- to late eighth century BC, although they describe many experiences of the early Israelites, make no mention whatsoever of the Creation, Adam and Eve or (for Christians) the Fall. Such evidence of writing as has been found, by archaeologists at seven sites in Judah and dating to earlier centuries, is invariably economic material (deliveries of wine or oil), or associated with government or administrative matters. In addition, the *Theogony* of Hesiod (*c.* 730–700 BC) contains some ideas that overlap broadly with Genesis. For example, in the *Theogony*, Pandora is the first woman, created out of man, just as Eve is in the Bible. In the 620s BC, in Athens, the first written law code in Greek was drawn up by Dracon. Did these elements inspire the Torah in Israel? The historicity (or otherwise) of the early parts of the Hebrew scriptures are also called into doubt by the fact that there is no independent corroboration for any of the early

figures, such as Moses, although people alive when he is supposed to have lived are well attested. For example, the Exodus, which he led, is variously dated to between 1400 and *c.* 1280 BC, at which time the names of Babylonian and Egyptian kings are firmly established, as are many of their actions. And many identifiable remains have been found. Yet, the earliest corroboration of a biblical figure is King Ahab, who battled the Assyrian king Shalmaneser III in 853 BC.

We can go further. According to archaeologists working in Israel (some of whom are Israelis, some of whom are not), there is no archaeological evidence that any of the patriarchs – Abraham, Noah, Moses or Joshua – ever existed, there was no exile of the Jews in Egypt, no heroic Exodus and no violent conquest of Canaan. For most biblical scholars, the issue now is not whether such figures as Abraham existed, but whether the customs and institutions found in their stories are historical; and not whether the Exodus or Conquest happened as it says in the Bible, but what kind of Exodus and Conquest they were. In addition to all this, there was no covenant between the Jews and God and, most fundamental of all, Yahweh, the God of the Jews, was not to begin with a very different kind of supernatural being, as the Israelites always claimed, but just one of a variety of Middle Eastern deities who, until the seventh century BC at least, had a wife – Judaism was not always a monotheistic religion.[19] In the very latest round of research, scholars have even cast doubt on the existence of David and Solomon and the 'United Monarchy,' that golden epoch of Jewish history when, according to the Bible, the twelve tribes lived under a king, beginning in the twelfth century BC, when such vast cities as Megiddo (Armageddon), Hazor and Jezreel were built. On this view, David and Solomon, if they were kings, were small-time rulers, not the great builders of palaces that dominated the region that is now Israel and are made so much of in the Bible.[20] In particular, the 'golden age of Solomon' is a problem historically.

An even more serious undermining of the Bible's authority has come, however, from the general realisation, as archaeology has developed, that a world that is supposed to be set in the Bronze Age – say, *c.* 1800 BC – is in fact set in the Iron Age, i.e., after 1200 BC. Place names in the Bible are Iron Age names, the Philistines (Palestinians) are not mentioned in other, extra-biblical texts, until around 1200 BC, and domesticated camels, though mentioned in the Bible as early as chapter 24 of Genesis, were not brought under human control until the end of the second millennium BC.[21]

Then there is the work of Israel Finkelstein. Professor of archaeology at Tel Aviv University, he is possibly the most charismatic and controversial archaeologist of his generation. His contribution is two-fold. Traditionally – that is, according to the Bible – the Israelites came into the land of Canaan from outside and, aided by their God Yahweh, conquered the Philistines (or Palestinians) in the thirteenth–twelfth century BC, subsequently establishing the glorious empire of David and Solomon in the twelfth and eleventh centuries BC. This 'United Monarchy' of Samaria in the north and Judea in the south then lasted until the sixth century BC when the Babylonians conquered Israel, and took the Jews into their 'second exile', in Mesopotamia as slaves. Yet it now appears that there is virtually no archaeological evidence whatsoever to support such a view. There is no evidence of a short military campaign of conquest by Joshua, and no evidence of any cities in the area being sacked or burned. Indeed, many of the cities said by the Bible to

have been conquered by Joshua – for instance, Arud, Ai and Gibeon – are now known not to have existed then. At the same time there is good evidence that life continued unchanged, much as it always had done. Early archaeologists claimed that the sudden appearance of a certain type of pottery – vases with a distinctive collar – and the four-room house, indicated a sudden influx into the region by outsiders – i.e., the Israelites. Subsequent research, however, has shown that these developments took about 150 years to mature, in different places, and in many cases pre-date when the Israelite outsiders were supposed to have arrived. If this view is correct, then of course it means that the Bible is wrong in a very important respect, namely, in seeking to show how *different* the Jews were from everyone else in the region. On this most recent scenario, the Jews did not arrive from outside Canaan and subdue the indigenous people, as the Bible says, but were just a local tribe, like many others, who gradually separated out, with their own gods (in the plural).[22]

The significance of this is that it supports the view that the Bible was first assembled by Jews returning from the 'second exile' in Babylon (the 'first' being in Egypt), who compiled a narrative which was designed to do two things. In the first place, it purported to show that there was a precedent in ancient history for Jews to arrive from outside and take over the land; and second, in order to justify the claims to the land, the Covenant with God was invented, meaning that the Israelites needed a special God for this to happen, an entity very different from any other deity in the region.[23]

And it is in this light that the recent work of Dr Raz Kletter comes in. Dr Kletter, of the Israeli Archaeological Service, has recently completed an examination of no fewer than 850 figurines excavated over the past decades. These figurines, usually small, made of wood or moulded from clay, have exaggerated breasts and are generally meant to be viewed only from the front. Many are broken, perhaps in a ritual, and many are discarded, found in refuse dumps. Others are found in *bamot*, open sacred places. All date from the eighth to sixth centuries BC. No one knows why these figurines are found where they are found, or take the form that they do. There are also a number of male figures, either heads alone, or whole bodies, seated on horses. According to Dr Kletter, and Ephraim Stern in his magisterial survey, *Archaeology of the Land of the Bible* (volume 2), the figurines represent Yahweh and his consort, Astarte. (The female figure of 'Wisdom' is presented as a consort for the biblical God in Proverbs 8.) Professor Stern says that these Israelite figurines and *bamot* are not so different from those in neighbouring countries and he concludes that they represent an intermediate stage in the development of Judaism, between paganism and monotheism, which he calls 'pagan Yahwehism'. The significance of these figurines lies in their date and the fact that there is no substantial difference between them and figurines in other countries. They appear to support the idea that full-blown Judaism did not emerge until the Babylonian exile. In short, the Israelites of the 'second exile' period converted Yahweh into a special, single God to justify their claims to the land.[24]

There is of course an opposing argument, which is argued equally robustly. If Tel Aviv University may be said to be the centre of the radical camp in these matters, the Hebrew University in Jerusalem is the conservative centre. Amihai Mazar is professor of archaeology at the Hebrew University and author of *Archaeology of the Land of the Bible* (volume 1). He admits that many of the early books of the Hebrew scriptures, particularly where they concern the patriarchs, cannot be treated as reliable. But beyond that he won't go. In the

first place, he points to the Meneptah stele in Cairo Museum. A stele is a slab of stone bearing inscriptions and Meneptah was an Egyptian pharaoh. This stele is dated to 1204 BC and describes the conquest, by the Egyptians, of several cities in the area that is now Israel, including Ashkelon and Gezer. But the stele also describes the destruction of 'the people of Israel'. Mazar further cites the discovery of the Tel Dan stele in 1993 which carries an inscription in Aramaic referring to 'Beit David', or the House of David, as in 'David's dynasty'. Dated to the ninth century BC, Professor Mazar argues that this stele supports the traditional view as given in the Bible.[25] And whatever revisions to the biblical chronology, and meaning, are necessary, as William Foxwell Albright has remarked, no one questions the fact that monotheism was a uniquely Israelite creation within the Middle East.

The first part of the Hebrew Tanakh, the five books from Genesis through to the end of Numbers, covers the period from the Creation to the Hebrews' arrival in the Promised Land. It is held by scholars to have been taken from four sources and put together by a fifth, an editor who tried to impose unity, some time between 520 and 400 BC. The next segment comprises eight books, from Deuteronomy to the second book of Kings. There is an 'underlying unity' to these books that make most scholars think that, save for Ruth, they were written by one author, the so-called Deuteronomist, or D. The unifying theme in these books is a focus on the prophets and their concern that Israel would one day be driven from the land, and this makes scholars think that the books must have been written *after* that calamitous event had already happened: in other words, these books were written *in* exile in the mid-sixth century BC.[26] The third section runs from Chronicles to Ezra and Nehemiah and these books tell of the return from exile and the re-establishment of the Law in the land. This author is generally called the Chronicler and his books were composed and edited about 350 BC. The remainder of the Hebrew Bible was written by several authors at various dates, ranging from around 450 down to the most recent, the book of Daniel, composed *c*. 160 BC.[27]

In Chapters Four and Five we saw how several of the biblical narratives are paralleled in earlier Babylonian literature: the child in the bulrushes, for example, or the flood, in which one chosen couple build a boat into which they put a pair of each species of animal. But perhaps the most perplexing thing about the Hebrew scriptures is the fact that they give two contradictory stories about the Creation. In the early chapters of Genesis, God creates the world in six days and rests on the seventh. He separates light from dark, heaven from earth, makes the sun and stars shine, then introduces trees and grass, before birds, sea creatures, and land animals. He creates humans in his own image, and divides them into men and women. They are set to rule over the animals and to eat fruits and herbs: 'the first creation is vegetarian'.[28] Later on in Genesis, however, there is a second account of the Creation. Here God creates man from the dust on the ground (in Hebrew '*adamah*). This creation is specifically male and in this account man exists before other living things, such as vegetation. It is only when God notices that man is alone that he creates animals and brings them to man so they can be named. He creates woman out of one of man's ribs, and she is called *wo-man* ('out of man').[29] The two versions are very different and have always puzzled scholars. In the seventeenth century, as was mentioned in the Prologue,

Isaac La Peyrère suggested that the first creation applied to non-Jewish people, and the second to Adam's particular race. This explained all sorts of anomalies, such as the fact that there were people in the Arctic and the Americas, places not mentioned in the Bible, and which the age of discovery had revealed. It wasn't until 1711 that a German minister, H. B. Witter, suggested that the truth was more prosaic: the creation accounts in Genesis were written by two separate people, and at different times.[30] A similar division exists in the accounts of how the ancient Hebrews arrived in the promised land. One account has the descendants of Abraham going to Egypt and then being led by Moses, via the wilderness, into Canaan. In the other account, the land is settled from the east, with no mention of Egypt. There are several other inconsistencies, but such disparities are a common feature of other religions too.

The inconsistency is (partly) explained by arguing that there are two principal sources for the early books of the bible, what are called E, or Elohist, after the name he used for God, and J, for Yahwist (partly explained because one would have expected a later editor to have ironed out the differences). E is regarded as the earlier source, though the material derived from E is less than from J. At times, J seems to be responding to E. These early sources date mainly from the eighth century BC, though some scholars prefer the tenth. It is the J source that refers to a special relationship between God and the Jews, but there is no mention of a covenant concerning the land. This is why the covenant is thought to be a later invention of the sixth century when, during exile, the Jews became aware of Zoroastrian beliefs in Babylon.[31] The third author of the Torah is known as P, for 'Priestly', who (perhaps; some scholars doubt it) pulled E and J together but also added his own material, mainly the laws for rituals and tithes. P also used Elohim, not Yahweh.[32]

In later years, after the exile, responsibility for the accuracy of the Tanakh lay in the hands of *masoretes*, families of scribal scholars whose job it was to copy faithfully the ancient texts. This is why the canonical scriptures became known as the Masoretic Text. We have some idea of how the scriptures varied in antiquity following the discovery of the Dead Sea Scrolls at Qumran, where out of 800 scrolls, 200 are biblical books. We know now, for instance, that the form of the Torah used by the Samaritans, a northern tribe, most of whom had *not* gone into exile, varies from the Masoretic Text in, roughly speaking, 6,000 instances. Of these, the Samaritan text agrees with the Septuagint version in 1,900 instances.[33] An example will show how important – and revealing – editorial control can be. In the Hebrew language, which has consonants but no fully expressed vowels, there was always the possibility of confusion. For the most part, Hebrew words are formed from three-letter roots, which can be built up in different directions, to create families of words that refer to similar things. This makes Hebrew very efficient in some contexts – one word will be enough where three or four would be needed in English or French. But confusion is easy. Consider, for example, the well-known story of David and Goliath. During their famous encounter, Goliath wore armour, including a helmet. Archaeological discoveries have shown that helmets of the period included a protruding strip of metal that would have covered the warrior's nose and brow. How it is possible, then, that a stone from David's sling could have hit Goliath's forehead and disabled him? One plausible answer lies in the fact that the Hebrew for forehead, *metzach*, could easily have been confused with *mitzchah*, meaning greaves – leg armour, not unlike cricket pads in principle. Both

come from the same root: *m-tz-ch.* If David had thrown his stone in such a way that it lodged between Goliath's greaves and his flesh, so that he was unable to bend his knee, he could have been knocked off balance, allowing David to tower above him, and kill him.[34]

The *Neviim,* or books of the prophets, are divided into the former prophets, such as Joshua, Judges, Samuel and Kings, which are mainly narrative in construction, and the latter prophets, Isaiah, Jeremiah and Ezekiel, which were covered in Chapter 5. Ben Sira, writing around 180 BC, makes mention of 'twelve prophets'; so this section of the Tanakh must have been settled by then.[35] The *Ketuvim* are comprised mainly of 'wisdom literature' and poetical works – Psalms, Ecclesiastes, the book of Job. They are much later works than the other sections and may have joined the canon only because, in the mid-second century BC, when the Jews were being persecuted by Antiochus Epiphanes, a successor of Alexander the Great, he tried to impose Greek ways and to destroy the Hebrews' scriptures. In response, the *Ketuvim* were accepted by Jews as part of their canon. In the opening to Ben Sira's Ecclesiasticus (a book that became part of the Apocrypha, and not to be confused with Ecclesiastes) he mentions three separate types of writing: the Law, the Prophets and 'other books'. Since Ecclesiasticus was translated into Greek around 132 BC (by the author's grandson), we may take it that the canon was more or less formed by then.[36] Just how 'official' this canon was is open to doubt. The Dead Sea Scrolls from Qumran, discovered after the Second World War, are a large and very varied group, which in itself suggests that there was a great range of scriptures available, some of them very different from the Masoretic Text. By the time Jesus was alive, though there was 'a' canon of writings, there is no reason to suppose that this was 'exclusive', and that other revered texts were not in widespread use.[37]

The Septuagint – the Greek version of the Tanakh – is a case in point. In the third century BC, King Ptolemy Philadelphus, of Alexandria (285–247 BC), had the best library in the world. (Alexandria, founded by Alexander the Great in 331 BC, and based on Aristotle's principles for planning the ideal city, was built on a spit of land between the sea and a lake and was as near as practicable to the westernmost mouth of the Nile. A Greek city in Egypt, it became filled with palaces and temples and a great library, which soon made it 'the intellectual and cultural capital of the world'.[38]) However, the king was told by his librarian, Demetrius, that he lacked five important books: the Torah. Accordingly, Ptolemy Philadelphus approached Eleazar, high priest in Jerusalem, who made seventy scholars available, to translate the Hebrew books into Greek. Without being aware of it, these seventy scholars each produced identical translations. A more probable chronology is that Hebrew, as a spoken language, began to die out during exile, to be replaced by Aramaic (the language of Jesus) as the spoken tongue. Gradually, Hebrew became a literary language (like medieval Latin) and, among the Hellenised Jews in Alexandria, the need arose for a Greek version of their Bible. The Torah may have been translated into Greek as early as the fifth/fourth century BC. What interests us here, apart from the fantastic nature of the translation legend, is the fact that the Septuagint comprised all the books of the Old Testament that we use (but in a different order), plus the Apocrypha and the Pseud-epigrapha.[39]

The books in the Apocrypha include Ecclesiasticus, Judith, the first and second book of

Maccabees, Tobit, and Wisdom. In Jerusalem they were not seen as divinely inspired, though they had a kind of second-rate authority. In Alexandria, they were accepted as part of the canon, though there too they were regarded as less important.[40] The Pseudepigrapha are so-called because it was the practice of the time to attribute what were in fact anonymous writings to famous figures from the past. For example, the Wisdom of Solomon was written down long after its 'author' was dead. The book of Jubilees describes the history of the world from the Creation to the Jews' wanderings in Sinai and adds such details as the names of Adam's children, following on from Cain, Abel and Seth. Other books provide extra details about the Exodus.[41] But most of all the Apocrypha and the Pseudepigrapha show how ideas were developing in Judaism in the years before Jesus was born. The idea of Satan emerges, the resurrection of the body is distinguished from the resurrection of the soul, and ideas about rewards and punishments beyond the grave emerge. 'Sheol', the underworld where hitherto the dead dwelt, in some discomfort, is now divided into two compartments, a form of heaven for the righteous and what was in effect hell for the unrighteous. These ideas may also have been first encountered when the Israelites were in exile among Zoroastrians in Babylon.[42]

It is worth noting, once more, how different the Hebrew scriptures were from Greek literature, produced at more or less the same time. In particular, the Tanakh was narrow in outlook. As Robin Lane Fox has observed, there is no detailed concern with politics, or with the great forces – economic, scientific, even geographic – that shape the world. Certain comparisons highlight this difference. For example, the Song of Deborah in the Old Testament is, like Aeschylus' *The Persians*, an examination of the impact of defeat in war on the enemy's royal women. The Hebrew scriptures are a victory ode, they gloat over the changed circumstances of the women with the words: 'So let all thine enemies perish, O Lord.' In contrast, Aeschylus' tragedy shows sympathy for the women: the gods may have fought on the side of Greece but that doesn't stop their enemies being treated as full human beings in their own right.[43]

An even bigger gulf existed between the history of Herodotus and Thucydides and the Hebrew scriptures. Herodotus does allow for miracles and Thucydides sees 'the hand of fate' behind events; however, whereas the Greeks researched their books, visited actual sites and interrogated eyewitnesses where they could, and whereas they regarded men as responsible for their actions, in both victory and defeat and, in Thucydides' case certainly, allowed little or no role for the gods, the Hebrew Bible is almost the exact opposite. The writings are anonymous, they show no signs of research – no one has travelled to see anything for themselves, or made any attempt to compare the Hebrew stories with outside, independent authorities. The Hebrew scriptures aim to tell the entire history of the world, since creation, treating distant events in much the same way as more recent happenings. The Genesis narrative (but less so the later books) is full of fantastic dates, never queried, unlike Thucydides, say, who was well aware of local calendars and how they differed from one another. The main point of the Old Testament is the Hebrews' relation with their God. It is a much more closed, inward-looking narrative. Several authors have made the point that the first time Judaism was used as a specific term was in the second book of Maccabees, written around 120 BC, to contrast the Jewish way of life with that of Hellenism.[44] What

is unquestionably moving about the Tanakh, however, is its focus on ordinary people faced with great questions. 'The Jews were the first race to find words to express the deepest human emotions, especially the feelings produced by bodily or mental suffering, anxiety, spiritual despair and desolation ...'[45] Some of the texts were 'borrowed' from earlier writings. Proverbs, for instance, was taken in disguised form from an Egyptian work, *The Wisdom of Amenope*. But throughout the Hebrew Bible there is the feeling of a small people living in God's shadow, 'which means, in effect, living for a large amount of time in ignorance of the divine will. Inevitably perhaps, this means it is about dealing with misfortune, often unforeseen and undeserved misfortune.'[46] Is any scripture as poignant, tragic and extraordinary as the book of Job? In its concern with evil it is not quite so unique as is sometimes made out. Job appears to have been written between 600 and 200 BC, by which time the problem of evil had been discussed in other Near Eastern literature.[47] Where Job *is* special is in two aspects. For a start, there are more than a hundred words in it that occur nowhere else. How the early translators dealt with his predicament has always baffled philologists. But the book's true originality surely lies in its examination of the idea of the unjust God. At one level the book is about ignorance and suffering. At the outset, Job is ignorant of the wager God has had with Satan: will Job, as his suffering multiplies, abandon his God? Although we, the reader, know about the wager, while Job does not, this does not necessarily mean that we know God's motives any better. The book is really about ignorance as much as it is about evil: what we know, what we think we know, what – in the end – we can know.[48] What is the place of faith in a world where God is unjust? Who are we to question God's motives?

After exile, the changed character of Judaism, as a religion of the book, had two important consequences, each very different from the other. Concentration on a canon made the Israelites a relatively narrow people (though there were exceptions, like Philo and Josephus). This may well have made them inflexible, unwilling to adapt, with momentous – not to say disastrous – consequences. On the other hand, a religion of the book almost by definition promoted literacy and a respect for scholarship that stood them in good stead. A respect for the written word – the law in particular – was also a civilising factor, giving the Jews a pronounced collective sense of purpose. Scholarship surrounding the scriptures led to the introduction of a new entity in Judaism: the synagogue, where the book was taught and studied in detail. Synagogue is at root a Greek word. It means simply a place where people gather together, and this too suggests that it developed during exile. In Babylon, the Jews may well have gathered together in each other's homes, on the newly-instituted Sabbath, to read (to begin with) the relevant parts of the Torah. This practice was certainly in place by the time of Ezra and Nehemiah, though the earliest synagogue we know about was in Alexandria, where the remains have been dated to the time of Ptolemy III (246–221 BC).[49]

The problem for the Jews was that, despite the success of their religion (as they saw it), their central political predicament had changed hardly at all. They were still a small people, uncompromisingly religious, surrounded by greater powers. From the time of Alexander the Great onwards, Palestine and the Middle East were ruled variously by Macedonians, the Ptolemies of Egypt and the Seleucids of Syria. Each of these – and this is the crucial

factor – was Hellenistic in outlook, and Israel became surrounded by cities, *poleis*, where, instead of the synagogue and Temple (as was true of Jerusalem), the gymnasium, the theatre, the lyceum, the agora and the odeum were the main cultural institutions. This was the situation in Tyre, Sidon, Byblos and Tripoli and as a result the towns of Samaria and Judaea were regarded as backwaters. This cultural division succeeded only in driving the more orthodox Jews back on themselves. Many retreated to the desert, in search of a ritual purity which they felt was unobtainable in cities, even Jerusalem. At the same time, however, there were many other Jews, often the better educated ones, who found Hellenistic culture more varied and better balanced than their own. At root, this meant that, for the Jews, Hellenisation, in Paul Johnson's words, 'was a destabilising force spiritually and, above all, it was a secularising, a materialistic force'.[50] This combustible mix ignited in 175 BC, when there was a new Seleucid ruler, Antiochus Epiphanes, referred to earlier (page 157). Prior to this date, there had been some attempts to reform orthodox Judaism. The Hellenism that existed throughout the Middle East promoted trade and, in general, the relaxation of religious differences. The Greeks had a different idea of divinity as compared with the Jews. 'To the Hellenistic imagination the gods are like ourselves, only more beautiful, and descend to earth in order to teach men reason and the laws of harmony.'[51] In line with this, the Greeks, Egyptians and Babylonians were prepared to amalgamate their gods – for example, Apollo-Helios-Hermes, the sun god.[52]

For orthodox Jews, however, this was pagan barbarism at its very worst and it was confirmed when Antiochus Epiphanes began a series of measures designed to promote Hellenisation and aid the reformers among the Hebrews in Israel. He dismissed the orthodox high priest, substituting a reformer, he changed the city's name, to Antiocha, he built a gymnasium near the Temple and took some of the Temple funds to pay for Hellenistic activities, such as athletic games (which, remember, were themselves religious ceremonies of a sort). Finally, in 167 BC, he abolished Mosaic law, replaced it with Greek secular law, at the same time demoting the Temple so that it became merely a place of ecumenical worship. This was a move too far for the *Hasidim* (= pious). They refused to accept these changes and they opposed Antiochus with a new tactic: religious martyrdom. For a quarter of a century, there was bitter religious conflict which resulted, for the time being, in victory for the *Hasidim*. Not only did the Jews win back their independence, including their religious independence, but the idea of reform was also discredited. From that time on, 'The temple was more sacrosanct than ever, fierce adherence to the Torah was reinforced and Judaism turned in on itself and away from the Greek world. The mob now became an important part of the Jerusalem scene, making the city, and Judaea as a whole, extremely difficult to govern by anyone … The intellectual freedom that characterised Greece and the Greek world was unknown in Palestine, where a national system of local schools was installed in which all boys – and only boys – were taught the Torah and nothing else. All other forms of knowledge were rejected.'[53]

Within this post-Antiochus Epiphanes world, and in the years preceding the birth of Jesus Christ, and despite the power of the *Hasidim*, Judaism continued to develop, and took four main forms. What happened subsequently cannot be understood without some grasp of these four developments.

*

The Sadducees were priests, sometimes described as the aristocracy of Jewish society, who were more open than most to foreign ideas and influences. They may have derived their name from Zadok, a high priest in Davidic times, though there are alternative explanations. Politically, they favoured peaceful co-operation with whichever occupying power happened to be governing the country. In religious terms they were characterised by a literal interpretation of the Torah. This did not make them as conservative as it might have done, however, because their literal beliefs led them to oppose the extension of the Torah into areas not specified in scriptures. Since they confined their Bible to the Pentateuch, they had no notion of the Messiah, nor any belief in resurrection.[54]

The idea of resurrection seems to have first developed around 160 BC, during the time of religious martyrdom, and as a response to it (the martyrs were surely not dying for ever?). It is first mentioned in the book of Daniel. We saw earlier how the idea of Sheol had evolved during exile, and then into a rudimentary concept of heaven and hell, and how the Jews may have garnered the notion of a covenant with God from Zoroastrian sources picked up in Bablyon. The same may be true of resurrection, which was another Zoroastrian idea. Although Zoroaster had said that all souls would have to cross a bridge at death, to reach eternal bliss, when the unrighteous would fall into the netherworld, he also said that, after 'limited time', there was to be bodily resurrection. The world would undergo a great ordeal in which all the metal in the mountains of the world would be melted, so the earth would be covered by a great stream of molten metal. For the righteous, the molten metal would not be a problem – 'It will be like walking on warm milk' – but the wicked would perish, the world would be purged of the sinful and, with only the righteous alive, the earth itself would now be paradise.[55] As many commentators have observed, the Jews' predicament, of being surrounded by powerful neighbours, was a natural setting for Zoroastrian beliefs, of a great conflagration, in which great evil powers would be destroyed, and the righteous would be resurrected. It was in such a scenario that the idea of a Messiah, who would lead the righteous to victory, also arose, but that came later.

The Pharisees were a diametrically opposite group to the Sadducees. They were a lay movement, very conservative, but extended the Torah to all areas of life, even those not specified in the scriptures. They were obsessed with ritual purity and held a deep belief in the Messiah and in resurrection. For them the synagogue rather than the Temple was the main way they spread their beliefs. 'They yearned for God to bring about the last days but did nothing to initiate the End themselves.'[56]

The Zealots were the extreme party – indeed, the word has entered the language as the symbol of extremism. Their main aim, unlike the Sadducees, was to 'purge' Israel of foreign 'defilement' and they were willing to go to war if necessary to achieve their aim. They believed that 'the people of God' would triumph.[57]

The Essenes held property in common and ate and lived together. It was in all probability an Essene community that lived at Qumran, where the Dead Sea Scrolls were discovered after the Second World War.[58] They were pious, hostile to other Jews, and held elaborate initiation rites. Their most notable idea was that they were living 'at the edge of time, in the very last days', and they spent those days preparing for the coming of God, who would relieve them of the world's bleak political realities and restore the Jews to glory. They

believed that there would be a Messiah, who would lead them to Paradise (some even believed in *two* Messiahs, one priestly, the other military, a return to ancient Mesopotamian ideas). Essene writings were found at Masada, where the sect was destroyed.

The idea of a Messiah ('the anointed') is, according to some scholars, implicit in Judaism. It is related to the idea there would come a new age of peace, righteousness and justice, following cataclysmic disorder.[59] It was also believed that there was a predetermined history of the world, from Creation to Eschaton ('the end', in the sense of the end of time, which 'will bring God's definitive and ultimate intervention in history').[60] The name given to this set of ideas is 'apocalyptic eschatology': a period of catastrophe, followed by the revelation of hidden things (which is the meaning of apocalypse), and the ultimate triumph of God. And, to quote Paula Fredericksen again, 'happy people do not write apocalypses'. The Messiah (*mashiah*) was an important factor in apocalyptic eschatology. There are some thirty-nine references to such a figure in the Old Testament where, to begin with, the term means king. 'Jewish tradition gave pride of place to the expectation that a descendant of David would arise in the last days to lead the people of God ... A human descendant of David would pave the way for a period of bliss for Israel.'[61] At this time, the Israelites would return to the vegetarian diet they had at the Creation.[62] This Messiah figure was not a supernatural phenomenon at first; in the Psalms of Solomon (Apocrypha), for instance, he is a man like other men – there is no doubt about his humanity.[63] The Messiah only became supernatural because the political situation of the Jews deteriorated, became 'so bleak that only a supernatural act could rescue them'.[64]

By the time of Jesus, the whole world of which Palestine formed a small part had to come to terms with Rome, the greatest occupying power the world had ever known. For a fundamentalist people, such as the Jews, for whom political occupation was the same as religious occupation, the world must have seemed bleaker than ever. In earlier bleak times, as we have seen, there had been an outbreak of prophecy and now, beginning in the second century BC, there was another, though this time, given that Zoroastrian ideas had been incorporated into the Jewish scheme of things, apocalyptic eschatology shaped these beliefs. Only a Messiah with supernatural powers could save the Jews. And it was into this world that Jesus was born. In Greek the term Messiah is translated as *Christos*, which is how, in time, this became Jesus' name, rather than his title.[65] In this way, too, general prophecies about the Messiah came to be applied to Jesus Christ.

Before we come to Jesus, we need to examine one other factor – the role of Herod and the Temple he rebuilt in Jerusalem. By the time Herod became a satellite king of the Romans in 37 BC, Palestine had been under Roman rule for a quarter of a century. The Jews had never stopped squabbling among themselves, as well as resisting foreign rule where they could. Herod had his own contradictory ideas and, as Paul Johnson says, he was a baffling figure, 'both a Jew and an anti-Jew'.[66] When he took power, one of his first acts was to execute forty-six members of the Sanhedrin, the Committee of Elders, who had been chiefly responsible for extending Mosaic law into traditional secular areas. Like Antiochus Epiphanes before him, he appointed more sophisticated, less fundamental figures in their stead, at the same time limiting the Sanhedrin to a religious court only.[67]

Herod agreed with many sophisticated people that Palestine was backward and could

benefit from closer acquaintance with the Greek way of life. Accordingly he built new towns, new harbours, new theatres. But he headed off the kind of revolt that Antiochus Epiphanes had provoked by a massive rebuilding of the Temple. This began in 22 BC, and took forty-six years to complete, meaning that the great Temple was under construction throughout Jesus' life. The scale of works was impressive. It took two years just to assemble and train the workforce of ten thousand. A thousand priests were needed to oversee the workforce, because only priests could enter restricted holy areas. The finished Temple was twice the size of what had gone before (about twice as high as what can be seen today on what Jews call the Temple Mount). It was a colourful and exotic place. There was a vast outer courtyard, open to all, where money-changers had their stalls and where they exchanged coins from any currency into the 'holy shekels' needed to pay Temple fees. (It was these money-changers to whom Jesus would take such exception.) In this outer section, there were large signs in Latin and Greek which warned non-Jews that they risked death if they went further. Beyond the outer courtyard was a series of smaller ones for special Jewish groups, such as women and lepers. The inner courtyard was open only to male Jews. The Temple was always crowded and busy. In addition to the thousands of priests who worked there, large numbers of scribes and Levites helped in the ceremonies, either as musicians, engineers or cleaners.[68] Only the high priest could enter the central compartment, the Holy of Holies, and even then only on the Day of Atonement every year.[69]

By tradition two lambs were sacrificed at dawn and dusk each day, but every pilgrim could offer their own individual sacrifices. This practice was accompanied by singing and music and wine drinking, and needed, we are told, an average of thirteen priests per sacrifice. One description of the Temple refers to seven hundred priests performing sacrifices, which means that more than fifty animals were killed at that one time. No wonder that their squeals, added to the music and chanting, struck many people as barbaric.[70]

The Temple was an impressive site. But under Herod the Jews were no happier in their skin, Palestine was still a client state, and orthodox Judaism still as uncompromising as ever. In AD 66, seventy years after Herod's death, the Jews revolted again, and this time were put down with such vehemence that his magnificent Temple was completely destroyed and the Jews were sent away from Palestine for two thousand years. Between Herod's death and the destruction of his Temple, there occurred one of the most decisive, yet mysterious, events in world history: the advent of Jesus.

Did Jesus exist? Was he a person or an idea? Can we ever know? If he didn't exist, why did the faith he founded catch on so quickly? These are questions which have provoked scholars since the Enlightenment when 'The Quest for the Historical Jesus' became a major academic preoccupation. It has to be said that, today, the scepticism, where it once existed, is declining: few biblical scholars now doubt that Jesus was a historical figure. At the same time, there is no escaping the fact that the gospels are inconsistent and contradictory, or that Paul's writings – letters mainly – predate the gospels and yet make no mention of many of the more striking episodes that make up Jesus' life. For example, Paul never refers to the virgin birth, never calls Jesus 'of Nazareth', does not refer to his trial, nor does he specify that the crucifixion took place in Jerusalem (though he implies it occurred in Judaea, in 1 Thessalonians 2:14/15). He never uses the title 'Son of Man' and mentions no

miracles Jesus is supposed to have performed. So there is, at the least, widespread scepticism about the *details* of Jesus' life.[71]

Scepticism also arises from the fact that the *idea* of Jesus was not entirely new. For example, there were at that time at least four gods – Attis, Tammuz, Adonis and Osiris – who were widely revered in the Middle East 'as victims of an untimely death'.[72] These were vegetation gods, not saviour figures explicitly, but they needed to be revived for the sake of the community: there was an overlap in meaning.[73] Nor should we forget that, in Hebrew, the very name of Jesus (*Ieshouah*) means salvation. Allied to the word *Christos* – 'Messiah', as was mentioned above, meaning king and redeemer – Jesus Christ, on this analysis, is less a historical personage than a ritual title.

The early Christian literature, and its relation to the development of Christian ideas, is uncertain. In all the shortcomings of the New Testament, discussed below, we should remember that the earliest gospels were written some forty years after Jesus' death and therefore they stand in much greater proximity to the events they purport to record than all but one of the books of the Hebrew Bible (the exception is Nehemiah).[74] Altogether, there are in existence about eighty-five fragments of New Testament passages which are datable to before AD 300. The four gospels that we use were all in existence by, roughly speaking, AD 100, but we know of at least ten others. These include a Gospel of Thomas, of Peter, of the Hebrews, and of Truth.[75] The Gospel of Peter, for example, like our gospels, details the Passion, Burial and Resurrection, making much more of the latter event. It also relates the Passion to Hebrew scriptures much more deliberately than do our gospels. The Gospel of Thomas has been dated to mid-second century and is a collection of sayings by Jesus, openly anti-women and turning some of the sayings of Jesus on their head.[76] And, as Robin Lane Fox reports, four fragments of a gospel 'of unknown identity' were discovered in 1935 from a papyrus found in Egypt; it contains many of the stories found in our gospels, but in a different order.

The preface of the third gospel (Luke) refers to 'many' previous attempts at writing a narrative about Jesus, but apart from Mark and Matthew none of these has survived. The same is true of at least some of Paul's letters. Paul wrote the earliest of his letters (to the Galatians, *c.* 48/50 AD), very soon after Jesus died, so if Paul made no mention of the more striking episodes, can they ever have happened? If they did not, where does the tradition come from? The first mention we have of Matthew's gospel comes in a series of letters written by Ignatius, bishop of Antioch, around 110, though Matthew isn't mentioned by name. The first evidence of John's gospel comes from a scrap of papyrus, datable by its handwriting to around 125 and there is a reference to a gospel by Mark a little later, *c.* 125–140.[77] The earliest gospel source is generally taken to be Mark, *c.* AD 75. This is mentioned in a quotation by Papias, bishop of Hierapolis (inland from the Ionian coast, in Asia Minor, Turkey, near the river Maeander). Writing around 120–138 he quoted John the Elder, a disciple of the Lord, who said that Mark was the interpreter of Peter 'and wrote down carefully what he remembered of what had been said or done by the Lord, but not in the right order'. However, the language of Mark (which, like all the gospels, was written in Greek) was in a style inferior to that used by educated writers. The chances are therefore that he was not a sophisticated man, may not have been directly linked with the apostles and, worse, may have been credulous and unreliable. Given that there is a gap of between

fifty and eighty years between Jesus' death and the writing of the later gospels, their accuracy must be called into question. Of the gospels, only one, John, refers to an author: 'the disciple whom Jesus loved.'[78]

The early Christians seem to have had contradictory ideas about the gospels. Around 140 Marcion, a noted heretic, who believed that the God of the New Testament was superior to the God of the Old Testament, thought that one gospel – Luke – was enough. By the 170s, however, our four gospels began to emerge as somehow special, for this was when Tatian, a pupil of Justin, the Roman Christian writer, brought them together, 'harmonised' as a special book. The four gospels we use were originally written in Greek but we know early translations in Latin, Syriac and Egyptian. Some of the translations are as early as 200 and resulted in many variations. Around 383, Jerome produced a major revision of the Latin versions using, it is said, earlier Greek texts to correct errors that had crept in. Jerome's Bible became the basis for the Vulgate, the standard Latin version, replacing earlier partial translations, called the *Itala*.[79] But the actual list of New Testament books that we use was not settled until the fourth century, when the early Christian bishops approved that grouping.[80]

The most significant difference in the gospels is that between John and the other three. Matthew, Mark and Luke are known as the 'synoptic' gospels because they are essentially narratives of Jesus' story, and these stories, it is often said, are like photographs taken of the same subject from different angles. (Luke may have been deliberately 'tweaking' Matthew and Mark, to bring out different aspects of Jesus.) In the synoptic gospels Jesus hardly ever refers to himself, still less to his mission from God.[81] But in John Jesus' life story is less significant than his *meaning*, as an emissary from the Father.[82] Even Jesus' manner of speaking is different in the fourth gospel, for he constantly affirms that he is indeed the 'Son of God'. It may well be that John is a later work, and one specifically designed to be a reflection on the events reported in the other three. But if so, why does it not even attempt to clear up some of the glaring inconsistencies? The very proximity of the gospels to the events they report only makes these inconsistencies more troubling.

They begin with Jesus' birth. For a start, neither Mark nor John even mentions the Nativity, despite its sensational nature. Matthew locates Jesus' birth in Bethlehem but says it took place in the later years of King Herod's reign, while Luke connects the Annunciation with King Herod's reign and associates the Nativity, in Bethlehem, with a specific event: 'And it came to pass in those days, that there went out a decree from Caesar Augustus, that all the world should be taxed.' This tax was first imposed during the time when Quirinius was governor of Syria, which was the year we understand as 6 AD, *after* Herod had died. According to this, then, Matthew and Luke have the birth of Jesus ten years apart.[83]

Details surrounding the virgin birth are even less satisfactory. The uncomfortable truth is that, despite its singular nature, there is no mention of it in either Mark or John, or in any of Paul's letters. Even in Matthew and Luke, according to Geza Vermes, the Oxford biblical scholar, it is treated 'merely as a preface to the main story, and as neither of these two, nor the rest of the New Testament, ever allude to it again, it may be safely assumed that it is a secondary accretion.'[84] In any case, the word 'virgin' was used 'elastically' in both Greek and Hebrew. In one sense it was used for people in their first marriage. Greek and Latin inscriptions found in the catacombs in Rome show that the word 'virgin' could

be applied to either a wife or husband after years of marriage. Thus 'a virgin husband' almost certainly meant a married man who had not been married before. Another meaning of the term was applied to women who could not conceive – i.e., had not menstruated. 'This form of virginity ended with menstruation.'[85] Even in those gospels where the virgin birth is mentioned, the inconsistencies multiply. In Matthew the angel visits Joseph to announce the birth, but not Mary. In Luke he visits Mary and not Joseph. In Luke Christ's divinity is announced to the shepherds, in Matthew by the appearance of a star in the east. In Luke it is the shepherds who make the first adoration, whereas in Matthew it is the Magi. Then there is the episode, mentioned in Matthew, where King Herod, worried about the birth of a 'new king', commands that all infants under two and living in Bethlehem should be killed. If such mass infanticide ever took place, it would surely have been mentioned in Josephus, who so carefully recorded Herod's other brutalities. But he does not.[86]

The wondrous virginity of Jesus' birth also interferes with his genealogy. Jewish messianic tradition, as we have seen, deemed that Jesus should be descended from David, which rules out Mary as the vehicle because she, we are told, came from the tribe of Levi, not of Judah, as did David.[87] But, according to the gospels, Jesus is not born of Joseph at all, but of the Holy Ghost. Therefore, there is no link to David.[88] On the other hand, according to a very early version of the New Testament (the Sinaitic palimpsest, dated to 200), 'Jacob begat Joseph; Joseph to whom was espoused Mary the virgin, begat Jesus, who is called the Christ.'[89] On this reading, can Jesus be regarded as divine at all? In the same way, in Luke, the twelve-year-old Jesus amazes the learned men in the Temple with his understanding. But when his worried parents come to find him, he rebukes them: 'Wist ye not that I must be in my father's house?' The gospel continues: 'They understood not the saying which he spake unto them.' In other words, they appear unaware of his divine mission. How can that be when Mary has experienced such a miraculous birth? These inconsistencies, and the silence of other New Testament books on the subject, have led many scholars to agree with Vermes, that this is a later addition. But how can such an idea have arisen? There is nothing in Jewish tradition to suggest it. In the Hebrew Bible several of the wives of the patriarchs were sterile women whose wombs, 'closed by God', were later 'opened'. This was divine intervention, 'but it never resulted in divine impregnation'.[90] One possibility is the prophecy of Isaiah (7:14), discussed in Chapter 5, which reads: 'The Lord himself shall give you a sign; a young woman shall conceive and bear a son, and shall call his name Immanuel' (a name which means 'God be with us'). But Isaiah is not suggesting anything supernatural here: the Hebrew word he used, *almah*, means 'young woman', who may or may not be a virgin. When this was translated into Greek, however, in the Septuagint, the word used, $\pi\alpha\rho\theta\acute{\epsilon}\nu o\varsigma$ (*parthenos*), does mean 'virgin', and the passage read: 'the virgin shall be with child and thou [the husband] shall call his name Immanuel'.[91]

In strong contrast with Jewish tradition, the pagan world contained many stories where important figures were virgin-born. In Asia Minor, Nana, the mother of Attis, was a virgin who conceived 'by putting a ripe almond or pomegranate in her bosom'. Then there is Hera who went far away 'from Zeus and men' to conceive and bear Typhon.[92] Similar legends existed in China but the closest parallel was the Mexican deity, Quetzalcoatl, who was born of a 'pure virgin' and was called 'the Queen of Heaven'. In her case too, an

ambassador from heaven announced to her that it was the will of god she could conceive a son 'without connection with men'. The anthropologist J. G. Frazer believed these stories were very primitive, deriving their force from a time when early man had yet to understand the male role in conception.[93] The writings of Philo of Alexandria (born about 20 BC, and therefore both contemporaneous with Jesus *and* earlier than the gospels) shows that ideas of virgin birth were common in the pagan world around the time that Christ lived.[94] And of course, Christmas itself eventually settled on the day that many pagan religions celebrated the birth of the sun god, because this was the winter solstice, when the days began to lengthen. Here, again, is J. G. Frazer: 'The pagans in Syria and Egypt represented the new-born sun by the image of an infant which on the winter solstice was exhibited to worshippers, who were told: "Behold the virgin has brought forth".'[95]

The fact that Jesus was a Galilean also takes us into difficult territory. For Galilee was both socially and politically different from Judaea. It was primarily a rural area, settled by peasants but it was rich from the export of olive oil. The larger cities were Hellenised and it had become Jewish only fairly recently. In the eighth century BC, for example, Isaiah had referred to 'The district (*gelil*) of the Gentiles'.[96] Galilee was also home to what we would today call terrorists – Ezekias, executed in about 47 BC, and his son Judas who, with Zadok, a Pharisee, founded the Zealots, a politico-religious party, who advocated paying no taxes and recognised no foreign masters. It was descendants of Judas who led the revolt at Masada, a fortress on top of a 1,300-foot high rock on the edge of the Judaean desert, where 960 'insurgents and refugees' were killed or committed mass suicide rather than surrender.[97] Galileans had a pronounced rural accent (the Bible comments on this) and so Jesus may have been seen as a revolutionary, whether he was or not. We must also remember that the Aramaic word for carpenter or craftsman (*naggar*) also stands for 'scholar' or 'learned man'. This might well account for the respect Jesus was held in from the start (and for the fact that he appears never to have had a job).[98] On this account, was he seen as the eloquent mouthpiece for a Galilean revolutionary party?[99]

Contradiction and inconsistency also surround Jesus' trial and Crucifixion, which throws yet more doubt on his identity and the nature of his beliefs. Christopher Rowland puts the issue plainly: Jesus was crucified by the Romans – why and what for? Specifically, why was he not punished by the Jews? Was his crime political, rather than religious, or political *and* religious (in the Palestine of the day it was often hard to distinguish the two). Jesus repeatedly espoused non-violent methods, which mean he could in no way be identified with the Zealots; on the other hand, his continual advocacy, that the kingdom of God was 'at hand', could easily have been seen as a political statement.

The first inconsistency concerns Jesus' reception in Jerusalem. We are told that he was received 'triumphantly' by 'the multitude' and that the priests, who led this multitude, were unanimous in their reception. Within days, however, he is on trial, with the priests clamouring for his death. All four gospels agree that Jesus was first examined by the Jewish religious establishment before being handed over to Pilate, governor of Judaea. The first meeting takes place at the house of the high priest, Caiaphas, in the evening.[100] With all the other scribes and elders gathered, Caiaphas asks Jesus if he really does claim to be the

Messiah and 'Jesus replies with words that the high priest deems to be blasphemous'.[101] What can this reply have been? Under Jewish law blasphemy was a capital crime but it was not blasphemous to claim to be the Messiah – Simon bar Cochba claimed to be the Messiah a hundred years after Jesus' death and was even accepted as such by certain prominent Jews.[102] The inconsistencies don't end there. After the meeting with Caiaphas, Jesus was passed on to Pilate. Yet Jewish law prevented a capital prosecution and execution at the time of the Sabbath, or festivals, as this was, and other laws prevented trials and executions on the same day, or at night. Finally, the penalty for blasphemy was stoning to death, not crucifixion.

The point is that none of this make any sense at all, in the context of the times, if Jesus' crime(s) was or were essentially religious.[103] But if his crimes were political, why is Pilate reported to have said, 'I find no fault in this man.' Other sources confirm that Pilate was 'constantly on the alert against invasion or uprising'. The Jews actually go so far, before Pilate, of accusing Jesus of fomenting revolution. 'We found this man perverting our nation and forbidding us to give tribute to Caesar and saying that he himself is Christ the king.' Yet none of Jesus' followers were arrested with him, which would surely have happened had he been at the head of a political group, and Pilate hands him back to the Jews, to carry out what is a Roman execution. In some of the gospels there is no formal judgement by Pilate, and no formal sentence – he just lets the Jews have their way.[104] Nor is the Crucifixion any clearer in its meaning. There is for example no known case of a Roman governor releasing a prisoner (such as Barabbas) on demand.[105] And in fact this episode may be both more and less than it seems. Barabbas actually means 'son of the father' (Bar Abba) and we now know that in some early copies of Matthew, Barabbas' name is given as Jesus Barabbas.[106] Finally, at the Crucifixion itself, we are told that the sun darkened and the earth shook. Is this supposed to be a real or a metaphorical event? There is no independent corroboration of this: Pliny the Elder (c. AD 23–79) devoted an entire chapter of his *Natural History* to eclipses and makes no mention of anything that would fit with the Crucifixion.[107]

The inconsistencies of the resurrection are even more glaring, though in the first place we should remind ourselves that we have no eyewitnesses for these events. This is true despite the fact that the earliest mention of who was present at this remarkable set of episodes is given by Paul in his first epistle to the Corinthians, written in the mid-50s, before the gospels. Regarding the discovery of the empty tomb, Matthew says the women came to look at it, whereas in Mark they had looked at it before and now returned with spices to embalm the body. John is different again: the body had been embalmed by Nicodemus. In three of the gospels the stone was already rolled back, but in Matthew an angel rolled it back in the presence of the women.[108] In Matthew the risen Jesus appears to the disciples in Galilee, whereas in Luke the episode takes place in Jerusalem.

In his first epistle to the Corinthians, composed in the mid-50s, well before the written gospels, though not necessarily before a gospel tradition was circulating orally, Paul gives a list of witnesses to the resurrection and the important observation to be made is that Paul, although he expected to live to see the last days, fails to mention the empty tomb.[109] Possibly more important, the language he uses to describe the appearance of the resurrected Christ to the disciples, *ophthe*, is the same as he used to describe his own vision on the

road to Damascus. In other words, it appears that for Paul the resurrection was not a physical thing, 'not the return to life of dead flesh and blood', but rather a spiritual transformation, a different form of *understanding*.[110]

There are arguments against this interpretation. For example, all the witnesses to the empty tomb were women and although there were wealthy women in Judaea, and despite the fact that women are heroines in contemporary literature, in general they had such a low status at that time that if someone were going to invent evidence they would surely not have chosen women. In the same vein, all the conversations which the risen Jesus has with those he meets are unremarkable, ordinary, no different from those he had before the Crucifixion. Again, had people invented these encounters then, given the singular nature of the phenomenon, the meetings would surely have been embellished to make them more significant.[111]

It is perfectly possible that Jesus was both a religious and a political threat – the two were by no means incompatible. If Jesus did call himself the Messiah, or even if he allowed his followers to look upon him in that way, he was automatically a political threat because of the Jewish conception of the Messiah as military hero who would lead the Jews to revolt against Rome. He was a religious threat because the Sadducees would be undone by someone whose conception of Judaism was so at odds with theirs. But this still does not explain the inconsistencies.

The very latest Jesus scholarship runs as follows: despite the differences discussed above, the striking similarities that remain in Matthew, Mark and Luke stem from the fact that Matthew and Luke each had a copy of Mark when they were composing their gospels. More, if you take out Mark from Matthew and Luke, you still have a lot of similar material, 'including vast sections that are nearly word-for-word.'[112] Nineteenth-century German scholars called this Q, for *Quelle*, or 'source'. Together with the find, in 1945, at Nag Hammadi in Upper Egypt, of the Gospel of Thomas, which scholars knew about but thought had vanished, this put a fresh light on the New Testament. The two most eye-catching and controversial views that have emerged from these discoveries are, first, Burton Mack's, that Jesus was 'a historical footnote', 'a marginal personality who, through whatever series of accidents, was turned into a god', and Paula Fredericksen's, that 'Jesus was a Jewish apocalypticist who expected a cataclysmic intervention of God into history ... and was devastatingly wrong. Christianity, then, amounts to a series of attempts to deal with this staggering error, most notably the doctrine of the Second Coming.'[113] Both of these give Jesus a much-reduced status but still consider him to have been a historical figure.[114]

Whatever Christianity means today, and we shall be following the ways in which its message changed in later chapters, the main idea of Jesus, as reflected in the New Testament, is relatively simple. It was that 'the kingdom of God is at hand'. The actual phrase itself was not common in Hebrew scriptures but, as we have seen, the idea of a Messiah had grown more popular among the Israelites and, in the hundred or so years before Jesus' birth, had changed its meaning, from 'king' to 'redeemer'. It is important to add, however, that Jesus never once called himself the Messiah.[115]

Johannes Weiss, the German New Testament scholar, argued in *Jesus' Proclamation of the Kingdom of God*, published in English in 1971, that this dominant idea of Jesus could

be broken down into four elements: that the messianic time was imminent; that, once God had established the kingdom, judgement and rule would be transferred to Jesus; that initially Jesus hoped he would live to see the kingdom established, but subsequently he realised his death would be required. Even then, however, he believed that the kingdom would be established *in the lifetime of the generation that had rejected him*, when he would return 'upon the clouds of heaven' and the land of Palestine would form the centre of the new kingdom. In other words, Jesus was not speaking just about spiritual renewal, but he envisaged fundamental change in the physical reality of the world, and he expected it soon.[116] Around the edges of this dominant idea, Jesus often took a more relaxed approach to the details of Jewish law (observance of the Sabbath, dietary restrictions), emphasising God's mercy rather than his punitive justice, and insisting on inner conviction rather than outward observance of ritual. His message was, after all, directed at Jews. He never envisaged a new religious system: 'I was sent to the lost sheep of the house of Israel, and to them alone.'[117] He even turned away Gentiles who sought him out.[118] This is a simple but all-important idea that has got lost in history.

After Jesus' resurrection, and his ascension into heaven, his followers continued to worship in the Temple, expecting his return at any moment and with it their own redemption. To this end, they tried to prepare Israel, urging on their fellow Jews the changes Jesus had proposed. But this, of course, conflicted with the authority of the traditional priests and scribes and, the further they spread from Jerusalem, the more this resistance deepened, among Jews who had no direct, first-hand experience of Jesus. In turn, this caused a major shift in Christianity (a term first coined among the Jewish-Christian community at Antioch): Gentiles were less resistant to the message of the apostles, because their traditional beliefs were less threatened. So that by the end of the first century, the early churches (rather than synagogues) had taken on a greater distance from Judaism than had been the case in the immediate aftermath of the Crucifixion. They repudiated the Torah, viewed the destruction of the Temple, by the Romans in 66, with some satisfaction and transferred the New Testament promises, originally aimed at Israel, to themselves.[119] This is how Christianity as we know it started, as first a form of Judaism, steadily separating out (thanks mainly to Paul), as it moved away from Jerusalem.

Paul, a near contemporary of Jesus, expected the Parousia (or Second Coming) in his lifetime. Mark saw the destruction of the Temple as the beginning of the end, but by the time Matthew and Luke were written the Second Coming was already seen as some way off. Even so, the early Christians followed in the Jewish tradition of assuming a special place for themselves theologically: they rejected the Hellenistic idea, not just of polytheism but of a variegated approach to understanding the world, and insisted instead on historical particularity – that the divine had manifested itself uniquely via a specific individual at a specific time. Their concern with this particular event, and particular place, is – however accidental – one of the most momentous ideas yet conceived.

# 8

# *Alexandria, Occident and Orient in the Year 0*

There was, of course, no year 0, and for several reasons. One is that the zero had not yet been invented: that happened in India, probably in the seventh century A D. Another is that many people around the world, then as now, were not Christians, and conceived time in completely different ways. A third reason is that the conventional chronology, used for dating events in the West over several centuries – A D, for *Anno Domini*, the year of Our Lord, and B C, before Christ – was not introduced until the sixth century. Jesus, as we have seen, never intended to start a new religion, and so people of his day, even if they had heard of him, never imagined that a new era was beginning. Use of the A D sequence did not in fact become widespread until the eighth century, when it was employed by Bede in his *Ecclesiastical History of the English Nation*, and the B C system, though referred to by Bede, did not come into general use until the latter half of the seventeenth century.[1] However, considering a hypothetical 'Year 0' allows us to look at ancient notions of time, and to see what other ideas were current in the world in the era when Jesus is supposed to have lived.

The understanding of time in the ancient world varied with local conditions and, in particular, local religions. The first coins to be dated were minted in Syria around 312 B C and were stamped with the year of the Seleucid era in which they were coined (Seleucus Nicator founded the Seleucid empire in 321 B C, two years after the death of Alexander the Great.[2]) The basic astronomical factor in the understanding of time in antiquity was the division of the earth into the East, or Orient (from the Latin for 'to be born, rise, grow'), and the West, the Occident (from 'to fall down, die'). The Babylonians, among others, noticed the so-called 'heliacal' rising of the stars. This is the phenomenon whereby, just before dawn, it is possible to observe the rising of stars which are close to the position of the sun. The Babylonians also noticed that, as the year passed, the sun traversed the stars in what appeared to be a regular cycle. They divided these constellations into twelve, no doubt because there were, roughly, twelve lunations in a year, and gave them names. The origins of these names are obscure but many of them were animals (perhaps reflected in the arrangement of the stars) and the practice, inherited from the Babylonians by the Greeks, gave us the zodiac, derived from the Greek word *zodion*, meaning 'little animal'. Just as the twelve months of the year are each divided into, roughly, thirty days, so the twelve regions of the zodiac were divided into thirty. This division of the sky eventually

gave rise to our practice of dividing the complete circle around a point into 360 degrees.[3]

Babylonian astronomical knowledge spread far and wide – to Greece, to Egypt, to India and even to China (though its influence in China has recently been called into question). This is perhaps responsible for the similarities in time-keeping in different cultures, though the basic division of the day into twenty-four hours seems to have arisen in Egypt. There it was noticed that at regular intervals throughout the night bright stars arose, and this is how, at first, the hours of darkness were divided into twelve. Later, the day was divided in the same way, though until medieval times, and the invention of the mechanical clock, the length of hours varied with the seasons: the longer the night, the longer the evening hours and the shorter the daylight hours. This Egyptian practice spread, and in Babylon itself the day was divided into twelve *beru*, in China into twelve *shichen*, and in India into thirty *muhala*. In Babylon a *beru* was divided into thirty *ges* and one *ges* was equal to sixty *gar*. In India one *muhala* was divided into two *ghati* which in turn were each divided into sixty *palas*. In other words, there was in ancient times a tendency to divide time into subdivisions that are multiples of twelve or thirty and almost certainly this has to do with the division of the year into (roughly) twelve lunations and each lunation into (approximately) thirty days. This 'sexagesimal' system of the Babylonians, using sixty as a base, also accounts for why we divide hours into sixty minutes, and minutes into sixty seconds. Just as we are now familiar with a decimal system, in which numbers to the right have only one tenth of the power of numbers to the left (think of 22.2), so in the Babylonian system sixty was the base. Furthermore, the names given to this system of subdivisions live on. The first was known by the Latin phrase, *pars minuta prima* (the first small division), the next was *partes minutae secondae* (second small division), and so on. In time, the phrases were corrupted, until all that was left of the first division was 'minute' and all that was left of the other phrase was 'second'. The first, second and further divisions were sometimes represented by ', ", and so on, which also survive today.[4]

The main problem in recording time was to reconcile the lunar cycle with the solar cycle. The sun governed the seasons – vital in agricultural societies – whereas the moon governed the tides and was an important deity, which appeared to change form in a regular rhythm. Most societies introduced extra months at certain times to overcome the discrepancy between the lunar and the solar year, but though such procedures often redressed the situation on a temporary basis, other intercalations, as they are called, were eventually needed. The most important amendment was introduced in Babylon, by 499 BC, though we know most about it from two Greeks, Meton and Euctemon, who introduced it to Greece in 432 BC. This 'Metonic' cycle, as it is called, lasts for nineteen years. Each of these years lasts for twelve months but seven extra months were added, one each in the third, fifth, eighth, eleventh, thirteenth, sixteenth and nineteenth years, while some months were 'full' (thirty days) and others 'deficient' (twenty-nine days). This might seem excessively complicated but the fact that the Indians and the Chinese took over the practice shows how important it was. (Endymion Wilkinson says that something very like the Metonic cycle was in use in China as early as the seventh century BC.) In medieval calendars the number which gave a year's position in the Metonic cycle was written in gold and to this day they are known as 'golden numbers'.[5]

Easter is also rooted in these practices. Both the Jewish and Christian calendars took

over the nineteen-year lunar–solar cycle, since it solved the problem of fixing dates for the new moon, so important for religious ritual. Originally, the Babylonian priest-kings needed to fix the New Year Festival with absolute precision, since the celebrations were regarded as re-enactments of the divine manoeuvres which established the creation of the world, and only exact correspondence could propitiate the gods. From this sprang the Christian idea to celebrate Easter on the correct date 'since this was the crucial time of combat between God (or Christ) and the Devil, and God required the support of his worshippers to defeat the Devil'.[6] The Babylonians also appear to have been the first to divide the lunar months into seven-day periods (each day being dedicated to one of seven divine planets, or 'wanderers', heavenly bodies which were not 'fixed' in the sky as the stars were). Each period ended with an 'evil day', when taboos were enforced so that, once again, the gods would be propitiated. Cuneiform records also show that the Babylonian *shabbatum* ('full-moon day') fell on the fourteenth or fifteenth of the month, and this seems to be the basis of the Hebrew term *shabbath*. The Christians took over this practice also. The order of the days of the week is derived from an elaborate table of hours. Each of the hours of the day was named after one of the seven planets, arranged in descending order according to the length of their orbits, beginning with Saturn (29 years), Jupiter (12 years), Mars (687 days), Sun (365 days), Venus (224 days), Mercury (88 days) and ending with the Moon (29 days). When this cycle of seven is laid in this order alongside the twenty-four hours of the day, the first hour of each subsequent day then becomes: Saturn; Sun; Moon; Mars; Mercury; Jupiter; Venus.[7]

The ancient Egyptians divided the year into twelve lunar months, of thirty days each, with five additional days at the end, which were considered very unlucky. This calculation was achieved on purely practical grounds, being the average amount of time between successive arrivals of the Nile flood at Heliopolis (the most important event in Egyptian life). The Egyptians soon noticed that, in fact, the actual year is slightly longer, $365\frac{1}{4}$ days, and made the adjustment. They also noticed that the rising of the Nile occurred just as the last star appeared on the horizon, the dog star Sothis (Sirius as we would say). This 'heliacal rising' became the fixed point of the so-called 'Sothic' calendar, and was more regular, and more accurate, than the flooding of the Nile. Astronomical calculations have shown that the first day of the two calendars – the pre-Sothic and the Sothic – agreed in 2773 BC, and scholars have concluded that this must have been when the Sothic calendar was introduced. So for the Egyptians, whether they knew it or not, the Year 0 was in fact 2773.[8]

The Greeks had two concepts of time – *aion*, sacred or eternal time, and *chronos*, ordinary time. There was in Greece a concept of time being the judge, and in the Athenian law courts water clocks, or clepsydras, were introduced, to limit speeches to half an hour.[9] Before the introduction of the Metonic cycle, in Greece in 432 BC, an eight-year cycle, the *octaeteris*, had been in use. This was based on a year of twelve months containing alternately, thirty days and twenty-nine days, giving a total of 354 days. This was reconciled with the sun by introducing an intercalated month of thirty days every other year. This meant that the calendar was out of step with the moon by a whole day after eight years. In the late sixth century, the Greeks adopted a system whereby they dropped the intercalated month every eight years and this eight-year cycle came to be considered a fundamental time

period. It survives today in the Olympic Games cycle, celebrated every four years, which is half an *octaeteris*.[10] The Greeks sometimes dated events by referring to the current Archon – a new one being elected every Year – and sometimes by reference to the Olympiads. The first Olympiad was reckoned to have been held in 776 BC and under this system, for example, the city of Alexandria was founded in the second year after the 112th Olympiad, written as 112.2 (our year 331 BC).[11]

Only four months of the year are mentioned in the Bible, but the probability is that the ancient Israelites had a lunar calendar, tied to a seasonal year that began in the autumn. This is inferred from other documentary evidence which suggests that if the Jews could see that the barley would not be ripe by 16 Abib ('the month of new fruits') an extra month was intercalated, to ensure that a sheaf of barley could be offered to God on the day after Passover. At the time of Jesus, most Jews used the Seleucid calendar, which began in 321 BC (matching the first dated coins) and was known as the 'era of contracts' because the Seleucids required all legal documents to be dated by their era.[12] According to Jewish calculations the world began on 7 October 3761 BC but these calculations are uncertain and complex. These *Anni Mundi* (a twelfth-century idea) were derived from discrepancies between the Jewish, Samaritan, Hebrew and Greek texts, all of which were different. For example, from the Creation to the birth of Abraham there are 1,946 years according to the Jewish Hebrew text, 2,247 years according to the Samaritan Hebrew text, and 3,412 years according to the Septuagint. 3761 BC is now the date preferred for the Creation.

The world in which Christianity emerged and developed was partly Hellenistic, partly Jewish, but also Roman. In Rome there were many religions, and many superstitions. On several days of the year, the religious calendars forbade business of any kind and ships would not leave harbour, for example, on 24 August, 5 October or 8 November.[13] Romulus, the legendary founder of Rome, was supposed to have invented the original calendar, which began in March and had ten months. This was revised by the second king of Rome, Numa, who set up the *pontifices*, a college of officials headed by the Pontifex Maximus. Their responsibilities included giving religious advice, looking after the bridges of Rome (which had great theological significance) and overseeing the calendar. Later on, the Christian leader in Rome became the Pontifex Maximus, which is why the pope is still referred to as the pontiff. According to legend, it was Numa who added the months of February and January (in that order), producing a year of 355 days that kept in step with the moon. He also introduced an intercalated month, known as Mercedonius, deriving from the word *merces* or 'wages,' (from which the English word 'mercenary' derives) because that was the season when people were paid.[14] In the fifth century there were further reforms, when January became the first month. This was because Janus was the god of gateways and it was felt appropriate for the beginning of a new year, when office-holders took up their positions in the Roman government.

A public clepsydra was set up in Rome in 158 BC, but rich Romans had their own water clocks and would employ slaves to announce the time aloud to them, on the hour.[15] The calendar we use today is actually a modified version of the one introduced in Rome by Julius Caesar on 1 January 45 BC. The previous year, 46 BC, was 445 days long, to bring it into line, and was known as 'the last year of confusion'.[16] The change was made because, under the previous system, intercalary months, of no determinate length, had been abused

by unscrupulous politicians for their own ends – for example, either to lengthen a term of office, or to bring forward an election.[17] Caesar abolished both the lunar year and inter-calary months and settled on the solar year of $365\frac{1}{4}$ days, introducing the idea of a leap year every four years to account for this extra quarter day. To begin with, January, March, May, July, September and November all had thirty-one days, the rest thirty, save for February, which had twenty-nine. The changes to the system we have now were introduced in 7 BC by Augustus, who wanted a month (Sextilis) named after him.[18] Officially, the Roman calendar began in the spring, on 1 March (which is reflected in the names for the months September to December) but this too was changed because Roman officials, elected for a year, took up office on 1 January. Early Christians disliked this arrangement because they felt it reflected a pagan habit and for a time used instead the Annunciation as the first day of the year (25 March, nine months before Christmas). The names Quintilis to December derive from the Latin names for the numbers five to ten and are probably very ancient. March is named after Mars, the god of war, May after Maia, a goddess of spring, June for Iuno, the wife of Jupiter. April may be derived from *aprire*, 'to open', or from Aphrodite. February may derive from a Sabine word, *februare*, meaning 'to purify'. July was named after Julius Caesar who had done so much to remove confusion from the calendar.

It was Varro, in the first century BC, who introduced the Roman system of dating *ab urbae condita* (from the foundation of Rome), which by tradition was placed in 753 BC. The Romans also took over the Babylonian idea of the seven-day week (the Greeks had *not* followed this practice), though originally their months had been divided into three: the Calends (from which our word 'calendar' is derived), which began on the first of the month, the Ides, which began on the thirteenth or fifteenth of the month, and Nones, beginning eight days before the Ides. Calends fell on the new moon, Ides on the full moon.[19] Originally, the days were numbered, not named, working backwards from the Calends, Nones and Ides but in imperial times, thanks to the widespread popularity of astrology, the days were named after the planets.

For the early Christians, who felt that the kingdom of God was 'at hand', time held little interest, not long-term time anyway (Paul, for one, didn't date his letters). At first the Christians followed the Jewish practice of numbering days rather than naming them, except for the Sabbath. But as more and more converts from paganism entered the fold, bringing with them astrological influences, Christians adopted the planetary week, but chose Sunday as the first day, because this was when Christ rose from the dead and because it distinguished them from the Jews. Easter was introduced in Rome in about the year 160. The first mention of Christmas Day, according to G. J. Whitrow, occurred in the Roman calendar for 354. Previously, 6 January had been celebrated, as the anniversary of Jesus' baptism, which was believed to have occurred on his thirtieth birthday. The change occurred because infant baptism was replacing adult baptism, as Christianity spread, and this led to a change in belief also. It was now held that Christ's divinity began at birth, rather than at his baptism.[20]

By the time of Jesus, Alexandria in Egypt – situated between the Occident and the Orient – had been a centre of learning, 'a centre of calculation', 'a paradigmatic place', for several

centuries. Founded by Alexander the Great in 331 BC, because he wanted to bring Egypt closer to the Greek world, and because he wanted a port that would not be affected by the Nile floods, Alexandria was from the first intended as a 'megalopolis', built in the shape of a *chlamys*, a Macedonian military cloak, with walls that would stretch 'endlessly' into the distance, with streets wider than any yet seen, based on Aristotle's design for the ideal city – a grid laid out in such a way as to benefit from sea breezes yet providing shelter from the wind.[21] A third of the city was 'royal territory' and it was conveniently located as a trading centre, at the eastern end of the Mediterranean, near where the Nile and the Red Sea formed an international crossroads, and where many caravan routes from inner Africa and Asia converged on the coast. It boasted two harbours, one with the famous lighthouse, the Pharos, 144 feet high, and a wonder of the ancient world that could be seen thirty-five miles away.[22] After the death of Alexander, his generals had quarrelled, leading to a split, in which Seleucus had gained control of the northern parts of the former empire, including Israel and Syria, while the Egyptian part was controlled by Ptolemy I, at least from 306 BC.

But it was for its learning that Alexandria was chiefly known. According to tradition, Alexander himself, when he had decided that the site was ideal for a new city, had also commanded that a library be built there, dedicated to the muses. The idea was not new: as we have seen, several libraries had been compiled in Babylon and others arose elsewhere on the edge of the Mediterranean, in particular at Pergamum and Ephesus. From the start, however, the ambition at Alexandria was bigger than elsewhere – in the words of one scholar 'an industry of learning' was launched there.[23] As early as 283 BC a *synodos*, or community of thirty to fifty learned men (only men), was associated with the library and given special status – the scholars were exempted from paying taxes and given free board and lodging in the royal quarter of the city. The library was directed by a scholar-librarian, appointed by the king, who also held the post of royal tutor.[24] This library had several wings, with lines of shelves, or *thaike*, arranged along covered walkways, with niches where different categories of learning were kept. There were lecture theatres and a botanical garden.

The first librarian was Demetrius and by the time of the poet Callimachus, one of his better known successors, in the third century BC, the library comprised more than 400,000 mixed scrolls plus 90,000 single scrolls. Later, a daughter library, the Serapeion, housed in the temple of Serapis, a new Graeco-Egyptian cult, which may have been based on Hades, the Greek god of the dead, held another 40,000 scrolls. Callimachus installed the first subject catalogue in the world, the *Pinakes*, one effect of which was that by the fourth century AD, as many as one hundred scholars at a time came to the library to consult the books and discuss the texts with others. This distinguished community existed in all for some seven hundred years. The scholars wrote on papyrus, over which Alexandria had a monopoly for some time, and then on parchment when the king stopped exporting papyrus in an attempt to stifle rival libraries being built up elsewhere, notably at Pergamum.[25] The papyrus and parchment books were written as scrolls (in length they were what we would mean by a chapter) and were stored in linen or leather jackets and kept in racks. By Roman times, not all the books were scrolls any more: the codex had been introduced, stored in wooden crates.[26]

The library also boasted many *charakitai*, 'scribblers' as they were called, in effect translators. The kings of Alexandria – the Ptolemies – were very keen to acquire copies of all the books they did not possess, in their attempt to attain all the wisdom of Greece, Babylon, India and elsewhere. In particular, the agents for Ptolemy III Euergetes scoured the Mediterranean and he himself wrote to all the sovereigns of the known world, asking to borrow their books for copying. When he was lent works written by Euripides, Aeschylus and Sophocles from Athens, he held onto the originals, forfeiting his deposit, and returned the copies. In the same way all ships passing through the harbours of Alexandria were forced to deposit any books they were carrying at the library, where they were copied and catalogued as 'from the ships'. For the most part the ships also had returned to them copies of the books that had been confiscated. This assiduous 'collecting' gave the Alexandrian library a pivotal role in the civilised world of antiquity.[27]

Among the famous scholars who made their name at Alexandria were Euclid, who may have written his *Elements* during the reign of Ptolemy I (323–285 BC), Aristarchus, who proposed a heliocentric basis for the solar system, and Apollonius of Perga, 'the great geometer', who wrote his influential book on conic sections in the city. Apollonius of Rhodes was the author of the epic *Argonautica* (about 270 BC) and he introduced Archimedes of Syracuse, who spent time observing the rise and fall of the Nile, and inventing the screw for which he became famous. Archimedes also initiated hydrostatics and began his method of calculating area and volume that, 1,800 years later, would form the basis of the calculus.

A later librarian, Eratosthenes (*c.* 276–196), was a geographer as well as a mathematician. A great friend of Archimedes, he believed that all the earth's oceans were connected, that Africa might one day be circumnavigated and that India 'could be reached by sailing westward from Spain'. It was Eratosthenes who calculated the correct duration of a year, who put forward the idea that the earth is round, and calculated its diameter to within an error of fifty miles. He did this by selecting two sites which were a known distance apart, Alexandria in the north and Syene (modern Aswan) in the south, which was assumed at that time to be exactly under the Tropic of Cancer, which meant that at the summer solstice the sun would be directly overhead and cast no shadow. At Alexandria on the same day, he used a *skaph* or bowl, a concave hemisphere, with a vertical rod or gnomon fixed at its centre. This cast a shadow which covered one-fiftieth of the surface of the bowl and so Eratosthenes calculated the circumference of the earth as 50 × 5,000 (= 250,000) stades (later amended to 252,000 stades, since it was more conveniently divisible by sixty). 250,000 stades was equal to 25,000 miles, not so far from the modern calculation of just under 26,000 miles.[28] Eratosthenes also began the science of chronology, carefully establishing when the fall of Troy occurred (1184 BC), the first Olympiad (776 BC) and the outbreak of the Peloponnesian war (432 BC). He also initiated the calendar that Julius Caesar eventually installed and devised a method for identifying prime numbers. He was known among fellow scholars as 'Beta' (Plato was 'Alpha').[29]

The *Elements* of Euclid is widely acknowledged as the most influential textbook of all time. Composed about 300 BC, some one thousand editions have been produced, making it perhaps the most republished book after the Bible (its contents are still taught in secondary schools today). Euclid (*eu* means 'good' and *kleis* – conveniently – means 'key')

may well have studied at Plato's Academy, if not with the great man in person (he was born in Athens around 330 BC), and although he produced no new ideas himself, *Elements* (*Stoichia*) is regarded as a history of Greek mathematics to that point.[30] The book begins with a series of definitions: of a point ('that which has no part'), a line ('a length without breadth'), various angles and planes, followed by five postulates ('a line can be drawn from any point to any other point'), and five axioms, such as 'all things equal to the same thing are equal to one another'.[31] The thirteen books, or chapters, that follow explore plane geometry, solid geometry, the theory of numbers, proportions, and his famous method of 'exhaustion'.[32] In this Euclid showed how to 'exhaust' the area of a circle by means of an inscribed polygon: 'If we successfully double the number of sides in the polygon, we will eventually reduce the difference between the area of the polygon (known) and the area of the circle (unknown) to the point where it is smaller than any magnitude we choose' (see Figure 8). One effect of Euclid's work was that the Alexandrians, unlike the Athenians, treated mathematics as a subject wholly distinct from philosophy.[33]

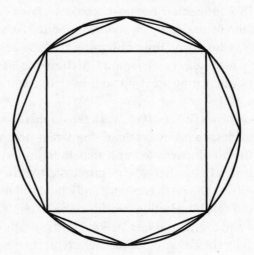

*Figure 8: Euclid's method of 'exhaustion' of a circle*

Apollonius of Perga was both a mathematician and an astronomer. Born at Perga in Pamphylia (southern Asia Minor), he studied at Pergamum, but flourished at Alexandria during the reign of Ptolemy Euergetes, dying in 200 BC. Several of his works have been lost but the *Conics* was the equal of Euclid's *Elements* in that it survived throughout antiquity without being improved upon. A jealous man, he was known as 'Epsilon', because in the Mouseion he always used the room numbered 5 in the Greek alphabet. In the *Conics* Apollonius studied the ellipse, parabola and hyperbola – the plane figures generated when a circular cone is cut at acute, right and obtuse angles – and set out a new approach to their definition and description. Cones would become important in both optics and astronomy.[34] In his astronomical works (which he sent to colleagues to critique before he released them generally), Apollonius built on the epicycles of Eudoxus of Cnidus to explain planetary motion. This system envisaged planets moving in small circles around a point,

as the point moved in a larger circle around the earth. At this stage, before elliptical orbits were conceived, this was the only way mathematical theory could be made to fit observation.[35]

The most interesting, as well as the most versatile of the Hellenistic mathematicians was Archimedes of Syracuse (*c.* 287–212 BC). He appears to have studied at Alexandria for quite a while, with the students of Euclid, and he was constantly in touch with the scholars there, though he lived mainly at Syracuse, where he died. During the second Punic war, Syracuse was caught up in the struggle between Rome and Carthage and, having sided with the latter power, the city was besieged by the Romans in 214–212 BC. During this war, we are told by Plutarch, in his life of the Roman general Marcellus, Archimedes invented a number of ingenious weapons to use against the enemy, including catapults and burning-mirrors to set fire to Roman ships. All to no avail, for the city eventually fell and, despite an order from Marcellus to spare Archimedes' life, he was killed when a Roman soldier ran a sword through him while he was drawing a mathematical figure in the sand.

He himself set little store by his innovations. He was more interested in ideas, and his range was remarkable. He wrote on levers, in *On the Equilibrium of Planes,* and on hydrostatics, in *On Floating Bodies.* This latter gave rise to his famous lines: 'Any solid lighter than a fluid will, if placed in a fluid, be so far immersed that the weight of the solid will be equal to the weight of the fluid displaced.' And: 'A solid heavier than a fluid will, if placed in it, descend to the bottom of the fluid, and the solid will, when weighed in the fluid, be lighter than its true weight by the weight of the fluid displaced.'[36] He explored large numbers, a preoccupation that would lead centuries later to the invention of logarithms, and he achieved the most accurate rendering of *pi.*[37]

The last of the great Hellenistic mathematicians at Alexandria was Claudius Ptolemy, who was active from AD 127 to 151. (The name Ptolemy here refers to the area of the city he came from; he was not related to the royal Ptolemies of Alexandria.) His great work was originally called *Mathematical Syntaxis* (*System*), thirteen books or chapters, but since this was often compared with other (lesser) collections by various authors, it became known as *megiste,* 'the greatest'. Later, in the Muslim world, there was a custom of calling this book by the Arabic equivalent, *Almagest,* and it is by this name that Ptolemy's work is usually known.[38] The *Almagest* is primarily a work of trigonometry, that branch of mathematics associated with triangles, how the angles and lengths of the sides are related, and how they are all related to the circles which encompass them. In turn, these are related to the orbits of the heavenly bodies and the angles the planets present to the observer here on earth. Books 7 and 8 of the *Almagest* listed over one thousand stars, arranged according to forty-eight constellations.

Towards the middle of the third century BC, Aristarchus of Samos had proposed putting the earth in motion about the sun. Most other astronomers, Ptolemy included, discounted this because they thought that if the earth moved by so much, the 'fixed' stars in the heavens should change their positions relative to one another. But they didn't. Ptolemy, armed with his calculations of trigonometry – of chords and arcs (similar to sines) – went on to develop his system of planetary cycles and epicycles, known as the Ptolemaic system. This system envisaged a geocentric universe, with other bodies moving in a grand circle

around a central point (the deferent), and in a smaller epicycle, as Eudoxus had imagined, all the while spinning on their axes.

Ptolemy's other great work was his *Geography*, in eight chapters. In Alexandria, geography had been put on the map, so to speak, by Strabo, who had written a history of the subject and of his travels, which showed for example that 'Egypt' had originally referred only to that strip of land or 'bandage' running along the Nile, but then extended further and further east and west, eventually taking in Cyprus. Strabo also noted the convexity of the sea.[39] But Ptolemy was a more theoretical and innovative geographer. His *Geography* introduced the system of latitudes and longitudes as used today, and catalogued around eight thousand cities, rivers and other features of the earth. At the time there was in fact no satisfactory way to determine longitude and, as a result, Ptolemy seriously underestimated the size of the earth, opting for a circumference of 180,000 stadia given by Posidonius, a Stoic teacher of Pompey and Cicero, rather than the 252,000 stadia calculated by Eratosthenes and amended by Hipparchus. One of the major consequences of this error was that subsequent navigators and explorers assumed that a voyage westward to India would not be nearly so far as it was. Had Columbus not been misled in this way, he might never have risked the journey he did make. Ptolemy also developed the first projection of the earth – i.e., a representation of the globe on a flat surface.[40]

Alexandria continued as the focus of Hellenistic mathematics: Menelaus of Alexandria, Heron of Alexandria, Diophantus of Alexandria, Pappus of Alexandria and Proclus of Alexandria all built on Euclid, Archimedes, Apollonius and Ptolemy. We should not forget that the great age of Greek maths and science lasted from the sixth century BC to the beginning of the sixth century AD, representing more than a millennium of great productivity. No other civilisation has produced so much over such a long period of time.[41]

There was another – very important and very different – aspect to mathematics, or at least to numbers, in Alexandria. These were the so-called 'Orphic mysteries' with the emphasis on mysteries and mysticism. According to Marsilio Ficino, writing in the fifteenth century, there was a line of succession of the six great theologians in antiquity. Zoroaster was 'the chief of the Magi'; the second was Hermes Trismegistus, the head of the Egyptian priesthood; Orpheus succeeded Trismegistus and was followed by Aglaophamus, who initiated Pythagoras into the secrets, who in turn confided in Plato. In Alexandria, Plato was built on by Clement and by Philo, to create what became known as Neoplatonism.

Three ideas underlie the Orphic mysteries. One is the mystic power of number. The existence of numbers, their abstract quality and their behaviour, relating to so much in the universe, had an enduring fascination for the ancients, accounting as they did (so it was felt) for celestial harmony.[42] The abstract nature of number also reinforced the idea of an abstract soul, which brought with it the further – all-important – idea of salvation, the belief that there was a future state of bliss, achieved by transmigration, or reincarnation. Finally, there was the principle of emanation – that there is an eternally-existent 'good', a unity or 'monad', from which all creation springs. Like number, this was felt to be an essentially abstract entity. The soul occupied a central position between the monad and the material world, between the totally abstract mind and the senses. According to the Orphics, the monad sent out ('emanated') projections of itself into the material world and

it was the task of the soul, using the senses, to learn. In this way, via repeated reincarnations, the soul evolved to the point where further reincarnations were no longer needed. A series of ecstatic moments of deep insight resulted in a form of knowledge known as *gnôsis*, 'in which the mind comes into a state of oneness with the thing perceived'. It can be seen that this idea, stemming originally from Zoroaster/Zarathustra, underlies many of the world's major religions. It is another core belief, to add to the others considered in earlier chapters.

Pythagoras believed in particular that the study of number and harmony could lead to gnosis. For Pythagoreans, one, 1, is not a true number but the 'essence' of number, out of which the number system emerges. Its division into two creates a triangle, a trinity, the most basic harmonic form, which would find echoes in so many religions. Plato, at his most mystical, believed that there was a 'world soul', also based on number and harmony, and out of which all creation arose. But he added the important refinement that the method to approach gnosis was by dialectic, the critical examination of opinions.[43]

Traditionally, Christianity reached Alexandria in the middle of the first century AD when the evangelist St Mark arrived, to preach the new religion. The spiritual similarities between Platonism and Christianity had been most fully perceived by Clement of Alexandria (*c.* 150–*c.* 215) but it was Philo Judaeus who first worked out the new amalgamation. Pythagorean and Platonic schools of thought had existed in Alexandria for some time, with educated Jews well aware of the parallels between Jewish and Hellenistic ideas, so much so that many of them thought that Orphism was no more than 'an unrecorded emanation of the Torah'. Philo was a typical Alexandrian who 'never relied on the literal meaning of things, and looked for mystical and allegorical interpretation'. He thought that we can 'connect' with God through the divine ideas, that ideas were 'the thoughts of God' because they brought 'unformed matter' into order. Like Plato he had a dualistic notion of humanity: 'Of the pure souls that inhabit ethereal space, those nearest earth are attracted by sensible beings and descend into their bodies.' Souls are 'the Godward side of man'. Salvation is achieved when the soul returns to God.[44]

Philo's ideas were built on by Ammonius Saccas (d. 242), who taught in Alexandria for more than fifty years. His pupils were both pagans and Christians and included some major thinkers, such as Plotinus, Longinus and Origen. For Ammonius, God was threefold: essence, intellect and power, the latter two being emanations of the essence (and in this way mirroring the behaviour of number). For Ammonius and other Neoplatonists the essence of God could not be known by intellect alone – this produced 'only opinion and belief'. This was a major difference between the early Christians and the Greeks: for the Christians all that was needed, they said, was faith, belief. But this cut across the Greek tradition of reason. The Neoplatonists, like the Orphics before them, posited what was in effect a third form of knowledge, gnosis, which was experiential, and not wholly within the power of the intellect. Philosophy and theology helped one towards gnosis and the Christian idea – that only belief was needed – appeared to the Neoplatonists to be an undermining of spiritual evolution. Under Plotinus, who moved from Alexandria to Rome, gnosis – appreciation of the divine – could be achieved only by doing good, by experiencing good, and by use of the intellect in self-contemplation, self-awareness leading to the monad, or the One, or unity. This is not Christianity; but its mystical elements, its ideas

about the Trinity, and the reasons for the Trinity (more difficult to grasp even than the Christian Trinity), and its use of the intellect and dialectic, did help to shape early Christian thought. The notion of biblical exegesis, the practice of asceticism, hermitism and monasticism are all founded in the Orphic mysteries, gnosis, and Neoplatonism.[45] It is difficult for us to grasp (even to write about) and shows how different early Christianity was from the modern version.

Clement thought that all knowledge – gnosis, philosophy, reason – was preparation for Christianity. Worship of the heavenly bodies, for example, was given to man at an early stage, 'that he might rise from these sublime objects to worship of the creator'.[46] The Father, he said, was the Absolute of the philosophers, whereas the Son was the reason (the Word) of God. It followed for him that a Christian life involved an inevitable conflict between the downward pull of the passions and the discipline of the disciple. Man is made for the *contemplation* of God, all knowledge was a preparation for this, all behaviour directed to this end.

This early world of Neoplatonic Christianity in Alexandria was engulfed at least twice by vicious quarrels. The first time arose in the second century as a result of a treatise, *The True Word*, by the pagan philosopher Celsus, who could not understand why so many Jews had left the Law of their fathers and converted to the new religion. Celsus turned his wrath on the Messiah, pointing out that he was born in a small village, to a poor woman whose husband had divorced her after she committed adultery with a soldier. This, he remarked sarcastically, was an unlikely beginning for a god. He then went on to compare Jesus' so-called healing powers with the 'wizards of Egypt', who performed similar tricks to the Messiah 'every day in the market place for a few obols'. 'We do not call them the Sons of God. They are rogues and vagabonds.'[47] Celsus insisted that the universe was no more made for man than it was made for lions or dolphins, that the view among Christians that they alone had possession of divine knowledge was ludicrous, and that the 'promise' of salvation and bliss was a delusion. But Celsus was not only a clever polemicist – he was an able researcher too: he showed where the idea of Satan had originated, he showed that the story of Babel was a plagiarism of early Greek ideas, and he showed that heaven itself was derived from a Platonic notion. Christianity was a collection of 'borrowed' and intellectually bankrupt ideas.

His charges went unanswered for more than a century until one of Clement's followers, Origenes Adamantius, better known as Origen, took it upon himself to do so. He was careful not to try to refute the irrefutable, arguing instead that religion, faith, will always be more rewarding, more emotionally satisfying, more morally uplifting than philosophy, and that insofar as Christians led moral and productive lives the religion justified itself.

But even Origen did not think that the Father and the Son were the same essence, part of the same Trinity. In fact, he thought there was an immense difference between them, that the Son was so far beneath the Father that he should not be worshipped. This view found echoes – more than echoes – in the second great controversy to shake the early Church, the so-called Arian heresy. It is not certain whether Arius was born in Libya or in Alexandria but he certainly lived his adult life in the city. He appears to have been a quarrelsome man, who was twice excommunicated by the bishop of Alexandria, but his most famous and troublesome assertion was to question the divinity of Christ, arguing

that Jesus was 'a created being' and therefore thoroughly dissimilar – and inferior – to God the Father. This became the subject of passionate debate on the streets and in the shops of Alexandria – blood was shed. For Arius, Jesus was a middle being between God and the World, who pre-existed before time, before all creatures, and was the executor of His thoughts. But he was made, said Arius – not in the essence of the Father – but out of nothing.[48] Jesus was therefore not eternal and not unchangeable. In his own defence, Arius noted that in the scriptures Christ had said: 'The Father is greater than I.'

The first ecumenical council of the church was called at Nicaea in 325 AD to decide this very question. The council decided against Arius, affirming that the Son *was* the same substance (*homoousios*) as the Father. Arius refused to accept this decision but even so was allowed back into Alexandria. On his return, however, on his way to the church, for the ceremony of readmission, he was seized with stomach cramps, his bowels were voided and extruded, he suffered a 'copious' haemorrhage, and expired almost immediately. For years afterwards, Alexandrians avoided the spot where Arius died.

There is a final Alexandrian idea to consider: empiricism. Ancient Egypt, we know, 'teemed' with doctors, though at the time being a doctor was mainly a job for theorists (iatrosophist was the technical term). That is to say, doctors had many theories about what caused illness, and what treatments might be effective, but they did no experimentation to test their theories. Such an idea had yet to occur to anyone. But it seems that in Alexandria, at the turn of the third century BC, at least two doctors, Herophilus and Erasistratus, were allowed to perform autopsies on the bodies of criminals, supplied 'out of prison by the king'. The experiments shocked many of the citizens but the vivisections led to so many discoveries that 'the Greek language was simply unable to name them all'.[49] Both owed a considerable debt to Aristotle, the man who – with the Stoics – had in effect achieved the secularisation of the corpse, the idea that 'things' are 'morally indifferent'.[50]

Herophilus made two advances. One was to establish, in a medical context, the culture of smallness, an appreciation of the small structures of the body. He discovered the existence of nerves, accurately distinguishing motor and sensory nerves, the ventricles of the brain, the cornea and the retina of the eye, he made the first accurate description of the liver, the first investigation of the pancreas, the ovaries, the Fallopian tubes, and the uterus, in the process demystifying the womb and the idea that, in some way, in hysterics, it had moved.[51] His second achievement was the mathematisation of the body, noting that there were stages in the development of the embryo, periodicity in ailments (such as fevers) and providing a quantitative theory of the pulse. This, he maintained, varied at different stages of life, each phase having a characteristic 'music' or rhythm. There was first the pyrrhic pulse in infancy (∪∪), a trochaic pulse in adolescence (–∪), a spondaic in the prime of life (––) and finally an iambic rhythm in old age (∪–). He devised a portable clepsydra to calibrate the pulse of his patients.[52] He also noted the geometry of wounds – round wounds heal more slowly than others.

In a sense, and to our modern way of thinking, Erasistratus went further down the mathematical route than Herophilus, maintaining that the body was a form of machine – that all physiological processes are explicable in terms of their material properties and structures.[53] Blood and air, he said, were distributed mechanically from the heart and the

liver through the arteries and psychic pneumata are radiated from the brain through the nerves. The heart, he thought, was a form of bellows, with valves to prevent backward flow. At this time, Ctesibious had devised a water pump with two chambers in it, though whether Erasistratus borrowed from Ctesibious or Ctesibious from Erasistratus isn't known. Erasistratus did, however, feel that the body had a purpose: he wasn't a complete mechanist as were, for example, the French physiologists in the Enlightenment.[54]

Despite its shocking nature and its astounding results, experimental medicine – experimental anything – does not seem to have caught on. It would be another 1,400 years before the experiment was taken seriously as a method.[55]

On the other hand, although experimentation didn't catch on, another form of empiricism did. This was founded by Philinus of Cos, who broke away from Herophilus. We don't know much about Philinus and what we do know comes from Galen, the famous Greek doctor of the second century A D. Philinus wrote several books about medical empiricism in Alexandria and tells us that they abandoned theory (which was then understood as what one could see with 'the mind's eye'), and argued instead that true insight could only be achieved as a result of observation and seeing what circumstances were attached to any given condition (such a cluster of observations was known as a 'syndrome'). Moreover, for Philinus there were three ways this experience could be gathered: *teresis*, or careful vigilance; *metabasis tou homoiou*, or analogical inference, which enabled a doctor to say, tentatively, that what applied to one part of the body might well apply to another part; and *historia*, research among earlier scrolls and codices. In this way, the writings of the Hippocratic tradition came to be regarded more or less as a research tool (as we would say) which added to, rather than detracted from, their authority. It was left to Galen, in the second century A D, to rediscover the importance of practical investigation. But he too was a literary type, often resorting to libraries, or haunting booksellers who specialised in medical books. It would be many centuries before medicine opened up to the empiricist tradition that has brought so much benefit in our own day.[56]

By the time of the Year 0 Alexandria had changed in two important ways. In 48 B C there had been a terrible fire which had destroyed at least part of the great library. Some accounts say that most of the books were lost, others that it was mainly the Serapeion that suffered, still others that the bulk of the library was destroyed much later by the Arabs in the sixth century of the common era. Since, as we shall see, the Arabs went to great lengths to preserve Greek and Near Eastern materials wherever they found them, it seems unlikely that the Muslims deliberately destroyed the library. But certainly, the destruction of the library in Alexandria was one of the ways by which the ideas of antiquity were lost, and not recovered for many centuries.

However, the main change that occurred in Alexandria during the second and first centuries B C was that the dominant form of scholarship evolved. It became less concerned with natural knowledge (natural science, as we would say) and more concerned with literature, literary criticism and 'custodial scholarship'.[57] 'By the beginning of the common era, Alexandria was a place where what could be known of Babylonian, Egyptian, Jewish and Greek thought was strenuously collected, codified, systematised, and contained. Alexandria became the foundation of the text-centred culture of the western tradition.'[58] It was

the notes, or *scholia*, written chiefly in the margins of Alexandrian books, that gave rise to our words scholar and scholarship.

In India, as elsewhere, dating depended on the religion followed. Pandit Nehru, writing in 1953, claimed there were over thirty calendars in use even then.[59] The Vedas refer to a calendar of twelve months of thirty days each. The year was divided into two parts, the *uttarayana*, when the sun moves north, and the *dakshinayana*, when the sun moves south, and into six seasons: Vasanta (spring), Grishma (hot), Varsha (rainy), Sarad (autumn), Hemanta (cold), and Sisira (dewy). Several astronomical works (the *Siddhantas*) were composed in the first century A D, and they show the influence of Babylon and Greece, notably in the division of time into ever smaller components of sixty, and in the names for signs of the zodiac.[60]

Before the first century B C, many Indians calculated time by regnal years though Buddhists took their dates from the attainment of *nirvana* (as opposed to the birth) of the Buddha: traditionally, 544 B C. The Jains did likewise, marking the death of Mahavira in 528 B C. After the first century B C, the Hindus used one of two systems. The Vikrama era began in 58 B C, and is said in the Jain text *Kalakakaryakathanka* to have been founded after the victory of King Vikramaditya over the Shakas. When this chronology is employed, Hindus use the word *vikramasamvat*, or simply *samvat*. But the most widespread chronology of all, still in use in India, is that which dates from the Shaka era itself, which began in A D 78. Kanishka, with whose accession the era began, was a great Kushan king/emperor, who ruled over vast distances and had his capital at Purushpar, or Peshawar, where there still exist the remains of a colossal monument, nearly a hundred metres in diameter and reported to have been 200 metres high. The Shakas are thought to have been incomers from Scythia, that area of the Caucasus that was west of the Volga and north of the Black Sea.[61]

By the time of Jesus Christ there were many links between the Mediterranean world and northern and western India. By Kushan times – the middle of the first century A D – Indian coins were minted with a mixture of Greek, Persian and Indian gods.[62] In the late first century B C there was an upsurge in the number of Indians travelling to Egypt and beyond, with several references in literature, including an ode by Horace in 17 B C, which mentions Indians and Scythians in Rome.[63] The anonymous Alexandrian sea captain who produced the *Periplus of the Erythraean Sea*, written some time between A D 50 and 120, gave an account of various ports of the Red Sea and round the Indian coast, including many details of western Indian harbours.[64] Several texts of ancient Indian literature mention the Greeks, using the word *Yavanas*, a term said to be derived from 'Ionian'.[65] Masses of red-glazed Arretine pottery were discovered in India, together with Roman coins which, because of their precious metal content, were much sought after. Other travel information was a weird amalgam of fact and romance. Megasthenes, who visited India as ambassador of the Seleucid king *c.* 300 B C, reported that some Indian tribes had dog's heads and barked instead of speaking; he said others had feet that turned backwards, or had no mouths, and that gold was sometimes to be found in the rivers.[66] But he also reported, accurately enough, on their special commissioners whose job it was to maintain the rivers, or to protect foreigners, and that there were pillars placed along the roads at regular intervals to indicate distances.[67]

But it is the affinities between Buddhism and Christianity that are, perhaps, the most intriguing ideas of the time. Given that Buddhism pre-dated Christianity by several hundred years, we may take it that if anyone borrowed from anyone else, it was the Christians. The *Tripitaka* ('The Three Baskets'), as the Buddhist scriptures are known, were in existence, at least in some form (possibly oral), by the time of the Buddhist emperor Ashoka, who lived in the third century BC.[68] Apart from any specific parallels between the Buddha and Jesus, the most striking similarity is the overall resemblance of their life stories. Jean Sedlar, who has studied both narratives, notes that both figures were born to a woman who was 'sexually untouched'. At the moment when both came into the world, celestial beings announced the event to an aged saint who prophesied the infant's future glory. Both were fulfilling an ancient prophecy and when they were grown, both lived as 'wandering ascetics and preachers'. Both could control the elements and cure the sick and, shortly before dying, each was transfigured. At the end, in both cases, a great earthquake shook the world. Both sent out disciples.[69] Some of the specific parallels are striking too. In the Buddhist story, the holy man Asita learned from the gods in heaven that a future Buddha had been born and hurried to see the infant to foretell his destiny. In the gospel of Luke we are told how the Holy Spirit revealed to Simeon that he would not die until he had seen the Messiah. Proceeding to the Temple, where – as stipulated by Jewish tradition – Mary and Joseph had taken the baby, to present him to the Lord, Simeon prophesied 'that Jesus would cause the fall and rising again of many in Israel'. Likewise, as with Peter in the Bible, the Buddhist scriptures describe a certain monk who crosses the river Ashiravati by walking on the water, until his faith deserts him, and he sinks.[70] Jean Sedlar, who also notes that both systems share an ethic of love and non-resistance to violence, self-denial, the renunciation of earthly satisfactions and an approval of celibacy, concludes that 'many of the general resemblances between Buddhism … and Christian ethics must be attributed to the similar other-worldly attitudes of these religions'. In both, for example, the goal of salvation after death was all-important. Though Sedlar believes that both religions borrowed from each other, she says there was more borrowing in the Apocrypha where, in most cases, 'the Buddhist versions are probably the originals'.[71] The similarities may mean less than they appear to at first sight.

The most famous instance of a link between Christianity and India concerns Thomas, one of Jesus' original twelve disciples. According to a Syriac source, the *Acts of Judas Thomas*, probably composed at Edessa, in north-west Mesopotamia in the third century AD, Jesus' disciples divided up the known world for evangelisation after the Crucifixion, and India fell to Judas Thomas.[72] Today, on the Malabar coast of south-west India, there exists a community of some 2 million Indian Christians who believe their church was founded by Thomas. According to local tradition, he landed there around AD 50 and built seven churches.[73] No one outside the Malabar community itself believes any longer that the Thomas who initiated the Indian church was the biblical disciple of that name, but the very presence of Christianity in the subcontinent does have some interesting ramifications. In particular, there is Vishnuism, one of the two main divisions of Hinduism, which arose in the second and third centuries. The god who is believed to be Vishnu's principal incarnation is called Krishna and, as European missionaries discovered in the eighteenth century, in some Indian dialects Krishna is pronounced Krishta, much the same pro-

nunciation as that given to Christ. As Jean Sedlar puts it, 'the theoretical possibility exists that Krishnaism might be a corrupt form of Christianity'.[74] There *are* parallels between the religions, but the fact remains that the name Krishna goes back to the sixth century BC. Again, we are unlikely ever to find a complete answer.[75]

In India, in the year we are calling 0, the subcontinent was politically divided. The Mauryan empire had ended around 180 BC and the Guptas would not emerge until AD 320.

The Mauryan era is, in the words of one historian, that 'to which the word "classical" is as readily applied as to those of Greece and Rome – and with good reason, in that it has since served India as an exemplar of political integration and moral regeneration'.[76] With their capital at Pataliputra, in the north, the Mauryas produced two – very different – leaders, and one classic text. The first of these two was known to history for many years as Sandrokottos. It was Sandrokottos' empire that was described in such fantastic terms by Megasthenes, the Seleucid ambassador to his court. And it was Sandrokottos who Sir William Jones, a British judge in India in the eighteenth century, realised in a flash of inspiration was the same person as Chandragupta, 'the Indian Julius Caesar' who left the greatest empire, stretching from Bengal to Afghanistan.[77]

Sir William Jones' association of Sandrokottos with Chandragupta was one flash of insight. Another was the brainchild of James Prinsep, the assay-master at the British mint in Calcutta, who in 1837 made what John Keay calls 'the single most important discovery in the unravelling of India's ancient history'.[78] Prinsep was familiar with a massive Buddhist *stupa* (or monument) at Sanchi, near Bhopal, in central India, which was covered with writing in an unknown script. This script was also reported from other parts of India. It was found on rocky outcrops, on cliffs, and on massive pillars, and many of the inscriptions seemed to say the same thing. Prinsep eventually identified the language as Pali, one of the derivatives of Sanskrit which, significantly, was popular in the Buddha's time. In fact, as Prinsep guessed (because so many of the inscriptions were similar), it was the sacred language of Buddhist scripture. In a sense Prinsep was only half right. Pali *was* the sacred script of Buddhism but the inscriptions were not only religious tracts; they included also 'hard statements of policy ... the directives of a single sovereign.'[79] They became known in India as the Edicts after being attributed to a certain Devanampiya Piyadassi. The first term means 'Beloved of the Gods' and though Prinsep had at first no idea who this figure was, it soon became clear that he was Ashoka, the third Maurya, the grandson of Chandragupta, and the greatest of Indian emperors, who was elevated *c.* 268 BC and ruled for forty years. Ashoka championed Buddhism in India and sent his son to introduce the system in Sri Lanka, where there were many records of his achievements among the Buddhist literature there.[80]

The Edicts – divided now into the fourteen Major Rock Edicts, the eight Minor Rock Edicts and Inscriptions, and the seven Major Pillar Edicts – describe Ashoka's accomplishments. The 'big idea' in the Edicts is Ashoka's concept of *dhamma*, equated with 'mercy, charity, truthfulness and purity', the renunciation of violence, piety, duty, decency and 'right conduct'.[81] The innovations of Ashoka cannot be fully understood other than against the background of the main classic text of the time, the *Arthasastra*, written by the 'steely Brahmin', Kautilya.[82] Chief minister to Chandragupta, Kautilya's treatise was a

comprehensive compendium of statecraft – how the state should be administered, how taxes should be levied and collected, how foreign relations, and war, should be conducted. It has been described as an almost paranoiac document, with sections on how to detect dissent, how the state should intervene in almost all activities and with bloodthirsty suggestions for ruthless law enforcement. On the other hand, it has also been described as laying the ground for the world's first secular welfare state.[83] Recent textual analysis by computer has shown that it was in fact written by several hands but it still remains 'a guide not only for the acquisition of this world but of the next'.[84] In the *Arthasastra*, the author(s) say(s) that it is the sacred duty of a king to conquer neighbouring states. The ideology of *dhamma*, in contrast, was an attempt by Ashoka to go beyond this. He had conquered many states and his empire was enormous. *Dhamma*, therefore, was an attempt to unify his empire: common laws were introduced, common taxes and, where possible, stand-ardisation – of measurements, punishments, and so on. It was an admirable aim, well justified by the comment of John Keay that this could be regarded as India's 'classical' age, with Chandragupta as Julius Caesar and Ashoka as Augustus.

But learning too was encouraged by Ashoka and other Maurya rulers. Originally, the main debates had been between the Brahmans and the monastic sects – Buddhists and Jains. Not much written material has survived from that time but it is known that when the Buddha was alive there were two centres of learning or, as we would say, universities. These were at Kasi and Taxila but they were overshadowed later, in the early part of the fourth century BC, by the institution at Nalanda, in Bihar, which has been called the Oxford of Buddhist India.[85] It consisted of a cluster of courtyards and buildings and many large-scale sculptures of the Buddha and Bodhisattvas. Brahmanical universities did not appear until much later, around the time of Christ, at Kasi (as Varanasi was then known). The foundation of the curriculum was grammar, politics and caste law, with medicine, fine arts, logic and philosophy introduced later.[86] It was the custom for the students to nail their theses to the doors of the lecture halls. The public would gather, read the theses, and then hear the students defend their arguments in the hall.

The rise of the universities encouraged the spread of literacy and of learning, including (1) the great epics, the *Mahabharata* and the *Ramayana*, (2) the *Upanishads*, short religious poems for memorising, (3) *sutras*, brief philosophical guides, in prose, for learning, (4) *sastras*, didactic verses presenting philosophical and legal principles, (5) dramas, (6) animal tales, and (7) the *Puranas*, the scriptures of later Hinduism.[87]

The *Mahabharata*, which means the Great Bharata, had its origin in Vedic times. Legend has it that this epic work existed in several forms in antiquity, variously of 24,000 and 100,000 verses. The version we have, however, was produced probably as late as *c.* 100 BC. Its theme is a fratricidal war of succession.[88] The story opens with Pandu being consecrated as emperor in the Bharata dynasty. He becomes emperor because his elder brother, Dhrtarastra, who should be emperor by rights, is blind and therefore legally disqualified. However, Pandu dies before his brother, who seizes power while claiming to act as regent for Pandu's son, Yudhisthira. Yudhisthira had been named as crown prince, given part of the kingdom to rule, and formed a marital alliance with Krsna (Khrishna), leader of another dynasty. This provokes jealousy in Duryodhana, Dhrtarastra's son, who challenges Yudhisthira to a

gambling duel, where he knows the odds have been fixed. In the duel, Yudhisthira loses everything, and is consigned to exile. After twelve years, Yudhisthira sends Krsna as envoy to negotiate the restoration of his kingdom. But Duryodhana will not give up even the smallest part and a great battle becomes inevitable. This takes eighteen days but, with the aid of Krsna, who engages in various acts of deceit, the Pandavas regain their kingdom and destroy their enemies. In the main the *Mahabharata* is seen as criticising the effects on man's nature of too much worldly ambition. In a sense this is both Buddhist and Greek.[89] Even today in India, TV adaptations of the story bring the country to a standstill.

The *Ramayana*, traditionally held to have been composed by Valmiki (fl. *c.* 200 BC), was the first narrative poem in Sanskrit. Metrically, it is later than the *Mahabharata*, lacking the archaic rhythms of the earlier epic and it has less material added in later ages. Here too we have a story of palace intrigue. Rama is excluded from the succession to his father's throne, and sentenced to twelve years' exile, in the south. There, he finds the land constantly raided by demons from Lanka (Ceylon) and even his own wife is abducted. In retaliation, he raises an army, invades Lanka, rescues his wife, and kills Ravana, the demon king. When he returns home the period of exile has lapsed and his brother magnanimously surrenders the kingdom. The *Ramayana* is a more generous story than the *Mahabharata*. Later translated out of Sanskrit into the vernacular languages of India, it became the nation's favourite poem and Rama its most popular hero. Episodes from the narrative were widely used in sculpture and the other arts.[90]

The five hundred years between the displacement of the Mauryas and the emergence of the Guptas (in AD 320), straddling the year 0, were once regarded as India's 'dark age'.[91] This view can no longer be justified. It was a time of great cities, of Pataliputra and Kasi, of Mathura and Ujjain, often built to a common plan, four-square, with a gate at the centre of each wall, surrounded by a moat. It was, above all, a great era of sculpture and rock-cut temples, for which India would become justly famous. The great sculptural reliefs of Bharhut, Sanchi and Amaravati all date from this period, commissioned not by emperors but by the newly-successful merchant class. Principally found in western India, in the hinterland behind Mumbai (Bombay), where the folds in the edges of the Deccan plateau create hundreds of natural caves, many of these monuments are more than temples – there are entire monasteries, with meditation cells, pillared halls, and elaborate connecting staircases, all carved out of the natural rock. Besides the rock-temples, two forms of sculpture emerged at this time. One, in the north, in the Punjab and Afghanistan, was very much influenced by Greek ideas, showing Buddhas and other figures with the attributes of Apollo and other Greek gods (this is now known as the Gandharan school). The second developed around the city of Mathura, using the distinctive pink sandstone of the area, showing mainly voluptuous female figures that may have been associated with various cults.[92] Indian sculpture – Indian carving – is much less well known than classical Greek carving of the same period, but it deserves similar acclamation.

The time straddling the year 0 in India was equally notable for its literature. In the second century BC, Patanjali, a Sanskrit grammarian, compiled the standard text on yoga. Yoga is defined as a cessation of mental states.[93] The yogin learns to position him- or herself in a particular position (*asana*) and to steadily arrest the processes of breathing. At

the same time he or she increasingly focuses on his or her own mental state, the aim being to 'deconstruct the fabric of the mind', learning a 'transcendental loneliness' (*kaivahya*), which brings with it ethical purity or a new wisdom. The greatest religious work was the *Bhagavad Gita*, a work of post-Maurya India. The *Bhagavad* builds on the Upanishads in a mixture of social administration and philosophy. It accepts the four castes and the four types of duties attached to them. For the brahmana, the duties are sacrifice and study; for the kshatriya, it is fighting and protection of the subjects; for the vaisya it is economic welfare, trade and agriculture; and for the sudra it is service and the menial jobs. Philosophically, the aim is to free oneself from all of the 'impurities of passion' – greed, antipathy, self-love. But even the seer or sage, the wise man, must pursue his public duties, as an example to others who may not possess his advantages.[94] However high a man may soar, in a philosophical sense, he is still bound by his social ties here on earth. The highest wisdom cannot be divorced from the world in which we live: it has to co-exist alongside. The *Bhagavad Gita* is scarcely less conservative than the *Analects* of Confucius.

The Buddhist equivalent of the *Gita* is *The Lotus of the Good Law, Saddharmapundarika* (see below, page 195). In some ways this was even more influential because, as we shall see, Buddhism was much more of a missionary religion than Hinduism. The *Lotus* provided China and Japan with new ideas about God and man and is found today on every Buddhist altar in Japan. In the second century AD, the *Kamasutra* of Vatsyana, the *Manusmriti* ('Manu's code' of law) and Kautilya's *Arthasastra* all found their final form.[95]

Probably the most significant long-term intellectual trend at this time in the East was the move of Buddhism *out* of the subcontinent, to China, Sri Lanka, Sumatra and so on, and of Hindu-Buddhist diffusion into Java, Malaysia and elsewhere. According to tradition, Buddhism entered China during the reign of Ming-ti (AD 58–75), but actually it was the main religion in the various states of Tokharestan long before this and it was from there, in 2 BC, that the Chinese ambassador, Tsing Kiang, received Buddhist texts as gifts to take back to the Chinese court.[96]

An official Chinese history, *The Record of the Later Han*, tells us that, by the first century AD, Buddhism had reached the Chinese capital. Liu Yang, a half-brother of the emperor, had received permission to practise Buddhism, which he did alongside worship of Laotzu. After the emperor had had a vision 'of a golden man with sunlight passing from the back of his neck, who flew about in time and space', envoys were sent to India to inquire after Buddhism and returned with monks, a number of sacred texts and many works of art. There are several accounts of journeys made into India, with drawings, written by Chinese pilgrims in the first century AD. For example, Wang Huan-ce travelled to India several times and made a copy of the Buddha image at Bodhgaya, the location where he achieved supreme enlightenment, which was then brought back to the Imperial Palace and served as the prototype for the Kongai-see temple. This early Buddhist art, imported from India, served only to stimulate a Chinese art of even greater beauty. By the middle of the first century, Buddhism was established north of the river Huai (half-way between modern Canton and Beijing), in eastern Honan and southern Shantung.[97]

The reasons why Buddhism caught on so quickly in China have to do with the nature of life and thought among the Han Chinese, who ruled from 206 BC to AD 222, neatly

straddling the year 0. The earliest settlements in China appeared around 3500 BC, with writing dating from the Shang period (*c.* 1600 BC). The origin of the Chinese script is a matter of lively debate. One theory, about the birth of numbers, is that – as in the Americas – characters began with knots in string, large knots for important memories, small knots for more trivial things. Figure 9, for example, shows the way string knots may have given birth to the Chinese characters for number.

| | | | | |
|---|---|---|---|---|
| ⸙ | *shi* 十 | (ten) | ᕙ *nian* 廿 | (twenty) |
| ⸙⸙ | *sa* 卅 | (thirty) | ⸙⸙⸙ *xi* 卌 | (forty) |
| ⸙ | *qian* 千 | (thousand) | 拜 *peng* 朋 | (two strings of five cowries) |

**Figure 9: Chinese 'knot' numerals**
[Source: Endymion Wilkinson, *Chinese History: A Manual*, Cambridge, Massachusetts: Harvard University Press, 2000, page 374]

Another theory is that rock art gave rise to some of the characters (for men, women, snakes, feet, mountains), and a third is that pottery marks, pictographs, which were used to indicate superstitious rites regarding the production and protection of pottery, also developed into Chinese characters. Finally, there are the oracle-bone inscriptions which also seem to prefigure the characters for, among others, the sun, the eye, and so on. It may well be, then, that Chinese characters had several origins. Their general shape, long and narrow from top to bottom, with the characters for animals having their heads at the top and their tails at the bottom, suggest they were originally written on bamboo stems, which have perished. The fact that the first known users were the diviners and scribes of the Shang kings suggests that writing proper in China did not emerge before 1600 BC and that its origin was religious/political rather than economic as in Mesopotamia.

From the earliest times the calendar was taken very seriously, with the Almanac Maker being a prestigious post in the imperial court. Excavations made between the two World Wars at Anyang, near the Yellow river, have uncovered many of the so-called oracle bones, usually the shoulder blades of oxen, or the under-shells of turtles. These produced cracks when heated, which were interpreted as part of the diviner's art. Some of them also concern payment of tribute and so contain information on the calendar. They show that originally the Chinese divided the day and night into one hundred equal units (*baike*) and that they were aware of the $365\frac{1}{4}$ year and a lunation of $29\frac{1}{2}$ days (there were originally four words for 'year' in Chinese). There were no eras, as such, in China, but time was understood to consist of a series of cycles. There was a ten-day cycle, with the days known as 'ten heavenly stems', and a twelve-day cycle, of the 'twelve earthly branches'. Together, these produced a sixty-day *ganzhi* cycle (the lowest common multiple), which by tradition was begun in a year corresponding to 2637 BC. But other cycles were known: the *chi*, of 31,920 years, the 'grand conjunctions', when all the planets came together after a cycle of 138,240 years, and a 'world cycle' of 23,639,040 years, the beginning of which was referred to as the 'supreme ultimate grand origin'.[98] Already, then, the Chinese had a very different idea of 'deep' time from anyone else. The Chinese also had a concept of approximate numbers (*yueshu*), so that, for example, *wulu wushi* means 'about 50'. The numbers 10, 100, 1,000 and 10,000

were used to indicate orders of magnitude and were known as *xushu*, hyperbolic numbers, similar to the English 'dozens' or 'hundreds'. The numbers 3, 9 and 12 were used respectively to mean 'several', 'many', and 'a lot', and some numbers were auspicious, associated with authority, power and longevity – thus all the doors in the Forbidden City have nine rows of nine nails. Alteration-proof characters were given to numbers to prevent falsification.

In 163 BC a new system, *nianhao* (reign-year title), was introduced and thereafter every emperor proclaimed a new *nianhao* at the beginning of the year following his accession. In 104 BC a new calendar was introduced, with twelve lunations and a thirteenth intercalated month, very similar to the Indian system and, indeed, to the zodiac. The seven-day week, however, was not adopted in China until the thirteenth century AD; before then the year was divided into twenty-four fortnightly periods beginning with Li Zhun ('spring begins') in February and ending with Da Han ('severe cold') in January. In China until Song times a 'meal drum' was sounded five times a day, signalling the three main meal times, the evening curfew and the morning lifting of the curfew. (This curfew was strictly enforced in every kingdom and especially in towns, where its aim was to prevent fire as much as crime.)[99]

By the time Buddhism arrived in China the Han dynasty was in decline and with it the philosophical system that had dominated there for so long. The underlying principle of traditional Chinese thought was to imagine a cosmological order to the universe, which was mirrored on earth by the ordered centralisation around the emperor. This idea of order governed everything from commerce to government to philosophy to religion. Trade in the great cities could be carried out only in government markets, where officials set the prices and the level of taxes. The government built and maintained the main roads, and charged for their use. The government also operated a monopoly over iron, metal money and salt (a daily requirement for a grain diet). In this way order was centrally generated and maintained.

Above all, the Han emperor had a special role in worship and he collected around him large numbers of scholars whose job it was to advise him and help him run the state. These educated men became a new aristocracy under the Han; they were powerful officials in the provinces and were an (intended) threat to the older, more independent aristocracy. In this fashion, the Han gradually evolved a number of dominant ideas that amalgamated Confucianism into a state philosophy. This is referred to now either as legal-Confucianism, or Imperial Confucianism, to distinguish it from the original doctrines. As John Fairbank, the great Harvard scholar of China, put it, 'The essential point about the Legalist-Confucian amalgam was that legalism was liked by rulers and Confucianism by bureaucrats.'[100] Confucians believed that the emperor's observance of ceremonial ritual and his own exemplary conduct gave him a certain virtue (*de*) that encouraged others to respect his position. The threat of force always hovered in the background but the elaborate college of Confucian experts ensured that the emperor always behaved in the 'right' way. It was the Confucian understanding of 'right conduct' that governed everything, always in the context of Chinese cosmology. This cosmology was very different from Western ideas and was itself a sort of astronomical Confucianism, in that the Chinese imagined the universe as an ordered whole. The Chinese differed from other peoples further west in that they

had no creation myth and no creator-lawgiver who was supernatural. They assumed that there was an ordered harmony in the universe but did not assume a supernatural deity who ordained this order. 'For the Chinese the supreme cosmic power was immanent in nature, not transcendent.'[101] Mankind was part of this ordered whole, his place defined and nurtured by the ruler and his ancestors.

As a result of this approach, the Han Chinese saw 'correspondences' and 'resonance' everywhere. The macrocosm was reflected in the microcosm of man which ordained his 'proper' place in the scheme of things. Thus, in the *Huainanzi*, written around 139 BC, 'the head's roundness resembles heaven's and the feet's squareness resembles earth. Heaven has four seasons, five phases, nine sections and 366 days. Man likewise has four limbs, five viscera, nine orifices and 366 joints. Heaven has wind and rain, cold and heat. Man likewise has taking and giving, joy and anger . . .'[102] This approach was most marked in the doctrine of the five phases, or elements: water, fire, wood, metal, earth. The 'fiveness' of the elements was reflected everywhere: the five planets (all that were then visible), the five colours, five directions, five musical tones, five punishments, and many more 'fives'. Where it suited them, or seemed wise, the Chinese invented devices for connecting correspondences that might otherwise prove difficult. We have already mentioned the ten celestial stems and the twelve earthly branches. To these were added the devices of *yin* (female) and *yang* (male), which allowed the correspondences of four, five, ten or twelve to be doubled. The most complicated, but popular, set of correspondences grew up around the *Yijing*, or 'Classic of Changes' (better known as the *I Ching*). This was primarily a hexagram of sixty-four squares, produced by six sets of parallel lines, either broken or unbroken. This produced sixty-four resulting figures, each with specific connotations, to be used in prophecy.[103] The most famous theorist of this system was Zou Yan of Qi (305–240) who extended his interpretation, or divination, to astronomy, geography, history and politics. According to him, political change was governed by the five elements, in the order: earth·wood·metal·fire·water.

This notion of correspondence led in turn to the idea of resonance (*ganying*), which also infiltrated all areas of life, from music to government. The strings on a lute, for example, resonated with one another but so did the ruler and the ruled: one good act should be balanced by a response. When the ruler set a good example, his people should and would follow.[104] Acupuncture was the perfect science of correspondences: certain puncture points in the body were found to control nervous sensitivity in other parts of the body. Although acupuncture anaesthesia was not introduced until the twentieth century, the very existence of acupuncture was held to be vivid evidence of correspondence and *ganying*.

As mentioned above, the central element in this elaborate system was the ruler and his ritual observances which reflected the cycle of the seasons and other celestial events.[105] Beginning with the oracle bones, Chinese records of the heavens were very detailed over many centuries, though they are most comprehensive for the early Han period. Natural events – eclipses, meteors, floods or earthquakes – could be interpreted as nature's verdict on a ruler's performance. It followed that the clever ruler, if he wanted to stay in power, appointed specialist advisors. If he followed their advice, and the advice was wrong, it was they who suffered, not him. By Han times it was understood that the great classics of

China contained secret knowledge, available only to erudite scholars. (The word *jing*, which means 'classic', originally referred to the warp, or vertical threads, in a loom, which were long-lasting.) In this way there grew up at court a whole raft of powerful Confucian philosopher/interpreters, people such as Dong Zhongshu (*c.* 175–105 BC). They advised the emperor how to relate to the cosmos, and then anxiously watched the results. It was the emperor's special privilege to worship heaven, and his ancestors, but he also controlled the police, the army and other institutions of social control. He therefore formed an ideological alliance with the Confucian literati who concerned themselves with precedents set by former emperors as recorded in the classics. These two elements – the emperor with his worship of heaven and the ancestors, and the trappings of force on the one hand, and the Confucian advisors around him – formed the governing/intellectual elite in China, the pinnacle of a two-class system in which the remainder were peasants.[106]

This approach reached its greatest influence in 124 BC with the formation of the imperial academy, or Taixue. Here there were specialists in the five classics: the *Yijing*, or 'Classic of Changes' (for divination), the *Shujing*, or 'Classic of History', the *Shijing*, or 'Classic of Songs' (ancient folk poems), the *Chunqiu*, or 'Spring and Autumn Annals' (chronicles of Confucius' own state of Lu in Shandong, plus commentaries), and the *Liji*, or 'Record of Ceremonies and Proper Conduct'. Alternative versions of some of the classics were found, allegedly in a wall of Confucius' house, sometime between 156 BC and AD 93. While this gave scope for different interpretations of the texts, and argument as to whether they were coded prophecies or not, they also stimulated an interest in textual criticism long before such a discipline existed elsewhere.[107] It was under the Han, too, that history was first written down in China in a systematic way, with many oral traditions finally being captured. The most important of these were *The Historical Records*, by Sima Qian (135?–93? BC) and *The History of the Han* (*Han-shu*), completed about AD 82 by Ban Gu and his sister Ban Zhao. Both these works were organised along similar lines: annals of the sovereign, treatises (on music, astronomy, canals, law etc) and biographies.[108] Already by this time examinations were in place for appointment to the ranks of imperial advisor, but now the emperor required an education in the classics before potential recruits could even sit the exam, though in the Confucian manner filial piety was also one of the criteria for selection.[109]

The classics, whose secret meaning was passed from one generation of scholars to the next, and the Confucian approach in general, governed thinking in the majority of areas. 'Most fundamental was the stress on hierarchy so evident in pre-historic times, which assumed that order can be achieved only when people are organised in gradations of inferiority and superiority.' Similarly, there was an emphasis on duties rather than rights: it was assumed that if everyone did his duty everyone would get what he deserved. 'With all duties performed, society would be in order, to everyone's benefit.'[110] The son obeyed the father, as the people obeyed the 'parental' government, with loyalty as the paramount value. It was the ruler's job, with a mixture of auspicious things (*chi*), such as bounties and amnesties, and inauspicious things (*hsiung*), such as penalties and punishments, to maintain cosmic harmony, to prevent excess.[111]

Despite the strength of Confucianism, Taoist beliefs had not disappeared and several Han emperors, or their wives, embraced Taoist principles and employed Taoist magicians.

Yang Xiong (53 BC–AD 18) wrote a famous Taoist work called *The Supreme Mystery*. By now the fundamental Taoist concern was with longevity and/or immortality. They believed that immortals existed, manifesting themselves in different forms down the ages, and Taoists sought to extend their lives by various alchemical, dietetic, gymnastic and even sexual rituals.[112]

The particular form of Buddhism that was translated to China was known as Mahayana Buddhism. This distinguished it from the Hinayana school. The schism had developed within the *sangha*, the order of monks, following the Fourth Buddhist Council, traditionally held under the auspices of Kanishka II, the Kushan emperor, who began his reign *c.* AD 120. In Hinayana Buddhists held that their beliefs were essentially an ethical system, while the Mahayanas elevated the Buddha and other 'enlightened ones' to the status of deities, who were to be worshipped. In other words, whereas Hinayana Buddhism remained a broad philosophical system, Mahayana Buddhism, which was exported to China, was much more a conventional religion. The Hinayana Buddhists, for example, did not to begin with represent the Buddha in human form: he was indicated by a footprint, a throne or a tree. The Mahayanists, on the other hand, adapted Greek ideas, clothing the seated Buddha in elegant folds of drapery, and giving him a placid, serene, classical expression (all the while keeping him ethnically distinctive). The leading figure in the Mahayana movement was the philosopher/poet Asvaghosa (fl. *c.* 150), whose *Buddhacarita*, or 'Life of Buddha', was for a long time the main document in Mahayana Buddhism.[113] Asanga, a monk who flourished between 300 and 350, introduced yoga and turned Mahayana Buddhism into a proper religion of salvation, being as much concerned with a 'future state' as with life here on earth.

After the second century AD, the chief Mahayana doctrinal work was the *Saddharmapundarika* or *The Lotus of the Good Law*, a statement of faith 'comparable with the Hindu *Bhagavad-gita* and the Christian Fourth Gospel'.[114] Addressed to the simple layman, it portrayed the 'coming Buddha', Maitreya, who taught the way of salvation:

> Buddhas ye shall all become;
> Rejoice and be no longer uncertain.
> I am the Father of you all.

This poem, longer than the New Testament, described the one true way to salvation, and affirmed that there was one eternal Lord. Maitreya overlapped in many ways with the Iranian Mithra. Mahayana Buddhists believed that the Buddha, sitting alone on a mountain peak, gave reality to everything. When evil built up in the world, he descended from his mountain-top in a new form, casting light and bringing mercy, and teaching the path of salvation. In other words, in addition to the original Buddha there was a series of Buddhas, each playing an important role in the evolution of the universe and the moral growth of mankind. More important still, future Buddhas, the Maitreya, would come to earth to rescue the world from evil.

Also integral to Mahayana Buddhism was the concept of the *bodhisattva*. Having achieved Buddhahood by a righteous life, the bodhisattva postponed *nirvana* in order to

remain on earth, serve and teach men. As part of this tradition, ten virtues were encouraged by the bodhisattvas, self-mastery being the cardinal individual virtue, and compassion – the love of others – the supreme social virtue.[115] This implied a further change in Mahayana Buddhism in that the teacher was more a priest than a monk. 'There was a single road to salvation but it had three gates: one for *arhats* ['accomplished ones', who had achieved *nirvana*], another for those who excelled in meditation, and still another for the altruistic and sociable.' Yoga was clearly important in self-mastery but so was the chanting of sacred words. 'Right conduct' was encouraged by the belief that one's last thought at the moment of death determined the fate of the soul. At death the soul was removed to purgatory where it 'suffered many torments'. There were sixteen kinds of hell, with different punishments for different types of sin.[116] For those who weren't sinners, the ultimate destination was the 'western paradise' of Amitabha (*A-mi-to-fo*). 'There seven fountains flowed with the waters of the right virtues. For six hours each morning and evening there was a rain of celestial flowers . . . Each morning the blessed offered the celestial flowers to the countless Buddhas who returned to their land at mealtimes. The continuous repetition of Amitabha's name was a sure way to reach this heaven.'[117] It was a long way from the vision of Gautama.[118]

A final factor in the spread of Buddhism in Han China was the emerging dichotomy between *wen* and *wu*. *Wen* refers to writing, literary culture and the values associated with it: reflective thought, rational morality, persuasion, civilisation. *Wu*, on the other hand, stands for violence, force, military order. The Confucian advisors disparaged *wu* and favoured *wen*. But this had two unfortunate knock-on effects. It drove a wedge between the ruling elite and the peasants in the provinces, thus weakening Han unity, making the country susceptible to attacks from the periphery and even outside China. And, second, it meant that Confucianism as a framework of thought and belief was less and less suited to the common people: it became an intellectual system for the elite.[119]

Beginning around AD 220, the aristocratic families in the north revolted and amid the resulting chaos the Toba Turks, steppe people from the north, invaded and set up the Wei dynasty. They too were Buddhists.

Not all Chinese thought of the Han period concerned itself with abstract 'big ideas'. The Chinese then, as ever, were a fiercely practical people. They were producing steel as early as the second century AD, by mixing together iron with different carbon content.[120] There was already a thriving international trade in Chinese technological inventions, particularly in luxury items such as silk, lacquer and bronze mirrors. The Han Chinese practised a highly original policy of 'ostentatious generosity' with their neighbours, 'which surprises us by its extremely high cost and systematic character. Probably no other country in the world has ever made such an effort to supply its neighbours with presents, thus elevating the gift into a political tool.' According to official records, in 1 BC, the Han gave away some 30,000 rolls of silk and by AD 91, the value of silk gifts had reached 100,900,000 pieces of currency.[121] Jacques Gernet, the great French orientalist, calculates that the annual revenue of the empire at that time was of the order of ten billion coins and that three or four billion were taken up with gifts, a substantial levy on the country's wealth which at the same time stimulated production and weakened the economy. But these gifts were part of a conscious, long-term policy by the Han Chinese to seduce their barbarian neighbours and to corrupt

them by accustoming them to luxury. It seems to have worked, insofar as it helped the Han achieve political stability on the borders of the empire for several centuries.[122]

The water-mill was invented in the reign of Wang Mang (9–23). At first it seems to have been a vertical wheel, turned by water, activating a horizontal axle which turned a battery of pestles. But by AD 31 one text records the use of hydraulic power to work piston bellows in forges. The breast-strap harness had been introduced very early, perhaps as early as the fifth century BC, but just as important was the wheelbarrow, invented in the first century AD. This allowed much greater loads to be carried by one person, and for them to be transported along paths that were too narrow or winding for horse-drawn vehicles.[123] Chinese ships had the rudder from AD 1 and the compass was introduced in AD 80. The systematic recording of spots on the sun began in 28 BC and in AD 132 the first seismograph was invented by Zhang Heng. This was a good example of the Chinese approach, for Zhang Heng's aim was to pinpoint earthquakes which, as we have seen, were regarded as a sign of disorder in nature. In AD 124, Zhang Heng (a poet as well as an astronomer) also produced a celestial globe, with an equatorial circle.[124] This had important consequences, not least in the development of logical/scientific thought. A key figure here was Wang Chong (27–97), who wrote *Lun-heng*, a ranging criticism of the superstitions of the time. He had a deep interest in physics, biology and genetics, ridiculed the idea that man had a special place in the cosmos, did not believe in life after death, individual destiny, or that the mind can exist independently of the body, preferring logical explanations for phenomena, based on experience.[125]

Arguably the most important Chinese innovation of this time was paper. Traditionally, this invention was commemorated in the story of Cai Lun, a eunuch who served at the court of the emperor Hedi as director of the imperial workshops (see page 298). He made *zhi* (Chinese for paper) from the bark of trees, remnants of hemp, old fishing nets and used it for writing. He was promoted for his discovery, to *Shangfangling*, or chief-commandant of skills and production, but this too is now the subject of revisionist history and, according to Jonathan Bloom, *zhi* was defined in a Chinese dictionary produced at the time Cai Lun lived as *xu yi shan ye*, in which *xu* refers to 'fibrous remnants obtained from rags or from boiling silkworm cocoons' and the word *shan* 'refers to a mat made from interwoven rushes used for covering something'.[126] These processes date back to the sixth century BC and so paper-making may be as old as that. Most Chinese authorities now think that paper as we know it had been invented by the second century BC, though it was coarse and not suitable for writing until, perhaps, the first century AD. A Chinese story, set in 93 BC, records the first use of facial tissue – an imperial guard advises a prince to cover his nose with a piece of *zhi*.[127] Paper required treating, with gypsum, gum, glue or starch, before it would take writing, and this seems to have occurred around the first century, or a little before. Already by AD 76, a scholar was instructing students by using copies of the classics written on *zhi*, so paper must have been reasonably common, and cheap, by then. The earliest examples show that Chinese papermakers formed sheets by pouring a pulp made of rags and textile waste on to cloth moulds floating in a pool of water. Later they dipped the mould into a vat of pulp, which was peeled off as it began to dry, allowing the mould to be used again. As the appetite for paper grew, they turned from waste materials and made their pulp direct from the fibres of hemp, jute, rattan, bamboo

or mulberry.[128] Lavatory paper was introduced by the sixth century.[129]

There were many innovations in the arts during the Han dynasty. Prominent among them were the *fu*, flamboyant and hyperbolic rhythmic poems of court life – the hunts, the parks, the parties – and an Office of Music (*Yue fu*), which collected popular songs, dances and musical instruments. This office was partly responsible for the *ku-shih*, a new poetic form with verses of five or seven characters. These would evolve into the regular poetry (*lu shi*) of the Tang age in the seventh century.[130]

In AD 190, following a period of revolt by peasants and army leaders against the central authority, the imperial library and the Han archives were destroyed in a fire caused by the fighting. The disruption and anarchy continued for a quarter of a century; urban societies disintegrated and the fine civilisation of the Han age trickled away into the Chinese Middle Ages.

# Law, Latin, Literacy and the Liberal Arts

When Aristotle died, in 322 BC, he left a considerable personal library. To aid his studies, he had amassed so many titles that, to quote Strabo, the geographer, 'He was the first to have put together a collection of books and to have taught the kings in Egypt how to arrange a library.'[1] Later, through 'the vagaries of inheritance', the library had come into the hands of a family living in Pergamum, 'who had kept it stored underground to save it from being confiscated by the king'.[2] They sold the books to Apellicon, a bibliophile who took them to Athens. Then, in 86 BC, the Roman dictator Sulla invaded Attica, sacked Athens and, when Apellicon died a short time later, seized his books and shipped them back to Rome. Sulla knew what he was doing: the library included titles by Aristotle and Theophrastus, his successor, that could be found nowhere else. The books were in terrible condition – worm-eaten and sodden from damp – but they could be read and were copied, and saved.[3]

The Roman reverence for the Greek way of life, of its thought and its artistic achievements, was one of the dominant ideas throughout the long era of its empire. When we speak now of 'the classics', we mean – as often as not – Greek and Roman literature. But it was the Romans who invented the very notion of the classics, the idea that the best that had been thought and written in the past was worth preserving and profiting from. In saying that, however, the real difference between Rome and Greece in the realm of ideas is obscured. Whereas the Greeks took an almost playful interest in ideas for their own sake, and explored the relationship between man and the gods, the Romans were much more interested in the relationships between man and man and in *utilitas*, the usefulness of ideas, the *power* that they could bring to affairs. As Matthew Arnold put it, 'The power of the Latin classic is in character, that of the Greek is in beauty.'[4] There are many Roman authors whom we now revere as classics in themselves: Apuleius in the novel; Catullus, Virgil, Horace, Ovid, Martial, Juvenal in poetry; Terence, Seneca and Plautus in the drama; Cicero, Sallust, Pliny and Tacitus in history. Each of these offered something over and above their Greek counterpart. But, enjoyable and instructive as these authors are, they do not comprise the major intellectual innovations of the Roman world. So far as *our* everyday lives are concerned, the two most important Roman ideas were republicanism, or representative democracy, and law. Direct democracy, as we have seen, was a Greek invention but – one has to admit – it has scarcely any modern imitators. Representative

democracy, however, was incorporated into the constitutions of the various republics which began to appear from the eighteenth century onwards, and now extends from Argentina to Russia to the United States of America. In ancient Rome, as is broadly true in America today, policy was agreed by the Senate, and implemented by magistrates with *imperium*, a particularly Roman notion.[5] The ancient kings, and then the aristocracy, and then the magistrates, were all invested with *imperium*, 'a key concept, which designated the acknowledged right to give orders to those of lower status and expect them to be obeyed ... This power was at all times ill-defined, wide-ranging and arbitrary. From the start a vital way in which this *imperium* could be expressed was in imposing by war the holder's authority and that of Rome on neighbouring communities who were thought to have challenged it.' Conquest was an integral part of Roman ideas about themselves.[6]

The Roman system had come into being in 510/509 BC, when the king had been expelled, to be replaced by elected officers. The key features of the consulship or magistracy, which replaced kings, were these: tenure was limited to one year; there were two magistrates with equal *imperium* – 'never again would a single individual be invested with supreme power'; there was accountability – the magistrate could be called to account for his actions at the end of the year.[7] Continual conquest, with recurring crises, meant that this system was modified on occasions, as revealed by Tacitus and Suetonius. In crisis a single *dictator* was appointed, reminiscent of the tyrant in the Greek world, and at other times, when there were simultaneous military actions in several places, more than one magistrate was allowed, some with military functions, others with civil administrative duties. In this way the administrative machinery of the republic took on its familiar form, of a body of magistrates, advised by a Senate (group of *senes*, or old men).[8]

Originally, the kings of Rome had been given *imperium* by the gods when the city itself was founded. Thus the kings had been granted the responsibility of getting things done on behalf of the people. As a result *imperium* was a quality that 'belonged' to the person who exercised the power and it was, therefore, accepted that he could use it at his own discretion. At the same time, *imperium* also stood for the power of Rome itself, or at least of her people. *Imperium* was the muscle by which the *res publica* got things done.[9] It was less an abstract notion of power, more a propensity to issue orders (from the Latin word *imperare*, 'to order'). Long after the kings had been disposed of, magistrates still consulted the gods (*auspicium*) about future courses of action. On his first day in office, a magistrate would rise early and pray to the gods, to ascertain whether he had divine approval for the exercise of his *imperium*. Despite the fact that there are no known cases of the gods refusing such approval, the ritual was always deemed necessary.[10]

As time passed, magistrates became divided into those with *imperium* and those without. Dictators and consuls had *imperium* and so did praetors, a new class of magistracy, created in 366 BC to relieve consuls of the task of hearing legal cases. Magistrates without *imperium* comprised the quaestors, in effect investigators in legal and financial matters, the tribunes of the plebeians, whose job it was to administer the plebeian council, and the aediles, who had responsibility for the fabric of the city, the upkeep of roads, walls, aqueducts etc. Finally, there were the censors, 'whose function had more to do with what we mean by census than what we mean by censor'. Among their duties was identifying those who had contravened the morality of the state (and who therefore could not hold public office).

Like all other magistrates they were entitled to wear a special toga and also held the *auspicia*, an elevated status which entitled them to consult the gods.[11]

The Roman form of representative democracy was quite complex. It had to be because, by the time of Augustus, the first emperor (63 BC–AD 14), there were one million inhabitants in Rome alone and the empire stretched almost 5,000 kilometres from west to east (the Atlantic to the Caspian Sea) and nearly 3,000 kilometres from north to south (England to the Sahara). Not even a man like Augustus, who had a passion for efficiency, could administer such an empire all by himself.

In practice there were four political bodies apart from the magistrates. The *comitia centuriata* began life as an assembly to represent the interests of the army but over time it comprised the whole population and was made up of 193 centuriae, with people being allocated to centuriae by the censors according to the amount of property they had. There were five classes: the top *classis* had seventy centuriae and at the bottom there was one centuria not even registered as a *classis* which represented those who had no property to register. Such unfortunates were known as the *proletarii* on account of the fact that they were outside the active (useful) agricultural system and could only produce children (*proles*).[12] In the case of the *comitia tributa* and the *concilium plebis* the voting unit was the tribe. In the beginning there had been just four tribes, all in Rome itself, but in time that number grew to thirty-five until, in 241 BC, it was stabilised. In these bodies, the wealthy did not enjoy the same in-built advantage that they had in the *comitia centuriata*. The essential point here was constitutional balance: the *comitia centuriata* was dominated by the landed aristocracy, the *concilium plebis* was an assembly of the *plebs* alone, and the *comitia tributa* was an assembly of the whole people. The assemblies were powerful, up to a point, but in practice still depended on the magistrates, who had control over business discussed and election timetables.[13]

The other important body was the Senate. Originally, the consuls chose a new Senate every year. Once the censors had acquired this responsibility (in the fourth century BC), however, senators were appointed for life, and this simple but all-important fact made the Senate the most continuous element in the structure of the state. Added to this, its members were all ex-magistrates – experienced, well-connected, no longer ambitious for office. This constitution gave the Senate immense prestige.[14] Strictly speaking, the Senate's role was solely advisory: 500 senators were present in Rome at any one time, the rest on duty in the provinces. The Senate could be convened only by the senior magistrate, and such meetings would begin with the consul presenting to the assembled company the matter on which he required advice. The senators would then respond, in a specified order. First came the consuls-designate for the following year, if the election had been made, second those who had already been consuls, and so on. As time ran out (the senate could not meet after dark) more junior senators expressed their opinion by crossing the floor of the assembly and sitting near those speakers with whom they agreed. They were called *pediarii*, 'foot soldiers', because they voted with their feet. At the end of the session, the consul took the mood of the meeting and if there were no dissent he would issue a *senatus consultum*, a decree of official 'considered opinion'.[15] If there were any doubt, there would be a vote. Although in theory the Senate's decision was merely 'advice', in practice it was difficult for the consul to ignore a *senatus consultum*. Consuls held office for a year only and afterwards

normally joined the Senate. Few consuls risked crossing colleagues with whom they would have to spend the rest of their working lives. The Senate also saw new legislation before the other assemblies, which meant above all that it had control over the strength of the army, which in effect governed foreign policy.[16] And since 'empire' was central to Rome's idea of itself, this too added immeasurably to the prestige of the Senate.

A case can be made for saying that Roman law is the most influential aspect of Roman thought.[17] The Greeks never developed a written body of law or a theory of jurisprudence and so what the Romans created is their own achievement. Roman law is the basis for much of the law used in the West today and is still part of some university law courses. According to historians of the French *Annales* school, the fact that so many countries in Europe shared a common legal heritage is partly responsible for the rise of Europe from the twelfth century onwards.

Roman law was first formalised in the Twelve Tables, introduced in 451–450 BC. Like the Ten Commandments, the Twelve Tables set out basic legal procedures and punishments, and this became an important part of education: in Cicero's youth schoolboys still learned the tables by heart. By the late Republic, criminal courts as we would recognise them had been established, in which *iudices* were appointed to hear cases in a set formula. This formula allowed for two new professions. First, there were those who spoke on behalf of clients – advocates. In Rome, this was an activity that any 'gentleman' might perform: his rhetorical education was supposed to prepare him for just such an undertaking. Advocates were supposed to work for the good of the community (*pro bono*) and both Cicero and Pliny were advocates in this manner. At the same time a profession of legal specialists emerged – the first lawyers. This had hitherto been the prerogative of the College of Priests, the *pontifices*, but, as Rome expanded and life became more complex (and because many disputes had nothing to do with religion), specialism became necessary. These jurists, as they were called, wrote legal opinions (including rebuttals) to add to and counter Senate decisions or imperial edicts. To begin with, leading jurists would take one or two 'pupils': later these developed into the first law schools.[18]

There is one work of Roman law which survives almost intact: this is the *Institutes*, by the jurist Gaius. Written around AD 150, it served for a long while as a textbook of Roman law.[19] Besides specific laws (*leges*), it records senatorial decrees, the decisions of emperors, and the consensus of legal specialists, showing how the body of law grew. This body of law applied to all Roman citizens in the empire.

At the root of Roman law was the distinction between different statuses. This is quite different from modern law where wealth, sex or nationality are treated as irrelevant by the courts. Roman law distinguished slave from free and allowed for different degrees of freedom: those subject to someone else (master, father or husband) and those legally independent but still subject to wardship (children and women). This made for complications: an outrage (*iniuria*) committed against a married woman meant that there might be three victims – the woman herself, her father if he were still alive, and her husband. The higher their status the greater the crime.[20]

The most visible aspect of status and *dignitas* was shown by the legal power of the father, *patria potestas*. The Roman father had absolute power – the power of life and death – over

his entire family: this is what *paterfamilias* meant. It was an absolute power over his legitimate children, including adult children, over his slaves and his wife if married in a form which transferred paternal control (*manus*) to the husband (see below). As has been often observed, the *familia* could be seen as 'a state within a state'. A father's authority was absolute and jealously guarded. In exceptional crimes sons and wives were transferred from the custody of the state to paternal authority.[21]

In Rome, so long as one's father were alive, no one could act as fully independent, in particular in financial matters and in contract law. An adult son could own property only by means of a *peculium*, a sort of trust guaranteed by his father, but revocable at any point. While his father was alive a son could not make a will or inherit property in his own right. That son might be a magistrate, even consul, but if his father were alive he was still under his *patria potestas*. At the same time, the demographics of Rome mitigated this picture. Nearly one-third of children lost their fathers by the time they were ten and, by twenty-five, when people normally got married, more than two-thirds were independent. By forty-one (the minimum age for a consulship) just 6 per cent had fathers who were still alive. A father could 'emancipate' his son, which originally meant releasing him from *manus*, but this does not seem to have been common.

No less important or complex was the legal relationship between husband and wife. Romans made much of the fact that husbands should keep their wives under strictest control, but in practice this depended on which form of marriage the couple had concluded. There were three forms of union. Two made use of ancient ceremonials. In one, the couple offered a cake made of emmer wheat in a joint sacrifice held in front of ten witnesses. In the other ceremony, a father 'sold' his daughter to her husband before five witnesses. In both cases, this had the effect of transferring a woman from the control of her father to that of her husband. Her property became his and she fell under his *manus*.[22]

Quite what women got out of these arrangements is hard to say, so it is important to add that there was an alternative. There was a third way by which a marriage could come into being and this was, as the Romans, in their inimitable style, called it, 'by usage'. If a man and wife lived together for a year, it was enough: she passed into her husband's control.[23] By the same token, if the couple spent three nights apart in any one year, this 'usage' lapsed. In practice, then, people could get married and divorced without much fuss, or their partner's consent. These customs had an effect on Romans' ideas about love, and about joint marital property, an idea that, essentially, didn't exist. If the couple had been married before witnesses, then the husband owned everything. If the marriage resulted from usage then a wife's property remained hers and, in the case of divorce, left with her.[24] It is therefore perhaps not surprising that divorce and remarriage were common in Rome.

The importance of law to the well-being of the Roman state was shown by the fact that decisions could be invalidated if the proper procedures were not followed. Not even an emperor's decisions could ignore the status of litigants involved in legal battle. In this way, as Pliny remarked, the law was now superior to the emperor rather than the other way round. This was a crucial advance in the development of civil society.

We may say that Roman law culminated in the code of Justinian (AD 527–565), which in turn largely shaped European law as it is exists today, both in Europe itself and in many

of those countries colonised by later European powers. This code consists of the following entities: the Institutes, elementary principles; the Digest, a collection of juristic writings; the Code, a collection of imperial Enactments and the Novels, Justinian's own legislative innovations. The layout of Justinian's work identified the evolution of ideas and names those responsible, so it is especially useful in showing the way legal thought developed and matured in Rome. Its most well-known and influential element is the *Corpus iuris civilis*, effectively statute law affecting civil administration and the reach of ecclesiastical power and privilege. During the Middle Ages, the code of Justinian was more influential in the eastern part of the empire (Byzantium) but it was one of those classical elements that was rediscovered in western Europe in the twelfth century.

Law, as we have seen, was an important part of the education of schoolboys in Cicero's day. Education in Rome, the whole paraphernalia of learning, was much more organised there than it had ever been before anywhere else. There were schools in Babylon and academies in ancient Greece, and libraries with scholars in Alexandria and Pergamum. In Rome, however, besides a more widespread system of schools, with a standardised curriculum, there were far more public libraries – twenty-nine that we know about – a thriving book trade, the first publishing businesses that we have records of, many new developments in literary criticism, an art trade where art exhibitions were common, interior decoration (mosaics in particular), larger theatres – built with the help of concrete, from the ground up, in the centre of cities – and a new literary form, satire. The life of the mind, the world of ideas, was more widespread, and more organised, than ever before.

A standard or 'core' curriculum was taught to all the sons of the elite, who wanted their boys to enter government. This core, this shared element, probably accounts for the spread of Roman culture in the West.[25] The first thing the boys were taught, between the ages of seven and eleven, was Latin. For the better part of two thousand years, Latin occupied a particular place in the history of the West. The success of the Roman empire meant that Latin became the one tongue spread over a wide area. It was then adapted by the early Christian church, with the result that it subsequently became the *lingua franca*, first of ecclesiastical matters, then of diplomacy and learning. At the same time, since ancient Greece and Rome were thought of as the origin of all that was civilised about the West, familiarity with the language came to be seen as the mark of a civilised individual. Latin, it was said, 'taught mental agility, it taught a proper aesthetic sense, and the hard work involved taught generations of boys the value of "grind" and showed them how to develop their powers of concentration'.[26] 'Latinity', the culture of Latin, was held to represent 'order, clarity, neatness, precision and succinctness, whereas the "vernacular" languages were disordered, incoherent, unsophisticated and coarse'.[27] Latin *was* important, if not quite in this way. As we shall see, in later chapters, it played a very important role, in the Church, in scholarly life, and in the emergence of modern Europe. Before all that, however, we need to consider its position in Rome.

Chapter 2, above, covered the state of the world's languages at the point where the peoples of the New World separated from those of the Old. The birth of Latin conveniently helps to update the story. The true historical importance of Latin has only been understood since 1786, when an English judge, serving in India, made an extraordinary intellectual

breakthrough. Sir William Jones had trained as an Oriental scholar before reading law (meaning, in those days, that he was taught Latin). When he got to Calcutta, in 1785, he started to study Sanskrit, the language in which the scriptures of India had been composed. After months of research and reflection, he gave a talk to the Asiatic Society of Bengal and the idea he broached there may be seen as the starting point for the whole study of historical linguistics. Jones' breakthrough was to see that Sanskrit, both in the roots of the verbs and in the forms of grammar, was very similar to both Greek and Latin. They were so similar, he said, that they must have sprung from a common source. The judge's argument was so convincing that, since his time, thousands of studies have been made of languages – both living and dead – right across the Eurasian continent. The broad conclusion of these studies is that there was indeed once a 'mother tongue', referred to as Indo-European, which was originally spoken by the people who invented farming and that, as farming spread, the language radiated with it, providing a common linguistic base for all, or most, languages right across the Eurasian landmass.[28] This is discussed in more detail in Chapters 2 and 29.

The Italic languages (Latin, Oscan, Umbrian) are so similar to the Celtic (Irish, Gaelic, Welsh, Cornish, Breton) that some scholars feel that speakers of a common Italo-Celtic group must have appeared somewhere on the central Danube no earlier than 1800 BC. Then, for some reason, the Italic-speaking group moved south, first into the Balkans, and then around or across the Adriatic into Italy. Meanwhile, the Celtic-speaking group migrated west into Gaul (France), from where they spread into Spain, northern Italy and the British Isles. As compared to Greek, Latin grammar and syntax are more archaic, closer to the original Indo-European. This is seen particularly in the process of inflection. Inflectional languages reveal the relation among words by adding endings to a stem. In addition, Latin also reveals relationship by adding prefixes.[29]

The Indo-European-Italic-speaking newcomers seem to have reached Italy in three waves during the second millennium BC. The first to arrive were the speakers of proto-Latin, who soon after were forced west by later arrivals: their language survived only in the lower Tiber valley, spoken by the Latini tribe, and as other dialects spoken around Falerii and in Sicily. The second wave settled in central Italy, in the mountains, and their dialect became Umbrian in north central Italy, and Oscan further south, named after the Osci, a tribe near Naples (the Romans called them Samnites and their principal tribe was the Sabines).[30] Finally, between 1000 and 700 BC, the Adriatic coast of Italy was overrun a third time, by immigrants whose tongue included Venetic in the north.

The first evidence for written Latin has been found, according to Mason Hammond, on the protecting catch of a gold safety pin or *fibula*, dated by some scholars to 600 BC. The inscription is written in Greek letters reading from right to left, the opposite of later usage. Converted into Roman letters it reads: *Manios med fhefheked Numasioi*. In later Latin this would be *Manius me fecit Numasio* = 'Manius made me for Numasius'.[31] There are very few inscriptions from before the third century BC, which makes one think that the Romans wrote very little, or did so on perishable substances. At the same time, the language spread piecemeal, to the Oscan area by 200 BC, and to Apulia, in the far south, by the first century BC.[32] Yet there were many areas of Italy where Oscan was spoken long after Latin was common in Spain. We do hear of documents in Latin as early as the treaty made by the

Roman consul Spurius Cassius with the Latini tribe in 493 BC, and the Twelve Tables already referred to (451–450 BC). But literacy must have been limited at this stage; otherwise more inscriptions would surely have survived.

The earliest literary survivals, in general, preserve the pattern and rhythms of oral speech. That is to say, they are repetitive, whether rhyming or rhythmical. This obviously makes sense: it was easier to remember stories if those narratives were rhythmical and rhyming.[33] Verse, as we call it, comes from a noun in Latin, *uersus*, literally, 'a turning', from the verb *uerto*, 'I turn'. It was a term originally applied to a furrow, because the plough both turned up the soil and turned back and forth in ploughing a field. From there the word was used for a line of plants laid out in a furrow and eventually it was used for any line, including a line of poetry. In English, verse and poetry mean the same thing, but verse, properly, applies only to the *form*, whereas poetry, from a Greek verb meaning 'I make', covers both form and content.[34] We nowadays contrast both verse and poetry with 'prose'. This word derives from *prosa*, a corruption of the Latin adjective *prorsus*, 'straightforward, right on'. *Prosa oratio* was 'speech that goes straight on', didn't turn, like verse did.

The vocabulary of Latin was poorer than that of Greek, and many words had been imported from elsewhere (for example, Latin borrowed twice as many words from Greek as did Greek from languages further east).[35] Some of the deficiencies were pretty basic – Greek, for example, had far more words for colours than did Latin.[36] In addition, compared to Latin Greek had an extra voice, number, mood and tense and twice as many particles.[37] On the other hand, the Romans had more words to do with family matters, distinguishing for instance between maternal and paternal relatives. And since the favourite food in Rome was pork we find they had many more words for swine than anyone else. There were many legal and military metaphors, but large parts of the empire were still agricultural and this influenced the language. The English word 'delirious', for example, comes from *delirare*, which literally means 'to go out of the furrow', and then to act like a madman.[38] By the same token, 'calamity' was originally *calamitas*, a plague, destructive to crops. The Romans themselves did not feel that Latin had the grace of Greek. They thought it was more suited to rhetoric than to lyricism, and to some extent this reflected their view that virility and dignity were the personal qualities that counted most. In Latin, 'There is hardly any trace of affectation or literary refinement,' says Oscar Weise, in his *Language and Character of the Roman People*. Latin on the lips of Romans was a disciplined language, with many subordinate clauses dependent on a single governing verb, 'which might be seen as a military arrangement of words, with all regimented clauses looking to the verb, as soldiers look to their commanding officer.' Latin was a concrete, specific language, avoiding abstractions. Classical Latin, says Joseph Farrell, was a masculine language. 'We know of many more women writing in Greek than in Latin.'[39]

Many English words, of course, come from Latin and their etymology helps illustrate Roman ideas. For example, the *tribuni* were originally headsmen of the tribes; they came to be magistrates whose job was to protect the people; the raised seat which they used, by virtue of their high office, was called a *tribunale* – hence our word 'tribunal'. *Candidatus* was the word used to describe an applicant for a magisterial post, but its origin lay in the bright white toga (*candida*) which was worn when soliciting votes.[40] Our word 'culminate',

comes from *culmen*, reed, with which roofs were made, completing a building. 'Contemplate' and 'temple' are related: *contemplari* originally meant to watch the heavens. To begin with, a consecrated building was a *fanum* and hence all unconsecrated ground which lay before the shrine was *pro fanum*.[41] Despite its shortcomings as a poetic language in comparison with Greek, Latin was an interlocking, internally logical system, which has made it the subject of great fascination down the ages.

The high point of classical Latin, the so-called 'golden age' (there was a 'silver age' too), fell at the time of Augustus, with the prose of Cicero and the verse of Virgil. After that, its trajectory or career was far from straightforward, until it became a dead language. After the end of the western Roman empire in the fifth century A D the speech of ordinary people in Europe changed and diversified into the various 'Romance vernaculars'. But Latin became an international language. As both a spoken and a written tongue, it was used for learning, diplomacy and in the church, certainly as late as the seventeenth century, and in some corners of Europe even later.[42] At the same time, the literary language – on the lips of writers trained in rhetoric – grew distant from the ordinary spoken Latin. In spite of Cicero's elegance, and Virgil's graceful fluency, a vulgar Latin was in common use among the masses. When Pompeii, a city south of Naples, was overwhelmed by an eruption of Vesuvius in A D 79, its everyday life was 'frozen' at a specific moment in time. Modern excavation has revealed, among other things, certain scribblings on its walls, called in Italian *graffiti*, 'writings'. These preserve the ordinary, everyday Latin of the common people in mid-first century A D. Many of these are ribald curses invoked against their author's enemies, in language a long way from Cicero and Virgil.[43]

Latin also took over in the church. Christianity had originally grown among Greek speakers in the eastern Mediterranean (the first bishops of Rome were all Greek speakers).[44] The first Christian missionaries and the authors of the New Testament (the Gospels and Epistles) had used the current Greek of the Hellenistic world, known as 'common' (*koine*) Greek. In Rome, however, the early Christians naturally spoke and wrote the Latin of the ordinary people who were the first converts. Moreover, they avoided the Ciceronian literary style because that was identified with upper-class paganism. But that changed. As the Roman empire declined and fell, and the church took over some of its functions (which are described in the next chapter), Christianity adopted Latin – and the finer elements of Ciceronian and Virgilian Latin at that. This is most clearly seen in the *Confessions* of St Augustine, in which, just before A D 400, he set out, in an intimate, confessional tone, the course of his conversion to Christianity.[45] Arguably even more important for the influence of Latin on the Western church was the translation of the Bible (*Biblia*), prepared by St Jerome over the years from about A D 380 to 404.[46] This, the Vulgate Bible, incorporated many classical traditions – satire, biography – to produce a standard work that endured for centuries.[47]

Returning now to the education of the young Roman, the next stage, from twelve to fifteen, was the study of language and literature. The main text studied here was Virgil's *Aeneid*. Students read aloud from this and other works and developed their skills of criticism, commenting on grammar, figures of speech, and the writer's use of mythology. At sixteen, boys moved from literature to rhetoric, which they studied by attending public lectures.

'Rhetoric,' says Simon Price, 'generally has a bad name today. We value "sincerity" over "artifice" and our modern preference poses real problems for our appreciation both of Latin and Renaissance literature. As C. S. Lewis also wrote: "Rhetoric is the greatest barrier between us and our ancestors ... Nearly all our older poetry was written and read by men to whom the distinction between poetry and rhetoric, in its modern form, would have been meaningless".'[48] Study of rhetoric fell into two: *suasoriae* and *controversiae*. *Suasoriae* were designed to help boys construct arguments. They argued over episodes from the past: for example, should Caesar accept the kingship? In *controversiae*, the boys were given difficult legal problems. For instance, in one case mentioned by Price a son falls out with his father and is banished from home. While in exile, he studies medicine. At a later date, his father falls ill and when his own doctors fail to cure him the son is summoned. The son prescribes a special medicine, which the father drinks, then dies. Calmly, the son takes his own medicine but does not die. Still, he is charged with parricide. In class, the students must provide a case for both prosecution and defence.[49]

The system seems to have worked, in that privileges for teachers became common in Rome, though Michael Grant argues that the authorities should have intervened more to maintain standards. Vespasian, emperor in AD 69–79, founded two salaried chairs for the teaching of Greek and Latin rhetoric. Even outside Rome, teachers were exempt from various civic obligations.[50]

The spread of literacy in Rome was piecemeal but all-important. The existence of graffiti, and the fact that more or less average soldiers were able to write letters home, suggests that literacy extended well beyond senators and politicians.[51] But we must be careful not to exaggerate – there were no eyeglasses in ancient Rome, no printed advertisements, no timetables, no mass circulation of the Bible.[52] One estimate is that not more than 5 per cent of the population in classical Athens was literate in the sense that we use the word today, and not more than 10 per cent in Augustan Rome.[53] In any case, to begin with, literacy may not have been seen as conferring the advantages that seem so obvious to us. Many people in antiquity developed prodigious memories and could faultlessly recall great chunks of material. Others were content to listen to their recitations, and respect for memory was deeply entrenched.[54] In effect, then, people could be 'literate' (in the sense of 'knowing books') in a 'second-hand' way.[55]

Arguments against the wider spread of literacy include the economic. In classical Rome, a scroll was made from sheets of papyrus, glued together. It was difficult to handle; and a long scroll made writing, with quill and ink, more difficult still, as the manuscript length-ened. Copies were produced, however, Cicero being just one who sent volumes to his friend Atticus, who had slaves standing by to make duplicates. Horace refers to the brothers Sosii, inferring that their bookselling/publishing business was profitable, and both Quintilian and Martial mention Tryphon and Arectus as publishers.[56] Yet this seems doubtful. According to one estimate, a sheet of papyrus in the first century AD cost $30–35 (at 1989 prices) in Egypt, where it was produced, and much more abroad. Martial's first book of epigrams – some seven hundred lines long – was priced at 20 *sestertii* (= 5 *denarii*), and his thirteenth (276 lines) at 4 *sestertii* (= 1 *denarius*). To give some idea of value, Martial himself says that 'you could get a chick-pea dinner *and* a woman for an *as*

each'. Since an *as* was worth $\frac{1}{18}$ of a *denarius*, then as John Barsby puts it, 'You could have had forty-five chick-pea dinners plus forty-five nights of love for the price of a copy of Martial's book of epigrams. It is a wonder he sold any copies at all.'[57]

Most writing, of course, was not epigrams or philosophy. It was functional, relating to the running of a farm or business, keeping accounts, sending letters and so on. This is what William Harris calls 'craftsmen's literacy'. In the *Satyricon*, the freedman Echion, referring to the ability to read legal matters, remarks: *Habet haec res panem* – 'This thing has bread in it.'[58] As time went by, written contracts gained status and in some cities the filing of contracts became compulsory – to the point where a document withheld from the archive was deemed to be invalid. There was also a growth in use of a new form of document for the borrowing of money – the *chirographum*, one written in the borrower's own hand.[59] Above all, the late republican Roman needed to inscribe a few letters in order to exercise his voting rights.[60]

Another measure of literacy comes from the extent of public and private libraries. There were no public libraries that we know about in ancient Athens but Pseudo-Plutarch, in his *Lives of the Ten Orators*, says that Lycurgus (*c.* 390–324 BC) proposed that official copies of plays performed at leading festivals should be stored in the public record office. Libraries may thus have begun in such a way.[61] The first public library in Rome that we hear about was that put together by Asinius Pollio in 39 BC (Caesar had commissioned one earlier but it had never been built). By the fall of Rome there were twenty-nine public libraries in that city alone.[62] Others that we know about existed at Comum (Como), paid for by Pliny, at Ephesus, Pergamum, and Ulpia.[63] The elite, of course, had their own private libraries – Cicero's letters make frequent references to books as he seeks to borrow titles from his friends. From time to time he would drop in on Lucullus' library, on one occasion finding Cato already there.[64] In 1752, excavations at Herculaneum revealed a private library of 1,800 book rolls.[65] Finally, in considering the extent of literacy, we may note the wide range of backgrounds of Roman authors. Terence was an ex-slave from Africa; Cato was a member of the ruling aristocracy, while Horace was a freedman's son from Venusia in south-east Italy. Statius, the poet, was the son of a schoolmaster. Still other clues may be gleaned from the fact that the army became heavily bureaucratised,[66] at least one book in Rome was produced in an edition of 1,000 copies,[67] and even graffiti refer to the works of Virgil.[68] (As the most famous writer in Rome, who never had a political or military position, he naturally appealed to the graffiti artists.) Probably, tens of thousands of people could read in Rome, where there was, for the first time, such a thing as a literate culture.[69] At the same time, oral culture continued for most people. In the market place, people still read out poems and spoke epics from memory.[70]

Writers were more or less free to say what they wanted. The Twelve Tables outlawed defamation and Augustus, who took little notice of lampoons directed against him personally, nevertheless made it a criminal offence to sign them. But there was social pressure instead. The Senate in particular was close-knit and Simon Price tells us that when Ovid was exiled to the Black Sea for writing about the sexual habits of the emperor's granddaughter, he felt 'hard done by' because others, higher up the social ladder, got away with pretty much the same offence.[71] In the main, writing was an urban activity and 'urbane' values were fashionable in Rome.[72] At the same time, Romans looked upon

themselves as an *active* people, fighting, administrating, *doing*. This takes us back to *utilitas*, the doctrine of usefulness, for ever contrasted in the Roman mind with *uoluptas*, pleasure. And so reading was a useful activity only if it led to writing, 'and especially if the writings proved to be *morally* useful'.

On this score, poetry was a problem. Everyone conceded that much of it was very beautiful – especially the earlier Greek poetry. But, at the same time, whole swathes were undeniably frivolous. Horace was forced to argue both ways: 'Poets either want to be of use or give pleasure, or to say things which are both pleasing and useful for life at the same time . . . The poet who has mixed the useful (*utile*) with the pleasurable (*dulce*) wins every vote, by delighting and advising the reader at one and the same moment.'[73] Yet the Romans also believed, as the Greeks had before them, that poets were special in some way, attaching to them the term *uates*, which meant 'prophet'.

As was mentioned earlier, it was the Romans who invented the idea of 'the classics', the notion that the best of what had been thought, said and written in earlier ages (especially in ancient Greece) was worth preserving. This idea was intimately bound up with the birth of scholarship, which was such a feature of Roman life.

Our words 'scholar' and 'scholarship' actually come from the medieval practice of writing commentary and critical remarks in the margins of texts – these comments were known as *scholia*. But the practice itself, the activity of criticism and commentary, began at the great library in Alexandria and it began because of certain characteristics of early books – the scrolls. These were made from thin strips of papyrus, from the fibrous pith of a reed that grew everywhere in the Nile delta. Two layers, at right angles to each other, were pressed together to form sheets, and the sheets glued together to form rolls, the first piece of which was called a 'protocol' and the last the 'eschatacol'. The average sheet could support a column of writing some eight to ten inches high, and was between twenty-five and forty-five lines deep. At times of shortage, when the Egyptian government embargoed the export of papyrus in an attempt to control the production of books, animal skins were used, in particular in Pergamum. The English word 'parchment' comes from Pergamum, as is seen in the Italian equivalent of the word, *pergamena*.[74] For the most part, papyrus was written on one side only. This was partly because scribes preferred to write only *with* the grain of the page and partly because, in a scroll, anything written on the *verso* side would quickly have worn away. The reader would unroll the scroll gradually, using one hand to hold the top roll, which he had already read. This had the effect of making the roll reversed after a reading, so that it had to be rerolled before another reader could use it. With some scrolls being ten metres long, this was a serious inconvenience, and the repeated rerolling shortened the life of scrolls. The inconvenience meant, too, that when one author decided to quote another, the chances were that he would rely on his memory rather than bother to unroll the relevant scroll. The copying of texts was therefore much more difficult than it sounds and it was not made easier by the fact that punctuation was rudimentary, even non-existent. For example, texts were written without word-division (this did not become systematised until the Middle Ages), changes of speaker were not always clearly indicated in dramatic texts (a horizontal line was used – like a dash – at the beginning of a line, but over the years it ran the risk of being rubbed out), and the names of characters

might be omitted altogether.[75] It was the inaccuracies and confusion created by this set of circumstances that helped give rise to scholarship.

Another reason arose from the fact that the librarians at the Mouseion in Alexandria made a conscious attempt to compile a complete library of Greek literature and in so doing they noticed that different copies from different parts of the world showed serious discrepancies. This set of circumstances gave rise to a number of devices which also contributed to the birth of scholarship. The first was the decision to produce a standard text of the authors commonly read by the educated public. The next step was to ensure that fifth-century (BC) books coming from Attica, some of which were written in archaic Greek, were transliterated into the Greek then in use. Until 403 BC, Athens had used the archaic alphabet in which the letter epsilon was used for three vowels: epsilon, epsilon-iota and eta; and omicron was used for omicron, omicron-iota and omega.[76] Third was the invention of a system of accentuation which, in effect, preceded the idea of punctuation. Fourth, the commentary was introduced, a separate book which discussed shortcomings in the text of the classic. In the first instance, a set of critical signs was introduced, which were made in the margin of the text, and referred the reader to the appropriate place in the commentary (it was these marginal signs which later became *scholia*). The most important of the critical signs was the *obelos*, a horizontal stroke placed in the margin to the left of the verse and indicating that the verse was spurious. Other signs included the *diple* (>), which indicated any noteworthy point of content or language, the *antisigma* (⊃), indicating that the order of lines had been disturbed, and the *asteriskos* (✳), which marked a passage incorrectly repeated somewhere else.[77]

In Rome this critical method of the Alexandrians was taken up by L. Aelius Stilo, active around 100 BC, who produced, among other things, lists of plays from both ancient Greece and early Rome which he regarded as genuine. He was interested in more than authenticity but, nevertheless, his approach and judgements, taken up by his pupil, Varro (116–27 BC), have determined in part what classics have come down to us. After this such authors as Seneca and Quintilian were always aware in Rome that texts could become corrupted and they often compared different copies of books with this in mind.

As the empire declined, and fewer books were produced, the continuity of classical culture came under threat. One way in which it was preserved was via the development of new forms of literature, the *epitome* and the *compendium*. The epitome is what we would mean by an 'abridged version', a short form of a book, containing its essence, often published together with other epitomes in a compendium. Although many details were lost in this way, the men who produced the compendia were forced to choose one version of a book over another, again exercising their critical judgement. Alongside the compendia, Romans also produced many commentaries which tell modern scholars which version of which classics were available, where, and when.[78]

It was during these years of decline that learning and literacy combined to produce at least three sets of books which would have a major impact, not just in Rome, but in later medieval times. The first of these was Aelius Donatus' two grammars, the *Ars Minor* and *Maior*, which, together with the *Institutiones grammaticae*, provided the Middle Ages with their main textbooks on grammar. The second was Nonius Marcellus' *De compendiosa doctrina*, a dictionary particularly noteworthy because it contains many quotations from

works which are, for the moment, lost. And third there was Martianus Capella's *De nuptiis Mercurii*, an allegorical treatise on the seven liberal arts. The 'liberal arts' were the subjects deemed suitable for the education of a Roman gentleman and were originally conceived by Varro, under the influence of Posidonius (*c.* 151–135 BC). Varro produced an influential encyclopaedia, *Nine Books of Disciplines*, in which he outlined nine arts: grammar, rhetoric, logic, arithmetic, geometry, astronomy, musical theory, medicine and architecture. Later writers omitted the last two arts.[79] In Rome, by the end of the first century AD, education had been more or less standardised and the seven liberal arts identified. In turn, these would become the basis of medieval education, when they split into two, the more elementary *trivium* (grammar, rhetoric and dialectic) and the more advanced *quadrivium* (arithmetic, music, geometry, astronomy). As we shall see in a later chapter, this system formed the basis of modern educational systems, and was one of the elements leading to the birth of the West.[80]

The other main innovation in Rome, which affected learning and literacy, was the gradual disappearance of the scroll, in favour of the codex. This took place between the second and fourth centuries. There had always been an alternative to the scroll – this was the writing tablet, which usually consisted of wax-coated boards. These could be wiped clean and so were convenient for casual use: teaching, letters, rough notes. The Romans, however, started to use them for legal documents, gradually replacing the boards with parchment and fastening a number of pages together with a thong or clasp.[81] Martial is the first author we know about to mention literary works being put together as a codex (in a poem written in the 80s), but the practice didn't seem to catch on at that time. It grew from the second century and really triumphed in the fourth, at least for pagan literature. It is not hard to see why the codex caught on. Papyrus rolls, though not fragile exactly, rarely lasted more than, say, three hundred years and it is likely that, had the change to codex not come when it did, many classical texts would have perished completely. The codex was much less bulky than the scroll, numbered pages made it a much handier reference format, it was less likely to be bruised in use, and it may well have been cheaper to produce.

But it seems that we have the early Christians to thank most for the codex. While the pagan codex was a rarity in the second century, it was much more common for Christian texts. This may have been because the Christians wanted to set themselves apart from pagans, and it may have been because codices were cheaper than scrolls. But it seems more likely that the codex was popular with Christians for an entirely different reason: with its format – numbered pages and a contents list – it was much harder to interpolate forgeries in a codex. In a young religion, when the accuracy and authoritativeness of the scriptures was a major concern, the advantages of the codex format would have been considerable.[82]

The Greeks had invented the main forms of literature – epic, history, comedy, philosophy, tragedy, pastoral, lyric, oratory, didactic. Though many of the Roman authors are now treated as 'classics', in fact the only real advance on the Greeks, so far as literature is concerned, lay in two areas: love poetry and satire. Except for these innovations, it was acceptable in Rome for writers to emulate the Greeks – *imitatio* was a legitimate literary device, alongside *uariatio*.

Cicero (106–43 BC) was the most famous Roman writer who assimilated Greek culture.[83] Besides the oration, of which he was the supreme master, his writings consisted mainly of letters and treatises on various phases of Greek learning. His *On the Nature of the Gods* and *On Duties* are among the best sources of our knowledge of Greek religious and ethical thought. His works, which have always been studied as much for their literary elegance as for their philosophical content, were so important that he is widely regarded as second only to Aristotle among the contributors to the intellectual content of the Western cultural tradition.[84]

Born into a well-to-do family, he trained as an advocate and was appointed to the office of augur, where his duties consisted of foretelling the future and interpreting omens. There was little in his work that was truly original but his style and the elegance of his Latin were unsurpassable: 'Century after century learned its philosophical grammar from these works and they are still valuable.'[85] Roman Stoicism, the most influential philosophy of Cicero's day, and his own viewpoint, was less a philosophy in the Greek sense, less a fundamental exploration of metaphysics, and more a practical, eclectic system concerned with morals, which in Rome had three main effects. The first was an overlap with Christianity, not so much in the writings of Cicero himself as of Seneca, who was often compared later on with St Jerome. At any rate, this played a part in the conversion of many pagans to Christianity. A second effect was on the Roman attitude to law. Stoicism included the idea that man should live according to nature and 'Nature had a code of laws of which the philosopher could catch a glimpse.'[86] In this way the concept of 'natural law' was launched, which was to have a long history in European thought. Finally, Stoic ideas about 'the brotherhood of man' had a great effect in Rome on the treatment of slaves.

For Cicero, 'True law is reason, right and natural . . . There will not be one law at Rome, one at Athens, or one now and one later . . .' (*On the State*, III, 33). He was most concerned with harmony between the orders, co-operation between the middle-class non-senators and the Senate. He was, in Michael Grant's words, a middle-of-the-road man: 'to the two tyrannies, reaction and revolution, he was opposed, and whenever either of them became menacing he was on the other side'.[87] He was a liberal. 'Indeed he is the greatest ancestor of that whole liberal tradition in western life.'

He was also the founder of *humanitas*, often called the essence of Ciceronianism. He believed that virtue 'joins man to God' and that from this it follows that all human beings, however humble, must count for something, and that this bond 'joins man to man, irrespective of state, race or caste.'[88] By *humanitas*, he meant not just humanity, or humaneness, or humanism, but consideration for others, tolerance, the liberal arts, education. In his translations of Greek works he adapted the smaller vocabulary of his native tongue to larger Greek ideas, inventing in the process such terms as *qualitas* and *quantitas*. The influence of Cicero on European ideas 'greatly exceeds that of any other prose writer, in any language'. Pope Gregory the Great went so far as to say he wished he could destroy Cicero's writings since 'they diverted men's attention from the scriptures'.[89] Though not a party to the assassination of Caesar, Cicero approved the act, yet thought that Antony's tyranny, which came after, even worse, and spoke out. As a result, he was himself assassinated in December 43 BC. (He was reading Euripides' *Medea* when the assassins caught up with him.)

Virgil (*c.* 70–19 BC) has been described as the poet laureate of the Augustan age. His *Eclogues* and his *Georgics* formed a type of apprenticeship to his great epic, the *Aeneid*, the Roman counterpart of the Homeric sagas, in which Augustus is openly disguised as Aeneas. By coincidence, the family of the Julii, to which both Caesar and Augustus belonged, claimed descent from Iulus, son of Aeneas, who was a character in the *Iliad*. Virgil's epic is accordingly typically Homeric, in that Aeneas wanders the Mediterranean, from Troy to the Tiber, in the manner of the *Odyssey*, and, in the second half, fights great battles in Italy, reminiscent of the *Iliad*.[90] In addition to its parallels with Homer, however, the book is a cipher: Aeneas is Augustus and the book is a disquisition on the nature of power. A central theme is *pietas*, which has two meanings, the Roman sense of obligation – to parents, the state, to God – and pity, but not in a conventional or modern sense. Aeneas has pity for other characters, Dido his wife and Turnus his enemy, but he leaves the former and kills the latter. This is Virgil's comment on war: it destroys equally those that we love and those whom we hate. Far from being an idealisation of Rome and imperial power, the ending is ambiguous. Virgil's humanity is of a piece with Cicero's, matching him in tenderness and sympathy.

Given the way power and the centres of civilisation shifted in the Mediterranean at, roughly speaking, the time of Jesus, it is no surprise to find that the foremost authority in medicine in antiquity followed those changes. Claudius Galen decided on a medical career when he was sixteen. Born at Pergamum in AD 131, he studied mathematics and philosophy before turning to medicine, travelling to Smyrna (the modern Izmir), Corinth and Alexandria in pursuit of his studies. He returned to Pergamum as physician to the gladiators, but finally settled in the powerhouse of Rome, where he became a fashionable doctor to the rich and famous, including the emperors Marcus Aurelius, Commodus and Septimius Severus. He died around 210. His surviving writings occupy twenty-two volumes in the standard nineteenth-century edition, which confirm his dominant position in the ancient world: rivalled only by Hippocrates, Galen's influence extended well into the modern period.[91]

It has been well said of Galen that he was more interested in the disease than the patient, 'viewing the latter as a vehicle by which to gain understanding of the former'. From Hippocrates, he took the notion of the four humours, the view that the four basic constituents of the human body are blood, phlegm, yellow bile and black bile, reducible to the fundamental qualities of hot and cold, wet and dry. Galen refined this, to argue that the four humours come together in different ways to form the tissues, and that these organs unite to make up the body. For him, disease occurred when there was either a disequilibrium among the humours or within the state of specific organs, and one of his main innovations was to localise disease in these particular organs. Generalised fevers, for example, were caused by putrefying humours throughout the body, producing heat, whereas localised illnesses stemmed from toxic humours in individual organs, leading to swelling, or hardening, or pain.[92] In making diagnoses, Galen in particular examined the pulse and the urine, but he was also alive to changes in the patient's posture, breathing, 'the nature of the upper and lower secretions', and the presence or absence of headache.

He was aware of the importance of anatomy but conceded that in his day the dissection of humans was no longer possible. He therefore urged his students to be alive to the

fortuitous possibility of making observations, as for example when a tomb was opened, or at the scene of an accident, and he recommended a visit to Alexandria, 'where the skeleton could still be examined first-hand'.[93] In general though, he acknowledged that his students would have to rely on the anatomy of animals, especially those species who resembled humans. He himself dissected several creatures, including a small monkey known then as the barbary ape, what we call the macaque. In doing this, he built on Plato's idea that there was a 'tripartite soul', arguing that the brain, the seat of the soul's rational faculties, was the source of the nerves; the heart, the seat of the passions, was the source of the arteries, conveying arterial blood to all parts of the body; and the liver, the seat of the appetite, or desire, was the source of the veins, which fortify the body with venous blood. Food, arriving in the stomach, was converted into juice (*chyle*), partly by 'cooking' through the body's heat, then absorbed through the lining of the stomach into surrounding veins, where it was passed to the liver. There it was further refined and cooked and converted into venous blood which nourished the various organs. Venous blood reached the heart, to nourish it, but the heart also received arterial blood, from the lungs. This blood provided life and it too was passed on to the organs. The brain, like other organs, received arterial blood. Here Galen made a particular mistake in arguing that this blood passes into the *rete mirabile*, a fine network of arteries he had found by dissection in certain ungulates and which he mistakenly thought existed in humans. In this network, he said, arterial blood was refined to 'the finest grade' of spirit or pneuma, the psychic pneuma, which was sent to all parts of the body through the nerves, accounting for sensation and motor functions.[94]

There is far more to Galen's sophisticated system than this, but it is enough to show the architecture of his thinking. This thinking was to dominate medical ideas throughout the Middle Ages and as far as the early modern period, and owed something to one of his other concepts. Although he wasn't a Christian, Galen believed in teleology, which made him appeal to both Christians and Muslims. Inspired by Plato's *Timaeus*, and Aristotle's *The Parts of Animals*, he concluded that there was 'intelligent design' in the human and animal form, and in his treatises he praised the 'wisdom and providence' of the Demiurge, an understanding clearly derived from Plato. Galen thought that the structure of the human body was perfectly adapted to its functions, 'unable to be improved upon even in imagination'.[95] This was the beginnings of a natural theology, a theory of god or the gods based in the evidence found in nature.

*Utilitas*, Roman unsentimentality and pride in her achievements, had a major effect on innovation in the visual arts. Portraits had become more realistic in Greece but they were still, to an extent, idealised. Not so in Rome. The emperor might want his likeness to echo the dignity of his office, but for other families the more realistic the better. There was a tradition in Rome, among patrician families at least, to keep wax masks of one's ancestors, to be worn by living members of the family at funerals. Out of these there developed bronze and stone busts, very realistic.[96]

In architecture the discovery of concrete made all the difference. Invented towards the end of the third century, possibly via Africa, it was found that a mixture of water, lime and a gritty material like sand would set into a durable substance which could be used either

to bond masonry or as a building material in its own right and one which, up to a point, could be shaped in a mould. This had two immediate consequences. It meant that major public buildings, such as baths or theatres, could be brought into the centre of the city. Large boulders did not need to be brought from far away – instead, the sand could be transported in smaller, much more manageable loads, and far more complex infrastructures could be erected, to accommodate larger numbers of people. Second, since concrete could be shaped when wet, it didn't have to be carved, as stone did. Therefore, it required less-skilled workmen, and even slaves could do the job. It was, in consequence, much cheaper. All this meant that monumental architecture could be practised on a much larger scale than before, which is one reason why Rome is the city of so many classical ruins today.[97]

The other development in the visual arts in Rome stemmed from the idea of 'the classics' mentioned earlier. This, as was said above, was originally a Roman idea and grew out of the feeling that, although Rome had triumphed over classical Greece, and although many Romans thought the Greeks effete and even effeminate, there was in Rome immense respect for Greek culture. (Defending the Greek poet Archias on a charge of illegally claiming Roman citizenship, Cicero said: 'Greek literature is read in nearly every nation under heaven, while Latin is confined to its own boundaries, and they are, we must grant, narrow.' He himself aimed to write 'in the Aristotelian manner'.)[98] From the first century BC on, Greek sculpture, and copies of Greek sculpture, were found in many upper-class homes in Rome. Many of these copies were very good and today much of Greek sculpture is known only, or mainly, through Roman copies which are, of course, now very valuable in their own right.[99] To begin with, Roman generals plundered what they could: in 264 two thousand statues were looted from Volsinii.[100] (George Meredith once said that the one abstract idea which the military mind is able to grasp is that of booty.[101]) Greek artists quickly adjusted and a thriving art market grew up in Athens (the so-called Neo-Attic workshops) catering to the taste of Roman tourists. Later still, Greek artists set up shop along the Tiber.[102] Rome itself, in a way, was an amalgam of Greek ideas and Latin ambition but, thanks in part to concrete, there is much more left of it than Athens.

Although Rome did not achieve the intellectual creativity of the classical Greeks (there is little evidence, for example, of Romans carrying out original mathematical work), their achievements lay elsewhere. The finest epitaph is still that of the eighteenth-century English historian Edward Gibbon: 'If a man were called to fix the period in the history of the world during which the condition of the human race was most happy and prosperous, he would, without hesitation, name that which elapsed from the death of Domitian to the accession of Commodus [AD 180]. The vast extent of the Roman empire was governed by absolute power, under the guidance of virtue and wisdom. The armies were restrained by the firm and gentle hand of four successive emperors, whose characters and authority commanded involuntary respect. The forms of the civil administration were carefully preserved by Nerva, Trajan, Hadrian and the Antonines, who delighted in the image of liberty, and were pleased with considering themselves as the accountable ministers of the laws.'[103]

Even if this verdict is no longer accepted in its entirety, the fact that the sentiment stood for so long is a testament to the many successes of Rome.

# 10

## *Pagans and Christians, Mediterranean and Germanic Traditions*

The Roman achievement was colossal. The Romans themselves were aware of it and it is no surprise that they came to believe in *Roma Aeterna*, the eternal city. But, as every schoolchild knows, Rome was not eternal. 'The best-known fact about the Roman Empire,' says Arthur Ferrill, 'is that it declined and fell.'[1]

This is due, in part at least, to what is probably the best-known modern work of history, referred to at the end of the last chapter, Edward Gibbon's *The History of the Decline and Fall of the Roman Empire*. That work is dated now, as scholars have built on Gibbon's ideas. For example, one recent German title, almost seven hundred pages long, lists no fewer than 210 factors that may have helped cause the decline.[2] Which doesn't take us forward very much, other than to underline the fact that there is now no consensus about the main causes. Gibbon, on the other hand, and despite the fact that his book appeared in six volumes from 1776 to 1788, had a simpler view of Rome. He identified two weaknesses – one internal, one external – which in his view above all others brought about the decline of the western empire. 'The internal weakness was Christianity, and the external one barbarism.'[3] This view still finds support. Again, as Arthur Ferrill has pointed out, in the last decade of the fourth century, one emperor, Theodosius, still ruled over an empire larger than that of the great Augustus, and commanded a massive army. Fewer than eighty years later, both empire and army in the west had been wiped out. Or, as the French historian André Piganiol put it, 'Roman civilization did not die a natural death. It was killed.'[4]

There can be no doubt that in Europe the change from the world of antiquity to the medieval world was characterised above all by the spread of Christianity. This is one of the most momentous changes in ideas that helped shaped the world as we know it. In tracking this change, there are two things to be kept in mind. We need to explain exactly how and in what order this change occurred, but at the same time we need to show *why* Christianity proved so extraordinarily popular.[5] To answer these questions we need to return to the creation of the gospels, a discussion already begun in Chapter 7.

In the New Testament, Judaea is described as the homeland of the new faith, with a mother church located in Jerusalem. There is no reference to contemporary political events, no mention for example of the Jewish revolt, or the siege and destruction of Jerusalem.[6] Traditionally, this silence has been ascribed to the fact that the revolt had no

significance for the church, because the early Christians had already removed themselves from the doomed city, and migrated to Pella, in Transjordan. For centuries no one queried this view because, in the first place, it fitted perfectly with the idea of Jesus as a divine figure who would not involve himself in politics and because the Jewish historian, Josephus, in *The Jewish War*, written in the 70s, explained that the revolt was due mainly to a party of fanatical Zealots who 'goaded a peaceable people in fatal revolt'.[7] This traditional picture is now widely doubted. In the first place, Pella never features in the scriptures as a centre of Christianity. Both St Paul's epistles and the Acts of the Apostles confirm that the mother church of Jerusalem was the 'accepted source of faith and authority' to which all adherents had to submit. Therefore, the complete silence about this mother church after AD 70 needs to be explained. This is where the new scholarship comes in.

The starting point is the gospel of St Mark, which has been the subject of much reinterpretation, in particular two ambiguous statements. The first is when the Pharisees (see above, page 161) tried to trap Jesus about his attitude to Rome, when he famously replied, 'Render to Caesar the things that are Caesar's, and to God the things that are God's.' Traditionally, Jesus' answer is seen as neat footwork and that, implicitly at least, he condones the idea that the Jews pay the tax. The alternative scholarship, however, starts from the point that the gospel of St Mark is scarcely a long book, so this episode was clearly important to the author. Since it was originally written in Greek, *in Rome*, around AD 65–75, it is now assumed that it was phrased so as to 'meet the needs' of Gentile Christians in Italy. This was very early on in Christianity and the faithful were worried about their status. On this reading, Jesus' attitude towards the payment of tribute to Rome was vital to their own well-being. This was because one of the main causes of Roman pressure, which led to the Jewish revolt in 66, was the non-payment of the tribute.[8] The founder of Zealotism, Judas, was, like Jesus, from Galilee. The suspicion now is, therefore, that what Jesus actually meant was the exact opposite of what the gospel of St Mark makes him say – namely, that the tribute should not be paid. That meaning was changed, because otherwise the situation of the early Christians in Rome would have been untenable. But it casts an interesting light on a second phrase in St Mark. This is when he names one of the twelve Apostles as 'Simon the Canaanean'. Gentiles in Rome in the first century AD would have had no idea what this was supposed to mean without elaboration. In fact, Simon was also known in Judaea as 'Simon the Zealot'. The gospel thus covers up the fact that one of the Apostles, chosen by Jesus, was a terrorist against Rome. As S. G. F. Brandon observes, 'It was too dangerous to be admitted.'[9] Against this view, other scholars maintain that the number of Christians in Rome was too small to bring about such a momentous change in the gospel, and that there were countless parts of the New Testament that would make no sense to Gentiles (e.g., circumcision) which were not changed.

These episodes, and their interpretation, are vital for an understanding of early Christianity. When put alongside the New Testament, in particular the Acts of the Apostles, we see that the alternative scholarship explains what has been called 'the Jewish infancy of Christianity'. We cannot forget that the original disciples were all Jews who believed that Jesus was the Messiah of Israel. Although his death had been a shock, they still thought he would return and redeem Israel. Their main job, as they saw it, was to convince their fellow Jews that Jesus really was the Messiah and that they should all prepare for the Second

Coming. And so they continued to live as Jews: they observed the Law and worshipped in the Temple in Jerusalem. They were led by James, the brother of Jesus, and won a number of converts, not least because James had a reputation for the zealous practice of Judaism. (So zealous, that he too was executed by the high priest, who was concerned to control revolutionary elements in Israel.[10])

Furthermore, while these events were taking place in Jerusalem, between the Crucifixion and the revolt, Paul had become active outside Israel. Paul, a tent-maker from Tarsus, west of Adana in modern Turkey, was not one of the original disciples of Jesus. Unlike Christ he was a city man, who was famously converted, around AD 33, 'on the road to Damascus', when he had a vision of Christ (Acts 9:1–9). (He had a chronic ailment, epilepsy being suspected.[11]) Paul had conceived his own version of Christianity and saw it as his duty to spread these ideas outside Israel in the Graeco-Roman world. His conversion, incidentally, should not be exaggerated: Paul was a Pharisee, and therefore a fervent believer in resurrection: so far as he was concerned, he was converting from one Jewish sect to another.[12] There can be little doubt that there were, at the time, rival versions of Christianity. In his second epistle to the Corinthians, for example, Paul says this: 'For if he that cometh preacheth another Jesus, who we did not preach, or if ye receive a different spirit, which ye did not receive, or a different gospel, which ye did not accept, ye will do well to bear with him.' Elsewhere he refers to his rivals as 'the chiefest apostle', and to James, Cephas (Peter) and John. Because some of Paul's ideas threatened the credibility and authority of the Jewish-Christian disciples in Israel he was denounced and, in 59 or thereabouts, arrested and taken to Rome (because he was a Roman citizen).[13] Had the revolt in 66–70 never occurred, the chances are that history would have heard nothing more of Paul. But the revolt did occur, Jerusalem and its Temple were destroyed and although vestiges of Jewish-Christianity lingered, for a century, it was never again the force it had been and eventually died out. Instead, Paul's version survived, with the result that there was a massive change in the character of the religion. What had been a Jewish Messianic sect now became a universal salvation religion propagated in the Hellenistic world of the Mediterranean – in other words, among Gentiles. Paul confirms his independence by specifically asserting that God had revealed 'his Son to me, that I might preach among the Gentiles'.

Paul's differences in belief, compared with the disciples in Jerusalem, lay mainly in two areas. One, as we have seen, was his conviction that he was to preach among Gentiles. To begin with, this may have been special groups of non-Jews, sympathisers with the Israelite tradition but who refused circumcision, and were known as 'god-fearers' (Acts 13:26).[14] Allied to this was Paul's belief that Jesus was not just a martyr, but divine, and that his death had a more profound meaning – profound for those outside Israel and profound historically speaking.[15] Paul's aim, here, according to Christopher Rowland, cannot be understood without reminding ourselves of his Hellenistic background, in particular the idea of a salvation-god and the fallen state of man. The classic example of a saviour god, it will be recalled, was the cult that worshipped the Egyptian deity, Osiris. Followers of this god believed that he had once died and risen from the dead and that, through ritual worship, they could emulate his fate. Paul has also to be seen against a background of the many Gnostic sects, some of which had adopted Platonist ideas and taught that every

human was a compound of an immortal soul 'imprisoned' in a physical (and mortal) body. Originally, the Gnostics said, the soul had fallen from its 'abode of light and bliss' and descended to the material world. In becoming 'incarnated' in this world, the soul had been ensnared by the demonic forces that inhabited earth (and other planets) and could be rescued only by a 'proper knowledge' (*gnosis*) of its nature. It was the object of gnosis to release the soul from its imprisonment in the body, so that it could return to its original abode.[16] Paul's Christianity was thus an amalgam of three elements: Jewish-Christianity (Jesus' belief in a saviour-God and saviour-Messiah), pagan-saviour-gods and Gnostic ideas about the fallen state of man. The latter two ideas were anathema to the Jerusalem Christians, as was Paul's view that the Law of Moses had been superseded by Jesus' arrival.[17] When Paul travelled to Jerusalem to negotiate these beliefs with the Jerusalem Christians he was set upon by a mob. He was rescued by Roman soldiers, whereupon he asserted his right as a Roman citizen to be tried before the imperial tribunal (he would almost certainly have been lynched in Jerusalem). This trial appears to have taken place in the year 59, though the verdict isn't known.

Paul's ideas caught on because they seemed to account for what had happened. In Jewish tradition a cataclysm would precede the coming of the Kingdom and what was the sacking of Jerusalem, if it wasn't a cataclysm? These events were seen as the forerunner of the Messiah's return and the end of the world.[18] Paul himself shared some of these views – for example, he never bothered to date his epistles, as if time didn't matter. But of course, the Messiah didn't reappear, the Second Coming didn't materialise and, gradually, the early Christians had to adjust. They did not abandon their hopes of apocalypse, but that aspect of their belief system gradually assumed less importance. And this brought about another innovation of Paul. Hitherto, Jewish-Christianity had accepted the basically Jewish view of history, that time would culminate with the coming of the Messiah. But for Christians Jesus had come. If his incarnation was part of God's plan for mankind, then time must be seen as having two phases, one that lasted from the Creation to the birth of Jesus, the preparation of Israel for the coming of Christ, which was documented by the Jewish scriptures; and a second phase from the time of Jesus forward. Paul had referred to the writings of the Jews as the Old Covenant, or Testament, and he now spoke of Jesus instituting a new covenant.[19] He saw Jesus as a saviour, a path for people to follow, by which they might obtain eternal life. In this way, Christianity became a religion of Gentiles and actively sought converts, as the only true way to salvation.

Paul also provided early Christianity with much of its 'colouring' around the edges. He condemned idol worship, sexuality and, implicitly, the practice of philosophy.[20] In Rome in the early years, Christians often paraded their ignorance and lack of education, associating independent philosophical thinking with the sin of pride.[21] Finally, we must note that this form of Christianity, Paul's kind, emerged in a Roman world, with Roman law and surrounded by Roman – pagan – gods. (*Paganus* = villager.) Loyalty to Rome, very important in the imperial context, meant acceptance of the divinity of the emperor and acceptance of the state gods, which were much older than Christianity. Tacitus (*c.* 55–116) was just one who dismissed Christianity as 'a new superstition'.

In Rome the secular and religious life had always been intertwined. Each city in the empire was 'protected' by its own god and the buildings in ancient Rome, from baths to

circuses, were graced with statues of the gods, with altars and small shrines. Augustus was very concerned with the religious life and during his reign restored eighty-two temples which had fallen into disrepair and authorised the building of another thirteen.[22] But no one in the pagan world expected religion to provide an answer to the meaning of life. People looked to philosophy for that kind of understanding. Instead, Romans worshipped the pagan gods to seek help during crisis, to secure divine blessing for the state, and to experience 'a healing sense of community with the past'.[23] The Christian god seemed to educated pagans as primitive. Whereas it made sense for a great emperor and warrior such as Alexander the Great to be a god, or the son of god, to worship a poor Jew who had died a criminal's death in a remote corner of the empire made no sense.[24] Although there were many gods which the pagans worshipped, and shrines everywhere ('The shrine is the very soul of the countryside', said one writer), in practice three cults in Rome were more important than the others. These were worship of the emperor, of Isis, and of Mithras.

Julius Caesar was deified posthumously after his death in 44 BC, the first emperor to receive this accolade. Being related to Caesar, Augustus openly referred to himself as the 'son of [the] god'.[25] He too was deified after his death, as was his successor, Tiberius. *His* successor, Caligula, deified himself during his lifetime. The pagans had a tradition of free thought and citizens were free to vary in the literalness with which they viewed the emperor as god. In the western part of the empire, it was often the emperor's *numen*, a general divine power, attaching to the rank, which was worshipped. In the east, on the other hand, it was often the man himself who was believed to be a god.

Many worshipped Apollo, the predominantly solar deity, which was encouraged by Augustus but also popular was the cult of Isis and Serapis (originally Osiris), which had been first conceived in Egypt. Serapis was identified with the divine Bull, Apis, which Osiris turned into after death, and this allowed him to be linked to Zeus, Poseidon and Dionysus, all of whom were associated with bulls in the Middle East. Isis was the mistress of magic and the bringer of civilisation to the world. She was a saviour-goddess, and reminiscent of the Great Goddess of earlier ages.[26] Mithraism was an offshoot of the Zoroastrian religion in Persia. The emperor Commodus (180–192) worshipped Mithras and the Stoic emperor Marcus Aurelius founded a Mithraic temple on the Vatican hill. This cult appears to have begun in Syria around AD 60 and was brought to Rome by soldiers: it remained a religion for soldiers, with no place for women in its rites.[27] There was an elaborate, and fearsome, initiation ceremony and seven grades of membership. Followers were called *sacrati*, 'consecrated ones', and the practices included a communion meal. Possibly for this reason, many Christians saw the Mithras cult as a debased and blasphemous version of their own faith. One of the central ideas of Mithraism was the dualistic notion that there is abroad in the world a perennial battle between good and evil, light and darkness. This too was shared with Christianity and contrasted strongly with the rest of pagan ideas, which saw the natural world as either basically good, or neutral. The feast day of Mithras was 25 December (this was a world without weekends, remember, when feast days were the only holidays). Although these figures were the dominant ones, it was not in the Romans' nature to conceive a monotheistic religion. They were more interested in finding links between their gods and the gods of other people. This made them tolerant.

Besides the three main cults, there was a pagan institution that was not paralleled in either Judaism or Christianity. This was the oracle. As in classical Greece, so in Rome: oracles were shrines, often much more than shrines, such as caves, where, it was believed, the gods spoke. Normally, an elaborate ritual was associated with this, with a dramatic and mysterious build-up, often at night. The gods spoke through individuals (the 'prophet') to whom the pilgrims put questions. Sometimes, the prophet was a local priest, sometimes he or she was chosen from among the pilgrims themselves. Sometimes there were two: one made inchoate noises, and the other turned them into verse. The best known were the oracles to Apollo at Didyma and Claros, both on the Ionian coast of modern Turkey. Robin Lane Fox tells us that pilgrims to Claros came from forty-eight cities stretching from modern Bulgaria to Crete and Corinth.[28]

Judaism and Christianity differed from pagan religions in the important respect that they offered 'revelation' rather than mystery. Each of the pagan cults offered a secret experience, initiation by way of ceremony, leading to a specific experience and message. Judaism and Christianity, on the other hand, offered a general truth, applicable and available to all, and were quite open about it.[29]

Christianity had been a separate religion from Judaism since the time of Paul. Following the Jewish revolt, and the destruction of Jerusalem, in 66–70, it had taken the Jews about twenty years to reorganise themselves. This they had done by abolishing the Temple priesthood and its sacrifices, replacing it with a rabbinical structure and, in the process, excommunicating all Christians.

Many of the most basic Christian ideas were anathema in Rome. For example, the idea of the spiritual worth of the poor was revolutionary. In the same way heresy was a foreign notion. People were free in Rome to belong to as many cults as they liked, though atheism was frowned upon. (Atheism, as we mean it, didn't exist. 'Atheists' were Epicureans, who denied the gods' providence, though not their existence.[30]) The implacable nature of the early Christians can be gauged from the behaviour of one group, who sold themselves into slavery in order to ransom fellow Christians who had been imprisoned.[31] The fact that women played a conspicuous role in the early Christian congregations was also at odds with Roman practice. But the greatest difference between the ideas of pagans and Jews on the one hand, and Christians on the other, lay in their attitudes to death. Pagans and Jews died and even if they believed in some sort of 'afterlife' – the Islands of the Blessed, for example – they did not envisage full bodily resurrection here on earth. The Christians did. The Second Coming might no longer be seen as imminent, but there was no doubt that, one day, resurrection in the full sense would occur.[32]

At that time, however, the empire was suffering on several fronts. There was a trade recession, the birth rate was falling, the Goths were threatening across the Danube and, to cap it all, the army returning from the east in 165–167 had brought with it the plague. This situation was made worse in the years that followed, as Rome allowed migrating tribespeople from outside the empire to join the army and, in consequence, to settle inside the boundaries (*limes*). Control of many units soon passed to able barbarians and, since the army played a major role in electing emperors, this diversity and instability was reflected in politics. Of the twenty emperors between 235 and 284 all but three were assassinated.[33] These circumstances were propitious for new ideas to flourish. One was the

rise of Neoplatonism, brought from Alexandria to Rome by Ammonius (fl. 235), Plotinus (204–275) and Porphry (fl. 270). They taught the ultimate unity of all religions, preaching the doctrine of 'emanation' from the spiritual Unity, the One, to the material multiplicity of the world. The Neoplatonists were rivalled by Mani (d. 276), who taught the essential evilness of the material world and the necessity for believers to continually purify themselves, in order to approach closer and closer to the eternal Light.[34] Mani believed that each human being had an angelic Twin, watching over and guarding him or her. Particles of light and goodness were trapped in evil matter, and both eating meat and working the soil were anathema. Stories were told about how vegetables had once wept to Mani, as they were about to be cut, and palm trees complained when they were about to be pruned.[35] When the Elect died, they went to the kingdom of light, whereas disbelievers went to hell at the ending of the world. This, the Future Moment, would follow Jesus' Second Coming, when the world would collapse in a massive fire lasting 1,468 years.

With orthodox and even heretical Christians unable and/or unwilling to accept the traditional practices of Rome, and with so many of their own ways at variance with established ritual behaviour, their faith and their loyalty naturally came under suspicion. Although the early church was not consistently suppressed (by 211 there were bishops around the Mediterranean and as far afield as Lyons), there were emperors who were very cruel in the number of martyrs they created. Given the apocalyptic view of the early Christians, this only added to their sense of mission and drama (virgins had sixty times the reward of ordinary Christians in heaven, it was affirmed, but martyrs received rewards a hundredfold).[36] And so, when Constantine became emperor in AD 312, and the fortunes of Christianity changed, persecution being replaced by favour, there was a great sense of triumph.[37] By this stage a canon of scriptures had emerged, which confirmed for the faithful that the 'divine purpose for mankind' had two phases, and that the slow but steady triumph of the Christian doctrine was part of that purpose.

This takes us back to the new view of time. Traditionally, time had been seen as moving in cycles. This was reinforced by the movements of the stars, each of which had a cycle, and many people felt that once these cycles were understood the mystery of the heavens would be revealed. But a cyclical view of time in a sense made history meaningless (it just repeated itself), whereas Christians now came to see time as a linear process, according to God's will. This meant that history moved towards a definite end, or *teleos*. The birth of Christ was the focal point in this linear process, but it now became the purpose of Christianity to understand the role of the incarnation as a way to help the salvation of all humans on earth. The early Christian writers were not backward in making the most of this situation. For example, Julius Africanus (*c.* 160–240) argued that the world would last for six thousand years. According to his calculations the birth of Christ had occurred exactly 5,500 years after the Creation and therefore, by his lifetime, there were about three hundred years waiting before God accomplished his divine purpose. In this way, Christianity was set apart. In the creation myths of other religions, there were only vague references to events that occurred in an indeterminate and remote past. But Christianity was specific; for Christians their God had intervened in history, proving he had a purpose, and that he was the true god.

These ideas had great appeal, the more so for the poorer slaves and labourers of the

Roman empire. The reasons were obvious enough: Christianity argued that 'suffering is noble' and offered a better world in the future, with the Second Coming imminent. This was most attractive for people at the bottom of the ladder and it was among the urban masses, rather than the Roman aristocracy, or the upper ranks of the army, for example, that the new religion caught on. (The pagans did not, of course, just give way. The emperor Maximin Daia introduced anti-Christian schoolbooks, which pictured Jesus as a slave and a criminal.[38])

Not even the most passionate Christian, however, could wait for the Second Coming for ever, and other devices were needed. One was provided by persecution. To begin with, as has been noted, the Romans were fairly tolerant, and required only that conquered peoples recognise Roman gods in the same spirit as their own. But they grew less tolerant after the inauguration of emperor-worship. Like many ancient peoples they believed that the continued prosperity of the state depended on continuing favour of the gods. Christians did more than refuse to worship the Roman gods, and the Roman emperor: the very idea of salvation, or a Second Coming, implied the overthrow of the state by somebody. That was bad enough but when they refused to hold public office or to undergo military service, that was a more direct affront. Moreover, in their services they did not distinguish between slaves and masters and that was an equally serious social flaw. They did pray to their God for the 'welfare of the state' but it wasn't enough and, slowly, imperial policy turned against the Christians.[39] First, the emperor Trajan made it a capital offence to fail to pay homage to the emperor. Then, in 248, after Christians had refused to take part in the celebrations to mark the thousandth anniversary of the founding of Rome, they became especially unpopular and Decius decreed that everyone must appear before a magistrate to offer sacrifice to the Roman gods. At this time, according to some estimates, Christians comprised as many as 10 per cent of the population and so the population of martyrs was especially high. But the Christians counter-argued that the reason for the obvious decline in the empire, which was evident to all at the time, lay in the fact that the Romans worshipped the wrong gods. This began to cut some ice with the upper classes and forced both Valerian and Diocletian to attempt to root out Christianity completely, by threatening senators with loss of office for life, if they converted, by purging the army, by destroying churches and burning books.

By the third century, a curious cross-over time had been reached, when 'the desire for martyrdom was almost out of control'.[40] By now Christians deliberately flouted Roman practices – they insulted magistrates and destroyed effigies of the pagan gods, in an attempt to emulate the suffering of Jesus. Persecution was what they *sought*. 'For suffering one hour of earthly torture, it was believed, the martyr would gain an eternity of immortal bliss.'[41] These were (depending on your point of view) fine sentiments. But in fact the crucial change, from persecuted religion to the official faith of the empire, came about not for any fundamental change in philosophy in Rome but because one emperor, Constantine (306–337), found Christianity more practically useful. In 312, at the battle of the Milvian bridge, outside Rome, Constantine faced the usurper, Maxentius. Constantine was advised by his Christian supporters that if he sought support of their God, he would win. In some accounts he is reported to have had a vision in which he was instructed to have his troops paint a looped cross, ☧, on their shields.[42] He agreed, and his victory was decisive. Thereafter,

he allowed all faiths in the empire to worship their own gods and, most importantly, removed the legal constraints that had been directed at Christians. From then until his own deathbed conversion, Constantine believed that he was guided by Christ. In frescoes he was depicted with his head surrounded by the nimbus of a saint.

He made other changes. The observation of Sunday became obligatory, at least in cities, and he initiated a fashion for collecting relics, to install in shrines. No less important, he transferred the capital of the empire away from Rome to the new city of Constantinople, which was founded in 330 on the ancient site of Byzantium. This city had once been protected by the goddess Hecate, but Constantine looted pagan shrines in the Aegean to enrich his new base, and had built a massive statue of himself, holding an orb, symbol of world dominion, in which was embedded a fragment of what was claimed to be the True Cross, discovered by his mother.[43] Christianity was widely spread by now – as much as half the population in Greece, Turkey (Asia Minor then), Egypt and Edessa (towards Armenia). But it extended, in pockets, to Abyssinia, Spain, Gaul and Persia, to Mauretania in Africa and Britain in the north of Europe. Its success was helped by the fact that its growing confidence enabled it to relax a little and absorb pagan practices where this was felt to serve its interests. Besides the adoption of the feast day of Mithras, 25 December, as the date of the Nativity, the very word 'epiphany' was a pagan concept, used when gods or goddesses revealed themselves to worshippers, as often as not in dreams.[44] The terms 'vicar' and 'diocese' were taken from the emperor's administrative reforms. The original 'Sunday observance' was conceived as a day of respect not for Jesus but for the sun. In 326 Constantine gave the shrine of Helios Apollo in Nero's circus to the Christians for the foundation of their new church of St Peter. The shaven heads of Christian priests were taken from the practices of pagan priests in Egypt and when Mary was first honoured as the Mother of God, at Ephesus in 431, the church dedicated to her was constructed on the site of the temple of Diana.[45] The incense used at the dedication ceremony was the same as that used to worship Diana.

From the early 340s comes the first Christian text which demanded the 'total intolerance' of pagan worship. Between 380 and 450 paganism shrank fast. In particular, after the 380s nothing more is heard of the gymnasium. This was partly to do with the declining fortunes of the empire: city authorities could no longer afford to fund the civic schools. But it was also due to Christian attitudes. ' "The physical side of education languished in a Christian environment": in the cities, it had been linked with naked exercise, paganism and consenting homosexuality. The eventual "collapse of the gymnasia, the focal point of Hellenism, more than any other single event brought in the Middle Ages".[46] In 529 the emperor Justinian closed the ancient school of philosophy at Athens, 'the last bastion of intellectual paganism'.[47] By 530, when the same man founded a new city in north Africa, the art there was totally Christian, all the pagan elements incorporated into a new iconography.

There was one final reason for the success of Christianity. People thought that religious solidarity would help the declining fortunes of the Roman state. In turn this implied a crucial change in the organisation of society, a change that, as we have already indicated, would shape the Middle Ages. This was the rise of the priesthood.

In the early days, the main idea sustaining the church was 'the gift of the spirit of Jesus'. It

was believed that the Apostles had received this spirit from Jesus: this is why Peter spoke in tongues, and Paul had visions. In turn the Apostles passed the spirit on to the early church leaders in Rome: these 'presbyters' were distinguished from their congregations in that they sat at a table, while the others stood. But the most important development, what made the priesthood a class apart, was the emergence of the bishops. The term 'bishop' is Greek, originally a word meaning 'overseer'. In the early church, congregations were grouped into colleges of seven, and the bishop was the chief of the seven presbyters.[48] Out of this, and combined with the 'gift of the spirit', there grew the idea that only bishops could mediate between Christians and their God, only they could interpret the scriptures.

To begin with there were bishops in all the great Mediterranean cities – Antioch, Ephesus, Alexandria, Carthage and Rome – and they were all more or less equal in power and influence. They would occasionally gather in councils, or synods, to settle matters of doctrine, such as whether they had the power to forgive sin. This had the effect of making the bishops a rank apart from the rest of the church. Celibacy was not yet an issue but a life apart, dedicated to meditation and study-reading, was becoming the fashion for priests. A final factor in the build-up of the priesthood was Constantine's decision to grant to the Christian clergy the benefit that had been granted to pagan priests – freedom from taxation and conscription in the army. A later emperor, Gratian (375–383), also freed priests from the jurisdiction of the civil courts, placing them instead under the bishops' courts in all cases except criminal matters. Given that bishops were also allowed to receive bequests, the priesthood had become, by the fifth century, a privileged class: they were rich, they were firmly in charge of church doctrine, and they were very largely a law unto themselves. As one historian put it, the priesthood had 'acquired those political, economic and intellectual privileges which were to make it for a thousand years always an important and sometimes a dominant element in western society'.[49]

The rise of Rome as a pre-eminent centre of Christianity was by no means a foregone conclusion. In the early days, if anyone was more important, it was the bishop of Antioch, but Carthage and Alexandria also ranked high. The bishops in each place were addressed as 'Patriarch'. But Rome was capital of the empire, and both Peter and Paul, according to tradition, had been there. So the 'spirit of Jesus' was especially strong along the Tiber. Even so, Clement, the first bishop of Rome (discounting Peter), did not claim to be above the other bishops. Not until the time of Victor (fl. c. 190–198) did this change, when he tried to excommunicate a number of bishops in the east who refused to accept his decision over the dating of Easter.[50] At the first ecumenical council, in 325, Rome was said to have more prestige than anywhere else, but not more power. But by the time of the Council of Serdica (modern Sofia in Bulgaria), which was held in 343, the delegates agreed that when certain ecclesiastical matters were disputed, they would be referred to Rome.

Rome's authority was never fully accepted in the east, of course, but a number of enterprising popes made Rome more and more of a focal point during the decline of the empire, when powers were leaching away from the emperors. ('Pope', Latin *Papa*, is of course the equivalent of Patriarch = Father.) Pope Damasus (366–384) drained the hill where his villa stood (this is now the Vatican) and took up where Constantine left off, collecting relics of the martyrs. He also renovated the tombs of the early Christians. Rome, therefore, became a spectacle for Christian pilgrims in a way that Antioch or Carthage, for

example, never did. Pope Leo I (440–461) identified (that is to say, invented) the doctrine of the 'Apostolic Succession', specifically quoting Matthew 16: 18 – 'Thou art Peter, and upon this rock I will build my church.' The gift of the spirit also came in useful here. Leo prevailed on the emperor of the time to insist that Rome's authority was supreme throughout the empire and was able to do so because of two spectacular diplomatic victories of his own – first, in 451, when he persuaded the Huns to withdraw from Rome; and second, in 455, when he saved the city from the Vandals.[51]

But early Christianity was not only about the development of the 'sacred hierarchy', the priesthood. The other dominant idea of the early years was the notion of monasticism, the idea that full spirituality is best achieved by renouncing the world and all its temptations.[52]

Monasticism, as we shall see, was not only a Western notion. But, in the Mediterranean area, it was born in a hollow known as Wadi Natrun, or the valley of Soda, 'about a day's camel journey west of the Nile delta'.[53] As early as the middle of the second century a group of hermits began to gather there. By the following century both men and woman from all over Christendom were drawn to the wadi, led by a hermit known as Ammon. Each hermit would build a two-roomed cell, hewn from the raw rock (this usually took about a year). After that they lived mostly by weaving rugs which merchants bought from them and sold in the markets of Alexandria. According to one estimate there were 5,000 hermits in the valley of Soda by the end of the fourth century. 'The attraction lay partly in the fact that, with the decline of persecution, and the opportunities it offered for martyrdom, the temptations of the daemons that were supposed to inhabit the Wadi Natrun were the next best thing.'[54] 'Hermit' derives from the Greek word for 'desert'.

In contrast to the hermits of the desert, the first community of monks was established very early in the fourth century, some 600 miles further up the Nile, at Tabennesi. Here, Pachomius (*c.* 292–346) conceived the first set of rules for a way of life removed from the world. Each monk had his own hut and his time was divided into two main segments – learning the New Testament by heart, and an occupation which was assigned to him.[55] As a result of all this, the first monks in Rome were known as 'Egyptians'. But the idea of retreat had grown popular and monasteries in the west began to be established at the beginning of the fourth century. The most influential, by far, was that founded by Benedict of Nursia (d. 543), who devised a form of living together that had a great influence on the intellectual life of Europe. (The period 550 to 1150 has often been called 'the Benedictine centuries'.)[56] His monastery was built at Monte Cassino, on a hill some hundred miles south of Rome. It took Benedict a long while to prepare his *Rules for Monks* which, after a number of painful experiments, aimed to provide the ideal religious life. He had tried the hermit approach, but found it lonely and even psychologically dangerous.[57] His community was conceived as entirely self-contained, economically and politically as well as spiritually. Outside interference was allowed only when scandal threatened. The abbot was elected by the monks for life and his authority was absolute. But *he* had a duty to feed his charges and keep them healthy. The 'black monks' (from the colour of their habit) were to live in silence and 'abstraction' from the world and admittance wasn't easy. To begin with, all applicants were kept waiting – refused entrance – for five days. Only if they were prepared to wait were they admitted, and only then as a novice, who was kept under the

protection and guidance of an established monk for a full year. Only after that time, and if the novice still wished to continue, was he granted 'stability', as full membership was called. And membership was very different from the Wadi Natrun, being communal in every respect. Men worked, prayed, ate and slept together and took vows of poverty, chastity and obedience. Their duties filled every hour of the day and services were held throughout the day and night.

Without meaning to, Benedict had created an institution that turned out to be perfectly suited to the early Middle Ages. Amid and after the fall of the empire, when the cities declined and the world became less organised and more localised, when schools and other civic functions decayed, monasteries – located far from the cities – remained strong and offered a lead in education, economic, religious and even political matters. The monks often became intercessors with the deity and in consequence monasteries were endowed by royalty and the aristocracy alike. They enjoyed immense riches and abbots became local powers of great influence.

Christianity was a new system of belief but it was also much more. Between the fourth and sixth centuries, in Europe mainly, its priestly elite took over many of the civil, political and even legal functions of the declining empire. Useful as this was, it determined the basic character of the Middle Ages, as a gap opened up between the clergy and the laity, who were no longer allowed to preach in the churches (there would come a time when they were not even allowed to read the Bible). Simultaneously, the church offered an escape from the harsh rigours of everyday life into an 'otherworld'. This idea in particular gave the clergy great control over the laity.

This authority of the clergy was reinforced by the development of the scriptures and the liturgy. In the very beginning, Jesus had written nothing. But gradually a canon of written works was established. The first two were in Aramaic, one known as *The Sayings of Jesus* and the other as *A Book of Testimonies*. These comprised mainly excerpts from the Old Testament which appeared to confirm that Jesus was indeed the Messiah. It was, in other words, a text aimed at Jews rather than Gentiles. There was a third work, called *The Teaching of the Lord by the Twelve Apostles*, which was a guide on how to organise the early church, and on the correct form of worship.[58] The very idea of holy scriptures was a Jewish idea, and Christianity retained its debt to Judaism in many areas (such as the observance of the Sabbath, albeit on a different day of the week). Baptism and communion were both Christian innovations, which are still with us, but there was a third practice that, but for a few sects, has dropped out. This was speaking in tongues, 'which was held to be the way the Holy Spirit made itself known to congregations'.[59] The practice had been taken over from the Greek mystery cults.

But the literary tradition really began to flourish after Paul began writing letters to the congregations he had founded ('Letter to the Corinthians', 'Letter to the Ephesians,' and so on). Neither Paul nor the congregations ever imagined these 'epistles' would one day form part of any sacred book; he was just commenting on the doctrine he had been handed down orally. Most were written between the years 50 and 56.[60] Interpreting Jesus' career was all very well but for the faithful, in the early years especially, the most important fact was that he had existed, been crucified and resurrected. Therefore, around 125, at Ephesus, the decision was taken to use all four gospels as the basis for worship. This would keep all

aspects of Jesus in perspective and contain any heresies that broke out. It was the early heresies that eventually resulted in the establishment of a canon of works. Three early heresies were particularly influential in shaping church doctrine. These were those of Valentinus (d. 160), who argued that Jesus was a phantom, not a real person, who had suffered no pain on the cross; of Marcion (fl. *c.* 144), who argued that Jesus wasn't Jewish and was the son of a 'higher and kindlier' god than Yahweh; and Montanus (fl. *c.* 150–180), who was against the church structure, arguing that the clergy should consist only of 'inspired prophets' who had 'the gift of the spirit' and that what *they* said, rather than any gospel, should determine worship.[61] In response to these wayward beliefs, the church came together to form not just the canon of New Testament works, but also the central elements of religious practice. This was when communion became established, a re-enactment of the Last Supper, by means of which Christians believed they atoned for their sins (a Jewish idea) and gained salvation (a Greek Gnostic idea). The phrase 'New Testament' was first used in 192.[62] And so, by the year 200 Christianity was well on the way to becoming a religion of the book, something else it shared with Judaism. This, of course, only added to the power of the priesthood because they were, for the most part, the only people who could read.

The apostolic tradition was of course a powerful tool for the faithful, and a useful way of asserting Rome's supremacy in Christendom. But Rome was not the only centre, not the only influential location for ideas. Just as the gospel of John was influenced by Greek and Gnostic beliefs at Ephesus, so other writers in the eastern Mediterranean combined philosophy and theology to produce a more sophisticated Christianity. These men are usually called the Church Fathers (*patres ecclesiae*). Outside Rome, there were two centres where they shone, at Alexandria and Antioch. The Alexandrians, much influenced by Gnostic beliefs, developed in particular an allegorical method of understanding the Bible – to such an extent that hidden meanings were found even in misspellings. It was in this way that the practice of biblical exegesis was begun.[63]

The best-known of the Alexandrians was Clement (*c.* 150–216), whose aim was to reconcile pagan scholarship – especially Greek ideas – with Christianity. In his book, *Pedagogus*, Clement argued that Plato occupied a position analogous to the prophets of ancient Israel. Plato's *Logos*, translated in English as 'Word', though it is more complex than that, was the eternal principle of reason, which creates a link between the higher world of God and the lower, created world of man. This was, said Clement, revealed to Plato as the prophets of Israel had had inspiration revealed to them, so that man might come to know the true faith, the preparation of Israel for the coming of Jesus. In Plato's theory of ideas, Clement found a 'contempt' for 'this world' which was echoed in the teachings of Jesus (and found expression, for example, in the practice of monasticism).[64]

Clement had run a school in Alexandria but was forced to leave. After a gap of some years, his school was reopened by Origen (*c.* 185–254), teaching pagan subjects (rhetoric, geometry, astronomy, philosophy) alongside Hebrew. He produced many books, two of which were the first work of Christian exegesis, known as the *Hexapla* and the 'earliest systematic presentation of Christian theology', *The Principles of Things*.[65] Origen's most famous innovation was that everything in the Bible has three meanings – the literal, the

moral and the allegorical and that only the last of these is the revealed truth. For him, for example, the Virgin Birth of Christ in the womb of Mary was not to be primarily understood in a literal way. It really represented the birth of divine wisdom in the soul.[66] Origen was the pupil of someone we have met before, Ammonius Saccas, the founder of Neoplatonism. Under his influence, Origen argued that the universe was 'a hierarchy of spiritual beings, with God at the apex and the devil and fallen angels at the base'.[67] God, Origen said, was knowable in two ways – through nature, the rationally ordered universe, and through Christ, who was the full revelation of his mercy and wisdom. Man comprised a rational soul in a body of flesh and because of that occupied a position half-way between the angels and the demons. The soul was corrupted by its presence in the body and the object of life was to 'behave in such a way that one corrupted one's soul as little as possible'.[68] For Origen the soul pre-existed man, while after the death of the body it passed into a state of purification and 'in the end all souls, purified by fire, will share in the universal restitution'.[69] Origen did *not* believe, however, that resurrection would be of the material body, and this view became more and more influential as time passed, and the Second Coming did not occur.

Jerome (*c.* 340–419) was an earnest, educated man, who had tried and failed to start his own monastery, and had studied Greek and Hebrew in the Near East. He was recalled to Rome in 377 by Pope Damasus (305–384), who charged him with translating the book of Psalms into Latin. In turn this led to Jerome's major claim to fame. In Rome he mixed with a group of wealthy women who eventually clubbed together and provided funds for him to build a monastery and research institute near Bethlehem and there he spent the rest of his life translating the entire Bible into Latin, a project which would replace the fragmentary translations that then existed, known as the *Itala*.[70] He used both Hebrew and Greek texts as source material and his aim was to write a work that would please not only scholars and bishops but ordinary people as well. What he produced was a text midway between the Ciceronian Latin of the educated literati and the vulgar language of the streets (the tongue that eventually became vernacular French, Spanish and Italian). This 'Vulgate' (popular) Bible was a great success and was the standard version for centuries.

Without question the greatest of the Latin Fathers of the Church, and a major figure in the history of ideas, is Augustine (354–430). Thanks to his own writings, a great deal is known about him. He was born on 13 November at Thagaste, now Souk-Ahras, south of Bône (Annaba) in Algeria. His father was a local government officer and a pagan, whereas his mother, Monica, was a Christian. (These 'mixed marriages' were not uncommon in the fourth century as the attitudes of Christians softened.) Augustine turned into a great writer (113 books, 200 letters) but he is famously known to history as 'a great sinner who became a great saint'.[71] According to his own confessions, he was a sinner until he was thirty-two, when he turned to Christianity, but even after that he was unable to live up to his hopes because of a 'weakness in dealing with sexual temptation'. ('Lord, give me chastity,' he used to pray, 'but not yet.'[72]) Augustine's great humanity makes him a very sympathetic character, to which he added the gifts of a great writer – the *Confessions* and *City of God* are masterpieces of vivid Latin which are of interest today because, before he turned to Christianity, Augustine flirted with most of the other systems of thought available at the time. Because his mother was a Christian, he was exposed to Christianity very early

on but, he tells us frankly, he found the *Itala* dull. He read *Hortensius*, allegedly written by Cicero, which led him to Plato and Aristotle and scepticism. For a while, he sampled Manicheism. That didn't last long. He took a mistress and they formed a stable relationship (fourteen years), creating more flesh (which Mani said was evil), by producing a son. Augustine next tried Neoplatonism but that didn't suffice either. Then, one day he was reading in his garden when he heard some children singing. The phrase he actually heard was 'Take up and read', whereupon, he says, he flipped open his copy of Paul's epistle to the Romans. (According to Marcia Colish, this opening of a book at random, in order to find a solution to a personal problem, was an early Christian practice derived from the pagan use of Homer and Virgil.[73]) The thought that Augustine's eye alighted on that day, and which so attracted his attention, was Paul's understanding of evil as the 'spoliation of order'. (The rise of the influence of Paul, the anti-intellectual, in the late fourth century, had an effect on the decline of classical learning, which is the subject of the next chapter.) Neoplatonism had been concerned with order – the hierarchy of beings in the universe. But Augustine's own great contribution was to add to this the idea of free will. Humans, he said, have the capacity to evaluate the moral order of events or episodes or people or situations, and can then exercise judgement, to order our own priorities, so that we shun the bad route and follow the good one. To *choose* good, he realised, was to know God. This has proved hugely influential.[74]

His humanity apart, Augustine's cleverness was important too. This was impressively revealed in his ideas about the Trinity, the most important and impassioned division within the early church, which had occasioned the famous council at Nicaea, on the shores of a picturesque lake, near the Sea of Marmara, in modern Turkey, in May 325, under Constantine. As we saw in Chapter 8, the division had been kindled by Arius, from Alexandria, who had argued that Jesus could not be divine in the same way as God the Father was. Arius wasn't denying that Jesus was divine in some fashion – but, nevertheless, Jesus himself had specifically said that God was greater than he.[75] For Arius, Jesus was therefore both different from humans, but different from God also. Insofar as Jesus called God his 'father', this implied prior existence and a certain superiority. For Arius, Jesus had been born mortal but *became* divine; if he had not been human, at least to begin with, there would be no hope for us. At Nicaea, however, the bishops took a different view and in the Nicaean Creed (still in widespread use), it was set down and agreed that God had made the world *ex nihilo*, from nothing, and that God the Father, the Son and the Holy Spirit were the same substance.

Just because the bishops had agreed didn't mean the laity had to go along with it. In fact, many early Christians found the idea difficult to grasp (many still do). After some years, however, three formidable theologians from Cappadocia, in eastern Turkey, came up with a solution that satisfied at least some, mainly in the east. These were Basil, bishop of Caesarea (329–379), his brother Gregory, bishop of Nyssa (335–395) and their friend, Gregory of Nazianzus (329–391). Their solution was to argue that God was a single essence (*ousia*), which remains incomprehensible to us, but there are three expressions (*hypostases*), through which he was known.[76] The Trinity was not three gods but a spiritual/mystical *experience*, the result of contemplation.

Augustine built on this and for many people it was his greatest achievement. He argued

that since God had made us in his own image (as it said in the Scriptures), 'we should be able to discern a Trinity in the depths of our minds'.[77] In *On the Trinity* he showed how this idea underlines so much of life. For example, he said there are three faculties of the soul – memory, intellect and will. There are three stages of penance after sin: contrition, confession and satisfaction. There are three aspects to love – the lover, the beloved and the love that unites them. There is memory of God, knowledge of God and love of God. There is the Trinity of faith: *retineo* (holding the truths of the incarnation in our mind); *contemplatio* (contemplating them); and *dilectio* (delighting in them). This was numerology of sorts but it was also a clever intellectual achievement, a fusion of theology and psychology that had never been conceived before.[78]

Augustine's other well-known work was *City of God*. This was written in response to the sack of Rome by the Visigoths in 410, by far the most traumatic and dramatic of setbacks, and he wrote the book, at least in part, to counter the charge that Christianity must take the blame for this catastrophic reversal. His main aim, however, was to develop a philosophy of history. Augustine was one of those who repudiated the ancient idea of time as cyclical; instead, he said, time was linear and, moreover, it was the property of God who could do with it as he liked. On this reading, the Creation, the covenant with the Old Testament patriarchs, the Incarnation and the institution of the Church may all be seen as the *unfolding* of God's will. He said that the Last Judgement would be the last event in history, 'when time itself will cease and everyone will be assigned their posthumous habitations for eternity'.[79] The fall of Rome, he insisted, took place because she had fulfilled her purpose: the Christianisation of the empire. 'But we should not be deflected by what happens on the grander scale.' The real purpose of history, he said, was to pit self love against the love of God. 'Self love leads to the City of Man, love of God to the City of God. These two cities will remain at odds and conflicted throughout time, until the City of God is eternalised as heaven and the City of Man as hell.'[80] Augustine's view of history also involved a great and influential pessimism. The fall of Rome, for example, coloured his doctrine of original sin, which would form such a central part of the Western Christian vision. Augustine came to believe that God had condemned humankind to eternal damnation, all because of Adam's original sin. This 'inherited sin' was passed on through what Augustine called concupiscence, the desire to take pleasure in sex rather than in God. This image, of the higher life of devotion, dragged down by 'the chaos of sensation and lawless passion' was paralleled by the decadence in Rome and as an idea would prove extremely durable. From Augustine on, Christians viewed humanity as chronically flawed.[81]

By the time Gregory the Great (540–604) achieved prominence, the barbarian invasions had transformed the map. For example, by the sixth century, the Ostrogoths – who had penetrated Italy more than half a century before – had themselves been chased out by the Lombards. There was still an emperor in Constantinople (Justinian, 527–565) but in the west the extent of barbarian rule meant that many of the functions traditionally carried out by the Roman civil service – education, poor relief, even food and water supply – were carried out by the bishops.[82] Gregory was a marvellous administrator and under him the church became ever more efficient in an everyday, worldly sense. But he was also a contemplative man and this mix made him perfectly suited to advancing doctrines that added to the appeal of the church for ordinary souls. For example, he wanted to make the

liturgy more accessible to the faithful and his genius was to involve music. Thus was born Gregorian chant. In the same spirit he invented the notion of purgatory. He was particularly concerned with what should happen when a sinner received absolution from a priest, and had been instructed in a programme of 'satisfaction', as it was called, but died before the programme could be completed. To Gregory, it would be grossly unfair to condemn such a person to hell, but at the same time he or she could not go to heaven, since it would be wrong to admit that person alongside those who *had* completed their programme. His solution was a new, albeit temporary destination – purgatory – where people could complete their satisfactions, endure their punishments, and then, all being well, move on – to heaven. His other 'user friendly' idea for the faithful was that of the seven deadly sins. Evil, for Gregory, would always be a mystery for man: God intended it as such, as a test of faith (as it had been for Job). But the seven deadly sins were intended by Gregory to be a guide for the faithful, so that they weren't always 'overwhelmed' by a sense of sin. The seven sins were set out on a scale of increasing seriousness: lust, gluttony, avarice, sloth, wrath, envy, pride.[83] This made it clear to all that sins of the intellect were more serious than sins of the flesh.

By now the Christianisation of time was almost complete. The main festivals of Christianity, celebrating the birth, death and resurrection of Jesus, had not been agreed upon for quite a while after Christ's crucifixion. The English word Easter was named after the old Scandinavian pagan goddess of dawn and spring, Eostre, and to begin with, this festival was far more important than Christmas, because it celebrated the resurrection, without which there would be no Christian faith. (The French Pâques – Italian and Spanish too – is derived from the Hebrew, *pesakh*, for Passover.) In Rome, Easter was being celebrated as early as AD 200, according to a letter written on that date, which mentions a ceremony involving the burning of wax candles. Christmas, on the other hand, was not celebrated until the fourth century.

Since the gospels give no information about Jesus's birth date the early theologians, as we have seen, took over pagan practices. Easter was a more complex matter. According to the gospels, Christ died on the first day of the Jewish Passover. This, according to Hebrew tradition, is the day of the full moon that follows the spring equinox and, because it is based on a lunar calendar of 354 days, changes its date in the solar rotation ($365\frac{1}{4}$ days) every year. This would have been a tricky enough calculation to do at the best of times but the early Christians made it even harder for themselves by adding a further twist. They decided that Easter should be always celebrated on a Sunday, since Christ's resurrection had taken place on that day, and because it set them apart from the Jews, who celebrated their Sabbath on Saturday. In the very early days of the Church, Easter was celebrated on different days in different countries around the Mediterranean, but in 325, at the Council of Nicaea, 318 bishops decided that the festival would be observed on the same date all over Christendom. The day chosen was the Sunday following the first full moon after the spring equinox. Apart from being mentioned in the Bible, the theological significance of this date was that it was a day of maximum light – twelve hours of daylight, followed by twelve hours of full moonlight. This contrasted strongly with Christmas, in the depths of darkness. In time Christian theologians built up layers and layers of allegory linking the

moon to the Easter story. Easter falls in the spring, the season when the world was first fashioned and the first man installed in Paradise. The moon itself is resurrected each month and, like Christ, offers a light to the world. The moon shines with reflected – i.e., borrowed – light from heaven, just as man's grace is borrowed from the Lord.[84]

Greek astronomers, as was discussed in Chapter 8, had discovered that, after nineteen years, the sun and the moon returned to their respective positions (the Metonic cycle). But this took no account of the seven-day week (which the Greeks didn't use) and once the Council of Nicaea had ordained that Easter must fall on a Sunday it took another century and more before Victorius of Aquitaine, in 457, worked out that a further 28-year cycle (accounting for days of the week and leap years) needed to be added to the arithmetic. He therefore came up with a 532-year cycle (28 × 19) as the only repeatable rhythm that took account of all the variables.[85] This continued to be tinkered with and was not properly finalised until the Venerable Bede, in England, put an end to the controversy in his great work on time, *De ratione temporum* (*On the Calculation of Time*), published in 725. But the 'Easter controversy', as it became known, had two further knock-on effects. Twentieth-century scholars, with the benefit of later archaeological discoveries, numismatical finds, not to mention the much more accurate astronomical advances that were made after the Copernican revolution, have been able to date the original Good Friday more and more precisely – the two most favoured dates now are 7 April AD 30 and 3 April AD 33. But the early Christian scholars had none of these advantages, and in the sixth century the abbot of Rome, Dionysius Exiguus ('Dennis the Little', on account of his self-demeaning manner), conceived the idea that the Easter tables, as well as being used to calculate the dates for Easters in the future, could also be worked in reverse, all the way back to find the exact date of the original Passion. Dating, as we have noted, had not been of prime concern to the early Christians, for two reasons. In addition to the fact that they were convinced that the Second Coming of the Messiah was imminent, they tried to stress, in Rome at least, that Christianity was an *old* faith, not a new one, that it had grown organically out of Judaism and was therefore much more established than the rival pagan cults. This helped them avoid the derision of critics, so they kept new dates to a minimum. But, as time went by, and the Messiah failed to appear, the liturgical calendar took on a new urgency, highlighting points in the year when the faithful could rally.[86]

The calendar in use at the time Exiguus made his calculations was based on the accession of the emperor Diocletian, which took place in 285. Thus, the year that we call 532 was for Dionysius the year 247. But Exiguus didn't see why time should start with a pagan emperor and it was during his Easter calculations that the abbot conceived the idea to divide time according to the birth of Christ. And here there befell Exiguus an extraordinary numerological coincidence. Victorius of Aquitaine, as we have seen, had come up with a 532-year cycle. As Exiguus worked back, in the year we call 532, he found that a Victorian cycle had begun in the *very* year in which he believed that Christ had been born – what we now call 1 BC. In other words, the sun and the moon, at the time he was working, were in *exactly* the same relation as they had been when Jesus was born. This was too much of a coincidence and, in the words of the Venerable Bede, confirmed for Dennis that 1 BC was indeed the year 'in which He deigned to become incarnate'. From then on, and thanks to Dennis, dates were given as *Anni Domini*, 'years of the Lord'. However, it was not until

the eighteenth century that it became customary to designate the preceding era 'before Christ'.[87]

Such dates had far more resonance then than they do now. This was because, according to the early theologians, the world would last for six thousand years. The reasoning behind this arose from the second letter of Peter (3:8), where it says, '. . . one day is with the Lord as a thousand years, and a thousand years as one day'. It had taken the Lord six 'days' to make the Earth, so it made tidy sense for it to last equally long. Using genealogies in the Bible, theologians such as Eusebius calculated that the world was 5,197 or 5,198 years old when Jesus was born. By AD 532, therefore, the world had only another 271 years, at the most, before the Apocalypse – and Paradise for the faithful. Accuracy in the calendar really mattered.

The second knock-on effect of the Easter controversy was the development of a new form of literature which, although largely forgotten now, was for centuries the most sacred form of all writing after the Bible itself. This was the computus. *Computus*, as a word, originally meant more or less what it means now – any kind of calculation. But in the Middle Ages it referred exclusively to the set of tables, compiled by mathematicians, which predicted the date of future Easters. These tables were sacred for reasons that were obvious to the medieval mind: the movement of the heavens was the most important and awesome mystery facing humankind and the fact that the rhythms of the sun and the moon could now be harmonised meant that God had revealed – to mathematicians at least – part of his grand design for the universe.[88] The attempts to date Easter had therefore caused a major mystery of the heavens to be revealed to humankind. For the faithful, this was another sign that Christianity must be true.

Between Augustine and the Easter controversy, the character of Christianity changed decisively, according to such historians as Peter Brown and R. A. Markus. During the years of persecution, with martyrdom so widespread, and with early (poor) Christians expecting the Second Coming at any moment, there was less emphasis on *this* life, on the Bible, on liturgy, on art. This was the era of the cult of the saints, which grew out of martyrdom, and in which saints and saints' relics were regarded by Christians as the main stimulants to faith and proof of Christianity's power and veracity, and yet which many pagans looked upon with horror. For these early Christians, chastity, self-denial and monasticism were the ideal. However, between say 400, roughly when Augustine was writing, and the 560s, when the last vestiges of paganism are recorded, Christianity came to terms with sex, and turned itself into a more communal – and more urban – faith. As the Second Coming receded in importance, as it seemed less and less likely to be imminent, the Bible came to the fore, the Christianisation of time helped the liturgy to expand throughout the year, and the Christianisation of geography, especially the eastern Mediterranean, created a raft of holy sites, pilgrimage routes, and with it a greater sense of history. The church's communal and urban character was helped by the depredations of the barbarians and Christianity began to take on a form recognisably similar to today.[89]

Whatever Christianity's true role in the decline of the Roman empire, German historians in particular have favoured Gibbon's idea that the barbarians were the main event. They have conceived the so-called *Völkerwanderung*, 'the age of barbarian invasions', which,

they argue, was the chief element in this era of history and produced a significant twist on Graeco-Roman classical civilisation.[90] Combined with Christianity, they say that this was 'a cataclysmic event, a sharp break in European history'.[91] This view is supported by the very simple – but undeniable – observation of A. H. M. Jones, who points out that the whole of the Roman empire did not fall in the fifth century: it continued to survive in the east in what we know as the Byzantine empire, until the Turkish conquest in the middle of the fifteenth century.[92] These observations are important, says Jones, 'for they demonstrate that the empire did not, as some modern historians have suggested, totter into its grave from senile decay, impelled by a gentle push from the barbarians. Most of the internal weaknesses . . . were common to both halves of the empire'.[93] If Christianity weakened the empire internally, since the religion was stronger and more divisive in the east, why did the west fall and the east continue to stand? The main difference, as Jones saw it, was that 'down to the end of the fifth century . . . the East was strategically less vulnerable and . . . subjected to less pressure from external enemies.' In short, the barbarian invasion was the main cause of the fall of Rome.[94]

'The origin of the word *barbaros* is early Greek, and it gained three central meanings in the course of classical antiquity which it has retained to the present day: an ethnographical, a political and an ethical definition.'[95] For example, Homer used it in the *Iliad*, referring to the Carians in Asia Minor; he said they 'spoke barbarically'. He meant he could not understand them, but he did not describe them as 'mute', as others in antiquity would dismiss foreigners, nor did he liken their language to 'the twittering of birds or the barking of dogs', as many others did, from China to Spain.[96] As time passed, however, the Greeks' view of themselves changed as their successes in philosophy, science, the arts and government began to ripen. They now started to think of themselves as the 'ideal people' and their enemies as lesser souls. In 472 BC, during the Persian wars, Aeschylus dismissed the enemy as 'barbarians' partly because 'they spoke like horses', but mainly because he thought their political traditions were primitive – they were little more than slaves subjugated to an oriental military tyrant, and did not enjoy the freedoms of the Greeks.[97] 'Barbarian' was no longer a neutral term, but an insult.

The meaning changed again during the Hellenistic period, when Greek culture and Roman government existed alongside each other in the eastern Mediterranean. Now, as men began to be judged by their humanity, according to their ethical and social habits, rather than by their military exploits, the term barbarian came to mean people who were raw, uncultivated, cruel.[98] According to Arno Borst, this was how Cicero understood the word '*barbarus*', which is why the literate, Hellenic-educated Romans maligned the Christians, calling them primitive, enemies of the empire, barbarians. (The early Christians were proud to accept the insult: 'Yea, we are barbarians,' said Clement of Alexandria.[99])

All of this, however, paled alongside the invasions of the Germanic peoples which overran the newly-Christianised Roman empire in the fifth century. The term barbarian was not only revived but 'magnified into the satanic'. 'The advancing Germanic tribes spoke incomprehensible dialects, had military power, were as robust as peasants and disdained urban civilisation; and their pagan superstitions rejected Christianity.'[100] The attitude of Christian Romans was summed up by Cassiodorus, around 550, who found a

hidden meaning in the very word *barbarus*: it was, he said, 'made up of *barba* (beard) and *rus* (flat land); for barbarians did not live in cities, making their abodes in the fields, like wild animals'.[101]

The very idea of the 'Middle Ages' as a 'dark' period of history was first expressed by the Italian humanists of the fourteenth and fifteenth centuries. Francesco Petrarch (1304–1374), for example, confessed to 'a stronger attachment and a closer spiritual kinship' with the great classical writers than to his more immediate medieval predecessors.[102] 'The disdain he expressed for the allegedly idle speculations and bad Latin of medieval authors soon became the fashionable slogan of the humanist movement.' The first man actually to use the term *media tempestas*, or Middle Age, was Giovanni Andrea, bishop of Aleria in Corsica, in a history of Latin poetry, published in 1469.

Our view of the dark ages is now somewhat different. The densest of the medieval centuries, between AD 400 and AD 1000, are recognised as the true dark ages – and dark for two reasons. One, because comparatively few documents survive to illumine them. Two, because so few of those monuments of art and literature as do survive can be considered as major achievements. But Europe by the thirteenth century, say, boasted great cities, thriving agriculture and trade, sophisticated government and legal systems. There were many universities and cathedrals spread across the continent, and copious master-pieces of literature, art and philosophy to rival those of any other period. The chronology of the 'medieval millennium' therefore needs to be adjusted accordingly. We now recognise the early Middle Ages (the dark ages) and the high medieval period, when many of the foundations of the modern world were laid down.

Just how dark these dark ages were is instructive. The true medieval mind was very different from our own way of thinking. Even Charlemagne, the first Holy Roman Emperor and the greatest of medieval rulers, was illiterate.[103] By 1500 the old Roman roads were still the best in Europe. Most of Europe's major harbours were unusable until at least the eighth century.[104] Among the lost arts was bricklaying: 'In all of Germany, England, Holland and Scandinavia,' says William Manchester, 'virtually no stone buildings, except cathedrals, were raised for ten centuries.'[105] The horse collar, harness and stirrup, all invented in China, much earlier, did not exist in Europe until around 900. Horses and oxen, though available, could hardly be used. The records of the English coroners show that homicides in the dark ages were twice as frequent as death by accident and that only one in a hundred murderers was ever brought to justice. (The threat of death was also widely used in the spread of Christianity. In conquering Saxon rebels the emperor Char-lemagne gave them a choice between baptism and execution. When they hesitated, he had 4,500 beheaded in a single morning.[106]) Trade was hampered by widespread piracy, agriculture was so inefficient that the population was never fed adequately, the name exchequer emerged to describe the royal treasury because the officials were so deficient in arithmetic they were forced to use a chequered cloth as a kind of abacus when making calculations.[107] As well as being dangerous, unjust and unchanging, the medieval way of life was also invisible and silent. 'The medieval mind had no ego.' Noblemen had surnames but this was less than 1 per cent of the population. Because so few inhabitants ever left the village in which they were born, there was in any case no need. Most of the villages had

no name either. With violence so common it is no surprise to learn that people huddled together in communal homes, married fellow villagers and were so insular that local dialects developed which were incomprehensible to people living only a few miles away.

The descriptions which the Roman writers left of the peoples of temperate Europe had some definite limitations. They were generally written in a military context, and they were written as outsiders – none of the Latin authors ever lived in an Iron Age village, nor did they travel among foreigners as merchants. They perceived a fundamental difference between their literate civilisations and the barbarians but they drew two different conclusions. At times they portrayed barbarians as uncouth, uncivilised savages, exceptionally strong and wild, and childlike in many respects. Caesar observed that the Germans were less civilised even than the Celts, lived in smaller communities, in landscapes less transformed by cultivation and had less highly developed religious practices. They had no permanent leaders but elected temporary chiefs for military escapades. The further north these people lived, the more extreme they were. At other times, however, they were idealised as simple, noble people, unspoiled by sophisticated lifestyles.[108]

When the classical texts were rediscovered in Renaissance times (see below, Chapter 18), preserved as copies in European monasteries, their descriptions were accepted as objective accounts but, as Peter Wells has shown, there are now good grounds for querying this. The main thrust of Caesar's account, for example, is that the Germans lived east of the Rhine and that the Celts lived to the west. Yet there is no reason to suppose that either the Celts or the Germans felt that they belonged to a common people, or that they saw themselves as members of a super-regional population. Caesar's reliability may be gauged from his description of the unusual creatures in the German forests, among them the unicorn and the elk, 'an animal without leg joints'. Because this meant the elk could not raise itself from the ground, and had to sleep standing up, the recommended way of catching one was to saw part-way through a tree. Then, when the elk leant against the tree, it fell over, and the animal fell with it, becoming easy prey.[109]

Our understanding of the early Middle Ages is in fact now a mixture of nineteenth-century philology and late twentieth-century archaeology. The terms 'Celtic' and 'Germanic' are artificial creations by philologists based on a study of known languages from later times: Breton and Irish, for Celtic; English, German and Gothic for German. As Patrick Geary puts it, 'Barbarians existed, when they existed at all, as a theoretical category but not as part of a lived experience.'[110] In the case of Celtic languages the earliest traces are inscriptions written in Greek in southern Gaul, as early as the third century BC. Personal names are mentioned and they are very similar to those mentioned by Caesar two hundred years later.[111] So far as Germanic is concerned, the earliest evidence comes in the form of runes, short messages written in characters made up of straight lines, and dating from the end of the second century AD.[112] The distribution of early Celtic in Gaul, and runes in northern continental Europe, do suggest a general geographical distinction between those who spoke Celtic and German at the time the Romans extended north and west. Herodotus said that the *Keltoi* lived around the headwaters of the Danube (i.e., in the Alps in what is now Switzerland) and archaeology has linked them with the culture known as Early La Tène. This was discovered at the east end of Lake Neuchâtel in Switz-

erland in the run-up to the First World War. Excavations revealed a predominantly wooden culture: wooden piles (the remains of houses?), two timber causeways and a quantity of tools and weapons of bronze, iron and wood. Several objects bore curvilinear patterns which have since become the hallmark of La Tène art everywhere from central Europe, to Ireland, to the Pyrenees.[113]

Recent anthropological evidence suggests that the very presence of powerful empires themselves cause changes among the people who occupy the fringes. To begin with, says Patrick Geary, barbarians consisted of small communities living in villages along rivers, sea coasts and clearings in forests, from the Black to the North Seas.[114] There were clans, with incest taboos, who came together for defence. They had divine genealogies and elected headmen for specific occasions, such as war ('barracks emperors').[115] They didn't think of themselves as Celts, Franks or Alemanni, until the empire forced such defensive identity upon them. (*Franci*, which means 'band', and *Alemanni*, 'all men', are Germanic words, which the Romans can only have learned from the groups themselves, or their neighbours.[116]) The anthropological evidence also shows that, broadly speaking, hitherto amorphous peoples, when presented with a threat, are forced together into 'tribes', groups who coalesce around a leader and acquire territorial claims.[117] There is some evidence that this is what happened near the edges of the Roman empire. Analysis of pottery, for example, shows that before the time of Caesar the communities of Germany had broadly similar pottery, ornaments and tools, and burial practices, but these varied quite considerably from one (small) region to another. (This is known to archaeologists as the Jastorf culture.[118]) At the time of the Roman expansion, however, and over the next centuries, this pattern changed and both pottery and burial practices became more uniform along wider regional lines. It appears that the presence of a nearby imperial power did indeed have the effect of 'solidifying' the tribes into larger and less diverse units. Around the time of the Gallic wars, at the turn of the second century, new and considerably larger settlements were established, of which Feddersen Wierde and Flögeln, both in Lower Saxony, are well-studied examples. The archaeology also shows that the peoples on the edge of empire began imitating the Romans in their burial practices, interring men with their weapons, even their spurs.[119]

About three dozen sites have now been excavated along the frontier of the Roman empire, a broadly north-west to south-east axis, as delineated by the Rhine and Danube rivers.[120] This has produced a whole raft of new information about the social organisation of the 'barbarians', about their beliefs, their art and their thought. In the first century BC, the barbarians are described by Caesar, and by Tacitus around AD 100, in a very different manner to the way they are portrayed by third-century writers. The earlier authors described smaller, tribal groups of people, inhabiting small localities. The third-century groups are much larger and better organised – tribal confederations. The Romans themselves had helped bring this about: they trained foreigners as auxiliaries, and the empire created a demand for goods, so that provincial centres expanded to cater to this market. Centres such as Jakuszowice, Gudme and Himlingøje grew up, though the best studied is Runder Berg, one of fifty hilltop forts on the border of the empire in south-west Germany. Here the archaeological evidence shows that the fort was occupied by an Alamannic king and his followers. Workshops in the fort produced not only weapons, but bronze and gold

ornaments, carved bone objects and gaming pieces. There was also an abundance of late Roman pottery and glassware, imported from Gaul, west of the Rhine and at least ninety miles away.[121]

The Celts worshipped in sacred groves or *nemetona* but did not have elaborate temples to house images of their deities. Dio Cassius wrote that the Britons had sanctuaries dedicated to Andraste, goddess of victory.[122] 'These groves were dread places, held in great awe and approached only by the priesthood.'[123] Reconstruction of such places of worship as have been found in the Germanic lands show them to have been modelled on Gallo-Roman temples. At Empel, on the south bank of the Maas river in Holland, metal fibulae and other objects indicate worship of the deity Hercules Magusenus, a typical combination of Roman and indigenous identities. Weapons and horse-riding equipment were left at these sanctuaries. Deposits of objects in water was another variant in ritual. The source of the Seine in eastern France was a site where wooden sculptures of human figures and human body parts were left, dedicated to the pre-Roman goddess Sequana. Wells were centres of ritual in the same way.[124] Gods worshipped by the barbarians also included Sirona, goddess of warm springs and healing (Moselle, Rhine; Sul or Sulis in Bath, England), Epona, a Celtic horse goddess, Nehalennia (North Sea coast of Holland), a goddess of seafaring, and the mother goddesses, Matronae Anfaniae and Matronae Vacallinehae, in the Rhineland.[125] Tacitus tells us in *Germania* that the Germans had only three seasons: spring, summer and winter. In fact, they had a six-fold year divided into sixty-day 'tides', or double months. The year started at the beginning of winter with a feast equivalent to the Celtic Samhain.[126] Runes began to appear in the first or second century AD, the prevailing view now being that this was a deliberate attempt to devise a system of writing comparable to the Latin alphabet, as a result of cross-cultural contact between the barbarians and the Latin-speaking Romans.[127]

Careful consideration of the archaeological evidence, therefore, leads us to conclude that, with one major exception, the barbarians did not appear from nowhere and that there was no raw 'clash of civilisations' in any overnight sense.

The exception was the Huns. A nomadic confederation under central Asian leadership, and living in the late fourth century in an area near the Black Sea, the Huns 'were like no people ever seen before by Romans or their neighbours'.[128] Everything – lifestyle, appearance, above all style of warfare – was terrible to the Old World, and more than anything else the Huns' arrival changed the way the Romans and barbarians thought about themselves. These steppe nomads had to keep moving to survive. Aided by their own invention, the double-reflex bow, which allowed them to fire deadly volleys of arrows while still on horseback, they attracted supporters from many tribes, growing from a band to an army and existing on pillage. Save for the reign of Attila (444–453, the 'scourge of God' but whose name means 'Daddy' in Gothic, showing how ethnically diverse they were), the Huns were never a unified or centralised people, and they disintegrated after a few generations. But their intervention – barbarian within barbarian – enabled other tribes to take advantage of the empire the Huns had ravaged.

These people *were* more primitive than the Romans – they did not have sophisticated systems of law or politics, no great communal architecture, no educational system, so far as we can tell, no great literature that has survived. (The earliest law code, the Visigoths'

code of Euric, dates from *c.* 470–480.[129]) But the Germanic invaders were more flexible and less implacable than some accounts imply. One by one, during the sixth century, the tribes adapted to Christianity and this had a curious consequence. A division was established that would never be fully rectified in Europe, a national gap between Latin and Germanic peoples, a social gap between Latin-versed clergymen and dialect-speaking peasants.[130] 'Because Franks and Anglo-Saxons were learning these [Christian] traditions as pupils instead of applying them as masters, they were haunted by feelings of inferiority. Frankish and Germanic writers had to suffer being mocked as "barbarians" by Latins throughout the entire Middle Ages.'[131] Einhard, Charlemagne's biographer, wrote in 830 that he himself was regarded as 'little more than a barbarian, ill-practised in the Roman tongue'. This division between Latin and Germanic peoples would never be entirely removed from the European mind-set, nor the associated notion that the former were somehow more 'cultured' than the latter. But the conversion of the Franks and Saxons to Christianity produced the final twist in this particular story. From then on, it was pagans and heretics who were the barbarians. This set the stage for the most vicious battle of ideas in the High Middle Ages. As we shall see, paganism, though 'defeated', was by no means destroyed.

# The Near-Death of the Book,
# the Birth of Christian Art

Augustus, a practical man, had limited the extent of the Roman empire, on one side to the three great rivers, the Rhine, the Danube and the Euphrates, and on the other, to the desert belt of Africa and Arabia. He felt that these were natural borders which both made the further expansion of empire difficult and at the same time helped to repel enemies. Despite this, by the third century a credible threat had developed along several sections of the imperial frontier as a number of tribes hitherto settled outside the borders decided to go on to the offensive.[1] By this time, in particular, the region beyond the Rhine was no longer split into the many small tribes as described by Tacitus in his famous book. As was explained in the last chapter, these numerous clans had coalesced into larger groups and from the third century onwards, warfare on both the Persian and Germanic fronts was continuous, with only rare breaks. A combination of geography and diplomacy ensured that the great bulk of the German attacks was directed against the western empire, while the eastern half remained less affected, especially after the Sassanid attacks were contained from the 240s on (there was, for instance, no fall in the value of money there). Constantinople – a fortress protected by the sea – remained impregnable. This would have incalculable consequences for the preservation of ideas in the dark ages.[2]

The imperial government moved at first to Milan, then to Ravenna (which was difficult to attack from the land and was open to the sea).[3] The Visigoths blockaded Rome itself three times and, on the third occasion, in 410, captured the city, ransacked it, carrying off as hostage the emperor's sister, Galla Placida. In the early fifth century, Gaiseric, king of the Vandals and Alans, landed in Africa, from Spain, where they had been entrenched, and the first sovereign Germanic state to exist on Roman soil was formed.[4] In the days of Augustus and Trajan, when the city was home to twenty-nine public libraries, Rome had a population of more than a million. During these bloody years, its population dropped to a low of 30,000 and it had 'neither the funds to support libraries, nor yet the people to use them'.[5] The disturbance to the existing order was, as Joseph Vogt puts it, 'undoubtedly tremendous'.[6] At the turn of the fourth century, brigandage was so bad that in some areas people were allowed to carry arms in self-defence, the worst-hit provinces being those affected by German invasions.[7] By now many public buildings were in ruins, citizens were forbidden to change occupations, permits were required for an absence from town (people were always trying to leave, to find work on the land). After the late fifth century, there is

no record of the Senate. Taxation was increased, and increased again. A new Latin word, *Romania*, was coined, to describe the civilised life of the Roman world, as distinct from savage barbarism.[8]

As ever, though, we do well not to exaggerate. Many of the Gallo-Roman aristocracy managed to keep their estates intact, even during the period of Germanic occupation. Fifth-century authors still managed to compile works which praised Rome and even listed her achievements. Again according to Joseph Vogt, the workshops of the potters and weavers 'appear to have suffered little interference from the storm'. The Visigothic king Theodoric I and his sons were initiated into Latin literature and Roman law by Avitus, and were grateful.[9] There are signs of dual law operating in the former empire: Roman law for the Romans, Burgundian law (with lighter penalties) for the Burgundians.[10] It was messy and, at times no doubt, unsatisfactory. But it was not complete chaos.

The picture which has emerged, therefore, is of one where the barbarians did as much damage as was necessary to instil their authority, while at the same time appreciating the superiority of the Roman civilisation, or at least large parts of it. We have to be careful, therefore, in attributing to the Franks, Vandals, Goths and others the blame for the loss of learning that undoubtedly seems to have occurred at this time. There were other reasons.

This brings us back to Christianity. As was mentioned above, in early antiquity religious toleration had been the rule rather than the exception, but that changed with the animosity with which the pagans and Christians regarded one another.[11] We should not overlook the change that had come about in men's attitudes with the arrival of Christianity as a state religion. There was an overwhelming desire to 'surrender to the new divine powers which bound men inwardly' and 'a need for' suprahuman revelation. As a result, the thinkers of the period were not much interested in (or were discouraged from) unravelling the secrets of the physical world: 'The supreme task of Christian scholarship was to apprehend and deepen the truths of revelation.'[12] Whereas paganism had imposed few restrictions on the intellectuals of Rome, Christianity actively rejected scientific inquiry. The scientific study of the heavens could be neglected, said Ambrose, bishop of Milan (374–397) at the time it was the capital of the western empire, 'for wherein does it assist our salvation?' The Romans had been more than comfortable with the notion, first aired in Greece, that the earth was a globe. In his *Natural History*, Pliny had written 'that human beings are distributed all around the earth, and stand with their feet pointing towards each other, and that the top of the sky is alike for them all and the earth trodden underfoot at the centre in the same way from any direction.' Three hundred years later, Lactantius challenged this. 'Is there anyone so senseless as to believe that there are men whose footsteps are higher than their heads? . . . that the crops and trees grow downwards? That the rains, and snow, and hail fall upwards to the earth?'[13] Lactantius' view became so much the accepted doctrine that, in 748, a Christian priest named Vergilius was convicted of heresy for believing in the Antipodes.

The whole structure of Christian thinking was at times inimical to pagan/classical traditions. Rhetoric provides one example. Traditionally, of course, rhetoric could not be separated from the individual who composed it. But in the Christian mind, it was God who spoke through his preachers. This is based on Paul, who stressed the power of the

spirit – it is the spirit rather than the individual who speaks, which ultimately means that philosophy and independent thinking in general is rejected as a means of finding truth.[14] Gregory of Nyssa was one of the so-called Cappadocian Fathers, great orators who were sympathetic to classical philosophy. Even he was moved to say: 'The human voice was fashioned for one reason alone – to be the threshold through which the sentiments of the heart, inspired by the Holy Spirit, might be translated clearly into the Word itself.' By the same token, the dialectical method – as epitomised by Aristotle, for example – was also outlawed: there can be no dialogue with God. It was largely as a result of this that, save for two works of logic, Aristotle vanished from the western world, preserved only because his works were hoarded by Arab interpreters. Scholars in Alexandria and Constantinople continued to read Aristotle and Plato but, as was mentioned above, saw their role as custodial rather than to add new ideas. In 529, as we have seen, Justinian closed the Platonic Academy in Athens on the grounds that philosophical speculation had become an aid to heretics and an 'inflamer' of disputes among Christians. Many scholars headed east, first to Edessa, a Mesopotamian city housing several famous schools, then across the border with Persia to Nisibis, where the university was considered the best in Asia. This, says Richard Rubenstein, is how the Arabs inherited Aristotle and the treasures of Greek science. The Nestorians, who were famous as linguists, translated much Greek science and medicine into Syriac, then the international language spoken in Syria and Mesopotamia.[15]

Medicine provides other examples of the Christian closing of the western mind. The Greeks had not been especially successful in finding cures for illnesses but they *had* introduced the method of observation of symptoms, and the idea that illness was a natural process. In the second century AD, in Rome, the great physician Galen had argued that a supreme god had created the body 'with a purpose to which all its parts tended'.[16] This fitted Christian thinking so completely that, around 500, Galen's writings were collected into sixteen volumes and served as canonical medical texts for a thousand years. It marked the abandonment of the scientific approach in favour of magic and miracles. Sacred springs and shrines were now invoked as cures, the plague was understood as 'sent by God' as a punishment, with medieval paintings in Italy still showing pestilence as being delivered from God through arrows, as had originally been the case with Apollo, more than a thousand years before in Homer's world. Hippocrates had described epilepsy as a natural illness; as late as the fourteenth century, John of Gaddesden, an English physician, recommended that the malady could be cured by the reading of the Gospel over the epileptic while simultaneously placing on him the hair of a white dog. This approach was summed up most succinctly by John Chrysostom, a keen disciple of Paul. 'Restrain our own reasoning, and empty our mind of secular learning, in order to provide a mind swept clear for the reception of divine words.'[17] It was not just indifference. Philastrius of Brescia implied that the search for empirical knowledge was itself heresy. 'There is a certain heresy concerning earthquakes that they come not from God's command but, it is thought, from the very nature of the elements . . . Paying no attention to God's power, they [the heretics] presume to attribute the motions of force to the elements of nature . . . like certain foolish philosophers who, ascribing this to nature, know not the power of God.'[18] Reports of miracles in the sixth century were much greater than in the third and the very idea of causation as a natural process was downplayed.

In some Christian quarters even books – texts – were a source of deep suspicion: they might be full of error and they might record traffic with the occult. In the account of the pagan historian Ammianus Marcellinus, detailing the actions of Valens, the eastern emperor in the fourth century, who conducted a persecution of pagan practices, he said that 'throughout the Oriental provinces, owners of books, through fear of a like fate, burned their entire libraries, so great was the terror that had seized upon all'.[19] His editor remarked 'Valens greatly diminished our knowledge of the ancient writers, in particular of the philosophers.' Several observers noted that books ceased to be readily available and that learning became an increasingly ecclesiastical preserve.[20] In Alexandria it was noted that 'philosophy and culture are now at a point of a most horrible desolation'. Edward Gibbon reported a story that Bishop Theophilus of the city allowed the library to be pillaged, 'and nearly twenty years afterwards, the appearance of the empty shelves excited the regret and indignation of every spectator whose mind was not totally darkened by religious prejudice'. Basil of Caesarea lamented the atrophy of debate in his home city. 'Now we have no more meetings, no more debates, no more gatherings of wise men in the agora, nothing more of all that made our city famous.'[21] Charles Freeman tells us that when Isidore of Seville began compiling his collection of *Etymologies*, a summary of sacred and secular knowledge, at the end of the sixth century, and although he had his own library, he was already finding it difficult to locate the texts of classical authors that he lacked. 'The authors stood,' he said, 'like blue hills on the far horizon and now it was hard to place them even chronologically.'

Rome was virtually devoid of books by the middle of the fourth century, according to Luciano Canfora. The twenty-nine famous lending libraries had been closed, for one reason or another. In Alexandria, in 391, the Christian archbishop had destroyed the great library of the temple of Serapis, second only to the Mouseion in size and prestige. The Mouseion itself survived for the time being, largely because it appears to have become a repository of sacred Christian texts, though they were ill-copied parchments 'crawling with errors' because Greek was more and more a foreign language. But when the Arabs conquered Alexandria, just before Christmas in 640, the chief librarian of the Mouseion pleaded with the conqueror, Amr ibn-al-As, to spare the library. He passed the request back to the caliph, who remarked 'If their content is in accordance with the book of Allah, we may do without them, for in that case the book of Allah more than suffices. If, on the other hand, they contain matter not in accordance with the book of Allah, there can be no need to preserve them. Proceed, then, and destroy them.'[22] The books were thus distributed around the public baths as fuel for the stoves. The burning scrolls heated the bath waters of Alexandria for six months. Only the works of Aristotle escaped the flames.

The papacy had a library, or at least an archive to begin with, which appears to have survived intact (in general, and for obvious reasons, Christian libraries survived better than non-Christian ones). It was established by Damasus I (366–384), who installed it in the church of San Lorenzo which he had built himself at the family home, on a site close to what is now the Cancelleria. Later it was moved to the Lateran Palace, where the papal offices were. Over time, bibles and manuals and various Christian writings were added, many of them heretical. In one room of the Lateran Palace, dated to the seventh century,

a mural has been found, showing St Augustine seated before a book, with a scroll in one hand. This room, it is presumed, was the original papal library.[23]

Another ancient library was that at Seville, in Spain, which belonged to Isidore, bishop there from 600 to 636. This library certainly included many secular works as well as Christian texts, even though the bishop thought the secular works unfit reading for his monks.[24] Isidore's books have disappeared but we know what was in his library because he composed a series of verses to go over the doors and bookshelves. The first verse begins plainly enough: 'Here are masses of books, both sacred and secular.' From the other verses we know that, among the Christian authors, he possessed Origen, Eusebius, Chrysostom, Ambrose, Augustine and Jerome, while among secular authors there were Paulus (poetry), Gaius (law), Hippocrates and Galen (both medicine).

However, one by one, the schools of classical antiquity closed (Justinian, remember, had shut the philosophical school in Athens in 529), so that by the middle of the sixth century only Constantinople and Alexandria remained. This was accompanied by a narrowing in the range of literature that was read. 'After the third century it becomes more and more uncommon to find any educated man showing knowledge of texts that have not come down to the modern world.'[25] Modern scholars believe this reflects a state of affairs whereby a prominent schoolmaster (Eugenius is a candidate) selected a syllabus that was so successful that all other schools copied it. 'With the general decline of culture and impoverishment of the empire no texts outside this range were read and copied often enough to be guaranteed survival.'[26] For example, seven plays by Aeschylus were selected and seven by Sophocles – and that is all we know.

By the end of the sixth century the decline of learning and culture had become serious. The only vital educational institutions in the main part of the empire were the imperial university at Constantinople, founded around 425, and a clerical academy under the direction of the patriarchate. The school at Alexandria was by now isolated. And, before things could get better, there was the notorious controversy over icon-worship (see below, this chapter). For three centuries – from the middle of the sixth century to the middle of the ninth (the true dark ages) – there is no record of the study of the classics and hardly any education. Very few manuscripts of any kind remain from this period.

The few schools of the time were located at Athens, Ephesus, Smyrna, Pergamum, Alexandria, Gaza and Beirut. The latter, and Antioch, were devastated in earthquakes in the sixth century, and Antioch was also sacked by the Persians in 540. We cannot say, therefore, that the loss of learning, which was pronounced by the sixth century, was due to any one overriding reason: natural causes, the barbarian invasions, the rise of Christianity, the rise of the Arabs – all played their part. But by the end of the sixth century there were fewer and fewer signs of a literary life. There was, for example, a decline – almost a disappearance – in the knowledge of Greek. Even if Constantinople had never been a completely bilingual city, both Latin and Greek had always been well understood (Greek was, for example, Justinian's first language). The most famous example of this state of affairs is a letter by Pope Gregory the Great in 597 which says that in Constantinople 'it is not possible to obtain a satisfactory translation'.[27] And though the age of Justinian (527– 565) was brilliant in many respects, there are grounds for thinking that book production had already begun to decline during his reign. Certainly, the withdrawal of the Greek and

Latin worlds from each other was a crucial development. By the sixth century virtually no western scholar was able to understand Greek.

But this was a near-death experience for the book, and for learning, not, as it turned out, terminal decline. One reason for this is that a concerted effort was made to preserve the classics, in Byzantium. In an address to the Emperor Constantius on 1 January 357, the Byzantine scholar Themistius (*c.* 317 – *c.* 388) outlined a plan 'to guarantee the survival of ancient literature'.[28] He was a man of such insight as to see that a scriptorium 'for the production of new copies of the classics', the survival of which was alleged to be threatened by neglect, would ensure that Constantinople would become a centre of literary culture. The authors most in need of this treatment were specified as Plato, Aristotle, Demosthenes, Isocrates and Thucydides. 'But,' continues Themistius, 'the successors of Homer and Hesiod, and philosophers such as Chrysippus, Zeno and Cleanthes, together with a whole range of other authors, are not in common circulation, and their texts will now be saved from oblivion.'[29] In 372 an order was issued to the city prefect, Clearchus, to appoint four scribes skilled in Greek and three in Latin 'to undertake the transcription and repair of books'.[30] Fifteen years had passed since Themistius had had the idea, but at last it was done. He had less influence than he had hoped.

Another reason for the eventual survival of classical ideas is that there was a set of writers who have become known as the 'Latin transmitters', men – encyclopaedists, mainly – who kept alive classical thought (or at least the texts of classical thought) and provided a crucial bridge between the fourth century and the Carolingian renaissance four hundred years later. Marcia Colish, among others, has described their work.

The first of these transmitters was Martianus Capella, a contemporary of Augustine and a fellow north African. Capella was probably a Christian but his religion is referred to nowhere in his writings. His main work bears a strange title: *The Marriage of Philology and Mercury.* The structure and text of the book are no less bizarre, but in a very readable way, which make it clear that he at least thought that the seven liberal arts were under threat at that time and needed preservation.[31] There were seven liberal arts – and not nine – partly because of the biblical text, in the Book of Wisdom: 'Wisdom hath builded herself an house, she hath hewn out seven pillars.' But medicine and law were omitted by Martianus (and hence from the arts faculties of medieval universities, and some modern liberal arts colleges) because they were not 'liberal', but concerned with 'earthly' things.[32] The action of *The Marriage* takes place on Mount Olympus and, to begin with, Mercury is the centre of attention. Having spent so much of his time acting as messenger for the gods, in their quarrels and in particular their love affairs, he has decided to seek a wife himself. He is introduced to Philology, the language arts, and the introduction is a great success. The other gods agree to confer divinity on Philology and after the couple have exchanged vows, Apollo announces his wedding gift – seven servants. 'These servants turn out to be none other than the seven liberal arts.' Each art now gives an account of herself, all being suitably attired. Grammar, for instance, is an old woman with grey hair, carrying a knife and a file, 'with which she excises barbarisms and smoothes the rough edges off awkward phrases'. Rhetoric is taller, much younger, far more beautiful, 'whose colourful dress displays the flowers of rhetoric ...'.[33] The arguments brought to bear by Martianus

rely on Greeks – Aristotle, Euclid, Ptolemy. Bizarre it may have been, but *The Marriage of Philology and Mercury* was very popular and helped keep alive at least the basics of Greek thought.

Boethius, the second of the transmitters, wrote his most famous work *Consolation of Philosophy* while he was in jail, awaiting execution. He had no reference library on which to fall back, just what was already inside his head. Before that, however, he had set himself the task of translating the entire works of Plato and Aristotle into Latin. His premature death meant that he did not complete his task, but his translation of Aristotle's logic was the only text of the great philosopher available in the west in the early medieval years, ensuring that some Greek philosophy was preserved. At the same time, Boethius' conviction that his translations were necessary reinforces the view that he was persuaded of the importance of Plato and Aristotle and that there was little instruction in these authors available at the time.

The book he wrote in jail, the *Consolation*, is designed as an elegant dialogue between Boethius himself and Lady Philosophy, and its subject – why a just man suffers – made it an immediate success. Lady Philosophy is an extraordinary figure: her head touches the clouds and the hem of her Greek-style dress is decorated with the words 'practical' and 'theoretical'. She begins by chasing away all the other muses in which Boethius had sought earlier consolation.

Cassiodorus was a contemporary of Boethius and, like him, rose to a high position in the government of the Ostrogothic king, Theodoric. And, like Boethius, Cassiodorus was concerned about the decline of Greek studies in the west. (Unlike Boethius, however, he lived to a ripe old age.[34]) His first idea was to found a Christian university in Rome. He approached the pope but, given the political unrest of the era, he was turned down. Cassiodorus next turned to the growing monastic movement. Using his own money, he founded (at Vivarium, in southern Italy) the first monastery that became a centre of scholarship, a practice followed by many other monasteries as the centuries passed. He collected manuscripts, of both Christian and secular works, and served as head of the school for the rest of his life. Cassiodorus shared the basic assumptions of the time in which he lived, namely that the main aim of education was the study of theology, church history, and biblical exegesis, but he also believed that, first, a proper grounding in the liberal arts was needed. He therefore prepared a kind of 'syllabus of universal knowledge' – this was his major work as a transmitter, the *Institutes Concerning Divine and Human Readings*, and appended to it a bibliography of classical writings that, he said, would aid monks' understanding.[35] Besides identifying titles that should be read, Cassiodorus outlined the history of each of the liberal arts, even including authors whose views were by then dated, but who had been important in their time. This set of ideas became the basis of the curriculum in many monastic schools of the Middle Ages and in order to be able to read the classical texts more copies of these books were needed. Therefore, it was at Cassiodorus' instigation that monasteries began to copy selected classical works, another reason why they became centres of scholarship. Cassiodorus also produced a book on spelling, which has generally been taken as proof that, in addition to the decline in Greek studies, there was at the same time a fall in Latin literacy as well.

We have already encountered Isidore, the early seventh-century bishop of Seville. His

most important work in the transmission of ideas was the *Etymologies*, the title of which reflects his view, not uncommon at a time fascinated by symbolism and allegory, that the road to knowledge led through words and their origins. He made many mistakes (just because the origins of words are similar does not mean that the objects or ideas they represent are similarly related), but he had an extraordinary range – biology, botany, philology, astronomy, law, monsters, stones and metals, war, games, shipbuilding and architecture, in addition to Christian subjects. The gusto and relish which he brought to his task reveals, says Marcia Colish, his view 'that if he did not save culture, armed with his own extensive knowledge and the weapons of scissors and paste, no one else would'. Despite its shortcoming, in the early Middle Ages *Etymologies* became a standard reference work. (As Charles Freeman has pointed out, 'reference' is the key word. 'There is little evidence that until the twelfth or thirteenth centuries these texts had any inspirational role.'[36])

The historian Norman Cantor argues that the transmitters were neither original thinkers, nor yet masters of language, but schoolteachers and textbook writers. Nonetheless, given the dangers of the time, and the attitude of many Christians to classical and pagan thought, perhaps it is just as well that the transmitters had the values they did. Thanks to them, the classical tradition (or a proportion of classical texts) was kept alive.

Despite the fact that the true dark ages, from the point of view of ideas, extend from the middle of the sixth century to the middle of the ninth, two important changes in the history of the book nonetheless took place. One was the arrival from the Orient of a new writing material – paper. This became an alternative to papyrus about the end of the eighth century, when the Arabs are believed to have learned the secret of the technique from some Chinese prisoners of war taken at the battle of Tales, in 751.[37] Certain late papyri from Egypt show scraps of the new material but the oldest Greek book written entirely on paper is generally agreed to be the famous codex in the Vatican Library (Vat. Gr. 2200) usually dated to *c.* 800.[38] Papyrus was still being used in western Europe in the eleventh century but even so the use of paper caught on quite quickly, possibly because the Arabs controlled the supply of papyrus leaving Egypt and because what was allowed out was of inferior quality. To begin with, the Byzantines imported paper from the Arabs, but by the thirteenth century there was a flourishing paper-making industry in Italy.

At much the same time, there was a second innovation which also reduced the amount of paper/papyrus needed for making books. This was a major change in the type of writing which was in common use. Traditionally, the uncial script, as it was known, consisting entirely of what we would call capital letters, had been fairly large. Though it was technically feasible for scribes to write uncial script in a small hand, in practice this does not seem to have happened very much, making it particularly expensive when used with parchment which, as N. G. Wilson reminds us, could only be produced from the slaughter of animals.[39] To save on costs, parchment was often used more than once. A parchment with more than one text on it is known as a palimpsest, from the Greek *palin psao*, 'I smooth over again'. Some authors, for example Sallust and certain writings of Cicero, are known only from the lower, half-rubbed-out scripts of palimpsests. Various experiments in what is now called the miniscule script were made around the turn of the ninth century but most were

difficult to read. However, the first precisely dated book written in a clear and accomplished cursive miniscule script is the famous gospel book named after the archimandrite Porphyri Uspenskij, who picked it up on one of his visits to the monasteries of the Levant.[40] It is dated to 835.

Besides the date of the new script being uncertain, the place of its invention is also unknown, though one plausible hypothesis is that it was developed at the Stoudios monastery in Constantinople (a leaf of the Uspenskij gospels records the obituaries of certain members of the community, some of whom are known to have been expert calligraphers). From 850 on, whenever a new copy of a literary text was needed, the chances were that it would be composed in the new script; and after 950 it invariably was (few books in capitals are now extant).[41] The new script was extremely significant for the preservation of ancient texts – a greater number of words could be fitted on to a page, meaning costs were reduced. In addition, the ligatures that were developed between letters (beginning with e, f, r and t) meant that writing was quicker. Other improvements included accents and 'breathings', aids to the reader, the beginnings of what we call punctuation. These were not in regular use, nor were they standardised, but a beginning had been made.[42] At much the same time – i.e., at the end of the ninth century – the scribes began to mark word division, and guidance in the use of accents and punctuation was made a regular part of book production, at least at the Stoudios monastery. Abbreviations were common: p' (= *post*), ⊃ (= *con*), li° (= *libro*). The question mark (?) evolved at this time, though Bernhard Bischoff found ten different forms; 300 might be written iii$^c$ and new letters were invented: ⊙ and *Δ*, for example.

In parallel with this, around 860, Bardas – the assistant emperor – revived the imperial university in Constantinople, which had disappeared in the preceding centuries. The school he founded was directed by Leo the Philosopher, together with Theodore the Geometrician, Theodegius the Astronomer and Cometas, a literary scholar. We now know that some ancient manuscripts had only survived in single copies and, to an extent, the school founded by Bardas became the official repository of these unique objects.[43] These were old uncial scripts and their transliteration into the new miniscule was now undertaken by the scholars of the ninth century. As Reynolds and Wilson say, 'It is largely owing to their activity that Greek literature can still be read, for the text of almost all authors depends ultimately on one or more books written in miniscule script at this date or shortly after, from which all later copies are derived.'[44]

It is also thanks to scholars in ninth-century Byzantium that we are aware, not just of what has been saved, but also what has been lost. A number of scholars, notably Photius (*c.* 810–*c.* 893), recorded the books they had read, or at least were aware of, and these listings contain many works we know about only from these sources. For example, before going on a long and dangerous journey, in 855, possibly to exchange prisoners of war with the Arabs, Photius wrote to his brother Tarasius a summary of books that he had read over a long period of time. Some accounts were two lines long, many much longer, but his *Bibliotheca*, as it is called, contained 280 sections, called codices, each related to a text in his possession. In this book Photius comments on a wide selection of pagan and Christian works.

He was born into a well-off, well-educated and well-connected family that was icon-

ophile. During the persecution of iconophiles that took place in 832–833 (see below, this chapter), Photius' family was sent into exile, where both his parents died. When the iconophiles regained influence in Constantinople, in the 840s, he was able to return and he and his brother rose to high rank in the government. (Among those who promoted him was Bardas.) Thereafter Photius had a stormy career but still managed to write. It is unclear when the *Bibliotheca* was completed – dates range from 838 to 875. The work seems always to have been intended as a compendium of what Photius had read, as is shown by the title he himself gave to it: *Inventory and Enumeration of the Books That We Have Read, Of Which Our Beloved Brother Tarasius Requested a General Analysis.*[45] The *Bibliotheca* lists 280 books, all but one of which Photius claimed to have read, but he left out the books that a well-educated Byzantine (like his brother) would have been familiar with, such as Homer, Hesiod and the great Greek playwrights. Where the *Bibliotheca* is of interest, in this context, however, is for the titles he mentions that are now lost – forty-two works in all.

Among the lost works is a biography of Alexander, by one Amyntianus (a book dedicated to Marcus Aurelius); a *Collection of Wonders*, by Alexander of Myndus (this work, says Warren Treadgold, in his study of Photius, falls into the genre of 'paradoxography'); a work entitled *For Origen*, by an anonymous fourth-century writer; *Marvellous Animals*, by Damascius of Damascus (roughly 458–533); *On Difficult Words in Plato*, by Boëthus (first/second century); a book on medicine by Dionysius of Aegeae (first/third century); an anonymous life of Pythagoras from the third/second century BC; and *On St Paul*, by John Chrysostom. Besides the forty-two works totally lost, there are a further eighty-one works known only through the *Bibliotheca*. Which means that, of 280 titles, fully 123 (44 per cent) are now effectively missing. This is a heart-breaking statistic.

We have seen that, between the middle of the sixth century, and the middle of the ninth, little was accomplished in the realm of scholarship. That this period comprised the true dark ages is supported by the fate of the cities of Byzantium – cities being the centre of intellectual life, as well as of the theatres, the baths, the hippodrome and the craft workshops. Until the fifth century, the Byzantine empire was an aggregate of fine cities – one handbook listed more than nine hundred though, as Cyril Mango says, by the time of Justinian (527–565), that number would have almost doubled. Most of these were laid out in the Roman style, with regular streets, two main avenues, the *cardo* and the *decumanus*, meeting at right angles and terminating at the city gates (the cities were walled, against the threat of barbarian attack). The avenues were wide, and contained colonnades, where the shops were located. By our standards they were small: Nicaea, for example, was 1,500 metres from north to south and east to west. The average population of a provincial Byzantine city would have been between 5,000 and 20,000, with Antioch at 200,000 and Constantinople half as big again.[46]

As a result of barbarian attack, however, one city after another was brought low. From Syria to the Balkans, Pergamum, Scythopolis, Singidunum (Belgrade) and Serdica (Sofia) were all destroyed or the population vanished. Plague, earthquakes and other natural disasters added to the chronic violence, making a bad situation worse. The Arab geographer Ibn Khordadhbeh (*c.* 840) recorded that in his time there were only five cities in Asia

Minor: Ephesus, Nicaea, Amorium, Ancyra and Samala, to which could be added a handful of fortresses. There was a sharp decline in the number of bronze coins in circulation and at Stobi, in the Balkans, according to Cyril Mango, no coins have been found dating after the seventh century.[47]

Although Constantinople was the exception to this picture, it was not completely immune. Its population almost certainly peaked around the year 500, after which it was hit by plague and declined. This retreat was long-lasting, reaching a low point around 750. In 740 when the walls of the city were devastated by earthquake, the local population lacked the resources to rebuild them and after the plague of 747 the emperor sought to rebuild the population by deliberate immigration from the Aegean islands. Even so, a guidebook of 760 depicts the city as 'abandoned and ruined'.[48] It was only from the end of the eighth century that recovery was sustained.

Byzantine Christian art, important though it is in any history of ideas, is nonetheless very different from later ideas of art. From Giotto on, art in Europe at least was not only an account of changing forms but of art*ists*, identifiable individuals, who made innovations, who had their own views, who were influenced by others and in turn influenced those who came after. In Byzantium, on the other hand, artists were looked upon as craftsmen and little else. (Only one Byzantine painter is known by name, 'Theophanes the Greek', active in Russia in the late fourteenth and early fifteenth centuries.) The same applies in architecture: we know that Anthemius and Isidore built Justinian's Agia Sophia in Constantinople, but that is all. Because Byzantine art evolved so slowly it is virtually impossible to date. That does not detract from its importance, however, because it is the first fully-fledged Christian art, the earliest art to show how Christian ideas – iconography – found visual form.

In view of what happened later, it is relevant to begin by noting that Jesus never suggested that figural images offended him.[49] Nevertheless, for the early Christians visual art was much less important than scripture, and so they never developed a programme of symbols and images. When Diocletian persecuted the Christians in 303 their church at Cirta contained scriptures, chalices and bronze candlesticks but there was no mention of an altar. In fact, prior to the second century there is really nothing that can be called Christian art. Despite Jesus' neutral attitude, many early Christians, perhaps under the influence of Jews, had no place for visual art. Clement, bishop of Alexandria in the third century, told his charges that although Christians were forbidden to make idols, as the pagans did, they were allowed to make signs (such as a fish or a ship) to indicate ownership or as a signature. Clement also allowed other images – the dove, for instance, or the anchor. The dove was a symbol of the Christian in the world, after Matthew 10: 16: 'I send you forth as sheep in the midst of wolves: be ye therefore wise as serpents, and harmless as doves.'

Byzantine art 'is the art of the later Roman Empire adapted to the needs of the Church'.[50] The first real blossoming took place at the time of Constantine's conversion, when he ordered a spate of splendid churches to be built. Before the fourth century, there was no such thing as Christian architecture. The early Christians used any convenient structure, which they called the *domus ecclesiae*, house for the church (community). The first churches – still recognisable today around the eastern end of the Mediterranean – took on

a form likewise used by the pagans: the basilica, a rectangular hall, colonnaded, with an elevated *bema* at one end. *Basilica*, a Greek word meaning simply a large hall, was first used by Christians to apply to the seven churches of Rome established by Constantine.[51]

But the earliest catacombs in Rome, and the very early chapel at Dura-Europos, on the Euphrates, show that even before Constantine, Christians had evolved certain visual traditions, possibly based on an ancient illustrated version of the Septuagint. These were scenes from the Old Testament (the Fall of Man, the Sacrifice of Isaac, the Crossing of the Red Sea) though the story of Jonah was a special favourite, because he was swallowed by a fish for three days before being thrown up on to the shore. Christians saw echoes here of baptism and resurrection. In the earliest depictions of Jesus, he is young and beardless; the nimbus does not appear until the fourth century.[52] The earliest example of a New Testament cycle in a monumental context is in the church of Sant' Apollinare Nuovo at Ravenna, dating to around 500, and in an illustrated manuscript in the *Codex Rossanensis* (now in Paris) and the Syriac *Rabula Codex*, now in Florence. These date from slightly later but both underline the idea that an established iconography was in existence, in an 'authoritative form' by, roughly speaking, AD 500. Some of these codices were sumptuous – St Jerome refers to them contemptuously as 'purple codices', which may not have been meant to be read, simply for use in ritual.

The other feature which early Christian art absorbed from imperial Rome was the trappings of the court. As Lawrence Nees puts it, 'at least in iconographic terms it is tempting to speak of a "conversion of Christianity" to a wholesale embrace of Roman and specifically imperial conceptions'.[53] Settings became more theatrical, the imperial purple was used more and more for holy figures, and important personages were rendered bigger than anyone else, often bigger than life-size. In the mausoleum of Galla Placida at Ravenna Jesus is no longer dressed as a shepherd: 'he is mantled in a purple tunic with golden stripes' (as Jesus Pantocrator, 'the ruler of all'). In other images at Ravenna he is shown receiving acclaim from the apostles as an emperor receives tribute from his subjects.[54] 'From the early fourth century on, the enthroned image of the Christian God suddenly becomes a central element of Christian iconography', and this idea of introducing opulence generally into Christian art, into the Christian *ideal*, was nothing less than revolutionary, given the faith's earlier appeal to the poor and outcast.[55] Slightly later than the introduction of the majesty of empire into Christian art, was the expansion of narrative. This might have occurred in the fourth century after the first basilicas began to be erected, providing more space on their walls, but in fact the breakthrough didn't occur until the fifth century, possibly inspired by the cycle of poems produced by Prudentius in the early 400s. Now the narratives were strung together chronologically as they occurred in the scriptures, rather than thematically. It was in these narratives that much Christian iconography was worked out, based on a close reading of the new (late fourth-/early fifth-century) Latin Bible (Jerome's Vulgate).[56]

At the end of the sixth century an important change took place across the Christian world in regard to beliefs about images. Instead of regarding images as representations of people in the great Christian passion, more and more worshippers came to regard the images themselves as holy. This 'cult of images' was most intense in the eastern half of the Christian world, in effect the Byzantine empire, and may have had something to do with

its relative proximity to the Holy Land, Palestine. Pilgrims to the Holy Land often returned with relics or souvenirs of one kind or another, such as stones from special sites that were regarded as in some way quasidivine (Justinian had sent a team of craftsmen to Jerusalem). This practice gradually spread throughout the West and even Rome itself was not immune: the Sancta Sanctorum in the Lateran Palace houses an eighth-century image of Jesus that, in the Middle Age at least, was itself regarded as holy, and was brought out at times of crisis.

The change of attitude towards images is inferred from two specific developments. One, there was an increase in their portability, suggesting they were used at home and when travelling, not just on tombs or in churches. Two, there was a tendency to reduce or remove action from the image, 'which conveys the holy figure as if divine, perhaps awaiting the holder's invocation to come alive.'[57] (It is this 'frozen' quality that has lent itself to our use of the word 'iconic'.) Despite this, and despite the fact that the scriptures give absolutely no information about the appearance of Jesus or the Apostles, or the Virgin Mary, by the sixth century Christian authors were providing descriptions in accordance with what they believed was tradition (often derived from visions). In one account, for example, St Peter was described as 'of medium height, with a receding hairline, white skin, pale complexion, eyes as dark as wine, a thick beard, big nose, eyebrows that meet ...' Christ is shown as bearded, long-haired, haloed, dressed in white and gold, holding a scroll with one hand, with his arm raised in authority.[58] The physical features were invariably assumed to be related to spiritual qualities. Some of the images were regarded as of miraculous origin and described as *acheiropoietai*, meaning 'not made by human hands'.[59]

To us, today, icons are highly stylised but that is not how they were experienced at the time. To the Byzantines, an icon was a real likeness which fully depicted the actual features of the holy figure shown. This is why the images were not allowed to change – they were a true record of someone sacred. In 692, at the Quinisext Council, a new approach to the representation of the human form had been sanctioned. Before that date, Christ had been shown as a lamb but this was now dispensed with. Henceforth, he could be shown as a human likeness. 'The drama of the church thus came down off the walls and on to the iconostasis, which separated the truly holy part of the church from the rest.' As Cyril Mango has written, icons were the visual equivalents of hagiographies: 'The faithful could gaze on their heroes (one of whom would surely fit with anyone's aspirations, or address their fears) as they worshipped Christ.' Hagiography emerged as a distinctive genre at this time.[60]

This was too much for some people and their anger was further kindled by the fact that Jesus' image was allowed on to coins by Justinian II. In the middle of the eighth century a sharp reaction set in against the worship of 'holy images' and this led to the so-called iconoclast controversy, which lasted from 754 to 843. Several reasons lay behind this battle of ideas, which had significant consequences for the concept of papal authority as well as for the expression of Christian art. In the first place lay the feeling that the making of images of Christ was blasphemous, that the divine nature of God, its very immateriality, could not by definition be rendered in any intelligible way and that to do so implied that Jesus was not divine, an attitude that accorded broadly with the views of the notorious Arian heretical sect (see above, Chapter 8). Second was the view that the depiction of

Christ and of saints was mere idolatry and marked a return to pagan-like practices. And third, the iconoclasts argued that the cult of images was essentially a new phenomenon that violated the earliest and purest phases of Christianity, when there had been no interest in images (which is why the scriptures had no interest in the appearance of Jesus or the apostles).[61]

These arguments lay behind the church Council of Hieria, in 754, held under the auspices of the emperor Constantine V, which officially condemned the veneration of images and sought their destruction. As ever, there was more to it than that. Two further reasons lay behind the actions of the iconoclastic emperors in the eighth and ninth centuries. One is that the men who came to power in Byzantium in those years were from the east and so were much more influenced by the traditions of the Middle East, in particular the Jews and the Arab Muslims, both of whom prohibited images in their places of worship. Alternatively, the iconoclast controversy may be seen as an attempt by the Byzantine emperors to extend their power. On this reading, the emperors found an obstacle to their aims in the activities in particular of Greek monks, who had become hugely popular via a series of allegedly miracle-working icons – which moved, or bled – and were kept in monasteries.[62]

Because of this, because of the strongly-held views of the pope of the time, Gregory II, a follower of Gregory the Great, who believed that images in art were vital as a means of education and religious instruction for the poor and illiterate, the iconoclast controversy turned into a tussle over papal authority. Gregory II sent a bellicose letter to Constantinople, accusing the emperor of interfering in doctrinal matters that were not his concern and (somewhat optimistically) threatening force if he should attempt to do so again. From this moment on, the papacy turned to the western kings, in the first place Pippin, leader of the Franks, for protection. The emperor replied by transferring ecclesiastical jurisdiction of south Italy and Dalmatia from Rome to Constantinople, and the split between the Roman church and what we today call the Greek Orthodox was begun.[63]

During the most bitter stages of the iconoclast campaign many images were destroyed, portable icons were burned, and murals and mosaics were at the least whitewashed over, or scraped off completely. Illuminated manuscripts were cut or otherwise mutilated (when they weren't incinerated), and liturgical plate was melted down. But this too was a near-death rather than a holocaust. The damage was worse in Constantinople itself and in Asia Minor than in other places – in other words, as Cyril Mango says, 'where the power was'. The iconoclasts certainly succeeded in reducing the quantity of Christian art, but they did not fulfil their aim to eradicate it entirely. There is some evidence that, as a result, mosaic techniques declined, as did the grasp of the human form among painters.[64]

In the churches, instead of human figures, the iconoclasts preferred what they termed 'neutral' motifs – animals, birds, trees, ivy and so on. The iconodules (the defenders of sacred images) replied that their opponents were turning God's house into a fruit shop.[65] Many – perhaps most – writings of the iconoclasts were themselves destroyed, unfortunately, whereas those of their opponents (St John Damascene, Germanus, Nicephorus) show us history as written by the winners. In the main their arguments explore the scriptural and patristic authority for human likeness, the relation between an image and,

say, the saint it depicted and, in particular, what authority there was for representing Christ – his dual nature, both God and man – in an image.

Eventually, after nearly two centuries of terrible conflict (with artists being tortured, having their noses slit or tongues cut out, and/or imprisoned), it was agreed that Christians could depict figures who had actually appeared on earth – that is to say Christ himself, the apostles and saints, and even some angels who had 'manifested' themselves in human form on specific occasions (for example, the Annunciation). But no attempt should be made to represent God the Father or the Trinity. A final important refinement was that any likeness must be 'identical as to person' – they must be a true rendering, as shown for example, in a mirror; the artist was not free to use his imagination. (One argument for rendering Jesus accurately was so that the faithful could recognise him on Judgement Day.) From this, it followed that traditional images could never be varied, nothing could be added or subtracted, rather in the way reasoned debate and innovation were discouraged elsewhere. By analogy, the same approach was applied to architecture and church decoration. Embellishment remained simple, with what the Byzantines called 'outside knowledge' being excluded. This meant there were no allegories, no liberal arts, no labours of the months. All that mattered, all that was allowed, was the central Christian drama – the birth, mission, Crucifixion and Resurrection of Jesus. (The Old Testament prophets were allowed, since they had announced the Incarnation.)

It was not only the faces of the Apostles that remained set. Scale and perspective continued to be ignored. The actual size of any one figure in a Byzantine painting is derived from its importance in the story rather than its position in space. This is why Mary, for example, is always bigger than Joseph, and it helps explain why saints may be as big as or bigger than the mountains in the background. Colour was not treated so as to give an impression of distance and figures throw no shadows that might interrupt the serene harmony of the composition. What mattered instead was that all elements of the painting should be bathed equally in celestial light. But, because no change was allowed in iconography, the anonymous artists of Byzantium directed their creativity into an ever more flamboyant and ostentatious use of colour. 'Byzantine art was far richer in its palette than anything that had gone before, giving rise to pictures which glowed with spirituality, where the gold leaf and other expensive colours sparkled like jewels, real examples of which, in some cases, were encrusted into the images.'[66]

To fully appreciate the first Christian art today we need to make an imaginative leap. Inevitably seen by smoky candlelight, its flickering, iridescent golds and purples and shiny jewels provided magical, mysterious, unchanging majesty and splendour in an uncertain and hostile world. Byzantine basilicas were richly coloured theatres where the point of the drama was that it never changed. 'That the Byzantines regarded these images as true likenesses gave their basilicas an intense, sacred aura that we can only guess at today.'[67] These hard-won ideas adopted at the end of the iconoclast controversy, in 843, would remain unaltered for centuries. Not until the great age of cathedral building would change be allowed.

Few would argue with the proposition that Christian art is one of the leading glories of human achievement. All the more remarkable, therefore, that it was sparked at a time

when other areas of intellectual activity were in decline. The very forces that produced Ravenna, San Lorenzo in Milan, or the monastery of St Catherine in Mount Sinai, had a dark side, to put alongside the light and colour with which they illuminated the world. The iconoclast controversy reminds us that cruelty and destruction and stupidity are as much the legacy of religious prejudice as are the finer things. That certain works of Cicero should survive only in one copy, and that the under-layer of a palimpsest, emphasises how fragile civilisation is.

# 12

# Falsafah *and* al-Jabr *in*
# *Baghdad and Toledo*

'Wisdom,' according to an ancient Egyptian proverb, 'has alighted on three things: the brain of the Franks, the hands of the Chinese, and the tongue of the Arabs.' Together with archery and horsemanship, eloquence completed the three basic attributes of 'the perfect man' in the Arabia of the Bedouins.[1]

These Bedouins, the indigenous people of the Arabian peninsula, were hardly civilised. The word Arab, or Ereb in the Old Testament, means nomad, a way of life which, as we have seen, prevents the collection of many belongings and obviates the need for any kind of public architecture where art can flourish. It was the camel which made the deserts habitable but this animal wasn't domesticated until around 1100 BC, so the Bedouins are unlikely to be much older. Being permanently on the move limits the size of tribes, to about six hundred maximum, and in the peninsula *ghazw*, or razzia in English, a variety of brigandage 'was virtually a national institution'.[2] In the words of one poet, 'Our business is to make raids on the enemy, on our neighbour and on our own brother, in case we find none to raid but a brother.'[3]

This did not make for a settled civilisation but, as that remark implies, the one cultural area where the early Arabs distinguished themselves was in poetry. Even today the rhythm and rhyme – the very music – of words produces in Arabs what they call 'lawful magic' (*sihr halal*). 'The beauty of a man,' says another proverb, 'lies in the eloquence of his tongue.'[4] The oldest written poetry dates from the sixth century in the form of the *qasidah*, or ode. But by then it must already have existed as an oral tradition for many generations because there was in place a set of fixed conventions. In form the ode could be up to a hundred lines long and might have a single rhyme threading through the entire work. There was a stereotyped beginning, in which the poet would invariably give an evocative description of an exotic destination he had visited. There was a small number of favourite themes, including a long camel journey, an equally narrow mix of metaphors, allusions and sayings, and the poet would conclude by reflecting 'on the limits of humanity in the face of an all-powerful world'. The odes were essentially narrative works rather than dramas or essays and what counted, for Arabs, was their delivery – it has even been argued that the steady rhythms of the *qasidah* are intended to echo the swaying of the camel as it moves across the desert. True or not, taken together these poems comprised the *diwan* of the Arabs, the 'register'

of their collective experience.[5] Poets and poetry had high prestige in the ancient Arab world.

The most famous ancient odes were the so-called 'Seven Mu'allaqat', or 'suspended' poems. These poems are still revered throughout the Arab world because, according to legend, they were awarded the annual prize at the poetry competition at the brilliant fair of Ukaz. This was a market town, near Mecca, which held an annual fair during the season when razzia was forbidden. Part of the fair included a literary congress where poets from all over the Arab world gathered to deliver their verses in a public contest. Following their victory at Ukaz, the Seven Mu'allaqat were written down in golden letters on linen sheets, and then suspended from the walls of the Ka'bah, the sacred stone at Mecca. They have been translated into English as *The Seven Golden Odes*.[6]

In keeping with their nomadic lifestyle, the Bedouins were not notably religious. Their early deities consisted of springs (oases) and rocks. There was a red stone deity in Ghaiman, a white stone at al-Abalat, a black stone at Najran and, the most famous, a cube-shaped meteorite at Mecca. This was the Ka'bah.[7] Since they were a pastoral people, the Bedouin also worshipped several lunar deities but there was, in addition, Hubal, a rare idol in human form, which some people think was imported from Babylon. However, the main god at Mecca was *al-ilah*, *allah*, the god. This name at least, written as *hlh*, was very old, going back to the fifth century BC, and appears to have originated in Syria. The name Mecca comes from *Makuraba*, meaning sanctuary, and implies that it was a religious centre from the earliest times. Certainly, Ptolemy assumed as much when he mentioned it in his *Geography*, written around AD 150–160.

Muslims now refer to this period, the era before Islam, as the *Jahiliyya*, 'the time of ignorance', when there was no attempt to bring together all the disparate myths and legends scattered across Arabia. And it was, perhaps, this very unco-ordinated nature of their early beliefs that helped give Islam, when it did appear, such an immediate appeal. According to tradition, Muhammad was born around AD 570, in Mecca, into a family who were part of the tribe of Quraysh. Mecca was itself in the middle of change at the time. In theory it formed a link in the trade routes between Rome and the East (the great caravan routes ended at the port of Yemen). But in practice, for the Romans 'Province Arabia' was the land of the Nabateans, who lived further north, with their capital at Petra (now in Jordan). So, like Syria, Arabia was a border province with an uncertain status. Traders were as likely to travel east via the Silk Route through central Asia, meaning prosperity in the peninsula was far from assured. On top of this there was repeated catastrophe when, three times between 450 and 570, the great dam at Ma'rib burst, destroying vast tracts of fertile land. Arab legends tell of serious economic decline in the sixth century.[8]

One other factor is important in understanding the emergence of Islam: there was by then a ring of monotheism encircling Arabia. In addition to developments in the north, there had long been a community of Jews in the Yemen, and Abyssinia had by now been converted to Christianity. The Red Sea was narrow and much-crossed and early, pre-Islamic pottery shows many Christian influences. Mecca itself was at a crossroads, where the north–south route to the Yemeni ports crossed the east–west route from the Red Sea to Iraq. Two huge caravans, one in summer, one in winter, set out from Mecca each year. This is another way by which ideas would have travelled.

Very little is known about Muhammad, despite the fact that writing, biography and scholarship were all well-developed by the sixth and seventh centuries. The first biography we know about was written in 767, well after the prophet's death, and even that is known only through a later edition, compiled in 833. As for non-Arab sources, the first mention of Muhammad by a Byzantine historian comes in the ninth century only, when he is referred to by Theophanes. We do have a physical description. He was neither tall nor short, and he was not fat. He had long, curly, black hair and a fair skin, dark black eyes with long lashes, broad shoulders, with strong arms and legs. He had a large mouth and beautiful teeth but he was not in any other way physically remarkable. What we also know is that, according to tradition, Muhammad's father died when he was six, after which he was brought up by his grandfather, then by his uncle. A number of traditions have it that Muhammad's relatives were the custodians of certain relics attached in some way to the Ka'bah, so the family may have had a particular pre-Islamic religious prestige. At twelve, he was taken by his uncle to Syria where he met a Christian monk, named Bahira according to the legend. At twenty-five, Muhammad married his employer, Khadijah, 'a wealthy and high-minded widow, fifteen years his senior'.[9] He helped run her business in the caravan trade for a time but it was the leisure afforded by his marriage that allowed Muhammad to spend time in a small cave just outside Mecca, called Hira.

He was in this cave one day in 610 when, suddenly, he heard a voice which ordered him to 'Recite!' At first he was unsure what to do and the voice repeated itself twice before he plucked up courage and replied 'What shall I recite?' At this the voice answered: 'Recite in the name of the Lord who created all things, who created man from clots of blood. Recite, for thy Lord is the most generous, who taught by the pen, who taught man what he did not know.' The night of that day later came to be known as 'The Night of Power'. There were later episodes, both in the cave and at home in Mecca, when Muhammad was so disturbed that he asked his wife to cover him with blankets. To begin with there were several voices but later there was only one, that of the archangel Jibril or Gabriel. Muhammad recorded all the instructions he received – some were written on palm leaves, some on stones, some he just memorised. Later, as we shall see, they were collected into a book, the Qur'an.[10]

In some ways, the message Muhammad received was not new. It overlapped with Zoroastrian, Hebrew and Christian ideas. God is one and there is no other. There is a Judgement Day with eternal paradise for those who faithfully follow His instructions and worship Him, and there is everlasting punishment in hell for those who go against His will.

Even as a boy, Muhammad had been known in his family and among his friends as 'al-Amin', the faithful, and so he may always have commanded a certain amount of religious respect. His first converts were his family and friends and then, as with Christianity, among slaves and the poorer classes. This brought him his first opposition, from the wealthier families, and he was forced to seek refuge on the other side of the Red Sea, in Ethiopia. There his visions continued, the most famous being the so-called *isra*, the nocturnal journey in which Muhammad was transported first to Jerusalem, and then to heaven, where he saw the face of God. This tradition is the basis for Jerusalem being the third holiest site in Islam, after Mecca and Madina.

The second crucial stage in Muhammad's career, after the voices in the cave, began in 621. In that year, while he was still in exile across the Red Sea, he was approached by some emissaries from a small town about 200 miles north of Mecca, called Yathrib. He had met some of these emissaries at the annual fair in Ukaz, they had been impressed by him, and now asked him if he would arbitrate in the town's disputes. In return, they said, they would offer protection for him and his followers. Muhammad agreed but he didn't hurry matters. About sixty families were sent on ahead, to test the waters, and he himself followed the next year. This migration, the *Hijra* in Arabic, is regarded by the faithful as the decisive moment in Islam and later, when the Muslim calendar was established, it started from the year in which the *Hijra* took place. The centre of the new religion was now transferred to Yathrib, referred to by the faithful as al-Madina: the City.[11]

In Madina the picture we have of Muhammad is mixed. On the one hand he became both a religious and a political and military leader. On the other, he was an ordinary citizen, who mended his own clothes and lived in an unpretentious clay house, surrounded (eventually) by twelve wives and lots of children, many of whom died. He continued to develop his ideas, gradually diverging from Judaism and Christianity. In Madina he substituted Friday for the Sabbath, instituted the *adhan*, the call to prayer from the minaret, fixed Ramadan as a month of fasting, and changed the *qiblah*, the direction to be faced when praying, from Jerusalem to Mecca. He also authorised the holy pilgrimage to al-Ka'bah in order to kiss the black stone. This was provocative because at that time al-Madina and Mecca were rival towns and in fact the third stage of Islam arose when, after a war of eight years, Muhammad's 300 troops secured victory over an army more than three times the size and captured the city. In the process, 360 idols were allegedly destroyed and Islam substituted. The area around the Ka'bah was declared sacred. Originally only polytheists (i.e., pagans) were forbidden from approaching the Ka'bah but gradually it was applied to all non-Muslims. According to Philip Hitti, in his *History of the Arabs*, first published in 1937, 'no more than fifteen Christian-born Europeans have thus far succeeded in seeing the two Holy Cities and escaping with their lives'.[12] This injunction of a sacred area around the Ka'bah is of course strongly reminiscent of that which applied to non-Jews approaching the inner sanctum of the Temple in Jerusalem (see above, page 163).

The fact that Muhammad was a political leader as well as a religious figure was very important for Islam. He made laws, dispensed justice, imposed taxes, waged war and formed alliances. His aim in all this was the restoration of true monotheism which he felt had been corrupted or distorted elsewhere. 'He was God's final revelation and at his death (according to tradition on 8 June 632) the revelation of God's purpose for humankind had been completed: after Muhammad there would be no more prophets and no further revelations.'[13]

As a set of ideas, Islam is closer to Judaism than to Christianity. In the Middle Ages, however, it was so similar to both monotheisms that, to begin with, many Christians thought it was merely a heretical Christian sect rather than a completely new faith.[14] Dante, in *The Divine Comedy*, places Muhammad in one of the lower levels of hell, together with the 'sowers of scandals and schism'.[15] As with Judaism, in Islam God's unity is the supreme

reality. He has ninety-nine 'excellent names', which is why the full Muslim rosary has ninety-nine beads. Islam is also closer to Judaism than Christianity in that its God is more a god of might and majesty than a god of love. This fits with Islam's concept of religion as a 'submission', or a 'surrender' to the will of God. What appears to have particularly impressed Muhammad is Abraham's willingness to sacrifice his son in the supreme test set by Yahweh. Abraham's submission, or *aslama* in Arabic, provided the word for the new religion.

After the idea of God as a unity, and submission, the next-most important idea in Islam is that Muhammad was the true messenger of God 'whose only miracle was the Qur'an'.[16] This solitary miracle reflects the essentially simple nature of the new faith – it had no theological complexities, like the Resurrection, the Trinity or Transubstantiation. There were no sacraments and there was no priestly hierarchy, at least not to begin with. The solitary miracle implied that the Qur'an was the word of God and therefore 'uncreated'. By far the worst sin, and in fact the only unpardonable one, was *shirk*, identifying other gods with Allah.

Islam also identifies five 'pillars', by which the faith is pursued. The first pillar is pro-fession of the faith, the second is prayer. The devout Muslim must pray five times a day and turn towards Mecca.[17] However, the Friday noon prayer is the only public observance in Islam and is obligatory for all males.[18] The third pillar is *zakah*, a tithe to help the poor and to provide funds to build mosques. According to Pliny, pre-Islamic Arabs had to pay a tax to their gods before they were allowed to sell spices at market, so it may be that Muhammad adopted this ancient idea. The fourth pillar is fasting from dawn till sunset during the month of Ramadan. Fasting was well known among Jews and Christians but there is no evidence of its use in pre-Islamic Arabia. The final pillar is the pilgrimage (*haj* or *hazz*) – once in a lifetime the faithful, of both sexes and if they can afford it, must visit Mecca at a holy time of the year. This idea may also have originated with ancient solar cults, which would congregate at the Ka'bah after annual fairs.

From the outside, then, there is a sizeable overlap between Islam and Judaism and Christianity, not to mention ancient pagan practices. One idea that differs from these other faiths is *jihad*, the holy war, espoused by certain small sects as the controversial sixth pillar. The Qur'an does specify that one of the duties of Islam is to keep pushing back the geographical boundaries that separate the *dar al-Islam*, the land of Islam, from the *dar al-harb*, 'the war territory', but the extent to which this is to be achieved by war, and how 'war' is to be understood, is far from clear.

In 633, the year after Muhammad died, Abu Bakr, the first caliph, observed that the Qur'anic memorisers, the *huffaz*, were dying out. Fearing what this might mean, he began to collect the palm leaves, stones, bones and parchment on which (according to tradition) the scattered verses of the 'book' were written. This took some time and it was left to his successor, Umar, together with Zayd ibn-Thabit, who had been secretary to the Prophet, actually to put the verses together, though it was yet another man, the third caliph, Uthman (644–656), who organised their final form. This edition, known as the *Uthmani*, existed in three copies, at Damascus, al-Basrah and al-Kufah, and became the authorised version, in use to the present day. That is the traditional view. Modern scholars suspect, however,

that there was no involvement of Abu Bakr. Instead, they think Uthman found various copies all over the Arab world, with divergent readings. He canonised the Medina version and ordered all others destroyed. On this view, the text of the Qur'an was finalised by two viziers only in 933. More than three hundred years therefore elapsed before the authorised version of the Qur'an was settled, much longer than for the Christian Bible after the Crucifixion.

Despite this, the faithful Muslim believes that every letter of the Qur'an was dictated to Muhammad by Jibril, and is therefore the inspired word of God. It contains one hundred and fourteen *surahs*, or chapters, divided into ninety Meccan and twenty-four Madinese. The Meccan chapters, the early ones, are in general short, fiery, impassioned and prophetic. The main themes are the ethical duties of man and the coming retribution for the unfaithful. (Islam in fact has two judgements: one at death, the other at resurrection.[19]) In contrast, the Madinese chapters, 'sent down' after the initial struggle was over, are much more verbose, and mainly concerned with legal matters. Details about religious ceremonies are sketched in, about what is and is not sacred, and laws are set out regarding theft, murder, retaliation, usury, marriage, divorce, and so on. There are also many references to both the Old and New Testaments. Adam, Noah, Abraham, Moses, David, Solomon, Jonah – all figure alongside the Fall, the Flood and Sodom. Scholars have noted that the forms of many Old Testament names in the Qur'an show that they are derived from Greek or Syriac sources, rather than Hebrew, and that certain miracles attributed to Jesus, such as speaking in the cradle, are found only in the Apocrypha. This throws a glimmer of light on the books available to Muhammad in the seventh century.[20]

The fact that the Qur'an is written in Arabic is all-important for pious Muslims, who believe that Arabic is the language of God and is the tongue spoken in Paradise. They believe that Adam originally spoke Arabic but forgot it and was punished by being made to learn other – inferior – languages. In fact, Arabic is a fairly modern form of the Semitic languages, which include Akkadian (Babylonian and Assyrian), Hebrew, Phoenician, Aramaic (the language of Jesus), Syriac and Ethiopic. Chronologically, this group is divided into three. The languages of Mesopotamia date back to the third millennium BC, those from Syria-Palestine to the second millennium BC, whereas the languages of Arabia and Ethiopia date from only the eighth century BC.[21] That is the modern scholarly view, but early Muslim authorities had little idea of where their language came from. One idea was that it was produced by imitating the sounds of nature, another that it was the product of a convention among early peoples, who decided it was the best language. In fact, Arabic as we understand it is derived from Aramaic, via the cursive script of the Nabateans who, as we have seen, had their capital at Petra, in what is now Jordan. Even in early Islamic times, the language was still being formed. There was, for example, no system for writing vowels and the diacritical marks that now help distinguish similar letters (a from ā) hadn't been invented. As an aid to reading, it became the practice to insert dots where vowels should go in red ink, with the rest of the script in black.[22]

So, far from being the first language, spoken by Adam, Arabic began as a relatively late dialect in the north-western region of the Arabian peninsula, where it happened to be spoken by the Quraysh aristocracy, into which Muhammad was born. Its status as the language of the Qur'an has led to anomalies. Muslims, even modern grammarians,

philologists and literary critics, often insist that Arabic is superior to other tongues, and that the Arabic of the Qur'an is of surpassing beauty that cannot be improved. This is why Muslims the world over must read the Qur'an in the original Arabic and why only one translation (into Turkish) has ever been authorised. This has remained the view of modern Islamic scholars, even after the origins of the language were unearthed beginning in the eighteenth century, and the presence of foreign loan words was detected.[23]

At Muhammad's death, Islam was confined to the Arabian peninsula. But, as the Prophet insisted, his conception of the new faith was intended to go beyond that. 'Islam was not a religion of the blood, but of the faith.' This was a new idea for Arabs but it was enormously successful. Within barely a hundred years, Islam had grown to the point where its borders touched India in the east, the Atlantic ocean in the west, the heart of Africa in the south, and Byzantium in the north. Its attraction lay partly in the certainties it offered, in the fact that, in its early years, it was a tolerant religion, certainly so far as earlier forms of revelation were concerned (Judaism and Christianity), and partly for entirely practical reasons – for example, it taxed people less than the Byzantine empire.

But there was another reason: the caliphate. At the Prophet's death, a new leader was needed. His close circle of followers chose Abu Bakr, who had been one of his earliest converts. When he was asked how he was to be addressed, he said he would take the title *Khalifa*, which in Arabic means both a successor and a deputy. This allowed for some ambiguity – did it mean that Abu Bakr was the deputy/successor of Muhammad or of God? Nevertheless, the institution of the caliphate was installed. It would have profound effects.[24]

To begin with, the institution was not hereditary (strangely, the Qur'an gave no guidance on the succession). The first four caliphs, not related, are labelled by modern Muslims as the *Rashidun*, 'the rightly guided ones', and, despite the fact that all but the first were assassinated, their period in office is usually regarded as a golden age. However, the fourth caliph, Ali, was Muhammad's son-in-law and cousin and, in offering himself for election as caliph, he was reverting to a pre-Islamic tradition. Given the history of assassinations, many of the faithful believed that a relative of the Prophet might offer leadership closer to the original. Ali's followers became a party known as *Ali, shi'atu, Ali*, which in time was collapsed into *Shi'a*.[25] Later, the Shi'a would become extremely influential – but not just yet, for Ali too was assassinated. In the Islamic civil war that ensued, the victor was Mu'awiya, the governor of a province in Syria and a member of the Meccan clan of Umayya. This brought about the next phase in Islamic development, because for nearly a century the succession of the caliphate was in the hands of the Umayyad dynasty. In subsequent orthodox history this period is relegated in importance. Before the Umayyads came the 'rightly guided ones' and after them, as we shall see, Islamic leadership was in the hands of the 'divinely approved' caliphs.[26] This reflects a major division that had opened up in Islam. The Shi'a took the view that the caliphate belonged by divine right to the blood descendants of the Prophet and in 680 this led to revolt when Husayn, the son of Ali and grandson of the Prophet, faced the Umayyads in battle. Husayn's forces were completely routed and according to tradition there was only one survivor. From here on there emerged two significant differences between Shi'a and so-called Sunni Muslims:

the former believed (a) that the caliphate should consist of the blood descendants of Muhammad; and (b) that the Qur'an was literally true.

The Umayyad victory over Husayn was no surprise. They were extremely astute political leaders (extending their empire in India, Africa and the Iberian peninsula). They also developed a wonderful architecture and promoted learning. This was the work mainly of Abd al-Malik (685–705) and his successor, Hisham (724–743), under whose rule Arabic replaced Greek and Persian as the official language of administration, Roman and Byzantine coins were replaced by Arabic ones, and the Dome of the Rock and its adjoining Aqsa mosque, 'the first great religious building complex in the history of Islam', were erected in Jerusalem.[27] This marked Islam's emergence as a major civilisation in its own right.

It was also under the Umayyads that the first Arabic centres of learning were created. These were at al-Basrah and al-Kufah. It was here that the first grammars and dictionaries were compiled, as the Arabic language came under systematic study. It was here too that the tradition of *hadith* grew up. *Hadith* means 'tradition', but it also has a more specific meaning. It was an act or saying attributed either to Muhammad himself or to one of his immediate circle. Regarded as second in importance only to the Qur'an, *hadith* provided the basis for much Islamic theology and *fiqh*, non-canon law.[28] In the Qur'an Allah speaks, in the *hadith* Muhammad speaks. In *hadith* only the meaning is inspired; in the Qur'an both meaning and the word are inspired.[29]

As mentioned above, it was also under the Umayyads that the earliest examples of Islamic architecture were created – the Dome of the Rock, in Jerusalem (691) and the Great Mosque of Damascus (706), where the Umayyads had their court. Many people think that the Dome of the Rock is still the most beautiful Islamic building ever conceived, and many Muslims think it demonstrates the superiority of Islam. This is true despite the fact that Islam never spawned any grand ideas of aesthetic theory – buildings were judged by their function as much as, if not more than, their appearance. This is not so surprising given that the Bedouin, as nomads, lived in tents and had no real need of architecture. The first mosque (from *masjid*, a place to prostrate oneself) at al-Madina, was a simple open courtyard that in time was covered over with palm leaves supported by palm trunks. A cut-down trunk served as the *minbar*, or pulpit, on which Muhammad would address the faithful. All early sources agree that the Prophet's own mosque, and those built by his companions, were very humble. Moreover, Muhammad is reported to have been hostile to the decoration of mosques and said that 'the most unprofitable thing that eats up the wealth of a believer is building'.[30]

If there were no formal aesthetics in Islam, however, there were some general ideas that became established as tradition. One was the idea of ornament, or embellishment. Islam concedes that God created the world and ornamented it and gave man the ability to produce 'devices of embellishment'. The Arabic word *zayyana* means both to embellish and to produce a beautiful thing, 'as God embellished the heavens with stars', though another word, *malih*, derives from the root *m-l-h*, which also forms the word *milh*, meaning salt. Thus in Arabic beauty implies 'delectation' rather than the Platonic idea of moral good.[31] A beautiful woman in Arabic poetry is inevitably adorned with jewellery and perfume. There is more to this idea of ornament than the word means in the West, however.

Islam understands that God created the world and that it is perfect. There is, as a result, little scope for man to truly create – all he can do is adorn what God has produced. It follows that adornment, embellishment, ornament are to be understood not as truly creative activities, or improvements on what God has given us, but as ways of venerating and glorifying God. Linked to this is the fact that pre-modern Muslims had no religious emblem to compare with the Christian cross (the crescent is a modern innovation). Only the word of God is sacred, all other forms and patterns are neutral and interchangeable.[32] The whole idea of mosque architecture and decoration therefore was to emphasise humility and the interiority of faith. The main decorative device was the arch but the central aspect of the mosque was the *mihrab*, the prayer niche, which faced Mecca. The area around the niche was usually the most heavily decorated, the two main forms of which were the arabesque and calligraphy.

The arabesque is not rooted necessarily in any prohibition on the representation of the human figure. The Qur'an does not prohibit such representation and paintings and sculptures in early Islamic societies were by no means unknown, even portraiture, even portraits of Umayyad caliphs. Figural depictions, in fact, did not begin to disappear until the fourteenth century. Rather, the idea underlying arabesques arose from geometry. The Arabs took from the Greeks the idea that proportion was the basis of beauty, and they also considered it was the basis of all science, since it encouraged man to think in abstract terms, 'an activity that led to purity'.[33] There is no Arabic word for arabesque and, again, there is no elaborate theory about its use. When all is said and done, line plays the main part in the effect. It is humble, egalitarian (no one design is more important than another), the visual equivalent of the word-plays so treasured in Islamic poetry. Its aim is to dazzle the beholder, leaving his or her mind clear for contemplation of God. No less important, these clean, coherent shapes cannot err.[34]

Calligraphy draws its force from the central fact that the Qur'an represents 'direct, divine speech', that Mohammad thought that handwriting 'was one of the keys of man's daily bread', and therefore it becomes something akin to the icon in Christian art. The Qur'an is to Muslims what Jesus (and not the Bible) is to Christians: it is the way God manifests himself to believers. Just as numerology has always been popular among mystics, some Sufis (see below) regarded the Arabic alphabet as occult. But a better and more typical way of looking at calligraphy is as a 'rhetoric of the pen', adornment of the word produced in ways that reflect a geometrical harmony.[35]

This approach to ornamentation brings us back to the Dome of the Rock. The building of the Dome was not simply the creation of a religious site. At another level it was a complex political act. Jerusalem was in fact not Jerusalem at that time. It is never mentioned directly in the Qur'an and where it is, in early Muslim writings, it is referred to as Aelia, the name chosen by the Romans, which was intended to de-sanctify the city and remove any Jewish or Christian associations. The Dome of the Rock was specifically built to outshine both the church of the Holy Sepulchre and the most sacred spot in Judaism, the place where, according to rabbinic tradition, Abraham had been willing to sacrifice his son, and where the Ark of the Temple had rested. As the historian Bernard Lewis has put it: 'This, 'Abd al-Malik seemed to be saying, was the shrine of the final dispensation – the new temple, dedicated to the religion of Abraham, replacing the Temple of Solomon,

continuing the revelations vouchsafed to the Jews and Christians *and correcting the errors into which they had fallen.*' For example, the Qur'anic inscription on the shrine explicitly denies Christian ideas about the Trinity: 'God is one, without partner, without companion.' Elsewhere: 'Praise be to God, who begets no son . . .' As the Dome of the Rock shows, Islam was more than a successor faith to Judaism and Christianity: it *superseded* them.[36]

Despite these political, military and cultural successes, there was an inherent instability in early Islam. In its ideals it was a far simpler faith than, say, Christianity. It was egalitarian and there was in theory no clergy, no Church, no rank in which some were more privileged, or closer to God, than others. But this did not sit well with the very existence of a dynasty, who exercised worldly as well as spiritual power. When the opponents of such a regime were also descendants of the Prophet himself, that instability was multiplied. This forms the background for the uprisings against the Umayyads, first in 747, then two years later, in favour of the Abbasids, descendants of the Prophet's uncle, al-Abbas.[37] After the second uprising, Abu'l-'Abbas, the leader of the Shi'a sect, was voted caliph by his troops and a new dynasty came into force. The Abbasid caliphate was to endure for half a millennium, and Abu'l-'Abbas' successor, al-Mansur, marked this sea-change by moving the capital, replacing Damascus with a brand-new city situated on the west bank of the Tigris river in what is now Iraq, near the site of the old Persian capital of Ctesiphon. The official name that al-Mansur gave to his new city was Madinat al-Salam, the City of Peace. But that never caught on and it was always known by the small city that had been there for generations – Baghdad.[38]

The name Baghdad means 'Given by God' but the city was also known as the 'Round City' because of its circular form. The new metropolis was built in four years, al-Mansur employing, allegedly, a hundred thousand labourers, craftsmen and architects. He chose the site partly because it was easy to defend, and partly because the Tigris gave access as far afield as China and, going upriver, Armenia. The ruins of the city of Ctesiphon served as the main source of stone.

The great Baghdad caliphs were al-Mansur himself, who was the second Abbasid, al-Mahdi, the third, and Harun al-Rashid, (786–809), and his son al-Ma'mun. 'Though less than half a century old, Baghdad had by that time grown from nothingness to a world centre of prodigious wealth and international significance, standing alone as a rival to Byzantium.'[39] The royal palace occupied a third of the round city and the luxury contained within it was legendary. The caliph's cousin-wife 'would tolerate at her table no vessels not made of gold and silver', and once, when welcoming foreign dignitaries, the procession is said to have boasted one hundred lions. In the Hall of the Tree the silver birds were built so as to 'chirp automatically'.[40] The harbours of the city were occupied by ships from China, Africa and the Indies.

From all over the known world, people flocked to Baghdad.[41] The city's position meant that it was within easy reach of India, Syria and, most important of all, Greece, and the Hellenistic world. In particular, it was close to an impressive centre of learning that already existed not far away at Gondeshapur in south-west Persia. Here there flourished a large community of Nestorians, a heretical Christian sect which, as we saw in the previous chapter, had been forced to flee from territory further west in the fifth century. (Nestorians

believed that Jesus was both divine *and* human.) Alongside them, other political and
religious refugees arrived in Gondeshapur, including some who had been expelled from
the pagan Academy in Athens (the one founded by Plato) when that institution was closed
down by Christians in 529. For many years, therefore, Gondeshapur had been home to
scholars of every belief and none and, in particular, to physicians. They, above all others,
had a vested interest in learning about medicinal herbs, surgical methods and other
treatments from across the known world. And so for them the translation of foreign texts
became a common procedure. Many of the Nestorian families in Gondeshapur developed
into medical dynasties, passing down the (translated) medical manuscripts from father to
son. Gondeshapur also had the first hospital, the Bismaristan. Inside the city there was a
great variety of languages spoken: Greek, Syriac, Aramaic, Sanskrit, reflecting many tradi-
tions, and texts were chiefly translated *out* of Greek and Sanskrit *into* Syriac and Aramaic.
After Gondeshapur was conquered by the Arabs in AD 638, these scholars quickly learned
the tongue of their conquerors and an intensive programme of translation into Arabic
from Greek and Indian medical, geometrical and other scientific manuscripts was begun.[42]

This was the model that was transferred to Baghdad and Damascus. Thus the very idea
of translating valuable foreign manuscripts was itself originally a Christian/Jewish/pagan
practice. There was no such tradition or precedent in the Arab world and, as Gondeshapur
was ecumenical and international, with as many Jews and pagans as Christians leading the
way, that is how the translations were organised in Baghdad. As the City of Peace grew in
size and importance, many descendants and successors of the Nestorian medical dynasties
physically transferred from there. Then, at the beginning of the ninth century, the Islamic
world was fortunate in having an open-minded caliph, al-Ma'mun, who was sympathetic
to a semi-secret sect, the Mu'tazilites, who were rationalists obsessed with reconciling the
text of the Qur'an and the criteria of human reason. Al-Ma'mun, it is said, had a dream –
possibly the most important and fortunate dream in history – in which Aristotle appeared.
It is as a result of this dream that the caliph decided to send envoys as far afield as
Constantinople in search of as many Greek manuscripts as they could find, and to establish
in Baghdad a centre devoted to translation.

Some time around 771 an Indian traveller in Baghdad brought with him a treatise on
astronomy, a *Siddhanta,* which al-Mansur insisted be translated. This became known in
the city as the *Sindhind.* The same traveller also brought with him a treatise on math-
ematics, which introduced a new set of numerals, 1, 2, 3, 4 etc., which we still use to this
day (before that numbers had been written out as words, or used letters of the alphabet).
These later became known as Arabic numerals though nowadays we credit them (at least
mathematicians do) with being Hindu numerals. The same work also introduced the 0,
which may have originally come from China. The Arabic word for 0, *zephirum,* is the
basis of both our words 'cipher' and 'zero'. These texts were translated into Arabic by
Muhammad ibn-Ibrahim al-Fazari, on whose work the famous Muslim astronomer, al-
Khwarizmi (*c.* 850) based much of his thinking.[43]

The Arabs did not interest themselves overmuch in Greek literature – poetry, drama,
history. Their own literary tradition, they felt, was more than enough. But medicine, as
represented by Galen, the mathematics of Euclid and Ptolemy, and the philosophy of Plato

and Aristotle were a different matter. The earliest Muslim thinker to have conceived an overall picture of the sciences was al-Farabi (d. 950), whose catalogue *Ihsa al-ulum*, known in Latin as *De Scientiis*, organised the different activities as: linguistic sciences; logic; mathematics, including music, astronomy and optics; physics; metaphysics; politics; jurisprudence; theology. Ibn Sina, later, divided the rational sciences into the speculative (seeking after truth) and the practical (aimed at well-being).[44] The speculative sciences included physiognomy, the interpretation of dreams, and of charms. The practical sciences included morality and prophetology.

A number of libraries and centres of learning had been established in the great Islamic cities, based largely on Greek models discovered during the Arab conquests of Alexandria and Antioch. But by far the most famous was al-Ma'mun's House of Wisdom (*Bayt al-Hikma*), founded in 833. Many translations were carried out in the House, as well as astronomical observations, chemical experiments, and teaching (though Hugh Kennedy casts doubt on this, claiming that the House was only a library). Even here, however, the 'sheikh of translators', as he was called, was yet another Nestorian Christian from al-Hirah, Hunayn ibn-Ishaq (809–873), who spoke four languages and was appointed superintendent of the House of Wisdom and given control of all scientific translation. He was, says Hugh Kennedy, a protégé of the Banu Musa family, who were the chief patrons of study of the exact sciences in Baghdad's golden age. Hunayn taught his son, Ishaq, and his nephew, Hubaysh, to follow him and between them they translated Aristotle's *Physics*, Plato's *Republic*, seven books of anatomy by Galen (now lost in Greek), and works by Hippocrates and Dioscorides. Hunayn also translated the Old Testament from the Greek Septuagint, but this too has been lost.[45] No less distinguished than Ibn Ishaq was Thabit ibn Qurra, founder of a second school of translators, who transcribed into Arabic the works of Euclid, Archimedes, Ptolemy (including the *Almagest*) and Apollonius. Had it not been for Ibn Qurra, the number of Greek works in existence today would have been smaller. Ibn Qurra wasn't a Muslim either – he was a member of a pagan sect, the Sabians, who, fortunately, were mentioned in the Qur'an and therefore had protected status. Ibn Qurra and Ibn Ishaq collaborated on a project to measure the circumference of the earth. They repeated their effort more than once, to confirm the result, an early demonstration of the experimental approach. They took it for granted that the earth was round.

It was no different in philosophy or literature, where the success of Christians and pagans underlined the openness of Baghdad. Abu Bishr Matta bin Yunus, a close colleague of the famous al-Farabi, who tried to reconcile Aristotle and the Qur'an, was a Christian and studied in Baghdad. One of the most important poets of the seventh and early eighth centuries was a Christian, Ghiyath ibn-al-Salt, from near to Hirah, on the Euphrates, who was even taken to Mecca by his caliph. Though appointed court poet, he refused to convert, or to give up his 'addiction' to wine, or to stop wearing his cross. He divorced his wife, married a divorcée, was often seen with prostitutes and drank 'to saturation', claiming that was the only way he got ideas for his poetry. He died in his bed.[46] It is no secret that the most famous of all so-called Arabic literary works, *Alf Laylah we-Laylah* (*A Thousand Nights and One Night*), was in fact an old Persian work, *Hazar Afsana* (*A Thousand Tales*), containing several stories, many of Indian origin. As time went by additions were made, not just from Arabic sources but Greek, Hebrew, Turkish and Egyptian.[47]

Besides academic institutes such as the House of Wisdom, hospitals as we understand them today were developed under Islam.[48] The first, and most elaborate, was built in the eighth century under Caliph al-Rashid (the caliph of the *Thousand Nights and One Night*), but the idea spread very rapidly. The medieval Muslim hospital, as it existed in Baghdad, Cairo or Damascus, was very sophisticated for the time, much more so than the Bismaristan in Gondeshapur. For example, there were separate wards for men and women, special wards were devoted to internal diseases, ophthalmic disorders, orthopaedic ailments, the mentally ill, and there were isolation wards for contagious cases. There were travelling clinics and dispensaries and armies were equipped with military hospitals. Mosques were attached to the bigger hospitals, with *madrasas* – colleges – where aspiring doctors from all over the world came to be trained. It was also in the eighth century, in the Arab lands, that the idea of the pharmacy, or apothecary, was born. In Baghdad at least, pharmacists had to pass an exam before they were allowed to produce and prescribe drugs. The exam covered the correct composition of drugs, the proper dosage, and the therapeutic effects. The Muslim contribution, on top of the ancient remedies, included camphor, myrrh, sulphur and mercury, plus the mixing of syrups and juleps.[49] One text in particular, Ibn al-Baytar's thirteenth-century *Al-Jami' fi al-Tibb* (*Collection of Simple Diets and Drugs*) consisted of more than a thousand entries based on plants the author had himself collected along the Mediterranean coast. The notion of public health also began with the Arabs – among other things, doctors would visit prisons, to see whether there were any contagious diseases among the convicts that might spread.

Two Islamic doctors from this time must rank among the greatest physicians in all history. Al-Razi, known in the West by his Latin name, Rhazes, was born in 865 in the Persian town of Rayy and was an alchemist in his youth but also a polymath. He wrote nearly two hundred books, on such diverse subjects as theology, mathematics and astronomy, though nearly half of what he produced was medical. He clearly had a sense of humour – two of his titles were *On the Fact That Even Skilful Physicians Cannot Heal All Diseases* and *Why People Prefer Quacks and Charlatans to Skilful Physicians*. He was the first chief physician of the great hospital at Baghdad and, in choosing the site, is said to have hung up shreds of meat in different places, selecting the spot where putrefaction was least.[50] (If true, this comes close to being the first example of an experiment.) But al-Razi is best known for making the first description of smallpox and measles.[51] His other great book was *Al-Hawi* (*The Comprehensive Book*), a twenty-three-volume encyclopaedia of Greek, pre-Islamic Arab, Indian and even Chinese medical knowledge. It covered diseases of the skin and joints, and explored the effects of diet and the concept of hygiene (not so straightforward before the germ theory of disease).

The other great Muslim physician was Ibn Sina, again known in the West by a Latinised name, Avicenna.[52] Like al-Razi he wrote some two hundred books, on a diverse range of subjects, but his most famous work was *Al-Qanun* (*The Canon*), a majestic synthesis of Greek and Arabic medical thought. The range of diseases and disorders considered is vast, from anatomy to purges, tumours to fractures, the spreading of disease by water and by soil, and the book codifies some 760 drugs. The *Qanun* also pioneered the study of

psychology, in that Ibn Sina observed a close association between emotional and physical states, the beneficial role of music, the role of the environment in medicine (i.e., rudimentary epidemiology), and in so far as he viewed medicine as 'the art of removing impediments to the normal functioning of nature', he may be said to have given the discipline its philosophical grounding. In the twelfth century the *Qanun* was translated into Latin by Gerard of Cremona (see below, this chapter) and, together with al-Razi's *Al-Hawi*, displaced Galen and served as the basic textbooks in European medical schools until at least the seventeenth century, well over half a millennium.[53]

In 641 Alexandria had fallen to the Muslims. For many years, as we have seen, that city had been the mathematical, medical and philosophical centre of the world, and the Muslims came across countless books and manuscripts on these subjects in Greek. Later, among the faculty members of the House of Wisdom, there was an astronomer and mathematician, Muhammad ibn-Musa al-Khwarizmi, whose name – like Euclid – was to become a household word throughout the educated world. His fame rested on two books, one of which was far more original than the other. The less original book was probably based on the *Sindhind*, which was the Arabic word for the *Brahmasphuta Siddhanta*, the treatise by Brahmagupta which had been brought to the court of al-Mansur and in which various arithmetical problems were described, as well as Hindu numerals. Al-Khwarizmi's work is known now only in a unique copy, a Latin translation, the original Arabic version having been lost.[54] The Latin title of this work is *De numero indorum* (*Concerning the Hindu Art of Reckoning*). Al-Khwarizmi gave such a complete account of the Hindu system that, as Carl Boyer points out, 'he is probably responsible for the widespread but false impression that our system of numeration is Arabic in origin'.[55] Al-Khwarizmi made no claim to originality on this score but the new notation became known as that of al-Khwarizmi or, carelessly, *algorismi*, ultimately corrupted to our word algorithm, now used for any peculiar rule of procedure. The actual descent of our numerals is shown in Figure 10 on page 272, which *doesn't* show how slowly these transformations took place. Even in the eleventh century, Arab scholars were still writing numbers out in full, in words.

But al-Khwarizmi is also known as the 'father of algebra' and, certainly, his *Hisab al-Jabr wa'l muqabalah* contains over eight hundred examples. Translated into Latin in the twelfth century, by Gerard of Cremona, the *Algebra* was in use until the sixteenth century as the principal mathematical textbook in European universities. From the introduction in the Arabic version (missing in the Latin copy) it seems possible that algebra originated in the complex Islamic laws governing inheritance. These often involved complicated calculations to determine which son inherited what and how debts were to be settled. The word *al-jabr* apparently meant something like 'restoration' or 'completion', and refers explicitly to the subtracted terms transferred to the other side of the equation, while *muqabalah* meant 'reduction' or 'balance' or something very like it. In *Don Quixote*, the word *algebrista* is used to mean a bone-setter – i.e., a restorer. In quadratic equations, elements are reduced either side of the equation, to restore balance.[56] In the *al-Jabr*, al-Khwarizmi introduces the idea of representing an unknown quantity by a symbol, such as $x$, and he provides six chapters, solving six types of equations composed of the three quantities: roots, squares and numbers. Although al-Khwarizmi's *al-Jabr* has traditionally

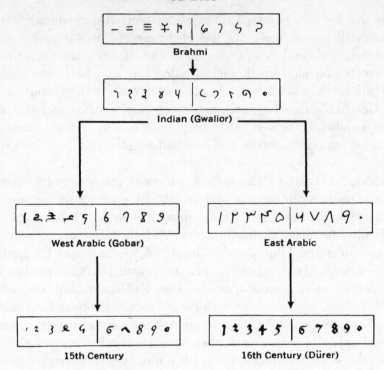

**Figure 10: Genealogy of our numerals**[57]

[Source: Carl Boyer, *A History of Mathematics*, New York: Wiley, 1991, page 237. This material is used by permission of John Wiley & Sons, Inc.]

been seen as the first work of algebra, a manuscript was found in Turkey in the late twentieth century which throws doubt on this. Entitled *Logical Necessities in Mixed Equations*, its subject matter was much the same, and some of the equations solved were *exactly the same*. It thus seems that one manuscript was derived from the other, though no one knows which came first.[58]

In the chemical sciences, the leading Arab figure was Jabir ibn-Hayyan, known in the West as Geber, who lived in al-Kufah in the last half of the eighth century. Like most chemists of the time, he was also obsessed by alchemy, in particular with turning base metal into gold (which Jabir believed was accomplished by means of a mysterious substance, *al-iksir*, or elixir, yet to be discovered). Alchemists also believed that their subject was the 'science of the balance', that precious metals could be produced by observing and then improving on the methods of nature.[59] But chemistry offered the chance of systematic experimentation and Jabir is certainly one of those who can be regarded as the founder of the experimental method. He was the first to describe systematically the principal operations in chemistry – calcination, reduction, evaporation, sublimation, melting and crystallisation. In parallel with this, al-Razi gave a systematic classification of the products of nature. Mineral substances, he said, were divided into spirits (mercury, sal ammoniac), substances (gold, copper, iron), stones (haematite, iron oxide, glass, malachite), vitriols (alums), boraxes and salts. To these 'natural' substances, he added 'artificial' ones –

verdigris, cinnabar, caustic soda, alloys. Al-Razi also believed in what we would call research in the laboratory and he had a lot to do with the separation of chemistry proper from alchemy.[60]

Just as the world was made perfect by God, so that 'art' could only ever be 'ornamentation', adoring God's original creation, so philosophy, *falsafah*, was knowledge of the way things are, but only in so far as man was capable of working things out for himself. In other words, *falsafah* was inevitably and by definition limited: revelation was, and would always remain, superior to reason. As with the sciences, Arab philosophy was essentially Greek, modified by Indian and other Eastern ideas, and expressed in Arabic, always with the proviso that reason was limited. *Hukama*, the sages, who practised *falsafah*, were contrasted with *mutakallim*, theologians, who practised *kalam*, theology.

The three greatest Arab philosophers were al-Kindi, al-Farabi and Ibn Sina. Al-Kindi, born in al-Kufah around 801, amalgamated the views of Plato and Aristotle, but he also awarded a high place to Pythagoras, whose mathematics, he thought, were the basis of all science. He was well-born, numbering among his ancestors Imru'-al-Qays (d. *c.* 545), one of the authors of the 'suspended odes'. Among his own people he was known as Faylasuf al-Arab and he is often referred to as the first Arab philosopher. In fact, al-Kindi was more a transmitter of philosophy – an advocate of the Greek way of thought – rather than an original thinker. He insisted on the difference between philosophy and theology and in doing so risked the ire of orthodox Muslims, because he thought theology should be made subject to the rules of philosophy, such as logic. He also argued that philosophy was open to all, unlike theology, where there was a hierarchy of access to the truth. He wrote a lot on the soul, which he regarded as a spiritual entity, created by God. But his main contribution may be summed up by the story told about him, where he entered al-Mal'mun's salon and sat above a theologian. When challenged, he replied that he deserved his higher seat because 'I know what you know and you don't know what I know.'[61]

Al-Farabi also attempted a synthesis of Plato and Aristotle, but it was Ibn Sina, whom we have already encountered in the section on medicine, who made the most of Greek thought in his adaptation of Plato.[62] His philosophy was speculative: he was drawn to Aristotle's metaphysics and Plato's theory of ideas. His idea of God was closer to Aristotle's unmoved mover (though Ibn Sina's was a creator god), with all other things being of a dual nature – body and soul. Man's soul was part of a universal soul emanating from God, the second of three emanations, the first being intellect, and the third matter. For Ibn Sina the soul continued at death but did not occupy other bodies. He thought that the highest state that humans could achieve was prophethood, the genuine prophet receiving his knowledge directly from God, without intermediary but via divine light. He felt that man had free will, though God had control of the major forces. This brought Ibn Sina into conflict with orthodoxy, which maintained that God had an eternal decree over what happened. It is difficult at this distance to appreciate how radical Ibn Sina was in his advocacy of philosophy as separate from theology. But Roger Bacon (d. 1294), the English philosopher, thought he was the greatest authority on philosophy after Aristotle.[63]

*

Islamic science and philosophy was often the work of Syrians, Persians and Jews. In contrast, Islamic theology – including canon law – was mainly the work of Arabs. The idea of *hadith* has already been introduced but in the eighth century this tradition went through several twists. The most notable stemmed from the famous edict of Muhammad, 'Seek ye learning though it be in China.' This encouraged many Muslim scholars to travel, to the extent that many such arduous journeys were seen as acts of piety, and men who lost their lives in the course of their travels were seen as martyrs, equivalent to those killed in holy war.[64] Travel gave a pious man authority – for who could contradict what he had seen and learned? As a result, in the eighth and ninth centuries in particular the number of *hadith* increased vastly. And here, we should not forget that even the pious were not above a little private enterprise. According to Philip Hitti, one teacher in al-Kufah, just before his execution in 772, admitted to having invented more than four thousand traditions. Because of this, it was later laid down that a 'perfect' *hadith* had to have two elements – a chain of authority, and an original text. On this basis, *hadith* became divided into genuine, fair or weak.

In the ninth century (the third Muslim century) the *hadiths* became canonised into six books. The most authoritative is generally regarded as that of Muhammad ibn-Isma'il al-Bukhari (810–870). Over sixteen years, so it is said, he visited one thousand sheikhs and, out of 600,000 traditions that he collected, he chose 7,397 which he accepted as sacred. These are divided into three categories: prayer, pilgrimage and holy war. This book is now regarded as second only in authority to the Qur'an; oaths taken on it are valid in Muslim countries, and it has exerted a profound influence on Islamic thought.

Study of the Qur'an dominated instruction in the schools of the early Islamic world. The core curriculum, as we would say today, consisted of memorising the Qur'an and *hadith*, together with writing and mathematics. The pupils practised their writing on secular poems, lest a mistake be made with sacred texts. 'Deserving pupils in the elementary schools (*kuttab*) of Baghdad were rewarded by being paraded through the streets while almonds were thrown at them.'[65]

The *Bayt al-Hikma*, the House of Wisdom, was the most pre-eminent educational institution in Baghdad, but the first academy to resemble a college, which was residential and concentrated on teaching rather than research (as we would say), was the Nizamiyah, the theological seminary founded in Baghdad in 1065–1067 by the Persian vizir, Nizam-al-Mulk.[66] The Arab term for seminary was *madrasa* and here too the Qur'an and ancient poetry formed the basis of a curriculum that extended to the humanities, much as the Greek and Roman classics formed the basis of European education in later centuries. The Nizamiyah was merged with another *madrasa*, al-Mustansiriyah, which was equipped with a hospital, baths and a kitchen and had a clock tower at its main gate. Ibn Battuta, the great Arab traveller, visited Baghdad in 1327 and found that the merged institution had four juridical schools.[67] Eventually there were about thirty of these *madrasas* in Baghdad and almost as many in Damascus. Until the introduction of paper, the chief method of recording what was learned was the memory and stories of astounding feats of memory were a common form of entertainment. Some scholars, it was said, could memorise 300,000 traditions. Mosques also had libraries and offered lectures on *hadith*. This was

something that all travellers could rely on. Books were common by now in the Islamic world. According to one author, in the late ninth century, there were more than a hundred book dealers in Baghdad, all congregated in one street. The booksellers were often calligraphers as well, who would copy books for a fee, and often used their shops like cafés in later times, as meeting places for authors.[68]

Not everyone agreed that the Qur'an was solely the work of God. In the middle of the second Islamic century (the eighth century AD) there emerged a school of thinkers that called almost all aspects of traditional Islam into question. They were known as the Mu'tazilis ('those who keep themselves apart'), and they believed that truth could be reached only by bringing reason to bear on what is revealed in the Qur'an. For example, if God is One, He has no human attributes and the Qur'an could not therefore have been spoken by Him – it must have been created in some other way. At the same time, since God is just, bound by the principle of justice, man must have free will – otherwise, to judge men for acts they are not free to undertake would be unjust.[69] The most daring of the Mu'tazilite thinkers was al-Mazzam (active in the first half of the ninth century AD) who proclaimed that doubt 'was the first requirement of knowledge'.[70]

   This form of thinking appealed in particular to al-Ma'mun, who promoted the Mu'tazilite view to a state religion, asserting a new dogma, 'the creation [*khalq*] of the Qur'an', directly opposed to the traditional view, that the Qur'an was 'the uncreated word of God'. As may be imagined, this reversal of beliefs caused great consternation, the more so as al-Ma'mun set up the *mihnah*, a tribunal similar to the Inquisition which tried those who denied the new dogma. This new dispensation, and the persecution of the orthodox views, was continued after al-Ma'mun's death by his two successors, but then the situation was reversed. The man usually given credit for starting the return to orthodoxy is Ahmad ibn Hanbal (780–855), who argued that since God is all powerful, his justice is not like human justice, and that if the Qur'an is one with him, this is not to say that he has human attributes – his attributes are divine and must be accepted as such, not on an analogy with human attributes. Ibn Hanbal was followed by Abu-al-Hasan 'Ali al-Ash'ari of Baghdad (active in the first half of the tenth century). Al-Ash'ari argued that God's hearing, sight and speech were not the same as those human attributes. Man must accept them, 'without asking how'. The Nizamiyah seminary in Baghdad was set up to propagate al-Ash'ari's ideas.[71]

   After him, much Islamic thought, like much Christian thought, became obsessed with reconciling Greek ideas with the sacred text. And here, al-Ash'ari was followed by the man who is universally regarded as the greatest Islamic theologian, Abu Hamid Muhammad al-Ghazali. Born in 1058 in Tus, Khurasan, Persia, he was in some respects the St Augustine of Islam. He roamed the world, acquiring wisdom, in the tradition inspired by the Prophet, and he flirted, intellectually, with both scepticism and Sufism. Sufism was and is the main form of Islamic mysticism, an ascetic movement, with elements of Gnosticism, Neoplatonism, Christianity and Buddhism. Wool (*suf*) was adopted as a form of dress in imitation of Christian monks, as was celibacy. Sufis were faintly apocalyptic, with their belief in an 'anti-Christ' and they were characterised by the achievement of ecstasy as a way to purify the soul. They introduced the rosary, probably taken over from the Hindus

(and passed to Christians during the Crusades), and they distinguished, as did the Gnostics, between knowledge of God, *ma'rifah*, and intellectual knowledge, *ilm*.[72]

Many Muslims now revere al-Ghazali as second only to the Prophet in importance. His main book, *Ihya 'ulum al-din* (*The Revivification of the Sciences of Religion*), is a blend of dialectic, mysticism and pragmatism. It had an enormous effect on individuals as diverse as Thomas Aquinas and Blaise Pascal and it has very largely shaped the Islam that is practised today. The book is divided into four parts. The first examines the pillars of Islam, the second goes beyond ritual to consider various everyday aspects of life, such as marriage, listening to music, the acquisition of worldly goods, while the third part looks at the passions and the desires. The last part is the most original and deals with the path to God. Throughout the early parts al-Ghazali reminds his readers continually to be aware of the soul at all times, that it is just that sort of self-awareness that makes someone bring something extra to all their activities, making them more worthwhile.[73] In this section, al-Ghazali argues that the path to God is marked by a series of stages. The first is repentance, then patience, fear, hope and renunciation of all those things that may not be sinful in themselves but are hindrances to reliance on God. At each stage, says al-Ghazali, there are revelations which comfort the individual on his journey. These, however, are given by the grace of God and are temporary. Yet, as the soul moves upward, its own efforts count for less and more is led from God. The main problem is getting stuck at any one stage and going no further. One must renounce all illusions and open oneself to God. The highest point is reached when man loses all awareness of himself, when God reveals himself through love, and man becomes aware of a new kind of knowledge, *ma'rifah*. Man may have a vision of God from a distance at this point, and be allowed a glimpse of the paradise to come. Ever since al-Ghazali, Sunni Islam (the belief that the Qur'an and the habitual behaviour of the Prophet is sufficient guide) has been the dominant form.

Openness and toleration thus ran right through Baghdad's golden age, when so much groundwork was being done in medicine, mathematics, philosophy, geography and other branches of science. The culmination came at the turn of the eleventh century. It was then that Ibn al-Nadim published his *al-Fihrist*, a compendium of books then available in the round city. This, as was mentioned earlier, showed an exotic array of activities that interested the Arabs of the time, but it is clear from this that people – merchants, theatre types, writers, scientists, astrologers and alchemists – were flocking to Baghdad, rather as people flocked to Berlin, Paris or New York in later ages, *because* it was so open, a kaleidoscope of humanity. The Arabs' own taste for travel was stimulated in the early eleventh century when the magnetic compass arrived from China, enabling ships' captains to dispense with coastal sailing.

But the great openness didn't last. The areas of study derived from Greek and Indian origin became known in some quarters as the 'foreign sciences', and were treated with suspicion by the pious. In 1065, or 1067, as we have seen, the Nizamiyah was founded in Baghdad. This was a theological seminary, where the Qur'an and the study of old poetry – rather than Greek science – became the backbone of study. Later merged with a younger outfit, the al-Mustansiriyah, this joint institution became the prototype of the *madrasas*, the theological colleges, often linked to mosques, which spread all over the Islamic world,

teaching primarily moral and ethical matters, based on the Qur'an. The curriculum included the 'religious sciences', the 'Qur'anic sciences', and above all *ilm al-kalam*, which means both theology and 'defensive apologia', the reassertion of the faith against the inroads of science and philosophy. Thus a great turning inward came about. In some ways the Arab world has never recovered.

Although it was more than 2,000 miles away to the west, Spain (or most of it) had been Muslim since the early eighth century. Before the Muslim conquest there, Spain had been one of the most recently Christianised European countries and therefore Arab civilisation was able to take firm hold. It was held for more than two hundred years – from 756 to 961 – by the Umayyad dynasty. After they had been deposed in Damascus by the Abbasids, one of their number, Abd-al-Rahman ibn Mu'awiyah, grandson of Hisham, had escaped and, with loyal Syrian troops, traversed north Africa arriving, finally, at the straits of Gibraltar. Despite opposition from the local Arabs already living there, who formed an alliance with Charlemagne, Abd-al-Rahman beat them back, to establish another Umayyad dynasty.

Arab civilisation achieved a glory in Spain to rival that in Iraq, with the high point coming in the last half of the tenth century. By that point, Cordova, the capital, was on a par with Baghdad and Constantinople as one of the three great cultural centres of the 'known world'. It had paved streets, where each house undertook to mount a light outside at night. There was a regular postal service, coins in gold and silver, gardens galore, a whole street of bookshops, and seventy libraries. 'Whenever the rulers of León, Navarre or Barcelona needed a surgeon, an architect, a master singer or a dressmaker, it was to Cordova that they applied.'[74]

Abd-al-Rahman III was the most impressive ruler of all. He founded the university of Cordova. This, located in the main mosque, preceded al-Azhar in Cairo and even the Nizamiyah in Baghdad. It was decorated with mosaics brought in from Constantinople and water was fed to it in lead pipes. There was a library of some 400,000 books. One visitor from the north remarked in his memoirs that 'nearly everyone could read and write'.[75] Among the ideas born in Cordova was comparative religion, in the work of Ali ibn-Hazm (994–1064). His *al-Fasl fi al-Milal w-al-Ahwa' w-al-Nihal* (*The Decisive Word on Sects, Heterodoxies and Denominations*) broke new ground, not only in its examination of the different Muslim groups, but also in the way Ibn Hazm drew attention to various inconsistencies in the biblical narratives. It would be five hundred years before Christian thinkers thought such matters important. Similarly, Ibn Khaldun (born in Tunis in 1332) made an equivalent breakthrough as the inventor of sociology. In his *al-Muqaddimah* he conceived a theory of historical development, taking account of geography, climate, and psychological factors, in an effort to discover rational patterns in human progress. This no doubt had a great deal to do with the fact that, in Egypt, where he finally settled in middle age, and was given a teaching position at al-Azhar, the oldest and most distinguished university in the area, he had the opportunity to meet scholars from Turkestan, India, east Asia and deepest Africa. His approach is clearly set out in the beginning of the *Muqaddimah*: 'On the surface, history is no more than information about political events, dynasties and occurrences of the remote past, elegantly presented and spiced with proverbs.

It serves to entertain large, crowded gatherings and brings us to an understanding of human affairs ... The inner meaning of history, on the other hand, involves speculation and an attempt to get at the truth, subtle explanations of the causes and origins of existing things, and deep knowledge of the how and why of events. History, therefore, is firmly rooted in philosophy. It deserves to be accounted a branch of philosophy.'[76] Ibn Khaldun called this science of society, which he claimed to have discovered, *ilm al-umran*, the science of civilisation. At the core of any civilisation, he said, lies social cohesion and this is the most important phenomenon to understand.[77]

Many of the ideas conceived by the Arabs in and around Baghdad actually filtered through to Europe via Spain, including ideas the Muslims had garnered from elsewhere. Hindu numerals are a case in point (see next Chapter for a fuller discussion). It was in Spain in the second half of the ninth century that Hindu numerals were modified into the form known as *huruf al-ghubar* ('letters of dust'). These *ghubar* numerals appear to have been introduced for use with a sand abacus, and they are closer in form to the ones we use today. The other way the Hindu-Arabic numerals were introduced to Europe was via the work of Leonardo Fibonacci, of Pisa (*c.* 1180–1250). Fibonacci's father was a merchant who did a lot of business in north Africa. As a result, his son travelled in Egypt, Syria and Greece and studied under a Muslim. He became steeped in Arabic algebra and, in doing so, learned about Hindu numerals.[78] In 1202 he wrote an invaluable book, albeit one with a misleading title. *Liber abbaco* ('Book of the abacus') is not at all about the abacus but is a good treatise on algebra, in which Hindu numerals are thoroughly introduced. It starts by describing 'the nine Indian numerals', together with the sign 0, 'which is called zephirum in Arabic'.[79] Fibonacci also used the horizontal bar in fractions, as had been used for some time in Arabia, but it didn't come into popular usage elsewhere until the sixteenth century.

It was the Arabs in Spain who made great advances in botany. They improved our understanding of germination (which plants grow from cuttings, which from seeds), the properties of soil and, in particular, of manure. In medicine they introduced the idea of cauterisation of wounds, and discovered the 'itch mite'. It was Arabs who conceived the idea of *sharab*, or syrup, originally a mix of sugar and water designed to conceal the taste of unpleasant medication. They also invented 'soda'. In medieval Latin *sodanum* was a remedy for a headache, based on the Arabic *suda*, meaning migraine. Alcohol, alembic and alkali are all Arabic chemical terms, as azimuth (*al-sumut*) and nadir (*nazir*) are astronomical usages.[80]

So far as influence on Western thinking is concerned, the greatest achievement of Muslim Spain was in the *falsafah* of Abu al-Walid Muhammad ibn-Ahmad ibn-Rushd, otherwise known as Averroës. As Sir Philip Hitti has pointed out, thought in Spain was quite adventurous. Ibn Najjah hinted at the possibility of atheism, and Ibn Tufayl showed some awareness of evolution. But, probably, they were too far ahead of their time. Averroës was much more the man of the moment. Born in Cordova in 1126, into a family of judges, he was educated at Cordova's mosque-based university, specialised in law and medicine and became both a doctor and a philosopher. He was the first person to notice that no one is ever afflicted with smallpox twice, the beginnings of the idea of inoculation, and he conceived the function of the retina, a crucial breakthrough.[81] But it is as a philosopher that Averroës had most influence, more so in Christendom than in the Muslim world. He

was commissioned by the sultan in Morocco to prepare a clear text on philosophy. Together with this went an honorarium, a robe of honour and an appointment as chief justice, first in Seville, then in Cordova, where he followed Ibn Tufayl.[82]

Averroës' writings did three things. First, like so many before him, he tried to reconcile the thought of the Greeks, especially Aristotle and Plato, with the Qur'an. Second, he tried to reconcile the role of reason and revelation. Third, he tried to show how various segments of the populace, according to their intellect and education, could relate to these ideas. In the manner of the times, his main work was a commentary on Aristotle, but it was a paraphrase as much as a commentary, in which he attempted to set out Aristotle's, and Plato's, original thought, dismissing later accretions and forgeries, and giving his own gloss. In his devotion to reason, his most important argument was that not all the words of the Qur'an should be taken literally. When the literal meaning of the text appears to contradict the rational truths of philosophers, he said, those verses are to be understood metaphorically. In particular, he argued that he could not accept the theological notion of predestination or corporeal resurrection. For him it was the soul, not the body, which was immortal and this changed the nature of paradise, which could not be sensual. He accepted, with Plato, that benign rulers can bring their people to God. And he advocated that there are three levels of humanity. Philosophy was for the elite (*khass*); for the generality (*'amm*), the literal meaning was sufficient; dialectical reasoning (*kalam*) was for minds in an intermediate position. Averroës' method was as important as his arguments. He introduced a measure of doubt, which was never very popular in Islam but proved fruitful in Christianity. And his idea of several levels of understanding was especially appealing in a religion with a favoured insider class, the clergy. In Venice, in the 1470s alone, more than fifty editions of Averroës' works were published and Averroism became established in the curricula of all the major European universities.[83]

Just as Baghdad and its House of Wisdom had been a major translation centre in the ninth century, so Toledo occupied a similar position after the Christian conquest of the city in 1085. Chronologically speaking, the first person to produce Latin translations of Arabic works was probably Constantine the African (d. 1087), a Tunisian Muslim who converted to Christianity, and who worked in Salerno, southern Italy. He produced fairly poor translations ('barbarous' according to one scholar) of works by Hippocrates and Galen, sometimes passing them off as his own. There were also a number of translators in Sicily, who worked on the Arab *falaysufs*, but the harvest in Toledo was incomparably greater.[84]

Translations from Arabic were made in Catalonia from the tenth century on, and Barcelona was the home of the first Spanish translator we have a name for – Plato of Tivoli. Between 1116 and 1138, with the help of an Andalusian Jew, Savasorda, he translated Jewish and Arab works on astrology and astronomy, but shortly afterwards the centre of these activities shifted to Toledo, which had become a jewel of Graeco-Judaic-Arab culture. Scholars flocked to Toledo to consult the primarily Arabic treasures that had been gathered in Spain during the years of Islamic dominance. The name of the archbishop of Toledo, Raymund (1125–1152), has become associated with this venture, and the term 'Toledo school' has been applied to this otherwise disparate collection of individuals. What seems to have happened is that, to begin with, very few of the Western scholars who arrived in

Toledo understood any Arabic, and they therefore made use of Jewish and Mozarabic scholars already living there (Mozarabs were Christians allowed to practise their faith under strictly controlled circumstances). These individuals turned the Arabic texts into Spanish, and the immigrant scholars then turned the Spanish into Latin. Gradually, however, this situation evolved, as the immigrant scholars themselves learned Arabic. Even so, the spirit of co-operation continued. Just as Plato of Tivoli had co-operated with Savasorda, so two of the most distinguished translators of the Toledo school had their collaborators. Dominicus Gundisalvi, archdeacon of Segovia, worked with the converted Jew Avendeath (Ibn Dawud), better known as Johannes Hispanus, and Gerard of Cremona, probably the best-remembered translator of all, worked with the Mozarab Galippus (Ghalib).[85]

Gundisalvi was the principal translator of the Arabic philosophers – al-Farabi, al-Kindi, al-Ghazali and Ibn Sina included. The pre-eminence of Gerard of Cremona (1114–1187) is testified by the fact that, after his death, his colleagues and pupils in Toledo compiled a biographical and bibliographical note which was inserted into the manuscripts of his many translations. 'From this note we learn that Gerard, scorning the worldly riches which he possessed, led an austere life entirely devoted to science, for love of which he learned Arabic and translated from that language more than seventy works, a list of these being given in the note.'[86] Prominent among these was the *Almagest* (which is how Ptolemy became known in the West), Ibn Sina's *Canon*, and works of Euclid, Aristotle, Hippocrates, Galen, al-Razi, al-Khwarizmi ('the beginning of European algebra') and al-Kindi. In effect, the whole range of Hellenistic-Arabic science, which had inspired the Abbasid culture of the ninth and tenth centuries, was preserved and transmitted by Gerard, who, after spending a considerable number of years in Toledo, returned home to Lombardy to die. To these names, we should add those of two Englishmen, Adelard of Bath, who translated Euclid and al-Khwarizmi, and Robert of Chester, notable for producing the first Latin version of the Qur'an and the first translation of al-Khwarizmi's algebra.[87]

By the close of the thirteenth century, the bulk of Arabic (and therefore Greek) science and philosophy had been transmitted to Europe. Since the land route from the north to the Iberian peninsula lay through Provence and the Pyrenees, the southern French towns – Toulouse, Montpellier, Marseilles, Narbonne – benefited. Translations were carried out at all these locations, with Montpellier becoming the chief centre of medical and astronomical studies in France. At the famous abbey of Cluny, north of Lyons, a number of Spanish monks helped make the abbey a focus for the diffusion of Arab learning. The abbot, Peter the Venerable (1141–1143), sponsored a new Latin translation of the Qur'an. Arab and Greek science passed north from there to Liège, among other places, and then on to Germany and England.

The overall shape of the Arab empire, encircling the east–west Mediterranean (like the Romans before), and extending as far as India, thus had an important role in the development of Europe. Greek learning was preserved, and added to, and by a roundabout route – across north Africa and up through Spain, rather than directly through Byzantium and the Balkans – reached western Europe. The long-term effects of that transmission will emerge over the remaining chapters of this book, but two points are worth making here.

The first is that Europe's initial encounter with the Greeks, Aristotle in particular, but Plato and other authors also, was via Arab 're-elaborations' rather than through direct transmission. For example, the logic, physics and metaphysics of Aristotle were studied either in translations from Arabic translations of the Greek originals, or in the works of Ibn Sina. This meant that, for a time at least, Greek philosophy was overlaid with the Islamic concern of trying to reconcile the Qur'an with rationalism, in particular Ibn Sina's view that passages which did not agree with reason were to be understood allegorically. This had a profound influence on people like Thomas Aquinas and on interpretations of the Bible.

In the second place it meant that Europe for a time accepted the close link established in Islamic thought between philosophy and medicine. This link (evidenced by the fact that the Arabic word *hakim* can mean either physician or philosopher) is seen especially in the works of al-Razi, Ibn Sina and Ibn Rushd. The obvious importance of Arab medicine, recognised in the West, added to the importance of philosophy, so closely associated with it.

Arab knowledge of mathematics, astronomy, medicine and philosophy were of crucial importance in the early days of science in the West. The roundabout route from Baghdad to Toledo kept alive the basic ideas by which we still live today.

# 13

## *Hindu Numerals, Sanskrit, Vedanta*

In the year AD 499 the Hindu mathematician Aryabhata calculated *pi* as 3.1416 and the length of the solar year as 365.358 days. At much the same time he conceived the idea that the earth was a sphere spinning on its own axis and revolving around the sun. He thought that the shadows of the earth falling on the moon caused eclipses. One wonders what all the fuss was about when Copernicus 'discovered' some of the above nearly a thousand years later. Indian thought in the Middle Ages was in several areas far ahead of European ideas. Buddhist monasteries in the India of the time were so well endowed that they acted as banks, investing surplus funds in commercial enterprises.[1] Such details as these explain why historians refer to the reunification of north India under the Guptas (*c.* 320–550) as a golden era. Their dynasty, combined with that of Harsha Vardhana (606–647), comprises what is now regarded as India's classical age. Besides the advances in mathematics, it saw the emergence of Sanskrit literature, new and enduring forms of Hinduism, including Vedanta, and a brilliant temple architecture.

Like the Mauryas before them (see above, Chapter 8), the economic base of the Guptas lay in the rich vein of iron in the Barabar hills (south of modern Patna, in Bihar). Chandra Gupta I, who was no relation to the Chandragupta who had founded the Mauryan dynasty, celebrated his coronation at Pataliputra in February 320 by striking a coin and taking the Sanskrit title Maharajadhiraja, or 'Great King of Kings'. By means of a series of conquests, and marital alliances, Chandra Gupta – or his son Samudra, 'skilled in a hundred battles' – routed nine kings of northern India, eleven more in the south, and made another five, on the periphery of empire, pay tribute: twenty-five rival clans were subdued. The highpoint of Gupta classicism, however, came in the reign of Samudra's son, Chandra Gupta II (*c.* 375–415). His most spectacular deed, if it ever happened, was recorded in a Sanskrit play composed later, possibly in the sixth century. This drama tells of how Chandra's elder brother Rama, a weak man, agreed to surrender his wife to a Shaka king who had humiliated him in battle. The cunning Chandra dressed as the wife and, as soon as he was admitted to the Shaka harem, killed the king and escaped. There may be something in the story, for the coins struck at the time show that the Shakas were indeed defeated by the Guptas in 409 (i.e., during Chandra Gupta II's reign), after which they had control over the ports on the west coast of India, which gave access to the lucrative trade of the Arabian Sea. More political marriages followed, so that Gupta territory – direct rule, tributary or influence – extended for all of modern India, save for the extreme south-west and the extreme

north. In terms of territory controlled, the Guptas were probably the most successful Indian dynasty of all time.[2]

The second Chandra Gupta's reign is better documented than most. He was written about in an important inscription, displayed on a pillar in the city of Allahabad; there also exists a vivid, detailed diary from that era kept by a Chinese Buddhist pilgrim, Faxian; in addition, Kalidasa, 'the Indian Shakespeare', probably wrote his plays and poems at that time; and finally, a new aid to historians appeared around then.

To take the last first, there emerged in the early centuries AD a corpus of land charters which evolved into what was virtually a literary form. To begin with they were written on palm leaves, but since these were hardly durable the charters began to be engraved, sometimes on cave walls, but more and more on copper plates. These charters, or *sasanas*, recorded the gift of land, usually donated by the king. That made them precious, which is why they were kept. Some were kept hidden, some were built into the fabric of a mansion or a farm, much as early deities had been encased in walls in the first civilisations of the Middle East. Where they were unusually complicated, the charters were recorded on several plates, which were held together by a metal ring.[3] But what made them historically important was the fact that they were more than just commercial dockets. They would begin with an elaborate panegyric to the royal donor and, even allowing for rhetorical exaggeration, these panegyrics became valuable historical records, listing which kings lived when, and incorporating other political and social details from which history could be reconstructed. They would end threatening dire penalties for anyone who went against the charter – for example, the penalty for overruling *sasanas* was commonly equated with that of killing 10,000 Varanasi cows, 'a sacrilege of unthinkable enormity'.[4] Without the copper plates we should know much less about the Guptas than we do.

Turning to the Allahabad inscription, this is probably the most famous in all India. It is written in a script known as Gupta Brahmi, but composed of Sanskrit verses and prose.[5] The earliest evidence for the alphabet in India comes from the third century BC, when two forms, Kharosthi and Brahmi, appear fully developed in the Ashokan inscriptions. The Kharosthi alphabet, written from right to left, was confined to north-west India, areas that had once been under Persian domination. It was an adaptation of the Aramaic alphabet and died out in the fourth century AD. The Brahmi alphabet, written from left to right, is the foundation of all Indian alphabets and of those other countries which came under Indian cultural influence – Burma, Siam, Java. It is derived from some form of Semitic alphabet but the exact evolution is unknown.[6] Until the invention of printing, Sanskrit was written in regional alphabets but with the adoption of type the north Indian alphabet known as Devanagari became standardised. The commonest writing material, to begin with, was palm leaf, which meant that most ancient manuscripts have perished. Thus the bulk of Sanskrit literature is preserved in manuscripts belonging to the last few centuries.[7] Chandra Gupta, it seems, intended the Allahabad inscription as an addition to the Edicts of Ashoka (see Chapter 8, page 187). Now in Allahabad, it is likely that the pillar was removed down-river from Kausambi, an ancient and architecturally distinguished city in the Ganges basin where some of the earliest examples of the arch have been found. It is through these pillar inscriptions that we know about Gupta campaigns and conquests and how Chandra distributed 100,000 cows as gifts to his Brahman supporters.[8] After the

inscription was translated into western languages in the nineteenth century, he was labelled 'the Indian Napoleon'.

To Faxian, a Buddhist pilgrim from China, visiting India at the very beginning of the fifth century, around the time of the final defeat of the Shakas, Gupta territory seemed little short of perfect. He records how he was able to travel the length of the Ganges in absolute safety, as he visited all the sites associated with the Buddha's life.[9] 'The people are very well-off, without poll tax or official restrictions ... The kings govern without corporal punishment; criminals are fined according to circumstance, lightly or heavily. Even in cases of repeated rebellion they only cut off the right hand. The king's personal attendants, who guard him on the right and on the left, have fixed salaries. Throughout the country the people kill no living thing nor drink wine, nor do they eat garlic or onions ...'[10] He found highly influential guilds, which governed the training of craftsmen, the quality control of goods, pricing and distribution.[11] The leaders of the various guilds met regularly, like a modern chamber of commerce.[12] He found, however, that Kapilavastu, the Buddha's birthplace, was abandoned, 'like a great desert', with 'neither king nor people'. Ashoka's palace at Pataliputra was likewise in ruins.[13] Yet Buddhism still had huge popular support in India. Faxian counted hundreds of stupas – some colossal – together with well-endowed monasteries, housing thousands of monks. Though Ashoka's palace might be abandoned, at Pataliputra Faxian witnessed an impressive annual festival, marked by a procession with some twenty wheeled stupas, lined with silver and gold.

It was now that Sanskrit came into its own. It was the 'discovery' of Sanskrit in the eighteenth century, and its relation to other languages, such as Latin and Greek, that began the whole enterprise of comparative philology. This is considered more fully below, in Chapter 29, but a few examples will show the overlap between Sanskrit and other 'Indo-European' languages. The Sanskrit word *deva*, 'god', lives on in the English words 'deity' and 'divinity'. The Sanskrit for 'bone', *asthi*, was echoed in the Latin *os*. 'In front of' = *anti* in Sanskrit, *ante* in Latin. 'Quickly' is *maksu* in Sanskrit, *mox* in Latin. 'Sneeze' = *nava* in Sanskrit, *niesen* in German.

More than most languages, Sanskrit embodies an idea – that special subjects should have a special language. It is an old tongue, dating back more than three thousand years. In its earliest period it was the language of the Punjab, but then it spread east. Whether the authors of the *Rig Veda* were Aryans from outside India, or indigenous to the area, as was discussed in Chapter 5, they already possessed a language of great richness and precision and a cultivated poetic tradition.[14] As was also described in Chapter 5, the custodians of this liturgical poetry were the families of priests, who eventually evolved into the Brahman/Brahmin caste. This poetry was developed in the centuries before about 1000 BC, after which the main developments were in prose, devoted to ritual matters. This prose form of Sanskrit was slightly different from the poetic, showing traces of Eastern influence. For example, the use of 'l' replaced the use of 'r', a sound-shift that also occurred in China. But both the poetic and prose literature was entirely oral at that time. It had changed a little, inevitably, but the families whose task it was to preserve the material had performed amazing feats of memory and so the language had changed far less than might be expected, and far less than the vernacular languages spoken by the rest of the population. Pre-classical Sanskrit literature is divided into the *Samhitas* of the *Rig Veda* (1200–800

BC), the Brahmana prose texts, mystical interpretations of the ritual (800–500 BC), and the *Sutras*, detailed instruction about ritual (600–300 BC).[15]

Then, some time in the fourth century BC, there came Panini and his *Grammar*. The importance of the grammarians in the history of Sanskrit is unequalled anywhere else in the world. The pre-eminence of this activity arose because of the need to preserve intact the sacred texts of the *Veda*: according to tradition, each word of the ritual had to be pronounced exactly. Almost nothing is known of Panini's life save for the fact that he was born at Salatura in the extreme north-west of India. His *Astadhyayi* comprises four thousand aphorisms. These describe in copious detail the form of Sanskrit in use by the Brahmans of the time. Panini was so successful in his aim that, uniquely, the Sanskrit language as described by him was fixed *for all time*, and was ever after known as *Samskrta* ('perfected').[16] Panini's achievement lay not only in his great efforts to describe the language completely but in the effect this had on language evolution in India. Even by then, the 'Aryan' language existed in two forms. Sanskrit was the language of learning, and ritual, reserved to the Brahman caste. On the other hand, Prakrit was the language of everyday intercourse. These actual terms did not come into use until much later, but the distinction had been there even by the times of the Buddha and Mahavira, and from Panini's time, as a result of his *Grammar*, normal linguistic evolution took place only in the vernacular tongue. It was a curious situation, highly artificial, and paralleled nowhere else. Even more curiously, although the gap between Sanskrit and Prakrit grew larger as the centuries passed, Sanskrit did not suffer. If anything, the opposite was true. For example, during Mauryan times, as can be seen from the inscriptions of Ashoka's reign, the language of administration was Prakrit. Over the following centuries, however, it was gradually replaced by Sanskrit, until by Gupta times it was the only tongue used for administrative purposes. An equivalent change took place among Buddhists. Originally, according to the Buddha himself, the texts and scriptures were to be preserved in the vernacular languages, a form of Middle Indo-Aryan known as Pali. But, in the early centuries AD, the northern Buddhists turned away from Pali: the old scriptures were translated – and new ones written – in Sanskrit. Exactly the same thing happened with the Jains, though at a much later date.[17] The 'modern' languages of India – Bengali, Hindi, Gujarati, Marathi – only begin to be recorded from about the end of the first millennium AD.[18]

General literacy began in India about the time that Panini compiled his *Grammar*. After this, for about two hundred years, most written Sanskrit texts were religious, but secular poetry, drama, scientific, technical and philosophical texts began around the second century BC. At that stage, all men of letters had to know the *Astadhyayi* by heart. This was a prolonged process but it showed they were educated.[19] As time passed, the rules Panini had set out were enforced more strictly – this was in an attempt to keep the language of learning and of sacred subjects pure. As sometimes happens, this strictness encouraged rather than hindered creativity, helping to stimulate the golden age of Sanskrit literature, which flourished in India between AD 500 and 1200, beginning with the most famous name of all, Kalidasa. It is important to add that the classical tradition in India is in essence secular. Religious scripture (*agama*) and scholarly writing (*sastra*) are usually distinguished from 'literature' (*kavya*).[20]

Kalidasa's origins are no more certain than Panini's. His name means 'slave of the

goddess Kali', which to some has suggested a birth in southern India, though Kali, a consort of Shiva, had a strong following in what became Bengal. At the same time, certain features of Kalidasa's writing hint that he was a Brahman from Ujjain or Mandasor (many details betray a close acquaintance with the fertile Narmada valley, in the region of Malwa). As with the plays of Sophocles, seven of Kalidasa's Sanskrit classics have survived. First and foremost, he was a lyric poet, but he composed epics and dramas as well. His most familiar work is the poem *Meghaduta*, 'Cloud Messenger', in which a lover attempts to send his beloved a message by means of a passing cloud at the beginning of the rains. During the course of this narrative, the cloud passes from the Vindhyas, the holy mountain range north of the Deccan plateau, to the Himalayas, floating above a landscape that changes and brings out the cloud's feelings – beautiful rivers, impressive mountains, elaborate palaces. But Kalidasa's most evocative drama is *Shakuntala*, about King Dushyanta, who comes across a beautiful nymph one day while he is out hunting. So captivated is he that he deserts his wife and court and consummates a union with the bewitching nymph. Eventually he returns to his court and in time forgets her. Later, when the king's son by Shakuntala appears in the capital, he at first refuses to recognise the boy. What stands out in this story, which is, after all, a simple plot, is the deceptive reality of Kalidasa's dialogue, the mutable humanity of his characters, the way he finds beauty everywhere. It was in particular Kalidasa's understanding and depiction of character, the way it can grow and develop – or deteriorate – that prefigured Shakespeare.[21]

The Guptas had their own theory about drama, described by Bhamaha (fifth century?), the earliest literary critic/theoretican there is evidence for, though he was adapting a much older tradition, the *Natyasastra* of 'Bharata' (the mythical first 'actor'). According to the *Natyasastra*, drama was invented to describe the conflicts that arose after the world declined from the golden age of harmony.[22] The main idea in the *Natyasastra* was that there are ten types of play – street plays, archaic plays about the gods, ballets, etc. – which explore the eight important emotions: love, humour, energy, anger, fear, grief, disgust and astonishment. It was the purpose of the drama, on this reading, to imitate the main events of the world and to give the audience various types of aesthetic appreciation (it was not the dramatist's aim simply to induce the audience to identify with the characters). The drama 'should show the audience what it meant to be sensitive, comic, heroic, furious, apprehensive, compassionate, horrified, marvellous'. Drama was to be enjoyable but the theatre should be instructive too. Bhamaha extended this analysis to literature as a whole.

The advanced brilliance of Indian literature at this time is reinforced by the fact that its ideas and practices spread throughout south-east Asia. Gupta-style Buddhas are found in Malaya, Java and Borneo.[23] Sanskrit inscriptions, which are first seen in Indo-China in the third and fourth centuries, are thought to indicate the beginnings of literacy there, 'nearly all the pre-Islamic scripts of south-east Asia being derivatives of Gupta Brahmin'.[24]

It was under Gupta rule that the Hindu temple emerged as India's classical architectural form. It is difficult to overestimate the importance of the Hindu temple. The world owes a great debt to Indian art, especially in China, Korea, Tibet, Cambodia and Japan, but in the West too. Philip Rawson, of the Gulbenkian Museum of Oriental Art at the University of Durham in the United Kingdom, describes it this way: 'Certain symbols and images

which appear in later historical art first showed themselves in the miniature sculptures, in the seals and the sealings of the Indus Valley. Examples are the ithyphallic deity seated with knees akimbo as "lord of the beasts", the naked girl, the dancing figure with one leg lifted diagonally across the other, the sacred bull, the stout masculine torso, the "tree of life", and innumerable modest types of monkeys, females, cattle, and carts modelled in terracotta.'[25]

Historically, Hinduism did not stipulate any permanent structure for its rituals. Hindus were free to make offerings anywhere in the countryside where the gods chose to reveal their presence.[26] During the second century AD, however, Hinduism started to reflect an alliance with the Indian theory of kingship, under which individual deities were adored by kings in order that they might associate themselves with the god's supernatural power. As a result, the evolution of Hindu stone architecture and temple carving took place at scattered – but highly elaborate – single sites which were for a time the capital cities of dynasties. The Brahmans used these sites in their sacred texts – the Puranas – to create legends which attracted pilgrims, many of whom built other temples. In this way temple complexes became a feature of Indian religious/architectural life.

As was true in classical Greece, the Hindu temple was understood as the home of a deity, with an icon inside, where people could offer gifts and pray. Every building was dedicated to a specific god – often some manifestation of Vishnu, Shiva and so on. (As in epics, the major gods tended to be accretions, of other cults, local deities, nature-spirits etc.) The design of the early temples was divided into three. On the outside was a porch, often decorated in sculpted reliefs showing the deity in various mythological scenes. Inside was a large, square hall, the ambulatory or *mandapa*, where the faithful could assemble and, sometimes, dance. This led to the third area, the sanctuary (the shrine-room, *garbha-griha*, means 'womb-house'). The temples were usually built of stone blocks, fitted together without mortar, and the entire complex was raised on a paved rectangle, intended to represent the cosmos in miniature, thus making the temple analogous to heaven. From such simple beginnings, the temples grew into flamboyantly ornate structures, some into entire cities. Many temples were later surrounded by concentric rings of enclosures with huge gates, and each was conceived as 'an axis of the world', symbolically representing the mythical Mount Meru, the central feature in the Hindu sacred cosmology.[27] Associated with the temple complexes were architectural schools.

The iconography of Indian temples obviously stems from different assumptions from Christian art, but it is no less closely conceived and no less interlocking. In general Hindu images are far more archaic than Christian ones, and in many cases older even than Greek art. The myths of the great gods – Vishnu and Shiva – which feature in the carvings, are repeated every *kalpa* – i.e., every four billion, three hundred and twenty million years. All the gods are customarily accompanied by or associated with vehicles – Vishnu by a cosmic serpent or snake (symbol of the primaeval waters of creation), Brahma by a gander, Indra by an elephant, Shiva by a bull. The gander was chosen, for example, because it exemplifies the two-fold nature of all beings: it swims on the surface of the water but is not bound to it.[28] The breathing noise of the gander is what the practitioners of yoga seek to attain – in fact, the rhythm of yogic breathing is known as 'the inner gander'.[29] The elephant, which traditionally supports Indra, is called Airavata, the celestial ancestor of all elephants and

symbol of the rain-bestowing monsoon-cloud.[30] Because elephants are the vehicle of Indra, king of the gods, elephants belong to kings.[31]

The basic and most common object in Shiva shrines is the lingam or phallus, a form of the god that goes all the way back to stone worship in the Neolithic period (see above, Chapter 3). There are elaborate myths in Hindu legend about the origins of the great lingam, which rises up from the ocean and then bursts open, to reveal Shiva inside. This is faintly reminiscent of the Aphrodite legend in Greek myths.

One of the most familiar figures from Indian art is that of Shiva represented as a dancing god, Nataraja, with four arms, surrounded by a ring of fire. This is a good example of the way Indian iconography works. Shiva, the divine dancer, lives on Mount Kailasa with his beautiful wife Parvati, his two sons, and his bull, Nandi. This is a form of family life, worshipped through the lingam. As the divine dancer, Shiva's steps will both dance the universe out of existence and create a new one.[32] (Dance in Indian tradition is an ancient form of magic, which can induce trance. But it is also an act of creation that can 'summons' the dancer to a higher personality.[33]) The upper right hand of Nataraja usually carries a drum, for the beating of rhythm. This evokes sound, the vehicle of speech, through which revelation will be obtained. Sound in India is associated with ether, the first of the five elements, out of which the others arise. The upper left hand holds a tongue of flame, the element of destruction and a warning of what is to come. The second right hand displays a 'fear not' gesture, while the second left hand points down to the foot that is raised, symbolising release from the earth and, therefore, salvation. The entire figure is dancing on a demon, not merely to show victory, but to show man's ignorance, because the attainment of true wisdom stems from the conquest of the demon. The ring of flames is not only fire but light, symbolising the potentially destructive forces abroad on earth but also the light of truth. This does not in any way complete the many meanings of this figure (the actual pose, for example, symbolises the 'whirligig of time'), but it conveys the interlocking nature of Indian iconography without which the temples of India cannot be understood.

A few dozen temples from the Gupta era survive, at Sanchi, Nalanda, Buddh Gaya and other sites in Madhya Pradesh, Uttar Pradesh and Bihar. But it is at Aihole and Badami, 200 miles south-east of modern Mumbai, that a 'feast of architecture and sculpture' marks the real arrival of the new form. At Aihole, the seventy or so temples are embellished with inscriptions of the poetry of Ravikirti, in one of which there is the first dated reference to Kalidasa. These were followed by the great stone-cut temples at the Pallavas' main port, Mamallapuram, half-way down the eastern coast (the Pallavas were a later dynasty – we are now in the late seventh/beginning of the eighth century). Carved out of granite hillocks, the 'seven pagodas' of Mamallapuram are among the finest examples of south Indian sculpture-cum-architecture. Much of the art of Cambodia and Java, including Angkor and Borobudur, was Hindu-Buddhist.[34]

A slightly later dynasty, the Rashtrakutas, patronised the site at Ellora (220 miles north-west of Mumbai). Here there is an exposed rock face two kilometres from end to end which had for long been dotted with cave temples. Out of this rock face, Krishna I, the Rashtrakuta king, began to carve what became without question the most impressive rock-cut monument anywhere in the world. Kailasa, so-called, was carved out of the rock until

it was an entirely free-standing excavation, a temple the size of a cathedral, containing individual cells for monks, staircases, shrines, precincts and gateways all cut from the raw rock. As John Keay rightly says, this may appear to be architecture, but it is in fact sculpture. Local inscriptions hint that even the gods were impressed and the sculptor himself was emboldened to remark 'Oh, how was it that I created this?' The sculpture/temple also throws light on the motivation of the Rashtrakutas. Mount Kailasa, in the Himalayas, is considered to be the earthly abode of Lord Shiva. In being hewn from the living rock, the Kailasa temple at Ellora was intended to reposition the holy mountain within Rashtrakuta territory, to bring the sacred geography of India inside their province.[35]

The subcontinent's largest concentration of temples, however, occupies Bhuvaneshwar, the capital of Orissa. Orissa and Khajuraho never fully succumbed to Islam, and at the latter site, twenty-five temples remain out of eighty, grouped around a lake.[36] Some have dance rooms separate from the main temple, and all have elaborate figure sculpture cut in deep relief, many in erotic postures and all profoundly sensual. It is important to say that, iconographically, the erotic carvings are intended to represent the delights awarded by celestial girls – called *apsaras* – *after* this life (though this is a big subject, very controversial, with much scholarship attached). Many critics regard these figures as the finest achievement of Indian art. In addition to the elaborate sculptures, the temples were covered in paintings, wall hangings and encrusted with jewels, most of which have been looted.

The temples at Orissa are probably the most impressive of all: they comprise two hundred but were once many more. The earliest were built in the seventh century, the latest in the thirteenth. Densely packed, vaguely egg-shaped, with large vertical flutes and many horizontal vanes, the concentration of buildings is intended to overwhelm the spectator, and the very idea of the complex may have been a response to the Islamic invasion of India. These complexes appear to have been spared by the invading Muslims only because they were so remote, and so soon abandoned to the jungle. They were rediscovered in the nineteenth century by a certain Captain Burt, who 'found the site choked with trees and its elaborate system of lakes and watercourses overgrown and already beyond reclaim. Like Cambodia's slightly later Angkor Wat when it was "discovered" by a wide-eyed French expedition, the place had been deserted for centuries and the sacred symbolism of its elaborate topography greedily obliterated by jungle.'[37] Since then, analysis of the inscriptions has resurrected some Chandela history, and exploration of the iconography has shown how important the sites were for Shiva worship.

For many people, the most impressive as well as the most beautiful single temple in all India is that built at Tanjore by the Chola kings in the early eleventh century. The Cholas were a Dravidian (south Indian) people who had occupied the Kaveri delta since prehistoric times. Kaveri underwent a revival beginning in 985 with King Rajaraja I, who decided, towards the end of his reign, to memorialise his achievements by building a temple in Tanjore. Erected over about fifteen years, it may well be the tallest temple in India, nearly 200 feet high and crowned by an eighty-ton domed capstone.[38] It bears an important inscription and is decorated with rare Chola paintings, showing Shiva mythology and celestial female dancers. There is a huge lingam in the main shrine, showing that Tanjore is dedicated to Shiva. The temple was the centre of a huge complex, with perhaps five hundred Brahmans and the same number of musicians and dancing girls taking part in

the ceremonies. For hundreds of miles around, people donated money and land to the temple, as did villages, offering tithes.[39] The Chola produced famous bronzes, many of the kind considered above, with Shiva as Nataraja, Lord of the Dance, surrounded by a circle of flame.

The Hindu temples of India are one of those self-evident glories that have never broken through in the West as artistic and intellectual equivalents of, say, classical Greek architecture. Yet they are easily on a par with the Hellenic achievements, being, like them, as much sculptural as architectural in conception.[40] The main thing to grasp is that both temples and sculpture reflect a set of ideal canons of form. The assumptions underlying these canons are not Western but they follow sacred principles and proportions which were handed down from generation to generation. On top of this, Western notions of 'classicism' do not incorporate the sensual, erotic exuberance that is such a central ingredient of Indian classicism. But we should never forget that this sensual nature of Indian art is not worldly. It is meant to remind the faithful of what awaits them in heaven, of the inadequacy of beauty here on earth, and the inconstancy of earthly pleasures. In a sense, this is what Plato was driving at – nevertheless, Indian art and architecture challenge the very idea of what classicism is.

The success of the Guptas was not confined to India. Embarking from the port of Tamralipti in Bengal (then called Vanga), Indian ships exported in the main pepper but also cotton, ivory, brassware, monkeys and elephants as far as China, bringing back silk, musk and amber. (Neither tea nor opium were yet traded.) But India, which had already exported Buddhism, now exported Hinduism and Sanskritic culture. The Hindu kingdom of Funan, now Vietnam, was ruled by the Brahman Kaundinya, and Bali, parts of Sumatra and Java also became 'islands of Hindu'. It is likely that literacy reached these parts of the world with the arrival of Sanskrit.[41]

But Gupta dominance didn't endure. The fifth generation of the dynasty, Skanda Gupta, was the last. Soon after his accession in 455, the Hunas (or Huns) massed on his northwest frontier and the cost of resistance drained the Gupta treasury. After Skanda's death in 467, the empire declined rapidly and, just before 500, Toramana, the Huna leader, took the Punjab, while his son later absorbed Kashmir and the Gangetic plain. By the middle of the sixth century Gupta glory had entirely faded. Half a century of fragmentation followed until, in 606, a line of later Guptas, not related to the imperial clan, emerged. The most remarkable of these was the first, Harsha Vardhana, who sought once again to unify all of north India. Like Chandra Gupta I, his brilliance was recognised and recorded at the time, once by a Brahman courtier, Bana, who wrote a hagiographical life of Harsha, *Harsha Carita*, as well as a more discerning record, by yet another visiting Buddhist pilgrim from China. This was Xuan Zang, whose journey, *In the Footsteps of the Buddha*, took him to Harsha's India between 630 and 644.

Harsha expanded his empire, but we remember him now as much for the fact that he was a poet as well as a warrior, for the fact that he rescued his sister as she was about to follow her husband on to the funeral pyre, and most of all for the important innovations in religious and philosophical ideas that occurred during his reign. It was under Harsha's rule that Hinduism grew so much in popularity, at the expense of Buddhism, taking on

its 'classical' form of worship, or *puja*. This entails the faithful bringing offerings – fruit, candies, other delicacies – to the sculptures or other images of the gods in the temples, together with the performance of certain secret rituals, all having to do with 'female power', or *shakti*, which have come to be known as Tantric. Tantrism is almost certainly a very old form of worship, associated with the ancient mother goddess, but just how and when its orgiastic nature began isn't clear. The basic beliefs of Tantrism are very different from either orthodox Hinduism or Buddhism and their very popularity, say some scholars, must attest to the fact that the ideas are very ancient. The basic belief was that true worship of the mother goddess could be achieved only by sexual intercourse (*maithuna*). In time this led to group intercourse, often performed at so-called 'polluted' cremation grounds. These episodes were also associated with the breaking of other taboos, such as eating meat and drinking alcohol.[42]

Tantrism affected (some would say infected) Buddhism as well, leading in the seventh century to a third form, after Hinayana and Mahayana. This was Vajrayana ('Vehicle of the Thunderbolt'), which introduced as its most powerful divinities a number of female saviours, known as *taras*, who were the consorts of 'weaker' Buddhas and Bodhisattvas.[43] In other words, Tantric Hinduism and Tantric Buddhism both exalted the female principle, regarding this as the highest form of divine power.

Tantric worship became secret and secretive because its practices were unacceptable to many of the orthodox, but its intimate connection with yoga added to its popularity. Yoga was practised because control of breathing and the body were essential components for the proper performance of *maithuna*. And yoga, as a system of thought, now emerged as a more codified organisation of beliefs, with the 'eight-fold' path of 'royal yoga', *raja yoga*. These eight paths were: self-control, the observance of proper conduct, the practice of correct posture (*asana*), breath control (*prana*), organic restraint, mind steadying, the perfect achievement of deep meditation (*samadhi*), and the absolute freedom of *kaivalya*.[44]

But yoga was only one of six schools of classical Hindu philosophy which emerged at the time of Harsha Vardhana. These six were generally grouped in three couplets. Yoga, for instance, was coupled with Samkhya, or the 'Numbers School', which may also be of ancient origin. According to the Samkhya philosophy, the world consists of twenty-five basic principles, all but one of which are 'matter' (*prakriti*), the other being *purusa* – man, spirit or self. In this system there is no creator, nothing divine, all matter is eternal, un-caused. But all matter has three qualities in varying degrees – it is either more or less truthful, more or less passionate, more or less dark. The mix of these qualities determines how virtuous or noble something is, how inert, cruel, strong or bright and so on.[45] The twenty-four forms of matter show some measure of evolution, in that they begin with *prakriti*, which 'brings forth' intelligence (*buddhi*), from which arises what we would call ego-sense (*aham kara*), giving rise to mind (*manas*). From mind the five senses emerge, and from them the five sense organs and the five organs of action. Underneath all matter lie the five elements – ether, air, light, water, earth. *Purusa*, the sense of being an individual, with one's own spirit, carries with it the idea that all people are equal but at the same time all are different. Salvation is achieved only when a person realises the basic separation between *purusa* and *prakriti*, which enables the spirit to cease suffering and attain complete

release. These very mystical ideas clearly overlap with Platonism and Gnostic beliefs from Greece and Alexandria.[46]

The other two couplets of classical Hindu philosophy are Nyaya/Vaisesika and Purva-mimansa/Vedanta. The Nyaya philosophy (or vision, *darshana* in Hindi) means 'analysis' and it teaches salvation through knowledge of sixteen categories of logic. These categories include syllogism, debate, refutation, quibbling, disputation and so on. Coupled with Nyaya, Vaisesika means 'individual characteristics' and is known as India's 'atomic system' since its basic premise is that the material universe emerges from the interaction of individual atoms that make up the four elements – earth, water, fire and air. Vaisesika also envisages non-atomic entities (*dravyas*), such as soul, mind, time and space. Once again, perfect knowledge leads to salvation, when the 'self' is released from matter and therefore from the cycle of death and rebirth. Nyaya, like yoga, is a system of behaviour, or way of thinking, whereas Vaisesika, like Samkhya, is a set of explanations as to how matter and mind are organised and are different from one another.[47]

Purva-mimansa ('early inquiry') was a form of fundamentalism, which took the *Rig Veda* as literal truth and therefore insisted that salvation could only be achieved by precise re-enactment of the Soma sacrifice.[48] The emphasis on ritual, and the absence of new ideas, seems to have ensured that Purva-mimansa lost adherents as time went by. In strong contrast, Vedanta ('end of the Vedas', and sometimes called 'later inquiry', Uttara-mimansa), has become India's most influential philosophical system, developing many subsidiary forms that have appealed to a wide range of thinkers and intellectuals down the ages, and not only in India. Again in contrast to Purva-mimansa, Vedanta takes its starting point from the speculations of the Upanishads, rather than Rig Vedic sacrifice, and seeks a synthesis of all seemingly contradictory Hindu scripture. It posits the existence of the 'Absolute Soul' in all things.

The most successful Vedanta teacher, and the second most-revered person in Indian history, after the Buddha himself, was Shankara (*c.* 780–820). He was a Brahman who, during his short career, wandered from his Kerala home to the Himalayas developing his idea that our world is an illusion (*maya*), and that the one reality was Brahman, or Atman, the world-spirit or soul.[49] Shankara's most famous doctrine was Advaita (literally, 'no second', or, as we would say, monism). In Advaita, Shankara maintained that nothing in the phenomenal universe is real, everything is a secondary emanation from the one 'ultimate, absolute being', the 'impersonal neuter entity' known as the Brahman, which had three attributes, being (*sat*), consciousness (*chit*) and bliss (*ananda*). Brahman, for Shankara, was unchanging and eternally stable and for Westerners sounds very mystical, like a cross between Plato's The One and Aristotle's Unmoved Mover.[50] Everything else in the universe, because it was at some level unreal, was subject to change. In humans, this takes the form of *samsara*, transmigration.

In one of his poems, Kalidasa mentions a revolving water-spray, for cooling the air. In antiquity and the Middle Ages, Hindu ingenuity was second only to Chinese, reflected also in the fact that, by the first century AD, Hindu doctors had perfected twenty kinds of knives for different surgical procedures. At the same time, their mathematicians conceived the notion of the *rasi*, a 'heap' of numbers, which recalls an ancient Egyptian idea that

may be regarded as the ancestor of the algebraic concept of *x*, for an unknown quantity.

In India, as in Egypt, mathematics appears to have begun with temple-building, where a system of ropes of different lengths was used for the laying out of holy sites, for the construction of right-angles and for the correct alignment of altars. This lore was set down in a series of *Sulvasutras*, *sulva* referring to the ropes or cords used for measurement, and *sutra* meaning a book of rules or aphorisms relating to a ritual or science.[51] Three versions of the *Sulvasutras*, all in verse, are extant, the best-known bearing the name of *Apastamba*. They are dated to anywhere between the eighth century BC and the second century AD. For that reason, we cannot be certain whether the ideas were originally worked out in India, or taken from Mesopotamia or the Hellenistic world. But Indian arithmetic certainly began in the temple: sacred formulas were conceived, for example, for the number of bricks to be used on altars.[52]

More reliably dated are the *Siddhantas*, 'systems' (of astronomy), of which there are five versions, all written around the turn of the fifth century, and which were early examples of the Sanskrit revival. Here too Hindu scholars insist that the ideas in the *Siddhantas* are original, whereas others see definite signs of Greek influence.[53] Whatever the truth of this, it was in the *Siddhantas* that the Hindus refined and expanded the trigonometry of Ptolemy. In the opinion of H. J. Winter, 'Hindu mathematics is undoubtedly the finest intellectual achievement of the subcontinent in medieval times. It brought alongside the Greek geometrical legacy a powerful method in the form of analysis, not a deductive process building upon accepted axioms, postulates, and common notions, but an intuitive insight in the behaviour of numbers, and their arrangement into patterns and series, from which may be perceived inductive generalisations, in a word algebra rather than geometry ... The quest for wider generalisation beyond the limits of pure geometry led the Hindus to abandon Ptolemy's methods of reckoning in terms of chords of a circle and to substitute reckoning in sines, thereby initiating the study of trigonometry. It is to the philosophical mind of the Brahman mathematician engrossed in the mystique of number that we owe the origin of analytical methods. In this process of abstraction two particularly interesting features emerged, at the lower end of achievement the perfection of the decimal system, and at the higher the solution of certain indeterminate equations.'[54] Ptolemy's trigonometry had been based on the relationship between the chords of a circle and the central angle they subtended. The authors of the *Siddhantas*, on the other hand, adapted this to the correspondence between a half of a chord and half of the angle subtended by the whole chord. And this was how the predecessor of the modern trigonometric function known as the sine of an angle came about.[55]

The second innovation of the Indians was the invention/creation of Hindu numerals. This was primarily the work of the famous Indian mathematician Aryabhata, introduced at the beginning of this chapter. In 499 he produced a slim volume, *Aryabhatiya*, written in 123 metrical verses, which covered astronomy and, for about a third of its length, *ganitapada*, or mathematics.[56] In the latter half of this work, where he is discussing time and spherical trigonometry, Aryabhata uses a phrase, in referring to numbers used in calculation, 'from place to place each is ten times the preceding'. 'Local value' had been an essential part of Babylonian numeration but they didn't use a decimal system. Numeration had begun in India with simple vertical strokes arranged into groups, a repetitive system

which was retained although the next move was to have new symbols for four, ten, twenty and one hundred. This Kharosthi script gave way to the so-called Brahmi characters, referred to earlier, which was similar to the Ionian Greek system, as follows:

| **A** | **B** | **Γ** | **Δ** | **E** | **F** | **Z** | **H** | **Θ** | **I** | **K** |
|---|---|---|---|---|---|---|---|---|---|---|
| 1 | 2 | 3 | 4 | 5 | 6 | 7 | 8 | 9 | 10 | 20 |
| **Λ** | **M** | **N** | **Ξ** | **O** | **Π** | **ꟼ** | **P** | **Σ** | **T** | **Y** |
| 30 | 40 | 50 | 60 | 70 | 80 | 90 | 100 | 200 | 300 | 400 |

From this arrangement two steps are needed to arrive at the one we use today. The first is to grasp that under the positional system only nine ciphers are needed – all the others, from **I** onwards in the above table, can be jettisoned. It is not certain when this move was first made but the consensus of mathematical historians is that it was taken in India, perhaps developed along the border between India and Persia, where remembrance of the Babylonian positional system may have sparked its use with the Brahmi alternative, or on the border with China, which had a rod system:

This may also have suggested the contraction to nine ciphers.[57]

The earliest literary reference to the nine Hindu numerals is found in the writings of a Syrian bishop called Severus Sebokt. It will be recalled from Chapters 11 and 12 that Justinian had closed the Athenian philosophical schools in the sixth century, whereupon some of the Greek scholars decamped to Syria (while some went to Gondeshapur). It may be that Sebokt was irritated by the fact that these Greeks looked down on learning elsewhere for 'he found it expedient to remind those who spoke Greek that "there are also others who know something" '.[58] To underline his point, he went on to refer to the Hindus, their discoveries in astronomy and in particular 'their valuable methods of calculation, and their computing that surpasses description. I wish only to say that this computation is done by means of nine signs.'[59]

Note the mention of nine signs, not ten. At that point, evidently, the Hindus had not yet taken the second crucial step to the modern system – notation for the zero symbol. According to D. E. Smith, in his history of mathematics, 'the earliest undoubted occurrence of a zero in India is in an inscription of 876' – in other words, more than two centuries after the first mention of the use of the other nine numerals. It is still not certain where the zero was first introduced, and the concept of nought, or emptiness, was independently arrived at by the Mayans, as we shall see in a later chapter. Joseph Needham, the Cambridge-based historian of Chinese science, favoured China as a source of the zero. 'It may be very significant,' he wrote, 'that the older literary Indian references simply use the word "*sunya*" – emptiness, just as if they are describing the empty spaces on Chinese counting boards.'[60] A Cambodian inscription of 683 uses the dot or *bindu* to represent zero, while

an inscription on Bangka island (off the coast of Sumatra) of 686 shows the closed ring.[61] But this is no doubt the result of Hindu influence, and it does seem that it was the Indians who first used all three of the new elements which are the basis of our counting system: a decimal base, a positional notation, ciphers for ten, and only ten, numerals. And this was in place by 876.

Nowadays, we use the simple goose egg, 0, for zero. At one stage it was assumed that the zero originally derived from the Greek letter omicron, the initial letter of the word *ouden*, which means 'empty'. This is no longer accepted – sometimes a dot was used, sometimes an upside-down version of our letter h.[62]

The final important innovation introduced by Indian mathematicians is the system known as *gelosia* multiplication and long division. *Gelosia* is an Italian word. After the system – also called lattice multiplication – was invented in the twelfth century, it was taken to China and the Arab world, from where it entered Italy in the fourteenth and fifteenth centuries. The lattices appeared to resemble the gratings, or *gelosia*, used on Venetian windows. Here is an example of lattice multiplication.

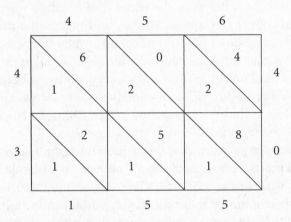

In this example, 456 is multiplied by 34, to produce the answer, 15,504. The single digits are multiplied, those along the top by those down the left-hand side, and the product written in the squares, divided by a diagonal. There is thus nothing more onerous in one's head than multiplying single digits. Then one simply adds the diagonal lines, beginning top right and carrying over, to get the final result.[63]

India was unaware of the advent of Islam until the early eighth century, and might have remained so for much longer but for an incident in AD 711, when the plundering of a richly laden Arab ship as it passed the mouth of the Indus so incensed the Umayyad governor of what is now Iraq that he launched a military expedition of six thousand Syrian horses and the same number of Iraqi camels against the rajas of Sind.[64] This force soon conquered Brahmanabad, where the infidels the Muslims found there had to convert or be killed. This early ferocity didn't last. The Arabs soon realised there were too many Hindus to exterminate, and second, Muslim scholars studied the extensive Hindu religious literature, and as a result allowed Hindus *dhimmi* status, a protected belief system alongside Judaism and Christianity (provided of course they paid the special tax, the *jizya*).[65]

Islam had conquered the Middle East so rapidly that it might have been expected to have the same effect in India, but it did not, as is revealed today by the existence of Muslim Pakistan and Bangladesh alongside Hindu India where, however, there are also several million Muslims. The military side of the Muslim conquest of northern India falls outside the scope of this book. It is enough to say that, over the centuries, Turks and Afghans were more involved than Arabs, and that the main forms of Islam in India were Sunnis and Sufis. Sufism received a boost in 1095 when al-Ghazali resigned from the chair of divinity at the Nizamiyah academy in Baghdad, to lead the life of a Sufi (though poetry also made Sufism popular). By the twelfth century, Sufis were divided into several different *silsilas* (orders), each led by a *pir* or preceptor and each centred on a *khanqah* or hospice, which attracted men from all over who were seeking the spiritual life.[66] To begin with, the *khanqahs* subsisted on charity but, as with Buddhist monasteries in Chinia, many evolved into very prosperous communities.

Sind, the Punjab and Bengal became the main centres of Sufism, the two most important orders being known as Suhrawardi and Chisht, the former named after the author of a manual on Sufism and the latter after the name of the village where the order began. Chishti Sufis led a life of poverty and asceticism, and practised a number of devices to assist concentration – *pas-i-anfas* (control of breath), *chilla* (forty days of hard exercises in a remote location) and, most extraordinary of all, *chilla-i-makus* (forty days of exercises performed with one's head on the ground and the legs tied to the branch of a tree). These practices shocked more orthodox Muslims – and there were several unsuccessful attempts to stamp them out. Just as Buddhism was Sinicised in China, so Islam was Hinduised in India.[67]

Throughout 1,500 years in India, Buddhism and Hinduism had co-existed peacefully, borrowing ideas and practices from each other. Following the Islamic invasions, however, the number of Buddhist centres – Nalanda, Vikramasila, Odontapuri – was much smaller and suppression correspondingly more successful. Buddhism in India died out and was not resurrected until the middle of the nineteenth century.[68]

The eastward diffusion of religious ideas, from Mesopotamia to India, and from India to south-east Asia and Japan, was matched, of course, by the westward movement of Christianity and Judaism. The radiation of these big ideas from such a small area of the globe, is, in terms of lives influenced, probably the greatest shift in thought throughout history.

# 14

# *China's Scholar-Elite,* Lixue *and the Culture of the Brush*

The Greek name for the Chinese was Seres, from which the Latin word *serica* derives, meaning silk. The writer Pliny was just one who railed against the luxurious indulgences of his stylish contemporaries, complaining that enormous quantities of Chinese silk had entered Rome. Chinese textiles travelled west along the so-called Silk Roads from at least 1200 BC because, until AD 200, or thereabouts, only the Chinese knew how to process silkworms.* As late as the seventh century travellers, including monks, carried silk rolls to use as money in the case of medical emergencies. According to legend, the Chinese lost their monopoly on silk production when a Chinese bride smuggled a cocoon out in her hair when she travelled to marry a central Asian prince. Certainly, by the fourth or fifth centuries, silk was made in Persia, India and Byzantium, as well as China, though the Chinese kept their competitive edge because they produced more densely woven silks with more complex weaves.[1]

As this implies, by medieval times, the most intellectually sophisticated country in the world, and the most technologically advanced, was China. In fact, China's pre-eminence was probably greater during the Song dynasty (960–1279) than at any other time. Joseph Needham (1900–1995), the Cambridge scholar who devoted his life to the study of early science in China, said in his massive history of the subject that 'Whenever one follows any specific piece of scientific or technological history in Chinese literature, it is always at the Song dynasty that one finds the major focal point.' However, as Endymion Wilkinson points out, this may have something to do with the fact that the development of printing (which we shall soon come to) ensured that more works survive from Song times than any period previously.[2] One sign of the sophistication and success of China was her population, which was in excess of 70 million in the twelfth century and may have been 100 million a century later, almost double what it was in Europe.[3]

Since the marvels of the Han age, covered in Chapter 8, several other dynasties had come and gone. China had been divided by barbarian nomads and reunified, divided and reunified again, the great walls and canals that lined the countryside had been built by conscript labour and a measure of stability and brilliance achieved under the Tang

---

* The romantic term 'Silk Road' was first coined in the 1870s by the German geographer Ferdinand Paul Wilhelm Freiherr von Richthofen, ancestor of the First World War flying ace, the Red Baron.

dynasty (618–906), whose emperors had ruled, been deposed, and restored, thanks to their massive eighth-century horse-breeding programme for the cavalry, which provided the backbone of their army before the invention of gunpowder. During the dynasty of the two Songs (960–1234 in the north, lasting until 1279 in the south), China reached the edge of modern science and brought about a minor industrial revolution. 'No country could compare in the application of natural knowledge to practical human needs.'[4]

A number of ideas and impressive technological inventions contributed to this sophistication of the Songs, the first of which was paper, which ultimately led to printing. The Chinese had writings as early as the Zhang dynasty (1765–1045 BC). These consisted of animal bones or tortoise-shells which had been cracked with red-hot pokers, for the purposes of divination, and on which written characters had been inscribed, interpreting the cracks in the bones. Around 3,500 different characters are found on these early scapulae and shells (modern Chinese has about 80,000 characters), which would on occasions be bound together. This practice gradually gave way to books made of bamboo slips, written on with a kind of stylus and using a form of varnish to write with. These too were bound together with strings or thongs. Confucius himself used books of this kind when he was studying the *I Ching* and he was apparently so earnest a pupil, so hard on his books, that he broke the thong three times.[5] According to Lucien Febvre and Henri-Jean Martin, in their history of the book, the oldest Chinese books to survive were excavated at the beginning of the twentieth century in the deserts of central Asia, where they were found to consist of strips of wood and bamboo on which were written vocabularies, calendars, medical prescriptions and official records relating to the daily life of the garrisons guarding the Silk Road. Written in ink brush, they dated from AD 98–137. However, since then books of wooden slips have been discovered in ancient tombs dating from as early as the fifth century BC.

Silk sometimes replaced bamboo – it was lighter, stronger, more resilient, and it could be wrapped around a rod, saving space. In this way, the Chinese word for 'roll' became the word for 'book' (as happened with *volumen* in Latin). But silk wasn't cheap and the Chinese were always on the look-out for alternatives. By a process of trial and error, using at first silk waste, then other forms of refuse (linen rags, old fishing nets, hemp, mulberry bark) they arrived at a paste which, when dry, would take writing. It was the practice then to attribute all innovations to the emperor's court and so the invention of paper was formally awarded to the director of the imperial workshops, the eunuch Cai Lun (d. AD 121). He it was who wrote the report to the emperor in AD 105 in which the invention of paper is first mentioned, but it must have been in use for some time by then, after being developed by some lesser soul whose name was never recorded.[6]

As it replaced silk (for all but luxury books), paper was produced in sheets about 24 cm × 45 cm ($9\frac{1}{2}$ × 18 in). The sheets were glued together to form long strips which could be rolled around rods. But the practice was cumbersome: if some specific passage were sought, the entire book had to be unrolled. This probably accounts for the division of books into leaves, though many of the sacred books of India had been written on palm leaves, bound together with twine, so a model was to hand. In an ancient Chinese library excavated at Dunhuang, where 15,000 manuscripts dating from the fifth to tenth centuries were found, different types of book were discovered walled up together. Besides rolls there were what

the Chinese called 'whirling books'. These had their vertical edges glued together and they were stored like the folds of an accordion, and opened out in zig-zag formation. This arrangement is still used for calligraphy, certain sacred Buddhist or Taoist texts, and books of paintings, but the edges tore easily and so the next step was made – to fold the sheets down the middle and sew the spines together. This left the leaves free to flutter at will, and gave these books their Chinese name – 'butterfly books'.[7]

With the coming of paper, so the invention of printing was not far behind. By the time paper arrived, it had long been the practice in China, as elsewhere, to engrave classical texts on great slabs of stone – stelae – in order to preserve the texts as accurately as possible, as well as making them accessible to the public. This led to a practice of carving the texts in reverse so that pilgrim/tourists could take away rubbings. This was of course printing in all but name. But it was in fact the development of the seal engraved in relief which led most directly to the printing of books. By the beginning of the first century AD, it had become the fashion in China for the pious to have seals engraved in relief, often containing lengthy religious texts, prayers and even portraits of the Buddha. These seals sometimes adorned the cells of Buddhist monks but the important breakthrough seems to have come from the capacity for paper to take an impression, something that didn't happen with silk. Such impressions would have provided people with the reverse images needed to produce proper printed pages that could be read. Experimentation proliferated and, from discoveries made, the earliest woodblock engraved in relief and in reverse is a small portrait of the Buddha discovered by Paul Pelliot, the great French prehistorian, near Kuche in Sinkiang, and dating from the mid-eighth century AD. The oldest printed book in the world is now in the British Library, a long roll printed by a xylographic (woodblock) process in 868. It is a Buddhist text and has a beautiful frontispiece, of such quality that it suggests the technique was already advanced. A book recently discovered in Korea may be older, but for the moment scholars cannot decide whether its origin is Korean or Chinese.[8]

Block printing seems to have emerged along the banks of the Yangtze river, from where it spread, mainly by religious authorities to preserve canonical writings. In AD 932, Feng Dao prepared a report for the emperor, in which he recommended the use of block printing to preserve the classics because the dynasty then in power did not have the financial means to do the job in the traditional way – namely by engraving a series of 'classics on stone'. The new project was very successful, encouraging literacy, and between 932 and 953 most of the existing literature was put into print. This sanctified the new technology, and Feng Dao was credited with the invention of printing. As before, with Cai Lun and paper, other, earlier anonymous souls were really responsible.

Experimentation continued but early attempts at copper engraving and the use of movable type were not successful. The first real attempts to make movable type came in the eleventh century and are attributed to Bi Sheng, a blacksmith and alchemist who used a soft paste to make the letters, which he then hardened in fire. They were then attached to an iron plate with a glue made of wax and resin which congealed when cold. By reheating, the letters could be detached and rearranged for a new text.[9] Hard woods, lead, copper and tin were also tried as founts for the letters but were never very successful. In one treatise of the time it was suggested that the characters be stored according to sound: that is, characters which rhymed would be boxed together.[10]

It is now clear, however, that printing with movable type went ahead fastest in China's neighbour, Korea. This was due to the intervention of a benevolent ruler, King Sejong, who in 1403 issued an extraordinary decree, which sounds enlightened even today and must have been extremely so at the time. 'To govern well,' he said, 'it is necessary to spread knowledge of the laws and the books, so as to satisfy reason and to reform men's evil nature; in this way peace and order may be maintained. Our country is in the east beyond the sea and books from China are scarce. Wood-blocks wear out easily and besides, it is difficult to engrave all the books in the world. I want letters to be made from copper to be used for printing so that more books will be made available. This would produce benefits too extensive to measure. It is not fitting that the people should bear the cost of such work, which will be borne by the Treasury.' Some 100,000 sorts (letters) were cast as a result of this edict, and ten more founts were made during the course of the century, the first three of which (1403, 1420 and 1434), we now know, preceded the invention of printing by Gutenberg.[11] But neither the Korean nor Chinese system seems to have travelled west quickly enough to influence the invention of printing in Europe.[12]

Though a good deal of the Song renaissance depended on the wider availability of texts, the Chinese themselves never regarded printing as the revolutionary process it was considered in Europe. One important reason for this was that the Chinese language did not possess an alphabet; instead it consisted of thousands of different characters. Movable type did not therefore confer the same advantages. Furthermore, Europeans in China during Renaissance and Reformation times noted that woodblock carvers could engrave a page of Chinese characters just as quickly as a European compositor could set up a page of, say, Latin text. And there were two other advantages to woodblock printing: the blocks could be kept and stored, for later editions; and they could be carved just as easily for illustrations as for text. Chinese books therefore had illustrations, and in colour, several hundred years before books in the West.[13]

Printing raises the issue of writing and language. The Chinese language, and script, are based on rather different ideas from, say, the Indo-European languages. Although there are many dialects of Chinese, Mandarin – the native tongue of north China – comprises about 70 per cent of what is spoken today. All its characters are monosyllabic so that, for example, in Mandarin 'China' is *Zhong guo*, which literally means 'middle country'. Moreover there are only about 420 syllables in Mandarin, as compared with, say, 1,200 in English, and because there are about 50,000 words in a Chinese dictionary there are many words pronounced using the same sound or syllable. To obtain the diversity of meaning that is needed, therefore, all syllables may be pronounced in one of four tones: high, high-rising, high-falling, low-dipping. To use the English example given by Zhou Youguang, think of the way English-speakers say 'Yes' under various circumstances – for example, when answering a knock on the door while immersed in a task, or when agreeing to something doubtful while still questioning it in one's head. Such differences in tone completely change the meaning of Chinese words. *Ma*, for instance, can mean 'mother', 'horse' or 'scold' according to the tone in which it is pronounced.[14] More complex still, there are forty-one meanings of the Chinese character *yi* pronounced in the fourth tone, including 'easy', 'righteousness', 'difference' and 'art'. Meaning must be inferred from context.

Because Chinese is a non-inflectional language, words do not change according to number, gender, case, tense, voice or mood. Relationships are indicated either by word order or the use of auxiliary words. Take for example this sentence as it would be delivered in Chinese: 'Yesterday he give I two literature revolution book.' 'Yesterday' indicates that 'give' means 'gave' (as we would say in English). Word order indicates that 'I' means me, and 'two' indicates that 'book' means 'books'. The most difficult interpretation in this sentence is 'literature revolution'. But the word order indicates that it must mean 'literary revolution' and not 'revolutionary literature'. And so the full sentence means 'Yesterday, he gave me two books on [the] literary revolution.'[15] Auxiliary words like *le* indicate a completed tense of a verb and 'I' followed by *wen* means 'we'. Words are also classified as 'solid' or 'empty'. Solid words have meaning in themselves, while empty ones are used in a grammatical sense, to fulfil prepositional, connective or interrogative functions. 'You are an Englishman *ma*', for example, means 'Are you an Englishman?'[16]

In the same way that the Chinese language is based on a different set of ideas from the Indo-European languages, so its script is very different from the Western alphabets. It recalls much more the early pictographs used in Mesopotamia at the birth of writing. All Chinese dialects use the same script, on which others such as Korean and Japanese are based. According to tradition, Chinese script was invented by Cang Re, an official at the court of the semi-mythical emperor, Huang Di, who lived at the beginning of the third millennium BC, though there is no archaeological evidence for the Chinese script older than 1400 BC on oracle bones and bronze vessels. The script is based on four ideas. The first is pictorial representation. The sun, for instance, was first written as a circle with a dot inside. This was later schematised as a rectangle with a short stroke in the middle. Three peaks stood for a mountain. (See Figure 11 overleaf for several examples.) The second principle was the use of diagrams. Numbers, for example, were simple strokes and the concepts 'above' and 'below' were represented by a dot above and below a horizontal stroke (again, see Figure 11.) The third principle was suggestion (and a certain sense of humour). 'Hear', for example, was shown by an ear between two panels of a door, and 'forest' was two trees side-by-side. The fourth principle is to combine signification and phonetics. For example, the character for 'ocean' and 'sheep' are both *yang*, with the same tone. So ocean became *yang* plus the character for 'water'. This is only a beginning, of course. Chinese characters are classified in dictionaries according to 214 'radicals', or identifying roots. These indicate the general characteristics of meaning, on which various embellishments have been added.[17]

Chinese script, traditionally written with a brush, rather than a pen, exists in various styles – such as the regular style, the running style, and the 'grass' style. In the regular style, each stroke is separate, comparable to manuscript writing in English or Latin. In the running style, separate strokes tend to merge into flowing lines, much more so than cursive script in English. The grass style is much abbreviated, like shorthand. For example, the character *li* (ritual, propriety) is written with seventeen strokes in regular style, nine in running style and just four in grass style.[18] The regular style is used in formal writing but running style is preferred in art, which includes calligraphy.

These various aspects of Chinese language and script have had a major influence on Chinese thought. There is not only the pictorial quality of the characters themselves, but

| | Original form: | Present form: |
|---|---|---|
| sun | ☉ | 日 |
| moon | ☽ | 月 |
| mountain | ⛰ | 山 |
| tree | 木 | 木 |
| door | 門 | 門 |
| 1, 2, 3 | 一, 二, 三 | 一,二,三 |
| above | 上 | 上 |
| below | 下 | 下 |
| centre | 中 | 中 |
| ear | 聞 | 聞 |
| forest | 林 | 林 |
| mother & baby (=good) | 好 | 好 |
| ocean | 洋 | 洋 |

*Figure 11: The development of Chinese characters*
[Source: John Meskill *et al.* (editors), *An Introduction to Chinese Civilisation*, 1973 © Columbia University Press. Reprinted with the permission of the publisher]

the various tones in which words are pronounced, which in particular, for example, give Chinese poetry added elements or dimensions that are quite lacking in Western languages. 'Movement', for example, is rendered in Chinese as 'advance-retreat', and 'politics' as 'rule-chaos'. The *experience* of Chinese is, in some circumstances, quite different from other languages, often reflecting the Confucian idea of antonyms, *ying/yang*. To give another example, 'Mountain big' is a complete sentence in Chinese. It is not necessary to use the verb 'to be'. 'Without the subject-predicate pattern of sentence structure,' says Zhou Youguang, 'the Chinese did not develop the idea of the law of identity in logic or the concept of substance in philosophy. And without these concepts, there could be no idea of causality or science. Instead, the Chinese develop[ed] correlational logic, analogical thought, and relational thinking, which, though inappropriate to science, are highly useful

in socio-political theory. That is why the bulk of Chinese philosophy is philosophy of life.'[19]

Always, however, in considering China, one comes back to the practical. Whatever the relationship between paper, printing, the Chinese script and Chinese thinking, paper and print had other, more down-to-earth uses. The banknote, for example, which was another invention of the Song. This, in effect, represented two new ideas: printed paper, and a written promise, an advance beyond coins which embodied, in their very selves, the value they represented in one metal or another. Banknotes are first recorded in the early eleventh century and seem to have been a response to several simultaneous crises. In the first place, in the tenth century in China, just before the Song, the country had been divided into ten or more independent states, each of which minted its own coins, using copper in the north, iron or lead in the south. When the Song achieved a kind of political unity at the end of the century, they imposed a single currency – of copper coin. However, this coincided with an increase in warfare, which in turn required enormous expenditure. In response, the state boosted the production of copper coins far more than hitherto but this was still not enough. And so, beginning with the merchants who supplied the military, the government started to issue certificates of deposit. These were called *fei qian,* or 'flying money'.[20] They were the precursors of true banknotes, which appeared in 1024 and spread rapidly, at least for a time, remaining important until the end of the Mongol period (mid-fourteenth century), when they fell into disrepute. Known as *jiao zi, qian yin,* or *guan zi,* paper money also stimulated other forms of negotiable instruments – promissory notes, bills of exchange, and so on, all of which first appeared in the eleventh century. To begin with, the government's newly-founded Bureau of Exchange Medium proposed that paper money be traded in every three years but, gradually, this rule was relaxed.[21]

In addition to its innovations in paper and printing technology, Chinese advances in iron and steel manufacture were several hundred years ahead of Europe. Coal was being mined from the eighth century on, and used in furnaces that produced high-quality iron and even steel. Some idea of Chinese success in this field is given by one calculation, that, in the eleventh century, China was already producing 70 per cent of the iron that would be manufactured in Great Britain at the beginning of the industrial revolution in the eighteenth century.[22] During the Mongol invasions and occupation (mid-thirteenth to mid-fourteenth centuries), the production of iron and steel dropped precipitously, never to recover.[23]

Some of the inventions we attribute to the Chinese – in particular the saddle and the stirrup (fifth century) – were probably conceived by the steppe nomads on her borders, and then taken up by the Chinese. But a whole raft of new technology *was* invented inside China[24] and two inventions in particular caught the imagination of the rest of the world, gunpowder and porcelain.[25] The discovery of the incendiary/explosive capacities of coal, saltpetre and sulphur originated in alchemical circles in the Tang age but was not used in anger until 904–906.[26] To begin with it was used as a flying, flaming projectile, called 'flying fires' (*fei huo*). But the technology soon proliferated, to produce both smoking and incendiary grenades, and finally explosive grenades. These were certainly used in 1161 at the battle of Anhui, where they helped the Song secure victory over the Nuzhen, ancestors

of the Manchu, known also as the Jin, who occupied territory to the north-west of the Song lands. In other words, although gunpowder began as an incendiary device, its most useful property, in terms of warfare, was its explosiveness.[27]

The third and most deadly development was the explosion of gunpowder in a tube, use of which dates from 1132. The first tubes, which formed a sort of mortar or rocket, in effect the first gun, were made of wood or bamboo, and gunpowder was used twice over, once as a propellant for the arrows, and secondly for adding fire to the tip. The first use of a metal tube in this context was made around 1280 in the wars between the Song and the Mongols, where a new term, *chong*, was invented to describe the new horror. By the time gunpowder reached the West, therefore, it was not just an explosive, but the basics of the gun had already been developed. Like paper, it reached the West via the Muslims, in this case the writings of the Andalusian botanist Ibn al-Baytar, who died in Damascus in 1248. The Arabic term for saltpetre is 'Chinese snow' while the Persian usage is 'Chinese salt'.[28] In the West the historic importance of gunpowder has been well documented and it is generally credited with helping to close the Middle Ages, by contributing to the downfall of the knightly class, ending the dominance of the sword and the horse.

Simultaneously with the rise of gunpowder, the production of porcelain also reached great heights under the Song dynasty, in terms of both quantity and quality.[29] The most important areas of porcelain production in the eleventh century were the imperial kilns at Kaifeng, on the Yellow river, and other towns in Henan and Hebei. Later, in the twelfth and thirteenth centuries, they were replaced by workshops further east, near the coast at Hangchow, and at Fujian and Jiangxi (north-east of Hong Kong, opposite Taiwan). This was one reason why, from the outside, China was looked upon as the 'land of luxury', producing coveted goods. Besides porcelain, the spread of hemp, the mulberry tree – for breeding silkworms – and cotton, began to take off in the thirteenth century, and the tea bush also began to spread in the uplands of Szechwan. Lacquer-producing trees likewise became more common in Hebei, Hunan and Chekiang.[30]

The last of the great inventions of the Chinese Middle Ages concern the development of the country's extraordinary seafaring activities, from the eleventh century on, which culminated in the great maritime expeditions of the Ming period in the years 1405–1433, which ventured as far as the Red Sea and the east coast of Africa. The early development of sailing in China owes a great deal to the pattern of winds in that part of the world.[31] The monsoons are regular winds where unexpected changes of direction, or flat calm, are much less common than in, say, the Atlantic or Mediterranean. As a result, there was much less need for rows of slaves, manning banks of oars: instead, different types of sail were perfected much in advance of the rest of the world. The regularity of the monsoon winds, and their seasonal change of direction – north-east in winter, south-west in summer – meant that an annual rhythm of long journeys was possible without ports of call, followed by a long stop-over until return was practicable. This made for substantial foreign colonies on the coasts of south-east Asia and India, affecting the traffic in ideas.[32] All this seems to have played a role in the appearance of the big Chinese high-seas junk in the tenth and eleventh centuries.[33]

Since antiquity, Chinese boats had their hulls divided up into separate watertight

compartments, an arrangement not adopted by Western ships until the beginning of the nineteenth century, but this was by no means the only advanced feature of Chinese naval technology. The most important, before the magnetic compass, was the stern-post rudder, which dates from the fourth century A D. This was made possible by the rectangular hulls of Chinese junks, which enabled a rudder to be fitted down the back of the ship. Until about 1180, when the stern-post rudder appeared in the West, European ships were steered by a rear oar. This offered much less control, and almost none at all in storms on the high seas. And it limited the size of ships that could risk ocean travel. By Song times, on the other hand, Chinese junks were huge (up to 400 feet long; Columbus' ships were barely eighty). They were the product of a long series of inventions and innovations, and were capable of carrying a thousand men on four decks, with four masts rigging twelve sails. Such ships would be provisioned for up to two years at sea. Among the other maritime inventions credited to the Chinese are the anchor, the drop-keel, the capstan, canvas sails and pivoting sails, and of course the magnetic compass. This was first referred to in a Chinese work, the *Pingzhou ketan,* by Zhu Yu, dated to 1119, which says it was used on Cantonese ships at the end of the previous century. The compass was not used on European ships before 1280, two hundred years later.[34]

Each of these inventions confirms the fact that the Chinese were not only an immensely creative people at this time, but also fiercely practical. All the innovations we have considered added to Chinese prosperity, and to their enjoyment of the world around them. But there was, at the same time, another side to medieval Chinese life, a more abstract, philosophical and metaphysical cast of mind which also produced many innovations of a very different kind. Underlying these was the Chinese idea of the scholar-bureaucrat, a concept which would find echoes in Europe, but reached much further, much earlier, in China.

During the classical age, arising from the struggle for power between warring states, a new social level had emerged in China. This, as introduced in Chapter 5, was the *shih.*[35] During the times of turmoil, the rights of birth had begun to count for less, and those of talent for more. A growing number of younger sons of noble families, who were educated but lacked rank, therefore took it upon themselves to exploit their education and offer themselves as scribes or secretariat for the central administration of whatever states had need of them. For some, whose advice was successful, political advancement followed: the *shih* began to form an influential social class. By Song times, this class had been through several changes, with access to it becoming more sophisticated and elaborate in the process. Its most important introduction was the written examination by means of which the scholar-elite was now chosen, to create what was in effect a civil service, and which administered the country. Before the examination was introduced, the *shih* had for many years been identified and selected by individuals who possessed some sort of credibility, though this at times had led to serious and/or absurd mistakes.[36] Because of this, it then became the practice for the *shih* to serve as apprentices in regional government offices but, naturally, such a system was also open to abuse as particular classes of people sought to perpetuate themselves. The result was that during the Sui and Tang dynasties (581–906) dissatisfaction grew. The first attempts at revision tried to make the nominators of scholars

legally responsible for the performance of their candidates. But that didn't work either and, beginning in the late sixth century, attempts were made to introduce a system of oral and written examinations to supplement the recommendation system.[37]

Gradually, throughout Tang times, the examination system won out over the apprentice/nomination alternative, and was formally institutionalised by the Song emperors. By then, the system consisted of three phases. Examinations, called *Keju*, were in general held every three years, and the first round was taken at the *zhou* or prefectural level, and were open to students of almost any background.[38] Typically, examinees prepared for the examination by enrolling in local academies, private establishments not dissimilar from modern 'crammers'.[39] Modern researchers have calculated that between 20,000 and 80,000 students sat the examinations and that pass rates were seldom above 10 per cent and often as low as 1 per cent: the examinations were hard.[40] Candidates who passed the qualifying examination were accepted for enrolment in the county or prefectural Confucian schools, which ensured that the candidates were prepared for the next level. The second-level examinations took place in the imperial capital (which had moved from Chang'an under the Tang to Kaifeng under the Song) and were organised by the Ministry of Rites. Successful candidates remained in the capital to sit for the highest-level examinations, sometimes regarded by Western historians as the equivalent of the PhD degree. Again, not more than one in ten passed the third round, and no stigma attached to failure. It was quite normal for students to begin sitting the examination at eighteen and not to pass until they were in their thirties – some did not pass until they were in their fifties. In fact, simply having been deemed suitable to sit the Ministry examinations, these candidates were called *juren*, 'elevated men', which set them apart. Originally, this third round was the end of the system but in 975 the first Song emperor saw the name of someone he felt lacked ability on the list of those who had passed and he ordered all the *juren* to be re-examined under his personal supervision. This practice stuck, in the process giving the system even greater prestige because of the emperor's personal involvement. From then on, only candidates who had passed at the *zhou* level and all three phases in the capital were considered to have graduated with the full degree.[41]

The examinations were divided into four sections, each section lasting for a whole day. Candidates could choose their subjects, between classics, history, ritual, law and mathematics. The four days were spread out over a couple of weeks, and the examinations were conducted in large public halls, later in rows of tiny cells to prevent cheating. Extraordinary attempts were made to be fair. Candidates' names were removed or pasted over and replaced by numbers, so that examiners could not identify who was who. In 1015 a bureau of copyists was established to make uniform copies of the answers so that candidates could not be identified by their handwriting. Each paper was read by two examiners and if they disagreed widely in their assessment, they had to reconcile their views before reporting to the chief examiner.[42] The main criticism of the examinations was that they were too academic, as we would say, too much concerned with book-learning. In general, candidates were tested on their ability to memorise the classics in their chosen field and in their ability to compose poetry in various genres, though there was also a requirement to compose essays on political and social issues of the day. Even here, however, candidates were expected to know history, to compose in ancient historical

prose styles, and to use the past to predict what might happen in the future. Critics felt that not enough credit was given to practical solutions to current problems.[43]

And in fact the way the examinations affected Song society is one of the most contentious issues in Chinese scholarship even today, in particular the extent to which the examinations were truly open and encouraged social mobility. Whether or not the system did stimulate social mobility (modern studies have produced results which both support and refute such a claim), it was *designed* to do so, and, as we have seen, elaborate rules were constructed in order to attain that ideal. 'The law of the land proclaimed that the recruitment system was open to virtually every male subject in the realm, holding up the ideal of success through individual achievement as an incentive to the entire society.' In this, China was far ahead of the rest of the world.[44] The examinations were not abolished until 1905.

Whether or not the examination system encouraged social mobility, it certainly played a part in helping to ensure that China continued as a relatively highly literate and well-educated civilisation in comparison with its rivals and neighbours. Education and learning were held as the keys to advancement in China from the earliest times, and by the Song age the process was institutionalised. In the realm of more abstract ideas, this produced some remarkable changes and advances.

The most general of these changes was that from Buddhism to Neo-Confucianism, known in Chinese as *Lixue*. The expansion of Buddhism in Asia was virtually contemporary with the spread of Christianity in Europe, but in fact Buddhism spread much further than the western faith, taking in a greater geographical range and a greater diversity of people: in terms of sheer numbers, it influenced more lives.[45] There were essentially three phases. From the birth of the first century AD until the fifth century there was a slow growth, as Buddhism gradually changed its nature, to accommodate the Chinese cast of mind and Chinese traditions; the fifth to the ninth centuries was the highpoint of Chinese Buddhism, a religious fervour reflected not only in the practice of the faith but in a great efflorescence of Buddhist art, architecture and thinking; and the period from the early ninth century, when Buddhism was proscribed, and the Chinese world reverted to Confucianism, albeit adapted to the needs of contemporary society.

Buddhism first conquered the Chinese world by following the trade routes and winning over the merchants but also because it became less an abstract search for *nirvana*, which is how it had begun, and more like a religion as we would recognise the term today. This form of Buddhism, as was mentioned in an earlier chapter, was known as Mahayana, the Greater Vehicle. Mahayana Buddhism proposed that salvation was open to all, whereas Hinayana – the Lesser Vehicle – proposed that only those who devoted their lives exclusively to Buddhism, such as monks, could be saved. Mahayana Buddhism was a Buddhism which stressed the Buddha himself (rather than the Way) and concerned itself with other Buddha-like figures, in particular the figure of the Maitreya, the saviour to come. This involved a cult of relics, of the great Buddha himself, and of immortalised Buddhist saints, the *arhats*. It was probably on the great trade routes out of India into China, across 'the roof of the world' in and around Pakistan, that the Buddha was first represented as a human figure, at which time Hellenistic influences in, perhaps, Gandhara, showed themselves in the folds of the drapery of the seated figure. The new religion caught on first in the countries at the

edge of China – the first translators of Buddhist texts into Chinese were not Indians but Parthians, Sogdians and Indo-Scythians (the area around modern Uzbekistan). The first allusion to a Buddhist community dates from AD 65, at Beng Zheng, a commercial centre in Jiangsu, and its early appeal seemed to lie partly in its emphasis on new techniques of concentration (yoga, for instance) and partly because some of its traditions seemed to overlap with Taoism, therefore making it seem less new. Three doctrines in particular seemed reminiscent of Taoism. These were the Buddhist doctrine of *karma* (the idea that our performance in this life determines the form of our existence in the next life), which was reminiscent of the Chinese concept of the individual lot, or *fen*, and destiny, or *ming*. Second was the Mahayana idea of the fundamental emptiness of the world, which linked to the School of Mysteries and its concern with being and non-being. (The School of Mysteries is considered in the next paragraph.) And thirdly, the practice of yoga, leading to trance, was not dissimilar from Taoist techniques of inducing trances and ecstasies.[46]

Despite this, Buddhism was at first restricted to a very limited range of people – merchants on the trade routes which the monks followed, and the local aristocracy. One reason for the aristocratic interest was the vogue for what were called 'pure conversations'. 'These conversations, in which the interlocutors vied with each other in producing witty remarks, amusing repartee, and polished epigrams, were gradually to extend their range … to literary, artistic, moral and philosophical problems.' The members of the School of Mysteries, who were also concerned with the writings of Laotzu, were fascinated by metaphysical problems, in particular the relation between being and non-being. Traditionally, these were not conceived as opposites, as we might think of them today. Instead, and this is hard to get across in the modern world, 'non-being' was seen as the reverse of 'being', an alternative and shadowy form of existence. To the School of Mysteries, the Buddhist idea of 'not being' as nothingness, sheer emptiness, was fascinating because it was entirely new.[47]

In this sense then, the Chinese interest in Buddhism began as a philosophical/metaphysical activity on the part of the literate aristocracy, and only then in the southern part of the country. It continued that way pretty much until the end of the fourth century after which it began to grow in influence in the north of China. But this was in some ways a different form of Buddhism, sparked by the actions of monks who both worked magic tricks and helped induce trances and ecstasies, through yoga, which had a much greater popular appeal. A number of monks managed to enlist the support of a range of sovereigns, who funded monasteries and, in particular, the translation of some of the great Buddhist texts, at the same time sponsoring the journeys of Chinese Buddhist monks to India. Two of the great names in Chinese Buddhism were Huiyuan (334–417) and Kumarajiva (350–413), through whom Buddhism came of age there. Thanks to their translations and teachings which, among other things, turned into Chinese the great treatises on monastic discipline (*Vinaya*), an organised priesthood, endowed with its own rules, began to develop in China. This made Buddhism an even greater religion of salvation and stimulated a demand for more pilgrimages to India, with Chinese monks going to 'seek the law'. In 402 Huiyuan assembled his whole community, both monks and lay people, in front of an image of the Buddha Amitabha (the Buddha of Infinite Light), and together they vowed to be reborn in the western paradise (Sukhavati, the Pure Land, *jing du*) which is the

habitation of this great figure of Mahayana Buddhism. 'This was the first demonstration of a belief shared by all the faithful, the first context in which Buddhism appears as a religion of universal salvation.'[48]

From the late fourth century on, China began to be dotted with storeyed towers (stupas, *da*) and sanctuaries. At the same time, Buddhist caves began to be carved out of rock, and the number of converts mushroomed. Conversion at this stage was no longer a matter of individual belief or conscience, but part of a group – even a mass – movement. Proof of the success of Buddhism at this time can be found in a striking parallel with Christianity in medieval Europe: the claim that the priesthood was autonomous. In 404 Huiyuan wrote his *Treatise Explaining the Reasons Why Monks Are Not Obliged to Pay Homage to Sovereigns.* As in Europe, church property was held to be inalienable, as were certain Buddhist practices, such as tonsure, celibacy and the observation of religious prohibitions.[49] The upsurge of faith was so great after the fifth century that a number of problems arose which were peculiar to this situation. There was, for example, an excessively large number of 'fictitious ordinations' (so that people could avoid paying taxes, or serving in the army), and many simulated gifts of land to monasteries, again to avoid paying taxes. So many bells and statues were cast that there was a shortage of metal for coins and ploughs. Central government also worried about the disruption to family life caused by the excessive number of sons leaving home to be itinerant and/or mendicant monks. Here lay the seeds of future dissatisfaction with Buddhism.

The pilgrimage movement was also at its height between the fifth and the ninth centuries. Many monks made the journey to India and wrote accounts. By far the most famous was that by Faxian, who left Chang'an in 399 when he was over sixty and was away for fifteen years. His account, *Fo guo ji* (*Report on the Buddhist Kingdoms*), was supplemented by a number of manuscripts he also brought back and translated. These accounts by monastic pilgrims were prodigiously accurate and together now provide much of the history of the Asian region at that time. In all, according to Jacques Gernet, 1,692 different texts are known, and include the richest source of sermons attributed to the Buddha. Between 515 and 946 some fourteen bibliographical catalogues of Buddhist translations into Chinese were prepared and these too allow us to reconstruct the transfer of ideas and practices when Buddhist influence was at its height. The most prolific translating team in all China was that directed by Xuan Zang (602–664), who went to India and spent five years studying at the famous monastery/university of Nalanda. He then returned home where, in the course of eighteen years, he and his team translated about a quarter of all Indian texts into Chinese – some 1,350 chapters out of a total of 5,100 translated in six centuries by 185 teams of translators.[50]

In tandem with the religious ideas that made the transition from India to China and Japan, Buddhist art also exercised a wide influence. This art was already imbued with Greek and Iranian influences.[51] The practice of hollowing caves out of rock also followed the Buddhist monks, and the first caves of the Thousand Buddha complex (Qian Fo Fong) near Dunhuang (at the western end of the Great Wall, near the Silk Road) were started in 366. But between then and the eighth century colossal statues were built all over China, the most notable being the caves of Yungang, where the biggest figures are 160 feet tall. Aside from

the statues themselves, the walls of the caves were decorated with Buddhist paintings, almost all of which have been lost. The scenes were usually taken from the life of the Buddha, images of Buddhist hell, and so on. Religious frescoes also decorated the walls of prominent monasteries. The classical Chinese style was for purity, simplicity, exactness: the traditional Chinese artist stripped away inessentials to achieve a concise expression of what he aimed at. Buddhism was more exuberant than that: it was an art of sumptuousness, of exaggeration, repetition and ornamentation. The same qualities affected Buddhist literature, which not only produced new subjects (again exploring the Buddha's previous lives, descents into hell, pilgrimages) but produced new forms – sermons, conversations between masters and pupils, edifying narratives – which helped the development in China of the novel and the drama.[52] In many ways this made Chinese literature for a time more similar to that elsewhere: the worlds of men, gods, animals, demons and beings from the underworld were all intermingled. This, we should remember, was quite alien to the Chinese experience, which hitherto had imagined no creator god, no hell, no world of spirits or demons.

And so, for half a millennium, beginning in the last half of the fourth century, Buddhism flourished in China (and, in turn, in Japan). The monasteries became great centres of learning and culture, with the monk – poet, painter and calligrapher – paralleled by the learned layman, interested in Buddhist philosophy and practising techniques of concentration.[53] Great sects grew up, of which the most important were the eclectic school of Tiantai (a mountain in north-west Zhejiang), founded by Zhi Yi (538–597), whose main text was the famous *Lotus of the True Law*, 'the very essence of Buddhism', and the *zhan* sect (Japanese *zen*), which began in the eighth century and became especially popular among the literati. This group rejected the long ascetic training so typical of many Buddhist sects, and by means of which, through ever-more difficult techniques of concentration, one could attain the 'extremity of being'. The *zhan* system instead aimed at 'sudden illumination' and sought to achieve this by detaching the mind from any discursive thought and from dwelling on the self. Recourse was therefore had to anything that would, as we say, take people out of themselves – paradox, 'meditation on absurd subjects', baffling exchanges, even shouts.

But then, in the years 842–845, there was a massive turnaround. Buddhism was proscribed and the religious communities dispersed.

Such a momentous change never happens that abruptly, of course. Opposition to Buddhism had been growing for some time, and it had two sources. One stemmed from an important difference between the aristocracy and commoners. The aristocracy in China had always been more open to foreign influence, and indeed that class contained more foreigners than the population at large – Turks, Sogdians, Tibetans. Wars of one kind and another increasingly cut off Buddhist channels of communication, and that had an effect, too. But a more important second influence was the educated literati who had risen in society by means of the examination system. That system encouraged the study of the Chinese classics and, slowly, the view formed among this class that China had been diverted from its true roots of simplicity and conciseness. One of the great Chinese writers, Han Yu (768–824), wrote a fierce diatribe in 819 when there was an outbreak of mass hysteria because a relic of the Buddha was due to be moved. This diatribe became famous and

helped promote anti-Buddhist (and anti-foreigner) feeling, which gradually spread from the literati to the rest of the people. A final complicating twist was that the monasteries held most of the stock of precious metals, in the form of bells and statues. When the bells were melted down for coins, many people refused to use them: knowing they had once formed sacred objects, they felt such coins were sacrilegious. This, too, did not endear the Buddhists to the educated scholar-bureaucrats. In 836 a decree was published forbidding the Chinese to have relations with 'people of colour' – i.e., foreigners. This was widely seen as an attack on foreign ideas and, soon enough, the Buddhist monasteries were purged of the hypocritical elements – uneducated monks, fictitious ordinations, fraudulent land deals. The noose was tightened a little further when the monasteries were made to conform to their vows: Buddhist monks took a vow of poverty, so all rich monasteries were stripped of their assets. In this way, eventually, some 260,000 monks and nuns were secularised, meaning they now had to pay taxes, and 4,600 monasteries were either demolished or converted into public buildings. (Another 40,000 smaller places of worship were also pulled down or converted.[54]) In the Song period, monasticism regained some strength, but it never returned to its former glory; it was cut off from India, which was itself threatened by Islam, and only *zhan* (or Zen) Buddhism retained any vigour, and that mainly in Japan. Instead, in Song times, there was a new enthusiasm: what became known as Neo-Confucianism.

Neo-Confucianism is in fact a Western word for what the Chinese called either *xin lixue* (school of human nature and universal order), or *li qi xue* (school of universal order and cosmic energy). In some ways these are better terms, since they convey the central concern of Neo-Confucianism, which was for *li*, the central rational principle of (order in) the universe, and the way – when understood – it explains both moral behaviour and matter. This linking of moral behaviour and matter is a very Chinese way of thinking, alien to (but not necessarily unattractive to) Western ways of thinking.

The development of Neo-Confucian thought in Song times is regarded as the greatest of intellectual triumphs, the jewel in the crown of what is now known as the Chinese renaissance. It affected all walks of life, from politics to religion to law (in the Tang Code, the first Chinese code to survive in full, murder of a father by a son was much more serious than the other way around, which might, in some circumstances, not be a crime at all.)[55] The achievements of Neo-Confucianism remained important down to the twentieth century. It was synthesised in the twelfth century by Zhu Xi, who listed five major thinkers – Zhou Dunyi, Shao Yong, Zhang Zai, Zheng Hao and his brother Zheng Yi – all of whom were eleventh-century figures, related to each other, pupils of one another or friends with each other, and whose concern, in one way or the other, was with the concept of the 'Great Ultimate', the force or power or principle which explained both the operation and development of the universe – time – and the emergence of ethical behaviour, and which ensured that this development continued in civilised fashion. All of these thinkers were scholar-bureaucrats, *jinshi*, graduates of the examination system, who thus shared a common education grounded in the great classics, Confucius and Mencius in particular. There were two important divisions within the Neo-Confucians. On the one hand, there were those who emphasised statecraft and ethics, and, on the other, those who emphasised

*li*, rational principle, and *xin* or mind, intuitionism. Those who emphasised statecraft argued that the Song philosophers were too divorced from reality, and that the intellectual's true role was to help achieve ethical behaviour within the boundaries of political reality, that the vast majority of men were less than ideal and that government must acknowledge this fact.

The best-known of the intuitionists, the principal spokesman for the idealist School of Mind, as it was known, was Lu Xiangshan (1139–1191). This school held a great appeal for many people because its adherents believed that one should acknowledge only those truths gained through one's own subjective awareness, that in effect one became one's own authority on what is right and wrong, true and false.[56] 'The universe is my mind and my mind is the universe' was Lu's most popular sentence, endlessly repeated. The rationalists opposed this view, seeing that it could undermine all authority, in both ethics and social behaviour.

The most distinguished rationalist Neo-Confucian thinker, indeed the man who is often spoken of as 'the most influential figure in Chinese intellectual history after Confucius himself', who some say 'completed' Confucianism, was Zhu Xi (1130–1200). He too graduated as *jinshi*, at only eighteen, and had a series of posts, and a series of political ups and downs, dying in exile but being completely exonerated two years later. While he was alive, his brand of Neo-Confucianism was denounced as 'false learning' (hence his disgrace and exile) but after his exoneration his views became overwhelmingly influential, so much so that he was vilified by the Communists in the twentieth century and blamed for the way China after the Middle Ages dropped behind other civilisations. His ideas are difficult to appreciate today, since they are so bland by later standards (this may account for the Communist attitude). But no one can deny their influence over many centuries.[57]

Zhu drew together a number of ideas of his immediate forerunners, such as Zheng Yi and Zhou Dunyi. Contrary to what the Buddhists and others had said, Zhu downplayed the role of the supernatural in man's affairs. The elements – rain, thunder, wind – now became again natural forces, expressions of the principle or principles underlying the universe. Wisdom, happiness, ethical living together was to be achieved, he said, by attunement to *lixue*, the pattern of nature that encompassed the entire world, and which explained both its existence and development.[58] Only when man pursued such a course of *lixue* could he discover the pre-established harmony of the world and approach perfection. Postulating that there were two ultimate forces or entities in the universe, the Supreme Ultimate and the Principle (*li*), Zhu said that the former, in essence, explained the existence of matter (and the absence of nothing, important since the advent of Buddhism), while the latter, *li*, explained the form and development (the ontology) of matter, leading to the development of humans and then of ethics. Zhu believed, as Confucius had before him, that the universe was self-renewing and to explain man's presence in the universe he said that there was a benevolent, generative element, *ren*, humaneness. This explained why, as Confucius and Mencius had argued, the universe is good and man's nature is to be, and do, good.[59] Zhu's authority partly lay in the elegance of his synthesis, but also in the great depth of his classical learning, for he was able to show, in a section called *Dao Tong*, the 'Transmission of the Way', how similar ideas had been transmitted from antiquity all the way through to Song times. In doing this, he was asserting the truly Chinese nature of

these ideas, a further element in the turning away from Buddhism. One of his favourite metaphors was that between man and a pearl in a bowl of dirty water. The pearl may appear dim and lustreless (to the man) but if taken from the water it still shines brilliantly. Evil conduct, Zhu thought, was the product of neglect or the lack of a proper education.[60]

With this in mind, he compiled *The Four Books*. This was his way of ensuring that Neo-Confucianism, his approach to *lixue*, was maintained and spread. He grouped together four books: the *Analects* of Confucius, the *Mencius*, and two chapters called *The Great Learning* (*Daxue*) and *The Doctrine of the Mean* (*Zhongyong*), excerpted from the Han compilation known as *The Book of Rites*. These four works, he said, should form the basis of education, together with interpretive commentaries which he provided, and the nine other Confucian classics. And indeed, this system soon dominated education. A few short years after his death, his editings of the Confucian classics were officially designated the standard for the civil service examinations and remained so until the examinations were abolished in 1905.

The return to Confucianism was more than a change in philosophy: it marked a change in sensibility, too, and one that helped to create the Song renaissance. The ornate, fantastic, otherworldly aspect of Buddhism disappeared, to be replaced by a more practical rationalism, a more purely intellectual world – contemplative and learned and suspicious of all that had gone before. It was a freedom, a freedom that resulted not just in an efflorescence of the civilised arts but, more relevant to the subject of this book, new *forms* of art and learning: poems set to music, a series of great encyclopaedias and anthologies, landscape painting, the garden, the first known treatise on forensic medicine, archaeology, critical history, social history and, eventually, the novel.

The Painting Academy, which had been founded as a section of the imperial university during the Five Dynasties period (a series of brief military dictatorships, 907–960, which saw incursions from the outside), was made an independent institution by the emperor Song Huizong (r. 1101–1126).[61] He also improved the status of the visual artist by introducing painting as one of the examinations for entry into the civil service. The question invariably consisted of a line from the classics, which had to be illustrated in an original way. Marks were awarded for ingenuity of composition rather than for life-like reproduction of natural objects. One has always to remember that, in China, where writing was carried out with a brush, rather than a pen, literature and painting were much closer to each other than they were in, say, the West of a later age. Each activity was a different form of brushmanship. Endymion Wilkinson says that at one point calligraphy (*shufa*) was regarded as more important than painting.

Landscape painting began to replace animal and figure painting towards the end of the Five Dynasties period, and by the late tenth and eleventh centuries it was the dominant art form. This partly had to do with the growth of cities in Song China, where country (and particularly mountain) landscapes were a distant rarity. But their attraction for the literati, the educated *jinshi*, was in their evocation of the contemplative life, emphasising the clear austerity and harshness of Chinese mountains, with their snow and clouds. It was, in effect, a romantic, nostalgic and deliberate return to the Confucian ideals of simplicity, conciseness, calm.

Related to landscape painting was the wholly Chinese idea of the designed garden. The rise of gardening, Yong Yap and Arthur Cotterell tell us, ran parallel to the art of landscape painting. 'Its roots lie in Taoism, that perennial call to return to nature, in both an inner and an outer sense, but Buddhism also encouraged the trend.'[62] Many Buddhist areas of instruction included parks and wealthy converts began a tradition of leaving their gardens to the faith.[63] By Song times, the Chinese garden had become an attempt at a genuine work of art, an expression of man's relation with the natural world. There were certain rules that were supposed to lie behind the design of a garden but, unlike later European gardens, say, this did not lead to conformity. There must be *shan shui*, or mountains and water (wild rocks and a pond), plus flowers, trees and some form of decorative architecture – bridges, a pavilion, or even just walls. The garden also formed part of the house – the 'Well of Heaven', the inner courtyard, was integral to daily life, which moved inside and outside without a thought. All palaces faced south.[64] The objects in the garden also had a symbolic quality, as aids to meditation. Water was central. There were no lawns, flowers were never patterned – instead, individual plants were placed next to craggy rocks. And there was a complex symbolism of flowers. For example, the chrysanthemum, the flower of autumn, 'stands for retirement and culture'; the water lily, 'rising stainless from its bed of slime', stands for purity and truth; the bamboo, 'unbroken by the fiercest storm', represents suppleness and strength but also lasting friendship and hardy age.[65] 'Asymmetrical and spontaneous, the Chinese garden is a statement of faith in Nature as well as an admission of the lowly place that mankind has in the natural order of things.'[66]

Like landscape painting and gardening, archaeology became an organised activity much earlier in China than elsewhere. Bronzes and jades dating from the second millennium BC were discovered during the reign of Huizong in Anyang, the chief Shang city, north of what is now the Yellow river in Hebei. This fostered a fashion in antiquities but it also stimulated an interest in the ancient inscriptions found on the objects, both for the information contained and for the styles of writing and how they changed. This led to the practice of critical archaeology and epigraphy. A treatise on ancient bells and tripods was published at this time and, in 1092, Lu Dalin released his *Archaeological Plates*, which attempted to classify and date a series of bronzes from the second and first millennia BC.[67] Books on ancient coins also started to appear and a husband and wife team produced their *Catalogue of the Inscriptions on Stone and Bronze*, a record of two thousand ancient inscriptions.

There was a resurgence of historical writing under the Song but here too, under Neo-Confucian influence, it involved a return to an earlier literary sensibility. This was the so-called 'ancient style' (*gu wen*), which embodied a recognition of earlier literary qualities and wasn't ashamed to resurrect them. In doing so, however, authors such as Ouyang Xiu (1007–1072) rewrote earlier histories, such as the *History of the Tang* (which became the *New History of the Tang*, 1060) but in the process turned what had been fairly routine, official (and largely anonymous) records into far more rigorous, evaluative and scientific works, of far more value than the earlier varieties. The most impressive and famous of these critical histories was that written between 1072 and 1084 by Sima Guang, the *Complete Mirror of the Illustration of Government*. This is a history of China from 403 BC to AD 959, but it was less the extraordinary range of the book which impressed later

scholars than its use of sources: of its 354 chapters, no fewer than thirty consisted of critical notes discussing the reasons why the author drew the conclusions he did, when different sources said different things. Sima Guang went to extraordinary lengths to check the grounding for all the events he recorded, in the process putting Herodotus to shame.

The overall impact of the examination system, and the scholar-elite which it engendered, may ultimately be gauged from the fact that the Northern Song is now famed as an age of 'consummate poetry and strong bellestric and historical prose writing, of magnificent painting and calligraphy, of matchless ceramics, and of a full complement of what the Chinese looked upon as minor arts'.[68] The same is true of book production, 'Song printings' being the most sought-after examples. It was a time when scholarship began to acquire some of its modern rigour, when the first encyclopaedias appeared which are valuable even today. 'The Song elite had progressed far beyond the "cabinet of curiosities" stage, still current in Europe at a much later date, and were engaged in intelligent research concerned with identification, etymology, dating and interpretation.'[69] The Song was also a high point in mathematics, science, medicine and technology. Maritime technology, bridges, military apparatus – all these made great strides under the Song.[70]

As F. W. Mote describes Song culture, all those things done with the writing brush, from poetry to painting to calligraphy, to writing history or critical studies of the classics, from governing and even writing out medical prescriptions 'were the proper activities for the scholars . . . They lived by the brush, and all that came from their brushes belonged to high culture.'[71] While this may not be a surprise, what was surprising was the fact that many other activities of mind and hand – sculpture, ceramics, lacquer-work – were regarded as the work of artisans and craftsmen, and thus did not belong to high culture. Later Chinese shared the Song hierarchy of cultural values well on into the twentieth century.

Nevertheless, the Song age did see fantastic new developments right across the board: the arts, technology, the natural sciences (an astronomical clock in the eighth century), social institutions, philosophy. This approach was epitomised by the career of Shen Gua (1031–1095), whom Mote calls 'perhaps the most interesting character in all of Chinese scientific history'.[72] Shen was a widely travelled careful observer who took particular note of fossilised sea creatures in the Daihang mountains, and realised that mountains had once been sea beds. But he also made advances in astronomy, mathematics, metallurgy, pharmacology and cartography. He produced the first detailed atlas of China, calculated contours to within an inch of absolute accuracy and was the first to write a meticulous account of the magnetic compass as it came to be applied to maritime navigation.[73]

Shen highlights the fact that, as we approach the end of this second section of the book, we can see that the great civilisations, the most important sources of ideas and inventions, at the end of what Westerners call the Middle Ages, were China, India and Islam. Asia was the dominant landmass, in terms of both political power, size of population, technological ingenuity and abstract thought. Europe was a long way from both the currents of civilisation and the great trade routes. But long-term, systemic change was under way. The thirteenth century was remarkable for many things, as we shall presently see, but as the American scholar Janet Abu-Lughod has pointed out, it was remarkable in particular for being a 'hinge' century. 'In region after region there was an efflorescence of cultural and

artistic achievement. Never before had so many parts of the Old World simultaneously reached cultural maturity. In China, the most glorious pottery ever produced, Song celadon-ware, was being created, and in Persia glowing turquoise-glazed bowls constituted the only serious rival. In Mamluk Egypt, craftsmen were fashioning elaborate furniture inlaid with complex arabesques of silver and gold ... The great Hindu temple complexes of south India climaxed at the same time. Almost everywhere there was evidence of a surfeit of wealth being devoted to ornamentation and symbolic display ... In all areas, prosperity ... yielded high culture.'[74]

Yet, as she also points out, this was the century when, in western Europe, the great cathedral-building movement reached its apex. In other words, Europe was on the rise. Why the East faltered after the thirteenth century, and then fell steadily behind, is a question that still taxes historians of all nations. In the wake of the events at the World Trade Center in New York City on 11 September 2001, it is arguably the most important historical legacy facing the world today.

# PART THREE

# THE GREAT HINGE OF HISTORY
European Acceleration

# 15

# *The Idea of Europe*

In the tenth century AD, the famous Arab geographer Mas'udi had this to say about the peoples of 'Urufa', as Muslims then called Europe: 'The warm humour is lacking among them; their bodies are large, their natures gross, their manners harsh, their understanding dull, and their tongues heavy . . . The farther they are to the north the more stupid, gross, and brutish they are.'[1] His slightly later colleague, Sa'id ibn Ahmad, qadi of the Muslim city of Toledo in Spain, wasn't much more impressed either. According to Bernard Lewis, the great Islamic scholar, in 1068, two years after the battle of Hastings, Ibn Ahmad wrote a book in Arabic on the categories of nations. He found that there had been eight nations that had contributed most to knowledge – including the Indians, Persians, Greeks, Egyptians and, of course, the Arabs. On the other hand he found that the north Europeans 'have not cultivated the sciences [and] are more like beasts than like men . . . they lack keenness of understanding and clarity of intelligence . . .'[2] Even as late as the thirteenth century, the Oxford scholar Roger Bacon had his eyes fixed firmly on the East. He petitioned the pope, Clement IV, to mount a grand project – an encyclopaedia of new knowledge in the natural sciences. He had in mind the great number of translations then being made from the Arabic, and he recommended the study of Oriental languages, and of Islam.

By the time of his near-namesake, Francis Bacon, however, the world was very different. A massive change had come over Europe, some time between AD 1000 and AD 1500, and the continent had drawn decisively ahead. Francis Bacon believed there was little to be learned from outside Europe.

What had happened? Why had 'the West' drawn ahead? What features of this 'frigid', 'gross' and 'apathetic' people, as Ibn Ahmad also called Europeans, were turned round, to create the conditions we see about us today, where the West undisputably leads the world in terms of wealth, technological advance, and religious and political freedoms? In the realm of ideas – the central concern of this book – the change that came over Europe, sometime between the year AD 1000 and, say, 1500, when the discovery of America had been achieved (by west Europeans), is probably the most fascinating question of all, eclipsing all others in importance and giving shape to the latest epoch of history. It is all the more important, in view of the fact that, even today, there is no real answer. There are plenty of theories, but they are all more or less conjectural.

It is in fact surprising that more inquiry has not been devoted to this subject, but from such scholarship as exists, the answers divide into six. They all agree that there *was* a

fundamental change in Europe between 1000 and 1500, and that that is when the 'West' first began. But this is as far as the agreement goes. The case for any one decisive factor has yet to be proved.

This chapter, which is in some ways a hinge of the book, will be somewhat different from the others. Whereas the other chapters describe ideas as they occurred, and attempt to assess their importance and place in chronology, this chapter stands back and looks at the possible *context* of ideas, trying to arrive at some sort of answer to the question as to why, for the remainder of history, the great preponderance of influential ideas arose in Europe, and western Europe at that. In doing so, we shall anticipate some of the developments covered in more detail in later chapters but the immediate aim here is to show why Europe became the home for so many of the ideas that have dominated our lives for the past thousand years.

An attempt at a geographical answer was made by the French historian, of the *Annales* school, Fernand Braudel. In two books, *The Mediterranean and the Mediterranean World in the Age of Philip II*, and *Civilisation and Capitalism*, in particular volume 1, *The Structures of Everyday Life*, he sought to explain why Europe took on the character that it did. He thought, for example, that there was a broad relationship between foodstuffs and the civilisations of the world. Rice, he found, 'brought high populations and [therefore] strict social discipline to the regions where they prospered', in Asia. On the other hand, 'maize is a crop that demands little effort', which allowed the native Americans much free time to construct the huge pyramids for which these civilisations have become famous. He thought that a crucial factor in Europe's success was its relatively small size, the efficiency of grain, and the climate. The fact that so much of life was indoors, he said, fostered the development of furniture, which brought about the development of tools; the poorer weather meant that fewer days could be worked, but mouths still had to be fed, making labour in Europe relatively expensive. This led to a greater need for labour-saving devices, which, on top of the development of tools, contributed first to the scientific revolution, and later to the industrial revolution.[3]

In his book on the Mediterranean, Braudel tried to be a little more specific, and attempted to identify those features of the sea which contributed to Europe's rise. He noted, for instance, that the sea is old geologically, and deep, with little in the way of coastal shelves. This 'tiredness' of the water and the lack of shallow seas made the Mediterranean relatively poor in fish, prompting long-distance trade. The proximity of mountains to the coastlines, in particular the Alps, meant that people from the upland villages migrated to the coasts, bringing a different technology with them. Migration was a major factor in the spread of ideas and this was facilitated in the Mediterranean (a) because the sea was east–west, in line with the prevailing winds, making sailing much easier; (b) because the islands and general configuration of the Mediterranean divided it up into much smaller areas – the Tyrrhenian Sea, the Adriatic, the Aegean, the Black Sea, the Ionian Sea, the gulf of Sirte – which made navigation and sailing even easier; (c) because the sea was ringed with a number of peninsulas (the Iberian, the Italian, the Greek), the geographical coherence of which promoted strong feelings of nationalism, which in turn fuelled international competition; (d) because the central Alps provided the

source for three rivers – the Rhine, the Danube and the Rhône/Saône – which supported transport into the very heart of Europe. The relatively small size of the continent, plus the fact that the three great rivers penetrated so deeply, encouraged the development of roads, to fill in the final phase of the transportation network. The roads, like the navigable seas and the great rivers, meant that the heartland of Europe was opened up as no heartland had been opened up before, with the result that immigrants – with their fresh ways and different ideas – were a more common sight in Europe than elsewhere.

This is fine as far as it goes (though Spain, for one, was less coherent than Braudel implies, with a very mixed population, of Arabs, Berbers, Mozarabs and Jews). However, all that has really been 'explained' is why, *at some stage*, Europe should have taken off. Braudel's central argument was that geography governed raw materials, the creation of cities (the markets) and trade routes. There was, in other words, a certain geographical *inevitability* about the way civilisations developed, which made Europe, rather than Asia, Africa or America, the cradle of both science and capitalism. But something more is needed. We still have to explain why the acceleration happened when it did. By no means everyone accepts that the rise of Europe was inevitable.

Not everyone accepts that change took place between 1050 and 1200 either. In his book *Origins of the European Economy: Communication and Commerce, AD 300–900* (2001), Michael McCormick, of Harvard, argues that Europe was on the move from as early as the late eighth century, and that change was fully underway by 1100, which meant that the advance of the continent was three times as long as is usually thought, 'and three times as difficult'.[4] He points out that the real low point, in western Europe at least, was 700, when there was a drastic reduction in all commercial activity, when the international trade in spices collapsed, when papyrus stopped reaching Frankland, when fewer palimpsests were produced.[5] He records that when the Venerable Bede died in 735 he gave away his pepper and incense on his deathbed. Four generations later, however, the pepper trade had increased to the point where it was no longer a once-in-a-lifetime gift. In the Carolingian empire, coinage was far more widespread and sophisticated than has hitherto been thought, he says, and he discovered fifty-four Arab coins at forty-two locations in the empire between the seventh and tenth centuries.[6] He argues there was a rise in ship-owning in the mid-ninth century, that he discovered accounts of nearly seven hundred people making long, arduous journeys at this time. There was enough traffic on the Danube in the ninth century for it to boast both pirates and toll collectors.[7] By the early tenth century, there were thriving markets in the Rhineland and in Paris and at the latter, at St Denis, the merchants came from Spain and Provence and dealt in goods from as far away as Iraq.[8] He points out that a crucial event was the conversion to Christianity of the Hungarian kingdom, around A D 1000, which reopened the overland route to Constantinople.[9]

McCormick's argument is persuasive (his book is 1,100 pages long and packed with detail). However, he seems to have identified a period of gestation, in which Europe was, as it were, getting itself together. Arabs who, like Mas'udi, travelled in Urufa (as shown by their coins) didn't appear to note yet that the continent was changing. It undoubtedly was, but the great leap forward had yet to occur.

*

The second type of explanation for the acceleration after the tenth century is economic, and falls into two parts. The economic/cultural situation in the 'Old World' has been described in detail by Janet L. Abu-Lughod, in *Before European Hegemony*.[10] She writes: 'The second half of the thirteenth century was a remarkable moment in world history. Never before had so many regions of the Old World come into contact with one another – albeit still only superficially. The apogee of this cycle came between the end of the thirteenth century and the first decades of the fourteenth, by which time even Europe and China had established direct, if limited, contact with each other.'[11] This economic world, she says, is not only fascinating in itself but, because it contained no single overriding power, it provided an important contrast to the world system that grew out of it: the one Europe reshaped to its own ends and dominated for so long.

Her argument is that in terms of time, the century between AD 1250 and 1350 constituted a fulcrum or critical 'turning-point' in world history, and in terms of space, the Middle East heartland region, linking the eastern Mediterranean with the Indian Ocean, constituted a geographical fulcrum on which West and East were then roughly balanced. The thesis of her book was, *contra* Braudel, that there was no *inherent historical necessity* that shifted the system to favour the West rather than the East. She noted that there were eight basic trading systems but that these collapsed into three main ones – the European, the Middle Eastern and the Asian. All of them had several features in common: the invention of money and credit; mechanisms for pooling capital and distributing risk; merchants with independent wealth. Therefore, while conceding that between the thirteenth and the sixteenth centuries Europe did overtake the Orient, she concludes that there was nothing 'special' about Europe; instead the Orient was 'temporarily in disarray'. She says there was progressive fragmentation of the overland trade routes that had been unified by Genghis Khan, that the depredations of Tamerlane around 1400 had a much worse effect on Asia than the Crusades ever did, and that the Black Death, 'which spread from China all the way to Europe in the mid-century between 1348 and 1351, decimated most of the cities along the great sea route of world trade, disturbing customary behaviour, changing the terms of exchange because of differential demographic losses, and creating a fluidity in world conditions that facilitated radical transformations, benefiting some and harming others.'[12] This could be seen in Europe, she says, where England, previously part of the periphery, began to play a more central role after the plague, since her 'die-off' rate was lower than on the continent. And it was the galleys of the Italian city-states that, by the end of the thirteenth century, had opened the north Atlantic to traffic, delivering the *coup de grâce* to a world system that had existed for centuries. This led to the Portuguese 'discovery' of the Atlantic route to the Indies, much of which had been known to Arab and Chinese traders for centuries. The Arab and Indian vessels, however, proved no match for the Portuguese men-of-war that appeared in their waters in the early 1500s.

Her point is that the world system in place by the thirteenth century was relatively stable, and truly cosmopolitan: different religious systems co-existed – Christianity, Islam, Buddhism, Confucianism, Zoroastrianism; and business practices were equally sophisticated the world over – 'The organisation of textile production in Kanchipuram was not unlike that in Flanders, the state built boats for trade in both Venice and China, trading centres – like Cairo, Zaytun and Troyes – grew in much the same way, and at a similar rate

in the centuries up to the thirteenth.'[13] For Janet Abu-Lughod, what happened in the thirteenth century was that a world trading system that had been stable for some time became unravelled, leaving the Western systems, centring on Bruges, Troyes, Genoa and Venice, relatively unscathed, while destroying those centres further east, at Cairo, Baghdad, Basra, Samarkand, Hormuz, Cambay, Calicut, Malacca and mainland China.[14] Abu-Lughod argues that, in general, historians have failed to 'begin the story early enough' and have therefore given a truncated and distorted causal explanation for the rise of the West. In fact, she says, the time between the thirteenth and sixteenth centuries marked the transition, and geopolitical factors within the rest of the world system created an opportunity without which Europe's rise would have been unlikely.

For Abu-Lughod, it was thus important that 'the rise of the west' was preceded by 'the fall of the east'. When the Mongols, severely weakened by the Black Death, 'lost' China in 1386, the world now forfeited the key link that had connected the overland route, terminating at Peking (Beijing), with the sea routes through the Indian Ocean and South China Sea, terminating at the ports of south-east China. The repercussions of this disjunction at the eastern end of the world system were felt throughout the trading world.[15] In particular, it favoured Genoa at the expense of Venice. Venice was, with Genoa, the gateway of this world system into Europe. But Genoa also had a more ready alternative – the Atlantic. And as the Atlantic opened up, ships plying that route were able to take advantage of the disarray in the East. This geographic reorientation displaced the centre of world gravity in a decisive manner.

The theory of Joseph Needham, the Cambridge-based historian of early Chinese science, is quite different. He begins by reminding us of the incredible number of inventions which came out of the East before AD 1000, many of which were described in the preceding chapter. Needham was of the opinion that, in the earlier centuries, Europe had been a much more unstable continent than China, socially, politically and culturally speaking, and that this had kept the region backward. It was poor in precious metals and its layout – a series of peninsulas and archipelagos (Iberia, Italy, Greece) – had made it more nationalistic, because there were many natural boundaries. In addition to this, he says, the alphabet system of writing, precisely because it was so flexible, exacerbated the problem by making it relatively easy for different tribes and groups to evolve mutually incomprehensible languages (in contrast to China which had a unifying script). All this kept Europe embroiled in repeated conflict, and therefore backward.[16]

But then came two inventions, both out of China. First was the stirrup, which, by adding immeasurably to the power of the knightly class, helped create feudalism. And second gunpowder, which helped *destroy* feudalism, at least in Europe, because it reduced the power of the knightly class. As feudalism decayed in the West, according to Needham, it gave rise to a mercantile class, which was closely associated with the rise of science. In China, however, this didn't happen. As a far more stable continent, with a more entrenched and unified imperial history, and despite the many inventions to its credit, feudalism there was replaced with 'bureaucratic feudalism', or a 'mandarinate', a scholar-elite class highly suitable to a large country, heavily centralised under an emperor, where mandarin bureaucrats could administer steady progress. The unfortunate side to all this, however, was

that under such a system the mercantile class was down-graded – the merchants were the lowest of the four ranks of society, after scholars, farmers and artisans. As well as stifling creativity, this arrangement meant that the city-state never developed in China: cities there were dominated instead by the representative of the emperor, which meant there were no mayors, no guilds, no councillors. Instead of being places of upward mobility, Chinese cities were ruled from the top down. As a result, and despite that long list of inventions, China never developed modern business methods or modern science. For Needham this was, in the end, fatal.[17]

Whether or not the city-state ever developed in China, the rest of Needham's argument has been both discredited *and* supported by more recent scholarship (entire conferences have been held on the 'Needham factor'). There are first the doubts over the utility of feudalism as a concept, not simply because the term was a later invention but because the idea of a nexus of land/law/fealty does not really match the medieval experience. The power of the lord over the peasants did not come from horses, and stirrups, but from the wider socio-political system that divided the world into three orders (those who pray, those who fight, those who work) and supported a legal system that upheld the power of the few over the many. Moreover, this system only came into existence about the year 1000 and so it makes no sense to talk of 'feudalism' in the early Middle Ages. And what finally made the lords' power over the peasants crumble had little to do with the fate of the knights – it was much more to do with the demographic crisis of the fourteenth century, when widespread plague and famine reduced the number of peasants, stimulating more demand for their labour, giving them more in wages and a greater freedom of movement, thus ending 'serfdom'.

At the same time, other historians have underlined the fact that there was indeed a difference between Western and Eastern scholarship. The ideas and research of Geoffrey Lloyd and Nathan Sivin, about the differences in structure between early Chinese and early Greek science, were covered in an earlier chapter (page 128). More recently, Toby Huff has claimed that an important difference between Occident and Orient in this context is that in China and the Islamic world a student's competence was judged by the state or the master. Neither of these systems fostered independent thought. Huff calculated that, in the twelfth and thirteenth centuries, Europe, China and the Islamic world had roughly the same number of scholars, but that in the East they never achieved a *corporate* identity; therefore in the Islamic world and in China scholarship never acquired the independent power that it was to achieve in Europe.[18] One reason it did develop in the West, he says, is because of the rediscovery of Justinian's code, the *Corpus iuris civilis* (see pages 203–204 above), towards the end of the eleventh century. This reintroduced the concept of a legal *system*, a new science of law, which led to the idea of *shared* knowledge, which could be discussed and argued over. The idea of corporate knowledge, Huff says, lay behind the idea of the universities as conceived in Europe but not in China or the Islamic world.[19] This meant there was no organised scepticism in the East. He shows for example that Arab astronomers knew what Kepler knew but because they had no concept of the *Corpus astronomicum*, a general body of astronomical work, which belonged to all and could be disputed, they never developed a Copernican view of a heliocentric universe.[20]

*

A somewhat different economic interpretation returns to Braudel's point that Europe is relatively small. In *The Rise of the Western World*, Douglas North and Robert Thomas argue that in the High Middle Ages, the years between 1000 and 1300, Europe was transformed 'from a vast wilderness into a well-colonised region'. There was a marked population increase which meant that, in effect, Europe was the first region in the history of the world to be 'full' with people. This was aided by the layout of its main rivers – the Danube, Rhine and the Rhône/Saône – which led deep into the heartland. Together, these factors had a number of consequences, not the least of which was to begin a change from the old feudal structure, and to give more and more people an interest in property, in owning land.[21] It was this wider ownership of land which would, before too long, lead to a rise in specialisation (at first in the growing of crops, then in the services to support such specialisation), then to the rise in trade, the spread of markets, and the development of a money economy, so necessary if surplus wealth were to be created, which were the circumstances from which true capitalism developed.[22]

As part of the evidence in support of their argument, North and Thomas note that a new system of agriculture was introduced in these years in Europe, namely the change from the two-field system to the three-field system. Under the two-field system all arable land had been ploughed but only half of it planted to crops, the other half being left fallow to recuperate its fertility. The three-field system now divided the arable land of the manor into three parts. Typically, one field was ploughed and planted to wheat during the autumn, the second ploughed and planted in the spring to oats, barley, or legumes, such as peas or beans, and the remainder was ploughed and left fallow. The next year the crops were rotated. This led to a massive 50 per cent rise in yield, at the same time as spreading agricultural labour throughout the year, and reducing the chance of famine through crop failure.[23] This period also saw a change from oxen to horse as the beasts of harness, the latter being 50 to 90 per cent more biologically efficient.

In turn, the eleventh century saw a rise in the use of watermills. This idea had begun outside Europe but its introduction spread rapidly in the new climate, despite the high capital expenditure that was required: in 1086, the Domesday Book recorded 5,624 mills for 3,000 communities in England. There is no reason to believe that England was technologically more advanced than the rest of Europe, though watermills naturally tended to multiply there because there were a lot of rivers in a small area. Hence wool and cloth manufacture became a major feature of England and Flanders.

These twin developments, of significantly more people having a stake in the land, and the idea that there was no more to go around, had two psychological effects, say North and Thomas. It helped make people more individualistic: because he or she now had a stake in something, a person's identity was no longer defined only by his or her membership of a congregation, or as the serf of a lord of the manor; and it introduced (or reintroduced) the idea of efficiency, because resources could now be seen to be limited. Allied to the increased specialisation that was developing, and the burgeoning markets (offering tempting goods from far away), this was a profound social-psychological revolution which, in time, would lead to the Renaissance.

This too is an idea which has suffered from recent scholarship, which emphasises that there was *always* a large proportion – say, 40–50 per cent – of the population which was

not serfs (in the sense of being 'unfree') and who already owned their own land. Carlo M. Cipolla, the Italian economic historian, further argues that there was no shortage of land in Europe, quite the opposite in fact: there was plenty. He notes that Europe may have differed from the East in having a larger proportion of the population who were unmarried, which helped avoid the breakup of estates and reduced the number of large families, both factors which helped ameliorate poverty. Cipolla also supports the arguments of Michael McCormick in showing a steady growth of technology: the watermill from the sixth century; the plough from the seventh; the crop rotation system from the eighth; the horseshoe and the neck harness from the ninth. In the same way the use of the mill proliferated to other uses, from beer-making in 861, through tanning in 1138, paper-milling in 1276, to the blast furnace in 1384.[24] All this argues for a steady take-off of Europe rather than anything sudden. Cipolla agrees with North and Thomas that there were new business techniques from the eleventh century, especially a change from the hoarding of savings (deflationary) to the investment of 'capital', in particular the *contratto di commenda*.[25] This was in effect a contract for one party to lend capital to another party, to finance foreign trade, the capital to be repaid, with interest, out of profits. Cipolla also notes that there was a growing demand for money (coins) from the tenth century on, and provides maps of the many mints sanctioned at that time. He notes that the terms 'banks' and 'bankers' make their first appearance in the twelfth century. Gold coinages appeared in Venice, Genoa and Florence between 1252 and 1284 and quickly became standards of value.[26] Whether these are causes or symptoms of change isn't clear.

An entirely different explanation for the rise of Europe, and the one with the most scholarship attached to it, relates to the Christian church and its role in the unification of the continent. At the time, the name Europe (Latin: *Europa*) was rarely used. It was a classical term, going back to Herodotus, and though Charlemagne called himself *pater Europea*, the father of Europe, by the eleventh century the more normal term was *Christianitas*, Christendom.

The early aim of the Church had been territorial expansion, the second had been monastic reform, with the monasteries – dispersed throughout Christendom – leading the battle for the minds of converts. Out of all this arose a third chapter in church history, to replace dispersed localism with central – papal – control. Around AD 1000–1100 Christendom entered a new phase, partly out of the failure of the millennium to provide anything spectacular in a religious, apocalyptic sense, partly as a result of the Crusades which, in identifying a common enemy in Islam, also acted as a unifying force among Christians. All this climaxed in the thirteenth century with popes vying with kings and emperors for supreme control, even to the point of monarchs being excommunicated (covered in the next chapter).[27]

Around and underneath this, however, there developed a certain cast of mind, which is the main interest here. The problems of the vast, dispersed organisation of the continent-wide church, the relations between church and monarch, between church and state – all these raised many doctrinal and legal matters. Because these matters were discussed and debated in the monasteries and the schools that were set up at this time, they became known as scholastic. The British historian R. W. S. Southern was most intimately involved

in showing how scholars, as a 'supranational entity', aided the unification of Europe. These pages are based largely on his work.

The role of the scholars was immediately obvious in the language they used – Latin. All over Europe, in monasteries and schools, in the developing universities and in bishops' palaces, the papal legates and nuncios exchanged views and messages in the same language. Peter Abelard's enemies perceived his books to be dangerous not only for their content but for their reach: 'They pass from one race to another, and from one kingdom to another … they cross the oceans, they leap over the Alps … they spread through the provinces and the kingdoms.'[28] Because of this, papal careers were notoriously international. Frenchmen might be seconded to Spain, Germans to Venice, Italians to Greece and England and then to Croatia and Hungary, as Giles of Verraccio was between 1218 and 1230. In this way there was in Europe between AD 1000 and 1300 a unification of thought, of the rules of debate, in the ways of discussing things and in agreeing what was important, that did not occur anywhere else. And it was not only in strictly theological matters, but was felt in architecture, in law, and in the liberal arts. Theology, law and the liberal arts were, according to Southern, the three props on which European order and civilisation were built during the twelfth and thirteenth centuries – 'That is to say, during the period of Europe's most rapid expansion in population, wealth and world-wide aspirations before the nineteenth century.' These three areas of thought each owed its coherence and its power to influence the world to the development of schools of European-wide importance. Both masters and pupils travelled from all regions of Europe to these schools and took home the sciences which they had learned.[29]

Even by the year 1250 there were still very few universities in Europe: Bologna in northern Italy, Montpellier in southern France, Paris in northern France, Oxford in England. But each of them was truly international. Later on, universities became very nationalistic but not in the beginning, and not only because Latin was the universal language.[30] The main groundwork of scholastic thought was laid down in the first half of the twelfth century, which brought about a new outlook on the world of nature and of organised Christian society.[31] The aim may read oddly now but it was in fact a coherent view of the Creation, of the Fall and Redemption of mankind, and of the sacraments, 'whereby the redeeming process could be extended to individuals'. Coherence was achieved because the men who created the system all used the same, ever-growing body of textbooks, and they were all familiar with similar routines of lectures, debates and academic exercises and shared a belief that Christianity was capable of a systematic and authoritative presentation.[32]

What had been inherited from the ancient world was very largely unco-ordinated. The scholars' aim now was to restore 'to fallen mankind, so far as was possible, that perfect system of knowledge which had been in the possession or within the reach of mankind at the moment of Creation'.[33] This body of knowledge, so it was believed, had been lost completely in the centuries between the Fall and the Flood, but had then been slowly restored by divinely-inspired Old Testament prophets, as well as by the efforts of a range of philosophers in the Graeco-Roman world. These achievements had, however, been corrupted once again and partly lost during the barbarian invasions which had overwhelmed Christendom in the early Middle Ages. Nevertheless, many of the important

texts of ancient learning had survived, in particular Aristotle, albeit in Arabic translations and glosses, as was covered in Chapters 11 and 12. It was understood as the task of the new scholars, from about 1050 onwards, to continue the responsibility of restoring the knowledge that had been lost at the Fall.[34] This responsibility included clarification, correction of errors caused either by corruption of the texts or by the partial understanding of their ancient authors, and finally systematisation, to make the new knowledge generally accessible throughout western Christendom. 'The *complete* knowledge of the first parents before the Fall had gone beyond recall, and there was a profound sense in which to seek to know everything was to fall into the sin of curiosity. But what could legitimately be sought was that degree of knowledge necessary for providing a just view of God, of nature and of human conduct, which would promote the cause of mankind's salvation ... The whole programme, thus conceived, looked forward to a time not far distant, when a two-pronged programme of world-wide return to the essential endowment of the first parents of the human race would have been achieved so far as was possible for fallen mankind.'[35] In the theological context of the times, there was a very practical aim to the restoration of knowledge.[36] 'The world would probably come to an end within decades or at most a few centuries, almost certainly before another millennium had passed. At all events, it would end when the perfect, but to us unknown, number of the redeemed had been accomplished, and the aim of the schools, as of the Church in general, was to prepare the world for this event, and to hasten it.'[37] Southern also reminds us that the scholastic synthesis did not appear quite as daunting as it would be today, since the number of basic texts across the whole range of subjects was very small by modern standards – no more than three or four hundred volumes of moderate size would have contained all the basic material.[38]

This hope of a final synthesis did not outlast the fourteenth century but by then the early universities had come into existence and their international character produced enough masters and pupils, sharing the same approach and values, to create across Europe an entire class of learned men (mainly men) who had been trained in the same texts and commentaries, and regarded the same questions as important. As noted, all shared the view that theology, the liberal arts, and the law were what counted.[39] In addition, the theory of knowledge on which the scholastic system was based – that all knowledge was a *reconquest* of what had been freely available to mankind in its pre-lapsarian state – brought with it the idea that a body of authoritative doctrine would slowly emerge as the years passed.[40] By 1175 scholars saw themselves not only as transmitters of ancient learning, but as active participants in the development of an integrated, many-sided body of knowledge 'rapidly reaching its peak'.[41] In stabilising and promoting the study of theology and law, the scholars helped create a fairly orderly and forward-looking society. Europe as a whole was the beneficiary of this process.

In addition to the theologians, three scholars in particular may be singled out for their contributions to the idea of the West. The first is the Bolognese monk, Gratian. Before him, canon law did not exist as a systematic body of study. Until then, most decisions had been taken locally by bishops and it is fair to say that, by 1100, the whole system was in disarray. So, when his treatise *A Concordance of Discordant Canons*, aka the *Decretum*, appeared in 1140 it was rapturously received right across the continent.[42] Gratian

attempted to rethink, reorganise and rationalise ecclesiastical law (which was of course the main form of law in a totally religious society) in such a way that blind custom was done away with. He did not always succeed but, after him, the law was much more subject to the test of reasonableness, so that it could be accepted by popes and local bishops and priests with more or less equal enthusiasm. It was liberating as well as unifying.

The second scholar was Robert Grosseteste (*c.* 1186–1253). A graduate of Oxford, who studied theology at Paris, Grosseteste is best known for being chancellor of Oxford. He was a translator of the classics, a biblical scholar and bishop of Lincoln. But he was also, and possibly most importantly, the inventor of the experimental method.* Roger Bacon was the first to point out, in his *Compendium Studii*, that 'before other men, Grosseteste wrote about science'.[43] In the half-century before Grosseteste was born, Western scholars had been translating Greek and Islamic scientific writings out of Arabic into Latin, and this in itself was a factor in the creation of the West. Grosseteste took part in the translation movement but it was he who saw that if progress beyond the classics were to be made, then the problem of scientific *method* had to be sorted out. There had been considerable technical advance in the West since the ninth century, when the new wheeled plough and new methods of harnessing draught animals were brought in. In addition, watermills and windmills had transformed corn-grinding and metallurgy, the compass and the astrolabe had been improved, and spectacles and the clock were invented. But, as with the law before Gratian, these were *ad hoc*, rule-of-thumb advances, and there was at the time no notion of how to generalise arguments, so as to establish proof, generate explanations, and provide more exact measurements and answers.

Grosseteste's main insight, building on Aristotle, was to develop his model of 'induction' and systematic testing. He said that the first stage of an inquiry was to break up the phenomenon under investigation into the principles or elements of which it was comprised – this was induction. Having isolated these principles or elements, one should recombine them systematically to build up knowledge of the phenomenon. He started with the rainbow, observing how it occurred in the sky, in the spray made by mill-wheels, by the oars of a rowing boat, by squirting water from the mouth, and by sunlight passing through a glass flask full of water. This eventually led to Theodoric of Freiburg's idea of the refraction of light through *individual* spherical drops of water and in this sense is the first example of the experimental approach.[44]

Grosseteste's innovation, which initiated an interest in *exactness*, led in turn to a concern with measurement and this too was a profound psychological and social change, which occurred first in the West in the thirteenth and fourteenth centuries. At the same time, the clock was invented (the 1270s). Until then, time had been seen as a flow (helped by the clepsydra, or water clock) and clocks were adjusted for the seasons, so that the twelve hours of daylight in summer were longer than the twelve hours of daylight in winter. Now clock towers began to appear in towns and villages, and workers in the field timed their hours according to the bell that sounded the hour. In this, exactitude and efficiency were combined. At the same time that Europeans' attitudes to time changed, so did their

* The empiricists in Alexandria had carried out experiments but never developed this as a systematic approach. So too with the Chinese in the Han age and al-Rhazi in ninth-century Baghdad.

understanding of space, where exactitude also became increasingly possible. These combined changes are discussed in Chapter 17.

The third scholar who helped to lay the fundamentals of the West was Thomas Aquinas (c. 1225–1274). His attempt to reconcile Christianity with Aristotle, and the classics in general, was a hugely creative and mould-breaking achievement, which is considered in more detail also in Chapter 17. Before Aquinas the world had neither meaning nor pattern except in relation to God. What we call the Thomistic revolution created, at least in principle, the possibility of a natural and secular outlook, by distinguishing, as Colin Morris puts it, 'between the realms of nature and supernature, of nature and grace, of reason and revelation. From [Aquinas] on, objective study of the natural order was possible, as was the idea of the secular state.' Aquinas insisted there is a natural, underlying order of things, which appeared to deny God's power of miraculous intervention. There is, he said, a 'natural law', which reason can grasp.[45] Reason was at last re-emerging from the shadow of revelation.

Aquinas was a hinge figure too, in one way the culmination of a particular strand of thinking, and in other ways the start of a totally new way of looking at the world. The strand of thought of which Thomas was the culmination was first made explicit by Hugh of Saint-Victor (St Victor being an Augustinian abbey in twelfth-century Paris), who proposed that secular learning – focused on the sheer reality of the natural world – was a necessary grounding for religious contemplation. 'Learn everything,' was his motto, 'later you will see that nothing is superfluous.' From this attitude grew the medieval practice of writing *summae*, encyclopaedic treatises aimed at synthesising all knowledge. Hugh wrote the first *summa* and Aquinas, arguably, the best. This attitude was also helped by Abelard's *Sic et Non* (*Yes and No*), a compilation of apparently contradictory statements by religious authorities. Though ostensibly negative in approach, its positive side was to draw attention to the fact that logical argument, by questioning contradictions and exploring syllogisms, can investigate beneath the apparent surface of knowledge.[46]

The recovery of the classics could not help but be influential, even though that recovery was made within a context where belief in God was a given. Anselm summed up this changing attitude to the growing power of reason when he said, 'It seems to me a case of negligence if, after becoming firm in our faith, we do not strive to understand what we believe.' At much the same time, a long tussle between religious and political authorities climaxed when the University of Paris won a written charter from the pope in 1215, guaranteeing its independence in the pursuit of knowledge. It was a scholar at Paris, and Aquinas' teacher, Albertus Magnus, who was the first medieval thinker to make a clear distinction between knowledge derived from theology and knowledge derived from science. In asserting the value of secular learning, and the need for empirical observation, Albertus set loose a change in the world, the power of which he couldn't have begun to imagine.

Aquinas accepted the distinction as set out by his teacher, and also agreed with Albertus in believing that Aristotle's philosophy was the greatest achievement of human reason to be produced without the benefit of Christian inspiration. To this he added his own idea that nature, as described in part by Aristotle, was valuable *because* God gave it existence. This meant that philosophy was no longer a mere handmaiden of theology. 'Human

intelligence and freedom received their reality from God himself.'[47] Man could only realise himself by being free to pursue knowledge wherever it led. He should not fear or condemn the search, as so many seemed to, said Aquinas, because God had designed everything, and secular knowledge could only reveal this design more closely – and therefore help man to know God more intimately. 'By expanding his own knowledge, man was becoming more like God.'[48]

Thomas' strong belief that faith and reason could be united at first drew condemnation from the church, and then support. But, like Albertus before him, he too had unleashed more than he knew. Other contemporaries at Paris, Siger of Brabant, for example, argued that philosophy and faith could *not* be reconciled, that in fact they contradicted one another and so, if this were the case, 'the realm of reason and science must be in some sense outside the sphere of theology'.[49] For a time, this was 'resolved' (if that is the word) by positing a 'double truth' universe. The church refused to accept this situation and communication was severed between traditional theologians and the scientific thinkers. But it was too late. Even now, the independent-minded scientist/philosophers still had faith, but they were more than ever concerned to follow reason wherever it led.

Aquinas had partially succeeded in amalgamating Aristotle and Christianity. This made Aristotle accepted where he hadn't been accepted before. In Christianising Aristotle, Aquinas eventually succeeded in Aristotelianising Christianity. A secular way of thinking was introduced into the world, which would eventually change man's understanding for all time. It is essentially the dominant theme underlying the next section of this book.

The scientific method, exact measurement, an efficient, intellectually unified, secular world: any definition of Western modernity would certainly include these as fundamental elements. Less tangible than all that, but more intriguing, is the notion that a basic psychological change, a certain form of *individuality*, was born in Europe some time between 1050 and 1200, and that this accounts most of all for the Western mentality and its surge ahead in all the matters reported above. If individuality is really what counts, then all the other advances – in science, in scholarship, in exactness, in the secular life, etc. – may be symptoms rather than causes.

There are three main candidates for this change in sensibility. One was the growth of cities. These promoted the development of different professions outside the church – lawyers, clerks, teachers. Suddenly there was more choice than ever before. A second candidate was the changing ownership of land, which encouraged a trend to primogeniture, brought in to slow the division of estates, which made them vulnerable to attack. One important side-effect of this was that younger sons, denied their birthright, were forced elsewhere in search of their fortunes. As often as not, this involved attaching themselves to other courts, as fighters. Such a society soon evolved a taste for heroic literature (younger sons seeking their fortunes), and it was amid this set of circumstances that the ideas of chivalry and courtly love emerged (though there were other reasons). All at once the intimate emotions moved centre-stage. For example, the focus on love stimulated an interest in personal appearance, meaning that the twelfth century was a time of daring innovation in dress, another way in which a growing individuality was expressed.[50]

A third stimulant to change was the renaissance of the twelfth century, the rediscovery

of classical antiquity, which among other things forced people to acknowledge the short-comings of the immediate past, to admit that the classical authors had shown that men may vary in their motives, in the way they solve common problems, and even that a full life was possible outside the church.[51] No less important, the new scholasticism showed that the great authorities of the past sometimes disagreed and disagreed profoundly. People were thus forced to rely on themselves, to find new solutions – their own – and to fashion a new doctrine. And this produced what was perhaps the most revolutionary idea of all: individual faith.[52] It was summed up, says Richard Southern, by the phrase 'Know yourself as a way to God'. The basic idea was that each soul was coloured by the individual's mind, that individuals had a lot in common with each other but that they also differed in the extent to which they approached God.[53] This change should not be overstated. It mainly affected the elite. There *was* added variety in worship but for the masses they still looked upon themselves as groups, as congregations.

An associated reason was the arrival, and passing, of the millennium, the year AD 1000 in the chronology of the time. While there were those who, around 1000, still expected an apocalyptic change in the order of life on earth, as the eleventh century progressed, and nothing happened, a belief in the resurrection of the body could not be sustained for ever. As a result, mystical thought increased and there was a rise in so-called Jerusalem literature, mainly in the form of new hymns. This involved a change in the meaning of Jerusalem. The city was no longer expected to descend from heaven, to form paradise on earth – instead the aim was to reach the New Jerusalem *in* heaven. This was a major shift because it implied that not everyone would be saved, only those who earned it. In turn, this promoted the idea of *individual* salvation.[54] These new ideas were reflected in an important change in the representation of the crucifix in art. In the early Middle Ages, there was a fairly standard iconography, in which the triumphant Christ is nailed to the cross, watched by Mary and John. The figure of Christ is alive and upright, feet side-by-side on a support. His eyes are open, his arms straight, he shows no sign of suffering. His face is often beardless and young. It is a remarkable fact that in the first thousand years of the church's history, years in which death was all around and threatening to most people, the figure of the dead Christ was almost never depicted. 'The crucifix was conceived as an expression of the triumph of Christ, the Lord of all things' (Pantocrator).[55] Christian tradition was uneasy about considering Christ as a suffering man, and preferred to see in him the expression of divine power. In the eleventh century, in contrast, we suddenly find Jesus slumped in agony, or dead, dressed in a flimsy loincloth and all too human in his deg-radation. The concern now is with the sorrow of Jesus, his inward suffering.

The old, pre-change mentality was evident most in the liturgy of the church.[56] The kings and aristocracy were so concerned to maintain monastic ritual that the government of the time has been described with justification as 'the liturgical state'. For example, at Cluny, the biggest and most influential monastic centre of the eleventh and twelfth centuries, the liturgy grew so much and became so complicated that it swallowed up the time allotted to study and manual labour. The bloated liturgy, together with the proliferation of vast buildings despite the fact that the peasants routinely lacked many of the bare necessities of life, and not least the conduct of ritual in a language incomprehensible to most of the laity – all this underlined the lack of individuality, as did the monastic practice of world-

renunciation.[57] Amid all this the ordinary, lay individual was allowed only to witness the re-enactment of God's victory in Christ, not take part.[58] The brutality and violence of the Middle Ages also played a part, for in the unhappy world of the tenth century, withdrawal seemed to many the only path to salvation.[59] This very different psychology is reinforced by the fact that, until about 1100, Christians believed that man had been created in order to make up for the number of fallen angels. In other words, man's purpose was not human but angelic. Man should not expect to develop his own nature, 'but to become something quite different'.[60] Hymns at this stage are communal, not personal.

Colin Morris notes that, in the literature of the early Middle Ages, especially in epic poetry, the stories inevitably narrate conflicts of loyalty and formal obligations in a rigid aristocratic and hierarchical society. There is next to no scope for personal initiative, or for the representation of the more intimate emotions.[61] But this too broke down in the eleventh century. Now we find an increased desire for self-expression. For example, there was in the period 1050–1200 a huge increase both in the preaching of sermons and in the extent to which individual interpretations of the gospel was advocated. Here is Guibert of Nogent: 'Whoever has the duty of teaching, if he wishes to be perfectly equipped, can first learn in himself, and afterwards profitably teach to others, what the experience of his inner struggles has taught . . .'[62] It is important to add that Guibert, though he saw himself as an intellectual rebel, was so only within strictly defined limits.

Parallel changes were seen in the church's disciplinary arrangements. Before the middle of the eleventh century, those who sinned had to be forgiven before the full assembly of the church following, in the case of serious offences, a period of exclusion from full membership. This had been supplanted by punishment of a specific penance. Southern quotes as an example the penalties imposed on the army of William the Conqueror after the battle of Hastings in 1066. Anyone who had killed a man had to do penance of a year for each man he had killed. Men who had wounded others had to do forty days per person they had struck. Anyone who didn't know how many he had killed or wounded had to do penance one day a week for the rest of his life. The point here is that there was no allowance for motive or for contrition, in short for the *interior* feelings of the soldiers. That is what changed in the twelfth century.[63] There was an awareness now that external penance was less important than inner repentance. Eventually, this stress on inward sorrow led to the wider adoption of individual confession. At first the use of confession was rare – an affair of the deathbed, or a pilgrimage, say. But, at the Fourth Lateran Council in 1215 an annual confession was imposed as a minimal requirement for every member of the church, so that the faithful might listen to the 'voice of the soul'. 'The pursuit of an interior religion had now gone beyond the elite to everyone.'[64]

These changes were mirrored outside worship. In the paintings of the period, according to Georges Duby, for the first time in Italian history, the various figures 'give vent to their deepest feelings': tenderness, veneration, desperation.[65] There was a growth of literature written in the first-person, the verb 'to earn' came into common use and, 'some time between 1125 and 1135, the stone cutters working on the porch of Saint Lazare in Autun apparently were ordered by those responsible for the iconography to forego abstraction and give individualised expression to each figure'.[66] There developed an obsession with cleanliness, Duby says, and then with bathing and nudity, making people more

self-conscious about their bodies. For those who could afford it, houses began to have rooms that offered privacy – e.g., studies.[67] More and more people had personal names, and in particular nicknames, which stressed individual characteristics. For example, in the 1140s three canons of the cathedral of Troyes were called Peter and each had his identifying nickname (in Latin, of course): Peter the Squinter, Peter the Drinker and Peter the Eater.[68] Autobiography, almost unknown in the ancient world, also saw an increase from the late eleventh century on.[69] So too with biography and letter-collections, which often explored the inner lives of the correspondents, their reactions to one another, their self-examination, a parallel to what was happening in confession.[70] (At least, it seems so to *us*.) And in strong contrast to the attitude in Byzantium, we read of identifiable art*ists* who for the first time expressed pride in their works.[71] For example, here is Eadwine, the scribe or designer of a psalter produced at Canterbury in about 1150: 'I am the prince of writers; neither my fame nor my praise will die quickly ... Fame proclaims you in your writing for ever, Eadwine, you who are to be seen here in the painting.'[72]

Art was changing in other ways too. After 1000 we see an increase in the personal details included in portraits. Colin Morris argues that in fact the portrait as we understand it was lost around the second century AD and did not return until the eleventh/twelfth century 'to form a new concept'.[73] For example, royal portraits and tomb sculpture become more explicit, less idealised, less often figures representing the virtues, following instead a more characteristically modern way of seeing the human form.[74] 'The figure of Eve, carved at Autun before the middle of the century by its sculptor Gislebert, has been called the first seductive female in western art since the fall of Rome.'[75] Memorial sculptures, virtually unknown before the late eleventh century, now become progressively more common.

A final aspect to this set of changes, linking individualism, psychology, and the church, was what one historian has called 'The Love Revolution'. The eleventh century saw an explosion of love literature which was no less accomplished – and maybe more so – than the greatest poets of Rome. More than one historian has said that all of European poetry derives from the love poetry of the High Middle Ages. What was new, certainly among the troubadours, whom we know most about, was the (highly stylised) subservience of the men to the women. The poets tried hard, on the page if not so much in real life, to be different in their reactions to everyone else and unrequited love became, if not an ideal, then a widespread preoccupation. One important reason for this was because it differed from the love of God. One could never know in this life how one compared with others in one's love of God – not until Judgement Day. On the other hand, unrequited love of a woman threw men back on themselves and forced them to consider why they had failed and how they might improve.[76]

And have we given enough consideration to the monasteries? The foundations for the monastic revival were laid between 910 and 940, while the numerical strength of the monastic world increased out of all proportion between 1050 and 1150. For England, where the figures are known fairly accurately, the number of monasteries for men rose between 1066 and 1154 (the accession of Henry II) from just under fifty to about five hundred, and Christopher Brooke calculates that the number of monks and nuns rose seven- or eight-fold in just under a hundred years.[77] The Cistercian order alone built 498 monasteries between 1098 and 1170.[78] In Germany the numbers of houses for women rose

from about seventy in 900 to five hundred in 1250.[79] This revival had a massive impact on architecture and on art, in particular on stained glass, book illumination, but above all, perhaps, on sculpture and on attitudes to women and womanhood. The great build-up of the monasteries, and then of the cathedrals (which are introduced in the next two chapters), fostered an explosion of sculptures which, besides being glories in their own right, would spark an interest in perspective, which was to become such a feature in the modernisation of art.[80] It was in the monasteries of the eleventh and twelfth centuries that the cult of the Blessed Virgin was established and developed. As well as providing a (male-conceived) ideal for women, worship of the Virgin was one aspect of the new *variety* of worship available to the faithful. 'There is copious evidence ... of a strong demand for greater opportunities for women in the religious life in the twelfth and thirteenth centuries.'[81] Women turned inward, as well as men.

'The discovery of the individual,' says Colin Morris, 'was one of the most important cultural developments in the years between 1050 and 1200.'[82] But did it contribute to the emergence of the distinctively Western view of the individual? It certainly seems to have been a cause or a symptom of a fundamental change in Christianity, which itself had done so much to help unify the continent. The new religious orders of the High Middle Ages, Franciscan rather than Benedictine, stressed vocation rather than organisation, and conscience won out over hierarchy. 'If any one of the ministers gives to his brothers an order contrary to our rule or to conscience, the brothers are not bound to obey him.'[83]

John Benton has argued that if men and women *did* turn inward in the years between 1050 and 1200 they must have had more self-esteem than their predecessors and that it was this change in mentality, combined with a greater (verbal and visual) vocabulary in considering the self that eventually gave rise to the increasing self-confidence of the West, the age of discovery and the Renaissance.

The case is not proved. But change did occur. The eleventh and twelfth centuries were a hinge period, when the great European acceleration began. From then on, the history of new ideas happened mainly in what we now call the West. Whatever the reason, it was a massive change that cannot be overestimated.

# PART FOUR

## AQUINAS TO JEFFERSON
### The Attack on Authority, the Idea of the Secular and the Birth of Modern Individualism

# 'Half-way Between God and Man':
# the Techniques of Papal Thought-Control

Towards the end of January 1077, in the middle of a bitter winter, the Holy Roman Emperor Henry IV arrived in Canossa, twenty miles south-east of Parma in north Italy. Henry was barely twenty-three at the time, a large energetic man, with blue eyes and flaxen hair, a typical Teuton. He was in Canossa to see the pope, Gregory VII, 'the Julius Caesar of the papacy', who was staying in the fortress there. Gregory, then in his early fifties, would later be canonised by the church but, as the church historian William Barry has said, he was in reality 'what men of the world call a fanatic'. Earlier that month he had gone so far as to excommunicate the emperor – ostensibly because Henry had dared to appoint bishops in Germany, and because he had taken no action to stamp out the then-widespread practice of simony, the buying of offices, or the equally common practice of allowing the clergy, bishops included, to be married.[1]

On the 25th of the month, Henry was admitted to the precincts of the castle. In deep snow, barefoot, fasting and dressed in only a long shirt, he was, according to legend, made to wait in the freezing cold for three days before Gregory consented to see him, and absolve him. This very public humiliation was a dramatic turning point in a quarrel that had been brewing for years and would continue for two more centuries.

At the end of the previous year, in a work he wrote for himself, called *Dictatus papae* (*The pope's dictate*), Gregory proclaimed that 'the Roman church has never erred, nor will it err in all eternity'. He claimed that the pope himself 'may be judged by no one', and that 'a sentence passed by him may be retracted by no one'. Gregory claimed moreover that a pope 'may absolve subjects from their fealty to wicked men', and that 'of the pope alone all princes shall kiss the feet', that the pope 'may be permitted to ... depose emperors' and that 'he alone may use the imperial insignia.'[2]

This great quarrel, what became known as the Investiture Struggle, was a protracted conflict with secular authorities for control of Church offices, where Gregory was merely the first in a long line of popes who followed his lead.[3] The process he began culminated in 1122 in the Concordat of Worms (during the reign of the French pope Calixtus II, 1119–1124), whereby the emperor agreed to give up spiritual investiture and allow free ecclesiastical elections. To historians, the Investiture Struggle, or Contest, was part of a wider movement appropriately called the Papal Revolution.[4] Its most immediate consequence was that it freed the clergy from domination by emperors, kings, and the feudal

nobility. With control over its own clergy, the papacy soon became what one observer called an 'awesome, centralised bureaucratic powerhouse', an institution in which literacy, a formidable tool in the Middle Ages, was concentrated.[5] The papacy reached the pinnacle of its power more than a century later in the pontificate of Innocent III (1198–1216), perhaps the most powerful of medieval and maybe of all popes, who frankly proclaimed that 'As God, the creator of the universe, set two great lights in the firmament of heaven, the greater light to rule the day and the lesser light to rule the night [Genesis, 1:15, 16], so He set two great dignities in the firmament of the universal church ... the greater to rule the day, that is, souls, and the lesser to rule the night, that is, bodies. These dignities are the papal authority and the royal power. And just as the moon gets her light from the sun, and is inferior to the sun in quality, quantity, position and effect, so the royal power gets the splendour of its dignity from the papal authority.'[6]

This was fighting talk, but it was by no means all. Between 1076 and 1302 there were two more papal bulls asserting superiority of the papacy and four more kings were either excommunicated or threatened with it. The 1302 bull *Unam sanctam* is widely regarded as the *ne plus ultra* of the claims of the medieval papacy and certainly, the pope of the time, Boniface VIII, meant it to be an assertion of his continued paramountcy.[7] The bull made no specific reference to the man who had provoked it, Philip IV, king of France, who had forbidden the export of coin from his country (thereby depriving the papacy of substantial revenue). Though agreement between the two men might have been reached, Boniface insisted on complete submission, but this only provoked the king to issue his own list of charges against Boniface, which included heresy. The pope retaliated with yet another bull, releasing Philip's subjects from their allegiance, an affront that was too much for a band of partisans loyal to the king, who broke into the papal quarters at Anagni, fifty miles south-east of Rome, and captured Boniface. He was soon released but died a month later, from shock. A successor was speedily elected but he reigned for only nine months and, after that, the cardinals wrangled for two more years before the archbishop of Bordeaux was elected. He surrounded himself with French cardinals and settled at Avignon, which was to remain the seat of papal government for more than six decades (1309–1378).[8] These events astonished all Europe and marked a turning point in papal fortunes. Never again would the papacy enjoy the supremacy it had known between *Dictatus papae* and *Unam sanctam*.

This period of papal supremacy, what has also been called papal monarchy, between the bulls of 1075 and 1302, was one of the most extraordinary in all history. It concealed three battles going on simultaneously in the High Middle Ages, three competing ideas which, though interwoven in terms of chronology and location (and newsworthiness), were conceptually quite distinct. There was first the battle between popes and kings as to who was the more senior. In turn, this struggle reflected on the nature of divine authority and the place of kings in that hierarchy. In the previous chapter, and in Chapter 11, the distinction was made between the eastern church, where the king drew his authority directly as Jesus' representative on earth, and the western church where the popes, drawing on the apostolic succession of St Peter, conferred authority *on* kings. In the West, as we shall see, because of the growth of cities and commerce, and the associated increased independence of a merchant class, who could not easily be suborned to make war on a

king's behalf, as the serfs and knights had before them, kingly authority came to be questioned more and more, parliaments and estates evolved to give voice to the new classes and their interests, and if the pope had greater power than the king, as it at times seemed, if kings weren't supreme, then kings became more and more subject to law. This was such a massive change that its description and discussion is begun below, in this chapter, and continued in Chapter 24.

The third idea we shall consider is that broached in the previous (hinge) chapter, namely the new understanding of faith, as something *interior*, something to be found within a person, an aspect of the new individuality. In some ways, this is the most interesting issue of all. An interior faith, while it made good sense in theological terms, and arguably conformed more closely to the teachings of Jesus Christ, as revealed in the scriptures, actually served as a *weakening* corrosive so far as the organised church was concerned. A private faith was beyond the reach of the priest or the bishop; furthermore, private faith might lapse into unorthodoxy, or even heresy. What unites these three issues, and other matters discussed in the rest of this chapter (though once again we should not make more of this unity than is there) is intellectual (and therefore political) *authority*. If kings and popes claimed divine sanction for their position and power, yet argued so bitterly and so publicly among themselves (as they did), if individual faith was the way to true salvation, wasn't this a new situation, a new predicament, both theologically and politically? It meant that there was, perhaps, a point to the new individuality, and the new freedom to consider a secular world.

This is important because it helps explain several paradoxes of the period, an understanding of which is essential if the High Middle Ages are to be fully comprehended. The above brief analysis helps explain, for example, why two such strong popes – Gregory VII and Innocent III – emerged when the papacy was actually *weakening* over the longer term; it explains why, as we shall see, the College of Cardinals and the Curia were formed at this time: they were attempts to strengthen the corporate nature of the church *because* of its inherent weaknesses in the new psychological/theological climate. It also helps explain the history of, in particular, England, France and Italy. There *were* attempts to reassert the kingly authority, as often as not by 'religious' means: the canonisation of Louis IX, and the attempts by the Capetians and Plantagenets to accrue sacrality to kingship by such devices as the 'royal touch', which, it was claimed, cured scrofula. But in England and France this was the time when, following the commercial revolution, the parliaments first asserted themselves, while in Italy, a country of city-states, the idea of the commune evolved as an entirely separate (secular) authority.

Each of these issues is a major topic of inquiry at the moment in the history of ideas. They relate intimately to the birth of the modern world and what, exactly, we mean by that. The Renaissance, as we shall see, is no longer regarded by professional historians as the birth of modernity. Instead, the period between 1050 and 1250 – in the church, in commerce, in politics and in scholarship – may well be, as R. W. S. Southern has said, the most important epoch in Western history apart from the equivalent time-frame 1750–1950. The changing fortunes of the papacy were intimately bound up with this.

Let us begin our detailed discussion with a return to medieval ideas about kingship. In the

West, kingship had arisen in two different configurations. In the eastern part of the Roman empire, Hellenistic and Oriental traditions gave rise to a conception of the emperor as the 'Expected One' of Christian prophecy, representing God on earth. By invoking God's name, the king could ensure prosperity and victory in war. This was also the idea adopted in Russia.[9]

In the western part of the Roman empire, on the other hand, kingship took its colour partly from the traditions of German tribes and partly from the expanding role of the Catholic church. The Germanic word for king, Reinhard Bendix tells us, developed from the word for kindred. The ancient supernatural beliefs of the German pagans attributed charismatic power not to individuals but to entire clans (this was an idea which even Adolf Hitler, centuries later, would find compelling). The Germanic ruler, or king, was not therefore especially linked to the gods, any more than the rest of the clan, but he was, in general, a superior military leader. His successes reflected the supernatural qualities of the entire people, not just of himself.

Christians, on the other hand, inherited through Rome and the Jewish/Babylonian/ Greek traditions the idea of priest-rulers as separate from, but at least equal to, military rulers. In addition, as the church had developed, the clergy had obtained more and more exemptions from various taxes and other obligations. Canon law had grown in importance, so that judicial sentences handed down by bishops came to be regarded 'like the judgements of Christ himself'.[10] This was reinforced by the fact that, in the early Middle Ages, the authority of the bishops tended to take the place of secular government, not least because the church often attracted abler men than what was left of the imperial administration.

All this made for an important distinction between East and West. An eighth-century mosaic in the church of St John Lateran, in Rome, shows St Peter conferring spiritual authority on Pope Leo III, and temporal power on Charlemagne. In fact, Catholicism derives its authority from the Apostle, not from Christ directly as in the Greek Orthodox tradition. According to this belief in the apostolic succession of the papacy, St Peter elevates the spiritual pope over the temporal king.[11] Later images show St Peter handing the keys of heaven to the pope while the king looks on. According to St Ambrose, bishop of Milan, 'the emperor is within the church, not above it'.[12] In the East, in contrast, the Byzantine emperors prevailed over the church because they had defeated the Germanic invaders and were in full control, politically. Pope Gregory I (590–603) addressed the ruler in Constantinople as 'Lord Emperor' while he referred to the kings of western and northern Europe as 'dearest sons'. In 751–752, Pippin, the Carolingian regent, was elected king by an assembly of nobles but was then immediately *anointed* by Bishop Bonifacius – the same procedure as that employed in the appointment of bishops. 'The Western Church had assumed the function of consecrating, and hence of authenticating, the royal succession in contrast to the Eastern Church which by crowning the emperor symbolised the divine origin of his authority. The Western Church put the king under God's law as interpreted by the king; the Eastern Church accepted the Emperor as representing Christ on earth.' In the East the emperor was, as we would say, head of the church; in the West the position of kings and of the Holy Roman Emperor was much more ambiguous.[13]

As a result the power balance between pope and kings and emperors switched back and forth throughout the Middle Ages. Charlemagne, based at Aachen, took the title 'by the

Grace of God', which was normally conferred by the pope, but it wasn't enough: at court he was addressed in biblical terms, as 'King David'. In other words, he saw himself as divinely endowed whatever the Catholic church in Rome said.[14] After his death, however, Charlemagne's sons never enjoyed the same level of power and allowed themselves to be anointed at their coronations. Though this played into the hands of the papacy in one way, Charlemagne's demise also meant that the pope, now lacking a powerful ally, was once more at the mercy of the notoriously unruly Roman nobility. The French kings, as we shall see, were also pitched against the pope, not least during the Avignon 'captivity'. It was this set of circumstances which allowed the power of local bishops to grow and it was their various idiosyncrasies, profligacies and other abuses that would lead to the need for major reform in the church.

A further complicating factor was that the church itself was all the while extending its secular power. Thanks to bequests, it acquired more and more land, which was then the main form of wealth. In order to retain the support of the church, kings became patrons, endowing monasteries, for example, which both enriched the church and gave clerics even stronger control over men's minds. 'Only if kings walked the ways of righteousness, as the church interpreted those ways, could they obtain felicity, good harvests, and victory over their enemies.'[15] In such circumstances, it was only a matter of time before something very like the Investiture Struggle came about.

Before we return to that, however, there is one other medieval idea to consider: feudalism. 'Feudalism' isn't a feudal word. It was invented in the seventeenth century, popularised by Montesquieu and adopted by Karl Marx among others.[16] The actual words used at the time to describe the feudal hierarchy were 'vassalage' and 'lordship'. Feudalism was, in fact, a specific form of decentralised government that prevailed in northern and western Europe from the ninth to the thirteenth centuries. Its basic characteristic was lordship – political, economic and military power concentrated in the hands of an hereditary nobility. But in addition to vassalage or lordship, there were two other principles – a property element (*fief*), and the decentralisation of government and law.

The embryo of feudalism, according to the historian Norman Cantor, was the *comitatus* or *gefolge*, the Germanic war band, based on the loyalty of warriors to their leader in return for protection. The term 'vassal' comes from a Celtic word meaning 'boy' and, certainly to begin with, the 'warriors' were often no more than gangs of boys. (This was very different from later ideas about 'chivalrous knights'.) In the early days, vassals had nothing to do with holding land – they lived in a barracks provided by their lord, who also clothed and fed them. What changed all this was a steady revolution in military technology. In the first place, the invention of the stirrup, in China, and its introduction into Europe, changed fundamentally the relationship between cavalry and infantry. The stirrup enabled the horseman to concentrate the combined force of weight and speed at the point of impact – at the end of his lance – radically enhancing his advantage.[17] But this change brought with it associated problems. The knight's armour, his sword and spurs, and the bits and bridles for his horses, were very expensive. War-horses were even more costly: knights needed at least two for battle proper, and these creatures also had to be fitted out with armour. The knight further needed several pack horses to move the equipment to the site of battle.

Thus it was that the lords who wanted such *chevaliers* or *cniht* (knights) to fight for them found it expedient to invest (*enfeoff*) them with their own manorial estates, out of which they might extract the necessary income to fulfil their obligations in battle. This inspired a land-hunger in the chevaliers which helped the formation of Europe. One effect of this situation, however, was that government and legal authority, or at least some of it, passed down from the king to his great feudal vassals, who appropriated the right to collect taxes and to hold courts, where they heard pleas and administered their own rough (sometimes very rough) justice. This was a system that worked only up to a point. It meant that the countryside – of France and England in particular – was divided into a patchwork of territories with different and overlapping systems of taxes, jurisdictions and loyalties. The king was, in effect, little more than the first among equals in this system.

The church had at first been hostile to this new set of arrangements, but before long the bishops – increasingly independent, as we have seen – found they could accommodate to the system as they themselves became vassals and lords in their own right, fully participating in feudal society except for actually making war. The hierarchical system, of interlocking loyalties, now stretched, it was said, throughout society 'and on to the heavenly regions'.[18]

Recent scholarship has modified this traditional picture in important ways. As was mentioned earlier, the whole concept of 'feudalism', as generally understood, has been called into question, in particular the central importance of lord and knight. What is now regarded as more important is the overall situation of the serf, many more of whom are now understood to have been landowners and therefore, in that sense, free. Another factor is that, on occasions at least, the bishops did make war: in 1381 peasants rising in East Anglia were put down militarily by Bishop Despenser. The fact that a good proportion of peasants owned land (as high as 40 per cent in some areas) throws the lord/knight/fealty network into some relief. When also put alongside the greater numbers of the rising mercantile class, feudalism can be seen as an aspect of kingly *weakness*. And what happened in the High Middle Ages was that a weakening papacy fought weakening kings. The papacy lost (eventually, after a long time) whereas kings, perhaps because there were more of them, were more flexible in their reactions to the changes going on and, outside Italy, consolidated their position. Perhaps the popes fought too many battles on too many fronts. But that too was a sign of weakness.

Despite the involvement of bishops in feudal society, power swung back to the kings in Germany, especially during the reign of Otto I the Great (936–973). He insisted on being crowned by the archbishop of Mainz and effectively used the solidifying power of the church to gain the ascendancy over the other vassals and dukes. At the same time, he asserted his authority over bishops, thanks to property laws special to Germany, which meant that monasteries on royal lands actually belonged to the royal family, not the church. A consequence of this was that, within Ottonian lands, the king had better control over the election of senior clergy than kings did anywhere else. This meant that the Investiture Struggle, when it came about, took place in Germany.

There was one other factor which lay behind the Struggle. Apart from the papacy, there was a semi-separate spiritual force in western Europe in the tenth and eleventh centuries,

and it too was a unifying element. This was the Benedictine order. And amid this order it was the emergence of Cluny, in southern Burgundy, that made the most impact. 'The Cluniac programme became the intellectual expression of the prevailing world order.'[19] The monastery at Cluny was the largest in all Europe, and the best endowed, and the religious life it cultivated became hugely influential.

The original order had been revised in 817 by St Benedict of Aniane, who had been given the task by Louis the Pious of introducing stability into monastic life. The crucial change that had come about in the intervening centuries was that Benedictines no longer supported themselves with their physical labour.[20] Instead, they now acted primarily as intercessors with the deity by means of an elaborate liturgy – which they supplemented with education, political and economic duties (levels of pastoral care improved and this had an effect in invigorating parish life). This was a new role, for the Benedictines anyway – and it was reinforced by their 'feudal' (or at least hierarchical) structure. Through a series of intelligent and long-lived abbots, in particular Odilo (d. 1049) and Hugh the Great (d. 1109), Cluny, while becoming known for the beauty of its liturgical devotions, established a chain of houses across northern Europe – Germany, Normandy, England – which accepted Cluniac domination, as vassals accepted direction from the next in line above in their system.

This evolving idea, of monks as intercessors, had important consequences. Kings and nobles hurried to endow the Cluniac monasteries, anxious to be mentioned in their prayers. Nobles would retreat to monasteries to die, believing they were closer to heaven. Monastic intercession encouraged a spate of church building and adoration of the clergy. But Cluny's most direct effect on history came through its expansion into Germany at the time of Henry III (1039–1056). Henry married the daughter of the duke of Aquitaine, whose house had founded Cluny in the first place, but Henry had larger ideas about theocratic kingship and saw the monastery as essential to his aims. He wanted to complete the Christianisation of Europe but, in order to do so, certain matters had to be attended to first. Henry believed, or chose to believe, that at his coronation he had received the sacraments of his office, and that this gave him the spiritual authority to consecrate bishops and order the affairs of the church. He also believed that he needed to reform the papacy which had been very weak for as much as a century. In 1045, for example, there were three rival popes in Rome and, partly as a result of this, Henry called a synod in that year to begin reform. Three Germans were appointed pope in quick succession, the last of whom, Leo IX (1049–1054), was Henry's relative. Before long, this pattern would prove too much for other churchmen, provoking the so-called Gregorian reform of the church. And that, in its turn, precipitated the investiture controversy.

Gregorian reform is the name historians now give to a period, 1050–1130, when four popes worked hard to change both the form of worship – the biggest upheaval since St Augustine's time – and the status of the papacy, which had been languishing for centuries, proscribed locally by the rival claims of Roman noble families and internationally, as we have seen, by the various kings around Europe. This joint aim has been described as nothing less than a world revolution, 'the first in western history'.[21] As a result, the church would gain a fair measure of freedom from secular control, there would be a marked improvement in the intellectual and moral level of the clergy, and the church itself would become a superstate, governed from Rome by the papal administration, or Curia.

But the Gregorian reforms were also associated with an even more important ground-shift in religious feeling in the eleventh century: the growth of lay piety. This came about partly as a reaction to the Cluniac movement. Thanks to the spread of the order across Europe, a devout attitude towards dogma, and a love of elaborate ritual (a 'relentless liturgy') became almost as common among ordinary people as it had been hitherto among monks and priests. But the self-representation of the Cluniacs as intercessors, in particular, while it satisfied the needs of many, conflicted with the new interiorisation of faith, where intercessors were not deemed necessary or desirable. More than that, the interiorisation of faith was leading some people in unusual and unorthodox directions: there was a resurgence of heresy. So two contradictory things were happening at once – an elaborate centralisation of worship, centring on the clergy as intercessors, and a proliferation of private beliefs, a good few of which could be characterised as heresy. This was the intellectual/emotional background to the rise of a new attitude to monastic life in the eleventh century: a reaction against Cluny. It involved a return to asceticism and eremitism and resulted, soon enough, in the Cistercian and Franciscan movements.

The idea behind the Cistercian reform was the restitution of the original Benedictine practice. The founder, Robert of Molême (c. 1027–1110), objected to the complexity of Cluniac art, architecture and in particular its liturgy, which he thought 'had taken embellishment to the point of no return', detracting from worship rather than enhancing it.[22] In its place, he proposed an austere lifestyle, with hard labour, modest clothing and a vegetarian diet. He positioned his Cistercian abbeys on the remote fringes of civilisation, away from temptation. The abbeys themselves were modest and plain affairs, relying on line and form for their aesthetic appeal, rather than decoration. A certain serendipity was at work here, too, since one effect of locating the Cistercian abbeys in remote areas meant that they became involved in the agricultural revival that took place at this time, many of them becoming models of efficient estate management, which added to their importance and influence. But that influence was not simply organisational: they also became spiritual leaders. One reason for this was the work of Bernard of Clairvaux. The son of a nobleman from Burgundy, Bernard received his calling at the age of twenty-two. Highly familiar with the classics, he developed a mellifluous writing and speaking style, which helped him serve several popes and more than one king. He was one of those who advocated church councils as a way to prevent heretical deviation, and he was an ardent champion of the Crusades, the course of action which took him farthest from Benedict's original ideal of the monk as a man of peace. He also promoted devotion to the Virgin Mary.

The cult of the Virgin was one of the more important examples of popular piety in the twelfth century. It was Bernard's contribution to conceive of Mary as, in a sense, the symbol for divine love, 'the mother of all mercies', whose intercession offered the chance of salvation to all. She is 'The flower upon which rests the Holy Spirit', said Bernard. Mary had not been an important figure in the early church but through Bernard she became a valued addition to the deity and the Son and the Holy Spirit in helping people approach God.[23] Bernard did not agree with some of his contemporaries that the Virgin was exempt from original sin. His point was that Mary was important for her humility – her willingness to serve as the vehicle for Christ's arrival on earth. Following Benedict, Bernard argued that humility is the queen of virtues and it was this which led Mary to accept the divine

plan freely. 'Through her, God, Who could have accomplished our redemption any way He wanted, teaches us the importance of our voluntary collaboration with divine grace.'[24] In fact, Mariolatry stood for even more than that. As Marina Warner has pointed out, '... by contrasting human women with the sublime perfection of the Virgin, earthly love could be discredited and men's eyes turned once again heavenwards'.[25] The new concentration on the Holy *Family*, implied by the cult of the Virgin, distinguished post-1000 Christianity from its earlier forms. In an effort to increase piety, the church was now more concerned with *this* world.[26]

The friars, who emerged in the thirteenth century, did so to fill a gap not addressed by either priests or monks. The founders of the friars, Francis of Assisi (1182–1226) and Dominic Guzmán (*c.* 1170–1234), both concluded that what the church needed at that time was clerics who were mobile, free to take to the streets, to preach, hear confessions and minister to people where they were, living their lives. Their very freedom made the friars highly organised, and open-minded: they adapted their orders to admit women and what they called 'tertiaries', lay people who associated themselves with their spirituality.

The Franciscans took their colour from their founder. Francis was the son of a wealthy cloth merchant. He led a carefree life as a boy, and was known for his courtesy and cheerfulness.[27] 'To the world a Sun is born,' wrote Dante of Francis. He loved French literature, in particular lyric poetry, and 'Francis' ('Frenchie') was in fact a nickname he was given because of his literary tastes. He was converted, if that is the word, in two stages. Captured in a skirmish between the Assisians and Perugians, he caught a fever and turned to God. Later, after his release, he one day met a leper on the road. There was a great fear of lepers in those days – they were required to carry bells and ring them when approaching a healthy person. Instead of giving this particular leper a wide berth, Francis embraced him. However, when he looked back no one was there and Francis became convinced it had been Christ who had appeared before him, and converted loathing into brotherly love. Extraordinarily moved by this experience, Francis used his family wealth to rebuild a ruined church. When challenged by his father, the young man – in front of the bishop of Assisi and the assembled crowds – turned his back on his family wealth and embraced poverty. It is a story reminiscent in some ways of the Buddha.

Not all conversions are as fruitful. But Francis' charisma was legendary. He thought that a religious leader taught best by giving a moral lead (though he was by all accounts an excellent preacher). His charisma meant that even when he preached to the animals this was not regarded as a mental aberration and he was still adored. Thanks to him the Franciscans venerated the infant Jesus and it is from this time that the Christmas crib was introduced. A number of other mystical experiences surrounded Francis, including an occasion when birds flocked around him with song and another when he received the 'stigmata', the physical wounds of the crucified Christ. These various episodes ensured that Francis was canonised within two years of his death, a world record. The main achievement of the Franciscans, following their founder's example, was to establish that the purpose of theology was to 'mobilise the heart and not merely to inform and convince the intellect'.[28] This was another aspect of the inward movement of faith.

But, in a sense, we are running ahead of ourselves. The new orders were a response to changes in lay piety but far from being the only ones. The fundamental aim of the

Gregorian reform was to establish a unified world system, *Christianitas*, as Gregory himself called it.[29] There were three popes and a handful of cardinals who tried to bring about this ambitious reformation. (The term 'cardinal', incidentally, comes from the Latin word for the hinge of a door, the crucial device which helps open and close the way.[30])

The first of the three reformers, who inaugurated a great debate on the nature of a Christian society, was Peter Damian. Born as the orphan of a poor family, he was adopted by a priest and as a result received a good education. He was one of those who found Cluniac life too much involved with the world. One of his particular worries, where the church was concerned, was the fact that so many of the clergy were either married or had children out of wedlock. Damian wrote an entire book denouncing these scandals, at the same time arguing strongly in favour of clerical celibacy. In Byzantium, ordinary priests were allowed to be married, though bishops were supposed to be celibate. (When a priest was promoted to bishop, his wife was expected to 'do the decent thing' and enter a convent.) But Damian was unhappy even with this: he believed that only if they were completely celibate would the clergy devote themselves exclusively to the church, rather than use their offices to inveigle property and jobs for their offspring, a practice which was everywhere bringing the priesthood into disrepute. (It seems that ordinary lay people were little bothered by clerical concubines. The demand for priestly celibacy came from the top down and had as one of its aims making the clergy more separate from the laity.)

Damian was also the first to give rein to the new piety that was overtaking the Catholic church, which was mentioned above and in the last chapter. This was the changed relationship between God and humanity. The original, jealous God of the Old Testament, which had dominated early medieval times, was now coming to be replaced by the more loving son as described in the New Testament, the God who suffered for our sins and whose 'sorrowful mother' was now being more and more invoked. In line with this, as has also been referred to, worship was becoming less a matter of formal, liturgical praying and singing, as in the Cluniac ideal, more an internal personal experience. In one way, this was enriching, in another it would prove unfortunate. Damian's intense, internal approach to piety helped to release a fierce religiosity in many people, an uncontrollable emotionalism which would lead to fanaticism. It was this intensity which, as we shall see, led to the Crusades, to heresy, to anti-Semitism and inquisition.[31]

The second of the three makers of the Gregorian reform was Cardinal Humbert of Silva Candida. He came from Lorraine and had been a monk at Cluny, where he too turned against the over-elaborate, all-consuming liturgy, feeling that the ideals of Cluny's founder had been betrayed. As a highly educated and very clever cardinal, with a good knowledge of Greek, he was sent as papal ambassador to Constantinople. Not remotely diplomatic, his appointment there was abrasive and not wholly successful. He ended his visit in 1054 by excommunicating the patriarch on the Bosporus, formally recognising a schism that had been fermenting for centuries. (In some ways, this schism has never been healed.) On his return to Rome, Humbert took over as chief ideas man among those who wanted to see radical change. Beginning in 1059 he published two works which were the real starting point for what came later. The first was a papal election decree, an ambitious piece of work which set out a new manner of electing popes, a plan that excluded both the German emperor and the Roman people as had hitherto been the case. Instead, a college of cardinals

(of about a dozen, in the first instance) was created and election was now fully in their hands. It is impossible to exaggerate the importance of this change: only a generation before, the German emperor had held the whip hand in papal elections. But the emperor of the day, Henry IV, was just then a minor, so Humbert calculated that such an opportunity might never come again. Humbert's other book was actually called *Three Books Against the Simoniacs* and this was an anti-German tract which, as Norman Cantor says, was an attack on the whole 'medieval equilibrium between the church and the world'. Even the tone of the book was new. Instead of adopting a high-flown rhetorical style, Humbert utilised the new learning, which is considered in the next chapter, in particular the so-called new logic, developed since the rediscovery of Aristotle. His style was controlled, cold even, but soaked through with a hatred of Germany. Its chief argument was that simony – the buying and selling of church offices – was an unforgivable interference in church affairs, and as dire as heresy.[32]

He didn't stop there. He went on to argue that if the clergy could be reformed in no other way, then the laity were entitled to consider the moral character of their priests and should they, too, be found wanting, the laity could refuse to take the sacraments from them. This was in effect a revival of the so-called Donatist doctrine, that the laity had a right to judge the priesthood. It was, intellectually and emotionally, a most dangerous development, the most provocative of reforms. It had for long been the practice for the church to argue that the efficacy of the sacraments was not dependent on the priest but on the divinely-constituted office. Now Humbert was throwing centuries of tradition by the wayside. It would lead, in the second half of the twelfth century, to the heretical movements which instigated both the inquisition and, in due course, the Protestant ideas that Martin Luther found so compelling.

The third of the reformers was not so much of an original thinker but he was the greatest organiser and synthesiser. This was Hildebrand, who became Pope Gregory VII. Norman Cantor argues that the three greatest popes before the sixteenth century were Gregory I, Gregory VII and Innocent III, the last of whom we shall meet shortly. 'And no pope was ever as controversial as Gregory VII, adored and hated in equal measure.' Even before he became pope, Hildebrand had coerced Italian scholars into beginning the great codification and synthesis of canon law that would play such a part in the revival of Europe and the establishment of the new universities that are the subject of the next chapter. But what really drew the world's attention was the publication, immediately after his election as pope in 1073, of *Dictatus papae*. This was by any measure a trenchant assertion of papal power, 'a sensational and extremely radical document'.[33] As was mentioned above, the bull insisted that the Roman pontiff was sanctified by St Peter, that the papacy had never erred and, according to the scriptures, never would err. Only the papal office was universal in authority, said the bull, only the pope could appoint bishops, nothing was canonical without papal assent, no one could be a true believer unless he agreed with the pope, and the pope himself was beyond the judgement of any human being. The pope had the power to depose emperors, and people with grievances against their rulers could lawfully bring those grievances to the Holy See.

Breathtaking in its range, the bull was intended to create a new world order, subservient to Rome, and Gregory was perfectly aware of this. So great was the revolution proposed

that not only the emperor and kings of northern Europe were unnerved by the bull; so too were the great ecclesiastics – the pope was proposing to change the *modus vivendi* that had existed for centuries. More than that, no medieval ruler had ever allowed a pope to interfere in the affairs of state. Most realised that a fight between popes and kings could not be far off. After the bull was published, however, Gregory did not sit on his hands but continued to develop his views in a series of pointed letters to Hermann, bishop of Metz. These were prepared in pamphlet form, as a series of questions put to the pope by the bishop, and sent to all the courts of Europe. In these letters, Gregory expanded his provocative views, further insisting that the state had no moral sanction, that royal power largely resulted from violence and crime, that the only legitimate authority in the world was that of the priesthood. Only complete *Christianitas* was acceptable.

In addition to this basic assault, however, Gregory also introduced – or reintroduced – an idea that had not been at the forefront of the church for some time. This was a concern for the poor. Gregory introduced the idea of the poor not so much as an economic issue as a quasi-political one. He himself instinctively sided with the downtrodden and at the same time loathed what he saw as their oppressors (kings included). Thus he introduced into Christianity a measure of social conscience and criticism, something it had lacked during the predominantly agricultural Middle Ages (though in his insistence on celibacy for priests, thousands of wives were turned out on to the street). This essentially emotional attitude towards poverty was a strengthening factor in the church for a time; it proved popular among the new urban classes, by no means all of whom were happy with life in the new towns.[34] Gregory also implied that many of the well-to-do were spiritually poor, and this made him more popular than he might otherwise have been. But it wasn't enough to put off the fight that was coming.

When Henry IV became king and emperor in 1065, it was just six years since Humbert had published his two books, one on electing the pope and the other on simony, both directed in particular against the Germans. Henry could not have been expected to go along with what was in those documents but in any case it took him until 1075 to stabilise his realm and reach a point where he felt sure that the peasants, burghers and aristocracy in Germany were content or at least quiescent. Then, a short time after Hildebrand became pope, as Gregory VII, the episcopal see of Milan fell vacant. Not long before, in 1073, Gregory had published *Dictatus papae*. A contest was looming and took material form when both Henry and Gregory proposed their own candidates for Milan. But Henry, fortified by his recent successes within his own territories, felt especially confident and so responded 'robustly' to the papal bull. He sent a letter to Rome in which, in frankly intemperate language, he damned Gregory as 'at present not pope but false monk'.[35] The letter urged Gregory 'to come down from the throne of Peter' and was, in the words of one historian 'contumacious and insulting'.[36]

Gregory retaliated. He informed the bishops and abbots of Germany that, unless they refused to recognise Henry, they would be collectively excommunicated. He amassed support from rival political powers, in case there should be war. It was a successful manoeuvre – support haemorrhaged away from Henry and, at papal suggestion, the German nobility began to talk of electing a new king from another dynasty. Gregory

rubbed salt into the wound by announcing that he would travel to Germany himself to preside personally over the assembly that would elect Henry's replacement.

These were the circumstances that drew Henry to Canossa in the depths of winter, 1076–1077. His advisors had suggested that his only hope in the struggle was to personally seek absolution from Gregory. The unvarnished truth is probably that Henry was in no way penitent and that Gregory, for his part, would have preferred *not* to have absolved him. But both Matilda of Tuscany, a kinswoman of Henry (and in whose castle at Canossa the pope was staying), and Hugh of Cluny were present and appealing on the king's behalf. Gregory could not risk Cluniac opposition nor that of other crowned heads across Europe, who were watching to see how high-handed he could be with a monarch who had made the journey personally to seek absolution. Henry was therefore absolved of his excommunication.

Today, excommunication holds few terrors for most of us but in the Middle Ages it was very different. In fact, Gregory VII had himself extended both the idea and practice of excommunication. The idea originated partly in the pagan ritual of *devotio*, when citizens who had committed serious crimes were sacrificed to the gods. In the process the criminals became *sacer* and were separated from everyone else.[37] In a world where law was weak, curses were added to contracts, as an additional means of enforcement, and this idea was also adopted by the early church. A final aspect was exile: Jews who married heathens during the Babylonian captivity were exiled and their property confiscated.[38] In the years before Jesus, in Palestine, heretics were banned from the synagogue and from community life. But the direct source of Christian excommunication was the gospel of Matthew, where it says that a Christian must admonish a sinner, at first privately, then in front of two or three witnesses and finally, and if necessary, before the whole church. 'But if he neglect to hear the church, let him be unto thee as a heathen man and a publican' (Matthew 18: 17). The New Testament describes several incidents of social ostracism as a form of discipline. The concept of excommunication was first described in detail in a third-century Syrian document, the *Didascalia*, allegedly written by anonymous Apostles, which divides liturgical exclusion from social exclusion and describes the penance sinners must do to be brought back within the church. Sex, litigation, military duty, the baths, and the games were all forbidden to those who had been excommunicated.[39] Traditionally, however, the church was always aware of the dangers of too much social exclusion – which might easily lead the sinner to the devil himself and so make matters worse.[40]

In 1078, Gregory produced a canon, *Quoniam multus*, that was designed to limit the 'contagion' of excommunication, setting out prescribed lists of those who could have dealings with excommunicants without themselves being excommunicated. (This was in fact done to correct the 'epidemic' of excommunications that had been generated by Gregory's very own papal reforms.) For example, an excommunicant's family could associate with him: worried that husbands who couldn't have sex with their wives would look elsewhere, the authorities took a pragmatic approach.[41] Gratian used the term 'anathema' to mean full social and religious excommunication, confining excommunication itself to mean 'mere' liturgical exclusion.[42] Only those convicted by the ecclesiastical courts could be anathematised, while excommunication was a matter of conscience and people could in theory excommunicate themselves. The Third Lateran Council (1179) excommunicated

all heretics – excommunication for heresy was always much harsher than anything else and could lead to imprisonment and death.[43] Gratian's division had become the norm by the turn of the twelfth/thirteenth centuries, but was by then known as 'minor excommunication' (exclusion from the liturgy) and 'major excommunication' (total social exclusion).[44]

After Henry's excommunication and subsequent absolution, there was now no need for Gregory to proceed to Germany and he returned to Rome. On the face of it, he had won a magnificent victory and had re-established the power of the church. (In returning Henry to royal status, he made him promise to obey future papal decrees.) But, at the same time, Henry had saved his kingdom and he now set about strengthening his position so that he would never again be in the position of weakness to which he had sunk before Canossa. The German church rallied to his support and he conducted another – successful – campaign against the nobility. In this way it soon became clear that he had no intention of obeying papal decrees and, some time later, he was excommunicated again. The fact that he largely ignored this papal manoeuvre the second time around shows how much things had changed. In 1085 he finally obtained the revenge he had secretly sought all along, when he drove the pope from Rome, to southern Italy, 'a humiliating exile from which Gregory did not return'.[45] Even Gregory was weaker than he appeared.

For many historians, this final outcome made the encounter at Canossa, in sporting terms, a draw or a tie. But that is not the same as saying that nothing came of it. Henry's appearance before the pope dealt a mortal blow to the very idea of theocratic kingship, comforting to the various 'estates' around Europe, and gave sustenance to the idea that popes had the right to judge kings. This undoubtedly boosted the political muscle of the Catholic Church but at the same time many people – crowned heads in particular – had not exactly relished the high-handed and humiliating way Gregory had used, or abused, his power. One of the men who succeeded Gregory, Urban II (1088–1099), began to seek a way out of the perpetual conflict with the emperor and attempted to unite Europe behind Rome through the First Crusade. But even his style of papacy was too much for many people and from this time on there emerged cardinals of a different stripe – quiet diplomats, bureaucrats whose experience told them that more could be achieved behind the scenes by discussion than by confrontation. Thus the papacy was changed no less fundamentally by Canossa than was the status of kings. The Curia was aware of the papacy's inherent weaknesses even if the more pugnacious popes were not.

While he was pope, Gregory also kept a keen eye on what became known as the *Reconquista* in Spain. Since the Muslims had conquered the Iberian peninsula in the eighth century, the ousted Christian nobles had sought refuge in the Pyrenees where, over two centuries, they had regrouped and, by the end of the tenth century, had regained at least some of the ground lost. It would take another four hundred years, to the end of the fifteenth century, before Muslim control was extinguished but, in the process, Christians came face-to-face with the Islamic idea of *jihad*, holy war, with its doctrine that the highest morality was to die fighting, on behalf of God.[46] In Christianity, the idea of 'just war' went back to St Augustine of Hippo and beyond, and Hildebrand was an ardent Augustinian. Just then Muslims were in control in the Middle East, as they were in Spain, and Christ's sepulchre

in Jerusalem was in the hands of unbelievers. When all this was added to the desire to reunite Eastern and Western churches (as an effective way to combat the threat of Islam) the idea of crusade was born.[47]

Of course, there were other reasons. A crusade would be the perfect expression of the papacy's supreme power, it would help unite north and south Europe and even, in an ideal world, assert Rome's dominance over Byzantium. Several birds would be killed by this one stone. So far as Gregory was concerned, however, the Investiture Struggle consumed too much of his time, and prevented him ever embarking on a crusade. It was left for his successor, Urban II, to take up the challenge. And by the time he was elected there were still more reasons why a crusade would prove useful. In the first place, it would help reunite Christendom after the bitter feuds sparked by Gregory's reforms. It would boost papal prestige at a time when the Germans were not, exactly, Rome-inclined. And it might well boost France's prestige – Urban had a French background. Because of the Investiture Struggle it was unlikely that the Germans would subscribe to a crusade, and the Normans, in the north of France and in Britain and Sicily, would likewise keep their distance. But in central and southern France, Urban knew that there were many lords, and the vassals of many lords, who would welcome the opportunity to obtain lands abroad and, in the process, save their souls.

Which is how it came about that Urban proclaimed the First Crusade at Clermont in central France in 1095. There he delivered a highly emotional and rhetorical speech to the assembled knights, appealing both to their piety and to their more earthly interests. He dwelt at length on the sufferings which Christians were experiencing at the hands of the Turks, and the threat of Muslim invasion that hung over both Byzantium and the Holy Sepulchre in Jerusalem.* Using a famous biblical phrase, Urban described Palestine as 'a land flowing with milk and honey' and, in promising papal protection for the property and family of any crusader, he introduced an idea that was to have far-reaching consequences. He said that, as keeper of the keys to the kingdom of heaven, he vouchsafed the crusaders 'plenary indulgence' for their sins.[49] The origin of this idea may well have lain in the Islamic assurance that any warrior who died fighting for the faith was guaranteed a place in heaven. But the Christian idea of indulgence was soon expanded – and abused, so much so that it was one of the practices attacked by Martin Luther in the sixteenth century and, eventually, by the Council of Trent. By the twelfth century the Catholic Church had extended the institution of indulgence not just to crusaders but to those who supported them financially, and it is this which seems to have done the damage. By the fourteenth century, the papacy allowed the sale of indulgences even without a crusading pretext – the rich could simply buy their way to heaven.[50] It is easy to be cynical about the reasons people had for joining the crusades, and many no doubt had mixed motives. Nonetheless, it is said that, at the close of Urban's address at Clermont, the assembled knights rose up and, as one, shouted '*Deus vult*' – 'God wills it.' Many tore strips from their red cloaks and refashioned them into crosses. Thus the familiar emblem of the crusades was born.[51]

---

* Among the things at risk in Constantinople was the greatest relic collection of all: the Crown of Thorns, the cloth from Edessa on which Christ imprinted his face, St Luke's portrait of the Virgin, the hair of John the Baptist.[48]

The intellectual consequences of the crusades have long been debated. There seems little doubt that they made some Christians more international in outlook and, of course, several Eastern practices were observed and adopted along the way (a taste for spices, for example, use of the rosary, and new musical instruments). But more generally it cannot be said that the crusades exerted widespread influence. Within two hundred years the Muslims had regained all the crusader settlements won by the Christians, and these Muslims were more hostile and bitter than they had been before the holy war – the Christians had shown themselves as no less fanatical than their enemies. In later years, when Christians tried to fashion a mode of living together with Jews or Muslims in the Middle East, the siege and sack of Jerusalem always got in the way. More surprising still, the crusades had much less effect on learning than might have been expected: the manuscripts that helped to stimulate the revival of scholarship in the West, which is the subject of the next chapter, were transmitted via Sicily, Spain and, yes, Byzantium. But not by crusaders.

If Gregorian reform had one achievement to its name, it had drawn attention to the church. In some ways this was a good thing but not in others. In the eleventh century Europe was changing and in the twelfth it would change more, as cities continued to grow. This was important ecclesiastically because the medieval church was essentially organised for coping with a primarily agricultural society, and now society was increasingly urban. Many of the inhabitants of the new cities were the new class of bourgeoisie, better educated, more literate and harder working than their predecessors, and intensely pious. As a result, they evolved a different attitude to the clergy. As the twelfth century got under way, we find criticism of the clergy becoming more and more intense. In the new universities it became the fashion for students to produce biting satires that portrayed the clergy as gross and corrupt. Papal legates, instead of being welcomed as envoys of His Holiness, were often treated as interlopers who interfered in legitimate local matters. Everywhere one turns, in the literature of the time, dissatisfaction with the established church was growing.

One expression of the new piety – the new internal religion – was, as we have seen, the development of new monastic orders. A second effect was that heresy proliferated and was viewed much more seriously.[52] In fact, there had always been heresy, especially in Byzantium, but between 380 and the twelfth century no one was burned. One element in the new situation was a reaction against a rich and worldly clerical establishment. Another was the rise of literacy and of speculative thought, as reflected in the new universities, Paris in particular. Two academic heretics at Paris were David of Denant and Amalric of Bena, but the most influential heresies of the twelfth century and the most fiercely combated, were the Waldensian, the millenarianism of Joachim of Fiore, and the Albigensian heresy of the Cathars.

Peter Waldo, a merchant from Lyons, was, like many heretics, a saintly, ascetic figure. The first anti-Cluniac monastery had been established at Lyons and the archbishop of the city had been a great follower of Hildebrand, so there was a tradition in the area which adhered to the idea of the apostolic poverty of the church. The disciples of Waldo called themselves the Poor Men of Lyons and, as well as embracing apostolic poverty, and going about barefoot, they preached against the clergy (this is known as antisacerdotal). For the

Waldensians, the line between heretic and saint was thin, the 'church' was not the prevailing Catholic organisation, but instead a purely spiritual fellowship comprised of saintly men and woman 'who had experienced divine love and grace'.[53]

An even more vituperative anticlericalism was promulgated by a southern Italian abbot, Joachim of Fiore, who, towards the end of the twelfth century, argued that the world had entered the age of the Antichrist, an age which immediately preceded the Second Coming and the Last Judgement. The idea of the Antichrist had its roots in the earlier existence of the 'human' opponents of God and his Messiah, in the apocalyptic tradition of Second Temple Judaism. These ideas were taken over by the early Christians in the second half of the first century AD, who argued that there were forces abroad trying to prevent the return of Jesus (the first mention of the term 'Antichrist' in a biblical context comes in the first epistle of John). The tradition flourished in Byzantium and migrated to the West in a famous tenth-century document, Adso's *Letter on the Antichrist*, which formed the standard Western view for centuries.[54] Adso, a monk, later abbot of Montier-en-Der, undertook a full 'biography' of the Antichrist in a letter addressed to Gerberga, sister of Otto II, the German ruler who renewed the western empire. It was a 'reverse' hagiography and a narrative, which accounted for its incredible popularity (it was widely translated). In Adso's version of events, the Antichrist (the *final* Antichrist) will be born in Babylon, go to Jerusalem where he will rebuild the Temple, circumcise himself and perform seven miracles, including the raising of the dead. He will reign for forty-two months and meet his end on the Mount of Olives, though Adso never made it clear whether Jesus or the Archangel Michael will bring about this end. In paintings and book illustrations, the Antichrist was often depicted as a king (less often a Titan) seated on or barely controlling beast(s) of the apocalypse.[55]

What set Joachim of Fiore apart (and one can see why) was his identification of the papacy itself as the Antichrist. For Joachim, exegesis of the Bible was the only way to an understanding of God's purpose. On this basis he identified from Revelation 12 that: 'The seven heads of the dragon signify seven tyrants by whom the persecutions of the church were begun.'[56] These were: Herod (persecution by the Jews), Nero (pagans), Constantine (heretics), Muhammad (Saracens), 'Mesemoths' (sons of Babylon), Saladin, and 'the seventh king', the final 'and greatest' Antichrist, which he thought was imminent. A Cistercian, he founded his own order and worked out his vision. This was in part that the future lay with the monastic life – he felt that all other institutions would wither away. But his examination of the Bible, and the seven-headed dragon, led him to conclude that the final Antichrist, in modelling himself on Jesus, would take both priestly and kingly form. Therefore, as the eleventh- and twelfth-century popes acquired the mantle of a monarchy, it followed that Joachim should see in this the very Antichrist he was looking for.[57]

His view turned out to be popular, possibly because of the simplicity of its appeal – everything was turned on its head. The more zealous the popes were in whatever they did, the more cunning the deceits of the Antichrist. The 'fact' that the end was imminent gave the millenarians more conviction than anyone else. Joachite reasoning had it that there were three ages in the history of the world (as mentioned in the Introduction), presided over by God the Father (Creation to Incarnation), God the Son (Incarnation to 1260), and God the Holy Spirit (1260 on), when the existing organisation of the church would

be swept away. The passing of the year 1260 without notable incident rather took the wind out of the Joachite sails, but their ideas remained in circulation for some time afterwards.[58]

But the heresy that was by far the biggest threat to the established church was that known as the Cathari (Pure Ones, Saints), or the Albigensian religion, named after the town of Albi, near Toulouse, where the heretics were particularly well represented.[59] The main ideas behind the Cathar movement had been in circulation underground for some time. These ideas recalled the Manicheans of the fourth century who, according to some historians, had been kept alive in a sect in the Balkans known as the Bogomils. Equally probable, however, Catharism developed from Neoplatonic ideas which existed in more conventional theology and philosophy. (There is good evidence that many Cathars were highly educated and became skilled in debate.) A final strand may well have come from Jewish mysticism, the Kabbalah, in particular that form of thought known as Gnosticism (see above, pages 181–182). The Manichees had believed that there are two gods, a god of good and a god of evil, a god of light and a god of darkness, who were in perpetual combat for control in the world. (There is clearly an overlap here with ideas about the Antichrist.) Associated with this set of beliefs, man is seen as a mixture of spirit (good) and matter, or body (evil). Like other heretics, the Cathars were ascetics whose aim was pure spirituality, the 'perfect' state. Marriage and sexual behaviour were to be avoided, for they led to the creation of more matter. The Cathars also avoided eating meat and eggs, because they came from creatures that reproduced sexually. (The limitations of their biological understanding allowed them to eat fish and vegetables.) They believed that the surest way to salvation was the *endura*, the belief that after receiving *consolamentum* on one's deathbed one shouldn't eat any more food as it would make one impure again. So in that sense they starved themselves to death.[60] They did concede, however, that those who did not live the absolutely pure life might still attain salvation by recognising the leadership of the 'perfects', or Cathari. These so-called 'auditors' of the true Cathar faith received a sacrament on their deathbed that wiped away all previous sin and allowed the reunion of their souls with the Divine Spirit. This deathbed 'catharsis' was the only true way to God for those who weren't 'perfect'.[61] All manner of lurid ideas swirled around the Cathars. It was said, for example, that they rejected the Incarnation because it involved the 'imprisonment' of God inside evil matter. It was said they were promiscuous, so long as conception was avoided. And they were said to expose their children to *endura*, death by starvation as a form of salvation and, at the same time, ridding the world of yet more matter. All of these evils were easily countenanced, it was said, because it was Cathar practice to allow catharsis on the deathbed, and so what was the point of any other type of behaviour?

In the end the progress of the Cathars was halted first by the Albigensian crusade, 1209–1229, which removed the nobles' support, then by the papal inquisition, which was created in 1231 to deal with the threat. As well as annexing this region for the kings of France, these campaigns helped redefine crusades as battles against heretics *within* Europe's borders.[62] This in turn helped sharpen Europe's idea of itself as Christendom.

As the year 1200 approached, it is fair to say that the papacy was under siege. The greatest – or at least the most visible – threat came from heresy, but there were other problems, not least the weakness of the popes themselves. Since the death of Alexander III in 1181, the

throne had been held by a succession of men who seemed incapable of coping with the great changes in the nature of piety, and the aftermath of the crusades, not to mention the new learning, unleashed at the new universities in Paris and Bologna. Strictly speaking, Aristotle – rediscovered in the universities – could not be deemed an heretic, since he had lived before Christ, but what he had to say still provoked anxiety in Rome. The very great importance of Aristotle is underlined in the next chapter.

It was in these circumstances that the cardinals in 1198 elected a very young pope, an extremely able lawyer, in the hope that he would have a long reign and transform the fortunes of the papacy. Though he didn't live as long as he might have done, Innocent III did not disappoint.

Lothario Conti, who took the title Innocent III (1198–1216), came from an aristocratic Roman family. He had studied law at Bologna and theology in Paris, making him as educated a man as any then alive in Europe, and he had been elevated to the College of Cardinals at the very early age of twenty-six, under his uncle, Lucius III. But this was not only nepotism at work, for Innocent's colleagues recognised his exceptional ability and his determination. On his coronation day, he made plain what was to come. He said: 'I am he to whom Jesus said, "I will give to you the keys to the kingdom of heaven, and everything that you shall bind up on earth shall be bound up in heaven. See then this servant who rules over the entire family; he is the vicar of Jesus Christ and the successor of Saint Peter. He stands half-way between God and man, smaller than God, greater than man".'[63]

Greater than man. Perhaps no pope had more self-confidence than Innocent, but in his defence it was as much conviction as bravado. Innocent believed that 'everything in the world is the province of the pope', that St Peter had been ordained by Jesus 'to govern not only the universal church but all the secular world', and he, Innocent, was intent on establishing, or re-establishing, a new equilibrium on Earth, one that would bring a new political, intellectual and religious order to Europe.[64] By the time he died, the church was back in the ascendant, combating heresy, attacking secular power, improving the quality of the clergy, fighting intellectual unorthodoxy. It was Innocent who raised the first papal tithes, to fund the crusades, an exercise so successful that in 1199 he levied the first income tax on churchmen to fund the papacy itself. And it was Innocent who, effectively, installed an inquisition to combat the Albigensian heretics. In 1208 a papal legate was murdered in France and the count of Toulouse was believed to have been involved. This gave Innocent the idea of launching a crusade against the heretics.[65] This wasn't the Inquisition (with a capital I) that was to achieve such notoriety in Spain (and was a royal institution rather than a papal one) but it was a similar idea. Innocent instituted a new legal process, a new practice, the systematic searching out of heresy, using investigation and interrogation, rather than waiting for someone to make an accusation. It too was a new expression of papal power and ambition (and of theological weakness).

This inquisition was not always the 'unholy Reich' it has been pictured but it was quite bad enough. There was also a bitter irony behind everything that occurred – because one reason heresy took root so quickly at that time, and so firmly, was the moral laxity and corruption of the clergy itself, the very people who would enforce the Vatican's new law. For example, the Council of Avignon (1209) referred to a case of a priest gambling for penances with dice, and taverns whose inn signs showed a clerical collar. The Council of

Paris (1210) exposed masses held by priests who had wives or concubines and parties organised by nuns.[66] Innocent III's opening speech to the Fourth Lateran Council in 1215 confirmed that 'the corruption of the people derived from that of the clergy'.[67]

It is important to say that heresy had little to do with the magical practices and deep-rooted superstitions that were found everywhere in the twelfth century, not least in the church itself. Keith Thomas has described the extent of these magical practices – the fact that the working of miracles was held by some to be 'the most efficacious means of demonstrating [the church's] monopoly of the truth'.[68] For example, people's belief that the host was turned into flesh and blood was at times literal. One historian cites the case of a Jewish banker in Segovia who accepted a host as security for a loan, another gives the example of a woman who kissed her husband while holding a host in her mouth 'so as to gain his love'.[69] Keith Thomas also mentions the case of a Norfolk woman who had herself confirmed seven times 'because she found that it helped her rheumatism'.[70] The church made clear the difference between heresy (stubbornly-held opinions, contrary to doctrine) and superstition (which included use of the Eucharist for non-devotional practices, as mentioned above). In any case, the heretics themselves had little interest in magic as it involved the abuse/misuse of the very sacraments they had themselves rejected.

To begin with, the church showed a reluctant tolerance of heresy. As late as 1162, Pope Alexander refused to condemn some Cathars consigned to him by the bishop of Rheims on the grounds that 'it was better to pardon the guilty than to take the lives of the innocent'.[71] But the crusade against the Cathars had the advantage for many that it would bring material and spiritual benefits without the risk and expenditure of an arduous and dangerous journey to the Middle East. In practice, its effects were mixed. At the beginning, at Béziers, seven thousand people were massacred, an event so terrible that it gave the crusaders a psychological edge for ever after.[72] At the same time, the Cathars were rapidly dispersed – meaning that their insidious appeal was spread further, faster, than might otherwise have been the case. The Fourth Lateran Council was called in response: it issued a 'detailed formulation of orthodox belief' containing the first outline of the new legal procedure.

This inquisition came into existence formally under the pontificate of Gregory IX, between 1227 and 1233, though the episcopal courts had hitherto used three distinct forms of action throughout the Middle Ages in criminal cases: *accusatio, denunciatio* and *inquisitio*. In the past, *accusatio* had depended on an accuser bringing a case, the accuser being liable to punishment if his or her allegations were not proven. Under the new system, *inquisitio haereticae pravitatis* (inquisition into heretical depravity), investigation was allowed, without accuser, but with 'investigatory methods'. What these were was revealed in February 1231, when Gregory IX issued *Excommunicamus*, which produced detailed legislation for the punishment of heretics, including the denial of the right of appeal, the denial of a right to be defended by a lawyer, and the exhumation of unpunished heretics.[73] The first man to bear the title *inquisitor haereticae pravitatis*, 'inquisitor into heretical depravity', was Conrad of Marburg who, believing that salvation could only be gained through pain, turned out to be one of the most bloodthirsty practitioners this ignoble trade ever saw. But the most terrible of all bulls in the history of the inquisition was issued in May 1252 by Innocent IV. This was luridly entitled *Ad extirpanda*, 'to extirpate', which

allowed for torture to obtain confessions, for burning at the stake, and for a police force at the service of the Office of the Faith (the Roman euphemism for the inquisition).[74]

The main task of the inquisition, however, was not punishment as such, not in theory at any rate. It was to bring heretics back to the Catholic faith. The *inquisitor generalis* usually found its way to towns where there were known to be large numbers of heretics (many small villages never saw an inquisitor at any point). All men over fourteen, and women over twelve, were required to appear if they themselves imagined they were guilty of an infraction. When the people were gathered, the inquisitor would deliver a sermon, known at first as the *sermo generalis* and later as an *auto de fe*.[75] Sometimes indulgences were promised to those who attended. After the *sermo* any heretic who confessed was absolved from excommunication and avoided the more serious forms of punishment. However, part of the process of confession and absolution was 'delation', the identification of other heretics who had not come forward. Delation was invariably used as a sign of the validity of the original heretic's confession. The heretics so identified would be interrogated and it was here that the terror began. Total secrecy surrounded the procedure, the accused was not allowed to know who had informed against him (otherwise no one would ever inform, or delate) and only if the accused could make a good guess, and be able to show that his accuser had a personal enmity against him, did he stand a chance of acquittal. The *auto de fe* carried out by Bernard Gui in April 1310 in the area of Toulouse shows the sort of thing that might happen. There, between Sunday, 5 April and Thursday, 9 April he tried and sentenced 103 people: twenty were ordered to wear the badge of infamy and go on pilgrimages; sixty-five were sentenced to perpetual imprisonment; and eighteen were consigned to the civil authorities to be burned at the stake. Not even the dead could escape. There were scores of cases of people being sentenced up to sixty years after their death. Their bodies were exhumed and the remains burned, the ash very often being thrown into rivers. In an age that believed in the afterlife and which worshipped relics, this was a terrible fate.[76]

Torture techniques included the ordeal of water, when a funnel or a soaking length of silk would be forced down someone's throat. Five litres was considered 'ordinary' and that amount of water could burst blood vessels. In the ordeal of fire the prisoners were manacled before a fire, fat or grease was spread over their feet, and that part of them cooked until a confession was obtained. The *strappado* consisted of a pulley in the ceiling by means of which the prisoners were hung six feet off the ground, with weights attached to their feet. If they didn't confess, they were pulled higher, then dropped, then pulled up short before they hit the ground. The weights on their feet were enough to dislocate their joints, causing unbearable pain.[77] Torture captures the eye but in a feudal society the signs of infamy, and the ostracism they brought could be just as bad (for example, the marriage prospects of someone's offspring were blighted).[78]

The new piety was recognised and formalised by the Fourth Lateran Council, held at the Lateran Palace in Rome in 1215. This was one of the three most important ecumenical councils of the Catholic church, the other two being the Council of Nicaea in 325 and the Council of Trent in the sixteenth century, which considered the Catholic church's response to Protestantism. Four hundred bishops and eight hundred other prelates and notables

attended Lateran IV, which set the agenda for many aspects of Christianity and clarified and codified many areas of worship and belief. It was Lateran IV that nullified Magna Carta and fixed the number of the sacraments as seven (the early church had never defined the number of sacraments and, previously, some theologians like Damian had preferred nine, or even eleven). These seven were: baptism, confirmation, marriage, and extreme unction, marking the stages in life, plus mass, confession and the ordination of priests. Lateran IV also decreed that every member of the church must confess his or her sins to a priest and receive the Eucharist at least once a year, and as often as possible. This, of course, was a reassertion of the authority of the priesthood and a direct challenge to heretics. But it did reflect the needs of the new piety. In the same vein the council also decreed that no new saints or relics were to be recognised without papal canonisation.[79]

The sacrament of marriage was a significant move by the church. At the millennium it would be true to say that most people in Europe were *not* married in a church. Normally, couples would just live together, though very often rings were exchanged. Even as late as 1500 many peasants were still married by the age-old rite of cohabitation. Nonetheless, by 1200, say, the majority of the wealthier and more literate classes were married by priests. This had the side-effect of curtailing marriage among priests and bishops, but more generally the sacrament gave the church control over divorce. Until Lateran IV, people needed church approval to marry anyone within the seventh degree of consanguinity (first cousins – which marriages are now allowed – are four degrees removed). In practice, people ignored this. Only later, when a divorce was in the offing, was this illegal degree of consanguinity 'discovered', and used as grounds for annulment. Lateran IV replaced this with the third degree of consanguinity, the chief effect of which, says Norman Cantor, was 'to increase the church's capacity to interfere in individual lives'. This was Innocent's aim.

His tenacity of purpose was remarkable. Innocent has been described as the greatest of popes and as the 'leader of Europe'. David Knowles and Dimitri Obolensky put it this way: 'His pontificate is the brief summer of papal world-government. Before him the greatest of his predecessors were fighting to attain a position of control; after him, successors used the weapons of power with an increasing lack of spiritual wisdom and political insight. Innocent alone was able to make himself obeyed when acting in the interests of those he commanded.'[80]

During the thirteenth century, however, the moral authority of the papacy was largely dissipated. The Curia continued as an impressive administrative force but the growth of national monarchies, in France, England and Spain, proved to be more than a match for the Vatican bureaucracy. In particular the growing power of the French king posed a threat to Rome. In the early Middle Ages, the monarch with whom the pope had most come into conflict was the German emperor. But, owing to those very conflicts, the Germans had not been so well represented among the crusaders as had the French. That had given the French more power with Rome and, on top of that, the French king had obtained a fair proportion of southern France as a result of the Albigensian crusade, so that in this sense the papacy had helped bring about its own demise. These evolving trends climaxed during the reign of the French king, Philip IV the Fair (1285–1314).

Following the crusades, and the campaign against the Cathars, there was a sizeable

French faction in the College of Cardinals, and the introduction of nationalism into the papacy made all elections at the time fairly fraught. The French house of Anjou ruled in Sicily but in 1282 the French garrison there was massacred by the Sicilians in a rebellion known as the Sicilian Vespers.[81] At that time, the Sicilians gave their loyalty to the (Spanish) house of Aragon. The pope just then was French, owing allegiance to Charles of Anjou. He therefore proclaimed that the throne of Aragon was forfeit and announced a crusade, to be financed in part by the church. This was an extreme measure, with no moral justification. In the eyes of neutrals it demeaned the papacy, even more so when the campaign failed. This failure turned Philip IV against the papacy, too, as he sought a scapegoat. Gradually, the French became more and more intransigent and this climaxed in 1292 when the papal throne became vacant and the French and Italian factions in the College of Cardinals cancelled each other out to the extent that they wrangled for two years without reaching agreement: no candidate achieved the required two-thirds majority.[82] A compromise was eventually reached in 1294 with the election of Celestine V, a hermit. Totally confused and bewildered by his election, Celestine abdicated after only a few months. This 'great refusal', as Dante put it, was a demeaning scandal in itself, for no pope had ever abdicated and there were many of the faithful who, mindful that the pope occupies the throne of St Peter by divine grace, took the view that a pope *couldn't* abdicate. Celestine said that he had been told to vacate his office by 'an angelic voice', but that to say the least was convenient. His place was taken by Cardinal Benedict Gaetani, who adopted the title of Boniface VIII (1294–1303). Boniface turned out to be arguably the most disastrous of all medieval popes. His *idea* of his office was hardly less ambitious than Innocent III's, but he lacked any of the skills of his illustrious predecessor.[83]

In 1294 war had begun between France and England and both powers were soon regretting the enormous cost and looking around for ways to raise funds. One expedient which occurred to the French was taxation of the clergy, a device used to fund the crusades which had been very successful. From Rome, Boniface disagreed, however, and he published a bull, *Clericis laicos*, which said so. The bull was particularly bellicose in tone and the French retaliated, expelling Italian bankers from the realm and, much more to the point, cutting off the export of money, which denied the papacy a considerable part of its income. On this occasion, Boniface gave way, conceding that the French king, and by implication all secular rulers, had the right to tax their clergy for the purposes of national security. (Taxing the clergy may not seem financially productive today, but remember this was a time when the church owned as much as a third of the land.) A few years later, however, in 1301, another stand-off loomed, when a dissident bishop in the south of France was arrested and charged with treason. The French authorities demanded that Rome divest the bishop of his office so that he might be tried for his crime. Boniface, characteristically, and emboldened by the thousands of pilgrims that had flocked to Rome in 1300 for a jubilee, responded in a high-handed manner. He revoked his previous concession to the French king, regarding clerical taxation, and summoned a council of French clergy to Rome to reform the church in France. A year later he published the notorious bull *Unam sanctam*, claiming that 'both the spiritual and temporal swords were ultimately held by Christ's vicar on earth and that if a king did not rightly use the temporal sword that had been lent him, he could be deposed by the pope'. The bull concluded: 'We

declare, proclaim and define that subjection to the Roman Pontiff is absolutely necessary for the salvation of every human creature.'[84]

The French advisors of Philip were no less extravagant in their tit-for-tat. At what was later described as the very first meeting of the French Estates General, Boniface was charged with every calumny conceivable – from heresy to murder to black magic. Even more contentiously, the Estates General insisted that it was the duty of the 'very Christian king' of France to rescue the world from the monster in Rome. The French were serious. So much so that one of the king's advisors, William de Nogaret, a lawyer from Languedoc, was sent on a secret mission to Italy where he was met by certain enemies of the pope, both lay and ecclesiastical. His aim was nothing less than the physical capture of Boniface, the pontiff himself, who was to be brought back to France and put on trial. In fact, Nogaret did succeed in capturing the pope, at his family home of Anagni, south of Rome, and he started north with his captive. But Boniface's relatives rescued His Holiness and hurried him back to the Vatican, where he soon died, a broken man. Dante saw this as a turning point in the history of civilisation.[85]

So it proved. 'The French had not succeeded in capturing the pope but they had succeeded, in a way, in killing him.' The man who succeeded Boniface was Clement V, a French archbishop, who chose to settle not in Rome but in Avignon. 'Dante wept.'[86] This was pictured, inevitably perhaps, as a 'Babylonian captivity' for the papacy but it endured for nearly seventy years. Even when the papacy returned to Rome, in 1377, the confusion and abuses didn't end. The pope elected, Urban VI, conducted such a vendetta against corruption that, after a few months, part of the College of Cardinals withdrew *back* to Avignon and elected their own pope. There were now two Holy Sees, two Colleges of Cardinals, and two sets of Curiae. Even at local level the Great Schism was uncompromising and absurd – monasteries with two abbots, churches with two competing masses, and so on. A council was held in Pisa in 1408 to end the confusion. Instead, a *third* pope was elected. The whole absurd, comical, tragic business was not settled until 1417.

By then much damage had been done. Politically, the papacy was never as forceful again. There would be other powerful popes – or seemingly powerful popes – in the Renaissance and as late as the nineteenth century. But, in reality, they would never come anywhere near Gregory VII or Innocent III in either their ambition or their reach. No pope would ever again claim to be half-way between God and man. And yet politics was only one aspect of the papacy's decline. It was the momentous changes in the intellectual field that were to do equally lasting damage.

# 17

# *The Spread of Learning and the Rise of Accuracy*

On 11 June 1144, twenty archbishops and bishops gathered in the abbey church of St Denis, in Paris, where as many altars as there were senior clerics present were dedicated that day. Most of the bishops, who had not visited St Denis before, were astonished by what they saw. It is no exaggeration to say that Abbot Suger, the man in charge of the church, had created there the first completely new architectural style in 1,700 years. It was an aesthetic and intellectual breakthrough of the first order.[1]

Traditionally, ecclesiastical buildings had been erected in the Romanesque style, an elaboration of eastern Mediterranean basilicas, essentially enclosed structures designed for use in hot countries, and which had originated using primitive materials. Suger's new St Denis was quite different. He used the new architectural understanding, which combined the latest mathematics, to create a vast edifice, where the horizontal emphasis of Romanesque churches was replaced by perpendicular planes and ribbed vaulting, where 'flying buttresses', on the *outside* of the buildings, supported the walls, enabling the immense nave to be largely free of pillars, and where huge perpendicular windows allowed in great swathes of light to illuminate the hitherto murky interior and to shine upon the altar. Not the least impressive feature of the cathedral was the stained-glass rose window over the main entrance. The iridescent colours and the intricate lace-like pattern of the stone-work were as breathtaking as the ingenuity shown by the craftsmen in using the glass to display biblical narratives in this new art form.

Though not himself of high birth, Suger had been the king of France's childhood playmate and that friendship helped guarantee him a place at the highest tables. Later in their lives, when Louis was absent on an ill-fated crusade, Suger acted as his regent and acquitted himself well enough. Though a Benedictine, he was not persuaded that renunciation of the world was the correct path. Instead, he thought that an abbey, as the very summit of earthly hierarchies, should display a magnificence that did no more than reflect that fact.[2] 'Let every man think as he may. Personally I declare that what appears most just to me is this: everything that is most precious should be used above all to celebrate the Holy Mass. If, according to the word of God and the Prophet's command, the gold vessels, the gold phials, and the small gold mortars were used to collect the blood of the goats, the calves, and a red heifer [in the Temple, in ancient Israel], then how much more zealously shall we hold out gold vases, precious stones, and all that we value most

highly in creation, in order to collect the blood of Jesus Christ.'[3] Accordingly, between 1134 and 1144 Suger totally rebuilt and readorned the abbey-church of St Denis, using all the resources at his command to create this new setting for the liturgy.

Suger proudly wrote up his achievement in two books, *On His Administration* and *On Consecration*. These tell us that he thought St Denis should be a summing up, a *summa*, of all the aesthetic innovations he had encountered in his travels across southern France and that it should surpass them. He took as his inspiration the theology of the saint after whom St Denis was named – Dionysius the pseudo-Areopagite (so called because, besides claiming to be one of Paul's first Greek disciples, he also identified himself as one of the officials of the Athenian court of law, the Areopagus).[4] Dionysius is traditionally held to be the author of a medieval mystical treatise, which had been given to St Denis by the pope in the eighth century, in which the main idea was that God is light. Every living thing, according to this theology, receives and transmits the divine illumination, which 'spills down and irrigates the world' according to a divinely ordained hierarchy. God is absolute light, whereas all creatures reflect His light according to their inner radiance. It is this concept that lay behind the very form of the twelfth-century cathedrals, of which Abbot Suger's was the prototype.[5]

In addition to the general concept of light, Suger introduced several new features. The two crenellated towers set in the façade were meant to give the cathedral a military feel, a symbol of militant Christianity and the king's role in defending the faith. The portal was triple, reflecting the doctrine of the Trinity. The rose window lighted three high chapels, 'dedicated to the celestial hierarchies' – the Virgin, St Michael and the angels. At the far end of the choir there was a semicircular sequence of chapels (the apse), which both enabled many monks/priests to say mass at the same time and endowed the choir with a glow of light which complemented that from the rose window. And, with the supporting buttresses now outside the church, there was room for an ambulatory, around the nave, from which side chapels, again lit by daylight, led off. These too enabled more and more monks/priests to say mass. But above all, the whole church was now open – especially as Suger removed the rood screen – all of it bathed in one light, so as to make the entire structure a single mystical entity.[6] The theology of light was responsible not only for the advent of stained glass but for the role in the liturgy of the new cathedrals of precious stones and metals – jewels, enamel, crystal – which so dominate medieval art. Precious stones were believed to have a mediating power, a moral value even, each one symbolic of some Christian virtue. All of these light-related entities were designed to help the faithful – gathered together as one enormous congregation – approach God.

Suger was more successful than perhaps even he anticipated. Between 1155 and 1180 cathedrals were built at Noyon, Laon, Soissons and Senlis. The rose window at St Denis inspired similar structures at Chartres, Bourges and Angers. The bishops of England and Germany soon imitated the cathedrals of France. They have lost none of their magnificence in the millennium that has passed since.

It was not only for liturgy that the early cathedrals were used. Experienced bishops allowed the guilds to meet there, and other lay meetings. So many locals had worked on the construction of the cathedrals that they all knew the building well. In Chartres, every guild

wanted its own stained-glass window.[7] It was in this way, with cathedrals attracting citizens as the monasteries never had – for they were well outside the cities, in the country – that they also became schools. The area of a town near the cathedral was usually known as the cloister, even though it was open, and this is where the pupils now began to congregate, along with artists and craftsmen. Moreover, the bishops' schools were different from the monastic ones. Being in the cities, they were more open, more of this world, and the education they offered reflected that. In the monasteries, tuition had been a matter of pairs – a young monk was attached to an older one. But in the cathedral schools it was quite different – a group of students sat at the feet of a master. To begin with, most of the pupils were still clerics, and for them learning was primarily a religious act. But they lived in the city, among lay people, and their eventual jobs would be pastoral, amid the people rather than world-renouncing, as in a monastery.

In such an environment, word travelled much faster than it had done at the time of the monasteries, and would-be clerics or would-be scholars quickly learned which masters were cleverer, who had the most books, in which schools the debate was liveliest. When contemporaries mentioned schools with distinctive doctrines, they usually referred to a renowned teacher. For example, the 'Meludinenses' were named after Robert of Melun, while the 'Porretani' were pupils of Gilbert of Poitiers.[8] In this way, first Laon, then Chartres, then Paris offered the best opportunities. By now the word *schola* was applied to all the people of a monastery or cathedral 'at its work of worship in the choir'.[9] What happened in the twelfth century was that the number of pupils mushroomed and extended well beyond the normal numbers required to man a church.

In these contexts, at least to begin with, the main skills taught were reading and writing Latin, singing, and composing prose and verse. But what the new students wanted, the students who were not going to become clerics, were more practical skills – law, medicine, natural history. They also wanted to learn to argue and analyse, and to be exposed to the main texts of the day.

Paris had a population of some 200,000 in the early thirteenth century and was growing fast, no longer confined to the Île de Paris. Its advantages were extolled on every side, not least the abundance of food and wine, and the fact that, within a hundred miles of the city, there were at least twenty-five other well-known schools. This made for a critical mass of educated people which helped fuel further demand. There were also many churches in the city, whose associated outbuildings often provided board and lodging for the students. Everard of Ypres, who studied at both Chartres and Paris, says he was in a class of four pupils in the former school but that in Paris he was in a class of three hundred, in a large hall.[10]

The sheer size of Paris was what counted. By 1140 it was the dominant school in northern Europe, by far, though 'schools' is a better word than the singular. Its reputation was based on the fact that there were many independent masters there, not just one, and it was these numbers which provided the interplay out of which scholastic thought developed. 'By 1140, it was possible to find nearly everything in Paris. True, it was necessary to go to Bologna for the higher flights of canon law, and to Montpellier for the latest and best in medicine; but for every branch of grammar, logic, philosophy, and theology, and even for a respectable level of law or medicine, Paris could provide everything that most

ambitious students could desire.'[11] From contemporary documents, R. W. S. Southern has identified seventeen masters in Paris in the twelfth century, including Abelard, Alberic, Peter Helias, Ivo of Chartres and Peter Lombard.

By the middle of the twelfth century hundreds of students arrived in Paris every year from Normandy, Picardy, Germany and England. Teaching was still carried on in the cloister of Notre Dame but it was beginning to spread, in the first instance to the left bank of the Seine. The new masters, Georges Duby tells us, rented stalls on the rue de Fouarre and on the Petit Pont. In 1180 an Englishman who had studied in Paris founded a college for poor students and south of the river a whole new district was growing up opposite the Île de la Cité where, in the narrow lanes, Paris University was born.

The intellectual life of the schools, and then of the universities, was very different from that in the monasteries. In the latter locations, it was not so different from contemplation, solitary mediation on a sacred text, though they did seek to build up good libraries: Fulda in Germany, for example, had two thousand books at the service of scholars and Cluny close to one thousand, including a Latin translation of the Qur'an. But in Chartres and Paris they debated, masters and students faced each other in the mental equivalents of knightly combat, with outcomes that, in the context of the times, were just as thrilling and equally unpredictable – the masters didn't always win. The basis of the curriculum of the schools was still the seven liberal arts that had been set down in the early Middle Ages but now the *trivium* came to be seen as the elementary – or preparatory – part of the course work. The main aim of the *trivium* was to prepare the cleric for his principal function, to be able to read the Bible and make critical interpretations of the sacred text so as to extract the truth. In order to do so, however, pupils had to understand the finer points of Latin and for this some of the classical/pagan authors were studied – Cicero, Virgil and Ovid in particular. Teaching in the schools therefore leaned to classicism and this fuelled a renewed interest in ancient Rome and antiquity in general.[12]

Even more important, however, was the emergence of logic, through the rediscovery of the translations of Aristotle. 'Beginning in the 1150s, Latin editions of the rediscovered writings began to flood the libraries of Europe's scholars.' In the twelfth century, logic evolved as the most important discipline in the *trivium* – one cleric went so far as to say that reason was what 'did honour to mankind'. (The only Platonic work known then was the *Timaeus* and that not fully.)[13] Logic, it was felt, would make it possible for man to gradually penetrate God's mysteries. 'Since it was believed that the principle of all ideas sprang from God veiled and concealed under terms that were obscure and sometimes even contradictory, it was incumbent on logical reasoning to dispel the clouds of confusion and clarify the contradictions. Students must take words as their basis and discover their deepest meaning.'[14] At the root of logic lay doubt, because in doubt began dialectical reasoning – argument, debate, persuasion (which was another basis of science). 'We seek through doubt,' said Abelard, 'and by seeking we perceive the truth.' One of the chief features of the 'old logic' was 'universals', the essentially Platonic idea that there is an ideal form of everything, 'chairs' or 'horses', say, the underlying principle being that, if these could be arranged in a systematic (logical) order, God's purpose would be understood. The 'new' logic, put forward in the first place by Peter Abelard in Paris (who is described by Anders Piltz, in his study of medieval learning, as 'the first academic'), argued that

many episodes in the Bible were contrary to reason and, therefore, could not be just accepted, but should be questioned. The real way of thinking, he insisted, should reflect Aristotle's writings and be based on syllogisms, such as: *all a's are b; c is an a; therefore c is a b.* Abelard's book *Sic et Non* epitomised this approach by identifying and then comparing contradictory passages in the Bible with the aim of reconciling them where he could. Alongside Abelard, Peter of Poitiers said 'Although certainty exists, nonetheless it is our duty to doubt the articles of faith, and to seek, and discuss.' John of Salisbury, an Englishman who had studied in numerous places, including Paris, placed logic central to understanding: 'It was the mind which, by means of the *ratio* [reason], went beyond the experience of the senses and made it intelligible, then, by means of the *intellectus*, related things to their divine cause and comprehended the order of creation, and ultimately arrived at true knowledge, *sapentia*.'[15] For us today, logic is an arid, desiccated word and has lost much of its interest. But in the eleventh and twelfth centuries it was far more colourful and contentious, a stage in the advent of doubt, with the questioning of authority, and offering the chance to approach God in a new way.

But the cathedrals were themselves part of a larger change in society which encouraged not just the creation of schools but also their evolution into what we call universities. The cathedrals, as we have seen, were urban entities and the towns were places where practical as well as religious knowledge was needed. Mathematics, for example, which had been much expanded thanks to the translations of Arabic books, which were themselves versions of Greek and Hindu works, was central to the very building of the cathedrals. Flying buttresses, invented in Paris in the twelfth century, owed their conception at least in part to the science of numbers. The new towns, where more and more people lived in close proximity, also had a great need of lawyers and of doctors, and these needs also stimulated the evolution of the schools into universities.[16]

Let us remind ourselves of the concept of the liberal arts.[17] For the Greeks the notion of liberal studies was that of an educational system suitable for the free citizen, though there were at least two versions – Plato's, which took a philosophical and metaphysical view of education designed to imprint moral and intellectual excellence, and Isocrates' version, which advocated a curriculum more suited to practical engagement with community and political life. This was refined first by the Romans, in particular Varro who, in the first century BC, compiled his *De Novem Disciplinis*, which identified nine disciplines – grammar, logic, rhetoric, geometry, arithmetic, astronomy, music, medicine and architecture. As was described in Chapter 11, in the early fifth century, Martianus Capella compiled his strangely-entitled *The Marriage of Mercury and Philology*, which reduced Varro's nine liberal arts by two, making medicine and architecture the first professions to become organised separately.[18] Capella's classification was widely adopted and over the intervening centuries it became customary to divide the seven liberal arts into the *trivium* – grammar, logic and rhetoric – and the more advanced *quadrivium* – arithmetic, geometry, astronomy and music. Before 1000, according to Alan Cobban, in his history of medieval universities, *quadrivium* subjects were relatively neglected, as they were deemed less important for the training of a body of literate clergy. 'The need to master enough arithmetical skill to calculate the dates of movable church festivals was often the sum total

of *quadrivium* expertise absorbed by the average student priest.'[19] Education was mainly a literary experience which did not challenge the trainee-priest's analytic abilities (writing was taught on wax tablets).[20] The transition from grammar and rhetoric to logic as the main intellectual discipline was a major intellectual metamorphosis and marked the break from 'an education system based upon the cumulative knowledge and thought patterns of the past to one deriving its strength from a forward-looking spirit of creative inquiry'. The idea that the liberal arts be regarded as a prelude to higher studies, and especially to theology, may strike us today as odd – such subjects had a tangential bearing on theology at best.[21] But it was part of the Greek legacy of liberal studies, reflecting the idea that the mind should be enlarged over a range of disciplines as a necessary preparation for a full life in a responsible democracy. The main difference was that theology became the crowning glory in the hierarchy of medieval education, a position which philosophy had occupied in the Greek world.

Another aspect of that legacy was the buoyant optimism in the schools. All the masters shared the view that man, even in his fallen state, was 'capable of the fullest intellectual and spiritual enlargement', that the universe was ordered and therefore accessible to rational inquiry, and that man's mastery of his environment through his intellect, cumulative knowledge and experience was possible.[22] Outside the realm of revealed truth, it was believed, man's capacity for knowledge and understanding was almost unlimited. This, as Alan Cobban puts it, was a major reorientation in the thinking of western Europe. It was shown clearly by the encounter between the Italian Anselmo, better known as St Anselm, archbishop of Canterbury, and the monk Gaunilo. Anselm had sought proof – logical proof – for the existence of God in the fact that, because we can *imagine* a perfect being, that perfect being – God – must exist. Otherwise, if it did not, there would be a being more perfect than the one we have conceived. This seems mere wordplay to us, as it did to Gaunilo, who dryly pointed out that we can imagine an island more perfect than any that exists, but that doesn't mean that the island actually exists. The point about the exchange, however, is that Anselm, a senior figure compared to the monk, published Gaunilo's response, together with his own rejoinder. The debate *assumed* that one could talk about God in terms that were 'reasonable', that God could be treated like anything else, and that rank had little to do with authority.[23] This was new.

The four areas of inquiry which propelled the early universities were medicine, law, science and mathematics. Medicine and law became very popular in the High Middle Ages.[24] They were practical, offering well-paid careers with a stable position in the community. The *ars dictaminis* or *dictamen*, the art of composing letters and formal documents, became a specialised offshoot of law and rhetoric, and together the applied subjects of law, medicine and *dictamen* soon became the natural enemies of literary humanism, since they reflected the practical side of the emergent universities, in strong contrast to the quiet and disengaged nature of the study of classical antiquity. Thus the earliest universities were not planned – their vocational nature arose out of practical needs. So far as science was concerned, however, the universities had an uncertain birth owing to persistent clerical distrust of pagan authors. For example, Peter Comestor, chancellor of Notre Dame of Paris from 1164, preached that the classical authors might be useful background in the study of scripture but that many of their 'outpourings' were to be avoided. Around 1200, Alexander

of Villedieu vilified the cathedral school of Orléans, an important centre of humanist studies before the mid-thirteenth century, dismissing it as a 'pestiferous chair of learning . . . spreading contagion among the multitude'. He insisted that 'nothing should be read which is contrary to the scriptures'.[25]

This attitude spread and in the early years of the thirteenth century, Aristotle himself came under attack. From the early studies of logic, Aristotle's books had been translated in growing numbers, especially his 'nature' books, about science, until his works formed what amounted to a complete philosophy and synthesis, compiled without any input from Christian beliefs. One historian says that the recovery of Aristotle's works was a 'turning point in the history of Western thought . . . paralleled only by the later impact of Newtonian science and Darwinism'.[26] At the University of Paris, certainly, the most intellectually exciting and troublesome community was the liberal arts faculty, where 'philosophy was king', where 'the masters of arts were the permanent element of intellectual unrest and the driving force of intellectual revolutions'.[27] In fact, the liberal arts faculty almost became a university within a university, and as Aristotle's works became available in Latin, the masters modified the curriculum to take account of this. Integrating the Philosopher's works on logic was one thing, but problems soon loomed with his books on 'nature'. In 1210 a local synod of bishops in Paris commanded that all study of Aristotle at Paris be halted. He was to be read neither privately nor taught publicly, 'under penalty of excommunication'.[28] The pope supported this ban, in 1231 and again in 1263, and the bishop of Paris added his voice once more in 1277. Later, private study was allowed but not public instruction. The ban that the church tried to exercise over Aristotle was yet another aspect of thought-control to add to those described in the previous chapter.

Other techniques of control were added. In 1231 it became a punishable offence to discuss scientific subjects in vernacular languages – the church did not want ordinary people exposed to such ideas. But no ban could be total – after all, for some people banning works only made them *more* alluring. And Aristotle was not banned elsewhere – Toulouse, for example, or Oxford. The ban began to break down more comprehensively after 1242 when Albertus Teutonicus, remembered today as Albertus Magnus – Albert the Great – became the first German to occupy a chair of theology at Paris. A strong opponent of heresy, Albert was nonetheless very interested in Aristotle's ideas – he thought the whole corpus should be available across Europe. For Albert, there were three ways to the truth: scriptural interpretation, logical reasoning and empirical experience. The latter two were of course both Aristotelian approaches, but Albert went one further: while allowing the Creator a role in the creation of the universe, he insisted that research (as we would say) into natural processes should be unhindered by theological considerations because, so far as these natural processes were concerned, 'only experience provides certainty'.[29] 'The proper concern of natural science is not what God *could do* if he wished, but what he has done; that is, what happens in the world "according to the inherent causes of nature".[30] Aristotle had said that 'to know . . . is to understand the causes of things'.[31]

We see here, in Albertus, the first glimmerings of the separation of different ways of thinking. Albertus had a strong faith and it was that strong faith which allowed him to consider what Aristotle could add to orthodox belief to enrich understanding.

Others, however, were more radical. For example, one very controversial effect of this

devotion to Aristotle was the so-called 'double truth' theory of the two scholars Siger of Brabant (d. 1284) and the Dane Bo, or in Latin, Boethius of Dacia. The ban on Aristotle at Paris University did not apply elsewhere in the city and this enabled the development of philosophy based on the Greek master's ideas. The most important innovation of these two men, which anticipated the great divide which was to come, was to consider the possibility – radical for the time, for any time – that one thing could be true in philosophy, and another in theology. Boethius in particular argued that the philosopher should enjoy the fruits of his intelligence, to explore the world of nature – *this* world – but that these skills did not entitle him to explore, say, the origin of the world, or the beginning of time, or the mystery of creation, how something can come from nothing. These matters, like what happens at the Day of Judgement, matters of revelation, not reason, are therefore outside the realm of the philosopher – there are two sets of truth, those of the natural philosopher and those of the theologian. As with Albertus, this was a distinction between two areas of thought that represents a stage in the development of ideas about a secular world.

Many in the church, however, found Siger even more troublesome, and this was because he seems to have relished the more disconcerting aspects of Aristotle's teaching: that the world and the human race are eternal, that the behaviour of objects is governed by their nature, that free will is limited by necessity, that all humans share a single 'intellective principle'. In his teaching he refused to spell out the implications of all this but it didn't take a genius to read between the lines: no Creation, no Adam, no Last Judgement, no Divine Providence, no Incarnation, Atonement or Resurrection.[32] This, of course, is what the orthodox clerics were worried about, this is why Aristotle had been banned, for where it might lead. In particular, Giovanni di Fidenza, who took the name Bonaventure and was another professor of theology at Paris, was disturbed by Aristotle's insistence that, although God is the first cause of everything that exists, natural beings have their own causes and effects, which operate without divine intervention.[33] To Bonaventure, and many like him, such reasoning pointed to a Godless world and he therefore tried to amend Aristotle so that, for example, when a tree's leaves turned brown, this was, he said, not due to some natural process but due instead to certain qualities built into the tree by God.

As these paragraphs show, the mid-thirteenth century was the high point of scholastic theology at Paris University, the high point of scholastic thinking in many ways, and it culminated in the great syntheses of Thomas Aquinas, the man who has been called 'the most powerful western thinker between Augustine and Newton'. Aquinas' great contribution was his attempt to reconcile Aristotle and Christianity, though as we shall see throughout the rest of this book, his Aristotelianisation of Christianity was more influential than his Christianisation of Aristotle. Born between Rome and Naples, the son of a count, Aquinas was a big man, deliberate in his movements and his thoughts and, at least to begin with, easy to underestimate. But Albertus, his teacher and master, appreciated his gifts and the big man did not disappoint.

In Aquinas' view, there were only three truths that could not be proved by natural reason and therefore must be accepted. These were the creation of the universe, the nature of the Trinity, and Jesus' role in salvation.[34] Beyond this, and more controversially and more influentially, Aquinas took Aristotle's side against Augustine. Traditionally, as Augustine

had argued, because of the Fall men and women are born to suffer in this world, and our only real hope for happiness is in heaven. Aristotle, on the other hand, had argued that *this* world, this life, offers countless opportunities for joy and happiness, 'the most lasting and reliable of which is the joy of using our reason to learn and understand'.[35] Thomas amended this to say that we can use our reason to have a 'foretaste' of the afterlife – with relative happiness – right here on earth. The natural world, he said, 'is not in any respect evil'.[36] How, he asked, could the body be evil when God had sanctified it with the incarnation of His Son? Moreover, Thomas thought that the body and soul were intimately linked. The soul was not a ghost in the machine, but took its form from the body as, say, a metal sculpture takes its form from the mould. This last was perhaps the most mystical aspect of his thinking.

In his day Aquinas was not seen as a radical, like Siger. For many, however, that made him more dangerous, not less. His was the reasonable face of medieval Aristotelianism, in particular his idea that *this* life was more important – because capable of more enjoyment than traditionalists allowed – and because Aristotle had so much to say about how this life might be enjoyed. By implication Aquinas downplayed the relative importance of the afterlife and clearly, over the ensuing decades and centuries, that had a big effect on the weakening authority of the church.

To some extent, the universities were anticipated by the philosophical schools of Athens, dating from the fourth century BC, by the law school of Beirut, which flourished between the third and sixth centuries, and by the imperial university of Constantinople, founded in 425 and continuing intermittently until 1453. Medieval scholars were aware of these institutions and Alan Cobban says there was a notion of the *translatio studii*, which appeared in the Carolingian age, and which held that the centre of learning had passed from Athens, to Rome, to Constantinople, to Paris. 'In this scheme the new universities were also the embodiment of the *studium*, one of three great powers by which Christian society was directed, the others being the spiritual (*Sacerdotium*) and the temporal (*Imperium*).'[37]

The modern term 'university' appears to have been introduced accidentally, taken from the Latin *universitas*. But in the twelfth, thirteenth and fourteenth centuries this word was used 'to denote any aggregate or body of persons with common interests and independent legal status' – it could be a craft guild or a municipal congregation, often with dress requirements.[38] It was not until the late fourteenth and fifteenth centuries that *universitas* came to be used in the sense we understand it today. Instead, the equivalent medieval term was *studium generale*. *Studium* meant a school with facilities for study, whereas *generale* referred to the ability of the school to attract students from beyond the local region. The term was first used in 1237 and the first papal document to employ the phrase dates from 1244 or 1245, in connection with the founding of the University of Rome.[39] Other terms in use were *studium universale*, *studium solemne* and *studium commune* but by the fourteenth century *studium generale* was used in connection with Bologna, Paris, Oxford, Padua, Naples, Valencia and Toulouse. The *Siete Partidas* (1256–1263), the legislative code of Alfonso X of Castile, lays out the legal basis of the early *studium generale*. Schools must have masters in each of the seven arts, for canon and civil law, and authority for the school

could be granted only by the pope, the emperor or the king.[40] There was no mention of what later came to be regarded as a further requirement: faculties of theology, law and medicine as postgraduate centres of excellence. At the turn of the thirteenth century only Bologna, Paris, Oxford and Salerno offered consistent teaching in the higher disciplines.[41]

The first imperial university, in fact the first university of all to be founded by a deliberate act, was installed at Naples in 1224 by the emperor Frederick II. The first papal university was at Toulouse, authorised by Gregory IX in 1229 and founded, in part, to combat heretical belief. These gave birth to the notion that the authority to found *studia generalia* was vested only in papal or imperial prerogative, a concept that was accepted doctrine by the fourteenth century.[42] This constitution was more important then than it would be today because the fledgling universities had earned a number of privileges which were not inconsiderable – two in particular are of interest. First, beneficed clergy had the right to receive the fruits of the benefice while studying at the *studium*. Since some courses of study lasted as long as sixteen years, this was no small thing. The second privilege was the *ius ubique docendi*, the right of any graduate from a *studium generale* to teach at any other university without further examination.[43] This went back to the idea of the *studium* – learning – as a 'third force' in society, which was understood to be universal, transcending the boundaries of nation and race. This idea of a commonwealth of teachers, moving around Europe, never really materialised. Each of the new establishments regarded itself as superior to the others and insisted on examinations for the graduates of other universities.[44]

The earliest universities were those at Salerno, Bologna, Paris and Oxford. Salerno, however, was rather different from the other three. Though not as important as Toledo, it played a role in the translation of Greek and Arabic science and philosophy texts but it did not provide superior faculty teaching in any discipline other than medicine.[45] It was in fact noted more for its practical medical skill rather than for anything else (it was surrounded by mineral springs where the lame and blind foregathered). The school was an assembly of medical practitioners, and though there must have been some kind of teaching there was no formal guild association. Nonetheless, the first signs of a medical literature occur at Salerno in the eleventh century – encyclopaedias, treatises on herbalism and gynaecology (a number of women doctors, including Trotula, practised in the town). There were also numerous works of Arabic science and medicine and some Greek medical texts which had been translated into Arabic.[46] These texts were made available mainly thanks to Constantine the African, a scholar of Arabic descent who settled in Salerno *c.* 1077 before moving north to the monastery of Monte Cassino where he continued translating until his death in 1087. The most influential Arabic treatises which he rendered into Latin were the *Viaticus* of al-Jafarr, Isaac Judaeus' work on diet, fevers and urine and the comprehensive medical encyclopaedia of Haly Abbas compiled in Baghdad one hundred and fifty years before. Constantine's translations provided a new impetus for the study of Greek medicine which resulted in the Salernitan doctors writing scores of new medical works in the following century. Salerno thus developed a medical curriculum that, after it was exported to Paris and other universities, was expanded under the influence of the new logic and scholasticism.[47] These advances progressed most at Bologna and Montpellier. The earliest reference for human dissection occurred at Bologna *c.* 1300. This may well

have been due to forensic investigations necessary for legal processes. (In due course the post-mortem examination became a convenient part of anatomical study.) The earliest text on surgery is the anonymous treatise now titled the *Bamberg Surgery* (c. 1150). Among the conditions described are fractures and dislocations, surgical lesions of the eye and ear, diseases of the skin, haemorrhoids, sciatica and hernia.[48] There is a description for the treatment of goitre with substances containing iodine, and for a form of surgical anaesthesia, a 'soporific sponge' soaked in hyoscyamus and poppy.[49]

Bologna, the oldest *studium generale* of all, belies the overall picture of medieval universities, in that it was a lay creation designed to meet the career needs of laymen who wanted to study Roman law. Only in the 1140s was canon law, the preserve of clerical teachers and students, introduced at Bologna.[50]

A boost to law was provided by the polemical turmoil arising from the Investiture Struggle. 'As Roman law was the best available ideological weapon with which to confront papal hierocratic doctrine, this system became the natural concern of laymen involved in generating an embryonic political theory to refute the claims of papal governmental thought.'[51] But it was the teaching of one of these early jurists, Irnerius (possibly a Latinisation of the German Werner), who taught at Bologna around 1087, which enabled Bologna to surpass the other fledgling Italian law schools, such as Ravenna or Pavia. In commenting on Justinian's *Corpus iuris civilis*, Irnerius used a method of critical analysis similar to Abelard's *Sic et Non* and in so doing succeeded in synthesising Roman law better than anyone had done before. The basic Roman legal texts were made widely available in a form suitable for professional study, as a particular area of higher education, and this established Bologna as a pre-eminent centre for civilian studies to which students began to migrate from distant parts of Europe.[52] Bologna's reputation was further enhanced when, only a little later, in the 1140s and the 1150s, canon law studies were added as a major academic counterpart. This development was spearheaded by Gratian, who was a teaching master of canon law at the Bolognese monastic school of San Felice. His *Concordia Discordantium Canonum* (the *Decretum*), completed *c.* 1140, paralleled in canon law what Irnerius had done for Roman law – producing a convenient synthesis appropriate for academic consumption. The impact of these changes may be seen from the fact that, in the two centuries following, a high percentage of popes were jurists, several of whom had been law professors at Bologna.[53]

A different achievement of Bologna was the *Habitas* – an academic constitution issued by the emperor Frederick I at Roncaglia in November 1158, apparently at the request of the scholars of the *studium*, and which was confirmed by the papacy. This came to acquire a fundamental academic significance which far outweighed the original intention, leading to a system of scholastic privilege which eventually ranked alongside the older-established *privilegium clericorum*.[54] In fact, the *Habitas* was ever after venerated as the origin of academic freedom 'in much the same way as Magna Carta became an indispensable reference point for English liberties'.[55] It began as an attempt by the Crown to reinforce the lay lawyers against the gains being made by the canon lawyers, which fuelled the Investiture Struggle. In the *Habitas* the emperor is referred to as the minister or servant of God, a doctrine which reflects the idea that imperial power was derived directly from God,

not through the intermediary of the Church.[56] This set of ideas was refined as time passed to deny the bishops any power over the universities.[57]

The papal/imperial struggles brought added civil strife to several Italian cities, Bologna being one of them. These near-anarchical conditions promoted the formation of mutual protection associations, known as tower societies or confraternities. It was in this context that the schools of Bologna were founded and this is why Bologna University had the flavour that it did – i.e., controlled by students. The student-university idea at Bologna owes a great deal to the contemporary concept of Italian citizenship. In a country increasingly fragmented by war, this was a valuable commodity. In a situation where the status of citizen provided personal protection, non-citizens – lacking such security – were vulnerable and it was only natural for foreign law students to band together to form a protective association, or *universitas*. Later, these subdivided into national associations, under the direction of rectors.[58]

If the papal/imperial rivalry was one factor giving Bologna its special character, another was economics. The city, realising the economic advantages of having a university in the commune, soon passed statutes prohibiting the masters from decamping anywhere else.[59] The students, aware of the power this gave them, responded by setting up, in 1193, a *universitas scolarium*, the intention of which was to establish a regime where students held onto power in all its guises. Under this system, contractual arrangements between individual students and doctors were replaced by organised (and frequently militant) student guilds (*universitates*). Such was the success of this arrangement that the *universitates* were eventually recognised by both the commune of Bologna and the papacy.[60] It is worth pointing out that 'student power' in those days owed something to the fact that a good number of Bologna law students were older than students are now. Many were in their mid-twenties and some were closer to thirty. Many already had an undergraduate arts degree before arriving in Bologna and a good few held ecclesiastical benefices. On top of this, their legal studies might last for up to ten years and, because of their benefices, many were well-off, so that their presence was a significant economic factor in city affairs.[61] All of which had a major impact on university life. Students elected their teachers several months in advance of the academic year and upon election the doctors had to take an oath of submission. A lecturer was fined if he started his lectures even a minute late or if he continued after the allotted time.[62] At the start of the academic year the students and doctors agreed on the curriculum to be followed and terms were divided into two-weekly *puncta* so that students knew when particular material was due to be taught. The students continuously rated the masters' performances, and could fine anyone they felt fell below par.[63] Any doctor who didn't attract at least five students to his course was deemed absent and fined anyway. If a teacher had to leave the city for some reason he was forced to lodge a deposit against his return.[64] As other universities proliferated, Bologna found that this strict regime was losing its allure – for teachers at any rate – and, from the late thirteenth century, the commune began offering salaries for lecturers. From then on the students gradually lost power.[65]

The form of the lecture also became established in the twelfth century. Beginning with the Bible, the texts were studied from four points of view: subject matter, immediate aim, underlying purpose, what branch of philosophy it belonged to. The master began by

discussing these aspects before giving a gloss on individual words and expressions, the whole process being known as the *lectio* ('reading') or *lectura*. To begin with, students were not allowed to take notes but as topics became more complex it became necessary to write down what was said.

The *studium generale* at Bologna was closed several times in the Middle Ages. The reasons varied from plague to papal interdict. Given the inherent conflict between canon and civil law(yers), this was perhaps inevitable. But as a direct result several daughter *studia* were founded: Vicenza: 1204; Arezzo: 1215; Padua: 1222; Siena: *c.* 1246 and Pisa: 1343.

Paris, the next-oldest *studium generale* after Bologna, differed (as we have seen) in that its dominant speciality was theology. 'Paris university provides both the earliest and the most dramatic example in European history of the struggle for university autonomy in the face of ecclesiastical domination.'[66] In this case the immediate ecclesiastical barrier to the exercise of university freedom was the chancellor and chapter of the cathedral of Notre Dame whose schools, dating from the eleventh century and situated in the enclosed area known as the *cloître*, were the primordial root of the *studium*. 'As these schools grew in reputation they were infiltrated by numerous outside students and this led to disorder. When the bishop and chapter curtailed the opportunities for study in the cloister, the students migrated to the left bank of the Seine, the present Latin Quarter. By the twelfth century there were many schools, dispersed on and around the bridges of the Seine, specialising in theology, grammar and logic.'[67]

Paris, unlike in Bologna, was from the first a university of masters. Grouped around Notre Dame, the Paris scholars were content with their clerical status because of the privileges and independence this gave them (they were exempt from certain taxes and military duty). This meant that the university in Paris was an autonomous enclave, protected by both the king and the pope. This autonomy, within the Paris urban area, helps account for the university's pre-eminence in theology and, later on, put it at the forefront of the debate for academic freedom.[68] As in Bologna the Capetian kings of France quickly recognised the economic value of the academic population and from the start pursued a tolerant and positive attitude towards both students and masters.[69]

In Paris, the arts faculty was much the largest. And in fact, because Paris was so large, each nation of students had its own school, with a rector who collected the fees. These schools were located, mainly, on the left bank, in the rue de Fouarre. In these different schools – French, Norman, Picard, English-German – lay the germ of the idea of colleges. The impact of the Hundred Years War hit Paris University badly, as foreign students drained away. Partly as a result of this, universities sprang up elsewhere – Spain, Britain, Germany and Holland, Scandinavia.

The original English universities, Oxford and Cambridge, differed from those on the continent in that they grew up in towns which had no cathedrals.[70] Oxford, in a way, evolved where it did by accident. In the twelfth century there were several places in England where a *studium generale* might have developed – there were, for example, good cathedral schools in Lincoln, Exeter and Hereford. York and Northampton were other possibilities.[71]

One theory has it that Oxford was initiated around 1167 by an exodus of scholars from Paris.[72] Another theory contends that at first the Northampton school was pre-eminent but the town was hostile, so the scholars left *en masse* and decamped, around 1192, to Oxford, which was conveniently located, being a meeting point of several routes between, for example, London, Bristol, Southampton, Northampton, Bedford, Worcester and Warwick.[73]

It is also possible – some would say likely – that the Northampton scholars were attracted by the remarkable teachers who already existed at Oxford. These included: Theobaldus Stampensis in 1117 and possibly as early as 1094; Robert Pullen, a pupil of John of Salisbury, in 1133; and Geoffrey of Monmouth, who was resident at Oxford between 1129 and 1151.[74] 'The earliest specific evidence for the existence of several faculties and a large concourse of masters and students at Oxford derives from the account of Gerald of Wales *c.* 1185 of the reading of his *Topographia Hibernica* before the assembled scholars, a feat which occupied three days. In *c.* 1190 Oxford is described as a *studium commune* by a Freisland student then studying [in the town] . . . This is reinforced by the known presence in Oxford, towards the end of the century, of a number of celebrated scholars, including Daniel of Morley and Alexander Nequam.'[75] Basically, Oxford was modelled on the Paris system (i.e., led by masters, not students), but it never attracted an international cache of students like Paris did. In organisational terms a distinction was made between northerners (*boreales*) and southerners (*australes*, south of the river Nene in what is now Cambridgeshire).[76]

Whereas Bologna's main speciality was law and in Paris it was logic and theology, so Oxford became known for its expertise in mathematics and the natural sciences.[77] As was mentioned briefly earlier on, this was due in no small part to a number of itinerant Englishmen in the twelfth century who had travelled widely to familiarise themselves with scientific data, revealed through the great translations in Toledo, Salerno and Sicily. Oxford was also the beneficiary of the papal ban on the teaching of the New Aristotle imposed at Paris in the early thirteenth century.

Robert Grosseteste is now seen as the key figure in the Oxford scientific movement (he made the study of Aristotle required reading). Bishop of Lincoln from 1235 to 1253, he was also an early chancellor of the university.[78] Grosseteste's translations (he knew Greek, Hebrew and French) and his assimilation of the new Aristotelian material led to two advances, both of which had a seminal influence on the growth of science in the Middle Ages. These were, first, the application of mathematics to the natural sciences as a means of description and explanation; and second, a stress upon observation and experiment as the essential method of testing a given hypothesis. 'These principles transformed the study of scientific data from a fairly random exercise to an integrated mathematical inquiry into physical phenomena based upon the tripartite cycle of observation, hypothesis and experimental verification.'[79]

He was followed by Roger Bacon, who runs him close as the first scientist in the sense that we now use that term. Having studied under Grosseteste at Oxford, Bacon lectured at Paris, where he was every bit as contentious as Abelard before him. He was convinced that, someday, scientific knowledge would give humanity mastery over nature and he forecast submarines, automobiles and airplanes (together with devices for walking on

water). Like Grosseteste he thought that mathematics was the hidden language of nature and that light, optics, then called 'perspective', would give access to the mind of the Creator (he thought that rays travelled in straight lines and had a finite, but very fast, speed). Bacon's thinking was a definite step forward, between the religious mind and the modern scientific way of thinking.

Between the early fourteenth century and 1500 the number of universities grew from about fifteen or twenty to about seventy, though Germany and Spain lagged behind elsewhere.[80] Most of the fifteenth-century universities were founded as secular institutions, by municipalities, and were only confirmed by the papacy. They included Treviso (1318), Grenoble (1339), Pavia (1381), Orange (1365), Prague (1347–1348), Valence (1452) and Nantes (1461). This multiplication enabled far more students to attend a local establishment, which in turn helped confirm the secular nature of the newer universities. Many of the fifteenth-century French *studia* – among them Aix (1409), Dôle (1422), Poitiers (1431) and Bourges (1464) – escaped ecclesiastical interference from the beginning, as was the case in Germany, Bohemia and the Low Countries. Vienna (1365), Heidelberg (1385) and Leipzig (1409) were founded by local rulers, whereas Cologne (1388) and Rostock (1419) were sponsored by town authorities. In the main, the northern universities were organised on Parisian lines, as a masters' university, whereas the southern European establishments were modelled on the Bolognese pattern, as a students' university.[81]

Medieval universities had no formal entrance requirements. A prospective student simply had to demonstrate a proficiency in Latin sufficient to understand the lectures. (He was also expected to converse in Latin while inside the university precinct.) There was no obligation to sit a written examination for a degree, but the student was assessed at every point in his academic career. 'Wastage was higher than today and universities felt no responsibility to shepherd someone to a dubious degree.'[82] Apart from attending lectures (obligatory, in the mornings, with no distractions), a student was also required to attend the public disputations which each master delivered once a week in the afternoon. These disputations fell into two types: *de problemate*, which comprised logical matters; and *de quaestione*, which related to mathematics, natural sciences, metaphysics and other areas of *quadrivium* study. Advanced students had to contribute to the magisterial disputations as a requirement of their degree. Even if many of the undergraduates were too young to make much of a contribution to the formal disputations, their very presence at these firework displays helped them transcend the rigid straitjacket of their hitherto 'authority-dominated' education. The most liberating of these occasions were the disputations *de quolibet*.[83] At these times, any proposition, regardless of authority, could be argued and any question, ecclesiastical or political, and however controversial, could be considered. They were open to everyone.[84]

Parallel with the rise of the universities, another major change was overtaking Europe, less coherent, less specific, less sensitive in either religious or political terms, but ultimately just as practical and certainly no less profound. This was the rise of quantification. In the half-century between, say, 1275 and 1325, a whole raft of innovations were made right across the board in Europe that totally changed man's habits and the way he thought about

the world. According to Alfred W. Crosby, 'there was nothing quite like this half century again until the turn of the twentieth century, when the radio, radioactivity, Einstein, Picasso, and Schönberg swept Europe into a similar revolution'.[85] During this narrow isthmus of time, and everywhere one turned, life was becoming more quantified and quanti*fiable*. Some historians see in this a major change, which propelled Europe to advance over China, India and the Islamic world.

Until this point, space and time had been vague. For historical and religious reasons that were 'obvious' to Europeans, Jerusalem was the centre of the world, which was divided into four kingdoms derived from a passage in the book of Daniel. Time was still not universally understood as divided into BC and AD. Some preferred a threefold division – the Creation to the Ten Commandments, the Commandments to the Incarnation and the Incarnation to the Second Coming.[86] It was widely understood that salvation was impossible for those who had lived before Jesus – which is why, in *The Divine Comedy*, Dante places Homer, Socrates and Plato in Limbo, rather than in Purgatory or Paradise. Although 'hours' existed, the medieval day was in practice divided into seven canonical 'hours' – matins, prime, tierce, sext, none (from which the English word 'noon' derives), vespers and compline, when prayers were to be said.[87] Everything below the heavens was made of the four elements and was changeable. But the heavens were perfect, formed a perfect sphere about the earth and were made of the fifth and perfect element, 'which was changeless, stainless, noble, and entirely superior to the four elements with which humans were in contact'.[88] This idea is reflected in our modern English word *quintessence*.

Number itself was an approximate notion in the Middle Ages. Recipes for making such things as glass, or the metal parts of organs, rarely included precise numbers – instead phrases such as 'a bit more' or 'a medium-sized piece' were accepted as sufficient. A large group of buildings, such as in the city of Paris, were described as like 'the stalks in a field'. Roman numerals were still in use, making arithmetic difficult and they were not always written as we understand them: MCCLXVII might be: x.cc.l.xvij. It was the practice to end large numbers with a 'j' so that additions could not be fraudulently introduced. Cardinal and ordinal numbers would be represented thus: $v^o$ and $v^m$.[89] In finger reckoning beyond ten, someone pointed to the joints of his or her fingers for multiples of ten, and for very large numbers – for instance, 50,000 – one pointed one's thumb at one's navel. 'Complaints were made that the higher numbers required "the gesticulations of dancers".'[90]

But, and this is the main point, at the end of the thirteenth century society in Europe changed from one where ideas mainly concerned *qualitative* perception to *quantitative* in all aspects. This may have had something to do with population changes – the West's population at least doubled between 1000 and 1340. Either way, there was introduced what Jacques le Goff has called 'an atmosphere of calculation' into European life.[91] This too had a great deal to do with the rediscovery of Aristotle. Alfred Crosby draws attention to Peter Lombard's standard textbook of theology, *Summa sententiarum*, written in the mid-1100s, which had only three quotations from secular philosophers, amid thousands from the Church Fathers, whereas Thomas Aquinas, in his *Summa theologiae*, written between 1266 and 1274, had 3,500 quotes from Aristotle alone, 1,500 of them from works unknown in the West a hundred years before.[92]

It was now, for instance, that literacy surged, partly stimulating and partly caused by

changes in writing (the stabilisation of word order – subject–verb–object – was also achieved). The best-known example of this is the change between Innocent III (1198–1216) who dispatched at most a few thousand letters a year, and Boniface VIII (1294–1303) who wrote as many as 50,000. M. T. Clanchy reports the extraordinary detail that, on average, England's royal chancery in the 1220s used 3.63 pounds of wax per week for sealing documents, but that this had risen to 31.9 pounds per week in the late 1260s. At that stage there were few or no divisions between words, sentences or paragraphs (the Romans had abandoned word separation). In general, this meant that reading was difficult and conducted aloud. It was only in the early fourteenth century that the new cursive writing (see above, pages 249–250) was combined with word separation, punctuation, chapter headings, running headlines, cross references and other devices we now take for granted (plus some that we don't, like a half-circle, ⊃, to indicate that a word was continued on the next line). Around 1200 Stephen Langton (a future archbishop of Canterbury) devised the chapter and verse system for the books of the Bible, which until then were almost entirely undifferentiated. Libraries had traditionally been organised along religious lines – the Bible came first, then the Church Fathers, with the secular books on the liberal arts last. But beyond this broad agreement the actual order of many texts was arbitrary and unreliable, and so it was now that the scholars introduced alphabetisation. Everyone understood it and the order implied no doctrinal significance.[93] In the same way scholars also introduced the analytic table of contents. Each of these innovations changed the experience of reading, in particular from reading aloud to reading in silence. In 1412 Oxford and in 1431 Angers introduced the regulation that libraries were to be quiet places – hitherto they had been anything but. In the same way, book learning displaced the emulation of charismatic figures as the central feature of education. This was extremely important, in that reading became a private and therefore a potentially heretical act (especially important in fifteenth-century England). There is also evidence that the privacy provided by silent reading led to an increase in erotica.[94]

The first clocks in towns had no faces or hands but were just bells. ('Clock' is related to the French *cloche* and the German *Glocke*, which mean 'bell'.) Bell clocks were very popular from the start. A petition for a city clock at Lyons read: 'If such a clock were to be made, more merchants would come to the fairs, the citizens would be very consoled, cheerful and happy and would live a more orderly life, and the town would gain in decoration.'[95] Many towns, even small ones, agreed to tax themselves so that they could have a clock. The mechanical clock was probably invented in the 1270s (the same decade as spectacles), and Dante refers to clocks in *Paradiso*, written about 1320. Although China had clocks before Europe, it was the West's enthusiasm for equal hours that changed perceptions of time – equal hours were in general usage in Germany in the 1330s.[96] Jean Froissart, historian of the Hundred Years War, began his chronicle using canonical hours, but shifted to equal hours in the course of his narrative. It was not long before the town clock determined when the working day should start and end.

The discovery of perspective (considered later in more detail in Chapter 19, on ideas about beauty), and its relation to mathematics, was another aspect of the quantification of life that took place about this time. We see the first hints of it in Giotto (1266/7 or 1276–1337), then with Taddeo Gaddi (d. 1366) and it was firmly in place by the time of Piero

della Francesca (1410/1420–1492). Each of these discoveries and applications complemented one another, so much so that Nicholas of Cusa (1401–1464) was moved to remark 'God is absolute precision itself.'[97] This form of thinking would result in the work of Nicholas Copernicus (1473–1543), which helped start the scientific revolution and made space both much bigger *and* yet more precise.

Al-Khwarizmi's book on Hindu numerals, and algebra, was translated into Latin by Robert of Chester in the twelfth century and from then on the influence of the new numerals began to grow (the last mathematics textbook to use Roman numerals was written in 1514).[98] There was, however, a curious cross-over period when people in Europe used both systems. One writer wrote the year as MCCCC94, that is, two years after Columbus discovered America, while Dirk Bouts dated his altarpiece at Louvain as MCCCC4XVII, which probably means 1447. The operational signs for arithmetic came later. In the last half of the fifteenth century Italians and others were still using P̄ for 'plus' and M̄ for 'minus'. The familiar 'plus' and 'minus' signs, + and −, appeared in print in Germany in 1489. Their origins, Alfred Crosby says, are obscure: 'Perhaps they sprang from the simple marks that warehousemen chalked on bales and boxes to indicate they were over or under weight.'[99] In 1542, Robert Recorde in England announced that 'thys figure +, whiche betokeneth to muche, as this lyne, − plaine without a crosse lyne, betokeneth to little'. And it appears to be Recorde who, in the sixteenth century, invented the 'equals' sign, =, to avoid repetition of the words 'is equal to' and because 'noe 2 thynges can be moare equalle'.[100] The × sign for multiplication was not settled for centuries: to begin with in medieval manuscripts it had as many as eleven different meanings. Fractions were a function of trade and, in the Middle Ages, could be very complicated, such as $\frac{197}{280}$ and, in one case, $\frac{3345312}{4320864}$. Decimals existed in embryo but the system was not finally completed for another three hundred years (see Chapter 23).

With the arrival of Hindu-Arabic numerals, algebra was at last capable of development. In the early thirteenth century Leonardo Fibonacci used a letter in place of a number, but never developed this idea. His contemporary, Jordanus Nemorarius, used letters as symbols for known and unknown quantities but he had no signs for plus or minus, or multiplication. It was the French algebraists in the sixteenth century who fully codified this system. Francis Vieta used vowels for unknowns and consonants for knowns, and then, in the seventeenth century, Descartes introduced the modern system, $a$ and $b$ and their neighbours at the beginning of the alphabet for knowns, and x and y and their neighbours at the end of the alphabet for unknowns.[101]

Alongside these changes in writing and mathematics ran parallel developments in music notation. Gregorian chant, the most famous form of medieval church music, is characteristically nonmensural: the structure of its musical line is determined by the flow of the Latin words. However, by, roughly speaking, the tenth century the number of different chants had grown so much that no one person could remember them all and a system was needed to record them. To begin with they produced what one scholar has called 'pneumatic notation' – a system of marks to indicate breathing, when the voice should rise in pitch (an acute accent, ´), or drop (grave, `), or rise and fall (circumflex, ^). This was improved when the monks lightly traced one and then two or more horizontal

lines across the page to make the high and low notes easier to recognise – this was the beginning of the staff or stave. The staff is traditionally credited to the Benedictine choirmaster, Guido of Arezzo, who, whether or not he invented it, certainly standardised it. He famously remarked, about his fellow choristers, 'we often seem not to praise God but to struggle among ourselves'.[102] With the new methods Guido said he could produce a good singer in two years rather than in ten. It was Guido who noticed that in the familiar hymn *Ut queant laxis*, sung for the feast of John the Baptist, the tones rose as in the staff:

> *Ut* queant laxis *Re*sonare fibris
> *Mi*ra gestorum *Fa*muli tuorum
> *Sol*ve polluti *La*bii reatum
> Sancte Iohannes*

The Italic notes above, *ut, re, mi, fa, sol* and *la*, became the basis of the elementary methods of teaching notes that all children now learn, with *do* replacing *ut* later on, possibly because the *t* of *ut* was unsingable.[104]

The basics of Gregorian chant were the tenor voices (from the Latin *tenere*, to hold), which formed the *cantus firmus* (firm song) or, as we might say, the basic drone. From the late ninth century, other – higher – voices began to break away, though at first they kept in parallel. Later still, they broke away more dramatically and this formed the basis of Western polyphonic music, which also appears to have been the first music to have been specifically composed, written down, in note form, rather than evolved through trial and error with voices. This occurred most of all in Paris, where the profession of musician first emerged. Music was part of the *quadrivium*, one of the advanced mathematical arts in which all advanced scholars were trained in the Middle Ages. Perotin, of the Notre Dame school, introduced rests (a concept possibly derived from the zero), while Franco of Cologne codified the notation system, determining time values for all notes and rests. He outlined four single-note signs in music notation – the double long, the long, the breve and the semibreve, which were exact multiples of each other. The basic unit was a *tempus*, defined as 'the interval in which the smallest pitch or smallest note is fully presented or can be presented'.[105] The new music – polyphonic music, written down, offering far more control over fine detail – became known as *ars nova*, compared with *ars antiqua*. Not everyone liked the new music, including – perhaps inevitably – the pope. In *Docta sanctorum patrum*, the first papal proclamation dealing with music, he raged against polyphony, which was forbidden in churches.[106]

The final important element in the growth of quantification was the introduction of double-entry book-keeping and its associated techniques. A continuous record of the books belonging to Francesco di Marco Datini, a merchant of Prato, from 1366 to 1410, shows that Hindu-Arabic numerals began to appear about 1366 and that until 1383 the accounts were kept in narrative form. After that date, however, the practice changed and assets and liabilities began to be kept in parallel columns either on the same page, or on

---

* 'Holy John, remove the sin from our unclean lips so that we, thy servants, can give free expression to our innermost feelings and praise thy wondrous actions.'[103]

facing pages. From then on it was immediately obvious, as it had not been obvious before, whether a business was in profit or loss.[107] In Tuscany, the technique was known as *alla veneziana*, in the Venetian manner, suggesting it was in use there earlier. Balancing the books has since become a sacred ceremony of our age but it was an important innovation for the age of discovery, which enabled men to keep control over their enterprises as businesses ventured thousands of miles around the world.

The spread of quantification, no less than the spread of learning, was amplified and accelerated by the invention of printing. In the thirteenth century the majority of students could not afford to buy copies of the texts they studied, at least not without great sacrifice, because of high manuscript price levels. Consequently, the student was very dependent on the reading and expounding of the texts in the university schools. The situation was eased in the later thirteenth century by the growth of cheaper, utilitarian methods of manuscript production, encouraged and then closely controlled by the universities.[108] The system was based on the multiple copying of *exemplars*, which were accurate copies of the texts and commentaries used in teaching. Each *exemplar* was divided into separate pieces or *peciae*, usually of four folios each (eight pages), and relating to different portions of the text. Several copyists could therefore work on the same *exemplar*, each reproducing a different *pecia*. The system enabled students to buy or hire relatively cheap copies of that particular section. The freer circulation of texts relieved the student of his reliance on the lecturer's every word, lessened the strain on his memory, and permitted study in a more relaxed and private environment.[109]

Before the introduction of paper, vellum books were expensive but not that expensive. Claims by some modern scholars that as many as a thousand animal skins were needed for each book are wide of the mark. If the average area of a skin was about half a square metre, it would make, roughly, twelve to fifteen pages of 24 × 16 cm, meaning that ten to twelve skins were needed for a 150-page book. It was still a lot. As the appetite for reading grew, as the universities became more popular, and more populous, so the demand for books rose and, as edition sizes increased, vellum or parchment books became less and less practicable.[110] In each university town a guild of scriveners or stationers was formed, which joined the scribes or copyists and the booksellers together and they often became quasi-official adjuncts to the university, with the right to be tried by university courts (this was partly to do with the fact that the university authorities insisted on inspecting texts for doctrinal accuracy).[111] The system was fairly efficient – more than two thousand copies of Aristotle's works have come down to us from the thirteenth and fourteenth centuries. It also suggests that a new reading public emerged in the thirteenth century.

Paper was in widespread use, at least in Italy, by the fourteenth century. Papermaking factories were generally upstream from towns, because the water was cleaner, and it was now that rag-and-bone men became familiar (it was a lucrative trade) and when even old rope became valuable (hence the phrase 'money for old rope'). Papermakers' guilds were formed from the turn of the fifteenth century and they too, like scriveners and booksellers, had a close association with the universities.[112]

The 'discovery' of printing in the West depended on three innovations: movable type cast in metal; a fat-based ink; the press. Among the precursors we may mention the

goldsmiths, who knew how to make stamps which were used to ornament the leather covers of books; pewter makers, who had die stamps, and thirteenth-century metal founders, who knew how to use punches engraved in relief to produce clay moulds from whose hollow matrices they made the relief inscriptions on crests.[113] And of course the production of coins had used dies struck by a hammer. The principles of printing were there for everyone to see.

With this as background, we may move on to the famous lawsuit which took place in Strasbourg in 1439. The somewhat enigmatic documents which have survived indicate that a certain Johann Gensfleisch, also known as Gutenberg, a goldsmith, had entered into a partnership with three others, Hans Riff, Andreas Dritzehn and Andreas Heilmann, whereby he was perfecting a number of secret processes and they were supporting him financially. The lawsuit arose after Dritzehn died and his heirs wanted to take his place. These secret processes included the polishing of precious stones, the manufacture of mirrors and a new art which involved the use of a press, some 'pieces' or *Stücke*, either separate or cast together, some forms made of lead, and finally 'things related to the action of the press'. Gutenberg was not the only one experimenting with printing. Another goldsmith, Procopius Waldvogel of Prague, entered into an agreement with the citizens of Avignon in the mid-1440s to construct some 'iron forms . . . pertinent to writing'. This too is enigmatic and the first undisputed mention of printing is found in the Cologne Chronicle of 1499, where the writer says he has been in touch with one Ulrich Zell, the first printer in Cologne, who was in touch with Schoeffer, one of Gutenberg's partners. He wrote: 'The noble art of printing was first invented at Mainz in Germany. It came to us in the Year of Our Lord 1440 and from then until 1450 the art and all that is connected with it was being continually improved . . . Although the art was discovered in Mainz, as we have said, the first trials were carried out in Holland in a Donatus printed there before that time. The commencement of the art dates from these books; actually it is now much more authoritative and delicate than it was in its first manner.' This controversy, as to whether Holland or Mainz was the site of the first printing, has never been satisfactorily resolved.[114] But Mainz was without question the cradle of the first printing industry.

Gutenberg appears to have returned to Mainz from Strasbourg in the late 1440s, where he teamed up with Johann Fust, a rich citizen who was his new backer, and Peter Schoeffer, an erstwhile student at the University of Paris who may have been a copyist before he turned printer. All seems to have gone well until 1455, when Fust and Gutenberg fell out and there was another lawsuit. Gutenberg lost, had to repay the interest on his loan, and what remained of the capital, and Fust and Schoeffer went on without him. On 14 October 1457, the first printed book that can be dated came from the new press. This was the so-called Mainz Psalter, the first product of a business that was to flourish for more than a hundred years. Lucien Febvre judges that the Psalter was of such a quality that it cannot have been the first attempt, and it is now more or less agreed among historians that other presses were in operation between 1450 and 1455 producing many books on a commercial scale – grammars, calendars, Missals, the famous 42-line and 36-line three-volume Bibles.[115] Gutenberg later got into debt but after that he was ennobled by the archbishop elector of Mainz, for personal services – so perhaps he installed a printing press. There was no uniformity in letter formation and none was agreed until the eighteenth century

in the French Enlightenment, when a standard measure, 'the point', was adopted. This was $\frac{1}{144}$ the size of the king's foot and is still in use today.[116]

At the time printing came in, four types of script were popular. These were 'black letter' gothic, favoured by scholars, a larger gothic, less rounded with more straight uprights, a 'bastard gothic', used in luxury books, and 'littera antique', the roman script used by the humanists. Inspired by the Carolingian miniscule, this was made fashionable by Petrarch. It was also associated with a cursive script, the *Cancelleresca*, based on the handwriting popular in the Vatican Chancellery – which was the origin of *italic*. Roman script was also made popular by Petrarch, who was an enthusiastic calligrapher; he and others wanted to give to classical texts – many newly discovered – a physical appearance closer to their original look.[117] But the triumph of roman and italic had a great deal to do with the famous Venetian printer Aldus Manutius. He had roman type, and italic, cut in 1501 by Francesco Griffo after a *cancelleria* script, which dramatically shortened the space which text occupied. These Venetian types were quickly adopted in Germany and France and soon became standard. For a while the universities continued to stick with gothic but in the vernacular literatures roman was preferred. From the middle of the sixteenth century, however, roman encroached more and more on the scholars' domain. Aldus also introduced pagination, though that didn't become customary until the second quarter of the sixteenth century.

With printing, books ceased to be precious objects. In owning books, readers wanted to be able to carry texts with them on journeys, and so they were produced in smaller and smaller sizes. Quarto books (folded once, to provide four pages) and octavo (folded twice, to produce eight) *were* printed from the beginning but again it was Aldus who, anxious to ease the reading of classical authors, launched his famous 'portable' collection, a format which was widely taken up by others. By the sixteenth century, therefore, the book business was divided into ponderous learned tomes intended for libraries and smaller literary or polemical works designed for the general public.[118]

It was in the nature of publishing that daring books would sell better because of the scandals they caused, with the result that the early publishers often sheltered writers suspected of heresy. Since they were the first people to read new manuscripts, publishers naturally kept abreast of fresh ideas and frequently were the first to be convinced by new arguments. In this way, printers were among the first converts to Protestantism. But they were also the most vulnerable to victimisation – they had the plant, and their names were on the title-pages of their books. It was only too easy for the Inquisition to argue that the easiest way to root out heresy was to close down the presses that were disseminating these ideas. As a result, in the early sixteenth century many printers were forced to flee France in particular to avoid spies, informers and censors. Augereau was just one publisher burned at the stake. Étienne Dolet was the best-known 'martyr of the book', a writer-turned-bookseller-and-printer, who worked for Gryphe as well as writing his own books and carrying on a dispute with Erasmus. But in 1542 he published several suspect religious works and when the authorities, alarmed, searched his premises they found a copy of a book by Calvin. Dolet was burned at the stake in August 1544, along with his books.

To begin with, in the early days of printing, authors were not paid by publishers. They received several free copies of their works and would send them to rich patrons, with

elaborate dedications, in the hope of receiving payment in that way. As often as not this worked and 'as few authors starved as later'. Some authors were forced to agree with their publishers to buy so many copies of their own books, as did the author Serianus who in 1572 bought 186 copies (out of an edition of 300) of his *Commentarii in Levitici Librum*.[119] By the end of the sixteenth, and certainly by the start of the seventeenth century, however, the modern practice had been introduced, of authors selling their manuscripts to publishers. As reading became more common, and more and more copies of books were sold, advances went up and by the seventeenth century they could be considerable (reaching, in France for example, tens of thousands of francs).[120] Copyright was introduced around the middle of the seventeenth century, beginning in England.[121] Edition sizes were small by modern standards – as few as a hundred copies in some cases. Bibles might be issued in editions of 930, or 1,000, but these were very large edition sizes and publishers who risked this often got into financial difficulties.[122] As technology improved, however, the cost of producing books dropped and it became safer to publish more copies – by the latter half of the sixteenth century edition sizes of 2,000 and more were common. Nicholas Clénard's Greek grammar of 1564 and his edition of the *Corpus Iuris Civilis*, published in 1566–1567, were both released in edition sizes of 2,500. Some Bibles in Holland reached 3,000–4,000 copies.[123]

The absence of a copyright law in the early years meant that pirated editions of many books were widely available. When attempts were made to stop the practice, with action by kings or parliaments, who tried to close down pirate publishers, this succeeded only in driving the pirate business underground. It was made worse by the attempts, from the fifteenth to the eighteenth centuries, to censor books. As early as 1475 the University of Cologne received a licence from the pope to censor printers, publishers and even readers of condemned books.[124] Many bishops tried to exercise the same power. In 1501 Pope Alexander VI published his bull *Inter multiplices*, which forbade the printing of any book in Germany without the permission of the ecclesiastical powers. At the Lateran Council of 1515 this power was extended to all Christendom and came under the Holy Office and the Inquisitor General. Censorship, of course, only makes the censored books *more* attractive, at least to some people, and in the course of the sixteenth century there was a rapid increase in the number of banned books and it became necessary to institute the *Index Librorum Prohibitorum*, which had to be continually updated. The first list of forbidden books for the entire Catholic church was issued in 1559 by Pope Paul IV and, though it was taken seriously, it soon became clear that in many areas (such as Florence, not so very far from Rome) if it were implemented in full it would destroy the newly-flourishing book trade. As a result, in many places it was never enforced in more than a token way. For example, the Inquisition's delegate in Florence agreed that books needed by lawyers, physicians and philosophers should be exempt.[125] The French tried a different system: each book published needed a licence from the king in advance. This too drove publishing underground as most publishers flouted the law and 'banned' books continued to circulate more or less everywhere with ease.[126]

There is no question but that printing caught on very quickly, which tends to confirm that pre-print books were far from unknown among many people. It has been calculated that

no fewer than 20 million books were printed *before* 1500.[127] Although to begin with the market was chiefly among universities and other academically-minded souls, books soon reached out to the general public. An entirely new literature grew up to reflect and encourage popular piety – the cult of the Virgin, for example, was still extremely popular and works celebrating the life and virtues of the Mother of God were very popular, as were works on the saints. Coinciding with the growth of humanism (see the next chapter), printing helped promote a new interest in antiquity. There was also an enormous increase in the number of grammars available, and in the chivalric romances of the earlier Middle Ages. But science and mathematics evoked great interest too, especially the scientists and mathematicians of antiquity. Astrology and travel were also popular.

The arrival of printing, therefore, did not so much change the shape of the culture as make it far more readily available to many more people (as was to be expected). The further changes it brought about had more to do with, for example, standards of accuracy (in setting up type for the classics, scholars wanted to use the best examples available), in the propagation of the Reformation (considered in Chapter 22) and in the triumph of humanism. Printing made far more people familiar with classical – i.e., pagan – authors, and far more aware of purely literary and stylistic qualities (as opposed to doctrinal matters), contributing further to the secularisation of life. To become a *homo trilinguis*, to know Greek, Latin and Hebrew, was the aim of many humanists and here printing helped.[128] But by no means everyone was trilingual and another effect of the printed book was that, in stimulating a taste among the general public for the classics, it also stimulated a taste for the classics *translated into the vernacular.* These translations often played a more vital role than the originals in the diffusion of ideas and knowledge.[129] In the same vein, the vernacular translations also promoted an interest in national languages, a process that began in Italy but went furthest in France where, in 1539, the Ordonnances of Villers-Cotterêts made French the official language in the courts of justice. Latin as the international language did not finally die until the seventeenth century and by then national literatures were well on the way to splitting the book market.

A final impact of printing was on spelling, which now became fixed, corresponding less and less to pronunciation. In other words, spelling paid more respect to the etymology of words.[130] This too was reinforced by the development of national languages. It became noticeable that, after 1530, Latin began to lose ground. For example, in Paris, out of the 88 titles produced in 1501 only 8 were in French; but by 1530, when 456 titles were published, 121 were in the vernacular, a rise from 9 per cent to 26 per cent. This is not surprising – many readers were bourgeois merchants, newly prosperous, who had no ambitions to be *homo trilinguis*, but the process was further accelerated in some countries by the Reformation, with its anti-Rome bias, and championing of local cultures. Luther, with the aid of the press, played a decisive role in the evolution of the German language.

And of course, eventually, the Bible – not to mention the Book of Common Prayer – was printed in the vernacular languages, making the scriptures accessible as they had never been before. We shall be discussing the consequences of this throughout the rest of the book, but for now we may say that, by and large, printing *fixed* the vernacular languages. It was thanks to the process of translation that many languages had been enriched by foreign words and expressions, but now spelling and usage were stabilised. Printers

deliberately introduced uniformity into the language, as these examples, taken from a translation of Ariosto, show:

| Manuscript | Printed text |
| --- | --- |
| bee | be |
| on | one |
| greef | grief |
| thease | these |
| noorse | nurse |
| servaunt | servant[131] |

The death of Latin was slow. Descartes wrote the *Discours de la Méthode* in French but his correspondence was usually in Latin. It was still imperative to write in Latin if one wanted to address a European audience. Latin did not finally succumb until the seventeenth century, after which French became the language of science, philosophy and diplomacy, when every educated European had to know French and when books in French were sold all over Europe.[132]

Printing thus began the destruction of the unified Latin culture of Europe, the culture that had helped propel Europe ahead of India, China and the Arab world, and it also marked the origins of a culture belonging to the masses. It was a change of seismic proportions. But it would take centuries before these lineaments became visible.

# 18

# *The Arrival of the Secular:*
# *Capitalism, Humanism, Individualism*

Jan van Eyck's double portrait known as *The Arnolfini Marriage* painted in 1434, is deservedly celebrated as a magnificent example of early Renaissance Flemish art. It shows the Italian merchant Giovanni Arnolfini and his new bride Giovanna Cenami, standing in a room of their house, tenderly holding hands. With fine brushwork and subtle lighting effects, the picture cleverly captures the pious, serene and yet slightly self-satisfied expressions of the bourgeois newly-weds – it is a striking psychological study. Yet it is also something else entirely. The painting invites the viewer to concentrate on the extraordinary range of possessions with which the newly-weds are blessed. There is the Oriental rug on the floor, woven in small, intricate lozenges; there is the high-backed chair, covered in cloth and embellished with carved pommels; there is the red-canopied bed, the convex Venetian mirror, its ornate frame inset with miniature enamels showing scenes from Christ's passion – all this beneath a shiny brass chandelier twisted into intricate floral patterns. Both figures are dressed lavishly, too, with fur-lined sleeves and hems to their tunics, and with complicated stitching and folding in Giovanna's headdress. Finally, on the floor lies a pair of wooden pattens, a form of thick-soled clog which shows that the Arnolfinis could afford to rise above the mud of the city streets. As the historian Lisa Jardine has remarked, this is not just a record of a pair of individuals – it is a celebration of ownership. 'We are expected to take an interest in all this profusion of detail as a guarantee of the importance of the sitter, not as a record of a particular Flemish interior ... The composition is a tribute to the mental landscape of the successful merchant – his urge to have and to hold.'[1]

The painting is highly relevant to the theme of this chapter because while the Renaissance is probably the single most familiar period of history, few aspects of the past have undergone such a profound reassessment in the last generations as the idea that there was a 'Renaissance' of thought and culture between 1350 and 1600. Beginning in the nineteenth century, and thanks mainly to the Swiss historian Jacob Burckhardt, in his book *The Civilisation of the Renaissance in Italy* (1860), a view evolved that the Renaissance was 'of transcendent importance' in the development of the modern world, that, after the stagnation of the Middle Ages, a 'cultural springtime' spread over Europe associated with a new appreciation of classical literature and a remarkable surge of brilliance in the visual arts. While some of this is undoubtedly true, what is no less true is that the Renaissance is

now understood far more as an economic revolution as a cultural one.[2]

On reflection, this ought not to be surprising in view of the fact that the Renaissance was itself the result of some important developments, many of which were economic in character. The last three chapters have shown that, probably from the tenth, and certainly from the eleventh century on, major changes were afoot in Europe – in religion, in psychology, in the growth of towns, in agriculture, and in the spread of learning. There were new forms of architecture, the pagan world of science, medicine and philosophy had been rediscovered and major innovations had occurred in time-keeping, mathematics, in reading, in music and in art, where perspective had been discovered. In no sense could the High Middle Ages be called a period of stagnation. Beginning with the Harvard historian Charles Haskins in the 1920s, scholars began to talk about the *twelfth-century* renaissance, a concept that is now widely accepted.[3]

In some quarters, there is now a scepticism towards 'mega' periods in history. This is regarded as a nineteenth-century 'triumphalist' version of the past, in which the Renaissance is pitched against the Middle Ages. It is also the case that, as twentieth-century historians such as Erwin Panofsky have pointed out, there have been several other 'renascences': the Carolingian renaissance, the Ottonian, the Anglo-Saxon and the Celto-Germanic. So it was not only the Italians of the fourteenth and fifteenth century who rediscovered classical antiquity. However, it is still true to say that, despite these reservations, the Italians – more than anyone else – recognised what was happening. Even Panofsky conceded that the Italian Renaissance was a 'mutation', a decisive and irreversible step forward, rather than an 'evolution'.[4]

Various factors – mainly technological and economic – appear to have combined to help create what we might call the Renaissance proper. Technologically, these were: the arrival of the magnetic compass from China, which made possible a number of exceptional off-shore navigational feats that opened the globe to European exploration; gunpowder – which also arrived from China and, as was alluded to earlier, contributed to the overthrow of the old feudal order and helped the rise of nationalism; the mechanical clock, which transformed man's relationship to time and in particular work, freeing the structure of human activity from the rhythms of nature; and the printing press, which accounted for a quantum jump in the spread of learning, and moreover eroding the monopoly on it once held by the church. In addition, silent reading promoted solitary reflection that helped in an insidious way to free individuals from the more traditional forms of thinking, *and from the collective control of thinking*, helping to fuel subversion, heresy, originality and individuality.

A great deal of ink has been spilled over the impact of the great plague, the Black Death, on the Renaissance. For example, in the fourteenth century, as a result of the plague, many areas of the countryside were short of people. This had the effect of forcing many landlords to give in to peasant demands and the resulting improvement in living standards has been born out by archaeological discoveries which have demonstrated a shift at this time from earthenware to metal cooking pots.[5] The plague seems to have had two main effects on the church, and on religious life. The very great number of deaths made people pessimistic and drove them inwards, towards a more private faith. Many more private chapels and charities were founded in the wake of the plague than hitherto, and there was a rise in mysticism. There was also a new focus on the body of Christ: whereas Lateran IV had

stipulated that Catholics should take communion at least once a year, the faithful now sought to partake as often as they could.[6] At the same time, of course, many people went in the opposite direction, psychologically speaking, and started to doubt the existence of a providential God. The second main effect of the plague was on the structure of the church itself: some 40 per cent of priests had been carried off and in many cases very young clergy were appointed to replace those who had died. These young priests were much less well-educated than their predecessors and this reinforced the fact that the church's authority in the area of learning was much reduced. Catholic schooling collapsed in many areas. Any link between the Black Death and the Renaissance is thus tenuous and the specific evidence goes both ways. Yes, the less well-educated clergy may have contributed to a lessening of clerical authority, but the greater piety in the wake of the plague is the very opposite of what we see in the Renaissance. Perhaps the best that can be said is that, in helping to destroy the old feudal system, which was already waning, the Black Death delivered the *coup de grâce*, allowing a new system to flourish.

More convincing are the explanations for why the Renaissance originated and went furthest in Italy. This had a great deal to do with the small size of the Italian city-states. They had retained their independence largely because of the long-running battles between the papacy and the Holy Roman Empire. In addition, Italy's geography – one-fifth mountainous and three-fifths hilly, a long, thin peninsula with a very long coastline – discouraged agriculture and encouraged commerce, seafaring, trade and industry. Together, this political and geographical set-up promoted the growth of towns: by 1300 Italy had twenty-three cities with a population of 20,000 or more. A relatively urban population, with a large measure of independence, together with its trading position, between northern Europe and the Middle East, meant that Italy's merchants were better educated than most and in a better position to profit from the changes taking place.

We saw in an earlier chapter that the twelfth-century renaissance was associated with a change in schooling – from monastic schools to cathedral schools, and a change in teaching, from solitary charismatic masters with pupils on a one-to-one basis, to much larger classrooms and book-learning. Likewise, in Renaissance Italy there was a further change which, says Paul Grendler in his study of *Schooling in Renaissance Italy*, cannot be overestimated. 'The extraordinary political, social, economic and even linguistic diversity [in Italy] – diversiveness would be a better term – threatened to pull the peninsula apart at any moment. But schooling united Italians and played a major role in creating the Renaissance. Humanistic pedagogues developed a new educational path very different from education in the rest of Europe in the early fifteenth century. Thereafter, Italy's elite of rulers, professionals, and humanists shared the language of classical Latin. They shared a common rhetoric. And they drew from the same storehouse of moral attitudes and life examples learned in school. The humanistic curriculum unified the Renaissance, making it a coherent cultural and historical epoch of great achievement.'[7]

Behind Renaissance education, says Grendler, lay the optimistic presupposition that the world was susceptible to understanding and control. By the mid-1300s, when the medieval church schooling system collapsed, there emerged in Italy three types of school. These were the Communal Latin School, run by the municipality, independent schools (or private schools, as we would say), and abbaco schools, for training merchant and business

skills. According to figures Grendler quotes for Venice, some 89 per cent of students attended independent schools, compared with 4 per cent who went to communal schools. He says that 33 per cent of boys of school age had a rudimentary literacy, 12 per cent of girls, and that overall about 23 per cent of the inhabitants of Venice were literate by 1587.[8] Venice, he says, was not atypical.

In the fifteenth century the humanists changed the curriculum. Out went the verse grammars and glossaries, the morality poems and the *ars dictaminis*. Instead, they substituted grammar, rhetoric, poetry and history based on recently recovered classical authors and, above all, they introduced the letters of Cicero 'as the Latin prose model'. Most of the schoolmasters were humanists and, by 1450, says Grendler, schools in a majority of northern and central Italian cities taught the *studia humanitatis*.[9] Education focused on learning to read, on eloquent letter-writing, on poetry, and history, 'a new subject not found in the medieval curriculum'. Grendler rejects the criticism that the study of Latin stifled originality and made students docile. The very fact of the Renaissance, he says, disproves this. Instead, he says that the majority of students 'loved Latin and the civilisation it unlocked'. This, he argues, is what helps explain the Renaissance, and he likens the learning of Latin then to the learning of music and athletics today. Young people so love what they do, and what lies at the end of their exertions, that those exertions are not felt as such: people are fascinated by the skill and know how important its mastery is for what lies ahead. Above all, the education was secular and that, of course, had a big effect on the outlook of countless graduates of the system, whether they were artists, civil servants or businessmen.

The abbaco schools took their name from the *Liber abbaco* written in the early thirteenth century by Leonardo Fibonacci, the son of a Pisan governmental official sent to direct the Pisan trading colony at Bougie, Algeria, where he encountered Hindu-Arabic numerals and other aspects of Arabic mathematics (see also Chapter 12). Fibonacci never had much effect on mathematical theory in the universities but he was a big influence on Italian Renaissance business. Boys studied abbaco for about two years at the mid-point of their other schooling. Niccolò Machiavelli, for example, enrolled in an abbaco school at the age of ten years and eight months and stayed for twenty-two months. Almost all boys who enrolled in these schools were between eleven and fourteen at the time. Sometimes the communes hired masters to teach abbaco, sometimes they were independent.[10] The importance of these skills are shown by the fact that even Leon Battista Alberti, in *Della famiglia*, recommends that children study abbaco. 'Students should then return to the "poets, orators and philosophers".'[11] Abbaco consisted of basic arithmetic, finger-reckoning, accounting, calculating interest, memorising multiplication tables, some geometry and, the heart of the system, study of up to two hundred mathematical problems of business – weights and measures, currency conversion, problems of division when there is a partnership, loans and interest, and double-entry book-keeping. The abbaco books – especially the section on merchant problems – acted as reference works after schooling was over: when a merchant couldn't solve a problem, he looked through the abbaco until he found something roughly comparable. These books also taught good business practice – how to tie up in a bundle all the paperwork of a particular financial year, how to keep a record of disputes, how to anticipate inheritance problems and so on. There was no reference to the 'just price'.[12]

Once again, we shouldn't make more of these schools than is there, but nor should we overlook the fact that this was the first time any civilisation had routinely and systematically trained its children, or adolescents, in good business practice. The explosion of imagination, for which the Renaissance is chiefly known, was not based only on commercial prosperity, but numeracy and business skills *were* regarded as an integral element in the education of Italian children in the fourteenth, fifteenth and sixteenth centuries, and their contribution ought not to be overlooked or minimised.

Among the Italian city-states, Florence stood out. At about 95,000 souls, its population was around half that of Milan, Venice or Paris, and much the same as Genoa and Naples.[13] Some way from the sea, Florence had no harbour but by the late fifteenth century it mixed the craft-related services of Milan or Venice with banking. There were, says Peter Burke, 270 cloth-making workshops, eighty-four for wood-carving and inlay, eighty-three for silk, seventy-four for goldsmiths and fifty-four for stone-dressers. The city's many new palaces had modern plumbing, as can be seen from contemporary accounts which are full of references for wells, cisterns, cesspools and latrines. The streets were already properly paved and kept clean by sewers that drained into the Arno.[14] All of which reflected the fact that between the twelfth and the fourteenth centuries, the economy of Florence grew to dimensions which were paralleled nowhere else. This was based on three foundations: trade in textiles, the textile industry itself, and banking. Italy in general and Florence in particular was home to a commercial revolution in which trade, and international trade at that, was the basis of everything else.[15] As an example, in the mid-fourteenth century, the Bardi family had agents in Seville, Majorca, Barcelona, Marseilles, Nice, Avignon, Paris, Lyons, Bruges, Cyprus, Constantinople and Jerusalem. The Datini family conducted transactions with two hundred cities from Edinburgh to Beirut.[16] Robert Lopez says that no other economic upheaval has had such an impact upon the world, 'with the possible exception of the Industrial Revolution of the eighteenth century ... It is no exaggeration to say that Italy played the same part in this first great capitalist transformation as England did in the second, four hundred years later.'[17]

Although there were some technological advances, such as the invention of the caravel and the mobile foresail, the commercial revolution was mainly one of organisation. 'A primitive striving after profit was replaced by expediency, calculation and rational, long-term planning.'[18] Money of account developed around the same time as double-entry book-keeping and maritime insurance was born in the Tuscan cities where international commerce flourished. This caused freight tariffs to become more complex, which in turn increased paperwork. The archives of the Datini family at Prato include more than 500 account books and 120,000 letters, dating from 1382 to 1410. This represents an average of 4,285 letters a year, just under twelve a day. 'Writing became the basis of all activity.'[19]

Does all this mark the birth of capitalism? Yes, in the sense that there was the steady accumulation of capital, an increased use of credit, the separation of management from the ownership of capital and the labour force. Yes, too, in the sense that there were deliberate attempts to expand the market through larger-scale operations. Yes, too, in the self-conscious way the young were educated in the skills for trade. But it was of course on a much smaller scale than today.[20]

But perhaps the most visible sign of capitalism was the success of the other main Florentine activity – banking. This was an economic revolution in itself. The late thirteenth and fourteenth centuries saw the rise of the great banking families – the Acciaiuoli, Amieri, Bardi, Penizzi and Scali – with networks of subsidiaries that were established by 1350 in all the principal trade centres: Bruges, Paris (twenty houses in 1292), and in London (fourteen). Most modern operations had already been introduced: currency exchange, deposit-taking, book transfers, credit for interest, overdrafts. Demand came from a relatively small group of European super-rich princes, whose passion for conspicuous consumption generated a huge demand for luxury goods – cloth, above all – and for banking services.[21] Richard Goldthwaite says that this small group of aristocratic houses may be regarded as the creators of the Renaissance.[22]

As commerce occupied more and more people, wealth became for the first time the main basis of class distinction, rather than birth. Merchants and even shopkeepers, if they were rich enough, were often knighted, whereupon, as often as not, they aped the old aristocracy by building palaces and buying country estates. It was this intermingling of the old aristocracy and the upper bourgeoisie, says Peter Burke, that produced a melding of values and qualities, 'the military courage of the noble and the economic calculation of the bourgeois'. Out of this came a new spirit of enterprise, 'part war-like, part-mercantile, first manifesting itself in maritime trade'. Eventually, this settled to the quieter, less adventurous form of inland trade, but it was the buccaneering spirit that first sparked the great commercial revolution.[23]

This marriage of aristocrat and bourgeois also sparked a new urban elite – highly literate, educated and rational, which embodied a new order, as typified by double-entry book-keeping, the mechanical clock, and the widespread use of Hindu-Arabic numerals. But this was still an artisan society. Intellectual activity remained functional, related to specific vocational and professional purposes, and directed to meeting social needs in a secular world.[24] Psychologically, this produced an emerging cult of *virtù*, the man who set himself above all religious traditions and relied upon himself – a not entirely accidental parallel with the Greek concept of the hero.[25] For individuals, aware that they had to rely on their own strengths, conscious of the superiority of rationality over tradition, and that time- and money-management were the key, life took on a faster pace. Clocks in Italy now struck twenty-four hours a day.

While all this explains why Florence was so full of new wealth, it does not tell us why such wealth brought about such a great cultural explosion. Peter Hall, an expert on cities, puts it down to the fact that (as was true of classical Athens, and was also to be true of nineteenth-century Vienna) 'the wealth-makers and the intellectual figures came from the same families'. Thus the aristocracy were not only patrons of art and learning, but were intimately involved. 'Nearly every prominent family included a lawyer and cleric, many a humanist scholar ... Cosimo de' Medici was a banker, statesman, scholar, a friend and patron of humanists (Bruni, Niccoli, Marsuppini, Poggio), of artists (Donatello, Brunelleschi, Michelozzo) and learned clerics (Ambrogio Traversari, Pope Nicholas V).' It was this which caused the pattern of artistic patronage to change and widen. Out of two thousand or so dated paintings from Italy produced between 1420 and 1539, Peter Burke has shown that 87 per cent are religious in subject matter, about half of which are of the

Virgin Mary and one-quarter show Christ (the rest show saints). At the same time change was in the air. The first sign was that commissions for ecclesiastical works of art came less from the church authorities themselves and instead either from the great guilds or spiritual fraternities, or from private patrons.[26] It was the newly-rich citizens, and not the clerics, who now chose the leading artists and discussed with them the details of the plans for, say, a dome or an entire church.

The second change came when secular patronage turned from the ecclesiastical to the public buildings of the cities as sites for commissions. For example, several important figures of fourteenth-century art – Giotto, Duccio and Ambrogio Lorenzetti – spent the bulk of their careers in government service. Associated with this change was a move to introduce new secular themes, in particular the principal innovation of *trecento* art, which was the establishment of narrative.[27]

A third change came in the status of art and the artist. To begin with, in the early Renaissance, art was still a craft, as it had been in Athens. A painting was a utilitarian object, commissioned for a particular altar, a sculpture for a specific niche. But the more intense demand which existed in fourteenth- and fifteenth-century Italy suggested to the artisan craftsmen that they develop new ideas and, above all, demonstrate their familiarity with new knowledge – perspective, anatomy, optics, classical art, even theory. 'There was now and henceforth a market for art, first for church and convent complexes, then, about the middle of the fourteenth century, for one's own house.'[28] Artists might in effect tout for commissions, but the patron could have considerable impact on the finished work. Contracts became in every sense business documents – they specified materials, price, delivery, size, the work of assistants and the details to be included (cherubs and lapis lazuli cost extra). A contract might specify that the master himself should execute the work; one, of 1485 between Giovanni d'Agnolo dei' Bardi and Botticelli for an altarpiece, specifies so much for colours and so much for his brush ('*pel suo pennello*'). Another, of 1445, for Piero della Francesca's *Madonna della Misericordia*, specifies in italics that 'no painter may put his hand to the brush other than Piero himself'.[29] Giotto was perhaps the first example: very successful in his business life, he seems to have combined the highest artistic skills with an acute commercial brain – by 1314 he had as many as six notaries looking after his interests.[30]

In line with this, artists began to put their own stamp on their works. Donor's families began to appear in paintings, and so too the artist, as Benozzo Gozzoli did, in his *Procession of the Magi* (1459), and Botticelli in his *Adoration of the Magi* (c. 1472–1475). 'By the fifteenth century a marked change in the social position of the artist was evident; Ghiberti and Brunelleschi both held important administrative posts in Florence, the latter even being a member of the Signoria.' Public respect for artists had increased immeasurably; by the sixteenth century, when the adjective 'divine' was applied to Michelangelo, it could amount almost to adulation. For art historian Arnold Hauser, 'The fundamentally new element in the renaissance conception of art is the discovery of the concept of genius; it was a concept unknown and indeed inconceivable in the medieval world-view, which recognised no value in intellectual originality and spontaneity, recommended imitation, considered plagiarism quite permissible, and disregarded intellectual competition. The idea of the genius was of course the logical result

of the new cult of the individual, triumphing in free competition in a free market.'[31]

Associated with this shift in sensibility went architectural change. Some time after 1450 architects began to elaborate the façades of individual residences to mark their difference from each other and from the medieval buildings nearby. Residences began to acquire ever more impressive principal entrances. Shops were removed, so that the rest of the world could see just how big a residence was. From about 1450 too, interiors followed suit and it became the fashion to buy objects for their artistic qualities, not just because they were useful, and this included art works of earlier times. Such collecting implied, of course, knowledge about art, and the history of art. '*Gentilezza*, or refinement, became a constant theme, expressed in the goods Italians bought – tableware, musical instruments, works of art.'[32]

And so the rise of the haute bourgeoisie and the rise of the artist went hand-in-hand. The church and the monarchy were no longer the sole – or even the main – sources of patronage for the arts. Art collecting was still confined to a minority but it was a vastly wider activity than it had been before. Towards the end of the fifteenth century prices began to rise for art works and after 1480, when artists began to be given titles of nobility, painters and sculptors could aspire to affluence, like Raphael and Baldassare Peruzzi.[33]

The other significant change in the Renaissance, according to Hans Baron, and this was over and above the concept of genius, was the abandonment of the medieval notion of renunciation. 'The monk no longer monopolised virtue.' Now the ideal was Aristotle, a man who concluded that he needed '*la casa, la possessione, et la bottega*'. The Florentines, like the Greeks before them, believed in achievement and saw life as a race. It was no longer the case, as Thomas Aquinas had argued, that everyone 'had a fixed station in life'.[34] 'The habit of calculation was central to Italian urban life'; numeracy was widespread; time was precious and had to be 'spent' carefully, through rational planning; thrift and calculation were the rule. 'The whole trend of humanist speculation in Florence in the early fifteenth century was toward accommodation with the here-below, and a rejection, implied and sometimes explicit, of the abnegation hitherto officially associated with religion.'[35] The result was many different views of the world, which may well have stimulated intellectual innovation.

The new humanism, which we shall come to presently, essentially provided an alternative to the divine order, setting up in its stead a rational order based upon practical experience. 'It was as if the world were one great mathematical entity with abstract, interchangeable, measurable and above all impersonal quantities.'[36] Virtue was therefore personal, obtained through individual endeavour and unrelated to the advantages of birth or estate, still less to supernatural powers. It was classical antiquity that provided the grounding for this approach and outside the church scholasticism was largely abandoned.[37] This retreat by the church was in large measure replaced by the state. Jacob Burckhardt in his famous study noted that 'in the Italian city, for the first time, we see the emergence of the state as a calculated, conscious creation, the state as a work of art'.[38]

In her study *Before European Hegemony: The World System A.D. 1250–1350*, the New York scholar Janet Abu-Lughod argues that, in the thirteenth century, 'a variety of protocapitalist

systems coexisted in various parts of the world, none with sufficient power to outstrip the others.'[39] She goes on to say that the advent of bubonic plague, in the fourteenth century, was one of the factors which affected adversely the Far Eastern trading networks disproportionately more than the European ones, and helped account for the rise of the West (these arguments were introduced in Chapter 15). Plague may well have played its part, and a vital part at that, but this purely economic analysis neglects the role of psychological and intellectual changes which also began in Italy, in Florence, in the fourteenth century. This was the rise of humanism and the acceleration of individualism.

The first figure in Renaissance humanism is Petrarch (1304–1374). It was Petrarch's achievement to be the first person to recognise the 'dark ages', that the thousand years more or less before he lived had been a period of decline, since the grandeur of ancient Rome and, before that, classical Greece. Petrarch's poem on Scipio Africanus, in looking back, also forecast a turning point in history.

> Poterunt discussis forte tenebris
> Ad puram priscumque iubar remeare nepotes
> Tunc Elicona noua reuitentem stripe iudebis
> Tunc lauros frondere sacras; tunc alta resurgent
> Ingenia atque animi dociles, quibus ardour honesti
> Pyeridum studii ueterem geminabit amorem.

'Then perhaps, with the darkness dispersed, our descendants will be able to return to the pure and ancient light. Then you will see Helicon green again with new growth, then the sacred laurel will flourish; then great talents will rise again, and receptive spirits whose ardour for the honest study of the Muses will duplicate the ancient love.'[40]

Petrarch was himself fortunate, of course, in living at a time when the efforts of the medieval schoolmen had borne fruit, in that, over the immediately preceding centuries, the ancient classics had gradually been recovered and translated. But Petrarch looked on these classics with a totally new eye. The scholars of the High Middle Ages, culminating in Thomas Aquinas, had concentrated, as we have seen, on the works of Aristotle and had attempted to integrate them with the Christian message. Petrarch's innovation was twofold. Instead of being concerned with Aristotle's science and logic, and with the Christian implications of the new learning, he responded to ancient poetry, history, philosophy and the rest *on their own terms*, as the 'radiant examples' of an earlier civilisation, which should be understood in that way. Europe, he felt, had simply forgotten this earlier period of greatness and he set about trying to understand its imaginative powers on its own terms. 'Thus,' says Richard Tarnas, 'Petrarch began the re-education of Europe.'[41]

In the world in which he lived, even Petrarch believed that Christianity was the divine fulfilment of all thought. But he added the idea that life and thought were not unidimensional, that the classical world was worth studying because it was the highest form of life available before Christ appeared on earth. In encouraging his fellow men to look back, Petrarch thus stimulated a further renewed search for the lost texts of antiquity. Here the West was fortunate in that this coincided with a period of change in Constantinople. Because of the threat of Turkish invasion (the city was to fall in 1453), many scholars

started to leave and head for the West, Italy in particular, bringing with them, among many other things, the Greek *Dialogues* of Plato, the *Enneads* of Plotinus and other texts in the Platonic tradition. And this was Petrarch's second contribution, to stimulate a *Platonic* revival reminiscent of the Aristotelian revival in the twelfth century. In fact, although Petrarch was always fascinated by Plato, at the time he lived in the fourteenth century the new manuscripts had not yet arrived in the West. It was not until the early part of the fifteenth century that the original Greek works actually appeared (very few people in the West knew Greek before 1450). It was then left to other humanists – men such as Marsilio Ficino and Pico della Mirandola – to build on Petrarch and introduce these ideas to their contemporaries.

Whereas Aristotelianism had been conducive to the scholastic mind, Platonism provided the humanists with a way of looking at the world that suited the change they were trying to bring about. The essential idea of Platonism was that the human mind is the image and likeness of God, the 'deiformity of knowledge', in William Kerrigan and Gordon Braden's clever phrase. More important still was 'The notion that beauty was an essential component in the search for the ultimate reality, that imagination and vision were more significant in that quest than logic and dogma, that man could attain a direct knowledge of things divine – such ideas held much attraction for the new sensibility growing in Europe.'[42] On top of everything, Plato's fluid style was far more attractive than Aristotle's mere notes, on which the twelfth-century revival had been based, and this too helped fashion the new sensibility. Many people believed that Aristotle's account of Plato was highly inaccurate. Coluccio Salutati and Niccolò Niccoli both believed that Plato was superior to Aristotle, that Socrates' eloquence was *the* ideal to be sought after, while Leonardo Bruni's books celebrating humanism and the stylistic splendours of Socrates, Plato and Cicero became a best-seller: 250 vellum copies of his manuscript survive today.[43] Hans Baron called Bruni's *Dialogi ad Petrum Paulum Histrum* the 'birth-certificate of a new period'.[44]

It was also the case that, by now, getting on for two hundred years after Aquinas, scholasticism was ossifying, becoming stultified and rigid in the universities, as scholars fought over the minutiae of what he and the other medieval masters had really meant. It was no accident therefore that when a Platonic academy was founded just outside Florence in the second half of the fifteenth century, it met not in the university but under the private patronage of Cosimo de' Medici, and was led by Marsilio Ficino, the son of a physician. It was here, in a very informal setting, that the traditional view of learning was transformed. Great banquets were given on Plato's birthday and a lit candle always illuminated his bust.[45] Ficino eventually translated the entire Platonic corpus into Latin.[46]

In Platonism, or Neoplatonism, the humanists recognised an ancient spiritual stream just as old as, and in many ways not dissimilar to, Christianity itself. In turn this threw a new light on the faith. Christianity might still be the final form of God's purpose for the world, but the very existence of Platonism implied that it was not the only expression of this deeper truth. In this vein, the humanists did not stop at Greek literature. The academy in Florence (actually at Careggi, outside the city) promoted the study of all intellectual, spiritual and imaginative writing, wherever it was found – in Egyptian and Mesopotamian texts, in Zoroastrianism, in the Hebrew Kabbalah. The point was, under Neoplatonism, which included the ideas of Plotinus as well as Plato, the whole world was permeated by

divinity, everything was touched by a 'numinous' quality, nature was in effect enchanted and God's purpose could, with care, be deciphered, his message being revealed through number, geometry, form – above all, through beauty. Platonism taught an *aesthetic* under-standing of the world, which helps explain both the efflorescence of art in the Renaissance *and* the improved status of artists. Marsilio Ficino wrote a book entitled *Platonic Theology* in which he argued that man was of 'almost the same genius as the Author of the heavens'.[47]

And because Platonism valued aesthetics above most things, imagination now came to be exalted above the Aristotelian virtues of close observation and, as we would say, research. Metaphysical truth, revealed by God to men of genius – through number, geometry, intuition – was assumed to offer greater access to ultimate knowledge. As part of this, astrology returned, along with horoscopes and the zodiac – and their mystical numerology. The old Graeco-Roman gods did not quite have the dignity of the Judaeo-Christian God, but classical mythology had a new lease of life and respect, understood sympathetically as the religious truth of those who had lived before the Incarnation. People even looked forward to a new golden age in which the religion of the future would be a mix of Christianity and Plato.[48]

Behind this, the importance of the accumulation of wealth should not be under-estimated. In the words of one historian, 'The man of the renaissance lived, as it were, between two worlds ... He was suspended between faith and knowledge. As the grip of medieval supernaturalism began to loosen, secular and human interests became more prominent. The facts of individual experience here on earth became more interesting than the shadowy afterlife. Reliance on God and faith weakened. The present world became an end in itself instead of a preparation for a world to come.'[49] The accumulation of wealth clearly assisted this change, a change which the same historian also highlights as one of the three great changes in sensibility in history, 'the other two being the arrival of ethical monotheism, around 600 BC ... and the change wrought by Darwin in the mid-nineteenth century'. On this reading, the Renaissance is understood as three interlinked developments which together comprise this new sensibility. These three elements are humanism, capi-talism and the aesthetic movement, the cult of beauty which led to the greatest proliferation of the arts the world has yet seen. Capitalism, now understood as a form of self-expression no less than of economics, could not have matured without the humanists' ideas about the primacy of 'this world', and the proliferation of the arts would not have been possible without the great fortunes amassed by the early capitalists.

Humanism was less concerned with the rediscovery of the sciences of the ancients than with re-establishing a pagan set of values, in effect the secular outlook of the Greeks and the Romans, in which man was the measure of all things. This attitude, as Petrarch was the first to realise, had been lost for about a thousand years, as Christians took heed of the warnings of Augustine against becoming 'too engrossed' in earthly interests, lest one's entry into the New Jerusalem be threatened (the City of Man rather than the City of God).[50] But the ancients had been more interested in a happy and fruitful life, right here on earth, than with the eternal destiny of their souls, and classical philosophy, for example, was more about how to live successfully now, than in the afterlife. The humanists took this on board. Here, for example, is Erasmus: 'Whatsoever is pious and conduces to good manners ought not to be called profane. The first place must be given to the authority of

the Scriptures; but, nevertheless, I sometimes find some things said or written by the ancients, nay, even by the heathens, nay, by the poets themselves, so chastely, so holily, and so divinely, that I cannot persuade myself but that, when they wrote them, they were divinely inspired ... To confess freely among friends, I can't read Cicero on Old Age, on Friendship ... without kissing the book.'[51] Erasmus had certain of his characters argue that such titles as St Socrates or St Cicero were not blasphemous.

Central to the humanist ideal was the notion that there was, in fact, a new aristocracy in Italy, which was aesthetic and educational, rather than based on inherited privilege, land or even money. It stemmed from cultural appreciation and achievement in the arts and learning, and it valued above all self-expression. The Renaissance was possibly the time above all when aesthetic theory was at its height (though Ernst Cassirer argued that the eighteenth century was even more conscious of this aspect of experience – see Chapter 29). Poetry and art were conceived as holding the secrets to the harmony of the world. This is considered in more detail in Chapter 19.

In the High Middle Ages, the intellectual revolution had shown, among other things, that the ancient authorities disagreed among themselves, and that moreover these authorities had often lived full lives without the benefit of the scriptures. At the same time, life had been communally organised – in congregations, guilds, universities. After the changes introduced by the clock, gunpowder, the plague and so on, and with growing wealth, individualism began to extend beyond the 'academic' world of cathedral and university. In addition, the old Middle Ages experience – of the clergy always being the better educated – also broke down as a result of the decimation of the church by the Black Death. When the introduction of printed books and silent reading was added in, the spread of individualism was more or less complete. Individualism plus wealth, whether it helped create capitalism or was itself a product *of* early capitalism, were jointly the first elements in what we would now call the modern way of life. In their different ways, Dante, Petrarch, Machiavelli and Montaigne wrote about intellectual freedom, individual expression, very often spiced with a scepticism towards the Christian message.[52] After the invention of printing, the rise of vernacular literatures provoked diversity at the expense of uniformity. It was this constellation of beliefs that gave Renaissance thought its character.

In Renaissance philosophy, Pietro Pompanazzi (1462–*c.* 1525) was typical. He concluded that Aristotelianism could not prove the independent existence of the soul and though he did not deny the soul's immortality, he thought that the question was insoluble and that, therefore, a system of ethics based on rewards and punishments after death was meaningless. Instead, he thought we should construct a system that related to *this* life. 'The reward of virtue is virtue itself,' he said, 'while the punishment of the vicious is vice.' The religious authorities looked on Pompanazzi with disfavour and he only escaped the stake because of his great friendship with Cardinal Pietro Bembo (1470–1547) who was himself an admirer of pagan/classical thought. But Pompanazzi's books *were* burned.

Nevertheless, his philosophy shows how views were beginning to change and that change included a growth in scepticism of a sort. Erasmus, Peter Ramus (1515–1572), Michel de Montaigne (1533–1592), Pierre Charron (1541–1603), Francisco Sánchez (1562–1632) and Blaise Pascal (1623–1662) could all be called sceptics; though none of them were

sceptics in the way that Hume or Voltaire would become sceptics, all objected to the pedantry of the schoolmen, the dogmatism of the theologians and the superstitions of mystics. Erasmus remarked that it made him 'angry and weary' to read Duns Scotus.[53] (This scepticism, the 'third force' in seventeenth-century thought, to use Richard Popkins' phrase, is considered more fully in Chapter 25.)

A great linguist and scholar, a fine Latin stylist, and a much-travelled sceptic, Erasmus was the most famous of the humanists, just as Aquinas was the most famous scholastic and Voltaire the most famous rationalist.[54] Born in Holland about 1466, his mind dominated intellectual Europe for a generation. One of his friends once said, 'I am pointed out in public as the man who has received a letter from Erasmus.'[55] His mother and father both died when he was in his early teens and his guardian sent him to a monastery. This might have been a dead-end, but in 1492 he became a priest and moved to the court of the bishop of Cambrai and then on to his goal, the University of Paris. This was a great disappointment, however, for once there Erasmus found the great institution much diminished and the verbal wrangles of the scholastics dry and rigid, preoccupied with sterile detail, harking back to the arguments of Duns Scotus, William of Ockham and Aquinas. The mind of the once-great university had withered.[56]

If Paris was a formative influence on Erasmus in a negative sense, the visit he made to England in 1499, where he met Thomas More, William Grocyn, Thomas Linacre, John Colet and other English humanists, changed his life fundamentally for the better. To Erasmus these pious and even ascetic men nevertheless seemed the perfect combination of classical scholars and devout Christians. These were generous souls, he felt, in honest pursuit of the truth, unblemished by the petty squabbles and arid self-defences of the Paris schoolmen. In the house of Sir Thomas More, he glimpsed what he came to realise should be his life's work – the reconciliation of Christianity with the classics. Not the classics as understood by Aquinas, of course, which had mainly been the Aristotelian canon, but the newer discoveries, which treated Plato as central. For Erasmus, Plato, Cicero and the others were a revelation. 'When I read certain passages of these great men,' he wrote, 'I can hardly refrain from saying, St Socrates, pray for me.'[57] This feeling was so strong that when he returned from England, and though he was already thirty-four, he set about learning Greek, so he could read his beloved classics in the original. It took him three years. Now began the most frantic time of his life as he translated and edited the works of antiquity. By 1500 he had formed a collection of eight hundred or so *Adages*, sayings and epithets from the Latin classics, which went into several popular editions. He didn't turn his back on Christianity, however, and still found time to produce his own translation of the Bible (Greek on one page, Latin on the facing page), together with editions of the Church Fathers.

In 1509 Henry VII of England died. Erasmus' friends wrote to him and urged him to come to England in the hope of finding advancement under Henry VIII. Then in Italy, Erasmus set out for England straight away, and while he was crossing the Alps he conceived the idea for what was to become his most famous work, *The Praise of Folly*. This satire on monkish life was written in a week, while he stayed again at the house of Sir Thomas More. As a form of acknowledgment Erasmus entitled the work *Moriae Encomium*. Published in 1511, it was an instant success, and was translated into many languages. For a later edition,

in 1517, Hans Holbein the Younger, then eighteen, added a set of drawings in the margins, making this surely one of the most beautiful, interesting and valuable books of all time. It also inspired a whole genre of satiric works, including those by Rabelais. The 'humour' of this book seems pretty heavy-handed to us today, as Erasmus lays into the sloth and stupidity and greed of the monks, but in the spirit of the times he seems to have judged his tone just right, in that his readers could laugh along with him without seriously questioning their beliefs. The fool had been a familiar figure in medieval stories and dramas and it was this genre that Erasmus evoked. As Petrarch had provided two messages – aesthetics and Plato – so Erasmus had two messages: that the classics were a noble and honourable source of knowledge and pleasure, and that the church was increasingly empty, pompous and intolerant.[58]

Tolerance, in particular religious tolerance, was a particular aspect of humanism with long-term consequences and here the names of Crotus Rubianus, Ulrich von Hutten and Michel de Montaigne shine through. *Letters of Obscure Men*, by Rubianus and von Hutten, is often called the most devastating satire before Swift. Its origins were complex. A German Jew, Johann Pfefferkorn, had converted to Christianity. Like many converts, he had become wildly fanatical in his new belief and proposed that Jews who had not seen the light as he had should be forced to attend Christian churches and be forbidden from lending money at interest. He also wanted all Jewish books save for the Old Testament to be burned. Because of who he was, or had been, Pfefferkorn's views were taken seriously and the opinions of many German clerics and scholars were canvassed. One of them, John Reuchlin, after considering the subject, concluded that, on the contrary, Jewish literature was to be praised, by and large, though he did concede that certain mystical works be discarded. And so, instead of approving Pfefferkorn's ideas, he took the opposite stance and went on to suggest that a chair of Hebrew should be established in all universities 'in order that Gentiles might become better acquainted with, and therefore more tolerant of, Jewish literature'.[59] Anti-Semites everywhere were enraged by this but Reuchlin received letters of support from many of his distinguished friends, some of which he published under the title *Letters of Eminent Men*. It was this that suggested to Rubianus and von Hutten a satire on the persecutors of Reuchlin. Published in 1515, *Letters of Obscure Men* purported to be a collection of missives written by lesser priests and ignorant churchmen to a real person, Ortuin Gratius, a leading German Dominican who at that time epitomised the bigotry and pedantry of the scholastics. Part of the point of the *Letters* was its coarseness and absurdity (the drunken churchmen ask whether it is a mortal sin to salute a Jew, when the chick in the egg becomes meat and is therefore forbidden on Fridays), but it was a major assault on scholastic pedantry, which never afterwards regained its former prestige.[60]

The other main achievement/effect of humanism was in education. So complete was its triumph that the language and literature of pagan antiquity became the basis of the curriculum, a position of pre-eminence which still exists in many places. This classical curriculum was first adopted in the Italian universities, from where it spread to Paris, Heidelberg, Leipzig, Oxford and Cambridge. The humanistic curriculum was introduced to Cambridge by Erasmus himself and to the universities of Germany by men such as Agricola, Reuchlin and Melanchthon. Erasmus advocated humanistic education all over Europe and he was enthusiastically supported in England by Thomas More and Roger

Ascham and in France by Le Fèvre d'Étaples and Guillaume Budé. Under the influence of the humanists the universities became more tolerant of science, in particular mathematics. Medicine also spread, as we shall see in a later chapter.

In 1517, the year Hans Holbein the Younger added his illustrations to *The Praise of Folly*, Martin Luther nailed his Ninety-Five Theses on indulgences to the door of Wittenberg church. Erasmus shared many of Luther's misgivings about the church but temperamentally the two men were very different. In early 1517, months before Luther took decisive action, he had written as follows about Erasmus: 'Human considerations prevail with him much more than the divine.' For a humanist, it was a back-handed compliment.

Unlike Luther, Erasmus knew that to push criticism of the church too far would only result in intransigence on both sides, a stand-off that would allow no movement and might actually *prevent* the sort of change they both wanted to see. The following exchange of letters between the two men sums up their differences and goes to the root of what humanism tried to achieve. 'Greeting,' Luther wrote. 'Often as I converse with you and you with me, Erasmus, our glory and our hope, we do not yet know one another. Is that not extraordinary? . . . For who is there whose innermost parts Erasmus has not penetrated, whom Erasmus does not teach, in whom Erasmus does not reign? . . . Wherefore, dear Erasmus, learn, if it please you, to know this little brother in Christ also; he is assuredly your very zealous friend, though he otherwise deserves, on account of his ignorance, only to be buried in a corner, unknown even to your sun and climate.' Erasmus's reply was tactful but crystal clear. 'Dearest brother in Christ, your epistle showing the keenness of your mind and breathing a Christian spirit, was most pleasant to me. I cannot tell you what a commotion your books are raising here [at Louvain]. These men cannot be by any means disabused of the suspicion that your works are written by an aide and that I am, as they call it, the standard-bearer of your party . . . I have testified to them that you are entirely unknown to me, that I have not read your books and neither approve nor disapprove anything . . . I try to keep neutral, so as to help the revival of learning as much as I can. And it seems to me that more is accomplished by civil modesty than by impetuosity.'[61]

After Luther was excommunicated in 1520, Albrecht Dürer appealed to Erasmus to take the side of Luther, but he wrote back that he had not the strength for martyrdom and that if 'tumult' should arise, 'I should imitate Peter.'

But, despite his moderation, Erasmus couldn't entirely escape the fight. Catholic bigots accused him of laying the eggs 'which Luther and Zwingli hatched' and *The Praise of Folly* was placed on the Index of Prohibited Books, while Erasmus himself was condemned by the Council of Trent as 'an impious heretic'. In other words, he was welcome in neither camp. This was perhaps inevitable but it was no less tragic for all that. Erasmus had lived, or tried to live, the ideal life of a humanist, as someone who believed in the life of the mind, that virtue could be based on humanity, that tolerance was as virtuous as fanatical certitude, that thoughtful men could become good men and that those who were familiar with the works of all ages could live more happily and, yes, more justly, in their own time.

In an earlier chapter we saw how the rise of Latin scholarship had helped unify Europe. The Reformation, considered in a later chapter, had strong nationalistic elements – for example, Luther was undeniably German and Henry VIII implacably English. There were

scholars who came after Erasmus who were no less cosmopolitan than he (Lipsius, Grotius) but, in a sense, he was the last truly European figure.

Giorgio Vasari (1511–1574) thought that the Florentine Renaissance was due to a change in human nature. He thought that rivalry, envy, the search for glory and fame had helped propel change in the city, that life now moved faster in the bourgeois world of merchant and banker. Nowadays, we are more apt to see these feelings and ways of behaving as symptoms of the change, rather than causes. Nevertheless, the new sensibility does need to be explored.

It was in Florence for instance that our modern idea of the artist as a genius and bohemian, operating by his own rules, was first aired. It arose out of an adaptation of ancient medicine. At that time, the four temperaments as identified by Hippocrates (choleric, sanguine, phlegmatic and melancholic) were still in use, though added to them was a system of 'correspondences'. For example, the sanguine temperament, believed to be explained by the preponderance of blood, made men quiet, happy, disposed to love and was associated with Venus and the spring. Melancholics, explained by the preponderance of black bile (hence 'melan'-'cholic'), were associated with Saturn and autumn. But Aristotle had suggested that all great men were melancholics and the humanist Marsilio Ficino built on this, adding in Plato's notion of inspiration as divinely inspired frenzy (*furor*). This picture, of the artist as a moody genius, proved enduring.[62]

But the greatest psychological change in the Renaissance, first drawn attention to by Jacob Burckhardt but added to by others since then, was the rise in individuality. Peter Burke says there are three aspects to this: a rise in self-consciousness, a growth of competitiveness (linked to capitalism?) and an increased interest in the uniqueness of people. The increase in self-portraits, autobiographies and diaries – greater even than in the period between 1050 and 1200 – was one aspect, as was the innovation of 'how to do it' books, such as Machiavelli's *Prince*, Castiglione's *Courtier* and Aretino's *Ragionamenti*, where the emphasis, as often as not, is on technique and on choice, meaning that individuals could select from alternatives whichever suited their character, pocket, or whim.[63] At much the same time, flat, non-distorting mirrors were first produced in bulk in fifteenth-century Italy (in Venice, mainly) and these too are held to have been important in promoting self-consciousness. A carnival song about mirrors in sixteenth-century Florence highlights this aspect. Translated into plain text it reads: 'A man's own defects can be perceived in the glass, defects which are not easy to see like those of others. So a man can take his own measure and say, "I will be a better man than I have been".'[64] Then there was Castiglione's idea of *sprezzatura*, nonchalance, that everything should be calculated to look natural – and this too was an aspect of self-consciousness, a reflection that individual style matters.[65]

Burckhardt further argued that the modern sense of fame was born in the Renaissance, though other scholars have dismissed this, arguing that the chivalry of knights in the Middle Ages embodied the same psychology. Peter Burke, however, finds that in the literature of the Renaissance words that imply self-assertiveness, competition and a desire for fame were very common – for example, emulation, competition, glory, rivalry, envy, honour, shame and, above all, valour or worth (*valore, virtù*).[66] Burckhardt himself noted the new use of *singolare* and *unico* as terms of praise, and Vasari, for instance, had this to

say: 'Rivalry and competition, by which a man seeks by great works to conquer and overcome those more distinguished than himself in order to acquire honour and glory, is a praiseworthy thing.'[67] The cult of fame is generally regarded as one of the most important products of humanism. 'The study of antiquity brought fresh contact with a generally pagan concept of personal glory – "*famam extendere factis, / hoc uirtutis opus*" (to broaden fame with actions, this is the task of virtue; *Aeneid* 10.468–9) – and the sheer survival of the classical records of such achievement gave force to the possibility that contemporary efforts might similarly endure.'[68] There was a sense of 'vertigo' associated with individualism, say William Kerrigan and Gordon Braden, and they quote Machiavelli: 'I am entirely convinced of this: that it is better to be impetuous than cautious, because fortune is a woman, and it is necessary, if one wishes to hold her down, to beat her and fight with her.'[69]

Linked to all this, there was a stress on achievement rather than on birth, which was another marked change from medieval times, where the values of 'blood' had been paramount. This was related to the idea that man was a rational, calculating animal. In Italian the word for 'reason', *ragione*, was used in a variety of ways, but all implied calculation. Merchants called their account-books *libri della ragione*. The Palace of Reason in Padua was a court, for justice involves calculation. In art, *ragione* meant proportion or ratio. The verb *ragionare*, which still means 'to talk' in Italian, reflects the fact that man reasons (and calculates) in his talk, which separates him from the animals. Calculation, which as we have seen began in various walks of life after the twelfth century, became ingrained in the Renaissance. Burckhardt draws our attention to the statistics of import and export in both Venice and Florence, and to the budgets of the church in Rome.[70] Until the end of the fourteenth century, time was in general divided up into the parts of the day, with short amounts counted in *Aves*, the amount of time it took to say a 'Hail Mary'. In the second half of the fifteenth century, however, public clocks went up in Bologna, Milan and Venice and shortly afterwards portable clocks were invented (*horologi portativi*). In Antonio Filarete's utopia, *Sforzinda*, even the schools had alarm clocks. In Leon Battista Alberti's treatise on the family, he argues that time is 'precious' and showed a hatred of idleness.[71] There was too a growing concern with *utilitas*, utility. Filarete, in his utopia, even went so far as to outlaw the death penalty, arguing that criminals were more 'useful' if they were forced to undertake the unpleasant duties that no one else wanted. This is crude, but it *is* calculation.

Insofar as education helped in one's calculations, study was felt to add to the dignity of man. Renaissance writers were especially concerned with what they called the *humana conditio*, the human condition. The ideal of the humanists was to become as rational as possible and so grammar, rhetoric, history, poetry and ethics were known in Florence as the *studia humanitatis*, the humanities, because they helped make a man complete. Self-knowledge was considered essential to the completion of man.[72] This led to a new concept of education, or rather we should say a *revived* concept – education not only as learning but understood as the production of good citizens, the old classical idea that the complete individual naturally takes part in the life of the *polis*. Medieval humanism had been aloof from the world. Renaissance humanism was a form of civic humanism and as such it represented another aspect of the rediscovery of antiquity.[73]

One should not exaggerate these changes but we should not downplay them either. There was a downside to the Renaissance. There was violence in the streets, bitter and prolonged family feuds, political factionalism, vicious cruelty. Piracy and banditry at times seemed endemic. Magic and devil worship proliferated and even papally-sanctioned assassination was not unknown. The church, 'the West's fundamental institution', seemed at times spiritually bankrupt.[74] Was this due to the rapid build-up of wealth and the disruption of traditional values? Was it a by-product of rampant individualism? There are those who doubt now that individualism was quite as new or as rampant in the Renaissance as Burckhardt argued. Indeed, he himself began to doubt it towards the end of his life.[75] Here is another area where the real change may have taken place in the renaissance of the twelfth century. But compared with the medieval view that man was a fallen, miserable creature, waiting here on earth in anticipation of a paradise somewhere else, the Renaissance humanists were far more concerned with the here-and-now, with the possibilities of *this* life, its pleasures and opportunities, with what could be achieved on earth.[76] In much the same way, the old obsession with the contemplative life and with poverty was replaced by a passion for the active life and the praise of wealth. For example, Poggio Bracciolini, philologist, polemicist and antiquarian, produced a dialogue *On Avarice*, which was a defence of something that hitherto had been a vice. Men must produce more than they need, he says, otherwise, 'All the splendour of cities will be removed, divine worship and its embellishments lost, no churches or arcades built, all the arts will come to an end . . . What are cities, commonwealths, provinces, kingdoms, but public workshops of avarice?'[77] Conspicuous consumption, another innovation of the Renaissance, was itself a form of calculation, for the effect it had on one's reputation and fame. Cosimo de' Medici said that his greatest mistake 'ever' was not to have begun to spend his money ten years before he did.[78]

Despite his backtracking on individualism, Burckhardt stood by his claim that the Italian was 'the first-born among the sons of modern Europe'. In the Renaissance, the secular world expanded hugely, though there was as yet no retreat from Christian belief.

# 19

# *The Explosion of Imagination*

On the last day of carnival in 1497 in Florence, and again a year later, a curious construction appeared in the Piazza della Signoria, overlooked by the Palazzo Vecchio. The centre of the structure was a great flight of stairs in the form of a pyramid. On the lowest step was displayed a number of false beards, masks and disguises used in the carnival. Above them was a collection of books (both printed and manuscript) – Latin and Italian poets, including the works of Boccaccio and Petrarch. Then came various female ornaments – mirrors, veils, cosmetics, scents – with lutes, harps, playing cards and chess pieces above them. At the very top, on the two highest tiers, were paintings, but paintings of a special kind, showing female beauties, in particular those bearing classical names: Lucretia, Cleopatra, Faustina, Bencina. As this 'bonfire of the vanities' was set ablaze, the Signoria, or assembly of politicians, watched from the balconies of their palazzos. Music was played, the people sang, and church bells rang out. Then everyone adjourned to the Piazza di San Marco where they formed into three concentric circles for the dancing. The monks were in the middle, alternating with boys dressed as angels. Outside them came other ecclesiastics and then the citizens.[1]

This was all performed for the satisfaction of the Dominican prophet, Fra Girolamo Savonarola of Ferrara. 'Pungent with charisma', convinced that he had been sent by God to aid the inward reform of the Italian people, and insistent that the office of preacher was a high one, 'the next place below the angels', he sought the regeneration of the church in, among other things, a series of Jeremiads – terrible warnings of the evils that would arise unless reform was total and immediate. In this, classical literature and learning had little or no place. 'The only good thing which we owe to Plato and Aristotle,' he said, 'is that they brought forward many arguments we can use against heretics. Yet they and other philosophers are now in hell. An old woman knows more about the Faith than Plato. It would be good for religion if many books that seem useful were destroyed.'[2]

This destruction of the representations and trappings of beauty was especially poignant because, as was mentioned in the previous chapter, art, artistic purpose and commitment to beauty were defining characteristics of Renaissance civilisation.[3] For Burckhardt at least, 'even the outward appearance of [Italian] men and women and the habits of daily life were more perfect, more beautiful and more polished than among the other nations of Europe'.[4] Aesthetics ruled in the Renaissance more than at any other time and the 'long' sixteenth century, 1450–1625, has aptly been called the aesthetic moment.

\*

In the realm of art, the fifteenth century was packed with innovations of which the most important were the invention of oil painting, the discovery of linear perspective, advances in the understanding of anatomy, a new concern with nature and, arguably the most pervasive and fundamental influence of all, the Platonic notion of universalism.

The technique of oil painting is traditionally credited to the van Eycks, Hubert and Jan, both active from the 1420s, in and around Ghent, Bruges and the Hague. Though this is no longer tenable, what is clear is that Jan van Eyck did perfect the method of oil painting, and varnishing, which has enabled his colours, and colour-effects, to have survived unchanged over the centuries. The important point about oil painting is that, unlike fresco – the most popular medium to that point – it dries slowly. Fresco dried so quickly that painters had to work very fast and their chances of changing what they had done were minimal. But pigments mixed with oil do not dry for weeks, meaning that alterations could be made, painters could improve weak patches, or change their minds completely if a new idea occurred to them. This made painters more thoughtful, more reflective, and also enabled them to take their time over mixing colours, to achieve more subtle effects. This was in evidence early on with the van Eycks, whose detailed rendering of objects and surfaces (next to impossible in fresco) meant that form and space were now much more developed and realistic. The same applied to the emotional force of paintings. The greater time allowed by oils enabled painters to explore facial expression in more detail, and in so doing to widen the range of emotions represented.

Linear perspective, known originally in Italy as *costruzione legittima*, was invented in the early fifteenth century, possibly by Brunelleschi, though it was built on and improved by Leon Battista Alberti and Piero della Francesca. The idea may have been slowly maturing since the great age of cathedral-building, which drew attention to distances, and spawned a surge in three-dimensional sculpture. Perspective was important not just for the added realism it gave to paintings but also for the fact that it involved an understanding of mathematics, which at that time was included in the liberal arts. If painters could therefore demonstrate that their art depended on, or benefited from, mathematics, it would further their claim that painting was a liberal art, and not a mechanical one. The essential point about linear perspective was that parallel lines never meet but they appear to do so, with all parallel lines converging at a vanishing point on the horizon. This transformed the verisimilitude of painting and accounted in large measure for its increased popularity.[5]

The greater realism allowed by oil painting and perspective was added to by both the close study of anatomy that many artists made in the fifteenth century – allowing a much more accurate rendering of musculature, thanks to advances in medical science (discussed in a later chapter) – and a new affinity for nature, provoked by humanism, and which likewise stimulated the portrayal of landscapes in addition to figures. Allied to this was a new interest in the narrative style – that is to say, paintings which, as well as glorifying God, told a story that would appeal to most people. As was mentioned earlier, Peter Burke found that out of two thousand dated paintings of the period, in 1480–1489 there were 5 per cent that were secular in character; by 1530–1539, this had risen to 22 per cent. This is a four-fold increase over half a century but the change should not be exaggerated: even at the later date the great majority of paintings were still religious in character.

Among the secular paintings, allegories grew in popularity after 1480. Allegorical

paintings look rather strange and are generally unpopular these days (except among art historians). Scantily clad women, dancing or dashing about amid classical ruins, small chubby cupids holding bows and arrows, or swords and ribbons, men who are half-beast, or goats with fishes' tails, do not sit easily with modern taste. But in the Renaissance, with humanism in full flood, allegory was as popular as, say, Impressionism is in our own day. Classical allegory became popular around the time Botticelli finished his *Primavera*, which is now among the most famous paintings in the world. Rich in complex Christian and mythological allusions, it includes among its nine figures Mercury, Cupid, the Three Graces and the most famous figure of all, Flora, decked in hundreds of flowers. Allegory grew in popularity throughout the sixteenth and seventeenth centuries but by the end of that period the heavy symbolism which had such an appeal to begin with had become so fragmented that mythology, as a way of presenting a particular message, had been fatally weakened.

Throughout the Renaissance, however, the fact that allegory flourished is of great significance. The popularity of the classical deities suggests, for instance, that they had never really disappeared but had simply gone underground, often adapted to the Christian tradition in hybrid form. In turn this raises the possibility that, in medieval times, the general public had never been quite so convinced of Christianity as the church liked to maintain. There were of course unavoidable elements of paganism in the Christian world, starting with the names for the days of the week and the very timing of Christmas. But it was more than that. During the great flowering of Christian art in the thirteenth and fourteenth centuries, astrologers in Italy directed the lives of whole cities. By the early fourteenth century, the pagan gods commonly appeared not just in literature but on monuments as well. In Venice they were used on the Gothic capitals of the Doges' Palace, and appeared at much the same time in Padua, Florence and Siena.[6] In the early fifteenth century the use of pagan mythology and astrology became even more open. In the Old Sacristy of San Lorenzo in Florence, just above the altar, there is a cupola containing mythical figures and a constellation of the heavens which coincides with the sky above the city at the time of the Council of Florence. Later equivalent decorations were to invade even the palaces of the popes (the list of St Peter's successors in the Borgia apartments is surrounded by celestial symbols, including Jupiter and Mars). Marsilio Ficino founded a whole school of exegesis in which it was accepted that wisdom could be sought in classical allegory, and this makes clear that allegory is more than simple allusion to mythology. To be able to decipher an allegory conferred a kind of insider status which appealed very much to the mood of the times and was adroitly developed by one of Ficino's followers, Pico della Mirandola (1463–1494). According to him, and others like him, the ancient myths were a kind of code which concealed a secret wisdom: this wisdom was veiled by allegory which, once deciphered, would reveal the secrets of the universe. Pico cited the teaching of Moses who, after all, had communed with God for forty days on the mountain and yet returned from Sinai with but two tablets: much more must have been revealed to him which he kept secret. Jesus himself confessed as much when he said to his disciples: 'It has been granted to you to know the secrets of the Kingdom of Heaven; but to those others it has not been granted.' To Mirandola, and many others like him, all religions shared mysteries, and only to a select few – philosophers – could the secrets be revealed

through the deciphering of ancient myths. One way of trying to do this was to explore the links and similarities between classical myths and Christianity.[7]

But the most dominant idea among the artists of the Renaissance was the essentially Platonic notion of universalism. Universalism is in fact one of the oldest and most influential ideas in history. It stems in part from ancient Greece, reflecting the theories of Pythagoras and Plato, though it also owes a great deal to the early Christian thinkers who adapted Greek ideas in Alexandria in the first centuries A D. By Renaissance times, the idea of universality had a long genealogy and had become more and more sophisticated.

In his survey of medieval theories about art and beauty, Umberto Eco concluded that medieval aesthetics was filled with repetitions and regurgitations and constituted a world 'where everything was in its proper place ... medieval civilisation attempted to capture the eternal essences of things, beauty as well as everything else, in precise definitions.'[8] The difference was shown most clearly in the status of artists: the medieval artist was someone 'dedicated to humble service of faith and the community' (a community that might be a monastery, remote in the countryside).[9] Underlying universalism in the Renaissance, however, was the idea that though nature was a 'divinely ordained' system, as it was held to be in the Middle Ages, it was now given to man – *especially artists and geniuses* – to apprehend that system. According to this theory, nature is homogeneous and all knowledge can therefore be reduced to a few primary axioms – 'natural law'. People such as Francis Bacon believed that man was divinely endowed to know nature and that the age was at hand when that knowledge would be perfected. Christians – knowingly or unknowingly – adopted Platonic ideas, in particular the notion that, since man shared some of the qualities of the divine mind, then the proper observation of nature, and of the links between the various arts and sciences, would provide man – and in particular the artist and scientist – with glimpses of the real essence of the universe, the underlying reality. In the Renaissance, this is what wisdom meant. Marsilio Ficino was specific. 'God has created all only that you may see it. As God creates so man thinks. Human understanding, on a limited scale, parallels the act of creation. Man is united to the gods by what he has of the divine, his intellect.'[10] Pico della Mirandola put it more strongly: 'In him are all things; so let him become all things, understand all things and in this way become a god.' Whereas beasts had a fixed nature, it was given to man – artists especially – to alter his nature and 'become all things'. This is what being an artist meant and why being an artist was so important.

Renaissance thinkers also believed that the entire universe was a model of the divine idea and that man was 'a creator after the divine creator'. Central to this was the concept of beauty, a form of harmony which reflected divine intentions. What is pleasing to the eye and ear and mind is good, is morally valuable in itself. More important, it discloses part of the divine plan for mankind, because it reveals the relation of the parts to the whole. This Renaissance ideal of beauty supported the notion that it had two functions and applied across all disciplines. At one level, architecture, the visual arts, music, and the formal aspects of the literary and dramatic arts all *informed* the mind; at a second level, they *pleased* the mind, by means of decorum, style and symmetry. In this way an association was established between beauty and enlightenment. Again, this is what wisdom meant.

The natural corollary was the desire for personal universality, and for mankind's achievement of a universal corpus of knowledge. The bringing together of disciplines was, in part, a conscious quest to deepen understanding, by exploring the generic similarities at the core of the different spheres of knowledge. Because of the then-recent rediscoveries of the Greek and Latin classics and the greater availability of such material, the assumed existence of these similarities was more than ever in the air. As a result, Renaissance men were often led naturally from involvement in one field of activity to another. Vitruvius had noted that all the sciences and arts have theory in common despite great differences in practice and technique. He therefore recommended that the architect, for example, become a master of the theoretical background of many different disciplines. 'He should be a man of letters, a skilful draughtsman, a mathematician familiar with scientific inquiries, a diligent student of philosophy, acquainted with music; not ignorant of medicine, learned in the responses of *juris consults*, familiar with astronomy and astronomical calculations.'[11] This idea of universality was taken up afresh by Renaissance men. It is found in the thought of humanists and in the ideals of the Florentine Academy. Jacob Burckhardt, in *The Civilisation of the Renaissance in Italy*, wrote: 'The fifteenth century is, above all, that of the many-sided men. There is no biography which does not, besides the chief work of its hero, speak of other pursuits all passing beyond the limits of dilettantism ... But among these many-sided men, some who may be truly called all-sided tower above the rest.' He singled out Alberti and Leonardo (who had his own advisor for mathematics, Luca Pacioli).[12]

Here is Burckhardt on Alberti: 'Assiduous in the science and skill of dealing with arms and horses and musical instruments, as well as in pursuit of letters and the fine arts ... showing by example that men can do anything with themselves if they will.' Alberti himself wrote a great deal about universality, as did Leonardo. For example, Alberti said: 'Man was created for the pleasure of God, to recognise the primary and original source of things amid the variety, dissimilarity, beauty, and multiplicity of animal life, amid all the forms, structure, coverings, and colours that characterise the animals.'[13] In his book on architecture we are explicitly told that 'the potential for awareness of harmony and beauty is innate in the mind' and that recognition of these truths occurs from the 'quick and direct' stimulation of the senses. 'In order to judge truly of beauty it is not opinion which matters but rather a kind of reason which is innate in the mind.' Man, Alberti says, possesses qualities of mind that are analogous to divine qualities, in particular the 'capacity to recognise' and the 'capacity to make'. All creatures perfect themselves as they fulfil their innate gifts.[14]

Nature, Alberti further argued, has been arranged harmoniously by God in accordance with a divinely conceived pattern that is best described in mathematical terms. Others, like Kepler, agreed. Man's conscious awareness of innate qualities – for example the awareness of beauty – can be increasingly magnified from an accumulation of good examples. This was the aim of art. In his search for truly good forms in nature, the artist continually shops around for beautiful examples – of, say, human bodies. From the range of these examples he gradually refines a clearer conception of what, for example, a beautiful body is. Eventually, over the course of many similar pursuits, the artist perfects his awareness of a general idea of beauty. Men are all gifted to recognise beauty but the artist practises to perfect his gift, and to represent his concept for his fellow men. He becomes

our teacher of beauty by the quality of the artistic examples that he places before our eyes. The recognition of beauty centres on the divine gifts to the human intellect. In Alberti's curriculum, there was no mention of Christian authors or the Bible, only classical sources.[15] Some forty-three treatises on beauty were written during Renaissance times. The idea of the universal man was a common feature of nearly all of them.

Peter Burke has identified fifteen universal men in the Renaissance ('universal' defined as talents in three or more areas, at a level beyond that of a dilettante): Filippo Brunelleschi (1377–1446), architect, engineer, sculptor, painter; Antonio Filarete (1400–1465), architect, sculptor, writer; Leon Battista Alberti (1404–1472), architect, writer, medallist, painter; Lorenzo Vecchietta (1405/1412–1480), architect, painter, sculptor, engineer; Bernard Zenale (1436–1526), architect, painter, writer; Francesco di Giorgio Martini (1439–1506), architect, engineer, sculptor, painter; Donato Bramante (1444–1514), architect, engineer, painter, poet; Leonardo da Vinci (1452–1519), architect, sculptor, painter, scientist; Giovanni Giocondo (1457–1525), architect, engineer, humanist; Silvestro Aquilano (before 1471–1504), architect, sculptor, painter; Sebastiano Serlio (1475–1554), architect, painter, writer; Michelangelo Buonarroti (1475–1564), architect, sculptor, painter, writer; Guido Mazzoni (before 1477–1518), sculptor, painter, theatrical producer; Piero Ligorio (1500–1583), architect, engineer, sculptor, painter; Giorgio Vasari (1511–1574), architect, sculptor, painter, writer.[16]

It will be noticed in this list that, out of fifteen universal men, fourteen were architects, thirteen were painters, ten were sculptors and six each were engineers and writers. What was it about architecture that it features so highly among this group? In the Renaissance, it was the aspiration of many artists to progress toward architecture. In the fifteenth century, architecture was one of the liberal arts, whereas painting and sculpture were only mechanical arts. This would change, but it helps explain the order of priorities in *quattrocento* Italy.

The careers of some of these universal men were extraordinary. Francesco di Giorgio Martini, for example, designed a large number of fortresses and military engines. Other ideas of his may be seen from seventy-two bas reliefs he constructed 'which consist wholly of instruments for the purposes of war'. He was a councillor in Siena and rather more than that, as it turned out, becoming a spy of sorts, who reported on papal and Florentine troop movements. Trained as a painter, he had a career that matured through sculpture to architecture in the 1480s and the writing of an important architectural thesis. In his treatise he contrasted such things as birds' nests and spiders' webs, arguing that their very invariability proved that animals were not touched by the divine quality of *invenzione* as humans were.[17] Giovanni Giocondo was a Dominican friar, 'a man of rare parts and a master of all the noble faculties'. Vasari depicts him chiefly as a man of letters, but adds that he was a very good theologian and philosopher, an excellent Greek scholar, when such a thing was rare in Italy, a very fine architect, and an excellent master of perspective. He became famous in Verona, where he lived, for the part he played in redesigning the Ponte della Pietra, a bridge built on such soft ground that it was always collapsing. In his youth he spent many years in Rome and in that way became familiar with the relics of antiquity, collecting many of the most beautiful things into a book. Mugellane called Giocondo 'a

profound master in antiquities'. He wrote commentaries on Caesar, taught Vitruvius to his contemporaries, and discovered the letters of Pliny in a Parisian library. He built two bridges over the Seine for the king of France. On the death of Bramante he was, with Raphael, given the commission to complete Bramante's work at St Peter's. He ensured that the foundations were renewed, exposing a number of wells in the process and filling them in. But his greatest accomplishment is probably his solution for the great canals of Venice, diverting water brought down by the river Brenta, and helping *La Serenissima* survive until today. He was a great friend of Aldus Manutius.[18] Brunelleschi had even more varied talents than those mentioned above. He was a clockmaker, a goldsmith and an archaeologist in addition to designing and directing the construction of the amazing dome of his city's cathedral of Santa Maria del Fiore. A friend of Donatello and Massaccio, he was more versatile than either.[19]

Has the concept of universal man, Renaissance man, been overdone? In the twelfth century certain scholars – Aquinas, for example – came close to having 'universal knowledge', knowing all that could be known (remember R. W. S. Southern's point, discussed in Chapter 15, that the sum-total of texts in those days was a few hundred, meaning that it *was* possible for someone to be acquainted with everything, or almost everything). Perhaps the real significance of the Renaissance idea of universal men is their attitude, their self-consciousness, their *optimism*. This, as much as anything, surely accounts for the explosion of imagination.

Intimately related to universality was the matter of *paragone* – whether painting was superior to sculpture, or vice versa. This was a major intellectual issue of the day in the fifteenth century and a central topic in the writings of, for example, Alberti, Antonio Filarete and Leonardo. Alberti argued for the superiority of painting. It had colour, could depict many things that sculpture couldn't (clouds, rain, mountains) and made use of the liberal arts (mathematics, in perspective). Leonardo thought that bas relief was a kind of cross between painting and sculpture and might be superior to both. The advocates of sculpture, on the other hand, argued that the three dimensions of statues were more real and that painters drew their inspiration from carved figures. Filarete argued that sculpture could never escape the fact that it was made out of stone or wood, say, whereas painting could show the colour of skin, of blonde hair, it could depict a city in flames, the light of a beautiful dawn, the shimmer of the sea. All this was beyond sculpture. To overcome the objections of those who argued for the superiority of sculpture, brushmen like Mantegna and Titian painted stone figures in *trompe l'oeil* 'relief'. Painting could imitate sculpture, but not the other way round.[20]

Just as painting and sculpture were endlessly compared at the time of universal men, so too were painting and poetry. For a while a great similarity was seen between the two activities. Lorenzo Valla, writing in 1442 and perhaps following the line taken by Alberti in his treatise *On Painting*, suggested that painting, sculpture and architecture are among the activities that 'most closely approximate to the liberal arts'. In the introduction to the section on painting and painters in his *De viris illustribus* (*On Famous Men*) of 1456, Bartolomeo Fazio gave more detailed but comparable arguments: '. . . there is . . . a certain great affinity between painters and poets; a painting is indeed nothing else than a wordless

poem. For truly almost equal attention is given by both to the invention and the arrange-
ment of their work … It is as much the painter's task as the poet's to represent those
properties of their subjects, and it is in that very thing that the talent and capability of
each is most recognised.'[21] It was Alberti who, in *On Painting*, written twenty years before
Fazio's biographies of painters, first articulated at length the need for artists to learn from
poets and to seek parity between painting and poetry. He wanted the painter 'as far as he
is able to be learned in all the liberal arts,' and so 'it will be of advantage if [he takes]
pleasure in poets and orators, for these have many ornaments in common with the
painter.'[22] Moreover, Alberti advised 'the studious painter to make himself familiar with
poets and orators and other men of letters, for he will not only obtain excellent ornaments
from such learned minds, but he will also be assisted in those very inventions which in
painting may gain him the greatest praise. The eminent painter Phidias used to say that
he had learned from Homer how best to represent the majesty of Jupiter. I believe that we
too may be richer and better painters from reading our poets …' For Alberti painting, like
poetry, uses parts of the *quadrivium* – geometry and arithmetic – in its theoretical basis;
therefore, like poetry, painting should rank as a liberal art.[23]

In a large number of notes written in preparation for his *Treatise on Painting*, Leonardo
da Vinci makes plain that in his view (which was based on classical arguments) painting
is the superior, nobler art. It is with Leonardo, in fact, that many of these ideas about
painting and poetry crystallise. 'If you assert that painting is dumb poetry,' Leonardo
wrote, 'then the painter may call poetry blind painting … but painting remains the
worthier in as much as it serves the nobler sense' – in other words, the sense of sight. He
insisted that the power of a painting that imitates nature to deceive the viewer is greater
than that of a poem. 'We may justly claim that the difference between the science of
painting and poetry is equivalent to that between a body and its cast shadow.'[24]

Some Renaissance painters sought to exercise their inventive abilities by writing poetry
themselves. They wanted recognition as poets because, in spite of Alberti's defence of
painting and Leonardo's arguments for the painter's superiority, throughout the early
Renaissance poets were more highly regarded than painters in intellectual circles. Bru-
nelleschi wrote a group of sonnets in self-defence in his argument with Donatello about
the decoration of the Old Sacristy of San Lorenzo in Florence and a number still survive.
Bramante, too, tried his hand at writing verse: thirty-three accomplished sonnets by him
survive. It was of course the young Michelangelo who of all Renaissance artists wrote
poetry of the truest literary merit.[25]

The very idea of universality implied that universal men were something special, set
apart, examples of the ideal. Thus it was only natural that these universal men should be
at the forefront of the movement by means of which the status of the artist improved in
the fifteenth century. One way this showed itself was in the art of self-portraiture. Antonio
Filarete was unmatched in the middle of the century in his consciousness of the value of
self-portraiture and associated imagery for publicising his intellectual and social position.
He incorporated not one but two self-portraits into the decoration of the bronze doors of
St Peter's, cast for Pope Eugenius IV between 1435 and 1445. The first is a profile portrait
closely based on Roman coins and medals. It is a small medal, let into the centre of the
bottom border of the left leaf of the doors; its reverse is in the same position on the right

leaf, and both have inscribed signatures.[26] Filarete's second acknowledgement of his own work is a relief attached to the inside of the door at floor level and which shows him and his assistants performing a dance. This is more than it seems because in his imaginary ideal city, Sforzinda, to which he devoted an entire treatise, he wrote: 'If all are to work together at the same time, the first as well as the last, it will have to be like a dance. The first dances like the last if they have a good leader and good music.'[27]

In line with the increased standing of the artist, the conceits of *paragone* and self-portraiture, were the twin concepts of *invenzione* and *fantasia*, invention and imagination, which together might be called artistic licence. During the fifteenth century, and especially with universal men, it came to be accepted that artists could not always be expected to do exactly what their patrons said. This was a major change. Here, for instance, is Isabella d'Este writing to Fra Pietro della Novellara in March 1501: 'If you think [Leonardo, the Florentine painter] will be staying there for some time, Your Reverence might then sound him out as to whether he will take on a picture for our *studiolo*. And if he is pleased to do this, we will leave both the subject and the time of doing it to him ...' In other words, there was no attempt even to specify a subject.[28]

The huge changes taking place in the visual arts are perhaps most neatly summed up by the appearance, in 1573, of Veronese before the Inquisition. The Inquisition will be explored more thoroughly a little later on but, after the Reformation, and the Catholic church's response – the Council of Trent, which met on and off from 1544 to 1563, with the aim of deciding Roman policy – one effect was that works of art were liable to censorship. Veronese had painted a vast, sumptuous feast canvas for the learned Dominican fathers of Santi Giovanni e Paolo in Venice, who needed to replace a painting of the *Last Supper* by Titian which had been lost in a fire. Veronese's picture was, in effect, a triptych, three Palladian arches with Christ in the central one and staircases leading off the canvas. Despite its religious theme, the picture is lively and shows a sophisticated Venetian celebration, with the partygoers in fine clothes, surrounded by jugs of wine, rich food, exotically garbed black people, dogs and monkeys and is painted in striking perspective. The Inquisition took him to task for this.

*Inquisitor.* What is the significance of the man whose nose is bleeding? And those armed men dressed as Germans?

*Veronese.* I intended to represent a servant whose nose is bleeding because of some accident. We painters take the same licence as poets and I have represented two soldiers, one drinking and the other eating on the stairs, because I have been told that the owner of the house was rich and would have such servants.

*I.* What is St Peter doing?

*V.* Carving the lamb to pass it to the other end of the table.

*I.* And the one next to him?

*V.* He has a toothpick and cleans his teeth.

*I.* Did anyone commission you to paint Germans [i.e., Protestants], buffoons and similar things in your picture?

*V.* No, my lords, but to decorate the space.

*I.* Are not the added decorations to be suitable?

*V.* I paint pictures as I see fit and as well as my talent permits.

*I.* Do you not know that in Germany and other places infected with heresy, pictures mock and scorn the things of the Holy Catholic Church in order to teach bad doctrine to the ignorant?

*V.* Yes, that is wrong, but I repeat that I am bound to follow what my superiors in art have done.

*I.* What have they done?

*V.* Michelangelo in Rome painted the Lord, His Mother, the Saints, and the Heavenly Host in the nude – even the Virgin Mary.

The inquisitors exacted an apology from Veronese and made him promise to amend the painting within three months. He did so, but not in the way the Inquisition anticipated. All that was changed was the picture's title, to *The Feast in the House of Levi.* That was much safer, since, in the Bible, the event was attended by 'publicans and sinners'.[29]

Such an exchange would have been unthinkable a century before and shows how the status of artists had changed. If it achieved nothing else, humanism brought about the emancipation of the artist, a development that is still very much with us.

In 1470, at a public festival in Breslau, in honour of the marriage of Matthias Corvinus, the king of Hungary, the newlyweds were treated to the sound of many trumpets and 'all kinds of string instruments'. This is regarded as the earliest account of a large number of strings, the essential ingredient of what would later come to be called an orchestra. A hundred years afterwards, roughly, between 1580 and 1589, a number of gentlemen started to meet regularly at the home of Count Giovanni dei Bardi in Florence. This group, known as the *camerata,* sounds like proto-*mafiosi* but in fact they consisted of a celebrated flautist, Vincenzo Galilei (father of the astronomer Galileo Galilei), Jacopo Peri and Giulio Caccini, also musicians, and Ottavio Rinuccini, a poet. In the course of their discussions, mainly about classical drama, the idea was conceived that such drama could be sung 'in a declamatory manner'.[30] In this way was opera born. Roughly speaking, in the century between these two dates, 1470 and 1590, we may say that the main elements of modern music came into being. It paralleled the explosion in painting.

The musical developments may be divided into three. There was first a number of technical advances, in instrumentalisation and vocalisation, which evolved the types of sound we hear today. There was, second, the development of a number of musical forms, which led to the *shape* of music as we know it today. And, third, in line with all this there emerged the first composers of modern music, the first famous names that we still remember.

Among the technical developments, we may identify first the principle of 'imitation'. This was an innovation of the Flemish school of music, of whom the most celebrated practitioners were Jean Ockeghem (*c.* 1430–1495) and Jacob Obrecht (*c.* 1430–1505). During the fifteenth century, however, and throughout a good part of the sixteenth, Flemish music was in the ascendancy, not just in the north of Europe but across Italy. At the papal court in Rome, at the cathedral of St Mark in Venice, in Florence and in Milan, Flemish musicians were those in demand. 'Imitation' in this context refers to the practice of having individual voices in a polyphonic work begin singing not together, but one after

another, each individual voice repeating the words. The device developed a great expressive power and has remained popular to this day in all forms of music. At the same time there was the introduction of massed voices in choirs and choruses. In particular, the papal choir became very important, though in Venice the Fleming Adrian Willaert (c. 1480–1562) introduced the double chorus, in which two vocal bodies were continually juxtaposed against each other. This had even greater dramatic force.[31]

It was in Venice too that a beginning was made in orchestration, the idea of designating specific instruments for every part.[32] This had to do with the fact that the printing of music also began in Venice around 1501, meaning that people could take away musical ideas, 'not in their heads, but in their luggage'.[33] Venice produced two remarkable musicians, Andrea Gabrieli and his nephew Giovanni. It was they who perfected the balance of choruses, with groups of strings, wind and brass, in opposing choir lofts, throwing the music back and forth, with two great organs as base. Yehudi Menuhin regarded this as 'the moment in Western music which marks the real beginning of independent instrumental music', and in particular a feature that was to be of vital importance throughout the modern age: the suspended dissonance. This deliberately planned dissonance, calling attention to itself and demanding to be resolved (at least until Schönberg, in 1907) heightened the emotionality of music and brought forth the technique of modulation, the free movement from one key to another and without which the romantic movement in music would have been impossible (Wagner, for instance).[34]

The fifteenth and sixteenth centuries also saw a growth in the number of instruments available and, in a rudimentary sense, the beginning of the orchestra. Most significant was, first, the spread of the bow from central Asia, via Islam and Byzantium, where the rabab and lura were played with a one- or two-stringed bow by the tenth century. The bow first appeared in Europe in Spain and Sicily but quickly spread north. The playing bow is a direct descendant of the hunting bow – the sound of plucked strings died away quickly but it was found that, with a bow, the notes of vibrating strings could be sustained for much longer, as it was drawn across the string. The second decisive event for the evolution of Western music was the crusades of the twelfth and thirteenth centuries. New instruments encountered in the Middle East spread quickly, in particular the fiddle. This is first seen in Byzantine illustrations in the eleventh century, when it had many shapes – oval, elliptical, rectangular – and was already often waisted for flexibility in bowing. Other instruments were the rebec and the gittern, the forerunner of the guitar, a massive instrument hollowed out of a solid block of wood.[35]

Stringed keyboard instruments appeared initially in the first half of the fifteenth century, perhaps developing out of a mysterious instrument, the *checker*, which is known only from drawings – no actual examples have survived. There was also an early form of clavichord, known as a *monacordys* (perhaps invented by Pythagoras), and an early harpsichord, a largeish instrument, out of which the smaller spinet and virginals developed. By the sixteenth century, the lute, the guitar, the viol and the violin had all grown greatly in popularity, as the taste for chromaticism in music expanded. Charles IX, who ruled as king of France between 1560 and 1574, ordered thirty-eight violins from Andrea Amati, the famous violin-maker of Cremona. He specified twelve large and twelve small violins, six violas and eight basses.

Among the wind instruments the organ had been in use since Roman times though from the tenth century on it had been exclusively a church instrument. The most important import from the East was the shawm, derived from the Persian *surna*, a double-reed instrument with finger-holes and a flared bell. The modern oboe was probably invented in the middle of the seventeenth century by a member of the Hotteterre family, where it was used at the French court.[36] The oboe was seen as complementary to the violins and helped in the continuo.

Several new forms of music emerged from the eleventh century on, of which we may single out the madrigal, the sonata, the chorale, the concerto, the oratorio and (as previously mentioned) the opera. Coming to prominence around 1530, the madrigal was the main secular form of music among the cultured classes of Italy. It originated in the *frottole*, which were usually love songs and designed as amusements rather than as serious comments on the affections of the heart, accompanied by a single instrument. Under the influence of Adrian Willaert the madrigal became more ambitious – five voices were the norm with him, enabling the choral work to grow richer and more sensuous. As the madrigal matured, the musical leadership of Europe passed from the Flemings to the Italians, Rome and Venice in particular, though we should not overlook the contribution of the French in creating the *chanson*, known elsewhere as the *canzon francese*. The *chanson* was very airy, sprightly, often comprising sentimental 'love-ditties', in Alfred Einstein's words, in which the voice would seek to imitate birds, battle scenes and so on, and it was out of this habit that the sonata eventually emerged. The great exponents of the madrigal and the *chanson*/sonata were Giovanni Pierluigi da Palestrina (1525–1594) and Orlando Lassus (1532–1594). Palestrina was *maestro di cappella* at St Peter's in Rome from 1571 on. He composed ninety-four masses and 140 madrigals, but he was essentially a religious composer, creating an unearthly purity in his music, whereas Lassus was the master of the madrigal and the motet, celebrating love in this life, on this earth. The pursuit of instrumental style and excellence led eventually to the emergence of the virtuoso musician, in particular on keyboard instruments and woodwind. Here we see another parallel with painting – the evolution of the musician as a respected artist in his own right.[37]

Towards the end of the century, the *canzon francese* divided into two types – the sonata for wind instruments, and the canzona for strings. The former developed into the concerto (and then, later, the symphony), while the latter evolved into the chamber sonata. The earliest meaning of concerto was a 'solo ensemble', and no distinction was made between voices and instruments. In fact, to begin with, 'concerto', 'sinfonia' and 'sonata' were used interchangeably. But then the meaning of sonata was modified to denote a composition for one instrument and, in the last decades of the seventeenth century, concerto came to mean an exclusively instrumental group as a whole, with the exclusion of voices. For a time, therefore, concerto meant, essentially, what we mean by orchestra, until that term came into use in the middle of the eighteenth century. After that 'concerto' coalesced to mean more or less what it means today, the standard term for solo instrument and orchestra.

The humanists in Florence who gave birth to opera were convinced that the prime function of music was to intensify the emotional impact of the spoken word. To begin with the new musical speech was called *recitativo* (recitative), in which the text was recited or declaimed against a musical background, which consisted mainly of a series of chords,

with the occasional dissonance for dramatic effect. From the start, however, there was an harmonic structure – what is called 'vertical' as opposed to merely 'horizontal' music. The chord, a musical unit composed of simultaneously sounding tones (written vertically), became an important element in opera.[38] This was very different from polyphony. The opera also encouraged the development of the orchestra, that particular name deriving from the fact that the ensemble of instruments was near the stage (in ancient Greece the orchestra was where the chorus stood, in front of the main acting area of the theatre).

The first great operatic composer was Claudio Monteverdi (1567–1643). His *Orfeo*, written for viols and violins and produced in Mantua in 1607, was a significant advance over the earlier operas produced in Florence. Monteverdi had an original harmonic gift which also allowed him to introduce some bold dissonances, but the chief characteristic of his music is its great expressive colour, much advanced on earlier works. *Orfeo* was so popular that the full score was published immediately, the first time this had happened, and comprised a major breakthrough in the printer's art. A year later, also in Mantua, he produced *Arianna*, arguably even more dramatic, and even more harmonic. During the writing of the opera, Monteverdi's wife died and he was plunged into despair. The result was the famous *Lament of Arianna*, which was probably the first operatic aria to become a popular song, 'and was hummed or whistled all over Italy'. Thanks to the successes of Monteverdi, opera houses began to be built across Europe, although up to 1637 they were private, the exclusive preserve of the nobility. Only after that date, again in Venice, was a paying audience admitted. Sixteen opera houses existed in Venice in the seventeenth century, four of which would be open on any given night.[39]

The oratorio is a sacred analogue of opera and it developed at much the same time. It embodied a sacred drama set to music throughout. This had been tried before but it was only when Emilio Cavalieri (*c.* 1550–1602), one of Count Bardi's circle, set to music *The Representation of the Soul and the Body*, in 1600, that the modern form of oratorio may be said to have begun. Its first performance was in the oratory of the church of St Philip Neri in Rome, and this is how the form got its name. In an oratorio, the full panoply of singers, musicians and chorus is used, but there is no 'action', no costumes or scenic effects.[40]

Story-telling came a little later to music than it did to painting, but once it had arrived, it soon found full expression. The secularisation of music, which is essentially what happened in the sixteenth century, freed it from religious constraints and the new forms became ways to tell different stories, of different length, and at differing levels of seriousness. It is probably the biggest change to have overtaken the history of music at any point.

At more or less the time that Veronese was appearing before the Inquisition in Venice, and the *camerata* were meeting in Florence, something equally noteworthy was happening in London. 'Contemporaries recognised it; foreign visitors marvelled at it, and in his *Itinerary* of 1617 Fynes Moryson identified it: "there be, in my opinion, more Plays in London than in all the partes of the worlde I have seene, so doe these players or Comedians excel all other in the worlde." What they were seeing was an explosion on the stages of London, an explosion that reflected a sudden creative

flowering in all forms of literature: the drama of Shakespeare and Marlowe, the poetry of Donne and Spenser, and the translation of the Authorised Version of the Bible.'[41] But it was drama in England that stood out most.

The defining point, Peter Hall says, was spring 1576, when James Burbage, a member of one of the great theatre companies, went outside the city limits, to Shoreditch, to build the first fixed home for drama and, in the process, 'turned a recreation into a profession'. In only a quarter-century after that, the new idea had reached its culmination: Shakespeare and Marlowe had come and gone, their dramas making new and huge demands on actors, and the main traditions of the stage had evolved and coalesced. In a dozen new theatres something like eight hundred plays had been performed, though how many more have been lost simply isn't known. What *is* known is that, in addition to Shakespeare and Marlowe, twenty other writers were responsible for twelve or more plays each: Thomas Heywood, John Fletcher, Thomas Dekker, Philip Massinger, Henry Chettle, James Shirley, Ben Jonson, William Hathaway, Anthony Munday, Wentworth Smith, Francis Beaumont.[42] Heywood wrote that he 'had a maine finger' in 220 plays.

The explosion of drama reflects the fact that London was now following Florence as one of the most successful bourgeois cities of the time. Central to this, in London's case, were the great sixteenth-century voyages of exploration, covered in the next chapter. The discovery of gold and silver in the Americas greatly increased the money supply in Europe, price inflation cheapened labour, and capitalists enjoyed super-profits. There was too a comparable increase in the professional classes. Enrolments to Oxford and Cambridge rose from 450 a year in 1500 to nearly a thousand a year by 1642, the cost increasing from £20 a year in 1600 to £30 in 1660. Admissions to the Inns of Court, where lawyers were trained, likewise quadrupled between 1500 and 1600. 'What happened between 1540 and 1640,' says Richard Stone, 'was a massive shift of relative wealth away from the Church and Crown ... toward the upper middle and middle classes'.[43] It was a similar change to that which happened in Florence. 'The realm aboundeth in riches,' said another account, 'as may be seen by the general excess of the people in purchasing, in building, in meat, drink and feastings, and most notably in apparel.'[44] This is a statement that recalls van Eyck's portrait of the Arnolfinis.

The change in London was fundamental. Religious figures disappeared, as the monasteries, chantries and hospitals were sold off. So too did the nobles, to be replaced by commerce and craftsmen. The Law Courts proliferated, 'as legislation became a favoured alternative to violence'. St Paul's cathedral was now the chief place for gossip and it had the air of a club. 'The Elizabethan-about-Town would habitually look in of a morning to see who was there, and if there were any major news, any minor scandal, any interesting comment on the latest book or play, or anything in the way of a new epigram or anecdote suitable for retailing at home.'[45] But the rendezvous *par excellence* was the Mermaid Tavern, the best of the pubs and Elizabethan London's literary and dramatic centre, the meeting place of its poets, dramatists and wits, who gathered there on the first Friday of every month. The most famous of Elizabethans would attend: Ben Jonson, Inigo Jones, John Donne, Michael Drayton, Thomas Campion, Richard Carew, Francis Beaumont, Walter Raleigh. Beaumont once wrote to Ben Jonson, summarising the Mermaid's appeal:

> ... What things we have seen
> Done at the Mermaid! heard words that have been
> So nimble and so full of subtle flame

Several economists, Maynard Keynes not least among them, have argued that England's commercial prosperity was directly responsible for the emergence of its theatre.[46] The defeat of the Spanish Armada in 1588 had engendered a sense of exuberance and irreverence among the population: nothing was sacred, even the Queen swore excessively, and 'spat at her favourites'.[47]

Although Burbage's move to Shoreditch was the catalyst for the renaissance (or naissance) of English theatre, it grew out of several medieval traditions – the mystery, miracle, and morality plays of the midlands and north, the royal revels during the twelve days of Christmas, which grew into the masque, and the guilds and livery companies which produced pageants. Even so, when Shakespeare was growing up there were no plays outside London and no professional theatres even there. A 'game-house' had existed in Yarmouth in 1538 and a *theatrum* in Exeter since the fourteenth century, where farces were performed. But there was no professional acting as such and, since the Reformation, even Passion plays had been discontinued. Classical theatre was studied in the universities and, from the 1520s, boys in the schools performed the comedies of Plautus and Terence, and the tragedies of Seneca.[48] In due course, schoolmasters and university dons were writing their own plays in the style of the classics and, around 1550, *Ralph Roister Doister*, in rhyming doggerel, was produced by a master at Eton. A decade later, a much better-known play, *Gammer Gurton's Needle*, was performed at Christ's College, Cambridge. But this was three years before Shakespeare was born and, since there is no evidence that he ever went to university, the connection cannot have been very strong. The archives of Westminster Abbey show that, throughout the 1560s, plays were performed there privately, acted in by the scholars and played before the Privy Council. In parallel, the monarch maintained two troupes of eight men each, who would produce entertainments – sometimes 'of a circus nature', sometimes more serious plays – as the theatre began to tell human stories and individual characters began to emerge.[49]

In terms of structures, the theatres that existed in London at that time were two circular outfits, the Bull-Ring and the Bear-Pit, situated on the south bank of the Thames and in existence for hundreds of years. But the baiting rings never housed plays – instead it was the inn-yards that made natural playhouses to begin with ('a wooden O', as Shakespeare called them), with a scaffold for a stage. Convenient as these were, there were problems. The authorities feared plague and riot – drink was never far away. The livery companies – companies of actors tied to a powerful patron, Leicester, Oxford, Warwick, for example – were designed to stop vagabondage and they gradually introduced interludes into their morality plays and these interludes grew in topicality and dramatic content. When, therefore, Burbage built his theatre, the energy and appetite reflected in all these developments was at once harnessed. 'What had been an almost feudal structure – the livery companies – was turned overnight into a capitalist one.'[50] The theatre was from the start a commercial venture, with more or less professional actors.

We should remember that these early plays were written to be heard, rather than read.

The reading public was, however, growing in London by leaps and bounds. In the early seventeenth century, only 25 per cent of London's tradesmen and artisans couldn't sign their names. Around 90 per cent of women were illiterate but they still comprised a good part of theatre audiences, which is why spectacle was more important then even than it is now and why there was no real distinction, as there is today, between 'high' culture and 'popular' culture.[51]

By the early seventeenth century, the term 'acting' had come to be applied to London's theatrical performers, reflecting the fact that there had been a significant advance on 'orators', that 'personation' and characterisation were being developed and deepened. Actors were not yet respectable, not in the full sense, but the practice of repertory (no play was given two days in succession) did draw attention to the successful actor's ability to portray very different roles in rapid succession, a versatility which could be easily appreciated. Nonetheless, when John Donne wrote his *Catalogus Librorum Aulicorum* in 1604–1605 he included no plays – he did not think of them as literature.

The plays that were produced in this atmosphere contained two essential ingredients – realism, as close as the techniques of the day permitted, and emotional immediacy (there was an incipient journalistic element in London theatre along with everything else). But probably the most important element was that the theatre reflected the changing world in which the audience of the time found itself. The social situation was changing, the old rules were breaking down, private reading was growing, many people could afford more goods than ever before.

Into this world stepped Shakespeare. As Harold Bloom pertinently asks, was Shakespeare an accident? He was not, after all, the immediately towering talent that he became. As Bloom also points out, had Shakespeare been killed at twenty-nine, as Marlowe was, his oeuvre would not have been anywhere near as impressive. '*The Jew of Malta*, the two parts of *Tamburlaine*, and *Edward II*, even the fragmentary *Doctor Faustus*, are a far more considerable achievement than Shakespeare's was before *Love's Labour's Lost*. Five years after Marlowe's death, Shakespeare had gone beyond his precursor and rival with the great sequence of *A Midsummer's Night Dream*, *The Merchant of Venice*, and the two parts of *Henry IV*. Bottom, Shylock, and Falstaff add to Faulconbridge of *King John* and in Mercutio of *Romeo and Juliet* we discover a new kind of stage character, light years beyond Marlowe's talents or his interests … In the thirteen or fourteen years after the creation of Falstaff, we are given the succession worthy of him: Rosalind, Hamlet, Othello, Iago, Lear, Edmund, Macbeth, Cleopatra, Anthony, Coriolanus, Timon, Imogen, Prospero, Caliban … By 1598 Shakespeare is confirmed and Falstaff is the angel of the confirmation. No other writer has ever had anything like Shakespeare's resources of language, which are so florabundant in *Love's Labour's Lost* that we feel many of the limits of language have been reached, once and for all.'[52]

Shakespeare arrived in London with no career plan worked out at that stage, nor any ambitions to be more than a popular, even a hack, writer, and he became known as an actor before he earned fame as an author. He turned out serious plays, light plays, plays tailored to his actors. He paid little attention to spelling or grammar and was constantly coining new words where he needed them. And yet, in the history of ideas Shakespeare stands in no one's shadow, a man responsible for two groundbreaking innovations. One,

mutability. Shakespeare's characters – the important ones at least – overhear themselves and show a capacity to change, to change in a psychological and moral sense, that was totally new. This shows itself in Hamlet and Lear but is best in Falstaff, arguably Shakespeare's greatest creation. Second, and all too easily overlooked, and which was also related to urbanisation, Shakespeare's work 'resists Christianisation': his plays exist in their own world, worlds complete unto themselves, which we accept almost without thinking. They are not avowedly humanist, in the obvious sense of drawing their inspiration from the classical past, nor do they make the most of learning (Milan is connected to the sea by a waterway). 'Shakespeare appears not to have been a passionate man (not in his marriage anyway), he has no theology, no metaphysics, no ethics and very little in the way of political theory.' Instead, in a very real sense, he invented the psyche in the way that we use the term today. Perhaps the defining Shakespearean play is *King Lear* where, at the end, there is what Bloom calls 'a cosmological emptiness', into which the survivors in the play, and the audience, are thrown. 'There is no transcendence at the end of *King Lear* ... The death of Lear is a release for him, but not for the survivors ... And it is no release for us either ... Nature as well as the state is wounded almost unto death ... What matters most is the mutilation of nature, and our sense of what is or is not natural in our own lives.'[53] This is an achievement quite unlike anything that had gone before.

Tradition has Shakespeare and Cervantes dying on the same day. A more important coincidence is that the novel, so common a form of literature in our own times, was born in Spain, with *Don Quixote*, and at more or less the same time as modern drama was launched in London. In Spanish literature, priority in terms of date is rightly given to *Celestina*, or *The Tragicomedy of Calisto and Melibea* (sixteen acts in the 1499 version, twenty-two in the 1526 version).[54] The plot, so far as there is one, centres around Celestina, a professional go-between, who brings together two lovers, Calisto and Melibea, whose death Celestina eventually causes, along with her own. There is a good deal of the low life in *Celestina* and this helped set up the tradition of the *picaresque* novel in Spanish literature of which *Lazarillo de Tormes* was the first important example (the story of a criminal family and their adventures), and *Don Quijote*, or *Don Quixote*, by far the most overwhelming.[55]

Unlike Shakespeare, Cervantes was an heroic man. Almost certainly a disciple of Erasmus, from a family who had been forced by the Inquisition to abandon their Judaism, he fought and shone at the battle of Lepanto, even though he was sick, survived long years of Moorish captivity and then in Spanish jails, where *Don Quixote* may have been begun. The book appeared at more or less the same time as *King Lear* and can claim to be as utterly original and as unprecedented. The centre of the book, and its greatness, lies in the 'loving, frequently irascible' relationship between the Don and his valet, Sancho Panza. Their individuality, their small-time and big-time heroism are a revelation and a celebration that fill the reader with as much warmth as the end of Lear leaves us bereft and cold. Much of the hinterland of the book is unexplained. Cervantes tell us the Don is mad, but we are not told why or given any clinical details. He may have driven himself crazy by reading chivalric romances of a different age, which caused him to set off on his impossible task of realising his dream, to live life in the course of his travels. As the friendship progresses – a relationship which has been compared to that between Peter and Jesus –

throughout their travels 'no thought on either side goes unchecked or uncritiqued. By mainly courteous disagreement, most courteous when most sharply in conflict, they establish an area of free play, where thoughts are set free for the reader to ponder.'[56] Despite the differences in rank, there is an 'equality of intimacy' between the Don and his valet that is both comic and serious all at the same time (some of the comic interludes are pure slapstick). The Don's eagerness for battle at every turn, his fantastic ability to mistake windmills for giants, and puppets for real persons, Sancho Panza's wish to gain fame rather than wealth (how strange *that* sounds today), their meeting with Ginés de Pasamonte, the famously dangerous criminal and trickster, all this is wholly original but the central point is that the Don and his valet *change* during the book, they change each other by listening to what each other has to say. As with Shakespeare's invention, mutability is the central psychological innovation of *Don Quixote*. Like Shakespeare, Cervantes created huge characters and like Shakespeare he moved well beyond learned humanism, well beyond antiquity, well beyond the church, to something new. 'It is not a philosophy,' said Eric Auerbach, describing the book. 'It [has] no didactic purpose; ... It is an attitude toward the world ... in which bravery and equanimity play a major part.' In a sense *Don Quixote* was not just the first novel but also the first 'road movie', a genre that is very much still with us.[57]

There was no one reason for the explosion of imagination (and of story-telling, and story-telling techniques). But the extent to which many of these great works began to move beyond Christianity ought not to go unrecognised. Without making heavy weather of it, works of the imagination offered a very varied alternative, a refuge, to the traditional drama of the liturgy and the narratives of the Bible.

# 20

# *The Mental Horizon of Christopher Columbus*

'To the end of his life Christopher Columbus maintained that he had reached the "Indies" he had set out to find. He had landed on islands close to Cipangu (Japan), and on the mainland of Cathay (China). He had skirted the coasts of Marco Polo's Mangi [China as well] and been only leagues away from the domains of the Great Khan himself.'[1] A medieval league was the distance the average ship could sail in an hour, say somewhere between seven and twelve miles. We may smile now at Columbus' dying delusion but that he should hold to his view tells us as much about his age as do his epic voyages of discovery. They show, in particular, that the man who discovered the New World was someone from medieval times rather than the modern age.

All manner of historical forces were represented by Columbus, whether he knew it or not. In the first place, his voyages were the culmination in a mammoth series of navigational triumphs that had begun centuries earlier. (These were surveyed and summarised by Bartolomé de las Casas in the sixteenth century.[2]) Some of these voyages had been much longer than his, and no less hazardous. In some ways, these journeys of discovery collectively represent man's most astounding characteristic: intellectual curiosity. Man's medieval ventures into the unknown are, save for space travel, simply impossible for us to share and therefore separate us from Columbus' time in a fundamental way. Although desire for commercial gain was as often as not a motive for these travellers, their journeys most certainly represented intellectual curiosity in its most unadulterated form.

As was discussed earlier, there was a time when western Europe did not hold the lead in travel and exploration. The Greeks had discovered the Atlantic in the seventh century BC, when they had named the Straits of Gibraltar the Pillars of Hercules. According to Hecataeus, the world was essentially a circular flat dish, with its centre somewhere near Troy or what became Istanbul, with the Mediterranean opening on to the ocean which entirely surrounded the land.[3] In the late sixth century BC a follower of Pythagoras in southern Italy put forward the idea that the earth was a sphere, one of ten such entities revolving around a central fire in space. These other entities included the sun, the moon, the fixed stars (heaven), the five planets, and a *counter* earth.[4] We on earth could not see the central fire or indeed the counter earth because the populated side of our planet was always turned away from the central fire. To many people the earth was self-evidently flat, but both Socrates and Plato accepted the Pythagorean view, Socrates going so far as to say

that the earth was apparently flat only because of its very great size.

The Greeks knew that there was land all the way from Spain eastward as far as India and there was rumoured to be more still farther east. Land in the north–south direction was less familiar though Aristotle believed that it extended about three-fifths of the east–west distance. More important, he took the view that Asia continued so far to the east that it extended all the way round the world and there was only a small body of water between Asia and the Pillars of Hercules. This was a powerful idea, which stuck, and was still relevant when Columbus set out centuries later.[5]

The first great traveller we know about was Pytheas, who lived at Massalia (the modern Marseilles). The inhabitants of Massalia knew from boatmen who had sailed up the Rhône and met other travellers that there was a great northern sea big enough to contain islands, which produced precious metals and a beautiful, brown, resinous substance, much prized and called amber. But the Rhône itself did not go as far as this north sea and no one really knew how far away it was. Then, about 330 BC, sailors returning to harbour from the western Mediterranean reported that for once the Pillars of Hercules were undefended. For the merchants of Massalia this was the chance they had been waiting for. The way was clear for them to go looking for this north sea. Pytheas was chosen for this voyage and equipped with a ship about 150 feet long (bigger than the one Columbus would use).[6] Hugging the land, Pytheas eventually found his way to northern France, and then, through cold rain and fog, he sailed up between England and Ireland, reaching islands he called Orka (and we still call the Orkneys), then moving beyond the Shetland and Faeroe islands until he reached a land where, on the first day of summer, the sun remained above the horizon for twenty-four hours. He called this place Thule, and for centuries Ultima Thule was, in effect, the end of the world in that direction – it could have been Iceland, or Norway, the Shetlands or the Faeroes. Pytheas returned via Denmark and Sweden, found a broad sea that reached far inland, the Baltic, and began his search for the Land of Amber. He discovered the rivers that flow from south to north (such as the Oder and the Vistula) and realised that this is how news of the northern sea had reached the Mediterranean. When he returned home, however, many people refused to believe him. Then the Carthaginians took control of the Pillars of Hercules and the Atlantic was once more cut off.[7]

In the other direction, the Greeks also knew that beyond Persia there was somewhere called India. They had heard fabulous tales of a king who was so grand he could order a hundred thousand elephants into war; men who, it was said, had the heads of dogs, where there were huge worms that could drag an ox or a camel into the river and devour it.[8] In 331 BC Alexander the Great began his series of conquests that took him beyond Persia into Afghanistan as far as the Indus river. And here he did encounter crocodiles – the giant worms of which legend told.[9] He followed the Indus south until he came to a great ocean, the great southern ocean that had been rumoured. So it was now a 'fact' – the land really was surrounded by sea as the ancients had said.[10]

All these travel details began to be collected by scholars, especially at Alexandria, with its famous library (see Chapter 8).[11] One of its most distinguished librarians, Eratosthenes (276–196 BC), may be regarded as the world's first mathematical geographer and he set about producing a more accurate map of the world. By the method already described in

Chapter 8, he calculated the circumference of the earth as just under 25,000 miles. This was not wide of the mark. And this was not Eratosthenes' only achievement. He also calculated the amount of habitable land, based on climate, and developed the concept of latitude, relating to the angle of the sun, which allowed for the more precise location of such cities as Alexandria itself, Massalia, Aswan and Meroë, which had been discovered by sailing up the Nile.[12] Eratosthenes' work was built on by Hipparchus who, around 140 BC, adjusted the circumference of the earth to 25,200 miles (252,000 stades) so that he could divide it exactly into 360 degrees of seventy miles each. This enabled him to draw lines of latitude on maps one degree apart, which he called *klimata* and from which our word 'climate' is derived.[13]

In Roman times, knowledge was advanced mainly as a result of trade. The Roman demand for silk meant that both the overland Silk Road and the sea routes to China were discovered and expanded. How much so may be judged from a navigational guidebook written by an anonymous Greek merchant from Alexandria around AD 100. Known as the *Periplus of the Erythraean Sea*, the text describes exploration of the east coast of Africa, as far south as Raphta (about 1,500 miles), then the northern shores of the Indian Ocean, from the Red Sea to the Indus, and then on to Ceylon (Sri Lanka) where, further east, the information becomes vague. But the anonymous Greek showed himself as aware of the Ganges and of Thinae, the land of silk (in other words, China), beyond. Silk, as was mentioned earlier, was responsible for much of the increased geographical knowledge of the world and this prompted constant updatings. The next, after Eratosthenes, was Claudius Ptolemy in AD 140.

Though Ptolemy had much more information at his fingertips than Eratosthenes, not all of it was accurate and he too was responsible for some of the misconceptions that Columbus took with him on his voyages. It was Ptolemy who introduced the idea of longitude, even though there was no real way at that time of calculating where the lines should go. His idea was to divide the world into equal squares that would aid exact location. In addition to China in his maps he also included more information about the Atlantic, where the Fortunate Islands were rumoured to be located off the coast of Africa.[14]

After Ptolemy, geography suffered a decline, as did many areas of thought during the era of Christian fundamentalism. In the sixth century Cosmas, a seafaring merchant and monk, argued that the earth was a rectangle. He did this on the basis of the book of Exodus in which God called Moses up to Mount Sinai and revealed to him many secrets. Instructing Moses to build a tabernacle, he said it should be *a copy of the figure of the world*, which to Cosmas implied that the world was tabernacle-shaped.[15] This in time led to a 'Christian topography' where earth was joined to heaven at its rim, with Paradise in the east, across the sea, on a 'sunburst' island near heaven.[16] In fact, said Cosmas, the earth, though flat, was slanting, which explained the mountains, and why the sun disappeared at night (the earth, he said, was only forty-two miles across). He said it also explained why rivers running north flowed more slowly than those running south (they were going uphill). Cosmas said the earth must be flat because if it were round people on the other side would be living upside down, a self-evident impossibility. But he didn't find it impossible that, under his system, the Nile was actually flowing uphill.

To early Christians – the Church Fathers in particular – the location of Paradise was of

major importance. Since, according to Christian belief, the Tigris and Euphrates rivers originated in Paradise, the location and layout of the two rivers had to be accommodated to the early belief that Paradise was itself situated at the eastern end of the world. One solution was to argue that the rivers of Eden flowed under the earth for some way before surfacing. But this was no real help because it meant that man could not follow the rivers to Paradise.[17] Another problem was the whereabouts of the monstrous races described in the scriptures, in particular the races of Gog and Magog who had invaded the ancient world from the north and, according to tradition, would reappear. Where exactly were they? Yet another difficulty was the centre of the earth. Two psalms and two references in the book of Ezekiel identified Jerusalem as that centre and this is how the city is portrayed in many medieval maps.[18] It soon became clear that the centrality of Jerusalem was difficult to maintain.

The first major adventurer of the Atlantic, after Pytheas, and the first Christian explorer in history, was the Irish monk known as St Brendan the Navigator. Born about 484 near Tralee and ordained priest in 512, Brendan grew up with the tradition that many Irish fishermen had been blown out to sea and returned with stories about islands off to the west in the ocean.[19] Brendan, we are told, was more deliberate. Seeking the 'Land Promised of the Saints', he and sixteen fellow monks embarked in 539 or thereabouts on an epic voyage of voyages. 'The story of his travels was not written down for another four hundred years, during which time many other voyages were made into the Atlantic by other monks. Yet Brendan's reputation was such that the voyages of the others were attributed to him … [He and his companions] had no compass but knew the stars and watched the birds on migration. They sailed west for fifty-two days when they came to an island where they disembarked. There was only a dog to welcome them but it led them to a building where they rested. As they were leaving, an islander appeared who gave them food. They were blown about in all directions before coming to an island with herds of pure white sheep and streams full of fish. They decided to winter there and were made welcome at a monastery. They moved on to a small barren island but as they cooked their meal the island shook and, as they scrambled for their boat, sank. As Brendan explained, it was a whale.'[20]

Over the next seven years Brendan visited many other islands in the Atlantic. There was the Island of Strong Men, covered with a carpet of white and purple flowers; they sailed around a great crystal column floating in the sea; and passed a nearby island peopled with 'gigantic smiths' who hurled lumps of burning slag at them. (This, they decided, was the outer boundary of Hell.) On one of their northern trips they caught sight of a mountain that shot flames and smoke into the sky.[21] But nowhere could they find the Land of Promise that was the object of their voyages. At length, the procurator on the Island of Sheep agreed to take them to the Land of Promise. It took forty days, through a bank of dense fog or cloud. They went ashore and explored the land for another forty days before coming to a river that was too deep to cross. Returning to their boats, they voyaged back through the cloud bank, and then on home.

There has been much speculation about these 'discoveries'. The Faeroes derive their name from a Danish word for sheep.[22] The Island of Strong Men with its purple and white flowers appears to have been the Canaries, or maybe the West Indies. The crystal column

can only have been an iceberg, the nearby Land of Giant Smiths could have been Iceland, while the flame-spouting island in the north fits with tiny Jan Mayen island. And the Land of Promise? Given the cloud banks, it could just have been North America. In any event, this story was told and retold till the Land of Promise became St Brendan's Isle, which in turn became a persistent feature of maps of the Atlantic down to 1650, though its exact position was never settled.[23]

In the tenth century the Norwegians had a different perspective. If you draw a line west of the Norwegian mainland you find the Shetlands, the Faeroes, Iceland, Greenland, and Baffin island. Iceland had been discovered early on, and not just by Irish monks – it was the Norwegian practice to banish recalcitrants to Iceland as exiles. Anyone blown off course on their way to Iceland had a chance of seeing Greenland, which was settled around 986. There they raised cattle and sheep and hunted walrus and polar bears. They also explored some lands to the south, though 'explore' is perhaps too deliberate a word for Bjarni Herjolfsson, a young Icelandic merchant, who was blown off course on his way back from Greenland and driven south, through a dense fog. He came to a hilly land, green with forests, that was nothing like Greenland or Iceland. After Bjarni had made it back to Greenland, and excited others with what he had seen, a young man called Leif Eiriksson set out to emulate him in 1001.

  He came first to barren lands – what he called Helluland, Flatstone Land, or Slab-Land. Farther south he rediscovered the forest landscape Bjarni had seen – this he called Markland, or Forest Land. And further south still he came to a grape- or berry-bearing land, which he called Vinland, where he wintered. Others followed Leif, but they all found the natives, which they called Skraelings, hostile and were eventually either killed or driven back. Adam of Bremen's account of Vinland, written in 1070, is regarded as authentic and, in 1117, a papal legate from Greenland visited Vinland, which implies that a community of souls existed there, at least for a time (in 1960 buildings were excavated in Newfoundland that resembled those in Greenland and were dated by $C^{14}$ to the eleventh century). Papal records at Rome indicate the memory of Greenland existed there at the end of the fifteenth century.[24]

In the other direction Asia was being fleshed out. 'The most popular notion about Asia was that somewhere in this great continent there was a powerful Christian ruler named Prester John, who was believed to be so great that kings waited upon him at table.' But he was never found, despite many epic voyagers of explorers and travellers (some think this was a corrupted legend originating with Alexander the Great). The first of the three great travelogues of the Middle Ages was by John of Plano Carpini, whose *History of the Mongols* begins in 1245, at Easter. Setting out from Lyons, John travelled on behalf of the pope. As far as Kiev he travelled in a steady, even stately way – he was overweight and riding wasn't easy. From Kiev, however, he found that the Mongols had established a highly efficient communications system, with post stations along the road that enabled them to change horses five or six times a day.[25] In this fashion he travelled by way of the Crimea, the Don, Volga and Ural rivers, north of the Aral Sea and then across Siberia to Karakorum, south of lake Baikal, where the Great Khan held his court. John was well received, had an audience

with the Khan, and was presented with a fox-skin coat by the Khan's mother, very useful on his return journey, since the roads were often covered in deep snow and they had to sleep in the open air. When he arrived home, his book based on his travels was a great success though, as he was at pains to point out, he had found no mention anywhere of Prester John.

Nonetheless, his journey added a great deal to knowledge about the East and the *History of the Mongols* was circulated throughout Europe (the English word 'horde', often used in connection with the Mongols, derives from the Turkish *ordu*, meaning 'camp'). For his part, the pope decided to send a preacher to Karakorum, in the hope of converting the Great Khan. The man chosen, William of Rusbruck, set out in 1253 and was disappointed to find that the Khan had no interest whatsoever in being converted.[26] However, while he was in Karakorum he observed several other Europeans, including a goldsmith from Paris, a French woman who had been abducted from Hungary and an Englishman, plus several Russians and some travellers from Damascus and Jerusalem. John of Plano Carpini had stimulated an interest in Asia among Europeans.

That interest was greatest in Venice, for its merchants had traditionally maintained good links with Arab/Muslim traders, who received goods from further east. This is why the Polo brothers, Nicolo and Maffeo, decided to make their way across Asia in 1260. This first trip was a great success because the Mongol ruler of the time, the great Kublai Khan, was as interested in Europe as they were in Asia and sent them back as his ambassadors. When they returned east, in 1271, they took with them Marco, the seventeen-year-old son of Nicolo. *This* journey turned into one of the great epic voyages of all time. They followed the old Silk Road – fifty-two days of travel – until they reached Kashgar and Yarkand on the edges of China. There they crossed the desert and finally reached Kanbalu (the modern Beijing), where the Khan's capital had moved to, from Karakorum. Marco Polo was entranced by Kanbalu; he described the city as 'greater than the mind can comprehend . . . no fewer than a thousand carriages and pack horses, loaded with raw silk, make their entry daily; and gold tissues and silks of various kinds are manufactured to an immense extent.'[27]

Like his father before him, Marco was an astute trader, with a keen market sensibility, and like his father he became a favourite of the Khan ruler. For fifteen years he was sent as an ambassador all over China and the East.[28] In fact, the Polos only returned home when a marriage contract was arranged between Kublai Khan and the ruler of Persia under the terms of which a young bride was to be sent west. A convoy of fourteen ships was made ready and the Polos were part of the bride's protective party. The ships left from Zaiton (modern Amoy) on the Pacific coast (which the Polos thought extended around the world to Europe) but first they travelled via Kinsai, modern Hangchow, which was another fantastic experience – a hundred miles in circumference, with ten major markets and twelve thousand bridges. 'Every day forty-three loads of pepper, each weighing 243 pounds, moved through the markets of Kinsai.'[29] From the sailors on the ships of the convoy, Marco heard about Zipangu (Japan), which, he was told, was about 1,500 miles off the mainland (in fact it is 600 miles from Shanghai and 200 miles from Korea). When the Polos finally reached home, their friends were astonished, imagining that they had been long dead. After Marco wrote up his account of his travels, *The Description of the World*, no one at first believed him, and he was given the nickname *Il Milione*, because of the 'tall tales'

he had fallen into the habit of telling (in fact he had a ghost writer, Rustichello of Pisa). And yet, the limits of Asia had been reached by the Polos, and they had seen a vast new ocean.

The third great traveller of the Middle Ages was the Arab, Ibn Battuta. He left his home in Tangier in 1325 aiming, in the first instance, to make a pilgrimage to Mecca. Once there, however, he decided to keep going. He travelled down the coast of east Africa, then up into Asia Minor, before cutting through central Asia to Afghanistan and India. Well received in India (as a *qadi*, a kind of judge, he was an educated man), Ibn Battuta lived there for seven years and, like Marco Polo before him, was appointed as an ambassador, in his case to the sultan of Delhi. On his behalf Ibn Battuta undertook a trip to China. He had many adventures along the way, including being attacked, robbed and left for dead, but he arrived in China in either 1346 or 1347, where he found many Muslims in the port cities, who were not at all surprised to see him. Returning home, he next travelled in Spain, then took off into west Africa, as far as the Niger river, where again he was well received by the Muslim Negroes. His travels became the basis for geographical, astronomical and navigational studies taught in the Muslim centres of learning in Cordova and Toledo. These traditions played a big role in shaping the ideas of Columbus.[30]

Columbus' mental horizon was thus determined at least in part by these experiences of early travellers. Travel was arduous, and frequently dangerous, but long – very long – journeys *were* made, and knowledge about the world was expanding sufficiently to whet the appetite of people like the Genoese general. However, there were many other influences on Columbus' mind besides the voyages of his predecessors. Foremost among them were the *mappae mundi*, or Christian maps of the world. In Columbus' entry in his journal for 24 October 1492, he writes of Cuba: 'The Indians of these islands and those whom I carry with me in the ships give me to understand by signs, for I do not know their language, it is the island of Cipangu, of which marvellous things are recounted; and in the spheres which I have seen and in the drawing of mappemondes, it is this region.'[31] These *mappae mundi* arrived with Christianity – indeed, they were one of the agents in the spread of the religion. In the gospel of St Matthew, for example, the Apostles were commanded to preach 'to all the nations' and so geography was given a religious importance. As Valerie Flint says, *mappae mundi* were, 'for the greater part, less geographical descriptions than religious polemics; less maps than a species of morality'.[32] These maps took passages from Revelation, the gospels, the Psalter and other books of the Bible as their principal guides. 'Thus says the Lord God,' in the book of Ezekiel, 'This is Jerusalem; I have set her in the centre of the nations, with countries round about her.' Jerusalem was therefore placed at the physical centre of the world. In the same way, east was placed at the top of the map because that privileged position contained Paradise which, according to Genesis, was in the east, with the four rivers of Eden pouring out of it.[33] The habitable world was divided into three continents, in accordance with God's 'delivery' of the dry land to Noah three days after the Flood.[34] These lands were often drawn as a circle, surrounded by ocean, in which the main inland waterways were in the form of a capital T. Leonardo Dati (1360–1425) was the first to describe these as 'T-O' maps, in his poem, *La Sfera*.[35] Other matters that needed to be included in the *mappae mundi* were the Magi, who came from somewhere in the

east, Prester John, and the monstrous races, which were to become extremely popular among mapmakers. India, in particular, was seen as home to many monsters. There could be found people with the heads of dogs, whose feet faced backwards, whose eyes, noses and mouths were in their chests, or who had three rows of teeth. India was also renowned for having 'a great pepper forest'. As time went by, mapmakers appear to have shown some awareness of the discoveries of travellers. The Caspian Sea, for example, no longer opens into a great northern ocean but is completely surrounded by land. The number of islands off the mainland of China also increased, in deference to the report of Marco Polo. The so-called *Catalan Atlas*, drawn up in 1375, pictured the islands of the Atlantic – Madeira and the Azores – with tolerable accuracy, India is clearly a peninsula, and some of the larger islands in the Indian Ocean are marked. China is in the extreme east, with some of its cities shown.

No less Christian in intent were the 'zone and climate' maps which, by tradition, divided the earth into five climatic zones – a northern extremely cold zone, a temperate, habitable band further south, a central, uninhabitable 'torrid zone' around the equator, and two further zones to the south, a temperate one, and a frozen one, echoing those in the north.[36] The idea of an impassable torrid zone, in particular an impossibly hot sea, seems to have been a Greek idea originally, taken up by the Christians. The effect of this was to suggest that a northern sea passage was impossibly cold, whereas a southern one was impossibly hot. This implied that the only way to travel the earth was by going west.

Early in the fifteenth century, the *Geography* of Ptolemy, the second-century geographer, was rediscovered. The Greek text was brought to the West by Chrysoloras and made generally available through a Latin version prepared around 1409 by Jacopo Angelo de Scarperia.[37] This work was supplied with maps, thanks to Cardinal Guillaume Fillastre, and the so-called 'new geography' became immensely popular (though there was some doubt about the very great size Ptolemy attributed to Asia).[38] Gatherings of scholars, in particular for the 1450 Papal Jubilee in Rome, encouraged more and more maps that made use of Ptolemy's ideas. One effect of these maps, which has provoked great interest among scholars concerned with the mind-set of Columbus, was to minimise the size of the globe. Though Columbus didn't accept the shortest estimates available, Samuel Morison, in his great life of the explorer, shows how, from a reconstruction of a chart by Paolo Toscanelli, a Florentine physician who was in correspondence with Columbus, fifteenth-century mapmakers had taken on board Marco Polo's observations, namely that Cipangu (Japan) was about 1,500–1,600 miles off the coast of China, with many islands in between. On this reckoning, Polo's Zaiton (the port he left from, when he journeyed home) might lie 'a little to the east of present day San Diego, California'.[39]

Valerie Flint's reconstruction of Columbus' known reading shows that, in addition to Italian, he was adept at Latin, Castilian and Portuguese and that his books – many heavily annotated to the point of defacement – fell into two broad areas. He was, as the remarks at the beginning of this chapter underline, fascinated by Asia, by the exotic people and treasures to be found there, which all reinforced his conviction that he would one day find a new route to the East. The less copious aspect of his reading was given over to how new countries might be governed and administered. This was against a general background

that you would expect for an explorer – a grounding in astronomy, arithmetic, geography, geometry, as well as history and philosophy.[40] It would appear that Columbus did not read widely, but he did read deeply. There survive five books heavily annotated by the admiral. These include the *Imago Mundi* of Pierre d'Ailly (1350–1420, bishop of Cambrai, then cardinal) which was printed in the early 1480s and claimed that in parts of the world it was day for six months followed by night for six months.[41] Columbus' copy contains 898 *postille*, or annotations. A second book, the *Historia Rerum Ubique Gestarum*, by Aeneas Silvius Piccolomini (Pius II, pope 1458–1464), had 862 annotations, and a third, *De Consuetudinibus et Conditionibus Orientalium Regionum*, produced by the Dominican friar Pipino of Bologna, in the early fourteenth century, had 366 annotations. A lot of Columbus' mental horizon can be reconstructed from these annotations. For example, we can observe Columbus as he settles on certain aspects of these books. He is very interested in the treasures they describe, in the effects of climate on human nature – he believes, for instance, that the peoples of the East, where the sun rises over them, are quicker by nature than other peoples, and 'inclined to high enterprise and to astrology'.[42] Columbus is particularly interested in any abnormalities of nature. He believes that extremes of climate may produce deformities in people, in particular cannibalism, an interest which pervades his writings. Among the monstrous and marvellous peoples, he seems to have had an abiding interest in Amazons, societies where the traditional gender and sexual roles are reversed, and where women are the leading lights.[43] He shared the feelings of many people of his age that the wearing of silk led to moral turpitude but he was fascinated by China because he believed it lay opposite Spain, across the Atlantic, with the northern part opposite Ireland.

Of course, he was interested in seafaring too, as may be imagined, and in particular ailments that might be encountered at sea. Remedies for kidney stones consist of a sea scorpion soaked in wine, or water-snakes' livers, or sea nettles also soaked in wine. Perhaps the most unexpected aspect of Columbus' reading was Plutarch's *Lives*, which was translated fully into Latin only in 1470.[44] As well as showing an interest in history, and historical biography, it seems that Columbus was looking for models of government that might be needed if he did indeed find new countries.[45] He noted instances of liberality and openness, the arrangements that induce fellow-feeling among citizens, and the amount of public display of wealth that is permissible.

So much was general background for Columbus. But there was a more immediate set of influences on his knowledge and thinking, and the first key figure here is Prince Henrique of Portugal, better known to history as Henry the Navigator. Henry's interest in navigation is said to have been stimulated by the war which Portugal waged against Morocco in 1412 when, after the Portuguese victory, Henrique was more taken by Ceuta market than anything else. 'There he saw goods that had travelled over desert routes reaching far south toward Timbuktu, in the heart of Africa, and eastward to the Red Sea. Henry came back to Portugal wondering if the ocean might not be a better highway to the south and east than the desert.' He settled down in the little town of Reposeira to study geography, astronomy and navigation, and to interview sailors from ships that anchored in the shadow of Cape St Vincent, the south-west corner of Europe.[46] It was a spot that could hardly be

bettered, for he could learn from both the Mediterranean and Atlantic traditions of seamanship.[47]

From the Mediterranean navigators came knowledge of the compass. This had been invented in China, thanks to the practice of the Chinese of always wanting to be buried lying in the most propitious direction. (Since we are alive on earth for only a short time, but lie in the ground for centuries, graves were regarded as much more important than, say, houses.) One of the ways a correct burial was achieved was by means of a special board, on which a spoon was spun. (Spoons were possibly used because their shape roughly conformed to the Great Bear in the sky, the constellation which fixes the Pole.) As the practice developed, so more precious materials were used for the sacred spoons – jade, rock crystal, lodestone. It was noticed that whereas all other materials produced variable results, lodestone spoons always ended up by pointing south. This was the basis of the compass, which was conceived around the sixth century AD, and spread gradually to the West. It replaced the very earliest method of navigation (across open sea, that is), which was to take birds on board and release them at intervals. They instinctively knew where land was and so the sailors followed them. Among other things, this was the method used to discover Iceland.[48] The great age of discovery would not have been possible without the compass.

Mediterranean ships also carried marine charts on which the course was plotted through daily records of sailing, known as dead-reckoning. These charts included a great deal of hard information, based on the conduct of regular trade. But the requirements of oceanic travel were somewhat different and this only emerged gradually. The plain fact was that the oceans were so large that the curvature of the earth became an important factor in navigation. It took time for men to realise this and it took time for them to find a solution.

The term *portolano* originally meant written sailing instructions but it was adapted to describe the Mediterranean marine charts. These portolano charts were hand-drawn, showing principal harbours, major landmarks and the intervening towns and ports, filled in according to experience. Their appearance hardly varies. Drawn on a single strip of parchment, three to five feet long and eighteen to thirty inches deep, the coastlines are in black, towns are in black, written perpendicular to the shoreline, with major features in red. There is little inland detail, save for rivers and mountain ranges.[49] Off-shore navigational hazards are marked, as dots or crosses, but no currents, depths, or tide races are given. The main aim of the cartographers at this point was to achieve accuracy in terms of distances and no account was taken of the sphericity of the earth. This did not cause much error in the Mediterranean, because it was a relatively narrow east–west sea, where the range of latitude was small.

Beginning in the middle of the fifteenth century, however, as Portuguese explorers extended their knowledge of the west African coast, and the islands of the Atlantic, there developed a demand for charts showing these parts of the globe. (The earliest Atlantic charts were produced between 1448 and 1468.) The first technical innovation of these new charts was the introduction of a single meridian, usually that of Cape St Vincent, stretching right down the chart from top to bottom, indicating degrees of latitude. Though this was an advance, the problem here was that the portolan tradition used magnetic north rather

than true north and, as exploration proceeded, this variation began to matter more and more. Some charts therefore contained a second meridian, drawn obliquely on the charts, at an angle relative to the central meridian, corresponding to the variation.[50] Maps of the late fifteenth and early sixteenth centuries show the progressive discoveries that had been made: for example, the Indonesian islands and the Moluccas – the long-sought Spice Islands – were more accurately rendered.

The earliest world chart to include both the Old World and the New is Spanish, bearing the date 1500, which was drawn up by the Biscayan cartographer and pilot Juan de la Cosa, who accompanied Columbus on his second voyage. It has no latitude marker and the two halves are drawn to a different scale. In a slightly later chart, known to historians as the Cantino chart, because it was smuggled out of Portugal by a man of that name, the outline shows the whole of west Africa and even the west coast of India, based on accounts of Vasco da Gama's discoveries, where a coastline of the New World, to the north-west of the Antilles, is clearly marked as '*Parte de Assia*'. The whole chart is headed: 'Chart for the navigation of the islands lately discovered in the parts of India.'

But the most important charts of the period were the Spanish *Padrón Real*, the official record of discoveries, first produced under royal command in 1508 and kept in the Casa de la Contratación in Seville, and continuously updated as discoveries proliferated.[51] Though none of these maps survives, some based on them, produced by Diogo Ribeiro and now in the Vatican, show that the proportions of the world were being progressively better understood. The dimensions of the Mediterranean shrink to something like their true layout, and Africa and India are more accurately represented. There is still one major error: the east–west extent of Asia, which was much elongated. People still felt that Asia was not so very far to the west of Spain.[52]

The medieval *mappae mundi*, biblically inspired, with Jerusalem at the centre and a terrestrial Paradise in the east, were becoming unrecognisable by the middle of the fifteenth century. What may be called a half-way map, which shows the evolution (rather than the revolution) of ideas, is the famous world map drawn up in Venice in 1459 by Fra Mauro. This is portolan in style; Jerusalem is central, latitudinally, but displaced to the west longitudinally, so that Europe and Asia are shown in more or less their proper proportions. Parts of Africa (*Ifriqiya*) bear Arabic place names, and Asia is shown with a number of features first described by Marco Polo. There is a continuous ocean to the south of both Africa and Asia. The monstrous races and the terrestrial Paradise have gone.

As more of the globe was discovered, so the portolan tradition began to fail navigators in more important ways. This was mixed up with the discovery of Ptolemy's *Geography*, which had attempted to cope with the curvature of the earth but at the same time posited a vast *terra incognita* in the south, beyond the torrid zone. It was now realised that there was no torrid zone, not in the ancient sense, and no *terra incognita*, at least in the sense of a whole continent connected to Africa or Asia.

The first printed map to show America, that produced by Giovanni Matteo Contarini in 1506, does show the curvature of the earth, while at the same time displaying the new world in three parts – the north joined to Cathay, the West Indies as a group of islands not far from Japan, and Terra Crucis, South America, as an entirely separate (and huge) continent in the south. A year later Martin Waldseemüller produced his famous world

map, twelve sheets drawn on a single cordiform projection, with its title describing it as 'according to the tradition of Ptolemy and the voyages of Amerigo Vespucci and others' (this is the first map to use the word America to describe the New World). It shows the Old World landmass as occupying 230° of longitude, but Waldseemüller later abandoned Ptolemy and produced maps which showed Asia in its more or less proper proportions.[53]

But Ptolemy's influence lived on in the inspiration he provided for those who sought to improve navigational techniques as the curvature of the earth came to be better understood. The first man to explore this problem was Pedro Nunes, a Portuguese mathematician and cosmographer. Though he never reached the point of actually projecting a chart, others did, in particular the Fleming Gerhard Kremer, or Mercator. Mercator was a land surveyor, and engraver, a maker of mathematical and astronomical instruments, as well as a cartographer. He was the most learned geographer of his day (he made an edition of Ptolemy, among other works), but his fame rests on his world map, which was very large, made up of twenty-four sheets.[54] It was drawn up to his new projection which, though modified many times since, still bears his name. The basic principle of the map is a graticule (or grid) of latitudes and longitudes, drawn as parallel straight lines. But Mercator overcame the effect of the curvature of the earth by increasing the length of the degree of latitude on his map progressively towards the poles in the same proportion that, on a curved surface, the meridians converge. In the phrasing of the time this meant that his maps had 'waxing latitudes'. In this way the correct relationship of angles between one place and another was preserved, and meant that navigators could plot courses as straight lines on their charts. Mercator's projection was, in a sense, a theoretical breakthrough, in that it introduced stability into navigation without, as it were, corresponding increases in the quality of the maps on which it was used. Longitude was still an impossibility at sea and, for the most part, throughout the sixteenth century the world was being discovered by sailors and explorers who did not know how to plot their discoveries on a chart. Mercator's map perpetrated one outlandish mistake, as John Noble Wilford puts it – the Greek concept of a great southern continent, *Terra Australis*, which covered the pole and extended north as far as South America and South Africa.[55]

None of this was made any easier by the fact that, once at sea, time-keeping was difficult and troublesome. Ships generally operated a two-watch system, each of four hours. The passage of time was measured by sandglasses, turned every half-hour and marked by a chant sung by the boy of the watch. (Made chiefly in Venice, these sandglasses were very fragile and numerous spares were carried – Magellan's ship had eighteen of them, just in case.) Noon was established by means of a compass card which produced a shadow that shortened, and then lengthened.[56]

Steering presented a problem, at least until the eighteenth century. There was a long tiller, mortised to the head of the rudder. The helmsman could usually not see where the ship was going and the course was called out to him by the officer of the watch. Rudders were of little use in a following sea, or even one that was beam-on, and in storms as many as fourteen men might be needed to hold the tiller steady. In the seventeenth century a whipstaff was introduced – this was a long lever working with a fulcrum set in the quarter-deck, and attached to the tiller by a ring. This allowed the helmsman to watch the sails and gave him some extra leverage, but again it was less than perfect in rough weather.

Eventually a yoke was fitted to the head of the rudder and lines were led through a series of blocks to a horizontal drum on the quarter-deck, which could be rotated by a wheel. But the ship's wheel did not appear until the eighteenth century.[57]

In addition to the compass (first used in Europe, by tradition, at Amalfi) there was the lead and line. By using a deep-sea lead and line the seaman could get an early indication of land – it was known that the sea descended to a depth of about 100 fathoms (600 feet) off Europe, then dropped precipitously to much, much deeper levels. Seamen learned that, off Portugal for instance, the continental shelf extended for about twenty miles, while further north, off Britain say, it extended for about a hundred miles. The lead weighed about fourteen pounds and was attached to a 200-fathom line, marked at twenty, then every ten, fathoms with knots indicating the marks. Off a familiar coast, soundings also aided position – seamen learned to remember patterns of the sea bottom. The lead was sometimes hollow and the detritus picked up also helped knowledgeable captains work out where they were.[58] Other aids included the *Compasso da Navigare*, a comprehensive pilot book, covering the whole of the Mediterranean and the Black Sea, which had been compiled by the late thirteenth century. These types of book came into use in the north much later, where they were known as *routiers* or, in English, 'rutters'. By the sixteenth century they gave detailed records of soundings.[59]

As ships ventured into the open sea, pilotage was replaced by navigation proper and one of the early problems here was that there was no way of measuring speed. The earliest method was a piece of wood tied to a rope that was knotted at intervals. When the 'log' was released the speed at which the knots ran out over the stern of the ship was timed with a sandglass. This was not very accurate and many sailors – Columbus included – regularly overestimated their speed. Calculation was not made any easier by ignorance of ocean currents but there were tables in place, from the late thirteenth century, which enabled navigators to work out how their position was affected when they tacked before the wind. Rudimentary knowledge of speed helped navigation by dead reckoning but the longer an ocean voyage went on, without knowledge of currents and tides, the greater the inaccuracies that could be expected. The only alternative was navigation by the heavens. The most prominent feature in the night sky was the Pole Star, whose height above the horizon grew less the further south one sailed. This is where the quadrant came in, to provide a reading of latitude. In Columbus' lifetime, a degree of latitude was reckoned to be $16\frac{2}{3}$ leagues (roughly fifty miles), a considerable error, traceable to Ptolemy. After about 9° N the Pole Star was lost sight of altogether but other stars, whose angular distance from the Pole Star was known, could then be used. The disappearance of the Pole Star of course confirmed (for those who didn't accept other evidence) that the earth was round.

One final factor was that, with navigation by the heavens, and latitude sailing, the variation between true north and magnetic north became more important, requiring the navigator to relate his course to the true, not the magnetic, north. It was at first assumed that the variation was consistent and systematic (and that a meridian without variation ran through the Azores). As time went by, however, experience in the great oceans of the world – the Indian and the Atlantic – showed that the picture was much more complex than that. Only the combined experience of sailors throughout the sixteenth century eventually produced the true picture, which required local knowledge recorded in

almanacs. Longitude remained an even more intractable problem, because it was bound up with speed and time. The problem is that, with the curvature of the earth, the distance of longitude varies: at the poles it is zero, at the equator it is nearly equal to a degree of latitude. If one knew one's latitude, therefore, one could in theory work out a degree of longitude, but again it was useful only if one could measure one's speed accurately, and that required accurate time-keeping. Essentially, as J. H. Parry has remarked, throughout the fifteenth and for most of the sixteenth century, navigation in the open ocean was a matter of dead-reckoning 'checked and supplemented by observed latitude'.[60]

In the short space of about twenty years, in the middle of the fifteenth century, a major revolution took place in shipping.[61] This was a marriage between the lateen-rigged Mediterranean ships and the square-rigged north Europe–Atlantic ships. 'The marriage produced the basic barque, the direct ancestor of all the square-riggers of the [age of] Reconnaissance and the later great age of sail.'[62]

The principal warship of the Mediterranean was the oared galley, which remained a component of Mediterranean navies until the seventeenth century.[63] Its main drawback was the large crew it required, making it unsuitable for long voyages out of sight of land. The other main idea in Mediterranean sailing had been taken from the Arabs – this was the lateen sail. The only type of sail seen on Arab ships, the lateen sail is essentially triangular, laced to a forward-leaning mast and a long yard. Whether or not the Arabs invented it, the lateen was spread through them, both in the Indian Ocean and in the Mediterranean. Its shape made the most of whatever wind was going and as a form of rig it was very versatile and made ships more manoeuvrable.[64]

The other tradition, that of the Atlantic seaboard nations of northern Europe, produced sturdier, tubbier more buoyant ships, with a single, massive, square sail. Known as 'cogs', they were clumsy and slow, to begin with at least, but had capacious holds and required far fewer men to man them. One calculation has it that fifty men were required in lateen-rigged ships to do the work done by twenty men in square-rigged northern cogs.

Fifteenth-century ships made use of both rigs – square forward and lateen aft. There were other changes, to the shape of the keels and to the superstructure, but the rigging and crewing requirements would prove the most important factors in the great discoveries of the world. The two most important forms of this 'marriage' were the carrack and the caravel. Carracks were huge by the standards of the day – 600 and even 1,000 tons. Caravels were much smaller – sixty or seventy tons – and faster. They were lateen-rigged, more convenient for exploring estuaries and islands, and they turned out to be very safe, despite their small size. Columbus took two caravels with him on the first voyage, of which one, the *Niña*, was lateen-rigged. She never gave any trouble and was used on the second voyage as well.

As well as helping to bring together the work of astronomers, sailors and geographers, Henry the Navigator and his brother, Prince Pedro, placed gentlemen from their households in personal command of their ships and instructed them to be more ambitious in their aims, demanding longer voyages, more detailed reporting, greater effort all round in pushing expeditions as far and as fast as they could go. Under Henry's patronage Portuguese

ships rounded Cape Bojador in 1434, Cape Branco in 1442, and the mouth of the Senegal river in 1444. In the same year Cape Verde was reached and two years later the mouth of the Gambia. Sierra Leone was discovered in 1460. Muslims and naked pagans were found on these shores, together with markets, where ostrich eggs and the skins of baboons were sold. The explorers saw elephants, hippopotamus and monkeys. Benin produced slaves and strong pepper.

The death of Henry, in 1460, temporarily halted exploration, though there was the added reason that, by the time Sierra Leone had been reached, the Pole Star was so low in the sky that sailors feared for their navigating abilities if it disappeared altogether. In 1469, however, the Crown leased Guinea to a private individual, Fernão Magalhães, who undertook to explore a hundred leagues of coastline annually for the five years of his lease. In those five years the Portuguese got as far as Cape St Catherine (in what is now Gabon), sited at 2° S. In a way, these discoveries were disappointing, because they showed that Africa extended much further south than many had hoped, which meant that an easy passage to India was less and less likely. King John II was not deterred, however, and he sponsored a series of further expeditions down the African coast. Bartolomeu Dias left Lisbon in 1487, and reached 40° S (the Cape of Good Hope is 34° S) before turning east, and then north, and making landfall in Mossel bay, between what is now Cape Town and Port Elizabeth. He had reached the cape without sighting it and Dias' people, tired and worried about their lack of provisions, persuaded him to turn back. On his way home he sighted the great cape and surmised that, without realising it, he had discovered the route to India. He got back to Lisbon in December 1488. He called the cape the Cape of Storms but it was the king, according to tradition, who changed its name to the Cape of Good Hope.[65]

Vasco da Gama's epic voyage did not leave Lisbon until July 1497, nearly eight years after Dias' return. J. H. Parry argues that during the interval many voyages, whose records have since been lost, must have been made in the south Atlantic during this time, and that da Gama's expedition made use of the knowledge amassed on these journeys. Parry maintains this because da Gama's expedition was at sea in the Atlantic for thirteen weeks without sighting land, 'by far the longest passage made until then by European seamen'.[66] Da Gama rounded the cape, provisioned from the store ship he had with him in Mossel bay, and then pushed on north. He gave the name Natal to the coast they passed at Christmas time, and eventually reached Mozambique and the area of Muslim influence. He was forced to use gunfire to repel boarders at Mombasa but found a better welcome at Malindi on what is now the Kenyan coast, at about 3° S. By great good fortune, da Gama secured the services of Ahmad ibn Majid, the best-known Arab navigator of his day, and the author of a collection of rutters and nautical instructions known as *Al Mahet*, who took the Portuguese across the Indian Ocean, to Calicut, which was reached in May 1498. Wherever da Gama went in the East he was disappointed to find that the Muslims had beaten him to it. In addition, he found that the goods he was travelling with – cloth and hardware that were popular on the coast of *west* Africa – were not at all suitable in the East. It was only with great difficulty that he managed to put together a return cargo of pepper and cinnamon. His journey back across the Indian Ocean met ferocious storms but once in the Atlantic he made good time and reached Lisbon in September 1499. He

had been at sea for three hundred days and lost more than half his company. The great church and monastery of Jerónimos at Belem was built in his honour.[67]

Columbus, the son of a weaver in Genoa, had sailed in Portuguese ships as far as Guinea, but he was less a professional seaman than an 'extremely persuasive geographical theorist'.[68] The agreement which sanctioned his voyage in 1492 stipulated that he was to 'discover and acquire islands and mainland in the ocean sea'. India had not yet been reached by way of the Cape and this was understood to mean Cipangu and Cathay. Such an expectation was by no means extraordinary: the earth was known to be round and there was no suspicion of intervening continents. Columbus had first made his proposal to the Portuguese Crown in 1484. He was turned down, and by the French and the English. He tried a second time with the Portuguese, and on this occasion, in 1488, he might have been successful but for the coincidence of Dias' triumphant return, which diverted all energies and attention. Columbus turned, therefore, to Castile. Here he was at last successful, finding support from the Crown and from wealthy individuals. He set sail on the 'Sea of Shadows' from Palos in August 1492.[69]

Modern scholarship has it that Columbus was not a very up-to-date navigator, but he was careful and meticulous. His course took him due west of the Canaries (27° N), though his later voyages were further south, where the winds were more reliable. But on that first voyage he was fortunate and, after thirty-three days of sailing, seeing nothing but weeds and birds, he sighted the outer cays of the Bahamas (San Salvador is 24° N). There is no question but that Columbus thought these cays were the outlying islands of an archipelago of which Japan formed a part. (This is exactly what Martin Behaim's 1492 globe depicts.) It was a combination of Marco Polo's errors (the east–west extent of Asia), the same man's mistaken report that Japan was 1,500–1,600 miles from China, and Ptolemy's underestimate of the size of the earth (25 per cent smaller than reality). Thus Columbus thought that Europe to Japan was about 3,000 miles, when in fact it is 10,600 nautical miles.*

The next step, therefore, was to find Japan itself. Columbus pressed on, found Cuba, and Hispaniola (the modern Haiti and Dominican Republic). The latter yielded a little alluvial gold, while gold nose-plugs and bracelets were obtained by barter from the 'natives'. After losing his flagship, wrecked by grounding, he decided to return home, leaving a few men behind with instructions to build a base and look for gold mines. On this return journey Columbus found that he needed to travel further north, near the latitude of Bermuda (32° N), to pick up the westerly wind. Approaching Europe, Columbus encountered heavy storms and was eventually forced to seek refuge in Lisbon harbour. The Portuguese interrogated him but remained sceptical about his story, having encountered Italian exaggeration before.[70] Still, they laid claim to his discoveries just in case.

The Spanish were no less careful. They instructed him to make a second voyage as quickly as possible, and to forestall the Portuguese claims they sought papal recognition for a monopoly of settlement and navigation. Since the pope of the time was himself

---

* A nautical mile, one minute of the great circle of the earth, is equal to 2,025 yards, roughly 15 per cent greater than a statute mile, 1,760 yards.

Spanish, this support was not difficult to obtain. On his second voyage, begun in September 1493, Columbus discovered Dominica, the Virgin Islands, Puerto Rico and Jamaica. The third, in 1498, was made without volunteers – instead, men had to be pressed, or released from prison. He went further south this time, and discovered Trinidad and the mouth of the Orinoco. The river was much larger than any other known to Europeans and the amount of fresh water it brought down showed how big the continent of which it was a part must be. And he toyed with the idea that it was too far south to form part of Asia. Columbus then turned north but at Hispaniola he found the men he had left there in open revolt. He was never as good a governor as he was an explorer and was himself sent home in irons. He was allowed one more voyage, in 1502, when he discovered the mainland at Honduras and Costa Rica. He died in 1506.[71]

By now it was beginning to dawn on people that the many islands that had been discovered were not part of the archipelago off Cathay, which was much further away. The discovery of the Orinoco was the first inkling that there was a whole continent in between. As early as 1494 Peter Martyr wrote, 'when treating of this new country one must speak of a new world, so distant is it and so devoid of civilisation and religion'.[72]

In the years ahead the English and Portuguese would discover North America (no silk or spices) and, gradually, the immense extent of South America was unveiled. Interest in the East began to wane as pearls were discovered off Venezuela, a valuable red dye in brazil-wood, and cod off Newfoundland. Eventually, in September 1519 Fernão Magalhães, or Magellan, sailed from Seville with a fleet of five ships laden with goods the Portuguese had found useful for trading in the East. He shared with Columbus the fact that he was a foreigner in command of awkward Spaniards.[73] Following a mutiny in Patagonia, which required Magellan to hang the ringleaders, and after losing two ships in the strait that bears his name, he arrived in the Pacific. The crossing of this vast ocean seemed as if it would never end and the men were reduced to eating rats and raw leather. They made landfall at Cebu in the Philippines, where they were involved in a local war. Forty men, including Magellan himself, were killed.

Magellan shares with Columbus and Vasco da Gama the title of greatest explorer but we should never forget that his own journey ended when he was only half-way round the world. It was completed by Sebastián del Cano, who avoided the Portuguese men-of-war in the area, crossed the Indian Ocean, rounded the Cape of Good Hope, and arrived back in Spain with one ship, the *Victoria*, and fifteen men, out of five ships that had left. It was, arguably, the greatest voyage of all time. And it changed the way men thought about their world.

# The 'Indian' Mind:
# Ideas in the New World

In many ways, the events of 1492 were as much an end as a beginning. If one accepts the evidence that, some time between 18,000 and 12,000 years ago, early man crossed from Siberia into the Americas, via the Bering Strait, then the epoch between that time and the close of the fifteenth century represents a unique natural experiment, when there were two huge groups of people, on two vast landmasses – what we might call the Old World and the New – entirely separated from one another and developing side-by-side, oblivious to the existence of each other. Such a state of affairs, though it has a great deal of short-comings as a perfectly designed experiment, ought still to tell us a great deal about what is intrinsic to human nature, and what can be put down to environment. The same goes for ideas: what ideas were shared by the Old World and the New, and what were specific to each? Why was that so?

Equally fundamental is the question: Why was it that the Europeans discovered America rather than the other way around? Why did the Incas, say, not cross the Atlantic from west to east and subdue the Moroccans or Portuguese? This issue has been examined recently by Jared Diamond, a professor of physiology at California Medical School but also an anthropologist who has worked in New Guinea, and who won the Rhône-Poulenc Science Book Prize in 1998 for *Guns, Germs and Steel*. Examining the evidence, Diamond found that the answer lay in the general layout of the planet, in particular the way the continents are arranged over the surface of the globe. Simply put, the continents of the Americas and Africa have their main axis running north–south, whereas in Eurasia it is east–west. The significance of this is that the diffusion of domesticated animals and plants is much easier from east to west, or west to east, than from north to south, or vice versa, because similar latitudes imply similar geographical and climatic conditions, such as mean temperatures, rainfall or hours of daylight. Diffusion from north to south, or south to north, on the other hand, is correspondingly harder to achieve and this simple geographical fact of life, Diamond says, inhibited the spread of domesticated animals and plants. Thus the distribution of cattle, sheep and goats was much more rapid, and thorough, in Eurasia than it was in either Africa or the Americas. In this way, he argues, the dispersal of farming meant the build-up of greater population densities in Eurasia as opposed to the other continents, and this had two further effects. First, competition between different societies fuelled the evolution of new cultural practices, in particular the development of weapons,

which were so important in the conquest of the Americas. The second consequence was the evolution of diseases contracted from (largely domesticated) animals. These diseases could only survive among relatively large populations of humans, and when they were introduced to peoples who had developed no immune systems, such as the Incas or the Aztecs, they devastated them. Thus the global pattern was set, says Diamond. In particular, Africa, which had 'six million years' start' in evolutionary terms compared with other parts of the world, failed to develop because it was isolated by vast oceans on three sides and desert on the north, and had few species of animals or plants that could be domesticated along its north–south axis.[1]

The same was true of the Americas. Apart from the Bering Strait, it too was surrounded by vast oceans and had few animals and plants that could be domesticated. The Americas had a relatively small area of Mediterranean climate, meaning a smaller variety of annuals, and its north–south orientation meant that farming practices spread relatively slowly. As compared with Eurasia, for example, which had thirty-three species of large-seeded grasses, the Americas had only eleven. Of the animal species that have been domesticated, Eurasia has thirteen (out of seventy-two species of mammal available), whereas the Americas have just two (out of a total of twenty-four species of mammal). As a result the New World was 'held back'. Writing was invented in Mesopotamia before 3000 BC but in Mesoamerica not until 600 BC. Pottery was invented in the fertile crescent and China about 8000 BC but in Mesoamerica not until 1250 BC. Chiefdoms arose in the fertile crescent around 5500 BC and but not in Mesoamerica until around 1000 BC.[2]

Diamond's account, though it has been criticised for being speculative, which it undoubtedly is, does if accepted bring a measure of closure to one area of human thought, showing why different peoples had reached different stages of development by 1500 AD.

The discovery of America was important intellectually for Europeans because the new lands and peoples challenged traditional ideas about geography, history, theology, even about the nature of man.[3] Insofar as America proved to be a source of supply for goods for which there was a demand in Europe, it had an economic and therefore a political significance. 'It is a striking fact,' wrote the Parisian lawyer Étienne Pasquier, in the early 1560s, 'that our classical authors had no knowledge of all this America, which we call New Lands.'[4] 'This America' was not only outside the range of Europe's experience but was beyond *expectation*. Africa and Asia, though distant and unfamiliar for most people, had always been known about. America was entirely unexpected and this helps explain why Europe was so slow in adjusting to the news.

Adjustment is the key word. There was, to begin with, and as John Elliott reminds us, plenty of excitement provoked by the news of Columbus' landfall. 'Raise your spirits ... Hear about the new discovery!' wrote the Italian humanist Peter Martyr in a letter to the archbishop of Granada on 13 September 1493. Christopher Columbus, he reported, 'has returned safe and sound. He says that he has found marvellous things, and he has produced gold as proof of the existence of mines in those regions.'[5] Martyr then explained that Columbus had found men who were 'gentle savages', 'who went around naked, and lived content with what nature had given them. They had kings; they fought among each other with staves and bows and arrows; although they were naked, they competed for power,

and they married. They worshipped the celestial bodies, but the exact nature of their religious beliefs was unknown.'[6]

Some measure of the initial impact of Columbus' discoveries can be had from the fact that his first letter was printed nine times in 1493, and reached twenty editions by the end of the century.[7] The Frenchman Louis Le Roy wrote 'Do not believe that there exists anything more honourable ... than the invention of the printing press and the discovery of the new world; two things which I always thought could be compared, not only to antiquity but to immortality.'[8] In 1552, in his *General History of the Indies*, Francisco López de Gómara (not always a reliable chronicler) provided the most famous verdict on 1492: 'The greatest event since the creation of the world (excluding the incarnation and death of Him who created it) is the discovery of the Indies.'[9]

Yet John Elliott rightly warns us that there was another side, that many sixteenth-century writers had a problem seeing Columbus' achievement in its proper historical perspective. For example, when Columbus died in Valladolid, the city chronicle failed to mention his passing.[10] Only slowly did Columbus begin to attract the status of a hero. A number of Italian poems were written about him but not until a hundred years after his death, and it was not until 1614 that he featured as the hero of a Spanish drama – this was Lope de Vega's *El Nuevo Mundo descubierto por Cristóbal Colón*.[11]

To begin with, interest in the New World was confined to the gold that might be found there and the availability of vast numbers of new souls for conversion to the Christian faith. Generally speaking, however, book readers were more interested in the Turks and in Asia than in America.[12] As late as the last two or three decades of the sixteenth century, the world was still thought of as having the layout laid down in the classical cosmographies of Strabo and Ptolemy. (Columbus appears to have used a version published by Aeneas Sylvius in the 1480s.[13]) In some senses the Renaissance itself was to blame: thanks to the humanists, antiquity was revered rather than the new.[14]

The men who first travelled to the New World were soldiers, clerics, merchants and officials trained in law and to them fell the initial task of observing what they saw. One effect was that the physical landscape of the Americas was ignored at the expense of detailed descriptions of the native inhabitants.[15] Columbus himself, when he first set eyes on the inhabitants of the Indies, was somewhat disappointed to find that they were not in any way 'monstrous or physically abnormal'.[16] He noted how 'poor' they were.[17] At the same time they were neither Negroes nor Moors, the races most familiar to medieval Christendom. How then did they fit into the biblical account?[18] Was the New World Eden perhaps, or Paradise? Early accounts all dwelt on the innocence, simplicity, fertility and abundance of the natives, who went around naked without any apparent feelings of shame.[19] This was a view especially seductive to religious figures and to humanists. Angered and despairing at the state of the European church, members of the religious orders saw in the New World a chance to found afresh the primitive church of the Apostles in a continent uncorrupted by the vices of European civilisation.

In 1607, Gregorio García, a Spanish Dominican, published a wide-ranging survey of the many theories that had been conceived to explain the origins of the 'Indians' of America. Sixteenth-century Europeans believed in 'a designed world' into which America must be

incorporated. But that still left a lot to be explained. García advocated that man's knowledge 'of any given fact' derived from one of four sources. Two of these – divine faith, as revealed through the scriptures, and *ciencia*, which explained a phenomenon by its cause – were infallible. The origin of the American Indians was a problem because the matter was not discussed in the scriptures, 'and the problem too recent to have allowed the amassing of any corpus of convincing authority'.[20]

If the problem of fitting the New World into the scheme of history as outlined in the scriptures was the most intractable of matters, explorers and missionaries alike found that, if evangelisation were to proceed, some understanding of the customs and traditions of the native peoples was required. Thus began their often-elaborate inquiries into Indian history, land tenure and inheritance laws, in a sense the beginning of applied anthropology.[21] The early missionaries, fortified by a naïve belief in the natural goodness of man, assumed that native minds were 'simple, meek, vulnerable and virtuous' or, in the words of Bartolomé de las Casas, *tablas rasas*, blank slates, 'on which the true faith could easily be inscribed'.[22] The missionaries were to be disappointed. In his *History of the Indies of the New Spain* (1581), the Dominican fray Diego Durán argued that the Indian mind could not be changed or corrected 'unless we are informed about all the kinds of religion which they practiced ... And therefore a great mistake was made by those who, with much zeal but little prudence, burnt and destroyed at the beginning all their ancient pictures. This left us so much in the dark that they can practice idolatry before our very eyes.' Such a view became the justification for the detailed surveys of pre-conquest history, religion and society undertaken by clerics in the later sixteenth century.[23] The Spanish Crown was intimately involved and in the process introduced the questionnaire, bombarding their officials in the Indies with this new tool of government.[24] The most famous were those drafted in the 1570s at the behest of the president of the Council of the Indies, Juan de Ovando. This was a time when the urge to classify was beginning to grow in every field of knowledge, and knowledge about America was part of the trend.[25] In 1565, Nicolás Monardes, a doctor from Seville, wrote his famous study of the medicinal plants of America, which appeared in John Frampton's English translation of 1577 under the title of *Joyfull Newes out of the New Founde Worlde*.[26] In 1571, Philip II sent an expedition to America under the leadership of the Spanish naturalist and physician Dr Francisco Hernández, to collect botanical specimens in a systematic way (but also to assess the capacity of the Indians to be converted).[27] In the same year, the Spanish Crown created a new post, that of 'Cosmographer and Official Chronicler of the Indies', though there was a political as well as a scientific reason for this initiative. The political motive was to provide a detailed account of Spanish achievements in the New World, to counteract foreign criticisms, and at the same time it was felt that the science was necessary to reduce the widespread ignorance of the councillors of the Indies about the territory they had responsibility for.[28]

But it was not until 1590, a full century after Columbus' discovery, with the publication in Spanish of José de Acosta's great *Natural and Moral History of the Indies*, that the integration of the New World into the framework of Old World thought was finally cemented.[29] This synthesis was itself the crowning achievement of a century of intellectual transformation, in which three very different aspects of the New World were incorporated

into the European mind-set. There was first the American landmass, as a totally unexpected addition to the natural world.[30] There was the American Indian, who had to be incorporated into the European/Christian understanding of humanity. And there was America as an entity in time, whose very existence transformed Europe's understanding of the historical process.[31] All this was, first and foremost, a challenge to classical learning.[32] According to the Bible, and to experience, there were three landmasses in the world – Europe, Asia and Africa – and to change this idea was as fundamental a break with tradition as the idea that there wasn't a torrid zone in the southern hemisphere. Moreover, the Bering Strait was not discovered until 1728. Until then it was not clear whether America formed part of Asia or not. When, in 1535, Jacques Cartier encountered rapids in the St Lawrence river above the site of what would become Montreal, he named them *Sault La Chine*, the Chinese Rapids. A century later, in 1634, Jean Nicolet, a French adventurer, was sent west to investigate rumours of a great inland sea, which led to Asia. When he reached lake Michigan and saw ahead of him the cliffs of Green bay he thought he had reached China and put on a robe of Chinese silk in their honour.[33] Classical learning was of no use either for interpreting the discoveries of the New World. How could it, if the great authors of antiquity were entirely unaware of the landmass? Time and again, the discoveries of the New World proved the superiority of personal observation over traditional authority. This too was a major mind shift.[34]

One of the most powerful – if implicit – ideas at the time of the discovery of America was the dual classification of mankind, whereby peoples were judged in accordance with their religious affiliation (Judaeo-Christian, or pagan) or their degree of civility or barbarity.[35] Inevitably, this had to be modified in the sixteenth century. As to the Indians' civility, this appears largely to have depended upon whether or not the observers had actually seen one. Anyone with prolonged contact with the native American was much less likely to maintain the idea of the innocent primitive.[36] Dr Chanca, who accompanied Columbus on his second voyage, observed the Indians of Hispaniola eating roots, snakes and spiders and concluded: 'It seems to me that their bestiality is greater than that of any beast in the world.' This paradox – whether or not the Indian was a beast or an innocent – was one of the main issues in the early literature of discovery and settlement. If the Indian was not a man then he had no capacity for faith. In *Sublimis Deus*, his bull of 1537, Paul III had this in mind when he declared that 'the Indians are true men'. Christians defined man by his ability to receive divine grace. The classical definition of man, on the other hand, was as a rational being. After *Sublimis Deus*, most Christians accepted that the native peoples of America could be classified as human on both grounds.[37]

Just how rational the Indians were was, however, open to doubt. Fernández de Oviedo (who had an abiding interest in the epics of chivalry from the Middle Ages) was convinced the Indians were an inferior form of being, 'naturally idle and inclined to vice'.[38] He discovered signs of their inferiority, he thought, in the size and thickness of their skulls, which he felt implied a deformation in a part of the body associated with a man's rational powers.[39] Fray Tomás de Mercado, in the 1560s, classified Negroes and Indians likewise as 'barbarians' because 'they are never moved by reason, but only by passion'. It was not far from there to the notorious theory of 'natural slavery'. This too was a major issue of the time. Pagans in the sixteenth century were divided into two, the 'vincibly ignorant' (Jews

and Muslims, who had heard the true word, and turned away from it), and the 'invincibly ignorant', those like the Indians who had never had the opportunity to hear the word of God, and therefore couldn't be blamed. This soon became corrupted, however, as people like the Scottish theologian John Mair argued that some people were by nature slaves, and some by nature free.[40] In 1512 King Ferdinand of Spain summoned a *junta* to discuss the legitimacy of employing native labour. Such documentation as has survived shows that many at the time argued that the Indians were barbarians and therefore natural slaves. But this was 'qualified slavery', as Anthony Pagden describes it. The Spanish had a convention, the *encomienda*, under which the Indians, in return for hard labour, would learn through Spanish example how to live 'like men'.[41] This was refined still further around 1530, by what came to be known as the 'School of Salamanca', a group of theologians that included Francisco Vitoria and Luis de Molina. They developed the view that if the Indians were not natural slaves then they were 'nature's children', a less developed form of humanity. In his treatise *De Indis*, Vitoria argued that American Indians were a third species of animal between man and monkey, 'created by God for the better service of man'.[42]

Not everyone shared these views, however, and others, more sympathetic to the Indian, sought signs of his talent. The most accurate account of this clash of civilisations, on *either* side, says Ronald Wright, was written by some Aztecs for Friar Bernardino de Sahagún in the 1550s, and is now known as Book 12 of the Florentine Codex. The authors were anonymous, possibly to shield them from the Inquisition. However, the very search for these signs of Indian virtue and talent, says John Elliott, helped to shape the sixteenth-century idea of what constituted a civilised man. Bartolomé de las Casas, for instance, pointed out that God works through nature, and on these grounds alone Indians were God's creatures and therefore available to receive the faith. He drew attention to Mexican architecture – 'the very ancient vaulted and primitive-like buildings' – as 'no small index of their prudence and good polity'. This was roundly rejected by Ginés de Sepúlveda, who pointed out that bees and spiders produced artefacts that no man could emulate.[43] But there were many other aspects of Indian social and political life which impressed European observers. 'There is,' wrote Vitoria in the 1530s, 'a certain method in their affairs, for they have polities which are orderly arranged and they have definite marriage and magistrates and overlords, laws, and workshops, and a system of exchange, all of which call for the use of reason; and they also have a kind of religion.'[44]

This was more important than it might seem. Rationality, especially the ability to live in society, was held to be the criterion of civility. But if this could happen outside Christianity, what happened to the age-old distinction between Christian and barbarian? 'Inevitably it began to be blurred, and its significance as a divisive force to decline.'[45] Las Casas took the surprisingly modern view that all men have a place in an historical scale which is the same for everyone and that those near the bottom of this scale are simply 'younger' than those further up. In other words, he was groping towards a cultural evolutionary view of man and society.

Even when it didn't produce startlingly new ideas, the discovery of America forced Europeans back on themselves, causing them to confront ideas and problems which existed inside their own cultural traditions. For example, the veneration for classical antiquity

meant that they were aware of other civilisations which had different values and attitudes to their own and in many ways had been superior. In fact, it was the existence and success of pagan antiquity which underpinned the two most notable treatises of the sixteenth century which attempted to incorporate America within a unified vision of history.

The first of these, Bartolomé de las Casas' massive *Apologética Historia*, was written during the 1550s, never published in his lifetime and not rediscovered until the twentieth century. It was written in anger and in response to Sepúlveda's savage polemic against the Indians, *Democrates Secundus*, in which he compared Indians to monkeys.[46] In fact, the two men staged a famous debate in Valladolid, in August or September 1550, Las Casas arguing that the Indian was an entirely rational individual, fully equipped to govern himself and therefore fit to receive the gospel.[47] Using Aristotle as his guide, Las Casas examined the Indian from the physical and the moral standpoint, which marks his essay as perhaps the first exercise in comparative cultural anthropology. The political, social and religious arrangements of the Greeks, Romans and Egyptians, ancient Gauls and ancient Britons, were examined alongside those of the Aztecs and the Incas.[48] According to Las Casas, the New World peoples did not suffer by this comparison. He paid proper due to the quality of Aztec, Inca and Mayan art and observed their ability to assimilate European ideas and practices that they found useful.

José de Acosta's *De Procuranda Indorum Salute* was written a little later than Las Casas' treatise, in 1576. His most original contribution, which advanced the understanding of anthropology, was, first, to divide barbarians into three categories, and then to distinguish three kinds of native. At the top, he said, were those who, like the Chinese and Japanese, had stable republics, with laws and law courts, cities and books. Next came those who, like the Mexicans and Peruvians, lacked the art of writing and 'civil and philosophical knowledge', but possessed forms of government. Lowest were those who lived 'without kings, without compacts, without magistrates or republic, and who changed their dwelling-place, or – if they were fixed – had those that resembled the cave of a wild beast.'[49] Acosta based his work heavily on research, as we would say, which enabled him to distinguish between the Mexica and the Inca, who formed empires and lived in settlements and did not 'wander about like beasts', and the Chuncos, the Chiriguanes, the Yscayingos and all the peoples of Brazil who were nomadic and lacked all known forms of civil organisation.[50] He also thought that the Indians lived in fear of their gods – an important difference, he said, between Christianity and paganism. The fact that Indians had some laws and customs, but that they were deficient or conflicted with Christian practices, showed he said that Satan had beaten Columbus to it in the discovery of the New World.[51]

Again, these arguments are more important than they look at first sight. The old theories, that geography and climate were primarily responsible for cultural diversity, were being replaced. A new issue was migration. 'If the inhabitants of America were indeed descendants of Noah, as orthodox thought insisted that they must be, it was clear that they must have forgotten the social virtues in the course of their wanderings. Acosta, who held that they came to the New World overland from Asia, believed that they had turned into hunters during their migration. Then, by degrees, some of them collected together in certain regions of America, recovered the habit of social life, and began to constitute polities.'[52] The importance (and the modernity) of this argument lay in its hypothesis or

assumption that there was a sequence of development from barbarism to civility. This
further implied that the ancestors of modern Europeans had once been like the fifteenth-
and sixteenth-century inhabitants of America. The natives of Florida, according to Las
Casas, were still 'in that first rude state which all other nations were in before there was
anyone to teach them ... We ought to consider what we, and all the other nations of the
world were like, before Jesus Christ came to visit us.'[53] By the same token, the existence of
primitives in the New World appeared to support the Judaeo-Christian idea of time, that
it was linear rather than cyclical.[54]

A final element in the discovery of America was the notion that the moderns had
achieved something that had not been achieved by antiquity. The idea of a distant golden
age was thus undermined, at the same time that the discoveries demonstrated incon-
trovertibly the value of first-hand experience over inherited tradition. 'The age which they
call golden,' wrote Jean Bodin, the sixteenth-century French philosopher, 'if it be compared
with ours, would seem but iron...'[55]

So much for the European perspective, and the immediate effects of the discovery of
America (some longer-term effects are discussed later, in Chapter 28). But, in the realm of
ideas, what exactly did the Europeans discover? It took many years – centuries – to answer
that question but, in 1986, the D'Arcy McNickle Center for the History of the American
Indian, which had been created in 1972 to improve the quality of research and teaching in
Indian history, commissioned an inquiry into just this subject, *America in 1492*, to mark
the 500th anniversary of the discovery of the New World in 1992. Much of what follows is
based on the findings of that project.[56]

In 1492, there were around 75 million Indians living in the Americas. Figures for what
is now the continental United States vary. The D'Arcy McNickle figure is 6 million but
Douglas Ubelaker, of the Smithsonian Institution, in the *Handbook of North American
Indians*, says the most accurate estimate is 1,890,000 at an average density of eleven people
per 100 square kilometres.[57] Whichever figure it was, the spread of the Indians was not
what it became. The Plains Indians, for example, had as yet no horses – because these were
introduced by Europeans. 'Far from being the stereotype of war-bonneted warriors, they
were essentially farmers who planted gardens along the Plains rivers and hunted game on
foot.'[58]

Many of the customs of the Indians were very much at variance with what Europeans
were used to. The subarctic people, the people we call Eskimos or Inuits, invariably shared
meat among other members of the tribe because they believed that animals would be more
co-operative with hunters who were themselves generous.[59] On the Pacific coast the tribes
were distinguished by huge totem poles. They used more than a hundred herbs and plants
and were familiar with their nutritional and medicinal properties.[60] They had special
lodges, or houses, used for ceremonial purification and for curing illness.[61] Many tribes
had gruesome initiation ceremonies, rites of passage by means of which adolescents
became adults. Tobacco was widely used for ceremonial purposes – a practice that had
devastating consequences for mankind. Then there was the practice of creating *kivas* –
huge underground halls used for ritual and as club-rooms for men. Sometimes the *kivas*
had their walls adorned with ritual paintings, though it was common practice for them to

be painted over once the ceremony was finished. Art in America had a different meaning than in Renaissance Europe.

There were, however, many parallels with practices in the Old World. The Indians had evolved the concept of the 'soul', though members of some tribes had multiple souls. Likewise, they had evolved marriage and agriculture (strip-farming run by families, slash-and-burn, floodplain farming, terraced fields in the mountainous regions). As in other areas of the world, the women gathered the local plants while the men hunted. Death was surrounded by elaborate ritual and many tribes had discovered how to mummify bodies. In certain places, widows were killed alongside their husbands, recalling a similar practice, *suttee*, in India. Cooking was advanced ('barbecue' is a Taino word), and fasting developed – as in the Old World – in connection with religious observance. A variety of beer existed, brewed from manioc. Obsidian was used and revered as much as in the Old World. There was a form of counting (but see page 452), taxation and some tribes even had a class of people 'who could only be described as civil servants'.[62]

The most obvious difference, in terms of everyday life, was the widespread practice in the Americas of living in 'longhouses'. Among the Iroquois these houses might be as much as 300 feet long, and were occupied by several families all at the same time, each of whom belonged to the same clan. Men married into these longhouses, which, if all the existing quarters were taken, were simply made even longer. 'As many as thirty nuclear families, or between one and two hundred people, related by blood and marriage, occupied each dwelling. Traditionally, the centre aisles of the longhouse split the buildings lengthwise. Paired family quarters faced each other, like compartments in a sleeping car, with a shared cooking hearth in the central aisle.'[63] Only two wall posts separated each family, which had its own fire that was always smouldering. 'Family hammocks (a New World word) were hung in a way that also served as a symbolic division of space.'[64]

The Tupinamba, in Brazil, were cannibals. They, together with the Caribs and Cubeos, believed in consubstantiation, and eating human flesh was part of the ritual, important to maintain the survival of the race and ensure the goodwill of ancestral spirits.[65] No less barbaric, so far as the early explorers were concerned, was the practice of headhunting, carried out by the Mundurucú, who inhabited the dense forests of the Amazon basin. These Mundurucú were feared for their aggressiveness and enforced their will by the gruesome practice of severing the heads of their enemies. However, any warrior who performed this act took on a heavy burden, for it sparked its own ritual that could last up to three years. 'When a head was taken its preparation was begun immediately. Long before the men's return to the village, the brains were removed and the teeth knocked out and retained. The head was then parboiled and dried, making the skin like parchment. A cord was strung through the mouth and out of one of the nostrils. The gaping eyes were closed with beeswax. The successful headhunter was considered an awesome hero with sacred status. He had to abstain from everyday activities, including sexual relations with his wife or any other woman. He took a ritual bath in the morning so as to avoid the sight of a woman. Spending most of his days in a hammock in the men's house, he talked sparingly and only on serious subjects. When he did eat he sat next to his wife but back to back . . . On the anniversary of the "catch" the skin was stripped from the skull, in another elaborate ceremony, and a year later the teeth were strung together and hung in a basket in the hero's

house in a final celebration. After three years of this, the hero resumed his normal station in life.'[66]

In the early years, the amassing of new facts was haphazard. As time passed, however, and scholars followed the merchant-explorers, a more systematic picture began to emerge. We may start with the position in regard to languages. 'In 1492 as many as two thousand mutually unintelligible languages were spoken in the Western hemisphere. Of these approximately 250 were spoken in north America, some 350 in Mexico and central America, and no fewer than 1,450 in south America.'[67] Native American languages were no less sophisticated than Old World tongues; they lacked some features but others were more common than in Eurasia. 'Rare among Indian languages, for instance, was the employment of suffixes on nouns to express such cases as nominative, accusative and dative (as occurs in Latin, for example), or of nominal and pronominal gender references (like the English "he" and "she" or the Spanish "*el*" and "*la*").'[68] At the same time, many Indian languages distinguish between nouns representing animate and inanimate entities and between objects possessed by definition (such as kin relations and body parts) and those incidentally owned (knives or tools, say). Inevitably, perhaps, there was a good number of sounds unknown in the Old World – in particular, glottal stops (an interruption of breath produced by a sudden closing of the vocal cords, as in the pause between 'uh' and 'oh' in the English phrase 'uh-oh').[69] Some words lacked vowels and there was too the unfamiliar practice of repeating or doubling a word, or part of a word, so as to alter its meaning. The Washo Indians of North America's Great Basin, for example, used *gusu* to mean 'buffalo', whereas *gususu* meant 'buffalo here and there'.[70] In other cases, verbs varied according to the validity of the information – for example, whether the information being communicated was personally known to the speaker, was mere gossip, or had occurred in a dream.[71]

Other differences seem more fundamental. In Europe, for instance, the main division of language was into nouns and verbs. In contrast, the Hopi of Arizona treated entities of short duration – lightning, say, or a wave or flame – as verbs, while entities that endured longer were nouns.[72] In Navajo, the English sentence 'He picks something up' can be translated in twelve different ways, 'according to whether the object is round and solid, long and slender, animate, mud-like etc'.[73] Metaphor was not so different from European usage (poetry was described as 'flower songs', a woman was 'a skirt') but the *absence* of speech was replete with meaning. For example, Apaches observed silence when meeting strangers, during the initial stages of courtship, or with relatives after a long period of separation.[74] Some tribes had trade languages, never spoken at home but only when merchants engaged in exchange with strangers.

Except in a few celebrated cases, the Indians lacked writing. This meant they had no written histories, philosophies or scriptures to fall back on.[75] But that did not stop them having religions, a concept of the soul and a number of origin myths, which often involved the sun, the moon and subterranean worlds, which had different layers. Childhood was acknowledged, since puberty and menstruation were marked with rites of passage. Interestingly, in some tribes the puberty rite seemed intended to shake adolescents out of their childish environment. In the case of the Hopi, for example, children were never allowed to see certain religious figures without their elaborate masks, and were encouraged

to think of them as spirits. At the ceremony of puberty, however, they were shown the figures behind the masks, as if to warn the newly-emergent adult to put away childish beliefs.[76]

The New World religions often had a priestly caste and sometimes 'Virgins of the Sun', selected when they were just ten, were chosen for roles 'that ranged from temple service to sacrificial victims'.[77] Sacrifice was widespread and could be very bloodthirsty: Pawnee virgins took part in a four-day ceremony before being shot through the heart.[78] But probably the most fundamental difference in a religious sense was the widespread use of hallucinogens. Here the tribes were led by shamans who had a medico-religious function, as in the Old World. Tribes had chiefs (though some only in times of war), who might serve also as shaman. Certain tribes recognised six types of gender: hyper-men (warriors), men, *berdaches* (androgynous), amazons, women, and hyper-women (who excelled at, say, female crafts). *Berdaches* and amazons were sometimes used as mediators in disputes.[79] The heart, not the brain or face, was considered the essence of a person, and shamans would sing 'heart songs' to sick people to cure them.[80] Many tribes conversed with animals and plants and assumed they were understood.

Native Americans had a very different understanding of the 'self' or 'person'.[81] Basically, they emphasised selflessness because people took their identity from various subgroups in society and had no separate status. People who behaved in a selfish way turned into witches, who were as likely to be men as women.

Babies were born with contributions from father, mother, and spirits. The father contributed hard substances, like bone, and the mother soft ones like flesh and blood. In the Pacific Northwest it was believed that unborn infants inhabited a special place, where they lived like other humans until *they* sought out parents here on earth. In general, they were not given names until the trauma of birth was over and it was safe to assume the child would live.[82] Girls were given flower names, whereas boys were named after carnivores. But extra names were added in celebration, to mark a child's first laugh, or whistle, its first word, or even its first haircut.[83] The biggest celebration was reserved for the first occasion when a child fulfilled an economic function, such as collecting berries. On occasion the coming of age of a daughter was marked by the removal of her clitoris. This, it was believed, removed any male aspects of her character.[84] Men, it was said, did not become fully 'adult' until they had grandchildren, a fairly transparent device to keep families together.[85]

Arguably the most important difference between the two hemispheres lay in ideas concerning economics. In the case of the Aztecs and the Incas, the two most prominent civilisations at the time of the conquest, the death of any ruler placed a great strain on the society. The bodies of the emperor and his queen were mummified and deposited in richly ornamented, specially built palaces. Vast numbers of slaves and concubines were sacrificed to be on hand for the emperor in the hereafter. But that wasn't all. Great estates were appointed to guard the palaces of the dead and to serve the mummies for ever after. This all meant that, at the end of every reign, a huge new drain on the empire's resources was added to those already existing.[86] In other words, every new dead king made a wasteful situation worse.[87] The end result was that labour lost to 'mummy service' could only be made up for by the conquest of more people, more land, which was not without risk. One

major effect of all this was that the capital necessary to advance individual enterprise never evolved.[88]

There was such a thing as science in the New World, and a primitive technology, but native Americans had few theories about phenomena as the Old World Europeans did. Both peoples thought that the sun went round the world, and was linked with the growing season. The Indians had the same kind of simple machines that Europeans used, similar to the five simple machines of classical Greek mechanics: the wedge, the inclined plane, the lever, the pulley, and the screw. (The advantage of a machine is that it augments the force used on it.) Each of these devices were known to the native Americans, who used them in activities from tree-felling to canoe-building. Yet whereas Europeans by the fifteenth century were searching for ultimate causes, whose outcomes could always be predicted, native Americans preferred to control the forces of nature by means of intimate relationships with the spirits that controlled these forces – achieved through ritual or dreams.[89] 'To Europeans the natural world was ruled by laws; to native people, it exercised will . . . The major point at which European and native science diverged was in the matter of experimentation. It would not have occurred to the Hopis to cease their ceremonies to see if the sun would indeed continue north rather than turning in its path.'[90]

Several peoples, such as the Navajo, characterised plants as male and female, depending on size and hardness or softness. This notion was based on analogy with men and women, rather than on the actual sexual organs of the plants themselves. Plant names among the Aztecs, for instance, contained a suffix that indicated whether they were food, medicine, or could be used for clothing or building.[91] In fact, classification of the natural world was often made on a basis very different from European ideas. The Navajos put insects and bats into the same category because of an ancient myth in which these two types of animal had lived together in a previous world.[92]

For Europeans the stars in the night sky were the basis for astrology but in America the horizon was more important.[93] This was a widespread idea and throughout the continent tribes built their temples to align with features on the horizon that coincided with notable celestial events. 'Casa Rinconada, a large circular *kiva* in the Chaco Canyon region of northwestern Mexico, has twenty-eight niches spaced equally around the interior of its stone wall. It also has six somewhat larger and irregularly spaced niches below those. At the time of the summer solstice, for four or five times around that date, light from a window placed high on the northeastern side of the *kiva* shines on one of the six niches.'[94] But the stars were used by Indians to devise their calendar, in the course of which they conceived their own system of counting. Originally this was a Mayan idea but it was improved upon by the Aztecs.[95] Calendrical calculations were the main – in fact, the only – use of mathematics among the Mayans, though in the Inca empire mathematical knowledge seems to have been recorded in the *quipu*.[96] This was an information storage system contained on a series of strings knotted together. The strings, some of which had dependent strands, were of different colours and these colours and knots were arranged in sequences. The 'language' or code of the *quipu* has never been deciphered but support for the notion that they were some sort of religious record comes from two pieces of woven fabric that have survived. The weaving on both is very intricate: one has ten rows of thirty-six circles and the diagonal arrangement of circles into groups adds up to 365. In the

other piece the rectangles add up to twenty-eight. These pieces surely have some sort of calendrical significance.[97]

Some scholars now believe that the sophistication of textiles in Mesoamerica 'may represent as complex a system of knowledge as metallurgy in Europe'. After battle, cloth was often demanded as tribute, and cotton slings were used in war.[98] Llamas and alpacas were each domesticated and served both as beasts of burden and as sources of wool. Fabric may even have been more important than ceramics as storage receptacles. 'The finest garments were made from thread with a diameter of $\frac{1}{125}$ of an inch, and some 125 separate shades and tints have been identified in Incan textiles. All of the major weaving techniques known in Europe in 1492 were known to the Incas – tapestry, brocade, gauze, and they also had an additional method, known as interlocking warp.'[99]

Although the New World had not domesticated many animals by 1492, a vast number of plants had been brought under control – including many unknown to Europeans at the time but which have since become familiar: maize, white and sweet potato, cacao, pumpkins, peanuts, avocado, tomato, pineapple, tobacco and chilli peppers. In the Andes there were already 3,000 different varieties of potato.[100] The New World civilisations were well aware of the medicinal use of plants. For example, *Aspilia* was known to act like an antibiotic, and stoneseed, used by women of the Paiute tribe as a contraceptive, has since been found to inhibit gonadotrophins in mice. The *tlepatli*, understood in Aztec medicine to be a diuretic and as useful in gangrene treatment, has been found to contain plumbagin, an anti-bacterial agent, effective against staphylococcus.[101] However, native Americans did not have the concept of chemistry, as such. For them, the medicinal power of plants was a spiritual matter.

There was no 'art' in the New World, not in the 'art for art's sake' sense, and none of the indigenous languages had a word for art (or religion, come to that).[102] This was because every carved object, say, every song or dance, had an intensely practical purpose and couldn't be conceived without that purpose. Aztec sculptures were sometimes inscribed on the side that was never seen but that didn't matter because they had a symbolic meaning which was more important than their appearance. There was, in other words, no aesthetics as such, only function, which gave something its meaning.[103] For this reason, there was hardly any instrumental music anywhere on the continent, because, in the normal course of events, song, dance and music went together in ritual. It was only in the more developed civilisations of Mesoamerica that professionalisation of the arts occurred. And it was only here that there was a division, as there was in Europe, into the high arts and the folk arts.[104] As a result, it was only in these civilisations that artists enjoyed high prestige – everywhere else all people were believed to have artistic powers to some degree. In the Inca empire certain specialisations, such as silversmiths and tapestry-weavers, were hereditary servants of the government and as such exempt from taxes.[105] To make matters even more complicated, astrology – or magic – came into play. The Aztecs, for example, believed that people born under the sign of *xochitl*, 'flower', were fated to become artisans or entertainers.[106] The function of the artist also overlapped with creation myths. One interesting way these myths differed in the New World is that, instead of imagining that God had created a perfect world, which it was the task of scholars, theologians and artists to understand, the New World natives believed it had been created imperfectly and that it

was the job of the artist to *improve* the world.[107] The Incas believed that the first men had been giants, fashioned from stone. But the Great Lord, Wiracoqa, was unhappy with his work and turned them back to stone – these were the giant statues the Incas worshipped. Then Wiracoqa created a second race of man, the same size as himself ('in his own image').[108] Mayan sculptors were not allowed to have sex while carving their works, but they did sprinkle their own blood on their carvings because this was believed to make them holy: as with Renaissance man, these artists were divine. Musical instruments were also divine for the Mayans and the carvers would pray while fashioning them and rub them with alcohol so they would be 'content, well-tuned and produce fine sound'.[109] Artists did not sign their works, even in those civilisations where they were professional artists, and artists never became famous as in Europe. The only exception was poetry, where poets who belonged to the nobility might be remembered long after their death. Nezahualcoyotl was remembered as 'the poet king' but even here it was his status as a king that caused him to achieve fame, as much as his prowess as a poet.[110]

Such writing systems as existed in the New World were in decline by 1492, and it is unlikely that many of the inscriptions of the classical period (AD 100–900) could still be understood.[111] Aztec and Mixtec writing was largely pictographic and scribes, in addition to being adept at carving the characters, also had to memorise the oral commentaries that accompanied the texts (oral delivery remained always the dominant form). Such codices as we possess concern the mythic past of the tribe and would have formed the central element in ritual where scribes added their commentaries. Those, of course, have been lost. The Aztecs were also among a few pre-Columbian peoples who consciously collected foreign and ancient art – in particular Olmec objects. This appears to confirm that the Aztecs at least had an interest in the past and perhaps some idea that the Olmec civilisation was the 'mother culture' of Mesoamerica.[112]

What did the Indians themselves make of the invasion? Some of the Indian nations had sacred books. The best-known of these was the *Popul Vuh*, a Quiché text that has been described as the equivalent of the Old Testament or the Sanskrit Vedas. Equally interesting, if less known and more apposite to our purpose, is the *Annals of the Cakchiquels*. This latter nation, like the Quichés, had a system of dual monarchy, a king and vice-king drawn from two royal lineages and known as Ahpo Zotzil and Ahpo Xahil. After the Spanish conquest, survivors of the Xahil family wrote down Cakchiquel history and then added to it, in a form of journal, into the seventeenth century. This account is surprisingly balanced. It describes a holocaust but also praises Spaniards who tried to help the Indians. Among the events described are an outbreak of plague in 1604, when the writer dies and another picks up his pen, an exchange of ambassadors, and genealogies. Similar documents were created by the Mayans, the *Books of Chilam Balam*, written in the Mayan language but using Spanish letters. These books were deliberately obscure, full of puns and riddles, so that outsiders could not understand them. They were also added to until the nineteenth century: every Mayan town had its own copy and they were expanded locally. The *Books of Chilam Balam* viewed the invasion as a battle of calendars, or chronologies. The Spanish had brought with them their own brand of time – rather crude to the Mayan way of thinking – and tried to impose it on the indigenous people. So for the Mayans this was the

chief battle of ideas, the way the rival religious systems were conceived – as a contest over time.[113]

We should briefly consider what the pre-Columbians lacked. The main absence, undoubtedly, was the wheel. This was also the most surprising, in view of the fact that ball games were played everywhere in the Americas and had religious significance. Draft animals were also conspicuous by their absence, as was mentioned at the beginning of this chapter, though the llama was domesticated. Also absent were large sailing vessels, and this may have had something to do with the vast oceans that surrounded the Americas. But it did mean that, alongside the lack of the wheel, native Americans remained more localised, and were much less travelled, than Europeans. Other ideas or inventions missing from pre-Columbian societies were coined money, ethical monotheism, the idea of the experiment and, in general, writing. There were no kilns – and therefore no glazed pottery, and no stringed instruments. Several of these missing elements – draft animals, large sailing vessels, writing, coined money – would all have limited economic development, in particular trade and the accumulation of surpluses. We have already seen that what surpluses were produced were as often as not dissipated in elaborate rituals for the dead and this difference in economic development, together with the lack of ethical monotheism and the absence of experimentation, are perhaps the three most important ways in which the Old World and the New differed.

In the realm of ideas, the discovery of America may have had an effect on the Catholic Counter-Reformation going on at much the same time, in that it robbed the Catholics of some of their most energetic and talented evangelists. By the same token, the Roman church had little say in what went on in America (which was largely ignored in the Council of Trent) and, as John Elliott says, one effect of this was to enhance the authority of the Spanish Crown, 'both among its own subjects and in its relations with the church'. More than one historian, from contemporary writers to those of our own day, have speculated on whether the 'enterprise of the Indies' siphoned off the more radical population, increasing authoritarianism and conservatism among those who remained.

The discoveries *in* America certainly had an economic impact, which in turn produced a revolution in ideas. Between 1521 and 1544, for example, the mines in the Habsburg territories produced four times as much silver as the whole of America. But between 1545 and the late 1550s these figures were reversed, and resulted in a decisive shift in economic power in those years, with the centre of economic gravity moving away from Germany and the Netherlands to the Iberian peninsula.[114] John Elliott says that, in the last half of the sixteenth century, 'it is ... legitimate to speak of an Atlantic economy'.[115] The political impact meant that Spain was on the rise, but so was Europe overall as against her traditional enemy – Islam. (It was only now that the Muslim world began to show any curiosity about the historical reasons for the rise of Spanish power.[116])

The rise of Spain, and the reasons for it, naturally attracted attention elsewhere, and it is true to say that from this moment dates the realisation that sea power would be of the greatest importance in the politics of the future, that Spain's power could be checked by interrupting the gold and silver on its way to Europe and that, in a world divided by

religion – Protestant and Catholic – the New World was the next battleground. In a sense, global politics began then.[117]

The developing battle for America exacerbated the growing nationalism of the sixteenth century and 'Black Legends' grew up, in regard to the Spanish in particular and their alleged atrocities (on one estimate they had massacred 20 million Indians).[118] But in any case, more and more Spaniards came to doubt the value of the Indies, and there emerged in Spain what has been called an 'anti-bullionist sentiment', which was suspicious of the moral consequences of sudden riches. The rival view was that true riches lay in trade, agriculture and industry, where wealth was truly earned and productively used.[119]

But the scramble for America did lead in time to the rudiments of international law. The continent itself was just too large for one country to control all of it, and the Spanish rejection of papal authority in the opening-up of the New World had a knock-on effect on attitudes to authority in general. Many people, as we have seen, thought that the Indians were entirely capable of governing themselves and that their freedom and autonomy should be respected. In the middle of the sixteenth century, Alfonso de Castro argued that the oceans could not be the preserve of any one nation, and with this as background Hugo Grotius, a Dutch jurist and statesman, developed his theoretical structure for the conduct of international relations. The New World thus became part of Europe's emerging structure of states and the agreements between them. It is fair to say that the conquest of America hastened and perhaps crystallised the awareness of the links between resources, geography, population and trade patterns as a guide to international power.

Earl J. Hamilton, in a famous essay, 'American treasure and the rise of capitalism', examined various factors that might have accounted for the phenomenon – the rise of nation states, war, the rise of Protestantism – and concluded that the discovery of America, and in particular of American silver, was the prime driving force behind European capital formation. 'No other period in history has witnessed so great a proportional increase in the production of the precious metals as occurred in the wake of the Mexican and Peruvian conquests.'[120] This is, in effect, a final element in the rise of Europe, consolidating earlier changes discussed in Chapter 15. The argument was built on and expanded by the Texan historian Walter Prescott Webb, who argued in *The Great Frontier* (1953) that the discovery of America 'decisively altered the ratio between the three factors of population, land and capital in such a way as to create boom conditions'.[121] In 1500 the population density of Europe was, he said, roughly speaking twenty-seven people per square mile. The discovery of America opened up an additional twenty million square miles which wasn't finally filled until around 1900. Webb concluded therefore that the years 1500–1900 were unique in history, 'the period in which the Great Frontier of America shapes and transforms Western civilisation'. As Europe moved once more to cities, the opening up of the frontier provided an opposing dynamic.[122]

In the Middle Ages a measure of stability had been achieved between the coinages of Christendom and the Islamic world, one producing silver, the other gold. But the discovery of America upset this balance: between 1500 and 1650 approximately 180 tons of gold were sent to Europe and 16,000 tons of silver. This produced a revolution in prices, which began in Spain and then spread, encouraging capital formation for those who were part of the new enterprise but pushing up prices *fivefold* in the sixteenth century, sparking

inflation, social unrest and social change. Here too there were grounds for worry about the 'morally harmful effects of wealth'.[123] Garcilaso de la Vega was just one who was not convinced by the influx of precious metals. At the beginning of the seventeenth century, he wrote that 'this flood of riches has done more harm than good, since wealth commonly produced vice rather than virtue, inclining its possessors to pride, ambition, gluttony and voluptuousness ... [My] conclusion is that the riches of the New World, properly understood, have not increased the volume of useful things necessary for human life, such as food and clothing, but have made them scarcer and rendered men effeminate in their power of understanding and in their bodies, dress, and customs, and that they lived more happily and were more feared by the rest of the world with what they had formerly.'[124] Earl Hamilton flatly disagreed, arguing that capitalism was consolidated by the lag between the rise in prices and the rise in wages. This is not a debate that is anywhere near settled – the issue is complex and there are holes in most of the theories, but there can be little doubt that the opening-up of America contained great opportunities for vast fortunes to be made and that social inequalities in wealth sharpened markedly in Europe at this time.

A final factor was population. The catastrophic decline in the Indian population, partly because of Spanish cruelty, partly because of imported disease, affected the labour supply, while some 200,000 Spaniards may have emigrated to America during the sixteenth century. It seems likely that they were above average in intelligence, ability and energy, so that they may well have produced a deleterious effect on the genetic quality of the population left in Spain (but then again monies would have been remitted home by a good proportion of these emigrants).

The impact of the discovery of America on Europe, and the rest of the world, has still not been fully assessed and perhaps it never can be, because it was so profound, far-reaching and, as Montaigne put it, 'topsyturvying'. But it would not be long before the sensible words of Garcilaso took over: 'There is only one world,' he wrote, 'and although we speak of the Old World and the New, this is because the latter was lately discovered by us, and not because there are two.'[125]

# History Heads North:
## the Intellectual Impact of Protestantism

'Peter and Paul had lived in penury, but the popes in the fifteenth and sixteenth centuries lived like Roman emperors.' In 1502, according to a parliamentary estimate, the Catholic Church owned 75 per cent of all the money in France.[1] In Germany, twenty years later, the Diet of Nuremberg calculated that the church there owned 50 per cent of the wealth in Germany. Such massive riches brought certain 'privileges'. In England, priests routinely propositioned women entering the confessional box: absolution was offered in exchange for sex.[2] William Manchester quotes a statistic that, in Norfolk, Ripton and Lambeth in England, 23 per cent of the men indicted for sex crimes against women were clerics, who comprised less than 2 per cent of the population. The abbot of St Albans was accused of 'simony, usury, embezzlement and living publicly and continuously with harlots and mistresses within the precincts of the monastery.' The most widespread corrupt practice was the sale of indulgences. There was a special office of *quaestiarii*, or pardoners, who had the pope's authority to issue indulgences. As early as 1450, Thomas Gascoigne, chancellor of Oxford University, remarked that 'sinners say nowadays: "I care not how many evils I do in God's sight, for I can easily get plenary remission of all guilt and penalty by an absolution and indulgence granted me by the pope, whose written grant I have bought for four or six pence".' He was exaggerating – other accounts tell of indulgences being sold for 'two pence, sometimes for a draught of wine or beer . . . or even for the hire of a harlot or for carnal love'. John Colet, dean of St Paul's in the early sixteenth century, was not the only one to complain that the behaviour of the *quaestiarii*, and the hierarchy behind them, had deformed the church, so that it was now no more than a 'money machine'.[3]

The tipping point came in 1476, when Pope Sixtus IV declared that indulgences also applied 'to souls suffering in purgatory'. This 'celestial confidence trick', as William Manchester terms it, was an immediate success: peasants would starve their families and themselves to buy relief for dead relatives.[4] Among those who took cynical advantage of this situation was Johann Tetzel, a Dominican friar who evolved his own peripatetic circus act. '[He] travelled from village to village with a brass-bound chest, a bag of printed receipts, and an enormous cross draped with a papal banner. His entrance into town was accompanied by the ringing of church bells . . . Setting up in the nave of the local church, Tetzel would begin his pitch by calling out, "I have here the passports . . . to lead the human

soul to the celestial joys of paradise." The fees were dirt-cheap, he insisted, especially when one considered the alternative. He appealed to the conscience of those listening to atone for their dead relatives who had gone to their graves unshriven: "As soon as the coin rings in the bowl, the soul for whom it is paid will fly out of purgatory and straight to heaven"."[5] At his very worst, Tetzel wrote letters which promised to the credulous that the sins a person was *intending* to commit would be forgiven.

He went too far. Traditionally, Tetzel's flamboyance and exaggerated claims are held to have attracted the attention of a priest who was also a professor of philosophy at Wittenberg, north of Leipzig in Germany – Martin Luther. Recently, however, Diarmaid MacCulloch, professor of the history of the church at Oxford, has drawn attention to several other developments in Catholicism which set the stage for Luther. For example, in the early sixteenth century there was already a difference between north and south Europe in the types of sermon preached in churches – in the north the preacher threw the spotlight on the congregation (the penitents) themselves, whereas in the south the sermons paid more attention to the priest and his role as a mediator in the absolution of sin.[6] There was much less dissatisfaction with the status of priests in Italy than further north and this seems to have had something to do with the role of guilds.[7] In and around Switzerland *Landeskirchen* were emerging, locally-run churches where the magistrate of the area, rather than the priest, played a leading role in teaching doctrine,[8] and there was a big increase in the number of Bibles available, which helped more and more people interiorise their faith.[9] The king of France called a council of cardinals in Pisa in 1511, to discuss church reform,[10] while in 1512 certain works of Origen became available in Latin, which suggested that there had been no Fall, as traditionally understood, and that everyone, including the devil himself, would be saved and return to Paradise.[11] On this reading, change was in the air.

Nevertheless, it was Luther who sparked that change. He was 'stocky, lusty', the son of a mine owner. At university he had hoped to become a lawyer but in 1505, during a storm, he underwent a mystical experience and came to believe 'that God was in everything'.[12] It was a fundamental change. Until then, he had been part of the humanist fraternity, a disciple and colleague of Erasmus and had translated several classics. After his conversion-experience, however, he turned in on himself, shunned the company of the humanists and became obsessed with inner piety. In 1510 – the peak of the Renaissance, when Leonardo, Michelangelo and Raphael were all thriving – he visited Rome. It shocked him. True, he adored the masterpieces of painting and sculpture and the great religious monuments, but he 'shuddered' at the behaviour of the priests and cardinals, in particular their cynical approach to the liturgy which, he felt, was the basis of their privilege.[13]

Back in Wittenberg by 1512, he led a quiet life there for a number of years. He had been profoundly shocked by his experiences in Rome and he turned away even more from the worldliness of the humanists, as much as from the corrupt cynicism, as he saw it, of the Catholic hierarchy. Instead, he returned to the scriptures themselves, in particular the Church Fathers, and above all St Augustine. He continued to observe the world around him with dismay and, as Jacob Bronowski and Bruce Mazlish say, he was perhaps at this time 'incubating both his views and his courage'. By 1517, however, he could no longer hold himself in and on 31 October, the eve of All Saints' Day, he made his move. In an action which would reverberate around the world, he nailed to the door of Wittenberg

church ninety-five theses attacking the sale of indulgences, and daring any one at all to come forward and argue with him.[14] 'I, Martin Luther, Doctor, of the Order of Monks at Wittenberg, desire to testify publicly that certain propositions against pontifical indulgences, as they call them, have been put forth by me . . .'

Luther's attack was directed not just at Tetzel, or the Vatican behind him. It was directed at the *theology* represented by indulgences. Indulgences existed, so the theory went, because of the 'surplus grace' that existed in the world. Jesus, and the saints who came after him, did so much good that there was a surplus of grace on earth. Purchase of an indulgence put the purchaser 'in touch with' this surplus. Luther didn't like the idea that grace could be traded like potatoes in the first place but, no less important, it obscured the important fact that purchase of an indulgence freed the buyer from penance for a sin, *but not from the sin itself.* For Luther, the sale of indulgences was therefore deeply misleading and untheological. It was not far from this point of view to Luther's second innovation, a return to the twelfth-century idea that 'true inward penitence', contrition, was needed for the proper remission of sins. The popes might claim plenary remission of all penalties but Luther insisted that contrition was a necessary condition. This next step was equally short but much more momentous. If, without contrition, an indulgence was invalid, then it soon became clear to Luther that contrition alone, 'without any papal paraphernalia', was itself sufficient. In making salvation dependent on an individual's faith and contrition only, Luther simply removed the need for the sacraments *and* for a hierarchy to administer them.[15] The idea of intercession – the very basis of the Catholic church – went out of the window.

These, then, were the simple theological ideas that formed the basis of the Reformation, what Diarmaid MacCulloch has called 'an accidental revolution'.[16] But there was another side to what subsequently happened, a political dimension.[17] Many of the humanists supported Luther when he denounced the abuses of the church. People like Erasmus shared his concern to reintroduce piety and Christian virtue back into worship rather than rely on dogma and scholastic hair-splitting. But these supporters drew back when they saw that Luther was attacking the very basis of the church itself, burning his books of canon law and papal edicts.[18] And this is where a nationalistic element emerged, which also had profound consequences. Most of the humanists who refused to follow Luther all the way were non-Germans.

In his theses and other writings, Luther didn't hold back: he made it plain that he saw the pope as little better than a thief and a murderer. He wanted German clerics to reject their allegiance to Rome, and he wanted a national church established, with the archbishop of Mainz at its head. Once he had gained the courage to speak out, Luther's imagination stretched into other areas that no one had dared enter before. For example, he insisted that marriage was not a sacrament, that a wife married to an impotent man might take other lovers until she conceived, and that it would not be improper to pass off this bastard as her husband's. He said he thought bigamy 'more sensible' than divorce.[19] He ranked different parts of the Bible in importance and in his edition of 1534 he separated out those sections that he was suspicious of, such as 2 Maccabees, into the 'Apocrypha'.[20]

One can imagine how Erasmus, not to mention the Vatican, took such arguments. But Luther was not completely alone, not by any means. There was, after all, a long history of

antipathy between Germany and the papacy, going all the way back to the Investiture Struggle, and even to the barbarians. In 1508, even before Luther went to Rome, the German Diet had voted to prevent papal revenues raised by indulgences leaving Germany. In 1518, the Diet of Augsburg resolved that the 'real enemy' of Christendom was not then the Turks but what they called the 'hound of hell' in Rome.[21] In theory, the leader of the Germans should have been the Holy Roman Emperor, Charles V. But he had his own ambitions and looked to Spain, newly rich through the discovery of America. He remained therefore a Catholic, who 'took Rome as his anchor'. All this only helped Luther. But he found that, much as his criticisms applied to the church throughout Christendom, it was easier to effect reform in his own country: 'He turned from reforming a world church into building a German one.'[22] This became clear in his *Address to the Christian Nobility of the German Nation* (1520), in which he adopted a tone little short of revolutionary, denied the belief that the clergy formed a 'separate spiritual estate' and urged German nobles to appropriate the lands of unreformed churchmen. There was no shortage of knights and princes ready to profit in this way, and so what had begun as a religious reform was soon merged with a wider struggle for political and economic supremacy seen in a national context.[23]

In the course of this 'nationalisation' of Protestantism, however, the first hints of its own form of corruption began to appear. In its original guise Lutheranism maintained that, in order to be free, one should never act, or be forced to act, against one's conscience. That was the true course of total honesty and was the intellectual backbone of the time, not just of Protestantism but of humanism and of the scientific revolution, then getting under way. But Luther changed. In an alarmingly small number of years he came to accept – and even to justify – the use of the sword ('civil force') in support of the faith.[24] He brought this on himself in a way, since he was forced into this new stance by three sets of overlapping events: the Knights' War, the Peasants' Revolt, and the Anabaptists.

The first of these events, the Knights' War, flared up as a direct result of Luther's own exhortation that the lands belonging to the church be confiscated. But this war, which broke out in 1522, failed, though it did succeed in making the political situation in Germany very tense. Three years later, in 1525, the German peasants, pressured beyond endurance by the nobles (who were starting to feel the pinch of inflation, stimulated by the arrival of American silver), and fortified by their understanding of Luther's doctrine that the word of God had revealed that all men are equal, rose in a rebellion of their own. Here, however, and unfortunately, the leadership of the rebellion was taken over by the Anabaptists. Taking their name from their opposition to infant baptism, on the grounds that infants were too young to have faith, and that without faith the sacrament was invalid, the importance and relevance of the Anabaptists lay in their total rejection of the papal hierarchy, which was replaced for them by a devout reliance on the word of God, as revealed in the scriptures. In fact, many Anabaptists were a good deal more extreme, believing that they themselves were directly in touch with the Holy Spirit and so had no need of the scriptures. For them, the return of Christ was once again imminent and the apocalyptic 'purification' of the world was at hand. The twentieth-century sociologist Karl Mannheim has argued that this alliance of 'chiliasm' – a belief in Christ's imminent return – together with the rebellion of the peasants, marked a decisive turning-point in modern history. His argument was that it introduced the era of social revolution. 'It is at this point

that politics in the modern sense of the term begins, if we here understand by politics a more or less conscious participation of all strata of society in the achievement of some mundane purpose, as contrasted with a fatalistic acceptance of events as they are, or of control from "above".[25]

Whether or not Mannheim was right, it needs emphasising that this reaction was not Luther's aim (the accidental revolution again). In fact, he supported the princes against the peasants. His view was that faith and politics should not be mixed and that it was the duty of Christians to obey legitimate authority. Specifically, for him, the church was subservient to the state. 'For Germany, the result of Luther's thought was a division between the inner life of the spirit, which was free, and the outer life of the person, which was subjugated to unattackable authority. This dualism in German thought has lingered from Luther's day to this.'[26]

The truth is, there was something in Luther's character that didn't add up. Part of him favoured authority but overall, it has to be said, Lutheranism destroyed authority, certainly so far as organised religion was concerned. In freeing men from religious authority, Protestantism set men free in other ways as well. The discovery of America, and the scientific revolution, both occurring simultaneously with Protestantism, were the perfect arenas where men who rejected authority, who could let their individuality shine through, would benefit. Luther himself was not over-fond of the growing economic individualism he saw around him – it didn't always sit well with the piety he valued. But it was ultimately unreasonable of him to expect religious individualism without all the other forms he had helped set loose.[27]

Very different from Luther was John Calvin. Born a generation later in 1509, he came from a bourgeois family in Noyon, Picardy, his given name being Jean Chauviner or Caulvin. He was intended for the church but abandoned theology for the law. His father sent him to Paris, where he studied at the Collège de Montaigu, where Erasmus and Rabelais also studied theology.[28] Dark haired, pale skinned, with a 'keen' temper, Calvin later had a 'sudden conversion' to Protestantism but in a sense he had been primed: his father had died 'excommunicate' and Calvin faced a 'sea of troubles' in obtaining a Christian burial for him. This embittered him against the Catholic church.

Turning his back on Rome after his conversion, Calvin also left France and, to begin with, when he was still not thirty, composed the first sketch of his *Institutes of the Christian Religion*, 'the most significant and lucid text of the Reformation'. Whereas Luther's writings had been emotional tirades, out-pourings of his pent-up inner feelings, Calvin began to set down a system of tightly reasoned, logically formulated morals, policy and dogma. A book that began as six chapters had, by the late 1550s, grown to eighty.[29] 'The core of this dogma was that man was a helpless being before an omnipotent God.' Calvin took Luther's arguments to their logical – even fanatical – conclusion. Man, he said, could do nothing to alter his fate: he was either born saved or predestined for hell. On the face of it this was hardly an optimistic doctrine but, under Calvin's system, no one ever quite knew whether they were saved or not. He said that, by and large, the 'elect' – his word for saved – would show it by their 'exemplary' behaviour on earth. But you could never be sure. It was, in some ways, a form of religious terror.

As it happened, Geneva had just turned on its Catholic bishop and the chaos that followed played into Calvin's hand and his view that the state should be subordinate to the church, that obedience to God came before obedience to the state (it was a replay, in different clothes, of the Investiture Struggle). With anti-Catholic feeling at fever-pitch in Geneva, with religious images being broken up, Calvin – as the distinguished author of the *Institutes* – was invited there to help organise it as a city on the biblical model.[30] On his arrival he was made a 'Reader in Holy Scriptures' and, strictly speaking, was never anything more than a pastor. But that is like saying that Nero was never anything more than a violinist. Calvin accepted the invitation only on condition that the Genevois adopt his terms – terms embodied in yet more regulations that he had drawn up, the *Ordonnances ecclésiastiques* and the *Ordonnances sur le régime du peuple*. From then on, the people of Geneva lived according to Calvin. Pastors visited each household once a year to ensure people remained true to the faith. Anyone who objected was forced to leave, jailed or in the worst circumstances executed.[31]

The essence of Calvinism was that morality was enforced and enforced strictly, while Protestant doctrine was developed at the University of Geneva, which Calvin founded.[32] And he set up two main arms of government, the Ministry and the Consistory. The main aim of the Ministry was to produce what might be called an 'army' of preachers who had to follow a particular programme and way of life and set an example. It was the job of the Consistory to govern morals. It comprised a court of eighteen – six ministers and twelve elders – and had the power of excommunication. It was this court, which met every Thursday, that was responsible for the dictatorship of terror in Geneva, what Daniel Boorstin calls the reign of biblical morality. It was in Geneva that a certain way of life – one that would become very familiar – was instigated: getting up early, hard work, being always concerned to set a good example (for example reading only uplifting literature). Thrift and abstinence were all-important virtues. As one historian put it, 'This was an attempt to create a new man ... the church was not simply an institution for the worship of God, but an agency for the making of men fit to worship Him.'[33] The regime gave its name to the 'Puritan' movement.[34]

But the social and intellectual changes implied by Lutheranism and Calvinism were more textured, more nuanced than this. For example, as biblical fundamentalists, they were not comfortable with the new findings of science, covered in the next chapter. However, philosophically speaking, these findings stemmed from observation, by individuals following their own conscience, and the Protestants had to support that. No less relevant was the fact that the new preachers were not intercessors, who controlled access to the deity through the sacraments, but the 'first among equals' who led a *literate* congregation who read the Bible for themselves in the vernacular. The stress in Calvinist schools was on equality of opportunity: and no one could determine where that would lead.[35]

Calvin's economic views also looked forward, rather than back (and, in a sense, *away* from the Bible). The traditional view, that people had no need of anything which is 'beyond what is necessary for subsistence', he thought outmoded. This – medieval – view had 'stigmatised the middleman as a parasite and the usurer as a thief'. Calvin disliked the ostentatious use of riches for their own sake but he conceded that the *accumulation* of wealth, properly handled, could be useful.[36] He agreed that a merchant should pay interest

on the capital he had borrowed, because that enabled everyone to make a profit.[37] At the beginning of the twentieth century, the German sociologist Max Weber created a lively controversy in his book *The Protestant Ethic and the Spirit of Capitalism*, in which he argued that, although the conditions for the evolution of capitalism had existed at many stages of history, it was only after the emergence of Protestantism, with its concept of 'the calling' and 'worldly asceticism', that a 'rational economic ethic' emerged. Later, R. H. Tawney, in *Religion and the Rise of Capitalism*, stressed Calvinism as even more sympathetic to capitalism than Lutheranism was.[38]

But there was a more direct way in which the Reformation created modern politics – by helping the rise of the modern state. The success of Luther's arguments not only destroyed the universalist ambitions of the Catholic hierarchy but it made religion (outside Geneva) subordinate to the state, the clergy being relegated to the role of guardians of only the 'inner life' of the individual. The religious conflict which followed, in Germany, France and then throughout the continent in the Thirty Years War, helped shape the Europe which emerged – a Europe of independent, sovereign nation-states.[39] A territorial nation-state and a business-based middle class are the two most important elements in what we call modern history. Luther never intended this but Protestantism was the main reason why, between the sixteenth and seventeenth centuries, power in Europe slipped away from the Mediterranean countries and settled north of the Alps.

The authorities in Rome badly misjudged what was happening in the north. Germany had been trouble to the popes for centuries but had always remained in the fold. This helps explain why there was no swift, terrible response from Rome, why Leo X, the pope of the time, felt that the Protestant revolt was a mere 'squabble among monks'.[40] In any case, it was next to impossible for a corrupt organisation to change. Inside the hierarchy the one senior figure who smelled danger was Cardinal Boeyens of Utrecht who, in 1522, became Adrian VI, the only Dutch pope in history. In his first speech to the college of cardinals, he frankly confessed that corruption was so bad that 'those steeped in sin' could 'no longer perceive the stench of their own iniquities'.[41] If he'd had his way, Adrian would have cleansed the stables from top to bottom, but he was surrounded by Italians with vested interests, who nullified his every move. Not that they needed to hold him up for very long – Adrian died after only a year. He was succeeded by Giulio de' Medici, who became Pope Clement VII (r. 1523–1534). He was a weak man from a (hitherto) strong house, a fatal combination. While Luther was pursuing his reforms in Germany, Clement played elaborate diplomatic games on the world stage – or what he thought of as the world stage. He tried to aggrandise himself and the papacy by playing off the king of France against the Holy Roman Emperor, Charles V, then ensconced in Spain. Clement signed secret treaties with both, but was found out, earning the healthy distrust of both. More disastrous still, the pope's misjudgements made Italy – weak in comparison to France and Spain – a battleground. Predatory eyes turned to Rome.[42]

In fact, the first attack came not from Spain or France but from one of the traditional enemies of Rome – the Colonna. In 1526, Pompeo Colonna – a cardinal himself – led an assault on the Vatican. Several of the pope's associates were murdered but Clement himself

took advantage of a secret corridor built in anticipation of just such an eventuality. The two warring families patched up their quarrel but the skirmish only underlined Rome's weakness. The real sack occurred twelve months later. Although the troops responsible nominally belonged to Charles V, they were in fact near-mutinous *Landsknechte*, mercenaries who had not been paid, despite breaking the army of the king of France. The kernel of the forces were Teutons – and therefore Protestants – from the Germanic lands of central Europe. Interested as much in the spoils of war as in religious beliefs, they marched enthusiastically on the capital of western Christendom.[43]

The sack itself, which began on 6 May 1527, was truly terrible. Anyone who resisted the Teutons was murdered. Mansions and palaces that weren't put to the torch were pillaged. The pope, the bulk of the cardinals in residence, and the Vatican bureaucracy, sought safety in the fortress of Sant' Angelo, though one cardinal, with the gate already closed, had to be chair-lifted to safety in a basket. As for the rest of the population ... 'Women of all ages were raped in the streets, nuns rounded up and herded into bordellos, priests sodomised, civilians massacred. After the first, week-long orgy of destruction, more than two thousand bodies were floating in the Tiber, nearly ten thousand others awaited burial and thousands more lay eviscerated in the streets, their remains half-eaten by rats and hungry dogs.'[44] Some 4 million ducats changed hands in ransoms alone – those who had the wherewithal to pay were freed, the rest killed. Tombs were broken, the bones of saints tossed to the dogs, relics denuded of their jewels, archives and libraries torched, save for enough paper to provide bedding for horses, which were stabled in the Vatican. The pillage only ended when, after eight months, the food ran out, there was no one left to ransom and plague appeared.[45]

Financial imprudence on the part of Charles V may have been the immediate cause of the sack of Rome but the Europe of the day was not short of other theories. Chief among them was the idea of divine retribution. Even a senior officer on the emperor's army agreed. 'In truth,' he wrote, 'everyone is convinced that all this has happened as a judgement of God on the great tyranny and disorders of the papal court.'[46] On the other hand, of course, the barbarity shown by the Teutons in Rome was seen there as 'the true face of the Protestant heresy', and while Rome at last woke up to the threat, the sack also hardened its heart. Rome would return brutality with brutality, intolerance with intolerance – 'the God of the Catholics demanded as much'.[47]

The great irony was that the original deformation of the Catholic church, which had driven so many believers from the faith of their ancestors, still flourished. Senior Catholic clergy were still profligate and dissolute, leading the same luxurious lives. Bishops still neglected their dioceses, and the Vatican was as familiar as ever with nepotism. The pontiffs of the day simply refused to see this and committed the church to virulent repression of dissent. A forest of trees was felled to provide for bull after bull deploring all aspects of Protestantism.[48] As William Manchester puts it: 'All deviation from the Catholic faith was rigorously suppressed by its governing commission of six cardinals, with intellectuals marked for close scrutiny ... The archbishop of Toledo, because he had openly expressed admiration of Erasmus, was sentenced to seventeen years in a dungeon.' In France, the mere possession of Protestant literature was a felony and promulgating heretical ideas sent someone to the stake. Informing on heretics could be very lucrative – informers were given

a third of the condemned person's estate. The court became known as *la chambre ardente*, the burning room.[49]

Book censorship was a new necessity in suppressing deviation. Printed books were still a novelty in the mid-sixteenth century but already it was clear to Rome that they represented the best way for seditious and heretical opinions to be broadcast. In the 1540s the church introduced a list of books which it was prohibited to read or possess. To begin with, it was left to local authorities to search out the offending books, destroy them and punish their owners. Later, in 1559, Pope Paul IV issued the first list of forbidden books for the entire church, the *Index Expurgatorius*, which, the pope said, would threaten the souls of anyone reading them.[50] All of the works of Erasmus were on the list (works that earlier popes had found a delight), as was the Qu'ran, as was Copernicus' *De revolutionibus*, which would remain there until 1758, and Galileo's *Dialogue*, proscribed until 1822. The Tridentine Index followed Paul's list, in 1565. This banned almost three-quarters of the books printed in Europe. In 1571 a Congregation of the Index was established to control and update the list. Canon law now required the *imprimatur*, 'Let it be published', to be printed in a permitted book, and on occasions the words *nihil obstat*, 'nothing prohibits', were included with the name of the censors.[51] The list included scientific and brilliant artistic works – Rabelais' *Gargantua* and *Pantagruel*, for example.

But people didn't take the Index lying down, as it were. Authors moved cities to avoid the censor, like Jean Crespin, who fled France to Geneva to write his influential account of Huguenot martyrs. Even in Catholic countries, the Index was not popular. The reason was simple commerce – books were a new technology and a new business opportunity. For example, in Florence Duke Cosimo calculated that if he were to comply with the church's directive, the cost in books lost would amount to more than 100,000 ducats. His reaction was typical. He organised a token book burning, disposing of books on magic, astrology etc. – books that were clearly Index-worthy but not so valuable commercially. Furthermore, local Index representatives often showed themselves as amenable to argument – for example, they agreed that Jewish medical books be spared: they were needed so that scientific progress might be made. And so, in one way or another, by delay, procrastination, or by decisions that certain books were exempt from the Index locally, the Florentines (as happened elsewhere – for example, France) managed to get round most of the legislation so that prohibited books continued to be circulated more or less freely. In any case, Protestant printers specialised in titles that were on the Index (which only made people curious) and had them smuggled to Catholic countries. 'Priests, monks, prelates even, vie with each other in buying up copies of [Galileo's] *Dialogue* on the black market,' one observer remarked. 'The black market price of the book rises from the original half-*scudo* to four and six *scudi* all over Italy.'[52]

The reactionary response of the Catholic church to the ideas of Luther and Calvin became known as the Counter-Reformation, or the Catholic Restoration. The Roman Inquisition and the Index were two early – and enduring – aspects of this battle of ideas, but by no means the only ones. Of the others, four were to have a lasting impact on the shape of our world.

The first set of events took place in England and became known as the Tyndale affair. William Tyndale was an English humanist and, like his colleagues, had welcomed the accession of Henry VIII.[53] When Henry sent word to Erasmus, in Rome, inviting him to settle in England, the humanists in London were encouraged still further. They were mistaken. Once Erasmus had arrived, Henry lost interest. And, to begin with at least, the king grew more Catholic than ever. Heretics were shown little mercy in Henry's England.

It was against this (for a humanist, tense) background that William Tyndale decided on an English translation of the Bible. The idea had first come to him while he was an undergraduate (at both Oxford and Cambridge) and no sooner was he ordained, in 1521, than he set to work. 'If God spare me,' he told a friend, 'ere many years I will cause the boy that driveth the plough to know more of Scripture than you do.'[54] Translation seems such an innocuous matter these days that it is not easy for us to grasp the full enormity of what Tyndale was about. But the sobering fact remains that the Church did not want a wide readership of the New Testament. Indeed, the Vatican actively rejected it – access to the Bible was reserved for the clergy, who could then *interpret* the message to suit the interests of Rome.[55] In such circumstances, a vernacular translation of the New Testament might well be dangerous.

The first hint that Tyndale had of the trouble ahead came when he failed to find a printer in England who was willing to set his manuscript into type. Forced across the channel, he at first found a publisher in (Catholic) Cologne. At the last moment, however, when Tyndale's text had already been set, the news was leaked to a local dean who appealed to the authorities and publication was squashed. Realising now that his very life was at risk, Tyndale fled the city. The Germans contacted Cardinal Wolsey in England, who alerted the king. Henry declared Tyndale a fugitive and criminal and posted sentries at all English ports, with orders to seize him on sight.[56] But Tyndale was passionate about his life's work. In Protestant Worms, in 1525, he found another printer, Peter Schöffer, who agreed to publish his work. Six thousand copies – a huge print run for the time – were freighted to England. But Tyndale was still a marked man and didn't dare settle anywhere for a good few years. Only in 1529 did he judge it safe to make a home in Antwerp. It was a mistake. His presence came to the notice of the British and, at Henry's personal insistence, he was jailed for more than a year in the castle of Vilvorde, near Brussels. He was eventually tried for heresy, convicted and garrotted in public. To ensure he didn't become a martyr, his remains were burned at the stake.[57]

Yet Tyndale's Bible lived on. It was a good rendering into English (serving as the basis for the King James version in 1611), although Thomas More dismissed it as flawed and misleading. Such was its popularity that copies that had been smuggled into England were passed from hand to hand and Protestant peers deep in the countryside were lending them out, 'like public libraries'. The Catholic hierarchy in England did what it could to stamp out this practice – for example, the bishop of London bought up all the copies he could find and had them burned at St Paul's.[58]

Rome was grateful to Henry and showed it. Earlier popes had conferred titles on the kings of Spain ('Catholic Sovereigns') and the French also ('Most Christian'). In Henry's case, Pope Leo came up with the title *Defensor Fidei*, Defender of the Faith.[59] No greater irony was ever contained in just two words.

*

The Inquisition and the Index were both essentially negative responses by the Catholic church. This attitude was exemplified in the person of Paul III, who set up both fearsome instruments. Merely to possess a book on the Index was punishable in Spain by death for a long time.[60] (The list was kept up to date until 1959, and was finally abolished by Pope Paul VI in 1966.) Paul IV was just as uncompromising. He had been the first Inquisitor General and, once pontiff, it was he who put fig leaves on the Vatican's famous collection of antique statues. It was Paul who found Daniele da Volterra, the painter instructed to paint over the 'more striking bits of nudity' in Michelangelo's *Last Judgement*.[61] Pius V was much the same. As Bamber Gascoigne says, 'Calvin was known as the pope of Geneva, but Pius certainly proved himself the Calvin of Rome.' Another erstwhile Grand Inquisitor, he proposed to make adultery a capital offence and tried hard to remove the prostitutes from the city. He failed in both tasks but at best Pius V realised that negative measures were not enough and he was largely responsible for acting on the decisions of the Council of Trent, which had sat, on and off, from 1545 to 1560.

Together with the Council of Nicaea, and Lateran IV, the Council of Trent was the most important council in the history of the church. To begin with, many Catholics hoped that the council would explore areas of compromise with the Protestants, but they were to be disappointed. The officers of the council dismissed Protestant theology completely and rejected any hope that the people might receive the bread and the wine in the mass or even hear the liturgy in their own language. The very dates of the council are revealing. It had taken some twenty years to be convened, a time-delay which confirms the conflicting forces within the hierarchy, though several princes had yet to make a definite decision as to which side they were on and there had been hopes for a deal in 1541–1542.[62] Rome also had an instinctive and traditional distrust of councils that, in the fifteenth century, had invariably attacked papal centralisation. We shall thus never know if the Protestant flame could have been snuffed out had the church responded more quickly. As it was, by the time the council began its deliberations, Luther could no longer be the focus of any attack. Within months of the council getting into its stride, he died in 1546.

Initially, the constitution of the council was unimpressive, comprising just four cardinals, four archbishops, twenty-one bishops, five heads of religious orders, plus various theologians and experts in canon law.[63] The first order of business was to decide how the cardinals and bishops should live during the council, a verdict being reached that their lifestyle would be 'frugal, pious and sober'. Only in the following year, by which time attendance had doubled, did the council turn to the meat of its problems. The very first decision took the Protestants head-on, for the council decided to award the 'traditions' of the Catholic church – for example, the biblical commentaries of the Church Fathers – *equal* authority with the scriptures.[64] There could have been a no more uncompromising move, for the council was endowing the Catholic church's traditions with divine authorship, on a par with scripture.[65] But the major battle, as expected, was fought over the concept of justification by faith alone. Luther's revolutionary idea was that all a sinner had to do was to truly *believe* in Christ and he would be redeemed. The council reiterated that this was not nearly enough. The church's argument was that, though damaged by the Fall, man retained the capacity to choose good over evil, but that he required Christ's example,

as *interpreted* by the church, so as to be, in effect, good by informed consent.[66] The council also reaffirmed that there were seven sacraments – Baptism, Confirmation, Holy Communion, Penance, Extreme Unction, Holy Orders, Matrimony – countermanding Luther's claim that, in the Bible, there were just two, Baptism and Holy Communion.[67] The number of sacraments was of course central to the structure of the church, for penance (confession) could only be heard by priests, who could only be appointed by bishops. And the council insisted that Purgatory, in reality a sixth-century 'revelation', really existed. In turn this helped maintain the doctrine of indulgences, though the council did outlaw any commerce in them.[68] Thus the main thrust of the Council of Trent was to reassert Catholic doctrine in all its corrupt glory, making many issues even more black and white than they had been before. The intransigence at Trent laid down the basis for the terrible wars of religion of the seventeenth century.[69]

Each of these Counter-Reformation manoeuvres mentioned so far was negative, prohibitive and/or violent. But there were those in the hierarchy who saw that the real way forward was to seize the initiative intellectually, to take the spiritual battle, and the argument, to the enemy. One who grasped this was Ignatius Loyola. Born in 1491 at the castle of Loyola in the Basque country, in the north of Spain, Ignatius might easily have become one of the increasing numbers of conquistadors then flocking across the Atlantic. By his own admission he was given over to 'the vanities of this world'. In fact, he did become a soldier but that career soon came to an end when his leg took a direct hit from a cannon ball during a siege. Recovering in his castle, so the story goes, he discovered that none of the books available was to his taste. Irritated, he picked up one of the lives of the saints and it proved a turning-point. There and then, 'He seems virtually to have decided to became a saint himself, a new sort of romantic hero. "St Dominic did this, therefore I have to do that; St Francis did this; therefore I have to do it".[70] The method of training that he set himself 'for sainthood' showed the discipline and attention to detail you would expect in a military man. Entitled *Spiritual Exercises*, it is still the basic course for self-discipline in the order which Loyola founded: the Jesuits. 'It is, literally, a four-week programme of exercises, a spiritual assault-course for the soldiers of Jesus, aiming to detach the mind from this world by concentrating on the horrors of hell, the saving truth of the gospel story, and the example of Christ.'[71] One exercise, intended to induce physical self-loathing, reads: 'Let me look at the foulness and ugliness of my body. Let me see myself as an ulcerous sore running with every horrible and disgusting poison.'

When he was thirty-three, Ignatius went to study at Barcelona University, later transferring to Paris. There, as his ideas developed, he attracted a small but dedicated band of followers, who performed his Exercises, and eventually took a joint vow to serve Christ, by offering themselves to Pope Paul III in Rome, promising 'complete obedience'.[72] In their charter they announced that their primary purpose was 'the propagation of the faith', in particular the 'instruction in Christianity of children and the uneducated'. They saw themselves as soldiers of Christ, of the pope, who would go wherever the pontiff sent them, 'whether to the Turks or to the New World or to the Lutherans or to others, be they infidel or faithful'.

By the time Ignatius died in 1556, the Jesuit church in Rome, the Gesù, had already

been commissioned. Today, opposite his tomb, lies a memorial to the soldier in Christ who took over from him. A fellow student from Paris, St Francis Xavier led the Jesuits' unprecedented mission to bring Christianity to the infidel in the East. Known as the *conquistador das animas*, the conquistador of souls, Xavier travelled from Goa to the Spice Islands and Japan. He died in 1552, waiting to gain access to the great jewel of the East, the closed empire of China.[73]

In fact, the Jesuits' experience in the East was very mixed. Inside Europe they specialised in educating the aristocracy, which reflected their policy of concentrating on leaders and opinion formers, as we would say, and the same was true in Asia. There was, after all, a good Christian precedent, in Constantine. They had an early success around 1580 with the Indian emperor Akbar, a Muslim. In China, however, it was rather different. The Jesuits did win the confidence of the emperor, but more through science than through theology. It took them many years to negotiate even access to Peking and when they did so their first gifts to the emperor comprised a statue of the Virgin and a clock which sounded the hours. The emperor was very taken with the clock, much less so with the Virgin, which he quickly passed on to the dowager empress, his mother. The Jesuits were a presence for nearly two centuries in Peking, becoming accepted for their superior skills in mathematics and astronomy. But they made few converts. On the contrary, they found a great deal to admire among the Chinese, so much so that they were soon wearing mandarin silks and attending Confucian ceremonies of ancestor worship.[74]

Japan, at least at first, seemed a better proposition altogether. In 1551, Xavier said that he had left behind him a community of about 1,000 converts, mainly *daimyos*, or local lords. By the early seventeenth century, however, the Jesuits claimed 150,000 converts and, on some counts, as many as 300,000. 'The warrior class or *samurai* were particularly susceptible, perhaps because they felt a kinship with many of the Jesuits who also had aristocratic or military backgrounds.' But this only made Christianity an issue in the internal politics of the Japanese ruling class and when this turned violent, around 1614, conversion backfired on the new Christians. A Japanese Inquisition emerged in which the Christians became the victims of torture methods which, when it came to cruelty, were easily the equal of anything that occurred in Europe. At Yedo, for example, three-score and more Japanese Christians were crucified upside down on the beach, 'to be drowned by the incoming tide'.[75]

The Jesuit efforts in the Far East were, overall, a comprehensive failure. They were, however, rather more successful in the West (the Christians of Latin America today form the largest single group in the church of Rome). But the Jesuits were not the only new orders to arise at the time of the Counter-Reformation: the Theatines, the Barnabites, the Somaschi, the Oratorians and the Fathers of the Nail (because they first worshipped at a church which preserved a relic of the nail used in the cross) all emerged as proselytising or teaching orders. Rome at last realised that, in the new climate, the best way to keep people within the Catholic faith was to catch them young.

Among the other effects of the Reformation we may underline the point that there were several Protestantisms: besides Lutheranism and Calvinism, there emerged for example the Anglican form, which made more of the sacraments and liturgical prayer than it did

of preaching, as was the case on the mainland continent of Europe, where the paramountcy of the sermon 'led to the drastic restructuring of Reformed church interiors from Ireland to Lithuania. This dramatically canopied wooden preaching-turret now became the chief focus of the congregation's eyes rather than the altar or communion table'.[76] Sermons were accompanied by an hourglass so that the faithful knew exactly how much more was to come. Diarmaid MacCulloch says the sermon was a much more popular form of theatre than the playhouse – in London there were 'hundreds' of sermons each week compared with only thirteen playhouses. This cult of the sermon was supported by the growth of catechisms, handbooks on religious doctrine, 'which for more than a century was the most common form of education throughout [Europe.]'[77] Further, this weekly 'diet of abstract ideas from the pulpit' made Protestant Europe more book-conscious and probably more literate than the Catholic south. According to one calculation, as many as 7.5 million copies of 'major religious works' were published in England between 1500 and 1639, in contrast to 1.6 million secular poems, plays and sonnets, while between 1580 and 1639 the religious writings of William Perkins 'scored' 188 editions compared with Shakespeare's 97.[78] This literacy had an incalculable effect on the later fortunes of the Protestant north.

Protestantism also revived the communal aspects of penance (the stool of repentance became familiar) and the so-called 'theatre of forgiveness', which sounds to us today like a great intrusion but had much to do with the discipline of capitalism that Weber made so much of. Protestantism kept illegitimacy rates low, and Thomas Cranmer's new wedding service was the first to affirm that marriage could be enjoyable 'for the mutual society, help, and comfort that the one ought to have of the other'.[79] The Reformed churches paid fresh attention to the idea of women's equality before God and established divorce as part of normal marriage law. Protestantism changed the ancient Catholic attitudes to medicine and created a desire for worship, not as solitary figures, or in a massive Europe-wide church, but in small groups, which eventually became Methodists, Quakers and so on. These different sects were one way by which tolerance grew … and doubt. An accidental revolution indeed.

At its very last session in December 1563 the Council of Trent turned its attention to the role of the arts in the post-Lutheran world.[80] The role of painting in the instruction of the faith was reaffirmed but, in the mood of the times, the council insisted that holy stories be strictly adhered to, as laid down in the scriptures, and the clergy was given the task of keeping watch over the artists. The very fact that the clergy were given this role sparked a spate of manuals by priests interpreting the decisions of the council. Many of these reached conclusions that were even more oppressive than Trent intended.[81]

In his examination of the effects of the Council of Trent on art, Rudolf Wittkower says that these interpreters – people like St Charles Borromeo, Cardinal Gabriele Paleotti, Gilio da Fabriano and Raffaello Borghini – stressed three things: art should be clear and straightforward, it should be realistic, and it should offer an 'emotional stimulus to piety'.[82] The chief change that came about, in contrast to Renaissance idealisation, Wittkower said, was that a stark display of truth 'was now deemed essential'. Where necessary, in the Crucifixion say, Christ should be shown 'afflicted, bleeding, spat upon, with his skin torn, wounded, deformed, pale and unsightly'. In addition, meticulous care had to be shown in

regard to a figure's age, sex, expression, gesture and dress. Artists had to pay attention to what it said in the scriptures and abide by those 'rules'. At the same time, the council took care to proscribe the worship of images: 'the honour shown to [the paintings and sculptures] refers to the prototypes which those images represent'.[83]

These unsettled intellectual circumstances combined to produce a great number of changes in art. The most important was the Baroque style, which was essentially the style of the Counter-Reformation. Following the Council of Trent, the energetic papacy of Sixtus V (1585–1590), during which he sought to rebuild Rome, to replace its glory after the sack, was the first move in the new art form. It was summed up by Cardinal Paleotti, who described the art of Rome at the turn of the seventeenth century in this way: 'The Church wants . . . both to glorify the courage of the martyrs and to set on fire the souls of her sons.' This is a good description of the aim of Baroque art. One of the popes who succeeded Sixtus, Paul V, completed the building of St Peter's and so between them Sixtus and Paul converted pagan Rome into Christian Rome, their aim being, 'by placing this sumptuous spectacle before the eyes of the faithful', to make the church 'the image of heaven on earth'. They did this especially in architecture and sculpture.[84] 'The High Baroque, at its best and fullest, is a union of the arts of architecture, painting and sculpture, acting in concert on the emotions of the spectator; inviting him, for example, to participate in the agonies and ecstasies of the saints.'[85] Its greatest exponent was Bernini, who did in stone what many people could not even do in paint.

But, while the flamboyant, swaggering figures of Bernini are classical Baroque, there was an upsurge of spiritual confidence at the beginning of the seventeenth century, which produced the very simple, but very strong, paintings of Caravaggio – very real, with meticulous attention to detail but with a powerful piety. Looking back on the Baroque, one cannot help but feel that, while the aims of the Counter-Reformation were kept in mind by artists such as Bernini and Caravaggio, there was also an exuberance, a love of art for art's sake, which the Council of Trent had abjured. This was the time, under Paul V, for example, that most of the fountains went up in Rome, which is now a city of fountains.

The new spiritual confidence was also reflected in an era of church-building, in Rome in particular, in which the churches, often dedicated to the new orders, were vast. These new buildings, designed to *overwhelm* the congregation, saw great, fiery sermons being preached from ornate, spectacular pulpits, under vast canopies – of gold and silver, jewels and fine textiles – and above all a new iconography. There was a marked shift away from traditional images, from Jesus narratives towards heroic examples (David and Goliath, Judith and Holofernes), on models of repentance (St Peter, the Prodigal Son), on the glory of martyrdom and saintly visions and ecstasies.[86] In line with this, and with the larger churches, pictures themselves grew in size and grandeur. This High Baroque is, as mentioned, typified by Bernini, 'a man of the theatre', who served five popes but, most of all, Urban VIII (1623–1644). Together they took a more aesthetic approach to art which helped improve its quality, moving it away from the mawkish mysticism that had characterised much turn-of-the-century Baroque art. The best example of this is possibly Bernini's *St Teresa*, a sculpture of the saint in rapture, which appears itself to be suspended in mid-air. 'This can only appear as reality by virtue of the implied visionary state of mind

of the beholder.'[87] Throughout Baroque art miracles and wondrous events are given a great air of verisimilitude. This was essentially based on Aristotle's reasoning in *Rhetoric*, where he says that the emotions are the basic ingredient in humans whereby persuasion is made to happen.

An entirely different set of events in art at this time was the development of the 'genres' – in particular, landscape painting, still-lifes, battle scenes and hunting scenes. Many art historians believe that a decisive step was taken in the seventeenth century, from a world in which art was primarily religious towards a more secular form. Rudolf Wittkower is one of these: 'It was in the years around 1600 that a long prepared, clear-cut separation between ecclesiastical and secular art became an established fact.'[88] After the first quarter of the seventeenth century artists were for the first time able to make a living by devoting themselves wholly to specialised genres. While still-lifes and battle scenes were popular, it was landscape painting which would become the most important of all non-religious genres, leading to Poussin and Claude.

When all is said and done, however, the outstanding achievement of Baroque Rome is St Peter's, and therein lies an important irony. This magnificent complex took two generations to complete (the baldacchino was finished in 1636, other parts in the 1660s). But the Peace of Westphalia (1648), ending the Thirty Years War, made it clear that, henceforth, the great European powers would settle their affairs without reference to the Holy See. At the point of her greatest physical glory, the intellectual ascendancy of Rome had begun, irrevocably, to wane. Power, and intellectual leadership, had moved north.

# 23

# *The Genius of the Experiment*

The scientific revolution 'outshines everything since the rise of Christianity and reduces the Renaissance and Reformation to the rank of mere episodes, mere internal displacements within the system of medieval Christendom.' These are the words of Herbert Butterfield, the British historian, in his book *The Origins of Modern Science, 1300–1800*, published in 1949.[1] They typify one view of 'the scientific revolution', that the changes which took place between Copernicus' publication of his book on the solar system, in 1543, and Sir Isaac Newton's *Principia Mathematica*, some 144 years later, in 1687, transformed our understanding of nature fundamentally and for all time – modern science was born. The Aristotelian view of the world was thrown out, to be replaced by the Newtonian view. (Newton, complained his contemporaries, some of them anyway, had destroyed the romance of the rainbow and killed the need for angels.) It was now that austere, cumulative, mathematical rationality replaced the fuzzy, haphazard, supernatural speculation of the Middle Ages. As Butterfield also insisted, this was the most important change in thinking since the rise of ethical monotheism.

This argument has come under attack in the last quarter of a century. The assault has a great deal to do with the discovery, mentioned in the Introduction to this book, of certain papers belonging to Newton, which were first discussed publicly by John Maynard Keynes. These papers showed that, besides his interest in physics and mathematics, Newton had an abiding fascination with alchemy and theology, in particular biblical chronology. This has led certain modern scholars – Betty Jo Teeter Dobbs and I. Bernard Cohen, for example – to question whether, with such interests as these, Newton and some of his contemporaries can be said to have had truly modern minds. Dobbs and Cohen remind us that Newton sought to demonstrate the laws of 'divine activity' in nature, in order to show 'the existence and providential care of the Deity' and they have therefore cast doubt on whether the transformation in thought was really so profound. They also point out that the change to modern chemistry came well after Newton, in the eighteenth century, and therefore, they argue, we cannot really speak of a scientific 'revolution', if by that we mean 'a change that is sudden, radical, and complete'.[2] They point out, further, that Copernicus was a 'timid conservative' in his private life – hardly a revolutionary – that there were barely ten 'heliocentrists' in the world in 1600, and that Kepler was a 'tortured mystic'. None of these 'heroes' were cold rationalists. The reader is warned therefore that the version of events which follows is very much in contention. I shall return to this discussion at the end of the chapter.

*

For scientists, we are now living our lives surrounded by the *second* scientific revolution. This began just over a hundred years ago at the turn of the twentieth century with the simultaneous discovery of the quantum, the gene and the unconscious. The *first* scientific revolution stemmed from a similar set of simultaneous and equally momentous events. These were the discovery of the heliocentric view of the heavens, the identification of universal gravitation, important advances in the understanding of light, of the vacuum, of gases, of the body and of microscopic life.[3] It is still not entirely clear why these advances all came together at much the same time. Protestantism, itself a revolutionary cause, with an emphasis on private conscience, surely had something to do with it. One of the other effects of the Reformation was to persuade reflective people that if there were so many, on all sides, who were convinced of their divine inspiration, they couldn't all be right. Therefore, divine inspiration must be, by definition, often wrong. Capitalism was a factor too, with its emphasis on materialism, money and interest, and its focus on calculation. The growing capacity in the world for precision in all walks of life also played a role. The discovery of the New World, with its very different geography, botany and humanity, contributed much. A final general background factor may have been the fall of Constantinople in 1453, which removed the last living link with ancient Greek culture, and what it had to offer. Not long before the city fell, the Sicilian manuscript dealer and collector Giovanni Aurispa brought back, after just one visit, no fewer than 238 Greek manuscripts, introducing Westerners to Aeschylus, Sophocles and Plato.[4]

Toby Huff has also drawn attention to the ways in which non-European sciences dropped behind. As late as the eleventh century there had been 'hundreds' of libraries in the Muslim Middle East, with one, in Shiraz, said to contain 360 rooms.[5] But under Islam astronomers and mathematicians usually had other roles, as *muwaqqit*, time-keepers and calendar-makers in mosques – they were thus hardly motivated to come up with new ideas that might have been threatening to the faith. Huff makes the point that Arab astronomers knew all the astronomy that Kepler knew but never thought it through to the heliocentric system.[6] The Chinese and Arabs never developed the 'equals' sign ($=$) and in fact the Chinese never believed that empirical investigation could ever completely explain physical phenomenon. In the thirteenth century there were, Huff says, the same number of scholars in Europe as in the Muslim world, or in China, but the latter two civilisations, because scholarship was validated centrally, either by the state or by masters, never developed *organised* or *corporate* scepticism and, ultimately, this is what counted. This is a question also addressed by the twentieth-century philosopher Ernst Cassirer, in his book *The Philosophy of Symbolic Forms*. He notes, for example, that in some African tribes the word for 'five' actually means 'completes the hand', whereas 'six' means literally 'jump' – i.e., to the other hand. Elsewhere number is not divorced from the object it is qualifying: 'two canoes' for instance is different from 'two coconuts', and with others the counting is simply organised as 'one', 'two', 'many'. With such a system, Cassirer says, the breakthrough to advanced mathematics is highly unlikely.[7]

In the sixteenth century, understanding the heavens was regarded as the most important aim of science, by which people chiefly meant physics. In a religious society, 'The whole fate of life and everything else was tied up with the movement of the heavens: the heavens

ruled the earth. Therefore, whoever understood how the heavens worked, would understand everything on earth.'[8] One of the chief effects of the scientific revolution – and it was clear by the time Newton's work had been assimilated – was that the heavens do *not* rule the earth. As J. D. Bernal says, the scientists of the day came to realise that the problem was actually not very important and this of course downgraded the standing of the heavens. In the process, however, the new science of dynamics had been discovered, with its own mathematics, the mathematics of differential equations. This has been the bedrock for theoretical physics ever since.

Nicholas Copernicus, a Pole, was fortunate in having an uncle who was a bishop, who took a great interest in his nephew and paid for his education in Italy. Copernicus was what we probably would call over-educated: he studied law, medicine, philosophy and *belles lettres*, and was also knowledgeable about astronomy and navigation.[9] He was fascinated by Columbus' discoveries but he would not have made a good navigator himself on Columbus' fleet, because Copernicus was in fact a weak astronomer – his observations were notoriously inaccurate. But these drawbacks were more than offset by his one simple observation: that the traditional way to explain the heavens was in disarray. Copernicus became convinced that Ptolemy had to be wrong because he sensed that nature would never have organised herself into a complex set of 'epicycles' and 'eccentrics' as the Greek maintained. Copernicus applied himself to this disarray, with a view to simplifying the explanation. He described his approach as follows: 'After I had addressed myself to this very difficult and almost insoluble problem, the suggestion at length came to me how it could be solved with fewer and much simpler constructions than were formerly used, if some assumptions (which are called axioms) were granted me. They follow in this order. 1. There is no one centre of all the celestial circles. 2. The centre of the earth is not the centre of the universe, but only of gravity and of the lunar sphere. 3. All the spheres revolve about the sun as their mid-point, and therefore the sun is the centre of the Universe. 4. The ratio of the earth's distance from the sun to the height of the firmament [in other words, the fixed stars] is so much smaller than the ratio of the earth's radius to its distance from the sun that the distance from the earth to the sun is imperceptible in comparison with the height of the firmament.'[10]

Everyone remembers that Copernicus displaced the earth as the centre of the universe but, as can be seen from his words above, two other things stand out. The first is that he was only saying what Archimedes had said two thousand years before. Second, and no less important theologically than his displacement of the earth as the centre of the universe, was his claim that the heavens – the realm of the stars – were much, much further away than anyone thought. This was shocking and disconcerting but, unlike Archimedes, Copernicus was – before too long – believed. One reason for his high credibility was a further set of arguments that fitted well with people's observations, namely that the earth has three different motions. In the first place, the planet revolves every year in a great circle around the sun. Second, it spins on its own axis. And third, there is a variation in the attitude of the earth to the sun. All of this, Copernicus said, meant that the apparent motion of the sun is not uniform. In some ways, this was his cleverest piece of reasoning: people had been puzzled for centuries as to why summer on earth does not last the same

length of time as winter, and why the equinoxes do not occur half-way through the year, or half-way between solstices. The real answer of course was that the planets, including the earth, orbited not in circles but in ellipses. But that crucial insight – which we shall come to – would not have been possible without Copernicus' observation about the relative movements of the earth and sun.

Copernicus' new ideas, systematised in his *On the Revolution of the Celestial Orbs*, commonly referred to by its Latin title as *De revolutionibus*, had some holes in it. For example, he still believed the medieval idea that the planets were fixed on the surfaces of a set of gigantic hollow concentric crystal balls. That apart, however, Copernicus had succeeded in his aim, of dispensing with the disarray and replacing Ptolemy's complicated epicycles.[11]

Though *De revolutionibus* was revolutionary, it was not immediately seen as incendiary. When Copernicus finally put pen to paper and sent it to the pope, the pontiff circulated the manuscript among fellow scholars, who recommended that it be printed. And although it was published by a Protestant printer, Copernicus' new ideas were regarded as 'perfectly respectable' all the way through the sixteenth century. It was not until 1615 that anyone complained that it contravened conventional theology.[12]

By then Copernicus' work was already being built on by the Danish nobleman Tycho Brahe. The Brahe family fortune came from a share in the toll which the Danes imposed on every ship going in or out of the Baltic through the Oresund, the straits between Denmark and Sweden. Tycho was an argumentative soul who, once, in a duel, had the end of his nose snipped off, and thereafter always had to appear in public with a neat silver tip glinting in the light. But the Danish Crown realised that Brahe was a talented scientist and granted him an island of his own in the Oresund where there were few opportunities for argument and where he was allowed to set up 'the first scientific institution of modern times', called Uraniborg, or Heaven's Gate.[13] The laboratory included an observatory.

Brahe may not have had as original a mind as Copernicus but he was a much better astronomer and, from his Oresund lab, he made many accurate astronomical measurements. These observations were left behind when, in 1599, Brahe quit Denmark and transferred to Prague, where he was appointed chief mathematician to the Holy Roman Emperor, Rudolf II, a highly eccentric man who was fascinated by alchemy and astrology. Back in Denmark, Brahe's measurements were held by his no less talented assistant Johann Kepler. He set about the task of trying to marry Brahe's measurements and Copernicus' theories.

Kepler was dogged and diligent and a keen observer. Like Copernicus he started with the belief that the stars were arranged, as traditionally thought, on a series of concentric crystal balls. Gradually, however, he was forced to dispense with this theory, when he found that Brahe's observations could not be reconciled with the crystal ball theory. His breakthrough came when, instead of trying to fit *all* the planets into a system, he concentrated on Mars.[14] Mars is particularly useful for astronomers because it can be observed almost all the time, and using Brahe's measurements, Kepler came to realise that, in its journey around the sun, Mars described not a circle but an ellipse. Once this breakthrough had been made, Kepler soon showed that all planets that orbit the sun do so elliptically and that even the moon's orbit of the earth is an ellipse. There were two immediate

implications of this, one physical and mathematical, the other theological. In terms of science, an ellipse, though a relatively simple shape, is nowhere near as straightforward as a circle and would take a great deal more explaining – how and why should an orbiting planet be further away from the sun at some points than others? Thus the discovery of elliptical orbits stimulated the study of gravity and dynamics. At the same time, what did the existence of ellipses do to the idea that the heavens consisted of a series of hollow concentric crystal balls? It made such an idea untenable.

Yet an elliptical orbit did explain why the seasons were of unequal length. An ellipse implied that the earth did not move around the sun at constant speed, but travelled faster when the planet was nearer the sun and slower when it was further away. There was, however, a constancy in the system, as Kepler found. The velocity multiplied by the radius vector (broadly the planet's distance from the sun) remained the same.[15] After his work with Mars, and Earth, and still using Brahe's calculations, Kepler was able to calculate the orbits, speeds and distances of the other planets, all in relation to the sun. He found that there was a constancy here too: the period of rotation and the distance from the sun was in the ratio of the square to the cube. There was thus a new and definite harmony to the heavens and, as Thomas Kuhn says, whether or not it pointed to God, 'it certainly pointed to gravity'.

The fourth of the great heroes of the scientific revolution, after Copernicus, Brahe and Kepler, was Galileo. Professor of mathematics and military engineering at Pisa University, Galileo somehow got his hands on a Dutch discovery that, because of the Dutch wars with Spain, was regarded as a military secret. This was the telescope. Though he was well aware of the military applications of the device (in helping one side count the enemy before they could themselves be counted), his own interest lay in an exploration of the heavens. And when he pointed his telescope at the night sky, he received one of the greatest shocks in all history. It was immediately clear that the heavens comprised far more stars than anyone had seen previously. There are, roughly speaking, two thousand stars in the sky at night that are visible to the naked eye. Galileo saw that, via the telescope, there are myriads more. Again, this had profound implications for the size of the universe and was therefore theologically challenging. But that wasn't all. With his telescope, Galileo also noticed three and then four 'stars' or 'moons' moving about Jupiter, just as the planets moved around the sun. This confirmed the Copernican theory of the heavens but at the same time provided Galileo with an example of what was in effect a celestial clock. The movement of these bodies was so far away as to be unaffected by the movement of the earth, thus providing a sense of absolute time. It offered navigators a way of finding longitudes at sea.[16]

As a professor of military engineering, another interest of Galileo's, naturally enough, was weapons – in particular what we call ballistics. At that point, as with much else, the basic understanding of dynamics (of which ballistics was a part) was essentially Aristotelian. Aristotle's theory of spear-throwing, for example, was that a spear, when thrown, moved through the air, and the air which was displaced from the tip of the spear somehow went round to the back of the shaft and pushed it along. But a spear did not shoot through the air for ever, because it got 'tired' and dropped to the ground. This was clearly unsatisfactory as an explanation of movement but, for two thousand years, no one had been able to come

up with a better one. That began to change after observations on another relatively new weapon – the cannon ball.[17] Part of the point of a cannon was that its angle of attack could be varied. As the gun barrel was raised from parallel with the ground, the range increased and went on increasing until 45°, after which it began to fall off again. It was this behaviour of cannon balls which provoked Galileo's interest in the laws of moving bodies, though another factor was the storms which periodically rocked Pisa and Florence, during which he noticed that the chandeliers and hanging lamps would sway and swing. Using his own pulse as measuring device, he timed the swaying of the lamps and found that there was a relation between the length of a pendulum and its swing. This became his square-root law.[18]

Galileo produced two famous treatises, *The Two Chief Systems* (1632) and *The Two New Sciences* (1638). Both were written in Italian (rather than Latin) and were in the form of dialogues – plays almost – designed to introduce his ideas to a wider audience. In the first, the relative merits of the Ptolemaic and Copernican systems were discussed between three men: Salviati (a scientist and scholar), Sagredo (an intelligent layman) and Simplicio (an obtuse Aristotelian). In the dialogue Galileo left little doubt as to where his sympathies lay but he also (and indirectly) satirised the pope. This led to his famous trial before the Inquisition, and to his imprisonment. During his year in jail, however, he prepared *The Two New Sciences*, a dialogue between the same three men, concerning dynamics. It was in this second book that he set out his views on projectiles and was able to show that the path of a projectile, disregarding air resistance, is a parabola.[19] A parabola is a function of a cone, as is an ellipse. For two thousand years, conics had been studied in the abstract: now, all of a sudden, two applications in the real world had emerged virtually simultaneously. Yet more harmony of the heavens had been revealed.

It was ironic that *The Two New Sciences* was written in jail. Galileo's imprisonment had been designed to keep the lid on the Copernican revolution. In fact, it provided Galileo with the opportunity to reflect and write the work which led to Newton and struck the greatest blow against religion.

According to a list of the most influential people in history, published in 1993, Isaac Newton ranked as number 2, after Muhammad and ahead of Jesus Christ.[20] Born in the same year that Galileo died, 1642, Newton grew up in an atmosphere where science was regarded as a quite normal occupation or interest. This is already very different from the world inhabited by Copernicus, Kepler or Galileo, where religion and metaphysics mattered most.[21] At the same time, Newton shared with them certain heroic qualities, in particular an ability to work almost entirely on his own. This was just as well because much of his ground-breaking labour was carried out in forced isolation in 1665 when London was devastated by the plague and he sought refuge in the village where he was born, Woolsthorpe in Lincolnshire. This was, in the words of Carl Boyer, in his history of mathematics, 'the most productive period of mathematical discovery ever reported', and was reflected later in Wordsworth's lines: 'a mind forever / voyaging through strange seas of thought alone.'[22]

At first Newton was interested in chemistry, rather than mathematics or physics.[23] But, at Trinity College, Cambridge, he started reading Euclid and attended the lectures of Isaac

Barrow, the (first) Lucasian professor, and became acquainted with the work of Galileo and others. The early seventeenth century was a time when mathematics became modern, taking a form that resembles what it has now.[24] In addition to Newton (1642–1727), Gottfried Leibniz (1646–1716) and Nicholas Mercator (1620–1687) were near-contemporaries and René Descartes (1596–1650), Pierre de Fermat (1601–1665) and Blaise Pascal (1623–1662) not long dead by the time he graduated.[25] Among the new mathematical techniques were symbolic expression, the use of letters, the working out of mathematical series, and a number of new ideas in geometry. But most of all, there was the introduction of logarithms, and the calculus.

   Some form of decimals had been used by both the Chinese and the Arabs and, in 1585, the French mathematician François Viète had urged their introduction in the West. But it was Simon Stevin, of Bruges who, in the same year, published in Flemish *De thiende* ('The Tenth'; French title *La disme*), which explained decimals in a way that more or less everyone could understand them. Stevin did not use the decimal point, however. He set out the value for $\pi$, *pi*, for instance, as:

Instead of the words 'tenth', 'hundredth' and so on, he used 'prime,' 'second' etc. It wasn't until 1617 that John Napier, referring to Stevin's method, proposed a point or comma as the decimal separatrix.[26] The decimal point became standard in Britain but the comma was (and is) widely used elsewhere.

   Napier (or Neper) was not a professional mathematician but an anti-Catholic Scottish laird, the baron of Murchiston, who wrote on many topics. He was interested in mathematics, in trigonometry and he conceived logarithms some twenty years before he published anything. Logarithm takes its name from two Greek words, *Logos* (ratio) and *arithmos* (number). Napier had been thinking about sequences of numbers since 1594, and while he was ruminating on the problem he was visited by a Dr John Craig, physician to James VI of Scotland (the future James I of England), who told him of the use of prosthaphaeresis in Denmark. Craig, almost certainly, had been with James when he crossed the North Sea to meet his bride-to-be, Anne of Denmark. A storm had forced the party ashore not far from Tycho Brahe's observatory and, while awaiting an improvement in the weather, they had been entertained by the astronomer and the device of pro-sthaphaeresis had been mentioned.[27] This term, derived from a Greek word meaning 'addition and subtraction', was a set of rules for converting the product (i.e., multiplication) of functions into a sum or difference. This is essentially what logarithms are: numbers, viewed geometrically, are converted to ratios, and in this way multiplication becomes a matter of simple addition or subtraction, making calculation much, much easier.* The tables Napier started were completed and refined by Henry Briggs, the first Savilian

---

* The *principle* of logarithms may be illustrated by the following simple sum: $100 \, (10^2) \times 1000 \, (10^3) = 100,000 \, (10^5)$. It is much easier and quicker to *add* the $^2$ and the $^3$ to equal $^5$ than to do the whole calculation.

professor of mathematics at Oxford. He eventually produced logarithms for all numbers up to 100,000.[28]

It is no criticism of Newton's genius to say, therefore, that he was fortunate to be the intellectual heir of so many illustrious predecessors. The air had, so to speak, been primed. Of his many sparkling achievements we may begin with pure mathematics, where his greatest innovation was the binomial theorem, which led to his idea of the infinitesimal calculus.[29] The calculus is essentially an algebraic method for understanding (i.e., calculating and measuring) the variation in properties (such as velocities) which may be altered in infinitesimal differences, that is, in properties that are continuous. In our study at home we may have 200 books or 2,000, or 2,001, but we don't have $200\frac{3}{4}$ books, or $2001\frac{1}{2}$. However, when travelling on a train its speed can vary continuously, infinitesimally, from 0 mph to 186 mph (if it is Eurostar). The calculus concerns infinitesimal differences and is important because it helps explain the way so much of our universe varies.

The measure of Newton's advance may be seen from the fact that, for a time, he was the only person who could 'differentiate' (calculate the area under a curve). For a time it was so difficult that when he wrote his greatest book, *Principia Mathematica*, he did not use differential notation as he thought no one would understand it. Published in 1687, *Philosophae naturalis principia mathematica*, to give the book its full title, has been described as 'the most admired scientific treatise of all times'.[30]

But Newton's main achievement was his theory of gravitation. As J. D. Bernal points out, although Copernicus' theory was accepted widely by this time, 'it was not in any way explained'. One problem had been pointed up by Galileo: if the earth really was spinning, as Copernicus had argued, 'why was there not a terrific wind blowing all round, blowing in the opposite direction to that in which the earth was rotating, from west to east?'[31] At the speed the earth was alleged to be rotating, the wind generated should destroy everything. There was at that stage no conception of the atmosphere, so Galileo's objection seemed reasonable.[32] Then there was the problem of inertia. If the planet was spinning, what was pushing it? Some people proposed that it was pushed by angels but that didn't satisfy Newton. Aware of Galileo's work on pendulums, he introduced the notion of the centrifugal force.[33] Galileo had begun with the swinging pendulum before moving on to circular pendulums. And it was this, the circular pendulum, which led to the concept of the centrifugal force which, in turn, led Newton to his idea that it was gravity which held the planets in, while they swing around perfectly freely. (In the case of the circular pendulum, gravity is represented by the weight of the bob and its tendency towards the centre.)

The beauty of Newton's solution to the problem of gravity is astounding to modern mathematicians, but we should not overlook the fact that the theory was itself part of the changing attitudes in the wider society. Although no serious thinker any longer believed in astrology, the central problem in astronomy had been to understand the workings of the divine mind. By Newton's day, however, the aim was much less theological and rather more practical: the calculation of longitude. Galileo had already used the satellites of Jupiter as a form of clock, but Newton wanted to *understand* the more fundamental laws of motion. Though his main interest was in these fundamentals, he was not blind to the fact that a set of tables – based on them – would be very practical.

The genesis of the idea has been recreated by historians of science. To begin with, G. A.

Borelli, an Italian, introduced the notion of something he called gravity, as a balancing force against the centrifugal force – otherwise, he said, the planets would just fly off at a tangent. Newton had grasped this too, but he went further, arguing that, to account for an elliptical orbit, where a planet moves faster the closer it gets to the sun, then the force of gravity 'must increase to balance the increased centrifugal force'. It follows that gravity is a function of the distance. But what function? Robert Hooke, the talented son of a clergyman from the Isle of Wight, who was in charge of the plans to rebuild the City of London after the Great Fire of 1666, had gone so far as to measure the weight of different objects deep in a mine shaft, and at the very summit of a church steeple. But his instruments were nowhere near accurate enough to confirm what he was looking for. From France Descartes, who had sought his own copy of Galileo's *Two Systems*, came up with the idea of the solar system as a form of whirlpool or vortex: as objects approach the centre of the whirlpool, so they are sucked in, unless they have enough spin to keep them out.[34] These ideas were all close to the truth but not the real thing. The breakthrough came with Edmund Halley. A passionate astronomer, he had sailed as far south as St Helena to observe the heavens of the southern hemisphere. Halley, who was to help pay for the printing of the *Principia*, urged several scientists, among them Hooke, Wren and Newton, to work on the proof of the inverse square law. Beginning with Kepler, several scientists had suspected that the length of time of an elliptical orbit was proportional to the radius but no one had done the work to prove the exact relationship. At least, no one had published anything. In fact, Newton, sitting in Cambridge, hard at work on what he considered the much more important problems of prisms, had already solved the inverse square law but, not sharing the modern scientist's urge to publish, had kept the results to himself. Goaded by Halley, however, he finally divulged his findings. He sat down and wrote the *Principia*, 'the bible of science as a whole and in particular the bible of physics'.[35]

Like Copernicus' major work, the *Principia* is not an easy book to read but there is a clarity of understanding that underlies the more complex prose. In explaining 'the system of the world', by which he meant the solar system, Newton identified mass, density of matter – an intrinsic property – and an 'innate force', what we now call inertia. In *Principia* the universe is, intellectually speaking, systematised, stabilised and demystified. The heavens had been *tamed* and had become part of nature. The music of the spheres had been described in all its beauty. But it had told man nothing of God. Sacred history had become natural history.

It is now accepted by most historians of science that Leibniz discovered the calculus entirely unaware that Newton had discovered it too, nine years earlier. The German (he was born in Leipzig) was no less versatile than his English counterpart – he discovered/invented binary arithmetic (representing numbers as a combination of 0s and 1s), an early form of relativity, the notion that matter and energy are fundamentally the same, and entropy (the idea that the universe will one day run out of energy), not to mention his concept of 'monads', from the Greek, μονας, meaning 'unit', constituent parts of matter, not just atoms, but incorporating a primitive idea of cells, too, that organisms are also made up of parts. In the case of both Leibniz and Newton, however, it is the calculus that represents their highest achievement. 'Any development of physics beyond the point reached by Newton would have been virtually impossible without the calculus.'[36]

*

Beautiful and complete as it was, in its way, *Principia Mathematica* and the calculus represented but two of Newton's achievements. His other great body of work was in optics. Optics, for the Greeks, involved the study of shadows and mirrors, in particular the concave mirror, which formed an image but could also be used as a burning glass.[37] In the late Middle Ages lenses and spectacles had been invented and later still, in the Renaissance, the Dutch had developed the telescope, from which the microscope derived.

Newton had combined two of these inventions – into the reflecting telescope. He had noticed that images in mirrors never showed the coloured fringes that stars usually had when seen directly through telescopes and he wondered *why* the fringes occurred in the first place. It was this which led him to experiment with the telescope, which in turn led on to his exploration of the properties of the prism. Prisms were originally objects of fascination because of their link to the rainbow which, in medieval times, had a religious significance. However, anyone with a scientific bent could observe that the colours of the rainbow were produced by the sun's light passing through water drops in the sky.[38] Subsequently it had been observed that the make-up of the rainbow was related to the elevation of the sun, with red rays being bent less than purple ones. In other words, refraction had been identified as a phenomenon but was imperfectly understood.[39]

Newton's first experiments with light involved him making a small hole in the wooden shutter to his rooms in Trinity College, Cambridge. This let in a narrow shaft of light, which he so arranged that it struck a prism and was then refracted on to the wall opposite. Newton observed two things. One, the image was upside down, and two, the light was broken up into its constituent colours. To him it was clear from this that light consisted of rays, and that the different colours were affected by the prism to a different extent. The ancients had had their own concept of light rays but it had been the opposite of Newton's idea. Previously, light was believed to travel *from* the observer's eye *to* the object being observed. But for Newton light was itself a kind of projectile, shot this way and that from the object looked at: he had in effect identified what we now call photons. In his next experiment, he arranged for the light to come in from the window and pass through a prism, which cast a rainbow of light on to a lens which, in turn, focused the coloured rays on to a second prism which cancelled the effect of the first.[40] In other words, given the right equipment, white light could be broken up and put back together again at will. As with his work on the calculus, Newton didn't rush into print but once his findings were published (by the Royal Society) their wider importance was soon realised. For example, it had been observed since antiquity (in Egypt especially) that stars near the horizon take longer to set and rise sooner than expected. This could be explained if it were assumed that, near Earth, there was some substance that caused light to bend. At that stage there was no understanding of the concept of the atmosphere but it is to Newton's credit that his observations kick-started this notion. In the same way, he noticed that both diamond and oils refracted light, which made him think that diamond 'must contain oily material'. He was right, of course, in that diamond consists largely of carbon. This too was a forerunner of modern ideas – the twentieth-century discoveries of spectrography and X-ray crystallography.[41]

*

Tycho Brahe's laboratory, on the Danish island of Hveen, has already featured in this story. In 1671 it featured again, when the French astronomer Jean Picard arrived there, to find that the whole place had been destroyed by ignorant locals. As he wandered around, however, traipsing through the ruins, he met a young man who seemed different from the others. Olaus Römer appeared very interested in – and knowledgeable about – astronomy. Touched that the man had worked so hard to better his knowledge, Picard invited Römer back to France. There, under Picard's guidance, the young man initiated his own observations of the heavens and, very early on, and to his considerable amazement, he discovered that Galileo's famous theory, based on the orbits of the 'moons' of Jupiter, was wrong. The speed of the 'moons' was not constant as Galileo had said, but appeared to vary systematically according to the time of the year. When Römer sat back and considered his data quietly, he realised that the speed of the 'moons' seemed to be related to how far Jupiter was from the earth. It was this observation which led to Römer's fantastic insight – that light had a speed. A lot of people took some convincing but the idea did have a precedent of sorts. By watching cannonballs fired on battlefields, soldiers knew all too well that sound had a speed: they saw the smoke from the gun well before they heard the sound of the shot. If sound had speed, was it so far-fetched that light could too?[42]

These were enormous advances in physics, reflecting a continuous period of innovation and creative thought. Newton himself, in a famous quote, comparing himself to Descartes, said in a letter to Robert Hooke, 'If I have seen farther than Descartes, it is because I have stood on the shoulders of giants.'[43] But on one question, Newton was wrong, and wrong in an important way. He thought that matter was made up of atoms and set out his view as follows: 'All these things being consider'd, it seems probable to me, that God in the Beginning form'd Matter in solid, massy, hard, impenetrable, movable Particles, of such Sizes and such Figures, and with such other Properties, and in such Proportion to Space, as most conduced to the End for which he form'd them; and that the primitive Particles being Solids are incomparably harder than any porous Bodies compounded of them; even so very hard, as never to wear or break in pieces ... But ... compound Bodies being apt to break, not in the midst of solid Particles, but where those Particles are laid together, and only touch in a few points.'[44]

As we have seen, Democritus had proposed that matter consisted of atoms two thousand years before Newton. His ideas had been elaborated on and introduced into western Europe by Pierre Gassendi, a Provençal priest. Newton had built on this but despite all the innovations he had made, his view of the universe and the atoms within it did not include the concept of change or evolution. As much as he had improved our understanding of the solar system, the idea that it might have a history was beyond him.

In 1543, the year in which Copernicus finally published *De revolutionibus orbium celestium*, Andreas Vesalius presented to the world in printed form his book on the structure of the human body. Arguably, this was even more important. Copernicus' theory never had much direct influence on the thought of the sixteenth century – its theological ramifications would spark controversy only much later. For biology, on the other hand, 1543 is a natural end-point and the beginning of a new epoch, for Vesalius' observations had

an immediate influence.[45] Everyone was curious about their own make-up (Vesalius' students begged him to make charts of the veins and arteries) and it was by no means unusual in the sixteenth century to see anatomical plates of skeletons displayed in barber shops and public baths. Vesalius' extremely meticulous study of anatomy also raised philosophical speculation, about man's purpose.[46]

His advances have to be placed in context. Until he published his book the dominant intellectual force in human biology was still Galen (131–201). It will be recalled from Chapter 9 that Galen was one of the monumental figures in the history of medicine, the last of the great anatomists of antiquity, but who worked under unfavourable conditions. Ever since Herophilus (born *c.* 320 BC) and Erasistratus (born *c.* 304 BC) dissection of the human body had been proscribed and Galen had been forced to make deductions based on his observations of dogs, swine, oxen and the barbary ape.[47] For more than a millennium, almost no advances had been made beyond him. Change had begun only in the time of Frederick II (1194–1250), king of Sicily and Holy Roman Emperor. A general concern for his subjects, combined with a genuine interest in knowledge, led Frederick to decree in 1231 'that no surgeon be admitted to practise unless he be learned in the anatomy of the human body'. The emperor backed this with a law that provided for the public dissection of the human body 'at least once in five years', at Salerno. This, the initial legislation for dissection, was followed by other states in due course. Early in the following century, the college of medicine for Venice, which was located at Padua, was authorised to dissect a human body once every year. In the early decades of the sixteenth century, Vesalius travelled to Padua for his training.[48]

That attitudes to the body were changing is shown from the drawings of Leonardo da Vinci, mostly executed around 1510, or three decades before Vesalius. There is a memorandum of the artist which shows that he had conceived a book on the 'human body' as early as 1489 (though this, like much else of his, was never completed).[49] What seems clear from the memorandum, and from Leonardo's drawings, is that he had studied anatomy professionally even before he joined forces with the anatomist Antonio della Torre, and that Leonardo continued to make dissections long after their relations were severed about 1506. The artist made more than seven hundred sketches showing the architecture of the heart and the layout of the vascular system, bones drawn from different aspects, the muscles and their attachments, cross-sections of the leg at different levels, and of the brain and nerves. The detail was sufficient not just for artists, but for medical students as well.[50] According to one source, by 1510 Leonardo had dissected no fewer than thirty human cadavers, of both sexes.

Born in Brussels on New Year's Eve 1514, Andreas Vesalius came from a family of physicians but was given a wide-ranging education. As a young man, he published a translation from the Greek of a medical book by Rhazes. Vesalius went from Brussels to the Universities of Louvain and Paris, returning home to become a military surgeon, serving in Belgium's wars. Finally, he moved to Padua, drawn by the relatively free access to bodies. In 1537, when he was still only twenty-three, he was placed in charge of anatomy teaching, and it was there, in the course of repeated dissections, that he began to see where Galen had gone wrong. This soon led him to reject Galen entirely and Vesalius began to teach only what he himself had uncovered. This proved enormously popular and students

flocked to his lectures, five hundred at a time according to some accounts.[51]

After five years in Padua and while he was still barely twenty-eight, he produced *The Structure of the Human Body*, with a dedication to Charles V. Published in Basle, it contained many plates and woodcuts.[52] (The illustrations were drawn by his fellow countryman John Stephen de Calcar, a pupil of Titian.) To the modern eye, de Calcar's images are bizarre: in an attempt to soften the sheer rawness of what he was depicting, the artist put his skeletons in lifelike poses, and arrayed them, for example, in picturesque landscapes. Bizarre or not, no drawings of such vivid detail had been seen before and the impact was immense and immediate. 'Vesalius corrected more than two hundred anatomical errors of Galen.'[53] Many contemporaries denounced him for this, but Vesalius had done the work and nothing they said could trump that. For example, he showed that the jawbone in man is a single bone, not divided as it is in the dog and other lower mammals. He proved that the thigh bone is straight, not curved as it is in the dog. He proved that the sternum is made up of three bones, not eight, as was thought. There were some who tried to argue that human anatomy had developed since Galen's day, or that 'the fashion for narrow trousers had caused man's leg bones to straighten'. Theologians also remained unconvinced. 'It was a widely accepted dogma that man had one less rib on one side, because from the scriptural account Eve was formed from one of Adam's ribs. Vesalius, however, found an equal number of ribs on each side.'[54] But this was the mid-sixteenth century, the Reformation and Counter-Reformation were under way and the church was implacable. The attacks on Vesalius got so bad that he resigned his professorship in Padua and accepted a position as court physician to the emperor Charles V, then living in Spain.

'But what Vesalius had begun, nothing could stop.'[55] The main figure to follow him was the Englishman William Harvey. Born at Folkestone in 1578, he studied for five years at King's School Canterbury, and then went up to Cambridge at the age of sixteen. Like Newton he did not shine early on (he was very young) and he studied mainly Latin and Greek, and an elementary level of physics. However, after graduation at nineteen, he immediately set out for Italy, and for Padua, showing he must have had some interest in medicine. There he studied under Fabricius, a famous teacher of the day.[56] Sixty-one when Harvey arrived, Fabricius was just then refining his understanding of the valves of the veins, though he also showed that the pupils of the eye responded to light. Fabricius' own knowledge was dated but he did stimulate in Harvey a great enthusiasm for medicine, which he took back home in 1602, having gained his doctorate. He went back to Cambridge, this time to earn an MD, which was necessary if he wanted to practise in Britain. He opened up shop in London and, within barely a decade, was appointed a lecturer at the Royal College of Physicians.[57] There is written evidence – the written evidence of his own spindly hand – that he was teaching the doctrine of the circulation of the blood within a year of his arrival at the Royal College, in 1616. But he was rather less forward than Vesalius who – remember – had published his anatomical observations when he was just twenty-eight. Harvey, we now know, had been lecturing on the circulation of the blood for a good twelve years before he committed himself to print. When his great classic, *The Movement of the Heart and the Blood*, appeared in 1628, Harvey was already fifty.

His observations were nothing if not thorough. In *De motu cordis et sanguinis*, to give

the book its Latin title, he refers to forty animals in which he had seen the heart beating. These animals included fish, reptiles, birds, mammals and several invertebrates.[58] At one point he confides as follows: 'I have also observed that almost all animals have truly a heart, not only (as Aristotle says) the larger red-blooded creatures, but also the higher pale-blooded crustacea and shell fish, such as slugs, snails, mussels, shrimps, crabs, crayfish and many others; nay, even in wasps, hornets and flies, with the aid of magnifying glasses (*perspicilli*), and at the upper part of what is called the tail, I have seen the heart pulsating myself, and have shown it to many others.'[59] The book is only seventy-eight pages long, is much more clearly written than either Newton's or Copernicus' masterpieces, and its argument is plain enough for even the layman to grasp: all the blood in the body moves in a circuit and the propelling force is supplied by the beating of the heart.[60] In order to make his breakthrough and conceive the circulation of the blood, Harvey must have deduced that something very like capillaries existed, connecting the arteries and veins. But he himself never observed a capillary network. He saw very clearly that the blood passes from arteries to veins 'and moves in a kind of circle'. But he preferred the idea that arterial blood filtered through the tissues in reaching the veins. It was only in 1660 that Marcello Malpighi, using lenses, observed the movement of the blood through the capillaries in transparent animal tissues.

Harvey's discovery of the circulation of the blood was the fruit of a clear mind and some beautiful observation. He used ligatures to show the direction of the blood currents – towards the heart in veins and away from the heart in arteries. And he calculated the volume of the blood being carried, to show that the heart was capable of the role he assigned to it. Observing the heart carefully, he demonstrated that its contraction expels blood into the arteries and creates the pulse. In particular, he showed that the amount of blood which leaves the left side of the heart must return, since in just under half-an-hour the heart, by successive beats, delivers into the arterial system more than the total volume of blood in the body.[61] It was because of Harvey, and his experiments, that people came to realise that, in fact, it was the blood which played the prime role in physiology. This change in perspective created modern medicine. Without it we would have no understanding of respiration, gland secretion (as with hormones) or chemical changes in tissues.

In the 1840s the English archaeologist Austen Layard discovered a lens-shaped rock crystal in the ruins of the palace at Nineveh in what is now Iraq. For some, this was 'a quartz lens of great antiquity', dating from 720–700 BC.[62] Few people believe this any longer – more likely it was a 'burning glass', to create fire, which we know was used in antiquity. In Seneca's *Natural Questions* (AD 63) he says: 'I may now add that every object much exceeds its natural size when seen through water. Letters however small and dim are comparatively large when seen through a glass globe filled with water.' Even this, which does show a reference to magnification, is no longer taken as evidence that magnifying appliances were used in ancient times.[63] The first accepted reference comes in the writing of Alhazen, the Arab physician, in a manuscript of 1052. The subject of the manuscript is not only the human eye and optical principles, but he also refers to globules of glass or crystals, by means of which he observes that objects are enlarged. Roger Bacon (1214–1294) in his

*Opus majus* (1267) says much the same, but there is no evidence that Bacon ever made either a telescope or a microscope.

This situation had changed by the end of the sixteenth century. We know that spectacle makers were common at the time in the Netherlands, Italy and Germany and it did not take long for people to happen upon a combination of lenses inserted into tubes. The Englishman, Leonard Digges (1571), and the Dutchman, Zacharias Jansen (1590), both flirted with telescopes, but it was very possibly Galileo who first used the telescope and the compound microscope fruitfully.[64] Following his first telescope in 1608, which has already been mentioned, a year later he made microscopical observations on tiny objects. In 1637, when Descartes published his *Discourse on Method*, it contained an appendix with printed pictures of microscopes.

This was all prologue. The first clear descriptions of minute living organisms were published by Athanasius Kircher in his *Ars magna lucis et umbrae*, released in 1646. There, he says that with the aid of two convex lenses, held together in a tube, he observed 'minute "worms" in all decaying substances' – in milk, in the blood of persons stricken with fever, and in the spittle 'of an old man who had lived soberly'.[65] In this way Kircher anticipated the germ theory of disease. He was followed by the Dutchman Antony van Leeuwenhoek of Delft, who in the course of his life made several hundred microscopes, some of which, it was said, could achieve magnification of up to 270 times.[66] At his death Leeuwenhoek left a couple of dozen of his instruments to the Royal Society of London, which had published a good deal of his work, and where he was elected a Fellow.[67] These microscopes account for his great success as an observer. Beginning in 1673, when Leeuwenhoek was forty-one years of age, and throughout his career, he sent 375 letters to the Royal Society.[68] Out of these, William Locy tells us, three in particular stand out. 'These are his discovery of protozoa, of bacteria, and his observation on the circulation of the blood.' 'In the year 1675,' Leeuwenhoek wrote, 'I discover'd living creatures in Rain water, which had stood but a few days in a new earthern pot, glazed blew within. This invited me to view the water with great attention, especially those little animals appearing to me ten thousand times less than those represented by Mons. Swammerdam, and by him called Water-fleas or Water-lice, which may be perceived in water with the naked eye . . . The first sorte by me discover'd in the said water, I divers times observed to consist of 5, 6, 7, or 8 clear globules, without being able to discern any film that held them together, or contained them. When these *animalcula* or living Atoms did move, they put forth two little horns, continually moving themselves . . .' Regarding size, Leeuwenhoek said that some of the 'animalcula' in question were 'more than 25 times less than a globul of blood'. One philosophical implication of this was that it seemed to supply the long looked-for bridge between visible organisms and inanimate nature.[69] Other observers soon followed and, by 1693, the world was given the first drawings of protozoa. For quite some time, little distinction was made between protozoa, bacteria and rotifers and even in the eighteenth century Linnaeus, who did not use the microscope, completely misconceived micro-organisms, placing them together in a single group which he called 'Chaos'.[70]

But in 1683, Leeuwenhoek discovered an even smaller form of life – bacteria. He had first observed them two years before but made careful drawings before he dared publish his discovery. (These too appeared in the *Philosophical Transactions of the Royal Society*.)

The drawings were essential because they make it clear that he had indeed observed the chief forms of bacteria – round, rod-shaped and spiral forms.[71] Here are some details from his letter: 'Tho my teeth are kept usually very clean, nevertheless when I view them with a Magnifying Glass, I find growing between them a little white matter as thick as a wetted flower: in this substance tho I could not perceive any motion, I judge there might probably be living Creatures. I therefore took some of this flower and mixt it either with pure rain water wherein were no animals; or else with some of my Spittle (having no Air bubbles to cause a motion in it) and then to my great surprise perceived that the aforesaid matter contained very many small living Animals, which moved themselves very extravagantly.'[72]

Leeuwenhoek's final triumph was his visual confirmation of the circulation of the blood. (Harvey, remember, had never actually *seen* the circulation of the blood through the capillaries. He had attempted to fit the final piece of the jigsaw – via the comb of a young cock, for example, the ears of a rabbit, the membranous wing of a bat. But that final observation had always eluded him.[73]) Then, in 1688, Leeuwenhoek trained his microscope on the transparent tail of the tadpole. 'A sight presented itself more delightful than any mine eyes had ever beheld; for here I discovered more than fifty circulations of the blood in different places, while the animal lay quiet in the water, and I could bring it before my microscope to my wish. For I saw that not only in many places the blood was conveyed through exceedingly minute vessels, from the middle of the tail toward the edges, but that each of the vessels had a curve or turning, and carried the blood back toward the middle of the tail, in order to be again conveyed to the heart.'[74] Nor should we overlook Leeuwenhoek's discovery, in 1677, of spermatozoa, though it would be another century before their true role was identified. Leeuwenhoek was the first person to make biologists aware of the vast realms of microscopic life.[75]

In biology, the seventeenth century proved to be as fertile as it was in physics. In 1688 Francesco Redi showed that insects were not the result of spontaneous generation, as had been thought, but developed from eggs laid by fertilised females. As early as 1672 Nehemiah Grew had speculated on the role of pollen as an agent in fertilisation in plants but it was not until 1694 that Rudolf Jakob Camerarius demonstrated, in his *De sexu plantarum epistola*, that anthers are the male sex organs in plants, and confirmed through experimentation that pollen (and very often wind) was needed for fertilisation. Camerarius showed himself well aware that sexual reproduction in plants was just the same in principle as in animals.[76]

Francis Bacon (1561–1626) and René Descartes (1596–1650) are both intermediary figures, in the sense that they lived their entire lives between the publication of Copernicus' *De revolutionibus* and Newton's *Principia Mathematica*. But they were not intermediate in any other sense: both were radical thinkers who used the scientific findings of their own day to move philosophy forward to accommodate the recent discoveries, and in so doing anticipated much of the world that Newton finally identified.

As Richard Tarnas, among others, has pointed out, there have been three great epochs in Western philosophy. During the classical era, philosophy – though influenced by the science and religion of the day – was a largely autonomous activity, mainly as a definer

and judge of all other modes of activity. Then, with the advent of Christianity, theology assumed a pre-eminent role and philosophy became subordinate to that. With the coming of science, however, philosophy transferred its allegiance from theology – and this is still more or less where we are today.[77] Bacon and Descartes were the main figures in bringing about this latest phase.

Francis Bacon wrote a number of works in which, in effect, he proposed a society of scientists, exploring the world together by experiment and showing no especial concern for theory (and none at all for traditional theory). Chief among these books were the *Advancement of Learning* (1605) (dedicated to James I), the *Novum Organum* (1620), and the *New Atlantis* (1626). Socrates had equated knowledge with virtue but for Bacon, a man of the world as well as a philosopher, it was to be associated with power – he had a very practical view of knowledge and this in itself changed beliefs about and attitudes to philosophy. For Bacon, science in itself became an almost religious obligation and, since his view was that history is not cyclical but progressive, he looked forward to a new, scientific civilisation. This was his concept of 'The Great Instauration', the Great Renovation, 'a total reconstruction of the sciences, arts, and all human knowledge, raised upon the proper foundations'.[78] Bacon shared the view of many contemporaries, that knowledge could only be built up by the observation of nature (rather than through intuition or 'revealed' knowledge), starting from concrete data rather than abstractions that had just occurred to someone. This was his main criticism of both the ancients and the schoolmen and what he most wanted to jettison before moving on. 'To discover nature's true order, the mind must be purified of all its internal obstacles.'[79] But Bacon also thought that the understanding of the High Middle Ages and of the Renaissance – that the study of nature would reveal God, by disclosing the parallels between man's mind and God's – was wrong. Matters of faith, he felt, were appropriate to theology but matters of nature were different, with their own set of rules. Philosophy, therefore, had to dispense with theology and go back to basics, examining the detailed findings of science and using those as the basis for further reasoning. This 'marriage', between the human mind and nature, was the basis of the modern philosophical approach. Bacon's view had a major influence on the fledgling Royal Society. 'It has been estimated that nearly 60 per cent of the problems handled by the Royal Society in its first thirty years were prompted by practical needs of public use, and only 40 per cent were problems in pure science.'[80]

Descartes was no less a child of his time than Bacon, though in many ways he was very different from the Englishman. He was, for a start, a considerable mathematician. He received a thorough Jesuit education, spent some time in the military, and wrote *La géométrie*, which introduced analytical geometry to his contemporaries.[81] This was not published separately, however, but as one of three appendices to the *Discours de la méthode*, which explained Descartes' general philosophical approach. The other two appendices were *La dioptrique*, which included the first publication of the law of refraction (actually discovered by Willebrord Snell), and *Les météores*, which contained among other things the first generally satisfactory quantitative explanation of the rainbow.[82] It was by no means clear why Descartes had included these appendices in the book, except that they showed the high place he accorded science in philosophy.[83]

His philosophy was in fact much influenced by the then-current vogue for scepticism.

This had been partly stimulated by the rediscovery of Sextus Empiricus' classical defence, which had been seized upon by Montaigne, who argued that all doctrine is 'humanly invented', that nothing was certain because belief was determined by tradition or custom, because the senses could deceive, and because there was no way of knowing if nature matched the processes of the human mind. Descartes brought his own brand of scepticism to bear on this. Geometry and arithmetic offered certainty, he said, observation of nature was free of contradiction and, in practical terms, life went on, with certain events at least being predictable. This was common sense. And when he looked about him, he realised that one thing was clear. The one thing that could not be doubted – because he was certain of it – was his *own* doubt. (This 'Pentecost of reason', Daniel Boorstin says, took place on the night of 10 November 1619.[84]) It was doubt that gave rise to Descartes' famous saying '*Cogito, ergo sum*' – I am thinking, therefore I am. But Descartes also believed that, since God was perfect, he would not deceive man, and therefore what could be worked out by reason 'was in fact so'. This led Descartes to his famous distinction between *res cogitans* – subjective experience, consciousness, the interior life, which is certain – and *res extensa* – matter, physical things, the exterior objective world, the universe 'out there'. Thus was conceived Descartes' famous dualism, in which soul is understood as mind. It was a bigger change than we might imagine today for, at a stroke, Descartes denied that objects in the world – stones and streams, which at one stage had been worshipped, machines and mountains, everything physical – had any human qualities, or any form of consciousness. God, he said, had created the universe but, after that, it moved on its own, composed of non-vital, atomistic matter. 'The laws of mechanics,' he said, 'are identical with those of nature,' and so the basic understanding of the universe would be discovered via mathematics, which was available to human reason. This was a major transformation, for underneath it all (but not buried in any way) Descartes was saying that God had been established by human reason, rather than the other way round. Revelation, which had once been a form of knowledge with equal authority to science, now began to slip: from here on, the truths of revelation needed to be reaffirmed by reason.

And so finally, after a long night of two thousand years, since classical Greece, the twin forces of empiricism and rationalism were back at the forefront of human activity. 'After Newton, science reigned as the authoritative definer of the universe, and philosophy defined itself in relation to science.' The universe 'out there' was devoid of human or spiritual properties, *nor was it especially Christian.*[85] After Bacon and Descartes (sitting on the shoulders of Copernicus, Galileo, Newton and Leibniz), the world was set for a new view of humanity: that fulfilment would come, not from the revelations of a religious nature, but from an increasingly fruitful engagement with the natural world.

While all these events were taking place, England was going through a civil war which resulted in the king losing his head. In the run-up to that event, the war produced some bizarre side-effects. At one point, for example, King Charles was forced to make his headquarters in Oxford. The professors and Fellows of the Oxford colleges proved very loyal to his majesty, but that backfired when he was driven out and they were all condemned by the rebels as 'security risks'. Removed from their positions, they were replaced by more republican-minded men from Cambridge and London. Several of these were scientists

and, as a result and for a while, science at Oxford blossomed. As part of this, a number of distinguished scientists began to meet in each other's rooms to discuss their problems. This was a new practice that was occurring all over Europe. In Italy, for instance, in the early years of the seventeenth century, the Accademia dei Lincei (the Academy of the Lynx-Eyed) was formed, with Galileo as its sixth member. There was a similar group in Florence, and in Paris the Académie Royale des Sciences was founded formally in 1666, though men such as Descartes, Pascal and Pierre de Fermat had been meeting informally since about 1630.[86]

In Britain there were two groups. One set formed around John Wallis, a mathematician, and met weekly at Gresham College in London from about 1645. (Wallis was a particular favourite of Oliver Cromwell because he had used his mathematical gift to break enemy ciphers.) The second group included the republican-minded men that centred in Oxford around the Hon. Robert Boyle, son of the Earl of Cork, who had spent some years in Puritan Geneva. He was a physicist interested in the vacuum and in gases. A rich aristocrat, Boyle was helped by his assistant Robert Hooke, who made the instruments and actually did the experiments. (Boyle called his group the Invisible College.) It may well have been Hooke who first had the idea of the inverse-square law and gravity.[87] Wallis and his group were among those who were put in place at Oxford by Cromwell, where they met up with Boyle and his Invisible College. This enlarged group turned into the Royal Society, which was formally founded in 1662, though for some time the Fellows of the new society were still known as Gresham Philosophers. Charles II, who was persuaded to start the society by John Evelyn, the diarist, must have thought the whole process somewhat odd because, as recent scholarship has shown, out of sixty-eight early Fellows, no fewer than forty-two were Puritans.[88] On the other hand, this make-up gave the society its complexion – such men showed an indifference to the authority of the past.

Among the other early Fellows of the Royal Society were Christopher Wren, better known as the architect of St Paul's and many London churches. There was also Thomas Sprat, later bishop of Rochester, who wrote what he called a 'history' of the Royal Society in 1667, only seven years after it had been founded, though it was more a defence of the so-called 'new experimental philosophy' and skipped over the awkward political colour of some of its members. (The frontispiece, besides showing the royal patron, also shows Francis Bacon.) After denouncing a number of dogmatic (speculative/metaphysical) philosophers, Sprat went on: 'The *Third* sort of *new Philosophers*, have been those, who have not onely disagreed from the *Antients*, but have also propos'd to themselves the right course of slow, and sure *Experimenting* ... For now the Genius of *Experimenting* is so much dispers'd ... All places and corners are now busie ...' And he described some of the members. 'The principal and most constant of them were Seth Ward, the present Lord Bishop of Exeter, Mr Boyle, Dr Wilkins, Sir William Petty, Mr Mathew Wren, Dr Wallis [a mathematician], Dr Goddard, Dr Willis [another mathematician], Dr Theodore Haak, Dr Christopher Wren and Mr Hooke.'[89]

Sir William Petty was a pioneer of statistical methods (though he was also a professor of anatomy at Oxford, where he carried out many dissections, and at one stage was credited with inventing the water closet, now thought to have been introduced in Elizabethan times). Once described as 'being bored with three quarters of what he knows', in 1662

Petty published a *Treatise on Taxes and Contributions* which was one of the first works to show an awareness that value in an economy derives not from its store of treasure but from its capacity for production.[90] In the same year, with Petty's help, John Graunt, another early FRS, published *Observations on the Bills of Mortality of the City of London*, which became the basis for life-insurance tables. These illustrate the very practical bent of the early Royal Society Fellows and their many-sided nature. None more so than Robert Hooke, the society's curator of experiments, whom history has treated unkindly. Hooke invented the balance spring of the modern watch, produced one of the first books to publish drawings of microscopic animals, *Micrographia* (a 'jolting revelation'), laid out the meridian at Greenwich, and had the idea, along with others, that gravitation extended throughout the solar system and held it together. As we have seen, it was discussions between Hooke, Wren and Halley that induced the latter to approach Newton, which resulted in the *Principia*. Hooke has been relatively forgotten because he quarrelled with Newton over his interpretation of the results of his optics experiments. Lately, however, Hooke has been rehabilitated.[91]

It was the Fellows of the Royal Society who developed the familiar form of scientific publication. One of Hooke's jobs, as an employee of the Society, was to help earn its keep by publishing *Philosophical Transactions* and selling them. Fellows, and other scientists, had begun writing in to the Society with their discoveries and in this way the Society became a clearing house and then publisher of the *Transactions*, which formed a model for subsequent scientific communication. In their hard-headed, practical way, the Fellows demanded good English in these papers, even going so far as to appoint the poet John Dryden to a committee to oversee the writing style of scientists.

It has often been claimed that the early universities played little role in the development of modern science – that most of the academies and societies were private or 'royal' affairs. Mordechai Feingold has recently cast doubt on this. He shows that there was a big increase in the university population between 1550 and 1650 (at least in England), that the Lucasian chair in mathematics was founded at Cambridge in 1663 and the Savilean chairs in mathematics and astronomy were also founded in Oxford at much the same time.[92] John Bainbridge, an early Savilean professor of astronomy, undertook expeditions to see eclipses and other phenomena, and when Henry Briggs, the logarithm expert (see above, page 481), died in 1630, his funeral was attended by all the heads of Oxford colleges. Feingold identified the correspondence of several individuals – Henry Savile himself, William Camden, Patric Young, Thomas Crane, Richard Madox – who each formed part of a Europe-wide network of scientists, linked to such figures as Brahe, Kepler, Scaliger and Gassendi. He shows that students *were* exposed to scientific results and that textbooks were modified in the light of those results.[93] Overall, the picture he paints is of the universities as part of the scientific revolution but without producing any great names of their own or major innovations. This is not perhaps a very dramatic or striking contribution, but Feingold insists it wasn't negligible either. Nor should we forget that Newton was a Cambridge man, Galileo a professor at Pisa, and Harvey and Vesalius both developed their ideas in a university context.

*

These few details about the early days of the Royal Society and the universities bring us back to the beginning of this chapter and the question as to whether or not we may speak of a scientific revolution. It is certainly true that 144 years elapsed between publication of Copernicus' *De revolutionibus* and Newton's *Principia Mathematica*, and that no less a figure than Newton himself was interested in alchemy and numerology, subjects or practices that were dying out. But, as Thomas Sprat's book shows, the men of the time did feel that they were taking part in something new, in a venture that needed defending from its critics, and that they took as their guiding spirit Francis Bacon, rather than some figure from antiquity. Experimentation, he said, was proliferating.

There is little doubt too that knowledge was being reorganised in new and more modern ways. Peter Burke, for example, has described this reorganisation in the sixteenth and seventeenth centuries. The word 'research' was first used in Étienne Pasquier's *Recherches de la France* in 1560.[94] Libraries were revamped in the seventeenth century, with a more secular layout, with subjects like mathematics, geography and dictionaries being promoted at the expense of theology.[95] The Catholic Index was alphabetised, an essentially artificial and non-theological arrangement, and Graunt and Petty's work on early statistics was augmented by the plague episodes of 1575 and 1630, which stimulated yet more counting of people. And by a royal census of trees in France.[96]

Richard Westfall has outlined what are perhaps the more important ways in which ideas changed during the scientific revolution. Beforehand, he says, theology was queen of all the sciences – now, it is 'not allowed on the premises any more'.[97] 'A once Christian culture has become a scientific one ... Scientists of today can read and recognise works done after 1687. It takes a historian to comprehend those written before 1543.'[98] '... in its most general terms, the Scientific Revolution was the replacement of Aristotelian natural philosophy, which aside from its earlier career had completely dominated thought about nature in western Europe during the previous four centuries.'[99] 'We have to look carefully ... to find experiments before the seventeenth century. Experiment had not yet been considered the distinctive procedure of natural philosophy; by the end of the century it was so recognised ... The elaboration and expansion of the set of available instruments was closely allied to experimentation. I have been collecting information on the scientists from this period that appear in the *Dictionary of Scientific Biography*, 631 in all. One hundred fifty-six of them, only a small decimal short of one-quarter, either made instruments or developed new ones. They are spread over every field of investigation.'[100]

In the end, Westfall thought it all came down to the relationship between Christianity and science. He quotes the episode, early in the seventeenth century, when the Catholic church, in particular Cardinal Bellarmino, condemned Copernican astronomy because it conflicted with certain overt passages in the scriptures. Sixty-five years later Newton engaged in a correspondence with a certain Thomas Burnet, who claimed that the scriptural account of the Creation was a fiction, composed by Moses for political purposes. Newton defended Genesis, arguing that it stated what science – chemistry – would lead us to expect. 'Where Bellarmino had employed Scripture to judge a scientific opinion, both Burnet and Newton used science to judge the validity of Scripture.' This was a huge transformation. Theology had become subordinate to science, the very

opposite of the earlier position and, as Westfall concluded, that hierarchy has never been reversed.[101]

In historical terms, sixty-five years is a very brief time-span. Without question, the changes wrought by science in the seventeenth century were 'sudden, radical, and complete'. In short, they were a revolution.

# Liberty, Property and Community:
# the Origins of Conservatism and Liberalism

Louis XIV, the Sun King of France, born in 1638, became king in 1643 and achieved his age of majority in 1661. Until his reign, the last sentence on laws in France usually read: 'In the presence and with the consent of the prelates and barons.' Later that changed to: '*Le roi a ordonné et établi par délibération de son conseil*', 'The king has resolved by deliberation in his council'.[1] This nicely illustrates the dominant political fact of the sixteenth and seventeenth centuries, which was the rise of the nation-state and absolute monarchy, emerging out of feudal dynasties and the 'city-states' that had characterised the Middle Ages and Renaissance.[2] These states gradually took on a form, and size, not seen since Roman times. Their emergence went hand-in-hand with a fresh round of political theorising, more impressive than at any other time, and the consequences of which are still with us.

These states emerged when they did thanks to a whole series of disasters and catastrophes, which left Europe little more than a wreck. In 1309 the popes began their exile at Avignon. In 1339 the Hundred Years War was begun between England and France. Increasing famines and plague culminated in the Black Death of 1348–1349. The Jacquerie, the French peasant insurrection, took place in 1358 and the Great Ecclesiastical Schism lasted from 1378 to 1417. There were risings in England and France in 1381–1382 and the Habsburgs were defeated by the Swiss Confederation four years later. In 1395 the Turks destroyed the Hungarian army at Nikopolis, the beginning of a campaign that culminated in 1453 with the fall of Constantinople. No area of Europe was immune, and Christendom itself was devastated. The Black Death reduced the population of the continent by a third but even so there was not enough food to go round and this widespread destitution and distress resulted in the most drastic upheaval in society that Europe had ever known.[3] At the same time that ideas about the universe (and therefore about God) were beginning to change, so law and order here on earth were disintegrating.

Men had been told, by the likes of Thomas Aquinas, that God had ordained the forms by which men should live together, and that any change was unthinkable. Under Aquinas, secular authority was allowed, but still as part of God's plan. Yet men, though they might still be very religious, though unbelief might still be an impossibility for them, were not fools. Some of them at least could not accept that chaos and disintegration were part of any divine plan.

The first man to attempt to think his way through this problem was Niccolò Machiavelli (1469–1527). He was fortunate (if that is the word) in living in Florence under three different systems of government – the rule of the Medici, until 1494, then of Savonarola and, after his fall, in 1498, of a republic. Indeed, Machiavelli was given a job in the new republic, as secretary to the second chancery, concerned with home matters, war, and some foreign affairs.[4] This did not give him much in the way of power but it did give him an inside view of politics. In his dealings with other city-states in Italy, he came in touch with the oligarchy of Venice and the monarchy of Naples in addition to the democracy in his own city. In Rome his travels also brought him up against the notorious Cesare Borgia, then in his mid-twenties. Machiavelli made Cesare Borgia the 'hero' of his book *The Prince*. This book, generally regarded as the first book of modern political theory, or *realpolitik*, as we would say, was in fact written only because the Florentine republic fell in 1512 and the Medici were restored to leadership. Machiavelli fell from favour, lost his position, was tortured and – all in quick succession – exiled from the city. In his enforced leisure, at his estate in San Casciano, he wrote *The Prince* very quickly, completing it in 1513, and dedicated it to Lorenzo de' Medici (grandson of Lorenzo the Magnificent). In this way he hoped to return to favour. In fact, Lorenzo never even read the book, and it wasn't printed in Machiavelli's lifetime.[5]

Machiavelli was a humanist and this coloured *The Prince*. It meant for example that he had a rigidly secular attitude to politics. Like Leonardo da Vinci, he was a scientist, the very first social scientist according to some, and in following this course he noted to himself that he was, in fact, opening up a 'new route'. What he meant was that he tried to look at politics objectively, in a disinterested way, so as to be able to generalise. He wanted to describe things as they were, not as they 'should be'. *The Prince* made a total break with the past in that Machiavelli didn't tell people what the good or honourable way to behave was, rather he was describing what he *saw*, how people actually do behave, 'how a prince must act if he wishes to prevail'.[6] In politics, Machiavelli was the first empiricist.

In some ways Machiavelli prefigured Galileo a century later. One of Galileo's ideas was that matter was the same everywhere, in the heavens as on earth, and Machiavelli argued that human nature was the same everywhere and at all times. He carried this further, insisting that while man's nature is both good and bad, for the purposes of politics we must assume it is bad. 'Men are wicked,' he writes, 'and will not keep faith with you ... Unless men are compelled to be good they will inevitably turn out bad.' It may be that Machiavelli took his 'new route' because he himself had been so disillusioned by his own political experiences, or it may be that he took his theory from the religious temper of the times, with its emphasis on evil. But in doing what he did, Machiavelli emancipated politics from religion. In working out that men would always tend to act in their own selfish, short-term interests, Machiavelli turned politics into an arena of secular thought.[7]

Machiavelli's other great innovation was his treatment of the state. In circumstances where men were selfish and evil and giving way constantly to evil inclinations, the only defence was *lo stato* – the state. 'This is a term which in its application to the organisation of political power occurs for the first time in Machiavelli, and which in fact was long limited to the Italian language.'[8] Hitherto, Hagen Schulze tells us, people had talked of 'rule' (*dominium*), 'government' (*regimen*), of 'kingdoms' or 'land' (*regio* or *territorium*),

'but when Machiavelli and his Italian contemporaries, from Villani to Guicciardini, spoke of *stato* they had in mind a form of government that had not been thought of before: basically a situation in which a concentrated form of public political authority was exercised uniformly throughout a given territory, irrespective of the person who exercised it, or in whose name it was exercised; a self-justifying system without transcendental dimension or reference.'[9] For Machiavelli the ends always justify the means and the maintenance of the state requires no justification beyond survival, because life without the state is unthinkable. 'A prince need only be victorious and maintain his rule, and whatever means he employs will be looked upon as honourable and will please everyone.'[10] This effectively marks the point of separation between theology and politics – in fact, at one point Machiavelli urges his readers to care more for their state than for their souls (though he thought the church should support the state and that success without such support would be difficult). His contemporary Francesco Guicciardini (1483–1540) went further, arguing that the medieval practice of subordinating politics to theology was now outmoded, that 'no one can live truly according to God's will unless he withdraws totally from the world; on the other hand, it is hard for man to live on tolerable terms with the world without offering offence to God'.[11]

It is worth mentioning here that, in calling his book *The Prince*, and using Cesare Borgia as a kind of anti-hero, as we would say today, Machiavelli wasn't writing a manual for tyranny. This was just a device of Machiavelli's, to make his book readable and accessible. The Prince, for him, is the *personification* of the state. He acts on behalf of the community and therefore must be willing 'to let his own conscience sleep'.[12] This is made clear when Machiavelli considers the rise and fall of states, which he says are governed by laws that differ from the laws of religion and from those of personal morality. 'The state has its own rules, its own code of behaviour, and its reasons of state that must govern the actions of statesmen, if they wish to succeed.'[13] The phrase 'reasons of state' was new too, but it entered the language firmly, never to leave. In essence it meant that a ruler was at liberty to break his word if the *publica utilitas*, the public interest, required him to do so. By the same token, the prince may lie to his own people – serve up propaganda – if, in his judgement, that serves the state. 'Men in general judge by their eyes . . . the common people are always impressed by appearances and results.' This was a decidedly un-Christian approach but it caught on, perhaps reflecting the fact that Machiavelli had it exactly right when he said that in man's nature, when it came to politics, the bad outweighed the good.

A final factor in the emergence of the state was the Protestant revolt, which broke the unity of Christendom.[14] In doing so it changed the position of the papacy. It was now, at least for Catholics, a state within the European community of states, rather than the supreme papacy it had been, or tried to be, in medieval Christendom. The significance of Luther and Calvin lay in the transfer of authority and political sovereignty from institutions to people.[15]

In his *Defence of Liberty Against Tyrants*, Hubert Languet (1518–1581), a famous Protestant divine, invoked 'a theory of contract between God on the one hand, and the prince and the people jointly on the other'. Both king and people were supposed to ensure that

each observed the correct forms of worship. It fell to the king to organise the church within his realm but if he defaulted, the people had a duty to coerce him, being guilty in the eyes of God if they lapsed and did not oppose a prince 'who was in error'. 'The common man is caught between two fires but he does have a role to play.'[16] This, politically speaking, was the crucial point.

Even the Catholics, even the Jesuits, were affected by this thinking to some extent. Among the Jesuits their two most important political theorists, Juan Mariana and Francisco Suárez, both Spaniards, were by no means deaf to what was happening elsewhere. Mariana argued that the social order derived from nature and that government evolved to accommodate the needs of civilised life and to protect property. From this, he said, it follows that the interests of the whole community come first and ought not to be subordinated to an absolute ruler. For him, the purpose of the state is the worship of God and the establishment of a Christian way of life, always of course in accordance with the doctrines of the church. Therefore, secular government cannot command spiritual loyalty unless sanctified by the church. But here too the people have a role, albeit limited. Suárez, in his *De Legibus ac Deo Legislatore* (1619) argued that 'all power comes from the community; men are born free and society is ordained to ensure order'. For him, therefore, a community is not simply an aggregate of individuals but an authority in itself, based on common consent. From this it follows that only the community can sanction authority. This is a much stronger statement than Mariana's.[17] Finally, in defining the papal position, the Jesuit theorists abandoned the traditional claim for papal sovereignty over all princes, which had caused so much trouble in the past, and in the process redefined the role of the headship of the church. In this way the pope became a sovereign on a par with other sovereigns, negotiating with them on equal terms for the benefit of Catholics.[18]

We may say then that four ideas emerged from this mix of events and theories: the secular side of politics had been emphasised, in which the people had a clearly defined role; the idea of individual liberty, and the right of rebellion, had crossed a psychological watershed (this was Karl Mannheim's point); the concept of the state had been introduced and clarified; and finally, the sheer, unending bitterness of religious strife had concluded in what John Bowle aptly calls 'a toleration of exhaustion'.[19] Politically speaking, this was the end of the medieval order and the birth of the modern world.[20]

The modern state, centred on a bureaucracy and organised for defence/aggression, first emerged in France. Louis XIV never actually said '*L'état, c'est moi*', but one can certainly see why the words were put into his mouth.[21] At that time the use of the word *état*, in the singular, in France, would have been particularly shocking. *Les états*, in the plural, were the 'estates', the different 'natural' groupings that made up French society – the nobles, the clergy, the commons, who ruled jointly with the monarch, who was himself an estate. (In both France and Holland the Parliaments were, and in Holland still are, known as the 'Estates General'.) The novel – the revolutionary – idea that the monarch should be the sole power in the state had been born as a result of the vicious civil war that tore France apart in the sixteenth century. Faced with such widespread demoralisation and the collapse of all civilised standards, and with religious fanaticism on all sides, humanists everywhere came to the view that any system of government that put an end to civil war was preferable

to continual fighting. In this way the equivalents of Machiavelli arose in France and England: Jean Bodin and Thomas Hobbes.

Surrounded by the bloodshed of the Huguenot wars in France, Jean Bodin (1529–1596), a lawyer and philosopher, realised that the salvation of his country lay in the strong rule of a central power, and as a direct consequence produced his doctrine of sovereignty. In the *Six Books of the Republic,* he sought to make the power of government so strong that it could always outweigh the special interests of regional autonomy and of religious persuasion. Like the Jesuits, he regarded the safeguarding of property as pre-eminent and, on this reading, his idea of the state was that it was there, above all, to preserve order.[22] It should be confessionally neutral and embodied in one man, the monarch.[23] This did not mean the sovereign could do as he pleased. He had to abide by natural law, fairness, and by God's law. 'This sovereignty [of the state] is unassailable. "He is sovereign who recognises nothing greater than himself save only Immortal God . . . The prince or people who possess sovereign power cannot be called to account for their actions by anyone but Immortal God"'. This sounds fanatical and Bodin's arguments certainly arose out of the vicious fanaticism shown in the French wars of religion.[24] But under his system, religious issues were deliberately excluded, and not permitted to govern the policies of the state. They were matters for the church and it was expressly forbidden that they be settled by force.[25] Thus was born the theory of the modern sovereign state. 'Both the classical Roman conception of a world order, and the ideal of a Christian society, formulated by St Thomas [Aquinas] and Dante, are abandoned.'[26]

As many people have commented, the eventual results of this change were to be disastrous, in the twentieth century. But, at the time, in the wake of vicious religious intolerance, and the changing fortunes of nobles and ordinary people, it was felt that the only immediate hope of efficient government was in the development of centralised power, for the sake of *order.*

In seventeenth-century France, it seemed to work. This was the time when she rose to a position of unchallenged supremacy in Europe, both politically and culturally. Her population was 20 million people, about twice that of the Holy Roman Empire, three times the combined population of England and Scotland, and four times that of Spain. The great feudal aristocracies had been tamed and domesticated by means of the court: this provided the setting for the glorification of the monarch, 'a temple for the worship of the ruler'.[27] No fewer than 10,000 people took part in the court's complicated rituals and no greater honour could be imagined than to be part of it. The strength and unity of the state was maintained by a standing army ten times the size of the court – 100,000 men. This standing army was the *ultima ratio Regis,* the ultimate instrument for the enforcement of royal authority (these Latin words were actually engraved on the cannon of the Prussian army). Such standing armies were expensive but were paid for, in part, by the state's involvement in trade.[28] The theory here was that the status and reputation of the sovereign were dependent on the economic prosperity of the state, which gave the state the right to intervene in commerce. This meant the introduction of taxes (and tax farming, to guarantee revenues) and the development of luxuries. The latter was based on the economic theory that the amount of money circulating in Europe was roughly constant, so that one country could only become wealthier by drawing money from somewhere else. The ideal

form of trade, therefore, was to import raw materials, relatively cheaply, and work them up to finished products, to be sold back abroad for much higher prices. So far as France was concerned, the idea worked spectacularly: the level of skill in arts and crafts was far higher there than elsewhere – French textiles, porcelain, furniture and perfumes brought in huge revenues, much of which was siphoned off by the state. Many other states in Europe modelled themselves on the Sun King.[29] A final element in absolutism was the new tactics of war. With huge standing armies in Europe, for the first time, the new tactics called for the manoeuvring of large bodies of men with great precision, and meant that much greater discipline was now needed. This led to a greater concentration of power of the absolute state at home, and indeed the idea of the state now overwhelmed men's minds.[30] This also had something to do with the ever-present European wars of the seventeenth to nineteenth centuries.

The first man to make the most of the scientific revolution in politics was Thomas Hobbes (1588–1679), the son of a vicar in Malmesbury, Wiltshire, in the west of England.[31] Hobbes was never a Fellow of the Royal Society, as John Locke was (see below), but he did send in scientific papers to the society and he carried out his own experiments in physiology and mathematics. (His friend John Aubrey, in his famous book, *Brief Lives*, described Hobbes as being 'in love with geometry'.) Hobbes acted as assistant to Boyle and amanuensis to Francis Bacon and met both Galileo and Descartes. He had an entirely materialistic view of the world, and developed the important doctrine of causality, the idea that the world is 'an endless chain of cause and effect'.[32]

Though Hobbes went further than Bodin, he shared some of the same views, and for much the same reasons. Just as Bodin produced *Six Books* against the background of the Huguenot wars in France, so Hobbes produced his works in the immediate aftermath of the English Civil War. Like Bodin, he thought religious atrocities were based on fantasies and illusions brought about by fanaticism; therefore, what he was after, above all, was security for people and property – *order*. Like Machiavelli, he assumed that men are reasonable and yet predatory, and like Bodin he built an argument for the absolute authority of the sovereign. Hobbes, however, considered that a sovereign could be either a monarch or an assembly (though he preferred the former), and he put the ecclesiastical power firmly under the secular power. The *Leviathan* (the biblical monster, 'which alone retained the wolf-like potential of man's primeval condition') is one of the great books of political theory and contains the most comprehensive description of Hobbes' ideas, though he wrote several other books, notably the *De Cive*, the *Tripos* and the *Philosophical Rudiments*.[33] In these, he reveals just what a heavy price he is willing to pay for order.

The *Leviathan*, 'my discourse of Civill and Religious Government occasioned by the disorders of the Present Time', was published in 1651.[34] The book is divided into four. 'Of Man', Part One, is an investigation of the state of human knowledge and of psychology. There are chapters on the 'Lawes of Nature' and the origins of the social contract. Part Two, 'Of Commonwealth', contains the main thrust of the book. In the third part Hobbes airs his religious views and in the last part, 'Of the Kingdom of Darkness', he culminates with an attack on the church of Rome.[35]

Hobbes was dogmatic, didactic, dogged. His attempt to be 'scientific' is everywhere

apparent. Underneath it all, he believed that sociological truth is just as discoverable in politics as it is in physics, biology or astronomy. 'The skill of making and maintaining Common Wealths consists in Certain Rules, as doth Arithmetique and Geometry; not (as Tennis play) in practice only . . .'[36] Hobbes argues openly that the state is a mere artificial contrivance for furthering the interests of the individuals who comprise it. He denied the Aristotelian belief that man is a social animal and argued that no society exists before the 'covenant of submission'.[37] Instead, he begins with the axiom that the natural condition of man is war. This is Machiavellian, only more so, and Hobbes' pessimistic outlook conditions all of the book. In the first part, on human knowledge and psychology, his survey of what was known at the time leads him to conclude (controversially enough, then) that nature has made man 'so equal in faculties of body and mind' that, 'when all is reckoned together, the difference between man and man is not so considerable as to prevent competition between them . . . So that in the nature of man we find three principall causes of quarrel. First, Competition; secondly, Diffidence [by which Hobbes meant fear]; thirdly, Glory.' The consequences of this are not good. Life, he famously remarked, was 'solitary, poore, nasty, brutish, and short'.[38]

There are no exceptions to this state of affairs. Even kings and queens, he comments, are continually jealous of each other 'in the state and posture of gladiators'. For Hobbes it therefore follows that, to avoid this primitive condition of perpetual war, men must submit to a common authority. Since the main law of nature is self-preservation, it follows that men are obliged to 'conferre all their power and strength upon one man, or upon one assembly of men that they may reduce all their wills . . . to one will . . .' This is what he means by the great Leviathan, a form of mortal God (as he put it) who alone has the power to enforce contracts and obligations. For Hobbes this contract is supreme. He does not allow any appeal to God or one's conscience 'because that would open the way for cunning men to get the better of their fellows, which is little more than a return to war'. Whatever the sovereign does, whatever taxes or censorship he imposes, they are all just because of the basis of his authority. Hobbes is not blind to the totalitarian nature of his system (as we would call it) and he concedes that it may be unpleasant to live under. He simply insists that it is far preferable to the alternative.[39] Of the three kinds of commonwealth – monarchy, democracy and aristocracy – Hobbes comes down firmly on the side of the first, and for clear reasons. In the first place, the personal interests of the monarch will tend to coincide with the public interest, and he can after all, always consult whom he pleases and 'cannot disagree with himself'. In response to the criticism that monarchs will always have favourites, he concedes 'they are an inconvenience' but adds that they will tend to be few, whereas 'the favourites of an assembly are numerous'.[40]

Hobbes knew that his book would be ill-received and he was not disappointed. Indeed, he was in sufficient danger from the Puritans, he felt, that he fled to France. He alienated the Parliamentarian Puritans because of his theory of 'servile absolutism', and he alienated the Royalists because, although he believed in absolute monarchy, he did not base his views on divine right.[41] A parliamentary commission was appointed to examine the *Leviathan* and only the intervention of Charles II saved Hobbes from persecution.[42] The poor reception of the book also had to do with the novelty of his ideas, partly because he broke with high-minded fashion and based his system not on a divinely inspired morality

but on its sheer usefulness. He also rejected any notion of 'natural law' or 'city of God', which men were familiar with and found comforting. For Hobbes, his Leviathan is justified not because of any high-flown reason that men could have rallied to but simply because it benefits those who comprise it – and that is all.

Today, we do not find Hobbes anywhere near as objectionable as his contemporaries did – because, for the most part, we actually live by many of the precepts he devised. We recognise now that men are indeed activated by fear or pride and we acknowledge moreover that both are equally dangerous. Above all we get by in societies where the often anonymous state is there to guard against the crude selfishness of human nature.[43] Machiavelli's pessimism, extrapolated by Hobbes', has lasted too long and too well to be entirely misplaced.

The rise of English and Dutch prosperity in the seventeenth century was a long-term consequence of two developments: a change in the salinity of the Baltic Sea which drove the herrings into the North Sea, boosting the catch there and augmenting the fishing industry of the countries that rimmed that body of water. And second, more important, it emphasised the drain away from the Mediterranean countries as the Atlantic Ocean opened up, following the discovery of America and the development of trade with the Indies and India. As a result, the politics of the new nation-states changed too, with trade rivalries beginning to take precedence over religious or dynastic feuds. The general increase in prosperity and the growth of mercantile influence on government produced a greater emphasis on property and more concern with the freedoms that should be allowed for individual business initiatives. It was this set of circumstances that produced the philosophy of John Locke.

'John Locke is the prophet of the English business commonwealth, of the rule of law and toleration. It was from the political speculation of Locke (1632–1704) and the actual working out in England of the principles of toleration and limited monarchy, that the French thinkers of the Enlightenment drew their inspiration. In their turn, they reinterpreted and generalised the more liberal aspects of English thought, so that it was translated from a local into a world influence.'[44] Locke does indeed epitomise the common sense of a generation wearied by religious and civil wars and a generation all too ready to benefit from colonialism and the subsequent emergence of a commercial class. Like Hobbes, Locke wrote on political philosophy but also on human nature, an *Essay Concerning Human Understanding* and *Two Treatises of Government*. This is one reason why his books were so influential: both aimed to fit political organisation into a wider system of understanding and both tried to do so scientifically. Locke studied medicine, was a Fellow of the Royal Society and his patron was Lord Shaftesbury, chancellor of England. He helped draft the constitution of Carolina.[45] Locke was a very practical, cautious soul, who disliked abstractions, and thought that truth was probable rather than absolute, making him not untypical of the people then coming to power in England. In his scheme of things, political power should be as far from 'divine right' as can be imagined. He thought it was foolish to claim that God passed power to Adam and then through his descendants to today's royal representatives. After all, he observed tartly, on that basis we are *all* descendants of Adam and it is impossible today to know who was who. He disagreed fundamentally with Hobbes in that he thought man's natural state was not war but the use of reason. 'Political

power ... I take to be a right of making laws with penalties of death, and consequently all the penalties for the regulating and preserving of property, and of employing the force of the Community in execution of such laws, and in the defence of the Commonwealth from foreign injury; and all this only for the public good.'[46] By their nature, he says, men are equal, as Hobbes had insisted before him. But for Locke that is not enough. He goes on to make a distinction between liberty and licence. Without licence, he says, liberty is no different from the continual warfare Hobbes so feared. Therefore, the purpose of civil society is the use of reason to avoid 'the inconveniences of the state of nature which follow from every man being made a judge in his own case, by setting up a known authority to which everyone may appeal and which everyone ought to obey'. Here he goes well beyond Bodin and Hobbes. Princes and kings, he says, can have no place in this scheme, 'for no man is exempt the law'. The will of the majority must always reign supreme.

Locke reflects the new situation in England more than ever when he goes on to argue that the reason men come together to live in society, with laws, is for the preservation of their property. Since men are 'driven' into society, it follows that the power of that society 'can never be suffered to extend further than the common good'. And this common good can only be determined by standing laws, statutes, that all are aware of and agree to, and *not* by extemporary decrees of, say, an absolute sovereign. Moreover, these laws must be administered 'by indifferent and upright judges'. Only in this way can the people (and rulers) know where they are.[47] In an important amendment to the idea of absolute monarchy, Locke said that the king can never suspend the law.[48] Finally, Locke gave voice to the main anxiety of the rising commercial classes in England (a fear of something which they saw happening in France, in state intervention in trade), that no power can take from a man his property without his consent. 'A soldier may be commanded by a superior in all things, save the disposal of his property.' In the same way, a man has property in his own person, meaning that a man's labour is his property too. The most important consequence of this, Locke says, is that people can be taxed only with their consent. (We recognise this now in the doctrine 'No taxation without representation.'[49])

This is in some ways the final break regarding the divine power of kings. The connection between the state and the individual is, for Locke, a purely legal and economic convenience, relating only to the practical aspects of existence. In other words, and very bluntly, the state had absolutely no part to play in matters of belief or conscience. Where religion was concerned, Locke was a great advocate of tolerance (he devoted two works to the subject, in his *Thoughts Concerning Education* and *Letters Concerning Toleration*). Tolerance, he says, should arise from the very obvious fact that different minds have different aptitudes, as is evident from the way different children grow up within the same family. Moreover, the principles of Christianity, he says, demand nothing less than toleration. 'No man can be a Christian without Charity, and without that faith which works not by force but by love ...'[50] The church, he insists, must be an entirely voluntary association; and it goes without saying that a person's religion should not affect his or her civil rights. 'The care of each man's salvation belongs only to himself.'

As with much of Hobbes' *Leviathan*, Locke's views today seem little more than commonplaces – again because we take them so much for granted. But they were very new in Locke's own day. The idea that government should derive its authority from the governed,

which implied that it should last only so long as the people wanted it, was breathtaking. 'At a time when kings ruled for a lifetime, this offered the prospect of change, even of revolution.'[51]

Baruch de Spinoza (1634–1677) was born two years after Locke but in some ways he had more in common with Thomas Hobbes. Like the latter, he thought that sovereign power is the price we pay for order. Unlike Hobbes, however, he had a better opinion of humanity and felt that, by making more use of the new sciences, intellectual and political liberty would be possible. In his optimistic way, he thought that mutual aid 'is as natural to men as fear and pride'. The purpose of society, for Spinoza, is therefore the extension of human awareness. In making this assumption, and then by examining man's psychology, as it is, the scientist can find a political structure to fit to that behaviour. As a result an ethical framework can be found that accords well with human nature.[52]

Spinoza thought that man can only realise his higher qualities when co-operating for some higher good and that 'the community alone is the medium through which this can be done'. Indeed, for him government is itself an expression of the impulse to mutual aid 'instinctive to mankind'. (This is clearly the very opposite of what Hobbes was saying.[53]) 'The aim of life and the State is the fullest realisation of its own being.' 'It follows,' he writes in the *Tractatus Theologico-Politicus*, his great work, 'that the ultimate aim of government is not to rule ... by Fear, not to exact obedience, but to free men from fear, that they may live in all possible security ... the object of government is not to change men from rational beings into beasts or puppets, but to enable them to develope their minds and bodies in security and to employ their reason unshackled; ... in fact the true aim of government is Liberty ... This outlook is the antithesis of the fear of life apparent in Calvin or St Augustine. We do not need to deny life to gain salvation. On the contrary, in the words of Jesus, the aim of mankind is "To have life and to have it more abundantly" and the State must be directed to this clear end.'[54] Spinoza believed in tolerance and freedom of speech because in this way, he thought, the state would be more secure.

His most startling attempt to promote freedom of thought comes in that part of the *Tractatus* where he gives an impartial analysis of the scriptures. In a radical departure, the book opens with ten chapters on the Old Testament, assessing the authenticity of the books and the exact nature of miracles. This was, in effect, the application of science to religion, a head-to-head confrontation. It leads on to an examination of Natural Law and Spinoza's conclusion that 'men are not conditioned to live by reason alone, but by instinct, So that they are no more bound to live by the dictates of an enlightened mind ... than a cat is bound to live by the laws of nature of a lion.'[55] This position of Spinoza was wholly original: he was a scientist but he wasn't as much in thrall to reason as most of his fellow scientists. But Spinoza did join with Hobbes in concluding that 'the basis of political obligation is the desire for security', a wholly utilitarian notion. And so, at a stroke, Spinoza overturned the entire classical and medieval assumptions that politics was a rational response to a divinely inspired Natural Law. Instead, Spinoza simply looked upon the sovereign state as Hobbes did, as the 'least of two evils'. He advised the sovereign to listen to the public, 'since an unpopular government does not last'. Democracy had its advantages, he said, because 'the danger of irrational commands is less to be feared, since it is almost

impossible that the majority of people, especially if it be a large one, should agree on an irrational design'.[56] 'The sovereign power should count all men, rich and poor, equal before it ... The power of the ruler is in practice limited by the fear he feels of his subjects: it is the fact of obedience, not the motive of obedience, which makes a man a subject. The aim of the statesman is to frame our institutions so that every man, whatever his dispositions, may prefer public right to private advantage; this is the task and this the test ... Public affairs ought to be administered on principles which are fool proof and knave proof.'[57]

For Spinoza, then, life was as much about the fulfilment of instinct as the exercise of reason, the human intellect was part of the divine mind and therefore reason has its shortcomings. 'Whenever, then, anything in nature seems to us ridiculous, absurd or evil, it is because we have but partial knowledge of things, and are in the main ignorant of the order and coherence of nature as a whole, and because we want everything arranged according to the dictate of our reason ... Every man has a right to fulfil his own being in so far as he has the power, and men have naturally authority over one another only in so far as they can impose it by force or persuasion; further no man need keep faith with another after he has judged it, rightly or wrongly, in his own interest to break it. Moral values are a human creation, cultivated in an artificial garden.'[58]

On this view of humanity, almost the only relevant political fact is the power of the majority. Since men are inevitably 'subject to passions', peace can be had only on these terms. In the same way, the only test of the state is the peace and security it brings.[59] It is no more than a convenience; the state exists for man, not the other way round.

Where Spinoza differed most from Hobbes and Locke was in his emphasis on knowledge. For knowledge changes and therefore 'the government must stand ready to change'. Further, insofar as the state is a convenience, an artificial garden, change is to be *expected*.[60]

In his recent book *Radical Enlightenment*, Jonathan Israel identifies Spinoza as a key figure in the creation of modernity, uniting the ideas discussed in this chapter, on political theories and arrangements, with those discussed in the previous chapter, on the scientific revolution, in the next chapter, on religious doubt, and in Chapter 26, on the Enlightenment search for the laws of human nature. After Descartes introduced the New Philosophy – his idea of a mechanistic universe – it was Spinoza, Israel says, who changed humanity's ways of thinking most, in the process creating the modern world. Israel's argument is that the Enlightenment was not, as generally pictured, a change in thought associated mainly with France, England and Germany (the *Aufklärung*) but was Europewide, taking in Scandinavia, Spain, Portugal and Italy, but led from the United Provinces, as the Low Countries then were. It was Spinoza, he says, who sparked the overall and general change in thought that encompassed five areas which we generally treat separately but where Spinoza's thought wove a neat web: philosophy, Bible criticism, scientific theories, theology and political thought. Spinoza's role has been insufficiently appreciated, Israel argues, because a lot of his support was clandestine. He discusses twenty-two 'Spinozist' manuscripts which circulated clandestinely and reports on many followers who were forced into exile, or whose works were banned by the authorities. Nevertheless, he describes countless groups of secret 'Spinozist' thinkers all over Europe, whose religious, political and scientific views went hand-in-hand, to incubate a new sensibility, which would burst into the open as the Enlightenment.[61]

It was Spinoza, he says, who finally replaced theology with philosophy as the major way to understand our predicament, and as the underpinning rationale of politics; it was Spinoza who dispensed with the devil and magic; it was Spinoza who showed that knowledge is democratic – that there can be no special-interest groups (such as priests, lawyers or doctors) where knowledge is concerned; it was Spinoza who more than anyone persuaded us that man is a *natural* creature, with a rational place in the animal kingdom; it was Spinoza who persuaded his fellow men and women that freedom could only be understood philosophically; it was Spinoza who laid the groundwork for republicanism and democracy; it was Spinoza who explained that the end-result of all these ideas was toleration. For Israel, Spinoza was Newton, Locke, Descartes, Leibniz, Rousseau, Bayle, Hobbes and, yes, maybe Aristotle all rolled into one, the most consequential figure, on this reading, since Aquinas.

'Man can know himself more profoundly and clearly than even Newton can grasp the laws of matter: consequently knowledge of history, being the story of human motives and their effects, can in principle be far more profoundly and minutely known than the external world, which is ultimately opaque.' Of all the original thinkers in the world, and despite Jonathan Israel's claims for Spinoza, the most underestimated figure is the Neapolitan Giambattista Vico (1668–1744). His simple insight, that men can know only what they make, coming as it did at the high point of the scientific revolution, completely transformed man's view of himself. In fact, it provided man with not one but two views of himself, mutually contradictory. Since these two views have never been reconciled (they are one of the main themes of the last part of this book), we may say that Vico is as responsible as anyone for the modern incoherence.[62]

Vico, a philosopher for whom history was more important than for anyone else of his time, tried hard to understand the mind of primitive man. Without such understanding, he thought, we can never understand ourselves. To do so he made highly original use of psychology, linguistics and poetry.[63] His most famous book was *Scienza Nuova*, published in 1725. His aim here was to uncover a secular philosophy of history, the laws of which, he believed, would help design workable political institutions for the future. As John Bowle says, by modern standards Vico had a weak understanding of biology, and it would be more than a century before evolution by natural selection was conceived. This limited his vision, yet at the same time Vico brought a magnificent energy to his task. Although he believed, like many people at the time, that God rules the world by means of laws evident in human affairs, he agreed with Spinoza that these laws were 'immanent' not transcendent – that is to say, they were not available through revelation but emerged in human institutions and could be deduced.[64] Unlike Hobbes and others he did not share the view that law stemmed from an overt rational contract; instead, he said it had been assembled from the instinctive realm of custom. 'Fallen humanity, no longer apprehending truth directly, is yet linked with God by the promptings of instinct. Through the darkness, men and nations still perceive glimmerings of the divine purpose by a "common wisdom", emergent in response to the challenge of the environment.'

Looking around him, and back through history, Vico uncovered three instincts, he said. These were the belief in Providence, the recognition of parenthood, and the instinct to

bury the dead, instincts which found expression in the customs and rites of religion, marriage and sepulture.[65] He accepted that man had fallen from grace, but he still believed he was the master of his own fate as he increasingly apprehended the evolution of civilised life. Civilisation was, to this extent, an expression of God's purpose, though philosophic knowledge could supplement instinct. The great collective enterprises of mankind – jurisprudence, the sciences, the arts, religion itself – may be examined for what they reveal about the aims of 'The Divine Architect'.[66]

The charm of Vico lies in the extent to which some of his ideas now seem so outmoded and absurd and yet in other aspects are so modern and still refreshing. For example, Vico maintained that after the Flood the human race was divided into men of normal size and idolatrous, bestial giants, 'living in the diluvial marshes' left by the receding waters. Humanity developed from these titans, though gradually we achieved the proportions we now have. Civilisation arose through a fear of thunder and lightning, which startled the giants out of their 'brutish stupor', for which they learned to feel nothing but shame. Thus shamed, they no longer cared to exercise their instincts in the open, and so carried off their mates into caves, where family life was founded. It was this first act of 'violent authority' which created the 'natural docility' of women and the 'natural nobility' of men. Vico was widely read in history and salted his views, for example, with scholarly references to the number of occasions where, in pagan mythology, thunder is made an attribute of Jove. In the same way, Old Testament giants are connected to Greek legends and the war of the Titans against the gods.[67] This first phase of human history is dubbed, naturally enough, The Age of the Gods, its purpose being for the ancestors of man to learn discipline. They conceived the gods who came to personify the sea, sky, fire and the crops and they evolved the rudiments of religion, family life, speech and property. (Vico thought this last derived from the burial of the dead.) The Age of the Gods was followed by the Heroic Age and then the Human Age.

In the third part of the book, Vico turned his attention to the human race and attempted to reconstruct its history by reference to language, notably poetry and the mythology of early man. 'Peoples who are in the depths of ignorance naturally interpret their surroundings by fables and allegories: the development of language naturally corresponds with the development of a society. During the Age of the Gods, when men were inventing speech, language was vague and poetical; the lapse of time was indicated by the number of harvests; the names of the gods symbolised the natural interests of food and agriculture. During the heroic age men communicated by symbols and heraldry.'[68] In another section he argues that man's social development derives from the three punishments inflicted on fallen humanity – the sense of shame, curiosity and the need to work. Each of the gods and heroes of mythology may be understood, he says, as manifestations of the effects of one or other of these punishments.

For us, today, Vico's arguments are unconvincing – the details, anyway – and many of those details are self-evidently absurd. But underneath the absurdity was a surprising piece of modern sense – that man evolves, and not just biologically but in terms of language, custom, social organisation, law and literature. And under all of that lay a bigger time-bomb: that religion itself evolves. Thus Vico helped also the advent of doubt, which is the subject of the next chapter.

*

The date of *The Prince*, 1513, to 1725, the date of *Scienza Nuova*, overlapped heavily with the scientific revolution and it is certainly no coincidence that all of these political philosophers attempted to construct their theories based on at least the *principles* of the new sciences, and to construct systems which could be generalised from state to state. It may be, however, that it was too early to apply the new sciences to the affairs of men. The most enduring legacy has in fact been the distinction between those who, like Machiavelli and Hobbes, were pessimistic about human nature (occasioning authoritarian or conservative philosophies), and those like Locke and Spinoza, who were more optimistic (the liberal philosophies). Broadly speaking, this is still the main political division by which most of us live, though we now call them, respectively, right and left.

The idea of 'community' (and its legitimacy as a political authority) has been a theme running through this chapter. But there is one meaning of the word that we have yet to encounter fully but which the Cambridge historian Tim Blanning says also came into being at this time – i.e., the seventeenth, and then the eighteenth century. This 'community' is 'the public', which he calls 'a new cultural space ... Alongside the old culture, centred on the courts and the representation of monarchical authority, there emerged a "public sphere", in which private individuals come together to form a whole greater than the sum of the parts. By exchanging information, ideas, and criticism, these individuals created a cultural actor – the public – which has dominated European culture ever since. Many, if not most, of the cultural phenomena of the modern world derive from the "long eighteenth century" – the periodical, the newspaper, the novel, the journalist, the critic, the public library, the concert, the art exhibition, the public museum, the national theatre, just to list a sample.'[69]

Blanning concentrates on three of these innovations: the novel, the newspapers and the concert. In the late seventeenth/early eighteenth century there was a 'reading revolution', he says, and he quotes scores of memoirs of the time to support this argument. In Britain, for example, the number of books published rose from about 400 per year in the early seventeenth century, to 6,000 a year by 1630, 21,000 in 1710 and fully 56,000 by the 1790s.[70] He notes that in the eighteenth century in Germany there was at this time a 'significant move' from using the words *die Gelehrten* (the learned) to *die Gebildeten* (the educated or cultivated). 'Even for those who rejected revealed religion and scriptural authority, *Bildung* offered a means of secular salvation through culture.'[71] Changing taste and the rise of the novel may also be seen from this table, taken from Blanning's book:

*Publishing in Germany: 1625–1800*

| Subject | 1625 | 1800 |
|---|---|---|
| Law | 7.4% | 3.5% |
| Medicine | 7.5 | 4.9 |
| History etc. | 12.0 | 15.7 |
| Theology | 45.8 | 6.0 |
| Philosophy | 18.8 | 39.6 |
| *Belles lettres* | 5.4 | 27.3 |

Blanning says that the chief attraction of the novel was its realism, imagination masquerading as factual *reportage*, and though many were trivial and lachrymose, Samuel Richardson expressed a more serious aim, to investigate 'the great doctrines of Christianity under the fashionable guise of an amusement'.[72] Another effect of the novel, and its concern with the here-and-now, was to push centre-stage family relationship and women, partly because most middle- and upper-class women enjoyed more leisure than their menfolk.

So far as newspapers and periodicals were concerned, it was during the last decades of the seventeenth century that the transition from sporadic to regular publication occurred in several parts of Europe – Antwerp, Frankfurt, Turin, as well as Paris and London. Bayle's *Nouvelles de la République des Lettres* ('News of the Republic of Letters') first appeared in 1684. By the 1730s in London, however, there were six dailies and by the 1770s there were nine, with a combined circulation of 12,600,000. Even those who couldn't read kept up; they gathered in one of London's 551 coffee houses, 207 inns or 447 taverns, where the newspapers were read out loud. These figures were eclipsed by those in the Holy Roman Empire, where there were more than a thousand newspapers and periodicals by the time of the French Revolution.[73]

This picture is amended somewhat by Jonathan Israel's discussion of 'learned journals' which also came into existence at this time. 'Overwhelmingly orientated towards recent developments in the world of thought, scholarship and science, they did much to shift the focus of the cultivated public's attention away from established authorities and the classics to what was new, innovative, or challenging, even when such innovation arose in distant lands and unfamiliar languages.' Whereas previously it took people years to find out about books which had appeared in a language different to their own, now they knew about them 'within a matter of weeks'.[74] In addition to making people better informed, these journals generally displayed the new values of toleration and intellectual objectivity, says Israel, and often contributed to the fragmentation of the 'deeply rooted notion, championed by kings, parliaments and Churches alike, that there existed a universally known, accepted and venerated consensus of truth. At the same time, the journals also attempted to marginalise the more radical aspects of the enlightenment, those parts promulgated by the Spinozists.'[75]

Though their use expanded enormously, books had existed in one form or another for centuries. In contrast, the public concert was a wholly new medium. Blanning says that the first public concert, in the modern sense (a clear distinction being made between audience and performers, an anonymous public admitted on payment of a fee), took place in London, at John Banister's house, 'over against' the George Tavern, in Whyte Freyers, in 1672. This stimulated a demand not only for other concerts but also for sheet music as people achieved musical literacy. This, in turn, created a demand for a certain kind of music, of which Haydn and then Handel in particular were the beneficiaries – the symphony was especially popular with the new musical public. Concert halls proved to be a major attraction at the great market towns (Frankfurt, Hamburg, above all Leipzig), as an added bonus of travel.[76]

The new ideas in music still came from the cities where the courts remained (Salzburg, Mannheim, Berlin) but Blanning's point is that the new public, the new public sphere, brought with it a much greater national feeling than had ever existed before. In fact, the

new, self-conscious public and the cultural ideas it developed a taste for formed a powerful cocktail or mix, a new forum for the circulation of ideas which hadn't existed before. This mix would not only determine what cultural ideas proved popular and enduring, but ensured that culture itself would become a virile and febrile aspect of nationalism. The powerful doctrine that nations should differ in their cultures, which was to prove energising and dangerous in equal measure, really stems from the emergence of the public sphere in the seventeenth century.

# The 'Atheist Scare' and the Advent
# of Doubt

Copernicus died in 1543. According to tradition, he received the first printed copy of *De revolutionibus*, his famous book on the heavens, on his deathbed. It makes for a dramatic and moving story, but we should not make more of this episode than it deserves. In fact, the 'revolution' which *De revolutionibus* sparked took quite a while to come about. In the first place, the book is virtually unreadable except to erudite astronomers. Second, more important, reports of Copernicus' research – including his new hypothesis, that the earth went round the sun, rather than vice versa – had been circulating in Europe, among scientists, since about 1515. For at least two decades Copernicus had been recognised as one of Europe's leading astronomers and his book, which would set out the details of the new theory, was keenly awaited by colleagues.

When *De revolutionibus* did appear, most of these colleagues recognised immediately the book's importance.[1] Indeed, many astronomers referred to Copernicus as a 'second Ptolemy' and, by the second half of the sixteenth century, his book had become a standard reference for nearly all professionals in the field. At the same time, and incredible as it may seem to us, the central argument of *De revolutionibus* was ignored. 'Authors who applauded Copernicus' erudition, borrowed his diagrams, or quoted his determination of the distance from the earth to the moon, usually either ignored the earth's motion or dismissed it as absurd.'[2] An English elementary textbook on the heavens, published in 1594, more than half a century after Copernicus' book appeared, took the earth's stability for granted. This is even more surprising than it may seem in retrospect because, except for the church, Copernicus was pushing at a door that was more open than one might think.

By the end of the sixteenth century, there was no shortage of people in Europe who felt that the Christian religion had been gravely discredited.[3] Protestants and Catholics had been killing each other in their thousands, and hundreds of martyrs had been put to death, often in spectacularly cruel ways, for holding opinions that no one could prove, one way or the other. As was mentioned above, if so many people were convinced their divine inspirations were right, and yet they disagreed so drastically, surely this must mean that divine inspiration was often illusory. Ironically enough, the Bible itself was instrumental in provoking some of these events. For it was now that vernacular translations of the scriptures brought the book before a mass audience. From the 1520s on, the Bible passed beyond the realm of the scholar and the divine and, as Brian Moynahan has pointed out,

the implications of what was *not* in it became as important as what was. In particular, what could now be seen clearly were the many church practices and privileges 'that were found to be blessed by custom but not directly by God'.[4] Menno Simons was just one twenty-eight-year-old, in Pingjum, Holland, who had his doubts – in his case about the bread and wine at mass being the flesh and blood of Christ. He attributed these doubts to the devil, trying to prise him from his faith. He had confessed this often, he said, when he finally got the idea 'to examine the New Testament diligently ... I had not gone very far when I discovered that we were deceived ...'[5] He was in fact 'quickly relieved', he said, to find no evidence that the bread and wine were anything other than mere symbols of Christ's passion. Relieved or not, it was still an overwhelming shock.

The access to the sacred book which the vernacular translations gave ordinary people was dangerous, and the church knew it. For example, it allowed the laity to discover for themselves the inconsistencies and contradictions in the text, inconsistencies and contradictions which had been kept from them. A young Englishman, in Chelmsford, Essex, was forbidden to read William Tyndale's English translation of the Bible (hundreds of copies of which were being smuggled into Britain) and ordered by his father to consult only the Latin edition, which the young man could not read. He rebelled, obtained a copy of the English translation and hid it under his bedstraw, reading it when he could. This soon led him to mock the reverence which his elders displayed to the cross, kneeling before it in church, raising their hands to it when it passed by in procession. He told his mother one night, when his father was asleep, that such practices were mere idolatry and against the wishes of God, who had said 'Thou shalt not make any graven image, nor bow down to it, nor worship it.'[6]

The practice of numbering biblical verses, introduced by the printer Robert Stephanus in Geneva in 1551, also played a part. Being able to find their way around the scriptures more easily for many people only pointed up the many glaring inconsistencies and conflicting truths. Anabaptists pointed out that Genesis supported polygamy. In Mark's gospel, on the other hand, Jesus said 'a man ... shall cleave to his wife' (10:6). Divorce is permitted in Deuteronomy but not in Matthew.[7] The book of Kings encourages the non-payment of taxes, whereas Matthew's gospel says they must be paid. Many other practices and traditions, sanctified by time, and which the laity assumed were in the scriptures, were actually nowhere to be found. These included papal authority, the celibacy of priests, transubstantiation, infant baptism, the canonisation of saints and the impossibility of salvation outside the Catholic church.[8]

The fragmentation epitomised by the inter-faith violence, and accompanied by the discovery by the wider public of the inconsistencies and contradictions in the Bible, helped to produce a situation where, by the end of the sixteenth century, sects with more or less extreme views had proliferated to the point of bewilderment so that there was now, if anything, too much theological choice, making the discovery of the 'true faith' more difficult, more impossible, than ever. One result was that the word 'atheist' came to be much more widely used than ever before.[9]

Atheism is a Greek word. The first recorded atheist in history was Anaxagoras of Clazomenae (fl. 480–450 BC). Certainly he was the first to be accused of atheism, and was

prosecuted and condemned for his free thought.[10] Yet Socrates tells us that Anaxagoras' books were widely available in Athens and that anyone could pick them up for a drachma – in other words, he wasn't regarded as a crank.[11] The poet Diagoras of Melos was also accused of atheism, after he had concluded that there could be no god because so many acts of iniquity went unpunished.[12] (We are also told that Diagoras broke up a statue of Hercules and used it for firewood, impudently daring the god to perform his thirteenth labour by cooking turnips.) More than one character in the plays of Euripides impeaches the gods, insisting there can be no truth in the 'miserable tale of poets'.[13] In ancient Rome, there was less freethought than in Athens. There are no references to religion in Cicero's private letters and in Petronius' *Satyricon* the characters take pleasure in ridiculing priests who officiate at mysteries they don't really comprehend.[14] But this too is scepticism rather than out-and-out atheism.

As was referred to in the Introduction, James Thrower has examined what he calls 'The Alternative Tradition', the rejection of religious explanations in the ancient world. He described, for instance, the Lokayata tradition in India, beginning in the sixth century BC, which was essentially a hedonistic approach to the world, based on a lost text, the *Brhaspati Sutra*. This system arose at much the same time as Buddhism and the Upanishads (it was also known as Carvaka) and its central beliefs were a rejection of tradition and magic, and that the body and the self were one and the same, meaning there was no life after death: one lived for pleasure in the here and now. Purana Kassapa, a wandering Indian ascetic, also attacked the fundamental Hindu doctrine of *karma*, held that there is no hereafter, and that morality is a natural phenomenon, whose only purpose is to help life on earth. He was followed by Ajita Kesakambali and Makkhali Gosala, the founder of the Ajivikas, a sect which survived at least into the thirteenth century AD, who had a naturalistic conception of man.[15] The notion of 'natural laws', which explain change and evolution in the world, was not at all uncommon in ancient and medieval Indian thought.[16]

Thrower also notes that in China the Taoists discouraged speculation about the ultimate origin and end of nature, stressing the eternity and uncreatedness of the *Tao*, that all was silent and empty before Heaven and Earth were produced, that there was a fundamental unity to nature – i.e., a set of laws, which it was the job of philosophy to apprehend, rather than creation as such. In China supernatural forces were ruled out by Xun Zi (298–238 BC), who discounted the efficacy of prayer and divination, who recommended the study of nature rather than its worship and, like his later epigone Wang Chong (AD 27–97), argued that what happens in the world is the fruit of human 'merit or demerit', rather than supernatural forces.[17] The naturalistic theories of Zhu Xi (1130–1200) were considered in Chapter 14.

Thrower's argument is that when these Indian and Chinese ideas are put together with Greek and Roman thought – Ionian science, the sophists, the Epicureans, Roman notions of *imperium,* their very great practicality in turning successful emperors into gods – the approach to the natural world, omitting supernatural elements, amounts to an alterative chain of thought that has had insufficient attention from historians.

J. M. Robertson, in his history of freethought in the West, says there was a 'startling display' of freethinking at Paris University in 1376, by the philosophical students. Among a list of

219 theses that they proposed, they denied the Trinity, the divinity of Jesus, the resurrection, and the immortality of the soul. They insisted that prayer was useless and that there are 'fables and falsehoods' in the gospels as in other books. They were sharply 'scolded' by the archbishop but nothing more serious seems to have resulted.[18]

The historian Jean Seznec has chronicled the survival of the pagan gods in Renaissance art, from Botticelli to Mantegna and from Correggio to Tintoretto. He shows how pagan antiquity had never really disappeared in the Middle Ages, not the gods anyway. The dukes of Burgundy had prided themselves on being descended from a demi-god and the Trojans were very popular at their court.[19] Jupiter and Hercules were included in the tapestries of Beauvais cathedral,[20] and four mythical divinities were represented in the fifteenth-century chapel of the Palazzo Pubblico in Siena, among them Apollo, Mars and Jupiter.[21] In the campanile in Florence Jupiter is dressed as a monk![22] Seznec's point, insofar as it relates to this part of our narrative, is that the pagan gods and the Christian God had lived side-by-side until the Renaissance, with medieval people unwilling to discard the classical gods entirely.[23]

While Copernicus was being (slowly) assimilated across Europe, Michel Eyquem, better known as Montaigne (1533–1592), was using his classical education and his mixed background (a devout Catholic father, and a Jewish mother who converted to Protestantism) to evolve a way of looking at the world which repudiated the orthodox Christian position and prepared his fellow men for the shattering changes that were about to break over them.

Montaigne's background made it next to impossible for him to accept that any one faith had a monopoly of divine revelation and this thinking he applied not just to beliefs but also to morality. Growing up amid the flood of discoveries from the New World had its effect too, producing in him a lively interest in the diversity of customs and beliefs found on the other side of the Atlantic, where people were 'Achristian', a label that would also come to be applied to early sceptics.[24] This gave Montaigne a great tolerance for others, and for different ways of thinking, and together these provided the basis for his complete rejection of one of the central tenets of Christianity. For Christians of the world in which Montaigne grew up, the chief purpose of someone's intellectual life was to secure salvation in the world to come (he was especially critical of Luther).[25] Philosophy's main function, in such a world, as the handmaiden of theology, was likewise 'the preparation of man for a safe death'.[26] Montaigne thought this was nonsense and reversed the proposition, arguing that the purpose of knowledge is to teach men how to live more adequately, more productively, more happily, right here on earth. This revision had a major effect on the shape of intellectual life. Among other things, it meant that, for Montaigne, theology, 'the queen of the sciences', and philosophy were now much less important: they were replaced as the chief objects of interest by psychology, ethnology and aesthetics. This was in effect the birth of the human sciences.

In doing this, Montaigne gave a huge injection of intellectual muscle to the secular world, and to the purpose and value of diversity. In arguing against the 'otherworldly' obsession of Christianity, he also cast doubt on ideas about the immortality of the soul.[27] 'If philosophy is to teach us how to live rather than how to die, we must gather the largest

possible amount of information as to the ways in which men live and then analyse this mass of material in calm and judicious fashion.'[28] It was immediately obvious to Montaigne, looking around him at the newly-gathered material from the New World and elsewhere, that men and women had devised many ways of adapting to their environment. It was therefore self-evident that God favoured diversity over uniformity.[29] In the same way, Montaigne's concentration on this life rather than the next also downgraded in importance yet another basic ingredient of Christianity, the concept of the soul, and the related tendency to assume that anything to do with the soul was good and wholesome and anything to do with the body was base and bad. From this two things followed. One, it hit at the clergy, as intercessors for the fate of the soul. And two, it freed people from the medieval belief that sexual relations were bad in themselves. Instead Montaigne maintained that sex should be dignified but no guilt should attach to its practice.

Montaigne's conceptual innovations amounted to a major break with the traditional Jewish/Christian tribal idea of God as a jealous, arbitrary and, yes, occasionally cruel God. Instead, as more than one historian has remarked, Montaigne shares with Lord Shaftesbury in England the honour of discovering that 'God is a Gentleman'. Montaigne never really doubted that there was a God, but he radically changed our idea of what God *is*.

One reason Montaigne never really doubted that there was a God was because to do so in his lifetime was next to impossible. In his classic book *The Problem of Unbelief in the Sixteenth Century*, the French historian Lucien Febvre argues that 'the conceptual difficulties in the way of a complete denial of God's existence at this time were so great as to be insurmountable'. 'Every activity of the day, which was punctuated with church bells summoning the faithful to prayer, was saturated with religious beliefs and institutions: they dominated professional and public life – even the guilds and universities were religious organisations.' What people ate was surrounded by religious rituals and prohibitions.[30] In Montpellier at the beginning of Lent the old pots used for cooking meat were broken and new ones installed, for fish. Cooking a capon on Friday was punishable by beating or public humiliation at Mass. If insects or rats infested the countryside, the priest was called first to get rid of them.[31] 'People had simply not yet achieved the objectivity necessary to question the existence of God, nor would this exist until a body of coherent reasons had been established, each based on scientific discoveries which nobody could deny.'[32]

And so, when people accused one another of 'atheism' they meant something different from what we mean today. Many equated atheism with libertinism.[33] The Frenchman Marin Mersenne (1588–1648), who was both a scientist and a friar, claimed that there were 'about 50,000 atheists' in Paris alone but the ones he named personally all believed in God. The fact is that Mersenne called people atheists when their views about God differed from his own and this was typical. At that time the word 'atheist' was used not as we would use it today but as an *insult*. People in the sixteenth century never dreamed of calling *themselves* atheists.[34]

Nevertheless, views and opinions did begin to change. Montaigne led the way but it took nearly a century before Copernicus' views were fully accepted, as people gradually grasped, and then got to grips with, the full implications of what he was saying. These events have been painstakingly set down by Thomas Kuhn.

Kuhn shows, as was mentioned earlier, that professional astronomers were for decades able to use *most* of the information provided by Copernicus without paying attention to his central thesis, that the earth went round the sun. The commotion was slow in starting and when it did start it was because its arguments had reached beyond astronomers. To begin with, Copernicus and those who agreed with him were ridiculed for the absurdity of their beliefs.[35] Jean Bodin (1529–1596), the French political philosopher, was particularly dismissive. 'No one in his senses, or imbued with the slightest knowledge of physics,' he wrote, 'will ever think that the earth, heavy and unwieldy from its own weight and mass, staggers up and down around its own centre and that of the sun; for at the slightest jar of the earth, we would see cities and fortresses, towns and mountains thrown down.'[36]

The most bitter objections, however, came from those who found that Copernicus' theory conflicted with scripture. Even before Copernicus published his book, but when his ideas were beginning to circulate, Martin Luther, in one of his 'Table Talks', held in 1539, was quoted as saying: 'People give ear to an upstart astrologer [*sic*] who strove to show that the earth revolves, not the heavens or the firmament, the sun and the moon . . . This fool wishes to reverse the entire science of astronomy; but sacred Scripture tells us [Joshua 10:13] that Joshua commanded the sun to stand still, and not the earth.'[37] As biblical citation was increasingly used against the Copernicans, they were labelled either 'infidels' or 'atheists'. Eventually, about 1610, when the Catholic church officially joined the battle against the new astronomy, the charge became one of formal heresy.[38] In 1616 *De revolutionibus* and all other works that affirmed the earth's motion were placed on the Index and Catholics were forbidden to teach or even to read Copernican doctrines.

By this time, as Kuhn shows, the full implications of Copernicanism had been assimilated, as people grasped that his results were potentially destructive of a whole system of thought. Kuhn's description is worth quoting at length: 'If, for example, the earth was merely one of six planets, how were the stories of the Fall and of the Salvation, with their immense bearing on Christian life, to be preserved? If there were other bodies essentially like the Earth, God's goodness would surely necessitate that they, too, be inhabited. But if there were men on other planets, how could they be descendants of Adam and Eve, and how could they have inherited the original sin, which explains man's otherwise incomprehensible travail on an earth made for him by a good and omnipotent deity? Again, how could men on other planets know of the Saviour who opened to them the possibility of eternal life? Or, if the earth is a planet and therefore a celestial body located away from the center of the universe, what becomes of man's intermediate but focal position between the devils and the angels? . . . Worst of all, if the universe is infinite, as many of the later Copernicans thought, where can God's Throne be located? In an infinite universe, how is man to find God or God man?' These questions helped to alter the religious experience of man.[39]

Both John Donne and John Milton thought that Copernicus might very well be right (Keith Thomas reminds us that Britain was more highly educated in Milton's day than at any time until the First World War) but in spite of this neither liked the new system and, in *Paradise Lost*, Milton reverted to the traditional view for his drama.[40] The Protestant leaders, Calvin as well as Luther, were just as keen to suppress the expression of Copernican beliefs but they never had the police infrastructure that the Counter-Reformation Catholics

did and so were much less effective. Even so, when in 1616, and more explicitly in 1633, the church prohibited the teaching or believing that the sun was the centre of the universe, many Catholics were shocked, and shocked for two reasons. One, the more educated could see that by then the new theory was being supported by fresh evidence that was emerging all the time. And two, this was an important change of stance by the church: hitherto it had always maintained a dignified silence on cosmological matters, which at least had the merit of preventing it from ever being in the wrong, and at the same time allowed the appearance of being open to new ideas. Now all that was thrown out.[41]

The traditional view became even harder to support in 1572 with the appearance in the night sky of a nova, or new star. Then there was a series of comets which appeared in 1577, 1580, 1585, 1590, 1593 and 1596. Each of these episodes showed that the heavens were mutable, again in contradiction of the scriptures.[42] No parallax was observed with these bodies, forcing people to conclude that they were further away than the moon, which meant that they occupied the zone of the heavens which was supposed to be filled by crystalline spheres. Bit by bit, Copernicus became harder to dismiss.[43]

Kepler, as we have already seen in an earlier chapter, discovered that the orbits of the planets were ellipses, not spherical, and this too destroyed the idea of crystalline spheres. Kepler, however, hesitated to face up to the full implications of his discoveries and it was Galileo, and his telescope, which provided 'countless' pieces of evidence which put Copernicanism beyond doubt.[44] First was his observation that the Milky Way, which to the naked eye had been just a pale glow in the sky, now turned out to be a vast collection of stars. Next, the moon was revealed to be covered by craters, mountains and valleys (from the size of the shadows cast Galileo was able to estimate their height). Thus the moon was shown to be not so very different from earth, further fuelling doubts about the difference between this world and the heavens.[45]

But the very worst observation, and the one which had the biggest impact on the seventeenth-century imagination, was Galileo's identification of the four 'moons' of Jupiter, orbiting the planet in roughly circular fashion. This not only confirmed exactly what Copernicus had argued, about the earth orbiting the sun, but – perhaps more important – it confirmed the more general notion that the earth was not the centre of the universe, that it was in fact just one body among thousands, maybe hundreds of thousands, in an infinite universe. It was now that the greatest opposition to the Copernican system was shown and that is perhaps to be expected. Until Galileo, it was possible to have honest doubts about Copernican theories; but to doubt the Copernican system after Galileo required people to deliberately misunderstand the evidence.[46] Cardinal Bellarmino, the leader of the church officials who condemned Copernican views, nevertheless acknowledged the problem. In a letter written in 1615 he said: 'If there were a real proof that the sun is the centre of the universe, that the earth is in the third heaven, and that the sun does not go round the earth but the earth round the sun, then we should have to proceed with great circumspection in explaining passages of Scripture which appear to teach the contrary, and rather admit that we did not understand them than declare an opinion to be false which is proved to be true.'[47] Not until 1822 did the church permit books to be printed which accepted that the earth's motion was real, a delay which fatally damaged

Catholic science and likewise church prestige.[48] And so, despite the evidence, it took two hundred years for Copernicus to be fully accepted. During these years, however, the attitude to God was being transformed.

The growth of doubt, what Richard Popkin has called 'the third force in seventeenth-century thought', occurred in four stages. These were what we may call rationalistic supernaturalism, deism, scepticism and, finally, full-blown atheism. It is also worth pointing out that the advent of doubt, besides being a chapter in the history of ideas, was also a stage in the history of publishing. The battle between orthodox traditionalists and free thinkers, to give the doubters their generic name, was fought out partly in books, but it was also a time when pamphleteering was at its height. (The pamphlet is the natural length of a sermon, or a letter, and this length seems to have caught on.) Many of the ideas to be discussed in the remainder of this chapter were published in book form but just as much was published as pamphlets – short, physically flimsy tracts, often with a combative style and title (for example, *A Discourse against Transubstantiation*, 1684; *Geologia; or a discourse about the earth before the deluge*, 1690; *The Unreasonableness of the Doctrine of the Trinity briefly demonstrated, in a letter to a friend*, 1692).

The first of the four stages of doubt, rationalistic supernaturalism, was especially popular in England. Its basic tenet was that religion should conform to reason and that in particular revelation should accord with reason.[49] One of the early advocates of this approach was John Tillotson (1630–1694), archbishop of Canterbury, who argued that religion – any religion, but Christianity in particular – must be considered as a series of rational propositions, supported by logic. Tillotson's main concern was with miracles.[50] These, he said, must clearly be beyond the power of human beings to perform, but miracles, to *be* miracles, must be performed for a logical reason, not simply as a display of magical ingenuity. On this score, he said, the miracles of Jesus conformed to reason: they were performed for a purpose. But not all the alleged miracles of the post-Apostolic saints fell into this category.[51]

John Locke, in addition to his many other activities, may be classified as a rationalistic supernaturalist. He believed that Christianity was a supremely reasonable religion because of its basic tenets, which he said were perfectly rational (though Locke, the apostle of toleration, would have denied free speech to religious sects that he thought were an irrational threat to the state, including Roman Catholics).[52] These basic tenets were that there is one omnipotent God, who requires that man should live a virtuous life in accordance with the divine will, and that there is an afterlife in which sinful deeds in this world will be punished and good deeds rewarded. This, for Locke, was a perfectly rational way for God to order the universe: it made good sense. He argued that miracles may be 'above reason' but cannot be contrary to reason.[53] A passionate follower of Locke was John Toland (1670–1722), who argued that if God 'has anything to reveal to us he is capable of revealing it clearly'. It followed for Toland that God would not wish for any possibility of misunderstanding and that therefore true revelation must accord with reason. For him, certain miracles, such as the virgin birth, failed this test and should therefore be jettisoned. In his *Second Thoughts Concerning the Human Soul*, published in 1702, William Coward argued that the idea of the human soul – a 'spiritual immortal substance, united to the Human Body' – was 'a plain Heathenish invention, and not consonant to the principles

of Philosophy, Reason, or Religion'. He thought it was 'absurd, and . . . abominable'.[54]

Deistic thought, the second stage in the advent of doubt, also came into existence in England, from where it spread both to the continent and to America. It lasted for about a century and a half, from Lord Herbert of Cherbury (1583–1648) to Thomas Jefferson (1743–1826). However, the actual word 'deist' was coined by the Genevois Pierre Viret (1511–1571), to describe someone who believed in God but not in Jesus Christ. One of the main influences on later deists were the new discoveries of science, which suggested to many people that God was not an arbitrary figure, as in ancient Judaism for example, but the maker of the laws which Copernicus, Galileo, Newton and the others had uncovered. Since God had made these laws, the deists contended, God would naturally abide by them and in this way set mankind an example. The discoveries in America, Africa and elsewhere only underlined that all men had a religious sense but on the other continents there was no awareness of Jesus. The deists therefore used this as evidence that religion requires no supernatural elements to support it, that prophecy and miracles have no place in a 'scientific religion', and that such a set of beliefs appeals to all reasonable men wherever they are.[55]

Most of the deists were anticlerical. This explains why, for the most part, the deist pamphlets of the time were written either in satirical vein or in an aggressive tone of ridicule.[56] Most deists insisted that the extensive superstitions and elaborate machinery of worship in the church were simply concoctions dreamt up by the priesthood, to satisfy their own selfish and political ends. The worst of these elements was that of intercession, which placed the priesthood between man and God, maintaining a set of privileges that had no basis in scripture and was all too easy to see through. More fundamental still were the attacks on the Bible by individuals such as William Whiston (1667–1752), who succeeded Newton as professor of mathematics at Cambridge, and who thought there was great deist significance in the identification of gravity. Another like-minded soul was Anthony Collins: between them they examined carefully the prophecies of the Old Testament and found scant support for the idea that they had predicted the coming of Jesus.[57] Peter Annet, in his *Resurrection of Jesus Considered* (1744), came out boldly with an argument that the apostolic accounts of the Resurrection were fabricated, while Charles Blount (1654–1693) was equally blunt about original sin, the concept of which he found unreasonable. He had the same view of heaven and hell, which he said had been invented by priests 'to increase their hold over the terror-stricken and ignorant masses'.[58]

The most influential French deist, who was a deist partly because he had been to England as a young man, and admired its system of government, was Voltaire. He was also motivated by an intense desire to destroy smugness and intolerance in France. (He thought fanaticism was 'unworthy' of any deity.[59]) He derided everything about Christianity, from the idea that the Bible is a sacred book to the miracles, which to him were sheer frauds. 'Every man of sense,' he wrote, 'every good man, ought to hold the Christian sect in horror. The great name of theist, which is not sufficiently revered, is the only name one ought to take. The only Gospel one ought to read is the great book of nature, written by the hand of God and sealed with his seal. The only religion that ought to be professed is the religion of worshipping God and being a good man.'[60] At the same time, Voltaire echoed the Athenians: he felt that the new views were fine for the literate upper classes, but that the lower classes

needed religion, old-style religion, as a form of social cement. In his *Social Contract*, Jean Jacques Rousseau (1712–1778) sought to establish deism as the civil religion of France. He thought that the existence of a 'powerful, intelligent, benevolent, prescient and provident divinity' should be acknowledged and that people should remain circumspect about 'what cannot be either disproved or comprehended'. But again, there was no place for Jesus.[61] What Rousseau meant by religion was really a philosophical concern with justice and charity towards one's neighbour.[62]

In Germany Immanuel Kant, while accepting the basic tenets of Christianity, as a loving religion, was implacable in opposing the supernatural elements – prophecy and miracles – calling them 'wholly evil'. He was also opposed to the medieval idea of grace, the super-abundance of which had led earlier to the abuse of indulgences. In America both Benjamin Franklin and George Washington were deists and so was Jefferson.[63]

The overall impact of the deists was to achieve a major transformation in the concept of God, arguably the greatest change in understanding since the development of ethical monotheism in the sixth century BC. Out had gone the jealous, petty-minded tribal God of the Israelites, adapted by the Christians and Muslims, and in its place was a 'grander, nobler God', the God of all the universe, compatible, as Alexander Pope said, with the new astronomy and natural science. God had lost his 'divine arbitrariness' and was now regarded as a law-making and law-abiding deity, identified with the 'unending repetitions and orderly behaviour of nature'.[64] This did, however, also run directly counter to the doctrine of the Trinity.

In both Europe and America, however, deism eventually foundered and it did so because it fell between two stools. It was too adventurous and too abstract to comfort the devout, the traditional and the orthodox, while at the same time it was seen as too timid to appeal to the truly sceptical. Nevertheless, it served as a sort of half-way house for the most radical change in ideas since the birth of ethical monotheism. Many people could not have gone directly from orthodox belief to atheism. Deism eased the way.

Thomas Hobbes did not call himself a sceptic, but it is hard to form any different view from his strongly worded remarks, in which he argued time and again that religious beliefs are essentially based on ignorance, in particular ignorance of science and of the future. He thought most religious and theological writing useless, 'which fill our libraries and the world with their noise and uproar, but wherefrom the last thing we may expect is conviction'.[65] It was strong stuff but a better, more rational and for that reason more devastating sceptic was David Hume, 'Le Bon David', as the French called him, whose huge appetite for intellectual battle may be seen from the range of titles of his works.[66] These included *Of Superstition and Enthusiasm* (1742), *Essay on Miracles* (1747) and *Essay on Providence and a Future State* (1748). Like Vico, Hume studied religion historically and this taught him, first and foremost, that it had a lot in common with other areas of human activity. He concluded that there wasn't anything special about religion, that it had emerged as just another aspect of human activity in ancient civilisations and that it was kept alive because parents taught it to their young children, who grew up unable to think in any other ways. He argued that polytheism was the earliest form of religion and arose out of man's experiences of good and bad. Benevolent gods were attributed to good events, malicious

gods to bad events. In either case, he observed, the gods took human form. On the other hand, he thought that monotheism – the more abstract form of the deity – had grown out of man's observations of nature. The great natural phenomena, strange happenings, such as earthquakes, lightning, rainbows and comets, convinced men that these were the actions of a powerful and arbitrary God. Hume observed, accurately enough, that polytheism has been more tolerant than monotheism.[67]

In particular Hume worked hard to show that the alleged proofs of God's existence were no such thing and that the anthropomorphic conception of God was also misplaced, even absurd. 'We cannot learn of the whole from knowledge of a part – does knowledge of a leaf tell you anything about a tree?'[68] 'Assuming that the universe had an author, he may have been a bungler, or a god since dead, or a male or female god, or a mixture of good and evil, or morally quite indifferent – the last hypothesis being the more probable.'[69] Then there were Hume's devastating criticisms of both miracles and the 'future state'. He did not deny in principle that miracles had ever taken place but his criteria for accepting the evidence were never met. His chief argument was that, when all is said and done, there is no unimpeachable evidence for any miracle that would be accepted by a reasonable person. Hume insisted that it was equally absurd to imagine that God would 'even the score' in a future life, making up for all the injustices in this one. The interrelations between people were too complicated, he said, and made a balancing of the books impossible.

The most important figure in French scepticism was Pierre Bayle, who attacked the Old Testament with all the gusto that Hume had brought to the demolition of miracles. Born in a village near the Pyrenees, amid the independent traditions of the Albigensian region, Bayle poured scorn on such episodes as Jonah and the whale, and his satire on faith was so extravagant as to make it seem all but ridiculous that men should maintain a belief in God in the face of all the evidence to the contrary.[70]

Despite the numerous withering criticisms of miracles, and the increasing scepticism that many held about the 'future state', there were very few men of the period who were prepared to come out and say flatly that they did not believe in God. The first outright atheist in this modern sense was probably Lucilio Vanini (1585–1619), an Italian scientist. Widely travelled, his lectures in this way reached many people. But the authorities caught up with him in Toulouse, where he was arrested for heresy and, after he had his tongue cut out, was burned at the stake (though his writings remained popular – Voltaire compared him to Socrates).[71] More reasoned atheists arose in England and France in the wake of Newton's discoveries.* In England, 'From All Souls [College, Oxford] to the Royal Society there was an outpouring of atheism in print such as the country had never seen before.'[73] There was a street called 'Atheists' Alley' near the Royal Exchange in London (probably so named because the coffee houses there were frequented by the newly knowledgeable 'men of the world', including unbelievers.)[74] John Redwood, in his history of the pamphlet war, tells us that the bookshops began to 'teem with pamphlets, tracts and

---

* Newton himself, who was an Arian – that is, he did not believe in the divinity of Christ – thought that God was 'immanent' in space and time, existing everywhere, and that matter alone had been created. This was in effect a return to the old Platonic doctrine of emanation.[72]

broadsheets dealing with the atheist scare'.[75] The theatres too were frequently home to atheist satires.[76] For plays now taught men 'how they might live without a Creator; and how, now they are, they may live best without any dependence on his Providence. They are call'd to doubt the existence of God ... His wise Providence at every turn is charged with neglect...'[77]

As intellectual heirs to Newton, the French atheists were known as mechanists (because they were inspired by the idea of a mechanical universe). One of the more prominent was Julien de La Mettrie, who wrote a book called *Man a Machine* in which he offered a thoroughgoing mechanistic analysis of man and the universe. This, he said, left no room for God. He was supported by Paul Henry Thiry, Baron d'Holbach (1723–1789), a German émigré who had moved to Paris. He was much more radical than the bulk of his colleagues, openly admitting that concepts of God and supernaturalism had been invented by primitive man who simply did not understand natural phenomena. Like Bayle and Shaftesbury, and the rest of the deists, he insisted that an acceptable morality does not depend on religion. For this reason, and unlike Voltaire, he thought that it was quite safe to teach atheism to the masses. Holbach was also one of the first to argue that man was really no different from other living creatures in the universe, neither better nor worse. It followed that man had to work out his own morality, not derive it from any supernatural authority. This was an important insight and, decades later, would help lead to the theory of evolution.

After the scientific discoveries of Copernicus, Galileo and Newton, the area of scholarship which most affected beliefs about religion was biblical criticism. The first major attack on the scriptures had come as early as the twelfth century, when the Jewish scholar Aben Ezra challenged the tradition that Moses was the author of the Pentateuch. But the first blow struck in modern times was delivered by Louis Cappel in the early seventeenth century, who showed that the original Old Testament had been written not in Hebrew but in Aramaic, making it a much later work than had previously been supposed. The most damning consequence of this was that the scriptures could not have been dictated to Moses by God: in other words, the Old Testament was not 'inspired'. This was a terrible blow. (The very existence of Cappel's approach was itself a sign of major change: the scriptures were now being treated like secular works, as susceptible of textual and other assessment.) Isaac La Peyrère (1596?–1676), mentioned in the Prologue, also claimed that Moses did not write the Pentateuch and, more controversially still, said that men and women existed before Adam and Eve, who were only the first Israelites (he also said that the Flood was local to the Jews). Thomas Hobbes built on this work, showing that the books of Joshua, Judges, Samuel and Kings were written long after the events they described. Cappel's and Hobbes' work was confirmed by Spinoza who argued that Genesis could not have been written by one author and showed that most books of the Old Testament were far later than had commonly been thought. (Spinoza's views circulated in a number of heterodox manuscripts – i.e., they were too controversial to be printed.[78]) Next came Richard Simon, a French Catholic scholar, who made the discovery – very significant at the time, and published with difficulty in the 1680s – that the books of the Old Testament had not always been in the order in which they had since become stabilised. This was important because it made more plausible William Whiston's 1722 analysis of certain passages of the Old

Testament, which he concluded had been falsified during this process. Likewise it made more palatable Anthony Collins' argument that the book of Daniel was much later than anyone had thought, a time-frame that cast doubt on the 'prophecies' in that book: they had in fact been written after the events. In a sense, this made the book of Daniel a forgery.

Then, in 1753, Jean Astruc, a French doctor with an interest in biblical studies, argued that Genesis was actually the fruit of *two* basic documents that had been amalgamated, or intertwined. He said that there is one source which describes God as 'Elohim' and a second source which refers to God as 'Jehovah'. These came to be known, and are still accepted, as the E and J sources.[79] Astruc was followed by a German, Karl David Ilgen, who argued that, in fact, there are nearly twenty documents that make up Genesis, assembled by three groups of writers. This is essentially the view that still prevails.* Thomas Burnet, in his *Archaeologiae and Theory of the Visible World* (1736), calculated the amount of water that fell in the forty days of the flood. He found it insufficient by a long way to drown the earth, and to inundate the highest mountains.[81] His calculations were later incorporated into Thomas Browne's massive attack on miracles.[82]

This obsession with the accuracy of the Bible brought with it a new examination of the age of the earth. In the Judaeo/Christian view human history was reckoned to have begun with Adam. The Jewish chronology calculated that the Creation had taken place in 3761 BC, but Christians had a more symbolic, and more symmetrical, view. Under their scheme, there would be seven symbolic ages of man, based on the idea, described in Chapter 10, of a cosmic week – seven ages, each lasting a thousand years (see page 235 above, for a more detailed discussion of the cosmic week). This involved Creation taking place in 4000 BC, and assumed that the Christian era would last two thousand years, after which there would be a final millennium. (Luther was one of those who agreed with this scheme; he argued that Noah had lived at 2000 BC.) Various other scholars made their own calculations. Using the genealogies in the Bible, Joseph Justus Scaliger worked out that Creation took place on 23 April 3947 BC, Kepler chose 3992 BC, while Archbishop James Ussher went still further, in his *Annals of the Old and New Testament* (1650–1653), in which he calculated that the week of Creation began on Sunday, 23 October 4004 BC, and that Adam was created on Friday, 28 October 4004 BC. Finally, John Lightfoot (1602–1675), a rabbinical scholar, added to Ussher's calculations, working out that Adam was born on Friday, 28 October 4004 BC, at nine o'clock in the morning.[83]

Not everyone agreed with Scaliger, Ussher or Lightfoot. As more and more people began to lose faith in the Bible, so the calculations of the earth's age based on the scriptures lost support also. The scientific discoveries – both here on earth and above, in the heavens – began to suggest that the earth must be a great deal older than it said in the Bible. This realisation was associated with the birth of geology, the main task of which in its early days was to understand that very process by which the earth had formed. One of the early insights stemmed from the study of extinct volcanoes in France, in particular in the Puy de Dôme district (near Clermont-Ferrand).[84] This led to the discovery that basalt, a rock

* In *The Book of J*, David Rosenberg and Harold Bloom (1990) argue that the author of J may well have been a woman of the royal house living at King Solomon's court (although the latest Israeli scholarship throws doubt on the very existence of Solomon: see Chapter 7, page 153).[80]

found everywhere, was in fact solidified lava. The early geologists gradually realised that layers of basalt had been laid down many years ago (by a process that could still be observed – and measured – today, where there were active volcanoes) and that the deeper layers were very ancient. In the same way, the newly-established geologists observed sedimentary layers, the rate of deposition of which could also be calculated. Those layers were regularly 10,000 feet thick, and sometimes 100,000 feet thick, making it ever clearer that the earth was very ancient indeed. At the same time it was observed that water – streams and rivers – had cut into many layers of rock, revealing that such layers could be folded, twisted, even turned over completely, showing that the planet had a violent history and, again by implication, that it was much older than it said in the Bible. Robert Hooke, at the Royal Society in London (whose journal, *Philosophical Transactions*, was strangely silent on this, the greatest philosophical question of the day), had observed that fossils, now recognised for what they were, showed animals that no longer existed.[85] He therefore put forward the idea that certain species had once flourished on earth and then died out. This too suggested that the earth was older, much older, than the Bible said: these species had come and gone before the scriptures were written.[86]

And so, at that stage, although the church regarded any figure that was substantially at variance from 4000 BC as heresy, the French natural historian Georges Louis Leclerc, comte de Buffon, in his *Les époques de la nature* (1779), calculated the age of the earth, first, as 75,000 years, later as 168,000 years, though his private opinion, never published in his lifetime, was that it was nearer half a million years old.[87] To sugar this bitter pill for the orthodox, he too recognised seven 'epochs': one, when the earth and planets were formed; two, when the great mountain ranges erupted; three, when water covered the mainland; four, when the water subsided and the volcanoes began their activity; five, when the elephants and other tropical animals inhabited the north; six, when the continents were separated from one another (he recognised that the fauna and flora of America and Eurasia were similar and concluded that they must have been connected at one point); and seven, when man appeared. Here too, then, was a remarkably modern set of views, which anticipated both continental drift and evolution.

The advent of doubt could not but have a major effect on ethical thinking. The supernatural basis for morality had been questioned since the emergence of humanism, in particular in the essays of Montaigne, mentioned earlier in this chapter. But the most specific development during this period, after Montaigne, was the line of thinking that led from Thomas Hobbes through Shaftesbury and Hume to Helvétius and Jeremy Bentham. Hobbes, it is no surprise to learn, argued that man's ethics, like the rest of his psychology, are based on self-interest. Life, its predicaments and attendant emotions, may be divided into the pleasurable and the painful. Hobbes thought that the conduct of life should be organised around attempts to maximise one's pleasure while causing the least pain to others. Shaftesbury (and Bayle, for that matter) accepted the implicit notion encased in this view, that religion and morality did not necessarily have anything to do with one another.[88] Many people found the separation of religion and morality shocking, but the tide was running. Hume, Helvétius and Holbach all shared what would come to be called a utilitarian view of ethics, that man is essentially hedonistic – pleasure-seeking, but he is

also a social animal. The test therefore of any doctrine or policy was, as Helvétius put it in a phrase that became famous, 'the greatest good for the greatest number'.[89] Social well-being, as well as individual happiness, must be taken into account. Bentham (1748–1832) publicised this approach most in what came to be called his 'felicific calculus', the core of utilitarian ethics, which assumed that man is a coldly rational animal and that, therefore, the greatest good for the greatest number is an achievable aim for politicians.

The arguments against God, therefore, not only brought about a decline of faith, in a strictly religious sense, but stimulated a new attitude to history (that the past went back much further than anyone thought), laid the grounding for much of modern science (evolution, continental drift, sociology), for modern economics (Adam Smith's economic theories, discussed later, in Chapter 26) and for modern politics. 'The greatest good for the greatest number' is yet another of those statements/clichés that we take for granted today. But it was unthinkable before scepticism and doubt had brought about the great divorce between religion and morality.

# *From Soul to Mind: the Search for the Laws of Human Nature*

In 1726, the French writer Voltaire arrived in England. He was thirty-two and in exile. Not long before, at the Opera in Paris, he had been insulted by an aristocrat, the chevalier de Rohan. 'M. de Voltaire, M. Arouet [Voltaire's real name], what's your name?' The implication was that Voltaire, in using the 'de', was giving himself pretentious airs and graces. Voltaire, never one to duck a fight, shot back: 'The name I bear is not a great one, but at least I know how to bring it honour.' A fight nearly broke out there and then, and both men had to be restrained. A few nights later, however, the chevalier had Voltaire ambushed by six of his men and beaten up. Undaunted, Voltaire challenged the chevalier to a duel, a response so daring and presumptuous that the Rohan clan had him thrown into the Bastille. Voltaire could only regain his freedom by agreeing to leave France. He chose England.[1]

This episode, though it didn't feel like it at the time – to Voltaire at any rate – was fortuitous. The abuse of privilege exercised by the French aristocracy, epitomised by the duel that never was, incensed the writer and, in a sense, his career became a lifelong duel with the authorities. The three years Voltaire spent in England had a profound effect on him and helped shape the views that he would express so well on his return. Voltaire, more than anyone else, was the focus of the set of events which came to be known as the French Enlightenment and though he died a full decade before the French Revolution broke out, it was his ideas, exercising an influence on people like Denis Diderot and Pierre-Augustin de Beaumarchais, that provided one of the intellectual underpinnings for the events of 1789.

During the time that Voltaire spent in England, the most significant episode for him was almost certainly the death of Sir Isaac Newton. An old man of eighty-four, Newton was President of the Royal Society and held in the highest esteem. And it was this that impressed Voltaire, that a man from a modest background, but blessed with great intellectual gifts, could rise so high in society and be so respected by his fellow men, whatever their own background. It contrasted hugely with his own country, 'just emerging from the shadow of Louis XIV' and where, as Voltaire's own predicament showed, the privileges of birth were still paramount. Voltaire's letters reveal that he was very impressed by the intellectual and political organisation in England, by the status of the Royal Society, the freedom allowed to Englishmen to write whatever they liked, and what he saw as the

'rational' system of parliamentary government. In France, the Estates General had not met since 1614, more than a century before, and, though he would never know it, would not meet again until 1789. The death of Newton, while Voltaire was in England, helped to stimulate his interest in the physicist's discoveries and theories and it was to be Voltaire's crowning achievement to amalgamate those ideas with the theories of Descartes and John Locke to create his own blend of understanding. According to one anecdote, when he returned to France, and his mistress, his first act (or at least his second) was to teach her the principles of Newton's theory of motion, involving gravity. His *Philosophical Letters Concerning the English* was widely praised, though the government, showing that very intolerance and high-handedness which he was criticising, had the book burned as a 'scandalous work, contrary to religion and morals and to the respect due to the established powers'.[2]

What Voltaire did, in essence, was to adapt the Cartesian tradition to the new thinking in Britain, as epitomised by Newton and Locke. Descartes, as a rationalist, started with the more traditional *a priori* 'essence of things', as grasped by intuition, plus the all-important role of doubt. Voltaire adopted the Newtonian system, which gave priority to experience, derived from disinterested observation, and then the principles were deduced afterwards. Most important of all, perhaps, he applied this to human psychology, which is where Locke came in, for he too looked about him, and described what he saw. This is what Voltaire had to say about Locke: 'After so many speculative gentlemen had formed this romance of the soul, one truly wise man appeared, who has, in the most modest manner imaginable, given us its real history. Mr Locke has laid open to man the anatomy of his own soul, just as some learned anatomists have done that of the body.'[3] Voltaire thought that science had shown that the universe was governed by 'natural laws' which applied to all men, and that countries – kingdoms, states – should be governed in the same way. This, Voltaire believed, gave men certain 'natural rights' and it was this set of core beliefs that would, in the end, give rise to revolutionary doctrine. Impressed by the achievements of Newtonian science, Voltaire became convinced that, through work, religious ideas would eventually be replaced by scientific ones. He insisted that man need no longer lead his life on the basis of atoning for his original sin and that instead he should work to improve his existence here on earth, by reforming the institutions of government, church, education and so on. 'Work and projects were to take the place of ascetic resignation.'[4] A further factor in Voltaire's importance, at least in France, is that the changes in thinking he recommended coincided with a desire on the part of many people to get rid of the *ancien régime*. The new thought therefore became a symbol of that desire. Many of the traditional concerns of French philosophy – freedom of the will and the nature of grace – were dismissed by Voltaire and his followers as meaningless; instead they argued that more practical matters were of greater importance.

In France, this all took place against a background in which protest and discontent were growing. As early as 1691, François de Salignac de la Mothe Fénelon had published his *Examination of Conscience for a King* and later his *Letter to Louis XIV*, where he drew a bleak portrait of the so-called Sun King's realm: 'Your peoples are dying of hunger. Agriculture is almost at a standstill, all the industries languish, all commerce is destroyed. France is a vast hospital.'[5] In 1737 René Louis, marquis d'Argenson, had written *Con-*

siderations on the Past and Present Government of France*, which exposed the abuses and corruption at the heart of the French system. So corrupt that the book couldn't be published until 1764.

It was against this background, largely created by Voltaire, that Denis Diderot launched the *Encyclopédie*. This too was originally an English idea, because at first all that Diderot intended was a translation of Ephraim Chambers' *Cyclopaedia*, originally released in Britain in 1728. The idea grew, however, beyond just technical subjects and statistics, to encompass the state of contemporary culture, a comprehensive description and a social and intellectual audit of all France. Diderot's declared aim was not only to produce a body of knowledge but to deliberately manufacture a change in the way men thought: *pour changer la façon commune de penser*.[6] The publication of the *Encyclopédie* is itself a chapter in the history of ideas. First appearing in 1751, it took twenty years to appear in full, and was alternately welcomed and suppressed by the censors.[7] Financially, it was very profitable for the publishers but Diderot was sent to prison more than once and several plates and articles were confiscated.

The *Encyclopédie* first found its feet in the twice-weekly dinners in Baron d'Holbach's *hôtel* in the rue Royale Saint-Roche (now 8 rue des Moulins), which became known as a 'synagogue of atheists'.[8] By the end of 1750, eight thousand copies of the prospectus for the *Encyclopédie* had been prepared: subscribers were to pay sixty *livres* on account and further sums amounting to 280 *livres*. Eight volumes, plus two of plates, were promised (though in all twenty-eight volumes were published, and more than 71,000 articles). The first volume, covering the letter A, appeared in June 1751 with its full title: *Dictionnaire Raisonné des Sciences, Arts et Métiers*, with a 'Preliminary Discourse' by Jean Le Rond d'Alembert, in which he explained that the work would serve as both encyclopaedia and dictionary, giving an 'eagle's-eye' view of knowledge that would show 'the secret routes' that connected different branches. The discourse described d'Alembert's view of intellectual progress since the Renaissance, which he pictured as a 'great chain' of propositions.[9] Of this great chain, he said, 'humanity has discovered only a very few links'. Indeed, there are only two kinds of certain knowledge, he said, knowledge of our own existence and the truths of mathematics. P. N. Furbank, in his critical biography of Diderot, argues that the *Encyclopédie* can only be fully understood via its authors' reactions to the attempts by the authorities to censor articles (for example, cross-referring was intended to direct readers to heretical or even seditious views in unlikely places).[10]

The first volume sold well, with the print run raised at the last moment from 1,625 to over 2,000. Later volumes had to contend with the censors but Diderot found a friend in Lamoignon de Malesherbes, the minister responsible for the book trade, who believed passionately in a free press and who hid manuscripts in his own home – presumably the safest place in all France. This proved Voltaire's point, of course – in England, as Jacob Bronowski and Bruce Mazlish point out, the book could have been printed untouched, even with much more daring material. But by the early 1760s even the king and Madame de Pompadour came round to the idea of the *Encyclopédie*.[11]

Diderot's many volumes were, in the end, more influential than, say, Chambers' *Cyclopaedia*, which came first, partly because it was a more ambitious project but also because,

in the eighteenth century, France was what Norman Hampson has called 'the cultural dictator' of Europe. People looked to France as the model and standard of taste in literature, art, architecture and the ancillary arts that had blossomed and even today occupy a special position: furniture, fashion and cuisine. More important still, by now the French language had replaced Latin as the common tongue of aristocratic Europe.[12] Even Frederick William I, the very embodiment of the Prussian spirit, spoke better French than German.[13]

French is one of the group of languages which, in all their essentials, are derived from Latin. They are known as the Romance languages and comprise Sardinian, Italian, Romanian, Spanish, Portuguese, Catalan, Provençal and French. In each case they stem from the spoken (vulgar) Latin of soldiers, merchants, colonists, rather than from the literary language (classical Latin). The original language of Gaul is presumed to have been a form of Celtic (very few inscriptions survive) which was in any case affiliated with Latin. The Latin of Gaul, as France then was, became differentiated into two, the dialect of the north (*langue d'oïl*) and of the south (*langue d'oc*) along a line that extended, roughly, from what is now Bordeaux via Lussac to Isère (Grenoble). Old French was discernible from the ninth century in the *Strasbourg Oaths* (842), with Middle French making its first appearance in the fourteenth century (1328, the accession of the Valois).[14]

Modern French dates from the seventeenth century. The dialects of the north began to take precedence over the south as Paris gradually emerged as the capital, with Francien, the dialect of the Île de France, destined to become the national tongue.[15] But not until the famous Ordonnances de Villers-Cotterêt (1539) was French officially recognised as the language of the law courts.[16] Even then, French was still considered an inferior tongue to Latin, which was still used for the new learning – i.e., science. But French was employed for popular literature, and with the advent of printing, and of more widespread reading, its growth in popularity and usage was confirmed. In 1549 Joachim du Bellay wrote his *Défense et Illustration de la langue Françoise*, which called for French not just to be the medium for vulgar stories but to be ambitious, even 'illustrious'. From then on, the French language was a self-conscious entity in France's intellectual and national life, in a way that other languages have never been. Throughout the seventeenth century there was a concern with *le bon usage* and *le bel usage*, as the language was refined and developed and purified.[17] This trend climaxed in the *Grammaire générale et raisonnée de Port-Royal* (1660), which put forward the idea of a philosophical grammar based on logic. By the eighteenth century, therefore, French was a much more self-conscious and, in a sense, artificial language than any other tongue. This rational tidiness helps account for the language's great beauty but also for its comparative dryness and its relatively small vocabulary.[18] Whereas other languages spread naturally, French was – to an extent – an official language, and for this reason even as late as the mid-twentieth century there were two million people in France whose mother tongue was not French (Alsatian, Breton, Provençal, etc.).[19]

At twenty-eight volumes, the *Encyclopédie* was, by any standards, a daunting read. That Diderot should consider the project even a remotely commercial proposition tells us a great deal about the changing reading habits of the eighteenth century. And indeed, in the latter half of the century reading habits did change in important ways. It was now that the traditional pattern of private patronage ebbed away. More and more writers began to live

on their income from book sales, depending on the new generation of readers, whose relation to the author was completely impersonal. Samuel Johnson and Oliver Goldsmith were among the first tranche of authors who wrote exclusively for these new readers. In reality, the publisher took the place of the patron though there was a middle stage – public subscription, which, as we saw, was the way the *Encyclopédie* was launched.[20]

Nor should we forget that in the sixteenth and seventeenth centuries it had been music that provided the main leisure activity of both the rich and poor, rather than reading.[21] 'Tinkers sang, milkmaids sang ballads; carters whistled; each trade, and even the beggars, had their special songs; the base-viol hung in the drawing-room for the amusement of waiting visitors; and the lute, cittern, and virginals, for the amusement of waiting customers, were the necessary furniture of the barber's shop.'[22] In London they had the theatre, but that audience was really no more than a quarter million out of a population of five million. Defoe and Bunyan were the first, among English writers at least, to exist outside what Steele called 'the circumference of wit', to mean that predominantly aristocratic society of writers who obtained patronage. 'If one inspects the memoirs ... of the many self-educated men who achieved distinction in the eighteenth and early nineteenth centuries, one finds almost invariably that their earliest contact with culture was through "*Pilgrim's Progress,* the Bible, *Paradise Lost, Robinson Crusoe.*" '[23]

One important effect of this, says Arnold Hauser, was the emancipation of middle-class taste from the dictates of the aristocracy. 'It forms the historical starting point of literary life in the modern sense, as typified not only by the regular appearance of books, newspapers and periodicals, but, above all, by the emergence of the literary expert, the critic, who represents the general standard of values and public opinion in the world of literature.'[24] The Renaissance humanists were unable to do this because they didn't have a periodical/newspaper press at their disposal. The system of private patronage meant essentially that the income an author received bore no relation to the intrinsic value or general attraction of their writing. Now that changed: the book became part of commercial society, a commodity, 'the value of which conforms to its saleableness on the free market'.[25] This public taste was especially strong for historical, biographical and statistical encyclopaedias.

Periodical publishing was also proving a growth business. In the tenth issue of *The Spectator* Joseph Addison wrote: 'My Publisher tells me that there are already Three thousand of them distributed every Day: so that if I allow Twenty Readers to every Paper, which I look upon as a modest computation, I may reckon about Threescore thousands Disciples in *London* and *Westminster.*' If this sounds high, we should remember that the coffee-houses of London were at that time the chief medium by which culture was channelled and by 1715 there were two thousand of them in London alone. It would be very easy for one copy of any newspaper to pass through a score of hands in this way.[26] The print-run of the *Spectator* later rose to between 20,000 and 30,000, on some accounts, giving a 'circulation', on Addison's calculations, of roughly half a million (the population of England in 1700 was a little over six million). This was later reflected in a rise in newspaper readership: between 1753 and 1775 the average daily sale of newspapers practically doubled.[27] James Lackington, a bookseller, wrote in his memoirs: 'The poorer sorts of farmers, and even the poor country people in general, who before that period [twenty

years previously] spent their winter evenings in relating stories of witches, ghosts, hob-goblins &c., and on entering their houses, you may see Tom Jones, Roderick Random, and other entertaining books stuck up on their bacon racks, &c.'[28] In 1796 the *Monthly Review* noted that twice as many novels had been published that year as in the previous one.[29]

One of the most influential books of the eighteenth century was Edward Gibbon's *Decline and Fall of the Roman Empire* (1776–1788) which, as we have seen, argued that Christianity, no less than the barbarians, had been responsible for replacing Roman civilisation, and helping to bring about the so-called dark ages. But there was another reason why Gibbon's message was important. It showed, or purported to show, how religion could interfere with – hinder, delay – progress. For the most part ancient civilisations had believed in either a static universe or else a cyclical one. The ancient Israelites' hope of a Messiah could be seen as a primitive notion related to progress, but such views were not widespread and in classical Greece the general approach – among Plato, Aristotle, Polybius – was either that civilisation was in decline, from a golden age, or that it was cyclical: monarchy led to tyranny which led to aristocracy to oligarchy to democracy to anarchy and back to monarchy.[30]

For Voltaire and the other *philosophes* in France, however, the recent discoveries of science, and the prospect for advancement that they seemed to offer, and the fact that more and more people could read of these advances, meant that the optimistic idea of progress was suddenly on everyone's mind, and this too was both a cause and symptom of changes in religious belief. Until the Italian humanists and Montaigne, the Christian life had been a sort of intellectual limbo: people on earth tried to lead a good life, as laid down by the church, but, in effect, they accepted the notion of perfection at creation, the Fall, and decline ever since. They were waiting for fulfilment in another realm.[31] Coincident with Newton's discoveries, however, a new feeling began to spread throughout Europe. Its most important feature was an assumption of the principle of *bienfaisance*, or benevolence, which was now believed to animate both God and man. The view gained ground that the earth 'was designed for man's terrestrial happiness'. (*Bienfaisance* and *optimiste* are both eighteenth-century words.) At times, this led to some absurd notions: Fénelon, for example, said that Providence had determined the shape and consistency of water-melons in such a way that they were easy to slice; the abbé Pluche pointed out that the existence of tides was designed to make it easier for ships to enter ports.[32]

This idea, that nature's harmony was a sign of God's benevolence, was doubly important during the eighteenth century, because attention was now turned to man himself. If the rest of the universe was governed by (relatively) simple laws – accessible to figures like Descartes, Newton, Leibniz, Lavoisier and Linnaeus – then surely human nature itself should be governed by equally simple and equally accessible laws. Investigation of human nature, of man's relationship to society, was perhaps a defining aspect of the Enlightenment. It was a time when many of the modern 'disciplines' that we recognise today – language studies (philology), law, history, moral and natural philosophy, psychology, sociology – either came into existence fully formed, or as proto-subjects, which would coalesce in the nineteenth century (for example, the word 'psychology' did not gain widespread currency in English until the 1830s, though it had been used, in Latin, in Germany).[33]

The underlying motor for this change, as Roger Smith points out in his *History of the Human Sciences*, was the reconceptualisation of the soul as the mind, with the mind increasingly understood by reference to consciousness, language and its relationship with this world, in contrast to the soul, with its immortality and pre-eminent role in the next world.[34] The man mainly responsible for this approach, as was mentioned earlier, was John Locke (1632–1704), in his *Essay Concerning Human Understanding*, published in 1690. In this book, prepared in draft as early as 1671, Locke himself used the word 'mind' not 'soul', and referred to experience and observation as the source of ideas, rather than some 'innate' or religious (revelatory) origin. He asked his readers to 'follow a *Child* from its Birth and observe the alterations that time makes', rejecting all innate ideas. Locke took it as read, however, that the mind did contain certain innate powers, such as a capacity for reflection, 'the internal Operations of our Minds, perceived and reflected on by our selves'.[35] Experience of the physical world, he said, gives us sensations (his examples included 'yellow', 'heat', 'soft' and 'bitter'). We reflect on these experiences and analyse them to form our ideas.

For the English at least, this was the modern world, formed by Newton and Locke. Newton had established the fundamental truths, while Locke, replacing metaphysics with the psychological, 'had revealed the mental mechanism through which experience generates truth'.[36] His vision and analysis were so new that he even provided the vocabulary for this new way of looking at the world, a change which was reflected in the fact that talk about the soul became an embarrassment, to be replaced by the more secular notion of the mind. Also, the pre-eminence Locke allowed to experience (as opposed to innate knowledge) led him to the view, as critics quickly pointed out, that belief is relative to experience. He observed for example that some people(s) have no idea of God, and used this in his attack on innate ideas. This was a key ingredient in the birth of psychology, even if that term was not used much yet. Locke argued that motivation was based on experience – nature – which helped form the mind, rather than derived from some transcendent force operating on the soul. He saw action as a response to the pleasure or pain accompanying sensations and that opened up the possibility of a deterministic/mechanistic view of motivation. One unsettling effect of this was to further remove God from morality, a stance which, as we saw in the last chapter, came to form the dominant view as the eighteenth century passed. Morality has to be taught; it is not innate. In the same way Locke removed 'the will' as an ingredient of the soul and explained it as simple choice, arrived at after reflection on the sensations the mind had received. Arguably most important of all, he said that the self, the 'I', was not some mystical entity relating to the soul, but an 'assemblage of sensations and passions that constitutes experience'.[37]

Locke's final contribution to the modern idea of psychology was his insight concerning language. Until the seventeenth century, language had a special status in the minds of many. It was felt that words were special things, in the sense that they resembled the objects which they described. The Bible was the *word* of God and some people believed that every object had originally possessed a name which identified it, and that the task of philology was to recover this original name. This was in particular the view of scholars such as Jakob Böhme, who argued for an 'Adamic language', the original form, believed by many to be closer to Hebrew than any other known language.[38] Locke, however, thought that language

was no more than convention and convenience, that languages changed and developed and that there was no sense in which we could (or, indeed, should) 'recover' some earlier form of words, as if this would help us recover some earlier form of wisdom. All of this shocked and disoriented people.

Despite Locke, many were still reluctant to accept the demotion of the soul, and the idea went through some very ornate configurations. Georg Stahl, known for his phlogiston theory of combustion, thought that the soul was incarnate in the whole body. Nicholas Malebranche (1638–1715) thought that God acted through the soul to create innate ideas and motivation. Antoine Arnaud (1612–1694) and Pierre Nicole (1625–1695), in their book *The Art of Thinking*, likewise argued that the soul was responsible for reasoning, though they did concede the idea that the structure of language reflects the way the mind works.[39] Leibniz proposed that 'what is exists as elementary units, called monads'.[40] It was these fundamental, indivisible, 'primary elements', he said, which underlie both body and soul. In Roger Smith's words, 'Leibniz became the figurehead for belief that stresses the soul's innate and essential activity when it grasps knowledge and originates conduct.'[41] This complicated reasoning regarding the soul shows the difficulties people got themselves into, in connection with an awkward concept. Locke's system, though shocking, was much simpler to explain.

But work on the soul wasn't dead, far from it. The Germans, like other Europeans of the day outside England, still believed that the soul was a unified entity which embodied divine design.[42] For example, Moses Mendelssohn (1729–1786), known as the 'Jewish Socrates', argued that there is a special faculty in the soul which functions only in regard to beauty, enabling man to respond to beauty, to 'know' it and recognise it, in a way that analysis can never achieve.[43] On this view, it was the soul that predisposed man to higher culture, and which separated him from the animals.

Just as psychology, in the modern sense, took time to disengage itself from the soul, so too was the distinction between psychology and philosophy slow in coming about. The man who did more than anyone else to distinguish the two was Immanuel Kant. His views were grounded in the essential difference between, on the one hand, scientific knowledge and philosophy (critical thinking) and, on the other, between science (rigorously understood) and pragmatic knowledge. Kant was fascinated with the self – the ego as we would say – and how it could know things. He concluded that not all knowledge is scientific, and that critical thinking shows we cannot know the world in itself.[44] Knowledge of the mind, for example, was not like mechanics, much as some eighteenth-century types wanted it to be. 'There cannot be a "science" of psychology because what we observe in our minds does not exist as objects knowable in terms of . . . space and time.'[45] Partly as a result of this Kant became interested in anthropology and physiognomy, which he himself defined as 'the art of judging what lies within a man, whether in terms of his way of sensing or of his way of thinking, from his visible form and so from his exterior'.[46]

And this, says Roger Smith, is what defined the Enlightenment. 'To quote references to human nature in the eighteenth century is a bit like quoting references to God in the Bible: it is the subject around which everything else revolves.'[47] Samuel Johnson claimed that the study of human nature first became fashionable at the end of the seventeenth century; in

the 1720s Joseph Butler, bishop of Durham, gave sermons on human nature and in 1739 David Hume published his *A Treatise of Human Nature*. This did not immediately become a classic (Hume said it 'fell still-born from the press'), but it did eventually help to bring about another defining aspect of the Enlightenment, namely the belief that knowledge would replace revelation as the way to achieve goodness.[48] These are the words of abbé de Mably: 'Let us study man as he is, in order to teach him to become what he should be.'[49]

The search for the laws of human nature took two main forms – the physical and the moral. The eighteenth century was fascinated by the body, by feelings, and by sensibility, the way the mind acted on the body through the nervous system. The Scottish physician Robert Whytt (1714–1766) experimented with decapitated frogs and found that they still moved their legs to brush off acid dabbed on their backs. He thus concluded they had a 'diffuse soul' in their spinal cord. A contemporary of Whytt, William Cullen (1710–1790), was the first to coin the term 'neurosis' but he applied it to all nervous disorders, which he thought more widespread than had hitherto been allowed. Neurosis acquired its modern meaning only in the late nineteenth century; nevertheless, in the eighteenth century, depression, anxiety and chronic anger *were* now described as 'nerves'.[50] Medical language moved away from the terminology of the humours, and madness was explained as a 'failure of the mind', understood as housed in a bodily organ, the brain.

The brain, in fact, had been explored as early as the 1660s, by Thomas Willis, one of the generation of early scientists who, with Wren, Hooke and Boyle, was in at the birth of the Royal Society. Willis had carried out numerous dissections of brains – humans and dogs mainly – and had developed a new way of extracting the brain from the skull, from underneath, which helped preserve the shape intact. His careful observations and dissections, and some clever staining techniques, helped to show that the brain was covered in a fine network of blood vessels, that the ventricles (the central spaces where the cortex was folded in on itself) had no blood supply and were therefore unlikely to be the location of the soul, as some believed. He showed that the brain was much more complex than anyone had thought, identifying for example new areas, such as the *corpus striatum* (the striped body), and he traced the brain's links – via the nerves – with the face, certain muscles, and the heart. His book *The Anatomy of the Brain and Nerves* (1664) did much to move the seat of the passions and the soul from the heart, making him famous in the process. He invented the term 'neurologie', which he called the doctrine of the nerves. He dedicated his book to Archbishop Sheldon, to highlight to everyone that he wasn't an atheist.

These changing attitudes and beliefs were embodied, perhaps inevitably, in a work which was to take them to extremes. This was *L'homme machine* (*Man a Machine*) by the French surgeon Julien Offray de La Mettrie, published in 1747, though to escape censorship in France he was forced to release his book in Leiden. In arguing that thought is a property of matter 'on a par with electricity', he was coming down on the side of determinism, materialism and atheism, all of which were to land him in hot water. His view was that human nature and animal nature were part of the same continuum, that human nature equated with physical nature and he insisted that there were no 'immaterial substances', thus casting huge doubt on the existence of the soul. Matter, he said, was animated by natural forces and has its own organisational powers. There was, he said, no essential

difference between any living organisms: 'Man is not moulded from a costlier clay; nature has used but one dough, and has merely varied the leaven.'[51]

Étienne Bonnot, abbé de Condillac (1714–1780), argued that all mental activity is produced by the pleasurable or painful quality of sensations, but he also said that the soul preceded sensations. Charles Bonnet (1720–1793) thought that mental activity took place in the fibres of the brain but nevertheless this activity required a soul.

In line with these changes, from soul to mind, went an associated development, what Dror Wahrman calls the emergence of the modern idea of the self. In a survey of the way the different sexes were portrayed in the eighteenth-century theatre, in the way race was written about, the way animals were conceived (in particular the relationship of the great apes to man), in the study of portraits of the time, the changing character of the novel, the proliferating fashions in clothes, Wahrman shows that the understanding of the self was transformed, from something that was mutable, and due to climate, history or religion, to something that came from within. This was not yet a biological concept of the self, but showed instead a realisation that the self could be *developed*. The discovery of America, as was mentioned in Chapter 21 and will be returned to in Chapter 28, had a great influence on European thinking about race, biology, culture and history, but in this context it was the American War of Independence that was for many people a watershed. In that conflict, different nationalities – British, French, Germans, Italians – fought together against the British: this had a profound effect, forcing people more than in previous wars to consider exactly who they were. The animal–human boundary was also reconsidered in the context of identity, and compared with class and gender boundaries. Portraits, which earlier on in the century had distinguished sitters chiefly by their clothing, now began to stress distinguishing facial features. The rise of the novel, Wahrman says, was just the most vivid example of this 'interiority complex' of the late eighteenth century. In the early part of the century, characters in novels were usually regarded as examples of types; by the turn of the nineteenth century, character was esteemed for itself and for its singularity. Novels explored not the familiar ways in which traditional character types met typical problems, but introduced the reader to 'strangers', with inner lives that might be totally different from their own, and invited sympathy and understanding.[52] It was in the late eighteenth century that the concept of development in character began to be stressed, the idea of *Bildung* in German, which reflected the view that in the course of a life the inner self may change in some areas while remaining consistent in others (Goethe's thinking was especially powerful here). By the same token, there developed in art an interest in child portraits (in the work of Joshua Reynolds, for example) and associated with this was the new idea of children as 'innocent blank slates' rather than miniature adults.[53] It was this new interest in character, identity, and where they both came from, which provoked the fashion for physiognomy, predicting character from facial features. All of which reflected and reinforced the Enlightenment concept of natural rights. Anonymous members of large class-groupings were unlikely to be as assertive or self-conscious as individuals with a strong sense of self.

That Paris – the home of Voltaire and the *Encyclopédie*, of Montesquieu and Descartes, of

La Mettrie and Condillac – should be a centre of enlightenment, and the search for the laws of human nature, was not so surprising. The city had been a capital of intellectual excellence and new ideas since its schools and university were founded in the eleventh century (see above, Chapter 17). What was far more surprising was that a small town in the very north of Europe should emerge as a rival.

'For a period of nearly half a century, from about the time of the Highland rebellion of 1745 until the French Revolution of 1789, the small city of Edinburgh ruled the Western intellect.' This is James Buchan in his recent book *The Capital of the Mind*. 'For near fifty years, a city that had for centuries been a byword for poverty, religious bigotry, violence and squalor laid the mental foundations for the modern world ... "Edinburgh, the Sink of Abomination" became "Edinburgh, the Athens of Great Britain". At one stage in the seventeenth century, and despite the fact that there were three mail coaches between Edinburgh and London every week, on one occasion the return mail contained only one letter from London to the whole of Scotland.[54] Against this background, a raft of luminaries – David Hume, Adam Smith, James Hutton, William Robertson, Adam Ferguson and Hugh Blair – became the first intellectual celebrities of the modern world, 'as famous for their mental boldness as for their bizarre habits and spotless moral characters. They taught Europe and America how to think and talk about the new mental areas opening to the eighteenth-century view: consciousness, the purposes of civil government, the forces that shape and distinguish society, the composition of physical matter, time and space, right actions, what binds and what divided the two sexes. They could view with a dry eye a world where God was dead ... The American patriot Benjamin Franklin, who first visited Edinburgh with his son in 1759, remembered his stay as "the *densest* happiness" he had ever experienced. The famous *Encyclopédie* of the French philosophers had devoted a single contemptuous paragraph to *Écosse* in 1755, but by 1762 Voltaire was writing, with more than a touch of malice, "today it is from Scotland that we get rules of taste in all the arts, from epic poetry to gardening".[55]

The immediate spur to this renaissance of the north was the rebellion of 1745. The Highland rebellion, led by Prince Charles Edward Stuart, to re-establish the (Catholic) Stuarts as the kings of Scotland (and Britain) briefly flourished in Edinburgh, before Charles, on his way to attack London, was defeated near Derby and forced to flee back to France. This concentrated minds in Edinburgh, forcing many to conclude that their future lay with England, that religious divisions, as reflected in the royal rivalries, did more harm than good, and that the future lay with the new learning rather than the old politics.

Almost as relevant to Edinburgh's success was the project to build Edinburgh New Town. 'Edinburgh New Town,' writes James Buchan, 'is intriguing not merely as a suite of handsome buildings, but as the material expression of ideas of civilian life ... They embody a new social existence that is suave, class-conscious, sensitive, law-abiding, hygienic and uxorious: in short, modern.' The extension of the city to the north of the old town was an expression not just of its expanding population but of its ambition. The new bourgeoisie wanted a more amenable city, one that was more rationally planned, with better commercial facilities, better meeting places, reflecting the way society was changing both economically and in the human relations that were now better understood via the new sciences. Churches and pubs were no longer enough: had not Montesquieu, no less, said

that concentrating people in capital cities increased their commercial appetites?[56] The truth was that people came to realise what they had known in antiquity – that cities could be hugely pleasurable. (Until 1745, Edinburgh had been run in a very strict Puritan fashion – indeed, the phrase 'Ten o'clock man' reflected the fact that elders of the kirk would tour the city's pubs at that hour, to ensure that no more alcohol was served.) Edinburgh New Town was built by public subscription, making it 'the largest public work in Europe until the canal mania of the late 1760s'.[57] While several individual buildings were the work of Robert Adam, or his brother John (or both), the overall conception of the New Town, its visual and intellectual integrity, owed most to James Craig. It was his plan – broad main streets, narrow service streets, with squares at either end and neo-classical, neo-Palladian, façades, all in perfect proportion – which gave Edinburgh its name as the 'heavenly city of the philosophers'.[58] 'There is no city like Edinburgh in all the world,' says James Buchan. 'It is what Paris ought to be,' wrote Robert Louis Stevenson. And, with the old castle high on its crag, like the Parthenon, looking down on the Palladian regularities of the New Town, the city's physical splendour was certainly more impressive even than Paris (whose grand boulevards and vistas date from the nineteenth century), the perfect example of eighteenth-century civic ambitions. Against this splendid backdrop, we may consider the Edinburgh luminaries.

In Britain, and particularly in Scotland, there was a special gloss on the way the relationship between the soul and psychology was conceived, which was known as moral philosophy. This was an ancient term, dating back to late medieval times, which reflected the view that the soul, human nature and the arrangement of social conditions were all linked, and that the study of human nature would reveal God's purposes for morality. (Moral philosophy was also taught in the early American colleges.[59]) There were those who argued that the moral sense was a faculty of the soul – this was how God showed man how to behave – but the man who grounded morality in the study of human nature was David Hume, the same Hume who we met in the last chapter attacking the rational defence of religion. Born in the Lawnmarket area of Edinburgh in 1711, the son of a Berwickshire laird, he developed a passion for literature and philosophy at college. His most important work was done while he was in his twenties but he was never made a professor, possibly because his scepticism bewildered and even frightened Edinburgh. On his deathbed, his friend Katharine Mure implored him to 'burn a'your wee bookies' before it was too late.[60]

In January 1739, at the age of twenty-eight, Hume published the first of two volumes, *A Treatise of Human Nature*. This set out to provide the groundwork to establish a science of man that would provide a rational moral code (its subtitle was: *Being an Attempt to Introduce the Experimental Method of Reasoning into Moral Subjects*). 'There is no question of importance, whose decision is not compriz'd in the science of man; and there is none, which can be decided with any certainty, before we become acquainted with that science. In pretending therefore to explain the principles of human nature, we in effect propose a compleat system of the sciences, built on a foundation almost entirely new, and the only one upon which they can stand with any security.'[61] He took out some of the strongest points, as likely to be *very* offensive to Christians, but even so, as one observer noted, he showed a level of scepticism 'not seen since antiquity'.[62] Like Locke, Hume based his

approach on Newton but he cannily observed that the physicist, while he had *described* gravity, had not really *explained* it. For example, he argued that the basis of knowledge is causation. We *know* something *is* because we experience it becoming so. But Hume insisted that this is illusion: we can never demonstrate causality. Famously, he said that when one billiard ball 'strikes' another, knocking it across the table, this does not reveal causation, only conjunction.[63] Experience orders life, 'knowledge becomes belief, "something felt by the mind", *not* the result of a rational process.' On this basis, all religion – with its ultimate causes and miracles – is complete nonsense.[64] Hume thought reason was completely in thrall to passion, and to that extent all science was suspect. There are no laws of nature, he said, there is no self, there is no purpose to existence, only chaos. Likewise he did not think it possible to explain 'the ultimate principles of the soul' but thought that there were four 'sciences' relevant to human nature. These were logic, morals, criticism and politics. 'The sole end of logic is to explain the principles and operations of our reasoning faculty, and the nature of our ideas: morals and criticism regard our tastes and sentiment: and politics consider men as united in society, and dependent on each other.'[65] Although his book was in three parts, on understanding, the passions, and morality, he argued that at base human nature is composed of two principal parts, affections and understanding. It was, he insisted, passion rather than reason that drove actions, that passion is always divisible into pleasure and pain and that these feelings affect what we think of as good and bad.[66] Hume too replaced soul with mind, which, he believed, could eventually be 'perfectly known'.[67] Though he placed the passions centre-stage, Hume was a moderate man in his own habits. He found many of his contemporaries 'agreeable' and, towards the end of his life, often cooked for his friends, who included several clergymen.[68]

Adam Ferguson, the son of a clergyman, was born on Tayside, the main eastern road into the Highlands, in June 1723. He grew up with a 'peppery' character and, according to Joseph Black, his physician, tended to wear 'an uncommon amount of clothing'. After a series of adventures and appointments, including chaplain to the Black Watch regiment, and service in Ireland and America, he was eventually appointed to the chair of natural philosophy in Edinburgh. His best known and most influential work was *An Essay on the History of Civil Society*, which received much criticism in Edinburgh, not least from David Hume, but found many enthusiastic readers in London, where it went through seven editions in Ferguson's lifetime. It also made a deep impression on the continent, giving to German philosophy the phrase 'civil society', *bürgerliche Gesellschaft*.[69] James Buchan says 'the *Essay* forms the essential bridge between Machiavelli and Marx: between an aristocratic dream of civic participation and the Leftist nightmare of an atomised and "alienated" personality.'[70]

Ferguson's argument is that progress is neither linear nor inevitable. There was never any golden age, from which humanity has fallen; instead, human beings are defined by four qualities: men are ingenious, cautious, obstinate and restless.[71] Humans are sociable and can only be understood 'in groupes, as they have always subsisted'. The rational world is not quite as the French *philosophes* would have us believe, and history proceeds in a mist. 'Every step and every movement of the multitude, even in what are termed enlightened ages, are made with equal blindness to the future; and nations stumble upon establishments, which are indeed the result of human action but not the execution of any

human design ... No constitution is formed by consent, no government is copied from a plan ...'[72] While part of him welcomed the development of industrial society (he had views about the 'stages' of history), Ferguson was one of the first to point out that manufacturing 'reduces the human being to a simple moving hand or foot, men become narrow-minded and specialised, they lose their notion of public good ... we make a nation of helots and have no free citizens'. 'Wages and liberty,' he said, 'are not synonyms.'[73] For Ferguson, we can love progress too much.

Until the seventeenth century there was no conception of 'the economy' as an entity in its own right. In the university curriculum, centred on Aristotle, the management of affairs was regarded as a branch of ethics. Only in the eighteenth century was there a separation of economic from moral questions. Until then the 'just price' for goods was set by guild corporations and royal representatives, not (at least not directly) by the market. The emergence of modern states in the seventeenth century – France, Austria, Prussia, Sweden – was a significant step, as they sought to understand the links between population levels, manufacturing and agricultural productivity, and the variable effects of the balance of international trade. As a result the eighteenth century saw in several of these countries (but not yet Holland or Britain) the establishment of university chairs of economics and the management of the state – political economy.[74]

A key figure here was Jean-Baptiste Colbert, Louis XIV's minister of finance between 1663 and 1683, who believed that the state needed accurate knowledge of social and economic conditions if it were to prosper. The French Académie des Sciences was instructed to study these issues when it was established in 1666.[75] In this way, details about credit arrangements, laws of contract, freedom of trade and the circulation of money became matters of interest in their own right. For the first time, it was realised that the quantity of money in circulation could be measured and related to economic performance.

The first British figure of consequence in the development of economics was William Petty (1623–1687), the Fellow of the Royal Society whom we met in Chapter 23 and who coined the phrase 'Political Arithmetick', the title of one of his books. He attempted a comprehensive quantification of Britain's capital assets, public finances and population (harder than it sounds, because Parliament did not sanction a census until 1801, and it wasn't comprehensive until 1851). It was Petty who, following Hobbes, envisaged economic activity as a system of discrete individuals, acting in their own rational self-interest. At the same time, he emptied the market – the system of exchange – of all moral considerations. A second figure was John Graunt (1620–1674), who pioneered the collection of social statistics (what he called 'Shop-Arithmetique'). This was originally done to counteract public fears about crime, but Graunt extended his approach to assess population levels in different areas. In this way, statistics about variations in mortality began to appear, of great interest to the fledgling life insurance business.[76]

In mainland Europe, where some of the states were quite small, there was in government little separation of economic, social, medical and legal matters, and these became known as 'cameralistics', after the *camera*, or chamber, of the ruler. In 1727 the first two chairs of 'cameral' sciences were established at the Prussian universities of Halle and Frankfurt-on-the-Oder. In fact the first chair at Halle was in *Oeconomie, Polizei und Kammer-Sachen*

(economy, police and cameralistics). In Britain, however, men argued that human nature rather than the state should govern economics. At the time, there was a general acceptance that society had entered a new stage – it had become 'commercial'. Commercial society, people felt, was the last (or at least the latest) stage in the progress of man. This approach or attitude was summed up by that other great Edinburgh man, Adam Smith. 'Every man thus lives by exchanging, or becomes in some measure a merchant, and the society itself grows to be what is properly a commercial society.'[77] In other words, a person's place in society is defined by what he or she (can) buy and sell.

Born in Kirkcaldy in 1723, Smith was a sickly child and on one occasion, according to some accounts, he was abducted by gypsies.[78] But he grew up to be something of a Renaissance man, familiar with Latin, Greek, French and Italian. He translated works from the French, so as to improve his English. He wrote on astronomy, philology, 'poetry and eloquence', and was professor of logic and rhetoric at Glasgow before he was appointed to the more prestigious chair of moral philosophy, in 1752. Though he lived and worked in Glasgow, he participated fully in Edinburgh life: the Glasgow–Edinburgh stage coach arrived each day in time for early-afternoon dinner.[79] He published *The Theory of the Moral Sentiments* in 1759, a work which Alexander Wedderburn, founder of the *Edinburgh Review*, described as disclosing 'the deepest principles of philosophy'. But it is for *The Wealth of Nations*, published in 1776, that Smith is remembered and revered around the world.

When he died, 'after a life of intellectual adventure and social prudence', a local newspaper complained in its obituary (4 August 1790) that he had 'converted his chair of moral philosophy at Glasgow University into one of trade and finance'.[80] There is more than an iota of truth in this but, because of the way Smith has been understood, and misunderstood, in the years since he lived, it is important to reiterate that he was an academic, a moral philosopher, who took a very moral view of his own work. 'Capitalism' is a term invented only at the turn of the twentieth century (as *Kapitalismus*, by Werner Sombart, the German economist and sociologist), and Smith would not have recognised either the word *or* the sentiment. His grasp of finance and banking was never especially strong and towards the end of his life he expressed profound misgivings 'about the moral complexion of commercial society'.[81] There is an irony here because Smith created an approach and a language that, ultimately, divorced economics from what most people mean by morals. But he himself felt that allowing absolute freedom of economic activity was itself a form of morality. Among other things, his book was a morally-outraged attack on the monopolistic practices of the grain trade.[82] He championed the interests of the consumer against the monopolists, identifying consumer demand as the engine for the creation of wealth.[83] We should not forget that state intervention in the eighteenth century was very important to economic development and Smith never disagreed with this.[84]

The formation of commercial society is, as both Roger Smith and Paul Langford highlight, a new stage in the evolution of a modern view of human nature. 'The term "economic man" is a code-word for the opinion that what is called society is only an association of individuals who act in the light of rational self-interest to maximise their material profit and well-being.'[85] As well as everything else, this clearly has implications for man's psychology, and it is important to be aware of the new world of the consumer into which Smith

introduced his book. 'The architect John Wood, writing in 1749, listed the novelties introduced since the accession of George II. Cheap and dirty floorboards gave way to superior deal covered with carpets. Primitive plaster was concealed with smart wainscoting. Stone hearths and chimney-pieces, customarily cleaned with a whitewash which left a chalk debris on the floor, were replaced with marble. Flimsy doors with iron fittings were abandoned for hardwood embellished with brass locks. Mirrors had become both numerous and elegant. Walnut and mahogany, in fashionable designs, superseded primitive oak furniture. Leather, damask, and embroidery gave seating a comfort unobtainable with cane or rush ... The carpets, wall-hangings, furnishings, kitchen and parlour ware in the homes of many shopkeepers and tradesmen in the 1760s and 1770s, would have surprised their parents and astonished their grandparents.'[86]

Smith's theories were especially poignant because at the time, in France, the only country where there was what we might call rival thinking, the theories of the so-called physiocrats were very different and, as it soon turned out, nowhere near as fruitful or accurate. The physiocrats were significant because they too encouraged the idea that, in the eighteenth century, there was a shift to commercial society and with this went an acceptance of commerce and exchange as important to the understanding of the laws of human nature. However, France, much more than England, was overwhelmingly rural and agricultural and this determined the theories of the physiocrats, the main figures here being François Quesnay (1694–1774) and the marquis de Mirabeau (1719–1789). Their view, argued in a series of books, was that all wealth derived from land, from agricultural productivity. Civilisation was essentially driven by the surplus of agricultural goods over the consumption of food required to produce it.[87] Expansion of this surplus, and the consumption it fuelled, produced the growth in population that worked yet more land, in a virtuous cycle. Quesnay's approach led him to view society in a particular way. There was a 'productive class', engaged in agriculture, there was a class of proprietors, landowners who included both the king and the church, who received the yield of agriculture in the form of tithes, taxes and rents, and there was what he called in a revealing phrase a 'sterile class', which included manufacturers, dependent on agriculture and, according to him, incapable of producing a surplus.[88]

Adam Smith in effect took the opposite view, that man had advanced beyond agricultural society, to a new stage in civilisation, commercial society. The basis of economic value, the origin of wealth, Smith said, lay in labour, work done. This was a marked change in that Smith did not identify any one occupational sector as the fundamental basis of wealth – what mattered instead, he said, was exchange and productivity, the value added in any transaction. This approach later became what was called 'classical economics', so it is important to reiterate here that Smith had no conception of a discipline of economics isolated from the study of moral relations, from the history of civilisation or from political questions about how Britain should be governed. 'He defined political economy "as a branch of the science of a statesman".'[89] Smith's view was essentially the modern one that we have today: a man was to be judged by his rational and moral qualities, and the extent to which they helped the welfare of his fellow men. This led Smith to change attitudes – towards entrepreneurs, for example: they were not shady moral types, he said, but important figures who accumulated capital and in that way facilitated productive work by others.

Although he came to be regarded as the father of free-market economics, in fact Smith believed that legislation was essential in certain areas of life, to maintain fairness and openness, and he himself lectured on jurisprudence.[90] J. A. Schumpeter, the great Austro-American economist of the twentieth century, said that Smith's seminal work, *The Wealth of Nations* (1776), was the most influential of all books on economics but that it was also, after Darwin's *On the Origin of Species*, the best of all scientific books. In the nineteenth century, H. T. Buckle thought *The Wealth* 'perhaps the most important book that has ever been written'.[91] Smith's approach, his rationalism, allowed mathematics to be applied to trade and exchange. This was not always successful but it did show that economic activity obeys certain laws or order and we have Smith to thank for this. He is often identified with the phrase '*laissez-faire* economics', but this is a French term, and reflects an eighteenth-century French view that did not become popular in Britain until the nineteenth century. In fact, Smith himself was always equally concerned with justice in civil society and with wealth creation. He justified this view by a comparison between Britain and elsewhere. By attaching value to labour, gross inequalities were not ironed out but, he argued, abject poverty was reduced, as he had predicted, much more so in Britain than elsewhere in Europe or, for example, India. People, he felt, would always naturally pursue their own self-interest and, other things permitting, this would lead to a high-wage economy which encouraged consumption, productivity and a general and continual upward cycle. Notably, Smith believed that God has so designed human nature that the average person, besides looking out for him- or herself, also shares sympathy for others. He believed that a civic humanism could go hand-in-hand with a commercial society.

The discipline of political economy was well launched by Adam Smith. One of Smith's most influential followers was the Reverend Thomas Robert Malthus (1766–1834), who became known as 'Population Malthus' on account of his theory of population and its effect on economics. The advent of the French Revolution and its bitter after-taste had concentrated minds on the political instability that seemed to be just below the surface everywhere and Malthus thought that, at the least, he had one answer if not *the* answer. Like so many others of his time he thought that there were discoverable laws of human nature but in his case he believed that there were limits to progress and he argued that he had hit upon one of the most intractable. He first published *An Essay on the Principle of Population, As It Affects the Future Improvement of Society* in 1798 but there was a second edition, almost a new version, in 1803, in which he expanded his argument. In these works Malthus produced a very pessimistic view of the future. His view was that there *are* laws of human nature and that one basic law is that the rate of population growth increases geometrically whereas the production of food increases only arithmetically. It follows from this that conditions of scarcity are a permanent feature of the human condition.[92] However, we should not overlook the fact that Malthus was a reverend and he viewed his discovery in a moral way, concluding not that starvation is an inevitability but that people should show restraint – prudence – and avoid contributing to a population that outstrips its ability to feed itself. The law he had uncovered, he said, was God's way of showing man that he had to show restraint on the procreation front, and work hard at wealth creation to ensure there was always enough food to go round.[93]

Malthus was, with Bentham, encountered earlier, a utilitarian. We may conclude this

section by considering the ideas of a colleague of Malthus, when he went to work as a curate at the new East India College, a teaching outfit where future employees of the East India Company were trained (the East India Company was the chief organ of British power in India during the high days of empire). At the college Malthus came across James Mill, father of John Stuart Mill (1806–1873), who was one of the most uncompromising – and scientifically-minded – utilitarians. In his *Analysis of the Phenomena of the Human Mind* (1829), James Mill said that his aim was to make 'the human mind as plain as the road from Charing Cross to St Paul's in London'. (In other words, for those who knew London, it was not a long journey and was, essentially, a straight line.) Mill tells us that he used the word 'analysis' in the title of his book to show that his methods at least aimed to be like those in chemistry. As one reviewer put it, 'sensation, association, and naming, are the three elements which are to the constitution of the human mind what the four elements, carbon, hydrogen, oxygen, and azote [nitrogen] are to the composition of the human body'.[94] Association was an important concept in early psychology and referred to the way in which sensations – pains and pleasures, and ideas and actions – come together to form regular patterns. This is another of those ideas which may seem self-evident to us but it was new at the time because it linked what goes on inside the head with behaviour and experience, and gave rise to much of modern psychology, such as learning theory, perception and motivation.[95]

Just as psychology had an uncertain and drawn-out birth during the eighteenth century, not really coalescing until the nineteenth, so too with what we now call sociology. During the Enlightenment there were conflicting views about man and his relation to his fellows. Some shared Hobbes' view that man was not naturally social whereas others considered sociability perfectly normal. It did not take a genius to see that man everywhere lived in civilisation, in cities, had formulated politics, so it seemed to many that the laws of 'society' (a late eighteenth-century term in this context) should be identifiable.[96]

One concern was the difference(s) between savage and civilised, which recalled the ancient barbarian/Greek and Roman divide. Carolus Linnaeus (1707–1778), for example, listed several categories of *Homo* under his famous classificatory system. These included *Homo ferus* (feral or wild man), *Homo sylvestris* (tree man, including the chimpanzee) and *Homo caudatus* (tailed man, partly mythical, partly designed to include imperfectly understood birth disorders). The first primates were imported into Europe at this time – orang-utans and chimpanzees – giving rise to the creation of comparative anatomy. People like Linnaeus and Edward Tyson could see the close relation in form to humans but at that stage lacked the conceptual framework to make more of the similarities. Erasmus Darwin (1731–1802), Charles Darwin's grandfather, wrote *Zoonomia: Or the Laws of Organic Life*, in the 1790s, in which he showed animals as changing over time in a progression. This was an early theory of evolution, but showed no understanding of natural selection. When people travelled in the eighteenth century, and met 'savage' or 'primitive' peoples, they had no idea whether such peoples were at an earlier stage of development, or a later one, and were in a state of decay from a higher civilisation. What distinguished man from the animals was his possession of a soul, and language. Skulls began to be collected, as evidence of different 'racial' types.

Roger Smith also says that the idea of Europe, as an entity by itself, as somewhere different from Christendom, as a civilisation of its own – the West, different from the East – also emerged in the eighteenth century. This is discussed in more detail in Chapter 29 (on the Oriental renaissance) but this idea, that Europe was artificial in comparison with more 'primitive' and 'natural' peoples, received a boost from Jean-Jacques Rousseau (1712–1778) in his idea of the 'noble savage'. Rousseau was, psychologically speaking, far from straightforward (his mother died in childbirth, his father disappeared when he was ten), and several modern historians have argued that he was psychologically disturbed.[97] He came to public attention in 1755 when he submitted an essay for his local Dijon Academy, addressing the question 'What is the origin of inequality among men, and is it authorised by natural law?' He began his answer by trying to describe and understand man's original, natural state, though he conceded that this was a difficult, even impossible task, as there were by then so many layers of artificiality. Nevertheless, he concluded that the moral life is a consequence of civilisation, not the natural state and that in achieving morality and civilisation men and woman have lost their innocence. In gaining something, something has also been lost. He advanced this view because he felt that man possesses a spirit, a consciousness of freedom, and that the soul revealed itself through the passions. 'Nature commands every animal, and the beast obeys. Man feels the same impetus, but he realises he is free to acquiesce or resist; and it is above all in the consciousness of this freedom that the spirituality of his soul is shown.'[98] Rousseau's natural man is 'individual, innocently at one with his feelings, feelings that are firmly feelings of *self* but include a desire for self-improvement and sentiment about others.'[99] This is one of the origins of the romantic movement, considered in Chapter 30. And it was this which separated man from the animals. 'Some actual savage societies, like the Carib, preserve a happy balance between "the indolence of the primitive state and the petulant activity of our vanity". Other societies developed iron and corn, "which have civilised men, and ruined the human race". Manufacturing and agriculture created a division of labour and, through labour, property and inequality ... men became what they once were not – deceivers, exploiters, legislators of inequality, defenders of oppression, tyrants.'[100] His *Social Contract*, which introduced the idea of the 'general will', became for some people a sacred text of the French Revolution.

C.-L. de Secondat, baron de Montesquieu (1689–1755), was the author of *De l'esprit des lois* (*The Spirit of the Laws*), published in 1748, which offered a contrary view to Rousseau. To Montesquieu (who was an amateur experimental scientist) it was self-evident that the social world, no less than the physical world, shows regularities and rhythms. From this he concluded, contrary to Adam Ferguson, that the world is not governed by blind chance and that the laws of human social conduct are discoverable. 'Laws, taken in the broadest meaning, are the necessary relations deriving from the nature of things; and in this sense, all beings have their laws ...'[101] Despite a number of frankly questionable statements, such as his view that warm climates 'expand the nerve fibres', making people indolent, his more substantial argument involved an examination of different types of government – monarchies, republics, despotisms – and their consequences for freedom, education, and other aspects of social life. His most important point was his conclusion that it was not so much the *system* of government that determined how rule was exercised but how

individuals administered the government. In the context of the times this was taken to be a criticism of the monarch's claim of divine authority, and *The Spirit of the Laws* was placed on the Index.

The final way in which the eighteenth century examined the laws of human nature was through the emergence of academic history. History itself was of course not new. What was new was, first, innovative techniques of study, which laid the groundwork for what would become an academic subject in its own right and second, an expansion of the historical imagination to include the history of civilisation. This helped produce the modern idea of progress.

Both Voltaire's *The Century of Louis XIV* (1751) and David Hume's *History of England* (1754–1762) questioned dogmatic Christianity as the central theme of historical change, while Edward Gibbon's *The History of the Decline and Fall of the Roman Empire* (1776–1788) 'ended on a tone of irreparable loss rather than excitement over the foundation of Christian Europe'.[102] In the 1750s a non-dogmatic view of history emerged. For example, the so-called 'four-stages theory' attributed social change to transformations in the mode of subsistence, from hunting, to pasture, to agriculture, to commerce. Though many people picked holes in this theory, nonetheless the idea of historical stages unrelated to Christianity proved popular because it accounted for the great diversity around the world that had been discovered in the age of exploration. It was in this way that the idea of progress became popular. If progress were to be possible, it had to be defined and measured, and that could only be done by the proper study of the past.[103]

As early as the fourteenth century the Muslim philosopher Ibn Khaldun (1332–1406) had argued that history was a science and should seek to explain the origin and development of civilisation, which he likened to the life of an individual organism.[104] Francis Bacon also had an idea of advancement. 'These be ancient times,' he wrote, 'when the world is growing old; our own age is more truly antiquity than is the time which is computed backwards, beginning with our age.' For him, just as a mature person is considered wiser than a child, so people in later times may be expected to have a great accumulation of knowledge.[105] Descartes also talked specifically of the 'improvement' of human health that would result from the discoveries of science. But it was in late seventeenth-century England, in a series of tracts, that there had been a celebrated exchange as to whether ancient or contemporary thought was better. In 1690 Sir William Temple, in his *Essay upon Ancient and Modern Learning*, went so far as to deny the importance of Copernican theory and the circulation of the blood, and argued that Pythagoras and Plato surpassed Galileo and Newton. Even Jonathan Swift, a protégé of Temple's, upheld (just) the superiority of the ancients in his satire *The Battle of the Books* (1697). Temple's errors were exposed, partly by William Wotton in his *Reflections upon Ancient and Modern Learning* (1694), but the very existence of the battle itself shows how much ideas about progress were in the air.

The French writer Bernard de Fontenelle (1657–1757) went further than any of the English authors. In *A Digression on the Ancients and Moderns*, he came to five surprisingly modern conclusions. These were that, from a biological point of view, there was no difference between the ancients and moderns; that in science and industry one achievement

depends on another and that, therefore, 'progress is cumulative', meaning that the moderns have indeed surpassed the ancients; this does not make the moderns cleverer than the ancients, they simply take advantage of what has gone before – they have more accumulated knowledge; in poetry and rhetoric, the arts, there is really no difference between the two periods; we should remember that 'unreasoning admiration' for the ancients is a bar to progress.[106] De Fontenelle was supported by Charles Perrault (1628–1703). Despite the accumulation of knowledge since classical times, Perrault thought the recent scientific discoveries had brought the modern world to perfection and that later ages would have little to add. 'We need only read the French and English journals and glance over the noble achievements of the Academies of these two great kingdoms to be convinced that during the last twenty or thirty years more discoveries have been made in the science of nature than during the whole extent of learned antiquity.'[107] Anne Robert Jacques Turgot (1727– 1781) was only twenty-four when he delivered a lecture at the Sorbonne in December 1750, later published as *On the Successive Advances of the Human Mind*. Despite his youth, his theory became very influential – he argued that civilisation is the product of geographical, biological and psychological elements and that, basically, man's biology doesn't change. Mankind has a common treasury of knowledge, preserved in writing, and builds on what has gone before. He distinguished three stages of intellectual progress – theological, metaphysical and scientific. He accepted that perfection was possible and would be achieved one day.

Voltaire wrote three works of history. The first concerned a single individual, Charles XII (1728), the second an entire century, *The Century of Louis XIV* (1751), and the third – his most important work – was the 1756 *Essay on Customs* (*Essai sur le moeurs et l'esprit des nations*), much more ambitious than the other books, aiming, as he put it, to explain the causes for 'the extinction, revival, and progress of the human mind'.[108] Voltaire's approach was new too in concentrating not on political history but on cultural achieve-ments. His self-imposed task was to show 'by what stages mankind, from the barbaric rusticity of former days, attained the politeness of our own'. He called this process the 'enlightenment' of the human mind, 'which alone made this chaos of events, factions, revolutions, and crimes worth the attention of men'.[109] He was not concerned with divine or 'first' causes, but showed how things worked and went on from there. In the same book he also introduced the phrase 'philosophy of history', meaning that history was to be looked at as a science, critically, with an empirical weighing of evidence and with no place for intuition.

Probably the most complete – certainly the most elaborate – idea about progress was that devised by the marquis de Condorcet (1743–1794) in his *Outline of an Historical Picture of the Progress of the Human Mind*, released in 1795. He took the view that 'nature has assigned no limit to the perfecting of the human faculties, that the perfectibility of man . . . has no other limit than the duration of the globe on which nature has placed us'.[110] He divided history into ten stages: hunters and fishermen; shepherds; tillers of the soil; the time of commerce, science and philosophy in Greece; science and philosophy from Alexander to the fall of the Roman empire; decadence to the crusades; the crusades to the invention of printing; printing to the attacks on authority by Luther, Descartes and Bacon; Descartes to the Revolution, 'when reason, tolerance and humanity were becoming the

watchwords of all'. He regarded the French Revolution as the dividing line between the past and a 'glorious future', in which nature would be mastered ever more completely, progress would be without limit, industry would make the soil yield enough food for everyone, there would be equality between the sexes and 'death will be the exception rather than the rule.'[111]

The Englishman William Godwin (1756–1836) saw progress in frankly political terms – that is to say, he saw politics as a way to achieve overall justice for mankind, without which man's fulfilment was impossible, and this fulfilment, he said, was the object of progress. The publication of his book *Enquiry Concerning Political Justice* (1793), with the French Revolution at its height, caused a sensation. 'Burn your books on chemistry,' Wordsworth is said to have told a student. 'Read Godwin on necessity.'[112] Godwin's theory was that mankind *is* perfectible but has not made much progress in the past and that this was due to the coercive power of oppressive human institutions, in particular government and the church. He therefore proposed that central government be abolished and that no coercive political organisation be allowed above the parish level. He proposed to abolish marriage and to equalise property holding. Progress, achieved when man is free to exercise his reason as he wishes (save for the moral censure of his peers), can be achieved only through political justice, which he felt depended on literature and proper education.[113]

Immanuel Kant (1724–1804), like his contemporary Gottfried Herder (1744–1803), accepted that there was a great cosmic purpose in history, toward which men are unwittingly guided by their observance of natural laws. (Kant's own laws were invariable; neighbours could set their watches by his daily walks.) For him one of the tasks of the philosopher is to uncover this universal plan for mankind. He thought that, in principle, these natural laws of history and progress would be discoverable, as Newton's laws of the planets had been discovered. He concluded his philosophy of history by putting forth nine propositions that outline mankind's progress. His main argument was that there is always a conflict within man, between the sociable being, who cares for the good of his neighbours, and the selfish being, who cares only for himself, for achievement and independence. This constant struggle, he thought, goes back and forth as times change, producing progress in both spheres, the social and the individual. This creative conflict, he argued, is at its best where there is a strong state, to regulate social life, and the most individual freedom, to let individuality thrive. He was clear in arguing that this was a moral concept of progress: the freedom of the greatest number – to realise their individuality and to look after their neighbours – was the aim.[114] Like Kant, Georg Wilhelm Friedrich Hegel (1770–1831) felt that progress was essentially about freedom. Throughout history Hegel distinguished four main phases of historical progress, during which freedom expanded. There was, first, the Oriental system, in which only one person is free – the despot. Next came the Greek and then the Roman systems, in which some people were free. Finally, there is the Prussian system, in which all people are free. This brief summary bends Hegel's views somewhat but he himself was required to bend quite a bit of evidence to show that his own world – nineteenth-century Prussia – was the best of all possible worlds.

Finally, so far as progress is concerned, let us return to France and the theories of Count Claude Henri de Saint-Simon (1760–1825) and Auguste Comte (1798–1857). Both men may be regarded as early sociologists, a concern with the concept of progress being a major

focus of this fledgling social science. These two men were also more interested in *realising* progress than in merely theorising about it. (In this sense, the invention of sociology was itself *part* of progress.) In a well-known paragraph Saint-Simon said: 'The imagination of poets has placed the golden age in the cradle of the human race. It was the age of iron they should have placed there. The golden age is not behind us, but in front of us. It is the perfection of social order. Our fathers have not seen it; our children will arrive there one day, and it is for us to clear the way for them.'[115] Saint-Simon accepted the three stages of progress that had been put forward by Turgot, adding that the advances of the scientific and industrial revolutions had really started progress in a big way. Disappointed by the violence and irrationalism of the French Revolution, he thought that industrialisation was man's only way forward and he became an eloquent propagandist for the machine. In particular, and most originally, Saint-Simon advocated certain new houses of Parliament, one which he called the House of Invention, to include engineers, poets, painters, architects, another the House of Examination, to include doctors and mathematicians, and a third, the House of Execution, consisting of captains of industry. His idea was that the first house would draw up laws, the second would examine them and pass them, and the third would decide how to put them into effect.

In his book *Positive Philosophy*, Comte argued that history divided into three great stages, the theological, metaphysical and scientific. He adapted Saint-Simon's ideas in the sense that he thought that the people who should guide industrial and technical progress were the sociologists ('sociologist-priests' as someone called them), that women should be the guardians of moral direction, and that the captains of industry, again, should actually administer the society. In politics he thought that 'imagination' should be subordinate to observation. Comte died in 1857, two years before Charles Darwin published *On the Origin of Species*, when the theory of evolution transformed and simplified ideas of progress for all time.

The eighteenth century, the Enlightenment, was characterised by the first attempts to apply the methods and approach of the natural sciences to man himself. They were not wholly successful but they were not a total failure either. It is a problem still very much with us. What we might call the 'hard' sciences – physics, chemistry and biology – have gone on making great progress. On the other hand, the 'soft' sciences – psychology, sociology and economics – have never acquired the same measure of agreement, or predictive power, and have never generated the same highly effective technology in the realm of human affairs as, say, nuclear physics, solid-state physics, organic chemistry and genetic engineering. Today, two centuries after the end of the Enlightenment, we still can't say for sure what laws human nature obeys or even if these laws are the same as those that obtain in the 'hard' sciences. This disjunction is, essentially, the main topic of the last section of the book.

# The Idea of the Factory and
# Its Consequences

'Coketown ... was a town of red brick, or of brick that would have been red if the smoke and ashes allowed it; but, as matters stood it was a town of unnatural red and black like the painted face of a savage. It was a town of machinery and tall chimneys, out of which interminable serpents of smoke trailed themselves for ever and ever, and never got uncoiled. It had a black canal in it, and a river that ran purple with ill-smelling dye, and vast piles of building full of windows where there was a rattling and a trembling all day long, and where the piston of the steam-engine worked monotonously up and down, like the head of an elephant in a state of melancholy madness. It contained several large streets all very like one another, and many small streets still more like one another, inhabited by people equally like one another, who all went in and out at the same hours, with the same sound on the same pavements, to do the same work, and to whom every day was the same as yesterday and tomorrow, and every year the counterpart of the last and the next.'[1]

Who else but Charles Dickens in one his grimmest 'industrial novels', *Hard Times*? Coketown, Mr Gradgrind, the school headmaster, Mr Bounderby, the banker and manufacturer, Mr Sleary, the horseman, Mrs Sparsit, presiding over Mr Bounderby's establishment and connected, in better days, to the Powlers and the Scadgers – the very names in Dickens always tell half the story. One of the main themes of the book, in Kate Flint's words, is an investigation of the mind-set 'of those who persist in seeing [the] workers as mere useful tools, as "hands", rather than as fully functioning, complex human beings.'[2] But Dickens was never a didactic writer: he didn't need to be.

If, as was maintained earlier, a crucial change in sensibility took place sometime between AD 1050 and 1200, to create what we may call the 'Western mind', a no less momentous change occurred in the eighteenth century. It had three elements. One was that the centre of gravity of the Western world moved away from Europe, to lie somewhere between it and North America, and this shift westward to an imaginary point in the Atlantic came about as a result of the American Revolution (see Chapter 28). A second momentous change involved the substitution of democratic, elected governments in place of the more traditional and often absolute monarchies of Europe. Apart from England, this owed its genesis for the most part to the French Revolution, which set off a chain of other revolutions which extended through the nineteenth and into the twentieth century, and partly to

the ideas worked out in America. The third change in the eighteenth century was the development of the factory, that symbol of industrial life, so different to what had gone before.[3]

Why did the factory and all that that implies occur first in Britain?[4] One answer was that in England many feudal and royal restrictions which remained in place in other European countries had been swept away by the revolutions of the seventeenth century.[5] Another reason, which we shall come to, was the shortage of wood, for this forced new developments in the use of the inferior but cheaper coal for fuel.[6] We should also remember that the first industrial revolution occurred in a very small area of England, bounded to the west by Coalbrookdale in Shropshire, to the south by Birmingham, to the east by Derby, and to the north by Preston in Lancashire. Each played its part in what became the industrial revolution: at Coalbrookdale in 1709, Abraham Darby smelted iron with coal; at Derby in 1721, the silk-thrower Thomas Lombe designed and constructed the world's first recognisable factory; in Preston in 1732, Richard Arkwright was born; in Birmingham in 1741 or 1742, John Wyatt and Lewis Paul first applied the system of spinning cotton by rollers, which Arkwright would appropriate and improve.[7]

The combined effect of factory organisation and technical innovation occurred first in spinning. The point of spinning machines is that they parallel the way humans, with their fingers, increase the tension on wool or cotton staples so as to draw out a continuous thread. One type of machine was invented by James Hargreaves in the 1760s and another patented by Richard Arkwright, a baker by trade. Their devices employed a series of spindles and rollers to gradually build up the tension. A decade or so later, Samuel Crompton invented a machine which performed both the functions of the other two men's devices and the spinning machine was more or less perfected.[8] The important point to take on board is that although Hargreaves and Crompton were inventors, it was Arkwright, the organiser with a nose for finance (who may even have stolen the ideas of the two earlier inventors), who patented the water frame and went on to make a fortune.[9] He realised that it was not with wool but with cotton that the future lay, for the growing trade with India was what counted. It had never been easy to spin strong cotton thread by hand and, traditionally, English weavers had woven a cloth in which the weft was cotton but the warp was linen (in the loom the threads of the weft are left stationary, whereas those of the warp are constantly strained as the shuttle leads them to and fro). Arkwright knew that a cotton thread tough enough to be used as warp as well as weft would transform the industry.[10]

The first factories were powered by running water, and this is why they were located in the often remote river valleys of Derbyshire – it was only here that the streams could be relied on to have enough water throughout all the year. Children from foundling homes and workhouses provided cheap labour. This was not in itself a new practice – Daniel Defoe had observed Yorkshire villages in the 1720s where women and children spent long hours at spinning machines. The new element was the factories themselves and the brutal discipline they demanded. As things stood, at least the children had what little free time they were given in the countryside. But even that changed when the steam engine took the place of water power at the beginning of the nineteenth century. This made it viable for

the factory to move to the source of labour, the town, coal being as plentiful there as in the countryside.[11]

The first use of the steam engine was to pump water from mines. (This was an old problem. Evangelista Torricelli had discovered as early as 1644 that a suction pump could not raise water much more than thirty feet.*) The deeper mines, well below the water table, needed to be drained either by bailing out with buckets or with a series of pumps. The first engine to power these pumps was invented by Thomas Newcomen, in the copper mines of Cornwall, around the turn of the eighteenth century. In this early form of engine, the steam which powered the piston was condensed in the cylinder, with the piston being brought back by the suction that resulted from condensation. This worked, after a fashion, but the drawback was that the entire cylinder was cooled after each stroke by the water that was injected to condense the steam. This was where James Watt came in. As a skilled instrument-maker at the University of Glasgow, Watt made some calculations about the efficiency of Newcomen's machine and began to wonder how the heat loss might be prevented or avoided. His solution was to condense the steam in a chamber that was connected to the cylinder but not part of it. This arrangement meant that the condenser was always cold, while the cylinder was always hot. Despite this breakthrough, Watt's engine did not function satisfactorily in Glasgow owing to the poor quality of workmanship by the local smiths. Matters were transformed when Watt found much more 'eminent casters' in Matthew Boulton's factory in Birmingham.[12]

This was, in many ways, the defining moment of the industrial revolution, the event which coloured so much of modern life. Once steam became the power base, coal and iron became the backbone of industry. In fact, iron technology was already well advanced. Until around 1700, only charcoal could reduce iron ore in the blast furnace. This was where the shortage of wood in England played a pivotal role. Wood remained plentiful in France and so charcoal continued to be used. But in England there was, in the place of wood, a rich supply of coal. Everyone knew this and more than one inventor grasped that one way to reduce iron ore would be to rid coal of its gases, thus converting it into coke, which enabled higher temperatures to be built up more safely.[13] This was first achieved around 1709, the ironmasters who made it being Abraham Darby and his family, who managed to keep their secret for more than thirty years.[14] The raw iron they produced still needed to be purified, to make it workable, but in time cast iron became, in Peter Hall's words, the plastic of its day.[15]

The agricultural revolution of the eighteenth century also played a part. Viscount Townsend's new methods of crop rotation, and Robert Bakewell's innovations in cattle breeding, which vastly improved efficiency, helped push people off the land, destroyed village life and forced the population to the cities – and into the factories.[16]

But the industrial revolution was not only, and in fact not mainly, about the great inventions of the time. The long-term change that the industrial revolution brought about was due instead to a more profound transformation in industrial *organisation*.[17] As one historian of this great change has pointed out, the abundance and variety of inventions 'almost defy compilation' but they could be grouped into three categories. There was the

---

* This was in itself a step leading towards the discovery of the pressure of the atmosphere.

substitution of machines (quick, regular, precise, unflagging) for human skill and effort; there was the substitution of inanimate sources of power (water and coal) for animate ones (horses, cattle), most notably engines for converting heat into work, opening to man a virtually unlimited supply of energy; and finally, all this meant that man could make use of new raw materials – mainly minerals – which were abundant.[18]

The point of these improvements was that they enabled an unprecedented increase in man's productivity and, moreover, one that was self-sustaining. In earlier times, any increase in productivity had always been quickly accompanied by a population increase which eventually cancelled out the gains. 'Now, for the first time in history, both the economy and knowledge were growing fast enough to generate a continuing flow of investment and technological innovation.' Among other things, this transformed attitudes: for the first time, the idea that something was 'new' made it attractive, preferable to something that was traditional, familiar, tried and tested.[19]

Some idea of the scale of the transformation can be had from the way the cotton industry progressed in Britain. In 1760 (generally regarded as the very beginning of the industrial revolution), Britain imported around 2.5 million pounds of raw cotton. In 1787 that had risen to 22 million pounds and by 1837 to 366 million pounds. At the same time, the price of yarn had fallen to about one-twentieth of what it had been and almost all of the workers in the cotton industry, save for the hand-loom weavers, worked in mills under factory conditions. The rise of modern industry, and the factory system, 'transformed the balance of political power, within nations, between nations, and between civilisations; revolutionised the social order; and as much changed man's way of thinking as his way of doing'.[20]

The primary reason for this change has been reconstructed by historians and appears to be due to the fact that the earlier village system was unequally mechanised. For example, the weaver's frame was an effective machine but the spinning wheel required little skill and, according to Daniel Defoe, 'anyone age four and above could do it'. Because of this, it paid very badly and was treated by women as a secondary occupation – after housework and raising children. As a result, spinning often became a bottleneck in the system. A second shortcoming was that while in theory the weaver was his own man, in practice he often had no choice but to mortgage his weaving frame to the merchant. At times when business was bad the weaver had to borrow money to survive, and his only security was his machine. At the same time, this did not necessarily benefit the merchant because when the good times came the weaver usually worked just hard enough to feed himself and his family and no more. Put another way, when the weaver needed more work the system was against him, and when the merchant needed more product the system was against *him*. There was thus no *surplus* in the arrangement. It was this (unsatisfactory) state of affairs which led to the factory. The essence of the factory was that it gave the owner control over materials and over working hours, enabling him to rationalise operations which needed several steps, or several people.[21] New machines were introduced that could be used by people with little or no training – women and children included.

For the workers, factory life was nowhere near so convenient. Thousands of children were recruited from the foundling homes and workhouses. William Hutton served his apprenticeship in the silk mills of Derby wearing pattens on his feet because he was too

small to reach the machinery. Like the adults around them, children were subject to factory supervision and discipline. This was a new experience: tasks became increasingly specialised, time ever more important. Nothing like this had existed before; the new worker had no means of either owning or providing the means of production; he or she had become no more than a hired hand.[22]

This fundamental change in the experience of work became all the more obvious when the invention of steam engines made the factory city possible. In 1750 there had been only two cities in Britain with more than 50,000 inhabitants – London and Edinburgh. By 1801 that had grown to eight, and to twenty-nine in 1851, including nine over 100,000, meaning that by this time more Britons lived in towns than lived in the country, another first.[23] The migration to the cities was forced on people – they had to go where the work was – but they were hardly enthusiastic and it is not hard to see why. Apart from being smoky and dirty, with a shortage of open spaces, and with sanitation and water-supply lagging behind the increase in population, the cities were home to epidemics of cholera, typhoid and pollution-induced respiratory and intestinal diseases. 'Civilisation works its miracles,' wrote the Frenchman, Alex de Tocqueville, who visited Manchester in 1835, 'and civilised man is turned back almost into a savage.'[24] But in the factory city, owners could immediately benefit from new inventions and new ideas, and this too was an important characteristic of the industrial revolution – that it was self-sustaining, intellectually as well as materially. It generated new products – in particular, iron products and chemicals (alkalis, acids and dyes), most of which required large amounts of energy/fuel for their manufacture. Another aspect of this arrangement was that the new industrialism stretched across the world, from the sources of the raw materials to the factories, and then on to the markets. This too stimulated new ideas and new demand for products. To give just one example, it was the developments in the industrial revolution that combined to make tea and coffee, bananas and pineapples everyday foods. According to David Landes, this change in man's material life was greater than anything since the discovery of fire: 'The Englishman of 1750 [i.e., on the eve of the industrial revolution] was closer in material things to Caesar's legionnaires than to his own great-grandchildren.'[25]

No less important in the long run, the industrial revolution also widened the gap between the rich and poor, helping to generate class conflicts of unprecedented bitterness.[26] The working class became not only more numerous but also more concentrated, and therefore more class-conscious. This change is worth dwelling on for a moment because it was to have an immense significance in politics. Pre-industrial labour was a very different entity from its later counterpart. Traditional peasants had their holdings or their craft shops, and they also had a master, with reciprocal duties (albeit very unequal ones). The industrial revolution, however, replaced the peasant or servant – the man – with the 'operative' or 'hand'. It also imposed a regularity, a routine, a monotony, on work, which had been largely absent in the pre-industrial rhythms of labour, based on the seasons, or the weather.[27] (People in pre-industrial times quite often chose to start the working week on Tuesday. Monday was known ironically as 'Saint Monday'.)

One reason for the poverty of the working classes, certainly for the low wages they were paid, was because income was diverted to the new business classes, who were investing in the new machines and factories. The industrial revolution did not create the first capitalists,

'but it did produce a business class of unprecedented numbers and strength'.[28] These 'chimney aristocrats', as they were called, came to dominate domestic government policy throughout most of Europe in the nineteenth century.

A quite separate aspect of the industrial revolution was economic. The origin of economics – the discipline – was outlined in the previous chapter. Added to this in Britain was the phenomenon of private savings, which began to accumulate after 1688. The king used these savings to fund war, and in this way a public debt was established. The Bank of England was founded in 1694 as part of this evolution, with merchants and landowners taking a share in the national debt, and drawing interest from it.[29] Government loans were paying 8 per cent before 1700, but by 1727 that had fallen to 3 per cent and this too had an effect on the industrial revolution. When interest rates are high, investors look for quick profits, but when rates are low, people are more willing to consider longer-term projects which might, in the future, offer better returns. This is a better climate in which to launch large-scale capital projects, such as sinking mines, digging canals, or building factories. The early factories – in the country – had been of such a scale that single families could afford to finance their construction but, as demand grew, and urban factories snowballed in size, to satisfy an expanding market, larger investment was needed.

Britain led the way in the industrial revolution, partly because many of the inventions were conceived there but also because the French Revolution and the Napoleonic wars held mainland Europe back until around 1815. However, once these other countries achieved a measure of political stability they lost no time in creating their own forms of financial intermediary, in particular the joint-stock investment bank, or the *crédit mobilier*, designed to fund their large-scale capital projects. Again according to David Landes, the earliest examples were semi-public institutions – the Société Générale in Brussels and the Seehandlung in Berlin. These institutions were particularly effective in funding the development of the railways, 'which needed money in unprecedented quantities'.[30]

A parallel development arose in the schools of science and technology, which fulfilled for the mainland European countries the function of the dissenting academies in Britain (see below, this chapter). The French led the way, first with its École Polytechnique (originally the École Central des Travaux Publics) in 1794. The competitive character of the school – admission by examination only, and with a public ranking on admission, partial completion and graduation – attracted the best students. Graduates who wanted a career in the new industries went on to the Écoles des Mines or the Ponts-et-Chaussées, where they learned applied science and did on-the-job training.[31] The École Centrale des Arts et Manufactures, designed to teach engineers and business managers, was founded privately in 1829 but was taken into the state system in 1856. These French examples served as models for other countries, rather than the original dissenting academies, because by the end of the eighteenth century the British strategy of 'learning by doing', though it had worked well enough to begin with, had now been overtaken by the sheer weight of innovation. More abstract and theoretical tuition was now needed, and in two areas – electricity and chemistry – advances were being made in so many different locations that only in these new schools could students keep up.

*

Advances in electricity and in chemistry in particular underpinned many of the new industries which comprised the industrial revolution. Electricity moved ahead after the period dominated by Newton, because it was one of those areas that Newton himself had not spent any time on and where other scientists were not intimidated. People had known that there *was* such a thing as electricity for hundreds of years, men being aware, for example, that amber, when rubbed, attracted small bodies. It was also discovered in the early eighteenth century that friction – in the form of a barometer shaken in the dark – produced a green light.[32] But the first real excitement was generated by Stephen Gray in 1729 when he was led to a more developed idea of electricity as something that could be sent over large distances. He first noticed that the corks which he put in the end of test tubes attracted small pieces of paper or metal when the tubes (not the corks) were rubbed. By extension he found that even silk loops that led from the tubes right round his garden also had the same property. He had discovered that electricity was something that could 'flow from one place to another without any appearance of movement of matter' – electricity was weightless, what he called 'an imponderable fluid'. Gray also discovered something anomalous but basic: electricity could be stored in bodies like glass or silk where it was generated, but it could not pass through them. And, conversely, those substances which conducted electricity could not generate or store it.[33]

Electricity became the rage in Europe, and then in America, after Ewald Georg von Kleist, in 1745, tried to pass a current (not that it was called that then) into a bottle through a nail. Accidentally touching the nail while holding the bottle, he received a shock. Soon everyone wanted the experience, with even the king of France arranging for a whole brigade of guards to jump as one by giving them shocks from batteries of jars. It was this idea which Benjamin Franklin took up, far away in Philadelphia. It was Franklin who realised that electricity in a body tends to settle at its natural level, when it is undetectable. If some were added, it became positively charged, and repelled objects, whereas if it lost some it was negatively charged, and attracted objects. This tendency to attract, Franklin also realised, was the source of sparks and shocks and, even more impressive, he realised that this was, essentially, what lightning was, a colossal spark. He demonstrated this by his famous experiment with a kite, showing that lightning was indeed electricity, and inventing the lightning conductor in the process.[34]

In 1795 Alessandro Volta (1745–1827), professor of physics at Pavia, showed that electricity could be produced by putting two different pieces of metal together, with a liquid or damp cloth between them, thus creating the first electrical current battery. But these batteries were very expensive to produce and it was only when Humphry Davy, in 1802, isolated the new metals sodium and potassium, at the Royal Institution in London, that electricity began to be the subject of serious experimentation. Eighteen years later, in 1820, Hans Christian Oersted in Copenhagen discovered that an electric current could deflect a compass needle and the final link was made between electricity and magnetism.[35]

More important even than the discovery of electricity, in the eighteenth and the early years of the nineteenth century, was the rise of chemistry. This discipline, it will be recalled from Chapter 23, had not really featured in the scientific revolution but now it came into its own. One reason it was held back was the enduring fascination with alchemy and the passion for finding ways to make gold. This is not so surprising as it may seem now.

Paracelsus' 1597 book, *Alchemia*, is the first good book on chemistry. Despite being absorbed in alchemy, Paracelsus recognised that coal-mining caused lung-disease and that opium deadened pain. However, only when chemistry became a rational science could it advance. The main area of interest, at least to begin with, was the phenomenon of combustion. What, actually, happened when materials burned in the air? Everyone could see that such materials disappeared in flame and smoke, to leave only ash. On the other hand, many substances didn't burn easily, though if they were left in the air they did change – for example, metals rusted. What was going on? What exactly *was* air?

One answer came from Johan Joachim Becher (1635–1682) and Georg Ernst Stahl (1660–1734), who argued that combustibles contained a substance, phlogiston, which they lost on burning. (The name phlogiston was taken from the principle of *phlox*, or flame.) On this theory, substances which contained a lot of phlogiston burned well, whereas those that didn't were 'dephlogisticated'. Though there was something inherently implausible about phlogiston (for example, it had been known since the seventeenth century that metals, when heated, *gained* weight), there were enough 'imponderable fluids' about at that time – magnetism, heat, electricity itself – to make the theory acceptable to many. But the concern with combustion was not merely academic: gases (*chaoses*) were of great practical concern to miners, for example, who ran the risk of treacherous fire-damps and 'inflammable airs'.[36] And it was this attention to gases that eventually provided the way forward, because hitherto, in experiments on combustion, just the weight of the ore had been measured. This, as J. D. Bernal puts it, made it impossible to 'balance the books' of chemistry. But when gases were taken into account, this led immediately to Mikhail Lomonosov's principle of the conservation of matter, established as fundamental by Antoine Lavoisier in 1785. The man who showed this more convincingly than anyone else was Joseph Black, a Scottish doctor, who weighed the amount of gas lost by such carbonates as magnesia and limestone when heated, and found that the lost gas could be reabsorbed in water, with an identical gain in weight.[37]

Black was followed by Joseph Priestley, who had the idea that air was more complex than it seemed. He experimented with as many gases as he could find, or manufacture himself, and one of them, which he made by heating red oxide of mercury, he called at first 'dephlogisticated air', because things burned better in it. After isolating the gas in 1774, Priestley went on to show, by experiment, that 'dephlogisticated air', or oxygen as we now call it, was used up, both in burning *and* in breathing. Priestley well realised the importance of what he was discovering for he went on to demonstrate that, in sunlight, green plants *produce* oxygen from the fixed air – carbon dioxide – that they absorbed. Thus was born the idea of the carbon cycle – from the atmosphere (another new idea of the time), through plants and animals and back to the atmosphere.[38]

Priestley was the experimentalist but Lavoisier was the synthesiser and systematiser. Like his English counterpart, the Frenchman was first and foremost a physicist. (In the early days of chemistry most of the great figures weren't chemists, who were too bogged down by alchemy and phlogiston.) Lavoisier appreciated that the discovery of oxygen, *le principe oxygène*, transformed chemistry, in effect turning the phlogiston theory on its head. It was Lavoisier who created modern chemistry by his realisation that he could now build on the work of Aristotle and Boyle, to create a much expanded, *systematic*, discipline.

He realised that water was hydrogen and oxygen, that air contained nitrogen as well as oxygen and, perhaps most important of all, that chemical compounds were largely made up of three types: oxygen and a non-metal, which were acids; oxygen and metals, which were bases; and the combination of acids and bases, which were salts.[39] In doing this, Lavoisier introduced the terminology for compounds that we still use – potassium carbonate, lead acetate, and so on. This brought chemistry to a systematic level that put it at last on a par with physics. 'Instead of being a set of recipes which had to be memorised, chemistry was now laid out as a system that could be *understood*.'[40]

The study of gases also led John Dalton (1766–1844), a Quaker and schoolteacher in Manchester, England, to his atomic theory. He had a particular interest in the elasticity of fluids and it was he who realised that, under different pressures, and incorporating the principle of the conservation of matter, gases of the same weight must be differently configured. The creation of new gases, and the studies of their weights, led him to a new nomenclature that we still use – for example, $N_2O$, $NO$, and $NO_2$. This systematic study made him realise that elements and compounds were made up of atoms, arranged on 'Newtonian principles of attraction and electrical principles of repulsion'.[41] His observation of certain other chemical reactions, notably precipitation, when, say, two clear liquids, on being put together, immediately produce a solid, or a major change in colour, also convinced him that a basic entity, the atom, was being reconfigured. His reasoning was soon supported by the new science of crystallography, in which it was shown that the angles between the faces of a crystal were always the same for any particular substance and that related substances had similarly-shaped crystals. Christiaan Huygens, the seventeenth-century Dutch physicist, realised this must mean that the crystal was built of identical molecules piled up together 'like shot'.[42] Finally, on this score, Humphry Davy and Michael Faraday showed that passing an electric current through salts separated out the metals, such as sodium, potassium and calcium and that, at base, all elements could be classified into metals and non-metals, with metals being positively charged and non-metals negatively charged. Faraday further demonstrated that the rate of transport of atoms in solution was related to the weights of the substances, which eventually led to the idea that there are 'atoms' of electricity, what we now call electrons. But they were not identified until 1897, by J. J. Thomson.

Besides his interest in the organisation of the elements, Lavoisier carried out a series of experiments which showed that a person's body behaved in an analogous way to fire, burning the materials in food and liberating the resulting energy as heat. The behaviour of materials after heating (some melt or vaporise, others burn, char or coagulate) led to the division between inorganic and organic chemistry, which was fully explored by German scientists in the nineteenth century.[43]

It is important to say that many of the inventions which created the industrial revolution were not made by traditional scientists, the kind who frequented the Royal Society, for example. The central preoccupation of the Royal Society had always been mathematics, regarded in a post-Newton world as the queen of the sciences. In such an abstract atmosphere, the practical inventor was not always regarded as a 'proper' scientist.[44] But in marked contrast there arose in the factory towns a series of 'dissenting academies', described as

such because they originated as schools to educate Nonconformist ministers – Quakers, Baptists, Methodists – who were not allowed into the regular universities. But these academies soon broadened both their aim and their intake. The three most famous of the dissenting academies were the Manchester Philosophical Society, the Warrington Academy and the Lunar Society of Birmingham, though other academies were prominent in towns like Daventry and Hackney. The career of Joseph Priestley offers a good example of the way the academies worked. Starting at Warrington Academy, shortly after it opened, Priestley was at first a teacher of English and other languages – in fact, at Warrington he founded possibly the first courses ever given on English literature and modern history. But while at Warrington he attended several of the lectures of his colleagues, and in this way was introduced to the new sciences of electricity and chemistry.[45]

   Almost certainly the most influential scientific academy of the eighteenth century was the Lunar Society of Birmingham. Its members (known agreeably as 'lunatics') met informally to begin with, in the homes of different friends. Formal meetings began around 1775. The group was led by Erasmus Darwin (1731–1802) and met monthly on the Monday nearest the full moon. Meetings petered out in 1791 after a riot at Priestley's house (see below).[46] The kernel of the society, at least in its early days, was composed of James Watt and Matthew Boulton. Watt, as we have seen, had developed his famous steam engine in Scotland, but found that craftsmanship north of the border was not up to scratch and joined forces with Boulton, whose Birmingham workshops operated to a much higher standard.[47] But Watt and Boulton were by no means the only stars of the Lunar Society. Josiah Wedgwood was another: he founded the Wedgwood potteries, and modelled his ceramics on ancient Greek vases discovered in the Etruscan countryside in Italy (he named his works Etruria). Typical of his time, Wedgwood drove himself hard to obtain the highest standards of workmanship in his factories. Among other things, he invented the pyrometer (though he insisted on calling it a thermometer), to measure high temperatures, which helped him make the fundamental discovery that at high temperatures all materials glow in the same way – that colour measures temperature no matter what the material is. In time this would help give rise to quantum theory.[48] Other members of the Lunar Society included William Murdoch, who invented the gaslight (first used in Boulton's Soho works in Birmingham) and Richard Edgeworth, one of the inventors of the telegraph.[49]

   Joseph Priestley did not arrive in Birmingham until 1780 but when he did he immediately established himself as the leading mind.[50] He also became a Unitarian minister. Unitarians were sometimes accused of atheism or deism and as a result were regarded as among the boldest thinkers of their time (Coleridge was a Unitarian).[51] Priestley was certainly bold enough in his *Essay on the First Principles of Government* (1768), in which he may well have been the first to argue that the happiness of the greatest number is the standard by which government should be judged.[52] Priestley's brother-in-law John Wilkinson was also a member of the Lunar Society. His brother had been at the Warrington Academy, which is how his sister met and married Priestley, while he was a teacher there. Wilkinson's father was an ironmaster and John too became brilliantly adept in the use of the metal. Abraham Darby and he designed and erected the famous bridge of iron at Ironbridge, opened in 1779. Wilkinson constructed the first cast-iron boat and sailed it under the bridge.[53] He died in 1805 and, true to his principles, was buried in an iron coffin.

As ever, we should not make too much of the Lunar Society's 'outsider' status. Priestley did lecture before the Royal Society, and won its prestigious Copley Medal. The group had (intellectual) links with James Hutton in Edinburgh, whose work on the history of the earth is considered in Chapter 31; Wedgwood was close to Sir William Hamilton, whose collection of ancient vases would eventually adorn the British Museum, and stimulated the idea for the graceful Wedgwood pottery; several 'lunatics' corresponded with Henry Cavendish, whose interest in science would encourage his descendants to found in his honour the Cavendish Laboratory in Cambridge (see the Conclusion); their activities were painted by Joseph Wright of Derby and George Stubbs. But between them the Lunar Society had many firsts to its credit: its members did much to promote the acceptance of machines in modern life, they were among the first to appreciate the notion of marketing, and advertising, and even shopping. These achievements also included: an understanding of photosynthesis, and its importance in life; an understanding of the atmosphere (achieved partly by their intrepid ascents in balloons); they made the first systematic attempts to understand and predict weather patterns; they developed modern mints for the printing of coins and improved the presses that would make mass newspapers practicable; their members conceived the idea of children's books as a way to inculcate the young into the mysteries and possibilities of science. They were early campaigners for the abolition of slavery. In Jenny Uglow's words: 'They were pioneers of the turnpikes and canals and of the new factory system. They were the group who brought efficient steam power to the nation . . . All of them . . . applied their belief in experiment and their optimism about progress to personal life, and to the national life of politics and reform . . . They knew that knowledge was provisional, but they also understood that it brought power, and believed that this power should belong to us all.'[54]

But let Robert Schofield, who made an earlier study of the Lunar Society, sum up its achievements and its significance. 'Polite society, by state and custom established, might still be concerned with land and title, they might still spend their time disputing in an unrepresentative Parliament, discussing literature and the arts in London coffee shops, and drinking and gambling at White's [a gentleman's club]; but the world they knew was a shadow. Another society, in which position was determined by an ungenteel success, was creating a different world more to its liking. The French war and political representation delayed the formal substitution of new for old, but it was the new society that provided power to win the war . . . The Lunar Society represents this "other society", pushing for place. If it was only qualitatively different from other provincial groups, then these deserve more searching study, for in the Lunar Society are to be found the seeds of nineteenth-century England.'[55]

In 1791 there was an attack on the Birmingham home of Joseph Priestley because it was believed (wrongly, as it turned out) that he was attending a dinner 'to celebrate the fall of the Bastille'. This was not the first of such attacks – it was part of an organised movement against people who were understood to sympathise with the aims of the French Revolution. In this case, Priestley's home was ransacked and set ablaze. Although the rumours abated, Priestley had had enough: he left Birmingham and decamped to the United States. This was a dramatic move and revealing: at that time, and whatever their views on the *French*

Revolution, many of the Nonconformist scientists and innovators just then were very sympathetic with the aims of the *American* variety. One reason for this was America's successful realisation of the aims of the Enlightenment, discussed in the next chapter. Another was the more practical and pressing fact that the new manufacturing towns, such as Birmingham or Manchester, which had been mere villages until the industrial revolution, were as a consequence under-represented in Parliament.[56]

Religious dissent and political dissent were different aspects of the same phenomenon. Men like Priestley and Wedgwood favoured free trade, a view which went diametrically against that of the landed aristocracy, who wanted above all to preserve the high price of grain grown on their estates. This turned into a significant difference. The German sociologist Max Weber was the first to advance the theory that the rise of Protestantism, especially Calvinism, was a crucial factor in the modern industrial economy. Others had made not dissimilar observations before but Weber was the first to come up with a coherent account of why the difference should exist and why the Protestants had the effect that they did. He argued that the Calvinist doctrine of predestination produced in believers a perennial anxiety about whether or not they would be saved, and this worry could only be kept under control if believers followed the kind of life that they *thought* would lead to salvation. This, Weber said, led them to adopt a life of 'in-this-world asceticism', where the only worthwhile activities were prayer and work. 'The good Calvinist was thrifty, diligent, austere.' In time, said Weber, this way of life became generalised. Even people who were not believers in salvation still lived – and worked – like Calvinists because they thought it was the right thing to do.[57]

The Protestant ethic, as it came to be called, did more than instill diligence, thrift and austerity – it gave us the view that something is real only if it can be perceived, described and, yes, measured by anyone so long as they have the right instruments. In the Protestant mind, in Weber's sense, a fundamental distinction grew up between two types of knowledge. On the one hand, there was the highly personal religious or spiritual experience and, on the other, scientific and technological progress that was cumulative and could be shared by anyone.[58] This distinction is still very much with us.[59]

If we call the development of the Protestant ethic a religio-sociological phenomenon, the main *political* effect of the industrial revolution, especially in its early decades, was to widen the gap between the rich and the poor, and to transform the character of poverty, from rural and agrarian poverty to urban poverty. In the new cities – dirty, squalid, crowded – the divisions between employer and employed were sharpened and embittered and with this the nature of politics changed for close on two hundred years.

As E. P. Thompson has shown, in his *The Making of the English Working Class*, the characteristic experience of the labouring population between 1790 and 1830 was a narrowing process, as their position declined and weakened in the world. The essence of the industrial revolution for the working class in England was the loss of common rights by the landless and the increasing poverty of many trades brought about by 'the deliberate manipulation of employment to make it more precarious'.[60] Before 1790 the English working classes existed in many disparate forms; the experience of oppression and the progressive loss of rights, which at first weakened them, eventually proved to be a major

unifying and strengthening force which, again, helped to forge modern politics.

On the other side of what was now a growing divide, and as a result of the material successes of the industrial revolution (i.e., ignoring the human cost), it was the manufacturing interest, together with its blood-brothers in trade and finance, who now became the dominant force behind government policy, taking over – for the first time in history – from the landed aristocracy. This was not just because the urban factory was so important but also because the traditional form of land tenure (involving feudal privileges and communal rights) was deliberately usurped by unlimited ownership of enclosed parcels. This radically transformed what was left of rural life. So two things were happening at once. The working classes were being both driven off the land and sucked into the cities, crowded and filthy and unsanitary. At the same time, there was a proliferation of the middle classes, made up of the increasingly-familiar professions – white-collar workers and engineers and the educational world – plus, another first, the new world of 'services' – for example, hotels, restaurants, and all the facilities associated with travel, now that railways and iron ships were an accessible reality. This bourgeoisie, newly installed, was every bit as self-conscious as the proletariat. In fact, many of them *defined* themselves by their differences from the working class. This too was new.[61]

And this division, which may be regarded as a defining characteristic of what became Victorian civilisation, produced new ideas in two crucial areas – in economics and in sociology.

Until the industrial revolution, the prevailing economic orthodoxy, as we have seen, was mercantilism, an approach first undermined by the so-called physiocrats in France, whose motto was '*laissez faire*' and whose leader, it will be recalled from the last chapter, was François Quesnay.[62] Although their ideas were never adopted outside France, they did show themselves as aware of the importance of the *circulation* of goods and it was this notion that was taken up by Adam Smith, whose ideas were also introduced in the last chapter. In the context of this chapter, it is important to reiterate that Smith himself was aware of the degrading effects of the factory regime on the lives of the workers, whereas it was those who followed him who seem to have turned a deliberate blind eye. Smith believed that the worker's situation could improve but only if society expanded, which could only happen in an atmosphere of *laissez faire*. He believed, argued, that the worker, no less than the manufacturer, should be left free to pursue his own self-interest. Man's nature, he said, must be accepted for what it was, and so it was not beneath the dignity of man to 'regard our own private happiness and interest . . . [as] . . . very laudable principles of action'.[63] Smith, a religious man, understood that self-interest could go too far, and in *The Wealth of Nations* provided several examples of where this had happened and businesses had overplayed their hand and brought ruin on themselves.[64]

In the short term, Smith's book provided the employers of the industrial revolution with a neat theoretical underpinning for their behaviour but it was two other economists who added the twist which brought out the worst in the manufacturers. These men were Thomas Malthus and David Ricardo. Malthus we have already considered. What we need to add here is that his conclusion – that whereas food production can only increase arithmetically, population can increase exponentially – was in the nineteenth century interpreted to mean that, in the medium-to-long term, the condition of the masses cannot

be improved. This became a powerful case against providing public or private charity.

David Ricardo was the son of a stockbroker who was Dutch-Jewish and who converted to Christianity when he married and was disinherited by his family. There has always been a suspicion that Ricardo's personal circumstances hardened his heart and, certainly, his theories made him a voice for the 'new ruling class in a new ruling order'.[65] His main contribution to economic theory was that, if industry is to succeed, then the value created by labour must be greater than that paid out in wages. It followed, he said, that if wages were kept low, to a level 'which is necessary to enable the labourers, one with another, to subsist and to perpetuate their race, without either increase or diminution', then there would never be too great an accumulation of capital, nor a general over-production. As J. K. Galbraith reminds us, this became known as the Iron Law of Wages, and established 'that those who worked were meant to be poor, and that any other state of affairs would threaten the whole edifice of industrial society'. Ricardo, known in Parliament, where he served, as the 'oracle', agreed with Adam Smith that an expanding economy would push up wages overall but this was the only concession he made to the poor.[66] As a classic *laissez-faire* capitalist, who argued that any taxes curtailed the amount of capital available for investment, he was one of those who provoked Karl Marx.[67]

Jeremy Bentham's Utilitarianism also needs consideration in this context because his idea of a 'felicific calculus', the overall aggregate of pleasure and pain, became identified with the maximisation of the production of goods, the most characteristic achievement of the new industrialism. The fundamental idea, 'the greatest happiness for the greatest number', was soon amended to include the twist that, no matter how acute the hardship might be for a minority (in terms of unemployment, for example), it must be tolerated. Bentham went so far as to say that 'one should steel oneself against compassion for the few – or action on their behalf – lest one damage the greater well-being of the many'.[68]

Not everyone could harden their heart like Ricardo or Bentham. Robert Owen for one. In his *Observations on the Effect of the Manufacturing System* he concluded that, while there were some 900,000 families in Britain involved in agriculture, there were well over a million in trade and manufacturing and this number was increasing dramatically. Owen did not need convincing that the long labouring shifts in factories took an appalling toll on the health and dignity of workers. In the factory, he said, 'employment' had become 'merely a cash relationship regardless of moral responsibility'.[69] This moral abdication was for him what mattered most. The poor man 'sees all around him hurrying forward, at mail-coach speed, to acquire individual wealth ...'[70] 'All are sedulously trained to buy cheap and sell dear; and to succeed in this art, the parties must be taught to acquire strong powers of deception; and thus a spirit is generated through every class of traders, destructive of that open, honest, sincerity, without which man cannot make others happy, nor enjoy happiness himself.'[71]

Owen had started work at the age of ten, after he moved from Montgomeryshire, in Wales, where he had been born, to London. He managed to prosper and became a partner in a business in Manchester, later moving on to become a manager and partner at the New Lanark mills in Scotland. And it was there, over the next two decades, that he carried out his famous experiments at social reform within an industrial environment. He had been

shocked when he had taken over at Lanark. 'The workers lived in idleness and poverty, usually in debt; they were often drunk and traded in stolen goods. They were used to lying and argument, and were united only in their vehement opposition to their employers.'[72] The position of the children was worse even than in a Dickens novel. They were provided from Edinburgh workhouses and were forced to labour from six in the morning until seven in the evening. It was scarcely surprising that Owen found that 'many of them became dwarfs in body and mind'.[73]

His response was radical. To discourage theft and drunkenness, he set up a system of rewards and punishments. He raised the minimum age of children from six to ten and funded a village school where the younger children were taught to read and write 'and enjoy themselves'.[74] He improved housing, paved the streets, planted trees and created gardens. To his great satisfaction, he was able to show that his improvements not only eased life for the labourers, but actually helped increase their productivity. He then embarked on a campaign to do the same on a nation-wide basis.[75]

This plan had three aims. First, Owen wanted free schools, state-funded, for all children between the ages of five and ten. Second, he campaigned for various Factory Acts to be passed, designed to limit the hours a person could work in any one day. He was successful insofar as a Factory Act was passed in 1819, though Owen himself did not feel it went anywhere near far enough. Finally, he campaigned for a national system of poor relief. He wasn't advocating cash handouts. Rather, Owen proposed a series of co-operative villages, with roughly 1,200 individuals in each, with a ring of land surrounding it. Every village would have a school and provide for itself, causing the number of poor to fall as the village inhabitants evolved into profitable members of society.[76] One or two villages of this kind were tried (Orbiston, nine miles east of Glasgow, for example), but, in the main, it has to be said, nothing much came of this latter idea. (Owen was a fervent critic of organised religion and this meant that he antagonised many potential benefactors.) But his two other main ideas did succeed, even if they did not fly as far or as fast or as high as he wanted: two out of three isn't bad. To an extent, he did manage to restore a certain dignity to the labouring classes which he felt had been lost with the arrival of the factory city.[77]

As a visit to Ironbridge, in Shropshire, England, will confirm even today, Britain was only semi-industrial in the eighteenth century. The first factories were built on (literally) greenfield sites, in the valleys of the countryside.[78] It was only when the factories were transferred to the towns that the full horror of the industrial revolution became truly apparent, and it was not until the nineteenth century that industrialisation and the great divide between rich and poor that went with it combined to forge a self-conscious and bitter class of people who felt excluded from the vast fortunes being acquired by the industrialists. According to Eric Hobsbawm, the 1840s had been reached before pre-industrial traditions finally died out (in the form, for example, of such pastimes as wrestling matches, cock-fighting and bull-baiting; the 1840s also marked the end of the era when folksong remained the major musical idiom of industrial workers).[79]

The important point, as several historians have observed, is that there was a marked *deterioration* in the conditions of the working class at the beginning of the nineteenth century. Hobsbawm himself provides several vivid examples: between 1800 and 1840 there

was a shortage of meat in London; out of 8.5 million Irishmen, close to a million literally starved to death in the famine of 1846–1847; the average wages of handloom weavers fell between 1805 and 1833 from 23 shillings a week to 6s 3d. The average height of the population – a good indication of nutrition – rose between 1780 and 1830, fell in the next thirty years, then rose again. The 1840s were known, even at the time, as the 'Hungry Forties'. Riots, mostly related to food shortages, broke out in Britain in 1811–1813, 1815–1817, 1819, 1826, between 1829 and 1835, in 1838–1842, 1843–1844 and 1846–1848. Hobsbawm quotes a rioter in the Fens in 1816: ' "Here I am between Earth and Sky, so help me God. I would sooner lose my life than go home as I am. Bread I want and bread I will have ..." In 1816, all over the eastern counties, in 1822 in East Anglia, in 1830 everywhere between Kent and Dorset, Somerset and Lincoln, in 1843–4 once again in the east Midlands and the eastern counties, the threshing machines were broken, the ricks burned at night, as men demanded a minimum of life.'[80] To begin with, the vast bulk of these riots occurred so that the rioters could get their hands on food. Beginning about 1830, however, the form of unrest began to change and, eventually, there arose the concept of a general trades union which had in its armoury 'the ultimate weapon, the general strike' (otherwise known, not entirely ironically, as the 'sacred month'). 'But essentially, what held all these movements together, or revived them after their periodic defeat and disintegration, was the universal discontent of men who felt themselves hungry in a society reeking with wealth, enslaved in a country which prided itself on its freedom, seeking bread and hope, and receiving in return stones and despair.'[81] This is not only present-day Marxist historians talking. One American passing through Manchester in 1845 confided as follows in a letter home: 'Wretched, defrauded, oppressed, crushed human nature lying in bleeding fragments all over the face of society ... Every day that I live I thank Heaven that I am not a poor man with a family in England.'[82]

In 1845 Friedrich Engels was working in Manchester (he got to know Owen). He was employed there in the cotton trade but he could see what was going on around him and was disturbed enough by what he witnessed to make his own exposé of the new industrial Britain. *The Condition of the Working Class in England*, released in that year, described in despairing detail the 'sheer misery and material squalor' in which tens of thousands lived. But, vivid though his book was, Engels only set the scene. It was his friend and collaborator who was to take the world by storm.[83]

Karl Marx was very moved by Engels' book but, as J. K. Galbraith has observed, the truth is that Marx was probably a 'natural revolutionary' in any case. Obsessed by freedom all his life, the thrust of Marx's lifetime achievement may be understood as an investigation and exposé 'of how man's inherent freedom has become hidden from him'. Born in Trier, in Germany, the son of a lawyer who was also an officer of the High Court, Marx was raised as a member of the local elite and his marriage to Jenny von Westphalen, daughter of a local baron, underscored his social position.[84] The change came for Marx after he went to Berlin to study under George Hegel. Hegel's dominant idea was that all economic, social and political life is in constant flux. This was his famous theory of thesis, antithesis and synthesis. Once one state of affairs has evolved, said Hegel, a second emerges to challenge it. This argument had more going for it then than it may do now, because at the time Marx was studying under Hegel the new industrialists had emerged and were

challenging the power of the *ancien régime*, the old ruling landed classes.[85] *Change* was the crucial concept here. Classical economics – in particular the system outlined by Ricardo – argued that the aim of economics was equilibrium, when the fundamental relationships in industrial society, between employer and worker, between land, capital and labour, never changed. Drawing a lesson from Hegel, Marx didn't accept the conventional wisdom for one moment.

Not that he derived all his views from Hegel and from Berlin. As with Ricardo, his own experiences were relevant too. After his time in the Prussian capital, Marx transferred to Cologne, to become editor of the *Rheinische Zeitung*. This was (and it is an important fact) an organ of the new industrialists of the Ruhr valley, and to begin with he did a good job. But then, gradually at first, and in small ways, his paper began to support a set of policies that contravened the interests of many of his readers. For example, he published his support for the right of the locals to collect dead wood in the nearby forests. As in many countries around Europe, this was a traditional privilege, but the right had been recently removed because wood was needed for the new industries. As a result, any local who ventured into the forest was now guilty of trespass. Marx also argued for changes to the divorce laws, making the role of the church less important. This barrage of radical editorials was too much for the local authorities in Cologne, and Marx was dismissed. Now began a period of wandering. He went first to Paris, where his aim was to write for a German-language periodical distributed among German expatriates. The censors seized the first issue and the Prussians complained to the French that 'harbouring Marx was an unfriendly act'.[86] He moved on to Belgium, but the Prussians hounded him there. After other adventures and expulsions he ended up in Britain.

By now of course he was a changed man and increasingly revolutionary. In Britain he collaborated with Engels on what J. K. Galbraith has called 'the most celebrated – and energetically denounced – political pamphlet of all time', *The Communist Manifesto*. In the *Manifesto*, Marx and Engels called the state under capitalism 'a committee for managing the common affairs of the whole bourgeoisie', adding 'The class which has the means of material production at its disposal, has control at the same time over the means of mental production.' They argued that industrial society was divided into 'two great hostile camps', the proletariat and the bourgeoisie, fundamentally antagonistic.[87] Warming to his theme, Marx embarked on his massive three-volume work, *Capital*. Engels edited the first volume and then, after Marx's death in 1883, put together the last two volumes from notes and pieces of manuscript.

It would be inadequate to label Marx as simply an economist. Many people regard him, alongside Auguste Comte, as one of the fathers of sociology. This mainly has to do with the fact that his interests went much wider than the purely economic. For Marx, in order for man to be free he has to *understand* freedom, and it was always his aim to show how the material outcome of history has interfered with this understanding. For Marx, this understanding was a central drama of politics.[88]

He was, above all, materialistic. He flatly rejected Hegel's ideas about history as a dialectic of spirit and of thesis producing antithesis. For Marx, the course of history is the result of the *material* conditions human beings have been faced with.[89] In particular, he argued that it is the labour and technology that people use in their work which either does

or does not bring them fulfilment. But he did use one idea of Hegel's, the notion of alienation, though Marx adapted it to mean that people can *appear* to be free (in their work, mainly), and yet in reality they are fettered.[90]

Throughout the 1850s, diligently burrowing away among the many facilities of the Reading Room of the British Museum, 'working like the devil', Marx consolidated his exposé of capitalist and industrial practices through which he intended to maintain that it is the material conditions of society – the way work is organised and wealth produced – that mould *every* aspect of that society, 'from the way we think to the institutions society allows and approves'.[91] It was a massive ambition and this is why Marx was much more than an economist. His main argument was that the conditions of production are the foundation, the fundamental base, on which society is built. 'All social institutions – what he called the superstructure – stem from this, be it the law, religion, the different elements that make up the state. In other words, power is what counts.'[92] Then, in equally copious detail (the book *is* three volumes long), he set out the personal consequences of this fundamental reality. Here, his most potent idea is the one alluded to above, his adaptation of Hegel's notion of alienation. Marx argued that, in industrial society where the division of labour is essential for efficiency and for adding value, 'the labourer is alienated from himself'. What he meant was that the very logic of factory organisation and production makes a man an automaton. The main human characteristic of factory life is that the identity of 'factory hands' is thereby diminished, since for the most part the workers hate what they do and, moreover, have no control over their work. No less important, and equally diminishing, they are forced to operate 'well within their capabilities'. This is alienation.[93]

Workers do not become aware that they are alienated, Marx says, because of something he called 'ideology'. As a result of the way society is organised, the way power is organised, a set of beliefs – an ideology – is produced, regarding the conditions of that society. This 'ideology' includes theories about human nature itself, theories which in themselves serve the interests of the dominant class; they help it preserve its power but are for the most part false. Marx said that organised religion was a good example of what he meant by ideology in action because it taught that people must accept God's will – the status quo – rather than take any action to change things.[94]

As well as being more than an economist, Marx was also in some ways more than a sociologist, a philosopher almost. Nowhere in *Capital* does he actually discuss 'human nature', as philosophers or theologians might, but that is the point. For him, there is no abstract essence of man: instead a man's sense of self emerges from his material situation, his relations with others significant in his life, and the economic, social and political forces by which he has been shaped. What mattered here, and what disturbed many people, was that Marx's argument implied that a man can change his nature by changing his circumstances. Revolution was psychological as well as economic.[95]

The final layer in Marx's new way of looking at the world was what many people found the most contentious of all. This was the idea that his work was scientific, that his investigations in the British Museum had uncovered something hitherto hidden but now revealed as objective about society, and that therefore his analysis unveiled a progression that was inevitable. While many objected to this, for others it gave 'Marxism' the character

of a millenarian religion, the more so as his huge book divided human history into stages, each stage being characterised by the dominant method of production. For Marx, the origins of the modern world occurred with the transition from feudalism to capitalism. And then, perhaps most famously of all, he went on to argue that economic instability and class conflict are inherent aspects of the history of production which must ultimately result in revolution, and the final transition – to communism. 'The knell of capitalist private property sounds.' (Before 'revolution', Marx first used the word 'dissolution'.)[96]

The timing of *Capital* was crucial. Here was a new world view, a theory beyond economics, beyond sociology, beyond even politics, imbued with a post-enlightenment scientific aura, which offered, or purported to offer, an all-encompassing understanding of human affairs at a time when religion was visibly failing. As a result, during the 1860s Marx himself became a political figure. Particularly after publication of the first volume of *Capital*, in 1867, he was taken up by the various European revolutionary movements, as the man who had, after years of research in the British Museum, provided scientific validation of revolutionary action. For example, his ideas were behind the Working Men's International Association, the so-called 'First International', which was established in 1864, and where the term 'Marxism' was first used.[97]

Among the imaginative responses to the industrial revolution was a set of 'industrial novels', written and set in Britain. These included *Mary Barton* (1848) and *North and South* (1855), both by Elizabeth Gaskell, *Sybil* (1845), by Benjamin Disraeli, a future prime minister of Great Britain, *Alton Locke* (1850), by Charles Kingsley, *Felix Holt* (1866), by George Eliot, and *Hard Times* (1854), by Charles Dickens, an extract from which began this chapter. The main themes of these books were not only criticism of the new society, but also a fear of violence that was felt might erupt from the working classes at any time.

While some of these *books* exerted a great impact, then and since, from the perspective of the twenty-first century a remarkable set of observations, about the new uses of certain *words*, are more pointed. The British critic Raymond Williams has shown that 'in the last decades of the eighteenth century, and in the first half of the nineteenth century, a number of new words, which are now of capital importance, came for the first time into common English use, or, where they had already been used in the language, acquired new and important meanings.' He went on to say that these words described a general pattern of new ideas which reflected a wider transformation in life and thought, and which, as we shall see, 'bear witness to a general change in our characteristic thinking about our common life'. These words were *industry, democracy, class, art* and *culture*.[98]

Before the industrial revolution, Williams said, the word 'industry' could be paraphrased as 'skill, assiduity, perseverance, diligence'. Although this traditional usage survives, industry also now came to be a collective word for manufacturing and productive institutions, and for their characteristic activities.[99] It was followed by 'industrious', 'industrial' and, from 1830, by 'industrialism'. The key phrase 'industrial revolution', he says, was first coined by French writers in the 1820s, modelled explicitly on an analogy with the French Revolution.[100] (Others credit its first use to Engels, see above, page 565.) 'Democracy', although in use from Greek times as a term for 'government by the people', only came into popular use at the time of the American and French Revolutions. In England, although

there may have been democracy, at least in theory, since the Magna Carta, or since the Commonwealth, or since 1688, it did not call itself a democracy and at the end of the eighteenth century democracy was more or less equivalent to Jacobinism or mob-rule. 'Democrats, at the end of the eighteenth and the beginning of the nineteenth centuries, were seen, commonly, as dangerous and subversive mob agitators.'[101] 'Class', in its important modern sense, dates from about 1740. Before that it was used mainly in its scholarly setting, to indicate a group in schools or colleges. First came 'lower class', to join 'lower orders', then 'higher classes' in the 1790s, followed by 'middle' or 'middling classes', with 'working classes' not appearing until about 1815, 'upper classes' soon after. 'Class prejudice, class legislation, class consciousness and class conflict and class war follow in the course of the nineteenth century.'[102] Williams is not so naïve as to claim that this was the beginning of social divisions in England but he is adamant that the new usage reflected a change in the character of those divisions. People were more aware of divisions, and found the vaguer meaning of 'class' more useful than 'rank', which had been used previously and now applied less and less.

The changing use of 'art', he said, was very similar to the changing use of industry. Its traditional meaning was 'skill' – any skill. 'Artist' had meant a skilled person, as had 'artisan'. But 'art' now came to stand for a particular group of skills, the imaginative or creative arts, and 'Art with a capital A came to stand for a special kind of truth, imaginative truth, making the artist a special kind of person . . . A new name, aesthetics, was found to describe the judgement of art and . . . The arts – literature, music, painting, sculpture, theatre – were grouped together, in this new phrase, as having something essentially in common which distinguishes them from other human skills. This is when the distinction between artist, on the one hand, and artisan and craftsman, on the other, arose, and when genius, which originally meant "a characteristic disposition", came to mean "exalted ability".[103]

The change in the meaning of 'culture' was perhaps the most interesting response of all. This term had originally meant a culture *of* something, as in the tending of natural growth, the biological sense. Its change in meaning went through several phases. 'It came to mean, first, "a general state or habit of the mind," having close relations with the idea of human perfection. Second, it came to mean "the general state of intellectual development, in a society as a whole". Third, it came to mean "the general body of the arts". Fourth, later in the century, it came to mean "a whole way of life, material, intellectual, and spiritual".[104] Matthew Arnold, in particular and most famously in *Culture and Anarchy* (1869), defined culture as an inward journey, an attempt to rid ourselves of ignorance, 'a pursuit of our total perfection by means of getting to know, on all matters which concern us, the best which has been thought and said in the world; and, through this knowledge, turning a stream of fresh and free thought upon our stock notions and habits, which we now follow staunchly but mechanically.'[105] Arnold thought that in each class in the new industrialised society there was 'a remnant', a minority which existed alongside the characteristic majority, who 'were not disabled' by the ordinary notions of their class and who loved human perfection. Through culture, in the sense he defined it, these people would develop their 'best selves' to set a standard of beauty and human perfection, thus 'saving' the greater mass of men. He did not see this as in any way elitist.[106] Arnold's ideas were a long way

from Marx's, or Owen's, or Adam Smith's, and the very concept of 'high culture', which is what he really had in mind, is now under much criticism and, to an extent, in retreat. All the more important, therefore, to add these lines of Arnold's which are often omitted: 'Culture directs our attention to the natural current there is in human affairs, and its continual working, and will not let us rivet our faith upon any one man and his doings. It makes us see, not only his good side, but also how much in him was of necessity limited and transient...'[107]

Kenneth Pomeranz has recently argued, in *The Great Divergence*, that the economies (and therefore the civilisations) of Britain and Europe accelerated after 1750, quickly outstripping those of India, China, Japan and the rest of Asia, to create the great inequalities in the world which we see around us today (and which are in the process, in some regions, of being rectified). He argues, however, that the industrial revolution, which is generally given credit for both the acceleration and divergence, is only part of the picture. For the full impact of the industrial revolution to be understood, he says, we need to allow for two extra factors. One is the invention of steam-driven transport (especially steamships), which greatly reduced the cost of long-distance trade, in the process making the second factor, the existence of the New World, a more viable economic market. The New World, with its mineral and other resources, its slave society (helping generate unprecedented profits), and its vast geographical extent, provided exactly the kind of market conditions to reciprocate with the new technologies and economies of scale represented by the industrial revolution. He says that the economies of India, China and other Asian regions in the early eighteenth century were not so different – hardly less sophisticated – than in Europe, and that the 'second acceleration' of the West (after the first surge ahead between 1050 and 1300) would not have been so decisive without this conjunction of factors. The growth of empires also played their part – they were essentially protected markets.[108]

A related, and possibly the most important long-term, effect of the industrial revolution was that the world was at peace for a hundred years between 1815 and 1914. This link is not often made but the case was persuasively set out in Karl Polanyi's *The Great Transformation*, published in 1944 but reissued in 2001.[109] Polanyi's argument was that the vast fortunes formed by the industrial revolution, and the prospect of equally or even vaster fortunes to be made in the future, together with the international character of many of the new businesses (cotton, railways, shipping, pharmaceuticals), plus the development of the bond market, which had matured since the sixteenth century, to the point where, generally speaking, foreigners owned a substantial proportion of any government's public debt (say 14 per cent), meant that, for the first time in history, there emerged 'an acute peace interest' and this was, he says, 'a distinct stage in the history of industrial civilisation'. After 1815 the change is sudden and complete. The backwash of the French Revolution reinforced the rising tide of the Industrial Revolution in establishing peaceful business as a universal interest. Metternich proclaimed that what the people of Europe wanted was not liberty but peace.[110] The institution which most characterised the 'peace interest', he said, was what he called *haute finance*, by which he meant international finance.

Polanyi didn't deny that there were 'small wars' in the nineteenth century (and more

than one revolution) but insisted there was no general or long war between any of the major powers from 1815 to the outbreak of the First World War. (Lawrence James characterises this period as a 'cold war'; and just how unusual it was may be seen from the statistics in Niall Ferguson's *The Cash Nexus*, where he quotes figures to show that there were 1,000 European wars between 1400 and 1984: 'On average a new war begins every four years and a Great Power war [i.e., a war involving more than one Great Power] every seven or eight years.') *Haute finance*, Polanyi said, functioned as the main link between the political and economic organisation of the world. These high financiers were not pacifists and had no objection to any number of minor, short or localised wars. 'But their business would be impaired if a general war between the Great Powers should interfere with the monetary foundations of the system.' *Haute finance* was not designed as an instrument of peace, he said, and it had no specific pro-peace organisation, but since it actually was independent of any single government, it comprised a new power in the world. The vast majority of holders of government securities, as well as other investments, were 'bound to be the first losers' if a general war should break out. These powerful people, therefore, had a vested interest in peace. The crucial factor, he said, was that loans, and the renewal of loans, hinged upon credit, and credit upon good behaviour. This was reflected in constitutional government and the proper conduct of budgetary affairs. Polanyi gave a few examples where financiers had in effect taken over (at least some of) the reins of government for a short time, in places such as Turkey, Egypt or Morocco, to administer financial problems (usually debt supervision) that were threatening political stability. All of which, he said, showed that trade had become linked with peace. This was the time that saw the emergence of financiers such as the Rothschilds. In 1830 James de Rothschild went so far as to quantify the cost of war – he said that, in the event of hostilities his rents would drop by 30 per cent. Disraeli calculated that the 1859 Franco-Italian challenge to Austria was costing 60 million sterling on the stock exchange, and the marquess of Salisbury observed in regard to the lack of outside investment in Ireland: 'Capitalists prefer peace and 3 per cent to 10 per cent with the drawback of bullets in the breakfast room.' The picture has been expanded and deepened by recent scholarship showing that exactly this period, 1820–1917, saw the greatest growth of democracy, and democracies, in history, apart from the years after the Second World War.[111]

In the end, *haute finance* failed to avert the First World War, which in turn would bring about a fundamental change in the banking system of the West. But a watershed *was* reached in 1815. Before then, governments and merchants had always accepted that wars provided the opportunity to expand trade. After the industrial revolution, with the rise of a prosperous middle class, the economics of war changed for all time. The hundred years peace, as Karl Polanyi called it, allowed the industrial revolution to spark the development of mass society, a totally new form of civilisation.

# The Invention of America

'The discovery of America, the rounding of the Cape, opened up fresh ground for the rising bourgeoisie. The East-Indian and Chinese markets, the colonisation of America, trade with the colonies, the increase in the means of exchange and in commodities generally, gave to commerce, to navigation, to industry, an impulse never before known, and thereby, to the revolutionary element in the tottering feudal society . . .'[1] This is Karl Marx and Friedrich Engels in *The Communist Manifesto*. Earl J. Hamilton, in his famous essay 'American treasure and the rise of capitalism', traced the various changes in sixteenth-century Europe – the advent of nation-states, the ravages and opportunities of war, the rise of Protestantism – and concluded that none of these had the effect that the discovery of America did. Hamilton was convinced that America was the main cause of European capital formation. 'The consequence of the discovery was to encourage the growth of European industries, which had to supply manufactures in exchange for the produce of America; [which provided] Europe with the silver it needed for its trade with the East – a trade which contributed powerfully to capital formation because of the vast profits which accrued to its promoters; and to provoke a price revolution in Europe, which again facilitated capital accumulation because wages lagged behind prices.'[2] In another famous work, *Aspects of the Rise of Economic Individualism* (1933), H. M. Robertson argued that the significance of the discoveries was 'not confined to the strictly material sphere. For the consequent expansion of commerce meant a necessary expansion of ideas'. Above all, he said, there was 'an increase of opportunity . . . [and that] from these new opportunities there emerged an entrepreneurial class with a spirit of capitalism and individualism, which acted as a solvent on traditional society.'[3]

Walter Prescott Webb, in *The Great Frontier* (1953), was more specific. For him, Europe was the metropolis whereas America was the great frontier. Despite the many problems encountered, and the new type of farming needed on the Great Plains, 'The opening of this frontier transformed the prospects of Europe in that it decisively altered the ratio between the three factors of population, land and capital in such a way as to create boom conditions.'[4] In particular, he said, in 1500 Europe's 3,750,000 square miles of land supported a population of roughly 100 million, which meant a density of 26.7 persons to the square mile. After the discovery of the New World, these 100 million people suddenly had access to an additional 20 million square miles of land. This surplus, Webb said, launched Europe on four centuries of boom, 'which came to an end with the closing of the frontier around the year 1900'. On this account, the four centuries between 1500 and

1900 were a unique period in history – a time-frame in which the 'Great Frontier' of America transformed Western civilisation.[5] As John Elliott says, 'The consensus of studies on the impact of America boil down to three recurrent themes – the stimulating effects of bullion, trade and opportunity.'*

The age of discovery, culminating in the sixteenth century, brought with it the establishment of the first global empires in history. This not only provided new sources of conflict between European states, 'far beyond the pillars of Hercules', Europe's traditional boundaries, but it also had consequences for the relationship between secular authorities and the church. The Vatican had always claimed world-wide dominion, yet its scriptures showed no awareness of the New World and made no mention of it.[7] On the face of things, the discovery of millions of people living without the benefits of Christianity offered the church an unparalleled opportunity to extend its influence. But in practice the consequences were more complex. For a start, the discoveries coincided with the Reformation and the Counter, or Catholic, Reformation. This latter preoccupied the religious authorities in Rome more than the opportunities in the New World though it may also be true that the debates in Europe suffered because so many of the more effective evangelists had decamped across the Atlantic (the Council of Trent barely discussed American affairs). But in any case the very presence of missionaries in the new territories was dependent on the permission of the secular powers. In particular, the Spanish Crown was ideally placed to direct the pace and form of evangelisation, the more so as it had negotiated a papal authority for its explorations, known legally as *patronato*.[8] It has even been suggested that the absolutist powers of the Spanish kings in the Indies helped generate the growth of absolutist ideas back in Europe.[9] In similar vein, Richard Hakluyt, in England, suggested that colonisation 'siphoned off' those individuals most prone to sedition.[10] 'Just as the authoritarian tendencies of the sixteenth- and seventeenth-century state may have encouraged the disaffected to emigrate, so, in turn, the emigration may have enhanced the prospects of authoritarianism at home ... There was presumably less inducement to fight for opportunities and rights at home if these could be secured at less cost by emigration overseas.'[11]

John Elliott confirms that the centre of gravity of the Holy Roman Empire shifted decisively in the 1540s and early 1550s away from Germany and the Netherlands to the Iberian peninsula.[12] 'The change was symbolic of the eclipse of the old financial world of Antwerp and Augsburg, and its replacement by a new financial nexus linking Genoa to Seville and the silver mines of America. In the second half of the sixteenth century, but not before, it is legitimate to speak of an Atlantic economy.'[13]

It is not so surprising then that the envy of Spain and Spanish conquests was aroused in France and England. The silver supplied from Peru first drew the attention of these rival powers, and these supplies were most vulnerable at the isthmus of land at Panama. A Protestant policy of taking Spain 'by way of the Indies' was another idea, and confirms that politics was acquiring a global dimension, marking the fact that sea power was

* John Elliott questions whether Baroque art, heavily dependent on gold and silver ornamentation, would have been possible without the riches of the New World.[6]

becoming recognised as more and more important. Politically speaking, the New World also played its part in the development of European nationalism. Spain naturally felt that, as the centre of civilisation shifted to the Iberian peninsula, she was now 'the chosen race'. But in the middle of the sixteenth century her image abroad suffered grievously from the publication of two works which gave birth to what became known as the 'Black Legend'. These books were Bartolomé de las Casas' *Brief Account of the Destruction of the Indies*, first published in Spain in 1552, which was a frank attempt to reclaim for the Indians a humanity that had been widely denied them, and Girolamo Benzoni's *History of the New World*, published in Venice in 1565.[14] Both books were quickly translated into French, Dutch, German and English, and the Huguenots, Dutch and English no less quickly confessed themselves appalled by the Spaniards' behaviour. Montaigne, after reading of the Black Legend, voiced what others also felt: 'So many goodly citties ransacked and razed; so many nations destroyed and made desolate; so infinite millions of harmlesse people of all sexes, states and ages, massacred, ravaged and put to the sword; and the richest, the fairest and the best part of the world topsiturvied, ruined and defaced for the traffick of Pearles and Pepper . . .'[15] The destruction of twenty million Indians was henceforth produced as evidence of the Spaniards' 'innate' cruelty. This, says John Elliott, was the first example, at least in European history, of a metropolitan power's colonial record being used against it.[16]

The fact remains that for more than a century after the discovery of America there was no real intellectual progress in assimilating the New World into European thought patterns. For a start, how was she to be explained? There was, for example, and as was referred to above, no mention of America in the scriptures.[17] Did that mean, perhaps, that she was a special creation, emerging late from the Deluge, or had she perhaps suffered her own quite different deluge, later than the one that had afflicted Europe and from which she was now recovering? Why was the New World's climate so different from Europe's? The Great Lakes, for example, were on the same latitude as Europe but their waters froze for half the year. Why was so much of the New World covered in marshes and swamps, why were its forests so dense, its soil too moist for agriculture? Why were its animals so different? Why were the people so primitive, and so thin on the ground? Why, in particular, were the people copper-coloured and not white or black? Most important of all, perhaps, where did these savages come from?[18] Were they descended perhaps from the lost tribes of Israel? Rabbi Manasseh Israel of Amsterdam believed that they were, finding 'conclusive evidence' in the similarity of Peruvian temples to Jewish synagogues. For some, the widespread practice of circumcision reinforced this explanation. Were they the lost Chinese perhaps, who had drifted across the Pacific? Were they the descendants of Noah, that greatest of navigators? Henry Commager says that the most widely held theory, and the one that fitted best with common sense, was that they were Tartars, who had voyaged from Kamchatka in Russia to Alaska and had sailed down the western coast of the new continent, before spreading out.[19]

The question as to whether America was part of Asia, or a landmass in its own right, was settled in the early 1730s. Vitus Bering had originally been commissioned by the Russian czar in 1727 to determine whether Siberia stretched all the way to America. He had reported back that there was sea between the two continents but the lack of detail in

his account, and its similarity to stories circulating among the local inhabitants on the Russian side of the water, threw doubts on the veracity of his claims, sparking a debate that has lasted to this day.[20] People in the Kamchatka area of Siberia knew that land wasn't very far over the horizon from the many reports of driftwood washed up on Karginsk island, where the wood came from a species of fir that didn't grow in Kamchatka. In 1728 Bering handed over his commission to another commander and it was two of his men, Ivan Fedorov and Mikhail Grozdev, who finally discovered Alaska in 1732.

While that issue was settled, and settled unequivocally, other arguments about America, her purpose and meaning, went on and on. Early ideas that the New World was an El Dorado, full of precious metals, magical rivers and seven enchanted cities, never materialised.[21] For some, America was a mistake, whose main characteristic was backwardness. 'Marvel not at the thin population of America,' wrote Francis Bacon, 'nor at the rudeness and ignorance of the people. For you must accept your inhabitants of America as a young people; younger a thousand years, at the least, than the rest of the world.'[22] The comte de Buffon, no less, argued that America had emerged from the Deluge later than the other continents, which explained the swampiness of the soil, the rank vegetation, and the density of the forests.[23] Nothing could flourish there, he said, and the animals were 'stunted', mentally as well as physically, 'For Nature has treated America less as a mother than as a step-mother, withholding from [the native American] the sentiment of love or the desire to multiply. The savage is feeble and small in his organs of generation ... He is much less strong in body than the European. He is also much less sensitive and yet more fearful and more cowardly.' Peter Kalm, a Swedish professor, thought that there were too many worms to allow plants to grow, making oaks in America feeble, 'and the houses built from them'. Even Immanuel Kant thought that native Americans were incapable of civilisation.[24]

Others expressed the view that America was so bad that she was nowhere near ready to be brought into the mainstream of history, not yet ready to be Christianised or civilised and that syphilis was a divine punishment for the 'premature' discovery and the great cruelty meted out by the Spanish during the conquest.[25] The buffalo was an unsuccessful and pointless cross between a rhinoceros, a cow and a goat.[26] 'Through the whole extent of America, from Cape Horn to Hudson's Bay,' wrote the abbé Corneille de Pauw in the *Encyclopédie*, 'there has never appeared a philosopher, an artist, a man of learning.'[27]

We read this now and smile. For the fact is, as the American historian Henry Steele Commager has put it, in many ways America actually *realised* the Enlightenment that Europe could only imagine. For 'America too had its *philosophes*, though for few of them was philosophy, or even science, a full-time activity. For the most part they were busily engaged in farming, medicine, law or the ministry. More important, they lacked the Courts, Cathedrals, the Academies, the Universities and the libraries that provided so large a part of the patronage and nurture of philosophy in the Old World. They had a confidence in reason and science (where useful) and many had studied in Europe. When they returned they brought Europe with them but selectively, for they saw more to disapprove than approve: this was most consequential.'[28]

It was indeed. The first Americans were not at all slow in creating their own Enlight-

enment, one that was carefully – and sensibly – tailored to the new conditions. There was, for instance, no religious establishment, no Puritanism or, come to that, no Catholic Counter-Reformation zeal. Early American thinking was secular and *practical*. In Phila-delphia the American Philosophical Society (modelled on the Royal Society of London) was created with the deist Benjamin Franklin as its president from 1769 until his death in 1790.[29] Philadelphia, William Penn's 'holy experiment', quickly became America's 'capital of the mind', adding a Library Company, a college that became a university, a hospital, a botanical garden, and a brace of museums (John Adams called it the 'pineal gland' of British America).[30] Early Philadelphia was, in its way, every bit as distinguished as, say, Edinburgh. The Reverend David Muhlenberg was a botanist who identified and classified well over a thousand species of plants, Thomas Godfrey, a mathematician and astronomer, devised a new quadrant, while his son Thomas wrote and staged the *Prince of Parthia*, the first drama in the New World. Philadelphia was home to the first college of medicine in the colonies, the creation of three Edinburgh-trained men – John Morgan, Edward Shippen and Benjamin Rush. Philadelphia was also the natural focus for the artists of the time, for Benjamin West, Matthew Pratt, who painted the Quaker gentry, and Henry Bembridge. It was in Philadelphia that Charles Williams Peale founded the first Academy of Fine Arts and it was to Philadelphia that distinguished émigrés from the Old World gravitated and settled, men such as Tom Paine and Dr Joseph Priestley.

Above all there was the 'presiding genius' of Benjamin Franklin.[31] A great coiner of proverbs ('Lost time is never found again') 'his particular genius was for being there ... He was there at the Albany Congress of 1754 where he drafted a plan that anticipated the ultimate American confederation; there at the House of Commons to defend the American distinction between external regulation and internal taxation; there in Carpenter's Hall to help Jefferson draft a Declaration of Independence; and there too on the committee that drew up Articles of Confederation for the new nation. He was there at the Court of Louis XVI to win French support and there at the peace negotiations that acknowledged American independence. He was there, finally at the Federal Convention that drew up a constitution for the new nation.'[32] And that was only the half of it. In England for fourteen years and France for eight, Franklin may be counted a major factor of the American, British and French Enlightenments, with many diverse talents – printer, journalist, sci-entist, politician, diplomat, educator and author of 'the best of autobiographies'.[33]

Benjamin Rush, Franklin's successor in Philadelphia, was scarcely less talented, with almost as many interests. A graduate of Edinburgh and London Universities, and a disciple of John Locke, he was far more than a doctor, like Franklin a politician and a social reformer.[34] Back home in America, he was appointed professor of chemistry at the new College of Philadelphia but still found time to study diseases among Indians and campaign against slavery.[35] He created the first dispensary and performed vaccinations against small-pox. It is said that he provided Tom Paine with the title *Common Sense* for his pamphlet.[36] After signing the Declaration of Independence he immediately enlisted in the army.

Joel Barlow, from Connecticut, was a graduate of Yale and, though a parson, conceived an early idea of evolution. But he found a wider fame as a 'cultural naturalist', 'the first poet of the republic'. He strained for twenty years to create an American epic on the scale of Homer or Virgil, producing in the end six thousand lines, *The Vision of Columbus*

(1887), that surveyed 'the melancholy history of the Old World and contrasted the glorious prospects of the New . . . Byron himself, whether in admiration or derision, called him the American Homer.'[37] A successful speculator when he wasn't writing poetry, Barlow lived in Paris for a while where his *salon* became immensely fashionable – Tom Paine and Mary Wollstonecraft were regulars. When Paine was jailed, Barlow ensured that the manuscript of the *Age of Reason* was successfully published. Like Barlow, Manasseh Cutler was a parson and like Benjamin Rush much more than a doctor – in his case, a lawyer, a diplomat and a geographer. Another passionate advocate of vaccination, he was also the first to begin systematically exploring Indian mounds.[38] 'It was from his parish that the first band of intrepid emigrants set out for the Ohio country with their ministers and their bibles and their muskets – new Pilgrims en route to a new world.'[39]

Joseph Priestley (who had been part of the American 'interest' in British politics) emigrated across the Atlantic at the age of sixty-one.[40] He was offered chairs at the Universities of Pennsylvania and Virginia but opted instead for the Pennsylvania frontier, and a farm overlooking the Susquehanna river. Disillusioned with the Old World, Priestley at one stage intended to found a Utopia in America, with his friends Shelley, Southey and Coleridge. Although that never materialised, he did manage to finish his massive *General History of the Christian Church*, where he compared the teachings of Jesus and Socrates (the book was dedicated to Jefferson).[41]

Thomas Paine had three careers, one in England, one America and one in France. Though he was not an easy man, or easy to classify, his abilities and his passion (even his fanaticism) were everywhere recognised and he made distinguished friends wherever he went – Franklin in America, Priestley in England, Condorcet in France. A true radical, who loved nothing so much as making trouble, he was at the same time a brilliant writer, a genius at making complex issues simple. 'He overflowed with aphorisms as Mozart overflowed with melodies.'[42] Perhaps because he was not especially well-educated, he simplified the leading ideas of the Enlightenment in a form that produced a large response. He argued that the laws of nature which regulated 'the great machine and structure of the universe' implied natural rights. The logic of this led him to favour revolution and, to his satisfaction, he did indeed witness revolution in two of the three countries where he lived.

Unlike many *philosophes*, Paine was no academic, or aesthetician. He was interested above all in practical progress. He urgently wanted an improvement in the material conditions of the underprivileged and a more egalitarian distribution of resources.[43] Part Two of *The Rights of Man* has as its subtitle 'Combining principle and practice'. Thus he was an early critic of slavery and derived much satisfaction by writing the preamble to the Pennsylvania Act which prohibited slavery in that commonwealth. In his other writings, particularly *Common Sense* (1776), which despite 'not being profound' sold 120,000 copies, he urged progressive income taxes and inheritance taxes which were to be used to finance schemes for social welfare.[44] He also wanted the young to be given bonuses so they would have a good start in married life. And he advocated free schooling for the children of the poor, and financial and material support for the unemployed. 'Thomas Paine was a world figure but it was America that made him. It was in America that he found his mission in life. It was to America that he returned in the end, after both England and France rejected him. It was on America, too, that his hopes were centred. Everywhere in the Old World

"antiquity and bad habits" supported tyranny . . . America was the only spot in the political world where the principles of universal reformation could begin.'[45]

Each of these men was remarkable and America could count herself lucky to have them. In time, as we shall see, they put together the best ideas of the Enlightenment to create – in the form of the American constitution – a new way of living together which was to prove as convincingly as anything ever is convincing that freedom and equality and prosperity are intimately linked and mutually supporting. Their first task, however, which went hand-in-hand with the creation of the first universities, the early hospitals and the first forays into scholarship, was to change some of the bad and/or mistaken impressions that many condescending Europeans clung on to. In retrospect, the way that life in America had advanced in the early years had beaten all expectations.

Thomas Jefferson himself was the most powerful and passionate advocate of America.[46] For example, his answer to the charge that nature was sterile and emaciated in the New World was to point to Pennsylvania, 'a veritable garden of Eden, with its streams swarming with fish, its meadows with hundreds of song birds'. How could the soil of the New World be so thin when 'all Europe comes to us for corn and tobacco and rice – every American dines better than most of the nobles of Europe'. How could the American climate be so enervating when statistical tables showed a higher rainfall in London and Paris than in Boston and Philadelphia?[47]

In 1780 a young French diplomat, the marquis de Barbé-Marbois, had the idea to canvas opinion from several governors of American states and sent them a series of questions about the organisation and resources of their respective commonwealths. Jefferson's response was the most detailed, the most eloquent and by far the most famous – *Notes on Virginia*. There is something surreal about this book now but the issues it attacked were keenly felt at the time. Jefferson met Buffon and the European sceptics head on. He compared the work rates of Europeans and Americans, as defined by actuarial statistics – to the advantage of the Americans.[48] Buffon had claimed that the New World had nothing to compare with the 'lordly elephant' or the 'mighty hippopotamus', or the lion and the tiger. Nonsense, said Jefferson, and pointed to the Great Claw or Megalonyx. 'What are we to think of a creature whose claws were eight inches long, when those of the lion are not $1\frac{1}{2}$ inches?' Even by 1776, enough fossil bones of the mammoth had been found to show that it was indigenous to the New World and that it was a beast easily 'five or six times' larger than an elephant.[49] Jefferson and his fellow Americans found other fruitful comparisons when they looked at population levels. In the rural areas of Europe, they pointed out, births outnumbered deaths. Not by much, but enough to keep population numbers stable. In the cities, however, the situation was much bleaker – numbers were dropping. In London alone there were five deaths for every four births and the city had added barely two thousand to her population in the first half of the century, and then only by dint of immigration from the surrounding countryside. Throughout England and France one in six babies did not live beyond their first birthday and some places were worse – in Breslau, for example, 42 per cent of children died before they were five.[50] Across the Atlantic, on the other hand, 'among Negroes as among whites', and from the north to the south, the population was thriving. The English colonies had comprised a quarter of a million souls

in the early years of the eighteenth century. By the time agitation for independence began, that had increased to more than a million and a half. Immigration was only half the picture. In the first American census, compiled in 1790 (a decade ahead of the first British effort), they counted almost four million inhabitants, but statistically the population was very different from that in Europe. 'Whereas the average marriage in London, Paris Amsterdam or Berlin produced four children, in America the number was closer to six and a half. In England there was one birth for every twenty-six inhabitants, in America one birth for every twenty inhabitants.'[51] The figures for death were even more revealing: the average length of life in Europe in those days was thirty-two years, but in America it was forty-five.

In Jefferson himself America had a one-man riposte to Europe. Here, inside this one skin, was a soul who imported Palladio to Virginia, building at Monticello what Gary Wills calls the most beautiful building in America. Jefferson embraced the new economics of Adam Smith, experimented with grains and plants (agriculture, he said, was 'a science of the very first order') and, on top of his concern to forge a new country without the vices of the Old World, still found time to learn Greek and Latin.[52] Jefferson led the way, intellectually at least, in his attempts to tame the wilderness. He carried out breeding experiments with cabbages and Jerusalem artichokes, with all kinds of nuts, with figs and rice, with mulberry trees and cork trees, and olive trees. 'He sat up all night watching Lombards make cheese so he could introduce the process to America . . . and tried, in vain, to domesticate the nightingale.'[53] He made astronomical observations and was one of the first to see the advantages that might derive from digging a canal through Panama.[54]

This sturdy, practical optimism of the early Americans succeeded far more often than it failed, to create a national mood and character and approach to life that exists to this day. There was only one area where the Americans were unsure of themselves: this was in their relations with the Indians. Buffon and some of the other French *philosophes* had (from 3,500 miles away) called the Indians degenerate. Try fighting him, Jefferson responded. 'You will sing a different tune.'[55] He referred to the rhetoric and eloquence of Logan, chief of the Mingoes: this underlined that Indian minds, no less than their bodies, were as well adapted to their circumstances as were Europeans.[56] But, if Logan and his fellow Indians were blessed with all the qualities Jefferson said, if the Indian leader had all the qualities of Demosthenes and Cicero, as Jefferson also said, what right had white Americans to slaughter them in such numbers and appropriate their land?[57] American views veered inconsistently, from the early Spanish argument, that the Indian was not wholly human, incapable of responding to the faith, to the view of the *philosophes*, that he was primitive, to that of the romantics, that he was noble. In time, they settled to a more realistic view, as epitomised in the works of Fenimore Cooper (1789–1851). But by then the damage had been done.

But it was in politics that the forceful genius of the early Americans was at its finest. Here too the comparisons with the Old World served to clarify what Americans were escaping *from*. For the most part, European political practices reflected a set of old ideas, now discredited.

England was as bad as anywhere, its political statistics shaming. Its population at the

time was roughly nine million but of those barely 200,000 had the vote.[58] This minority, 2.2 per cent of the population, filled all the offices of government, army, navy, church, law courts and the colonial administration. Except in Scotland, only they were entitled to enter the universities, where all were expected to take ordination. It was little better elsewhere. This was the age of absolutism in many countries, where monarchies ruled without any requirement to consult parliaments or estates. In France, ruled by a king, commissions in the army were available only to those who could show four generations of noble forebears. In many areas of Europe, government offices were hereditary and in England seventy seats in parliament were returned from constituencies with no electors. 'In Hungary the nobles had exclusive right to office, filled all the places in the Church, the Army and the Universities, and were exempt most taxes.'[59] In Germany the margrave of Ansbach shot one of his hunting party because the man had dared to contradict him and the Count of Nassau-Diegen likewise executed a peasant just to show he could get away with it.[60] In Venice, which had a population of some 150,000, only 1,200 nobles were entitled to attend the Great Council.[61] In the Low Countries (which had loaned the new republic substantial sums), where there were a free press, free universities and a higher level of literacy, the gulf between rich and poor was not so glaring.[62] 'Even so, Amsterdam was still ruled by thirty-six men who inherited their offices and held them for life.'[63]

Put like this (and I have depended heavily on Henry Steel Commager's account of the early days of America), it is not hard to see why Franklin, Jefferson and their colleagues should wish to be different. At the same time, however, America offered some striking natural advantages. It was a land without a monarchy, there was no established church and the hierarchy that entailed. There was no empire, no established legal system, none of the pomp of tradition. Politics was the natural beneficiary of this.

The pristine nature of America ensured, for example, that democracy was established on the western shores of the Atlantic and – equally important – that it was similar from community to community. Town meetings and local courts emerged in much the same way across all fledgling states, and they moved toward male suffrage at much the same pace in Pennsylvania, Virginia, North Carolina, Vermont and Georgia. 'It was out of this world that Benjamin Franklin and Charles Thomson emerged in Pennsylvania, Samuel Adams and Joseph Hawley in Massachusetts, Alexander McDougall and Aaron Burr in New York, Patrick Henry and Edmund Pendleton in Virginia.' In the Old World, as has often been observed, these men would have been excluded from politics. Moreover, the Franklins and the Pendletons were not separated from their constituents in a capital city or a distant court.[64]

There *were* shortcomings. The early state constitutions all stipulated a religious quali-fication for voters. Pennsylvania, so liberal in other ways, and so oil-rich, had to begin with no religious restrictions, but then required all office-holders to be Protestants and to swear their belief in the divine inspiration of both the Old and the New Testaments.[65] On occasions, offices seemed to run in families (Connecticut, New York and the South) but they were a long way from the hereditary practices of Europe.

Early America at its best is shown by the Convention that drafted the federal constitution. This 'assembly of demigods' (the phrase is Jefferson's) provided, for the first time in history, that all offices – all – would be open to each and every man. Even for the president himself –

the New World equivalent of a monarch in Europe – there were only two requirements: he must be native born and thirty-five years old (the average life-span in Europe at the time, remember, was thirty-two). There were no religious requirements, another move unprecedented in modern history. 'In America Plato was vindicated: for the first time in history philosophers were kings.'[66]

The sheer speed with which these events unfolded was as important as their content and direction. The nations of Europe had taken generations – centuries – to evolve their different identities but in America, a new nation with a fully-fledged self-consciousness and a distinctive identity was fashioned in a single brilliant generation. In Thomas Paine's words, 'Our citizenship in the United States is our national character ... Our great title is Americans.'

'Not only was American nationalism achieved with a swiftness unprecedented in history, but what was achieved was a new kind of nationalism. It was not imposed by a conqueror or a monarch. It was not dependent on an established church at whose altars all worshipped alike, or upon the power of a ruling class. It did not draw its strength from a traditional enemy. It came from the people; it was an act of will.'[67] Nor should we overlook the fact that, for many Americans, their nation was a repudiation – conscious or unconscious – of the worst features of the Old World. More than a few had been forced to flee and so their new nation was all the sweeter and all the more speedily and satisfactorily formed. People were free in ways almost unthinkable in the Old World, free to marry whoever they wanted, free to worship whichever God they wanted, free to work at whatever occupation they wanted, free to attend whichever college they wanted and, above all, free to say and think whatever they wanted. In this sense, the invention of America was a moral act.[68]

This was all made easier by two factors. One was the presence of the Indian, the 'cudgelled people' in W. H. Auden's phrase, which enabled the newcomers to unite against a common enemy, and to provide Americans with their own imaginative focus.[69] The second factor was that, for the first time, the religious dissenters and sectarians made up a majority. There *were* established churches in America – Congregational and Anglican for example – but the majority of people who had themselves been victims of religious bigotry had no wish to perpetuate the sin.[70]

Finally, we must not overlook the revolution itself and the processes leading up to it, as a set of events instrumental in creating a sense of common destiny and of nationalism. Men from very different states fought side-by-side, with no mercenaries. Alongside their military successes, over a considerable Old World force, it provided them with a series of legends and heroes – Washington and Valley Forge, Nathan Hale and John Paul Jones – and it gave them the symbols of the new nation, the flag and the bald eagle.[71] (Hugh Brogan says the flag is one of only two sacred things in the United States – the other is the White House.[72])

Something approaching a colonial government had been broached as early as 1754, in the Albany Plan of Union. In the 1760s the Stamp Act Congress brought together delegates from nine colonies, among whom were several who were to feature in the Revolution. Which meant that by the time of the First Continental Congress many of America's leaders knew one another. This proved critical in helping form the union just six months before

Yorktown. 'Had there not been an effective union before this, there might never have been a Yorktown ... To an extent unimaginable in the Old World, American nationalism was a creation of the people themselves: it was self-conscious and self-generating. Here it was the frontiersmen and the farmers, the fishermen and the woodsmen, the shopkeepers and apprentices, the small-town lawyers (there were no barristers), the village clergy (there were no bishops), the country schoolteachers (there were no dons) who provided the warp and woof for the fabric of nationalism.'[73] In 1782, M. G. Jean de Crèvecoeur, a naturalised Frenchman, decided that America had fashioned 'a new race of men', and came up with the image of a 'melting pot'.[74]

Lacking a monarch, a court, an established church, and centuries of 'tradition', the Founding Fathers of the new republic, in their wisdom, turned to law. As Henry Steel Commager has observed, for forty years every president of the new nation, every vice-president and Secretary of State, with the exception of Washington himself, was a lawyer.[75]

Lawyers had written the Declaration of Independence and it was mainly lawyers who drafted the constitutions of the states and of the new United States. One effect of this was to shape early American literature. In Revolutionary America there were no poets, dramatists or even novelists who could begin to compare with the political writings of Jefferson, John Adams, James Madison, Tom Paine or James Wilson. The new nation was politically-minded and legally-minded. 'They did away with ecclesiastical law, administrative law and even chancery law, and limited the reach of common law – it all reeked of the Old World of privilege and corruption.' It was this attitude that gave rise to the idea of judicial supremacy, and judicial review. It was this attitude that gave rise to the separation of powers. It gave rise to the law school and to the abolition of the distinction between barrister and solicitor.[76] There would be no America as we know it without the Puritan Revolution, the ideas of John Locke and Montesquieu and a knowledge of republican Rome, but Tom Paine (the 'lethargic visionary' in John Ferling's words) was surely right when he observed that 'the case and circumstance of America present themselves as in the beginning of a world ... We are brought at once to the point of seeing government begin, as if we had lived at the beginning of time.'[77]

'Tradition' has a fine ring to it, especially in the Old World. But another way of looking at it is as a principle by which the dead govern the living and this was not the American way. Early Americans wanted their new world to be open and malleable and so they wanted tradition in its place. That is why the Founding Fathers allowed for revision and amendment of the constitution.[78] In practice, this facility has been used conservatively.

Arguably the most brilliant, and at the same time the most fragile, part of the American politico-legal system was federalism. The creation of a genuine union out of thirteen states, each asserting its own independence and sovereignty, took some doing. Was the new United States a confederation or a nation? The issue would be tested more than once, most famously in the Civil War. James Madison, fourth president and as thorough as ever, prepared himself with a comprehensive study of other confederations, including the Italian, Hanseatic and Helvetic leagues, the confederation of the United Netherlands and the history of the Holy Roman Empire. All of them, he concluded, had suffered the same fatal defect: they were too weak to protect themselves against foreign aggression or internal

dissension. For Madison and his colleagues, the central problem was always how they could create a federal government strong enough to defend itself against a foreign enemy *and* contain domestic dissension. At the same time the government must not be too strong to threaten the liberty of its citizens or the prosperity that derived from local government.[79]

In the division of authority between the federal government and the states they managed just fine. Where they were less successful was in the measures they devised by which the central government could insist recalcitrant states abide by the terms of the division. The solution the Founding Fathers worked out, which was threatened by the Civil War but worked well enough at other times, was to vest all authority in the people of the United States. They, in their sovereign capacity, apportioned appropriate powers between the states and the nation. Conflicts between the two were to be resolved, not by force but by law.[80] And here a 'nice' distinction was to be made: 'Force was not to be used against state or nation but only against *individuals* who violated the law.'[81] This balance of power between the states and the nation was arguably the most brilliant element in the constitution, placing checks on government (at a time when absolutism was paramount in Europe). This was the concept of *federal domination*.[82] But a second brilliant achievement, that ran the balance of powers close, was the Bill of Rights. There *were* precedents, of course, particularly in England: Magna Carta, as long ago as 1215, the Petition of Rights of 1628, the immortal Bill of Rights of 1689.[83] Massachusetts had introduced a 'Body of Liberties' in 1641, also inspired by Magna Carta, but the American Bill of Rights, attached to the Constitution, was of an altogether different order.[84] In England rights were never 'inalienable' and it was by no means unknown for either the Crown or Parliament to rescind them. And so here are the essential differences between Magna Carta and the American Bill of Rights. Magna Carta guaranteed due process of law, the proscription of cruel and unusual punishments, excessive fines or bail; later, a standing army was also proscribed without the consent of Parliament; interference in free elections was likewise outlawed, and Parliament's control of the public purse was established. The American Constitution and its Bill of Rights guaranteed: freedom of religion, freedom of speech, freedom of the press and of assembly, and many other freedoms. Five states forbade self-incrimination; six specifically asserted the supremacy of the civil over the military. North Carolina and Maryland prohibited the creation of monopolies, which were pronounced 'odious and contrary to the spirit of free government'. Delaware abolished the slave trade, others soon followed and Vermont, newly opened up, abolished slavery altogether.[85] Jefferson had insisted on the phrase 'pursuit of happiness' in the Declaration, and the sentiment embodied in these few words influenced American freedoms profoundly.[86]

Watching these events from afar, the Reverend Dr Richard Price in London wrote that 'The last step in human progress is to be made in America.' He was almost right. But in fact it was to be France that benefited most immediately from the American genius. The Declaration of the Rights of Man of August 1789 was largely the work of Lafayette, Mirabeau and Jean Joseph Mounier, 'but it derived philosophically from the American Bill of Rights'. (While he had been in Paris, Jefferson was constantly consulted in secrecy by Lafayette: the 'pursuit of happiness' became, in Lafayette's French, *la recherche du bien-être*.)[87] In many ways the French *Déclaration* went a good deal further even than the

American version. It abolished slavery, removed primogeniture and entail, eliminated honorary distinctions and the privileges of the clergy, and emancipated the Jews. It guaranteed the care of the poor and aged and education at public expense.[88]

And it was a Frenchman who delivered the first, and what is still in some ways the most thoughtful and least partisan, verdict on this 'last step in human progress'. Alexis de Tocqueville was born in Paris on 11 Thermidor in year XIII of the French revolutionary calendar, or 29 July 1805. The son of a Normandy count, he became a magistrate, with an abiding interest in prison reform, and looked forward to a career in politics. However, because of his father's allegiance to the deposed Bourbon monarchy, Alexis found it expedient to travel to America with his friend and colleague Gustave de Beaumont. The ostensible reason for their visit was to study prison regimes in the New World but they travelled widely and on their return both wrote books about America.[89]

They remained in the United States for a year and took in New York, Boston, Buffalo, Canada and Philadelphia. They travelled the frontier, down the Mississippi to New Orleans, and back up through the South to Washington. They sampled all the different Americas and Americans. In Boston they stayed at the Tremont Hotel, the first large luxury hotel in the United States, where each room had a private parlour and each guest was provided with a pair of slippers while his boots were polished.[90] 'Here luxury and refinement prevail,' wrote Tocqueville. 'Almost all the women here speak French well, and all the men we have seen so far have been to Europe.'[91] It made a change, he said, from the 'stinking' arrogance of the Americans in New York, where they had stayed in a boarding house on 'fashionable' Broadway, and encountered 'a certain crudeness of manners', when people would spit during a conversation.[92]

To begin with, and until they reached the frontier, they were disappointed by the lack of trees in America, and by the Indians, whom they found small, with thin arms and legs, 'brutalised by our wines and liquors'.[93] They visited Sing Sing, a prison on the banks of the Hudson, met John Quincy Adams, Sam Houston (the founder of Texas, who brought his stallion aboard ship on the Mississippi), and were entertained by the American Philosophical Society (where Beaumont was bored).[94] As their journey progressed, although their creature comforts didn't improve (one of the steamers they took on the Ohio river struck a reef and sank), Tocqueville's admiration for America grew and on his return to France he resolved to write a book about the most important feature which he felt distinguished America: democracy. His book appeared in two editions, the first in 1835, which concentrated on politics, and a second, in 1840, which added his thoughts and observations on what we would call the sociological effects of democracy. The latter was darker than the former, as Tocqueville addressed what he felt was the main problem with democracy – the danger that it would make men's minds mediocre and in that way damage their ultimate freedom.

But in almost all other ways he was full of admiration for the democratic spirit and structure of America. Americans formed a society, he found, in which classes were much less distinct than in Europe and where even the ordinary sales clerk did not have the 'bad form' of the lower classes in France. 'This is a *commercial* people,' his colleague Beaumont wrote at one point. 'The entire society seems to have melted into a middle class.'[95] Both men were impressed by the advanced position of women, the hard work, the general good

morals, and the absence of military force. They were further impressed by the sturdy individualism of the small landowners, whom they saw as the most typical Americans.[96] 'The Americans are no more virtuous than other people,' Tocqueville wrote, 'but are infinitely more enlightened (I'm speaking of the great mass) than any other people I know …'[97] In the *Democracy*, Tocqueville made much of the stability of the American system (though he drew attention to the danger of rising expectations), which he contrasted with France and, to an extent, Britain (which he had also visited).[98] He put this down to ordinary Americans being more involved than their European counterparts in (a) political society, (b) civil society and (c) religious society, and to the fact that America operated in ways which were almost the direct opposite of those in Europe: 'The local community was organised before the county, the county before the state, and the state before the union.'[99] Tocqueville greatly admired the role of the courts in America, where they took precedence over the politicians, and the fact that the press, though no less 'violent' than the French press, was left alone: no one even thought of censoring what was said.

He was not blind to the problems of America. He thought the issue of race was insoluble. In the ancient world, slavery had been about conquest but in America, he saw, it was about race and he thought there was no way out. He concluded that democracies tended to elect mediocre leaders, which would in time hinder progress, and he thought majorities too intolerant of minorities. He gave as examples the fact that laws against bankruptcy weren't passed in America because too many thought themselves liable, and it was the same with liquor, though the link between alcohol consumption and crime was even then self-evident.[100]

In the realm of pure ideas, he felt that democracies would make more progress in practical than in theoretical sciences, he was impressed by the architecture of Washington, particularly its grandeur in a city that was, after all, 'no bigger than Pontoise'. He expected poetry to blossom in America because 'there was much nature'. He found families more intimate and more independent-minded than in Europe, and was heartily in favour of the trend whereby marriage was based more on love and affection than on economic or dynastic considerations.[101]

Despite his caveats, Tocqueville's admiration for America and its obsession with equality (part of the French revolutionary trinity) shone through his text and, when it was published, his book was well received. In France it won the Montyon Prize, worth 12,000 francs, and in Britain J. S. Mill described Tocqueville's book as 'the first great work of political philosophy devoted to modern democracy'.[102] Since then, other books have tried to emulate Tocqueville's but his has become a kind of classic. In a sense, of course, such books, though fascinating, are irrelevant. The most infallible verdict on America was the vast number of immigrants who left Europe, and then other countries across the world, to find freedom and prosperity in the United States. They are still voting with their feet.

# PART FIVE

# VICO TO FREUD
## Parallel Truths: The Modern Incoherence

# The Oriental Renaissance

At the very time the Portuguese were exploring the west coast of Africa, and then discovering Brazil and the Far East, the invention of printing was transforming the intellectual life of Europe. Though the growth of literacy represented considerable progress in a general sense, it also made it more difficult than ever for the Portuguese to keep to themselves the news of their momentous discoveries.

There seems little doubt that there *were* concerted attempts to keep the news secret. In the time of King John II (1481–1495), for example, the Portuguese Crown used oaths and all types of punishment, including death, to 'dissuade' people from leaking the news. In 1481, the Cortes petitioned the king to forbid foreigners – Genoese and Florentines especially – from settling in the kingdom because 'they stole the royal secrets as to Africa and the islands'.[1] A little later, in 1504, King Manuel reaffirmed that complete secrecy be maintained in regard to south-eastern and north-eastern navigation – offenders would be put to death. 'Thereafter, it would appear, all the charts, maps, and logs concerning the routes to Africa, India and Brazil were housed in the royal chartroom and placed under the custody of Jorgé de Vasconcelos.'[2] Several historians have argued that more than one official Portuguese chronicle of discovery was deliberately left uncompleted so as to preserve crucial information. Donald Lach, in his survey of Portugal's control of information, says that a policy of suppressing news about African discovery and trade was almost certainly carried out by the Portuguese: 'It is hard to believe that chance alone is sufficient to account for the fact that not a single work on the new discoveries in Asia is known to have been published in Portugal between 1500 and mid-century.'[3]

Such an embargo could not last. Portuguese cartographers peddled their services and their information on the overseas world, selling their inside knowledge to the highest bidders, as did navigators and merchants who had been on such voyages. Some people appear to have felt guilty about this and, very often, military details were omitted. But, gradually, as the sixteenth century lengthened, the discoveries became common currency. Tantalising hints were dropped in the general pronouncements of the Portuguese kings, who sent official communications to their fellow monarchs around Europe, and to the papacy. Another way information circulated was via the many Italian merchants in Lisbon, some of whom at least were Venetian spies. In this way, the route to India, although classified as a state secret, was the subject of several early accounts written by foreigners from inside Portugal. A general – if hazy – picture could be reconstructed by those interested in doing so.[4] The Portuguese policy of secrecy, says Lach, was largely successful

for about fifty years, but broke down around mid-century, when it became clear that Portugal could not maintain a monopoly on the spice trade. After about 1550 there was a great vogue for travel literature and it was also about now that the Jesuits began publishing their famous 'letterbooks'. These provided the most comprehensive description of the Far East for many years.[5]

A series of papal bulls issued in the sixteenth century enabled the Portuguese Crown to create something that came to be called the *padroado* (not unlike the Spanish *patronato*). The Crown was granted the use of certain ecclesiastical revenues in Portugal for exploration and the right to propose to the papacy a number of candidates for the sees and ecclesiastical benefices of Africa and the Indies.[6] In this way, in the Indies, Goa became established as the headquarters of Jesuit activity and, in 1542, four months after his arrival there, Francis Xavier addressed a letter to the father of his order in Rome in which he referred to Goa as already an 'entirely Christian city'.[7] (Its original name was Ticuari, which meant 'Thirty Villages'.) With Xavier's arrival in India, the Jesuits became the acknowledged leaders of the Christian missionary effort within the *padroado*.

Each of the early explorations had included missionaries or ecclesiastics of one kind or another, and many of them had written accounts of their experiences. But it was not until the Jesuits became active in overseas missions that a comprehensive system for correspondence was established and the dissemination of information became virtually routine. Ignatius Loyola explicitly ordered members of his order to send letters to him in Rome. Important matters were to be sent in a formal letter, while less important or more private concerns were included on a separate sheet known as *hijuela*. All such correspondence was to be written out in triplicate and sent to Rome by three different routes.[8] 'These reports were to be prepared with great thought and care, for they were to be used for the edification and guidance of the Society and for the inspiration of public interest in its far-flung enterprises.'[9] An office was established in Rome that was responsible for communicating with the missionaries and for receiving the incoming letters, editing and translating them and then circulating them throughout Europe. In this way information on the peoples and cultures and ideas of India were first spread. With Goa being used as the administrative centre, all information, wherever it was gathered – China or Japan, say – became known as 'Indian letters'. About this time, a Jesuit college was established at Coimbra in Portugal and this too became a repository and clearing house for Jesuit letters sent to Europe, and then passed on to Rome.[10] There were five types of letter – the *hijuelas* already mentioned, hortatory letters, designed to stimulate interest in the East among the brothers back home, accounts for public distribution, which were more restrained in tone, personal accounts, and 'allied documents', in effect appendices, such as histories of specific tribes, or chronicles about specific matters or issues about which the missionaries thought that people back home would require further detailed knowledge.[11] Eventually, as the letters became stabilised, the Jesuits in Rome and Coimbra stopped translating them into all the different languages of Europe and instead published them in Latin, as *Epistolae indicae*.[12]

The writings of the Jesuits, unlike the secular authors, of whom there were several, were not concerned with trade. They do refer to military action, but in general they cover cultural matters, the ideas and practices, the institutions and customs of far-off peoples.

For example, in so far as Malabar was concerned (the Malabar Coast was the western coast of India, below what is now Bombay or Mumbai), the Jesuits reported the death of a ruler, showing how the mourners gathered in a field, for the cremation, how they shaved their bodies completely, 'saving only their eyelashes and eyebrows' and, after cleaning their teeth, refrained from eating betel, meat or fish for thirteen days.[13] Their accounts likewise show how the administration of justice varied according to the caste of the offender, and how trial by ordeal was not uncommon, some offenders being required to plunge the first two fingers of their right hand into boiling oil. 'Should his fingers be burnt, the accused is tortured to force a confession of what he has done with the stolen goods. Whether he confesses or not, he is still executed. Should the accused's fingers not be burnt, he is released and the accuser is either executed, fined or banished.'[14] Bengalis were described as 'sleek, handsome black men, more sharpwitted than the men of any other known race'.[15] But they were also denounced for being 'overly wary and treacherous' and the reports noted that elsewhere in India it was an insult to call someone a Bengali. The accounts further report that the government of Bengal had been taken over by Muslims about three hundred years before the arrival of the Portuguese – substantially correct. And it was from Portuguese Jesuits that Europe first learned in some detail about the advent of the Mughals in India, and the struggle for supremacy between them and the Afghans.[16]

Most Jesuits realised that the key to understanding India lay in the mastery of native languages and in the exploration of the local literatures.[17] In trying to root out Hinduism, certain sacred books were seized and sometimes translated and the translations sent to Europe. These included eighteen books of the *Mahabharata*. But in general the Jesuits learned little systematically about Hinduism, dismissing many of the legends as 'fables'.[18] The names of the Hindu gods Vishnu, Shiva and Brahma reached Europe, and the fact that they constituted the *Tri-murti*, a form of Trinity, but here too the Jesuits treated such beliefs as 'hopeless superstitions'. The letters refer often to the *pagodas* of the Hindus, 'very large houses, all of stone or marble', which 'contain images of bulls, cows, elephants, monkeys, and men'.[19] Some of the Jesuits, plainly impressed by the size of these monuments, believed they had been built by Alexander the Great, or the Romans. The Jesuits recognised that the Hindus had three types of priest – Brahmans, Yogis and Gurus. They observed and described the threads which the former wore over their shoulders from the age of seven on, each thread honouring a different god, and how the three threads were knotted together in places 'and thus they claim to have a Trinity like ours'. But in general the Jesuits had no respect for these ranks and were horrified that Hindu priests were able to marry.[20] They were fascinated by caste and by general marital practices, one observer noting that there were 'many people married to cousins, sisters and sisters-in-law'. This observer went so far as to use the Indian practices as an argument with the pope, to encourage him to allow marriage in Europe between the third and fourth degrees of consanguinity. But the Jesuits never acquired either a respect or a sympathy for native scholarship or Indian high culture. This is one reason why the Oriental renaissance, when it occurred, had the impact it did.

China, although furthest removed from Europe, nevertheless showed some curious parallels in the realm of ideas. At the end of the sixteenth century, for example, she experienced her own 'renaissance', an upsurge in developments in the theatre, in the novel, and in

philosophy. Many intellectuals belonged to a political and literary club, the 'Society of Renewal' (*fushe*). It was now, for example, that the influence of Zhan Buddhism began to grow and the concept of *liang zhi*, or 'innate moral knowledge'. This, in a way, was a Chinese form of Platonism, which held that there is a principle of good inherent in the mind before any contamination by egoistic thoughts and desires 'and which one must try to discover in oneself'. This school of 'innate knowledge' was highly controversial because its advocates denounced Confucius, arguing that he prevented thought, which was inherent in everyone.[21] Another aspect of the Chinese renaissance in the sixteenth and seventeenth centuries saw the growth of schools and libraries as China reacted to the discovery in the West of printing by movable type.[22]

Other innovations at this time included the *Lu xue jing yi* (*Essence of Music*), by Zhu Zaiyu (1536–1611), who was the first person in the world to define the equally tempered scale.[23] Li Shizhen (1518–1598) produced *Ben tsao gang mi*, which described a thousand plants and a thousand animals with medicinal uses. He also mentioned, for the first time, a method of smallpox injection, much the same method as that which, in the West, later gave rise to the science of immunology. A primitive form of sociology was also introduced in China, by Wang Fuzhi. He conceived of societies as evolving by natural forces, and this was especially influential in the Chinese context because it killed off any hope – entertained by some – that there would be a return to a golden age, the time of the Han empire, when the old ways would be resurrected. Wang actually saw the distant past as 'bestial',[24] and insisted there was no going back, a particularly important (and unpopular) stance in China since it was branded as anti-Confucian.

As well as having its own renaissance of sorts, Ming China also had its own Inquisition. This grew out of the resumption of the official civil service competitions – the written examination – from 1646 onwards.[25] It happened because, in connection with these examinations, a vast number of private academies proliferated. And, since the dynasty kept a strict control over the curriculum for the examinations, they were able to control much of the thought of the people, and to curtail criticism. In the early eighteenth century this eventually led to more direct control and a device which, like its counterpart in the West, included an index of prohibited books: 10,231 titles were on the list at one point and more than 2,300 were actually destroyed. At the same time, action was taken against dissident authors – forced labour, exile, property confiscated, even execution in some cases.[26]

As in England and France, the Chinese developed a taste in the early eighteenth century for encyclopaedias. One, printed in movable copper type, had no fewer than 10,000 chapters. In 1716 the famous dictionary, the *Gang hsi zi dian*, appeared – this was to serve as the basis for Western sinologists down to the twentieth century. Altogether, says Jacques Gernet, there was a canon of more than fifty 'big publications' in the eighteenth century, codifying Chinese learning and acting as a lively parallel to the enlightenment projects of Western Europe. The traffic in ideas wasn't all one way of course, and the main influence of the Jesuits in China was in astronomy, cartography and mathematics. In 1702 the scholar Gangshi asked the Jesuit father Antoine Thomas to fix the length of the *li* as a function of the terrestrial meridian. This innovation was made after the mile but before the kilometre was settled in Europe in the same way.[27]

As the eighteenth century wore on, China became the subject of great fascination for Europeans – at times it amounted almost to a mania. 'Soon everyone was proclaiming the wisdom of Confucius, or extolling the virtues of a Chinese education, or painting in what they took to be the Chinese style, or building Chinese pagodas in gardens landscaped in the Chinese manner . . .'[28] In 1670 the Jesuit Athanasius Kircher had reported that China 'is ruled by Doctors, *à la mode of* Plato', while a second, Father Le Comte, in his book *Nouveaux mémoires sur l'état de Chine*, argued that China had practiced the Christian virtues for more than two thousand years.[29] For his pains, he was condemned by the scholastics of the University of Paris, who said he had made Christianity 'superfluous'. Leibniz thought that in most matters of ethics and politics China was ahead of Europe and went so far as to suggest that Chinese be taught as a universal language. Voltaire agreed.

Chinese forms of beauty swept through Europe, and 'all royalty joined in'. There was a Chinese pavilion at Sans Souci, a porcelain palace at Dresden, a Chinese park in Weimar and a whole Chinese village, named Canton, was built at Drottningholm, the royal summer residence of the Swedish monarch. There was another Chinese village outside Cassel and pagodas at Kew and Nymphenburg. The duke of Cumberland kept a Chinese yacht on the Thames, complete with a dragon, and Watteau and Boucher painted in the Chinese style. Everyone drank tea from Chinese porcelain cups.[30]

The Islamic world of course came closer to home for European travellers than the Far Eastern civilisations. The first thing to say about Islam is that the idea itself had proved extremely successful. By the eighteenth century, the Muslim faith stretched from the Atlantic Ocean to the South China Sea and from the Ural river almost to the mouth of the Zambezi. It was the dominant faith in lands which totalled at least three times the area occupied by Christianity.

Isfahan, in Persia, had emerged as a worthy successor to Baghdad and Toledo, as the focus of an Islamic renaissance in art, letters and philosophy. At that stage Persian was the *lingua franca* of the Islamic world, rather than Arabic. Isfahan was the capital of the Safavi empire, where there flourished a school of painters of miniatures, led by Bihzard, of carpet weavers, and of highly individualised writers of memoirs. The brilliance of Isfahan also attracted many scholars, in particular *falsafahs*, even though philosophy was still a dubious enterprise in the eyes of the orthodox. There was a renewed interest in Aristotle, Plato and 'pagan' values. Among the philosophers was Mir Damad (d. 1631), who held that the world consisted entirely of light, and Suhravardi, a kind of Platonist who believed there was a 'realm of images' elsewhere. This 'Persianate flowering' also produced three great law-givers, new forms of literary biography, the idea of connoisseurship for both painting and calligraphy, and a new school of translation.[31] The flowering has been compared with the Italian Renaissance in the sense that it was a 'lyrical' movement rather than a 'positivist' one.[32]

Part of this 'lyrical', or Platonic, side to sixteenth- and seventeenth-century Islam were Abulfazl's innovations in Sufism. It is not strictly correct to call Sufism 'Platonic' or 'Neoplatonic', nor, according to some scholars, is it right to call it 'mystical'. Nevertheless, this *is* how many people conceive of Sufism, as a very private form of Islam, an ascetic

search for the path to God, deep inside oneself, and of which, it is held, we all have an inkling in our inherent nature ('innate knowledge', as the Chinese put it). Sufis wear a woollen habit (*sufi* means 'wool') and sometimes form themselves into *tariqahs*, schools with their own distinctive approach to the path to God. Sometimes this involves venerating saints, as Sufis who have achieved closeness to God and are now in Paradise. Besides Platonism, there are overlaps here with Buddhism.

Abulfazl (1551–1602) wasn't based at Isfahan, but at Akbar's court in India and his book was called *Akbar-Namah*, the *Book of Akbar*.[33] The basic idea of Sufism, in Abulfazl's interpretation of it, as related to the organisation of civilisation, is the encouragement of a 'gentling' of relations between men and women – conciliation in all things. This is very different from many people's ideas of Islam (especially now, after 9/11) and, by the late eighteenth century, when a sizeable proportion of Muslims were crying out for reform of the faith, the corruption that had undoubtedly seeped into Sufism (which, again, recalls the corruption that infiltrated Buddhism in China in the Middle Ages) caused it to provoke a violent reaction. Muhammad bin Abd-al-Wahhab (d. 1791) took particular exception to Sufism, especially its veneration of the saints, which he felt smacked of idolatry and was, in effect, an abandonment of Muhammad. In orthodox law this was a capital offence and Wahhabi and his followers, who by then included Ibn Saud, a local ruler in Saudi Arabia, worked hard to establish a state based on their uncompromising principles. Then, to the horror of the Muslim world, they set about destroying many of the sacred sites, not just of Sufism but of mainstream Islam itself, because they too were tainted by idolatry. To cap it all, the Wahhabis massacred many of the pilgrims visiting those sites.

Eventually – and with difficulty – they were put down. But the Wahhabis would never go away completely. And in the short run their suppression raised a quite different issue, for they were overcome by a new kind of Ottoman army – one that used equipment and tactics that had been evolved in the West. This signalled a major change in thinking on the part of the Ottomans.[34] As we shall now see, Islam's relations with the West, and with Western ideas, was very chequered.

Despite its retreat in Spain by 1492 and its near-victory at Vienna in 1683, the Muslim world for a long time remained wary, even uninterested in what was happening, intellectually speaking, in Western Europe.[35] Bernard Lewis, the well-known scholar of Islam, writes that 'The great translation movement that centuries earlier had brought many Greek, Persian and Syriac works within the purview of Muslim and other Arabic readers, had come to an end, and the new scientific literature of Europe was almost totally unknown to them. Until the late eighteenth century, only one medical book was translated into a Middle Eastern language – a sixteenth-century treatise on syphilis, presented to Sultan Mehmed IV in Turkish in 1655.' This translation was no accident, says Lewis. Syphilis, reputedly of American origin, had arrived in the Islamic world from Europe (and is still known in Arabic, Persian, Turkish and other languages as 'the Frankish disease'). Even when major conceptual breakthroughs were made in the Islamic world, they were not always recognised. For example, William Harvey's *Essay on the Motion of the Heart and Blood*, published in 1628, was anticipated by the work of a thirteenth-century Syrian physician called Ibn al-Nafis. His treatise, which bravely argued against the traditional

wisdom of Galen and Avicenna, set out the principle of circulation but it remained unknown and had no effect on the practice of medicine. In a letter written in 1560, Ogier Ghiselin de Busbecq, ambassador from the Holy Roman Emperor to the sultan in Turkey, had this to say: 'No nation has shown less reluctance to adopt the useful inventions of others; for example, they have appropriated for their own use large and small cannons and many other of our discoveries. They have, however, never been able to bring themselves to print books and set up public clocks. They hold that their scriptures, that is, their sacred books, would no longer be scriptures if printed; and if they established public clocks, they think that the authority of their *muezzins* and their ancient rites would suffer diminution.'[36]

This can't be quite right, or it gives an incomplete picture. True, there are several accounts of the Ottomans feeling 'morally superior' to Europeans, showing a 'vanity' toward the infidel, 'glorifying in their ignorance', apparently convinced that nothing could be learned from the West.[37] But, from the sixteenth century on, more recent scholarship shows that the Turks did follow developments in the West, especially in the fields of war, mining, geography and medicine. Istanbul had its own observatory as early as 1573, where the chief astronomer, Taqi al-Din, had fifteen assistants, though it was demolished seven years later. Taqi al-Din developed a new method of calculation to determine the latitudes and longitudes of the stars. His method was more precise than any yet devised and he also invented new astronomical instruments.[38] Ottoman ambassadors visited observatories in Paris in 1721, in Vienna in 1748, and Italian and French astronomical works were translated into Turkish in 1768 and 1772.[39]

Professor Ekmeleddin Ihsanoglu, the Turkish historian of science, shows that the number of *madrasas* in the Ottoman lands grew from forty in the fourteenth century to ninety-seven in the fifteenth, and 189 in the sixteenth. Later still, the total grew to 665 in all the empire.[40] The Ottomans produced, in particular, many geographical books, and Kâtip Çelebi (1609–1657), the most famous of the Turkish bibliographers and translators of the era, provided for his readers a wide-ranging survey of European scientific and artistic institutions, giving the first indications (by implication) that the Ottomans were backward in the sciences.[41] Çelebi's book *Kesfü z-zünun* provided a critical survey of Renaissance academies, and he also translated Mercator.

A concerted attempt at the translation of European works was begun around 1720, on the orders of Grand Vizier Nevsehirli Damat Ibrahim Pasa, during the reign of Sultan Ahmet III, a period known in Ottoman history as the 'Tulip Age'.[42] This activity was reinforced by the embassies to Europe already referred to (there was one to St Petersburg, as well as to Paris and Vienna). Fatma Müge Göçek's account of the embassy to Paris, in 1720–1721, shows that the Turks brought military gifts while the French reciprocated with technological objects.[43] At that time, says Göçek, the medical schools were in decline in Turkey and the Ottomans were having a problem controlling untrained practitioners.[44] The French were told that although there were twenty-four public libraries in Istanbul at the time, 'books filled with "lies" (history, poetry, astronomy, philosophy)' could not be endowed or bequeathed to these libraries.

The picture that has therefore emerged from more recent scholarship is that the Turkish conquest of Constantinople/Istanbul, though it drove many Greek/Byzantine scholars west, with or without manuscripts, did kick-start a revival of Islamic scholarship, with an

interest in Western/Renaissance thought. For some reason, this interest declined in the seventeenth century, only to be renewed in the early years of the eighteenth.

Gradually, however, throughout the eighteenth century, the isolation of the Ottoman lands from Europe was reduced and there emerged a new category of visitor to Muslim countries. They comprised what we would now call experts, individuals offering specialist services to Islamic employers. This was true even of the Muslim countries further east, in Mughal India for example, where the Italian doctor Manucci was employed. This in time sparked a change in attitudes, which for many Muslims was shocking: one might learn from the previously despised infidel.[45] There was also more travel from east to west. In earlier centuries, only captives and a few diplomatic envoys had travelled in that way. After all, there were no holy places for Muslims to make pilgrimages to in Europe and in theory at least little to attract merchants interested in luxuries. (One exception was Evliya Celebi, who travelled in Europe in the second half of the seventeenth century, and left a fascinating record.) In the eighteenth century that began to change. As Gulfishan Khan has recently shown, there were many Indians – Muslims and Hindus – who travelled to Europe.[46] Now, not only were special envoys sent out in increasing numbers, with instructions to observe, but attitudes to foreigners softened. A mathematical school was introduced for the Turkish military in 1734, initiated by a Frenchman, and a printing press was started in 1729, under the guidance of a Hungarian. Still, the improvements were patchy. Bernard Lewis describes a Turkish version of one of Columbus' maps (now lost), prepared in 1513, which survives in the Topkapi Palace in Istanbul. It remained there, unconsulted and unknown, until it was discovered by a German scholar in 1929.[47]

But travel from east to west did continue to increase. First the pasha of Egypt, then the sultan of Turkey, then the shah of Persia each dispatched students to Paris, London and other Western capitals. To begin with they were after military know-how, but this entailed learning French, English and other European languages and once they could do so, these envoys were free to read whatever came their way. Even here, however, they were in a sense handicapped. This was because Islam regarded Christianity as an earlier form of revelation, and it therefore made no sense to go backwards. Their chief interests in the West, therefore, lay in economics or in politics.[48]

Islamic envoys in the western European countries were interested chiefly in two political ideas, the first being patriotism, coming from France and England in particular. This appealed especially to the younger Ottoman politicians, who realised that if an Ottoman patriotism could be fashioned, it might unite the very varied populations and tribes of the empire by means of a common love of territory, which would also mean a common allegiance to its ruler. The second idea was nationalism. This was more of a central and eastern European notion and referred mainly to ethnic and linguistic identities. The longer-term effects of this idea were far less successful, tending to divide and disrupt, rather than unify.[49]

Outside politics, the topics which attracted most interest of the envoys were the status of women, science and music. 'Islam permits both polygamy and concubinage. Muslim visitors to Europe speak with astonishment, often with horror, of the immodesty and forwardness of Western women, of the incredible freedom and absurd deference accorded to them, and of the lack of manly jealousy of European males confronted with the

immorality and promiscuity in which their womenfolk indulge.'[50] This attitude stemmed from basic Islamic law, according to which there were three groups which did not enjoy full protection – unbelievers, slaves and women.[51] Interest in mathematics and astronomy was growing in Muslim India in the late eighteenth century and Newton's *Principia Mathematica* was translated into Persian in the second decade of the nineteenth century by a Muslim in Calcutta. Incubators were invented in Egypt and vaccination against smallpox introduced in Turkey.[52]

There have been various theories for this 'asymmetry' of achievement in the Arab/Islamic world.[53] One argument relates it to the 'exhaustion' of precious metals in the Middle East, coinciding with the discovery by Europeans of gold and silver and other precious resources in the New World. One biological theory puts the Arabic failure down to the prevalence of cousin marriage in Islamic countries. Another biological theory blames the poor goat which, by stripping the bark off the trees and tearing up grass by the roots, condemned once-fertile lands to become deserts. Others have drawn attention to the relative abandonment of wheeled vehicles in the pre-modern Middle East, though this seems more to beg the question than answer it. 'Familiar in antiquity, they became rare in medieval centuries, and remained so until they were reintroduced under European influence or rule.'[54]

None of these explanations seems satisfactory. For one reason, by this time the Islamic world no longer equated to the Middle East – there were many Muslims in India and further east, and in Africa. As was mentioned earlier, Islam had been immensely successful in its spread around the world – judged in purely spiritual (rather than in material) terms, the faith that had originally been Arab had been exceedingly successful, second to none as an export. And so the wider answer, about the 'asymmetry', if there is one, surely lies in the great opening-up of the world, in the age of exploration, which provided Europeans with access to vast tracts of fresh land, in Africa, Australia and the Americas, with their associated flora, fauna and natural resources and, above all, their huge markets which allowed for trade, innovation and capital formation on an unprecedented scale. This is the simplest explanation, and the most convincing.

In France in the seventeenth century the king, Louis XIV, was told that the Portuguese settlements in India were not as secure as they might be and saw his chance. Without fuss, he added six young Jesuits – all scientists as well as prelates – to a mission he was sending to Siam.[55] The men were put ashore in the south of India, the first of the French (as opposed to Portuguese) 'Indian missions' which were to gain both fame and notoriety for the ordeals they endured and for their collection of *Lettres édifiantes et curieuses* which gave detailed accounts of their experiences. These Jesuits were far more sympathetic and accommodating to the Indians than their previous colleagues. This was shown expressly in the so-called 'concessions' which they allowed regarding Catholic worship – these became known as the *rites malabars* or *cérémonies chinoises*, a hybrid form of worship, which was denounced in Rome and eventually condemned in 1744. But if this tolerant approach didn't satisfy the Vatican, it appealed to the abbé Bignon, the French king's librarian and the man who reorganised the Académie des Inscriptions in Paris. He requested the missionaries to be alert for Indic manuscripts, which he was keen to obtain

to form the backbone of an Oriental library. In 1733, in the *Lettres édifiantes*, the Jesuits announced their response: the discovery of one of the 'big game' of the hunt, a complete Veda, long thought to have been lost.[56] (It was in fact a complete *Rig Veda* in Grantha characters.*) Had the French Jesuits not taken the tolerant, accommodating approach that they did, it is unlikely they would have got close enough to local clerics and intellectuals to have been shown the Hindu scriptures in the first place, nor might they have realised what they had. Some years later, owing to Vatican intolerance, Jesuit relations with literate Indians deteriorated and shipments from the subcontinent were discontinued. By then, however, Europe had been exposed to Sanskrit and this turned into a major intellectual event.

'Only after 1771 does the world become truly round; half the intellectual map is no longer blank.' These are the words of Raymond Schwab, the French scholar, in his book *The Oriental Renaissance*, a title he took from Edgar Quinet who, in 1841, described the arrival of many Sanskrit manuscripts in Europe in the eighteenth century and compared them with the impact of Homer's *Iliad* and *Odyssey*.[57] I have adopted Quinet and Schwab's title for this chapter, and in what follows have relied heavily on their work. What Schwab meant was that the arrival of the Hindu manuscripts, together with the deciphering, at much the same time, of the Egyptian hieroglyphics, was an event more or less comparable with the arrival of the ancient Greek and Latin manuscripts, many in Arabic translation, that had transformed European life in the eleventh and twelfth centuries (see above, Chapter 17). Schwab himself felt that the discovery of the Sanskrit language and its literature was 'one of the great events of the mind'.[58]

This transformation began almost certainly in 1771 when Abraham Anquetil-Duperron, 'an obscure luminary', published his translation of the *Zend Avesta* in France. This, says Schwab, was 'the first time anyone had succeeded in breaking into one of the walled languages of Asia'.[59] Anquetil was described by Edward Said as a French scholar and 'ecumenist of beliefs (Jansenist, Catholic, and Brahmin)'. He transcribed and translated the *Zend Avesta* while in Surat, 'freeing,' in Schwab's words, 'the old humanism from the Mediterranean basin.'[60] He was the first Western scholar to visit India expressly for the purpose of studying their scriptures. At first he called Sanskrit Sahanscrit, Samcretam or Samscroutam.†

The real start of the Oriental renaissance, however, properly began with the arrival in Calcutta of William Jones and the establishment of the Bengal Asiatic Society on 15 January 1784. This society was established by a group of highly talented English civil servants, employed by the East India Company, who, besides their official day-to-day duties helping to administer the subcontinent, also pursued broader interests, which included language studies, the recovery and translation of the Indian classics, astronomy and the natural sciences. Four men stood out. These were, first, Warren Hastings (1732–1818), the governor of Bengal, and a highly controversial politician, who was later impeached for corruption (and, after a trial that lasted, on and off, for seven years,

---

* See above, page 283, for a discussion of the Indian alphabets.
† Edward Said's controversial views about Western attitudes to 'the Orient' are considered in Chapter 33, below.

acquitted), but throughout it all energetically encouraged the activities of the society.[61] It was Hastings who ensured that learned Brahmans gathered at Fort William to supply the most authentic texts, which illustrated Indic law, literature and language. The others in the group were William Jones, a judge, Henry Colebrooke (the 'Master of Sanskrit') and Charles Wilkins. Between them, these men accomplished three things. They located, recovered, and translated the main Indian Hindu and Buddhist classics, they kick-started the investigation of Indian history, and Jones, in a brilliant flash of insight, uncovered the great similarities between Sanskrit on the one hand and Greek and Latin on the other, in the process reshaping history in a manner we shall explore throughout the rest of this chapter.

These men were all brilliant linguists, Jones especially. The son of a professor of mathematics, he was, on top of everything else, an accomplished poet. He published poems in Greek at the age of fifteen, while at sixteen – having learned Persian from 'a Syrian living in London' – he translated Hafiz into English.[62] He later said that he had studied twenty-eight languages and had a thorough knowledge of thirteen.

Apart from Jones' breakthrough, the next most eye-catching was Jean François Champollion's, in deciphering Egyptian hieroglyphics. In 1822 Champollion wrote his famous *Letter to M. Dacier*, which provided the key to the hieroglyphic script, making use of the trilingual Rosetta Stone, brought back from Egypt, as its key. 'On the morning of September 14, 1822, Champollion ran across the rue Mazarine on which he lived, into the library of the *Institut des Inscriptions*, where he knew he would find his brother, [Jean Jacques] Champollion-Figeac, at work. He cried out to him, "I've got it," went home, and fell unconscious. Coming out of a five-day coma, he immediately picked up the sequence of a waking dream that was almost as old as he was, and asked for his notes. On the 21st he dictated a letter to his brother, dated the next day, which he read to the *Académie des Inscriptions* on the 27th.'[63]

The process of decipherment has since become well known. The fact that there were three languages on the Rosetta Stone was both an opportunity and a hindrance. One language, Greek, was known. Of the other two, one was ideogrammatic, the figuration of ideas, and the other alphabetic, the representation of spoken sounds.[64] The ideographs were broken when it was realised that a certain small number of unknown characters, often repeated, must be vowels and that cartouches were reserved for the names of kings, with the father *following* the son ('*A*, son of *B*'). Champollion realised that the unknown alphabetic script was a translation of the Greek, and the hieroglyphics a form of shorthand of the same message.

When the Bengal Asiatic Society was instituted, in 1784, Warren Hastings was offered the presidency, but declined, and so it was offered to Jones. He had been in India barely eighteen months. His great discovery, the relationship of Sanskrit to Greek and Latin, was first aired in his third anniversary address to the Asiatic Society. Each year for eleven years he commemorated the founding of the society with a major address, several of which were important statements on Eastern culture. But his third address, 'On the Hindus', delivered on 2 February 1786, was by far the most momentous. He said: 'The Sanskrit language, whatever be its antiquity, is of a wonderful structure; more perfect than the Greek, more copious than the Latin, and more exquisitely refined than either, yet bearing to both of

them a stronger affinity, both in the roots of the verbs and in the forms of the grammar, than could possibly have been produced by accident; so strong, indeed, that no philologer could examine them all three, without believing them to have sprung from some common source, which, perhaps, no longer exists.'[65]

It is difficult for us today to grasp the full impact of this insight. In linking Sanskrit to Greek and Latin, and in arguing that the Eastern tongue was, if anything, older than and superior to the Western languages, Jones was striking a blow against the very foundations of Western culture and the (at least tacit) assumption that it was more advanced than cultures elsewhere. A major 'reorientation' in thought and attitude was needed. And it was more than merely historical. Anquetil's translation of the *Zend Avesta* was the first time an Asian text had been conceived in a way that completely ignored both the Christian and classical traditions. This is why Schwab said the world only became truly round now: the history of the East was at last on a par with that of the West, no longer subordinate to it, no longer necessarily *a part* of that history. 'The universality of the Christian God had been ended and a new universalism put in its place.' In his study of the French *Société Asiatique*, Felix Lacôte said in an article entitled 'L'Indianisme' that 'Europeans doubted that ancient India was worth the trouble of knowing. This was a tenacious prejudice against which Warren Hastings still had to struggle in the last quarter of the eighteenth century.'[66] Nevertheless, by 1832 things had been turned upside down and the German romantic August Wilhelm Schlegel took a different line. He said that his own century had produced more knowledge of India than 'the twenty-one centuries since Alexander the Great'.[67] (Schlegel was, like Jones, a linguistic prodigy. He spoke Arabic and Hebrew by the time he was fifteen and, at the age of seventeen, when he was still a pupil of Herder, he lectured on mythology.[68]) In the nineteenth century, Friedrich Max Müller, a German Orientalist who became the first professor of comparative philology at Oxford, said this: 'If I were asked what I considered the most important discovery of the nineteenth century with respect to the ancient history of mankind, I should answer by the following short line: Sanskrit *Dyaus Pitar* = Greek Zeùs Πατηρ = Latin Juppiter = Old Norse Tyr.'[69]

Sanskrit was the key. But it was not the only breakthrough. Schwab identifies five major discoveries of this era, all of which produced a comprehensive reorientation in thought. These were the deciphering of Sanskrit in 1785, of Pahlavi in 1793, the cuneiforms in 1803, hieroglyphics in 1822 and Avestan in 1832 – 'these were all openings in the long-sealed wall of languages'. One immediate effect of these events was that the study of the Far East was demystified for the first time, moving beyond the conjectural. The Laudian chair of Arabic had been established at Oxford since *c.* 1640 but Indic and Chinese studies now began in earnest.[70]

In 1822, the English sent back from Asia to London the sacred books of Tibet and Nepal that were coming to light. The most important of these was the Buddhist canon – one hundred volumes in Tibetan, eighty in Sanskrit – which were discovered and sent west by the English ethnologist Brian Hodgson. It was as a result of the translations of these texts that Western scholars became aware of the similarities between Christianity and Buddhism, as discussed above in Chapter 8. In Germany the philosopher of history Johann Gottfried von Herder was deeply affected by Anquetil's translation of the *Zend Avesta* and was moved to render certain verses of Wilkins' English text of the *Bhagavad Gita* (translated in 1784)

into German. But for Herder his main transformation came when he read a German translation of Jones' English version of Kalidasa's *Shakuntala* (1789). Schwab sets out the significance of this as follows: 'It is well known how Herder, in rekindling for a deciphered India the enthusiastic interest that had been felt for an imagined India, spread among the Romantics the idea of placing the cradle of the divine infancy of the human race in India.'[71] Likewise the German translations of the *Bhagavad Gita* and *Gita Govinda*, published in the first decade of the nineteenth century, had a tremendous influence on Friedrich Schleiermacher, F. W. Schelling, August Schlegel, J. C. Schiller, Novalis and, eventually, on Johann Goethe and Arthur Schopenhauer.

But it was the *Shakuntala* that 'remained the great miracle'. As well as seducing Herder, it gripped Goethe, who didn't much care for the polytheism of Hinduism but nonetheless penned the lines: '*Nenn' ich Sakontala dich, und so ist alles gesagt*' ('When I mention *Shakuntala*, everything is said'). *Shakuntala* was one of the influences that prompted Schlegel to learn Sanskrit. Jones became as famous for his translation of *Shakuntala* as for his identification of the similarities between Sanskrit and Latin and Greek. Goethe called him 'the incomparable Jones'. '*Shakuntala* was the first link with the authentic India and the basis on which Herder constructed an Indic fatherland for the human race in its infancy.'[72] Heine modelled several of his verses on *Shakuntala*. In France, in 1830, the appearance of Antoine-Léonard de Chézy's translation of Kalidasa's classic 'was one of the literary events that formed the texture of the nineteenth century, not just by its direct influence but by introducing unexpected competition into world literature.'[73] Chézy's translation included Goethe's famous verses as an epigraph, in which the German poet confessed that *Shakuntala* was 'among the stars that made his nights brighter than his days'. Lamartine saw in Chézy's translation 'the threefold genius of Homer, Theocritus and Tasso combined in a single poem'.[74] By 1858 *Shakuntala* was so well-known in France, and so well-regarded, that it became a ballet at the Opéra de Paris, with music by Ernst Reyer and a scenario by Théophile Gautier.

The effect of the *Bhagavad Gita* was no less profound. Its poetry, its wisdom, its sheer complexity and richness brought about a major change in attitudes to India, the East and its capabilities. 'It was a great surprise,' wrote the French scholar Jean-Denis Lanjuinas, 'to find among these fragments of an extremely ancient epic poem from India, along with the system of metempsychosis, a brilliant theory on the existence of God and the immortality of the soul, all the sublime doctrines of the Stoics . . . a completely spiritual pantheism, and finally the vision of all-in-God.'[75] Others found precursors of Spinoza and Berkeley in India, and Lanjuinas himself went on to argue that the *Hitopadesha* (instructions in politics, friendship and worldly wisdom, dating back to the third century BC) contained one of the great moral treatises of all times, on a par with the scriptures and the Church Fathers. These verdicts were confirmed by Friedrich Schlegel who, in *Über die Sprache und Weisheit der Indier* ('on the Language and Wisdom of the Indies'), discussed the metaphysical traditions of India on an equal footing with Greek and Latin ideas. This was far more important then than we may feel now, because, against a background of deism and doubt, such an approach allowed that the Indians – the inhabitants of the far-off East – had as thorough a knowledge and belief in the true God as did Europeans. This was quite at variance with what the church taught. Jones had speculated that Sanskrit, Greek

and Latin had a common origin, but there were those who suspected that Sanskrit, which *doesn't* mean 'holy writing' but 'perfected', from *samskrta*, was actually the original tongue spoken after the world had been created by God. What was the relation between Brahman and Abraham?

The sheer richness of Sanskrit also went against the Enlightenment belief that languages had begun in poverty and gradually grown more elaborate.[76] This brought about a growing realisation that Vico had been right, and that the structure of languages could reveal a great deal about the antiquity of man. In turn, this launched the great age of philology, as it was then called, in the nineteenth century, as grammar was studied as well as vocabulary, to reveal groups of languages – for example, the separation of the Germanic languages from Greek, Latin and Balto Slavic.[77] Here the work of Schlegel and Franz Bopp influenced Wilhelm von Humboldt, the minister who helped establish the first chairs in Sanskrit in Germany in 1818.[78] Humboldt in particular was interested in what language could teach us about the psychology of different peoples. Many religious souls at the time remained convinced that the earliest (and most perfect) language had to be Hebrew, or something very like it, because it was the language of the Chosen People. Bopp turned his back on these preconceptions and showed how complex Sanskrit was even thousands of years ago, in the process throwing doubt on the very idea that Hebrew was the original tongue. It was in this way that language was recognised as having a *natural* history rather than a sacred history, that language studies were, in effect, susceptible of scientific inquiry.[79]

Schelling took the ideas of Jones one step further. In his 1799 lecture on the *Philosophie der Mythologie* he proposed that, just as there must have been a 'mother tongue', so there must have been one mythology in the world shared by all peoples. He thought that it was the task of German scholars trained in languages to create, for modern Europe, 'a fusion of the mythological traditions of all humanity ... All the legends of India and Greece, of the Scandinavians and the Persians "had to be" accepted as components of a new universal religion that would regenerate a world distracted by rationalism.'[80] In much the same vein, Hippolyte Taine took the view that the concordance between Buddhism and Christianity was 'the greatest event in history', because it revealed the root myths of the world.[81] India was so big, so alive and its religions so sophisticated that it was no longer enough simply to curse pagans, to dismiss them and to hope that they might be one day converted. Christianity had to assimilate a heterodoxy millennia-old and still very much alive.[82]

One final, fundamental way in which the discovery deeply affected people was in the notion of 'becoming'. If religions were at different stages of development, and yet all linked in some mysterious way – only glimpsed at so far – did this mean that God, instead of just *being*, could himself be said to be 'becoming', as the rest of life on earth was understood in the classic Graeco-Christian tradition? This was clearly a major question. The most important aspect of all these varied views was that deism was given a new lease of life. God came to be seen, not in an anthropomorphic sense, but as an abstract metaphysical entity. There was, once again, a very real, very large difference between God and man.[83]

The growing understanding that the languages of mankind were related in a systematic way, occurring as it did at much the same time as the new classifications in biology, devised by Linnaeus, together with the advances in Huttonian geology (see below, Chapter 31),

played an important part in reinforcing early ideas about what would become known as evolution. But the Oriental renaissance also played a vital role in a quite different development, one that dominates life even today. This was its links to the origins of the romantic movement.

The most obvious and most virile link was between Indic studies and German romanticism. Indic studies proved popular in Germany for broadly nationalistic reasons. Put bluntly, it seemed to German scholars that the Aryan/Indian/Persian tradition linked in with the original barbarian invasions of the Roman empire from the east and, together with the myths of the Scandinavians, provided an alternative (more northerly) tradition to the Greek and Latin Mediterranean classicism that had dominated European life and thought for the previous 2,500 years (see chapter 10). Furthermore, the similarities between Buddhism and Christianity, the Hindu ideas of a world soul, all this seemed to the Germans as a primitive form of revelation, in fact the original form, out of which Judaism and Christianity might have grown, but which meant that God's real purpose was hidden somewhere in the Eastern religions, that the first religion in the world, before the churches, was somehow to be found in the ancient writings of India. Such a view implies that there was a single God for all mankind, and that there was a world mythology, the understanding of which would be fundamental. In Herder's terms, this ancestral mythology was 'the childhood dreams of our species'.[84]

A further factor which influenced romanticism was that the original Indian scriptures were written in poetry. The idea became popular, therefore, that poetry was 'the mother tongu', that verse was the original way in which wisdom was transmitted from God to mankind ('Man is an animal that sings'). Poetry, it was thought, was the original language of Eden, and it was through the ancient poetry of India that the Edenic world could be rediscovered. In this way the philologists and poets combined to produce what Schwab called 'the revenge of plurality on unity'.[85] At the very moment that the scientists were seeking to bring the world under control, seeing it operate according to fewer and fewer rules, at a time when theories of progress looked forward to a narrowing of experience, as societies were all expected to develop in one and the same direction, the philologists and poets went the other way and sought the regeneration of society through new religion. Their view was that there was a primitive unity to the human race, but it had, over time, developed different religions that were equally valid, its legends and myths and practices equally authoritative, equally suited to the environments and countries in which they held sway. According to this argument, there had been an original monotheism, which had become dispersed into polytheism, meaning that the content of revelation was not, in principle, different from that in mythology. 'All the legends of India and Greece, of the Scandinavians and the Persians "had to be" accepted as components of a new universal religion that would regenerate a world distracted by rationalism.'[86]

The range of poets, writers and philosophers who came under the influence of these views spanned the Atlantic. Emerson and Thoreau were steeped in Buddhism. One of Emerson's first poems was called 'Brahma', and was inspired by the *Bhagavad Gita*. His *Journals* contain many references to Zoroaster, Confucius, the Hindus and the Vedas. On 1 October 1848 he wrote: 'I owed . . . a magnificent day to the *Bhagavad Geeta*. It was the first of books; it was as if an empire spake to us, nothing small or unworthy, but large,

serene, consistent, the voice of an old intelligence which in another age and climate had pondered and thus disposed of the same questions which exercise us.'[87] Thoreau left Emerson his collection of Oriental books. Whitman confessed he had read Hindu poetry in preparation for his own. Goethe learned Persian and wrote in the preface to the *West-Ostliche Divan*: 'Here I want to penetrate to the first origin of human races, when they still received celestial mandates from god in terrestrial languages.'[88] Heine studied Sanskrit under Schlegel at Bonn and under Bopp in Berlin.[89] As he wrote: 'Our lyrics are aimed at singing the Orient.' Schlegel believed that the Aryans, the original inhabitants of India, were 'attracted' to the North – i.e., were the ancestors of the Germans and Scandinavians. Both Schlegel and Ferdinand Eckstein, another German Orientalist, believed that the Indic, Persian and Hellenic epics rested on the same fables which formed the basis of the *Nibelungenlied*, the great medieval German epic of revenge, which Wagner was to rely on for his musical drama *The Ring*.[90] Eckstein sought 'an anterior Christianity ... in the antiquities of paganism'.[91] 'For Schleiermacher, as for the entire circle around Novalis, the source of all religion "can be found", according to Ricarda Huch, "in the unconscious or in the Orient, from whence all religions came".'[92]

Schopenhauer's encounter with the East transformed him. His view of Buddhism was that 'Never has myth come closer to the truth, nor will it.'[93] He was convinced that 'our religions are not taking nor will they take root in India; the primitive wisdom of the human race will not allow itself to be diverted from its course by some escapade that occurred in Galilee.'[94] Christianity, but not Judaism, Schopenhauer said, 'is Indian in spirit, and therefore more than probably of Indian origin, although only indirectly, through Egypt'.[95] Not entirely logically, he then proceeded to examine what he saw as the Indo-Iranian origins of Christianity: 'Although Christianity, in essential respects, taught only what all Asia knew long before, and even better, yet for Europe it was a new and great revelation.' And he went on: 'The New Testament ... must have some sort of Hindu origin; its ethics, which translate morals into asceticism, its pessimism, and its *avatar* all attest to such an origin ... Christian doctrine, born of Hindu wisdom, had completely covered the old trunk of a grosser Judaism completely uncongenial to it.'[96]

Lamartine confessed that Indian philosophy moved him most of all. '[It] eclipses all others for me: it is the oceans, we are only clouds ... I read, reread, and read again ... I cried out, I closed my eyes, I was overwhelmed with admiration ...'[97] He had plans – never realised – for a great sequence of poems, 'an epic of the soul', which he described as *Hindoustanique*.[98] 'From it [India] one inhales a breath at once holy, tender, and sad, which seems to me to have recently passed from an Eden closed to mankind.'[99] For Lamartine, the discovery of India and its literature was not merely 'a new wing to be added to old libraries; it was a new land to be hailed in the cheers of shipwrecked men'.[100] For that other great French writer, Victor Hugo, the Orient both attracted and repelled. In September 1870, when he launched his address 'To the Germans', in which he tried to convince them to spare Paris, during the siege, he made a comparison that many others had made, and which, indeed, Germany liked to make about itself. 'Germany is to the West what India is to the East, a sort of great forebear. Let us venerate her.'[101] His poetry contained many references to Ellora, the Ganges, Brahmans, an 'immense wheel', and magical birds based on Farid al-Din's *Mantiq ut-Tair* (*The Conference of the Birds*).[102] Gustave Flaubert wrote

of 'an immense Indian forest where life throbs in every atom',[103] while Verlaine spent his vacations 'plunged into Hindu mythology'.[104]

In 1865, the French (self-appointed) count, Joseph-Arthur de Gobineau, a notorious racial theorist, published *Les religions et les philosophies dans l'Asie centrale* (1865), the central tenet of which was that all European thought originated in Asia. Gobineau even travelled to Persia in 1855 while he was working on the book, to verify his thesis.[105] He did not agree with others that the northern European languages were descended from India but he did think that its peoples were. For him the Aryans were the nobility of mankind and he considered the word 'Aryan' related to the German *Ehre* (which means 'honour', 'uprightness'). In the final part of *On the Inequality of Human Races*, which he called 'The capacity of the native German races', he argued that the Germanic Aryan is sacred, the race of the lords of the earth, while in the conclusion he announced that 'The Germanic race has been furnished with all the energy of the Aryan variety ... After it the white species had nothing powerful and active to offer.'[106]

At the end of his life, Wagner 'rushed into Gobineau's arms'.[107] He met the man and wrote an introduction to his collected works. Wagner found the Frenchman's philosophy and 'science' congenial to his own aim of displacing French-Italian opera as the centre of the canon and to fashion instead 'a music of the future' that promoted a radically different tradition – German epic, German paganism, 'the unalterable source of purity'.[108] 'As Wagner recounts in *My Life*, it was while working on the orchestration of *Die Walküre* in 1855 that the event occurred which could not fail to fulfil his destiny: "Burnouf's Introduction to the *History of Indian Buddhism* interested me most among my books, and I found material in it for a dramatic poem, which has stayed in my mind ever since ... to the mind of the Buddha the past life (in a former incarnation) of every being who appears before him stands revealed as plainly as the present".'[109] Wagner's diaries are punctuated with references to the Buddha and Buddhist concepts. 'Everything is strange to me, and I often cast a nostalgic glance toward the country of Nirvana. But for me Nirvana again becomes, very quickly, Tristan.'[110] Elements of the *Ramayana* occur in *Parsifal*, and at one stage the composer planned a drama to be taken from the book *Stimmen vom Ganges* (*Voices of the Ganges*).[111]

The Oriental renaissance, then, was many things. It threw new light on religion, on history, on time, on myth, on the relations between the peoples of the world. In the middle of the Enlightenment, and the industrial revolution, it breathed new life into poetry and the poetic and aesthetic approach to human affairs. In the short run it was one of the forces that helped create the romantic revolution, the subject of the next chapter. But in the long run the discovery of the common origins of Sanskrit and Greek and Latin would form part of the modern scientific synthesis, linking genetics, archaeology and linguistics, which has taught us a great deal about the peopling of our world, surely one of the greatest and most important aspects of our history. This represents a significant mind-shift that, too often, is ignored against the backdrop of the other developments in the eighteenth century.

# *The Great Reversal of Values –*
# *Romanticism*

The French composer Hector Berlioz was a remarkable man. 'Everything about him was unusual,' says Harold Schonberg in his *Lives of the Composers*. 'Almost single-handedly he broke up the European musical establishment. After him, music would never be the same.'[1] Even as a student he stood out in a way that many people found shocking. 'He believes in neither God nor Bach,' said the composer-conductor-pianist Ferdinand Hiller, who described Berlioz in this way: 'The high forehead, precipitously overhanging the deep-set eyes; the great, curving hawk nose; the thin, finely-cut lips; the rather short chin; the enormous shock of light brown hair, against the fantastic wealth of which the barber could do nothing – whoever had seen this head would never forget it.' Indeed, Berlioz was almost as well known for his head, and his behaviour, as for his music. Ernest Legouvé, the French dramatist, was at a performance of Weber's opera *Der Freischütz* one evening when a commotion broke out. 'One of my neighbours rises from his seat and bending towards the orchestra shouts in a voice of thunder: "You don't want two flutes there, you brutes! You want two piccolos! Two piccolos, do you hear? Oh, the brutes!" Amidst the general tumult produced by this outburst, I turn around to see a young man trembling with passion, his hands clenched, his eyes flashing, and a head of hair – such a head of hair. It looked like an enormous umbrella of hair, projecting something like a moveable awning over a beak of a bird of prey.' Contemporary cartoonists had a field day.[2]

Berlioz was no mere show-off or exhibitionist, though there were those who thought that he was. Mendelssohn was one who found him affected. After their first meeting, he wrote: 'This purely external enthusiasm, this desperation in the presence of women, the assumption of genius in capital letters, is insupportable to me.'[3] This does no justice to Berlioz's grand ambition, in particular his vision for the orchestra, which Yehudi Menuhin attributes to a new view of society.[4] By common consent, Berlioz was the greatest orchestral innovator in history. By the 1830s, orchestras rarely consisted of more than sixty players. As early as 1825 Berlioz had brought together an orchestra of 150 but his 'dream orchestra', he confessed, would consist of 467, plus a chorus of 360. There were to be 242 strings, thirty harps, thirty pianos and sixteen French horns.[5] Berlioz was far ahead of his time, the first of music's true romantics, an enthusiast, a revolutionary, 'a lawless despot', the first of the conscious avant-gardists, as Schonberg puts it.[6] 'Uninhibited, highly emotional, witty, mercurial, picturesque, he was very conscious of his romanticism. He loved the very

*idea* of romanticism: the urge for self-expression and the bizarre as opposed to the classic ideals of order and restraint.'[7]

Romanticism was a massive revolution in ideas. Very different from the French, industrial and American revolutions, it was no less fundamental. In the history of Western political thought, says Isaiah Berlin, though he is using 'political' in its widest sense, 'there have occurred three major turning-points, when by turning point we mean a radical change in the entire conceptual framework with which questions have been posed: new ideas, new words, new relationships in terms of which the old problems are not so much solved as made to look remote, obsolete and, at times, unintelligible, so that the agonising problems and doubts of the past seem queer ways of thought, or confusions that belong to a world which has gone.'[8]

The first of these turning-points, he says, occurred in the short interval at the end of the fourth century BC between the death of Aristotle (384–322) and the rise of Stoicism, when the philosophical schools of Athens 'ceased to conceive of individuals as intelligible only in the context of social life, ceased to discuss the questions connected with public and political life that had preoccupied the Academy and the Lyceum, as if these questions were no longer central, or even significant, and suddenly spoke of men purely in terms of inner experience and individual salvation'.[9] This great transformation in values – 'from the public to the private, the outer to the inner, the political to the ethical, the city to the individual, from social order to unpolitical anarchism' – was so profound that nothing was the same afterward.[10] The transformation was discussed in Chapter 6.

A second turning-point was inaugurated by Machiavelli (1469–1527). This involved his recognition that there is a division 'between the natural and the moral virtues, the assumption that political values not merely are different from, but may in principle be incompatible with, Christian ethics'.[11] This produced a utilitarian view of religion, in the process discrediting any theological justification for any set of political arrangements. It too was new and startling. 'Men had not previously been openly called upon to choose between irreconcilable sets of values, private and public, in a world without purpose, and told in advance that there could in principle exist no ultimate, objective criterion for this choice.'[12] Machiavelli's political ideas were outlined in Chapter 24.

The third great turning-point – which Berlin argues is the greatest yet – was conceived toward the end of the eighteenth century, with Germany in the vanguard.[13] 'At its simplest the idea of romanticism saw the destruction of the notion of truth and validity in ethics and politics, not merely objective or absolute truth, but subjective and relative truth also – truth and validity as such.' This, says Berlin, has produced vast and incalculable effects. The most important change, he says, has come in the very assumptions underlying Western thought. In the past, it had always been taken for granted that all general questions were of the same logical type: they were questions of fact. It followed from this that the important questions in life could be eventually answered, once all the relevant information had been collected. In other words, it was taken as read that moral and political questions, such as 'What is the best way of life for men?', 'What are rights?', 'What is freedom?' were in principle answerable in exactly the same way as questions like 'What is water composed of?', 'How many stars are there?', 'When did Julius Caesar die?'[14] Wars have been fought

over the answers to these questions, says Berlin, but 'it was always assumed that the answers were discoverable'. This was because, despite the various religious differences that have existed over time, one fundamental idea united men, though it had three aspects.[15] 'The first is that there is such an entity as a human nature, natural or supernatural, which can be understood by the relevant experts; the second is that to have a specific nature is to pursue certain specific goals imposed on it or built into it by God or an impersonal nature of things, and that to pursue these goals is what makes men human; the third is that these goals, and the corresponding interests and values (which it is the business of theology or philosophy or science to discover and formulate), cannot possibly conflict with one another – indeed they must form a harmonious whole.'[16]

It was this basic idea that gave rise to the notion of natural law and the search for harmony. People had been aware of certain inconsistencies – Aristotle, for example, observed that fire burned in the same way in Athens and Persia whereas moral and social rules varied. Nonetheless, down to the eighteenth century people still assumed that all experience in the world was capable of harmonisation once enough data had been collected.[17] The example Berlin gave to underline this point were the questions 'Should I pursue justice?' and 'Should I practise mercy?' As any thoughtful person could see, situations could arise when to answer 'Yes' to both these questions (which most people would go along with) would be incompatible. Under the traditional view, it was assumed that one true proposition could not logically contradict another. The rival contention of the romantics was to cast doubt on the very idea that values, the answers to questions of action and choice, could be discovered *at all*. The romantics argued that some of these questions had no answer, full stop, period. No less originally, they argued further that there was no guarantee that values could not, in principle, conflict with one another. To argue the contrary, they insisted, was 'a form of self-deception' and would lead to trouble. Finally, the romantics produced a new set of values, in fact a new way of looking at values, radically different from the old way.[18]

The first man to glimpse this new approach was Giambattista Vico (1668–1744), the Neapolitan student of jurisprudence we first met in Chapter 24 and who, with stunning simplicity, sabotaged Enlightenment ideas about the centrality of science. In 1725, it will be recalled, he published *Scienza Nuova*, in which he claimed that knowledge about human culture 'is truer than knowledge about physical nature, since humans can know with certainty, and hence establish a science about, what they themselves have created.' The internal life of mankind, he said, can be known in a way that simply does not – cannot – apply to the world man has not made, the world 'out there', the physical world, which is the object of study by traditional science. On this basis, Vico said, language, poetry and myth, all devised by man, are truths with a better claim to validity than the then central triumphs of mathematical philosophy. 'There shines the eternal and never failing light of a truth beyond all question: that the world of civil society has certainly been made by men, and that its principles are therefore to be found within the modifications of our own human mind. Whoever reflects upon this cannot but marvel that the philosophers should have bent all their energies to the study of the world of nature, which, since God made it, He alone knows: and that they should have neglected the study of the world of nations, or the civil world, which, since men made it, men could come to know.'[19]

Very important, if very simple, things followed from this, said Vico, but man had been too busy looking outside himself to notice. For example, people share a nature and must therefore assemble their cultures in similar or analogous ways.[20] This made it possible, even imperative, he said, for careful historians to reconstruct the thought processes of other ages and the phases they go through.[21] He thought it was self-evident that in any civil society men should hold certain beliefs in common – this is what common sense *was*, he thought. And he found that there were three important beliefs that were shared everywhere. These were a belief in Providence throughout history and in all religions, in the immortal soul, and a recognition of the need to regulate the passions.[22] Man, he said, has expressed his nature throughout history and so it must follow that the record of myth and poetry 'is the record of human consciousness'.[23] In saying all this, Vico transformed the human sciences, promoting them so that they were on a par with the natural sciences.

Vico's innovations were not picked up elsewhere for several decades, and it was not until Kant that the new approach began to catch on. Kant's great contribution was to grasp that it is the mind which shapes knowledge, that there *is* such a process as intuition, which is instinctive, and that the phenomenon in the world that we can be most certain of is the difference between 'I' and 'not-I'.[24] On this account, he said, reason 'as a light that illuminates nature's secrets' is inadequate and misplaced as an explanation.[25] Instead, Kant said, the process of birth is a better metaphor, for it implies that human reason *creates* knowledge. In order to find out what I should do in a given situation, I must listen to 'an inner voice'. And it was this which was so subversive. According to the sciences, reason was essentially logical and applied across nature equally.[26] But the inner voice does not conform to this neat scenario. Its commands are not necessarily factual statements at all and, moreover, are not necessarily true or false. 'Commands may be right or wrong, corrupt or disinterested, intelligible or obscure, trivial or important.' The purpose of the inner voice, often enough, is to set someone a goal or a value, and these have nothing to do with science, but are created by the individual. This was a basic shift in the very meaning of individuality and was totally new.[27] In the first instance (and for the first time), it was realised that morality was a creative process but, in the second place, and no less important, it laid a new emphasis on creation, and this too elevated the artist alongside the scientist.[28] It is the artist who creates, who expresses himself, who creates values. The artist does not discover, calculate, deduce, as the scientist (or philosopher) does. In creating, the artist invents his goal and then realises his own path towards that goal. 'Where, asked Herzen, is the song before the composer has conceived it?' Creation in this sense is the only fully autonomous activity of man and for that reason takes pre-eminence. 'If the essence of man is self-mastery – the conscious choice of his own ends and form of life – this constitutes a radical break with the older model that dominated the notion of man's place in the cosmos.'[29] At a stroke, Berlin insists, the romantic vision destroyed the very notion of natural laws, if by that was meant the idea of harmony, with man finding his place in accordance with laws that applied across the universe. By the same token, art was transformed and enlarged. It was no longer mere imitation, or representation, but *expression*, a far more important, far more significant and ambitious activity. A man is most truly himself when he creates. 'That, and not the capacity for reasoning, is the divine spark within me; that is the sense in which I am made in God's image.' This new ethic invited a

new relationship between man and Nature. 'She is the matter upon which I work my will, that which I mould.'[30]

We are still living with the consequences of this revolution. The rival ways of looking at the world – the cool, detached light of disinterested scientific reason, and the red-blooded, passionate creations of the artist – constitute the modern incoherence. Both appear equally true, equally valid, at times, but are fundamentally incompatible. As Isaiah Berlin has described it, we shift uneasily from foot to foot as we recognise this incompatibility.

The dichotomy was shown first and most clearly in Germany. The turn of the nineteenth century saw Napoleon's great series of victories, over Austria, Prussia and several smaller German states, and this advertised the economic, social, and political backwardness of the German-speaking world. These failures created a desire for renewal in the German lands and, in response, many German-speakers turned inward, to intellectual and aesthetic ideas as a way to unite and inspire their people.[31] 'Romanticism is rooted in torment and unhappiness and, at the end of the eighteenth century, the German-speaking countries were the most tormented in Europe.'[32]

In the 1770s cultural and intellectual life centred on the many local courts scattered across greater Germany and it was in one of these that the tradition of Vico and Kant was built upon.[33] Duke Karl August of Saxe-Weimar employed both Johann Wolfgang Goethe and Johann Gottfried Herder at his court. Goethe we shall come to shortly, but first Herder. He had studied theology and then under Kant at Königsberg, where he had been introduced to the works of Hume, Montesquieu and Rousseau.[34] Under their influence he was moved to produce the four volumes of his *Ideas for the Philosophy of the History of Mankind*, between 1784 and 1791. In these books, Herder consciously expanded the ideas of Vico, arguing that the growth in human consciousness, as shown in literature and art, were part of a (generally rosy) historical process.[35] 'We live in a world we ourselves create.'[36] For Herder, it was the 'expressive power' of human nature that had produced some very different cultures across the world, which were demonstrably shaped also by geography, climate, and history. It followed for him that human nature could only be understood by means of the comparative history of different peoples.[37] Each *Volk*, Herder said, had its own history, producing a characteristic consciousness and a particular form of art and literature, not to mention its very language.[38] 'Has a nation anything more precious than the language of its fathers?' Poetry and religion, he said, unite a *Volk* and these truths are therefore to be understood in a spiritual or symbolic way rather than as merely utilitarian. (Ancient poetry, he said, was a form of fossil.)[39] After Herder, as Roger Smith says, the study of the humanities – notably history and literature – became central elements in the new way of understanding society.[40]

An important factor in the creative act was the will. This was first and most vividly introduced as an idea by Johann Gottlieb Fichte.[41] Taking up where Kant left off, Fichte argued that 'I become aware of my own self, not as an element in some larger pattern but in the clash with the not-self, the *Anstoss*, the violent impact of collision with dead matter, which I resist and must subjugate to my free creative design.' On this account, Fichte portrayed the self as 'activity, effort, self-direction. It wills, alters, carves up the world both in thought and in action, in accordance with its own concepts and categories.' Kant had

conceived this as an unconscious, intuitive process but for Fichte it was instead 'a conscious creative activity ... I do not accept anything because I must,' Fichte insists, 'I believe it because I will.'[42] There are two worlds, he says, and man belongs to both. There is the material world, 'out there', governed by cause and effect, and there is the inner spiritual world, 'Where I am wholly my own creation.'[43] This insight (itself a construct) brought about a radical change in the understanding of philosophy. 'My philosophy depends on the kind of man I am, not vice versa.' In this way the will assumed a larger and larger role in human psychology. All people reason in essentially the same way, says Fichte. Where they differ is in their will; and this can and does produce conflict whereas reason is unable to, because logic is logic.[44]

The effects of this were momentous. For one thing, the understanding of work changed. Instead of being regarded as an ugly necessity, it was transformed into 'the sacred task of man', because only by work – an expression of the will – could man bring his distinctive, creative personality to bear upon 'the dead stuff' of nature.[45] Man now moved ever further from the monastic ideal of the Middle Ages, in that his real essence was understood not as contemplation but as *activity*. In a sense, and among the German romantics in particular, the Lutheran concept of vocation was adapted to the romantic ideal but instead of God and worship being the object of activity, what mattered now was the individual's search for his freedom, in particular 'the creative end which fulfils his individual purpose'.[46] What matters for the artist now is 'motive, integrity, sincerity ... purity of heart, spontaneity'. *Intention*, not wisdom or success, is what counts. The traditional model – the sage, the man who knows, who achieves 'happiness or virtue or wisdom, by means of understanding' – is replaced by the tragic hero 'who seeks to realise himself at whatever cost, against whatever odds'.[47] Worldly success is immaterial.

This reversal of values cannot be overstated. To begin with, man creates himself and therefore has no identifiable nature, which determines how he behaves, reacts and thinks. And unlike anything that has gone before, he is not answerable for the consequences. Second, and arguably more shocking, since man's values are not discovered but created, there is no way they can ever be described or systematised, 'for they are not facts, not entities of the world'. They are simply outside the realm of science, ethics or politics. Third, the uncomfortable truth is that the values of different civilisations, or nations, or individuals, might well collide. Harmony cannot be guaranteed, even within one individual whose own values may shift over time.[48]

Here too the importance of the change in thinking cannot be exaggerated. In the past, if a Christian killed a Muslim, say, in a crusade, he might regret that such a brave adversary had died for a faith that was false. But, and this is the central point, the very fact that the Muslim, say, held his false faith sincerely only made the situation worse. The more the enemy was attached to his false faith, the less he was admired.[49] The romantics took a completely contrary view. For them, martyrs, tragic heroes, who fought gallantly for their beliefs against overwhelming odds, became the ideal.[50] What they valued above all else was defeat and failure when it arose in defiance of compromise or worldly success.[51] The artist or hero as outsider is born in this way.

It is an idea that leads to a form of literature, painting and (most vividly) music that we

instantly recognise – the martyred hero, the tragic hero, the outcast genius, the suffering wild man, rebelling against a tame and philistine society.[52] As Arnold Hauser rightly says, there is no aspect of modern art which does not owe something important to romanticism. 'The whole exuberance, anarchy and violence of modern art . . . its unrestrained, unsparing exhibitionism, is derived from it. And this subjective, egocentric attitude has become so much a matter of course for us, so absolutely inevitable, that we find it impossible to reproduce even an abstract train of thought without talking about our own feelings.'[53]

The very beginning of the romantic movement, the decade of the 1770s, saw the phenomenon of *Sturm und Drang*, 'storm and stress', a young generation of German poets who rebelled against their strict education and social conventions to explore their emotions.[54] The best-known of these 'ill-considered' works was Goethe's *The Sorrows of Young Werther* (1774).[55] Here we have the perfect romantic scenario, in which the individual is set against and is at odds with society. Werther is a young, enthusiastic, passionate individual isolated amid strict, desiccated, pious Lutherans. But Goethe was only the beginning. The despair and disillusion, the sentimentality and melancholy of Chateaubriand and Rousseau kick-start romanticism, alongside Goethe, exploring the ways in which conventional society is unable to meet the spiritual needs of its heroes. The vast, the sprawling panoramas of Victor Hugo and the 'Bohemian groves' of Théophile Gautier and Alexandre Dumas, in which political and personal ambitions are intertwined, confirm Hugo's argument that 'romanticism is the liberalism of literature'.[56] The approach of Stendhal and Prosper Mérimée, viewing art as a 'secret paradise forbidden to ordinary mortals', highlights one of the aims of romanticism, which became know as *l'art pour l'art*, art for art's sake. Balzac stressed the 'unavoidable necessity' of taking sides in the great questions of the day, the argument that one could not be an artist and sit on the sidelines.[57]

Whereas French romanticism was essentially a reaction to the French Revolution, the English variety was a reaction to the industrial revolution (Byron, Shelley, Godwin and Leigh Hunt were all radicals, though Sir Walter Scott and Wordsworth remained or became Tories). As Arnold Hauser frames it, 'The romantics' enthusiasm for nature is just as unthinkable without the isolation of the town from the countryside as is their pessimism without the bleakness and misery of the industrial cities.'[58] It is the younger romantics – Shelley, Keats and Byron – who adopt an uncompromising humanism, aware of the dehumanising effects of factory life on life in general, and even the more conservative representatives, Wordsworth and Scott, share their 'democratic' sympathies in that their work is aimed at the popularisation – even the politicisation – of literature.[59] Like their German and French counterparts, the English romantic poets believed in a transcendental spirit which was the source of poetic inspiration. They wallowed in language, explored consciousness, and saw in anyone who had the power to generate a poetic form of words an echo of Plato's contention that here was some sort of divine intention. This is what Coleridge meant by his famous epigram that 'poets are the unacknowledged legislators of mankind'. (Wordsworth feared an 'apocalypse of the imagination'.[60]) In a sense the poet became his own god.[61] Shelley is perhaps the classic romanticist: a born rebel, an atheist, he saw the world as one great battle between the forces of good and evil. Even his atheism, it has been said, is more a revolt against God as a tyrant, than a denial of Him. In the same vein, Keats' poetry is imbued with a pervading melancholy, a mourning for 'the beauty

that is not life', for a beauty that is beyond his grasp. The mystery of art is in the process of replacing the mystery of faith.

Byron was probably the most famous romantic. (Describing 'the romantic *moi*', Howard Mumford Jones aptly notes that whereas Wordsworth's egotism was internalised, Byron's was 'there for all Europe to see'.[62]) In his work Byron's portrayal of the hero as an eternally homeless wanderer, partly doomed by his own wild nature, is by no means original. But earlier heroes of this type invariably felt guilty or melancholic about the fact that they were outside society, whereas in Byron the outsider status becomes transformed into 'a self-righteous mutiny' against society, 'the feeling of isolation develops into a resentful cult of solitude', and his heroes are little more than exhibitionists, 'who openly display their wounds'.[63] These outlaws, who declare war on society, dominate literature in the nineteenth century. If the type had been invented by Rousseau and Chateaubriand, by Byron's time it had become narcissistic. '[The hero] is unsparing towards himself and merciless towards others. He knows no pardon and asks no forgiveness, either from God or man. He regrets nothing and, in spite of his disastrous life, would not wish to have anything different . . . He is rough and wild but of high descent . . . a peculiar charm emanates from him which no woman can resist and to which all men react with friendship or enmity.'[64]

Byron's significance went wider even than this. His idea of the 'fallen angel' was an archetype adopted by many others, including Lamartine and Heine. Among other things, the nineteenth century was characterised by guilt, at having fallen away from God (see Chapter 35), and the tragic hero of Byronic dimensions fitted the bill to perfection. But the other changes wrought by Byron were equally significant in their long-term effects. It was Byron, for example, who encouraged the reader to indulge in intimacy with the hero. In turn this increased the reader's interest in the author. Until the romantic movement, the private life of a writer was largely unknown, and of little interest, to readers. Byron and his self-advertisements changed all that. After him, the relationship between a writer and his audience came to resemble, on the one hand, that of therapist and patient and, on the other, that of a film star and his fans.[65]

Associated with this was another major change, the notion of the 'second self', the belief that inside every romantic figure, in the dark and chaotic recesses of the soul, was a completely different person and that once access to this second self had been found, an alternative – and deeper – reality would be uncovered.[66] This is in effect the discovery of the unconscious, interpreted here to mean an entity that is hidden away from the rational mind which is nonetheless the source of irrational solutions to problems, a secret, ecstatic something, which is above all mysterious, nocturnal, grotesque, ghostlike and macabre.[67] (Goethe once described romanticism as 'hospital-poetry' and Novalis pictured life as 'a disease of the mind'.) The second self, the unconscious, was seen as a way to spiritual enlargement and was expected to contribute to the great lyricism that was such a feature of romanticism.[68] The discovery of the unconscious is the subject of Chapter 36.

Furthermore, the idea of the artist as a more sensitive soul than others, with perhaps a direct line to the divine, which went back to Plato, carried with it a natural conflict between the artist and the bourgeoisie.[69] The early nineteenth century was the point at which the very concept of the *avant-garde* could arise, with the artist viewed as someone who was ahead of his time, ahead of the bourgeoisie certainly. Art was a 'forbidden fruit', available

only to the initiated and most certainly denied to the 'philistine' bourgeoisie. And it was not far from there to the idea that youth was seen as more creative than – and as inevitably superior to – age. The young inevitably knew what the coming thing was, inevitably had the energy to embrace new ideas and fashions, being naturally less familiar with more established patterns. The very concept of genius played up the instinctive spark in new talent at the expense of painfully acquired learning over a lifetime of effort.

In painting romanticism produced Turner, whose pictures, said John Hoppner, were like looking into a coal fire (a metaphor adopted for the music of Berlioz), and Delacroix, who said that a picture should above all be a feast for the eyes. But it was in music that romanticism surpassed itself. The great generation of romantic composers were all born within ten years of one another – Berlioz, Schumann, Liszt, Mendelssohn, Verdi and Wagner. Before all these, however, there was Beethoven. All music leads up to Beethoven, says Mumford Jones, and all music leads away from him.[70] Beethoven, Schubert and Weber comprised a smaller grouping, of what we might call pre-romantic composers, who between them changed the face of musical thought, and musical performance.

The great difference between Beethoven (1770–1827) and Mozart, who was only fourteen years older, was that Beethoven thought of himself as an artist. There is no mention of that word in Mozart's letters – he considered himself a skilled craftsman who, as Haydn and Bach had done before him, supplied a commodity. But Beethoven saw himself as part of a special breed, a creator, and that put him on a par with royalty and other elevated souls. 'What is in my heart,' he said, 'must come out.'[71] Goethe was just one who responded to the force of his personality, writing, 'Never have I met an artist of such spiritual concentration and intensity, such vitality and great-heartedness. I can well understand how hard he must find it to adapt to the world and its ways.'[72] Even the crossings-out in his autograph music have a violence that Mozart, for example, lacked.[73] Like Wagner after him, Beethoven felt that the world owed him a living, because he was a genius. At one stage, two Viennese princes settled some money on Beethoven, to keep him in the city. After one of them was killed in an accident, Beethoven took the man's estate to court, to enforce payment. He felt it was his entitlement.[74]

In a lifetime of creating much beautiful music, two compositions stand out, two works which changed the course of music for all time. These were the *Eroica* symphony, which had its premiere in 1805, and the Ninth symphony, first performed in 1824.[75] Harold Schonberg wonders what went through the mind of the audience on the momentous occasion when the *Eroica* was first performed. 'It was faced with a monster of a symphony, a symphony longer than any previously written and much more heavily scored; a symphony with complex harmonies, a symphony of titanic force; a symphony of fierce dissonances; a symphony with a funeral march that is paralysing in its intensity.'[76] This was a new musical language and for many the *Eroica* and its pathos were never surpassed. George Marek says it must have been an experience similar to hearing the news of the splitting of the atom.[77]

Beethoven was a romantic enough figure anyway but the hearing difficulties that began to afflict him around the time that *Eroica* was first performed and would in time develop into complete deafness, also drove him inwards. *Fidelio*, his grand opera (though perhaps with too many characters), the great violin and piano concertos, the famous piano sonatas,

such as the *Waldstein* and the *Appassionata*, all had their mysterious, mystic, monumental elements. But the Ninth symphony was pivotal, and was always held in the highest esteem by the romantics who came after. By all accounts, its premiere was disastrous, after only two rehearsals and when many of the singers could not reach the high notes. (The lead singers begged Beethoven to change them, but he refused – no one had a more magnificent will than he.[78]) However, what the *Eroica* and Ninth symphonies have in common, what made their sounds so new and so different from the music of, say, Mozart, was that Beethoven was concerned above all with inner states of being, with the urge for self-expression, the dramatic intensity of the soul. 'Beethoven's music is not polite. What he presented, as no composer before or since, was a feeling of drama, of conflict and resolution . . . The music [of the Ninth] is not pretty or even attractive. It merely is sublime . . . this is music turned inward, music of the spirit, music of extreme subjectivity . . .'[79] It was the Ninth symphony, its gigantic struggle 'of protest and release', that most influenced Berlioz and Wagner, that remained the (largely unattainable) ideal for Brahms, Bruckner and Mahler.[80] Debussy confessed that the great score had become, for composers, 'a universal nightmare'. What he meant was that few other composers could match Beethoven, and perhaps only one, Wagner, could surpass him.

Franz Schubert has been described as 'the classical romantic'.[81] He had a short life (1797–1828), all of which he spent in Beethoven's shadow. But he too felt that he could only be an artist, telling a friend that 'I have come into the world for no purpose but to compose.' He began life as a boy singer in a choir and then as a schoolteacher after his voice broke. But he hated that and turned to composing. Like Beethoven, he was small, five feet one and a half inches, as compared with five feet four. He was nicknamed *Schwammerl* ('Tubby') and as Beethoven's hearing was bad, so Schubert's eyesight was poor. More important, he was the perfect example of the romantic with two selves. While, on the one hand, he was very well read and made his name by setting many poems – of Goethe, Schiller and Heine – to music, he drank more than he should, contracted venereal disease and in general let his craving for pleasure drag him down. This showed in his music, especially his 'Song of Sorrow', the symphony in B minor.[82] He was also the master of music for the unaccompanied voice.[83]

Schubert died in the year that followed Beethoven's death. By that time, much of the modern world was coming into existence. New railways were connecting people rapidly. Thanks to the industrial revolution, vast fortunes were being made by the bourgeoisie, alongside desperate poverty. Aspects of this rubbed off directly on the world of music. It was no longer simply a court experience but was now enjoyed by the newly-emerging bourgeoisie. They had discovered dance music, with the waltz, in particular, becoming a craze at the time of the Congress of Vienna, in 1814–1815. In the 1820s, at the time of Carnival, Vienna offered as many as 1,600 balls in a single night.[84] But the city also had four theatres which offered opera at one time or another, and many smaller halls, at the university and elsewhere. Middle-class music-making had arrived.

Besides the new theatres, for concerts and opera, for example, the new technologies had a profound impact on instruments themselves. Beethoven had increased the size of the orchestra and, as was mentioned at the beginning of this chapter, Berlioz would increase it still more. At the same time, the new metal technology greatly improved the otherwise

unreliable wind instruments of the eighteenth century. Keys and valves were devised which enabled horns and bassoons, for example, to play more consistently in tune.[85] The new metal, articulated keys also enabled players to reach holes their fingers couldn't otherwise span. The tuba evolved and Adolph Sax invented the saxophone.[86] At the same time, as orchestras grew in size, there emerged the need for someone to take control. Until then, most ensembles could be controlled either by the first violinist, or whoever was playing the clavier. But after Beethoven, around 1820, the conductor as we know him today emerged. The composers Ludwig Spohr and Carl Maria von Weber were among those who conducted their own music with a baton, together with François-Antoine Habeneck, the founder of the Paris Conservatory Orchestra (in 1828), who conducted with his bow.

It was around this time, too, that the modern piano emerged. Two elements were involved here. One was the evolution of the steel frame, steel being developed as a result of the industrial revolution, which enabled pianos to become much more massive and sturdy than they had been in, say, Mozart's day. The other factor was the genius (and marketing) of Niccolò Paganini (1782–1840), who debuted at nineteen and may just have been the greatest violinist who ever existed.[87] A superb technician and a flamboyant showman, who liked to deliberately break a string during a performance, and complete the evening using only three strings, he was the first of the supervirtuosi.[88] But he did expand the technique of the violin, introducing new bowings, fingerings and harmonics, in the process stimulating pianists to try to emulate him on their new, more versatile instruments.[89]

The man who most emulated Paganini, on the piano at any rate, was Franz Liszt, the first pianist in history to give a concert on his own. It was partly thanks to these virtuosi that so many concert halls were built all over Europe (and, in a small way, in north America), to cope with the demand from the newly-enriched bourgeoisie, who were eager to hear these performers. In turn a raft of composer-instrumentalists emerged to take advantage of this development: Weber, Mendelssohn, Chopin and Liszt were the four greatest pianists of their time and Berlioz, Mendelssohn, Weber and Wagner were the four greatest conductors.[90]

'Within one decade, roughly 1830–1840,' says Harold Schonberg, 'the entire harmonic vocabulary of music changed. It seemed to come from nowhere, but all of a sudden composers were using seventh, ninth, and even eleventh chords, altered chords and a chromatic as opposed to classical diatonic harmony ... the romantics revelled in unusual tone combinations, sophisticated chords, and dissonances that were excruciating to the more conventional minds of the day.'[91] Romantic music thus had its own sound – rich and sensuous, its own mood, mystical – but it was also new in that it had a 'programme', it told a story, something that had been unthinkable hitherto.[92] This development underlined the new, close alliance between music and literature where its aim, often enough, was to describe – as Beethoven had pioneered – inner states of feeling, or states of mind.

Carl Maria von Weber was, like Schubert, another very romantic figure, if not quite in the Beethoven or Berlioz sense. He had a diseased hip and walked with a limp but, on top of that, he was a consumptive, perhaps *the* illness of the romantic age, a slow, tragic, wasting-away (the heroines of *La Traviata* and *La Bohème* are consumptives). Weber was also a virtuoso of the guitar and an excellent singer, until he damaged his voice by

accidentally drinking a glass of nitric acid. But he also had enormous hands, which meant that he could play certain passages of his music that cannot be played by ordinary mortals.[93] He was summoned to Dresden to take control of the opera house there, where he made the conductor (himself) the single most dominant force, setting a fashion. But he also worked hard to counter what was then a craze for Italian opera, based mainly on the works of Rossini. It was thanks to Weber that a German operatic tradition emerged that was to culminate in Wagner. Weber's own opera *Der Freischütz*, first performed in 1820, opened up a new world. It dealt with the supernatural, with the mystical power of evil, a form of plotting that would remain popular throughout the nineteenth century. He himself said that the most important line in the opera is spoken by the hero, Max: '*Doch mich umgarnen finstre Mächte!*' ('But the dark powers enmesh me').[94]

Berlioz was the first composer in history to express himself in music in a frankly autobiographical way, though he also 'took his fire' from Shakespeare, Byron and Goethe.[95] He has been described as 'the first truly wild man of music', eclipsing even Beethoven on this score. A revolutionary, a mercurial figure who shared with Beethoven a self-consciousness about his genius that would become the hallmark of the romantic movement, he wrote a vivid autobiography but his music was autobiographical too. His first great work – and perhaps the greatest of his life, his 'opium nightmare', the *Symphonie fantastique* – recorded his passionate love affair with the Irish actress Harriet Smithson.[96] The affair was hardly romantic to begin with, at least in the conventional sense. He saw her on stage and began to bombard her with letters before they had even met. These letters were so passionate and so intimate that she became bewildered, even frightened. (He would go to the theatre to watch her, only to scream in rage and leave when she was embraced by her stage lover.) So distressed was he by her behaviour that when he heard rumours that she was having an affair, he put her into the last act of his symphony as a whore. When he learned that the rumours were false, he changed the music. The afternoon when she finally consented to be seen in public at one of his performances set the seal, says David Cairns, 'on one of the high dates of the romantic calendar'.[97] Until Berlioz, music had never been made to tell a story to quite this extent and such an idea changed composers and audiences. Among those who was most impressed was Wagner, who thought there were only three composers worth paying attention to – Liszt, Berlioz and himself. This does little justice to Schumann and Chopin.

Robert Schumann was in some ways the most complete romantic. Surrounded by insanity and suicide in his family, he was worried all his life that he too would succumb in one way or the other. The son of a bookseller and publisher, he grew up surrounded by the works of the great romantic writers – Goethe, Shakespeare, Byron and Novalis – all of whom exerted a great influence on him. (He burst into tears when he read Byron's *Manfred*, which he later set to music.[98]) Schumann tried to write poetry himself and emulated Byron in other ways too, embarking on numerous love affairs. In the early 1850s he suffered a week of hallucinations, when he thought that the angels were dictating music to him, while he was threatened by wild animals. He threw himself off a bridge but failed to kill himself and, at his own request, was placed in an asylum. His best-known, and perhaps best-loved, work is *Carnaval*, in which he paints pictures of his friends, his wife Clara, Chopin, Paganini and Mendelssohn. (*Carnaval* was a great influence on Brahms.[99])

Though he was a friend of many of the great romantics, including Delacroix (who was the recipient of many letters regarding the love affair with George Sand), Chopin affected to despise their aims. He was polite – rather than enthusiastic – about Delacroix's painting, he had no interest in reading the great romantic authors, but he did share with Beethoven, Berlioz and Liszt the awareness that he was a genius. Polish by birth, he moved to Paris in the 1830s and 1840s, when that city was the capital of the romantic movement, and at the musical evenings held at the salon of the musical publisher Pleyel he would play four-handed piano with Liszt, with Mendelssohn turning the pages.[100] Chopin invented a new kind of piano playing, the one that we are familiar with today. He had certain reflexes in his fingers which set him apart from other players, at that time at least, and this enabled him to develop piano music that was both experimental and yet refined. 'Cannon buried in flowers' is how Schumann described it. (The sentiment was not returned.)[101] Chopin introduced new ideas about pedalling, fingering, and rhythm, which were to prove extremely influential. (He preferred the English Broadwood pianos, less advanced than some available.)[102] His pieces had the delicacy and yet the vivid colourings of impressionist paintings, and just as everyone knows a Renoir from a Degas, so everyone knows Chopin when they hear it. He may not have thought of himself as a romantic but his polonaises and nocturnes are romanticism implicit (after him and his polonaises, music was invaded by nationalism).[103] The piano cannot be fully understood without Chopin.

Or without Liszt. Like Chopin he was a brilliant technician (he gave his first solo at ten), and like Beethoven (whose Broadwood he acquired) and Berlioz, he had charisma.[104] Good-looking, which was part of that charisma, Liszt invented bravura piano playing. Before him, pianists had played from the wrist, holding their hands close together and near the keyboard. He, however, was the first of the pianists whose performance would begin with his arrival on stage. He would sit down, throw off his gloves, dropping them anywhere, hold his hands high, and then attack the keyboard (women would fight to obtain one of Liszt's gloves).[105] He was, then, a showman, and for many people that has made him a charlatan.[106] But he was undoubtedly the most romantic of piano players, arguably the greatest there has ever been, who absorbed the influence of Berlioz, Paganini and Chopin. He invented the solo recital and pianists from all over Europe flocked to study with him. He influenced Wagner enormously, introducing new musical forms, in particular the symphonic poem – one-movement programme music with great symbolism inspired by a poem or a play.[107] In his bold chromaticism, he introduced dissonances that were copied by everyone from Chopin to Wagner. Liszt grew into the grand old man of music, outliving most of his contemporaries by several decades. One of 'the snobs of history', his flowing white hair and 'collection of warts' gave his head as distinctive an appearance in old age as it had had in his youth.[108]

Felix Mendelssohn was possibly the most widely accomplished musician after Mozart. A fine pianist, he was also the greatest conductor of his day and the greatest organist. He was an excellent violinist and was well read in poetry and philosophy. (He was the romantic classicist, says Alfred Einstein.[109]) He came from a wealthy Jewish banking family, and was the grandson of the philosopher Moses Mendelssohn. A fervent German patriot, he believed that his compatriots were supreme in all the arts. Indeed, if there is such a thing, Mendelssohn was *over*-cultured. As a boy he was made to get up at 5.00 am to work on his

music, his history, his Greek and Latin, his science and his comparative literature. When he had been born his mother had looked at his hands and remarked 'Bach fugue fingers!'[110] Like so many of the other romantic musicians, he was a child prodigy, though he was doubly fortunate in that his parents could afford to hire their own orchestra and he could have them play his own compositions, where he would conduct. He went to Paris and met Liszt, Chopin and Berlioz. For his first work he took as his inspiration Shakespeare: this was *A Midsummer Night's Dream*, a fairyland that was perfect romantic material (though Mendelssohn never had much in the way of internal demons).[111] After Paris, he went to Leipzig as musical director and in a short while made it the musical capital of Germany. One of the first conductors to use the baton, he employed it to turn the Leipzig orchestra into the foremost instrument of music of the day – precise, sparing, with a predilection for speed. He increased the size of the orchestra and revised the repertoire. In fact, Mendelssohn was probably the first conductor to adopt the dictatorial manner that seems so popular today, as well as being the main organiser of the basic repertoire that we now hear, with Mozart and Beethoven as the backbone, Haydn, Bach (whose *St Matthew Passion* he rescued from a hundred years' slumber) and Handel not far behind, and with Rossini, Liszt, Chopin, Schubert and Schumann also included.[112] It was Mendelssohn who conceived the shape of most concerts as we hear them: an overture, a large-scale work, such as a symphony, followed by a concerto. (Until Mendelssohn, most symphonies were considered too long to hear at one go: interspersed between movements there would be shorter, less demanding pieces.)[113]

The seal was set on the great romantic onslaught in music by developments in what is possibly the most passionate of all art forms – opera. The nineteenth century produced the two great colossi of opera, one Italian, the other German.

Giuseppe Verdi (1813–1901) was unlike most of his musical contemporaries in that he was no child prodigy. His piano playing was weak and he failed to get into the Milan conservatory at his first attempt. His first opera was a modest success, his second a failure but his third, *Nabucco*, made him famous throughout Italy. During rehearsals for this opera no work was done off-stage because the painters and machinists were so excited and so moved by the music they heard being put together that they left their tasks to crowd round the orchestra pit. Besides the music, and the fact that Verdi used a larger than conventional orchestra, *Nabucco* became popular in Italy because it was seen as symbolic of the Italian resistance to Austrian domination and occupation of the country. 'The "*Va, pensiero*" chorus, which concerns the longing of the Jewish exiles for home, was identified by all Italian listeners with their own longing for freedom.'[114] On the first night the audience stood up and cheered.[115] Verdi was a fervent nationalist himself, who lived to see the unification of Italy, and later became a (reluctant) deputy in the new parliament. The letters V.E.R.D.I., scratched on a wall in any Italian town under Austrian occupation, were understood to mean: 'Vittorio Emmanuele, Re d'Italia'.[116]

In the operas that followed *Nabucco* – *I Lombardi* and *Ernani*, and in particular *Macbeth* – Verdi produced a type of opera music that hadn't been heard before, but took as its cue what was happening among the romantic composers. Instead of pretty, melodious, controlled music, Verdi was looking for the sounds produced by the singers' voices to

reflect their inner states, their turmoil, their love, their hate, their psychological stress and distress. Verdi himself explained this explicitly in a letter he wrote to the director of the Paris Opera just as *Macbeth* was about to go into rehearsal. Among other things, he objected to the choice of Eugenia Tadolini, one of the great singers of the day. 'Tadolini has too great qualities for this role [as Lady Macbeth]. Perhaps you think that is a contradiction! Tadolini's appearance is good and beautiful, and I would like Lady Macbeth twisted and ugly. Tadolini sings to perfection, and I don't wish Lady Macbeth to sing at all. Tadolini has a marvellous, brilliant, clear, powerful voice, and for Lady Macbeth I should like a raw, choked, hollow voice. Tadolini's voice has something angelic. Lady Macbeth's voice should have something devilish . . .'[117] Verdi was moving toward musical drama, melodrama, in which raw emotion is presented on stage 'in great primary colours: love, hate, revenge, lust for power'.[118] It was led by melody rather than the harmony of the orchestra and so has a humanism that is lacking in Wagner.[119] Even so, it was quite different from anything that had gone before, and meant that while his operas were hugely popular with audiences (the doors for the first performance had to be opened four hours in advance, the crush was so great), they received an unprecedented critical onslaught. For one performance of *Rigoletto*, in New York in 1855, two men tried to take the production to court, to have it banned on grounds that it was too obscene for women to see it.[120]

At the end of his long life, when he was an institution in Italy, Verdi returned to Shakespeare, with *Otello* and *Falstaff*. As in the original Shakespeare story, *Falstaff* is both a comedy and a tragedy, perhaps the hardest of genres to pull off (it was in Verdi's contract that he could withdraw the opera after the dress rehearsal if it wasn't right). We do and we do not like Falstaff. It is hard to feel that a fool can be a tragic character, but of course he is to himself. Verdi's music – its very grandeur – adds to Shakespeare's stories, to enable us to see that tragedy can indeed take place, even when there is no tragic hero in an obvious way. In this sense, Verdi's *Falstaff*, premiered at La Scala in Milan in February 1893, brings romanticism to a close.[121]

By then Wagner and his brand of romanticism were already dead. Whether or not Wagner is a bigger musician than Verdi, he was certainly a bigger and more complex man, Falstaffian in dimensions and perhaps as hard to warm to. Character-wise, Wagner was in the Beethoven/Berlioz mould, even eclipsing them, and always very self-conscious about his genius. Drama was in his very bones.[122] 'I am not made like other people. I must have brilliance and beauty and light. The world owes me what I need. I can't live on a miserable organist's pittance like your master, Bach.'[123] Like Verdi he was a slow starter and it was not until he heard Beethoven's Ninth symphony, and *Fidelio*, when he was fifteen, that he decided to become a musician. He could never do more than tinker with the piano, and admitted he was not the greatest of score readers. His early works, says Harold Schonberg, 'show no talent'.[124] As with Berlioz, Wagner's intensity filled some of his early lovers with fear, and as with Schubert he was constantly in debt, at least in the early years of his career. In Leipzig, where he received some tuition (but was dismissed), he was known as a heavy drinker, a gambler and a compulsive and dogmatic talker.

But after a series of adventures, when his creditors pursued him from pillar to post, he eventually produced the five-act *Rienzi* and this made him famous, as *Nabucco* had made Verdi famous.[125] It was staged at Dresden, which immediately secured the rights to *Der*

*fliegende Holländer*, after which Wagner was appointed *Kapellmeister* there. *Tannhäuser* and *Lohengrin* followed, which were well received, the latter especially, with its novel blend of woodwind and strings, though he himself had to flee Dresden after he sided with the revolutionaries during the uprising of 1848.[126] He decamped to Weimar, staying with Liszt and then moved on to Zurich, where for six years he produced next to nothing. He was trying to work out his artistic theories, familiarised himself with Schopenhauer, and this eventually generated a number of written works, *Art and Revolution* (1849), *The Art Work of the Future* (1850), *Judaism and Music* (1850) and *Opera and Drama* (1851), but also a big libretto based on the medieval Teutonic legend, *Nibelungenlied*. This was Wagner's concept of what he called the *Gesamtkunstwerk*, the unified art work, in which he claimed that all great art – words, music, settings and costumes, fused together – must be based on myth, as the first recorded utterances of the gods, as a modern (and romantic) gloss on holy scripture. For Wagner, it was necessary to go to pre-Christian traditions because Christianity had perverted what had gone before. One possibility, as the Oriental renaissance had shown, was the Aryan myths of India but Wagner, following the German Indics, preferred the Northern tradition, which played counterpoint with the classical Mediterranean tradition. This was how he arrived at the Teutonic *Nibelungenlied*.[127] In addition to the new myth, Wagner developed his ideas of a new form of speech, or rather he recreated on old form, *Stabreim*, which recalls the poetry found in the sagas, in which the vowels at the end of one line are repeated in the first syllables or words of the next line. On top of this came his new ideas for the orchestra (even bigger for Wagner than for Beethoven and Berlioz). Here he developed his concept of music unbroken throughout a composition. The orchestra thus became as much a part of the drama as the singers. (Wagner was proud of never having written '*recitative*' over any passage, and he himself called this 'the greatest artistic achievement of our age'.[128])

The effect of all this, says one critic, is that while Europe was whistling Verdi, it was *talking* about Wagner. Many people hated the new sounds (many still do), and another (British) critic dismissed Wagner as 'simply noise'. But others thought the composer was 'an elemental force' and when *Tristan und Isolde* was produced this view was confirmed. 'Never in the history of music had there been an operatic score of comparable breadth, intensity, harmonic richness, massive orchestration, sensuousness, power, imagination and colour. The opening chords of *Tristan* were to the last half of the nineteenth century what the *Eroica* and Ninth Symphonies had been to the first half – a breakaway, a new concept.' Wagner later said he had been in some sort of trance when he produced the opera. 'Here, in perfect trustfulness, I plunged into the inner depths of soul-events and from the innermost centre of the world I fearlessly built up to its outer form.' *Tristan* is a relentless work, 'gradually peeling away layers of the subconscious to the abyss within'.[129]

Wagner's unique position was revealed most clearly in the last phase of his life when he was saved, appropriately enough, by the mad King Ludwig II of Bavaria. Ludwig, a homosexual, was certainly in love with Wagner's music, and may just have been in love with Wagner himself. In any event, he told the composer that he could do more or less what he wanted in Bavaria and Wagner didn't need to be asked twice. 'I am the most German of beings. I am the German spirit. Consider the incomparable magic of my works.'[130] Although he was forced into exile for a while, on account of his extravagance

and a scandalous foray into politics, his involvement with Ludwig did lead eventually to the culmination of his career and another culmination of romanticism. This was his idea of a festival theatre dedicated to his works alone – Bayreuth, and to the *Ring*. The first Bayreuth Festival was held in 1876, and it was here that *Der Ring des Nibelungen* – the fruit of twenty-five years' work – was first performed.[131] For the first festival, some four thousand disciples descended on Bayreuth, along with the emperor of Germany, the emperor and empress of Brazil, seven other royals, and some sixty newspaper correspondents from all over the world, including two from New York who were allowed to use the new transatlantic cable to get their stories published almost immediately.[132]

Although he had his critics, and would always have his critics, the magisterial sweep of the *Ring* was another turning-point in musical ideas. An allegory, a 'cosmic drama of might redeemed by love', which explained why traditional values were the only thing which could rescue the modern world from its inevitable doom, it also gave no comfort to Christianity.[133] Though set in myth, it was curiously modern, and this was its appeal. (Nike Wagner also says the story has many parallels with the Wagner family itself.) 'The listener is swept into something primal, timeless, and is pushed by elemental forces. The *Ring* is a conception that deals not with women but Woman; not with men, but with Man; not with people, but with the Folk; not with mind, but with the subconscious; not with religion, but with basic ritual; not with nature, but Nature.'[134] Wagner lived from then on like a cross between royalty and deity, fêted, lauded, dressed in the finest silks, doused in the finest incense, and took the opportunity to develop his writing as much as his music. These views – on the Jews, on craniology, on the claim that the Aryans had descended from the gods – have weathered less well, much less well, than his music. Some of them were frankly ludicrous. But there is no question that Wagner, by his very self-confidence, his Nietzschean will, by his creation of Bayreuth as an asylum from the everyday world, did help to establish a climate of opinion, particularly in Germany at the end of the nineteenth century (see Chapter 36).[135] In music he was a strong influence on Richard Strauss, on Bruckner and Mahler, on Dvořák, and even on Schoenberg and Berg. Whistler, Degas and Cézanne were all Wagnerians, while Odilon Redon and Henri Fantin-Latour painted images inspired by his operas. Mallarmé and Baudelaire declared themselves won over. Much later, Adolf Hitler was to say, 'Whoever wants to understand National Socialistic Germany must know Wagner.'[136]

An unfortunate comment. The real aim of romanticism, the underlying aim, had been set forth by Keats, who wrote poetry, he said, to ease 'the burden of the mystery'. Romanticism was always, in part, a reaction to the decline in religious conviction, so evident in the eighteenth century, and then throughout the nineteenth. Whereas the scientists tried – or hoped – to explain the mystery, the romantics *relished* it, made the most of it, used it in ways that many scientists could not, or would not, understand. This is why poetry and music were the chief romantic responses – they were better at easing the burden.

This dichotomy, what Isaiah Berlin calls this incompatibility or incoherence, between the scientific world-view and the poetic, could not continue. The world of the romantics, the inner world of shadows and mystery, of passion and interiority, might produce a redeeming beauty, might even produce wisdom, but in a practical Victorian, nineteenth-

century world of new technologies, new scientific breakthroughs, when the external world was expanding as never before, being conquered and controlled as never before, a new accommodation was needed, or at least was bound to be attempted. This accommodation led to two developments, which will close this book. In literature and the arts, in music, poetry and painting, it led to the movement we know as 'Modernism'. And on the other side of the divide it led to what is still perhaps the most extraordinary phenomenon of modern times. This was the attempt to make a *science* of the unconscious.

# The Rise of History, Pre-history
# and Deep Time

In May 1798 one of the most extraordinary expeditions in the history of ideas set out from Toulon, in France. No fewer than 167 chemists, engineers, biologists, geologists, architects, painters, poets, musicians and doctors were gathered together, referred to as *savants* by the 38,000 troops also collected in the southern French port. Like the troops, the *savants* didn't know where they were headed, for their young commanding officer, Napoleon Bonaparte, had kept the destination secret. The average age of the *savants* was twenty-five, the youngest fourteen, but there were also well-known figures among the group which included: Pierre-Joseph Redouté, the flower painter, Gratet de Dolomieu, the geologist after whom the Dolomite mountains are named, and Nicholas Conté, a prominent chemist and naturalist.[1]

In fact, they were bound for Egypt, where Napoleon, hailed by Victor Hugo as 'the Muhammad of the West', landed at Alexandria on a ship called *L'Orient*. The venture was a mixture of colonialism and cultural/intellectual adventure. Bonaparte's avowed aim was not merely conquest, he said, but to synthesise the wisdom of the pharaohs with the pieties of Islam and to that end everything the *Armée* did in Egypt 'was explained and justified in precise Koranic Arabic'. Alongside the *Armée*, the *savants* were let loose to study the Middle Eastern world. The results of their endeavours were in many ways astounding. Conditions were harsh and they were forced to improvise. Conté invented a new kind of pump, and a new kind of pencil, without graphite. Larrey, a surgeon, turned himself into an anthropologist and made notes on the relations between the mixed population of Jews, Turks, Greeks and Bedouin. Every ten days or so they published a periodical, partly to keep the troops amused, partly to record their own activities and discoveries. Debates were organised by Napoleon himself, as a form of sophisticated entertainment for the *savants*, where questions of government, religion and ethics were aired.[2] Most important, in the long run, the *savants* collected material for what would become *The Description of Egypt*, twenty-three large volumes, each page of which was one metre square (the metre, remember, being a new measure) and published over the following twenty-five years. Many things were explored in the *Description*. It began with a one-hundred-plus-page introduction by Jean-Baptiste-Joseph Fourier, secretary of the Institut de l'Égypte, which Napoleon had set up in some secrecy. Fourier made it clear that the French saw Egypt as 'a centre of great memories', a focal point between Asia, Africa and Europe (as Alexandria had been in

earlier ages) and as such was 'saturated with meaning for the arts, sciences and government', and of which great things were expected in the future. The *Description* went on to outline new fauna and flora, new chemical substances, which existed naturally in Egypt, new geological features. But what most caught the imagination of many of the *savants* – turning them into the world's first Egyptologists – and then proved especially popular among the public back home, were the archaeological treasures, of such size and in such abundance that everyone who came into contact with them was entranced. Doubly so when a big block of granite was found at Rosetta, where a contingent of soldiers was clearing a piece of land which they intended to turn into fortifications. This stone bore three texts, one in hieroglyphics, one in a demotic, cursive form of Egyptian, and one in Greek. It promised the possibility that hieroglyphics would soon be deciphered. (See Chapter 29 above.)[3]

One could say that archaeology in the West began with this expedition and that we have Napoleon to thank for it. In fact, in the realm of ideas, we have Napoleon to thank for rather more than this. After his return from Egypt, he went on to mount a campaign against Germany and this too was, indirectly, no less beneficial. By the turn of the nineteenth century, some two thousand self-governing German-speaking units that had survived the Thirty Years War had been reduced to around three hundred. This was still a lot by the standards of elsewhere but, in 1813, and led by Prussia, the Germans managed at last to defeat Napoleon, in the process learning the virtues of order and respect for rules that was to pay so handsomely thereafter.[4] This was an important step on the road to unification, which finally was to arrive in 1871.

Thought in the eighteenth century in the fragmented kaleidoscope of small German-speaking states had lagged well behind other countries – behind Holland, Belgium, Britain and France – both in terms of political freedom, trading success, scientific advance and industrial innovation. This had been brought home by Napoleon's rapid advances before his final defeat. The nineteenth century would see the rise of Germany, not just politically but also intellectually. Until Napoleon cut his swathe through Europe, roughly speaking in the second decade of the century, the German universities had been notable by their absence. In the 1700s, only Göttingen could lay claim to any academic distinction. However, stung into action by Napoleon's campaigns, and example, which humiliated many Germans, the Francophile Prussian minister Wilhelm von Humboldt (1767–1835), who had spent time in Paris prior to the rise of Napoleon, took it upon himself to push through a number of administrative reforms that had a profound effect on German intellectual life. In particular, Humboldt conceived the idea of the modern university, not merely as colleges which trained the clergy, doctors and lawyers – the traditional format – but as places where *research* was a primary activity. In parallel with this, Humboldt introduced the practice whereby high school teachers in Germany must have a degree in order to teach. This linked the universities to schools much more directly than hitherto and helped spread the ideal of scholarship, based on original research, throughout German-speaking society. The PhD, a higher degree based on original research, was introduced. German intellectual life was transformed and before long the effects were felt across Europe and in north America.[5]

This was the start of the golden age of German intellectual influence, which was only brought to an end by the ravages of Adolf Hitler following 1933. These developments were

felt first at the University of Berlin (later the Humboldt University). Among the notable thinkers there were Georg Wilhelm Friedrich Hegel (1770–1831) in philosophy, Bartold Georg Niebuhr in history and Friedrich Karl Savigny in jurisprudence. But it was more than just names. New disciplines were invented, which went beyond the traditional breakdown into law, medicine and theology. For example, specialisations such as philosophy, history, chemistry and physiology all came into being at that time and deepened and proliferated.[6] The idea of specialisation itself took on a new force as a new literature – history for historians, chemistry for chemists – evolved. As Roger Smith has pointed out, this was when the difference first emerged between specialist literature and a general readership. As Smith also says, these new academic disciplines did not yet include sociology or psychology, which began in a far more practical way, as a result of observations away from the universities, in prisons, asylums or workhouses.[7]

Hegel was partly responsible for the rise of history. In his book *The Philosophy of History*, he advanced the view that the 'divine will' unfolds over time, as the universe reveals itself, and so history is in effect a description of this divine will. For him, this meant that theology was to be replaced by history as the way to apprehend the ultimate truths. On his account, man was not a passive creature, an observer of history, but in all senses a participant, a creator, or co-creator of it, in co-operation with the divinity. Hegel's famous theory as to how history moves forward – thesis, antithesis, synthesis – and his concept that, at certain critical times, 'world historical figures' (like Napoleon) emerge, to distil and personify the central arguments of an age, was for many the most satisfying concept about the past, and how it leads to the present.[8]

But it wasn't only Hegel. We have already encountered the discipline that also helped to spark the revival in historical studies in Germany – philology, the comparative science of languages. Even in the nineteenth century, the classical languages maintained a certain position, even though language studies had been transformed by Sir William Jones' observations about the links between Sanskrit and Latin and Greek (covered in Chapter 29). Jones' insights had had the impact they did because, in those days, far more people had an acquaintance with the classics, not least because doctoral theses – even in the 'hard' sciences – had to be written in Latin. In schools, there was an emphasis on Greek and Latin because of the part the classical authors had played in the development of logic, rhetoric and moral philosophy. The initiative of William Jones, and the subsequent discovery and translations of the ancient Indian scriptures, transformed not only philology, but the study of all texts. The most important effort in this regard took place first at Göttingen in the late eighteenth century, when the text of the Bible itself came under critical scrutiny. In time this had a profound effect on theology and meant that, in the early part of the nineteenth century, philology became the central discipline in the new universities, at least so far as the humanities were concerned.[9]

Humboldt himself was particularly interested in philology. He had formed a friendship with Condillac in Paris, and the Frenchman had helped overturn the standard idea that language had originated in a single God-given tongue, from which all other languages were descended. With Condillac, Humboldt shared the view that languages had evolved, reflecting the different experiences of different tribes and nations.[10] Language, Humboldt concluded, was 'mental activity', and as such it reflected the evolutionary experience of

mankind.[11] So this is how philology and history came to form a central part of university scholarship, which would grow in importance throughout the nineteenth century. Combined with the Oriental renaissance, philology made India a fashionable area of study for a while and the analyses of language changes seemed to indicate that four waves of people had migrated from the original homeland, via the Middle East, to Europe. This is no longer the accepted view, but it proved important because it was in the context of this debate that Friedrich Schlegel, in 1819, first used the word 'Aryan' to describe the original Indo-European peoples. This idea was badly mangled by later ideologues.[12]

In Humboldt's reformed German university system, by far the most controversial and yet influential form of historical/philological scholarship was textual criticism of the Bible and associated documents.[13] As the world had opened up, thanks to the Oriental renaissance and Napoleon's travels, in Egypt and elsewhere in the Middle East, more and more early manuscripts had been discovered (in Alexandria, and in Syria, for example), manuscripts that varied in interesting and instructive ways, which not only taught scholars how early ideas had varied, but proved helpful in perfecting dating techniques. Philologists-turned-historians, like Leopold von Ranke (1795–1886), were pioneers in the critical inspection and dating of primary sources.

In particular, attention turned to the New Testament. Exegesis, the interpretation of the meaning of the text, was nothing new, as we saw in Chapter 25. However, the new German philologists were much more ambitious: with the new techniques at their disposal, their first achievement was to accurately date the gospels, the effect of which was to throw a new light on the inconsistencies in the different accounts, so that their overall reliability began to be questioned. It is important to say that this did not occur overnight, nor was it deliberate. Originally, scholars such as F. D. E. Schleiermacher (1768–1834) had merely wished to distil a reasonable trajectory for the biblical narrative, one that could be accepted by any rational person. In the process, however, so much doubt was cast on the texts themselves that Jesus' very existence as a historical figure began to be undermined and this risked sabotaging the very meaning of Christianity.[14] The most controversial of all the Germanic textual bombshells was *The Life of Jesus, Critically Examined*, published in 1835 by David Strauss (1808–1874). Strauss was much influenced by German romanticism – he wrote a romantic tragedy that was performed, and took a great interest in magnetic and hypnotic cures. In this way he acquired an understanding of God as immanent in nature, but not as someone who would intervene in the course of history.[15] Strauss thus used history *against* religion, arguing that its details were insufficient, by a long way, to support Christianity as it existed in the nineteenth century. So incendiary were his findings – that Jesus was not a divine figure, that the miracles never took place, that the church as we know it has little connection with Jesus – that Strauss's appointment to a professorship in Zurich in 1839 sparked a local riot so worrying to the local authorities that he had to be 'retired' before he even had chance to take up his chair. His conclusions could not be retired so easily, however. In England, Marian Evans, better known as George Eliot, 'nearly drove herself to despair with the soul-stupefying labour involved in the translation of Strauss into English, but she thought it her duty to humanity'.[16] As we shall see in Chapter 35, Strauss's work was just one element in the nineteenth century's struggle with religion, and what some were beginning to call 'the death of God'.

*

'Once the Parisians see me three or four times,' said Napoleon Bonaparte, then twenty-eight, after his victorious campaign in Italy, 'not a soul will turn his head to look at me. They want to see *deeds*.'[17] His next campaign, as we have seen, was in Egypt, where he took those 167 *savants* or scholars, who discovered and brought back to Europe the highlights of a fascinating early civilisation. These discoveries were soon built on by others, to make the early nineteenth century both the birth and the heroic age (in the West at least) of yet another new historical discipline, archaeology.

Archaeology, a term first used in the 1860s, amplified and deepened the work of philology, going beyond the texts and confirming that there was a more distant past for men, pre-history, from before writing. In 1802, the schoolmaster Georg Friedrich Grotefend (1775–1853) delivered three papers to the Göttingen Academy of Sciences, in which he revealed that he had deciphered the Persepolis cuneiform script, which he achieved mainly by rearranging the groups of wedges ('like birds' feet in soft sand') and putting spaces between groups of letters, and then relating their form to Sanskrit, as a (geographically) nearby language. He guessed that some of the inscriptions were king-lists, and the names of some kings were known.[18] The other forms of cuneiform, including the Babylonian, were deciphered some years later. In the 1820s, Champollion deciphered the Egyptian hieroglyphics, as we saw in Chapter 29, and in 1847 Sir Austen Layard excavated Nineveh and Nimrud, in what is now Iraq. There, he uncovered the wonderful palaces of Assurnasirpal II, king of Assyria (885–859 BC) and Sennacherib (704–681 BC). The great guardians of the gates that were uncovered, some half-bulls, some lions, far larger than life-size, created a sensation in Europe and did much to make archaeology popular. These excavations eventually led to the discovery of a cuneiform tablet on which was written the epic of Gilgamesh, notable for two reasons: that it was much older than either Homer or the Bible, and because several episodes in the narrative – such as a great flood – were reminiscent of the Old Testament.

Each of these discoveries pushed back the age of mankind and began to cast a new light on the scriptures. But, save for the Gilgamesh epic, there was nothing that was radical about the new dating: it did not fundamentally contradict the biblical chronology. All that began to change in 1856 when workers started clearing out a small cave in the side of the Neander valley (Neander Thal in German) through which the river Düssel flows into the Rhine. There, a skull was found, buried beneath more than a metre of mud, together with some other bones. The workmen who found the bones passed them to a local friend who, they felt, was educated enough to make something of them, and he passed them on to Hermann Schaaffhausen, professor of anatomy at Bonn University. Schaaffhausen identified the remains as the top part of a skull, two thigh-bones, parts of a left arm, part of a pelvis, and other smaller remains. In the paper he subsequently wrote on the discovery, Schaaffhausen drew attention to the thickness of the bones, the large size of the scars left by the muscles that were attached to them, the pronounced ridges above the eyes, and a low, narrow forehead. Importantly, Schaaffhausen concluded that the bones were not deformed, either because of where they had been kept over the years, or because of some pathological process. 'Sufficient grounds exist,' he wrote, 'for the assumption that man co-existed with the animals found in the *diluvium*; and many a barbarous race may, before

all historical time, have disappeared, together with animals of the ancient world, whilst the races whose organisation is improved have continued the genus.' He concluded that his specimen 'may probably be assigned to a barbarous, original people, which inhabited the north of Europe before the *Germani*.'[19] This is not quite the same as what we mean today by Neanderthal but it was nonetheless a breakthrough. It didn't immediately change attitudes to time because it was too controversial, but it formed part of the 'background radiation' of ideas in the late nineteenth century, against which the insights and discoveries of Boucher de Perthes, and others, discussed in the Prologue, took hold. One of the first outlines of pre-history, as we now understand it, was given by John Lubbock's *The Origin of Civilisation* and *The Primitive Condition of Man* (1870): 'The archaeological evidence revealed a steady improvement in technical ability from the earliest crude stone tools to the discovery of bronze and iron. In the absence of fossil evidence for the *biological* improvement of man, evolutionists seized on the evidence for *cultural* progress as at least indirect support for their claims. The great development of prehistoric archaeology that took place in the late nineteenth century allowed the construction of a sequence of cultural periods that were supposed to have succeeded one another as the human race progressed. Little thought was given to the possibility that different cultures might exist side by side in the same epoch.'[20]

By this time, the word 'science' had begun to acquire its modern meaning. (The term 'scientist' was coined by William Whewell in 1833.) Until the end of the eighteenth century, the phrases 'natural philosophy' or 'natural history' had been preferred. This was so because natural philosophy sounded softer, more humane and it was also a portmanteau term: many local 'natural history' societies ran lectures on, say, literary topics, the humanities, and philosophy. Gradually, as the various disciplines emerged, first in Germany and then elsewhere, and as specialisation proliferated, science began to be the preferred term for these new activities.

It may be difficult for us to understand now but, in the late eighteenth/early nineteenth centuries, when the philologists were attacking the very basics of Christianity, the men of science did not for the most part join in. For the most part biologists, chemists and physiologists remained devoutly religious. Linnaeus is a case in point. One of the main figures of the Enlightenment and one of the fathers of modern biology, who also formed part of the deep background to evolution, he was very different from, say, Voltaire. An early break with the Chain of Being had been made by John Ray, a naturalist who realised that every species – thousands of which were discovered in the New World and in Africa – could not all be graded on one meaningful hierarchy, that forms of life *varied* in many ways. Linnaeus therefore thought that *re*classifying the organisms of the world might give him some idea of the divine plan. He didn't claim to *know* the mind of God and freely confessed that his system of classification was an artificial one. But he thought it might produce some approximation of the Creator's divine design. What turned out to be especially crucial was that in his own field, botany, he drew on R. J. Camerarius' discovery (in 1694) of plant sexuality, which meant that Linnaeus made the reproductive organs the key characteristic on which to base his system.[21] (At that time, sexual reproduction was variously believed to be due to spontaneous generation, to 'germs', to male and female

semen 'mixing' in the womb, with these germs or seminal fluids containing 'memories' which ensured they 'knew' which forms to develop into.) Also, the binomial nomenclature that Linnaeus developed, in *Species Plantarum* (1753), *Genera Plantarum* (1754) and *Systema Naturae* (1758), drew attention to the systematic similarities between species, genera, families and so on. It became obvious from this that the Creator's plan was not linear and led Buffon, in attacking Linnaeus, to his theory of 'degeneration', that for example all two hundred mammalian species known to him had been derived from thirty-eight 'original' forms. This was an early idea of evolution.[22]

But another discipline was in the process of formation that would put history, and in particular pre-history, on to a different footing and further prepare the way for Darwin – this was geology. Geology differed fundamentally from all the other sciences, and from philosophy. It was, as Charles Gillispie has said, the first science to be concerned with the history of nature rather than its order.

In the seventeenth century Descartes had been the first to link the new astronomy and the new physics to form a coherent view of the universe, in which even the sun – let alone the earth – was just another star. He speculated that the earth might have formed from a ball of cooling ash and become trapped in the sun's 'vortex'. (To avoid criticism from the church, he said only that this 'might' have happened.) Bernard de la Fontenelle, in *A Plurality of Worlds* (1688), had stressed man's insignificance in the new order of things, and had even wondered if other stars might be inhabited.[23] The idea that physics operated on the same principles throughout the universe was a major change in thinking that could not have occurred to the medieval mind. The basic ideas of heaven and earth, as understood in the West at least, were Aristotelian and the two realms were held to be fundamentally different: one could not give rise to the other.[24] Eventually, Descartes' physics were replaced by Newton's, the 'vortex' with gravity, but that didn't alter early geological theories very much. In 1691 Thomas Burnet published his *Sacred Theory of the Earth*, in which he argued that various materials had coalesced to form the earth, with dense rock at the centre, then less dense water, then a light crust, on which we live. This conveniently explained the Flood – just beneath the thin crust were vast tracts of water. A few years later, in 1696, William Whiston, Newton's successor at Cambridge, proposed that the earth could have been formed from the cloud of dust left by a comet, which coalesced to form a solid body, and was deluged with water from a second passing comet.[25] This idea, that the earth was once covered by a vast ocean, which then retreated, proved enduring. G. W. Leibniz added the thought that the earth had once been much hotter than it is now, and that earthquakes would therefore have been much more violent in the past. (Even then it was clear that present-day earthquakes had very trivial effects on the surface of the earth.)

In the eighteenth century, in his 'nebular hypothesis', Kant proposed that the entire solar system was formed from a condensing cloud of gas, a theory that received support from the observations of William Herschel, whose vastly improved telescopes showed, or appeared to show, that some of the nebulae 'or hazy patches' seen in the night sky were gas or dust clouds 'apparently condensing into a central star'.[26] Buffon built on this, but like Descartes before him he too sought accommodation with the church, arguing that the earth started out as very hot, but cooled in seven phases (analogous to the seven days of the week in biblical creation), the last of which gave rise to man.

Slowly, then, a view was forming that the earth itself had changed over time. Nonetheless, however the earth had formed, the central problem faced by the early geologists was to explain how sedimentary rocks, formed by deposition from water, could now stand on dry land. As Peter Bowler has pointed out, there can be only two answers – either the sea levels have subsided, or the land has been raised. 'The belief that all sedimentary rocks were deposited on the floor of a vast ocean that has since disappeared became known as the Neptunist theory, after the Roman god of the sea.'[27] The alternative became known as Vulcanism, after the god of fire. By far the most influential Neptunist in the eighteenth century, in fact the most influential geologist of any kind, was Abraham Gottlob Werner, a teacher at the mining school in Freiburg, Germany, who proposed that, once one assumed that the earth, when it cooled, had an uneven surface, and that the waters retreated at a different rate in different areas, the formation of rocks could be explained. Primary rocks would be exposed first. Then, assuming the retreat of the waters was slow enough, there would be erosion of the primary rocks, which would drain into the great ocean, and then these sediments would be revealed as the waters retreated further, to create secondary rocks, a process that could be repeated and repeated. In such a way the different types of rock had been formed in a succession which comprised five stages. The first of them produced the 'primitive' rocks – granite, gneiss, porphyry – which had crystallised out of the original chemical solution during the Flood, and the last, which was not formed until all the flood waters had receded, was generated by volcanic activity – accounting for how lavas and tuff, for example, had been produced. According to Werner, volcanoes around the earth were caused by the ignition of coal deposits.[28] He thought that volcanic activity had a trivial effect on the formation of the earth and though he was himself in no way interested in religion his Neptunist theory fitted very well with the biblical account of the Flood, which is one reason why it was so popular across Europe. It gave rise to the phrase 'scriptural geology'.

This theory had tidiness to recommend it, but beyond that there were some serious problems. For a start, it did not even begin to explain why some types of rock that according to Werner were more recent than other types, were often found situated *below* them. Still more problematical was the sheer totality of water that would have been needed to hold all the land of the earth in solution. It would have to have been a flood many miles deep, and in turn that provoked an even bigger problem: what had happened to all that water when it had receded?

The chief rival to Werner, though nowhere near as influential to begin with, was a Scot, from the Edinburgh Enlightenment, James Hutton (1726–1797), and his Vulcanism. From the middle of the eighteenth century, some naturalists began to suspect that volcanic activity *had* produced some effect on the earth. It was noticed, for instance, that certain mountains in central France had the form of volcanoes though there was no record of such activity in history. Others pointed to the Giant's Causeway in Ireland, which appeared to consist of columns of basalt that had solidified from a molten state and were therefore of volcanic origin. Hutton did not begin with the origins of the earth, but instead confined himself to observation rather than speculation. He looked around him at the geological changes he could see occurring in his own day and adopted the view that these processes had always been going on. In this way he observed that the crust of the earth, its outermost,

most accessible layer, is formed by two types of rock, one of igneous origin (formed by heat), and the other of aqueous origin. He further observed that the main igneous rocks (granite, porphyry, basalt) usually lie beneath the aqueous ones, except where subterranean upheavals have thrust the igneous rocks upward. He also observed what anyone else could see, that weathering and erosion are even today laying down a fine silt of sandstone, limestone, clay and pebbles on the bed of the ocean near river estuaries. He then asked what could have transformed these silts into the solid rock that is everywhere about us. He concluded that it could only have been heat. Water was ruled out – an important breakthrough – because so many of these rocks are clearly insoluble. And so where did this heat come from? Hutton concluded that it came from inside the earth, and that it was expressed by volcanic action. This action, he realised, would explain the convoluted and angled strata which could be observed at many places all over the world. He pointed out that volcanic action was still occurring, that different landmasses were still rising and falling (there was evidence just then that areas of Scotland and Sweden were being raised), and that the rivers – again as anyone could see – were still carrying their silts to the sea.[29]

Hutton first published his theories in the *Transactions* of the Royal Society of Edinburgh in 1788, followed by the two-volume *Theory of the Earth* in 1795, 'the earliest treatise which can be considered a geological synthesis rather than an imaginative exercise'.[30] One of Hutton's important premises was that the origin of fossils had been fully settled ('fossils' originally meant anything dug up). They were recognised by Nicholas Steno and John Woodward in the seventeenth century as the residue of living creatures, many of which were now extinct.[31] But it was also understood that the presence of fossils on the tops of mountains was accounted for by Noah's Flood. At the time Hutton's book appeared, the historical reality of the Flood was beyond question. 'When the history of the earth was considered geologically, it was simply assumed that a universal deluge must have wrought vast changes and that it had been a primary agent in forming the present surface of the globe. Its occurrence was evidence that the Lord was a governor as well as a creator.' Just as the Flood was undisputed, so the biblical narrative of the creation of the world, as revealed in Genesis, was also beyond question. On this account, the length of time since creation was still believed to be about six thousand years, and though some people were beginning to wonder whether this was long enough, no one thought the earth *very* much older. A separate question was whether the animals had been created earlier than mankind, but even this did not, of itself, greatly add to the antiquity of man.[32]

There was no question but that Hutton's Vulcanism fitted many of the facts better than Werner's Neptunism. Many critics resisted it, however, because Vulcanism implied vast tracts of geological time, 'inconceivable ages that went far beyond what anyone had envisaged before'.[33] As Werner and others had observed, volcanic and earthquake activity today actually produce only 'trivial' effects on the surface of the earth. If this has always been the case, then not only must the earth be of very great antiquity, for great mountains, say, to have been raised to such heights, but Hutton's ideas also posited a 'steady state' for the earth. This compared badly with the idea that the earth was once much hotter than it is now, when geological events – Flood or no Flood – were much grander. This at least implied a *development* of the earth. There was also something unromantic about Hutton's theory because it argued that the earth as we know it had been formed by a succession of

'infinitesimally small events', rather than by dramatic catastrophes, such as floods. It further required a number of nimble intellectual tricks to reconcile Hutton's vulcanism with the Bible. One effort had it that there was once a 'great evaporation' (which would explain how all the flood waters had disappeared). Nevertheless, as Charles Gillispie has shown, there were many eminent men of science in the nineteenth century who, despite Hutton's theories, still subscribed to Neptunism: Sir Joseph Banks, Humphry Davy and James Watt, not to mention W. Hyde Wollaston, secretary of the Royal Society.[34] Hutton's theory did not really begin to catch on until John Playfair published a popular version in 1802 (see Chapter 35, below, for the crucial role of popularisers in the nineteenth century, and their part in the decline of faith).

But Hutton (a deist) was not alone in believing that the observation of processes still going on would triumph. In 1815, William Smith, a canal builder often called the 'father' of British geology, pointed out that similar forms of rock, scattered across the globe, contained similar fossils. Many of these species no longer existed. This, in itself, implied that species came into existence, flourished, and then became extinct, over the vast periods of time that it took the rocks to be laid down and harden. This was significant in two ways. In the first place, it supported the idea that successive layers of rock were formed, not all at once but over time. And second, it reinforced the notion that there had been separate and numerous creations and extinctions, quite at variance with what it said in the Bible.[35]

Objections to the biblical account were growing. Nevertheless, it was still the case that hardly anyone at the beginning of the nineteenth century questioned the Flood. Neptunism, the biblical account, was still the most popular version. Peter Bowler says that at this time geological texts sometimes outsold popular novels, but that science 'was respectable only so long as it did not appear to disturb religious and social conventions of the day'.[36] Neptunism did, however, receive a significant twist in 1811 when the Frenchman Georges Cuvier published his *Recherches sur les ossements fossiles* (*Researches on Fossil Bones*). Going through four editions in ten years, this showed that a new, updated Neptunism was what people most wanted. Cuvier, a curator at the Musée d'Histoire Naturelle, formed from the pre-1789 Jardin du Roi, argued that there had been not one but several cataclysms – including floods – in the history of the earth. Looking about him, in the Huttonian manner, he concluded that, because entire mammoths and other sizeable vertebrates had been 'encased whole' in the ice in mountain regions, these cataclysms must have been very sudden indeed. He also argued that if whole mountains had been lifted high above the seas, these cataclysms could only have been – by definition – unimaginably violent, so violent that entire species had been exterminated and, conceivably, earlier forms of humanity.[37] Excavations in the Paris basin further showed an alternation of deposits between salt and fresh water, suggesting 'a series of major changes in the relative position of land and sea'.[38] But Cuvier's researches weren't entirely consistent with the biblical account. He also observed, and this was important, that in the rocks the deeper fossils were more different from life forms in existence today and that, moreover, fossils occur in a consistent order everywhere in the world. This order was: fish, amphibia, reptilia, mammalia. He therefore concluded that the older the strata of rock the higher was the proportion of extinct species. Since, at that time, no human fossils had turned up anywhere, he concluded that '... mankind must have been created at some time between the last

catastrophe and the one preceding it'.[39] He also observed that the expedition to Egypt had brought back mummified animals thousands of years old, which were identical to those now living, which confirmed the stability of species. Fossil species must therefore have lived for a long time too, before dying out.[40] This was, in a sense, a half-way version of the biblical story. Man had been created since the Flood, but not the animals, which were much older.

Nevertheless, Cuvier's observations helped keep Neptunism and Catastrophism popular, especially in Britain, where acceptance of Hutton's theories was delayed at least until the 1820s. Robert Jameson, the leading light of the Wernerian Society of Edinburgh, even managed to stop Hutton's ideas from having much influence in his native city.[41] There was in fact one other reason why many geologists – again, especially in Britain – subscribed to the great Flood theory: this was the existence of huge rocks of a completely different type from the land surrounding them. These would later be shown to have been deposited by the ice sheets during the Ice Age, but to begin with their distribution was attributed to the great Deluge. The man who insisted most on this was William Buckland, Oxford's first professor of geology. In 1819, in a famous inaugural lecture, *Vindiciae Geologicae; or, the Connexion of Geology with Religion Explained*, he tried 'to shew that the study of geology has a tendency to confirm the evidences of natural religion; and that the facts developed by it are consistent with the accounts of the creation and deluge recorded in the Mosaic writings.'[42] Furthermore, before he had been at Oxford very long, some miners in 1821 stumbled upon a cave at Kirkdale in the Vale of Pickering in Yorkshire, where they discovered a huge deposit of 'assorted bones'. Buckland saw his chance. Hurrying to Yorkshire, he quickly established that while most of the bones belonged to hyenas, there were also many birds and other species, including animals no longer found in Britain – lions, tigers, elephants, rhinoceroses and hippopotamuses. Moreover, each of the bones and skulls were deformed or broken in much the same way and he concluded that what the miners had found was a den of hyenas. He wrote up the discovery, first as an academic paper, which won the Royal Society's Copley Medal, and then followed it with a more popular account. His aim in this book was to reinforce the existence of the Flood and the recent creation of man. His thesis was nothing if not neat: most of the bones in Kirkdale belonged to species now extinct in Europe; such bones are never found in alluvial (riverine) deposits of sand or silt; there is no evidence that these animals have ever lived in Europe since the Flood. It therefore followed, said Buckland, that the animals whose remains the miners had found, must have been interred *prior* to Noah's time. He finally argued that the top layer of remains was so beautifully preserved in mud and silt 'that they must have been buried suddenly and, judging by the layer of postdiluvial stalactite covering the mud, not much more than five or six thousand years ago.'[43]

However, there were still problems with the flood theory, not least the fact that, as even Buckland acknowledged, the various pieces of evidence around the world placed the Flood at widely varying epochs. (Buckland, like many others, didn't let his faith warp his science *too* much.)[44] In addition, by the 1830s the cooling earth theory was gaining coherence as an explanation as to why geological activity was greater in the past than now, further fuelling the view that the earth developed, and that life forms had been very different in the past. In 1824 Buckland himself described the first known dinosaur, the gigantic

Megalosaurus, though the word 'dinosaur' wasn't coined until 1841, by the great anatomist Richard Owen. That was also the year that John Philips identified the great sequence of geological formations, the Palaeozoic, the age of fishes and invertebrates, the Mesozoic, the age of reptiles, and the Cenozoic, the age of mammals.[45] This was based in part on the work of Adam Sedgwick and Sir Roderick Murchison in Wales, which began the decoding of the Palaeozoic system. The Palaeozoic period would eventually be shown to have extended from roughly 550 million years ago to 250 million years ago, and during that time plant life had moved out of the oceans on to land, fish appeared, then amphibians and then reptiles had reached land. These new forms of life were all wiped out, about 250 million years ago, for reasons that are still hard to fathom. But it was clear from the analyses of Sedgwick and Murchison that early forms of life on earth were very old, that life had begun in the sea, and then climbed ashore. Deluge or no deluge, all this was again in dramatic contradiction of the biblical account.[46]

The study of fossils and of rock sequences was also put together now with the growing science of embryology. The key figure here was Karl Ernst von Baer, who argued against the early prevailing wisdom that the human embryo, in developing, recapitulates the invertebrate/fish/reptile/mammal progression, and said instead that all embryos are simple to begin with, then develop specialised characteristics that equip them for their place in the world: lower animals are not, as it were, immature forms of man.[47] It was von Baer who also showed that the organisation of life forms is not a 'man-centred hierarchy', that the human form is just one end-result among many. Robert Owen in his *Archetypes and Homologies of the Vertebrate Skeleton* (1848) and *On the Nature of Limbs* (1849) showed that vertebrates have a basically similar structure, which are adapted in different ways but are not 'aimed' in a linear way at man.[48]

We are running ahead of ourselves, and of the geological story. The importance of the discoveries of Cuvier, Buckland, Sedgwick and Murchison, over and above their intrinsic merit, was that they brought about a decisive change of mind on the part of Charles Lyell. In 1830 he published the first volume of what would turn into his three-volume *Principles of Geology.* Lyell's argument was contained in the subtitle, *Being an Attempt to Explain the Former Changes of the Earth's Surface, by Reference to Causes Now in Operation.* He was also much influenced by Georges Scrope, a Frenchman whose studies in the Massif Central had shown, he said, that 'rivers working over limitless centuries had cut their own valleys'. Before his own book was released, Lyell made a tour of Europe, meeting fellow geologists such as Étienne de Serres, to study a number of geological features, most notably the active volcanoes of Sicily, where he found that the massive cone had been built up gradually though a long series of small eruptions. Furthermore, the volcano was resting on sedimentary rocks of recent origin, as shown by the fact that the fossil molluscs were identical with present-day ones. This convinced Lyell that there was no need to posit a single catastrophe for this mountain.

But essentially *Principles* was a work of synthesis, rather than of original research, in which Lyell clarified and *interpreted* already-published material to support two conclusions. The first, obviously enough, was to show that the main geological features of the earth could be explained as the result of actions in history that were exactly the same as those that could be observed in the present. In a review of his book, the term 'uni-

formitarianism' was used and caught on. Lyell's second aim was to resist the idea that a great flood, or series of floods, had produced the features of the earth that we see around us. He laid great store by Scrope, supporting his view that the world's rivers had carved out their own valleys, and that 'gently winding river beds' could not be the product of – nor produce – violent events, still less catastrophes. On the religious front, Lyell took the common-sense view, arguing that it was unlikely God would keep interfering in the laws of nature, to provoke a series of major cataclysms. Instead, he said, *provided that one assumed that the past extended back far enough*, then the geological action that could be observed as still in operation today was enough to explain 'the record in the rocks'.[49] There was, he added, no shortage of evidence to show that volcanoes had erupted regularly throughout history and that this had nothing to do with either floods or catastrophes. And he compared the findings of stratigraphy, palaeontology and physical geography to identify three separate eras with three distinct forms of life. These became known as the Pliocene, Miocene and Eocene epochs, the last of which went back 55 million years. Yet again this was a much longer time-frame than anything in the Old Testament.

Volume One of the *Principles* took issue with the Flood, and began the process whereby the idea would be killed off. In volume two, Lyell demolished the biblical version of creation. Inspecting the fossils as revealed in the record of the rocks, he showed that there had been a continuous stream of creation, and extinction, involving literally countless species. In the eighteenth century, Linnaeus had speculated that there must once have been 'a special corner of the globe' that had been reserved as a 'divine incubator', where life and new species had started. Lyell demonstrated how mistaken this notion was. Life, he showed, had begun in different 'foci of creation'. He thought that man had been created relatively recently but by a process that was just the same as for other animals.[50]

The big problem with Lyell's theory was that it revived Hutton's 'steady-state' theory of the earth, arguing that the world we see about us is the product of constructive and destructive forces. But where did the energy for all this come from? As the science of thermodynamics developed in the middle years of the nineteenth century, physicists such as Lord Kelvin argued that the earth *must* be cooling and calculated on that basis that it was at least 100 million years old. This was nowhere near the truth but still very much greater than it said in the Bible. (Only in the twentieth century did physicists realise that the radioactivity of certain elements is capable of maintaining the earth's central heat.)[51] With hindsight, one can say that Lyell's book flirted with evolution. But it was only flirtation: he had no concept of natural selection. On the other hand, he did kill off Neptunism.

There were, however, a number of last-ditch attempts to marry the biblical narrative with the flood of scientific discoveries, and these culminated in a series of papers that became known as the Bridgewater Treatises. 'This strange and, to the modern reader, deadly series was commissioned by the will of the Reverend Francis Henry Egerton, eighth earl of Bridgewater, a noble clergyman who had always neglected his parish assiduously and who died in 1829. Lord Bridgewater charged his executors, the archbishop of Canterbury, the bishop of London, and the president of the Royal Society, with the duty of selecting eight scientific authors, each from a main branch of the natural sciences, who were capable of demonstrating "the Power, Wisdom, and Goodness of God, as manifested

in the Creation; illustrating such work by all reasonable arguments, as for instance, the variety and formation of God's creatures in the animal, vegetable and mineral kingdoms ...". The eight 'scientific' authors chosen in fact comprised clergymen, physicians and geologists.[52] None of them said anything that much advanced the debate but the very existence of the series showed how far some people were prepared to go to try to keep science in its place. Among the arguments used were the view that the universe is so improbable statistically that 'divine direction' must be at work, and that our world is so benevolent that it can only have been made by God – examples included the observation that fish have eyes specially suited to marine vision, that iron ore is always discovered in the neighbourhood of coal, by means of which it can be smelted, and so on.[53] In the final treatise, Dr Thomas Chalmers insisted that the very existence of a conscience among men, the very notion of morality, was 'conclusive evidence of an exquisite and divinely established harmony...'[54]

The treatises proved popular. Released between 1833 and 1836, each had gone through four editions at least by the 1850s. Their main weakness lay in their unreflective approach to science, each being composed as a final word, as if geology, biology, philology and the other new disciplines would not have further shocks up their sleeves, to add to those that had already occurred and which it had been the aim of the treatises to explain away.

The most immediate response to the Bridgewater Treatises was Charles Babbage's unofficial *Ninth Bridgewater Treatise*, published in 1838, which argued that a creator could work as he himself had worked in creating his famous 'calculating engine', a forerunner of the computer, in which, he noted, he could programme his machine to change its operations according to some pre-determined plan. Thus was born an idea that was to prove popular – the 'laws of creation', rather like the laws of reproduction. This was made the most of by Robert Chambers, yet another Edinburgh figure, whose *Vestiges of the Natural History of Creation*, published in 1844, was a very radical break, so radical that Chambers published the book anonymously. This work promoted the basic idea of evolution, though without in any way anticipating Darwinian natural selection. Chambers described the progress of life as a purely natural process. He began by saying that life started through spontaneous generation 'citing as evidence certain soon-to-be-discredited experiments in which small insects had apparently been produced by electricity'.[55] Using Babbage's *Ninth Treatise* as an example, he posited vague laws of creation to account for the progression. But his main contribution, as was introduced in the Prologue, was to organise the palae-ontological record in an ascending system and to argue that man did not stand out in any way from other organisms in the natural world. Though he had no grasp of natural selection, or indeed of how evolution might work, Chambers did introduce people to the *idea* of evolution fifteen years before Darwin.[56] James Secord, in his book *Victorian Sensation* (2000), has explored the full impact of *Vestiges*. He goes so far as to say that Darwin was, in a sense, 'scooped' by Chambers, that wide and varied sections of (British) society discussed *Vestiges*, at the British Association, in fashionable intellectual salons and societies, in London, Cambridge, Liverpool and Edinburgh, but also among 'lower' social groups, that the ideas the book promoted passed into general discussion, being referred to in paintings, exhibitions, cartoons in the new, mass-circulation newspapers, and that it was discussed among feminists and freethinkers. Secord makes the point that Chambers was

not really a scientist but a middle-brow intellectual from a publishing family and that his book, which in essence provided a narrative of the 'progress' of history, drew as much on the narrative technique of recent novels (themselves a relatively new phenomenon) as much as science. Chambers believed his book would create a sensation: one reason he published it anonymously was in case it didn't do well; another reason was in case it *did* do well. But the need for anonymity by the author, Secord says, shows that the whole question of evolution was very much in the air in the 1840s and very controversial. His especially important point is that it was *Vestiges* that introduced evolution to a huge range of people (there were fourteen editions) and that, viewed in such a light, Darwin's *Origin of Species* resolved a crisis and did not create one: 'The idea of evolution is not a Darwin-centred narrative'. This is a major revision in the history of ideas.[57]

A no less convincing response to the Bridgewater Treatises came at almost the same time as *Vestiges* and underlined the unfolding nature of science. This was the discovery of the great Ice Age, by Louis Agassiz and others. Agassiz was a Swiss geologist who later, in 1847, on account of his work on glaciation, was invited to Harvard. The original idea of a great Ice Age was not his: in 1795 James Hutton, in one of his rare instances of speculation, had wondered whether some strange, 'erratic' boulders near Geneva had been carried and left there by glaciers that had since retreated. But it was Agassiz who collected and collated the greatest mass of detail that put the issue beyond doubt. What Lyell did for the antiquity of the earth, Agassiz did for the Ice Age.

By observing present-day glaciers (of which there was no shortage in the Swiss Alps), Agassiz came to the conclusion that much of northern Europe had once been buried by a covering of ice, in places up to three kilometres thick. This conclusion (all the more remarkable because, at the time, he was more interested in fossil fishes) was based chiefly on three types of evidence found at the edges of glaciers even today – 'erratics', moraines, and tills. Erratics are large boulders – like those near Geneva – whose constitution is quite different from the rock all around them.[58] They are pushed by the edges of glaciers, as the ice expands, and then left in a 'foreign' environment, when the earth warms up again and the ice retreats. Thus geologists suddenly find a massive boulder of, say, granite, in an area otherwise made up of limestone. Early geologists had thought that this type of phenomenon was produced by the Flood, but Agassiz showed that it was ice that produced this effect. Till is a form of gravel formed by the ice as it expands over the earth and acts, in J. D. Macdougall's words, like a giant sheet of sandpaper.[59] (Till provides a lot of gravel resources for modern construction industries.) Moraines are mounds of till that build up at the edges of glaciers and can be quite large: most of Long Island, in New York state, is a moraine more than 110 miles from end to end. Agassiz and others concluded that the most recent great Ice Age began about 130,000 years ago, peaked at 20,000 years ago, and ended quickly at 12,000–10,000 years ago. In time this would prove extremely significant, in that it tallied with the emerging evidence for the beginnings of agriculture.[60] This provided coherence in both chronological terms and in respect of cultural evolution.

The term 'evolution' was originally used in biology exclusively for the growth of the embryo. In the original Latin it means 'to unfold'. Outside that usage, terms like 'progressionism' or development were used to convey the cohering notion that simpler organ-

isms had, in an as yet unknown fashion, given rise to more complex ones. Experts were divided as to whether this progression included man. Evolution was next used in a cultural sense, following the observations of Vico, Herder and others, who saw in the development of human societies a progression from more primitive to more advanced forms of civilisation. Peter Bowler makes the point that early anthropologists such as E. B. Tylor and L. H. Morgan argued that different races progress through a similar sequence of cultural phases, with peoples who are still 'primitive' belonging to 'retarded lines of cultural development, held up at a stage through which the white race had passed at an earlier phase'.[61]

Lamarck was one of the most important advocates of progressionism. Jean-Baptiste de Monet, chevalier de Lamarck (1744–1829), was not quite the knave and fool he has sometimes been painted. It was he who noticed that some fossil species were analogous to creatures that are still living, which gave him the idea that some fossil lines, at least, might not be extinct, but instead had changed, responding to alterations in conditions on earth, and were therefore still living 'but in an amended form that we don't recognise'. This is a pre-Darwinian concept of adaptation.[62] Lamarck was convinced of the great age of the earth and that life forms had continuously changed over long periods of time. And he considered man the end-product of this progression.[63] Lamarck's idea of evolution was two-fold. In the first place, he believed that nature embodied a principle towards increasing complexity. Second, he believed that organs within any creature developed more strongly the more often they were used and that these strengthened – or acquired – characteristics were passed on to later generations, always 'provided that the changes acquired are common to both sexes, or to those which produce the young'.[64]

Because of these factors, and others, which we shall come to, it has been said that there was something 'in the air' in the middle of the nineteenth century, which helped give rise to what Darwin would call natural selection.[65] A struggle for existence had been implied by Malthus, as long ago as 1797. Each tribe in history would have competed for resources, he said, with the less successful becoming extinct. 'It is now known that in addition to Malthus, Darwin gained insights from reading the work of Adam Smith and other political economists. The concept of divergence through specialisation reflects the economic advantages supposed to accrue from the division of labour.'[66] Another theory was advanced by William Charles Wells in 1813, 'An Account of a Female of the White Race of Mankind', where he suggested that the human races might have been formed when groups moved into unoccupied territory and where they were faced with a new environment.[67] Accidental variations within the population would mean that some individuals would be better adapted to the new conditions, who would thus tend to become the parents of the new race.

Wherever one looked in the mid-nineteenth century, then, the role played by struggle, by competition, in society and in nature, was on everyone's lips.[68] It was by now difficult to contradict the evidence of the rocks, where the basic picture was clear. 'The earliest rocks [600 million years ago] yielded only the remains of invertebrates, with the first fish appearing only in the Silurian [440–410 million years ago]. The Mesozoic [250–65 million years ago] was dominated by the reptiles, including the dinosaurs. Although present in small numbers in the Mesozoic, the mammals only became dominant in the Cenozoic [65

million years ago → the present], gradually progressing to the more advanced creatures of today, including the human species.'[69] (The dates in square brackets were not, of course, accepted in the nineteenth century.) It was hard for people not to read some sort of 'end' in this progression, 'leading', via stages, to humans, 'and thus revealing a divine plan with a symbolic purpose'. In books of the time, most 'trees of life' showed a main stem, thicker than others, leading directly to man.

This picture, of course, now has to be revised in the light of James Secord's recent work. In his book, he provides an illustration of Darwin's notes, made when he was reading *Vestiges* in the British Museum Reading Room. Darwin was far from impressed by many aspects of the argument (he never bought his own copy of the book), but *Vestiges*, coming on top of the 'something in the air', clearly had an effect in allowing Darwin to sharpen the distinction between his own theory of natural selection and its competitors.[70]

A final element in this 'climate of opinion', this 'something in the air', as regards 'progressionism' and how it was achieved, was the work of Alfred Russel Wallace. Wallace's reputation, and role, in the discovery of evolution have gone through their own progression in recent times. For many years it was accepted that the paper he sent to Darwin in 1858, 'On the Tendencies of Varieties to Depart Indefinitely from the Original Type', contained a clear exposition of natural selection, such that Darwin was forced to begin a move towards publication of his own book, *On the Origin of Species*. As a result, some scholars have argued that Wallace was never given the recognition he deserves and have even implied that Darwin and his followers deliberately kept him out of the limelight.[71] More recently, however, a closer reading of Wallace's paper has shown that his idea about natural selection was not the same as Darwin's, and that it was much less powerful as an explanatory device. In particular, Wallace did not stress competition between individuals, but between individuals and the environment. For Wallace, the less fit individuals, those less well-adapted to their environment, will be eliminated, especially when there are major changes in that environment. Under this system, each individual struggles against the environment and the fate of any one individual is independent of others.[72] This difference, which is fundamental, may explain why Wallace appears to have shown no resentment when Darwin's book was published the year after he had sent him his paper.[73]

None of the foregoing, however, should be allowed to cloud the fact that when *On the Origin of Species* did appear, in 1859, it introduced 'an entirely new and – to Darwin's contemporaries – an entirely unexpected approach to the question of biological evolution'. Darwin's theory explained, as no one else had done, a new mechanism of change in the biological world. It showed how one species gave rise to another and, in Ernst Mayr's words, 'represented not merely the replacement of one scientific theory ("immutable species") by a new one, but demanded a complete rethinking of man's concept of the world and of himself; more specifically, it demanded the rejection of some of the most widely held and most cherished beliefs of western man.' For Peter Bowler, 'The historian of ideas sees the revolution in biology as symptomatic of a deeper change in the values of western society, as the Christian view of man and nature was replaced by a materialistic one.'[74] The most notable flash of insight by Darwin was his theory of natural selection, the backbone of the book (its full title was *On the Origin of Species by Means of Natural Selection, or the Preservation of Favoured Races in the Struggle for Life*). Individuals of any

species show variations and those better suited were more likely to reproduce and give rise to a new generation. In this way, accidental variations that fitted better than others were encouraged. No 'design' was necessary in this theory, or process, which was at the same time far more parsimonious than any other, and could be observed on all sides.[75]

Although Darwin had been stimulated to published the *Origin* after being contacted by Wallace, he had been germinating his ideas since the late 1830s, after his now-famous voyage on the *Beagle*. His time in South America, in particular the Galapagos Islands, had taught him to think in terms of *populations* rather than individuals, as he studied variation from island to island. He had become familiar with the common rhea, a flightless bird, while travelling the open pampas of Patagonia, and had eaten different forms of the creature as he moved around. He noticed that, at the edges of the territory occupied by the two populations, there was a struggle for supremacy. And he began to wonder why there were related species on different islands and continents – would the Creator have visited each location and made these fine adjustments?[76] From a study of barnacles he noted how much variety was possible in a species, and all these observations and inferences gradually came together. When the book was published, on 24 November 1859, 1,250 copies were snapped up on the first day. He himself took the waters at Ilkley, in Yorkshire, waiting for the storm to break.[77] It did not take long and it is not hard to see why: Ernst Mayr concluded that there were six major philosophical implications of Darwin's theories: (1) the replacement of a static by an evolving world; (2) the demonstration of the implausibility of creationism; (3) the refutation of cosmic teleology (the idea that there was a purpose in the universe); (4) the abolition of any justification for absolute anthropocentrism (that the purpose of the world is the production of man); (5) the explanation of 'design' in the world by purely materialistic processes; (6) the replacement of essentialism by population thinking.

We must be clear about the impact of the *Origin*. It owed something to Darwin's solid reputation and because his book was packed with supporting details – it was not produced by a nobody.[78] Yet its impact also had something to do with the fact that, as James Secord has pointed out, the book *resolved* – or appeared to resolve – a crisis, not because it sparked one. Natural selection was, essentially, the last plank in the evolutionary argument, not the first one, the final filling-in of the theory, providing the mechanism by which one species gave rise to another. The non-revolutionary nature of the *Origin*, to use Peter Bowler's term, is shown by Secord's chart in his book, which records that the *Origin* did not decisively outsell *Vestiges* until the twentieth century.[79]

That said, the *Origin* did promote enormous opposition. Darwin himself realised that his theory of natural selection would prove the most contentious element in his argument and he was not wrong. John F. W. Herschel, a philosopher whom Darwin admired, called natural selection the 'law of higgledy-piggledy', while Sedgwick (who was both a divine and a scientist) condemned it as 'a moral outrage'.[80] Many of the favourable reviews of the *Origin* were lukewarm about natural selection: Lyell, for example, never accepted it fully, and described it as 'distasteful', while T. H. Huxley did not think it could be proved.[81] In the late nineteenth century, while the theory of evolution was widely accepted, natural selection was ignored, and this was important because it allowed people to assume that evolution was 'intended to develop toward a particular goal, just as embryos grew to

maturity'. Viewed in this way, evolution was not the threat to religion it is sometimes made to appear.[82] Indeed, the *Origin* had two chapters on the geographical distribution of living forms, making use of the geology and palaeontology reported above, and people had much less difficulty accepting this than the mechanism of selection. *Vestiges* had prepared part of the way. Ernst Mayr says the selection aspect of Darwin's theory was not finally accepted until the evolutionary synthesis of the 1930s and 1940s.[83] Many people simply thought that the implications of the *Origin* were immoral and remained convinced that the world was manifestly well-ordered – evidence for a divinity – and that Darwin's ideas about accidental ('higgledy-piggledy') evolution could not produce such harmony. Darwinism was selfish and wasteful, they said, and a benevolent deity would never allow such a process. What was the Darwinian purpose of musical ability, or the ability to perform abstract mathematical calculations?[84] Darwin, it should be said, was never entirely happy with the word 'selection', and many misunderstood how to interpret the term 'fittest'. Several critics argued that Darwin's method of theorising was unscientific because his theory could not be falsified.

Darwin's theory certainly had a major weakness. There was no account of the actual mechanisms by which inherited characteristics were passed on ('hard heredity'). These were discovered by the monk Gregor Mendel in Moravia in 1865, but Darwin and everyone else missed their significance and they were not rediscovered and given general circulation until 1900. Until the rediscovery of Mendel, the theories of the German biologist Auguste Weismann attracted most attention, in particular the idea of 'germ plasm', which he developed out of cell theory. It will be remembered that cells had first been observed following the invention of the microscope, when they had been called 'globules' or 'bubbles' (see above, page 488). By the early nineteenth century, when significant advances were made in the design of microscopes, biologists, following Marie-François Xavier Bichat, recognised twenty-one categories of animal tissue and realised that they were all made up of cells, now shown to consist of more than their walls and to contain a sticky 'substance of life', baptised 'protoplasm' by J. E. Purkinje in 1839.[85] The men who finally showed that all plants and animals were made up of cells were J. J. Schleiden (plants, 1838) and Theodor Schwann (animals, 1839). Weismann noted the nucleus in cells and gradually came to the view that the germ plasm does not consist of whole germinal cells but is concentrated in the rod-like structures in the nucleus which, because they stained differently, were called chromosomes. But even when Mendel was rediscovered it was not immediately apparent that his mechanism in a sense 'completed' Darwinism. This is because a debate was then raging as to whether selection, if it occurred, operated on continuous variation or only on disparate variation, that is, characteristics (such as blue or brown eyes) that varied discretely or, say, height, that varied continuously. Mendel himself seems to have chosen discrete characteristics (flower colour, whether seeds were wrinkled or not) because they were cleaner examples of the theory he was trying to prove *and* because he had his own rival theory to Darwin, namely that selection acted on hybrids, on intermediate forms. (Hybrids traditionally posed a theological problem, as forms intermediate between divinely created species.) The full significance of Mendelian genetics for Darwinian selection was not recognised until the 1920s.[86]

*

Darwin didn't stop with the *Origin*. No account of Darwinism can afford to neglect the *Descent of Man*. The idea of 'progressionist evolution' was everywhere in the nineteenth century, as we have seen, even in physics, with Kant and Laplace's nebular hypothesis, the notion that the solar system has condensed from a vast cloud of dust under the influence of gravity.[87]

This is one reason why, as the sciences of sociology, anthropology and archaeology began to emerge in the mid-nineteenth century, they were united in developing within a framework of progressionism. As early as 1861, Sir Henry Maine, in *Ancient Law*, had explored the ways in which the modern legal system had developed from the early practices found in 'patriarchal family groups'.[88] Other titles with a similar approach included John Lubbock's *Origin of Civilisation* in 1870 and Lewis Morgan's *Ancient Society* in 1877, though the most impressive, by far, was James Frazer's *Golden Bough*, published in 1890. Early anthropologists had also been affected by the colonial experience: on several occasions attempts were made to educate colonised populations, the aim being to convert them to the 'obviously' superior European cultural practices. The fact that these attempts had all failed persuaded at least some anthropologists that there had to be 'a fixed sequence of stages through which all cultures develop'.[89] And it followed from this that one could not, artificially, boost one culture from an earlier stage to a later one. Lewis Morgan defined these major stages as savagery, barbarism and civilisation, a comforting doctrine for the colonial powers. The main ideas he discusses are the growth of the idea of government, the growth of the idea of the family, and the growth of the idea of property.[90]

It was in this intellectual climate that archaeologists began conceiving the advances in regard to stone hand-axes that were described in the Prologue, when the 'three-age system' (of stone, bronze and iron) was introduced. We saw then that at first the idea of a 'stone age' of great antiquity met with fierce resistance. No one could accept that the earliest humans had co-existed with now-extinct animals, and it was only when Boucher des Perthes discovered stone tools side-by-side with the bones of extinct animals in the gravel beds of northern France that ideas began to change. But then, roughly speaking in 1860, thanks in part to publication of the *Origin*, there was a rapid evolution in opinion, and the much greater antiquity of the human race was at last accepted. Charles Lyell finally acceded to the progressionist view of the earth, then collected a mass of evidence in favour of the new view, and synthesised it in *Geological Evidences for the Antiquity of Man* (1863).

The extremely crude nature of the earliest stone tools convinced many that early man's social and cultural circumstances were equally primitive, and this led John Lubbock to argue that there had been an evolution of society from savage origins. This was more shocking than it might seem because nineteenth-century religious thinkers still viewed modern man as degenerate as compared with Adam and Eve before the Fall. It was in his book *Prehistoric Times* (1865) that Lubbock first used the terms 'Palaeolithic' and 'Neolithic' to describe the transition from the Old to the New Stone Age, which he said could be distinguished by the change in use from chipped to polished stone, though more sophisticated variations were soon observed.[91]

For many people, the crucial issue underlying the debate as to whether man was evolved from the apes revolved around the question of the soul. If man was, in effect, little more

than an ape, did that mean that the very idea of a soul – the traditional all-important difference between animals and men – would have to be rejected? Darwin's *Descent of Man*, published in 1871, tried to do two things at once: to convince sceptics that man really was descended from the animals and yet to explain what exactly it meant to be human – how humans had acquired their unique qualities.

'Although Darwin gradually abandoned his belief in a benevolent creator, he was certainly inclined to hope that the white race did indeed represent the high point of an inevitable (if irregular) advance toward higher things.'[92] In the *Descent*, he knew that, above all, he had to explain the very great – the enormous – increase in mental power from apes to humans.[93] If evolution was a slow, gradual process, why did such a large gap exist? This was the answer that the religious sceptics were looking for. His answer came in chapter four of the book. There, Darwin advanced the proposition that man possesses a unique *physical* attribute, the entity with which this book began, namely an upright posture. Darwin argued that this upright posture, and the bipedal mode of locomotion, would have freed the human's hands and as a result we eventually developed the capacity to use tools. And it was this, he said, which would have sparked the rapid growth in intelligence among this one form of great ape.[94] In the *Descent* Darwin did not offer any cogent reason as to why ancient man had started to walk upright and it was not until 1889 that Wallace suggested it could well have been an adaptation to a new environment. He speculated that early man was forced out of the trees on to the open savannah plains, perhaps as a result of climate change, which shrank the forests. On the savannah, he suggested, bipedalism was a more suitable mode of locomotion.

The importance of the upright posture, despite the fact that the idea was introduced by Darwin himself, was not at first regarded as very significant. It was not until Eugene Dubois discovered 'Java man', *Pithecanthropus* (now *Homo*) *erectus*, in 1891–1892, that the theory came into its own (and confirmed the importance of the Neanderthal finds: see Chapter 1). The *Pithecanthropus* remains included a femur constructed in such a way as to suggest bipedalism, together with a piece of skull of a size that indicated a brain capacity between that of apes and humans. Even so, the importance of man's upright posture was not fully accepted until the 1930s.[95]

The legacy of Darwinism is complex. 'The advent of evolutionism is seen by some as a watershed separating modern culture from the traditional roots of Western thought.'[96] There is no question but that its timing, quite apart from its intellectual substance, played a major role in the secularisation of European thought, considered in Chapter 35.[97] Darwinism forced people to a new view of history, that it occurred by accident, and that there was no goal, no ultimate end-point. As well as killing the need for God, it transformed the idea of wisdom, as some definite attainable state, however far off. This undermined traditional views in all sorts of ways and transformed the possibilities for the future. To mention just two, it was Darwinism's model of societal change that led Marx to his view of the inevitability of revolution, and it was Darwin's biology that led Freud to conceive the 'pre-human' nature of subconscious mental activity. As we shall see in a later chapter, Darwin's concept of what comprises 'fitness', in an evolutionary context, has been much misunderstood, and gave rise, consciously or unconsciously, to many social arrangements

that were unjust and cruel. But since the rediscovery of the gene, in 1900, and the flowering of the technology based on it, Darwinism has triumphed. Except for one or two embarrassing 'creationist' enclaves in certain rural areas of the United States, the deep antiquity of the earth, and of mankind, is now firmly established.

# New Ideas About Human Order:
# the Origins of Social Science and Statistics

Joseph-Ignace Guillotin was born in Saintes in the west of France on 28 May 1738, the ninth of twelve children. By a curious irony his birth was premature, precipitated by his mother's chance witnessing of a distressing public execution. Perhaps because of this, as Joseph-Ignace grew up, he was always aware that in France, as elsewhere, execution techniques varied widely according to the social standing of the condemned criminal. In general, members of the aristocracy suffered a quick death, while for those lower down the scale it was often protracted and agonising. In France in the eighteenth century there were more than one hundred offences that carried the death penalty, the most grotesque of which was reserved for François Damiens (1714–1757), the unfortunate who attacked Louis XV with a penknife and succeeded in scratching the royal arm. Damiens' flesh was torn from his breast, arms and thighs with red-hot pincers, his right hand – which had held the penknife – was burned in sulphur, molten lead and boiling oil were poured on the exposed flesh where the skin had been torn away and then his body was quartered by four horses pulling in four directions. The executioner showed his sympathy for his victim by loosening the sinews of the man's joints with a sharp knife so that he could be more easily torn apart.

By the time of the revolution, Joseph-Ignace was a substantial figure, a distinguished doctor, a professor of anatomy and Doctor-Governor of the Faculty of Medicine at the University of Paris. He became a representative in the National Assembly. He was also a pacifist and, motivated by humanitarian concerns, in December 1789 he introduced into the Assembly six propositions aimed at creating a new and more humane penal code, one which treated all men the same and did not distinguish, in the penalties imposed, between different ranks. The second article of this new code recommended that capital punishment should henceforth consist of decapitation by means of a new and simple mechanism. The Assembly spent time examining Dr Guillotin's recommendations, before adopting them, and during the debates a journalist asked – sarcastically and rhetorically, for the new mechanism had not yet been designed, let alone built – 'Should this device bear the name of Guillotin or Mirabeau?'

Guillotin did not either design or build the instrument that did, indeed, come to bear his name. The designer was another doctor, Antoine Louis (at one stage the plan was to call the new device a 'Louisette'), while the man who actually constructed the execution

machine was a Monsieur Guedon or Guidon, the carpenter who normally provided the state with scaffolds. The new contraption was tested on 17 April 1792 (using straw, sheep and several corpses). When a corpse with a particularly thick neck was not decapitated after three attempts, Dr Louis raised the height of the drop and changed the shape of the blade from a convex curve to a straight blade angled at 45°. A banquet was held to celebrate 'Dr Guillotin's daughter', with toasts to a 'most distinguished project for equality'.

The guillotine was first used 'in anger', so to speak, a week later, on 25 April 1792, when the thief and assassin Jacques Nicholas Pelletier met his end.[1] Thousands flocked to see the new instrument but many were disappointed – the execution was over so quickly.

Neither Dr Guillotin or Dr Louis could have foreseen how often their new, improved instrument was to be used in the years ahead, or at how efficiently it struck at all ranks equally. The French Revolution of 1789 is remembered first and foremost for what Hegel called its 'shrieking aftermath', five years of bloody terror, lynchings and massacres, and for years of tumultuous political upheaval, culminating eventually in the dictatorship of Napoleon Bonaparte and unleashing twenty years of war. The roll call of people sent to the guillotine, often for the flimsiest of reasons, still has the power to shock: Antoine Lavoisier, the chemist, because he was a former tax-gatherer; André Chénier, the poet, because of an editorial someone didn't like; Georges Danton, Camille Desmoulins, denounced by Robespierre; Robespierre himself, along with 2,500 others. Robespierre's loyal follower Philippe Le Blas blew his brains out but even so was taken to the Place de la Révolution (now the Place de la Concorde) and beheaded all the same. People spoke of 'guillotinemania' and of 'the red mass' being celebrated by 'worshippers of the scaffold'.[2]

How many lessons may be learned from this mayhem? The historian Jacques Barzun argues that many of the 'revolutionaries' who wanted the monarchy, nobility and clergy brought to heel, under the banner of 'Liberty, Equality, Fraternity', were ordinary but articulate people – lawyers, artisans, local officials or landowners – who for the most part lacked political and administrative experience. Such individuals, even though many were educated, could behave as a mob at times, and this helps to account for the vicious switchback of fortunes that the aftermath became. Abroad, in Britain especially, the French Revolution was regarded with horror.[3]

But its legacy was much more complex – and in a score of ways more positive – than that. One indication of the seriousness with which many regarded those events may be had from the statistic that Rousseau's *Social Contract* (see above, page 545) was reprinted on average every four months in the decade that followed 1789.[4] And a whole system of reforms was introduced, some of which didn't last, but many of which did. The universities and *grandes écoles* were reshaped, reducing the powers of the church, the royal library was reorganised as the Bibliothèque Nationale, and the Conservatoire established, where musicians could be trained at public expense.

One of the most enduring and influential innovations was the metre. Under the old system, there were in France an incredible 250,000 different units of weights and measures, though the most widely used unit of length was the *pied*, held to be equal to the length of the king's foot, and this had other uses – for example, the 'point' in printing, which was $\frac{1}{144}$ of a foot. Perhaps nothing could have been more incendiary than this in a revolutionary context, even though, in this instance, the events of 1789 only precipitated reform that

had been talked about since 1775, when the chief minister, Turgot, had asked Condorcet to draw up a plan for a scientific system of weights and measures based on the one-second pendulum. This went back to Galileo, the idea being that the basic unit of length should be the distance a pendulum swung when beating for one second (this was Talleyrand's idea). But there were too many problems associated with this, mainly having to do with the fact that the earth is not a perfect sphere, being flattened at the poles and bulging at the equator. Even Newton had been aware that gravity varies slightly with latitude, and not consistently, so that the swing of a pendulum is more erratic than one might think. The next proposal was to base the unit on something from nature, and a commission appointed by the French opted for a measure of the circumference of the earth, in which everyone had a stake. The commission calculated that a measure equal to the circumference divided by 40 million would give a value very near the *aune* of Paris, a familiar three-foot length comfortably on the human scale.[5] This proved popular, the more so as it could be seen as the basis for a far more rational system of measures: a gram would be one cubic centimetre of rain water weighed in a vacuum at the temperature of maximum density (4° C); a franc would be 0.1 grams of gold, divisible into 100 centimes. All this came to pass, save for the decimalisation of time: the new calendar which named twelve months of thirty days – again after nature – never caught on (Brumaire, the month of fog, Thermidor, the month of heat, Ventôse, the month of wind), nor the practice of dividing days into ten hours and hours into a hundred minutes. People never got used to the idea that five o'clock was mid-day, or that ten o'clock was midnight, and the system was ignored.

But the metre was important for more than itself. It occasioned a celebrated experiment, or seven-year survey, when two men, Jean-Baptiste-Joseph Delambre and Pierre-François-André Méchain, mapped the meridian from Dunkirk to Barcelona (passing through Paris), which determined the exact length of the circumference of the earth, on which the metre measure was based. The survey led to the first international scientific conference, in 1799, to consider collaboratively the evidence produced by Delambre and Méchain and to decide on the definitive length. Ironically, the survey produced a set of errors which, because of their importance, formed an important stage on the way to the invention of sophisticated statistics, which are discussed later in this chapter.[6] The length the two men calculated for the circumference of the earth differs from modern-day satellite surveys by less than eight pages of this book.

But the most shattering aspect of the aftermath of the events of 1789 was of course the Terror, followed by the Directorate and the Consulate. This suggested to many that the old oppression had merely been replaced by a new kind. For still others, the aftermath merely reinforced the view that man's true nature was as savage as it was wicked, vengeful as it was baleful, justifying the need for absolute authority in both the temporal and spiritual realms.[7] A third reaction was different again. This view held that the revolution had got out of hand because while some people had been eager to put liberty before order, for others the priority was the other way round, order before liberty. What was the best form of order to maximise liberty? This was one of the founding sentiments which gave rise to the idea of sociology.

Roger Smith notes that it was the French revolutionaries who described change as *l'art*

*social*, and that one of the first references to *la science sociale* came in a tract by the abbé Sieyès, *What is the Third Estate?*, which tried to identify what, exactly, was 'the commons' in France, in contrast to the monarchy, or the nobility, or the church. *La science social* was, in the mind of Sieyès and others who came after him, in effect a new stage in thought, a step on from the idea of a secular world, because men were now considering social organisation, social order, without resort to political grouping.[8] Condorcet, who among other things was the permanent secretary of the Académie des Sciences (and had been in hiding, under threat of the guillotine), took up Sieyès' phrase on the founding of the *Société de 1789*, the specific aim of which was the social reconstruction of France using *les sciences morales et politiques*. Although the Société did not outlast Condorcet's death, in prison, the ideal of a science of society lived on and, following the reform of the universities and *grandes écoles* in 1795, the *Classe des sciences morales et politiques* at the new Institut National had a department named *Science sociale, et législation*.[9]

It was not at all surprising that *la science sociale* should prove popular in France. After the Revolution, the French nation was no longer composed of 'subjects' but of 'citizens', which, it was felt, meant learning a new way of living together. This was made all the more pressing because citizens of both the left and the right (terms which were first used to reflect the seating plan in the French Constituent Assembly after 1789) felt the need for something new.[10]

If Sieyès and Condorcet were the first to coin the term 'social science', the first social scientist worth the name, at least in France, was Claude-Henri de Saint-Simon (1760–1825). He had fought for the Americans in the War of Independence, and was therefore well aware of how the young republic was using Enlightenment ideas, where appropriate, to bring about democracy, science and progress, and, like many Frenchmen of his generation, he was much taken with the recent advances in mathematics and the natural sciences. The contrast that he saw about him between their steady advance and the mayhem and aimlessness of political manoeuvring pushed him in the direction of *la science sociale*. This progress of the sciences, and the general optimism which they brought with them, caused him to introduce the term 'positive' to describe those activities of man that had finally eliminated any reliance on metaphysical explanations. Following the Revolution he thought that the science of man would become more and more positive, especially if physiology continued the progress it appeared to be making. He believed there were regularities, patterns, to be found within 'the concrete conditions of social life such as climate, health, diet and labour'. He became convinced that there was *organisation* in life that had nothing to do with politics (or theology, come to that). For Saint-Simon, medicine was a better metaphor for this organisation of society, and physiology in particular. He began to ask whether there might be laws governing social conduct, of which we are unaware, just as at one time the principle of the circulation of the blood was unknown.[11]

But if the social sciences, as a new way of thinking, a new theory of human order, emerged first in France, it was rapid industrialisation, in particular the wholesale migration from the countryside to the towns in England, that threw up the obvious practical need for this new approach. Between 1801 and 1851 the population of England and Wales more or less doubled, from 10.5 million to 20.8 million, but in the cities the increase was out of all proportion. Birmingham went from 71,000 to 233,000, up by 328 per cent, Glasgow

jumped from 84,000 to 329,000 (392 per cent), and Manchester/Salford from 95,000 to 401,000, a staggering rise of 422 per cent.[12] Such massive increases could not but have enormous consequences, the worst of which were the bad housing, the overcrowded factories, the vicious cruelty of child labour, primitive and inadequate sanitation and its associated diseases. Hundreds of thousands, if not millions, of workers lived in cramped and crowded homes, in buildings that were disfigured by soot and smoke from blast furnaces and lacked even the most basic amenities. Conditions were so bad that an entire region, between Birmingham and Stoke, became known as 'the Black Country'.[13]

John Marks has collected several accounts of the horrors of child labour and disease. 'Large numbers of poor children were handed over to employers from the age of seven, to work for over twelve hours a day, Saturdays included, under the control of overseers who often used the whip on them. Sometimes children worked for fourteen or fifteen hours a day for six days a week, with meal times being given up to clean machinery . . . Here is part of the evidence given to the government Committee on Factory Children's Labour in 1831–32: "At what time in the morning, in the brisk time, did those girls go to the mills?" "In the brisk time, for about six weeks, they have gone at 3 o'clock in the morning, and ended at ten, or nearly half past, at night." "What intervals were allowed for rest or refreshment during those nineteen hours of labour?" "Breakfast, a quarter of an hour, and dinner, half an hour, and drinking, a quarter of an hour." "Was any of that time taken up in cleaning the machinery?" "They generally had to do what they call dry down; sometimes this took the whole of the time at breakfast or drinking, and they were to get their dinner or breakfast as best they could; if not, it was brought home." '[14] Beginning in 1819, Acts of Parliament were passed to limit such excesses but they didn't go anywhere near far enough and conditions remained pitiable.

Under this system, children became so washed out that they often needed to be shaken awake in the mornings, and had to be dressed by the adult overseers. 'In some of the mines conditions were even harsher – children might be taken as early as age four, to perform the function of opening and closing the ventilation traps. They had to sit for hours in small niches cut into the coal where, in the words of one Commissioner, their work "was solitary confinement of the worst order".[15] Not surprisingly, the death rates arising from these arrangements were alarming, not least from children falling asleep on the job and sliding into machinery. That at least had the merit of being a quick death. But there were many diseases that thrived amid the squalid sanitation, most especially the unholy trinity of tuberculosis, cholera and typhoid.

Dickens and other writers produced their 'industrial novels', Robert Owen and others campaigned for a change in the law, but the first person who thought industrialisation was a problem that could be studied systematically was the Frenchman Auguste Comte (1798–1857). Comte, notable physically for his unusually short legs, had an exceptional upbringing in that he was raised in a family made up entirely of women, and this seems to have had a permanent effect: he always had a problem with women and was always interested in those less well-off than himself. The son of a civil servant, he entered the École Polytechnique in Paris, then well-known for its courses in science and engineering, and concentrated on the study of the French and industrial revolutions. It was at the Polytechnique that Comte discovered his lifetime aim, to 'apply the methods of the physical

sciences to society'.[17] Comte understood that society around him was changing in a fundamental sense: what he called 'theological' and 'military' values were giving way to 'scientific' and 'industrial' ones. In such a world, he said, industrialists replaced warriors, and scientists replaced priests. The social scientists, 'because they managed human harmony, essentially fulfilled the role of high priest in the new social order'.[18]

Between 1817 and 1824, after his time at the École Polytechnique, Comte became Saint-Simon's secretary. After they fell out (because Comte felt that Saint-Simon had not given him enough credit on a paper he published), the secretary set off on his own. He was a great believer in phases and it was in his book *Cours de Philosophie Positive* (*Course of Positive Philosophy*) that he argued that both humanity and science had passed through three stages.[19] There was first the theological stage in which people attribute phenomena to a deity; in the second, metaphysical stage, humans attribute causes to abstract forces or forms; in the third, what he called the positive stage, science 'abandons the search for ultimate causes' and looks instead for regularities and predictable sequences in 'observable phenomena'. He believed that humanity had made systematic progress in the main sciences: the physical sciences in the seventeenth century, and the life sciences in the eighteenth century and his own time, the early nineteenth century. From now on, he said, science – and in particular life science – would be at the centre of progressive civilisation.[20] In his own mind the life sciences were called 'organic physics' and were divided into physiology and social physics, what he later came to call sociology, a neologism he coined. Social physics, he said, is essentially divided from physiology, 'it has its own subject matter, the regularities of the social world, which cannot be translated into the laws of another science'.[21] Comte was specifically and deliberately seeking to replace political philosophy with sociology – he said it was 'inevitable' – as a less partisan basis for social harmony and, indeed, morality. Social phenomena, he said, are like all other phenomena in that they have their own invariable natural laws. But he did distinguish two forms of sociology. One, the 'static' form, governed the organisation of society, producing order and morality, whereas the 'dynamic' form governed the laws of change.[22]

Comte then rather lost his way. His obsession with social order, combined with his scornful view of organised religion (not to mention a passionate love affair), led him to attempt his own form of social order, in a new religion, the aim of which was 'to live in love on the basis of positive knowledge'. Comte loved religious ritual – he thought it helped bring about social harmony – but there was little that was 'positive' about these institutions that were founded in his name. In fact, more than anything else, they paralleled the Catholic church, except that the love of humanity was the object of worship.[23] Comte's considerable creative energies were thus deflected and dissipated. This hindered the maturation of his system of social physics, which ultimately fell down on two accounts. There was no allowance in his system for psychology, for individual motivation. And he was so obsessed with order, and how to achieve it, that he neglected the role of conflict in society, the crude reality of power. This left a gap for Marx to fill.[24]

Comte had an English counterpart in Herbert Spencer (1820–1903), who, like the Frenchman, was much influenced by hard science and engineering. In Spencer's case this had much to do with the fact that he was brought up in Derby, a railway town in the British midlands, where Spencer's first employment was for a railway company. But he

differed from Comte in one fundamental way: whereas the Frenchman's aim, ultimately, was for sociology to influence government policy, Spencer was always anxious to have sociology show that government 'should interfere as little as possible in human affairs'. He was an admirer of both Adam Smith and Charles Darwin and he adapted their ideas to produce a picture of society that he viewed as increasingly complex and therefore needing, as in a factory, both structural differentiation and the specialisation of functions. This was necessary, he said, because such a structure made societies more adaptable in a Darwinian sense. He insisted that evolution occurs among societies at every level, resulting in 'the survival of the fittest' (the phrase is his, though he only partially assimilated the theory of natural selection). This process, he said, would 'weed out' less adaptable peoples, an approach that became known as social Darwinism.[25]

Spencer was more popular than Comte, certainly in Britain and America, where his most famous book, *The Study of Sociology* (1873), was published both between hard covers and as a series in the press. One reason for his popularity was that he told the Victorian middle classes what they wanted to hear: that individual moral effort is the motor of change, and that therefore sociology supported ideas of *laissez-faire* economics and minimum government intervention in industry, health and welfare.

During the course of the nineteenth century, German sociology caught up with and then overtook its French and English counterparts. Following the horrors of Stalinism and the grim conditions in many Eastern European countries during the Cold War (not to mention China), the name of Karl Marx (1818–1883) carries much baggage. His political theories were discussed earlier, in Chapter 27. For many people, however, he has always been regarded as much as a sociologist as a political theorist. His sociological ideas revolve around his concepts of alienation and ideology – these too were discussed earlier, but a brief recapitulation will help.[26] Alienation refers to the extent to which people's lives and self-image are determined and often damaged by their material working conditions. 'People working in factories,' Marx said, 'become factory workers,' by which he meant that they come to feel they have no control over their lives and frequently are made to operate far below their capabilities. By 'ideology' he meant prevailing world views, unconsciously represented in a society, which make people think that, for example, nothing can be done about their state of affairs, nothing can be improved because the way things are is 'natural'. Marx's other sociological idea was that of the 'base' and 'superstructure' in society. For him, the conditions of production comprise the base, the fundamental reality of society, whereas social institutions – the law, say, the civil service, or the church – make up the superstructure. For Marx, economics is the fundamental human science, not psychology, and in saying this he created a new way of looking at human affairs – the relation between belief or knowledge, or social institutions, and the operation of power. 'Whereas Enlightenment writers or nineteenth-century liberals started their thinking from claims about human nature, Marx reversed the equation and sought to explain human nature via historical and economic factors.'[27]

It may seem surprising now but, to begin with, Marx's ideas were not really assimilated in western Europe till the end of the century (Harold Perkins says Marxism was 'hardly known' in England before the 1880s). To begin with, there was far more interest in him in

Russia, which was then a very retarded country, politically and socially, and where people had begun to wonder whether such a backward state could 'leap-frog' forward or whether it needed to go through the different reforms, revolutions and renaissances that the West had already experienced. Marx came to the attention of the West only later, as events in Russia turned violent and appeared to ratify his arguments.

The other German sociologists who helped shape both the discipline of sociology and the twentieth century were Max Weber, Ferdinand Tönnies and Georg Simmel. Like Marx, Weber's theories were predominantly economic but he also owed something to Comte and was probably the first German to call himself a sociologist. (Reference to society, as 'society', was not common before the end of the nineteenth century. People referred to 'political society', 'savage society', etc. but not to anything more abstract.[28])

The main concern among German sociologists was 'modernity', how modern life differed in a social, political, psychological, economic and moral sense from what had gone before. This idea was particularly prominent in Germany because of the country's formal unification on 1 January 1871. All of Max Weber's work was aimed at identifying what made modern, Western civilisation distinctive but, as Roger Smith has characterised it, all the early sociologists were interested in how modernity came about. Here is Smith's table:

Herbert Spencer: modernity involved a change from a predominantly militant [military] society to an industrial one;

Karl Marx: the change was from feudalism to capitalism;

Henry Maine (the British sociologist/anthropologist, whose most famous work was *Ancient Law*, which took an evolutionary approach): status → contract;

Max Weber: traditional authority → rational-legal authority;

Ferdinand Tönnies: *Gemeinschaft* (community) → *Gesellschaft* (association).[29]

Weber thought that social science should be developed to help the newly unified German state by analysing and clarifying just what, exactly, were the 'inescapable modern social and economic conditions'. He was part of a group of scholars – predominantly economic historians – who in 1872 founded the *Verein für Sozialpolitik* (Society for Social Policy) whose aim was just this, to research the links between social conditions and industrialisation.[30] As they saw it, members of the Verein thought that Germany was faced with a dilemma. They agreed that the Second Reich, in which they lived and worked, had no option but to accept industrialisation, but at the same time did not believe that the economy satisfied everyone equally. They therefore recommended that the government develop policies which reflected this reality, such as a system of national insurance, to alleviate working-class poverty.[31]

Within sociology, Weber was a polymath. To begin with he wrote economic history, then made a survey of the agricultural depression in Prussia in the 1880s, before turning to a different aspect of history, the ancient religions of Israel, India and China, which provided him with a comparative perspective for (modern) Western economic development.[32] This gave an added authority to his best-known work, *The Protestant Ethic and the Spirit of Capitalism*, which appeared in 1904. In this work he sought to explain that 'the crucial economic development in the modern world, capitalism, was first and foremost

an exercise carried out by Protestants – even in Catholic countries'.[33] Moreover, these Protestants were not necessarily concerned with wealth creation, as such, for the luxuries money could buy, but far more by work as a form of moral obligation, a calling (*Beruf*), as the best way to fulfil one's duty to God. In effect, whereas for Catholics the highest ideal was purification of one's own soul by withdrawal from the world and by contemplation (as with monks in a retreat), for Protestants the virtual opposite was true: fulfilment arises from helping others.[34]

Though a passionately political man, Weber was just as eager as Comte was for sociology to produce 'value-free facts' about society – that is, facts free from the personal or collective values of the scientists carrying out the research. At the same time, Weber was at pains to point out that science could not provide values or tell us how to live; it could only provide new facts which might help us in our *decisions* about how to live. He thought that the most salient fact about the modern world is that it brings disenchantment. It is a world in which, he said, 'the gods neither have nor can have a home'.[35] Modernity, for Weber, meant rationality, the organisation of affairs based on the trinity of efficiency, order and material satisfaction. This for him was achieved by means of legal, commercial and bureaucratic institutions that increasingly govern our relations with one another. The problem, as he saw it, was that commercial and industrial society, whatever freedoms and other benefits it has, brings disenchantment into our lives, eliminates any 'spiritual purpose' for mankind.[36] He didn't think there was anything to be done about this; disenchantment was here to stay and had to be lived with.

A final point of Weber's was that the new human sciences, of which sociology was one, were fundamentally different from the natural sciences. While we can 'explain' natural occurrences in terms of the application of causal laws, human conduct is 'intrinsically meaningful', and has to be 'interpreted' or 'understood' in a way which has no counterpart in nature.[37] This Weberian dichotomy has remained vivid and pertinent down to our own day.

Hardly less influential than this dichotomy, at the time anyway, was the distinction made by Ferdinand Tönnies (1855–1936). In 1887 he characterised pre-modern societies as based on *Gemeinschaft* (community), whereas modern societies he said were based on *Gesellschaft* (association). Communities in the traditional sense grow organically and have 'sacred' values which are shared by everyone, most of which are unquestioned. Societies in the modern world, on the other hand, are planned along rational, scientific lines and are maintained by bureaucracies. It follows, Tönnies said, that there is inevitably something artificial and arbitrary about modern societies, with no guarantee that the people we associate with will share our own values. This view was often expressed by the arts of modernism (Chapter 36).

The fourth of the great nineteenth-century German sociologists was Georg Simmel, who in 1903 published an essay, 'The metropolis and mental life'. He explained there that 'The psychological foundation, upon which metropolitan individuality is erected, is the intensification of emotional life due to the swift and continuous shift of external and internal stimuli.'[38] For Simmel, who taught both Karl Mannheim and Georg Lukács, the vast new cities of the nineteenth century (metropolises, not medieval university towns) were a new type of space, with important implications for human interaction, 'a space

that both excites and alienates … a place that leads to the atrophy of individual culture through the hypertrophy of objective culture …'[39] If the first phrase sounds like the city the impressionists were trying to portray, that explains why Simmel was known as 'the Manet of philosophy' in Berlin. His other influential point was his distinction between 'objective' and 'subjective' culture. Objective culture for Simmel was what we would call 'high culture', what Matthew Arnold described as the best that has been thought, written, composed, and painted. This culture was objective in that it was 'out there', in concrete form, for everyone to see, hear, or read, and Simmel thought that how people related to this 'canon' of works was the best way in which to define a society or culture. On the other hand, in 'subjective culture', said Simmel, an individual seeks 'self-fulfilment and self-realisation' not in relation to any culture 'out there' but through his or her own resources. Nothing – or very little – is shared in subjective culture. Simmel thought that the classic example of subjective culture was the business culture; everyone was turned in on his or her own particular project. In such a world everyone could be more or less satisfied with their lot yet be unaware of the collective *dis*satisfaction, manifested as alienation. In 1894 Simmel became the first person to teach a course specifically called sociology.[40]

Simmel leads us back to France again, for his opposite number there was Émile Durkheim (1858–1917). The son of a rabbi from Lorraine, a Jew and a provincial, Durkheim was doubly marginal, which perhaps gave an edge to his observations. France had been through some regular periods of turbulence since 1789 – the revolution of 1848, the Franco-Prussian War and siege of Paris, 1870–1871 – and this gave Durkheim an abiding interest in the conditions of social stability, what determines and what destroys it, and which factors give individuals a sense of purpose, keep them honest and optimistic.[41]

In a career sense, Durkheim was a beneficiary of a raft of changes then overtaking higher education in France. Following the siege, and the Commune, the French republicans and Catholic monarchists had fought for control, especially in education, with the republicans eventually emerging victorious. Among their priorities was the reform of the universities, where departments of scientific research were established, on the German model. Durkheim was caught up in these changes: by 1887 he was on the faculty at Bordeaux University, where he offered a new course: 'social science'.[42] And so, when the authorities restructured Bordeaux, along with the other universities, Durkheim was perfectly positioned to take advantage and invent (at least in France) the brand-new discipline of sociology. Sensing his moment, he moved quickly, to produce a textbook on the subject and two, narrower, more polemical works, *The Division of Labour in Society* (1893), and *Suicide* (1897). A year later, he also established a journal, *L'année sociologique*. In 1902 he was promoted to the Sorbonne.

*Suicide* is his best-known book. On the face of it, as Roger Smith says, this does not appear to be a *sociological* topic.[43] It is nothing if not intimate, private, subjective (Gide was later to argue that suicide is in principle inexplicable). But that was Durkheim's point: to show that psychology had a sociological dimension. In the first part of his book, he used statistics to show that suicide rates varied, for example, according to whether someone was Protestant or Catholic, whether they lived in the countryside or in the town. This had never been done before and people were shocked by his findings. But Durkheim himself was not satisfied with these more obvious variables. He also thought that less tangible

social features were just as important, and he divided suicides into egoistic, altruistic, anomic and fatalistic. 'Egoism' he described as 'a measure of a society's failure to become the focus of the individual's sentiments'.[44] In a society where such failures show themselves, a high proportion of people are aimless and 'unintegrated'. 'Anomie' he defined as a general measure of a society's lack of norms, which mean that many people lead unregulated lives, with numerous side-effects such as high crime. Durkheim was arguing, therefore, that there *is* such a thing as society, that there *are* social phenomena – egoism, anomie – that in a sense exist outside individuals and cannot be reduced to biology or psychology.[45]

Another of Durkheim's achievements, in making the case for a sociological approach to human behaviour, was that he also laid the groundwork for sociological medicine, what we now call epidemiology. He wasn't the only one of course – the German states, Austria and Sweden had all begun to collect data for this purpose in the eighteenth century. But social medicine, epidemiology, was also born in the great industrial cities as people struggled to cope with unprecedented problems and experiences, not least in regard to hygiene. One of the first in Britain, who scored a notable early success, and acted as a model for others, was Sir John Snow, who took a statistical/sociological approach to cholera. In 1854, there was in London a terrible outbreak of cholera which had caused over five hundred deaths in fewer than ten days. In going through the lists of deceased and afflicted persons, Snow noted that most cases had occurred in the neighbourhood of Broad Street. 'Upon interviewing members of the families of the deceased, Snow was able to isolate a single common factor, namely the Broad Street [water] pump, from which victims had drunk in every case. Corroborating evidence was made from the observation that in the local workhouse, also in the Broad Street area, only a few inmates had contracted cholera and that in every case they had contracted it before being admitted to the workhouse. Snow hypothesised (and found) that the workhouse drew water from a separate well ... The pay-off for Snow's careful investigation occurred when, finally convinced that impure water from the Broad Street pump was the cause of the cholera, Snow appealed to the authorities to have the pump closed.' This brought the outbreak to an end. Though it had little immediate effect, the episode subsequently became a legend. What makes the investigation doubly unusual is the fact that the cholera bacillus was not discovered, by Robert Koch, until some twenty-eight years after Snow's investigation.[46]

The germ theory of disease did not emerge fully until the 1880s. At much the same time that Snow made his deductions, Ignaz Semmelweis, a Hungarian, observed that cases of childbed fever could be reduced by having surgeons wash their hands between deliveries. Joseph Lister went further in 1865, advocating the use of carbolic acid (phenol) on patients' wounds during surgery. But it was not until Louis Pasteur noticed that weakened bacteria could be used to provide immunity from diseases they provoked at full strength, that the idea of vaccination was conceived and quickly used for a widening number of ailments which proliferated in cities – tuberculosis, diptheria, cholera.[47]

The problems of urbanisation also prompted the British to establish a decennial census, beginning in 1851. The aim here was to provide a simple but empirical basis for the social dimensions of modern Britain. In turn, the census stimulated the first systematic attempts to assess the dimensions of poverty and of the housing problem. This, says Roger Smith,

'transformed the political and moral consciousness of the country'.[48]

The census reflected a growth of interest in statistics. The British Association for the Advancement of Science, itself a new organisation, founded in 1831, established a statistical section in the same year. The Manchester Statistical Society was founded two years later, and the London Society a year after that. It was by now taken as read that collecting figures on morbidity, say, or the incidence of crime or insanity, or the facts of nutrition, would comprise the empirical basis both for social policy on the part of government, and for social science in the universities. All of a sudden, then, or so it seemed, a mass of data became available, describing life in Britain and elsewhere. It was the sheer volume of this detail that provoked more sophisticated statistical analysis, rather than simple counting. The first two types of statistical approach concentrated on the *distribution* of measurements of any particular aspect of life, while the second looked at the *correlation* between measurements. Besides having policy implications, these techniques had two further effects. They showed how certain different phenomena tended to go together, throwing up fresh questions, and they revealed the extent to which correlations were invariably less than perfect. Because measurements varied (along a distribution) questions began to be asked about the *indeterminacy* of the world, a preoccupation which loomed large in the twentieth century, even in hard sciences, like physics.[49]

More formal statistics began with the Belgian astronomer L.-A.-J. Quetelet (1796–1874). He went to Paris in 1823 to study astronomy and while there he encountered the theories of probability conceived by Pierre-Simon Laplace, then in his seventies (he died in 1827). And this is where we come back to the survey by Delambre and Méchain, in developing an accurate measure for the metre. Ken Alder, in his book on the survey, notes that the two men were very different in their working methods. Delambre wrote everything down in ink, in notebooks with numbered pages: any errors he made were there for all to see. Méchain, on the other hand, used separate sheets, often just scraps of paper, and wrote in pencil, which might fade or could be rubbed out or lost. Whether these working techniques were symptomatic, it certainly became clear to Delambre, when the two men came to compare notes, that his colleague had fudged a lot of his data, mainly to conform to expectations. One of the reasons these 'discrepancies' arose was because, in fact, the earth is a more irregular body than Méchain believed, meaning that meridians vary slightly, and so gravity varies slightly too at certain points, affecting the plumb lines they were using. But Méchain thought he had obtained anomalous results because he had miscalculated his readings of the stars in his triangulation exercises. Now, by then the exact position of the stars had become almost a classical problem, in both astronomy and mathematics. On the face of it, determining the exact location of a star (and its apparent motion) seems simple, but in fact it isn't simple at all. By the time of the metre survey it was well known that, even with the latest telescopes, the exact location of distant stars was difficult to pin down. Observations tended to produce a range of results. To begin with, the arithmetic mean of these observations was taken as the 'true' answer. Then it emerged that people differed systematically in their readings and so teams of researchers were used to eliminate this bias. But many mathematicians still weren't satisfied: they felt that observations nearer the mean should have more validity, more weight, than observations further away. This gave rise to two important developments. First, Adrien-Marie Legendre devised the method of

least squares to do just this. Under this method, the best fit of any set of observations was held to be that 'which minimised the square of the value of the departure of each data point from the curve'.[50] From our point of view, the important point is that Legendre came up with his theory and first worked it out on Delambre and Méchain's data.

This work by Laplace, Quetelet and Legendre was built on by Karl Friedrich Gauss (1777–1855), who made the second advance. Essentially, the astronomical techniques had shown that when observations by different astronomers were plotted on a graph, they were found to be, in the formal phrase, 'regularly distributed'. This regular distribution was found to apply to a number of other phenomena and so the phrase was changed to 'standard distribution' (about a mean). The idea was further refined in the 1890s by the English mathematician Karl Pearson (1857–1936), who introduced the term 'normal distribution curve', what became known as the bell(-shaped) curve. And this was, perhaps, the most influential idea of all, at least at that time, because the bell-shaped curve was used by Quetelet to produce what he called *l'homme moyen*, the average man.[51] It was this notion which caught the imagination of many and before long it was made wide use of – for example, by writers, marketing people, and manufacturers. In addition to that, however, there were questions raised by this discovery that seemed to pose more fundamental issues regarding human nature. Was the average man the ideal? Or was he the most mediocre? Were people at the edges of the distribution exotic or degenerate? Did *l'homme moyen* represent what was essential about man?[52]

People came to realise that there was something basic – even mysterious – about statistics. The very notion of a normal distribution, of the average man, meant that men and women behaved, to an extent, according to the logic of numbers. For example, although any individual murder was unpredictable, crime statistics revealed a regularity, even a stability – from year to year – in how many murders were committed and, more or less, where. Durkheim had observed the same thing with suicide. What did this say about the complexities of modern life, that such patterns should lie hidden? 'Statistics therefore appeared to be the means by which the study of social facts is made as objective and as precise as the study of physical facts, and the means by which social science, like physical science, uncovers general laws.' Such ideas provided hope for those who believed that 'the competitive system . . . must be reconstructed for the general welfare', that there should be state intervention to cushion at least some of the damage inflicted by raw industrialism.[53] This was one of the core beliefs of the Fabian Society, founded in London in 1883–1884, and of the London School of Economics and Political Science, where sociology was taught from 1903.[54]

But, as we saw in Chapter 17, the development of measurement, the increase in accuracy, and the rise of quantitative thought, in the thirteenth and fourteenth centuries, was one of the factors that led to the modern West, and a further leap forward in this regard took place in Victorian times. A final influence here came in the form of Edwin Chadwick, who insisted that one particular question, 'cause of death', be included in government surveys.[55] Chadwick was the researcher, the 'commissioner for fact', on two royal commissions (on the Poor Law, and on the sanitary conditions of labour) and, thanks to him, the Victorian mania for counting was consolidated (the statistics collected for the Poor Law Commission filled fifteen volumes). Chadwick's most shocking figure was that, out of 77,000 paupers

studied, no fewer than 14,000 had been made poor by catching fever.[56] This correlation thus identified a problem that no one had imagined existed before and which, to an extent, is still with us. Chadwick identified, and published, such damning figures as the increasing death rate in industrial towns, which had doubled in ten years, and showed that, in poor areas, there was a 'usually inaccessible privy' for an average of 120 – yes, 120 – people.[57]

These figures outraged many among the Victorian middle classes, playing a part in the development of modern politics (the establishment of the Labour Party, for example). At the same time, still other Victorians thought that the urge to count and measure was a form of control. The historian G. M. Young wrote 'It has been suggested to me that the Railway timetable did much to discipline the people at large.'[58] But in a mass society, statistics were a necessity and, far from being a controlling factor, proved for many people to be a form of freedom. To the Victorians, statistics were exciting, both philosophically, for what they revealed about determinacy and indeterminacy in collective life, and practically, for the help they gave government in the new – and often grim – metropolises. Nowadays, for most people, statistics have become dry and have completely lost the exciting ring that they once had. Even so, modern society, not least the idea of the welfare state, is unthinkable without them.

# The Uses and Abuses of Nationalism and Imperialism

In 1648, more than 150 years after the discovery of the Indies, and of America, the Treaty of Westphalia was finally concluded. This brought to an end the Thirty Years War, when Protestant and Catholic nations had fought themselves to a standstill over how to interpret God's intentions. They agreed that, from now on, each state would be left free to pursue its own inclination. So much blood had been shed, for ideas that could never be settled one way or the other, that a 'toleration of exhaustion' seemed the only way forward.[1] However, it was impossible to avoid the fact that there were several uncomfortable consequences which followed from this new state of affairs. For one, the papacy was sidelined; Spain and Portugal lost power, and the centre of gravity of Europe moved north, to France, England and the newly independent United Netherlands.[2] But by now it had become clear that the globe was bigger, more varied and more recalcitrant than the first explorers had anticipated and this brought about a change in sensitivity in the northern nations, whose very existence had been confirmed by the outcome of the Thirty Years War. Instead of the outright conquest of other peoples, which had brought Spain such vilification for its treatment of the American 'Indians', the northern nations were more interested in trade and commerce. (Only around a quarter of the Spanish and Portuguese migrants to pre-independence Latin America were women, whereas British settlers in North America were encouraged to bring their wives and children. As a result, far fewer British migrants took sexual partners from the indigenous population.) This change in feeling, between the early 'Catholic' attitude and the later 'Protestant' one, had a great deal to do with the fact that new mercantile classes were replacing the traditional military and landowning aristocracies as the main political force. There was thus an intellectual and moral basis in this development: commerce was believed to be a civilising and humanising force, for both parties. 'Commerce was not simply the exchange of goods, it involved contact and tolerance.'[3]

Crucial here were the Protestant countries, Britain and Holland. Each had a strong tradition of trading and, as countries which had achieved religious tolerance at some cost, they had no wish to inflict the same sin on the populations they found in distant lands. If they could, they would rescue these 'primitives' from paganism, as a subsidiary aim of trading, but they would not use force.[4]

If anything, Britain was now more important in this regard than Holland. Britain had her American colonies and, after the Seven Years War with France, she had emerged as the

most powerful of the maritime nations. But the seven-year campaign had driven her into massive debt and it was her attempt to make good her financial losses, through taxation of the American colonies, combined with the government's flat refusal to allow these colonies any direct representation in Parliament, that finally brought on the War of Independence (though the *levels* of taxation in the American colonies were quite low compared with those in Britain).[5] This was not a foregone conclusion but, at the same time, for many people, in Britain and elsewhere, it was only too clear that colonisation could never work in the long run. Experience was to show that either the colonies became dependent, and then a drain, on the metropolitan countries or, once they showed signs of becoming economically self-sufficient, they wanted to go their own way. One of Adam Smith's most pertinent predictions was that free Americans would prove better trading partners than as colonised subjects. Niall Ferguson says that there is good reason to believe that by 1770 New Englanders were 'about the wealthiest people in the world'.

Historians now call America Britain's 'first empire', to distinguish it from the second – in Asia, Africa and the Pacific – where settlement policies were very different. While there was always a military *presence* in the second empire, outright conquest was never a desirable (or achievable) aim.[6] As epitomised by the very name of the East India Company, and the Dutch East India Company, which became dominant features of this phase of empire, the watchword was trade, protected trade. The colonies of the East comprised in the main what the Portuguese called *feitorias*, factories, self-governing independent enclaves, as often as not acquired by treaty, the intention being to make them international entrepôts for both European and Asian merchants. Necessarily fortified, they nevertheless had no real military strength – in India, for instance, they could never have posed a threat to the Mughal forces. Nine hundred British civil servants and 70,000 British soldiers managed to govern upwards of 250 million Indians. (*How* they did it is a question for a separate book.)[7]

But the imperial presence did grow, aided by the retreat of the Muslims, and in time commerce triumphed, the East India companies growing in strength and influence. In India the company eventually emerged as the effective ruler of large parts of the country but even then, according to Anthony Pagden, India was always different from America and from later colonies in Africa. 'India, and Asia generally,' he says, 'was always a place of passage, not of settlement . . . No sense of being a distinct people ever emerged among the Europeans in India. There was never a Creole population or very much of the interracial breeding which transformed the population of many of the former Spanish American colonies into truly multi-ethnic communities.'[8]

Even so, there were risks inherent when two very different cultures rubbed up against each other. We saw in Chapter 29 how the activities of the Bengal Asiatic Society helped to kick-start the Oriental renaissance, when Sir William Jones drew attention to the deep similarities between Sanskrit and Greek and Latin, and when Warren Hastings, governor-general of Bengal, attracted Hindu scholars to Calcutta to research the Hindu scriptures (he was himself fluent in Persian and Hindi). But in 1788, three years after his term as governor-general had ended, Hastings was impeached by Parliament in London, accused of having 'squirreled away' an enormous personal fortune, filched partly from the East India Company itself and partly from the rulers of Benares and Avadh. Though Hastings

was eventually acquitted, seven long years after the impeachment began, his trial 'was a great theatrical event', largely stage-managed by Edmund Burke, and the former governor-general never really recovered. Burke was convinced that the East India Company had betrayed its aims, which, as well as trading, were 'to spread civilisation and enlightenment in the empire'. Instead, he said, the company under Hastings' leadership had become tyrannical and corrupt, 'subjugating Indians and betraying the very benevolence it was ordered to propagate'. (Later historians have concluded differently, that the more Hastings studied Indian culture, the more respectful he became.[9]) The way Burke spoke, Hastings had betrayed a high ideal of empire, the benevolent spread of Western civilisation, an attitude echoed in Napoleon. This was perhaps disingenuous of Burke (and of Napoleon). What Hastings' impeachment really showed was a priggishness in the imperial mind: whatever high-flown aims they arrogated to themselves, they were not so different as they thought from the more naturally aggressive colonialists of the first empire. Niall Ferguson lists nine ideas on which the 'second' British empire was based, which they wished to disseminate most. These were: the English language, English forms of land tenure, Scottish and English banking, the common law, Protestantism, team games, the limited or 'night watchman' state, representative assemblies, and the idea of liberty.[10]

Then there was the contentious issue of slavery. Empires had always involved slavery of one kind or another. We can never forget that both Athens and Rome had slaves. At the same time, to be a slave in ancient Greece or Rome did not necessarily involve degradation. Unlucky slaves were sent into the army or the mines; lucky ones might serve as a tutor to children.

Modern slavery was not like that: the very idea of the slave *trade* was itself degrading and horrendous. 'It began on the morning of 8 August 1444 when the first cargo of 235 Africans, taken from what is now Senegal, was put ashore at the Portuguese port of Lagos. A rudimentary slave market was improvised on the docks and the confused and cowed Africans, reeling from weeks confined in the insalubrious holds of the tiny ships on which they had come, were herded into groups by age, sex and the state of their health.'[11] No trading was allowed until Prince Henry 'the Navigator' had been notified and arrived at the quayside. As sponsor of the voyage, he was entitled to a fifth of the booty, in this case forty-six humans. This is how the traffic in 'black gold' (as slaves became known) began.

While it was new to Europe, a slave trade had existed in Africa for hundreds of years. What changed now was the size of the demand. The European slave trade was driven by a new form of commercial enterprise – the sugar plantation. And Europe's taste for sugar turned out to be such that, between 1492 and 1820, according to Anthony Pagden, 'five or six times as many Africans went to America as did white Europeans'. This statistic, however well-known, still has the power to shock. It shaped the Americas and provided the United States with, arguably, its most intractable problem. One deep reason for this abiding American dilemma arose from the fact that modern slavery involved a new understanding of the relationship between master and slave.[12] Neither Aristotle nor Cicero was ever comfortable with the idea of slavery. On occasion they tried to argue that slaves were a different 'type' of person, but they knew that was unconvincing when in many cases slaves had merely been on the losing side in a war. The main monotheisms took much the same

view. Both the Old Testament and the Qur'an authorise the taking of slaves, but only after a 'just war'.[13] The early Christians did not look favourably on the enslaving of other Christians but did not extend the same charity to non-Christians. In the early years of the trade, there were some attempts by Catholic clerics and jurists to claim that the wars deep inside Africa were 'just' but few took their arguments seriously and an advance of sorts was made in 1686 when the Holy Office condemned the slave trade. But, significantly, it did not condemn slavery itself.[14]

The Vatican's view reflected what was for a time the general opinion – that the slave trade was more offensive than slavery itself – but protests continued to snowball and drew attention to the fact that, underneath it all, there was a paradox. It was held by many that Negroes were 'an inferior type of people, little better than animals', and as if to confirm this they were often given the names of pets – Fido, Jumper and so on. Yet this attitude was flatly contradicted by the fact that masters often required their slaves to undertake tasks that demanded a full mental equipment.[15] No less dangerous was the possibility that female slaves would be found sexually attractive by their masters, producing mixed-blood offspring and a new type of social problem. So the new relationship was fraught with inconsistencies and tensions.

Racist views remained strong, right up to and beyond the time slavery was finally abolished. William Wilberforce was just one of the abolitionists who could not dispel his belief that European Christian culture was a civilising force. At one point he confessed that the emancipation of the slaves 'might actually be less important than that the reign of light and truth and happiness might be brought among them through Christianity and British laws, institutions and customs'. But Wilberforce did join the sponsors of an experimental colony, Sierra Leone, founded in 1787 to 'introduce civilisation among the natives and to cultivate the soil by means of free labour'. Sierra Leone flourished and its capital, Freetown, became one of the bases for the new Royal Navy anti-slaving squadron.[16] In the event, it was Denmark which, in 1792, became the first European nation to outlaw the slave trade. Britain took action to end the trade in 1805 and slaving had become a hanging offence by 1824. But elsewhere it went on for another half-century – the last landing was made in Cuba in 1870.[17]

The Treaty of Westphalia, in 1648, had created one set of European states. The Congress of Vienna, called in 1815, to decide the shape of Europe in the wake of Napoleon's fall, created another. Attitudes were very different then from now. For the British Foreign Minister Lord Castlereagh, one of the architects of the new Europe, Italy was no more than a 'geographical concept', and its unification as one state 'unthinkable'.[18] A German at the congress had much the same view about his own country. 'The unification of all the German tribes in a single, undivided state,' he said, was no more than a dream that had 'been refuted by a thousand years of experience and ultimately cast aside . . . It is incapable of realisation by any operation of human ingenuity, nor can it be enforced by the bloodiest of revolutions; it is an aim pursued only by madmen.' He concluded that if the idea of national unity gained the upper hand in Europe, 'then a wasteland of bloody ruins will be the only legacy that awaits our descendants'.[19]

The main aim of the Congress of Vienna was to prevent there ever again being a

revolution in Europe, and to that end the assembled diplomats and politicians set about recreating much the same landscape as had existed immediately after 1648. 'Spain and Portugal were restored under the former ruling families, Holland was enlarged by the former Austrian Netherlands, later to become Belgium, Switzerland was reconstituted, Sweden stayed united with Norway, and since the Pentarchy, the club of five major European powers, was unthinkable without France, the latter was left intact with its 1792 border.'[20] But this carefully balanced European system depended on central Europe remaining fragmented, diffuse and powerless.[21] Many of the Europeans at the Vienna Congress were very disturbed by the so-called 'Germanophiles', who were determined to unify Germany and turn her into a nation-state. As the French Foreign Minister Charles-Maurice de Talleyrand-Périgord wrote to Louis XVIII from Vienna: 'They are attempting to overturn an order that offends their pride and to replace all the governments of the country by a single authority. Allied with them are people from the universities, youngsters who have been primed with their theories, and all those who ascribe to German particularism all the sufferings that have been inflicted on the country in the course of the wars that have been fought there. The unity of the German fatherland is their slogan, their faith and their religion, they are ardent to the point of fanaticism … Who can calculate the consequences, if the masses in Germany were to combine into a single whole and turn aggressive? Who can say where a movement of that kind might stop?'[22]

At that point, in other words, the principle of nationality was acknowledged, as Hagen Schulze has pointed out, only where it was linked to the legitimate rule of a monarch: in Great Britain, France, Spain, Portugal, the Netherlands and Sweden – north and western Europe. The German-speaking lands, and Italy, were left out. This helps explain why nationalism, *cultural* nationalism, began as a German idea. The political fragmentation of the region was actually the logical outcome of the European order. One only has to look at the map to see why. 'From the Baltic to the Tyrrhenian Sea, it was Central Europe that kept the great powers apart, kept them at a distance and prevented head-on collisions.'[23] No one wanted an undue concentration of power in central Europe, for if anyone should take control, they could easily become 'mistress of the entire continent'.[24] For many, the minuscule Italian and German states guaranteed freedom. Although Italy and Germany were in a similar situation, in this regard, much of Italy was occupied by a foreign power (Austria in the north, the Bourbons in the south), and this too explains why modern nationalism began in Germany. In fact, the unification of Germany, and of Italy, were two of the seminal political events of the nineteenth century which – together with the Civil War in America – did so much to bring about the great industrial rivalry in the last decades of the 1800s, fashioning our modern world, but which also led eventually to the First World War, setting the stage for the calamitous twentieth century. How prescient Talleyrand was.[25]

The first person to identify what we may call 'cultural nationalism' was Johann Gottfried Herder (1744–1803), though the great German historian Friedrich Meinecke said that Friedrich Karl von Moser had first found signs of a 'national spirit' in 1765 'in those parts of Germany where 20 principalities could be seen during a day's journey'. The stage had been set, as we saw in Chapter 24, with the emergence (not just in Germany) of a self-conscious 'public' in the late seventeenth century. 'Nature,' Herder said, 'has separated nations not only by woods and mountains, seas and deserts, rivers and climates, but

most particularly by languages, inclinations and characters, that the work of subjugating despotism might be rendered more difficult, that all the four quarters of the globe might not be crammed into the belly of a wooden horse.'[26] For Herder the *Volk* was irreducible, incompatible with the idea of empire, which he said went against the grain of the 'natural plurality' of the world's peoples.[27] The Germans wanted unification, a nation-state, and this had to be 'cultivated' because they had for too long been the theatre of war for the European powers, where 'today's ruler might turn out to be tomorrow's enemy'.[28] In place of the 'jumbled patchwork' of states that had occupied central Europe for centuries, the nineteenth century saw two massive powers come into being. The nature of this change cannot be overestimated.

The other European nations responded to these German and Italian sentiments with what Hagen Schulze has called 'patriotic regeneration'.[29] This was especially true in France, for example, where the entire education system was placed in the service of the nationalist cause. The teaching of history and national politics was to be the cause of national regeneration after revolution and repeated defeat. The most obvious – one might say the most lurid – example of this was G. Bruno's *Le Tour de la France par deux enfants: devoir et patrie.* This was the story of a fourteen-year-old boy, André Valden, and his brother Julien, aged seven. The story is set in the wake of the Franco-Prussian War after the two boys have been orphaned and stranded in their home-town of Phalsburg, which has been annexed by Germany. They escape and journey throughout France in the course of their adventures, ultimately finding a new home in the country, which, thanks to those adventures, they now see in all its glory. Appearing first in 1877, the book went through twenty reprints in the next thirty years. Another example of the fervent nationalism of the times is that while Jules Ferry (1832–1893) was education secretary, every classroom was required to display a map of France with Alsace and Lorraine shown surrounded by black mourning crepe. Jules Michelet (1798–1874) wrote about France as the 'pontificate of modern civilisation', meaning that it was the pioneer of the modern enlightened state: 'the French idea of civilisation had thus become the very core of a national religion.' (The *Marseillaise* was adopted as the national anthem in 1879.)[30]

England responded too, but in a different way. The colonial expansion of the British empire achieved unprecedented dimensions between 1880 and the First World War, as this table makes clear:

*Colonial dependencies (in thousands of square kilometres)*

|      | Great Britain | France | Germany | Spain | Italy |
|------|---------------|--------|---------|-------|-------|
| 1881 | 22,395 | 526 | 0 | 432 | 0 |
| 1895 | 29,021 | 3,577 | 2,641 | 1,974 | 247 |
| 1912 | 30,087 | 7,906 | 2,907 | 213 | 1,590[31] |

Here are some contemporary comments, quoted at length, to show not only their tenor but how widespread they were. 'Imperialism has become the very latest and the highest embodiment of our democratic nationalism. It is a conscious expression of our race' (the Duke of Westminster). 'The British are the greatest governing race the world has ever seen'

(Joseph Chamberlain.) On seeing the port of Sydney, Charles Darwin wrote 'My first feeling was to congratulate myself that I was born an Englishman.' 'I claim that we are the leading race in the world, and the more of the world we populate, the better it will be for mankind ... Since [God] has obviously made the English-speaking race the chosen instrument by which He means to produce a state and society based on justice, freedom and peace, then it is bound to be in keeping with His will if I do everything in my power to provide that race with as much scope and power as possible. I think that, if there is a God, then He would like to see me do one thing, that is, to colour as much of the map of Africa British red as possible' (Cecil Rhodes).[32]

The downside to this outbreak of nationalism, which looks inevitable with the benefit of hindsight, was yet more racism. Anti-Semitism was especially virulent in France and Germany. This partly had to do with the envy of Britain[33]: the French and German empires were so small, compared with the British, that the view formed, as Paul Déroulède, founder of the League of Patriots in France, put it, 'We cannot hope to achieve anything abroad before we have cured our domestic ills.'[34] And there was no doubt who was internal enemy number one – the Jews. In 1886 Edouard Drumont published *La France juive*, a 'concoction' of Jewish life and customs, which, though crude and clumsy, became an instant best-seller. It turned out to be the prelude to a wave of anti-Semitism in that country, culminating in the Dreyfus affair, when a Jewish officer was falsely accused of being a German spy. In Germany, the so-called *Kulturkampf*, the 'cultural battle', though it was waged over the supervision of schools and the appointment of parish priests, was really about the attempt by the Protestant state to make Catholic politicians conform to Prussian policy. In amongst this intolerance, the role of Jews was inevitably discussed.

Nationalism reached its ultimate form at the turn of the century in Maurice Barrès' trilogy, *Le roman de l'énergie nationale* (1897–1903). Barrès' idea was that the cult of the ego was the main cause of the corruption of civilisation. 'The nation ranked above the ego and had therefore to be regarded as the supreme priority in a man's life. The individual had no choice but to submit to the function assigned to him by the nation, "the sacred law of his lineage", and to "hearken to the voices of the soil and the dead".'[35] As Hagen Schulze has rightly pointed out, nationalism, the idea of a nation, which at the turn of the nineteenth century had been seen as a form of utopia, as a natural political and cultural entity, had become by the turn of the twentieth century a polemical factor in domestic politics. 'It no longer stood above the parties uniting society, but itself turned into a party and divided society.' The consequences were to be catastrophic.

Once again, we should be careful of exaggeration. Nationalism was catastrophic in many ways, but it also had its positive side. This was nowhere more evident than in regard to the great flowering of German intellectual life in the nineteenth century which, whether or not it was *caused* by unification of the country, and by the great feeling of nationalism that accompanied the unification, certainly occurred at exactly the same time.

Sigmund Freud, Max Planck, Ernst Mach, Hermann Helmholtz, Marx, Weber, Nietzsche, Ibsen, Strindberg, von Hofmannsthal, Rudolf Clausius, Wilhelm Röntgen, Eduard von Hartmann, ... all these were German or German-speaking. It sometimes escapes our attention that the period between 1848 and 1933, overlapping the turn of the century,

when this book comes to a close, was the high point of the German genius. 'The twentieth century was supposed to have been the German century.' These words were written in 1991 by the American historian Norman Cantor. They are echoes of those by Raymond Aron, the French philosopher, talking to the German historian Fritz Stern, when they were in Berlin to visit an exhibition commemorating the centenary of the births of the physicists Albert Einstein, Otto Hahn and Lise Meitner. All were born in 1878–79 and this moved Aron to remark: 'It could have been Germany's century.'[36] What Cantor and Aron meant was that, left to themselves, Germany's thinkers, artists, writers, philosophers and scientists, who were the best in the world between 1848 and 1933, would have taken the freshly-unified country to new and undreamed-of heights, were in fact in the process of doing so when the disaster that went by the name of Adolf Hitler came along.

Anyone who doubts this claim – that the period 1848–1933 was the German century – need only consult the list of names which follows. One could start almost anywhere, so complete was this dominance, but let's begin with music: Johannes Brahms, Richard Wagner, Anton Bruckner, Franz Liszt, Franz Schubert, Robert Schumann, Gustav Mahler, Arnold Schönberg, Johann Strauss, Richard Strauss, Alban Berg, Anton Webern, Wilhelm Furtwängler, Bruno Walter, Fritz Kreisler, Arthur Honegger, Paul Hindemith, Kurt Weill, Franz Lehár, the Berlin Philharmonic, the Vienna Philharmonic. Medicine and psychology were not far behind – in addition to Freud, think of Alfred Adler, Carl Jung, Otto Rank, Wilhelm Wundt, Hermann Rorschach, Emil Kraepelin, Wilhelm Reich, Karen Horney, Melanie Klein, Ernst Kretschmer, Géza Roheim, Jacob Breuer, Richard Krafft-Ebing, Paul Ehrlich, Robert Koch, Wagner von Jauregg, August von Wassermann, Gregor Mendel, Erich Tschermak, Paul Corremans. In painting there was Max Liebermann, Paul Klee, Max Pechstein, Max Klinger, Gustav Klimt, Franz Marc, Lovis Corinth, Hans Arp, Georg Grosz, Otto Dix, Max Slevogt, Max Ernst, Leon Feininger, Max Beckmann, Alex Jawlensky; Wassily Kandinsky was of Russian birth but it was in Munich that he achieved the single most important breakthrough in modern art – abstraction. In philosophy, in addition to Nietzsche, there was Martin Heidegger, Edmund Husserl, Franz Brentano, Ernst Cassirer, Ernst Haeckel, Gottlob Frege, Ludwig Wittgenstein, Rudolf Carnap, Ferdinand Tönnies, Martin Buber, Theodore Herzl, Karl Liebknecht, Moritz Schlick.

In scholarship and history there was Julius Meier-Graefe, Leopold von Ranke, Theodor Mommsen, Ludwig Pastor, Wilhelm Bode and Jacob Burckhardt. In literature, in addition to Hugo von Hofmannsthal there was Heinrich and Thomas Mann, Rainer Maria Rilke, Hermann Hesse, Stefan Zweig, Gerhard Hauptmann, Gottfried Keller, Theodor Fontane, Walter Hasenclever, Franz Werfel, Franz Wedekind, Arthur Schnitzler, Stefan George, Berthold Brecht, Karl Kraus, Wilhelm Dilthey, Max Brod, Franz Kafka, Arnold Zweig, Erich Maria Remarque, Carl Zuckmayer. In sociology and economics, there was Werner Sombart, Georg Simmel, Karl Mannheim, Max Weber, Joseph Schumpeter and Karl Popper. In archaeology and biblical studies, in addition to D. F. Strauss there was Heinrich Schliemann, Ernst Curtius, Peter Horchhammer, Georg Grotefend, Karl Richard Lepsius, Bruno Meissner. Finally (though this could just as easily have come first) in science, mathematics and engineering there were: Ernst Mach, Albert Einstein, Max Planck, Erwin Schrödinger, Heinrich Hertz, Rudolf Diesel, Hermann von Helmholtz, Wilhelm Röntgen, Karl von Linde, Ferdinand von Zeppelin, Emil Fischer, Fritz Haber, Herman Geiger, Heinz

Junkers, George Cantor, Richard Courant, Arthur Sommerfeld, Otto Hahn, Lise Meitner, Wolfgang Pauli, David Hilbert, Walther Heisenberg, Ludwig von Bertalanffy, Alfred Wegener, not to mention the following engineering firms of one kind or another: AEG, Bosch, Benz, Siemens, Hoechst, Krupp, Mercedes, Daimler, Leica, Thyssen.

This still does not do full justice to the German genius. The year 1900, the close of our time-frame, saw the deaths of Nietzsche, Ruskin and Oscar Wilde but it saw three ideas introduced to the world which, it may be said without exaggeration, formed the intellectual backbone of the twentieth century, certainly so far as the sciences were concerned. These ideas were the unconscious, the gene and the quantum. Each of these was of Germanic origin.

In explaining the great and rapid triumph of German ideas, in the period 1848–1933, we need to examine three factors, each special to Germany and German thinking but also to the theme of this chapter. First, we need to understand German ideas about culture, what it was, what it consisted of and what its place was in the life of the nation. For example, in English, 'culture' does not normally distinguish sharply between the spiritual and the technological areas of life but, in German, *Kultur* came to stand for intellectual, spiritual or artistic areas of creative activity but not the social, political, economic or technical-scientific life. As a result, whereas in English the words 'culture' and 'civilisation' are complementary aspects of the same thing, in German that is not the case. In the nineteenth century, *Kultur* denoted manifestations of spiritual creativity – the arts, religion, philosophy; in contrast, *Zivilisation* referred to social, political and technical organisation and, most important, *these were deemed to be of a lower order.* Nietzsche made much of this, and it is a vital distinction, without which a full understanding of German thought in the nineteenth century is impossible.

There was thus in Germany what C. P. Snow would have called a 'two cultures' mentality, and with a vengeance. One of the effects of this was to highlight and deepen the divide between the natural sciences, on the one hand, and the arts and humanities on the other. Several of the sciences, by their very nature, formed a natural alliance with engineering, commerce and industry. But, at the same time, and despite their enormous successes, the sciences were looked down upon by artists. Whereas in a country like England, or America, the sciences and the arts were, to a much greater extent, seen as two sides of the same coin, jointly forming the intellectual elite, this was much less true in nineteenth-century Germany. A good example of this is Max Planck, the physicist who (in 1900) discovered the quantum, the idea that all energy comes in very small packets, or quanta. Planck came from a very religious, somewhat academic family, and was himself an excellent pianist. Despite the fact that his discovery of the quantum rates as one of the most important scientific discoveries of all time, in Planck's own family the humanities were considered a superior form of knowledge to science.[37] His cousin, the historian Max Lenz, would jokingly pun that scientists (*Naturforscher*) were in reality foresters (*Naturförster*) – or, as we would say, hicks.*

The work of Ernst Mach reinforces this point. Mach (1838–1916) was one of the most

---

* Some of these paragraphs are an elaboration of discussion in the author's previous book, *A Terrible Beauty: The People and Ideas That Shaped the Modern Mind.*

impressive and ardent reductionists, with many discoveries to his credit, including the importance of the semicircular canals in the inner ear for bodily equilibrium, and that bodies travelling at more than the speed of sound create two shock waves, one at the front and the other at the rear, as a result of the vacuum their high speed creates (this is why we speak of a 'Mach number' on Concorde, or used to). But Mach was implacably opposed to metaphysics of any kind and denounced what he called 'misapplied concepts', like God, nature and soul. He regarded Freud's concept of the 'ego' as a 'useless hypothesis'. He felt that even the concept of the 'self' was 'irretrievable', that all knowledge could be reduced to sensation and that the task of science was to describe sense data in the simplest and most neutral manner possible. Mach was widely read in his day: both Lenin and his disciples, and the Vienna Circle, were adherents. Mach firmly believed that science had the answers, and that such subjects as philosophy and psychoanalysis were largely useless.[38]

This profound division – between the sciences on the one hand, and the arts and humanities on the other – had serious consequences. One that is particularly relevant here was that the intuition of artists was given more respect, accorded a far higher status, in Germany than anywhere else at the time. This was reflected in a second division, over and above that between the arts and the sciences, between *Kultur* and *Zivilisation*. This was the opposition between *Geist* and *Macht*, the realm of intellectual or spiritual endeavour and the realm of power and political control. It is important to say that the relationship between *Geist* and *Macht*, whether culture or the state should take precedence, was never satisfactorily resolved in Germany. The consequences were momentous, as a brief excursion into political/social history will show.

In 1848, Germany's attempt at a bourgeois revolution failed and with it the struggle of the German professional and commercial classes for political and social equality with the *ancien regime*. In other words, Germany failed to make the socio-political advances that England, Holland, France and North America had achieved, in some cases generations before. German liberalism, or would-be liberalism, was based on middle-class demands for 'free trade and a constitutional framework to protect their economic and social space in society'. When this attempt at constitutional change failed, to be followed in 1871 by the establishment of the Reich, led by Prussia, a most unusual set of circumstances came into being. In a real sense, and as Gordon Craig has pointed out, the people of Germany had played no part in the creation of the Reich. 'The new state was a "gift" to the nation on which the recipient had not been consulted.'[39] Its constitution had not been earned; it was simply a contract among the princes of the existing German states, who in fact retained their crowns until 1918. To our modern way of thinking, this had some extraordinary consequences. For example, one result was that 'the Reich had a Parliament without power, political parties without access to governmental responsibility, and elections whose outcome did not determine the composition of the government'. In addition to the Reichstag, there was the Bundesrat, not an elected body at all but a committee of state governments, which shared power with Parliament, but neither of whom could depose the Chancellor. Moreover, the internal arrangements of the individual states were not affected by the events of 1871. The franchise for the Prussian Parliament, for example (and Prussia made up three-fifths of the population), depended on the taxes one paid, meaning

that the top 5 per cent of tax-payers had one-third of the votes, the same proportion as the bottom 85 per cent.[40] Nor did the Chancellor rule with the aid of a cabinet: the imperial departments, which expanded their influence as time went on, were run by subordinate state secretaries. This was quite unlike – and much more backward than – anything that existed among Germany's competitors in the West (though this 'belatedness' or otherwise of Germany is the subject of lively academic controversy right now). Matters of state remained in the hands of the landed aristocracy, although Germany had become an industrial power. This power was increasingly concentrated in fewer hands for, with urbanisation, the growth of commerce and the expansion of industry, the patchwork of old German states became less and less powerful and the empire more of a reality. The state thus became progressively more authoritarian as it took on a greater role in regulating economic and social issues. In short, as more and more people joined in Germany's industrial, scientific and intellectual successes, the more it was run by a small coterie of traditional figures – landed aristocrats and military leaders, at the head of which was the emperor himself. This essential dislocation was fundamental to 'German-ness' in the run-up to the First World War. It was one of the greatest anachronisms of history.[41]

This great dislocation had two effects that concern us. One, the middle class, excluded politically and yet eager to achieve some measure of equality, fell back on education and *Kultur* as key areas where success could be achieved – equality with the aristocracy, and superiority in comparison with foreigners in a competitive, nationalistic world. 'High culture' was thus always more important in imperial Germany than elsewhere and this is one reason why it flourished so well in the 1871–1933 period. But this gave culture a certain tone – freedom, equality or personal distinctiveness tended to be located in the 'inner sanctum' of the individual, whereas society was portrayed as an 'arbitrary, external and frequently hostile world'. The second effect, which overlapped with the first, was a retreat into nationalism, but a class-based nationalism which turned against the newly-created industrial working class (and the stirrings of socialism), Jews and non-German minorities. 'Nationalism was seen as moral progress, with utopian possibilities.'[42] One effect of this second factor was the idealisation of earlier ages, before the industrial working class existed, in particular the Middle Ages and the Renaissance, which stood for an integrated daily life – a 'golden age' – in pre-industrial times. Against the background of a developing mass society, the educated middle class looked to culture as a stable set of values that uplifted their lives, set them apart from the 'rabble' (Freud's word) and, in particular, enhanced their nationalist orientation. The *Volk*, a semi-mystical, nostalgic ideal of how ordinary Germans had once been – a contented, talented, a-political, 'pure' people – took hold.

These various factors combined to produce in German culture a concept that is almost untranslatable into English but is probably the defining factor in understanding so much of German thought as the nineteenth century turned into the twentieth, and which helps explain both the (predominantly German) discovery of the unconscious and why Germany became so dominant in this area. The word in German is *Innerlichkeit*.[43] Insofar as it can be translated, it means a tendency to withdraw from, or be indifferent to, politics, and to look inwards, inside the individual. *Innerlichkeit* meant that artists deliberately avoided power and politics, guided by a belief that to participate, or even to write about it, was a

derogation of their calling and that, for the artist, the inner rather than the external world was the real one. For example, and as Gordon Craig tells us, before 1914 it was only on rare occasions that German artists were interested, let alone stirred, by political and social events and issues. Not even the events of 1870–1871 succeeded in shaking this indifference. 'The victory over France and the unification of Germany inspired no great work of literature or music or painting.'[44] Authors and painters did not really find their own day 'poetic enough' to challenge their talents. 'As the infrastructure of the new Reich was being laid, German artists were writing about times infinitely remote or filling their canvases with nereids and centaurs and Greek columns.' Even the great Wagner was composing musical drama that had only the remotest connection with the world in which he lived (*Siegfried*, 1876; *Parsifal*, 1882).[45]

There were of course exceptions. In the 1880s, for example, there was a movement in the arts known as Naturalism, inspired in part by the novels of Émile Zola in France, the aim being to describe the social ills and injustices caused by industrialism. But in comparison with the literature of other European countries, the German Naturalist movement was half-hearted in its attempt to make radical criticism and the Naturalists never turned their attention to the political dangers that were inherent in the imperial system. 'Indeed,' writes Gordon Craig, in his history of imperial Germany, 'as those dangers became more palpable, with the beginnings under Wilhelm II of a frenetic imperialism, accompanied by an aggressive armaments programme, the great majority of the country's novelists and poets averted their eyes and retreated into that *Innerlichkeit* which was always their haven when the real world became too perplexing for them.'[46] There were no German equivalents of Zola, Shaw, Conrad, Gide, Gorky or even Henry James. Among the major (German) names of the day – Stefan George, Rainer Maria Rilke, Hugo von Hofmannsthal – hard, harsh reality was subordinated to feeling and the attempt to fix on paper fleeting impressions, momentary moods, vague perceptions. Hofmannsthal's concept of *Das Gleitende*, the 'slip-sliding' nature of the times, where nothing could be pinned down, nothing stayed the same, where ambiguity and paradox ruled, is discussed in Chapter 36. Gustav Klimt did exactly the same thing in paint, and his example is instructive.

Born in Baumgarten, near Vienna, in 1862, Klimt was the son of a goldsmith. He made his name decorating the new buildings of the Ringstrasse with vast murals. These were produced with his brother Ernst but on the latter's death in 1892 Gustav withdrew for five years, during which time he appears to have studied the works of James McNeill Whistler, Aubrey Beardsley and Edvard Munch. He did not reappear until 1897, when he emerged with a completely new style. This new style, bold and intricate at the same time, had three defining characteristics: the elaborate use of gold leaf (using a technique he had learned from his father), the application of small flecks of iridescent colour, hard like enamel, and a languid eroticism applied in particular to women. Klimt's paintings were not quite Freudian: his women were not neurotic, far from it. The women's emancipation movement in Germany had been far more concerned than elsewhere with *inner* emancipation, and Klimt's figures reflected this.[47] They were calm, placid, above all lubricious, but they were still 'the instinctual life frozen into art', as Hofmannsthal said. In drawing attention to women's sensuality, Klimt was subverting the familiar way of thinking every bit as much as Freud was. Here were women capable of the very perversions reported in Richard Krafft-

Ebing's book *Psychopathia Sexualis*, which made them tantalising and shocking at the same time. Klimt's new style immediately divided Vienna but it also brought about his commission from the university.

Three large panels were asked for: 'Philosophy', 'Medicine' and 'Jurisprudence'. All three provoked a furore but the rows over 'Medicine' and 'Jurisprudence' merely repeated the fuss over 'Philosophy'. For this first picture the commission stipulated as a theme 'The triumph of light over darkness'. What Klimt actually produced was an opaque, 'deliquescent tangle' of bodies that appear to drift past the onlooker, a kaleidoscopic jumble of forms that run into each other, and all surrounded by a void. The professors of philosophy were outraged. Klimt was vilified as presenting 'unclear ideas through unclear forms'. Philosophy was supposed to be a rational affair; it 'sought the truth via the exact sciences'. Klimt's vision was anything but that, and as a result it wasn't wanted: eighty professors collaborated in a petition that demanded Klimt's picture never be shown at the university. The painter responded by returning his fee and never presenting the remaining commissions.[48] The significance of the fight is that in these paintings Klimt was attempting a major statement. How can rationalism succeed, he is asking, when the irrational, the instinctive, the unconscious, is such a dominant part of life? Is reason really the way forward? Instinct is an older, more powerful force. It may be more atavistic, more primitive, and a dark force at times, but where is the profit in denying it?[49]

The concept of *Innerlichkeit* was one thing in the hands of Freud, say, or Mann, Schnitzler or Klimt – it was original, energising, challenging. But there was another side, typified by the likes of Paul Lagarde and Julius Langbehn. Neither of these is as well-known now as Freud, Klimt, Mann and the others, but at the time they were equally famous. And they were famous for being viciously anti-modern, for seeing all about them, amid the fantastic and brilliant innovations, nothing but decay. Lagarde, a biblical historian (one of the areas where German scholarship led the world), hated modernity as much as he loved the past. He believed in human greatness and in the will: reason, he said, was of secondary importance. He believed that nations have a soul and he believed in *Deutschtum*, Germanism: he thought the country embodied a unique race of German heroes with a unique will. Lagarde was also one of those calling for a new religion, an idea that, much later, appealed to Alfred Rosenberg, Göring and Hitler himself. Lagarde attacked Protestantism for its lack of ritual and mystery, and for the fact that it was little more than secularism. In advocating a new religion, he said he wanted to see 'a fusion of the old doctrines of the Gospel with the National Characteristics of the Germans'. Above all, Lagarde sought the resurgence of the German people. To begin with he adopted 'inner emigration': people should find salvation within themselves; but then advocated Germany taking over all non-German countries of the Austrian empire. This was because the Germans were superior and all others, especially Jews, were inferior.[50]

In 1890 Julius Langbehn published *Rembrandt als Erzieher* (*Rembrandt as Teacher*). In this book, Langbehn's aim was to denounce intellectualism and science. Art, not science or religion, was the higher good, he said, the true source of knowledge and virtue. In science, the old German virtues were lost: simplicity, subjectivity, individuality. *Rembrandt als Erzieher* was a 'shrill cry against the hothouse intellectualism of modern Germany' which Langbehn thought would stifle the creative life; it was a cry for the irrational energies

of the people or tribe, the *Volk-geist*, buried for so long under layers of *Zivilisation*. Rembrandt, the 'perfect German and incomparable artist', was pictured as the antithesis of modern culture and as the model for Germany's 'third Reformation', yet another turning-in.[51] One theme dominated the entire book: German culture was being destroyed by science and intellectualism and could be regenerated only through the resurgence of art, reflecting the inner qualities of a great people, and the rise to power of heroic, artistic individuals in a new society. After 1871 Germany had lost her artistic style and her great individuals, and for Langbehn Berlin above all symbolised the evil in German culture. The poison of commerce and materialism ('Manchesterism' or, sometimes, *Amerikanisierung*) was corroding the ancient inner spirit of the Prussian garrison town. Art should ennoble, Langbehn said, so that naturalism, realism, anything which exposed the kind of iniquities that a Zola or a Mann drew attention to, was anathema.[52]

In other words, it can be argued – it has been argued – that nineteenth-century Germany produced a special kind of artist, and a special kind of art, inward-looking and backward-looking, and that the German fascination and obsession with *Kultur* had let *Zivilisation* run riot. Among other things, this formed the deep background to the emergence of scientific racism.

Modern (scientific) racism stems from three factors. One, the Enlightenment view that the human condition was essentially a biological state (as opposed to a theological state); two, the wider contact between different races brought about by imperial conquest; and three, the application and misapplication of Darwinian thinking to the various cultures around the world.

One of the early propagators of biological racism was Jules Virey, a French doctor who addressed the Parisian Académie de Médecine in 1841 on 'the biological causes of civilisation'. Virey divided the world's peoples into two. There were the whites, 'who had achieved a more or less perfect stage of civilisation', and the blacks (the Africans, Asians and American Indians), who were condemned to a 'constantly imperfect civilisation'. Virey was deeply pessimistic that the 'blacks' would ever achieve 'full civilisation', pointing out that, like white people, domesticated animals, such as cows, have white flesh, whereas wild animals – deer, say – have dark flesh. This didn't square with science even then (it had been known since the sixteenth century that, under the skin, all human flesh is the same colour) but for Virey this 'basic' difference accounted for all sorts of consequences. For example, he said that 'just as the wild animal was prey to the human, so the black human was the natural prey of the white human'.[53] In other words, slavery – far from being cruel – was consistent with nature.[54]

One new element in the equation was the development in the nineteenth century of racist thinking *within* Europe. A familiar name here is Arthur de Gobineau who, in *On the Inequality of the Human Races* (1853–1855: i.e., before Darwin and natural selection but after the *Vestiges of Creation*), claimed that the German and French aristocracy (and remember that he was a *self-appointed* aristocrat) 'retained the original characteristics of the Aryans', the original race of mankind. Everyone else, in contrast, was some sort of mongrel.[55] This idea never caught on but more successful was the alleged difference between the hard-working, pious – even joyless – northern Protestants, and 'the languid,

potentially passive and potentially despotic Latins' of the Catholic south. Not surprisingly perhaps, many northerners could be found (Sir Charles Dilke was one) who became convinced that the northern 'races', the Anglo-Saxons, Russians and Chinese, would lead the way in the future. The rest would form the 'dying nations' of the world.[56]

This reasoning was taken to its limits by another Frenchman, Georges Vacher de Lapouge (1854–1936). Lapouge, who studied ancient skulls, believed that races were species in the process of formation, that racial differences were 'innate and ineradicable' and any idea that they could integrate was contrary to the laws of biology.[57] For Lapouge, Europe was populated by three racial groups, *Homo Europaeus* – tall, pale-skinned and long-skulled (dolichocephalous), *Homo Alpinus* – smaller and darker with brachycephalous (short) heads, and the Mediterranean type – long-headed again but darker and shorter even than *Alpinus*.[58] Lapouge regarded democracy as a disaster and believed that the brachycephalous types were taking over the world. He thought the proportion of dolichocephalous individuals was declining in Europe, due to emigration to the United States, and suggested that alcohol be provided free of charge in the hope that the worst types might kill off each other in their excesses. He wasn't joking.[59]

After publication of Darwin's *On the Origin of Species* it did not take long for his ideas about biology to be extended to the operation of human societies. Darwinism first caught on in the United States of America. (Darwin was made an honorary member of the American Philosophical Society in 1869, ten years before his own university, Cambridge, conferred on him an honorary degree.[60]) American social scientists William Graham Sumner and Thorsten Veblen of Yale, Lester Ward of Brown, John Dewey at the University of Chicago, William James, John Fiske and others at Harvard, debated politics, war and the layering of human communities into different classes against the background of a Darwinian 'struggle for survival' and the 'survival of the fittest.' Sumner believed that Darwin's new way of looking at mankind had provided the ultimate explanation – and rationalisation – for the world as it was. It explained *laissez-faire* economics, the free, unfettered competition popular among businessmen. Others believed that it explained the prevailing imperial structure of the world in which the 'fit' white races were placed 'naturally' above the 'degenerate' races of other colours.[61]*

Fiske and Veblen, whose *Theory of the Leisure Class* was published in 1899, flatly contradicted Sumner's belief that the well-to-do could be equated with the biologically fittest. Veblen in fact turned such reasoning on its head, arguing that the type of characters 'selected for dominance' in the business world were little more than barbarians, a'throwback' to a more primitive form of society.[62]

In the German-speaking countries, a veritable galaxy of scientists and pseudo-scientists, philosophers and pseudo-philosophers, intellectuals and would-be intellectuals, competed to outdo each other in the struggle for public attention. Friedrich Ratzel, a zoologist and geographer, argued that all living organisms competed in a *Kampf um Raum*, a struggle for space, in which the winners expelled the losers. This struggle extended to humans, and the successful races had to extend their living space, *Lebensraum*, if they were to avoid

---

* Again, these paragraphs are based, in part, on material which appeared in the author's *A Terrible Beauty: The People and Ideas That Shaped the Modern Mind.*

decline.[63] Ernst Haeckel (1834–1919), a zoologist from the University of Jena, took to social Darwinism as if it were second nature. He referred to 'struggle' as 'a watchword of the day'.[64] However, Haeckel was a passionate advocate of the principle of the inheritance of acquired characteristics and, unlike Spencer, he favoured a strong state. It was this, allied to his bellicose racism and anti-Semitism, that led people to see him as a proto-Nazi.[65] For Houston Stewart Chamberlain (1855–1927), the renegade son of a British admiral, who went to Germany and married Wagner's daughter, racial struggle was 'fundamental to a "scientific" understanding of history and culture'.[66] Chamberlain portrayed the history of the West 'as an incessant conflict between the spiritual and culture-creating Aryans and the mercenary and materialistic Jews' (his first wife had been half-Jewish).[67] For Chamberlain, the Germanic peoples were the last remnants of the Aryans, but they had become enfeebled through interbreeding with other races.

Max Nordau (1849–1923), born in Budapest, was like Durkheim the son of a rabbi. His best-known book was the two-volume *Entartung* (*Degeneration*) which, despite being six hundred pages long, became an international best-seller. Nordau became convinced there was 'a severe mental epidemic; a sort of black death of degeneracy and hysteria', which was affecting Europe, sapping its vitality, and was manifest in a whole range of symptoms, 'squint eyes, imperfect ears, stunted growth ... pessimism, apathy, impulsiveness, emotionalism, mysticism, and a complete absence of any sense of right and wrong'.[68] Everywhere he looked there was decline.[69] The impressionist painters were the result, he said, of a degenerate physiology, nystagmus, a trembling of the eyeball, causing them to paint in the fuzzy, indistinct way that they did. In the writings of Baudelaire, Wilde and Nietzsche, Nordau found 'overwheening egomania', while Zola had 'an obsession with filth'. Nordau believed that degeneracy was caused by industrialised society – literally the wear-and-tear exerted on leaders by railways, steamships, telephones and factories. When Freud visited Nordau he found him 'unbearably vain' with a complete lack of a sense of humour.[70] In Austria, more than anywhere else in Europe, social Darwinism did not stop at theory. Two political leaders, Georg von Schönerer and Karl Lueger, fashioned political platforms that stressed the twin aims of, first, power to the peasants (because they had remained 'uncontaminated' by contact with the corrupt cities) and, second, a virulent anti-Semitism, in which Jews were characterised as the very embodiment of degeneracy. It was this miasma of ideas that greeted the young Adolf Hitler when he first arrived in Vienna in 1907 to attend art school.

France, in contrast, was relatively slow to catch on to Darwinism, but when she did she had her own passionate social Darwinist. In her *Origines de l'homme et des sociétés*, Clémence Auguste Royer took a strong social Darwinist line, regarding 'Aryans' as superior to other races and warfare between them as inevitable in the interests of progress.[71] In Russia, the anarchist Peter Kropotkin (1842–1921) released *Mutual Aid* in 1902, where he took a different line, arguing that although competition was undoubtedly a fact of life, so too was co-operation, which was so prevalent in the animal kingdom as to constitute a natural law. Like Veblen, he presented an alternative model to the Spencerians in which violence was condemned as abnormal. Social Darwinism was, not unnaturally, compared with Marxism and not only in the minds of Russian intellectuals.[72]

Not dissimilar arguments were heard across the Atlantic in the southern states of the

USA. Darwinism prescribed a common origin for all races and therefore could have been used as an argument *against* slavery, as it was by Chester Loring Brace.[73] But others argued the opposite. Joseph le Conte (1823–1901), like Lapouge or Ratzel, was an educated man, not a red neck but a trained geologist. When his book *The Race Problem in the South* appeared in 1892, he was the highly-esteemed president of the American Association for the Advancement of Science. His argument was brutally Darwinian.[74] He said that when two races came into contact one was bound to dominate the other.

The most immediate political impact of social Darwinism was the Eugenics movement, which became established with the new century. All of the above writers played a role in this, but the most direct progenitor, the real father, was Darwin's cousin Francis Galton (1822–1911). In an article published in 1904 (in the *American Journal of Sociology*), he argued that the essence of eugenics was that 'inferiority' and 'superiority' could be objectively described and measured.[75]

Racism, or at the very least uncompromising ethnocentrism, shaped everything. Richard King, an authority on ancient Indian philosophy, says it was Orientalists who, in the eighteenth and nineteenth centuries, 'effectively created' the religions of Hinduism and Buddhism.[76] What he means is that though complex systems of belief had evolved in the East over many centuries, the peoples who lived there did not have the concept of religion 'as a monolithic entity which involved a set of coherent beliefs, doctrines and liturgical practices'. He says that the very idea of religion, as an organised belief system, using sacred texts, and with a dedicated clerisy, was a European notion, stemming from the Christians of the third century after they had redefined the Latin word *religio*. To begin with, that had meant a 're-reading' of the traditional practices of their ancestors, but the early Christians – then under threat from the Romans – had redefined the word so that for them it meant 'a banding together, in which a "bond of piety" would unite all true believers'.[77] It was in this way, says King, that religion came to mean a system that emphasised 'theistic belief, exclusivity and a fundamental dualism between the human world and the transcendental world of the divine ... By the time of the Enlightenment, it was taken for granted that all cultures were understandable in this way'.[78]

In fact, says King, the term 'Hindoo' was originally Persian, a version of the Sanskrit *sindhu*, meaning the Indus river. In other words, the Persians employed the word to single out the tribes inhabiting that region – it did not then have a religious meaning.[79] When the British arrived in India, he says, they first described the local inhabitants 'as either heathens, the children of the devil, Gentoos (from the Portuguese *gentio* = gentile) or Banians (after the merchant population of Northern India)'. But the early colonialists could just not conceive of a people without a religion as they understood the term, and it was they who attached to this complex system of beliefs the phrase 'the religion of the Gentoos'.[80] Towards the end of the eighteenth century, 'Gentoo' was changed to 'Hindoo' and then, in 1816, according to King, Rammohan Roy, an Indian intellectual, employed the word 'Hinduism' for the first time.[81]

And it was much the same with Buddhism. 'It was by no means certain,' says King, 'that the Tibetans, Sinhalese and the Chinese conceived of themselves as Buddhists before they were so labelled by Europeans in the eighteenth and nineteenth centuries.'[82] In this case,

the crucial figure was Eugène Burnouf, whose *Introduction à l'histoire de Bouddhisme indien* effectively created the religion as we recognise it today. Published in 1844, Burnouf's book was based on 147 Sanskrit manuscripts brought back from Nepal in 1824 by Brian Hodgson (see above, page 600).

In both cases, and this is crucial, says King, the current manifestations of these religions were seen as 'degenerate' versions of a classic original, and in great need of reform. This 'mystification' achieved three purposes. One, in viewing the East as 'degenerate and backward,' imperialism was justified. Two, insofar as the East was ancient, the West was by comparison 'modern' and progressive. Three, the ancient religions of the East satisfied Europe's nostalgia for origins, very prevalent at the time. Friedrich Schlegel had voiced what many thought when he wrote 'Everything, yes, everything without exception has its origins in India.'[83]

Warren Hastings, whom we have already encountered, was appointed governor-general of Bengal in 1772. He was firmly of the view that British power in India, if it were to flourish, needed the agreement and support of the Indians themselves. The inherent implausibility of such an approach seems not to have detained or deterred anyone. Instead, he began a series of initiatives on the educational front designed to curry favour with a certain class of Indian. First, he proposed a professorship in Persian at Oxford. Drawing a blank there, his next move, with William Jones and others, was to found the Asiatic Society of Bengal, which was discussed in Chapter 29. More practical still was Hastings' provision for officials of the East India Company to be taught Persian, which was the language of the Mughal court, and for Hindu *pandits* to be brought to Calcutta to teach these same men Sanskrit and at the same time translate ancient scriptures. One effect of this was to produce several generations of British officials who were familiar with the local languages and sympathetic to Hindu and Muslim culture. Here are some lines from Hastings' preface to the translation he commissioned of the *Bhagavad Gita*: 'Every instance which brings [the Indians'] real character home to observation will impress us with a more generous sense of feeling for their natural rights, and teach us to estimate them by the measure of our own. But such instances can only be obtained by their writings; and these will survive, when the British dominion of India shall have long ceased to exist, and when the sources which it once yielded of wealth and power are lost to remembrance.'[84]

Hastings' achievements were built on in 1800 when Marquess Wellesley, the new governor-general, created the College of Fort William, which later became known as the 'university of the East'. Here, language tuition was expanded and, in addition to Persian and Sanskrit, Arabic and six Indian local languages were offered, together with Hindu, Muslim and Indian law, science and mathematics. Wellesley also saw to it that Western teaching techniques were introduced, in particular written examinations and public disputation. 'For many years the ceremony at which the disputations were conducted was seen as the principal social event of the year.' The college was an ambitious undertaking, at least in the early days. It had its own printing press which published textbooks, translations of Indian classics, studies of Indian history, culture and law, and a library was begun where a collection of rare manuscripts was formed.[85]

This enlightened policy didn't last. The first setback came when the 'court' of the East

India Company proposed that the college, or at least that part of it which taught European subjects, be transferred to England. And then, in the wake of the massacre of British subjects at Vellore (in south-east India), policy was changed decisively and a decision was taken that British power in the subcontinent could be sustained only if there were a mass conversion of Hindus.[86] This was such a fundamental change that it was never going to occur without a fight. In a celebrated pamphlet, entitled *Vindications of the Hindoos, by a Bengal Officer,* Colonel 'Hindoo' Stewart argued that any attempt at mass conversion was doomed to failure, one reason being that the Hindu religion was 'in many respects superior … The numerous Hindu gods represented merely "types" of virtue, while the theory of the transmigration of souls was preferable to the Christian notion of heaven and hell.'[87]

It did no good. After the renewal by Parliament of the charter of the East India Company in 1813, a bishopric of Calcutta was established, the College of Fort William was dismantled and its collection of books and manuscripts dispersed. In January 1854 it was officially dissolved.[88] The Asiatic Society of Bengal was left to run down. The fate of the college, and the society, served as a barometer of wider changes. The Orientalist policies pursued by the British in the late eighteenth and early nineteenth centuries had at the least helped produce a major extension of Western knowledge about the East. The new attitude, the attempts at mass conversions, merely helped polarise India, into coloniser and colonised.

What is the legacy of imperialism in terms of ideas? The answer is complex and cannot be divorced from the social, political and economic development of former colonies in the modern world. For many years, following the Second World War, when decolonisation accelerated, imperialism carried much negative baggage: it was a byword for racism, economic exploitation, cultural arrogance on the part of the colonisers at the expense of the 'other', the colonised. A large part of the post-modern movement had as its aim the rehabilitation of former colonised cultures. The Indian Amartya Sen, a Nobel Prize-winning economist who has held professorships at Harvard and at Cambridge, reported that India has had far fewer famines since the British left.

Recently, however, a more textured picture has emerged. 'Without the spread of British rule around the world, it is hard to believe that the structures of liberal capitalism would have been so successfully established in so many different economies … India, the world's largest democracy, owes more than it is fashionable to acknowledge to British rule. Its elite schools, its universities, its civil service, its army, its press and its parliamentary system all still have discernibly British models. Finally, there is the English language itself … the nineteenth-century Empire undeniably pioneered free trade, free capital movements [what Lawrence James calls the "unseen empire of money"] and, with the abolition of slavery, free labour. It invested immense sums in developing a network of global communications. It spread and enforced the rule of law over vast areas.' Niall Ferguson has shown that, in 1913, at the height of empire, 63 per cent of foreign direct investment went to developing countries, whereas in 1996 only 28 per cent did. In 1913 some 25 per cent of the world stock of capital was invested in countries with per capita incomes of 20 per cent or less of US per capita GDP; by 1997 that had fallen to 5 per cent. In 1955, near the end of the colonial period, Zambia had a GDP that was a seventh that of Great Britain; in 2003, after some forty years of independence, it was a twenty-eighth. A recent survey of forty-nine countries showed that 'common-law countries have the strongest, and French civil-law

countries the weakest, legal protections of investors'. The vast majority of the common-law counties were once under British rule. The American political scientist Seymour Martin Lipset showed that countries which were former British colonies had a significantly better chance of achieving 'enduring democratization' after independence than those ruled by other countries. On the other hand, the effects of colonisation were more negative where the imperialists took over countries that were already urbanised, with their own sophisticated civilisations (India, China), where the colonisers were more interested in plunder than in building new institutions. Ferguson thinks this may well explain the 'great divergence' by which these latter two countries were reduced from being leading civilisations – perhaps as late as the sixteenth century – to relative poverty.

Imperialism, therefore, wasn't just conquest. It was a form of international government, of globalisation, and it did not only benefit the ruling powers. The colonialists comprised not just Cecil Rhodes, but Warren Hastings and Sir William Jones.[89]

The extent to which Orientalism developed as an aspect of imperialism has been the subject of much debate at the end of the twentieth century and on into the present one. The argument which has had most attention is that developed by the Palestinian critic and professor of comparative literature at Columbia University in New York, the late Edward Said. In two books, Said argued first that many nineteenth-century works of art depicted an imaginary Orient, a stereotypical Orient full of caricature and simplification. Jean-Léon Gérôme's painting *Snake Charmer* (1870), for example, shows a young boy, naked except for the snake wrapped around him, standing on a carpet and entertaining a group of men, dark-skinned Arabs festooned in rifles and swords, lounging against a wall of tiles decorated with arabesques and Arabic script. Said's argument was that the intellectual history of Oriental studies, as practiced in the West, has been corrupted by political power, that the very notion of 'the Orient' as a single entity is absurd and belittling of a huge region that contains many cultures, many religions, many ethnic groupings. He showed for example, that the Frenchman Silvestre de Sacy, whose *Chrestomathie arabe* was published in 1806, was trying to put 'Oriental studies' on a par with Latin and Hellenistic studies, which helped produce the idea that the Orient was as homogeneous as classical Greece or Rome. In this way, he said, the world comes to be made up of two unequal halves, shaped by the unequal exchange rooted in political (imperial) power. There is, he says, an 'imaginative demonology' of the 'mysterious Orient' in which the 'Orientals' are invariably lazy, deceit-ful, and irrational.[90]

Said took his argument further in *Culture and Imperialism* (1993). It was in the 'great cultural archive,' as Said put it, that the 'intellectual and aesthetics in overseas dominion are made. If you were British or French in the 1860s you saw, and you felt, India and North Africa with a combination of familiarity and distance, but never with a sense of their separate sovereignty. In your narratives, histories, travel tales, and explorations your consciousness was represented as the principal authority . . . your sense of power scarcely imagined that those "natives" who appeared either subservient or sullenly cooperative were ever going to be capable of finally making you give up India or Algeria. Or of saying anything that might perhaps contradict, challenge . . .'[91] At some basic level, Said insisted, 'imperialism means thinking about, settling on, controlling land that you do not possess,

that is distant, that is lived on and owned by others ... For citizens of nineteenth-century Britain and France, empire was a major topic of unembarrassed cultural attention. British India and French North Africa alone played inestimable roles in the imagination, economy, political life and social fabric of British and French society and, if we mention names like Delacroix, Edmund Burke, Ruskin, Carlyle, James and John Stuart Mill, Kipling, Balzac, Nerval, Flaubert, or Conrad, we shall be mapping a tiny corner of a far vaster reality than even their immense collective talents cover.' It was Said's contention that one of the principal purposes of 'the great European realistic novel' was to sustain a society's consent in overseas expansion.[92]

Said focuses on the period around 1878, when 'the scramble for Africa' was beginning, and when, he says, the realistic novel form became pre-eminent. 'By the 1840s the English novel had achieved eminence as *the* aesthetic form and as a major intellectual voice, so to speak, in English society.'[93] All the major English novelists of the mid-nineteenth century accepted a globalised world-view, he said, and indeed could not ignore the vast overseas reach of British power.[94] Said lists those books which, he argues, fit his theme: Jane Austen's *Mansfield Park* and Charlotte Brontë's *Jane Eyre*, Thackeray's *Vanity Fair*, Charles Kingsley's *Westward Ho!*, Charles Dickens' *Great Expectations*, Disraeli's *Tancred*, George Eliot's *Daniel Deronda* and Henry James' *Portrait of a Lady*. The empire, he says, is everywhere a crucial setting. In many cases, Said says, 'the empire functions for much of the European nineteenth century as a codified, if only marginally visible presence in fiction, very much like the servants in grand households and in novels, whose work is taken for granted but scarcely ever more than named, rarely studied or given density...'[95]

The main narrative line of *Mansfield Park* (1814), for example, is to follow the fortunes of Fanny Price, who leaves the family home near Portsmouth, at the age of ten, to live as a poor relation/companion at Mansfield Park, the country estate of the Bertram family. In due course, Fanny acquires the respect of the family, in particular the various sisters, and the love of the eldest son, whom she marries at the end of the book, becoming mistress of the house. Said, however, concentrates on a few almost incidental remarks of Austen's, to the effect that Sir Thomas Bertram is away, abroad, overseeing his property in Antigua in the West Indies. The incidental nature of these references, Said says, betrays the fact that so much at the time was taken for granted. But the fact remains, 'What sustains life materially is the Bertram estate in Antigua, which is not doing well.'[96] Austen sees clearly, he says, that to hold and rule Mansfield Park is to hold and rule an imperial estate in close, not to say inevitable association with it. 'What assures the domestic tranquillity and attractive harmony of one is the productivity and regulated discipline of the other.'[97]

It is this tranquillity and harmony that Fanny comes to adore so much. Just as she is herself an outsider brought inside Mansfield Park, a 'transported commodity' in effect, so too is the sugar which the Antigua estate produces and on which the serenity of Mansfield Park depends. Austen is therefore combining a social point – old blood needs new blood to rejuvenate it – with a political point: the empire may be invisible for most of the time, but it is economically all-important. Said's underlying point is that Austen, for all her humanity and artistry, *implicitly* accepts slavery and the cruelty that went with it, and likewise accepted the complete subordination of colony to metropolis. He quotes John Stuart Mill on colonies in his *Principles of Political Economy*: 'They are hardly to be looked

upon as countries, but more properly as outlying agricultural or manufacturing estates belonging to a larger community ... All the capital employed is English capital; almost all the industry is carried on for English uses ... The trade with the West Indies is hardly to be considered an external trade, but more resembles the traffic between town and country.'[98] It is Said's case that *Mansfield Park* – rich, intellectually complex, a shining constituent of the canon – is as important for what it conceals as for what it reveals, and in that was typical of its time.

Both Kipling and Conrad represented the experience of empire as the main subject of their work, the former in *Kim* (1901), the latter in *Heart of Darkness* (1899), *Lord Jim* (1900) and *Nostromo* (1904). Said pictures *Kim* as an 'overwhelmingly male' novel, with two very attractive men at the centre. Kim himself remains a boy (he ages from thirteen to seventeen in the book) and the important background to the story, the 'great game' – politics, diplomacy, war – is, says Said, treated like a great prank. Edmund Wilson's celebrated judgement of *Kim* had been that 'We have been shown two entirely different worlds existing side by side, with neither really understanding the other ... the parallel lines never meet ... The fiction of Kipling, then, does not dramatise any fundamental conflict because Kipling would never face one.'[99] On the contrary, says Said, 'The conflict between Kim's colonial service and loyalty to his Indian companions is unresolved not because Kipling could not face it, but because for Kipling *there was no conflict*.' (Italics in the original.) For Kipling, India's best destiny was to be ruled by England.[100] Kipling respected all divisions in Indian society, was untroubled by them, and neither he nor his characters ever interfered with them. By the late nineteenth century there were, he says, sixty-one levels of status in India and the love–hate relationship between British and Indians 'derived from the complex hierarchical attitudes present in both peoples'.[101] 'We must read the novel,' Said concludes, 'as the realisation of a great cumulative process, which in the closing years of the nineteenth century is reaching its last major moment before Indian independence: on the one hand, surveillance and control over India; on the other, love for and fascinated attention to its every detail ... In reading *Kim* today we can watch a great artist in a sense blinded by his own insights about India ... an India that he loved but could not properly have.'[102]

Of all the people who shared in the scramble for empire, Joseph Conrad became known for turning his back on the dark continents of 'overflowing riches'. After years as a sailor in different merchant navies, Conrad removed himself to the sedentary life of writing fiction. Conrad's best-known books, *Lord Jim* (1900), *Heart of Darkness* (published in book form in 1902), *Nostromo* (1904) and *The Secret Agent* (1907), draw on ideas from Darwin, Nietzsche and Nordau to explore the great fault-line between scientific, liberal and technical optimism in the twentieth century and pessimism about human nature. He is reported to have said to H. G. Wells on one occasion, 'the difference between us, Wells, is fundamental. You don't care for humanity but think they are to be improved. I love humanity but know they are not!'[103]

Christened Józef Teodor Konrad Korzeniowski, he was born in 1857 in a part of Poland taken by the Russians in the 1793 partition of that often-dismembered country (his birthplace is now in the Ukraine). His father, Apollo, was an aristocrat without lands, for the family estates had been sequestered in 1839 following an anti-Russian rebellion.

Orphaned before he was twelve, Conrad depended very much on the generosity of his maternal uncle Tadeusz, who provided an annual allowance and, on his death in 1894, left about £1,600 to his nephew (well over £100,000 now). This event coincided with the acceptance of Conrad's first book, *Almayer's Folly* (begun in 1889), and the adoption of the pen name Joseph Conrad. He was from then on a man of letters, turning his experiences and the tales he heard at sea into fiction.[104]

Some time before Conrad's uncle died, Józef stopped off in Brussels on the way to Poland, to be interviewed for a post with the Société Anonyme Belge pour le Commerce du Haut-Congo – a fateful interview which led to his experiences between June and December 1890 in the Belgian Congo and, ten years on, to *Heart of Darkness.* In that decade, the Congo lurked in his mind, awaiting a trigger to be formulated in prose. That was provided by the shocking revelations of the 'Benin massacres' in 1897, as well as the accounts of Stanley's expeditions in Africa. *Benin: The City of Blood* was published in London and New York in 1897, revealing to the Western civilised world a horror story of native African blood rites. After the Berlin Conference of 1884, Britain proclaimed a protectorate over the Niger river region. Following the slaughter of a British mission to Benin (now a city of Nigeria), which arrived during King Duboar's celebrations of his ancestors with ritual sacrifices, a punitive expedition was dispatched to capture this city, long a centre of slavery. The account of Commander R. H. Bacon, intelligence officer of the expedition, in some of its details parallels events in *Heart of Darkness.* When Commander Bacon reached Benin he saw what, despite his vivid language, he says lay beyond description: 'It is useless to continue describing the horrors of the place, everywhere death, barbarity and blood, and smells that it hardly seems right for human beings to smell and yet live.'[105] Conrad avoids definition of what constituted 'The horror. The horror' – the famous last words in the book, spoken by Kurtz, the man Marlow, the hero, has come to save – opting instead for hints such as round balls on posts that Marlow thinks he sees through his field-glasses when approaching Kurtz's compound. Bacon, for his part, describes 'crucifixion trees' surrounded by piles of skulls and bones, blood smeared everywhere, over bronze idols and ivory.

Conrad's purpose, however, is not to elicit the typical response of the civilised world to reports of barbarism. In his account Commander Bacon had exemplified this attitude: '. . . they [the natives] cannot fail to see that peace and the good rule of the white man mean happiness, contentment and security'. Similar sentiments are expressed in the report which Kurtz composes for the International Society for the Suppression of Savage Customs. Marlow describes this 'beautiful piece of writing', 'vibrating with eloquence'. And yet, scrawled 'at the end of that moving appeal to every altruistic sentiment it blazed at you, luminous and terrifying, like a flash of lightning in a serene sky: "Exterminate all the brutes!"'.[106]

This savagery at the heart of civilised humans is also revealed in the behaviour of the white traders – 'pilgrims' as Marlow calls them. White travellers' tales, like those of H. M. Stanley in 'darkest Africa', written from an unquestioned sense of the superiority of the European over the native, were available to Conrad. *Heart of Darkness* thrives upon the ironic reversals of civilisation and barbarity, of light and darkness. Here is a characteristic Stanley episode, recorded in his diary. Needing food, he told a group of natives that 'I

must have it or we would die. They must sell it for beads, red, blue or green, copper or brass wire or shells, or ... I drew significant signs across the throat. It was enough, they understood at once.'[107] In *Heart of Darkness*, by contrast, Marlow is impressed by the extraordinary restraint of the starving cannibals accompanying the expedition, who have been paid in bits of brass wire, but have no food, their rotting hippo flesh – too nauseating a smell for European endurance – having been thrown overboard. He wonders why 'they didn't go for us – they were thirty to five – and have a good tuck-in for once'.[108] Kurtz is a symbolic figure, of course ('All Europe contributed to the making of Kurtz'), and the thrust of Conrad's fierce satire emerges clearly through Marlow's narrative. The imperial civilising mission amounts to a savage predation: 'the vilest scramble for loot that ever disfigured the history of the human conscience', as Conrad elsewhere described it.[109]

At the time *Heart of Darkness* appeared there was – and there continues to be – a distaste for Conrad on the part of some readers. It is that very reaction which underlines his significance. This is perhaps best explained by Richard Curle, author of the first full-length study of Conrad, published in 1914.[110] Curle could see that for many people there is a tenacious need to believe that the world, horrible as it might be, can be put right by human effort and the appropriate brand of liberal philosophy. Unlike the novels of his contemporaries, Wells and Galsworthy, Conrad derides this point of view as an illusion at best, and the pathway to desperate destruction at its worst.[111] Evidence shows that Conrad was sickened by his experience in Africa, both physically and psychologically, and was deeply alienated from the imperialist, racist exploiters of Africa and Africans at that time. *Heart of Darkness* played a part in ending Leopold's tyrannical misrule in what was then the Belgian Congo.

Born in Poland, and despite the fact that *Heart of Darkness* is set in the Belgian Congo, Joseph Conrad wrote in English. A final achievement of Empire, which began in earnest with the American colonies but culminated in India and the 'scramble' for Africa, was the spread of the English language. Today, there are as many English-speakers in India as there are in England, and five times that number in North America. Across the world, one and a half billion people speak English. Yet for many years – for centuries – English was a minority tongue, which hung on only with great difficulty. Its subsequent triumph, as the world's most useful language, is, as Melvyn Bragg has said, a remarkable adventure.

The first inkling we have of English was when it arrived in the fifth century AD, spoken by Germanic warriors, who were invited to Britain as mercenaries to shore up the ruins of the recently-departed Roman empire.[112] The original inhabitants of the British Isles were Celts, who spoke Celtish, no doubt laced with a little Latin, thanks to the Romans. But the Germanic tribes – Saxons, Angles and Jutes – spoke a variety of dialects, mutually intelligible, and it was some time before the Angles won out. The present-day language of Friesland, by the North Sea in Holland, is judged to have the closest language to early English, where such words as *trije* (three), *froast* (frost), *blau* (blue), *brea* (bread) and *sliepe* (sleep) are still in use.[113]

Early English took on a few words from Latin/Celtic, such as 'win' (wine), 'cetel' (cattle) and 'streat' (street), but the great majority of English words today come from Old English – you, man, son, daughter, friend, house and so on. Also the northern words 'owt' (anything)

and 'nowt', (nothing), from 'awiht' and 'nawiht'.[114] The ending '-ing' in place names means 'the people of . . .' – Reading, Dorking, Hastings; the ending '-ham' means farm, as in Birmingham, Fulham, Nottingham; '-ton' means enclosure or village, as in Taunton, Luton, Wilton. The Germanic tribes brought with them the runic alphabet, known as the *futhorc* after the first letters of that alphabet. Runes were made up mainly of straight lines, so they could more easily be cut into stone or wood. The language had twenty-four letters, lacking j, q, v, x and z but including æ, Þ, ð and uu, later changed to w.[115]

'Englisc', as it was originally called, did not begin to grow until the Viking invasions, when endings such as '-by' were added to places, to indicate farm or town: Corby, Derby, Rugby. The Danes made personal names by adding '-son' to the name of the father: Johnson, Hudson, Watson. Other Old Norse words taken into Englisc at this time included 'birth', 'cake,' 'leg', 'sister', 'smile', 'thrift' and 'trust'.[116]

The language came under most threat in the three hundred years following the battle of Hastings in 1066. When William the Conqueror was crowned in Westminster Abbey on Christmas Day that year the service was carried out in English and Latin but he himself spoke French throughout. French became the language of the court, and of the courts, and of Parliament. But, while English survived, words from French were transferred. Mainly, they described the new social order: army (*armée*), throne (*trone*), duke (*duc*), govern (*governer*), but also cooking: pork (*porc*), sausages (*saussiches*), biscuit (*bescoit*), fry (*frire*) and vinegar (*vyn egre*).[117] Old English didn't simply die out: often it adapted. For example, the Old English 'æppel' was used to mean any kind of fruit, but after the French word *fruit* came in, the Old English retreated, to mean just one kind of fruit, the apple.[118] Other French words that entered English at this time included chimney, chess, art, dance, music, boot, buckle, dozen, person, country, debt, cruel, calm and honest. The word 'checkmate' comes from the French *eschec mat*, which in turn comes from the Arabic *Sh h m t*, meaning 'the king is dead'.[119] These were the words that became Middle English.[120]

Middle English began to replace French in England only at the end of the fourteenth century. England had been changed, as everywhere had been changed, by the Black Death, which had carried off many churchmen, Latin- and French-speakers. The Peasants' Revolt also had a great deal to do with the resurgence of English, as the language of the protestors. When Richard II addressed Wat Tyler and his troops at Smithfield, Bragg says, he spoke in English. And Richard is the first recorded monarch using only English since the Conquest. In 1399, when Henry, Duke of Lancaster, crowned himself, after deposing Richard II, he too spoke in what the official history calls his 'mother tongue', English.[121] 'In the name of Fadir, Son, and Holy Ghost, I, Henry of Lancaster challenge this reyme of Yngland and the corone with all the members and the appurtenances, als I that am disendit be right lyne of the blode comying fro the gude lorde Kyng Henry Therde . . .'[122] About a quarter of the words used by Chaucer are from the French, though often they have meanings now lost ('lycour' = moisture, 'straunge' = foreign, distant), but he used English with a confidence that showed a corner had been turned.[123]

This confidence was reflected in the desire to translate the Bible into English. Although John Wycliffe is remembered as the man who first attempted this, Bragg says it was Nicholas Hereford, of Queen's College, Oxford, who did most of the work. His scriptoria, organised in secrecy at Oxford, produced many manuscripts – at least 175 survive.[124]

In the bigynnyng God made of nouyt heuene and erthe
Forsothe the erthe was idel and voide, and derknessis weren on the face of depthe; and
    the Spiryt of the Lord was borun on the watris.
And God seide, Liyt be maad, and liyt was maad.

Spelling was still haphazard. Church could be cherche, chirche, charge, cirche, while people could be pepull, pepille, poepul, or pupill. Order was first put in to this by the Master of Chancellery, shortened to Chancery. This entity was a cross between the Law Courts, the Tax Office and Whitehall, in effect an office that ran the country, and 'Chancery English' came to be regarded as the 'official', authorised version. Ich was replaced by I, sych and sich by suche, righte became right. Spelling became even more fixed after the invention of printing, which was also accompanied by the Great Vowel Shift, when a systematic change was made in the pronunciation of English. No one quite knows why this shift took place but the example Bragg gives shows that the sentence 'I name my boat Pete' would have been pronounced 'Ee nahm mee bought Peht.'[125]

All these were signs of increasing confidence, as was the great innovation of 1611, the King James version of the Bible, based on William Tyndale's translation. Here we see modern English in the process of formation, its poetry as well as its form:

Blessed are the povre in sprete: for theirs is the kyngdome off heven.
Blessed are they that morne: for they shalbe comforted.
Blessed are the meke: for they shall inherit the erth.
Blessed are they which honger and thurst for rightewesnes: for they shalbe filled.

In the Renaissance and the age of discovery, English began to burst with new words: bamboo (Malay), coffee and kiosk (Turkish), alcohol (Arabic), curry (Tamil). The rise of humanism, and an interest in the classics resurrected many Greek and Latin words (skeleton, glottis, larynx, thermometer, parasite, pneumonia). Their usage led to the so-called Inkhorn Controversy. An inkhorn was a horn pot which held ink for a quill and came to symbolise those who liked to coin new words, to show off their erudition in the classics. This blew itself out, but though we still use the words mentioned above, not all neologisms remained – for example, 'fatigate' (to make tired), 'nidulate' (to build a nest) and 'expede' (the opposite of impede).[126] Shakespeare was part of this renaissance and he was the first to use many words and phrases, whether he invented them or not. Whole books have been written on Shakespeare's English but among the words and phrases we find fresh in his plays and poems may be included: obscene, barefaced, lacklustre, salad-days, in my mind's eye, more in sorrow than in anger. However, he too used words that didn't fly: cadent, tortive, perisive, even honorificabilitudinatibus.[127]

In America the new landscape and the new people inspired many fresh words or innovative coinages, from foothill, to bluff, to watershed, to moose, to stoop. Then there were squatter, raccoon (rahaugcum at one point), and skunk (segankw). Familiar words were put together to describe new things and experiences: bull-frog, rattlesnake, warpath. Traditional meanings changed in the New World: lumber meant rubbish in London but became cut timber in the United States. Noah Webster, a schoolteacher who wrote the

best-selling *American Spelling Book*, which sold more copies than any other book in the New World save for the Bible, sparked that country's obsession with pronunciation: today, whereas the British say cemet'ry and laborat'ry, Americans pronounce the whole word, cem<u>e</u>tery and laborat<u>o</u>ry.[128] It was Webster who dropped the 'u' from colour and labour, the second 'l' from traveller. They were, he said, unnecessary. He changed theatre and centre to theater and center — that was clearer, as was check for cheque. Music and physic lost their final 'k'.[129] The opening up of the frontier introduced more Indian words — maize, pecan, persimmon, toboggan, though tamarack and pemmican didn't catch on so well. The poor travelled west on rafts which were steered with oars known as riffs — hence 'riff-raff'. 'Pass the buck' and 'the buck stops here' came from card games played out west. The 'buck' was originally a knife with a buck-horn handle, which was passed to show who had the authority, who was dealing.[130] OK, or okay, allegedly the most-used word in the English language, has many alleged etymologies. The Choctaw Indians had a word *Okeh*, meaning 'it is so'. In Boston it was said to be short for Orl Korrekt, and some Cockneys claim they too used Orl Korrec. Labourers working in Louisiana used to scrawl *Au quai* on bales of cotton that were ready to be transported downriver to the sea. But these derivations just scratch the surface and the issue is far from settled.[131] 'Jeans' owe their existence to Mr Levi Strauss, who used a cloth called geane fustian, which had originally been manufactured in Genoa.

The Enlightenment and the industrial revolution naturally introduced yet more new words — reservoir, condenser, sodium (1807), Centigrade (1812), biology (1819), kleptomania (1830), palaeontology (1838), gynaecology and bacterium (both 1847), claustrophobia (1879). It has been estimated that between 1750 and 1900 half the world's scientific papers were published in English.[132] In India, at the height of the British empire, it was arguable as to which people had the linguistic power. For a start, the deep and distant background of much English, as an Indo-European language, was Sanskrit. But new words taken into English from Indian languages included bungalow, cheroot, thug, chintz, polo, jungle, lilac, pariah, khaki (which means 'dust-coloured') and pyjamas.[133] The English renamed Kolkata as Calcutta, though it has recently returned to the original.

But as English spread in the nineteenth century, with the British empire, to Australia, the West Indies, to Africa and many areas of the Middle East, it became what Arabic, Latin and French had once been, the common currency of international communication, a position it has held ever since. Gandhi felt enslaved by English, or said that he did, but the excellence and popularity of Indian novelists writing in English belies this sentiment. The triumph of English across the world may reflect earlier notions of nationalism and imperialism but it has gone well beyond them. English is the language not only of empire, but of science, capitalism, democracy — and the Internet.

# *The American Mind and the Modern University*

The high point of empire in the Old World coincided more or less with the American Civil War. In a way, therefore, each continent faced a similar predicament – how different peoples, different races, should live together. The Civil War was a watershed in all ways for America. Although not many people realised it at the time, her dilemma over slavery had kept the country back and the war at last allowed the full forces of capitalism and industrialism to flex their muscles. Only after the war was the country fully free to fulfil its early promise.

The population in 1865 was upwards of 31 million, and therefore, relatively speaking, still small compared with the major European states. Intellectual life was – like everything else – still in the process of formation and expansion.[1] After the triumphs of 1776, and the glories of the Constitution, which many Europeans had found so stimulating, Americans did not want for lack of confidence. But there was, even so, much uncertainty: the frontier was continuing to open up (raising questions about how to deal with the Plains Indians), and the pattern of immigration was changing. Louisiana was purchased from the French in 1803. On all sides, therefore, questions of race, tribe, nationality, religious affiliation and ethnic identity were ever-present. In this context, America had to fashion itself, devising new ideas where they were needed, and using ideas from the Old World where they were available and relevant.[2]

The gradual assimilation of European ideas into an American context has been chronicled both by Richard Hofstadter and, more recently and more fully, by Louis Menand, professor of English at Harvard, by means of biographical accounts of a small number of nineteenth-century individuals, all New Englanders, who knew each other and who between them invented what we may call the characteristically American tradition of modern thought, the American mind. The first part of this chapter relies heavily on Menand's work.[3] The specialities of these few individuals included philosophy, jurisprudence, psychology, biology, geology, mathematics, economics and religion. In particular we are talking of Ralph Waldo Emerson, Oliver Wendell Holmes, William James, Benjamin and Charles Peirce, Louis Agassiz and John Dewey.

'These people had highly distinctive personalities, and they did not always agree with one another, but their careers intersected at many points, and together they were more responsible than any other group for moving American thought into the modern world

... Their ideas changed the way Americans thought – and continue to think – about education, democracy, liberty, justice and tolerance. As a consequence, they changed the way Americans live – the way they learn, the way they express their views, the way they understand themselves, and the way they treat people who are different from themselves ... We can say that what these thinkers had in common was not a group of ideas, but a single idea – an idea about ideas. They all believed that ideas are not "out there" waiting to be discovered, but are tools – like forks and knives and microchips – that people devise to cope with the world in which they find themselves ... And they believed that since ideas are provisional responses to particular and unreproducible circumstances, their survival depends not on their immutability but on their adaptability ... They taught a kind of scepticism that helped people cope with life in a heterogeneous, industrialised, mass-market society, a society in which older human bonds of custom and community seemed to have become attenuated ... There is also, though, implicit in what they wrote, a recognition of the limits of what thought can do in the struggle to increase human happiness.'[4] Along the way we shall be concerned with the creation of some major intellectual centres in America – the Universities of Yale, Princeton, Chicago and Johns Hopkins, and of Harvard and MIT in Cambridge, Massachusetts.

One founding father of this American tradition was Dr Oliver Wendell Holmes, *Senior*. He was well-connected, numbering the Cabots, the Quincys and the Jacksons – old, landowning families – among his friends; but he was himself a professor who had studied medicine in Paris. It was Holmes Sr who invented the term 'Boston Brahmin', to include those who were both well-born and scholars at the same time. It was Holmes Sr, in his guise as a doctor, who discovered the causes of puerperal (childbed) fever, demonstrating conclusively that the disease was transmitted from childbirth to childbirth by doctors themselves. This hardly made him popular among his medical colleagues, but it was an important advance in the development of the germ theory of disease and antisepsis.[5] His academic career culminated as dean of Harvard Medical School, though he became just as widely known for being what many people regarded as the greatest talker they had ever heard, and for his role in founding the Metaphysical Club, also known as the 'Saturday Club', where literary matters were discussed over dinner and whose other members included Emerson, Hawthorne, Longfellow, James Russell Lowell, and Charles Eliot Norton. Holmes also helped establish the *Atlantic Monthly*; he himself conceived the title to reflect the link between the New World and the Old.[6]

The other founding father of the American intellectual tradition was Emerson. Holmes Sr and he were good friends, mutual influences on one another. Holmes Sr was in the audience when Emerson gave his famous Phi Beta Kappa address on 'The American Scholar' at Harvard in 1837. This address was the first of several in which Emerson declared a literary independence for America, urging his fellow citizens to a writing style all their own, away from the familiarities of Europe (although among his 'great men' there were no Americans). A year later, in a no less notorious speech, to Harvard Divinity School, Emerson reported how he had been 'bored to distraction' by a sermon, and had contrasted its artificiality to the wild snow storm then raging outside the church. This (plus many other musings) had caused him, he said, to renounce his belief in a supernatural Jesus,

and organised Christianity, in favour of a more personal revelation. Partly as a result of this, Harvard – then a Calvinist institution – turned its back on Emerson for thirty years.[7] Holmes Sr, however, remained true to his friend. Above all, he shared Emerson's belief in an *American* literature, which is why he was so involved in the *Atlantic Monthly*.[8]

Holmes *Junior* was as impressed with Emerson as his father had been. As a freshman at Harvard in 1858, he said many years later, Emerson 'set me on fire'. But Holmes Jr was not in exactly the same mould as his father. Though Holmes Sr had been an abolitionist on religious grounds, he never had much direct involvement with blacks. Holmes Jr, on the other hand, felt the situation rather more keenly. He found *The Pickwick Papers* distasteful because of its treatment of West Indians and he likewise detested minstrel shows – they were, he said, 'demeaning'.[9] He agreed with Emerson, that a scientific world view did not preclude a moral life, or that it was possible to live in a better relation with one's fellow men outside organised religion than within it.

Holding such views, the Civil War, when it broke out in 1861, provided him with an opportunity to do something practical. True to his word, Holmes accepted a commission 'in a spirit of moral obligation'.[10] His very first engagement, the battle of Ball's Bluff, on 21 October that year, was far from being a success: 1,700 Union soldiers made the advance across the river, but less than half returned. Holmes took a bullet near the heart, the first of three injuries he was to suffer in the war and these wounds, as Menand observes, shaped him. (His handwriting in his letters was less than perfect, he told correspondents, because he had to lie flat on his back.)[11] Subsequently, although he might recount his fighting exploits from time to time, he never read histories of the Civil War.[12] He knew what he knew and he had no need and no wish to revisit the horror. The Civil War was fought with modern weapons and pre-modern tactics. The close-order infantry charge was designed for use against the musket, a gun with a range of about eighty yards. Nineteenth-century rifles had a range of 400 yards. This accounts for the terrible carnage of the Civil War, which is still the war in which most American lives have been lost and why it had such an effect on Holmes and others.[13]

Amid the carnage, he learned one thing that was to remain with him all his life. It was a distrust of absolutes and certainty, a conviction that 'certitude leads to violence'.[14] He looked about him and observed that, although the abolitionists in 1850 appeared to many Northerners as subversives, by the end of the war 'they were patriots'. He concluded from this that 'There is no one way that life must be.'[15] This guided him and formed him into the wise judge that he became. This wisdom emerged in his great book *The Common Law*,[16] which began life as the Lowell Lectures at Harvard University, all twelve given before a full house, where he spoke without notes.[17]

His biographer Mark DeWolfe Howe says Holmes was the first lawyer, English or American, to subject the common law to the analysis of a philosopher and the explanation of an historian.[18] The philosophical brilliance of Holmes was to see that the law has no one overriding aim or idea. (This was the idea he brought from the disaster of the Civil War.)[19] That it had evolved pragmatically.[20] Every case, in terms of facts at least, is unique. When it reaches court, it is swept up in what Menand calls a 'vortex' of intentions, assumptions and beliefs. There is, for example, the intention to find the solution that is just in this case. At the same time, there is an intention to arrive at a verdict that is

consistent with analogous cases in the past. There is also the intention to arrive at a verdict that will be most beneficial to society as a whole – the result that will deter others.[21] Then there are a number of less pressing aims, which also impinge on a verdict, some of which, Holmes conceded, are unvoiced. These may include a wish to redistribute costs from parties who can't afford them (often victims) to parties who can (often manufacturers or insurance companies). 'However over this whole weather pattern – all of which is in motion, so to speak, before any case ever arises – is a single meta-imperative: not to let it appear as though any one of these lesser imperatives has decided the case at the blatant expense of the others. A result that seems just intuitively but is admittedly incompatible with legal precedent is taboo; the court does not want to seem to excuse reckless behaviour (like operating a railroad too close to a heavily populated area), but it does not want to raise too high a liability barrier to activities society wants to encourage (like building railroads).'[22]

Holmes' genius was to face the fact that there are no hard-and-fast distinctions in any of these areas. This was made plain in a sentence that became famous, near the opening of *The Common Law*, where he said 'The life of the law has not been logic; it has been experience.'[23] He thought it was his job to speak harsh truths, not give way to historical legends.[24] His argument was that, for the most part, common law judges make up their minds first and come up with 'a plausible account' of how they got there afterwards. He even allowed that there were 'unconscious' influences on a judge, an early and interesting use of the word.[25] Holmes wasn't saying that judges are wayward, random or even idiosyncratic in their pronouncements. He just wasn't sure that experience is reducible to general abstractions, even though human beings spend so much time trying to do just that. 'All the pleasure of life is in general ideas,' he wrote in 1899, 'but all the use of life is in specific solutions – which cannot be reached through generalities any more than a picture can be painted by knowing some rules of method. They are reached by insight, tact and specific knowledge.'[26] He then built on this idea of experience to arrive at his most important contribution to civil law – his invention of the 'reasonable man'. Holmes thought that the point of experience is that it is 'collective and consensual', social not psychological. This goes to the heart of modern liability theory and is one of the main points where the law treats the question: how are we to live together? In the classic case, as Menand puts it, someone is injured as a result of what someone else does, giving rise to the question: what brings about civil liability? Traditionally, three arguments are brought to bear on this. One, it is enough to prove causation. All citizens act on their own responsibility; therefore they are liable for any costs their actions incur, whether they could have foreseen the consequences or not. This is 'strict liability'. Two, a citizen is liable for injuries he or she intended but not for those never contemplated. Legally this is called *mens rea* – the doctrine of 'the guilty mind'. Third, there is the argument of negligence: even if a citizen, in acting in a particular way, never anticipated the possibility of injury to anyone, that person is liable anyway, if the action were careless or imprudent.[27]

Holmes' contribution in this area was to replace the traditional legal terms 'guilt' and 'fault' with words like 'carelessness' and 'recklessness'.[28] He thought that by doing this, it would help make clear what we mean by behaviour that counts as reckless or careless. The main question, as he saw it, was to identify what was and what wasn't the 'permissible by-

product' of any activity. His answer, he said, was 'experience', and his achievement was to define this 'experience'.[29] What he meant by it, in this context, he said, is that of 'an intelligent and prudent member of the community'. Law, he said, was not a 'brooding omniscience in the sky'; it had to operate according to the precepts of an 'average' member of society, best exemplified by a jury.[30] 'When men live in society,' Holmes insisted, 'a certain average of conduct, a sacrifice of individual peculiarities . . . is necessary to general welfare.' Thus it was the 'reasonable man', his beliefs and conduct, that governed Holmes' understanding of liability. Now this is, as Menand also points out, a statistical fiction and the 'legal cousin' of Adolphe Quetelet's *homme moyen*. 'The "reasonable man" knows, because "experience" tells him, that a given behaviour in a given circumstance – say, taking target practice in a populated area – carries the risk of injuring another person.'[31]

Holmes also said at one point that a judge 'should not have a politics'. Yet he himself was in favour of capitalists, as risk takers and wealth generators, and there were those who thought that his arguments actually moved the law away from the theory of strict liability towards that of negligence, which made it easier for big businesses to escape their 'duty' to workers and customers. 'Nevertheless, in his theory of torts, Holmes did what Darwin did in his theory of evolution by chance variation and Maxwell did in his kinetic theory of gases: he applied to his own special field the great nineteenth-century discovery that the indeterminacy of individual behaviour can be regularised by considering people statistically at the level of the mass.'[32] This was a crucial step forward in the democratisation of law.

Experience, so important to Oliver Wendell Holmes in the realm of the law, would prove no less invaluable to his colleague from the Saturday Club, the philosopher and psychologist William James. Despite his impeccably Welsh name, James was in fact of Irish stock.[33]

The first William James, the philosopher's grandfather, was a dry goods millionaire who, but for John Jacob Astor, would have been the richest man in New York state.[34] His son Henry liked the bottle too much and was disinherited on William's death, but contested the will, and won. According to Richard Hofstadter, William James was the first great beneficiary of the scientific education then emerging in the United States during the 1860s and 1870s (and considered later in this chapter). A wag suggested that he was a better writer than his brother Henry, who was a better psychologist. Like Wendell Holmes, William James was sceptical of certitude. One of his favourite phrases was 'Damn the Absolute!'[35] Instead of a formal education, he had travelled across Europe with his family, and although he had never stayed long at any particular school, this travelling gave him *experience*. (Somewhere he picked up the ability to draw, too.[36]) He did finally settle on a career, in science, at Harvard in 1861 and formed part of the circle around Louis Agassiz, the discoverer of the Ice Age and at the time one of the most vociferous critics of Charles Darwin, who based his opposition, he insisted, on *science*.[37] After his early successes, Agassiz' fortunes had taken a turn for the worse when he lost a quantity of money on a publishing venture. The offer of a lecture series in America promised a way out and indeed, in Boston he was a great success (the Saturday Club was often referred to as Agassiz' Club). At the time he was in Boston, Harvard was in the process of setting up its school of science

(see below, this chapter), and a special chair was founded for him.[38]

It was Agassiz' battle with Darwin that interested James the most and, says one of his biographers, it was the example of the Swiss that decided him to become a scientist.[39] Agassiz, a deist, described Darwin's theory as 'a mistake'; he disputed its facts and considered it 'mischievous' rather than serious science.[40] James wasn't so sure. He was particularly sceptical of Agassiz' dogmatism whereas he thought evolutionary theory sparked all sorts of fresh ideas and, what he liked most, revealed biology as acting on very *practical*, even pragmatic, principles. Natural selection, for James, was a beautiful idea because it was so simple and down-to-earth, with adaptation being no more than a way to address practical problems wherever they occurred.[41] Life, James liked to say, is to be judged by *consequences*.[42]

In 1867, after his spell at Harvard, James went to Germany. In the nineteenth century some nine thousand Americans visited Germany to study in the universities there, which, as we have seen, were organised along the lines of the various disciplines, rather than as places to teach priests, doctors and lawyers. James went to study with the leading experimental psychologist of the day, Wilhelm Wundt, who had set up the first psychological laboratory, at Leipzig. Wundt's speciality – physiological psychology, or 'psychophysics' – was then regarded as the most likely area to produce advances. The basic assumption of physiological psychology was that all mind (conscious) processes are linked with brain processes, that every conscious thought or action has an organic, physical basis. One of the effects of this was that experimentation had replaced introspection as the primary means of investigation. In this so-called New Psychology, feelings and thoughts were understood as the result of 'brain secretions', organic changes which would in time yield to experimental manipulation. James was disappointed by the New Psychology, and by Wundt, who is little read now (and in fact it has now emerged that Wundt himself was drifting away from a rigid experimental approach to psychology).[43] Wundt's chief legacy is that he improved the standing of psychology thanks to his experimental approach. This improved standing of psychology rubbed off on James.

If Wundt's influence turned out to be incidental, that of the Peirces was much more consequential. Like the Wendell Holmeses and the Jameses, the Peirces were a formidable father-and-son team. Benjamin Peirce may well have been the first world-class mathematician the United States produced (the Irish mathematician William Rowan Hamilton thought that Peirce was 'the most massive intellect with which I have ever come into close contact') and he too was one of the eleven founding members of the Saturday Club.[44]

His son Charles was equally impressive. A prodigy who wrote a history of chemistry when he was eleven and had his own laboratory at twelve, he could write with both hands at the same time. No wonder, perhaps, that he was bored at Harvard, drank too much, and graduated seventy-ninth in his class of ninety.[45] That was the low point. Later, he built on his father's work and, between them, they conceived the philosophy of pragmatism, which was grounded in mathematics. 'It is not easy to define pragmatism: the Italian Papini observed that pragmatism was less a philosophy than a method of doing without one.'[46] In the first place, Benjamin Peirce became fascinated by the theories and calculations of Pierre-Simon Laplace and Karl Friedrich Gauss (covered in Chapter 32), in particular

their ideas about probability.[47] Probability, or the laws of error, had a profound impact on the nineteenth century because of the apparent paradox that the accidental fluctuations that make phenomena deviate from their 'normal' laws, are themselves bound by a (statistical) law. The fact that this law applied even to human beings pointed many towards determinism.[48]

Charles Peirce was not one of them. He believed that he could see spontaneous life around him at every turn. (And he attacked Laplace in print.) He argued that, by definition, the laws of nature themselves must have evolved.[49] He was Darwinian enough to believe in contingency, indeterminacy, and his ultimate philosophy was designed to steer a way through the confusion.[50] In 1812, in his *Théorie analytique des probabilités*, Laplace had said 'We must ... imagine the present state of the universe as the effect of its prior state and as the cause of the state that will follow.' This is Newton's billiard-ball theory of matter, applied generally, even to human beings, and where chance has no part.[51] Against this, in his *Theory of Heat*, published in 1871, the Scottish physicist James Clerk Maxwell had argued that the behaviour of molecules in a gas could be understood probabilistically. (Peirce met Maxwell on a visit to Cambridge in 1875.)[52] The temperature of a gas in a sealed container is a function of the velocity of the molecules – the faster they move, the more they collide and the higher the temperature. But, and most importantly from a theoretical point of view, the temperature is related to the *average* velocity of the molecules, which vary in their individual speeds. How was this average to be arrived at, how was it to be understood? Maxwell argued that 'the velocities are distributed among the particles according to the same law as the errors are distributed among the observations in the theory of the "method of least squares"'. (This had first been observed among astronomers: see above, page 657.)[53] Maxwell's point, the deep significance of his arguments, for the nineteenth century, was that physical laws are not Newtonian, not absolutely precise. Peirce grasped the significance of this in the biological, Darwinian realm. In effect, it created the circumstances where natural selection could operate. Menand asks us to consider birds as an example. In any particular species, of finch say, most individuals will have beaks within the 'normal distribution', but every so often, a bird with a beak outside the range will be born, and if this confers an evolutionary advantage it will be 'selected'. To this extent, evolution proceeds by chance, not on an entirely random basis but according to statistical laws.[54]

Peirce was very impressed by such thinking. If even physical events, the smallest and in a sense the most fundamental occurrences, are uncertain, and if even the perception of simple things, like the location of stars, is fallible, how can any single mind 'mirror' reality? The awkward truth was: 'reality doesn't stand still long enough to be accurately mirrored'. Peirce therefore agreed with Wendell Holmes and William James: experience was what counted and even in science juries were needed. Knowledge was social.[55]

All this may be regarded as 'deep background' to pragmatism (a word that, for some strange reason, Peirce hardly ever used; he said it was 'ugly enough to be safe from kidnappers').[56] This was, and remains, far more important than it seems at first sight, and more substantial than the everyday use of the word 'pragmatic' makes it appear. It was partly the natural corollary of the thinking that had helped create America in the first place, and is discussed in Chapter 28 above. It was partly the effect of the beginnings of

indeterminacy in science, which was to be such a feature of twentieth-century thought, and it was partly – even mainly – a further evolution of thought, yet another twist, on the road to individualism.

Here is a classic pragmatic problem, familiar to Holmes, made much use of by James, and highlighted by Menand. Assume that a friend tells you something but in the strictest confidence. Later, in discussions with a second friend, you discover two things. One, that he or she isn't aware of the confidence that has been shared with you; and second, that he is, in your opinion, about to make a bad mistake which could be avoided if he knew what you know. What do you do? Do you stay loyal to your first friend and keep the confidence? Or do you break the confidence to help out the second friend, so that he avoids injury or embarrassment? James said that the outcome might well depend on which friend you actually preferred, and that was part of his point. The romantics had said that the 'true' self was to be found within, but James was saying that, even in a simple situation like this, there were several selves within – or none at all. In fact, he preferred to say that, until one chose a particular course of action, until one *behaved*, one didn't know which self one was. 'In the end, you will do what you believe is right but "rightness" will be, in effect, the compliment you give to the outcome of your deliberations.'[57] We can only really understand thinking, said James, if we understand its relationship to behaviour. 'Deciding to order lobster in a restaurant helps us determine that we have a taste for lobster; deciding that the defendant is guilty helps us establish the standard of justice that applies in this case; choosing to keep a confidence helps us make honesty a principle and choosing to betray it helps confirm the value we put on friendship.'[58] Self grows out of behaviour, not the other way round. This directly contradicts romanticism.

James was eager to say that this approach didn't make life arbitrary or that someone's motivation was always self-serving. 'Most of us don't *feel* that we are always being selfish in our decisions regarding, say, our moral life.' He thought that what we do carry within us is an imperfect set of assumptions about ourselves and our behaviour in the past, and about others and their behaviour, which informs every judgement we make.[59] According to James, truth is circular: 'There is no noncircular set of criteria for knowing whether a particular belief is true, no appeal to some standard outside the process of coming to the belief itself. For thinking just *is* a circular process, in which some end, some imagined outcome, is already present at the start of any train of thought ... Truth *happens* to an idea, it *becomes* true, is *made* true by events.'[60]

At about the time James was having these ideas, there was a remarkable development in the so-called New [Experimental] Psychology. Edward Thorndike, at Berkeley, had placed chickens in a box which had a door that could be opened if the animals pecked at a lever. In this way, the chickens were given access to a supply of food pellets, out through the door. Thorndike observed 'that although at first many actions were tried, apparently unsystematically (i.e., at random), only successful actions performed by chickens who were hungry were learned'.[61] James wasn't exactly surprised by this, but it confirmed his view, albeit in a mundane way. The chickens had learned that if they pecked at the lever the door would open, leading to food, a reward. James went one step further. To all intents and purposes, he said, the chickens *believed* that if they pecked at the lever the door would open. As he put it, 'Their beliefs were rules for action.' And he thought that such rules

applied more generally. 'If behaving as though we have free will, or as if God exists, gets us the results we want, we will not only come to believe those things; they will be, pragmatically, true ... "The truth" is the name of whatever proves itself to be good in the way of belief.'[62] In other words, and most subversively, truth is not 'out there', it has nothing to do with 'the way things really are'. This is not why we have minds, James said. Minds are adaptive in a Darwinian sense: they help us to get by, which involves being consistent, between thinking and behaviour.

Most controversially of all, James applied his reasoning to intuition, to innate ideas. Whereas Locke had said that all our ideas stem from sensory experience, Kant had insisted that some fundamental notions – the idea of causation being one – could not arise from sensory experience, since we never 'see' causation, but only infer it. Therefore, he concluded, such ideas 'must be innate, wired in from birth'.[63] James took Kant's line (for the most part), that many ideas are innate, but he didn't think that there was anything mysterious or divine about this.[64] In Darwinian terms, it was clear that 'innate' ideas are simply variations that have arisen and been naturally selected. 'Minds that possessed them were preferred over minds that did not.' But this wasn't because those ideas were more 'true' in an abstract or theological sense; instead, it was because they helped organisms to adapt.[65] The reason that we believed in God (when we did believe in God) was because experience showed that it paid to believe in God. When people stopped believing in God (as they did in large numbers in the nineteenth century – see next chapter), it was because such belief no longer paid.

America's third pragmatic philosopher, after Peirce and James, was John Dewey. A professor in Chicago, Dewey boasted a Vermont drawl, rimless eyeglasses and a complete lack of fashion sense. In some ways he was the most successful pragmatist of all. Like James he believed that everyone has his own philosophy, their own set of beliefs, and that such philosophy should help people to lead happier and more productive lives. His own life was particularly productive. Through newspaper articles, popular books, and a number of debates conducted with other philosophers, such as Bertrand Russell or Arthur Lovejoy, author of *The Great Chain of Being*, Dewey became known to the general public in a way that few philosophers are.[66] Like James, Dewey was a convinced Darwinist, someone who believed that science and the scientific approach needed to be incorporated into other areas of life. In particular, he believed that the discoveries of science should be adapted to the education of children. For Dewey, the start of the twentieth century was an age of 'democracy, science and industrialism' and this, he argued, had profound consequences for education. At that time, attitudes to children were changing fast. In 1909 the Swedish feminist Ellen Key published her book *The Century of the Child*, which reflected the general view that the child had been rediscovered – rediscovered in the sense that there was a new joy in the possibilities of childhood and in the realisation that children were different from adults and from one another.[67] This seems no more than common sense to us, but in the nineteenth century, before the victory over a heavy rate of child mortality, when families were much larger and many children died, there was not – there could not be – the same investment in children, in time, in education, in *emotion*, as there was later. Dewey saw that this had significant consequences for teaching. Hitherto, schooling, even in America,

which was in general more indulgent to children than in Europe, had been dominated by the rigid authority of the teacher, who had a concept of what an educated person should be and whose main aim was to convey to his or her pupils the idea that knowledge was the 'contemplation of fixed verities'.[68] Dewey was one of the leaders of a movement which changed such thinking, and in two directions. The traditional idea of education, he saw, stemmed from a leisured and aristocratic society, the type of society that was disappearing fast in European societies and had never existed in America. Education now had to meet the needs of democracy. Second, and no less important, education had to reflect the fact that children were very different from one another in abilities and interests. In order for children to make the best contribution to society that they were capable of, education should be less about 'drumming in' hard facts which the teacher thought necessary, and more about drawing out what the individual child was capable of. In other words, pragmatism applied to education.

The ideas of Dewey, along with those of Freud, were undoubtedly influential in helping attach far more importance to childhood than before. The notion of personal growth and the drawing back of traditional, authoritarian conceptions of what knowledge is, and what education should seek to do, were liberating ideas for many people. (Dewey's frank aim was to make society, via education, more 'worthy, lovely and harmonious'.)[69] In America, with its many immigrant groups and wide geographical spread, the new education helped to create many individualists. At the same time, the ideas of the 'growth movement' always risked being taken too far – with children left to their own devices too much. In some schools where teachers believed that 'No child should ever know failure . . .', examinations and grades were abolished.[70]

Dewey's view of philosophy agreed very much with James and the Peirces. It should be concerned with living in this world, now.[71] Both thinking and behaviour are different sides of the same coin. Knowledge is part of nature. We all make our way in the world, as best we can, learning as we go as to what works and what doesn't: behaviour is not pre-ordained at birth.[72] This approach, he felt, should be applied to philosophy where, traditionally, people had been obsessed by the relation between mind and world. Because of this, the celebrated philosophical mystery, How do we know?, was in a sense the wrong question. Dewey illustrated his argument by means of an analogy which Menand highlights: no one has ever been unduly bothered by the no less crucial question, the relation between, for example, the *hand* and the world. 'The function of the hand is to help the organism cope with the environment; in situations in which a hand doesn't work, we try something else, such as a foot or a fish-hook, or an editorial.'[73] His point was that *nobody worries* about those situations where the hand doesn't 'fit', doesn't 'relate to the world'. We use hands where they are useful, feet where they are useful, tongues where they are useful.

Dewey was of the opinion that ideas are much like hands: they are instruments for dealing with the world. 'An idea has no greater metaphysical stature than, say, a fork. When your fork proves inadequate to eating soup, you don't worry about the inherent shortcomings in the nature of forks; you reach for a spoon.' Ideas are much the same. We have got into difficulty because 'mind' and 'reality' don't exist other than as abstractions, with all the shortcomings that we find in any generalisation. 'It therefore makes as little sense to talk about a "split" between the mind and the world as it does to talk about a split

between the hand and the environment, or the fork and the soup.' 'Things,' he wrote, '... are what they are experienced as.'[74] According to Menand, Dewey thought that philosophy had got off on the wrong foot right at the start, and that we have arrived where we are largely as a result of the class structure of classical Greece. Pythagoras, Plato, Socrates, Aristotle and the other Greek philosophers were for the most part a leisured, 'secure and self-possessed' class, and it was pragmatically useful for them to exalt reflection and speculation at the expense of making and doing. Since then, he thought, philosophy had been dogged by similar class prejudices, which maintained the same separation of values – stability above change, certainty above contingency, the fine arts above the useful arts, 'what minds do over what hands do'.[75] The result is there for us all to see. 'While philosophy pondered its artificial puzzles, science, taking a purely instrumental and experimental approach, had transformed the world.' Pragmatism was a way for philosophy to catch up.

That pragmatism should arise in America is not so surprising, not surprising at all in fact. The mechanical and materialist doctrines of Hegel, Laplace, Malthus, Marx, Darwin and Spencer were essentially deterministic whereas for James and Dewey the universe – very much like America – was still in progress, still in the making, 'a place where no conclusion is foregone and every problem is amenable to the exercise of what Dewey called intelligent action'. Above all, he felt that – like everything else – ethics evolve. This was a sharp deduction from Darwin, quickly reached and still not often enough appreciated. 'The care of the sick has taught us how to protect the healthy.'[76]

William James, as we have seen, was a university man. In one capacity or another, he was linked to Harvard, Johns Hopkins and the University of Chicago. Like some nine thousand other Americans in the nineteenth century, he studied at German universities. At the time that Emerson, Holmes, the Peirces and the Jameses were developing their talents, the American universities were in the process of formation and so, it should be said, were the German and the British. Particularly in Britain, universities are looked upon fondly as ancient institutions, dating from medieval times. So they are, in one sense, but that should not blind us to the fact that universities, as we know them now, are largely the creation of the nineteenth century.

One can see why. Until 1826 there were just the two universities in existence in England – Oxford and Cambridge – and offering a very restricted range of education.[77] At Oxford the intake was barely two hundred a year and many of those did not persevere to graduation. The English universities were open only to Anglicans, based on a regulation which required acceptance of the Thirty-Nine Articles. Both seats of learning had deteriorated in the eighteenth century, with the only recognised course, at Oxford at least, being a narrow classics curriculum 'with a smattering of Aristotelian philosophy', whereas in Cambridge the formal examination was almost entirely mathematical. There was no entrance examination at either place and, moreover, peers could get a degree without examination. Examinations were expanded and refined in the first decades of the nineteenth century but more to the point, in view of what happened later, were the attacks mounted on Oxford and Cambridge by a trio of Scotsmen in Edinburgh – Francis Jeffrey, Henry Brougham and Sydney Smith. Two of these were Oxford graduates and in the

journal they founded, the *Edinburgh Review*, they took Oxford and Cambridge to task for offering an education which, they argued, was far too grounded in the classics and, as a result, very largely useless. 'The bias given to men's minds is so strong that it is no uncommon thing to meet with Englishmen, whom, but for their grey hair and wrinkles, we might easily mistake for school-boys. Their talk is of Latin verses; and, it is quite clear, if men's ages are to be dated from the state of their mental progress, that such men are eighteen years of age and not a day older ...'[78] Sydney Smith, the author of this attack, went on to criticise Oxbridge men for having no knowledge of the sciences, of economics or politics, of Britain's geographical and commercial relations with Europe. The classics, he said, cultivated the imagination but not the intellect.

There were two responses we may mention. One was the creation of civic universities in Britain, particularly University College and King's College, London, both of which were established deliberately to accept Nonconformists, and which were based partly on the Scottish universities and their excellent medical schools. One of the men involved in the creation of University College, London, Thomas Campbell, visited the Universities of Berlin (founded 1809) and Bonn (1816), as a result of which he opted for the professorial system of tuition, in use there and in Scotland, rather than Oxford's tutorial system. Another source of inspiration came from the University of Virginia, founded in 1819 thanks largely to the efforts of Thomas Jefferson. The main ideals of this institution were set out in the report of a State Commission which met at Rockfish Gap in the Blue Ridge in 1818 and which became known as the Rockfish Gap Report. The specific aim of this university, according to the report, was 'to form the statesmen, legislature and judges, on whom public prosperity and individual happiness are so much to depend ...' Politics, law, agriculture, commerce, mathematical and physical sciences, and the arts, were all included. University College, London, followed this more practical vision and the even more prac-tical – and novel – idea was adopted of floating a public company to finance the building of the college. Non-denominational university education was begun in England.[79]

This became a bone of contention, which culminated in May 1852 in a series of five lectures given in Dublin by John Henry Newman, later Cardinal Newman, on 'The Idea of the University'. The immediate spur to Newman's lectures was the founding of the new universities, like the University of London, and the Queen's Colleges in Ireland (Belfast, Cork and Galway), in which the study of theology was excluded *on principle*. Newman's lectures, which became famous as the classic defence of what is still sometimes called 'a liberal education', argued two points. The first was that 'Christianity, and nothing short of it, must be made the element and principle of all education'.[80] Newman argued that all branches of knowledge were connected together and that to exclude theology was to distort wisdom. His second point was that knowledge is an end in itself, that the purpose of a university education was not to be immediately useful but to bear its fruits throughout life. 'A habit of mind is formed which lasts throughout life, of which the attributes are, freedom, equitableness, calmness, moderation, and wisdom; or what in a former Discourse I have ventured to call a philosophical habit ... Knowledge is capable of being its own end.'[81] Newman's seminal idea, and the most controversial – a dispute that is still with us – was set out in his seventh lecture (five were given at Dublin, five others published but not delivered). In this, he says: '... the man who has learned to think and to reason and to

compare and to discriminate and to analyse, who has refined his taste, and formed his judgement, and sharpened his mental vision, will not indeed at once be a lawyer, or a pleader, or an orator, or a statesman, or a physician, or a good landlord, or a man of business, or a soldier, or an engineer, or a chemist, or a geologist, or an antiquarian, but he will be placed in that state of intellect in which he can take up any one of the sciences or callings I have referred to ... with an ease, a grace, a versatility, and a success, to which another is a stranger. In this sense, then, ... mental culture is emphatically *useful*.'[82]

Apart from Newman's concern with 'liberal' education, his emphasis on religion was not as out of place as it may seem, especially in America. As George M. Marsden has shown, in his survey of early American colleges, some five hundred were founded in the pre-Civil War era, of which perhaps two hundred survived into the twentieth century. Two-fifths were either Presbyterian or Congregationalist colleges, down from over a half in Jefferson's day, at the expense of Methodist, Baptist and Catholic establishments, which accelerated after 1830 and especially after 1850.[83] In nineteenth-century America, in the educational sphere, there was a widely shared article of faith that science, common sense, morality and true religion 'were firmly allied'.[84]

For many years, say the mid-seventeenth to the mid-eighteenth century, Harvard and Yale were almost all there was to American higher education. Only toward the end of that period was an Anglican college established in the South, William and Mary (chartered in 1693, opened in 1707, and only gradually becoming a fully-fledged college). Beyond that, most of the colleges that became well-known universities were founded by New Light clergy – New Jersey (Princeton), 1746, Brown, 1764, Queen's (Rutgers), 1766, and Dartmouth, 1769. 'New Light' was a religious response in America to the Enlightenment. Yale had been founded in 1701 as a response to a perceived decline in theological orthodoxy at Harvard. The new moral philosophy presupposed that 'virtue' could be discovered on a rational basis, that God would reveal to man the moral basis of life, based on reason, much as He had revealed to Newton the laws by which the universe operated. This was essentially the basis on which Yale was founded.[85] In a short while the new approach developed into what became known as the Great Awakening, which, in the American context, described a shift from the predominantly pessimistic view of human nature to a far more optimistic – positive – outlook, as typified by Anglicanism. This was a far more humanistic cast of mind (unlike Harvard, which remained Calvinist) and led to a much greater appreciation of the achievements of the Enlightenment in those colleges, such as Princeton, which followed Yale.

Such thinking culminated in the famous Yale Report of 1828, which argued that the human personality was made up of various faculties of which reason and conscience were the highest, and that these must be kept in balance. So the goal of education was 'to maintain such a proportion between the different branches of literature and science, as to form in the student a proper *balance* of character'.[86] The report then went on to argue that the classics should form the core of this balanced character-building.

A large mission of the colleges was to spread Protestant Christianity to the untamed wilds of the west and in 1835, in his *Plea for the West*, Lyman Beecher urged that education

beyond the seaboard could not be achieved simply by sending teachers out from the east – the west must have colleges and seminaries of its own. There was then a fear that Catholics would take over the west, a fear fortified by the growing immigration into America from the Catholic countries of southern Europe. The warning was heeded and, by 1847, Presbyterians had built a system of about a hundred schools in twenty-six states.[87] The University of Illinois was founded in 1868 and California in 1869. It was about now that the attractions of the German system began to be appreciated, with several professors and university administrators travelling to Prussia, in particular, to study the way things were done there. In this way, religion began to occupy less of a role in American university education. The fact that the Germans led the way in history, for example, increasingly implied that theology was itself an historical development, and this encouraged biblical criticism. Germany was also responsible for the idea that education should be the responsibility of the state, not just a private matter. Finally, it was a German idea that the university should be the home of scholars (researchers, writers) and not just of teachers.

This was nowhere more evident than at Harvard. It had begun as a Puritan college in 1636. More than thirty partners of the Massachusetts Bay Colony were graduates of Emmanuel College, Cambridge, and so the college they established near Boston naturally followed the Emmanuel pattern. Equally influential was the Scottish model, in particular Aberdeen. Scottish universities were non-residential, democratic rather than religious, and governed by local dignitaries – a forerunner of boards of trustees.

The man who first conceived the modern university as we know it was Charles Eliot, a chemistry professor at Massachusetts Institute of Technology who, in 1869, at the age of only thirty-five, was appointed President of Harvard, where he had been an undergraduate. When Eliot arrived, Harvard had 1,050 students and fifty-nine members of the faculty. In 1909, when he retired, there were four times as many students and the faculty had grown ten-fold. But Eliot was concerned with more than size. 'He killed and buried the limited arts college curriculum which he had inherited. He built up the professional schools and made them an integral part of the university. Finally, he promoted graduate education and thus established a model which practically all other American universities with graduate ambitions have followed.' Above all, Eliot followed the German system of higher education, the system that gave the world Planck, Weber, Strauss, Freud and Einstein. Intellectually, Johann Fichte, Christian Wolff and Immanuel Kant were the significant figures in German thinking about education, freeing German scholarship from its stultifying reliance on theology. As a result, and as we have seen, German scholars acquired a clear advantage over their European counterparts in philosophy, philology and the physical sciences. It was in Germany, for example, that physics, chemistry and geology were first regarded in universities as equal to the humanities.[88] The graduate seminar, the PhD, and student freedom were all German ideas.

From Eliot's time onwards, the American universities set out to emulate the German system, particularly in the area of research. However, this German example, though impressive in advancing knowledge and in producing new technological processes for industry, nevertheless sabotaged the 'collegiate way of living' and the close personal relations between undergraduates and faculty which had been a major feature of American higher education until the adoption of the German approach. The German system was

chiefly responsible for what William James called 'the PhD octopus'. Yale awarded the first PhD west of the Atlantic in 1861; by 1900 well over three hundred were being granted every year.[89]

The price for following Germany's lead was a total break with the British collegiate system. At many universities, housing for students disappeared entirely, as did communal eating. At Harvard in the 1880s the German system was followed so slavishly that attendance at classes was no longer required – all that counted was performance in the examinations. Then a reaction set in. Chicago was first, building seven dormitories by 1900 'in spite of the prejudice against them at the time in the [mid-]West on the ground that they were medieval, British and autocratic'. Yale and Princeton soon adopted a similar approach. Harvard reorganised after the English housing model in the 1920s.[90]

At much the same time that the pragmatists of the Saturday Club were forming their friendship and their views, a very different group of pragmatists was having an effect on American life. Beginning around 1870, in the wake of the Civil War, America produced a generation of the most original inventors that nation – or any other – has seen. Thomas P. Hughes, in his history of American invention, goes so far as to say that the half-century between 1870 and 1918 was a comparable era to Periclean Athens, Renaissance Italy or the Britain of the industrial revolution. Between 1866 and 1896 the number of patents issued annually in the United States more than doubled and in the decade from 1879 to 1890 rose from 18,200 to 26,300 a year.[91]

Richard Hofstadter, in his book *Anti-Intellectualism in American Life*, has written about the tension in the United States between businessmen and intellectuals, of Herman Melville's warning, 'Man disennobled – brutalised / By popular science', of Van Wyck Brooks chiding Mark Twain because 'his enthusiasm for literature was as nothing beside his enthusiasm for machinery', of Henry Ford who famously remarked 'history is more or less bunk'.[92] But America's first generation of inventors do not seem to have been especially anti-intellectual. Rather, they inhabited a different culture and this was because, as we have seen, scholarship and research were still coming into being in the nineteenth-century universities. They were still predominantly religious institutions and would not become universities as we know them until the very end of the nineteenth century.

And likewise, since the industrial research laboratory didn't come into common use until around 1900, most of these inventors had to construct their own private laboratories. It was in this environment that Thomas Edison invented the electric light and the phonograph, Alexander Graham Bell invented the telephone, the Wright brothers invented their flying machine, and telegraphy and radio came into being.[93] It was in this environment that Elmer Sperry pioneered his gyrocompass and automatic control devices for the navy and in which Hiram Stevens Maxim, in 1885, set up for manufacture, and demonstrated, 'the world's most destructive machine gun'. By using the recoil from one cartridge to load and fire the next, the Maxim far surpassed the Gatling gun, which had been invented in 1862. It was the Maxim gun that inflicted a great deal of the horror in colonial territories at the high point of empire.[94] It was the German Maxim which inflicted 60,000 casualties at the Somme on 1 July 1916. And it was these inventors who, in collaboration with financial entrepreneurs, were to create some of America's most enduring business and

educational institutions, household names to this day – General Electric, AT&T, Bell Telephone Company, Consolidated Edison Company, MIT.

In the context of this book, perhaps the telegraph is worth singling out from these other inventions. The idea of using electricity as a means of signalling had been conceived around 1750 but the first functioning telegraph had been set up by Francis Ronalds, in his garden in Hammersmith in London, in 1816. Charles Wheatstone, professor of experimental philosophy at King's College, London, and the man who had first measured the speed of electricity (wrongly), was the first to realise that the ohm, a measure of resistance, was an important concept in telegraphy and, together with his colleague Fothergill Cooke, took out the first patent in 1837. Almost as important as the technical details of telegraphy was Wheatstone and Cooke's idea to string the wires alongside the newly-built railways. This helped ensure the rapid spread of the telegraph, though the much-publicised capture of John Tawell, who was arrested in London after fleeing a murder scene in Slough, thanks to the telegraph, hardly did any harm. Samuel Morse's code played its part, of course, and Morse was one of several Americans pushing for a transatlantic cable. The laying of this cable was an epic adventure that lies outside the scope of this book. While the cables were being laid, many had high hopes that the more speedy communication they would permit would prove an aid to world peace, by keeping statesmen in closer touch with one another. This hope proved vain, but the transatlantic cable, achieved in 1866, made its mark quickly in commercial terms. And, as Gillian Cookson has written in *The Cable: The Wire that Changed the World*, 'From this moment began a sense of shared experience, a convergence of cultures, between the two English-speaking nations.'[95]

# Enemies of the Cross and the Qur'an – the End of the Soul

In 1842, George Eliot, the English novelist, stopped going to church. Her doubts over Christianity had begun early but she had been deeply influenced by David Friedrich Strauss's book *The Life of Jesus, Critically Examined*, which as we have seen was published in Germany in the middle 1830s and which she had rendered into English. In her rather tortured translation, Strauss had concluded 'There is little of which we can say for certain that it took place, and of all to which the faith of the Church especially attaches itself, the miraculous and supernatural matter in the facts and destinies of Jesus, it is far more certain that it did not take place.'[1] In much the same way, when Tennyson read Lyell's *Principles of Geology* in 1836 he was troubled, as so many were, by Lyell's interpretation of the fossil evidence, that 'the inhabitants of the globe, like all other parts of it, are subject to change. It is not only the individual that perishes, but whole species.'[2]

The sad, slow, but inexorable loss of faith in the nineteenth century by so many people, prominent or otherwise, has been explored by the writer A. N. Wilson. His survey of Eliot, Tennyson, Hardy, Carlyle, Swinburne, James Anthony Froude, Arthur Clough, Tolstoy, Herbert Spencer, Samuel Butler, John Ruskin and Edmund Gosse confirms what others have said, that the loss of faith, the 'death of God', was not only an intellectual change but an *emotional* conversion as well. Specific books and arguments made a difference but there was also a change in the general climate of opinion, the cumulative unsettling effect of one thing, then another, often quite different.[3] When Francis Galton, Darwin's step-cousin, circulated a questionnaire to 189 Fellows of the Royal Society in 1874, inquiring after their religious affiliation, he was surprised by the answers he received. Seventy per cent described themselves as members of the established churches and while some said that they had no religious affiliation, many others were Nonconformist of one stripe or another – Wesleyan, Catholic, or some other form of organised church. Asked in the same questionnaire if their religious upbringing had in any way had a deterrent effect on their careers in science, nearly 90 per cent replied 'None at all.'[4] Among those who, as late as 1874, still believed in a deity may be included Michael Faraday, John Herschel, James Joule, James Clerk Maxwell and William Thomson (Lord Kelvin). Wilson shows that there were almost as many reasons as there were people for the loss of faith, where it occurred. Some were much more convinced than others that God was dead, while 'some managed to be both anti-God *and* anti-science at the same time'.[5]

Unlike the intellectual battles fought over unbelief in the sixteenth and seventeenth centuries, in the nineteenth there were many more issues that the faithful had to deal with, over and above the doubts raised about the literal truth of the Bible, say, or the implausibility of the miracles. Wilson locates the change of atmosphere as beginning in the late eighteenth century. The atheism of the French *philosophes* of the Enlightenment was one factor but in Britain, he says, there were two books which did more than any other to undermine faith. These were Edward Gibbon's *The History of the Decline and Fall of the Roman Empire*, published in three instalments between 1776 and 1788, and David Hume's *Dialogues Concerning Natural Religion*, published in 1779, three years after his death. Gibbon offered no important metaphysical or theological arguments, says Wilson.[6] Instead, 'Gibbon was (is) destructive of faith . . . in his blithe revelation, on page after page, of the sheer contemptibility, not only of the Christian heroes, but of their "highest" ideals. It is not merely in the repeated and hilarious identification of individual Christian wickedness that Gibbon reaches his target. Rather it is in his whole attitude, which resolutely refuses to be impressed by the Christian contribution to "civilisation".[7] It was Gibbon's constant contrast between 'the evident wisdom' of pre-Christian cultures and the superstitious and irrational anachronisms and barbarisms of the early Christians that had such an effect on readers.[8]

Hume's critique of 'mind' and order in the universe was discussed in an earlier chapter (see above, pages 538–539), as was Kant's argument that such concepts as God, Soul and Immortality can never be proved.[9] If these matters might be characterised as 'deep background' to the general loss of faith, there were other factors specific to the nineteenth century. The historian Owen Chadwick divided these into 'the social' and 'the intellectual'. Among them he includes liberalism, Marx, anticlericalism and the 'working class mentality'.

Liberalism, says Chadwick, dominated the nineteenth century.[10] But it was a protean word, he admits, one that in origin simply meant free, free from restraint. In the later Reformation it came to mean too free, licentious or anarchic. This is how men such as John Henry Newman understood it, in the mid-1800s. But liberalism, like it or not, owed much to Christianity. In dividing Europe by religion, the Reformation invited – eventually – a toleration, but Christianity at one level had always sought for a religion of the heart, rather than the mere celebration of rites, a reverence for individual conscience which, in the end, and fatally, says Chadwick, weakened the desire for sheer conformity. 'Christian conscience was [thus] the force which began to make Europe "secular"; that is, to allow many religions or no religion in a state.'[11]

What had begun in the liberty of toleration turned into the love of liberty for its own sake, liberty as a *right* (this, it will be remembered, was John Locke's contribution, and was one of the ostensible reasons for the French Revolution). And this was not really achieved, in the leading countries of western Europe, until the years between 1860 and 1890.[12] It owed a lot, Chadwick says, to John Stuart Mill, who published his essay *On Liberty* in the same year that Darwin published *On the Origin of Species*, 1859. Mill's investigation of liberty, however, involved what he saw as a new problem. Much influenced by Comte, he was less bothered by the liberties that might be threatened by a tyrannical state, for that was an old and familiar problem. Instead, he was more concerned, in new

democracies, with the tyranny of the majority over the individual or the minority, with intellectual *coercion*. He could see all around him that 'the people' were coming to power, and he anticipated that those 'people', too often the mob of past ages, would deny others the right to a difference of opinion.[13] He thus set about defining the new liberty. 'The only purpose for which power can be rightfully exercised over any member of a civilised community against his will, is to prevent harm to others. His own good, either physical or moral, is not a sufficient warrant. He cannot rightfully be compelled to do or forbear because it will be better for him to do so, because it will make him happier, because, in the opinion of others, to do so would be wise, or even right.'[14] This was more important than it looked because it implied that a free man 'has the right to be persuaded and convinced', which is just as important an implication of democracy as 'one man, one vote'. And it was *this* which linked liberalism and secularisation. Mill's essay was the first argument for the full implications of the secular state. The total lack of passion in the text was the way Mill set an example as to how affairs are to be conducted.[15]

Judging by the way ordinary people spoke and behaved, Chadwick observes that it was during the years 1860–1880 that English society, at least, became 'secular'.[16] One can see this, he says, from the memoirs and novels of the time, which report the reading habits and conversations of the average individual, and show the increased willingness of devout men, say, to form friendships with men who were not devout, 'to honour them for their sincerity instead of condemning them for their lack of faith'.[17] It can be seen too in the role played by the new mass-circulation press.[18] The press in fact played a number of roles, one of which was to enflame, to impassion, to polarise the battle of ideas and in so doing turn many citizens – for the first time – into political beings (because they were now *informed*). This too was a secularising influence, replacing religion with politics as the main intellectual preoccupation of ordinary people. The new profession of journalist became established at much the same time as teachers became distinct from the clergy.[19]

As literacy expanded, and journalism responded, ideas about liberty went through another twist. Individual liberty, in an economic sense, or applied to conscience or opinion, was discovered to be not the same as true political or psychological liberty. Through the newspapers, people became more than ever aware that industrial development, left to itself, only increased the divide between rich and poor. 'A doctrine which ended in the slums of great cities could hardly contain all truth.'[20] This brought about a profound change in liberal minds – indeed, it began to change the very meaning of liberalism itself, and Chadwick says it marked the beginning of what we may call collectivist thinking, when people began to argue more and more for government interference as the way to improve the general welfare.[21] 'Liberty was henceforth seen more in terms of the society than of the individual; less as freedom from restriction than as a quality of responsible social living in which all men had a chance to share.'[22]

This new way of thinking made Marxism more attractive, including his fundamental tenet, that religion was untrue, which became another factor in secularisation.[23] Marx's explanation for the continued popularity of religion was of course that it was a symptom of sickness in social life. 'It enables the patient to bear what otherwise would be unbearable ...'[24] Religion was necessary to capitalist society, he said, to keep the masses in their place:

by offering them something in the next life, they would more easily accept their lot in this one.[25] Christianity – most religions – accept the existing divisions in society, 'comfort' the dispossessed that their misfortune is the just punishment for their sin, or else a trial, the response to which is ennobling or uplifting. Marxism became important not only because of events in the nineteenth century – the Paris Commune, the impact of the Commune upon the International, the German socialists, the growth of a revolutionary party in Russia – which appeared to confirm that what it said was true, but because *it too* offered a version of the afterlife: revolution, following which justice and bliss would be restored to the world. In offering a secular afterlife, Chadwick argues, Marxism produced an unintended spin-off: socialism and atheism became linked, and religion was politicised.

But Marx was not alone, not by any means. In his *Condition of the Working Classes in England in 1844*, Engels reported 'almost universally a total indifference to religion, or at the utmost some trace of Deism too undeveloped to amount to more than mere words, or a vague dread of the words infidel, atheist, etc. . . .'[26] Outright atheists were never very common but, in the middle 1850s, across Britain, the first 'Secular Societies' were founded. Paradoxically, there was a puritan streak in these groups, many of which were linked with the temperance movement. This appears to have peaked around 1883–1885, one reason being that atheists were given the right to sit in Parliament.[27]

Another general factor in creating a more secular world was urbanisation itself. Statistics from Germany and France show a fall in church attendance down the decades, with the greater falls occurring in the larger towns, and a parallel fall in ordinations.[28] This may have been nothing more than an organisational failure on the part of organised religion but it was important – for it revealed an inability of the churches to adapt themselves quickly enough to the towns. 'The population of Paris rose by nearly 100 per cent between 1861 and 1905, the number of parishes by about 33 per cent, the number of priests by about 30 per cent.'[29]

The view that we now have about the Enlightenment, that it was 'a good thing', a step forward, a necessary stage in the evolution of the modern world, was not the nineteenth-century view.[30] For the Victorians it was the age which ended in the guillotine and the Terror. Thomas Carlyle was just one who thought that Voltaire and his deism were 'contemptible'. For him, Napoleon was the last great man and Carlyle was proud that his own father had 'never been visited by doubt'.[31] Throughout the Napoleonic period and well on into Queen Victoria's reign, 'Men thought the Enlightenment a corpse, a cul-de-sac of ideas, a destructive age overthrowing the intellectual as well as the physical landmarks by which human society may live as a civilised body.'[32]

Opinions didn't begin to change until the 1870s. In fact, the very first time that the English word Enlightenment was used to mean *Aufklärung* dates from 1865, in a book on Hegel by J. H. Stirling. But even here the word is pejorative – and it did not gain a fully favourable meaning until 1889, in Edward Caird's study of Kant, where there is the first use of the phrase, the 'Age of Enlightenment'.[33] But the man who really rescued the Enlightenment and its secular values from the negative territory to which they had been consigned, was John Morley, a journalist for the *Fortnightly Review*. It was Morley (who was also an MP) who felt that the British reaction to the excesses of 1789 had been

generalised to the *philosophes*, and that the romantics' passion for the inner life had combined in what he called a form of philistinism to obscure the real achievements of the eighteenth century. He was stimulated to act, in a series of articles, because he saw about him the church trying to stifle positive science.[34]

There was a parallel change in France. That country had had its equivalent of Carlyle in Joseph de Maistre, who wrote: 'To admire Voltaire is the sign of a corrupt heart, and if anybody is drawn to his works, then be very sure that God does not love such an one.'[35] Napoleon, whose attitude to the church was erratic, nonetheless is said to have ordered his ranks of tame writers to attack Voltaire.

Then came Jules Michelet, the historian. In the early 1840s, together with a group of friends – Victor Hugo and Lamartine among them – Michelet attacked the church head-on. Catholicism was unforgivably narrow, he said, celibacy was an 'unnatural' vice, confession was an abuse of privacy, the Jesuits were devious manipulators. These broadsides were delivered in a series of intemperate lectures at the Collège de France and, unlike elsewhere, the focus of his offensive was not science but ethics. Ironical, of course, since Voltaire had been fanatically opposed to the fanaticism he himself sparked. Michelet bombarded the churches 'in the name of justice and freedom', and it was as a result of these sorties that Voltaire became the focus of a vicious war of ideas in France.[36] For example, on Louis Napoleon's accession in 1851 libraries everywhere were compelled to remove the volumes of Voltaire and Rousseau from their shelves. To give another example, an otherwise respected scholar, editing Voltaire's papers, warned his readers that Voltaire had 'caused' 1789 and the Terror of 1793.[37] Matters came to a head in 1885, when rumours began to circulate in Paris that the remains of both Voltaire and Rousseau were not in the Panthéon, where they should have been, as the resting place of the illustrious.[38] It was alleged that, in 1814, a group of royalists, unable to stomach these remains in a sacred spot, had removed the bones in the dead of night and disposed of them on waste land. The rumours were not based on anything other than circumstantial evidence but they were so widely believed, and so outraged Voltaire's supporters, that in 1897 a government committee was appointed to investigate. The investigation went so far as to have the tombs reopened and the remains examined. They were declared to be those of Voltaire and Rousseau.[39] People realised at last that this dispute had gone far enough and the bones were reinterred where they belonged. Following this all-round embarrassing episode, attitudes about the Enlightenment began to change, more or less to the view that we have now.

George Eliot, as we have seen, was influenced in her beliefs by David Strauss's book on *The Life of Jesus,* but she was not entirely typical. A more common reaction was that of the Swiss, whose threatened riots caused Strauss to be released from his professorship before he had even started. Most of the books of the nineteenth century that we now regard as important in bringing about a decline in religious belief did not usually act directly on the vast mass of people. The general public did not read Lyell, Strauss or Darwin. What they did read, however, were a number of popularisers – Karl Vogt on Darwin, Jakob Moleschott on Strauss, Ludwig Büchner on the new physics and the new cell biology. These men were read because they were willing to go a good deal further than Darwin, say, or Lyell. The

*Origin of Species* or the *Principles of Geology* did not, in and of themselves, attack religion. The *implication* was there, but it was the popularisers who interpreted these books and spelled out these implications for a wider readership. 'Religion is a commoner interest of most of the human race than is physics or biology. The great public,' says Owen Chadwick, 'was far more interested in science-versus-religion than in science.' It was these popularisers who alerted the Victorian middle classes to the idea that alternative explanations for the way the world was were now available. They did not immediately say that all religion was wrong but they did cast serious doubt on the accuracy, veracity and plausibility of the Bible.[40]

The greatest of the popularisers was Ernst Haeckel, a German who in 1862 published *The Natural History of Creation*. This, a very readable polemic in favour of Darwin, just three years after the *Origin* and spelling out its implications, went through nine editions by the end of the century and was translated into twelve languages. *Die Welträtsel*, translated into English in 1900 as *The Riddle of the Universe*, and which explained the new cosmology, sold 100,000 copies in German and as many in English.[41] Haeckel was far more widely read than Darwin, and became for a time equally famous – people flocked to hear him talk.[42]

The other populariser, who did for Strauss what Haeckel did for Darwin, and became just as famous in the process, was Ernest Renan. Originally destined for the priesthood, he lost his faith and put his new conviction into several books, of which the *Life of Jesus* (1863) was by far the most influential.[43] Though he said different things at different times, it seems that it was the study of history that destroyed Renan's faith, and his book on Jesus had the same effect on others.[44] The book had the influence it did, partly because of its exquisite French, but also because it treated Jesus as a historical figure, denied his super-natural acts, presented in a clear manner the scholarship which threw doubts over his divinity, and yet showed him in a sympathetic light, as the 'pinnacle of humanity', whose genius and moral teaching changed the world. It seems that Renan's evident sympathy towards Jesus made the shortcomings he highlighted more palatable. At the same time, he dismantled the need for churches, creeds, sacraments and dogmas. Like Comte, Renan thought positivism could be the basis for a new faith.[45] He underlined that Jesus was a moral leader, a great man, but not in any way divine – organised religion, as it existed in the nineteenth century, had nothing to do with him. This was a form of religion, an ethical humanism, that many people educated in the new universities could accept. His approach was at times – well, unusual. 'Divinity has its intermittent lapses; one cannot be Son of God through a lifetime without a break.' This was a little like a return to the Greek idea of gods as part heroic, part human. Renan's book appealed for the same reason that deism appealed in the seventeenth and eighteenth centuries – it helped people lose their belief in supernatural entities without losing their belief entirely. Most people could not go from belief to unbelief in one step. Renan's *Life* was the most famous title published in French in the nineteenth century and it created a sensation in England too.

What impressed many people, over and above the sympathetic picture which Renan provided, was what he revealed about the shaky foundations of Christianity, so far as its basic documentation was concerned. For example, the Swiss historian Jacob Burckhardt read Strauss's life of Jesus and realised that the history of the New Testament 'could not

bear the weight which faith sought to place on it', and many people underwent a similar reaction.[46]

One other new element which made the secularisation debate in the nineteenth century different from that of the sixteenth and seventeenth centuries involved the revised notion of 'dogma'. Originally, dogma meant an *affirmation* of beliefs, or doctrines – in other words, it had a positive flavour. But that gradually changed so that, by the age of the Enlightenment, to be dogmatic was to be 'unenlightened and closed to alternative interpretations of the truth'.[47] This was an important transformation because although the Catholic hierarchy was by no means inexperienced at combating heretical dogmas, the very notion of dogma was itself now under attack. The successful methods of the positive sciences offered an alternative and were increasingly used as tools for attacking the church. One organisation that sounds fanciful now but which was typical of the time was the Society for Mutual Autopsy. This was a group (of anthropologists mainly) who were so concerned to prove that there was no soul that they all bequeathed their bodies to the society, so that they could be dissected and examined, to kill off ideas of where the soul might be located. They held dinners where the food was served on prehistoric pottery or in the cavities of human and, in one case, giraffe skulls, to emphasise that there was nothing special about human remains, that they were no different from animal remains. As Jennifer Michael Hecht points out, in her book on the end of the soul, one anthropologist wrote 'We have attested many systems in order to maintain morality and the fundamentals of law. To tell the truth, these attempts were nothing but illusions ... The conscience is nothing but a particular aspect of instinct, and instinct is nothing but an hereditary habit ... Without the existence of a distinct soul, without immortality, and without the threat of an afterlife, there are no longer any sanctions.'[48]

In these circumstances, the reactions of the Catholic establishment were, more often than not, grudging. This, in itself, became an issue, a factor in the growth of anticlericalism, which was another aspect of secularisation, at least for a vociferous minority. In Britain, says Chadwick, it surfaced for the first time in a *Saturday Review* leader in May 1864, criticising the wilful inability of the Curia in Rome to concede the advances of modern science, in particular Galileo's discoveries and insights, by then hundreds of years old. In this way, clericalism came to be synonymous with obscurantism and administrative stonewalling and was broadened beyond the Roman Catholic Church to all churches and their opposition to modern thinking, including political thinking.[49] Among educated Catholics everywhere there was some regret at the Vatican's anti-modern stance but in Italy there was an additional problem.

In 1848, the year of revolution across Europe, the Italians mounted their war of liberation against Austria. This put Pope Pius IX in an unwinnable position. With whom would the Vatican side? Both Italy and Austria were sons of the church. At the end of April that year Pius announced that 'as supreme pastor' he could not declare war on any fellow Catholics. For many Italian nationalists this was too much and they turned against the Vatican. It was the first time anticlericalism had appeared in Italy.

In France anticlericalism played havoc with the established church. Over and above the attacks on church authority – Strauss, Darwin, Renan, Haeckel – in France, Catholic

clericals were systematically expelled from institutes of higher education, meaning that as time passed the church had a weaker and weaker grip on the minds of the young.[50] The French church was paying the price for the fact that, in the eighteenth century, the country's bishops had been drawn overwhelmingly from the aristocracy. Decimated by the Revolution, the French church changed its complexion so much that the pope was forced to anathematise the entire Gallican hierarchy, refusing to consecrate any new bishops. The French church was thus cut off from Rome for a time though this did little to reduce anticlerical feeling, since for many ordinary people Rome was now even further away than ever.[51]

A further complicating twist was the attempts in France to reconcile the church with the aims of the Revolution. These were led by Félicité de Lamennais, a priest but a man with a strong commitment to secular educational institutions. He founded a daily periodical, *L'Avenir*, which advocated religious liberty, educational liberty, liberty of the press, liberty of association, universal suffrage, and decentralisation. This was very modern, too modern. *L'Avenir*'s policies proved so controversial that, after several times when publication was suspended, the pope went so far as to issue an encyclical, *Mirari vos*, condemning this particular periodical.[52] Lamennais responded two years later by releasing *Paroles d'un croyant* (*Words of a Believer*) in which he denounced capitalism on religious grounds and called for the working classes to rise up and demand 'their God-given rights'. This provoked another encyclical, *Singulari nos*, which criticised *Paroles d'un croyant* as 'small in size but immense in perversity', and said it was spreading false ideas that were 'inducing to anarchy [and] contrary to the Word of God'. Gregory ended by demanding that Catholics everywhere submit to 'due authority'. But this too backfired, in a sense, because it appeared not long before the revolution of 1848, which revived republicanism among French Catholics, and for the first time significant numbers of the church hierarchy appeared to be sympathetic to revolution.[53]

Pius was originally a liberal (he was elected at fifty-five, a comparatively young age for a pope). But he was as changed by the events of 1848 as the rest of his fellow Italians. 'Now cured of all liberalism', Pius gave a triumvirate of cardinals a free hand to restore absolute government in Rome.[54] However, since this attempt was accompanied by a general loss of traditional authority across the broader political landscape (e.g., Italy's war of independence against Austria, the unification of Germany) this only provoked new waves of anticlericalism. In 1857, in *Madame Bovary*, Gustave Flaubert portrayed a people who were anticlerical most of the time, even though their children were baptised and they continued to receive the last rites from a priest.[55] In France, indifference to religion was growing among ordinary people, just as Engels had noted a decade earlier in England.

Anticlericalism in France came to a head in the last decades of the century over the secularisation of the schools. For the Vatican, to lose the schools meant the final blow to its influence.[56] This is why a number of Catholic universities were established across Europe in the mid-1870s – it was an attempt by the church to recover some of its losses. But this only created a new battleground: priests and schoolteachers were now pitched against one another.

The teachers won. They were led by the Third Republic's new minister of education, Jules Ferry. Ferry was convinced, as Auguste Comte was convinced before him, that the

theological and metaphysical eras were a thing of the past and that the positive sciences would be the basis of the new order. 'My goal,' Ferry declared, 'is to organise society without God and without a king,' and to this end he expelled more than 100,000 religious teachers from their posts.[57]

The Vatican responded to this latest move by setting up Catholic Institutes in Paris, Lyons, Lille, Angers and Toulouse. Each boasted a theological faculty independent of state universities, whose task was to develop their own scholarship to combat what was happening in science and biblical historiography. Lester Kurtz sets out the Vatican thinking.[58] 'First, it defined Catholic orthodoxy within the bounds of scholastic theology, thereby providing a systematic, logical response to the probing questions of modern scholarship. Second, it elaborated the doctrines of papal authority and of the *magisterium* (the teaching authority of the church), claiming that the church and its leadership alone had inherited authority in religious matters from the apostles of Jesus. Finally, it defined Catholic orthodoxy in terms of what it was not, by constructing an image of an heretical conspiracy among deviant insiders.'[59] The church now gradually identified a new era of 'heresy', set out mainly in the conservative Catholic press (in particular the Jesuit publications, *Civiltà cattolica* in Rome and *La Vérité* in Paris). There was also a series of papal edicts (*Syllabus of Erros*, 1864; *Aeterni Patris*, 1879; *Providentissimus Deus*, 1893), followed by the condemnation of Americanism, *Testem benevolentiae* (1899), and, finally, a full-bloodied assault on modernism, *Lamentabili* (1907).

A fatal mistake in the Vatican's approach, which ran through all these edicts and condemnations, was the church's characterisation of its critics as a conspiratorial group, intent on undermining the hierarchy while pretending to be its friend.[60] This underestimated and at the same time patronised the opposition. The real enemy of the Vatican was the very nature of authority in the new intellectual climate. The papacy insisted throughout on its traditional authority, its historical, apostolic succession.[61] These ideas were carried to their extreme in the doctrine of papal infallibility, which was declared for the first time by the First Vatican Council in 1870. Nineteenth-century Catholicism was similar in many ways to twelfth-century Catholicism, not least in the fact that it was dominated by two long pontificates, those of Pius IX (1846–1878) and his successor, Leo XIII (1878–1903). Amazingly, at a time when democracies and republics were being formed on all sides across the world, these two popes sought to resurrect monarchical theories of governance, both within and outside the church. In his encyclical *Quanto conficiamur*, Pius IX looked back as far as *Unam sanctam*, the papal bull issued by Boniface VIII in 1302 (see above, Chapter 16). In other words, he was seeking to resurrect the medieval notion of absolute papal supremacy. In *Testem benevolentiae*, his attack on Americanism, Leo XIII ruled out any hope of democracy for the church, arguing that only absolute authority could safeguard against heresy.[62]

In these circumstances, and with the papal states compromised by the Italian desire for independence and unification, anticlericalism deepened in Italy. This was one of the important background factors to Pope Pius IX's apostolic letter which called for the First General Council of the Vatican.[63] Political turmoil meant that the council very nearly didn't get off the ground. When it did, it faced the problem of re-establishing the hierarchy of the church and in attempting to do this it produced two famous statements. The first

was this: 'The Church of Christ is not a community of equals in which all the faithful have the same rights.' Instead, some are given 'the power from God ... to sanctify, teach and govern'. And second, the most famous statement of all: 'We teach and define that it is a dogma divinely revealed: that the Roman Pontiff, when he speaks *ex cathedra*, that is, when in discharge of the office of Pastor and Doctor of all Christians, by virtue of his supreme apostolic authority he defines a doctrine regarding faith or morals to be held by the Universal Church, by the divine assistance promised him in Blessed Peter, is possessed of that infallibility with which the divine redeemer willed that his Church should be endowed for defining doctrine regarding faith or morals.'[64]

And so the doctrine of papal infallibility became an article of faith for Catholics for the first time.[65] This was highly risky and had been resisted since at least the fourteenth century. The Vatican may have felt that, with the great travel and communications revolutions of the nineteenth century, it would be able to exert its authority more effectively than in the Middle Ages and this may explain why, in addition to papal infallibility, Leo XIII issued *Aeterni Patris* in 1879 in which he singled out St Thomas Aquinas to be the dominant guide in modern Catholic thought. This, like Pius' edict *Quanto conficiamur*, involved a return to pre-Enlightenment, pre-Reformation, pre-Renaissance thinking of the Middle Ages. Scholastic theology was notable for being pre-scientific, for being a speculative exercise, inside people's heads, an attempt to marry Christianity and other forms of thought, and noted for its cleverness rather than a truthfulness that could be widely agreed upon.[66] In effect, Catholic thought was again becoming a closed and self-referential circular system, mainly in the hands of Jesuit theologians. The most influential of these were grouped around *Civiltà cattolica*, a journal created in 1849 at the behest of the pope, as a response to the events of 1848.[67] These Thomists (of whom Gioachino Pecci, bishop of Perugia, later Leo XIII, was a leading figure) were implacably opposed to developments in modern thought. Modern ideas should be rejected, they insisted, 'without exception'.

The main feature of this neo-Thomist thought was that it rejected any idea of evolution, of change. It looked back, beyond the twelfth century, to Aristotle, to the idea of timeless truth as affirmed by scholastic thought. After *Aeterni Patris* bishops were ordered to appoint as teachers and priests only men who had been instructed in 'the wisdom of St Thomas'.[68] At every turn, their aim was to show that the new sciences, when in conflict with revealed doctrine, were in fact 'erroneous'. This was 'papal infallibility' in action but, in addition, the doctrine of *magisterium* was also reintroduced and redefined. It was enforced by what Lester Kurtz says was the most far-reaching change – the attempt to make the Gregorian University, the most important university in the Catholic world, a major centre for Thomistic studies. Crucial appointments were made, to change the balance of power within the university, to ensure that it conformed to the new papal orthodoxy. The Curia was more concerned than ever with perpetuating old ideas, understood as still sufficient, rather than discovering new ones.[69]

As if all this were not enough, in 1893 Leo issued *Providentissimus Deus*, which aimed to contain the new scholarship regarding the Bible. This edict argued, more than thirty years after Darwin, and nearly sixty years after Strauss and Lyell, that 'a profitable understanding of sacred writings' could not be achieved by way of the 'earthly sciences'. Wisdom comes from above, reiterated the edict, and of course on these matters the pope was

infallible. The papal document dismissed the charge that the Bible contained forgeries and falsehoods and pointed out that science was 'so far from the final truth that they [the scientists] are perpetually modifying and supplementing it'.[70]

Yet another way to stifle debate on biblical matters came in the form of a Biblical Commission, which Leo appointed in 1902. In an apostolic letter *Vigilantiae*, he announced that the commission would be made up of men of learning whose duty was to interpret the divine text in a manner 'demanded by our times' and that this interpretation would henceforth 'be shielded not only from every breath of error, but also from every temerarious [reckless] opinion'.[71] Leo's final attempt to stem the tide was his apostolic letter *Testem benevolentiae*, which denounced 'Americanism' as heresy. This extraordinary move reflected the inherent conflict between democracy and monarchy and the views of some conservative Catholics in Europe, who thought that the American Catholic elite were guilty of undermining the church through their support of 'liberals, evolutionists ... and by talking forever of liberty, of respect for the individual, of initiative, of natural virtues, of sympathy for our age'.[72] In *Testem benevolentiae*, the pope declared his 'affection' for the American people but his main aim was to 'point out certain things which are to be avoided and corrected'. He said that efforts to adapt Catholicism to the modern world were doomed to failure because 'the Catholic faith is not a philosophical theory that human beings can elaborate, but a divine deposit that is to be faithfully guarded and infallibly declared'. He likewise insisted on the fundamental difference between religious authority and political authority: the church's authority came from God and could not be questioned, whereas political authority comes from the people.[73]

The dilemma that faced the Vatican at the end of the nineteenth century, the century of Lyell, Darwin, Strauss, Comte, Marx, Spencer, Quetelet, Maxwell and so many others, was that a strategy to keep the still-faithful within the church could never appeal to those who had already fled the fold – it could only ever be a holding action. In 1903, when Pius X ascended the papal throne, he did so believing that 'the number of enemies of the cross of Christ has in these last days increased exceedingly'. He said he was convinced that only believers could be 'on the side of order and have the power to restore calm in the midst of this upheaval'.[74] He therefore took it upon himself to continue Leo's fight against modernism, and with renewed vigour. In *Lamentabili*, his decree of 1907, he condemned sixty-five specific propositions of modernism, including the biblical criticisms, and reasserted the doctrine of the principle of the mystery of faith. Yet more books were placed on the *Index* and candidates for higher orders were obliged to swear allegiance to the pope, in a form of words which required their rejection of modernist ideas. *Lamentabili* reasserted the role of dogma one more time, in the famous phrase: 'Faith is an act of the intellect made under the sway of the will.'[75]

Faithful Catholics across the world were grateful for the Vatican's closely reasoned arguments and its firm stance. By 1907, fundamental discoveries in the sciences were coming quick and fast – the electron, the quantum, the unconscious and, most of all, perhaps, the gene, which explained how Darwin's natural selection could take place. It was good to have a rock in a turbulent world. Beyond the Catholic church, however, few people were listening. While the Vatican wrestled with its own modernist crisis, the wider movement in the arts, also known as modernism, marked the final arrival of

the post-romantic/post-industrial revolution/post-French Revolution and post-American Civil War sensibility. As Nietzsche had foreseen, the death of God would unleash new forces. 'Christianity resolved to find that the world was bad and ugly,' wrote this son of a pastor, 'and has made it bad and ugly.' He thought nationalism would be one new force and he was right. But other forces also filled the vacuum that was being created. One of these was Marxist socialism, with its own version of an afterlife, and a second was an allegedly scientific psychology with its own, up-dated version of the soul – Freudianism.

We saw in Chapter 29, on the Oriental renaissance, that the Muslim world's relationship with the West was chequered, to say the least, a mixture of arrogance that there was little Islam could learn from Europe, later tempered as European achievements filtered across the religious divide. But the gap only really began to close with the retreat of the Ottoman empire, based in Turkey, which culminated in the Crimean War of the 1850s. This proved crucial because that war was the first real alliance in history between Christian and Islamic forces, when Turkey joined together with France and Britain against Russia. As a result of this closer-than-usual co-operation, Muslims discovered that there was a huge amount they could learn and benefit from Europe, not just about weapons and fighting, and medicine, which had always attracted them, but in other walks of life too.

The new attitude surfaced first in Turkey, where, for example, there was a movement known as *Tanzimat*, or 'Reform'.[76] The country initiated a Supreme Council of Reform and was reorganised along French lines with the *sharia* being confined to family law alone. Tax farming was replaced by tax collection and the people became 'subjects'. The key figure here was Namik Kemal (1840–1888), who edited a journal, *Freedom*, whose aim was freedom to pursue technological achievement, freedom of the press, the separation of powers, equality of all before the law and a reinterpretation of the Qur'an so as to make it consistent with parliamentary democracy. The most important message that Namik Kemal had was that not everything is predetermined by God. Ishak Efendi was appointed *bashoca* of the Imperial School for Military Engineering and in 1834 published his four-volume *Mecmua-i Ulum-i Riyaziye*, based on foreign sources, which introduced many of the modern sciences to the Muslim world. Twelve years later Kudsi Efendi produced his *Asrar al-Malakut*, which did its best to reconcile the Copernican system with Islam. In 1839 thirty-six students were selected from the military and engineering schools to study in Paris, London and Vienna and in 1845 a Temporary Council of Education began to consider the idea of 'educating the public'. The first book of modern chemistry was published in Turkish in 1848 and the first title of modern biology in 1865. Factory-building, along Western lines, began in earnest in the 1860s. A civilian school of medicine was founded in Istanbul in 1867 and two years later registration began for the Darülfünân, or university. It opened for classes in 1874–1875, consisting of schools of letters, law and, instead of science, as originally intended, civil engineering (this latter was based on the French École des Ponts et Chaussées). The Encümen-i Danis (Learned Society), not dissimilar to the Académie Française, was conceived in 1851, a translation council was set up in 1866, the metric system adopted in 1869 and, when Pasteur discovered the rabies vaccine in 1885, the Turks sent a delegation of physicians to Paris to absorb the new information and to confer on the great man a Turkish decoration.[77]

Overlapping with Namik Kemal in Iran was Malkom Khan (1844–1908), who had been educated in Paris, much influenced by Auguste Comte, and who wrote a *Book of Reform*, in which he advocated the separation of powers, a secular law and a Bill of Rights. He edited a newspaper *Qanun* or 'Law' in which he proposed two assemblies, a popular assembly and an assembly of the *ulama* or learned. Again overlapping with both of these was Khayr al-din al-Tunisi (1822–1890), a Tunisian who also studied in Paris, who made a survey of twenty-one European states and their political systems, much as Aristotle did in classical Greece. He argued that it was a mistake for Muslims to reject what others had achieved, simply because they weren't Muslims, and he recommended the Islamic world should 'steal the best' of what Europe had to offer.[78]

In all there were well over fifty major thinkers of the Islamic world who emerged at this time to campaign for the modernisation of Islam – people such as Qasim Amin of Egypt, Mahmud Tarzi of Afghanistan, Sayyid Khan of India, Achmad Dachlan of Java and Wang Jingshai of China. But the three most influential Islamic modernists, whose names deserve to be more widely known in the West, were: Sayyid Jamal al-Din al-Afghani, of Iran (1838–1897), Muhammad Abduh, of Egypt (1849–1905), and Muhammad Rashid Rida (1865–1935), who was born in Lebanon but spent most of his adult life in Egypt.

Al-Afghani's main message was that European success was basically due to two things, to its science and to its laws, and he said that these were derived from ancient Greece and India. 'There is no end or limit to science,' he said, 'science rules the world.' (This was in 1882.) 'There was, is, and will be no ruler in the world but science.' 'The English have reached Afghanistan; the French have seized Tunisia. In reality, this usurpation, aggression and conquest have not come from the French or the English. Rather it is science that everywhere manifests its greatness and power.' Al-Afghani wanted the whole Islamic position to be reconsidered. He argued that 'mind is the motor of historical change' and he said that Islam needed a Reformation. He pilloried the *ulama* or religious scholars of the day who read the old texts but didn't know the causes of electricity, or the principles of the steam engine. How, he asked, could these people call themselves 'sages'? He likened the *ulama* to a light with a narrow wick 'that neither lights its surroundings nor gives light to others'. Al-Afghani studied in France and Russia and while he was in Paris he became friendly with Ernest Renan. Al-Afghani specifically said that the religious person was like an ox yoked to a plough, 'yoked to the dogma whose slave he is', and he must walk eternally in the furrow that has been traced for him in advance. He blamed Islam for the ending of Baghdad's golden age, admitting that the theological schools stifled science, and he pleaded for a non-dogmatic philosophy that would encourage scientific inquiry.

Muhammad Abduh also studied in Paris, where he produced a famous journal called *The Strongest Link*, which agitated against imperialism but also called for religious reform.[79] Returning to Egypt he became a leading judge and served on the governing body of the al-Azhar mosque-college, one of the most influential bodies of learning in the Arab world. He campaigned for the education of girls and for secular laws, beyond the *sharia*. He was especially interested in law and politics. Here are some of the things he wrote: 'Human knowledge is in effect a collection of rules about useful benefits, by which people organise the methods of work that lead to those benefits ... laws are the basis of activities organised ... to produce manifest benefits ... the law of each nation corresponds to its level in

understanding ... It is not possible therefore to apply the law of one group of people to another group who surpass the first in level of understanding ... order among the second group will be disturbed ...'. Politics, he insisted on another occasion, should be determined by circumstances, not by doctrine. Abduh went on to make the case for legal reform in Egypt, for clear simple laws, avoiding what he called the 'ambiguities' of the Qur'an. He referred Egypt to France after the Revolution, which he said went from an absolute monarchy, to a restricted monarchy, to a free republic. He wanted a civil law to govern most of life, agreed by all in a logical manner. In his legal system, there was no mention of the prophet, Islam, the mosque, or religion.

Muhammad Rashid Rida attended a school in Lebanon which combined modern and religious education. He spoke several European languages and studied widely among the sciences.[80] He was close to Abduh and became his biographer. He too had his own journal, *al-Manar* (*The Beacon*), which disseminated ideas about reform until his death. Rida's view was that social, political, civic and religious renewal was necessary and ongoing, so that societies could 'ascend the paths of science and knowledge'. 'Humans at all times need the old and the new,' he said. He noted that while the British, French and Germans mostly preferred their own ways of doing things, and thinking, they were open to foreign influences as well. He admitted to being helped by, and liking, men who he deemed heretics. He sounds here a bit like Erasmus but he also recalls Owen Chadwick's point, mentioned earlier, where he said that it was only from about 1860 that Europeans who regarded themselves as Christian could be friendly with non-believers. Most importantly, Rida said that the *sharia* has little or nothing to say about agriculture, industry and trade – 'it is left to the experience of the people'. The state, he says, consists of precisely this – the sciences, arts and industries, financial, administrative and military systems. They are a collective duty in Islam and it is a sin to neglect them. The one rule to remember is 'Necessity permits the impermissible.'

The collective achievement of modernism in the Islamic world consisted of the following elements. (1) Cultural revival. This was an attempt to revive Islamic arts and culture, mainly by referral to what had happened in the Enlightenment in Western Europe. Here are a few examples: the practice of hagiography was changed and became much more like modern biography; there developed a tradition of travelogues in the Arab world, which openly marvelled at the prosperity of Europe and America – the gas lamps, the railways and the steamships. The first plays began to appear, in Lebanon in 1847, with an adaptation of a French drama; the first Urdu play was produced in India in 1853 and the first Turkish play was performed in 1859. A new periodical press appeared in the Arab world, with the development of the rotary press (as in Europe). Titles: *Liberty, Warning, Interpreter.* Algeria even had a reformist newspaper, *The Critic.* The critic al-Tahtawi wrote a book about Voltaire, Rousseau and Montesquieu, and about Western laws; Namik Kemal, in Turkey, translated Bacon, Condillac, Rousseau and Montesquieu. (2) Constitutionalism. Constitutionalism in this context meant government restricted by law, what we would today call the separation of powers, with elected parliaments rather than government by kings, sheikhs, or tribal leaders. The constitutionalists specifically took a decision to ignore the concept of paradise, and argued that what mattered was equality in *this* life, here on earth. Constitutionalist proposals were produced, or passed, in Egypt in 1866, in Tunisia in 1861,

in the Ottoman Empire in 1876 and 1908, in Iran in 1906 and again in 1909. In Afghanistan a modernist movement was suppressed in 1909.[81] People even started to talk of 'the constitutional countries'. (3) Science and education was the third aspect of modernism. There was a great worry about Darwin, because many Islamic scholars were persuaded by Herbert Spencer's ideas on social Darwinism and they thought that Muslim societies were old-fashioned and would go under. They therefore urged the adoption of the Western sciences, in particular, which were to be taught in the new schools. There was a new school movement at this time, *usul-I jaded*, meaning 'new principles', which taught religious and secular subjects side-by-side but where the aim, quite clearly, was to replace traditional religious scholars with more modern ones. Sociology became popular among the Islamic modernists; they followed Comte in particular and his view that societies could be divided into three progressive stages: natural, social and political. Afghani took the view that man does not differ from the animals and could be studied like them, arguing that the fittest would survive. Like Marx and like Nietzsche, he thought that, in the end, life was about power. Abduh visited Herbert Spencer, whose book he translated. Most important of all, the modernists argued that laws came from human nature, from the study of the regularities of nature, that that was how God revealed himself, not through the Qur'an. (4) As was happening in the West in the nineteenth century, with the deconstruction of the Bible (as we would say), so the text of the Qur'an and *hadith* came under criticism. Rida was a relentless critic of the *hadith*, as a set of texts introduced by later figures which he felt was most to blame for keeping Islam back. So far as the Qur'an itself was concerned, he argued that its text was only a guidance, not a command. Al-Saykh Tartawi Jawhari (1870–1940) made an exegesis of the Qur'an in twenty-six volumes, based on modern science. (5) Women. The nineteenth century saw the promotion of girls' schooling in several Islamic countries, if not everywhere. It saw women's organisations in Bengal and in Russia. It saw an end to polygamy in India. It saw women's suffrage in Azerbaijan in 1918 (before France in 1947, and Switzerland even later). In the Lebanon in 1896 and in Tunisia in 1920 there were campaigns for women to be given free access to the professions.

The reader may well ask what became of this modernist movement in the Islamic countries. The short answer is that it flourished until the First World War and then fragmented. Because it falls outside the time-frame of this book, a short summary of what happened between the First World War and the present is given in the notes.[82]

Both Christianity and Islam came under sustained onslaught in the late nineteenth century. Who is to say, now, which faith resisted these attacks more successfully?

# *Modernism and the Discovery*
# *of the Unconscious*

As a youth Sigmund Freud did not lack for ambition. Though he had a reputation for being a bookworm, his dark eyes and lush dark hair gave him an air of assurance to which the adjective 'charismatic' has been applied.[1] He fantasised himself as Hannibal, Oliver Cromwell, Napoleon, Heinrich Schliemann – the discoverer of Troy – and even Christopher Columbus. Later in life, after he had made his name, he compared himself less fancifully with Copernicus, Leonardo da Vinci, Galileo and Darwin. In his lifetime he was lionised by André Breton, Theodore Dreiser and Salvador Dali. Thomas Mann thought he was 'the oracle', though he later changed his mind. In 1938, the United States president, Franklin Roosevelt, took a personal interest in Freud's protection, as a Jew under the Third Reich, and eventually induced the Nazis to let him leave Austria.[2]

Perhaps no figure in the history of ideas has undergone such revision as Freud – certainly not Darwin, and not even Marx. Just as there is a disparity today between professional historians and the general reading public, concerning the Renaissance and what we might call, for shorthand, the Prenaissance – the period 1050–1250 when the modern world began – so there is a huge gap now between the general public's understanding of Freud, and that of most psychiatric professionals.

The first act of revision, as it were, is to remove from Freud any priority he may ever have been credited with in the discovery of the unconscious. Guy Claxton, in his recent history of the unconscious, traces 'unconscious-like' entities to the 'incubation temples' of Asia Minor in 1000 BC where 'spirit release' rituals were common. He says that the Greek idea of the soul implied 'unknown depths', that Pascal, Hobbes and Edgar Allen Poe were just three who had some idea that the self has a double that is mysterious, half-hidden, yet somehow exerts an influence over behaviour and feelings. Poe was by no means isolated. 'It is difficult – or perhaps impossible – to find a nineteenth-century psychologist or medical psychologist – who did not recognise unconscious cerebration as not only real but of the highest importance.' This is Mark D. Altschule in his *Origins of Concepts in Human Behavior* (1977). The terms 'psychosis' and 'psychiatric', as we now use them, were introduced by Baron Ernst von Feuchtersleben (1806–1849) in Vienna after 1833. Among novelists, the nineteenth century was known as 'our century of nerves', and the word 'neurasthenia' was coined by George Beard in 1858.[3] The British philosopher Lancelot Law Whyte says that around 1870 the unconscious was a topic of conversation, not merely for

professionals, but for those who wished to show they were cultured. The German writer Friedrich Spielhagen agreed: in a novel he published in 1890, he described a Berlin salon in the 1870s where two topics dominated the conversation – Wagner and the philosophy of the unconscious. But not even this does justice to the extent to which the unconscious, as an idea, had developed in the nineteenth century. For that we need to turn to Henri Ellenberger and his massive, magisterial work, *The Discovery of the Unconscious*.[4]

Ellenberger divided his approach into three – what we might call the distal and proximate medical background to psychoanalysis, and the nineteenth-century cultural background. They were equally important.

Among the distal causes, he said, were such predecessors as Franz Anton Mesmer (1734–1815), who was at times compared to Christopher Columbus, for he was believed to have discovered 'a new world', but in his case an inner world. Mesmer treated people with magnets attached to their bodies, after swallowing a preparation containing iron. After noting how some psychological symptoms varied with the phases of the moon, his aim was to manipulate 'artificial tides' within the human body. The method appeared to remove the symptoms in some instances, at least for several hours. Mesmer believed he had uncovered an 'invisible fluid' in the body, which he could manipulate: this coincided with the discovery of other 'imponderable' fluids, such as phlogiston and electricity, and partly accounts for the intense interest in his innovations, which were built on by the marquis de Puységur (1751–1825). He developed two techniques known as 'perfect crisis' and 'artificial somnabulism', which appear to have been forms of magnetically-induced hypnotism.[5]

Jean-Martin Charcot (1835–1893) was perhaps the first proximate precursor of Freud. The greatest neurologist of his time, who treated patients 'from Samarkand to the West Indies', he was the man who made hypnotism respectable when he used it to distinguish hysterical paralysis from organic paralysis. He proved his case by having patients produce paralyses under hypnosis. Subsequently he was able to show that hysterical paralyses often occurred after traumas. He also showed that hysterical memory loss could be recovered under hypnosis. Freud spent four months at the Salpêtrière hospital in Paris, studying with Charcot, though doubt has recently been thrown on the Frenchman's work: it now seems that his patients behaved as they did to accommodate their therapists' expectations.[6]

Hypnosis was a very popular form of treatment throughout the nineteenth century, linked also to a condition known as ambulatory automatism, when people seemed to hypnotise themselves and perform tasks of which they were unaware until they recovered. Hypnosis likewise proved useful with a number of cases of what we now call fugue, where people suddenly dissociate from their lives, leave their homes and may even forget who they are.[7] As the nineteenth century progressed, however, interest in hypnosis waned, though hysteria remained a focus of psychiatric attention. Because there were, roughly speaking, twenty female cases for every male one, hysteria was from the beginning looked upon as a female disease and although the root cause had originally been conceived as in some mysterious way having to do with the movement or 'wandering' of the uterus, it soon became clear that it was a form of psychological illness. A sexual role was considered possible, even likely, because hysteria was virtually absent among nuns but common in prostitutes.[8]

Arguably the first appearance of the unconscious as we now understand the term came

after the magnetisers noticed that when they induced magnetic sleep in someone, 'a new life manifested itself of which the subject was unaware, and that a new and often more brilliant personality emerged'.[9] These 'two minds' fascinated the nineteenth century, and there emerged the concept of the 'double ego' or 'dipsychism'.[10] People were divided as to whether the second mind was 'closed' or 'opened'. The dipsychism theory was developed by Max Dessoir in *The Double Ego*, published to great acclaim in 1890, in which he divided the mind into the *Oberbewussten* and the *Unterbewussten*, 'upper consciousness' and 'under consciousness', the latter, he said, being revealed occasionally in dreams.

Among the general background factors giving rise to the unconscious, romanticism was intimately involved, says Ellenberger, because romantic philosophy embraced the notion of *Urphänomene*, 'primordial phenomena' and the metamorphoses deriving from them.[11] Among the *Urphänomene* were the *Urpflanze*, the primordial plant, the *All-Sinn*, the universal sense, and the unconscious. Another primordial phenomenon, according to Gotthilf Heinrich von Schubert (1780–1860), was *Ich-Sucht* (self-love). Von Schubert said man was a 'double star', endowed with a *Selbstbewussten*, a second centre.[12] Johann Christian August Heinroth (1773–1843), described by Ellenberger as a 'romantic doctor', argued that the main cause of mental illness was sin. He theorised that conscience originated in another primordial phenomenon, the *Über-Uns* (over-us).[13] Johann Jakob Bachofen (1815–1887), a Swiss, promulgated the theory of matriarchy, publishing in 1861 *The Law of Mothers*.[14] He believed, he said, that history had gone through three phases, 'hetairism, matriarchy and patriarchy'. The first had been characterised by sexual promiscuity, when children did not know their fathers; the second was established only after thousands of years of struggle, but women had won out, founded the family and agriculture and wielded all the social and political power. The main virtue at this time was love for the mother, with the mothers together favouring a social system of general freedom, equality and peace. Matriarchal society praised education of the body (practical values) above education of the intellect. Patriarchal society emerged only after another long period of bitter struggle. It involved a complete reversal of matriarchal society, favouring individual independence and isolating men from one another. Paternal love is a more abstract principle than maternal love, says Bachofen, less down-to-earth and leading to high intellectual achievement. He believed that many myths contain evidence of matriarchal society, for example the myth of Oedipus.[15]

A number of philosophers also anticipated Freudian concepts. The following list of books is instructive but far from exhaustive (*Unbewussten* means 'unconscious' in German): August Winkelmann, *Introduction into Dynamic Psychology* (1802); Eduard von Hartmann, *Philosophy of the Unconscious* (1868); W. B. Carpenter, *Unconscious Action of the Brain* (1872); J. C. Fischer, *Hartmann's Philosophie des Unbewussten* (1872); J. Vokelt, *Das Unbewusste und der Pessimismus* (1873); C. F. Flemming, *Zur Klärung des Vegriffs der unbewussten Seelen-Thätigkeit* (1877); A. Schmidt, *Die naturwissenschaftlichen Grundlagen der Philosophie des Unbewussten* (1877); E. Colsenet, *La Vie Inconsciente de l'Esprit* (1880).[16]

In *The World as Will and Representation*, Schopenhauer conceived the will as a 'blind, driving force'. Man, he said, was an irrational being guided by internal forces, 'which are unknown to him and of which he is scarcely aware'.[17] The metaphor Schopenhauer used was that of the earth's surface, the inside of which is unknown to us. He said that the

irrational forces which dominated man were of two kinds – the instinct of conservation and the sexual instinct. Of the two, the sexual instinct was by far the more powerful, and in fact, said Schopenhauer, nothing else can compete with it. 'Man is deluded if he thinks he can deny the sex instinct. He may *think* that he can, but in reality the intellect is suborned by sexual urges and it is in this sense that the will is "the secret antagonist of the intellect". Schopenhauer even had a concept of what later came to be called repression which was itself unconscious: 'The Will's opposition to let what is repellent to it come to the knowledge of the intellect is the spot through which insanity can break through into the spirit.'[18] 'Consciousness is the mere surface of our mind, and of this, as of the globe, we do not know the interior but only the crust.'[19]

Von Hartmann went further, however, arguing that there were three layers of the unconscious. These were (1) the absolute unconscious, 'which constitutes the substance of the universe and is the source of the other forms'; (2) the physiological unconscious, which is part of man's evolutionary development; and (3) the psychological unconscious, which governs our conscious mental life. More than Schopenhauer, von Hartmann collected copious evidence – clinical evidence, in a way – to support his arguments. For example, he discussed the association of ideas, wit, language, religion, history and social life – significantly, all areas which Freud himself would explore.

Many of Freud's thoughts about the unconscious were also anticipated by Nietzsche (whose other philosophical views are considered later). Nietzsche had a concept of the unconscious as a 'cunning, covert, instinctual' entity, often scarred by trauma, camouflaged in a surreal way but leading to pathology.[20] The same is true of Johann Herbart and G. T. Fechner. Ernest Jones, Freud's first (and official) biographer, drew attention to a Polish psychologist, Luise von Karpinska, who originally spotted the resemblance between some of Freud's fundamental ideas and Herbart's (who wrote seventy years before). Herbart pictured the mind as dualistic, in constant conflict between conscious and unconscious processes. An idea is described as being *verdrängt* (repressed) 'when it is unable to reach consciousness because of some opposing idea'.[21] Fechner built on Herbart, specifically likening the mind to an iceberg 'which is nine-tenths under water and whose course is determined not only by the wind that plays over the surface but also by the currents of the deep'.[22]

Pierre Janet may also be regarded as a 'pre-Freudian'. Part of a great generation of French scholars which included Henri Bergson, Émile Durkheim, Lucien Lévy-Bruhl and Alfred Binet, Janet's first important work was *Psychological Automatism*, which included the results of experiments he carried out at Le Havre between 1882 and 1888. There, he claimed to have refined a technique of hypnosis in which he induced his patients to undertake automatic writing. These writings, he said, explained why his patients would develop 'terror' fits without any apparent reason.[23] Janet also noticed that, under hypnosis, patients sometimes developed a dual personality. One side was created to please the physician while the second, which would occur spontaneously, was best explained as a 'return to childhood'. (Patients would refer to themselves, all of a sudden, by their childhood nicknames.) When Janet moved to Paris he developed his technique known as 'Psychological Analysis'. This was a repeated use of hypnosis and automatic writing, during the course of which, he noticed, the crises that were induced were followed by the patient's

mind becoming clearer. However, the crises became progressively more severe and the ideas that emerged showed that they were reaching back in time, earlier and earlier in the patient's life. Janet concluded that 'in the human mind, nothing ever gets lost' and that 'subconscious fixed ideas are both the result of mental weakness and [a] source of further and worse mental weakness'.[24]

The nineteenth century was also facing up to the issue of child sexuality. Physicians had traditionally considered it a rare abnormality but, as early as 1846, Father P. J. C. Debreyne, a moral theologian who was also a physician, published a tract where he insisted on the high frequency of infantile masturbation, of sexual play between young children, and of the seduction of very young children by wet nurses and servants. Bishop Dupanloup of Orléans was another churchman who repeatedly emphasised the frequency of sexual play among children, arguing that most of them acquired 'bad habits' between the ages of one and two years. Most famously, Jules Michelet, in *Our Sons* (1869), warned parents about the reality of child sexuality and in particular what today would be called the Oedipus complex.[25]

Two things of some importance emerge from even this brief survey of nineteenth-century (mainly German and French) thought. The first is to dispense thoroughly with any idea that Freud 'discovered' the unconscious. Whether or not the unconscious exists as an entity (an issue we shall return to later), the *idea* of the unconscious pre-dates Freud by several decades and was common currency in European thought throughout most of the 1800s. Second, many of the other psychological concepts inextricably linked with Freud in the minds of so many – such ideas as childhood sexuality, the Oedipus complex, repression, regression, transference, the libido, the id and the superego – were also not original to Freud. They were as much 'in the air' as the unconscious was, as much as 'evolution' was at the time Darwin conceived the mechanism of natural selection. Freud had nowhere near as original a mind as he is generally given credit for.

Surprising as all this is, for many people, it is still not the main charge against him, not the main sin so far as Freud's critics contend. These critics, such figures as Frederick Crews, Frank Cioffi, Allen Esterson, Malcolm Macmillan and Frank Sulloway (the list is long and growing), further argue that Freud is – not to beat about the bush – a charlatan, a 'scientist' only in quotation marks, who fudged and faked his data and deceived both himself and others. And this, the critics charge, completely vitiates his theories and the conclusions based on them.

The best format to convey the new view of Freud is first to give the orthodox view of the ways in which he conceived his theories, and their reception, and then to give the main charges against him, showing how the orthodox view now has to be altered (this alteration, it should be said one more time, is drastic – we are talking here about critical scholarship over the last forty years but, in the main, the last fifteen years). Here, to begin with, is the orthodox version.

Sigmund Freud's views were first set out in *Studies in Hysteria*, published in 1895 with Joseph Breuer, and then more fully in his work entitled *The Interpretation of Dreams*, published in the last weeks of 1899. (The book was technically released in November 1899,

in Leipzig as well as Vienna, but it bore the date 1900 and it was first reviewed in early January 1900). Freud, a Jewish doctor from Freiberg in Moravia, was already forty-four. The eldest of eight children, he was outwardly a conventional man. He believed passionately in punctuality and wore suits made of English cloth, cut from material chosen by his wife. He was also an athletic man, a keen amateur mountaineer, who never drank alcohol. He was, on the other hand, a 'relentless' cigar-smoker.[26]

Though Freud might be a conventional man in his personal habits, *The Interpretation of Dreams* was a deeply controversial and – for many people in Vienna – an utterly shocking book. It is in this work that the four fundamental building blocks of Freud's theory about human nature first come together: the unconscious, repression, infantile sexuality (leading to the Oedipus complex), and the tripartite division of the mind into ego, the sense of self, superego, broadly speaking the conscience, and id, the primal biological expression of the unconscious. Freud had developed his ideas – and refined his technique – over a decade and a half since the mid-1880s. He saw himself very much in the biological tradition initiated by Darwin. After qualifying as a doctor, Freud obtained a scholarship to study under Charcot, who at the time ran an asylum for women afflicted with incurable nervous disorders. In his research, Charcot had shown that, under hypnosis, hysterical symptoms could be induced. Freud returned to Vienna from Paris after several months and, following a number of neurological writings (on cerebral palsy, for example, and on aphasia), he began a collaboration with another brilliant Viennese doctor, Josef Breuer (1842–1925). Breuer, also Jewish, had made two major discoveries, on the role of the vagus nerve in regulating breathing, and on the semicircular canals of the inner ear which, he found, controlled the body's equilibrium. But Breuer's importance for Freud, and for psychoanalysis, was his discovery in 1881 of the so-called talking cure.[27]

For two years, beginning in December 1880, Breuer had treated for hysteria a Vienna-born Jewish girl, Bertha Pappenheim (1859–1936), whom he described, for case-book purposes, as 'Anna O'. She had a variety of severe symptoms, including hallucinations, speech disturbances, a phantom pregnancy, intermittent paralyses, and visual problems. In the course of her illness(es) she experienced two different states of consciousness, and also went through extended bouts of somnambulism. Breuer found that in this latter state she would, with encouragement, report stories that she made up, following which her symptoms improved temporarily. However, her condition deteriorated badly after her father died – there were more severe hallucinations and anxiety states. Again, however, Breuer found that 'Anna' could obtain some relief from these symptoms if he could persuade her to talk about her hallucinations during her auto-hypnoses. This was a process she herself called her 'talking cure' or 'chimney sweeping' (*Kaminfagen*). Breuer's next advance was made accidentally: 'Anna' started to talk about the onset of a particular symptom (difficulty in swallowing), after which the symptom disappeared. Building on this, Breuer eventually (after some considerable time) discovered that if he could persuade his patient to recall in reverse chronological order each past occurrence of a specific symptom, until she reached the very first occasion, most of them disappeared in the same way. By June 1882, Miss Pappenheim was able to conclude her treatment, 'totally cured'.[28]

The case of Anna O. impressed Freud deeply (he had been distinctly unimpressed by George Beard's arguments about neurasthenia). For a time Freud himself tried elec-

trotherapy, massage, hydrotherapy and hypnosis with hysterical patients but abandoned this approach, replacing it with 'free association' – a technique whereby he allowed his patients to talk about whatever came into their minds. It was this technique which led to his discovery that, given the right circumstances, many people could recall events that had occurred in their early lives and which they had completely forgotten. Freud came to the conclusion that though forgotten, these early events could still shape the way people behaved. Thus was born his concept of the unconscious and with it the notion of repression. Freud also realised that many of these early memories which were revealed – with difficulty – under free association, were sexual in nature. When he further found that many of the 'recalled' events had in fact never taken place, he refined his notion of the Oedipus complex. In other words, the sexual traumas and aberrations falsely reported by patients were for Freud a form of code, showing not what had happened but what people secretly *wanted* to happen, and confirmed that human infants went through a very early period of sexual awareness. During this period, he said, a son was drawn to the mother and saw himself as a rival to the father (the Oedipus complex) and vice versa with a daughter (the Electra complex). By extension, Freud said, this broad motivation lasted throughout a person's life, helping to determine character.[29]

These early theories of Freud were met with outraged incredulity and unremitting hostility. The neurological institute of Vienna University refused to have anything to do with him. As Freud later said, 'An empty space soon formed itself about my person.'[30] His response was to throw himself deeper into his researches and to put himself under analysis – with himself. The spur to this occurred after the death of his father, Jakob, in October 1896. Although father and son had not been very intimate for a number of years, Freud found to his surprise that he was unaccountably moved by his father's death, and that many long-buried recollections spontaneously resurfaced. His dreams also changed. He recognised in them an unconscious hostility directed toward his father that hitherto he had repressed. This led him to conceive of dreams as 'the royal road to the unconscious'.[31] Freud's central idea in *The Interpretation of Dreams* was that in sleep the ego is like 'a sentry asleep at its post'.[32] The normal vigilance by which the urges of the id are repressed is less efficient and dreams are therefore a disguised way for the id to show itself.

The early sales for *The Interpretation of Dreams* indicate its poor reception. Of the original 600 copies printed, only 228 were sold during the first two years and the book apparently sold only 351 copies during its first six years in print.[33] More disturbing to Freud was the complete lack of attention paid to the book by the Viennese medical profession.[34] The picture was much the same in Berlin. Freud had agreed to give a lecture on dreams at the university, but only three people turned up to hear him. In 1901, shortly before he was to address the Philosophical Society he was handed a note which begged him to indicate 'when he was coming to objectionable matter and make a pause, during which the ladies could leave the hall'. The isolation wouldn't last and in time, and despite fierce controversy, many people came to consider the unconscious the most influential idea of the twentieth century.

So much for the orthodox view. Now for the revised version. There are four main charges. In increasing order of importance they are that, one, Freud did *not* invent the 'free

association' technique. This was invented in 1879 or 1880 by Francis Galton and reported in the journal *Brain*, where the new technique is described as a device to explore 'obscure depths'.[35] The second charge is that it is a myth that Freud's books and theories met with a hostile reception – recent scholarship has revealed the extent of this myth. Norman Kiell, in *Freud Without Hindsight* (1988), reports that out of forty-four reviews of *The Interpretation of Dreams* published between 1899 and 1913 (which is in itself a respectable number), only eight could be classified as 'unfavourable'. Hannah Decker, herself a Freudian, in her book *Freud in Germany: Revolution and Reaction in Science, 1893–1907* (1977), concludes that 'an overwhelming percent of the [published] lay response to Freud's theories about dreams was enthusiastic'.[36] Though *The Interpretation of Dreams* may not have sold well, a popular version did do well. The history of the unconscious, reported earlier in this chapter, and the evolution of such ideas as the superego, childhood sexuality, and repression, show that Freud was not saying anything that was completely new. Why, therefore, should people have taken such exception? He never had any problems getting his views published. He never published his views anonymously, as Robert Chambers did when he introduced the idea of evolution to a wide range of readers.

The third charge is that the picture Freud himself painted of one of Breuer's most famous patients, 'Anna O.', or Bertha Pappenheim, was seriously flawed and quite possibly based on deliberate deceit. Henri Ellenberger himself traced the clinics where Pappenheim was treated and unearthed the notes used by Breuer. Since some of the wording in these reports is identical with the later published paper, we can be sure that these are indeed the original notes. Ellenberger, and others since, found that there is no evidence at all that Pappenheim ever had a phantom pregnancy. This is now believed to be a story Freud invented, to counter the apparent lack of sexual aetiology in the Anna O. case as recounted by Breuer, which was completely at odds with Freud's insistence that sexual matters lay at the root of all hysterical symptoms. In his biography of Josef Breuer (1989), Albrecht Hirschmüller goes so far as to say that 'The Freud–Jones account of the termination of the treatment of Anna O. should be regarded as a myth.'[37] Hirschmüller himself was able to show that many of Pappenheim's symptoms went into total or partial remission spontaneously, that she went through no catharsis or abreaction – in fact the case notes end abruptly in 1882 – and that, following treatment by Breuer, she was hospitalised in the next years no fewer than four times, each time being diagnosed with 'hysteria'. In other words, Freud's claim that Breuer 'restored Anna O. to health' is false and, moreover and equally important, Freud *must have known* it was false because there is a letter of his which makes clear that Breuer knew Anna O. was still ill in 1883, and because she was a friend of Freud's fiancée Martha Bernays.[38]

The significance of the Anna O. case, or at least the way Freud reported it, is threefold. It shows that Freud exaggerated the effects of the 'talking cure'. It shows that he introduced a sexual element when none was there. And it shows that he was cavalier with the clinical details. We shall see that these tendencies all repeated themselves in important ways throughout the rest of his career.

The fourth charge against Freud is by far the most serious but stems from the case of Anna O. It is that the entire edifice of psychoanalysis is based on clinical evidence and observations that are at best dubious or flawed, and at worst fraudulent. Perhaps the single

most important idea in psychoanalysis is Freud's conclusion that infantile sexual wishes persist in adults, but outside awareness, and can thus bring about psychopathology. 'At the bottom of every case of hysteria,' he reported in 1896, 'there are one or more occurrences which belong to the earliest years of childhood but which can be reproduced through the work of psychoanalysis in spite of the intervening decades.' What is strange about this is that, although in 1896 he had never before reported a single case of sexual abuse in infancy, within four months he was claiming that he had 'traced back' unconscious memories of abuse in thirteen patients described as hysterical. Allied to this was his argument that the event or situation that was responsible for a particular symptom could be revealed through his technique of psychoanalysis, and that 'abreacting' the event – reliving it in talk with the associated emotional expression – would result in 'catharsis', remission of the symptom. He became convinced that this was, in his own words, 'an important finding, the discovery of a *caput Nili* [source of the Nile] in neuropathology ...'[39] But he then went on to add – and this is what has brought about the great revision – 'these patients never repeat these stories spontaneously, nor do they ever in the course of a treatment suddenly present the physician with the complete recollection of a scene of this kind'. For Freud, as he presented his findings, these memories were unconscious, outside the patient's awareness, 'traces are never present in conscious memory, only in the symptoms of the illness'. His patients, going into therapy, had no idea about these scenes and, he confessed, they were 'indignant as a rule' when they were told. 'Only the strongest compulsion of the treatment can induce them to embark on reproducing them' (the early circumstances of abuse). As Allen Esterson and others have shown, Freud's techniques in the early days were not those of a sensitive analyst sitting quietly on a couch, listening to what his patients had to say. On the contrary, Freud would touch his patients on the forehead – this was his 'pressure' technique – and he would insist that something would come into their heads – an idea, image or memory. They were made to describe these images and memories until, after a long stream, they would alight on the event that caused the (supposed) hysterical symptom. In other words, say the critics, Freud had very fixed ideas about what lay at the root of various symptoms and rather than passively listen and let the clinical evidence emerge from observation, he forced his views on his patients.

It was out of this unusual approach that there came his most famous set of observations. This was that the patients had been seduced, or otherwise sexually abused, in infancy, and that these experiences lay at the root of their later neurotic symptoms. The culprits were divided into three: adult strangers; adults in charge of the children, such as maids, governesses or tutors; and 'blameless children ... mostly brothers who for years on end had carried on sexual relations with sisters a little younger than themselves'.[40] The age at which these precocious sexual experiences were alleged to have taken place occurred most commonly in the third to fifth year. To this point, what the critics chiefly argue is that Freud's allegedly 'clinical' observations are no such thing. They are instead a dubious 'reconstruction', based on symbolic interpretation of the symptom. It is necessary to repeat that a close reading of Freud's various reports shows that patients never actually volunteered these stories of sexual abuse. On the contrary they vehemently denied them. Invariably, it was Freud who 'informed', 'persuaded', 'intuited' or 'inferred' these processes. In several places he actually admitted to 'guessing' what the underlying problem was.

However, and this is another event of some significance, within eighteen months Freud was confiding to his colleague Wilhelm Fleiss (but only to Fleiss) that he no longer believed in this theory of the origins of neurosis. He thought it improbable there should be such widespread perversions against children, and in any case he was failing to bring any of his analyses based on these ideas to a successful conclusion. 'Of course I shall not tell it in Dan, nor speak of it in Askelon, in the land of the Philistines, but in your eyes and my own ...' In other words, he was not prepared to do the scientifically honourable thing, and acknowledge publicly that he was withdrawing his confidently-claimed 'findings' of the previous year. It was now that he began to consider the possibility that these events were unconscious fantasies rather than memories. However, even then this new variation took time to coalesce fully, because Freud at first thought that infants' fantasies occurred in order to 'cover up the auto-erotic activity of the early years of childhood'. In 1906 and again in 1914 he said that, around puberty, some patients conjured up unconscious memories of infantile 'seductions' to 'fend off' memories of infantile masturbation. In 1906 the 'culprits' of the fantasies were adults or older children, while in 1914 he did not specify who they were. In that report, however, he did at last fully retract his seduction theory. Even so, it was only in 1925, *nearly thirty years after the events in question*, that he first said publicly that most of his early female patients had accused their father of having seduced them. The size of this *volte-face* cannot be overstated. In the first place, there is no question but that he radically changed the scenario of seduction – from real to fantasised, and further, he changed the identity of the seducers from strangers/tutors/brothers to fathers. The important point to take on board is that this change occurred as a result of no new clinical evidence: Freud simply painted a different picture, using the same ingredients, except that this time he was a quarter of a century away from the evidence. Second, and no less important, during the long years between the late 1890s and 1925, during which time he treated many female patients, Freud never reported that any of them mentioned early seductions, by their fathers or anyone else. In other words, it seems that once Freud stopped looking for it, this syndrome ceased to show itself. This is surely further evidence, say the critics, that the seduction theory, and by extension the Oedipus and Electra complexes, perhaps the most influential aspect of Freudianism, and one of the most important ideas of the twentieth century, in both medical and artistic terms, not to say common parlance, turns out to have the most unusual, tortured – and quite frankly improbable – genealogy. The inconsistencies in the genesis of the theory are blatant. Freud did not 'discover' early sexual awareness in his patients: he inferred or intuited or 'guessed' it was there. He did not discover the Oedipus complex from careful and passive observations of clinical evidence: he had a pre-set idea which he forced on the 'evidence', after previous 'impositions' had failed even to convince himself. Furthermore, it was a process that could not be reproduced by any independent, sceptical scientist, and this is perhaps the most damning evidence of all, the final nail in the coffin so far as Freud's claim to be a scientist is concerned. What sort of science is it where experimental or clinical evidence cannot be replicated by other scientists using the same techniques and methodology? Anthony Clare, the British psychiatrist and broadcaster, has described Freud as a 'ruthless, devious charlatan' and concluded that 'many of the foundation stones of psychoanalysis are phoney'.[41] It is hard not to agree. Given Freud's 'pressure' technique, his 'persuading'

and 'guessing', we are entitled to doubt whether the unconscious exists. Essentially, he made the whole thing up.

This concept, the unconscious, and all that it entails, can be seen as the culmination of a predominantly German, or German-speaking, tradition, a medico-metaphysical constellation of ideas, and this genealogy was to prove crucial. Freud always thought of himself as a scientist, a biologist, an admirer of and someone in the tradition of Copernicus and Darwin. Nothing could be further from the truth, and it is time to bury psychoanalysis as a dead idea, along with phlogiston, the elixirs of alchemy, purgatory and other failed notions that charlatans have found useful down the ages. It is now clear that psychoanalysis does not work as treatment, that many of Freud's later books, such as *Totem and Taboo* and his analysis of the 'sexual imagery' in Leonardo da Vinci's paintings, are embarrassingly naïve, using outmoded and frankly erroneous evidence. The whole Freudian enterprise is ramshackle and cranky.

That said, the fact remains that the above paragraphs describe the latest revision. At the time Freud lived, in the late nineteenth century and in the early years of the twentieth, the unconscious was regarded as real, was taken very seriously indeed, and played a seminal role underpinning the last great general idea to be covered by this book, a transformation that was to have a profound effect on thought, in particular in the arts. This was the idea known as modernism.

In 1886 the painter Vincent van Gogh produced a small picture, *The Outskirts of Paris*. It is a desolate image. It shows a low horizon, under a grey, forbidding sky. Muddy paths lead left and right – there is no direction in the composition. A broken fence is to be found on one side, a faceless dragoon of some kind in the foreground, a mother and some children further off, a solitary gas lamp stuck in the middle. Along the line of the horizon there is a windmill and some squat, lumpish buildings with rows of identical windows – factories and warehouses. The colours are drab. It could be a scene out of Victor Hugo or Émile Zola.[42]

The dating of this picture, which shows a *banlieue* on the edge of the French capital, is important. For what Van Gogh was depicting in this drab way was what the Parisians called 'the aftermath of Haussmannisation'.[43] The world – the French world in particular – had changed out of all proportion since 1789 and the industrial revolution, but Paris had changed more than anywhere and 'Haussmannisation' referred to the brutality of this change. At the behest of Napoleon III, Baron Haussmann had, over seventeen years, remade Paris in a way that was unprecedented either there or anywhere else. By 1870 one-fifth of the streets in central Paris were his creation, 350,000 people had been displaced, 2.5 billion francs had been spent, and one in five workers was employed in the building trade. (Note the nineteenth-century passion for statistics.) From now on, the boulevard would be the heart of Paris.[44]

Van Gogh's 1886 picture recorded the dismal edges of this world but other painters – Manet and the impressionists who followed his lead – were more apt to celebrate the new open spaces and wide streets, the sheer 'busy-ness' that the new Paris, the city of light, was the emblem of. Think of Gustave Caillebotte's *Rue de Paris, temps de pluie* (1877) or his *Le Pont de l'Europe* (1876), Monet's *Le Boulevard des Capucines* (1873), Renoir's *Les Grands*

*Boulevards* (1875), Degas' *Place de la Concorde, Paris* (*c.* 1873) or any number of paintings by Pissarro, showing the great thoroughfares, in spring or autumn, in sunshine, rain and snow.

It was in the cities of the nineteenth century that modernism was born. In the later years, the internal combustion engine and the steam turbine were invented, electricity was finally mastered, the telephone, the typewriter and the tape machine all came into being. The popular press and the cinema were invented. The first trades unions were formed and the workers became organised. By 1900 there were eleven metropolises – including London, Paris, Berlin and New York – which had more than a million inhabitants, unprecedented concentrations of people. The expansion of the cities, together with that of the universities, covered in an earlier chapter, were responsible for what Harold Perkin has called the rise of professional society, the time – from roughly 1880 on – when the likes of doctors, lawyers, school and university teachers, local government officers, architects and scientists began to dominate politics in the democracies, and who viewed *expertise* as the way forward. In England Perkin shows that the number of such professions at least doubled and in some cases quadrupled between 1880 and 1911. Charles Baudelaire and Gustave Flaubert were the first to put into words what Manet and his 'gang' (as a critic called them) were trying to capture in paint: the fleeting experiences of the city – short, intense, accidental and arbitrary. The impressionists captured the changing light but also the unusual sights – the new machinery, like the railways, awesome and dreadful at the same time, great cavernous railway stations, offering the promise of travel but choking with soot, a beautiful cityscape truncated by an ugly but necessary bridge, cabaret stars lit unnaturally from footlights underneath, a barmaid seen both from the front and from behind, through the great glittering mirror on the wall. These were visual emblems of 'newness' but there was much more to modernism than this. Its interest lies in the fact that it became both a celebration and a condemnation of the modern, and of the world – the world of science, positivism, rationalism – that had produced the great cities, with their vast wealth and new forms of poverty, desolate and degrading.[45] The cities of modernism were bewildering, full of comings and goings, largely contingent or accidental. Science had denuded this world of meaning (in a religious, spiritual sense) and in such a predicament it became the job of art both to describe this state of affairs, to assess and criticise it, and, if possible, to redeem it. In this way, a climate of opinion formed, in which whatever modernism stood for, it also stood for the opposite. And what was amazing was that so much talent blossomed in such bewildering and paradoxical circumstances. 'In terms of sheer creativity, the epoch of modernism compares with the impact of the romantic period and even with the renaissance.'[46] There grew up what Harold Rosenberg called 'the tradition of the new'. This was the apogee of bourgeois culture and it was in this world, this teeming world, that the concept of the *avant-garde* was conceived, a consecration of the romantic idea that the artist was ahead of – and usually dead against – the bourgeoisie, a pace-setter when it came to taste and imagination, but whose role was as much sabotage as invention.

If anything united the modernists – the rationalists and realists on the one hand, and the critics of rationality, the apostles of the unconscious, and the cultural pessimists on the other – it was the *intensity* of their engagement. Modernism was, more than anything,

a high point of the arts – painting, literature, music – because cities were an intensifier: by their nature they threw people up against one another – and better communications ensured that all encounters were accelerated.[47] As a result exchanges became sharper, louder, inevitably more bitter. We take this for granted now but at the time stress increased, and people found that was a creative force too. If modernism was often anti-science, this was because its pessimism was sparked by that same science. The discoveries of Darwin, Maxwell and J. J. Thomson were disconcerting, to say the least, seeming to remove all morality, direction and stability from the world, undermining the very notion of reality.

Of the many writers who struggled to find their way in this bewildering world, Hugo von Hofmannsthal (1874–1929) is as reasonable a starting-point as any, for he clarified a good part of the confusion. Von Hofmannsthal was born into an aristocratic family, and blessed with a father who encouraged – even expected – his son to become an aesthete. Despite this, Hofmannsthal noted the encroachment of science on the old aesthetic culture of Vienna. 'The nature of our epoch,' he wrote in 1905, 'is multiplicity and indeterminacy. It can rest only on *das Gleitende* [the slipping, the sliding].' He added that 'what other generations believed to be firm is in fact *das Gleitende*'.[48] Could there be a better description about the way the Newtonian world was slipping after Maxwell's and Planck's discoveries? (These are covered in the conclusion.) 'Everything fell into parts,' Hofmannsthal wrote, 'the parts again into more parts, and nothing allowed itself to be embraced by concepts.'[49] Hofmannsthal was disturbed by political developments in the Austro-Hungarian Empire, in particular the growth of anti-Semitism. For him, this rise in irrationalism owed some of its force to science-induced changes in the understanding of reality; the new ideas were so disturbing as to promote a large-scale reactionary irrationalism.

In addition to Hofmannsthal, Ibsen, Strindberg and Nietzsche together represent the final northwards movement of European thought, after the centre of gravity had shifted, following the Thirty Years War. These latter three owe quite a lot of their prominence to Georg Brandes, a Danish critic who, in 1883, in his book of that title, identified *Men of the Modern Breakthrough*.[50] The 'modern minds' that he highlighted included Flaubert, John Stuart Mill, Zola, Tolstoy, Bret Harte and Walt Whitman, but above all Ibsen, Strindberg and Nietzsche. Brandes defined the task of modern literature as the synthesis of naturalism and romanticism – of the outer and inner – and cited these three men as supreme examples.

The Ibsen phenomenon burst in Berlin and then spread to Europe. It began in 1887, with *Ghosts*, which was banned by the police (a perfect modernist/*avant-garde* occurrence). Closed performances were given and heavily oversubscribed. (The book, however, sold very well and had to be reprinted.[51]) An Ibsen banquet was held where the 'dawn of a new age' was declared. This was followed by an 'Ibsen Week', which saw *The Lady from the Sea*, *The Wild Duck* and *A Doll's House* playing simultaneously. When *Ghosts* was finally allowed on to the open stage, later that year, it provoked a sensation and was an important influence on James Joyce, among others. Franz Servaes had this to say: 'Some people, as though inwardly shattered, did not regain their calm for days. They rushed about the city, about the Tiergarten …' Ibsen fever raged for two years.[52] 'The most important event in the history of modern drama,' it has been said, 'was Ibsen's abandonment of verse after *Peer Gynt* in order to write prose plays about contemporary problems.'[53] Many other authors – Henry James, Chekhov, Shaw, Joyce, Rilke, Brecht and Pirandello among them – owed a

great deal to him. The new territory which he made his own included contemporary politics, the growing role of mass communications, changing morals, the ways of the unconscious, all with a subtlety and intensity unmatched by anyone else. It is a tribute to Ibsen that he made modern theatre so much his own that we have difficulty these days seeing what all the fuss was about, so pertinent were his themes: the role of women (*A Doll's House*), the generation gap (*The Master Builder*), the conflict between individual liberty and institutional authority (*Rosmersholm*), the threat of pollution brought about by commerce that yet provides jobs (*An Enemy of the People*[54]). But it was the subtlety of his language and the sheer intensity of his characters' inner lives that attracted many people; critics claimed they could detect 'a second unspoken reality' below or behind the surface drama or, as Rilke was to put it, Ibsen's works together comprised 'an ever more desperate search for visible correlations of the *inwardly* seen'.[55] Ibsen was the first to find a dramatic structure for the 'second self' of the modern age, and in doing so illuminated for everyone the central incoherence of man's predicament ever since Vico. He showed how that predicament could be tragic, comic, or merely banal. Just as Verdi (and Shakespeare of course) had realised that the most profound form of tragedy concerns the *non*-hero (as Joyce would again show so perfectly in *Ulysses*, 1922), Ibsen showed that banality, absurdity, meaninglessness – or the threat of them – was the unstable bedrock of modernism. Darwin had done his worst.

Where Ibsen's strength was his intensity, Strindberg's was his versatility. He had, in the words of one observer, a 'mind on horseback', a multi-faceted genius that, for some people, put him on a par with Leonardo and Goethe.[56] A novelist, a painter, but above all a playwright like Ibsen, he himself *lived* the great convulsions of the modern world. In an early book, such as *By the Open Sea*, completed in June 1890, his theme was, as he put it, 'the ruin of the individual when he isolates himself'.[57] Borg, the central character, 'has been forced to live too rapidly in this era of steam and electricity', and is turning into a modern human being, deranged and full of 'bad nerves'. These were the symptoms, Strindberg said, of an increased 'vitality' (stress) in life, which was making people increasingly 'sensitive' (psychologically ill). It resulted in 'the creation of a new race, or at least of a new type of human being'.[58] Later, in the plays that he wrote after his own breakdown in his forties (what he called his 'Inferno crisis'), he became more and more interested in dreams (*To Damascus, A Dream Play*), by what one critic called 'an assertive inner reality, the sense of the illogical's inner logic and the recognition of the supremacy of those forces (both within and without the individual) which are not wholly under conscious control'. He took a great interest in the new stage technology, to create 'expressionist' theatre.[59] In *To Damascus*, it is not even clear whether the unnamed characters *are* characters or else psychological archetypes representing mental or emotional states, including the Unknown, like one of Ellenberger's Ur-phenomena. As Strindberg himself said, 'The characters split, double, multiply; they evaporate, crystallise, scatter and converge. But a single consciousness holds dominion over them all; that of the dreamer.'[60] (This could be Hofmannsthal talking of *Das Gleitende*.) The play is quite different from *By the Open Sea*: here Strindberg is saying that science can tell us nothing about faith, that sheer rationality is helpless in the face of the most fundamental mysteries of life. 'Dreams offered a means for giving form to apparent randomness – mixing, transforming, dissolving.' And again:

'Sometimes I think of myself as a medium: everything comes so easily, half unconsciously, with just a little bit of planning and calculation ... But it doesn't come to order, and it doesn't come to please *me*.'[61] Rilke said much the same about the 'arrival' of the *Duino Elegies* and Picasso spoke of African masks acting as 'intercessors' in his art.[62]

The fact that Strindberg was so many things, and not one thing, his experimentalism (in other words his dissatisfaction with tradition), his turning away from science after his breakdown, his fascination with the irrational – with dreams, the unconscious, the stubbornness of faith in a post-Darwinian world – all this marked him as quintessentially modern, a focus of the many forces pressing in on individuals from all sides. Eugene O'Neill said Strindberg was 'the precursor of all modernity in our present theater ...' He was, as James Fletcher and James McFarlane have said, the unique *sensor* of the age.[63]

He and Ibsen were joined in this concern with the intensity of the inner life by the Russians, by Tolstoy, Turgenev, Pushkin, Lermontov and above all Dostoevsky. Some of the most original investigations of what J. W. Burrow has called 'the elusive self' were Russian, possibly because Russia was so backward in comparison with other European nations, and writers there had less standing and were more rootless.[64] Turgenev went so far as to use the term, 'superfluous man' (*Diary of a Superfluous Man*, 1850), superfluous because the protagonists were so tormented by their self-consciousness that they achieved little, 'dissipating their lives in words and self examination'.[65] Rudin, in Turgenev's 1856 novel of that name, Raskolnikov in Dostoevsky's *Crime and Punishment* (1866), Stavrogin in *The Devils* (1872), Pierre in Tolstoy's *War and Peace* (1869) and Levin in *Anna Karenina* (1877) all attempt to break out of their debilitating self-consciousness via crime, romantic love, religion or revolutionary activity.[66] But Dostoevsky arguably went furthest, in 'Notes from Underground' (1864), where he explores the life – if that is what it is – of a petty official who has come into a small inheritance and is now retired and lives as a recluse. The story is really a discussion of consciousness, of character, selfhood. Although at one stage, the official is described as spiteful, vengeful and malicious, at other times he confesses to the opposite qualities. This inconsistency in personality, in character, is Dostoevsky's main point. The petty official ends up confessing: 'The fact is that I have never succeeded in being anything at all.' He doesn't *have* a personality; he has a mask and behind the mask there are only other masks.[67]

The link to William James' and Oliver Wendell Holmes' pragmatism is clear. There is no such thing as personality, in the sense of a consistent entity, coming from within. People behave pragmatically in a variety of situations and there is no guarantee of coherence: in fact, if the laws of chance are any guide, behaviour will vary along a standard distribution. Out of that, we draw what lessons about ourselves that we can, but the Russian writers were apt to say that we often make these choices arbitrarily, 'just in order to have an identity of some kind'.[68] Even Proust was influenced by this thinking, exploring in his massive masterpiece, *Remembrance of Things Past*, the instability of character over time. People in Proust are not only unpredictable, they assume incompatible characteristics in a disconcerting manner, while others are the complete opposite.[69]

Finally, there was Nietzsche (1844–1900). He is generally thought of as a philosopher, though he himself claimed that psychology occupied pole position among the sciences. 'All psychology has so far got stuck in moral prejudices and fears; it has not dared to

descend into the depths ... the psychologist who thus "makes a sacrifice" [to explore such depths] ... will at least be entitled to demand in return that psychology shall be recognised as the queen of the sciences, for whose service and preparation the other sciences exist.'[70] Walter Kaufmann called Nietzsche 'the first great (depth) psychologist' and what he was referring to was Nietzsche's ability to go beyond a person's self-description 'to see hidden motives, to hear what is not said'.[71] Freud also acknowledged a debt to Nietzsche but that debt was far from straightforward. In showing that our feelings and desires are not what we say they are, Freud arrived at the unconscious, whereas for Nietzsche it was instead the 'will to power'. For Nietzsche, the elusive or second self wasn't so much hidden as insufficiently recognised. The way to self-fulfilment, self-realisation, was through the will, a process of 'self-overcoming' or breaking the limits of the self. For Nietzsche, one didn't find one's inner self by looking in; rather one discovered it by giving an outward expression to the inner, by striving, by acknowledging that such motives as pride existed and were nothing to be ashamed of but entirely natural; one discovered oneself when one 'overcame' one's limits.[72]

Nietzsche thought the scientific cult of objectivity irrelevant, that – as the romantics had said (though for him they were often hypocrites too) – one *made* one's life, one *created* one's values for oneself – only by *acting* did one discover one's self. 'The self-discipline and constant self-testing which concentrated and intensified life ... were at the opposite pole from the self-denial and repression which ... diverting the will to power inwards against the self, breed as in Christianity, self-hatred, guilt, rancour towards the healthy, fulfilled and superior ... In a world characterised by the flux of consciousness and bare of any metaphysical guarantee of moral meaning, the idea of *vocation* offered an obvious way of testing, forging, stabilising the self in a social context, through chosen, regulated, disciplined activity, and self-chosen acceptance of its obligations.'[73]

Underneath it all, modernism may be seen as the aesthetic equivalent of Freud's unconscious. It too is concerned with the inner state, and with an attempt to resolve the modern incoherence, to marry romanticism with naturalism, to order science, rationalism and democracy while at the same time highlighting their shortcomings and deficiencies. Modernism was an aesthetic attempt to go beyond the surface of things, its non-representationalism is highly self-conscious and intuitive, its works have a high degree of self-signature, yet another climax of individuality. Its many '-isms' – impressionism, post-impressionism, expressionism, fauvism, cubism, futurism, symbolism, imagism, divisionism, cloisonnism, vorticism, Dadaism, surrealism – are a sequence of *avant-gardes*, understood as revolutionary experiments into future consciousness.[74] Modernism was also a celebration that the old regimes of culture were gone and buried, and that art, alongside science, was taking us into new concepts of mental and emotional association, its experimental forms – both absurd and meaningless at the same time – redeeming 'the formless universe of contingency'.[75] There was too an impatience for change, amid the belief of the Marxists (still a new 'faith' at the time) that revolution was inevitable. Nihilism was never far beneath the surface, as people worried about the impermanent nature of truth, as thrown up by the new sciences, and by the very nature of the human self in the new metropolises – more elusive than ever. The doctrine of 'therapeutic nihilism', that

nothing could be done, about the ills either of the body, or of society, flowered in metropolises like Vienna. The apposite work here is Oscar Wilde's *The Picture of Dorian Gray*, a fantasy ostensibly about a work of art that functions as a soul, which reveals the 'real' self of the main character.

Which is what made *The Interpretation of Dreams* such an important and timely book and set of theories. Freud (according to non-specialists inhabiting a 'pre-revisionist world') had introduced 'the respectability of clinical proof' to an area of the mind that was hitherto a morass of jumbled images.[76] His wider theories brought a coherence to the apparently irrational recesses of the self and dignified them in the name of science. In 1900 this appeared to be the way forward.

# Conclusion

## *The Electron, the Elements and the Elusive Self*

The Cavendish Laboratory, in the University of Cambridge, England, is arguably the most distinguished scientific institution in the world. Since it was established in the late nineteenth century it has produced some of the most consequential and innovative advances of all time. These include the discovery of the electron in 1897, the discovery of the isotopes of the light elements (1919), the splitting of the atom (also in 1919), the discovery of the proton (1920), of the neutron (1932), the unravelling of the structure of DNA (1953), and the discovery of pulsars (1967). Since the Nobel Prize was instituted in 1901, more than twenty Cavendish and Cavendish-trained physicists have won the prize for either physics or chemistry.[1]

Established in 1871, the laboratory opened its doors three years later. It was housed in a mock-Gothic building in Free School Lane, boasting a façade of six stone gables and a warren of small rooms connected, in Steven Weinberg's words, 'by an incomprehensible network of staircases and corridors'.[2] In the late nineteenth century, few people knew, exactly, what 'physicists' did. The term itself was relatively new. There was no such thing as a publicly-funded physics laboratory – indeed, the idea of a physics laboratory at all was unheard-of. What is more, the state of physics was primitive by today's standards. The discipline was taught at Cambridge as part of the mathematical tripos, which was intended to equip young men for high office in Britain and the British empire. In this system there was no place for research: physics was in effect a branch of mathematics and students were taught to learn how to solve problems, so as to equip them to become clergymen, lawyers, schoolteachers or civil servants (i.e., not physicists).[3] During the 1870s, however, as the four-way economic competition between Germany, France, the United States and Britain turned fiercer – mainly as a result of the unification of Germany, and the advances of the United States in the wake of the Civil War – the universities expanded and, with a new experimental physics laboratory being built in Berlin, Cambridge was reorganised. William Cavendish, the seventh duke of Devonshire, a landowner and an industrialist, whose ancestor Henry Cavendish had been an early authority on gravity, agreed to fund a laboratory provided the university promised to found a chair in *experimental* physics. When it was opened, the Duke was presented with a letter, informing him (in elegant Latin), that the laboratory was to be named in his honour.[4]

The new laboratory became a success only after a few false starts. Having tried – and failed – to attract first William Thomson, later Lord Kelvin, from Glasgow (he was the man who, among other things, conceived the idea of absolute zero and contributed to the second

law of thermodynamics), and second Hermann von Helmholtz, from Germany (who had scores of discoveries and insights to his credit, including an early notion of the quantum), Cambridge finally offered the directorship to James Clerk Maxwell, a Scot and a Cambridge graduate. This was fortuitous. Maxwell turned into what is generally regarded as 'the greatest physicist between Newton and Einstein'.[5] Above all, Maxwell finalised the mathematical equations which provided a fundamental understanding of both electricity and magnetism. These explained the nature of light but also led the German physicist Heinrich Hertz at Karlsruhe in 1887 to identify electromagnetic waves, now known as radio.

Maxwell also established a research programme at the Cavendish, designed to devise an accurate standard of electrical measurement, in particular the unit of electrical resistance, the ohm. Because of the huge expansion of telegraphy in the 1850s and 1860s, this was a matter of international importance, and Maxwell's initiative both boosted Britain to the head of this field, and at the same time established the Cavendish as pre-eminent in dealing with practical problems and devising new forms of instrumentation. It was this latter fact, as much as anything, that helped the laboratory play such a crucial role in the golden age of physics, between 1897 and 1933. Cavendish scientists were said to have 'their brains in their fingertips'.[6]

Maxwell died in 1879 and was succeeded by Lord Rayleigh, who built on his work, but retired after five years to his estates in Essex. The directorship then passed, somewhat unexpectedly, to a twenty-eight-year-old, Joseph John Thomson, who had, despite his youth, already made a reputation in Cambridge as a mathematical physicist. Universally known as 'J. J.', Thomson, it can be said, kick-started the second scientific revolution, to create the world we have now. The first scientific revolution, it will be recalled from Chapter 23, occurred – roughly speaking – between the astronomical discoveries of Copernicus, released in 1543, and those of Isaac Newton, centring around gravity, and published in 1687 as *Principia Mathematica*. The second scientific revolution would revolve around new findings in physics, biology, and psychology.

But physics led the way. It had been in flux for some time, due mainly to a discrepancy in the understanding of the atom. As an idea, the atom – an elemental, invisible and indivisible substance – went back to ancient Greece, as we have seen. It was built on in the seventeenth century, when Newton conceived it as rather like a minuscule billiard ball, 'hard and impenetrable'. In the early decades of the nineteenth century, chemists such as John Dalton had been forced to accept the *theory* of atoms as the smallest units of elements, in order to explain chemical reactions – how, for example, two colourless liquids, when mixed together, immediately formed a white solid or precipitate. Similarly, it was these chemical properties, and the systematic way they varied, combined with their atomic weights, that suggested to the Russian Dimitri Mendeleyev, playing 'chemical patience' with sixty-three cards at Tver, his estate 200 miles from Moscow, the layout of the periodic table of elements. This has been called 'the alphabet out of which the language of the universe is composed' and suggested, among other things, that there were elements still to be discovered. Mendeleyev's table of elements would dovetail neatly with the discoveries of the particle physicists, linking physics and chemistry in a rational way and providing the first step in the unification of the sciences that would be such a feature of the twentieth century.

Newton's idea of the atom was further refined by Maxwell, when he took over at the Cavendish. In 1873 Maxwell introduced into Newton's mechanical world of colliding miniature billiard balls the idea of an electro-magnetic field. This field, Maxwell argued, 'permeated the void' – electric and magnetic energy 'propagated through it' at the speed of light.[7] Despite these advances, Maxwell still thought of atoms as solid and hard and essentially mechanical.

The problem was that atoms, if they existed, were too small to observe with the technology then available. Things only began to change with Max Planck, the German physicist. As part of the research for his PhD, Planck had studied heat conductors and the second law of thermodynamics. This law was initially identified by Rudolf Clausius, a German physicist who had been born in Poland, though Lord Kelvin had also had some input. Clausius had presented his law at first in 1850 and this law stipulates what anyone can observe, that energy dissipates as heat when work is done *and*, moreover, that heat cannot be reorganised into a useful form. This otherwise common-sense observation has very important consequences. One is that since the heat produced – energy – can never be collected up again, can never be useful or organised, the universe must gradually run down into complete randomness: a decayed house never puts itself back together, a broken bottle never reassembles of its own accord. Clausius' word for this irreversible, increasing disorder was 'entropy', and he concluded that the universe would eventually die. In his PhD, Planck grasped the significance of this. The second law shows in effect that time is a fundamental part of the universe, or physics. This book began, in the Prologue, with the discovery of deep time, and Planck brings us full circle. Whatever else it may be, time is a basic element of the world about us, is related to matter in ways we do not yet fully understand. Time means that the universe is one-way only, and that therefore the Newtonian, mechanical, billiard ball picture must be wrong, or at best incomplete, for it allows the universe to operate equally in either direction, backwards and forwards.[8]

But if atoms were not billiard balls, what were they?

The new physics came into view one step at a time, and emerged from an old problem and a new instrument. The old problem was electricity – what, exactly, was it?* Benjamin Franklin had been close to the mark when he had likened it to a 'subtile fluid' but it was hard to go further because the main naturally-occurring form of electricity, lightning, was not exactly easy to bring into the laboratory. An advance was made when it was noticed that flashes of 'light' sometimes occurred in the partial vacuums that existed in barometers. This brought about the invention of a new – and as it turned out all-important – instrument: glass vessels with metal electrodes at either end. Air was pumped out of these vessels, creating a vacuum, before gases were introduced, and an electrical current passed through the electrodes (a bit like lightning) to see what happened, how the gases might be affected. In the course of these experiments, it was noticed that if an electric current were passed through a vacuum, a strange glow could be observed. The exact nature of this glow was not understood at first, but because the rays emanated from the cathode end of the electrical circuit, and were absorbed into the anode, Eugen Goldstein called them

---

* It was called electricity after the Greek word ηλεκτρον, *elektron*, which means amber. In ancient Greece it had been first observed that amber, when rubbed, attracts all articles towards it.

*Cathodenstrahlen*, or cathode rays. It was not until the 1890s that three experiments stemming from cathode-ray tubes finally made everything clear and set modern physics on its triumphant course.

In the first place, in November 1895, Wilhelm Röntgen, at Würzburg, observed that when the cathode rays hit the glass wall of a cathode-ray tube, highly penetrating rays were emitted, which he called X-rays (because *x*, for a mathematician, signified the unknown). The X-rays caused various metals to fluoresce and, most amazingly, were found to pass *through* the soft tissue of his hand, to reveal the bones within. A year later, Henri Becquerel, intrigued by the fluorescing that Röntgen had observed, decided to see whether naturally-fluorescing elements had the same effect. In a famous but accidental experiment, he put some uranium salt on a number of photo-electric plates, and left them in a closed (light-tight) drawer. Four days later, he found images on the plates, given off by what we now know was a radio-active source. Becquerel had discovered that 'fluorescing' was naturally-occurring radio-activity.[9]

But it was Thomson's 1897 discovery which capped everything, produced the first of the Cavendish's great successes and gave modern physics its lift-off, into arguably the most exciting and important intellectual adventure of the modern world. In a series of experiments J. J. pumped different gases into the glass tubes, passed an electric current, and then surrounded them either with electrical fields or with magnets. As a result of this systematic manipulation of conditions, Thomson convincingly demonstrated that cathode 'rays' were in fact infinitesimally minute *particles* erupting from the cathode and drawn to the anode. Thomson further found that the particles' trajectory could be altered by an electric field and that a magnetic field shaped them into a curve.[10] More important still, he found that the particles were lighter than hydrogen atoms, the smallest known unit of matter, and exactly the same *whatever* the gas through which the discharge passed. Thomson had clearly identified something fundamental – this was in fact the first experimental establishment of the particulate theory of matter.

The 'corpuscles', as Thomson called these particles at first, are today known as electrons. It was the discovery of the electron, and Thomson's systematic examination of its properties, that led directly to Ernest Rutherford's further breakthrough, a decade later, in conceiving the configuration of the atom as a miniature 'solar system', with the tiny electrons orbiting the massive nucleus like stars around the sun. In doing this, Rutherford demonstrated experimentally what Einstein discovered inside his head and revealed in his famous calculation, $E = mc^2$ (1905), that matter and energy are essentially the same.[11] The consequences of these insights and experimental results – which included thermonuclear weapons, and the ensuing political stand-off known as the Cold War – fall outside the time-frame of this book.* But Thomson's work is important for another reason that does concern us here.

He achieved the advances that he did by systematic *experimentation*. At the beginning of this book, in the Introduction, it was asserted that the three most influential ideas in history have been the soul, the idea of Europe, and the experiment. It is now time

---

* They are, however, discussed fully in the present author's *A Terrible Beauty: The People and Ideas That Shaped the Modern Mind*.

to support this claim. It is most convincingly done by taking these ideas in reverse order.

It is surely beyond reasonable doubt that, at the present time, and for some considerable time in the past, the countries that make up what we call the West – traditionally western Europe and northern America in particular, but with outposts such as Australia – have been the most successful and prosperous societies on earth, in terms of both the material advantages enjoyed by their citizens and the political and therefore moral freedoms they have. (This situation is changing now but these sentiments are true as far as they go.) These advantages are linked, intertwined, in so far as many material advances – medical innovations, printing and other media, travel technology, industrial processes – bring with them social and political freedoms in a general process of democratisation. And these are the fruit, almost without exception, of scientific innovations based on observation, experimentation, and deduction. Experimentation is all-important here as an independent, rational (and therefore democratic) form of *authority*. And it is this, the authority of the experiment, the authority of the scientific *method*, independent of the status of the individual scientist, his proximity to God or to his king, and as revealed and reinforced via myriad technologies, which we can all share, that underlies the modern world. The cumulative nature of science also makes it a far less fragile form of knowledge. *This* is what makes the experiment such an important idea. The scientific method, apart from its other attractions, is probably the purest form of democracy there is.

But the question immediately arises: why did the experiment occur first and most productively in what we call the West? The answer to this shows why the idea of Europe, the set of changes that came about between, roughly speaking, AD 1050 and 1250, was so important. These changes were covered in detail in Chapter 15 but to recap the main points here, we may say that: Europe was fortunate in not being devastated to the same extent as Asia was by the plague; that it was the first landmass that was 'full' with people, bringing about the idea of efficiency as a value, because resources were limited; that individuality emerged out of this, and out of developments in the Christian religion, which created a unified culture, which in turn helped germinate the universities where independent thought could flourish and amid which the ideas of the secular and of the experiment were conceived. One of the most poignant moments in the history of ideas surely came in the middle of the eleventh century. In 1065 or 1067 the Nizamiyah was founded in Baghdad (see above, page 274). This was a theological seminary and its establishment brought to an end the great intellectual openness in Arabic/Islamic scholarship, which had flourished for two to three hundred years. Barely twenty years later, in 1087, Irnerius began teaching law at Bologna and the great European scholarship movement was begun. As one culture ran down, another began to find its feet. The fashioning of Europe was the greatest turning-point in the history of ideas.

It may seem odd to some readers that the 'soul' should be a candidate as the third of the most influential ideas in history. Surely the idea of God is more powerful, more universal, and in any case isn't there a heavy overlap? Certainly, God has been a very powerful idea throughout history, and indeed continues to be so across many parts of the globe. At the

same time, there are two good reasons why the soul has been – and still is – a more influential and fecund idea than the Deity itself.

One is that, with the invention of the afterlife (which not all religions have embraced), and without which any entity such as the soul would have far less meaning, the way was open for organised religions the better to *control* men's minds. During late antiquity and the Middle Ages, the technology of the soul, its relation with the afterlife, with the Deity, and most importantly with the clergy, enabled the religious authorities to exercise an extraordinary authority. It is surely the idea of the soul which, though it enriched men's minds immeasurably over many centuries, nevertheless kept thought and freedom back during those same centuries, hindering and delaying progress, keeping the (largely) igno-rant laity in thrall to an educated clerisy. Think of Friar Tetzel's assurance that one could buy indulgences for souls in purgatory, that they would fly to heaven as soon as the coin dropped in the plate. The abuses of what we might call 'soul technology' were one of the main factors leading to the Reformation which, despite John Calvin in Geneva, took faith overall away from the control of the clergy, and hastened doubt and non-belief (as was discussed in Chapter 22). The various transformations of the soul (from being contained in semen, in Aristotle's Greece, the tripartite soul of the *Timaeus*, the medieval and Renaissance conception of *Homo duplex*, the soul as a woman, a form of bird, Marvell's dialogue between the soul and the body, Leibniz's 'monads') may strike us as quaint now, but they were serious issues at the time and important stages on the way to the modern idea of the self. The seventeenth-century transformation – from the humours, to the belly and bowels, to the brain as the locus of the essential self – together with Hobbes' argument that no 'spirit' or soul existed, were other important steps, as was Descartes' reconfiguration of the soul as a *philosophical* as opposed to a religious notion.[12] The transition from the world of the soul (including the afterlife) to the world of the experiment (here and now), which occurred first and most thoroughly in Europe, describes the fundamental difference between the ancient world and the modern world, and still represents the most important change in intellectual authority in history.

But there is another – quite different – reason why, in the West at least, the soul is important, and arguably more important and more fertile than the idea of God. To put it plainly, the idea of the soul has outlived the idea of God; one might even say it has evolved beyond God, beyond religion, in that even people without faith – perhaps *especially* people without faith – are concerned with the inner life.

We can see the enduring power of the soul, and at the same time its evolving nature, at various critical junctures throughout history. It has revealed this power through one particular pattern that has repeated itself every so often, albeit each time in a somewhat different form. This may be characterised as a repeated 'turning inwards' on the part of mankind, a continual and recurrent effort to seek the truth by looking 'deep' within oneself, what Dror Wahrman calls our 'interiority complex'. The first time this 'turning in' took place (that we know about) was in the so-called Axial Age (see Chapter 5), very roughly speaking around the seventh to fourth centuries BC. At that time, more or less simultaneously in Palestine, in India, in China, in Greece and very possibly in Persia, something similar was occurring. In each case, established religion had become showy and highly ritualistic. In particular a priesthood had everywhere arisen and had arrogated

to itself a highly privileged position: the clerisy had become an inherited caste which governed access to God or the gods, and which profited – in both a material and sacred sense – from its exalted position. In all of the above countries, however, prophets (in Israel) or wise men (the Buddha and the writers of the Upanishads in India, Confucius in China) arose, denounced the priesthood and advocated a turning inward, arguing that the way to genuine holiness was by some form of self-denial and private study. Plato famously thought that mind was superior to matter.[13]

These men led the way by personal example. Much the same message was preached by Jesus and by St Augustine. Jesus, for example, emphasised God's mercy, and insisted on an inner conviction on the part of believers rather than the outward observance of ritual (Chapter 7). St Augustine (354–430) was very concerned with free will and said that humans have within themselves the capacity to evaluate the moral order of events or people and can exercise judgement, to decide our priorities. According to St Augustine, to look deep inside ourselves and to choose God was to know God (Chapter 10). In the twelfth century, as was discussed in Chapter 16, there was another great turning inward in the universal Roman Catholic church. There was a growing awareness that inner repentance was what God wanted, not external penance. This was when confession was ordered to be made regularly by the Fourth Lateran Council. The Black Death, in the fourteenth century, had a similar impact. The very great number of deaths made people pessimistic and drove them inwards towards a more private faith (many more private chapels and charities were founded in the wake of the plague, and there was a rise in mysticism). The rise of autobiography in the Renaissance, what Jacob Burckhardt called the 'abundance of pictures of the inmost soul' was yet another turning in. In Florence, at the end of the fifteenth century, Fra Girolamo Savonarola, convinced that he had been sent by God 'to aid the inward reform of the Italian people', sought the regeneration of the church in a series of Jeremiads, terrible warnings of the evil to come unless this inward reform was immediate and total. And of course the Protestant Reformation of the sixteenth century (Chapter 22) was conceivably the greatest 'turning in' of all time. In response to the Pope's claim that the faithful could buy relief for their relatives' souls 'suffering in purgatory', Martin Luther finally exploded and advocated that men did not need the intervention of the clergy to receive the grace of God, that the great pomp of the Catholic church, and its theoretical theological stance as 'intercessor' between man and his maker, was a nonsense and nowhere supported by the scriptures. He urged a return to 'true inward penitence' and said that above all inner contrition was needed for the proper remission of sins: an individual's inner conscience was what mattered most. In the seventeenth century, Descartes famously turned in, arguing that the only thing man could be certain of was his inner life, in particular his doubt. Late-eighteenth-century/early-nineteenth-century romanticism was likewise a turning-in, a reaction against the Enlightenment, the eighteenth-century attitude/idea that the world could best be understood by science. On the contrary, said the romantics, the one unassailable fact of human experience is inward human experience itself. Following Vico, both Rousseau (1712–1778) and Kant (1724–1804) argued that, in order to discover what we ought to do, we should listen to an inner voice.[14] The romantics built on this, to say that everything we value in life, morality above all, comes from within. The growth of the novel and the others arts reflected this view.

The romantics in particular show very clearly the evolution of the idea of the soul. As J. W. Burrow has observed, the essence of romanticism, and one might say of all the other 'turnings in' throughout history, is the notion *Homo duplex*, of a 'second self', a different – and very often a higher or better – self, whom one is trying to discover, or release. Arnold Hauser put it another way: 'We live on two different levels, in two different spheres ... these regions of being penetrate one another so thoroughly that the one can neither be subordinated to nor set against the other as its antithesis. The dualism of being is certainly no new conception, and the idea of the *coincidentia oppositorum* is quite familiar to us ... but the double meaning and duplicity of existence ... had never been experienced so intensively as now [i.e., in romantic times].'[15]

Romanticism, and its sense of a 'second self' was – as we have seen – one of the factors which Henri Ellenberger included in *The Discovery of the Unconscious*, his massive work on the royal road that led to depth psychology and culminated with the ideas of Sigmund Freud, Alfred Adler and Carl Jung. The unconscious is the last great turning in, an attempt, as discussed in the previous chapter, to be scientific about our inner life. But the fact that it failed is important in a wider sense than its inadequacy as treatment, as we shall now see.

Romanticism, the will, *Bildung*, Weber's sense of vocation, the *Volkgeist*, the discovery of the unconscious, *Innerlichkeit* ... the theme of the inner life, the second, inner, or as Kant called it the higher self, runs as strongly through nineteenth-century thought as it does throughout history, if not more strongly. A predominantly German concern with the irrational, it has been seen by some as forming the 'deep background' to the horrors of Nazism in the twentieth century (with the creation of the superior human being – the individual who has overcome his limitations by the exercise of will – as the goal of human history). That is not a trivial matter but it is not the main concern here. Instead, we are more interested in what this helps us conclude about the history of ideas. It surely confirms the pattern discussed above, of man's recurring attempts to look deep inside himself in search of ... God, fulfilment, catharsis, his 'true' motives, his 'real' self.

Alfred North Whitehead famously once remarked that the history of Western thought consisted of a series of footnotes to Plato. At the end of our long journey, we can now see that, whether Whitehead was being rhetorical or ironical, he was at best half right. In the realm of ideas, history has consisted of two main streams (I am oversimplifying here, but this *is* the Conclusion). There has been the history of 'out there', of the world outside man, the Aristotelian world of observation, exploration, travel, discovery, measurement, experiment and manipulation of the environment, in short the materialistic world of what we now call science. While this adventure has hardly been a straight line, and advances have been piecemeal at times, and even held up or hindered for centuries on end, mainly by fundamentalist religions, this adventure must be counted a success overall. Few would doubt that the material progress of the world, or much of it, is there for all to see. This advance continued, in accelerated mode, in the twentieth century.

The other main stream in the history of ideas has been the exploration of man's inner life, his soul and/or second self, what we might label (with Whitehead) Platonic – as opposed to Aristotelian – concerns. This stream may itself be divided into two. In the first

place, there has been the story of man's moral life, his social and political life, his development of ways to live together, and this must be counted a qualified success, or at least as having a predominantly positive outcome. The broad transition in history from autocratic monarchies, whether temporal or papal, through feudalism, to democracy, and from theocratic to secular circumstances, has certainly brought greater freedoms and greater fulfilment to greater numbers of people (generally speaking, of course – there are always exceptions). The various stages in this unfolding process have been described in the pages above. Although political and legal arrangements vary around the world, all peoples *have* a politics and a legal system. They have concepts of justice that extend well beyond what we may call for simplicity's sake the law of the jungle. In an institution such as the competitive examination, for example, we see the concept of justice extending beyond the purely criminal/legal area, to education. Even the development of statistics, a form of mathematics, was at times spurred by the interests of justice, as we saw in Chapter 32. Though the achievements of the formal social sciences have been limited in comparison with those of physics, astronomy, chemistry or medicine, say, their very evolution was intended as a more just improvement on the partisan nature of politics. All this must be accounted a (perhaps qualified) success.

The final theme – man's understanding of himself, of his inner life – has proved the most disappointing. Some, perhaps many, will take issue with this, arguing that the better part of the history of art and creation *is* the history of man's inner life. While this is undoubtedly true in a sense, it is also true that the arts don't *explain* the self. Often enough, they attempt to *describe* the self or, more accurately, a myriad selves under a myriad different circumstances. But the very popularity in the contemporary world of Freudianism and other 'depth' psychologies, concerned mainly with the 'inner self' and self-esteem (and however misguidedly), surely confirms this assessment. If the arts were truly successful, would there be a need for these psychologies, these new ways of looking-in?

It is a remarkable conclusion to arrive at, that, despite the great growth in individuality, the vast corpus of art, the rise of the novel, the many ways that men and women have devised to express themselves, man's study of himself is his biggest intellectual failure in history, his least successful area of inquiry. But it is undoubtedly true, as the constant 'turnings-in', over the centuries, have underlined. These 'turnings-in' do not build on one another, in a cumulative way, like science; they replace one another, as the previous variant runs down, or fails. Plato has misled us, and Whitehead was wrong: the great success stories in the history of ideas have been in the main the fulfilment of Aristotle's legacy, not Plato's. This is confirmed above all by the latest developments in historiography – which underline that the early modern period, as it is now called, has replaced the Renaissance as the most significant transition in history. As R. W. S. Southern has said, the period between 1050 and 1250, the rediscovery of Aristotle, was the greatest and most important transformation in human life, leading to modernity, and not the (Platonic) Renaissance of two centuries later.

For many years – for hundreds of years – man had little doubt that he had a soul, that whether or not there was some 'soul substance' deep inside the body, this soul represented the essence of man, an essence that was immortal, indestructible. Ideas about the soul changed in the sixteenth and seventeenth centuries and, as the loss of belief in God started to gather

pace, other notions were conceived. Beginning with Hobbes and then Vico, talk about the self and the mind began to replace talk about the soul and this view triumphed in the nineteenth century, especially in Germany with its development of romanticism, of the human or social sciences, *Innerlichkeit* and the unconscious. The growth of mass society, of the new vast metropolises, played a part here too, provoking a sense of the loss of self.[16]

Set against this background, the advent of Freud was a curious business. Coming after Schopenhauer, von Hartmann, Charcot, Janet, the dipsychism of Max Dessoir and the *Urphänomene* of von Schubert, or Bachofen's *Law of Mothers*, Freud's ideas were not as startlingly original as they are sometimes represented. Yet, after a shaky start, they became immensely influential, what Paul Robinson described in the mid-1990s as 'the dominant intellectual presence of the [twentieth] century'.[17] One reason for this was that Freud, as a doctor, thought of himself as a biologist, a scientist in the tradition of Copernicus and Darwin. The Freudian unconscious was therefore a sophisticated attempt to be scientific about the self. In this sense, it promised the greatest convergence of the two main streams in the history of ideas, what we might call an Aristotelian understanding of Platonic concerns. Had it worked, it would surely have comprised the greatest intellectual achievement in history, the greatest synthesis of ideas of all time.

Today, many people remain convinced that Freud's efforts succeeded, which is one reason why the whole area of 'depth psychology' is so popular. At the same time, among the psychiatric profession and in the wider world of science, Freud is more generally vilified, his ideas dismissed as fanciful and unscientific. In 1972 Sir Peter Medawar, a Nobel Prize-winning doctor, described psychoanalysis as 'one of the saddest and strangest of all landmarks in the history of twentieth-century thought'.[18]* Many studies have been published which appear to show that psychoanalysis does not work as treatment, and several of Freud's ideas in his other books (*Totem and Taboo*, for example, or *Moses and Monotheism*) have been thoroughly discredited, as misguided, using evidence that can no longer be substantiated. The recent scholarship, considered in the previous chapter, which has so discredited Freud, only underlines this and underlines it emphatically.

But if most educated people accept now that psychoanalysis has failed, it also has to be said that the concept of consciousness, which is the word biologists and neurologists have coined to describe our contemporary sense of self, has not fared much better. If, by way of conclusion, we 'fast-forward' from the end of the nineteenth century to the end of the twentieth, we encounter the 'Decade of the Brain', which was adopted by the US Congress in 1990. During the ten-year period that followed, many books on consciousness were published, 'consciousness studies' proliferated as an academic discipline, and there were three international symposia on consciousness. The result? It depends who you talk to. John Maddox, a former editor of *Nature* which, with *Science*, is the foremost scientific journal in the world, wrote that 'No amount of introspection can enable a person to discover just which set of neurons in which part of his or her head is executing some thought-process. Such information seems to be hidden from the human user.' Colin

---

* In a sense, the gene has developed properties of the soul in the contemporary world. I mean this in the sense that it is a hidden, indestructible substance, which to an extent governs our nature irrespective of what we consciously might wish for ourselves. A gene is not a soul, but many people seem to regard it as such.

McGinn, a British philosopher at Rutgers University, New Jersey, argues that consciousness is resistant to explanation, *in principle* and for all time.[19] Other philosophers, such as Harvard's Thomas Nagel and Hilary Putnam, argue that at present (and maybe for all time) science cannot account for 'qualia', the first-person phenomenal experience that we understand as consciousness, why, in Simon Blackburn's words, the grey matter of the brain can provide us with the experience of, for example, yellow-ness. Benjamin Libet, in a series of controversial experiments, has claimed that it takes about half a second for consciousness itself to happen ('Libet's delay'). Whether this (if true) is an advance is not yet clear. John Gray, professor of European thought at the London School of Economics, is one of those who has identified such phenomena as the 'hard problem' in consciousness studies.[20]

On the other hand, John Searle, Mills Professor of philosophy at the University of California, Berkeley, says there is nothing much to explain, that consciousness is an 'emergent property' that automatically arises when you put 'a bag of neurons' together. He explains, or tries to, by analogy: the behaviour of $H_2O$ molecules 'explains' liquidity, but the individual molecules are not liquid – this is another emergent property.[21] (Such arguments are reminiscent of the 'pragmatic' philosophy of William James and Charles Peirce, discussed in Chapter 34, where the sense of self emerges from behaviour, not the other way round.) Roger Penrose, a physicist from London University, believes that a new kind of dualism is needed, that in effect a whole new set of physical laws may apply inside the brain, which account for consciousness. Penrose's particular contribution is to argue that quantum physics operates inside tiny structures, known as tubules, within the nerve cells of the brain to produce – in some as yet unspecified way – the phenomena we recognise as consciousness.[22] Penrose actually thinks that we live in three worlds – the physical, the mental and the mathematical: 'The physical world grounds the mental world, which in turn grounds the mathematical world and the mathematical world is the ground of the physical world and so on around the circle.'[23] Many people, who find this tantalising, nonetheless don't feel Penrose has *proved* anything. His speculation is enticing and original, but it is still speculation.

Instead, it is two forms of reductionism that, in the present climate, attract most support. For people like Daniel Dennett, a biologically-inclined philosopher from Tufts University near Boston in Massachusetts, human consciousness and identity arise from the narrative of our lives, and this can be related to specific brain states. For example, there is growing evidence that the ability to 'apply intentional predicates to other people is a human universal' and is associated with a specific area of the brain (the orbitofrontal cortex), an ability which in certain states of autism is defective. There is also evidence that the blood supply to the orbitofrontal cortex increases when people 'process' intentional verbs as opposed to non-intentional ones and that damage to this area of the brain can lead to a failure to introspect. Other experiments have shown that activity in the area of the brain known as the amygdala is associated with the experience of fear, that the decisions of individual monkeys in certain games could be predicted by the firing patterns of individual neurons in the orbitofrontal-striatal circuits of the brain, that neurotransmitters known as propranolol and serotonin affect decision-making, and that the ventral putamen within the striatum is activated when people experience pleasure.[24] Suggestive as this is, it is also

the case that the micro-anatomy of the brain varies quite considerably from individual to individual, and that a particular phenomenal experience is represented at several different points in the brain, which clearly require integration. Any 'deep' patterns relating experience to brain activity have yet to be discovered, and seem to be a long way off, though this is still the most likely way forward.

A related approach – and this is perhaps to be expected, given other developments in recent years – is to look at the brain and consciousness in a Darwinian light. In what sense is consciousness adaptive? This approach has produced two views – one, that the brain was in effect 'jerry built' in evolution to accomplish very many and very different tasks. On this account, the brain is at base three organs, a reptilian core (the seat of our basic drives), a palaeomammalian layer, which produces such things as affection for offspring, and a neomammalian brain, the seat of reasoning, language and other 'higher functions'.[25] The second approach is to argue that throughout evolution (and throughout our bodies) there have been emergent properties: for example, there is always a biochemical explanation underlying a physiological or medical phenomenon – sodium/potassium flux across a membrane can also be described as 'nerve action potential'.[26] In this sense, then, consciousness is nothing new in principle even if, for now, we don't fully understand it.

Studies of nerve action throughout the animal kingdom have also shown that nerves work by either 'firing' or not firing; intensity is represented by the rate of firing – the more intense the stimulation the faster the turning on and off of any particular nerve. This is of course very similar to the way computers work, in 'bits' of information, where everything is represented by a configuration of either 0s or 1s. The arrival of the concept of parallel processing in computing led Daniel Dennett to consider whether an analogous procedure might happen in the brain between different evolutionary levels, giving rise to consciousness. Again, though tantalising, such reasoning has not gone much further than preliminary exploration. At the moment, no one seems able to think of the next step.

So, despite all the research into consciousness in recent years, and despite the probability that the 'hard' sciences still offer the most likely way forward, the self remains as elusive as ever. Science has proved an enormous success in regard to the world 'out there' but has so far failed in the one area that arguably interests us the most – ourselves. Despite the general view that the self arises in some way from brain activity – from the action of electrons and the elements, if you will – it is hard to escape the conclusion that, after all these years, we still don't know even how to *talk* about consciousness, about the self.

Here, therefore, and arising from this book, is one last idea for the scientists to build on. Given the Aristotelian successes of both the remote and the immediate past, is it not time to face the possibility – even the probability – that the essential Platonic notion of the 'inner self' is misconceived? There *is* no inner self. Looking 'in', we have found nothing – nothing stable anyway, nothing enduring, nothing we can all agree upon, nothing conclusive – *because there is nothing to find*. We human beings are part of nature and therefore we are more likely to find out about our 'inner' nature, to understand ourselves, by looking outside ourselves, at our role and place as animals. In John Gray's words, 'A zoo is a better window from which to look out of the human world than a monastery.'[27] This is not paradoxical, and without some such realignment of approach, the modern incoherence will continue.

# Notes and References

When two dates are given for a publication, the first refers to the hardback edition, the second to the paperback edition. Unless otherwise stated, pagination refers to the paperback edition.

INTRODUCTION: THE MOST IMPORTANT IDEAS
IN HISTORY – SOME CANDIDATES
1. Michael White, *Isaac Newton: The Last Sorcerer*, London: Fourth Estate, 1997, page 3. Keynes also said: 'I fancy his [Newton's] pre-eminence was due to his muscles of intuition being the strongest and most enduring with which a man has ever been gifted.' Robert Skidelsky, *John Maynard Keynes*, London: Macmillan, 2003, page 458.
2. Norman Hampson, *The Enlightenment*, London: Penguin, 1990, pages 34 and 36.
3. James Gleick, *Isaac Newton*, London: Fourth Estate HarperCollins, 2003/2004, pages 101–108; Frank E. Manuel, *A Portrait of Isaac Newton*, Cambridge, Massachusetts: The Belknap Press of Harvard University Press, 1968, page 398n.
4. Joseph Needham, *The Great Titration*, London: Allen & Unwin, 1969, page 62.
5. Charles Freeman, *The Closing of the Western Mind*, London: William Heinemann, 2002, page 322.
6. *Ibid.*
7. *Ibid.*, page 327.
8. Marcia Colish, *Medieval Foundations of the Western Intellectual Tradition: 400–1400*, New Haven and London: Yale University Press 1997, page 249.
9. Harry Elmer Barnes, *An Intellectual and Cultural History of the Western World*, volume two. *From the Renaissance Through the Eighteenth Century*, New York: Dover, 1937, page 825.
10. Francis Bacon, *Novum Organum*, Book 1, aphorism 129, quoted in Joseph Needham *et al.*, *Science and Civilisation in China*, volume 1, Cambridge, England: Cambridge University Press, 1954, page 19.
11. *Ibid.*
12. Barnes, *Op. cit.*, page 831.
13. John Bowle, *A History of Europe*, London: Secker & Warburg/Heinemann, 1979, page 391.
14. Hagen Schulze, *States, Nations and Nationalism*, Oxford: Blackwell, 1994/1996, page 395.
15. Ernest Gellner, *Plough, Sword and Book*, London: Collins Harvill, 1988.
16. *Ibid.*, page 19f.
17. Barnes, *Op. cit.*, pages 669ff.
18. Adam Smith, *An Inquiry Into The Nature and Causes of the Wealth of Nations*, edited by R. H. Campbell and A. S. Skinner, two volumes, Oxford: Oxford University Press, 1976, volume 1, page 265.
19. Gellner, *Op. cit.*, page 19.
20. Carlo Cipolla, *Guns and Sails in the Early Phase of European Expansion, 1400–1700*, London: Collins, 1965, pages 5 and 148–149.
21. Richard Tarnas, *The Passion of the Western Mind*, London: Pimlico, 1991, pages 298ff.
22. Johan Goudsblom, *Fire and Civilisation*, London: Allen Lane The Penguin Press, 1992, pages 164ff.
23. Isaiah Berlin, *The Sense of Reality: Studies in Ideas and Their History*, edited by Henry Hardy, London: Chatto & Windus, 1996, pages 168–169.
24. Jared Diamond, *Guns, Germs and Steel*, London: Jonathan Cape, 1997, pages 200–202.
25. Jacob Bronowski and Bruce Mazlish, *The Western Intellectual Tradition*, New York: Harper & Brothers, 1960, page 495.
26. Barnes, *Op. cit.*, page 720.
27. Bronowski and Mazlish, *Op. cit.*, page 259.
28. Arthur O. Lovejoy, *The Great Chain of Being*, Cambridge, Massachusetts: Harvard University Press, 1936/1964, page 23.
29. Edward P. Mahoney, 'Lovejoy and the hierarchy of being', *Journal of the History of Ideas*, volume 48, 1987, page 211.
30. Lovejoy, *Op. cit.*, page 55.
31. *Ibid.*, page 89.
32. *Ibid.*, page 91.
33. *Ibid.*, page 201.
34. *Ibid.*, page 211.
35. *Ibid.*, page 232.
36. *Ibid.*, page 241.
37. Paul Robinson, 'Symbols at an exhibition', *New York Times*, 12 November 1998, page 12.
38. Gladys Gordon-Bournique, 'A. O. Lovejoy and the history of ideas', *Journal of the History of Ideas*, volume 48, 1987, page 209.
39. This was similar to an idea of Hegel's which he called 'philosophemes'. See: Donald A. Kelley, 'What is happening to the history of ideas?', *Journal of the History of Ideas*, volume 51, 1990, page 4.
40. Philip P. Wiener (editor), *Dictionary of the History of Ideas*,

four volumes, New York: Charles Scribner's Sons, 1973.

41. Kelley, *Op. cit.*, pages 3–26.

42. James Thrower, *The Alternative Tradition*, The Hague: Mouton, 1980.

PROLOGUE: THE DISCOVERY OF TIME

1. Jacquetta Hawkes (editor), *The World of the Past*, London: Thames & Hudson, 1963, page 29.

2. *Ibid.*, page 33.

3. James Sackett, 'Human antiquity and the Old Stone Age: the 19th-century background to palaeoanthropology', *Evolutionary Anthropology*, volume 9, issue 1, 2000, pages 37–49.

4. Hawkes, *Op. cit.*, pages 30–34 and 147–148.

5. *Ibid.*, page 27.

6. Glyn Daniel, *One Hundred and Fifty Years of Archaeology* (second edition), London: Duckworth, 1975, pages 25–26.

7. Bruce G. Trigger, *A History of Archaeological Thought*, Cambridge: Cambridge University Press, 1989, page 53.

8. Ian Tattersall, *The Fossil Trail*, Oxford and New York: Oxford University Press, 1995/1996, page 8; and Hawkes, *Op. cit.*, pages 25–26.

9. Hawkes, *Op. cit.*, pages 28–29.

10. Sackett, *Op. cit.*, page 46.

11. Peter J. Bowler, *Evolution: The History of an Idea* (revised edition), Berkeley, Los Angeles and London: University of California Press, 1989, pages 32–33.

12. Trigger, *Op. cit.*, pages 92–93.

13. James A. Secord, *Victorian Sensation: The Extraordinary Publication, Reception, and Secret Authorship of 'Vestiges of the Natural History of Creation'*, Chicago and London: University of Chicago Press, 2000, page 146.

14. *Ibid.*, page 105.

15. Peter Burke, 'Images as evidence in seventeenth-century Europe,' *Journal of the History of Ideas*, volume 64, 2003, pages 273–296.

16. Burke, *Op. cit.*, pages 283–284.

17. Trigger, *Op. cit.*, page 74.

18. *Ibid.*, page 76.

19. Sackett, *Op. cit.*, page 48.

20. *Ibid.*

CHAPTER 1: IDEAS BEFORE LANGUAGE

1. George Schaller, *The Last Panda*, Chicago: University of Chicago Press, 1993, page 8.

2. Robert J. Wenke, *Patterns in Prehistory*, Oxford: Oxford University Press, 1990, pages 119–120.

3. But see Stephen Oppenheimer, *Out of Eden: The Peopling of the World*, London: Constable, 2003, page 10.

4. *Journal of Human Evolution*, volume 43, 2002, page 831, reported in *New Scientist*, 4 January 2003, page 16. Of course, action by wooden implements, if they existed, wouldn't show up as remains.

5. Paul Mellars and Chris Stringer, *The Human Revolution*, Edinburgh: Edinburgh University Press, 1989, page 70 and chapter six, 'Multi-regional evolution: the fossil alternative Eden', by Milford H. Wolpoff. Chimpanzees are now thought not to be as closely related to man as once believed – see *New Scientist*, 28 September 2002, page 20. The most recent, but still disputed evidence puts the chimpanzee–human divergence back to 4–10 million years ago – see Bernard Wood, 'Who are we?', *New Scientist*, 26 October 2002, pages 44–47.

6. *New Scientist*, 13 July 2002, page 6; and 13 July 2002, page 6. As Bernard Wood points out, the Djurab desert is 150 kilometres (95 miles) *west* of the East African Rift valley, which means this area may no longer be regarded as the exclusive home of early humans: 'Who are we?', *New Scientist*, 26 October 2002, page 47. *Sahelanthropus* was later criticised as being a form of early ape, not an ancestor of man – see the *Times Higher Educational Supplement*, 25 October 2002, page 19. The find of a leg bone was reported in 2000, said to be the remains of our 'Millenial Ancestor', dated to six million years ago, which had upright posture. *New Scientist*, 15 December 2000, page 5. Stephen Oppenheimer says the earliest 'clear evidence' for bipedalism is seen in the skeleton of *A. anamensis* at four million years ago. Oppenheimer, *Op. cit.*, page 5.

7. Oppenheimer, *Op. cit.*, page 11.

8. Steven Mithen, *The Prehistory of the Mind*, London: Thames & Hudson, 1996, page 238.

9. Richard G. Klein with Blake Edward, *The Dawn of Human Culture*, New York: John Wiley, 2002, page 56.

10. Another theory is that the upright posture allowed for greater cooling of the body in the African heat, via the top of the head, which was now more exposed. Oppenheimer, *Op. cit.*, page 5.

11. One recent theory argues that rapid climate change, which occurs every 100,000 years or so, is responsible for the development of intelligence: *Times Higher Educational Supplement*, 4 October 2002, page 29.

12. Klein with Edward, *Op. cit.*, page 65.

13. This may have something to do with the fact that when mammals began to flourish, after the dinosaurs died out 65 million years ago (after the earth was hit by an asteroid), the early species were nocturnal creatures and therefore required larger brains to process information from several senses – touch, smell and hearing as well as sight. Chimpanzees, for example, seem better at drawing inferences from acoustic clues than from visual ones. Mithen, *Op. cit.*, pages 88 and 114.

14. Oppenheimer, *Op. cit.*, page 11.

15. Mithen, *Op. cit.*, pages 108–109.

16. Wenke, *Op. cit.*, page 120.

17. Mithen, *Op. cit.*, page 22. *Homo habilis* is known as *Australopithecus habilis* among some palaeontologists. See Bernard Wood, 'Who are we?', *New Scientist*, 26 October 2002, page 47.

18. Mithen, *Op. cit.*, page 126.

19. Oppenheimer, *Op. cit.*, pages 14–15. John Noble Wilford, 'Experts place ancient toolmaker on a fast track to northern China,' *New York Times*, 5 October 2004, citing a report in the then current *Nature*.

20. The latest *H. erectus* discoveries, at Dmanasi, in Georgia, consist of individuals with much smaller brains, with a 600 cc capacity. This suggests they moved out of Africa not because they were more intelligent than other hominids, or had better tools, but because, owing to climate, African conditions extended into Europe. Alternatively, these examples were actually children. *The Times* (London) 5 July 2002, page 14.

21. Wenke, *Op. cit.*, pages 145–147.

22. Richard Rudgley, *The Lost Civilisations of the Stone Age*, New York: The Free Press, 1999, page 143.

23. Goudsblom, *Fire and Civilisation*, *Op. cit.*, pages 16 and 34.

24. *Ibid.*, pages 25–27.

25. Rudgley, *Op. cit.*, page 88 and Mellars and Stringer, *Op. cit.*, page 428. A curious aspect to stone tool technology is that in some sites the hand-axes do not appear to have been used. This has prompted some palaeontologists to

suggest that the accumulation of such 'tools' was in fact an early form of 'peacock plumage', in effect a showing-off device as an aid to attracting mates. Klein and Edgard, *Op. cit.*, page 107. Even today, certain Eskimo groups distinguish between tools used on animals and tools used only on social occasions. Mellars and Stringer. *Op. cit.*, page 359. *H erectus* is sometimes known as *H. rhodesiensis* in Africa but this term is falling into disuse.

26. Rudgley, *Op. cit.*, page 163. Experiments conducted on Neanderthal bones, by Steven Churchill at Duke University in Chapel Hill, North Carolina, support the idea that they used both arms to thrust spears, not throw them. This, at 230,000–200,000 years ago. *New Scientist*, 23 November 2002, pages 22–23. Archaic *H. sapiens* is also known as *H. helmei* and *H. heidelbergensis*.

27. Rudgley, *Op. cit.*, page 176.

28. *Ibid.*, page 177.

29. *Ibid.*, page 226.

30. Mellars and Stringer, *Op. cit.*, 214.

31. *El País* (Madrid), 12 August 2002, page 1.

32. Francesco d'Errico, 'The invisible frontier. A multiple species model for the origin of behavioral modernity', *Evolutionary Anthropology*, volume 12, 2003, pages 188–202.

33. Mellars and Stringer, *Op. cit.*, page 156.

34. This may also explain why Neanderthals made repeated use of caves for short periods of time: to build fires, raise the temperature in a confined space, and get at the meat. Then they moved on.

35. Rudgley, *Op. cit.*, page 217. At the same time, these skeletons have been found only in areas relatively light on carnivores, which may mean that all we are seeing is the differential remains of other animals' scavenging behaviour.

36. Mellars and Stringer, *Op. cit.*, page 217.

37. *Ibid.*, page 219.

38. Paul Mellars, 'Cognitive changes in the emergence of modern humans in Europe', *Cambridge Archaeological Journal*, volume 1, number 1, April 1991, pages 63–76. This view is contradicted by a study published later in the same journal, by Anthony E. Marks *et al.*, which showed that there is no difference between burins produced by Neanderthals and anatomically modern humans. 'Tool standardisation in the middle and upper Palaeolithic', *Cambridge Archaeological Journal*, volume 11, number 1, 2001, pages 17–44.

39. Mellars, *Op. cit.*, page 70.

40. James Steele *et al.*, 'Stone tools and the linguistic capabilities of earlier hominids', *Cambridge Archaeological Journal*, volume 5, number 2, 1995, pages 245–256.

41. Merlin Donald, *Origins of the Modern Mind: Three Stages in the Evolution of Culture and Cognition*, Cambridge, Massachusetts: Harvard University Press, 1991, pages 149–150.

42. *Ibid.*, page 163.

43. Merlin Donald, *A Mind So Rare: The Evolution of Human Consciousness*, New York: W. W. Norton, 2001, page 150.

44. Donald, *Origins of the Modern Mind, Op. cit.*, page 210.

45. Donald, *A Mind So Rare, Op. cit.*, page 150.

46. John E. Pfeiffer, *The Creative Explosion*, New York: Harper & Row, 1982.

47. N. Goren-Inbar 'A figurine from the Acheulian site of Berekhet Ram', *Mitekufat Haeven*, volume 19, 1986, pages 7–12.

48. Francesco d'Errico and April Nowell, 'A new look at the Berekhet Ram figurine: Implications for the Origins of Symbolism', *Cambridge Archaeological Journal*, volume 9, number 2, 1999, pages 1–27.

49. For the beads at Blombos cave, see: Kate Douglas, 'Born to trade', *New Scientist*, 18 September 2004, pages 25–28; for the 'flute', see: I. Turk, J. Dirjec and B. Kavur, 'Ali so v slovenjii nasli najstarejse glasbilo v europi?' [The Oldest musical instrument in Europe discovered in Slovenia?], *Razprave IV, razreda SAZU (Ljubliana)*, volume 36, 1995, pages 287–293.

50. Francesco d'Errico, Paolo Villa, Ana C. Pinto Llona and Rosa Ruiz Idarraga, 'A Middle Paleolithic origin of music? Using cave-bear bones to assess the Divje Babel bone "flute"', *Antiquity*, volume 72, 1998, pages 65–79.

51. Oppenheimer, *Op. cit.*, pages 115–117.

52. *Ibid.*, page 127.

53. Mithen, *Op. cit.*, page 174.

54. *Ibid.*, page 175.

55. Mircea Eliade, *A History of Religious Ideas*, volume 1, London: Collins, 1979, page 17.

56. *The Times* (London), 17 February 2003, page 7. *New York Times*, 12 November 2002, page F3.

57. *International Herald Tribune*, 16 August 2002, pages 1 and 7.

58. Stephen Shennan, 'Demography and cultural innovation: a model and its implication for the emergence of modern human culture', *Cambridge Archaeological Journal*, volume 11, number 1, 2001, pages 5–16.

59. Oppenheimer, *Op. cit.*, pages 112–113.

60. Mithen, *Op. cit.*, page 195.

61. By the same token, the fact that the Neanderthals were around in the Ice Age, and produced no art that we know of, strongly suggests that they were intellectually incapable of producing such artefacts.

62. Mithen, *Op. cit.*, 197.

63. *Ibid.*

64. Rudgley, *Op. cit.*, 196.

65. At the el-Wad cave in the Mount Carmel area near Haifa in Israel, a piece of flint was discovered, dating to 12,800–10,300 BP, which had been modified as a sort of artistic double-entendre. From certain angles, the figure resembles a penis (say the modern palaeontologists), from another angle it looks like a set of testicles, though the actual carving, when examined in detail, represents a couple, seated, facing each other, and engaged in sexual intercourse. Rudgley, *Op. cit.*, pages 188–189.

66. Eliade, *Op. cit.*, page 20.

67. *Scientific American*, November 2000, pages 32–34.

68. Mellars and Stringer, *Op. cit.*, page 367. Randall White further reports that many of the beads were made of 'exotic' materials – ivory, steatite, serpentine – the raw materials for which were obtained in some cases from 100 kilometres (60 miles) away. This raises the possibility of early ideas of trade. *Ibid.*, 375–376. Different sites had similar motifs (sea shells, for example) at similar excavation levels, showing that early aesthetic ideas radiated between peoples (an early form of fashion?). *Ibid.*, page 377.

69. Mithen, *Op. cit.*, page 200.

70. David Lewis-Williams, *The Mind in the Cave*, London and New York: Thames & Hudson, 2002, page 127.

71. *Ibid.*, pages 199–200 and 216–217.

72. *Ibid.*, pages 224–225.

73. *Ibid.*, pages 285–286.

74. Will Knight and Rachel Nowak, 'Meet our new human relatives', *New Scientist*, 30 October 2004, pages 8–10.

CHAPTER 2: THE ORIGINS OF LANGUAGE AND THE CONQUEST OF COLD

1. The actual figures were 67 and 82 respectively, but this seems overly specific. Mithen, *Op. cit.*, page 119.
2. Mellars and Stringer, *Op. cit.*, page 343.
3. Klein with Edgard, *Op. cit.*, page 19.
4. The Nelson Bay inhabitants had ostrich shells which they used as water containers on their journeys inland; those at Klasies did not.
5. Mithen, *Op. cit.*, page 250. For the lice research, see: Douglas, *Op. cit.*, page 28.
6. Mellars and Stringer, *Op. cit.*, page 439.
7. *Ibid.*, page 451.
8. Oppenheimer, *Op. cit.*, pages 54 and 68.
9. Stuart J. Fiedel, *The Pre-history of the Americas*, Cambridge, England: Cambridge University Press, 1987, page 25.
10. Oppenheimer, *Op. cit.*, page 215.
11. *Ibid.*, page 225.
12. Brian Fagan, *The Great Journey*, London and New York: Thames & Hudson, 1987, pages 188–189.
13. *Ibid.*, page 73.
14. Fiedel, *Op. cit.*, page 27.
15. Fagan, *Op. cit.*, page 79.
16. See Oppenheimer, *Op. cit.*, page 233, for a map of the southerly routes.
17. Fagan, *Op. cit.*, page 89.
18. *Ibid.*, page 92. Though Berelekh is the most likely route taken by the palaeo-Indians, the Dyukhtai stone culture does not *exactly* resemble that found in north America and this is where another site comes in – Ushki, on the Kamchatka peninsula. Ushki is a large site of 100 square metres, where the stone tools at lower levels (12,000 BC) lack the wedge shape so characteristic of Dyukhtai. However, by later levels (8800 BC) the Dyukhtai tools are there. This raises the intriguing possibility that the Dyukhtai people pushed out the Ushki people, who were forced to look elsewhere. Fagan, *Op. cit.*, pages 96–97. If Berelekh *was* the route taken, it would mean that early man travelled along the top of the world, walking or sailing (or rafting) along the shores of the East Siberian Sea and then the Chukchi Sea, to reach what is now Chukotskiy Poluostrov (Chukotsk peninsula). Uelen (Mys Dezhneva) is 50–60 miles from Cape Prince of Wales in Alaska. The very latest evidence traces the first Americans to the Jomon culture in Japan. *International Herald Tribune*, 31 July 2001.
19. Fagan, *Op. cit.*, pages 108–109.
20. *Ibid.*, page 111.
21. Frederick Hadleigh West, *The Archaeology of Beringia*, New York: Columbia University Press, 1981, pages 156, 164 and 177–178.
22. Fagan, *Op. cit.*, pages 93ff.
23. Antonio Torroni, 'Mitochondrial DNA and the origin of Native Americans', in Colin Renfrew (editor), *America Past, America Present: Genes and Language in the Americas and Beyond*, Cambridge, England: McDonald Institute for Archaeological Research, University of Cambridge, Papers in the Prehistory of Language, 2000, pages 77–87.
24. There is *some* evidence for Monte Verde being dated to 37,000 years ago and for Meadowcroft at 19,000 years ago. See: Oppenheimer, *Op. cit.*, pages 287 and 291. But many archaeologists remain unconvinced.
25. Hadleigh West, *Op. cit.*, page 87.
26. Fagan, *Op. cit.*, page 92; Hadleigh West, *Op. cit.*, page 132.
27. According to Michael Corballis, professor of psychology at the University of Auckland in New Zealand, language may have developed out of gestures. He makes the point that chimpanzees are much better at sign language than speaking and that, in their brains, the area corresponding to Broca's area is involved with making and perceiving hand and arm movements. Deaf humans also have no difficulty developing sign languages. Corballis speculates that bipedalism enabled early man to develop hand and facial gestures first and that speech only developed after the rules had been laid down in the brain for grammar, syntax etc. See: Michael Corballis, *From Hand to Mouth: The Origins of Language*, Princeton, New Jersey, and London: Princeton University Press, 2002. For Kanzi's 'words', see: Anil Ananthaswamy, 'Has the chimp taught himself to talk?', *New Scientist*, 4 January 2003, page 12.
28. Mellars and Stringer, *Op. cit.*, page 397.
29. Oppenheimer, *Op. cit.*, page 27.
30. Mellars and Stringer, *Op. cit.*, page 406.
31. *Ibid.*, page 412.
32. *Ibid.*, chapter 10, 'New skeletal evidence concerning the anatomy of middle Palaeolithic populations in the Middle East: the Kebara skeleton', especially page 169. 'Neanderthals not so dumb', Mark Henderson, *The (London) Times*, 22 June 2004, page 4.
33. *International Herald Tribune*, 16 August 2002, page 1.
34. The gene was located in, among other sites, fifteen members of one family living in Britain, all of whom have profound speech defects and all of whom had a defective version of FOXP2.
35. Tore Janson, *Speak*, Oxford and New York: Oxford University Press, 2002, page 27.
36. Les Groube, 'The impact of diseases upon the emergence of agriculture', in David R. Harris (editor), *The Origins and Spread of Agriculture and Pastoralism in Eurasia*, London: University College London Press, 1996, page 103.
37. Johanna Nichols calculates there are 167 American language 'stocks'. Stephen Oppenheimer observes there are far more languages in South America than in the north. He provides a table, of different parts of the world, calibrating language diversity and period of human occupation. His graph shows essentially a straight line – in other words, there is a strong relation between time depth and language diversity. Oppenheimer, *Op. cit.*, page 299. For William Sutherland's claim that there are 6,809 languages in the world, see *New Scientist*, 17 May 2003, page 22.
38. Rudgley, *Op. cit.*, page 39.
39. Terence Grieder, *Origins of Pre-Columbian Art*, Austin: University of Texas Press, 1982.
40. Oppenheimer, *Op. cit.*, page 304.
41. Colin Renfrew and Daniel Nettle (editors), *Nostratic: Examining a Linguistic Macrofamily*, Cambridge, England: McDonald Institute for Archaeological Research, 1999, page 5.
42. *Ibid.*, page 130.
43. *Ibid.*, pages 12–13.
44. Nicholas Wade, 'Genes are telling 50,000-year-old story of the origins of Europeans', *New York Times*, 14 November 2000, page F9.
45. Renfrew and Nettle (editors), *Op. cit.*, pages 53–67; Merritt Ruhlen, *The Origin of Languages*, New York: Wiley, 1994. Luigi Cavalli-Sforza and Francesco Cavalli-Sforza, *The Great Human Diasporas*, New York: Addison-Wesley, 1995, pages 174–177 and 185–186.
46. Renfrew and Nettle (editors), *Op. cit.*, page 68.
47. *Ibid.*, pages 68–69.

48. *Ibid.*, pages 54 and 398.

49. Gyula Décsy, 'Beyond Nostratic in time and space', in Renfrew and Nettle (editors), *Op. cit.*, pages 127–135.

50. Steven Pinker and P. Bloom, 'Natural language and natural selection', *Behavioural and Brain Science*, volume 13, 1990, pages 707–784. Robin Dunbar, *Grooming, Gossip and the Evolution of Language*, London: Faber & Faber, 1996.

51. Mellars and Stringer, *Op. cit.*, page 485.

52. *Ibid.*, page 459.

53. *Ibid.*, pages 468–469.

54. Donald, *Origins of the Modern Mind*, *Op. cit.*, page 215.

55. *Ibid.*, page 334.

56. *Ibid.*, pages 333–334.

57. Mellars and Stringer, *Op. cit.*, page 356.

58. Alexander Marshack, 'Upper Palaeolithic notation and symbols', *Science*, volume 178, 1972, pages 817–828.

59. Franceso d'Errico, 'A new model and its implications for the origin of writing: the La Marche Antler revisited', *Cambridge Archaeological Journal*, volume 5, number 2, October 1995, pages 163–206.

60. Rudgley, *Op. cit.*, page 74.

61. *Ibid.*, page 77.

62. *Ibid.*, page 79. 'Three is the magic number alphabets have in common', *New Scientist*, 12 February 2005, page 16.

63. Donald, *Origins of the Modern Mind*, *Op. cit.*, page 348.

## CHAPTER 3: THE BIRTH OF THE GODS, THE EVOLUTION OF HOUSE AND HOME

1. Mithen, *After the Ice*, *Op. cit.*, page 54.

2. *Ibid.*, pages 12–13.

3. Chris Scarre, 'Climate change and faunal extinction at the end of the Pleistocene', chapter 5 of *The Human Past*, edited by Chris Scarre, London: Thames & Hudson, forthcoming, page 13.

4. David R. Harris (editor), *The Origin and Spread of Agriculture and Pastoralism in Eurasia*, London: University College London Press, 1996, page 135.

5. *Ibid.*, page 144.

6. *Ibid.*

7. Goudsblom, *Op. cit.*, page 47.

8. Scarre, *Op. cit.*, page 11.

9. Harris (editor), *Op. cit.*, pages 266–267. For the pig reference see Scarre, *Op. cit.*, pages 9ff.

10. *New Scientist*, 10 August 2002, page 17.

11. Harris (editor), *Op. cit.*, page 264. Bob Holmes, 'Manna or millstone,' *New Scientist*, 18 September 2004, pages 29–31.

12. Daniel Hillel, *Out of the Earth*, London: Aurum, 1992, page 73.

13. Mark Nathan Cohen, *The Food Crisis in Prehistory*, New Haven: Yale University Press, 1977.

14. Groube, 'The impact of diseases upon the emergence of agriculture' in Harris (editor), *Op. cit.*, pages 101–129.

15. V. G. Childe, *Man Makes Himself*, London: Watts, 1941.

16. *Ibid.*, pages 554–555.

17. Jacques Cauvin, *The Birth of the Gods and the Origins of Agriculture*, Cambridge, England: Cambridge University Press, 2000 (French publication, 1994, translation: Trevor Watkins), page 15.

18. *Ibid.*, page 16.

19. *Ibid.*, page 22.

20. *Ibid.*, pages 39–48. See also: Ian Hodder, *The Domestication of Europe*, Oxford: Blackwell, 1990, pages 34–35, for an allied theory.

21. Cauvin, *Op. cit.*, page 44. See John Graham Clark, *World Prehistory*, Cambridge, England: Cambridge University Press, 1977, page 50, for curvilinear houses at Beidha in Jordan.

22. Cauvin, *Op. cit.*, page 69.

23. *Ibid.*, page 125.

24. *Ibid.* See Erlich Zehren, *The Crescent and the Bull*, London: Sidgwick & Jackson, 1962, for an earlier discussion of bull tombs in the Middle East.

25. Cauvin, *Op. cit.*, page 128.

26. *Ibid.*, page 132.

27. Mithen, *After the Ice*, *Op. cit.*, page 59.

28. Fred Matson (editor), *Ceramics and Man*, London: Methuen, 1966, page 241.

29. *Ibid.*

30. *Ibid.*, page 242.

31. *Ibid.*

32. Goudsblom, *Op. cit.*, pages 58–59.

33. Matson, *Op. cit.*, page 244.

34. Mithen, *After the Ice*, *Op. cit.*, page 372.

35. Matson, *Op. cit.*, page 245.

36. *Ibid.*, page 210.

37. *Ibid.*, page 211. See Clark, *Op. cit.*, page 55, for key radiocarbon dating for Tepe Sarab.

38. Matson, *Op. cit.*, page 207.

39. *Ibid.*, page 208.

40. *Ibid.*, page 220.

41. *Ibid.* See also Clark, *Op. cit.*, pages 61ff. for another outline of where pottery first appeared.

42. Mircea Eliade, *A History of Religious Ideas*, *Op. cit.*, volume 1, pages 114–115. Some of the dolmens are vast – one at Soto, near Seville in Spain, is 21 metres long and has as pediment a granite block that is 3.40 metres high.

43. Colin Renfrew, *Before Civilisation*, London: Cape, 1973, pages 162–163.

44. *Ibid.*, page 164.

45. *Ibid.*, page 165.

46. Alastair Service and Jean Bradbery, *Megaliths and Their Mysteries*, London: Weidenfeld & Nicolson, 1979, page 33.

47. *Ibid.*, page 34.

48. *Ibid.*, page 35.

49. Chris Scarre, 'Shrines of the land: religion and the transition to farming in Western Europe', paper delivered at the conference 'Faith in the Past: Theorising an Archaeology of Religion'. Publication forthcoming, edited by David Whitley, page 6.

50. Douglas C. Heggie, *Megalithic Science: Ancient Maths and Astronomy in North-Western Europe*, London and New York: Thames & Hudson, 1981, pages 61–64.

51. Eliade, *Op. cit.*, page 117.

52. Service and Bradbery, *Op. cit.*, pages 22–23.

53. Marija Gimbutas, *The Gods and Goddesses of Old Europe: 6500 to 3500 BC*, London: Thames & Hudson, 1982, page 236.

54. *Ibid.*, page 237.

55. *Ibid.*, page 177.

56. *Ibid.*, page 24. This is confirmed by Hodder, *Op. cit.*, at page 61, where he also explores female symbolism on pottery.

57. In her book *The Gods and Goddesses of Old Europe: 6500 to 3500 BC*, *Op. cit.*, Marija Gimbutas also explores links between these original ideas and the ideas of the Greeks in regard to their gods. In particular, she finds that the Great Goddess survives as Artemis: the rituals surrounding her worship recall the ceremonies hinted at in the ancient statues of Old Europe (for example, Artemis Eileithyia – 'child-bearing'), pages 198–199.

58. Matson, *Op. cit.*, page 141.

59. *Ibid.*, page 143.

60. Leslie Aitchison, *A History of Metals*, London: Macdonald, 1960, page 37.

61. *Ibid.*

62. *Ibid.*, page 38.

63. *Ibid.*, page 39. See Clark, *Op. cit.*, page 92, for a discussion of Susa pottery and the adoption of metallurgy.

64. Aitchison, *Op. cit.*, page 40.

65. *Ibid.*, pages 40–41.

66. *Ibid.*, page 41.

67. One explanation for this rapid dispersal of technological knowledge has been put down by James Muhly to the invention of writing, which we will come to in Chapter 4. See Theodore Wertime *et al.* (editors), *The Coming of the Age of Iron*, New Haven: Yale University Press, 1980, page 26. But there are other possibilities. The earliest true bronzes – tin bronzes – that occur in any quantity are found at Ur, in Mesopotamia, just before the middle of the second millennium BC, though the suggestion has been made that, since the Sumerians were immigrants from further east, and since the same metallurgical advances were also found at Mohenjo-Daro, on the Indus, perhaps the Sumerians first appreciated the principle of bronze-making in their original homeland, and the knowledge then spread in both directions, but needed the discovery of substantial tin deposits before it could find proper expression: Aitchison, *Op. cit.*, page 62. This theory is further supported by the fact that Sumer's bronze period lasted for only 300 years, then dropped off, as local tin deposits became exhausted: Wertime, *Op. cit.*, page 32.

68. Aitchison, *Op. cit.*, page 78.

69. *Ibid.*, page 82.

70. *Ibid.*, page 93. See Clark, *Op. cit.*, pages 179 and 186 for illustrations showing daggers lengthening into swords.

71. Aitchison, *Op. cit.*, page 98.

72. Wertime, *Op. cit.*, pages 69–70 and 99.

73. *Ibid.*, page 100.

74. *Ibid.*, page 101.

75. *Ibid.*, page 17.

76. *Ibid.*, page 102. See Clark, *Op. cit.*, pages 185f for a wider discussion of the impact of iron technology and for an illustration of a Greek iron-smith taken from a black-figured vase.

77. Wertime, *Op. cit.*, page 103.

78. *Ibid.*, page 82.

79. *Ibid.*, page 116. Clark, *Op. cit.*, page 186 discusses the cheapness of later iron.

80. Wertime, *Op. cit.*, page 121.

81. *Ibid.*, page 194.

82. *Ibid.*, page 105.

83. *Ibid.*, page 82.

84. *Ibid.*, pages 197 and 215. Clark, *Op. cit.*, page 170, discusses the role of gold as embellishment in armour.

85. Wertime, *Op. cit.*, page 198.

86. Jack Weatherford, *A History of Money*, New York: Three Rivers Press, 1997, page 21.

87. *Ibid.*, page 27.

88. *Ibid.*, page 31. See Clark, *Op. cit.*, page 194 for illustrations of early Greek coins.

89. Mithen, *After the Ice*, *Op. cit.*, pages 67–68.

90. Weatherford, *Op. cit.*, page 32.

91. *Ibid.*, page 37.

92. Georg Simmel, *The Philosophy of Money*, London: Routledge Kegan Paul, 1978, page 152.

CHAPTER 4: CITIES OF WISDOM

1. H. W. F. Saggs, *Before Greece and Rome*, London: B. T. Batsford, 1989, page 62. Petr Charvát, *Mesopotamia Before History*, London: Routledge, 2002, page 100. (First published as: *Ancient Mesopotamia – Humankind's Long Journey into Civilization* by the Oriental Institute, Prague, 1993)

2. Renfrew, *Before Civilisation*, *Op. cit.*, page 212, and Rudgley, *Op. cit.*, page 48.

3. Gwendolyn Leick, *Mesopotamia*, London: Penguin, 2002, page xviii. For Tell Brak and Tell Hamoukar, see: Graham Lawton, 'Urban legends', *New Scientist*, 18 September 2004, pages 32–35.

4. Hans J. Nissen, *The Early History of the Ancient Near East*, Chicago: University of Chicago Press, 1988, pages 5 and 71. Charvát, *Op. cit.*, page 134.

5. Nissen, *Op. cit.*, page 56. Scientists from the Universities of Georgia and of Maine reported in *Science* in 2002 that there was a sudden drop in temperature across the world 5,000 years ago, and that this may have encouraged the development of complex civilisations in both hemispheres. A study of ancient fish bones indicates that the temperature fall brought about the first El Niño, the periodic warming of the Pacific, which brings unusual weather patterns every two-to-seven years. Off South America, the fish population rocketed, which may have triggered people to build large temples (to maintain the catch through communal worship). But the change in weather and temperature would have dried out many areas, forcing people in the Old World in particular to congregate in river valleys. *Daily Telegraph* (London), 2 November 2002, page 10.

6. Nissen, *Op. cit.*, page 67.

7. *Ibid.*, page 56.

8. *Ibid.*, page 69.

9. Leick, *Op. cit.*, page 2.

10. *Ibid.*, page 3.

11. Charvát, *Op. cit.*, page 93.

12. Mason Hammond, *The City in the Ancient World*, Cambridge, Massachusetts: Harvard University Press, 1972, page 38.

13. Nissen, *Op. cit.*, 72.

14. *Ibid.*, pages 130–131.

15. *Ibid.*, pages 132–133. Charvát, *Op. cit.*, page 134.

16. Hammond, *Op. cit.*, pages 37–38. Charvát, *Op. cit.*, page 134.

17. *Ibid.*

18. Hans Nissen cautions us that we know so little about the 'temples' and 'palaces' of Mesopotamian cities that we are not really justified in referring to them other than as 'public buildings'. Nissen, *Op. cit.*, page 98.

19. The use of this particular word has provoked the idea among some modern scholars that the ziggurats were an attempt to reproduce similar shrines that had been built on natural hills in the original homeland of the Sumerians. This would imply that they had moved down into the Mesopotamian delta from the highlands of Elam to the north and east. Hammond, *Op. cit.*, page 39.

20. *Ibid.*

21. *Ibid.*, page 45.

22. D. Schmandt-Besserat, *Before Writing*, volume 1: *From Counting to Cuneiform*, Austin: University of Texas Press, 1992.

23. Rudgley, *Op. cit.*, page 50.

24. *Ibid.*, page 53.

25. *Ibid.*, page 54. The French scholar who has cast doubt

on this reconstruction is: Jean-Jacques Glassner, in *The Invention of the Cuneiform: Writing in Sumer*, Baltimore and London: Johns Hopkins University Press, 2003.

26. S. M. M. Winn, *Pre-writing in South Eastern Europe: The Sign System of the Vinca Culture, circa 4000 BC*, Calgary: Western Publishers, 1981.
27. *Le Figaro* (Paris), 3 June 1999, page 16.
28. Saggs, *Op. cit.* page 6.
29. *Ibid.*, page 7.
30. Nissen, *Op. cit.*, page 74.
31. *Ibid.*, page 76.
32. *Ibid.*, pages 78–79.
33. Saggs, *Op. cit.*, page 83.
34. Rudgley, *Op. cit.*, page 70.
35. Nissen, *Op. cit.*, page 84.
36. Saggs, *Op. cit.*, page 62.
37. *Ibid.*, page 65.
38. *Ibid.*, pages 66–68.
39. *Ibid.*, pages 68–69.
40. G. Contenau, *Everyday Life in Babylon and Assyria*, London: Edward Arnold, 1954, page 158.
41. *Ibid.*, page 160.
42. *Ibid.*, pages 162–163.
43. Leick, *Op. cit.*, page 66.
44. Nissen, *Op. cit.*, page 138.
45. Leick, *Op. cit.*, page 73.
46. Nissen, *Op. cit.*, page 139.
47. Leick, *Op. cit.*, page 75.
48. David C. Lindberg, *The Beginnings of Western Science*, Chicago: University of Chicago Press, 1992, page 12.
49. Nissen, *Op. cit.*, page 140. Charvát, *Op. cit.*, page 127.
50. Saggs, *Op. cit.*, pages 78–84.
51. *Ibid.*
52. *Ibid.*, page 81.
53. Nissen, *Op. cit.*, page 136.
54. Saggs, *Op. cit.*, page 98.
55. *Ibid.*, page 104. Most scribes were men but by no means all. The daughter of Sargon of Agade, who was high-priestess of the Moon-god in Ur, became famous as a poet. When scribes signed documents, they often added the names and positions of their fathers, which confirms that they were usually the sons of city governors, temple administrators, army officers or priests. Literacy was confined to scribes and administrators.
56. Saggs, *Op. cit.*, page 105.
57. *Ibid.*
58. *Ibid.*, page 107.
59. *Ibid.*, page 110.
60. *Ibid.*, page 111.
61. *Ibid.*, page 112.
62. *Ibid.*, page 103.
63. Leick, *Op. cit.*, page 214.
64. *Ibid.*, page 82.
65. Contenau, *Op. cit.*, page 196.
66. William B. F. Ryan *et al.*, 'An abrupt drowning of the Black Sea shelf', *Marine Geology*, volume 38, 1997, pages 119–126. In October 2002 *Marine Geology* dedicated an entire issue to the Black Sea hypothesis. Most writers were negative.
67. George Roux, *Ancient Iraq*, London: Penguin, 1966, page 109.
68. Nissen, *Op. cit.*, page 95.
69. *Ibid.*
70. H. and H. A. Frankfort *et al.*, *Before Philosophy*, London: Penguin, 1949, page 224. Andrew R. George, *The Babylonian Gilgamesh Epic: Introduction, Critical Edition and Cuneiform Texts* (2 vols), Oxford: Oxford University Press, 2003.
71. Contenau, *Op. cit.*, page 204.
72. Frankfort *et al.*, *Op. cit.*, page 225.
73. *Ibid.*, page 226.
74. Contenau, *Op. cit.*, page 205.
75. Frankfort *et al.*, *Op. cit.*, page 226.
76. Lionel Casson, *Libraries in the Ancient World*, New Haven: Yale University Press, 2001, page 4.
77. *Ibid.*, page 7.
78. *Ibid.*, page 13.
79. Charvát, *Op. cit.*, page 101.
80. *Ibid.*, page 210.
81. *Ibid.*
82. Leick, *Op. cit.*, page 90.
83. Stuart Piggott, *Wagon, Chariot and Carriage*, London and New York: Thames & Hudson, 1992, page 16.
84. *Ibid.*, page 21, map.
85. *Ibid.*, page 41.
86. *Ibid.*
87. *Ibid.*, page 44.
88. Yuri Rassamakin, 'The Eneolithic of the Black Sea steppe: dynamics of cultural and economic development 4500–2300 BC', in Marsha Levine *et al.*, *Late Prehistoric Exploitation of the Eurasian Steppe*, Cambridge, England: McDonald Institute for Archaeological Research Monographs, 1999, pages 136–137.
89. *Ibid.*, pages 5–58.
90. *Ibid.*, page 9.
91. Quoted in Saggs, *Op. cit.*, page 176.
92. Arthur Ferrill, *The Origins of War*, London and New York: Thames & Hudson, 1985, page 15.
93. *Ibid.*, pages 18–19.
94. *Ibid.*, page 21.
95. *Ibid.*, page 26. In Sumer, writing provides evidence that they had no compunction in raiding mountain peoples to kill, loot and enslave. The ideogram for 'slave-girl' is a combination of 'woman' and 'mountain'. Saggs, *Op. cit.*, page 176.
96. Ferrill, *Op. cit.*, page 46.
97. *Ibid.*, pages 66–67.
98. *Ibid.*, page 72. The Israeli archaeologist Yigael Yadin has used Assyrian sculptural reliefs to study the development of siege techniques in warfare. Sieges became necessary after the rise of armies in the second and first millennia BC had stimulated the building everywhere of fortified sites. Assyrian generals developed a variety of specialised equipment. There was the battering ram and the mobile tower, both on wheels. The discovery of carburised iron encouraged the development of special poles and pikes to scrape away at weak point in city walls. Sieges were never easy: most cities kept enough food and water to live on for more than a year, by which time anything could have happened (when the Assyrians were besieging Jerusalem in 722 BC, they were decimated by plague). Assault was always preferred to a waiting game. See Ferrill, *Op. cit.*, pages 76–77.
99. Saggs, *Op. cit.*, page 156.
100. Roux, *Op. cit.*, page 185.
101. W. G. De Burgh, *The Legacy of the Ancient World*, London: Penguin, 1953/1961, page 25.
102. Saggs, *Op. cit.*, pages 156–158.
103. Roux, *Op. cit.*, page 187.
104. *Ibid.*, page 171.
105. *Ibid.*, page 173.
106. Saggs, *Op. cit.*, page 160.

107. *Ibid.*, page 161.
108. *Ibid.*, page 162.
109. *Ibid.*
110. *Ibid.*, page 165.
111. Charvát, *Op. cit.*, page 155.
112. *Ibid.*, page 230.
113. *Ibid.*, page 236.

CHAPTER 5: SACRIFICE, SOUL, SAVIOUR: THE 'SPIRITUAL BREAKTHROUGH'

1. Brian Fagan, *From Black Land to Fifth Sun: The Science of Sacred Sites*, Reading, Massachusetts: Helix/Perseus Books, 1998, pages 244–245.
2. The Khonds, a Dravidian tribe of Bengal, offered sacrifices to the earth goddess. The victim, known as Meriah, was either bought from his parents, or born of parents who were themselves victims. The Meriahs lived happily for years, and were regarded as consecrated beings; they married other 'victims' and were given a piece of land as a dowry. About two weeks before the sacrifice, the victim's hair was cut off in a ceremony where everyone assisted. This was followed by an orgy and the Meriah was brought to a part of the nearby forest 'as yet not defiled by the axe'. He was anointed in melted butter and other oils, and flowers, and then drugged with opium. He was killed by being either crushed, strangled, or roasted slowly over a brazier. Then he was cut into pieces. These remains were taken back to nearby villages where they were buried to ensure a good harvest. Mircea Eliade, *Patterns in Comparative Religion*, London: Sheed & Ward, 1958, pages 344–345.
3. If tears are shed to beg the god to send rain, that is regarded by anthropologists, such as J. G. Frazer, as sheer religion. If tears are shed to *imitate* the falling of rain, that is sympathetic magic and religion combined: humans act out what they magically induce the gods to do. See also: Eliade, *Patterns, Op. cit.*, page 345. Miranda Aldhouse Green, *Dying for the Gods: Human Sacrifice in Iron Age and Roman Europe*, London: Tempus, 2001.
4. B. Washburn Hopkins, *Origin and Evolution of Religion*, New Haven and New York: Yale University Press, 1924, page 116. Royden Keith Kerkes, *Sacrifice in Greek and Roman Religions and Early Judaism*, London: Adam and Charles Black, 1953, page 31.
5. Hopkins, *Op. cit.*, page 50.
6. Eliade, *Patterns, Op. cit.*, page 86.
7. *Ibid.*, page 88.
8. *Ibid.*, page 90.
9. *Ibid.*, page 91.
10. *Ibid.*, page 217. For the history of the Dravidians, see A. C. Bouquet, *Comparative Religion*, London: Cassell, 1961, pages 116ff.
11. Eliade, *Patterns, Op. cit.*, page 219. Kerkes, *Op. cit.*, page 92.
12. Eliade, *Patterns, Op. cit.*, page 332.
13. *Ibid.*, page 334.
14. See: Michael Jordan, *Gods of the Earth*, London: Bantam, 1992, page 106, for ceremonies of allegorical fertilisation in Egypt.
15. Eliade, *Patterns, Op. cit.*, page 342.
16. *Ibid.*, page 343.
17. For the history of maize in Mesoamerica see Barry Cunliffe, Wendy Davies and Colin Renfrew (editors), *Archaeology: The Widening Debate*, Oxford: Oxford University Press, 2002. And for the maize-mother see Frank B. Jevons, *An Introduction to the History of Religions*, London: Methuen, 1896/1904, pages 257–258.
18. C. Jouco Bleeker and Geo Widengren (editors), *Historia Religionum*, volume 1, *Religions of the Past*, Leiden: E. J. Brill, 1969/1988, page 116.
19. Eliade, *Patterns, Op. cit.*, page 75.
20. *Ibid.*, page 102.
21. *Ibid.*, page 104.
22. The oldest Indo-Aryan root connected with heavenly bodies is the one that means 'moon' (*me*) and in Sanskrit it is transformed into a word that means 'I measure'. Words with the same root and the same meaning exist in Old Prussian, Gothic, Greek (*mene*) and Latin (*mensis*). Consider the English words 'commensurate' and 'menstruation'. Eliade, *Patterns, Op. cit.*, page 154.
23. *Ibid.*, page 165. See too Jevons, *Op. cit.*, pages 228–229, and Zehren, *Op. cit.*, pages 94–95 and 240–241 for the moon-bull.
24. Hopkins, *Op. cit.*, page 109. E. B. Tylor, *Primitive Culture: Development of Mythology, Religion, Art, Astronomy etc.*, London: John Murray, 1871.
25. *Ibid.*, pages 124–126.
26. *Ibid.*, page 130.
27. S. G. Brandon, *Religion in Ancient History*, London: Allen & Unwin, 1973, pages 147ff.
28. *Ibid.*, page 69.
29. *Ibid.*, page 70.
30. Bleeker and Widengren (editors), *Op. cit.*, pages 96–99.
31. Brandon, *Op. cit.*, page 71.
32. *Ibid.*, page 7.
33. *Ibid.*, page 72. See Zehren, *Op. cit.*, pages 283–284 for discussion of the crescent moon as a 'sun ship' sailing before daybreak to the sun and the afterlife (the aureole of the sun).
34. Brandon, *Op. cit.*, page 72.
35. *Ibid.*, page 73.
36. Edwin Bryant, *The Quest for the Origins of Vedic Culture*, Oxford and New York: Oxford University Press, 2001, pages 298–299; George Cordana and Dhanesh Jain (editors), *The Indo-Aryan Languages*, London: Routledge, 2003; Asko Parpola, 'Tongues that tie a billion souls', *Times Higher Education Supplement*, 8 October 2004, pages 26–27.
37. Bryant, *Op. Cit.*, page 165.
38. *Ibid.*, page 166.
39. *Ibid.*
40. Brandon, *Op. cit.*, page 87.
41. *Ibid.*
42. *Ibid.*, page 86.
43. Jan N. Bremmer, *The Rise and Fall of the Afterlife*, London and New York: Routledge, 2002, page 1.
44. *Ibid.*, page 2.
45. Brandon, *Op. cit.*, page 74.
46. *Ibid.*, page 75.
47. *Ibid.*, pages 31–32.
48. *Ibid.*, page 76.
49. Bremmer, *Op. cit.*, page 4.
50. *Ibid.*, page 5 and ref. See Jevons, *Op. cit.*, chapter 21, 'The next life', for a discussion of Hades.
51. Needing a guide on the way to Hades has suggested to some scholars that there was a growing anxiety about one's fate after death, perhaps because of recent wars. The grandest mention of the Elysian Fields is in the *Aeneid*, when Aeneas visits the fields to see his father, Anchises.
52. Bremmer, *Op. cit.*, page 7.
53. Brandon, *Op. cit.*, page 79.
54. *Nephesh* never means the soul of the dead and is not contrasted with the body. The Israelites had a word, *ruach*,

usually translated as 'spirit', but it could as easily mean 'charisma'. It denoted the physical and psychical energy of remarkable people, like Elijah. Bremmer, *Op. cit.*, page 8.

55. *Ibid.*, pages 8–9.

56. Karl Jaspers, *The Origin and Goal of History*, London: Routledge, 1953, page 2. For a more sociological version of this theory, see Robert Bellah's article, 'Religious evolution', reprinted in his *Beyond Belief: Essays on Religion in a Post-Traditional World*, Berkeley, Los Angeles and London: University of California Press, 1970/1991.

57. Grant Allen, *The Evolution of the Idea of God*, London: Grant Richards, 1904, page 180.

58. Cyrus H. Gordon and Gary A. Rendsburg, *The Bible in the Ancient Near East*, New York: Norton, 1997, pages 109–113.

59. Allen, *Op. cit.*, page 181.

60. *Ibid.*, page 182.

61. *Ibid.*

62. *Ibid.*, page 184.

63. *Ibid.*, pages 185–186. See John Murphy, *The Origins and History of Religions*, Manchester: Manchester University Press, 1949, pages 176ff, for other early Hebrew traditions.

64. Menhirs and dolmens, though perhaps not as impressive as in western Europe, are still found all across ancient Phoenicia, Canaan, modern-day Galilee and Syria (Herodotus described a stela he saw in Syria that was decorated with female pudenda). Allen, *Op. cit.*, pages 186–187.

65. *Ibid.*, page 190.

66. *Ibid.*, page 192.

67. 'If Israel obeys Yahweh,' says the Deuteronomist, 'Yahweh will make thee plenteous for good in the fruit of thy belly, and in the fruit of thy cattle, and in the fruit of thy ground,' but if Israel 'ignores the jealous god, then "cursed shall be the fruit of thy body, and the fruit of thy land, the increase of thy kine, and the flocks of thy sheep"'. Allen, *Op. cit.*, page 194. Finally, in this context of Yahweh as a god of fertility, there is his demand that the first-born be offered as a sacrifice. In the pagan world the first child was often understood to be the offspring of a god 'who had impregnated the mother in an act of *droit de seigneur*'. Karen Armstrong, *A History of God*, London: Vintage, 1999, page 26.

68. Allen, *Op. cit.*, page 212.

69. *Ibid.*, page 213.

70. *Ibid.*, page 215.

71. *Ibid.*, pages 216–217.

72. *Ibid.*, page 219. See Bouquet, *Op. cit.*, chapter 6, 'The golden age of religious creativity', pages 95–111. Kerkes, *Op. cit.*, page 32.

73. Allen, *Op. cit.*, page 22 for the forgery of Deuteronomy.

74. Bruce Vawter, *The Conscience of Israel*, London: Sheed & Ward, 1961, page 15.

75. *Ibid.*, page 18.

76. Paul Johnson, *A History of the Jews*, London: Weidenfeld & Nicolson, 1987, page 38. See also Norman Podhoretz, *The Prophets*, New York: The Free Press, 2002, page 92.

77. The phenomenon broke out at the time of the Philistine wars, and this links the prophets with the Nazirites, who indulged in ecstatic dances and other physical movements repeated so often that they finally succumbed to a kind of hypnotic suggestion, under the influence of which they would remain unconscious for hours. Vawter, *Op. cit.*, pages 22–23. Ecstaticism had burned itself out by the time that the great moral prophets of the eighth century made their appearance. The Israelites had shared with neighbouring tribes the practice of divination, such as auguring with animal livers, but that too had fallen into disuse. *Ibid.*, pages 24 and 31.

78. *Ibid.*, pages 39–40.

79. Johnson, *Op. cit.*, pages 36–38. The prophets, incidentally, opposed images of God, because this deprived the king of the day of appropriating such images to himself – and the 'divinity' and power that went with it – and because an 'invisible', interior god, helped their vision, driving men and women back on themselves as moral agents. *Ibid.*, page 124.

80. Vawter, *Op. cit.*, page 66. See also: Israel Finkelstein and Neil Asher Silberman, *The Bible Unearthed*, New York: The Free Press, 2001, pages 172–173.

81. Vawter, *Op. cit.*, page 82.

82. *Ibid.*, page 95; Podhoretz, *Op. cit.*, pages 119f.

83. Vawter, *Op. cit.*, page 111.

84. *Ibid.*, page 72.

85. Micah, the next of the prophets, took as his main target what historian Bruce Vawter calls 'Judahite capitalism', the growth of large estates (confirmed by archaeology), the concentration of wealth in the hands of a few, relegating the rest of the population to the status of 'helpless dependants', though priests were attacked for the personal gain they put before all else, and because, in collaboration with the Assyrians, they turned away from Yahweh-worship to other gods. Micah was active between 750 and 686 BC, and so as late as this Yahweh-worship was not settled in Israel. Vawter, *Op. cit.*, page 154.

86. Podhoretz, *Op. cit.*, page 183; Vawter, *Op. cit.*, pages 165–166.

87. Thomas L. Thompson, *The Bible in History*, London: Cape, 1999, page 56. Vawter, *Op. cit.*, page 170.

88. Vawter, *Op. cit.*, page 175.

89. *Ibid.*, page 75.

90. Podhoretz, *Op. cit.*, page 187 and 191; Gordon and Rendsburg, *Op. cit.*, page 253. Vawter, *Op. cit.*, page 75.

91. Podhoretz, *Op. cit.*, pages 219ff. Finkelstein and Silberman, *Op. cit.*, page 297.

92. Paul Kriwaczek, *In Search of Zarathustra*, London: Weidenfeld & Nicolson, 2002, page 206.

93. *Ibid.*, page 222.

94. *Ibid.*, page 119.

95. *Ibid.*, page 120.

96. *Ibid.*, page 49. See also: *A Nietzsche Reader*, selected and translated, and with an introduction by R. J. Hollingdale, London: Penguin, 1977, especially pages 71–124, on morality.

97. Brandon, *Op. cit.*, page 96.

98. Kriwaczek, *Op. cit.*, page 210.

99. Eliade, *Op. cit.*, page 309.

100. Since the primitive *daevas* all at some time or another practise deceit, Zarathustra demands that his disciples no longer worship them. In envisaging the 'way of righteousness', Zoroastrianism prefigures both Plato (in his concern with Good), Buddhism and Confucianism. In demanding that his disciples no longer worship the *daevas*, his ideas may have helped the Jews move from henotheism (the belief that only one god out of many is worthy of worship) to true monotheism (the belief that there *is* only one god). Kriwaczek, *Op. cit.*, page 183.

101. *Ibid.*, page 210.

102. *Ibid.*

103. Eliade, *Op. cit.*, page 308.

104. *Ibid.*, page 312.

105. Kriwaczek, *Op. cit.*, page 195.

106. Eliade, *Op. cit.*, page 330.

107. Pat Alexander (editor), *The World's Religions*, Oxford: Lion Publishing, 1994, page 170.

108. *Ibid.*, page 173.

109. *Ibid.*, page 174.

110. Karen Armstrong, *Buddha*, London: Weidenfeld & Nicolson, 2000, page 15.

111. *Ibid.*, page 19.

112. *Ibid.*, page 23.

113. S. G. F. Brandon (editor), *The Saviour God*, Manchester: Manchester University Press, 1963, page 218.

114. *Ibid.*, page 86.

115. *Ibid.*, page 89.

116. *Ibid.*, page 90.

117. Armstrong, *A History of God*, *Op. cit.*, page 41.

118. *Ibid.*, page 42.

119. *Ibid.*

120. R. M. Cook, *The Greeks Till Alexander*, London and New York: Thames & Hudson, 1962, page 86. See also: Armstrong, *A History of God*, *Op. cit.*, page 45.

121. Armstrong, *Op. cit.*, page 46. See Cook, *Op. cit.*, page 41 for the way Plato modified his theories.

122. Armstrong, *A History of God*, *Op. cit.*, page 48.

123. *Ibid.*, page 49.

124. D. Howard Smith, *Confucius*, London: Temple Smith, 1973. John D. Fairbanks, *China*, Cambridge, Massachusetts: The Belknap Press of Harvard University Press, 1992, pages 50–51.

125. Fairbanks, *Op. cit.*, page 25.

126. *Ibid.*, pages 33–34.

127. Brandon, *Op. cit.*, page 98.

128. Armstrong, *A History of God*, *Op. cit.*, page 43.

129. *Ibid.*, page 45.

130. Fairbanks, *Op. cit.*, page 63.

131. *Ibid.*, page 66. See also Bouquet, *Op. cit.*, page 180.

132. Benjamin I. Schwartz, *The World of Thought in Ancient China*, Cambridge, Massachusetts: The Belknap Press of Harvard University Press, 1985, page 193. Brandon (editor), *Op. cit.*, page 179.

133. D. C. Lau, Introduction to *Lao Tzu, Tao te ching*, London: Penguin, 1963, pages xv–xix.

134. Schwarz, *Op. cit.*, page 202. Brandon (editor), *Op. cit.*, page 180.

## CHAPTER 6: THE ORIGINS OF SCIENCE, PHILOSOPHY AND THE HUMANITIES

1. Allan Bloom, *The Closing of the American Mind*, London: Penguin, 1987, page 369.

2. H. D. F. Kitto, *The Greeks*, London: Penguin, 1961.

3. Peter Hall, *Cities in Civilisation*, London: Weidenfeld & Nicolson, 1998, pages 24.

4. Daniel J. Boorstin, *The Seekers: The Story of Man's Continuing Quest to Understand His World*, New York and London: Vintage, 1999, Part II.

5. A. R. Burn, *The Penguin History of Greece*, London: Penguin, 1966, page 28.

6. *Ibid.*, pages 64–67.

7. *Ibid.*, page 68. See above, pages 90–91.

8. Robert B. Downs, *Books That Changed the World*, New York: Mentor, 1983, pages 41. See also Burn, *Op. cit.*, page 73.

9. John Roberts, *A Short Illustrated History of the World*, London: Helicon, 1993, page 108.

10. Burn, *Op. cit.*, 119.

11. *Ibid.*, pages 119–121. Tyrant became a pejorative term under the later, democratic Greeks. See also: Peter Jones, *An Intelligent Person's Guide to Classics*, London: Gerald Duckworth, 1999/2002, page 70.

12. Kitto, *Op. cit.*, pages 75 and 78. For the population of Athens, see Jones, *Op. cit.*, page 65.

13. Roberts, *Op. cit.*, page 109.

14. Kitto, *Op. cit.*, page 126.

15. *Ibid.*, page 129.

16. Erwin Schrödinger, *Nature and the Greeks and Science and Humanism*, Cambridge, England: Cambridge University Press, 1954/1996, pages 55–58.

17. Geoffrey Lloyd and Nathan Sivin, *The Way and the Word: Science and Medicine in Early China and Greece*, New Haven, Connecticut, and London: Yale University Press, 2002, pages 242–248.

18. Geoffrey Lloyd, *The Revolution in Wisdom: Studies in the Claims and Practices of Ancient Greek Science*, Berkeley and London: University of California Press, 1987, page 85.

19. *Ibid.*, pages 56, 62, 109 and 131.

20. *Ibid.*, page 353.

21. Schrödinger, *Op. cit.*, page 58.

22. Michael Grant, *The Classical Greeks*, London: Weidenfeld & Nicolson, 1989, page 46.

23. Kitto, *Op. cit.*, page 177.

24. Freeman, *The Closing of the Western Mind*, *Op. cit.*, page 9.

25. Kitto, *Op. cit.*, page 179.

26. *Ibid.*, page 181.

27. Burn, *Op. cit.*, page 131; see also: Cook, *Op. cit.*, page 86.

28. Burn, *Op. cit.*, page 138.

29. E. G. Richards, *Mapping Time: The Calendar and Its History*, Oxford: Oxford University Press, 1998, page 36.

30. David C. Lindberg, *The Beginnings of Western Science*, Chicago: University of Chicago Press, 1992, page 29.

31. *Ibid.*, page 34.

32. Burn, *Op. cit.*, page 247. See Cook, *Op. cit.*, page 147 for a discussion of Anaxagoras' understanding of perspective.

33. Burn, *Op. cit.*, page 248.

34. Schrödinger, *Op. cit.*, page 78.

35. Lindberg, *Op. cit.*, page 31.

36. *Ibid.*, page 113.

37. Burn, *Op. cit.*, page 271; also Cook, *Op. cit.*, page 144.

38. Lindberg, *Op. cit.*, page 116.

39. Burn, *Op. cit.*, page 272.

40. Geoffrey Lloyd, *Magic, Reason and Experience*, Cambridge, England: Cambridge University Press, 1979, chapter 4.

41. Lloyd and Sivin, *Op. cit.*, page 241.

42. Grant, *Op. cit.*, page 47.

43. *Ibid.*, page 70. Cook, *Op. cit.*, page 138, says that sophists often became the butt of jokes.

44. Grant, *Op. cit.*, page 72.

45. Freeman, *Op. cit.*, page 24.

46. Burn, *Op. cit.*, page 307.

47. Grant, *Op. cit.*, pages 209–212.

48. Lindberg, *Op. cit.*, pages 40–41.

49. Pierre Leveque, *The Greek Adventure*, translated by Miriam Kochan, London: Weidenfeld & Nicolson, 1968, page 358. The notion (we have to be careful here when using the word 'idea'), that there is another world, beyond the immediate realm of the senses, Plato also applied to the soul. 'The soul was an independent substance which did not have an organic relationship to the body; it could reflect and conceive ideas.' *Ibid.* But the body was always

getting in the way, and defiling the experience of the Forms. Morality, the good life in Socrates' sense, consisted in trying to escape from the corrupting influence of the body. 'While we live we shall be nearest to knowledge when we avoid, so far as possible, intercourse and communion with the body ... but keep ourselves pure from it.' The soul – and the Ideas – could occasionally be glimpsed in the here and now: this is what contemplation, scholarship, poetry and love were for. For Plato death spelled the end for the body but the soul remained incorruptible 'because of its participation in the ideas'. The soul was drawn in a chariot by two horses, the horse of noble passions and the horse of base passions, driven by reason.

50. Leveque, *Op. cit.*, page 359.
51. *Ibid.* See Cook, *Op. cit.*, page 146 for Plato's writing style.
52. Leveque, *Op. cit.*, page 361.
53. Boorstin, *Op. cit.*, page 57.
54. *Ibid.*, page 58.
55. *Ibid.*, page 59.
56. *Ibid.*, page 61.
57. *Ibid.*, page 62. In politics he had an assistant survey 150 different city-states around the Mediterranean. Cook, *Op. cit.*, page 143. The story of that survival is itself a web of Byzantine complexity. The books were inherited several times, buried in an underground cellar, taken to Rome, where they were catalogued by one Andronicus of Rhodes.
58. Boorstin, *Op. cit.*, page 64.
59. *Ibid.*, page 65.
60. Lereque, *Op. cit.*, page 365.
61. Boorstin, *Op. cit.*, page 69.
62. *Ibid.* But see Cook, *Op. cit.*, pages 142–143 for Aristotle's theory that virtue was a mean between two vices.
63. Boorstin, *Op. cit.*, page 71.
64. Leveque, *Op. cit.*, page 363.
65. *Ibid.*, page 364.
66. *Ibid.*
67. Grant, *Op. cit.*, page 252.
68. Burn, *Op. cit.*, page 204.
69. Grant, *Op. cit.*, page 39.
70. Burn, *Op. cit.*, page 124.
71. *Ibid.*
72. Grant, *Op. cit.*, page 39.
73. *Ibid.*, page 40. See also Cook, *Op. cit.*, page 145.
74. Burn, *Op. cit.*, page 205.
75. Grant, *Op. cit.*, page 110.
76. *Ibid.*, pages 129–130. Cook, *Op. cit.*, page 145.
77. Boorstin, *Op. cit.*, page 79.
78. Grant, *Op. cit.*, page 158.
79. *Ibid.*, page 159. Cook, *Op. cit.*, page 118.
80. John Boardman, *Greek Art*, London and New York: Thames & Hudson, 1996, page 145.
81. Cook, *Op. cit.*, page 157. Grant, *Op. cit.*, pages 95–96.
82. Grant, *Op. cit.*, page 81.
83. What many people consider to be the climax of classical Greek sculpture was discovered in 1972 in the sea off Riace in Calabria, southern Italy. These are the so-called Riace bronzes, two male figures about six feet tall. Both were bearded, were originally helmeted and may have carried shields, though these have been lost, possibly looted. The figures have luxuriant hair, with lips and nipples (and possibly eyelashes) made of copper. Technically, and realistically, the statues are second to none and although, in truth, we do not know who fashioned them, the two main candidates are, first, Pythagoras, a sculptor described by Pliny as the 'first to represent such anatomical details as sinews and veins and hair' and whose native town was

Rhegium (the modern Reggio Calabria), near where the bronzes were brought up; and second, Polyclitus. This attribution is based on the fact that he worked a lot in bronze, in Argos, and because the statues have various Argive features. His work, too, is known only through copies, one the 'Youth Holding a Spear' (*Doryphorus*), in Naples, and the other, 'Youth Binding a Fillet Round His Head' (*Diadumenus*) of which there are various copies. But Polyclitus also wrote a *Canon*, embodying his view of what the ideal proportions for a human being should be. This shows that Polyclitus had a mathematical view of beauty – it was a philosophical matter of proportions, the human body 'a supreme demonstration of mathematical principle'. Pliny said that many people were influenced by the *Canon*. Polyclitus beat Phidias in a competition for the statue of an Amazon for the temple of Artemis at Ephesus. But none of this proves that the Riace bronzes are by him and the possibility is real that the climax of classical Greek sculpture was produced by an unknown hand. Grant, *Op. cit.*, pages 81ff.

84. *Ibid.*, page 59.
85. John Boardman, *Athenian Red Figure Vases: The Classical Period*, London and New York: Thames & Hudson, 1989, page 8. Richard Neer, *Style and Politics in Athenian Vase-Painting: The Craft of Democracy, Circa 530–470* BCE, Cambridge, England: Cambridge University Press, 2002.
86. *Ibid.*, pages 263–264.
87. Hall, *Op. cit.*, pages 32–33. But many sculptures were painted: see Cook, *Op. cit.*, 151 for a discussion.
88. Hall, *Op. cit.*, page 30.
89. Grant, *Op. cit.*, page 279.
90. *Ibid.*, page 280.
91. *Ibid.*, page 224.
92. *Ibid.*, page 281.
93. Walter Burkhart, *The Orientalizing Revolution*, Cambridge, Massachusetts: Harvard University Press, 1992 (1984 in German), *passim*.
94. Martin Bernal, *Black Athena: The Afroasiatic Roots of Classical Civilisation*, London: Free Association Books, 1987/Vintage paperback 1991, page 51.
95. M. L. West, *The East Face of Helicon: West Asiatic Elements in Greek Poetry and Myth*, Oxford: Oxford University Press, 1997. West says that Egyptian literary influences on Greece are 'vanishingly small' but Peter Jones, *Op. cit.*, page 225, says that though many details in Bernal's account are absurdly exaggerated, much of his general argument is sound.
96. Isaiah Berlin, *Liberty* (edited by Henry Hardy), Oxford: Oxford University Press, 2002, pages 302–303.
97. *Ibid.*, page 294 and ref.
98. *Ibid.*, page 304.
99. *Ibid.*, page 308.
100. See Peter Jones (editor/director), *The World of Rome*, Cambridge, England: Cambridge University Press, 1997, page 289, for Zeno's paradox.
101. Berlin, *Op. cit.*, page 310.
102. Leveque, *Op. cit.*, pages 328ff.
103. Berlin, *Op. cit.*, page 312.
104. *Ibid.*, page 314.
105. Grant, *Op. cit.*, page 263.
106. Translated by Erwin Schrödinger in his *Nature and the Greeks and Science and Humanism*, *Op. cit.*, page 19.

CHAPTER 7: THE IDEAS OF ISRAEL, THE IDEA OF JESUS
1. Johnson, *History of the Jews*, *Op. cit.*, page 78.

2. *Ibid.*, page 82.

3. Robin Lane Fox, *The Unauthorised Version*, New York: Knopf, 1991, page 71–72. See Finkelstein and Silberman, *Op. cit.*, pages 120–121, for the Israelites' uneasy relationship with YHWH.

4. Lane Fox, *Op. cit.*, page 70. Gordon and Rendsburg, *Op. cit.*, page 323.

5. Lane Fox, *Op. cit.*, page 56.

6. Johnson, *Op. cit.*, page 83.

7. Lane Fox, *Op. cit.*, page 275.

8. Johnson, *Op. cit.*, pages 84–85.

9. *Ibid.*, page 85.

10. Lane Fox, *Op. cit.*, page 85.

11. *Ibid.*, page 107. Richard Friedman argues that it was Ezra who gave the final shape to the Law of Moses; see Finkelstein and Silberman, *Op. cit.*, page 310.

12. Philip R. Davies, *Scribes and Schools*, London: SPCK, 1998, page 24.

13. *Ibid.*, page 7.

14. Lane Fox, *Op. cit.*, page 109.

15. *Ibid.*, page 10.

16. *Ibid.*, page 116.

17. Philip Davies argues against this. He maintains that the final form of Hebrew scriptures tells us nothing about their evolution. Davies, *Op. cit.*, pages 89–90. In fact, these three divisions of Old Testament writings describe four phases of Israelite history: the ancient history of the world and the election of the ancestors of Israel (in Genesis); the creation of the nation, from the descendants of Jacob in Egypt and the Lord's gift of a constitution (law) and land; a period of decline, from the leadership of Moses, through Joshua and Saul to David and Solomon, and then through the less than ideal monarchies of Israel and Judah, culminating in exile in Babylon (Exodus to Kings and Chronicles); the restoration of Judah, the rebuilding of the Temple, and the reconstitution of Judah/Israel as a religious entity 'devoted to the convenant with Yahweh and to worship in his temple'. At this point canonised history ends, though of course Jewish history does not end. For Christians, Judaism comes to an end theologically, with the birth of the Messiah. *Ibid.*, page 55.

The word 'Jew' comes from the Hebrew *yehudi*, Judahite or Judaean, a descendant of Judah, Jacob's fourth son and heir, 'the historical carrier of the Blessing of Yahweh, first given to Abram (Abraham)'. Allen Bloom, *Closing, Op. cit.*, page 4.

It is worth remembering that the Christian Old Testament is arranged differently from the Hebrew Bible. The first five books are in the same order but have different titles. The Christian Genesis is the Hebrew Bereshith, 'In the beginning'; the Christian Numbers is the Hebrew Bemidbar, 'In the wilderness'. Hebrew practice, like the files of Microsoft Word, means they often take their titles from the first words of the chapter. After the Torah, or Pentateuch, there is little in common in the order of the books between the Old Testament and the Hebrew Bible. The Christian Old Testament ends with Malachi proclaiming a new Elijah, a new prophet, whereas the Hebrew Bible ends with the second book of Chronicles, the return to Jerusalem and the rebuilding of the Temple.

18. Allen Bloom, *Op. cit.*, pages 4–5.

19. Finkelstein and Silberman, *Op. cit.*, pages 246ff

20. Keith W. Whitelam, *The Invention of Ancient Israel*, London: Routledge, 1996, pages 128–129.

21. Finkelstein and Silberman, *Op. cit.*, pages 81ff.

22. Israel Finkelstein, personal interview, Tel Aviv, 22 Novem-

ber 1996. But see also: Finkelstein and Silberman, *Op. cit.*, pages 72ff.

23. Amihai Mazar, personal interview, Tel Aviv, 22 November 1996.

24. Raz Kletter, personal interview, Tel Aviv, 25 November 1996. Ephraim Stern, *Archaeology of the Land of the Bible*, volume 2, New York: Doubleday, 2001, pages 200–209. Finkelstein and Silberman, *Op. cit.*, pages 246ff, also argue that the move to worship YHWH exclusively began only in the late eighth century BC.

25. Finkelstein and Silberman, *Op. cit.*, page 129.

26. Anne Punton, *The World Jesus Knew*, London: Olive Press/Monarch Books, 1996, page 182.

27. Lane Fox, *Op. cit.*, page 197.

28. *Ibid.*, page 16. Gordon and Rendsburg, *Op. cit.*, pages 36ff.

29. Lane Fox, *Op. cit.*, page 19.

30. *Ibid.*, page 21.

31. *Ibid.*, pages 58–59. See Finkelstein and Silberman, *Op. cit.*, pages 44–45, for the role of Abraham, the rise of Jerusalem and other consequences of the E and J versions. See also Thompson, *Op. cit.*, pages 105ff for the world of Genesis.

32. Harold Bloom, the American scholar, has argued that in fact J is the earliest element of the Old Testament, the origin of the scriptures, and, moreover, that its author was a woman. Commenting on a new translation of the J elements, he argues that this tenth-century woman conceived Yahweh more as a Greek or Sumerian god – highly anthropomorphic: exuberant, mischievous, capricious, 'an outrageous personality'. Bloom conceives the Old Testament as an amalgam analogous to a mixture of Homer and Hesiod. This all adds to the concept of the evolution of God, discussed in the previous chapter. David Rosenberg and Harold Bloom, *The Book Of J*, New York: Grove Weidenfeld, 1990, page 294.

33. Johnson, *Op. cit.*, page 91.

34. Punton, *Op. cit.*, page 83.

35. *Ibid.*, page 209.

36. *Ibid.*

37. *Ibid.*

38. Jean-Yves Empereur, *Alexandria*, London and New York: Thames & Hudson, 2001/2002, page 38.

39. Punton, *Op. cit.*, page 102.

40. Lane Fox, *Op. cit.*, page 123. See also: R. H. Charles, *The Apocrypha and Pseudepigrapha of the Old Testament*, Oxford: Oxford University Press, 1913.

41. Punton, *Op. cit.*, page 217.

42. A final element in the scriptures was the Oral Torah. This arose because, for all its authority, the written Torah did not – could not – account for all situations. For example, it allowed for divorce but did not specify what form divorce should take, nor how it should be arranged. Interpretation and explanation of the law thus proliferated and with it developed an oral tradition. In time, this oral tradition became as canonical as the written Torah and scholars with phenomenal memories devoted their lives to memorising and passing on this tradition (these men were called *Tanna'im*). Eventually, however, this body of tradition became so unwieldy that it, too, had to be written down. It was a move also provoked by two disasters that had befallen the Jews – the destruction of the second Temple in AD 70, and the failed revolt against Rome in AD 131–135. After the failed revolt, the Jews were so shattered, and so dispersed, that it seemed the oral tradition might be lost. In these circumstances Judah the Prince, a rabbi, decided to make it his life's work to record and organise

all the important oral traditions. He and his colleagues completed the work by AD 200 and this work is called the Mishnah. It covers the food laws, ritual purity, festivals and Temple practice, marriage and divorce, adultery and civil rights. Punton, *Op. cit.*, page 20.

43. Lane Fox, *Op. cit.*, page 167ff.
44. Davies, *Op. cit.*, page 176; Lane Fox, *Op. cit.*, page 200. See also: F. M. Cornford, *Principium Sapientiae: The Origins of Greek Philosophical Thought*, Cambridge, England: Cambridge University Press, 1952.
45. Johnson, *Op. cit.*, page 93.
46. Lane Fox, *Op. cit.*, page 402.
47. *Ibid.*, page 410.
48. *Ibid.*, page 412. See Gordon and Rendsburg, *Op. cit.*, page 78, for another way Job is special – its division into prose and poetry, and the significance of this.
49. Punton, *Op. cit.*, page 192.
50. Johnson, *Op. cit.*, page 99.
51. Kenneth Clark, *Civilisation*, London: BBC, 1969, page 19.
52. Johnson, *Op. cit.*, page 102.
53. *Ibid.*, page 106.
54. Paula Fredericksen, *From Jesus to Christ*, New Haven and London: Yale University Press, 1988, page 87.
55. Colleen McDannell and Barnhard Lang, *Heaven: A History*, New Haven and London: Yale University Press, 1988, pages 12–13.
56. Frederiksen, *Op. cit.*, pages 88–89.
57. Christopher Rowland, *Christian Origins*, London: SPCK, 1985/1997, pages 72–73.
58. Rowland, *Op. cit.*, page 73; Frederiksen, *Op. cit.*, page 89.
59. Rowland, *Op. cit.*, page 88.
60. Frederiksen, *Op. cit.*, page 82.
61. *Ibid.*, page 93.
62. Gordon and Rendsburg, *Op. cit.*, page 265.
63. Rowland, *Op. cit.*, page 94.
64. Frederiksen, *Op. cit.*, page 77. The Apocryphal Testaments of Levi and Reuben speak of a priestly as well as a Davidic Messiah, and this is confirmed in the Dead Sea Scrolls.
65. Frederiksen, *Op. cit.*, page 78.
66. Johnson, *Op. cit.*, page 111.
67. *Ibid.* But see Finkelstein and Silberman, *Op. cit.*, page 316 for the power of the Bible in unifying the disparate Israelites.
68. The incense for the perpetual altar flame was made from a secret recipe by the Avtina family, whose women never wore perfume, so they could never be accused of corruption.
69. Johnson, *Op. cit.*, page 116.
70. Some idea of the size of the sacrifices may be had from the fact that there were thirty-four cisterns below the Temple to receive the water used to wash away the blood. Alongside these cisterns were vaults where was kept the money received as Temple fees from pilgrims from all over the world. Johnson, *Op. cit.*, pages 116–117.
71. G. A. Wells, *The Jesus of the Early Christians*, London: Pemberton Books, 1971, page 131.
72. *Ibid.*, page 4.
73. Eliade, *Patterns, Op. cit.*, page 426.
74. Lane Fox, *Op. cit.*, page 202.
75. *Ibid.*, pages 147–148.
76. *Ibid.*, page 151. See Walter Bauer, *Orthodoxy and Heresy in Early Christianity*, Philadelphia: Fortress Press, 1971, pages 80ff, for a discussion of the world that gave rise to non-canonical gospels.
77. Lane Fox, *Op. cit.*, pages 123–124. See also: Bauer, *Op. cit.*, pages 184ff, for a discussion of the early manuscripts of the gospels.
78. Lane Fox, *Op. cit.*, page 126.
79. *Ibid.*, page 114. Bauer, *Op. cit.*, pages 128–129, for the role of Marcion.
80. In 1966 the United Bible Societies issued a new Greek text of the Bible, for students and translators. According to the UBS, 'There were two thousand places where alternative readings of any significance survived in good manuscripts.' Lane Fox, *Op. cit.*, page 156.
81. Frederiksen *Op. cit.*, page 51.
82. Rowland, *Op. cit.*, page 127.
83. Around AD 200 there were Christians who argued that Christ had been born on 3 November (this was based on a misunderstanding about Herod's death), while others argued for the spring. Christmas has been celebrated on 25 December only since the fourth century and even then Christians in the eastern half of the empire preferred 6 January. Lane Fox, *Op. cit.*, page 36. See page 175 of this book.
84. Geźa Vermes, *The Religion of Jesus the Jew*, London: SCM Press, 1993, page 214.
85. *Ibid.*
86. Russell Shorto, *Gospel Truth*, New York: Riverhead/ Puttnam, 1997, page 33.
87. Wells, *Op. cit.*, page 12.
88. *Ibid.*, page 13.
89. *Ibid.*
90. Vermes, *Op. cit.*, page 217.
91. Lane Fox, *Op. cit.*, page 29.
92. *Ibid.*, page 30.
93. *Ibid.*
94. *Ibid.*, page 32. Bauer, *Op. cit.*, page 45, quotes a report that Philo was in touch with Peter in Rome.
95. Lane Fox, *Op. cit.*, page 33. Sir James Frazer, *The Golden Bough*, Oxford: Oxford University Press, 1890/1994, page 358.
96. Vermes, *Op. cit.*, pages 46–47.
97. Johnson, *Op. cit.*, page 139.
98. Lane Fox, *Op. cit.*, page 21.
99. But Galilee is important in another way too. In the late 1990s, Dr Elhanen Reiner, of Tel Aviv University, came across some *midrash* – ancient commentaries on the Old Testament – dating back to 200 BC. These early documents contain several references to a Galilean figure of that date called Joshua who sounds very familiar. In Galilee, 'Jesus' was a common corruption of 'Joshua' and the narrative of Joshua has many parallels with that of Jesus, namely: (1) The first phase of Joshua's leadership took place in Transjordan; Jesus' first appearance in the Bible as an adult occurs with him bathing in the Jordan. (2) Joshua appointed twelve elders to apportion the land of Israel, just as Jesus appointed twelve disciples. (3) Joshua's death 'agitated the world', an angel came down and there was an earthquake to mark the fact that God thought Joshua's death a terrible thing, which few others did. Much the same happens with Jesus: the earth trembles and an angel descends. (4) The closest people to Joshua are called Joseph and Miriam (Mary). (5) Joshua's death took place on 18 Iyyar, three days before Passover, the same day as the Crucifixion. (6) There is a Hebrew tradition, in an Aramaic book, that Jesus' Crucifixion took place not in Jerusalem but in Tiberias – i.e., Galilee. (7) The stories of Joshua and Jesus both contain a Judah or Judas who plays a crucial, negative role. (8) At some point in the story, Joshua flees to Egypt, just as the family of the infant Jesus

flees to Egypt. This is not the end of the parallels between the two traditions but even these few are enough to raise doubts about Jesus' true identity. Personal interview, Tel Aviv, 26 November 1996.

100. Wells, *Op. cit.*, page 93.

101. *Ibid.*, page 94.

102. *Ibid.*, page 95.

103. *Ibid.*, page 99. See also: Brian Moynahan, *The Faith*, London: Aurum, 2002, pages 11–13.

104. Frederiksen, *Op. cit.*, pages 120–121.

105. Wells, *Op. cit.*, page 245.

106. *Ibid.*

107. *Ibid.*, page 103.

108. *Ibid.*, page 40. See Moynahan, *Op. cit.*, page 16, for a clear account of the deposition.

109. Rowland, *Op. cit.*, page 189.

110. *Ibid.*

111. *Ibid.*, pages 191–192. See Moynahan, *Op. cit.*, page 19, on the role of women.

112. Shorto, *Op. cit.*, page 147.

113. *Ibid.*, pages 160–161.

114. In October 2002 a limestone ossuary was found, allegedly south of the Mount of Olives in Jerusalem. The box had actually been looted but the Geological Survey of Israel confirmed that the limestone did come from the Jerusalem area. What was notable about the box was that it was inscribed, in Aramaic, with the words 'James, son of Joseph, brother of Jesus'. According to Professor André Lemaire, of the Sorbonne in Paris, the style of writing dated the ossuary to between AD 10 and AD 70. The names James, Joseph and Jesus were not uncommon at the time: 233 first-century ossuaries have been found and nineteen mention Joseph, ten Jesus and five James (Ya'aqov in Aramaic). Given a male population of Jerusalem of about 40,000, and assuming that each man had two brothers, Professor Lemaire has calculated that there would have been about twenty men at the time who were 'James, son of Joseph, brother of Jesus'. But, given that James (mentioned as Jesus' brother in both Matthew and Mark), was the leader of the Jerusalem church until AD 62, when he was stoned to death as a heretic, and that Jesus would also have been well known, Professor Lemaire argues that the odds on the ossuary really referring to Jesus Christ would be shorter than twenty to one. It was very rare for brothers to be mentioned in ossuaries and, of the 233 known, only one other case mentions brothers. In fact, doubts have since emerged about the authenticity of the box, which is now regarded as a fake. *Daily Mail* (London), 24 October 2002, page 13.

115. Vermes, *Op. cit.*, page 140.

116. *Ibid.*, pages 154ff.

117. *Ibid.*, page 26.

118. Frederiksen, *Op. cit.*, page 39.

119. *Ibid.*, page 135.

## CHAPTER 8: ALEXANDRIA, OCCIDENT AND ORIENT IN THE YEAR 0

1. G. J. Whitrow, *Time in History*, Oxford and New York: Oxford University Press, 1988, page 70.

2. E. G. Richards, *Mapping Time*, *Op. cit.*, page 7.

3. Whitrow, *Op. cit.*, page 32.

4. Richards, *Op. cit.*, pages 82–83. For the doubts on Babylonian influence in China, see: Endymion Wilkinson, *Chinese History: A Manual* (revised and enlarged edition), Cambridge, Massachusetts, and London Harvard University Asia Center, for the Harvard-Yenching Institute,

distributed by Harvard University Press, 2000, page 177.

5. Whitrow, *Op. cit.*, page 95. Wilkinson, *Op. cit.*, page 171.

6. Whitrow, *Op. cit.*, page 32.

7. *Ibid.*, page 271. Moon lore is treated in twenty-three cuneiform tablets in the library of Ashurbanipal. See: A. Leo Oppenheim, *Ancient Mesopotamia*, Chicago: University of Chicago Press, 1964, page 225.

8. Whitrow, *Op. cit.*, page 26.

9. *Ibid.*, page 39.

10. Richards, *Op. cit.*, 95.

11. *Ibid.*, page 106.

12. *Ibid.*, page 222.

13. Whitrow, *Op. cit.*, page 57.

14. Richards, *Op. cit.*, page 207.

15. Whitrow, *Op. cit.*, page 66.

16. Richards, *Op. cit.*, page 215.

17. Whitrow, *Op. cit.*, page 66.

18. Though it was also said that he wanted to commemorate Cleopatra, who had committed suicide in that month. Richards, *Op. cit.*, page 215.

19. Whitrow, *Op. cit.*, page 68.

20. Richards, *Op. cit.*, pages 218–219.

21. Empereur, *Op. cit.*, page 15. Peter Green, 'Alexander's Alexandria', Kenneth Hamma (editor), *Alexandria and Alexandrianism*, Malibu, California: J. Paul Getty Museum, 1996, page 11.

22. Roy Macleod (editor), *The Library of Alexandria*, London: I. B. Tauris, 2000, page 36. Günter Grimm, 'City planning?', in Hamma (editor), *Op. cit.*, page 66.

23. Empereur, *Op. cit.*, page 3.

24. *Ibid.*, page 4.

25. Theodore Vrettos, *Alexandria: City of the Western Mind*, New York and London: Free Press, 2001, pages 34–35. Lilly Kahil, 'Cults in Hellenistic Alexandria' in Hamma (editor), *Op. cit.*, page 77.

26. Empereur, *Op. cit.*, page 6.

27. *Ibid.*, page 7. A brief overview of Alexandrian scholarship is given in E. M. Forster, *Alexandria: A History and a Guide* (editor, Miriam Allott), London: André Deutsch, 2004, pages 34–35.

28. Vrettos, *Op. cit.*, pages 52–53.

29. *Ibid.*, page 55.

30. *Ibid.*, page 42.

31. Empereur, *Op. cit.* pages 6–7.

32. Carl Boyer, revised by Uta C. Merzbach, *A History of Mathematics* (second edition), New York: John Wiley, 1968/1991, pages 104f.

33. Vrettos, *Op. cit.*, page 43. The originals of many of Euclid's works have been lost and they survive only in Arabic translations, later rendered into Latin and modern languages. Among those completely lost is one which may consist of his most original idea, *Porisms*. It is not quite clear what a porism was to Euclid but from later commentators it appears to have been a conception intermediate between a theorem and a problem. Boyer, *Op. cit.*, page 101.

34. Lindberg, *Op. cit.*, page 87.

35. Vrettos, *Op. cit.*, page 50.

36. Ettore Carruccio, *Mathematics and Logic in History and Contemporary Thought*, London: Faber, 1964, pages 80–83.

37. Lindberg, *Op. cit.*, page 88. Archimedes also developed 'the method'. This, which explained his way of working, came to light in the most colourful of fashions. It was recovered almost by accident in 1906 by the Danish historian of science, J. L. Heiberg. He had read that at Con-

stantinople there was a palimpsest 'of mathematical content'. Boyer, *Op. cit.*, page 139. A palimpsest is a parchment from which the original writing has been washed away and written over with a new text. Heiberg found that on this occasion the original writing had been imperfectly removed and, with the aid of photographs, he could read the original. This turned out to be a letter written by Archimedes to Eratosthenes, mathematician and librarian at Alexandria, containing fifteen propositions outlining his way of working which included, in some cases, hanging threads as one balances weights in mechanisms, to test his calculations. In other words, *The Method* explains how Archimedes went from levers to more advanced maths using the same principles. *Ibid.*, page 137.

38. Lindberg, *Op. cit.*, page 89.
39. Vrettos, *Op. cit.*, page 58.
40. *Ibid.*, pages 60ff.
41. Boyer, *Op. cit.*, pages 140ff.
42. Lindberg, *Op. cit.*, page 97.
43. Vrettos, *Op. cit.*, pages 163–168.
44. *Ibid.*
45. *Ibid.*
46. *Ibid.*, page 177.
47. *Ibid.*, page 185.
48. *Ibid.*, page 195.
49. Lindberg, *Op. cit.*, page 97.
50. Heinrich von Staden, 'Body and machine: interactions between medicine, mechanics and philosophy in early Alexandria', in: Hamma (editor), *Op. cit.*, pages 85ff.
51. Von Staden, *Op. cit.*, page 87.
52. *Ibid.*, page 89.
53. *Ibid.*, page 92.
54. *Ibid.*, page 95.
55. Lindberg, *Op. cit.*, page 105. In Alexandria, doctors could be divided into those using folklore remedies, practitioners who could not read and write, and literate doctors, who sought to gain experience by reading texts, and translations of texts, from all over the world, studying theories and practices that other doctors used, or said that they used, seeking authority in the past.
56. *Ibid.*
57. Empereur, *Op. cit.*, page 7.
58. *Ibid.*, page 8.
59. Richards, *Op. cit.*, page 173.
60. *Ibid.*, page 27.
61. John Keay, *India: A History*, London: HarperCollins, 2000, pages 130–133.
62. Jean S. Sedlar, *India and the Greek World*, Totowa, New Jersey: Rowman & Littlefield, 1980, page 65.
63. Sedlar, *Op. cit.*, page 82.
64. *Ibid.*, page 84.
65. *Ibid.*, page 92–93.
66. Radhakamal Mukerjee, *The Culture and Art of India*, London: Allen & Unwin, 1959, page 99.
67. *Ibid.*, page 107.
68. Sedlar, *Op. cit.*, page 109.
69. *Ibid.*, page 111.
70. *Ibid.*, page 112.
71. *Ibid.*, page 122. H. G. Keene Cie, *History of India*, London: W. H. Allen, 1893, pages 28–29, dismisses this, arguing that Buddha emerged out of Brahmanism, which may also have given elements to early Judaism and thence to Christianity.
72. Sedlar, *Op. cit.*, page 180.
73. *Ibid.*, page 176.
74. *Ibid.*, page 180.

75. *Ibid.*, page 187.
76. Keay, *Op. cit.*, page 78.
77. *Ibid.*, page 85. Chandragupta was a Jain and retired to Karnataka, at Stravana Belgola, west of Bangalore. There, in a cave in a hill, the emperor is said to have starved himself to death, 'the ultimate act of Jain self-denial'. Apparently, the emperor, so successful in many ways, abdicated after learning of an imminent famine from a famous monk, Bhadrabahu, said to be the last Jain monk to have known the founder of the faith, Mahavira Nataputta. *Ibid.*, page 86.
78. A. L. Basham (editor), *A Cultural History of India*, Oxford and New Delhi: Oxford University Press, 1975, page 42.
79. *Ibid.*, page 88. For the Pali/Prakrit scripts, see Richard Lannoy, *The Speaking Tree: A Study of Indian Culture and Society*, Oxford: Oxford University Press, 1971, page 328.
80. Keay, *Op. cit.*, page 89.
81. *Ibid.*, page 97. See Keene Cie, *Op. cit.*, pages 34–35 for some of the alliances formed by Ashoka, and for the spread of Brahmanism.
82. Keay, *Op. cit.*, page 80.
83. Mukerjee, *Op. cit.*, page 91.
84. Keay, *Op. cit.*, page 81.
85. Ralph Turner, *The Great Cultural Traditions*, volume II, New York: McGraw-Hill, 1941, pages 758–759.
86. *Ibid.*, page 760.
87. *Ibid.*, page 762.
88. Basham (editor), *Op. cit.*, page 171.
89. *Ibid.*, pages 170–171.
90. Keay, *Op. cit.*, pages 44–47.
91. *Ibid.*, page 101.
92. *Ibid.*, page 103. See Keene Cie, *Op. cit.*, pages 29ff, for the India known to the Greeks.
93. Basham (editor), *Op. cit.*, page 116.
94. *Ibid.*, page 122.
95. Keay, *Op. cit.*, page 104.
96. D. P. Singhal, *India and World Civilisation*, volume 1, London: Sidgwick & Jackson, 1972, page 272. Indian traders and missionaries extended their influence in south-east Asia. Excavations in the Mekong delta, in what is now Vietnam, have uncovered stone statues of Vishnu and other Hindu deities dating to the second century A D. Other finds support the idea that writing was introduced into south-east Asia from India.
97. Fairbanks, *Op. cit.*, pages 72ff.
98. Richards, *Op. cit.*, page 170. Wilkinson, *Op. cit.*, pages 388ff, for the origins of Chinese script and the discovery of oracle bones; page 175 for the *ganzhi* system; pages 181 for the various words for year; page 202 for the 100 units; page 225 for approximate and authoritative numbers; page 241 for anti-falsification devices.
99. Richards, *Op. cit.*, page 166. Wilkinson, *Op. cit.*, page 206 for the meal drum and curfew.
100. Fairbanks, *Op. cit.*, page 62.
101. *Ibid.*, page 63.
102. *Ibid.*, page 64.
103. *Ibid.*, page 65. Charles O. Hucker, *China's Imperial Past*, London: Duckworth, 1975, pages 194ff, says it was still being written in the second century B C.
104. Fairbanks, *Op. cit.*, page 65.
105. Jacques Gernet, *A History of Chinese Civilisation* (second edition), Cambridge, England: Cambridge University Press, 1982, page 163. (French edition: Paris: Librairie Armand Colin, 1972; translated by J. R. Foster and Charles Hartman.)

106. Fairbanks, *Op. cit.*, page 70. See also: Wilkinson, *Op. cit.*, page 476, for the derivation of the word for 'classic'.
107. Gernet, *Op. cit.*, pages 163–164.
108. *Ibid.*, page 167.
109. Fairbank, *Op. cit.*, page 67 and Gernet, *Op. cit.*, page 159. By the mid-second century AD, some 30,000 students were reported at the academy, though presumably not all were resident at the same time. (China then had a population of about 60 million.)
110. Fairbank, *Op. cit.*, page 68.
111. Hucker, *Op. cit.*, page 56.
112. Gernet, *Op. cit.*, page 160.
113. Turner, *Op. cit.*, page 776.
114. *Ibid.*, page 777.
115. *Ibid.*, page 778.
116. *Ibid.*
117. Hucker, *Op. cit.*, page 213.
118. Gernet, *Op. cit.*, page 124.
119. Fairbanks, *Op. cit.*, page 63.
120. Gernet, *Op. cit.*, page 140.
121. *Ibid.*, pages 131–132.
122. *Ibid.*, pages 134–135. See Werner Eichhorn, *Chinese Civilisation*, London: Faber & Faber, 1969, page 155, for a discussion of the economics of silk and the etymology of the words. (The Chinese word for silk is *ssu.*)
123. Gernet, *Op. cit.*, page 141.
124. Eichhorn, *Op. cit.*, page 114 for an example of his poetry. Gernet, *Op. cit.*, page 162.
125. Hucker, *Op. cit.*, page 200.
126. Jonathan Bloom, *Paper Before Print: The History and Impact of Paper in the Islamic World*, New Haven and London: Yale University Press, 2001, page 32.
127. *Ibid.*, page 33.
128. *Ibid.*, page 34.
129. *Ibid.*, page 36.
130. Gernet, *Op. cit.*, pages 168–169.

CHAPTER 9: LAW, LATIN, LITERACY AND THE LIBERAL ARTS

1. Lionel Casson, *Libraries in the Ancient World*, New Haven and London: Yale University Press, 2001, pages 26–28.
2. *Ibid.*, page 68.
3. *Ibid.*
4. Joseph Farrell, *Latin Language and Latin Culture*, Cambridge, England: Cambridge University Press, 2001, page 32.
5. Jones *et al.*, *The World of Rome*, *Op. cit.*, page 7.
6. *Ibid.*, page 7.
7. *Ibid.*, page 9.
8. Michael Grant, *The World of Rome*, London: Weidenfeld & Nicolson, 1960, page 26.
9. Jones *et al.*, *Op. cit.*, page 84.
10. *Ibid.*
11. *Ibid.*, page 96.
12. Grant, *Op. cit.*, page 13.
13. Jones *et al.*, *Op. cit.*, page 116.
14. *Ibid.*, page 118.
15. Grant, *Op. cit.*, page 27.
16. Jones *et al.*, *Op. cit.*, page 121.
17. J. D. Bernal, *Science in History*, volume 1, London: Penguin, 1954, page 230, gives a general perspective on Roman law.
18. Jones *et al.*, *Op. cit.*, page 275. For the jurists, see: O. F. Robinson, *The Sources of Roman Law*, London and New York: Routledge, 1997, pages 42ff.
19. Jones *et al.*, *Op. cit.*, page 257.
20. Beryl Rawson (editor), *The Family in Ancient Rome*, London and Sydney: Croom Helm, 1986, pages 5ff and the references mentioned.
21. *Ibid.*, pages 16–17; and chapter 5, *passim.*
22. Bernal, *Op. cit.*, page 230.
23. Jones *et al.*, *Op. cit.*, page 214.
24. *Ibid.*
25. *Ibid.*, page 238.
26. C. W. Valentine, *Latin: Its Place and Value in Education*, London: University of London Press, 1935; see chapter headings, pages 41, 54 and 73.
27. Farrell, *Op. cit.*, *passim.*
28. Mason Hammond, *Latin: A Historical and Linguistic Handbook*, Cambridge, Massachusetts: Harvard University Press, 1976, pages 21–23.
29. *Ibid.*, page 25.
30. *Ibid.*, page 39.
31. *Ibid.*, page 51.
32. J. Wight Duff, *A Literary History of Rome*, London: Ernest Benn, 1963, page 16.
33. Jones *et al.*, *Op. cit.*, page 200.
34. *Ibid.*
35. Oscar Weise, *Language and Character of the Roman People*, London: Kegan Paul, Trench, Trübner & Co., 1909, translated by H. Strong and A. Y. Campbell, page 4.
36. *Ibid.*, page 8.
37. Farrell, *Op. cit.*, page 40.
38. Duff, *Op. cit.*, page 19.
39. Farrell, *Op. cit.*, pages 54–55.
40. Jones *et al.*, *Op. cit.*, page 214.
41. *Ibid.*, page 218.
42. For the authority of classical Latin, and its metres in poetry, see: Philip Hardie, 'Questions of authority: the invention of tradition in Ovid's Metamorphoses 15', in Thomas Habinek and Alessandro Schiesaro (editors), *The Roman Cultural Revolution*, Cambridge, England: Cambridge University Press, 1997, page 186.
43. Jones *et al.*, *Op. cit.*, page 232.
44. *Ibid.*, page 234. Moynahan, *The Faith*, *Op. cit.*, page 28.
45. Moynahan, *Op. cit.*, pages 241–242.
46. Jones *et al.*, *Op. cit.*, page 234.
47. Colish, *Op. cit.*, page 24.
48. Jones *et al.*, *Op. cit.*, page 239.
49. *Ibid.*, page 240.
50. Grant, *Op. cit.*, page 71.
51. *Ibid.*, page 262.
52. William V. Harris, *Ancient Literacy*, Cambridge, Massachusetts: Harvard University Press, 1989, page 19.
53. *Ibid.*, page 328.
54. *Ibid.*, page 32.
55. *Ibid.*, page 35. Some modern scholars have argued that literacy – writing – made it possible for the Greeks to organise city-states and, no less fundamental, that writing kick-started philosophy and science by stimulating a critical attitude by allowing rival arguments to be set out side-by-side. *Ibid.*, page 40. Another argument is that writing enabled laws to be displayed in public, aiding the spread of democracy. In turn, these arguments have been dismissed as 'woolly'. *Ibid.*, page 41. Even so, it seems clear that the vast Roman empire could not have been built without the help of writing, or literacy. How else could one man send out orders over thousands of miles and expect his authority to be obeyed?
56. L. D. Reynolds and N. G. Wilson, *Scribes and Scholars: A Guide to the Transmission of Greek and Latin Literature*

(third edition), Oxford: The Clarendon Press of Oxford University Press, 1968/1991, page 25.

57. Jones *et al.*, *Op. cit.*, page 266.
58. Harris, *Op. cit.*, page 202.
59. *Ibid.*, pages 204–205.
60. *Ibid.*, page 214.
61. Reynolds and Wilson, *Op. cit.*, page 5.
62. *Ibid.*, page 22.
63. *Ibid.*, page 25.
64. *Ibid.*, page 22.
65. Jones *et al.*, *Op. cit.*, page 263.
66. *Ibid.*, page 217.
67. Boorstin, *The Seekers*, *Op. cit.*, page 146.
68. Jones *et al.*, *Op. cit.*, pages 259–261.
69. As for the 'literary' graffiti, most had spelling errors after the first three or four words, implying that the phrases had been memorised and copied by hands unfamiliar with the orthographical rules of Latin.
70. See Jones *et al.*, *Op. cit.*, page 264.
71. *Ibid.*, page 269.
72. For some of the 'urbane' values in Rome see: Andrew Wallace-Hadrill, '*Mutatio morum*: the idea of a cultural revolution', in Habinek and Schiesaro (editors), *Op. cit.*, pages 3–22.
73. Jones *et al.*, *Op. cit.*, page 272.
74. Reynolds and Wilson, *Op. cit.*, page 3. For papyrus, see also: Bernhard Bischoff (translated by Dáibhi Ó Cróinin and David Ganz), *Latin Palaeography: Antiquity and the Middle Ages*, Cambridge, England: Cambridge University Press, 1991/2003, page 7.
75. Reynolds and Wilson, *Op. cit.*, page 4.
76. *Ibid.*, page 8.
77. *Ibid.*, page 11.
78. *Ibid.*, pages 31ff.
79. Lindberg, *Op. cit.*, page 138.
80. Reynolds and Wilson, *Op. cit.*, page 33.
81. William H. C. Frend, *The Archaeology of Early Christianity*, London: Geoffrey Chapman/Cassell, 1996, pages 34–36, which discusses early codices.
82. Reynolds and Wilson, *Op. cit.*, page 35.
83. J. M. Ross, introduction to: Cicero, *The Nature of the Gods*, London: Penguin Books, 1972, page 7.
84. *Ibid.*, page 59.
85. R. H. Barrow, *The Romans*, London: Penguin Books, 1949/61, page 156.
86. *Ibid.*, page 165.
87. Cicero, *Selected Works*, London: Penguin Books, 1960/71, Introduction by J. M. Ross, page 11.
88. *Ibid.*, page 12.
89. *Ibid.*, page 25.
90. Virgil, *The Aeneid*, Oxford: Oxford University Press, 1986/98, introduction by Jasper Griffin, page xvii. Boorstin, *Op. cit.*, pages 145f, says it took Virgil eleven years to compose the *Aeneid*.
91. Lindberg, *Op. cit.*, page 125.
92. *Ibid.*, page 126.
93. *Ibid.*
94. *Ibid.*, page 129. See Bernal, *Op. cit.*, pages 222–223 for a brief overview and the fact that Galen was translated fully into English only in 1952.
95. Lindberg, *Op. cit.*, page 130.
96. Jones *et al.*, *Op. cit.*, page 295.
97. *Ibid.*, page 292.
98. Boorstin, *Op. cit.*, page 63.
99. Jones *et al.*, *Op. cit.*, page 245.
100. *Ibid.*, page 288.
101. W. G. De Burgh, *The Legacy of the Ancient World*, *Op. cit.*, page 256.
102. Jones *et al.*, *Op. cit.*, page 290. Pasiteles and his workshop, for example, specialised in pastiches – statues which, for instance, combined the head from one Greek original with the posture of another.
103. Edward Gibbon, *The History of the Decline and Fall of the Roman Empire*, London, 1788, chapter 3. I have used the Dell version, published in New York in 1963.

## CHAPTER 10: PAGANS AND CHRISTIANS, MEDITERRANEAN AND GERMANIC TRADITIONS

1. Ferrill, *Op. cit.*, page 12.
2. *Ibid.*
3. *Ibid.*, page 15.
4. *Ibid.*, page 17.
5. Turner, *The Great Cultural Traditions*, *Op. cit.*, page 270.
6. *Ibid.*, pages 270ff. Bauer, *Op. cit.*, page 57, discusses a 'Gospel of the Hebrews'.
7. Turner, *Op. cit.*, page 273.
8. *Ibid.*, pages 275–276.
9. *Ibid.*, page 278. This embarrassing fact may also explain why the gospel of Mark transfers the responsibility for Jesus' execution from Pontius Pilate to the Jewish leaders. *Ibid.* Some modern scholars believe that Brandon exaggerates the meaning of the term 'zealot' – that they were more bandits than full-scale revolutionaries.
10. *Ibid.*, page 279. Moynahan, *Op. cit.*, page 36, considers the *four* brothers of Jesus.
11. Freeman, *Op. cit.*, page 108.
12. Rowland, *Op. cit.*, page 195.
13. Turner, *Op. cit.*, page 280.
14. Rowland, *Op. cit.*, page 216. See Moynahan, *Op. cit.*, pages 23ff, for Paul's conversion and the importance of Antioch in early Christianity.
15. Turner, *Op. cit.*, page 317.
16. *Ibid.*, page 318.
17. Rowland, *Op. cit.*, pages 220ff.
18. Turner, *Op. cit.*, page 374.
19. *Ibid.*, page 375. Moynahan, *Op. cit.*, page 26 for the details.
20. Freeman, *Op. cit.*, page 121.
21. *Ibid.*, page 119.
22. Prudence Jones and Nigel Pennick, *A History of Pagan Europe*, London: Routledge, 1995, page 53.
23. Armstrong, *A History of God*, *Op. cit.*, page 109.
24. *Ibid.*, page 110.
25. Jones and Pennick, *Op. cit.*, page 55.
26. *Ibid.*, page 57.
27. *Ibid.*, page 58.
28. Lane Fox, *Op. cit.*, pages 168ff; Moynahan, *Op. cit.*, page 29, for the links between Stoicism and Christianity.
29. Lane Fox, *Op. cit.*, page 94.
30. *Ibid.*, page 30, but see Chapter 25 of this book.
31. *Ibid.*, page 299.
32. Another idea, not exactly anathema to pagans, but seen by them as irrational, was that of angels. These divine presences had apparently been conceived in late Judaism (among the Essene sects at Qumran, who wrote the Dead Sea Scrolls, for example), and Paul had made much of them on his travels. They appeared at times of crisis, to help believers, and so the early years of the church were especially favourable circumstances.
33. See Robin Lane Fox, *Pagans and Christians*, London and New York: Viking, 1986, chapter 9, pages 419ff, for the violence of this time.

34. Jones and Pennick, *Op. cit.*, page 62. Bauer, *Op. cit.*, pages 24f.

35. Lane Fox, *Pagans and Christians, Op. cit.*, page 567.

36. Turner, *Op. cit.*, page 377. See Moynahan, *Op. cit.*, pages 70ff, for the different tortures used on martyrs and the different ways they devised for being crucified.

37. It should not be overlooked that his immediate predecessor, Galerius, had issued an edict of toleration in 311 on his deathbed. Many consider this, rather than the conversion of Constantine, the turning-point in religious history. Jones and Pennick, *Op. cit.*, pages 64–65. In 311 the same man reported how the people of several cities had approached him to plead for a renewed persecution of the Christians. Lane Fox, *Pagans and Christians, Op. cit.*, pages 612–613.

38. Jones and Pennick, *Op. cit.*, page 65. Bauer, *Op. cit.*, page 45, for the role of Julius Africanus and that of the early bishops. And see Moynahan, *Op. cit.*, page 104, for Julius' role in specifying holy sites, such as that for Noah's Ark.

39. Turner, *Op. cit.*, page 1054.

40. *Ibid.*, page 1057. Moynahan, *Op. cit.*, page 76, for the problems faced by Diocletian and Valerian.

41. Turner, *Op. cit.*, page 1059.

42. Lane Fox, *Pagans and Christians, Op. cit.*, pages 613–614. Moynahan, *Op. cit.*, pages 91–93, for a vivid description of the battle of the Milvian bridge.

43. Jones and Pennick, *Op. cit.*, pages 68–69.

44. Lane Fox, *Pagans and Christians, Op. cit.*, pages 150–151.

45. Jones and Pennick, *Op. cit.*, page 75.

46. Lane Fox, *Pagans and Christians, Op. cit.*, page 670.

47. Armstrong, *A History of God, Op. cit.*, page 147.

48. The number seven was chosen because that was the number of sub-leaders appointed by the Apostles in Jerusalem. Turner, *Op. cit.*, pages 1070–1071.

49. *Ibid.*, page 1075.

50. *Ibid.*, page 1076.

51. However, he was forced to surrender church vessels and gold. Moynahan, *Op. cit.*, page 154.

52. Turner, *Op. cit.*, page 1080.

53. *Ibid.*, and Moynahan, *Op. cit.*, pages 129ff.

54. Turner, *Op. cit.*, page 1080.

55. Monks were not allowed to wash and had to cover their heads at meals, because Pachomius thought that eating was 'an unbecoming act'. *Ibid.* See Moynahan, *Op. cit.*, page 133, for Pachomius and his method for the prevention of fraud.

56. Norman Cantor, *The Civilisation of the Middle Ages*, New York: HarperCollins, 1963/1993, page 149.

57. *Ibid.*, page 149.

58. Turner, *Op. cit.*, page 1095, and Moynahan, *Op. cit.*, page 44 for early Christian writing.

59. Turner, *Op. cit.*, page 1096.

60. *Ibid.*, page 1097.

61. *Ibid.*, page 1104. See Moynahan, *Op. cit.*, pages 115–116, for the Montanist beliefs about diet.

62. The 'Muratorian Fragment', so called after its discoverer Muratori (1672–1750), was written at about this time and its layout suggests that Roman congregations had by then long regarded the canon as divinely inspired.

63. Turner, *Op. cit.*, page 1112.

64. Moynahan, *Op. cit.*, pages 56–57.

65. Armstrong, *A History of God, Op. cit.*, page 113.

66. *Ibid.*, page 118. See Moynahan, *Op. cit.*, page 46, for Origen's doubts about Paul's authorship of 'his' epistles.

67. Turner, *Op. cit.*, page 1114.

68. *Ibid.*

69. Barrow, *Op. cit.*, page 364.

70. Colish, *Op. cit.*, page 22.

71. St Augustine, *Confessions*, London: Penguin Books, 1961, introduction by R. S. Pine-Coffin, page 11. Moynahan, *Op. cit.*, pages 144ff, for a vivid picture of the young man, with his hard-drinking father and his boisterousness.

72. He had a further weakness for being liked, a fault (as he saw it) which led him to rob an orchard as a boy and as an adult to admit to crimes he had not committed.

73. Colish, *Op. cit.*, page 28.

74. *Ibid.* In his later books he carried this thinking further. In *On Order*, for example, he considers two types of evil – natural and moral. An example of a natural evil is an earthquake. It is evil because innocent people suffer. At the same time, however, earthquakes in the long run enhance the fertility of the soil, so they are also good. This is not so much an explanation as an explaining away: the residual Neoplatonist in Augustine was alive and well. Moral evil was more difficult, and he admitted as much. Some of it could be explained away – two examples he gives are sewers and prostitutes, both of which are evil in the short term, but both of which are needed in the wider scheme, to maintain order. But Augustine always had a problem with, for example, murder. He couldn't explain that away, and he couldn't explain why God allowed it. See Moynahan, *Op. cit.*, page 149, for a discussion of Augustine's idea of predestination.

75. Armstrong, *A History of God, Op. cit.*, page 126.

76. *Ibid.*, page 135.

77. *Ibid.*, page 142.

78. Colish, *Op. cit.*, page 29.

79. *Ibid.*

80. Armstrong, *A History of God, Op. cit.*, pages 139ff.

81. *Ibid.*, page 145. But see Moynahan, *Op. cit.*, page 149 for what he says is Augustine's denial of original sin.

82. Moynahan, *Op. cit.*, pages 192ff, for Gregory's administrative genius.

83. Colish, *Op. cit.*, page 40.

84. The full moon shows the glory of perfection, to which man must aspire, and which only Jesus attained. Accurate dating of future festivals was also important because early Christians believed that to celebrate Easter too soon was sacrilegious. To do so meant you thought you could be 'saved without the assistance of God's grace', hubris on a colossal scale. To celebrate too late was also sacrilegious – it meant you didn't care, were not assiduous in the profession of your faith. The date of Easter was thus pivotal, and many other feasts depended on it. Richards, *Op. cit.*, pages 345ff.

85. *Ibid.*, page 350.

86. Moynahan, *Op. cit.*, page 57, for details about the early variations in the celebration of Easter.

87. *Ibid.*, pages 1–2.

88. There was even a tradition that the rules of the computus had been disclosed to St Pachomius, the fourth-century Egyptian monk, who had been visited by an angel. See Bauer, *Op. cit.*, pages 152–154 for details.

89. Richards, *Op. cit.*, page 350. Regarding the changing nature of Christianity, see, for example: Peter Brown, *The Cult of the Saints*, Chicago: University of Chicago Press, 1981/1982; and R. A. Markus, *The End of Ancient Christianity*, Cambridge, England: Cambridge University Press/Canto, 1990/1998.

90. Ferrill, *Op. cit.*, pages 17–18.

91. *Ibid.*, page 18.

92. *Ibid.*

93. *Ibid.*, page 17.
94. *Ibid.*
95. Arno Borst, *Medieval Worlds: Barbarians, Heretics and Artists in the Middle Ages*, London: Polity, 1991, page 3.
96. *Ibid.*
97. *Ibid.*, page 5.
98. *Ibid.*
99. *Ibid.*
100. *Ibid.*, page 6. See Moynahan, *Op. cit.*, page 152, for St Augustine's reaction.
101. Borst, *Op. cit.*, page 6.
102. D. Herlihy, *Medieval Culture and Society*, London: Macmillan, 1968, page xi.
103. William Manchester, *A World Lit Only by Fire*, New York and London: Little Brown, 1992, page 3.
104. *Ibid.*, page 5.
105. *Ibid.*
106. *Ibid.*, page 7.
107. *Ibid.*, page 15.
108. Peter S. Wells, *The Barbarians Speak*, Princeton, New Jersey and London: Princeton University Press, 1999, page 100.
109. *Ibid.*, page 103.
110. P. J. Geary, *The Myth of Nations: The Medieval Origins of Europe*, Princeton, New Jersey and London: Princeton University Press, 2002, page 64.
111. Wells, *Op. cit.*, pages 107–108.
112. *Ibid.*, page 108.
113. Warwick Bray and David Tramp, *The Penguin Dictionary of Archaeology*, London: Penguin Books, 1970, page 130.
114. Geary, *Op. cit.*, page 73.
115. *Ibid.*, page 79. See Moynahan, *Op. cit.*, pages 191ff, for a vivid account of pagan conversions to Christianity.
116. Geary, *Op. cit.*, page 81.
117. Wells, *Op. cit.*, pages 116–117.
118. *Ibid.*, page 118.
119. *Ibid.*, pages 118 and 126.
120. *Ibid.*, page 123 – see map there.
121. *Ibid.*, page 114.
122. Jones and Pennick, *Op. cit.*, page 81.
123. *Ibid.*
124. Wells, *Op. cit.*, pages 163ff.
125. *Ibid.*, page 185.
126. Jones and Pennick, *Op. cit.*, pages 120ff.
127. Wells, *Op. cit.*, page 256.
128. Geary, *Op. cit.*, page 93.
129. *Ibid.*, page 109.
130. Borst, *Op. cit.*, page 6. Moynahan, *Op. cit.*, page 197, describes pagan and Christian practices that existed side-by-side 'for many centuries'.
131. Borst, *Op. cit.*, pages 6–7.

## CHAPTER 11: THE NEAR-DEATH OF THE BOOK, THE BIRTH OF CHRISTIAN ART

1. Joseph Vogt, *The Decline of Rome*, London: Weidenfeld & Nicolson, 1967, page 51.
2. *Ibid.*, page 183.
3. *Ibid.*, page 185. Moynahan, *Op. cit.*, pages 150–151.
4. Vogt, *Op. cit.*, page 187.
5. Lionel Casson, *Libraries in the Ancient World*, New Haven and London: Yale University Press, 2001, page 137.
6. Vogt, *Op. cit.*, page 188.
7. *Ibid.*, page 198.
8. Moynahan, *Op. cit.*, page 153fn.
9. Vogt, *Op. cit.*, page 236.
10. *Ibid.*, page 234.
11. Reynolds and Wilson, *Op. cit.*, page 48.
12. Anne Glynn-Jones, *Holding Up a Mirror*, London: Century, 1996, page 201.
13. *Ibid.*, pages 201–202.
14. Freeman, *Op. cit.*, page 321.
15. Richard E. Rubenstein, *Aristotle's Children: How Christians, Muslims, and Jews Rediscovered Ancient Wisdom and Illuminated the Dark Ages*, New York and London: Harcourt, 2003, pages 77–78.
16. Freeman, *Op. cit.*, page 325.
17. *Ibid.*, page 327.
18. *Ibid.*, pages 322–323.
19. Vogt, *Op. cit.*, page 202. Moynahan, *Op. cit.*, page 101.
20. Freeman, *Op. cit.*, page 323.
21. *Ibid.*
22. Vogt, *Op. cit.*, page 203.
23. Casson, *Op. cit.*, page 139.
24. *Ibid.*, page 140.
25. Reynolds and Wilson, *Op. cit.*, page 53.
26. *Ibid.*
27. *Ibid.*, page 59. See also: Michael Angold, *Byzantium: The Bridge from Antiquity to the Middle Ages*, London: Weidenfeld & Nicolson, 2001, pages 138–139, for the schools of Constantinople.
28. Nigel Wilson, *Scholars of Byzantium*, London: Duckworth, 1983, page 50.
29. *Ibid.*, page 51.
30. *Ibid.*
31. Colish, *Op. cit.*, page 43.
32. Cantor, *Op. cit.*, page 82.
33. Colish, *Op. cit.*, page 43.
34. *Ibid.*, page 48.
35. Cantor, *Op. cit.*, page 82. Angold, *Op. cit.*, page 98.
36. Colish, *Op. cit.*, page 51. Charles Freeman, personal communication, 30 June 2004.
37. Gernet, *A History of Chinese Civilisation*, *Op. cit.*, page 288. See also below, Chapter 12, note 47.
38. Reynolds and Wilson, *Op. cit.*, page 63.
39. *Ibid.*, page 65.
40. *Ibid.*, page 66. Bischoff, *Op. cit.*, page 183.
41. Reynolds and Wilson, *Op. cit.*, page 67. Angold, *Op. cit.*, pages 89–90, for the survival of some manuscripts.
42. Reynolds and Wilson, *Op. cit.*, page 68.
43. *Ibid.*, page 61. Angold, *Op. cit.*, page 124, for the role of Bardas. See Bischoff, *Op. cit.*, pages 97, 150ff, 170 and 176 for abbreviations.
44. Reynolds and Wilson, *Op. cit.*, page 60.
45. Warren T. Treadgold, *The Nature of the Bibliotheca of Photius*, Washington, DC: Dumbarton Oaks, Center for Byzantine Studies, Trustees for Harvard University, 1980, page 4. See Angold, *Op. cit.*, page 124, for a perspective on Photius.
46. Cyril Mango, *Byzantium*, London: Weidenfeld & Nicolson, 1980, page 62.
47. *Ibid.*, pages 71–72.
48. *Ibid.*, page 80. See also Angold, *Op. cit.*, page 70. Moynahan, *Op. cit.*, page 96, says there were 4,388 buildings of 'architectural merit' in the city's heyday.
49. Lawrence Nees, *Early Medieval Art*, Oxford: Oxford University Press, 2002, page 31.
50. Mango, *Op. cit.*, page 258. For Diocletian, see: John Beckwith, *Early Christian and Byzantine Art*, London: Penguin, 1970/1979, page 14.
51. Mango, *Op. cit.* See also: Moynahan, *Op. cit.*, page 96.
52. Mango, *Op. cit.*, page 259.
53. Nees, *Op. cit.*, page 52. David Talbot Rice, *Byzantine Art*,

London: Penguin Books, 1935/1062, page 84, considers Ravenna superior to Rome. For purple codices, see Beckwith, *Op. cit.*, pages 42–43.

54. Mango, *Op. cit.*, page 261. Angold, *Op. cit.*, pages 35f, for imperial themes in Christian art.

55. Nees, *Op. cit.*, page 52. Dominic Janes, *Gold and Gold in Late Antiquity*, Cambridge, England: Cambridge University Press, 1998.

56. A word here about Christian art in books. The development of the codex, between the second and the fourth centuries, was, as we have seen, at least partly associated with the rise of Christianity, the codex being harder to forge than the scroll. The earliest illustrated biblical manuscript is that known as the Quedlinburg *Itala*, a much-damaged version of the book of Samuel. No less a person than Jerome himself, the creator of the Vulgate, criticised the production of luxuriously illustrated books, suggesting they were a new phenomenon. The Quedlinburg *Itala* had illustrations with loosely-painted atmospheric backdrops, and with shadows on the ground, each scene being painted in a small square frame. There was nothing like this in antiquity, says Lawrence Nees (except illustrated parchment codices of Homer and Virgil), which suggests that these illustrated books were central to Christian society and probably helped it become even more a religion of the book. Nees, *Op. cit.*, pages 94–96.

57. *Ibid.*, page 141. Beckwith, *Op. cit.*, page 59, for Justinian.

58. *Ibid.*, page 142. See Talbot Rice, *Op. cit.*, page 147, for the 'golden ages' of Byzantine art, and page 149 for the schools of icon painting. Beckwith, *Op. cit.*, pages 125–126.

59. Nees, *Op. cit.*, page 143.

60. Mango, *Op. cit.*, page 264.

61. Nees, *Op. cit.*, page 146. Moynahan, *Op. cit.*, pages 210ff; Angold, *Op. cit.*, pages 70ff; Talbot Rice, *Op. cit.*, pages 22ff. Beckwith, *Op. cit.*, page 168.

62. Cantor, *Op. cit.*, page 173. Moynahan, *Op. cit.*, page 211. Beckwith, *Op. cit.*, page 169.

63. Nees, *Op. cit.*, page 149.

64. Beckwith, *Op. cit.*, pages 151 and 158. Nor should we overlook the fact that the iconoclasts did not object to the use of human figures in non-Christian art. Cyril Mango says that the Milion arch in Constantinople, for example, marked the start of a great road that crossed the entire Balkans. This arch was dominated by an elaborate sculpture of the emperor's favourite charioteer. No one thought of attacking this. Mango, *Op. cit.*, page 266.

65. *Ibid.*, page 267. See Moynahan, *Op. cit.*, page 211, for how the iconodules were themselves mocked.

66. Mango, *Op. cit.*, pages 271–272. See Talbot Rice, *Op. cit.*, page 151, for painting techniques. Beckwith, *Op. cit.*, page 191.

67. Mango, *Op. cit.*, page 278, for the 'intense aura'. See Angold, *Op. cit.*, for a similar interpretation. Beckwith, *Op. cit.*, page 346.

## CHAPTER 12: *FALSAFAH* AND *AL-JABR* IN BAGHDAD AND TOLEDO

1. Philip K. Hitti, *A History of the Arabs*, London: Macmillan, 1970, page 90.

2. *Ibid.*, page 25.

3. *Ibid.*

4. *Ibid.*, page 91.

5. In fact, in certain circumstances it was more. The Arabian poet, the *sha'ir*, was understood to be privy to secret knowledge, not all of which was good and some of which might come from demons. As a result, the eloquent poet could bring misfortune on the enemy at the same time that he inspired his own tribe to valour. Even in peacetime he had a role, Philip Hitti says, as a sceptic to subvert the 'claims and aims' of demagogues. See Angold, *Op. cit.*, page 60, for the place of poetry in Arab society.

6. Some of the pre-Islamic poets are household names in the Arabic world, even today. The love poems of Imru' al-Qays and the moral maxims of Zuhayr are probably better-known than most. Apart from poets, high prestige also attached to the orator (*khatib*) and the *rawi*, who related the legends of bygone ages. Their stature dominated that of the scribes who became significant only after the rise of Islam. Hitti, *Op. cit.*, page 56.

7. G. F. von Grunebaum, *Classical Islam*, London: Allen & Unwin, 1970, page 24.

8. Hitti, *Op. cit.*, pages 64–65.

9. *Ibid.*, page 112.

10. Anwar G. Chejne, *The Arabic Language: Its Role in History*, Minneapolis: University of Minnesota Press, 1969, pages 7–13. Hitti, *Op. cit.*, page 123.

11. Bernard Lewis, *The Middle East*, London: Phoenix, 1995, page 53.

12. Hitti, *Op. cit.*, page 118. See Angold, *Op. cit.*, page 61, for a discussion of the *qiblah*.

13. Lewis, *Op. cit.*, page 53.

14. Hitti, *Op. cit.*, page 128.

15. *Ibid.*

16. *Ibid.*, page 129.

17. Originally, Allah asked to be prayed to fifty times a day, but Muhammad reached a compromise when he was in heaven on his nocturnal journey there.

18. Hitti, *Op. cit.*, page 132. The prohibition on alcohol, incidentally, may not have been insisted on from the beginning. One of the chapters in the Qur'an contains a suggestion that it was introduced early on to prevent disturbances during the Friday service.

19. *Ibid.*, page 124. For Islamic judgement see: Jane Idleman Smith and Yvonne Yazbeck Haddad, *The Islamic Understanding of Death and Resurrection*, Oxford and New York: Oxford University Press, 2002, page 64.

20. Hitti, *Op. cit.*, pages 124–126.

21. Chejne, *Op. cit.*, page 25.

22. *Ibid.*, page 28.

23. *Ibid.*, page 356.

24. Lewis, *Op. cit.*, page 54. Angold, *Op. cit.*, page 60, on the battles for the caliphate.

25. Lewis, *Op. cit.*, page 64.

26. *Ibid.*, page 65.

27. *Ibid.*, page 68. Angold, *Op. cit.*, pages 57–59, for the role of coins.

28. Hitti, *Op. cit.*, page 242. See Angold, *Op. cit.*, pages 61ff, for the Umayyads and, in particular, their architectural achievements.

29. Hitti, *Op. cit.*, page 393.

30. Doris Behrens-Abouseif, *Beauty in Arabic Culture*, Princeton, New Jersey and London: Markus Wiener/Princeton University Press, 1998/1999, page 126. Angold, *Op. cit.*, page 62, for the Dome of the Rock and page 65 for the Great Mosque of Damascus.

31. Behrens-Abouseif, *Op. cit.*, page 124.

32. *Ibid.*, page 132.

33. Lewis, *Op. cit.*, page 37. Albert Hourani, *A History of the Arab Peoples*, Cambridge, Massachusetts: The Belknap Press of Harvard University Press, 1991, pages 56ff.

34. Behrens-Abouseif, *Op. cit.*, page 148.

35. Angold, *Op. cit.*, page 67. Calligraphy was important in

all walks of life, political as well as religious, and many objects were adorned with writing or, in some cases, simply with beautiful letters which had no intrinsic meaning relevant to the context. Two forms of calligraphic script in particular developed in tenth-century Baghdad. These were Kufic and Nashki, the first of which emerged in a religious tradition, and the latter in a secular, bureaucratic tradition. Kufic tends now to be used in traditional religious contexts, whereas Nashki is used for historical purposes, often against richly decorated backgrounds. Hourani, *Op. cit.*, page 56.

36. Apart from its prohibitions on the visual depiction of the human form, Islam was also inherently hostile to music. In yet another *hadith*, Muhammad described the musical instrument as 'the devil's muezzin', the means by which he called people to worship him. Despite this, the Umayyads did patronise music at their court, to the extent that 'four great singers' are still remembered, one of whom, Ibn Surayj (*c.* 634–726), is credited with being the man who introduced the baton for conducting musical performances. Hitti, *Op. cit.*, page 275.

37. Lewis, *Op. cit.*, page 75.

38. *Ibid.*, page 77.

39. Hitti, *Op. cit.*, page 301.

40. *Ibid.*, page 303.

41. In 988, al-Nadim composed *al-Fihrist*, a sort of compendium of books then available in this city and this gives some idea of the range of ideas and activities then current. He refers to manuscripts devoted to such subjects as hypnotism, sword-swallowing, glass-chewing and juggling. But there were more serious subjects too.

42. Howard R. Turner, *Science in Medieval Islam*, Austin: University of Texas Press, 1995, pages 28–29 and 132–133.

43. Boyer, *Op. cit.*, pages 211ff.

44. P. M. Holt *et al.* (editors), *The Cambridge History of Islam*, volume 2, Cambridge, England: Cambridge University Press, 1970, page 743.

45. Hugh Kennedy, *The Court of the Caliphs: The Rise and Fall of Islam's Greatest Dynasty*, London: Weidenfeld & Nicolson, 2004, pages 246 and 255. William Wightman, *The Growth of Scientific Ideas*, Edinburgh: Oliver & Boyd, 1950, page 322.

46. Dimitri Gutas, *Greek Thought, Arabic Culture*, London: Routledge, 1998, page 132. Kennedy, *Op. cit.*, pages 258–259.

47. The translation of Greek, Persian and Indian authors was encouraged by the introduction of paper. This was a Chinese invention, probably from the first century AD. According to tradition, paper reached the Middle East in 751 after the Arabs had captured some Chinese prisoners at the battle of Talas (in modern Kyrgystan, 150 miles north-east of Tashkent). On this account, the prisoners taught their conquerors how to manufacture the new product and their lives were spared. This is now thought unlikely, however, as it appears that Chinese painters, weavers and goldsmiths were living in Kufa, in southern Iraq, at the time of the Arab conquest. Almost certainly they were familiar with papermaking as well. But it doesn't change the point that this was another important idea/invention that flourished in Baghdad having come from outside. The ancient Arabic word for paper, *kaghdad*, is derived from Chinese. In Baghdad, there was an area of the city known as the Suq al-warraqin, the Stationer's Market: lining its streets were more than a hundred shops selling paper. Baghdad was an important centre of papermaking and, for the Byzantines at least, it was the best. They referred to paper as *bagdatixon* and the standard size, 73 cm × 110 cm, was known as a 'Baghdadi sheet'. There were many different types, usually named after rulers: Talhi paper, Nui paper, Tahiri paper. Paper was the new technology and the Arabs were the masters. Jonathan Bloom, *Paper Before Print, Op. cit.* See also Gutas, *Op. cit.*, page 13.

48. Howard R. Turner, *Science in Medieval Islam, Op. cit.*, page 133.

49. *Ibid.*, page 139.

50. Hitti, *Op. cit.*, pages 364–365.

51. His book on this subject went through forty editions between the fifteenth and nineteenth centuries. Turner, *Op. cit.*, page 135.

52. He was born in the ninth century in the central Asian region of Bukhara and, early on in his career – to great acclaim – cured the local ruler of an illness. This gave him access to that ruler's formidable library which, combined with Ibn Sina's phenomenal memory, turned him into one of the most impressive synthesisers of all time.

53. Turner, *Op. cit.*, page 136. See: Wightman, *Op. cit.*, pages 165 and 335–336 for a chronology of translation. Ibn Sina's grave, at Hamadan, in Iran, is now an impressive monument. These two were the greatest doctors but far from being the only ones: Hunayn Ibn Ishaq's ninth-century treatise on the eye opened the way for modern optics; al-Majusi discovered the capillary system of the blood in the tenth century; and in the twelfth Ibn al-Nafis described the circulation of the blood between the heart and lungs, some centuries before William Harvey discovered the greater, or complete circulation (see Chapter 23). Turner, *Op. cit.*, page 137.

54. Boyer, *A History of Mathematics, Op. cit.*, page 227. See also: Bernal, *Op. cit.*, volume 1, pages 275ff.

55. Boyer, *Op. cit.*, page 227.

56. *Ibid.*, page 229.

57. *Ibid.*, page 237.

58. Boyer, *Op. cit.*, page 234.

59. Turner, *Op. cit.*, page 190.

60. Holt *et al.* (editors), *Op. cit.*, page 777. See: Bernal, *Op. cit.*, volume 1, page 278 for optics and the beginnings of scientific chemistry.

61. Philip K. Hitti, *Makers of Arab History*, London: Macmillan, 1969, page 197.

62. *Ibid.*, page 205.

63. *Ibid.*, page 218. And see: Hourani, *Op. cit.*, page 173, for further discussion of Ibn Sina's idea of the soul. For other Islamic ideas about the soul, and its relation to the body, see: Smith and Haddad, *Op. cit.*, pages 40ff.

64. Hitti, *Op. cit.*, pages 393–394. The current phrase 'suicide bomber', as applied to the many outrages perpetrated in particular in the Middle East, is strictly speaking inaccurate. Suicide is a mortal sin in Islam, as it is in Catholic Christianity. But a *martyr's* death guarantees the faithful a place in paradise. See Smith and Haddad, *Op. cit.*, page ix.

65. Hitti, *Op. cit.*, page 408.

66. *Ibid.*, page 410.

67. Ross E. Dunn, *The Adventures of Ibn Battuta*, Los Angeles and Berkeley: University of California Press, 1989, page 98.

68. Hitti, *Op. cit.*, page 414.

69. Hourani, *Op. cit.*, pages 63–64.

70. Hitti, *Op. cit.*, page 429.

71. Hourani, *Op. cit.*, page 65.

72. Hitti, *Op. cit.*, page 434. See also: Bernal, *Op. cit.*, volume 1, page 275.

73. Hourani, *Op. cit.*, pages 167–171.

74. Holt *et al.* (editors), *Op. cit.*, page 527. See also: Ivan van Sertina, *The Golden Age of the Moor* (a special issue of the *Journal of African Civilisations*, volume 11, Fall 1991), New Brunswick, New Jersey, and London: Transaction Publishers 1992.

75. Holt *et al.* (editors), *Op. cit.*, page 531. And see Hourani, *Op. cit.*, page 193 for new forms of poetry developed in Cordova.

76. Hitti, *Op. cit.*, page 252, quoting Franz Rosenthal, *Ibn Khaldun, The Maqaddimah: An Introduction to History*, volume 1, New York: Pantheon Books, 1958, page 6.

77. Cordova was the biggest university but it wasn't the only one. Similar institutions were set up at Seville, Malaga and Granada. The core departments were astronomy, mathematics, medicine, theology and law, though at Granada philosophy and chemistry were offered as well. Books were plentiful owing to the spread of papermaking, imported into Spain from Morocco in the middle of the twelfth century. (The English word 'ream' derives from the Arabic *rizmah*, meaning 'bundle'.)

78. Boyer, *Op. cit.*, pages 254–271.

79. *Ibid.*, page 254.

80. Holt *et al.* (editors), *Op. cit.*, page 579.

81. *Ibid.*, page 583.

82. Philip K. Hitti, *Islam: A Way of Life*, Oxford: Oxford University Press, 1970, page 134.

83. Hourani, *Op. cit.*, page 175. See also: Bernal, *Op. cit.*, volume 1, page 275 on 'the two truths'. For Islamic ideas on paradise see: Smith and Haddad, *Op. cit.*, pages 87–89.

84. Reynolds and Wilson, *Scribes and Scholars*, *Op. cit.*, pages 110 and 120.

85. Holt *et al.* (editors), *Op. cit.*, page 854.

86. *Ibid.*, page 855.

87. Bernal, *Op. cit.*, volume 1, pages 303f. It was this translation which produced the English word 'sine'. The Hindus had originally given the name *jiva* to the half-chord in trigonometry. The Arabs had taken this over, as *jiba*. However, in Arabic there is also a word *jaib*, meaning 'bay' or 'inlet'. When Robert of Chester came to translate the technical term, *jiba*, he seems to have confused it with *jaib*, possibly because in Arabic vowels were omitted. He therefore used the Latin word for bay or inlet – *sinus*.

Adelard of Bath was also one of those who introduced Latin readers to Arab-Hindu numerals. These caught on surprisingly slowly, with many people still using the nine Greek alphabetical letters, plus a special zero symbol. One reason for the slow adoption of the Hindu system was that its advantages were not so apparent while people still used the abacus. There was in fact keen competition between the 'abacists' and the 'al-gorists' for several centuries. It was only with the wider spread of literacy that the advantages of Arabic-Hindu numerals became clear (in pen-and-paper calculations, rather than with an abacus). The algorists didn't finally triumph until the sixteenth century. Boyer, *Op. cit.*, pages 252–253.

## CHAPTER 13: HINDU NUMERALS, SANSKRIT, VEDANTA

1. Basham (editor), *A Cultural History of India*, *Op. cit.*, page 48.

2. John Keay, *India: A History*, London: HarperCollins, 2001, page 138. Romila Thapar, *A History of India*, London: Penguin Books, 1966, volume 1, pages 136ff.

3. Keay, *Op. cit.*, pages 156–157. See Thapar, *Op. cit.*, page 146, who says that Chinese Buddhist pilgrims mentioned them.

4. Keay, *Op. cit.*, page 157.

5. *Ibid.*, page 136.

6. T. Burrow, *The Sanskrit Language*, London: Faber & Faber, 1955, page 64. See also: Thapar, *Op. cit.*, page 58.

7. Burrow, *Op. cit.*, page 65.

8. Keay, *Op. cit.*, page 139.

9. *Ibid.*, page 145. See also: Thapar, *Op. cit.*, page 140.

10. Keay, *Op. cit.*, page 145.

11. Guilds even acted as bankers, lending money on occasion to the royal court.

12. Keay, *Op. cit.*, page 145.

13. *Ibid.*, page 146.

14. Basham (editor), *Op. cit.*, page 162.

15. Burrow, *Op. cit.*, page 43.

16. Basham (editor), *Op. cit.*, page 162; see also Keay, *Op. cit.*, page 61 and Thapar, *Op. cit.*, page 123.

17. Burrow, *Op. cit.*, page 58.

18. *Ibid.*, page 2.

19. *Ibid.*, page 50.

20. Basham (editor), *Op. cit.*, page 170.

21. Keay, *Op. cit.*, page 151.

22. Basham (editor), *Op. cit.*, page 172.

23. Keay, *Op. cit.*, page 152.

24. *Ibid.* Inside India itself, the development (or non-development) of Sanskrit led to certain anomalies. In Kalidasa's plays, for example, there was a theatrical convention that servants, people belonging to the lower castes, and all female and child characters, spoke and understood only Prakrit, showing that it was everybody's first language. Burrow, *Op. cit.*, page 60. Sanskrit is preserved in the drama only for the 'twice-born' principals – kings, ministers, learned Brahmans. Keay, *Op. cit.*, page 153. Because Sanskrit was frozen, writers who lived a full millennium after Panini were forced to replace innovation with ingenuity. One consequences was that, eventually, sentences sometimes ran to several pages, and words might have more than fifty syllables. (In early Sanskrit, in contrast, the use of compounds is no different from, say, Homer.) Burrow, *Op. cit.*, page 55. But although Sanskrit was understood by just a tiny minority of the population, that minority was all-important and, as we shall see, this did not inhibit the development or the spread of new ideas. Sanskrit acted as a cultural bond in India, as the vernacular languages fragmented and proliferated.

25. Basham (editor), *Op. cit.*, page 197.

26. *Ibid.*, page 203.

27. *Ibid.*, 204. See Thapar, *Op. cit.*, page 158, for the plan of the Vishnu temple at Deogarh.

28. Heinrich Zimmer, *Myths and Symbols of Indian Art and Civilisation*, Princeton, New Jersey, and London: The Bollingen Series of Princeton University Press, 1972/1992, page 48.

29. *Ibid.*, page 49.

30. *Ibid.*, page 53.

31. Unlike in so many areas of the world, the sun was not worshipped in India. On the contrary, it was seen as a deadly power. The moon, however, was understood as life-giving. The dew followed its appearance and the moon also controlled the waters through the tides. Water was the earthly equivalent of *amrita*, the drink of the gods (and a word related to the Greek *ambrosia*). Water, sap, milk and blood were all different forms of *amrita* and its most conspicuous manifestations on earth were the three

holy rivers – the Ganges, Sarasvati and Jumna. Sinners who expire near these rivers are released from all their sins. Basham (editor), *Op. cit.*, page 110.

32. *Ibid.*, page 81.
33. Keay, *Op. cit.*, page 152.
34. *Ibid.*, page 174.
35. Thapar, *Op. cit.*, page 190, for a detailed description.
36. Keay, *Op. cit.*, page 206.
37. *Ibid.*, page 214.
38. *Ibid.*, page 208. See also: Thapar, *Op. cit.*, page 195.
39. Keay, *Op. cit.*, page 217, while Thapar, *Op. cit.*, page 210 gives details of the income of the temple.
40. Keay, *Op. cit.*, page 209.
41. Gernet, *Op. cit.*, page 92.
42. Thapar, *Op. cit.*, pages 143–146. Gernet, *Op. cit.*, page 96.
43. Mukerjee, *The Culture and Art of India, Op. cit.*, pages 269–271.
44. *Ibid.*, pages 267ff.
45. Thapar, *Op. cit.*, pages 161ff.
46. S. N. Das Gupta, 'Philosophy', in Basham (editor), *Op. cit.*, pages 114ff.
47. Das Gupta, *Op. cit.*, page 118.
48. Mukerjee, *Op. cit.*, pages 255ff.
49. Thapar, *Op. cit.*, page 162.
50. Basham (editor), *Op. cit.*, page 119. Thapar, *Op. cit.*, page 185.
51. Boyer, *A History of Mathematics, Op. cit.*, page 207.
52. Basham (editor), *Op. cit.*, page 147.
53. Tamil poems of the first four centuries A D make frequent references to Yavanas, Westerners familiar with Hellenic science and Roman technology. As was mentioned earlier, this word is seen by some as derived from 'Ionian'. Basham (editor), *Op. cit.*, page 151 and W. W. Tam, *The Greeks in Bactria and India*, Cambridge, England: Cambridge University Press, 1951.
54. Basham (editor), *Op. cit.*, page 154.
55. As discussed earlier (Chapter 12, note 87), the actual word 'sine' emerged through a mistranslation of the Hindu name, *jiva*.
56. Boyer, *Op. cit.*, page 210. See also: Thapar, *Op. cit.*, page 155.
57. Boyer, *Op. cit.*, page 198.
58. *Ibid.*, page 212.
59. D. E. Smith, *History of Mathematics*, New York: Dover, 1958, volume 1, page 167.
60. Joseph Needham *et al.*, *Science and Civilisation in China*, volume 3, Cambridge, England: Cambridge University Press, 1954, page 11n.
61. Basham (editor), *Op. cit.*, page 157.
62. Boyer, *Op. cit.*, page 215.
63. *Ibid.*, page 216. The mathematics of India have influenced the whole world. But Westerners should never forget that, historically, India's international influence has been primarily on the countries to the *east* of her. In particular, Sanskrit literature, Buddhism and Hinduism, in their various guises, have helped shape south-east Asia. In terms of sheer numbers of people affected, certainly up to the medieval period, India's influence on the world is second to none. Hindu doctors believed that life began in the 'primal waters', that the appearance of people (their physiognomy) recalled the appearance of different gods, and that fever was due to demons, as was indigestion, the commonest cause of illness. Basham (editor), *Op. cit.*, page 148. Health was maintained by the proper balance of the three humours – phlegm, gall and wind (or breath), which depended on diet (blood was added later, as a

fourth humour). The lungs were believed to transport water through the body and the navel was the ultimate source of the blood vessels. Hindus had a vast pharmacopoeia based on a theory that certain essences of herbs and foods corresponded to the humours in differing proportions. Honey was believed to have healing powers and was associated with *amrita*, the 'elixir of immortality'. *Ibid.*, page 149. There was, interestingly, no conception of brain disease – consciousness was centred on the heart. Dropsy, consumption, leprosy, abscess, certain congenital diseases and a number of skin complaints were recognised and described. The name of the Hindu god of medicine was Asvin and the best-known physician was Charaka, who described many real and not-so-real conditions. For example, he gave the name *Ayurveda* to the science of longevity. *Ibid.*, page 150. All illnesses were seen as having an ethical element, resulting in some way from a moral lapse. There was a specialist tradition of elephant medicine.

64. S. A. A. Rizvi, 'The Muslim ruling dynasties', in Basham (editor), *Op. cit.*, pages 245ff.
65. *Ibid.*, pages 281ff.
66. Basham (editor), *Op. cit.*, page 284.
67. Mukerjee, *Op. cit.*, pages 311–327. Thapar, *Op. cit.*, pages 306–307, explores Sufism's links to mainstream Islam and its role in non-conformism and rationalism.
68. Mukerjee, *Op. cit.*, pages 298–299.

## CHAPTER 14: CHINA'S SCHOLAR-ELITE, *LIXUE* AND THE CULTURE OF THE BRUSH

1. Valerie Hansen, *The Open Empire*, New York: Norton, 2000, pages 171–174. Our word 'China' is derived from transliteration of Qin, the Chinese empire of the third century B C.
2. Needham *et al.*, *Science and Civilisation in China, Op. cit.*, page 134. Wilkinson, *Chinese History: A Manual, Op. cit.*, page 844.
3. Janet Abu-Lughod, *Before European Hegemony: The World System*, A D *1250–1350*, Oxford and New York: Oxford University Press, 1989, page 316.
4. Yong Yap and Arthur Cotterell, *The Early Civilisation of China*, London: Weidenfeld & Nicolson, 1975, page 199.
5. Lucien Febvre and Henri-Jean Martin, *The Coming of the Book*, London: Verso, 1976, page 71.
6. The oldest samples of paper were discovered by Sir Aurel Stein in central Asia, in the stonework of an abandoned tower on the Great Wall which had been evacuated by the Chinese army in the mid-second century A D. Febvre and Martin, *Op. cit.*, page 72. Microscopic analysis revealed that the pages – letters written in Sogdian – were made solely from hemp. (Sogdiana was a central Asian kingdom near Samarkand, now modern Uzbekistan.) Paper thus spread rapidly. See Richard N. Frye, *The Heritage of Central Asia: From Antiquity to the Turkish Expansion*, Princeton, New Jersey, and London: Markus Wiener/Princeton University Press, 1998, pages 151ff, for the Silk Road; pages 183ff, for the world of the Sogdians.
7. Febvre and Martin, *Op. cit.*, pages 72–73.
8. Gernet, *Op. cit.*, page 332. For the intellectual effects of printing, see: Hucker, *China's Imperial Past, Op. cit.*, page 272. Wang Tao, personal communication, 28 June 2004.
9. Febvre and Martin, *Op. cit.*, page 75.
10. Gernet, *Op. cit.*, page 335.
11. Febvre and Martin, *Op. cit.*, page 76.
12. *Ibid.*
13. Hucker, *Op. cit.*, page 317. Curiously, the Europeans

seemed singularly uninterested in what the East had to offer in this area. For example, the Mongols sent a number of xylographs with bright red seals printed on some messages to the kings of France and England, and to the pope, in 1289 and again in 1305, but no one in the West picked up on the new technique. Even Marco Polo, inveterate traveller and a man of normally extraordinary curiosity, marvelled at the banknotes he saw in China but seems not to have grasped that they had been printed from engraved woodblocks. Febvre and Martin, *Op. cit.*, page 76.

14. Yu-Kuang Chu, 'The Chinese language', in: John Meskill *et al.* (editors), *An Introduction to Chinese Civilisation*, New York: Columbia University Press, 1973, pages 588–590.

15. *Ibid.*, page 592.

16. *Ibid.*, page 593.

17. *Ibid.*, page 595 and 612.

18. *Ibid.*, pages 597–598.

19. *Ibid.*, page 603. See Hucker, *Op. cit.*, page 197, for a discussion of the difference between 'new text' and 'old text' Chinese writing, and the scholarship attached to old words.

20. Gernet, *Op. cit.*, page 325.

21. Hansen, *Op. cit.*, page 271. Among other things, paper money aided the development of the Chinese merchant navy which, at the time, was by far the largest in the world (see pages 304–305).

22. Raymond Dawson, *The Chinese Experience*, London: Weidenfeld & Nicolson, 1978, pages 181–182. Gernet, *Op. cit.*, page 324.

23. A completely different set of innovations was introduced in China as a result of advances in 'wet rice' growing. From the sixth century on, the Chinese began the systematic selection of seeds so that, by the eleventh century, five hundred years later, yields had been dramatically improved and there were two harvests a year. Traditional *keng* (rice) had needed 120–150 days to ripen. But, by the turn of the eleventh century, an early-ripening and drought-resistant form had been evolved at Champa on the south coast of Vietnam. Although its yield was less, the fact that it ripened in sixty days solved many problems (fifty-day rice was developed in the sixteenth century and a forty-day variety in the eighteenth century). Early-ripening rice had a major impact on the population of China and meant that the country was able to meet its food needs more adequately than was possible in Europe during the same period. 'It was precisely because of her more abundant food supply that China's population began to increase relatively rapidly since the opening of the eleventh century, while the rapid growth of Europe had to wait till the late eighteenth century.' Ho Ping-Ti, 'Early-ripening rice,' in James Liu and Peter Golas (editors), *Change in Sung China*, Lexington, Massachusetts: D. C. Heath and Co., 1969, pages 30–34. In association with the new form of rice, the crank gear, the harrow and the rice-field plough were all developed at this time. Probably the most effective piece of new technology was the chain with paddles (*long guzhe*), which allowed water to be lifted from one level to another by means of a crank gear. Hansen, *Op. cit.*, page 265.

24. The wheelbarrow (the 'wooden ox'), by means of which loads of 300 lb could be carried along narrow, winding paths, was invented in the third century.

25. Gunpowder was in fact only one of several advances in military techniques which were to have a marked effect on world history. The Chinese also perfected a selection

technique for its forces – giving recruits a series of tests (shooting ability, eyesight) and assigning them to specialised units on that basis. New weapons were invented, including repeating crossbows, a type of tank, and a paraffin flame-thrower operated by a piston to ensure a continuous jet of flame. A treatise on military matters, *General Principles of the Classic on War* (*Wu jin zong yao*), discussed new theories about siege warfare. Gernet, *Op. cit.*, page 310. Published in 1044, this treatise also contains the first mention of the formula for gunpowder (the first reference in Europe is by Roger Bacon, in 1267).

26. Gernet, *Op. cit.*, page 311.

27. *Ibid.*

28. *Ibid.*, page 312.

29. David Battie (editor), *Sotheby's Concise Encyclopaedia of Porcelain*, London: Conran Octopus, 1990, pages 15ff.

30. Gernet, *Op. cit.*, page 320. See also: Hucker, *Op. cit.*, page 204.

31. Gavin Menzies, *The Year That Changed the World: 1421*, London: Bantam Press, 2002. Its thesis, that the Chinese circumnavigated the world and discovered America, has been heavily challenged.

32. Gernet, *Op. cit.*, pages 326–327.

33. This was probably born in the great estuary of the Yangtze, 10 to 20 kilometres wide at its mouth, and which stretched inland for 150 kilometres. Here the transition from river to ocean is imperceptible. Gernet, *Op. cit.*, page 327.

34. Taoist experiments initiated the compass (see Chapter 20). The idea of the experiment was also introduced ahead of Europe though it was not sustained. See Hucker, *Op. cit.*, page 204. Chinese maps were also better than European maps at this time, using an early idea of both latitude and longitude. European maps were held back by religious concepts. Gernet, *Op. cit.*, page 328.

As Joseph Needham has pointed out, the Song were a pivotal people in Chinese history, and not least in naval affairs. The greater foreign trade promoted by the Song encouraged the rise of its navy, and the associated inventions and innovations. However, despite her prominence as a sea power, China always remained primarily a land empire. Politically and militarily, she faced her greatest threats from inner Asia and she always raised more financial support from agricultural taxes than she did from taxes on international commerce. This basic truth never altered, says Lo Jung-Pang, and helps to explain why, although the Chinese were so ingenious, it was ultimately others who took greatest advantage of her many inventions. Lo Jung-Pang, 'The rise of China as a sea power', in Liu and Golas (editors), *Op. cit.*, pages 20–27.

35. Yong Yap *et al.*, *Op. cit.*, page 43.

36. F. W. Mote, *Imperial China*, Cambridge, Massachusetts: Harvard University Press, 1999, page 127.

37. *Ibid.*

38. *Ibid.*, page 128.

39. This meant that very poor families might have to save for two to three generations until they could afford to send a favoured son to a private academy.

40. For this and other aspects of the examination system in Song China, see: John W. Chaffee, *The Thorny Gates of Learning in Sung China: A Social History of Examinations*, Cambridge, England: Cambridge University Press, 1985, pages 104–105, and *passim*.

41. See Frye, *Op. cit.*, page 164 for details about Chang'an.

42. Chaffee, *Op. cit.*, page 104.

43. Fairbanks, *Op. cit.*, page 95.

44. Chaffee, *Op. cit.*, page 134. See Hucker, *Op. cit.*, pages

315–321, where he says later dynasties fell back on the sponsorship system.

45. C. K. Young, *Religion in Chinese Society*, Berkeley and London: University of California Press, 1961, page 216.
46. Gernet, *Op. cit.*, page 215. See Frye, *Op. cit.*, pages 195–196, for the organisation of Sogdian society, especially the absence of a priestly hierarchy.
47. Gernet, *Op. cit.*, page 216.
48. Hucker, *Op. cit.*, page 210, says Kumarajiva's translation of *The Lotus Sutra* is the single most influential book in east Asian Buddhism. See also Gernet, *Op. cit.*, page 218, and Frye, *Op. cit.*, pages 145–147, for Buddhist complexes between India and China.
49. Gernet, *Op. cit.*, page 221.
50. Young, *Op. cit.*, pages 119–120.
51. Gernet, *Op. cit.*, page 226.
52. See Frye, *Op. cit.*, for archaeological discoveries at Dunhuang.
53. In 1900, a Daoist known as Wang took up residence at the site of the Cave of a Thousand Buddhas, at Dunhuang in Gansu, an important monastic centre along the Silk Road. In the course of Wang's exploration he noticed a gap in the plaster of one of the caves and, when he tapped it, he found it was hollow behind. This was how he discovered the so-called Library Cave, which contained 13,500 paper scrolls, from which daily life in eighth-century Dunhuang has since been recreated. These scrolls show that, in a town of 15,000, there were thirteen monasteries and that one in ten of the population was directly linked to these establishments, either as monks or nuns or as workpeople. Hansen, *Op. cit.*, pages 245–251.
54. Gernet, *Op. cit.*, page 295.
55. Hansen, *Op. cit.*, page 198.
56. Mote, *Op. cit.*, page 339.
57. See Hucker, *Op. cit.*, page 370, for a portrait of Zhu Xi.
58. *Lixue*: alternatively, *li-hsueh*, see *Ibid.*, page 365. Yong Yap *et al.*, *Op. cit.*, page 198.
59. Mote, *Op. cit.*, page 342.
60. Yong Yap, *et al.*, *Op. cit.* page 198.
61. *Ibid.*, page 208.
62. *Ibid.*, page 170. Wilkinson, *Op. cit.*, page 686.
63. Yong Yap *et al.*, *Op. cit.*, page 171.
64. *Ibid.* Wilkinson, *Op. cit.*, page 679.
65. Yong Yap *et al.*, page 171. In the eleventh century, the emperor Song Huizong sent officials all over the country in search of rocks, strangeness of shape and texture being most sought-after, in particular limestone that had been turned into fantastic shapes by water, which were witness to the awe-inspiring forces of nature. These forces of life had to be lived with and the perfect garden was a reminder of that. See Hucker, *Op. cit.*, page 260 for the role of grottoes and cliffs.
66. Yong Yap *et al.*, *Op. cit.*, page 172.
67. Gernet, *Op. cit.*, page 341.
68. Mote, *Op. cit.*, page 151.
69. *Ibid.*
70. Mark Elvin, *The Pattern of the Chinese Past*, London: Eyre Methuen, 1973, pages 164ff and 179ff.
71. Mote, *Op. cit.*, page 152. And see Hucker, *Op. cit.*, page 263 for the difference between 'clerical script' and 'cursive script'.
72. Mote, *Op. cit.*, page 326.
73. *Ibid.*, but see also: Robert P. Hymes, 'The elite of Fy-Chou, Chiang-hsi', in his *Northern and Southern Sung*, Cambridge, England: Cambridge University Press, 1986. See also: Nathan Sivin, *Science and Technology in East Asia*, New York: Science History Publications, 1987, xv–xxi.
74. Abu-Lughod, *Op. cit.*, page 4.

## CHAPTER 15: THE IDEA OF EUROPE

1. Alfred W. Crosby, *The Measure of Reality: Quantification and Western Society, 1250–1600*, Cambridge, England: Cambridge University Press, 1997, page 3.
2. Bernard Lewis, *The Muslim Discovery of Europe*, London: Weidenfeld & Nicolson, 1982, page 82.
3. The argument was also developed in Fernand Braudel, *Civilisation and Capitalism*, volume 2, *15–18th Centuries, The Wheels of Commerce*, London: Collins, 1982, pages 68ff.
4. Michael McCormick, *Origins of the European Economy: Communication and Commerce, AD 300–900*, Cambridge, England: Cambridge University Press, 2001, page 794.
5. *Ibid.*, pages 704–708.
6. *Ibid.*, page 344.
7. *Ibid.*, page 789.
8. *Ibid.*, page 790. Recent underwater excavations have supported this argument. See: Dalya Alberge, 'Shipwrecks cast new light on the Dark Ages', *The (London) Times*, 9 June 2004, page 8.
9. McCormack, *Op. cit.*, page 796.
10. Abu-Lughod, *Before European Hegemony*, *Op. cit.*, page 4.
11. *Ibid.*, page 3.
12. *Ibid.*, page 19.
13. *Ibid.*, page 357.
14. *Ibid.*, page 34.
15. *Ibid.*, page 360.
16. Needham, *The Great Titration*, *Op. cit.*, page 121.
17. *Ibid.*, page 150. But Frye, *Op. cit.*, pages 194–195, says nearby Sogdiana was very different, with a thriving merchant class.
18. Toby E. Huff, *The Rise of Early Modern Science in Islam, China and the West*, Cambridge, England: Cambridge University Press, 1993, page 120.
19. *Ibid.*, page 129.
20. *Ibid.*, page 189.
21. Douglas North and Robert Thomas, *The Rise of the Western World*, Cambridge, England: Cambridge University Press, 1973, page 33.
22. *Ibid.*, pages 34–35.
23. *Ibid.*, page 41.
24. Carlo M. Cipolla, *Before the Industrial Revolution: European Society and Economy, 1000–1700* (third edition), London and New York: Routledge, 2003, page 141.
25. *Ibid.*, pages 160–161.
26. *Ibid.*, page 180. See also: J. R. S. Phillips, *The Medieval Expansion of Europe*, Oxford: Oxford University Press, 1988, page 103.
27. Anthony Pagden (editor), *The Idea of Europe*, Cambridge, England, and Washington: Cambridge University Press/Woodrow Wilson Center Press, 2002, page 81.
28. *Ibid.*, page 84.
29. R. W. Southern, *Scholastic Humanism and the Unification of Europe*, volume 1, *Foundations*, Oxford: Basil Blackwell, 1995, page 1.
30. Pagden (editor), *Op. cit.*, pages 83–84.
31. Southern, *Op. cit.*, page 2.
32. *Ibid.*, page 3.
33. *Ibid.*, pages 4–5.
34. *Ibid.*, page 5.
35. *Ibid.*, pages 5–6.
36. Herbert Musurillo SJ, *Symbolism and the Christian Imagination*, Dublin: Helicon, 1962, page 152.

37. *Ibid.* See Moynahan, *The Faith*, *Op. cit.*, pages 206ff, for general events around the year AD 1000.
38. Southern, *Op. cit.*, page 6.
39. *Ibid.*, page 11.
40. *Ibid.*
41. *Ibid.*, pages 189–190.
42. Southern, *Op. cit.*, pages 205–206. See also: Moynahan, *Op. cit.*, page 242.
43. D. A. Callus (editor), *Robert Grosseteste*, Oxford: Oxford University Press, 1955, page 98.
44. *Ibid.*, page 106.
45. Colin Morris, *The Discovery of the Individual: 1050–1200*, London: SPCK, 1972, pages 161ff. See also Freeman, *The Closing of the Western Mind*, *Op. cit.*, page 335. Robert Pasnau, *Aquinas on Human Nature*, Cambridge, England: Cambridge University Press, 2003.
46. Tarnas, *The Passion of the Western Mind*, *Op. cit.*, page 177.
47. *Ibid.*, page 181.
48. *Ibid.*, page 188. See also: Joseph Canning, *A History of Medieval Political Thought, 300–1450*, London: Routledge, 1996, pages 132–133, who emphasises that Aquinas did not accord total autonomy to the secular world.
49. Tarnas, *Op. cit.*, page 191.
50. Robert Benson and Giles Constable (editors), *Renaissance and Renewal in the Twelfth Century*, Oxford: Oxford University Press, 1982, page 45.
51. *Ibid.*, page 56.
52. *Ibid.*, page 61.
53. *Ibid.*, pages 65–66.
54. *Ibid.*, pages 150–151. See Moynahan, *Op. cit.*, page 229, for the range of views about Jerusalem.
55. Morris, *Op. cit.*, page 23.
56. *Ibid.*, pages 26–27.
57. *Ibid.*, page 28. Moynahan, *Op. cit.*, page 216.
58. Morris, *Op. cit.*, page 27.
59. *Ibid.*, page 31.
60. Musurillo SJ, *Op. cit.*, page 135.
61. Morris, *Op. cit.*, page 34.
62. Benson and Constable (editors), *Op. cit.*, page 67.
63. *Ibid.*, page 71.
64. *Ibid.* See Moynahan, *Op. cit.*, page 302, for Lateran IV and transubstantiation. This question of intention was matched by a keen interest in the twelfth century in psychology. For example, two lovers in Chrétien de Troyes' *Cliges* spend several pages debating their feelings for one another. Many theological works – for the first time – examined whatever *affectus* or *affectio* influenced someone's actions. Psychology was understood as the 'Godward movement of the soul'. Morris, *Op. cit.*, page 76.
65. Georges Duby (editor), Arthur Goldhamer (translator), *A History of Private Life*, volume II, *Revelations of the Medieval World*, Cambridge, Massachusetts, and London: The Belknap Press of Harvard University Press, 1988, pages 272–273.
66. *Ibid.*, page 512.
67. *Ibid.*, page 538.
68. Benson and Constable (editors), *Op. cit.*, page 281.
69. Morris, *Op. cit.*, page 79.
70. *Ibid.*, page 84.
71. *Ibid.*, page 85.
72. See Musurillo SJ, *Op. cit.*, chapters 10 and 11, for a somewhat different view, and the gradual escape of the Christian imagination from St Augustine's influence, as revealed through poetry.
73. Morris, *Op. cit.*, page 88.
74. Illuminated manuscripts show the same naturalism and interest in individual character.
75. Morris, *Op. cit.*, page 90.
76. *Ibid.*, pages 134ff.
77. Christopher Brooke, *The Age of the Cloister*, Stroud, England: Sutton Publishing, 2003, page 110.
78. *Ibid.*, page 10.
79. *Ibid.*, page 18.
80. *Ibid.*, pages 126ff.
81. *Ibid.*, page 211.
82. Morris, *Op. cit.*, page 283. The speed of canonisation also reflected this change. See: Moynahan, *Op. cit.*, page 247.
83. *Ibid.*, page 158.

## CHAPTER 16: 'HALF-WAY BETWEEN GOD AND MAN': THE TECHNIQUES OF PAPAL THOUGHT-CONTROL

1. Cantor, *Op. cit.*, pages 269ff.
2. *Ibid.*, pages 258–259.
3. Edward Grant, *God and Reason in the Middle Ages*, Cambridge, England: Cambridge University Press, 2001, page 23.
4. *Ibid.*, page 23.
5. *Ibid.*, page 24. See Moynahan, *Op. cit.*, page 216, for other measures, including celibacy for all clerics above deacon.
6. Grant, *Op. cit.*, page 24.
7. David Knowles and Dimitri Obolensky, *The Christian Centuries*, volume 2, *The Middle Ages*, London: Darton, Longman & Todd, 1969, pages 336–337.
8. *Ibid.*, *Op. cit.*, page 337.
9. Reinhard Bendix, *Kings or People: Power and the Mandate to Rule*, Los Angeles: University of California Press, 1978, page 23.
10. *Ibid.*, page 27.
11. *Ibid.*, page 29.
12. *Ibid.*, page 31. For Ambrose, see Canning, *Op. cit.*, page 34.
13. Bendix, *Op. cit.*, page 32. No less important to the developing notion of king-hood, and its relation to the papacy, was the notorious 'Donation of Constantine', now generally agreed to have been a forgery produced by sources very close to the pope himself. 'It is impossible,' says Walter Ullmann, 'to exaggerate the influence which this fabrication had upon medieval Europe generally and on the papacy specifically.' This idea, based on the *Legenda Sancti Silvestri*, a novelistic best-seller of the fifth century, alleged that Constantine had been cured of leprosy by the pope, Sylvester, and in contrition had prostrated himself before His Holiness, divesting himself of his imperial emblems – including his crown – and had performed the office of *strator*, or groom, and had led the papal horse for a short distance. The message could not be plainer. Walter Ullmann, *A History of Political Thought: The Middle Ages*, London: Penguin Books, 1965, page 59.
14. Cantor, *Op. cit.*, pages 178–179. Charlemagne was subjected to a bizarre – but revealing – encounter in Rome in 800. The pope of the time, Leo III, was unsuccessful and unpopular. So unpopular that he had been beaten up by a Roman mob, charged with 'moral turpitude' and forced to seek Charlemagne's protection. When the emperor arrived in Rome for the trial of Leo, when he purged himself of the charges against him, Charlemagne went to visit the tomb of St Peter, on Christmas day 800, to pray. As he rose from his prayers, Leo suddenly stepped forward and placed the crown on the king's head. This was a crude attempt to reassert the right of the papacy to award the

imperial title and Charlemagne was not at all pleased – he said he would never have entered the church had he known what the pope intended. Cantor, *Op. cit.*, page 181. See also Canning, *Op. cit.*, page 66, for a discussion of Carolingian theocratic ideas.

15. Bendix, *Op. cit.*, page 33.

16. Cantor, *Op. cit.*, page 195. See also Canning, *Op. cit.*, pages 60–61.

17. David Levine, *At the Dawn of Modernity*, Los Angeles: University of California Press, 2001, page 18.

18. Cantor, *Op. cit.*, page 203.

19. *Ibid.*, pages 218–223. See also Canning, *Op. cit.*, page 75, for Otto and his imperial affectations.

20. Cantor, *Op. cit.*, page 218.

21. *Ibid.*, page 244.

22. Colish, *Op. cit.*, page 227.

23. Cantor, *Op. cit.*, page 341.

24. Colish, *Op. cit.*, page 228.

25. Marina Warner, *Alone of All Her Sex*, London: Weidenfeld & Nicolson, 1976, pages 147–148.

26. Levine, *Op. cit.*, page 74.

27. Colish, *Op. cit.*, page 235. See also Moynahan, *Op. cit.*, page 272.

28. Colish, *Op. cit.*, page 237.

29. Cantor, *Op. cit.*, page 249.

30. Colish, *Op. cit.*, page 245.

31. Canning, *Op. cit.*, page 85.

32. Cantor, *Op. cit.*, pages 254–255.

33. *Ibid.*, page 258. See also: Canning, *Op. cit.*, page 88.

34. Moynahan, *Op. cit.*, page 218. See Canning, *Op. cit.*, pages 98ff, for the debate sparked by Gregory. See also: Cantor, *Op. cit.*, page 262.

35. Cantor, *Op. cit.*, page 267.

36. *Ibid.*, page 268.

37. Elisabeth Vodola, *Excommunication in the Middle Ages*, Los Angeles: University of California Press, 1986, pages 2–3.

38. *Ibid.*, page 4.

39. *Ibid.*, page 10.

40. In the early Middle Ages monarchs usually lent their weight to church decisions, so that excommunicants lost their civil rights too. This derived from the Roman concept of *infamia*, which disqualified immoral persons and criminals from voting.

41. Also, people who didn't know that an excommunicant *was* an excommunicant were also judged not to be contaminated. Vodola, *Op. cit.*, page 25.

42. *Ibid.*, page 29.

43. *Ibid.*, page 32. See also: Moynahan, *Op. cit.*, page 87.

44. Vodola, *Op. cit.*, page 52.

45. Cantor, *Op. cit.*, page 271.

46. *Ibid.*, page 290. Moynahan, *Op. cit.*, pages 186–187 for Christian losses.

47. Moynahan, *Op. cit.*, pages 190ff.

48. Cantor, *Op. cit.*, pages 292–293.

49. Moynahan, *Op. cit.*, page 222, lists five accounts of Urban's historic speech which, he says, 'are substantially different'.

50. The First Crusade was fortunate in its timing. Emotions among Christians still ran high. The millennium – AD 1000, as it then was – was not long over, and the millennium of the Passion, 1033, closer still. In addition, because of a temporary disunity among the Arabs, which weakened their ability to resist the five thousand or so who comprised the Christian forces, the crusaders reached Jerusalem relatively intact and, after a siege lasting well over a month, took it. In the process they massacred all Muslim and Jewish residents, the latter being burned in their chief synagogue.

51. Steven Runciman, *The First Crusade*, Cambridge, England: Cambridge University Press/Canto, 1951/1980, page 22.

52. The veneration of saints and relics offered an incentive for large numbers of the pious to make pilgrimages, not just to the three major sites – Jerusalem, Rome and Santiago de Compostela – but to many other shrines associated with miracles or relics. David Levine speaks of an 'economic geography of holiness [that] sprouted in rural Europe'. Areas of France were criss-crossed with pilgrimage routes – for example, the *chemin de Paris* and the *chemin de Vézelay*, which funnelled the faithful from the north to Spain, where they met up with others who had travelled along the *chemin d'Arles*. Levine, *Op. cit.*, page 87. The basic view was that as given by Henry of Ghent (*c.* 1217–1293), the influential Parisian scholastic and metaphysician, who argued that saints and certain visionaries have access to God's mind and therefore have 'full and infallible certitude' in their knowledge. Colish, *Op. cit.*, page 305. Patrick Geary, professor of history at the University of Florida, studied more than one hundred medieval accounts of the thefts of saints' relics, and found that these were often carried out not by vagabonds but by monks, who transferred the relics to their home towns or monasteries. As the pilgrimage routes showed, relics stimulated a constant demand for hospitality – food and lodging. In other words, relics were a source of economic support. But the cult of the saints may also be seen as a return to a form of polytheism: the saints' disparate characters allowed the faithful to relate to figures they found sympathetic – humans rather than gods – who had done something extraordinary. Geary shows that the cult of saints was so strong that in Italy at least there were also professional relic thieves, operating a lively trade to points north. Patrick J. Geary, *Furta Sacra: Thefts of Relics in the Central Middle Ages*, Princeton, New Jersey: Princeton University Press, 1978/1990.

53. Cantor, *Op. cit.*, page 388, and Moynahan, *Op. cit.*, page 279. See also: Peter Biller and Anne Hudson (editors), *Heresy and Literacy, 1000–1530*, Cambridge, England: Cambridge University Press, 1994, page 94.

54. Bernard McGinn, *AntiChrist*, New York: Columbia University Press, 1994, page 6.

55. *Ibid.*, pages 100–113; see also Moynahan, *Op. cit.*, page 215.

56. McGinn, *Op. cit.*, page 138.

57. *Ibid.*, pages 136–137.

58. Colish, *Op. cit.*, page 249.

59. Cantor, *Op. cit.*, page 389.

60. Biller and Hudson (editors), *Op. cit.*, pages 38–39. Colish, *Op. cit.*, page 251. See Moynahan, *Op. cit.*, page 280–281, for an account of the Bogomils.

61. Cantor, *Op. cit.*, page 390.

62. Colish, *Op. cit.*, page 251.

63. Edward Grant, *God and Reason in the Middle Ages*, *Op. cit.*, page 24.

64. Cantor, *Op. cit.*, page 417. Canning, *Op. cit.*, page 121, agrees that Innocent's reign was the crux of the medieval papacy.

65. Cantor, *Op. cit.*, pages 389–393.

66. Edward Burman, *The Inquisition: Hammer of Heresy*, Wellingborough, Northamptonshire: Aquarian Press, 1984, page 16.

67. *Ibid.*

68. *Ibid.*, page 23.
69. *Ibid.*, See Stephen Haliczer (editor), *Inquisition and Society in Early Modern Europe*, London and Sydney: Croom Helm, 1987, page 10, for more statistics.
70. Burman, *Op. cit.*, page 23.
71. *Ibid.*, page 25.
72. James B. Given, *Inquisition and Medieval Society*, Ithaca, New York: Cornell University Press, 1997, page 11. See also: Moynahan, *Op. cit.*, page 281.
73. Burman, *Op. cit.*, page 33 and Given, *Op. cit.*, page 14, for the early organisation of the inquisition.
74. Burman, *Op. cit.*, page 41. See also: Moynahan, *Op. cit.*, page 41.
75. Burman, *Op. cit.*, page 57.
76. *Ibid.*, pages 60–61. On another occasion, he had eighty men, women and children burned in Strasbourg. See: Moynahan, *Op. cit.*, page 286.
77. In the wheel the prisoner was tied to a cartwheel and beaten. The rack, as is well known, stretched the body to breaking point, a bit like the *strappado*.
78. Jews offered a different but allied problem. There was a large and prosperous Jewish community in the south of France – Cathar territory – and, as we have seen, there may well have been Jewish ideas mixed up in the genealogy of Catharism. So although Innocent forbade attempts to convert Jews by force, he did advocate ghettoisation – physical separation – which not only limited contact but implied that they were social pariahs. It was at the Fourth Lateran Council, held towards the end of Innocent's papacy in 1215, that it was decreed the Jews should wear a yellow patch 'so they could be easily distinguished as outcasts'. See: Cantor, *Op. cit.*, page 426.
79. William Chester Jordan, *Europe in the High Middle Ages*, London: Allen Lane The Penguin Press, 2001, page 9; and Cantor, *Op. cit.*, pages 418–419. See also as a general reference: Jacques le Goff, *The Medieval Imagination*, translated by Arthur Goldhammer, Chicago: University of Chicago Press, 1985, especially part 2, section 2, 'The perception of Christendom by the Roman Curia' and 'The organisation of an ecumenical council in 1274'.
80. Knowles and Obolensky, *Op. cit.*, page 290.
81. Cantor, *Op. cit.*, page 491.
82. Canning, *Op. cit.*, pages 137–148.
83. Cantor, *Op. cit.*, page 493.
84. *Ibid.*, page 495. See also: Canning, *Op. cit.*, pages 139–140.
85. Cantor, *Op. cit.*, page 496.
86. Moynahan, *Op. cit.*, pages 298ff.

CHAPTER 17: THE SPREAD OF LEARNING AND THE RISE OF ACCURACY
1. Georges Duby, *The Age of the Cathedrals*, Chicago: University of Chicago Press, 1981, pages 97ff.
2. *Ibid.*, page 98.
3. *Ibid.*
4. Anders Piltz, *The Medieval World of Learning*, Oxford: Blackwell, 1981, page 26. See also: Moynahan, *Op. cit.*, page 269, and Le Goff, *Op. cit.*, page 54.
5. Duby, *Op. cit.*, page 100.
6. *Ibid.*, page 101.
7. *Ibid.*, page 111.
8. R. W. S. Southern, 'The schools of Paris and the schools of Chartres', in Benson and Constable (editors), *Op. cit.*, page 114.
9. *Ibid.*, page 115.
10. *Ibid.*, pages 124–128.
11. *Ibid.*, page 129.

12. Chester Jordan, *Op. cit.*, page 116. R. W. S. Southern, *Western Society and the Church in the Middle Ages*, The Penguin History of the Church, London: Penguin Books, 1970/1990, page 94. See also: Le Goff, *Op. cit.*, page 179, for the concept of *civitas* in the Middle Ages.
13. Rubenstein, *Aristotle's Children*, *Op. cit.*, page 127. See also: Chester Jordan, *Op. cit.*, page 113, and Duby, *Op. cit.*, page 115.
14. Duby, *Op. cit.*, page 115.
15. *Ibid.*, page 116.
16. Alan Cobban, *The Medieval Universities*, London: Methuen, 1975, page 8.
17. *Ibid.*, page 9.
18. *Ibid.*, page 10.
19. *Ibid.*, page 11.
20. Piltz, *Op. cit.*, page 18.
21. Cobban, *Op. cit.*, page 12.
22. *Ibid.*, page 14.
23. Rubenstein, *Op. cit.*, page 104.
24. Cobban, *Op. cit.*, page 18. Alexander also studied at Montpellier. See: Nathan Schachner, *The Medieval Universities*, London: Allen & Unwin, 1938, page 263.
25. *Ibid.*, page 15. See Schachner, *Op. cit.*, pages 132–133, for the prosperity of medieval doctors.
26. Rubenstein, *Op. cit.*, page 17.
27. *Ibid.*, page 162.
28. *Ibid.*
29. *Ibid.*, page 186.
30. *Ibid.*, page 187.
31. *Ibid.*, page 42.
32. *Ibid.*, page 210.
33. *Ibid.*, page 197.
34. *Ibid.*, page 198.
35. *Ibid.*, page 220.
36. *Ibid.*, page 221.
37. Cobban, *Op. cit.*, page 22.
38. *Ibid.*, page 23. See also: Schachner, *Op. cit.*, page 62, for the dress requirements.
39. Cobban, *Op. cit.*, pages 23–24.
40. *Ibid.*, page 24.
41. *Ibid.*, page 25.
42. Hastings Rashdall, *The Universities of Europe in the Middle Ages* (new edition in three volumes), edited by F. M. Powicke and A. B. Emden, Oxford: Clarendon Press of Oxford University Press, 1936, volume II, page 22.
43. *Ibid.*, pages 24ff.
44. Cobban, *Op. cit.*, page 31.
45. *Ibid.*, page 37. See Schachner, *Op. cit.*, page 51, for the lame and blind.
46. Chester Jordan, *Op. cit.*, page 125. Cobban, *Op. cit.*, page 41.
47. Olaf Pederson, *The First Universities*, Cambridge, England: Cambridge University Press, 1997, pages 122ff.
48. Cobban, *Op. cit.*, page 44.
49. *Ibid.*, page 45.
50. Hilde de Ridder-Symoens (editor), *A History of the Universities in Europe*, volume 1, Cambridge, England: Cambridge University Press, 1992, pages 43ff.
51. Cobban, *Op. cit.*, page 49–50.
52. Chester Jordan, *Op. cit.*, page 127. Cobban, *Op. cit.*, page 50. Schachner, *Op. cit.*, page 151, says that there is some doubt that Irnerius ever existed.
53. Cobban, *Op. cit.*, page 51.
54. *Ibid.*, page 52.
55. *Ibid.*, page 53.
56. Rashdall, *Op. cit.*, page 23.

57. Cobban, *Op. cit.*, page 54. See Schachner, *Op. cit.*, page 153, for the ages and economic status of Bologna students.
58. Cobban, *Op. cit.*, page 55.
59. Carlo Malagola, 'Statuti dell' università e dei collegii dello studio Bolognese', 1888. In: Lynn Thorndike (editor), *University Records and Life in the Middle Ages*, New York: Octagon, 1971, pages 273ff.
60. Cobban, *Op. cit.*, page 58.
61. *Ibid.*, page 62.
62. Ridder-Symoens (editor), *Op. cit.*, pages 148ff.
63. *Ibid.*, page 157. See also: Schachner, *Op. cit.*, page 160f.
64. Cobban, *Op. cit.*, page 65.
65. *Ibid.*, pages 66–67.
66. See Thorndike (editor), *Op. cit.*, page 27, for the rules of Paris University and page 35 for papal regulations.
67. Cobban, *Op. cit.*, page 77.
68. *Ibid.*, pages 82–83. And see Schachner, *Op. cit.*, pages 74ff, for the concept of the 'nations'.
69. Cobban, *Op. cit.*, page 79.
70. *Ibid.*, page 96.
71. See Ridder-Symoens (editor), *Op. cit.*, page 342, for the introduction of learning into Britain via Northampton, Glasgow and London.
72. Cobban, *Op. cit.*, page 98.
73. *Ibid.*, page 100.
74. Thorndike (editor), *Op. cit.*, pages 7–19.
75. Cobban, *Op. cit.*, page 101.
76. Pederson, *Op. cit.*, page 225, describes early life in Oxford.
77. Cobban, *Op. cit.*, page 107.
78. Schachner, *Op. cit.*, pages 237–239. See also: Rubenstein, *Op. cit.*, page 173.
79. Cobban, *Op. cit.*, page 108.
80. Chester Jordan, *Op. cit.*, page 119, Cobban, *Op. cit.*, page 116.
81. Cobban, *Op. cit.*, page 116. Colleges were especially a feature of Paris, Oxford and Cambridge. These were usually legal bodies, self-governing, and generously endowed. Often, they were charitable and pious foundations. Colleges were also established to reflect the idea that student poverty should not be a barrier to academic progress. This was true most of all of Paris, the origin of the collegiate idea in the sense that colleges existed there first. 'The earliest European college about which there is information,' says Alan Cobban, 'is the Collège des Dix-Huit which had its beginnings in Paris in 1180, when a certain Jocius de Londoniis bought the room he had in the Hospital of the Blessed Mary of Paris and endowed it for the perpetual use of eighteen poor clerks.' The idea was soon followed but it was the foundation of the College of the Sorbonne, begun *c.* 1257 by Robert de Sorbon, chaplain to Louis IX, which really created the system familiar today. This college was intended for graduates, for established scholars who had already gained an MA, and were about to embark on the doctorate in theology. Some nineteen colleges were established in Paris by 1300, and at least three dozen by the end of the fourteenth century, 'which was the century par excellence of collegiate expansion in western Europe'. Another eleven were founded in the fifteenth century, making sixty-six in all. The Paris colleges were suppressed in 1789 at the French Revolution, and the university was never allowed to revert to collegiate lines.

   English colleges originated later than in Paris and were always intended for graduate use – undergraduates were a later innovation. Originally housed in taverns, or hostels, Merton College was first, in 1264, followed by University College *c.* 1280, and by Balliol in 1282. At Cambridge, Peterhouse was established in 1284. By 1300, Cambridge had eight colleges, housing 137 fellows. At Oxford, King's Hall was the first to admit undergraduates, in the early part of the fourteenth century. The graduate colleges were gradually transformed into undergraduate ones, largely for economic reasons – tutorial fees. This process was completed, for the most part, by the Reformation. It was the (undergraduate) colleges which introduced the tutorial system of instruction, as the public lecture system was falling into disarray. Cobban, *Op. cit.*, pages 123–141, *passim*.
82. *Ibid.*, page 209.
83. *Ibid.*, page 214. See also: Schachner, *Op. cit.*, pages 322ff.
84. Cobban, *Op. cit.*, page 215.
85. Crosby, *Op. cit.*, page 19. This may have been aided by what Jacques le Goff calls the new education of the memory, brought about by Lateran IV's requirement for the faithful to make confession once a year. Le Goff also says that preaching became more precise at this time. *Op. cit.*, page 80.
86. Crosby, *Op. cit.*, pages 28–29.
87. *Ibid.*, page 33.
88. *Ibid.*, page 36.
89. Paul Saenger, *Space Between Words: The Origins of Silent Reading*, Stanford and London: Stanford University Press, 1997, page 136.
90. Crosby, *Op. cit.*, page 42. Numbers still had their mystical side. Six was perfect because God made the world in six days, seven was perfect because it was the sum of the first odd and the first even number, and because God had rested on the seventh day after the Creation. Ten, the number of the commandments, stood for law, whereas eleven, going beyond the law, stood for sin. The number 1,000 also represented perfection because it was the number of the commandments multiplied by itself three times over, three being the number of the Trinity and the number of days between the Crucifixion and the Resurrection. *Ibid.*, page 46.
91. Jacques le Goff, 'The town as an agent of Civilisation, 1200–1500', in Carlo M. Cipolla (editor), *The Fontana Economic History of Europe: The Middle Ages*, Hassocks, Sussex: Harvester, 1976–1977, page 91.
92. Crosby, *Op. cit.*, page 57.
93. Saenger, *Op. cit.*, pages 12, 17 and 65. John Man, *The Gutenberg Revolution*, London: Review/Headline, 2002, pages 108–110.
94. Chester Jordan, *Op. cit.*, page 118. Crosby, *Op. cit.*, page 136. Saenger, *Op. cit.*, page 250.
95. A. J. Gurevich, *Categories of Medieval Culture*, London: Routledge & Kegan Paul, 1985, pages 147–150. See Le Goff, *The Medieval Imagination*, *Op. cit.*, pages 12–14, for medieval ideas of space and time.
96. Crosby, *Op. cit.*, page 82.
97. *Ibid.*, page 101. Jacques le Goff says there was a great wave of anti-intellectualism at this time which retarded the acceptance of some of these innovations. Jacques le Goff, *Intellectuals in the Middle Ages*, Oxford: Blackwell, 1993, pages 136–138.
98. Crosby, *Op. cit.*, page 113.
99. The German marks fought for supremacy with $\bar{P}$ and $\bar{M}$ throughout the sixteenth century and were not finally adopted until the French algebraists used them.
100. Crosby, *Op. cit.*, page 117.
101. *Ibid.*, page 120.

102. Charles M. Radding, *A World Made by Men: Cognition and Society, 400–1200*, Chapel Hill: University of North Carolina Press, 1985, page 188.

103. Piltz, *Op. cit.*, page 21.

104. Crosby, *Op. cit.*, page 146.

105. Albert Gallo, *Music of the Middle Ages*, Cambridge, England: Cambridge University Press, 1985, volume 2, pages 11–12.

106. In particular a form of syncopation known as the *hoquet*, a French word for the technique where one voice sang while another rested, and vice versa rapidly. Hoquet eventually became the English word 'hiccup'. Crosby, *Op. cit.*, page 158.

107. Piltz, *Op. cit.*, pages 206–207.

108. Man, *Op. cit.*, page 87, for the demand stimulated by universities.

109. Crosby, *Op. cit.*, page 215. In intellectual terms, the disputation was perhaps the most important innovation of the university, allowing the students to see that authority isn't everything. In an era of ecclesiastical domination and canon law, this was crucial. The exemplar system of manuscript circulation also enabled more private study, another important aid to the creative student, and something which would be augmented by the arrival of the printed book at the end of the fifteenth century.

110. Even so, a country like France easily produced 100,000 bundles of vellum a year, each bundle containing forty skins. Febvre and Martin, *Op. cit.*, page 18.

111. *Ibid.*, page 20.

112. Man, *Op. cit.*, pages 135–136.

113. Febvre and Martin, *Op. cit.*, page 50. For early presses see: Alister McGrath, *In the Beginning: The Story of the King James Bible*, London: Hodder & Stoughton, 2001, pages 10ff.

114. Febvre and Martin, *Op. cit.*, page 54. See also: Moynahan, *Op. cit.*, page 341.

115. Febvre and Martin, *Op. cit.*, page 56. Moynahan, *Op. cit.*, page 341 on the print quality of early books.

116. Douglas MacMurtrie, *The Gutenberg Documents*, New York and Oxford: Oxford University Press, 1941, pages 208ff.

117. Febvre and Martin, *Op. cit.*, page 81. See McGrath, *Op. cit.*, page 13, for Gutenberg's type.

118. Martin Lowry, 'The Manutius publicity campaign', in David S. Zeidberg and F. G. Superbi (editors), *Aldus Manutius and Renaissance Culture*, Florence: Leo S. Olschki, 1998, pages 31ff.

119. McGrath, *Op. cit.*, page 15, for early edition sizes.

120. Febvre and Martin, *Op. cit.*, page 162.

121. The first move was when publishers agreed not to print a second edition of a book without the author's permission, which was only granted on payment of a further sum. Febvre and Martin, *Op. cit.*, page 164.

122. *Ibid.*, page 217.

123. McGrath, *Op. cit.*, page 18, says the price of a Gutenberg Bible was equivalent to that of a large town house in a German city in 1520.
     From the start, books were were sold at book fairs all over Europe. Lyons was one, partly because it had many trade fairs and merchants were familiar with the process. It was also a major crossroads, with important bridges over the Rhône and Saône. In addition, to preserve the fair, the king gave the merchants in Lyons certain privileges – for example, no merchant was obliged to open his account books for inspection. Some forty-nine booksellers and printers were established in the city, mainly along the rue Mercière, though many of them were foreign. This meant that books in many languages were bought and sold at the Lyons book fair and the city became an important centre for the spread of ideas. (Law books were especially popular.) The main rival was at Frankfurt (not far from Mainz). There too there were many trade fairs – wine, spices, horses, hops, metals. Booksellers arrived at the turn of the sixteenth century, together with publishers from Venice, Paris, Antwerp and Geneva. During the fair they were grouped in the Büchergasse, 'Book Street', between the river Main and St Leonard's church. New publications were advertised at Frankfurt, where the publisher's catalogue seems to have started, and it also became known as a market in printing equipment. Thus Frankfurt slowly became a centre for everyone engaged in the book trade – as it still is for two weeks every year in October. Lucien Febvre and Henri-Jean Martin went through these Frankfurt book catalogues in their study on the impact of the book and they found that, between 1564 and 1600, more than 20,000 different titles were on offer, published by 117 firms in sixty-one towns. The Thirty Years War (1618–1648) had a catastrophic effect on book production and on the Frankfurt fair. Instead, political conditions favoured the Leipzig book fair and it would be some time before Frankfurt regained its pre-eminence. Febvre and Martin, *Op. cit.*, page 231.

124. *Ibid.*, page 244.

125. Lisa Jardine, *Worldly Goods*, London: Macmillan, 1996, pages 172–173.

126. Febvre and Martin, *Op. cit.*, page 246.

127. *Ibid.*, page 248.

128. See for example, Ralph Hexter, 'Aldus, Greek, and the shape of the "classical corpus"', in Zeidberg and Superbi (editors), *Op. cit.*, page 143ff.

129. Febvre and Martin, *Op. cit.*, page 273. See McGrath, *Op. cit.*, pages 24ff and 253ff, for the rise of vernacular languages caused by printing.

130. Febvre and Martin, *Op. cit.*, page 319.

131. *Ibid.*, page 324. See McGrath, *Op. cit.*, page 258, for Robert Cawdry's *The Table Alphabetical of Hard Words* (1604), which listed 2,500 unusual or borrowed words.

132. Hexter says Aldus promoted Greek as well as Latin. Hexter, *Op. cit.*, page 158.

CHAPTER 18: THE ARRIVAL OF THE SECULAR: CAPITALISM, HUMANISM, INDIVIDUALISM

1. Jardine, *Worldly Goods*, *Op. cit.*, pages 13–15.

2. Harry Elmer Barnes, *An Intellectual and Cultural History of the Western World*, volume 2, New York: Dove, 1965, page 549.

3. Charles Homer Haskins, *The Twelfth Century Renaissance*, Cambridge, Massachusetts: Harvard University Press, 1927, though William Chester Jordan, in *Europe in the High Middle Ages*, *Op. cit.*, page 120, wonders whether the twelfth century just saw 'an exceptional series of towering figures'.

4. Erwin Panofsky, *Renaissance and Renascences in Western Art*, Stockholm: Almqvist & Wiksell, 1960, pages 3, 25 and 162.

5. Norman Cantor, *In the Wake of the Plague*, New York: HarperCollins, 2001, page 203.

6. *Ibid.*, pages 204–205. For Florence and the plague, see Gene Brucker, *Renaissance Florence*, Los Angeles: University of California Press, 1983, pages 40ff.

7. Paul F. Grendler, *Schooling in Renaissance Italy: Literacy*

*and Learning 1300–1600*, Baltimore and London: Johns Hopkins University Press, 1989, page 410.

8. *Ibid.*, page 43.
9. *Ibid.*, pages 122–124.
10. *Ibid.*, pages 72–73.
11. *Ibid.*, pages 310–311.
12. *Ibid.*, pages 318–319.
13. Hall, *Cities in Civilisation, Op. cit.*, 1998, page 78.
14. R. A. Goldthwaite, *The Building of Renaissance Florence: An Economic and Social History*, Baltimore: Johns Hopkins University Press, 1989, pages 20–22.
15. Gene Brucker, *Florentine Politics and Society, 1343–1378*, Princeton, New Jersey: Princeton University Press, 1962, pages 33ff, for the old- and new-style merchants.
16. G. Holmes, *Florence, Rome and the Origin of the Renaissance*, Oxford: Oxford University Press, 1986, page 39. See also: Brucker, *Op. cit.*, page 71.
17. R. S. Lopez, 'The trade of medieval Europe: the south', in M. Postan *et al*, (editors), *The Cambridge Economic History of Europe*, volume 2: *Trade and Industry in the Middle Ages*, Cambridge, England: Cambridge University Press, 1952, pages 257ff.
18. Hall, *Op. cit.*, page 81.
19. J. Lamer, *Italy in the Age of Dante and Petrarch: 1216–1380*, London: Longman, 1980, page 223.
20. Hall, *Op. cit.*, page 81. The woollen industry showed different aspects of fledgling capitalism. For example, most of the 200 woollen companies were associations of two or more *lanaiuoli*, entrepreneurs who provided the capital for the plant's operation, but rarely got involved in management, which was done by a salaried factor who might have as many as 150 people under him – dyers, fullers, weavers and spinners. In the 1427 census, wool merchants were the third most numerous profession in Florence after shoemakers and notaries. The spirit of capitalism was also evident from the growing concentration into fewer and larger firms, which reduced in number between 1308 and 1338 from 300 to 200. 'Fortunes were made but there were also many bankruptcies.' *Ibid.*, page 83 and Lamer, *Op. cit.*, page 197.
21. Hall, *Op. cit.*, page 84. See Brucker, *Op. cit.*, page 105, for the arrogance of the Bardi family.
22. Hall, *Op. cit.*, page 85.
23. Brucker, *Op. cit.*, page 105 for the conflict between mercantile and noble values.
24. Hall, *Op. cit.*, page 101.
25. *Ibid.*, page 87.
26. See Brucker, *Op. cit.*, pages 217–218, for the *convegni* of like-minded groups.
27. Hall, *Op. cit.*, pages 94–95.
28. *Ibid.*, page 98.
29. For painters and sculptors, the fundamental unit was the *bottega* or workshop, often producing a variety of objects. Botticelli, for instance, produced *cassoni* or wedding chests and banners. And masters worked with assistants, like modern artisans. Ghirlandaio, Raphael and Perugino all had workshops, which were often family affairs. Hall, *Op. cit.*, pages 102–103 and M. Wackenagel, *The World of the Florentine Renaissance Artist: Projects and Patrons, Workshop and Market*, Princeton, New Jersey: Princeton University Press, 1981, pages 309–310. Translation: A. Luchs.
30. Brucker, *Op. cit.*, pages 215–216.
31. Hall, *Op. cit.*, page 108.
32. Brucker, *Op. cit.*, page 26.
33. Hall, *Op. cit.*, pages 98 and 106.
34. *Ibid.*, page 108.
35. Brucker, *Op cit.*, pages 214–215, for the role of Dante.
36. D. Hay, *The Italian Renaissance in Its Historical Background*, Cambridge, England: Cambridge University Press, 1977, page 139.
37. Hall, *Op. cit.*, page 110.
38. *Ibid.*
39. *Ibid.*, page 371.
40. William Kerrigan and Gordon Braden, *The Idea of the Renaissance*, Baltimore and London: Johns Hopkins University Press, 1989, pages 7–8.
41. Tarnas, *The Passion of the Western Mind, Op. cit.*, page 212.
42. Brucker, *Op. cit.*, pages 226–227.
43. James Haskins, *Plato in the Italian Renaissance*, Leiden: E. J. Brill, 1990, volume 1, page 95.
44. Hans Baron, *The Crisis of the Early Italian Renaissance: Civic Humanism and Republican Liberty in an Age of Classicism and Tyranny* (two volumes), Princeton, New Jersey: Princeton University Press, 1955, volume 1, page 38.
45. Kerrigan and Braden, *Op. cit.*, page 101. Some scholars have doubted that the academy ever existed.
46. *Ibid.* One reason Ficino found Plato so congenial, rather than Aristotle (over and above the fact that the texts were newly available), was his belief that 'deeds sway us more than the accounts of deeds' and that 'exemplary lives' (the Socratic way of life) are better teachers than the moral instruction of Aristotle.
47. Tarnas, *Op. cit.*, page 214; Brucker, *Op. cit.*, page 228. Haskins, *Op. cit.*, page 295.
48. Tarnas, *Op. cit.*, page 216. Haskins, *Op. cit.*, page 283.
49. Barnes, *Op. cit.*, page 556.
50. *Ibid.*, page 558.
51. A. J. Krailsheimer, 'Erasmus', in A. J. Krailsheimer (editor), *The Continental Renaissance*, London: Penguin Books, 1971, pages 393–394.
52. McGrath, *Op. cit.*, pages 253ff. See also: Krailsheimer (editor), *Op. cit.*, page 478ff, for Montaigne.
53. Barnes, *Op. cit.*, page 563.
54. *Ibid.*
55. Bronowski and Mazlish, *The Western Intellectual Tradition, Op. cit.*, page 61.
56. Kerrigan and Braden, *Op. cit.*, page 77.
57. Bronowski and Mazlish, *Op. cit.*, page 67.
58. Krailsheimer (editor), *Op. cit.*, pages 388–389, for the background to *Adages* and its success.
59. Barnes, *Op. cit.*, page 564.
60. *Ibid.*, page 565.
61. Bronowski and Mazlish, *Op. cit.*, page 72. See Moynahan, *Op. cit.*, page 339, for what Erasmus wrote elsewhere about Luther.
62. Francis Ames-Lewis and Mary Rogers (editors), *Concepts of Beauty in Renaissance Art*, Aldershot: Ashgate, 1998, page 203.
63. Peter Burke, *Culture and Society in Renaissance Italy, 1420–1540*, London: Batsford, 1972, page 189.
64. *Ibid.*, page 191.
65. Kerrigan and Braden, *Op. cit.*, page 17.
66. Burke, *Op. cit.*, page 191.
67. Kerrigan and Braden, *Op. cit.*, page 11.
68. *Ibid.*, pages 19–20. Even the economic records of the Datini family, referred to earlier, were kept for 'posterity', as if they equated to some sort of literary archive in which money was the equivalent of poetry. *Ibid.*, pages 42–43.
69. *Ibid.*, page 62.
70. Burke, *Op. cit.*, page 194. And see Brucker, *Op. cit.*, page

100 for criticism of Burckhardt and the conclusions he draws.

71. Burke, *Op. cit.*, page 195.

72. *Ibid.*, page 197.

73. Hall, *Op. cit.*, page 90. Brucker, *Op. cit.*, pages 218–220, for universities and tolerance in Florence.

74. Tarnas, *Op. cit.*, page 225.

75. Peter Burke, Introduction to Jacob Burckhardt, *The Civilisation of the Renaissance in Italy*, London: Penguin Books, 1990, page 13.

76. They even felt they could conquer death, in the sense of gaining a measure of fame that would outlive them, and cause them to be remembered. In fifteenth-century tomb sculpture, for example, the macabre is almost totally absent. Burke, *Culture and Society in Renaissance Italy, Op. cit.*, page 201.

77. *Ibid.*, page 200. See Brucker, *Op. cit.*, pages 223–225, for Bracciolini and Florentine attitudes to money and fame.

78. Burke, *Op. cit.*, page 201.

CHAPTER 19: THE EXPLOSION OF IMAGINATION

1. There are many accounts. See, for example: Herbert Lucas SJ, *Fra Girolamo Savonarola*, London: Sands & Co., 1899, pages 40ff; and see Pierre van Paassen, *A Crown of Fire: The Life and Times of Girolamo Savonarola*, London: Hutchinson, 1961, pages 173ff, for other tactics of Savonarola.

2. Burckhardt, *The Civilisation of the Renaissance in Italy, Op. cit.*, pages 302–303. See also: Moynahan, *Op. cit.*, pages 334–335, for another account.

3. Elizabeth Cropper, Introduction to Francis Ames-Lewis and Mary Rogers (editors), *Concepts of Beauty in Renaissance Art*, page 1.

4. *Ibid.*, page 2, and Burckhardt, *Op. cit.*, volume II, page 351.

5. Aerial perspective deals with the tendency for all observable objects, as they recede from the spectator, to become more muted in tone and to become bluer in proportion to their distance, owing to the density of the atmosphere. (This is why mountains in the background always appear blueish.) Peter and Linda Murray, *Dictionary of Art and Artists* (seventh edition), London: Penguin Books, 1997, pages 337–338.

6. It was a bishop, the Bishop of Meaux, who argued in his mammoth poem, *Ovide Moralisé*, that Christian instruction could be found in many of the myths of Ovid. Burke, *Op. cit.* And see Moynahan, *Op. cit.*, page 335, for the way Botticelli changed under the influence of Savonarola.

7. In line with all this there grew up what could be called an allegorical literature. As academies like Ficino's spread to other cities beyond Florence, it became a desirable accomplishment for a courtier to be able to decipher allegories. Books of emblems began to appear in which a mythological device was shown alongside a few lines of verse explaining the meaning and moral of the picture. Venus, for instance, standing with one foot on a tortoise, teaches 'that woman's place is in the home and that she should know when to hold her tongue'. See: Peter Watson, *Wisdom and Strength: The Biography of a Renaissance Masterpiece*, New York: Doubleday, 1989, page 47. The impresa was a parallel innovation: it consisted of an image and text but was devised specifically for an individual, and commemorated either an event in that person's life, or some trait or character. It did not appear in book form but as a medallion or sculpture or bas relief, the latter as often as not on the ceiling of the distinguished person's bedroom so that he could reflect on its message as he went

to sleep. There was also an array of popular manuals which appeared in the middle of the sixteenth century, such as *The History of the Gods* (1548) by Lilio Gregorio Giraldi, and *The Images of the Gods* (1556) by Natale Conti. Conti explains best the purpose of these works: that from the earliest times – first in Egypt, then in Greece – thinkers deliberately concealed the great truths of science and philosophy under the veil of myth in order to withdraw them from vulgar profanation. He therefore organised his own book according to what he thought were the hidden messages to be revealed: the secrets of nature, the lessons of morality, and so on. Jean Seznec sums up the spirit of the times when he says that allegories came to be regarded as a means of 'rendering thought visible'. Jean Seznec, *The Survival of the Pagan Gods*, Princeton, New Jersey: Princeton University Press/Bollingen Series, 1972/1995.

8. Umberto Eco (translated by Hugh Bredin), *Art and Beauty in the Middle Ages*, New Haven and London: Yale University Press, 1986/2002, pages 116–117.

9. *Ibid.*, page 114.

10. Ames-Lewis and Rogers (editors), *Op. cit.*, pages 180–181.

11. Dorothy Koenigsberger, *Renaissance Man and Creative Thinking*, Hassocks, Sussex: Harvester Press, 1979, page 236.

12. Burckhardt, *Op. cit.*, page 102.

13. Koenigsberger, *Op. cit.*, page 13.

14. *Ibid.*, pages 19–21.

15. *Ibid.*, page 22. See also Brucker, *Op. cit.*, page 240.

16. Burke, *Culture and Society in Renaissance Italy, Op. cit.*, pages 51–52.

17. Ames-Lewis and Rogers (editors), *Op. cit.*, pages 113–114.

18. Burke, *Op. cit.*, pages 51–52.

19. *Ibid.*, pages 55–56. Brucker, *Op. cit.*, page 243, says Brunelleschi also 'learned some mathematics'.

20. Ames-Lewis and Rogers (editors), *Op. cit.*, pages 32–35.

21. *Ibid.*, page 33.

22. Koenigsberger, *Op. cit.*, page 31.

23. Ames-Lewis and Rogers (editors), *Op. cit.*, page 81.

24. *Ibid.*, page 72.

25. One particular aspect of the effect of humanism on art was the notion of *ekphrasis*, the recreation of classical painting based on ancient written accounts of works which the classical authors had seen but were now lost. In the same way, Renaissance artists emulated ancient artists. For example, Pliny recounts a famous story about the *trompe l'oeil* qualities of the grapes in a painting by Zeuxis that were so lifelike the birds mistook them for real grapes and flew down to peck at them. Likewise, Filarete paraphrased an anecdote about Giotto and Cimabue: 'And we read of Giotto that as a beginner he painted flies, and his master Cimabue was so taken in that he believed they were alive and started to chase after them with a rag.' *Ibid.*, page 148.

26. Burke, *Op. cit.*, illustration facing page 148.

27. *Ibid.*

28. In fact, nothing came of this approach.

29. Watson, *Op. cit.*, page 31.

30. Barnes, *Op. cit.*, page 929.

31. *Ibid.*, page 931.

32. Yehudi Menuhin and Curtis W. Davis, *The Music of Man*, London: Methuen, 1979, page 83.

33. *Ibid.*, page 83.

34. *Ibid.*, page 84.

35. Al-Farabi thought the rabab most closely matched the voice. Anthony Baines (editor), *Musical Instruments Through the Ages*, London: Penguin, 1961, page 216.

36. Joan Peysor *et al.* (editors), *The Orchestra*, New York: Billboard, 1986, page 17. See Baines (editor), *Op. cit.*, page 68, for more on Pythagoras. *Ibid.*, page 53, also links the shawm to instruments in Ur. John Spitzer and Neal Zaslaw, *The Birth of the Orchestra: History of an Institution, 1650–1815*, Cambridge, England: Cambridge University Press, 2003.

37. Alfred Einstein, *A Short History of Music*, London: Cassell, 1936/1953, page 54.

38. Barnes, *Op. cit.*, page 930.

39. Baines, *Op. cit.*, page 117, who says, page 192, that *Orfeo* also made use of a double harp.

40. Barnes, *Op. cit.*, page 932.

41. Hall, *Cities in Civilisation*, *Op. cit.*, page 114. Sheldon Cheney, *The Theatre: Three Thousand Years*, London: Vision, 1952, page 266, says only a third of the plays have survived.

42. Hall, *Op. cit.*, page 115.

43. Richard Stone, *The Causes of the English Revolution, 1529–1642*, London: Routledge Kegan Paul, 1972, page 75.

44. L. C. Knights, *Drama and Society in the Age of Jonson*, London: Chatto & Windus, 1937, page 118. See also Cheney, *Op. cit.*, pages 261ff, for the social changes behind the rise in theatre.

45. N. Zwager, *Glimpses of Ben Jonson's London*, Amsterdam: Swets & Zeitlinger, 1926, page 10.

46. Hall, *Op. cit.*, page 125.

47. *Ibid.*, page 126.

48. See Annabel Patterson, *Shakespeare and the Popular Voice*, Oxford: Blackwell, 1989, pages 20–21, for repeated attempts to control the theatre.

49. See Cheney, *Op. cit.*, page 264, for another candidate. Patterson, *Op. cit.*, page 30, points out that at least five of the characters in Hamlet are university men.

50. Hall, *Op. cit.*, page 130, and Cheney, *Op. cit.*, page 169. See the latter source, page 271, for a rare, uncontested drawing of a Shakespearean theatre.

51. But see Patterson, *Op. cit.*, page 33, for the cultural divisions of the time, and pages 49–50, for Shakespeare's own attack on illiteracy.

52. Harold Bloom, *The Western Canon*, New York: Harcourt Brace, 1994, pages 46–47.

53. *Ibid.*, pages 67–68. Cheney, *Op. cit.*, page 273, for Shakespeare's adaptations and hack writing.

54. Barnes, *Op. cit.*, page 620.

55. Krailsheimer (editor), *Op. cit.*, page 325, for *La Celestina*.

56. Angus Fletcher, *Colors of the Mind*, Cambridge, Massachusetts: Harvard University Press, 1991. See also: William Byron, *Cervantes*, London: Cassell, 1979, pages 124ff, for the battle of Lepanto, and page 427 for more on the relation between the Don and Sancho Panza.

57. Byron, *Op cit.*, page 430.

## CHAPTER 20: THE MENTAL HORIZON OF CHRISTOPHER COLUMBUS

1. Valerie Flint, *The Imaginative Landscape of Christopher Columbus*, Princeton, New Jersey, and London: Princeton University Press, 1992, page 115.

2. Beatrice Pastor Bodmer, *The Armature of Conquest*, Stanford, California: Stanford University Press, 1992, pages 10–11.

3. John Parker, *Discovery*, New York: Scribner, 1972, page 15.

4. *Ibid.*, page 16.

5. *Ibid.*, pages 18–19.

6. For the dimensions and speeds of Columbus' ships, see E. Keble Chatterton, *Sailing the Seas*, London: Chapman & Hall, 1931, pages 150–151.

7. Parker, *Op. cit.*, page 24.

8. *Ibid.*, page 25.

9. *Ibid.*, page 26.

10. To prove this once and for all, Alexander instructed Nearchus, a trusted officer, to sail back west to Persia, where Alexander would meet him. Nearchus' voyage was eventful. He encountered people who lived only on fish – they even made bread out of fish; he saw terrifying whales which spouted water like geysers; and he was blown in all directions by unpredictable winds. But some of the ships made it and Nearchus and Alexander met up again in the Persian Gulf, having discovered the way to India by both land and sea. Parker, *Op. cit.*, pages 30–32.

11. *Ibid.*, page 33.

12. John Noble Wilford, *The Mapmakers*, New York: Vintage, 1982, pages 19–20.

13. For Eratosthenes' map of the world, see: Ian Cameron, *Lode Stone and Evening Star: The Saga of Exploration by Sea*, London: Hodder & Stoughton, 1965, page 32.

14. Parker, *Op. cit.*, pages 48–49.

15. *Ibid.*, page 51.

16. Evelyn Edson, *Mapping Time and Space*, London: British Library, 1997, pages 108–109, which includes a map showing Paradise in the east as a 'sunburst-island' with four rivers draining out of it.

17. Parker, *Op. cit.*, page 54.

18. *Ibid.*, page 55.

19. See Tryggi J. Oleson, *Early Voyages and Northern Approaches 1000–1632*, Oxford and New York: Oxford University Press/McClelland Stewart, 1964, pages 100ff, for other 'mythical' voyages.

20. Noble Wilford, *Op. cit.*, page 38.

21. Parker, *Op. cit.*, page 62.

22. *Ibid.*, page 63.

23. Oleson, *Op. cit.*, page 101, says that Brendan 'probably' reached the St Lawrence.

24. *Ibid.*, chapter 6, for the Skraelings. Phillips, *The Medieval Expansion of Europe*, *Op. cit.*, pages 166–179, for the medieval discovery of America. The Vinland Map, at Yale University, purportedly made about 1440, but very probably a forgery, shows that these 'western isles' were still (fairly accurately) in the mind of the mapmaker and that they constituted a traditional part of the idea of the north Atlantic.

25. Parker, *Op. cit.*, page 83. Phillips, *Op. cit.*, page 192 for the Prester John/Alexander the Great legend.

26. Bodmer, *Op. cit.*, pages 13–14. And Phillips, *Op. cit.*, page 69.

27. Parker, *Op. cit.*, page 89.

28. Bodmer, *Op. cit.*, page 15.

29. Moynahan, *Op. cit.*, page 188, for Polo's other (Christian) adventures.

30. Ross E. Dunn, *The Adventures of Ibn Battuta*, Los Angeles and Berkeley: University of California Press, 1986/1989. Phillips, *Op. cit.*, page 113, for Rustichello of Pisa.

31. Flint, *Op. cit.*, page 3.

32. *Ibid.*, page 7.

33. This position also implied an arduous uphill journey to reach it, which accorded well with the moral preoccupations of the time.

34. Flint, *Op. cit.*, page 9.

35. *Ibid.*, page 10.

36. *Ibid.*, page 26.

37. *Ibid.*, page 36.

38. Bodmer, *Op. cit.*, page 13.
39. Flint, *Op. cit.*, page 40 and ref. Samuel Morison, *Christopher Columbus: Mariner*, maps by Erwin Raisz, London: Faber, 1956, page 103.
40. Flint, *Op. cit.*, page 42.
41. Bodmer, *Op. cit.*, page 15.
42. Flint, *Op. cit.*, page 53.
43. He would actually set up a council to govern the first island he discovered, based on his reading. Joachim G. Leithäuser, *World Beyond the Horizon*, translated by Hugh Merrick, New York: Knopf, 1955, page 73.
44. *Ibid.*, page 44.
45. Bodmer, *Op. cit.*, chapter 4, which includes a discussion of 'models', ways to understand the new world and its social arrangements.
46. Flint, *Op. cit.*, page 95.
47. *Ibid.*, page 96.
48. J. D. Bernal, *The Extension of Man: The History of Physics Before the Modern Age*, London: Weidenfeld & Nicolson, 1954, pages 124–127.
49. J. H. Parry, *The Age of Reconnaissance*, London: Weidenfeld & Nicolson, 1963, pages 100ff. See also: Edson, *Op. cit.*, especially chapter 1; and Noble Wilford, *Op. cit.*, chapters 4 and 5, pages 34–72.
50. Parry, *Op. cit.*, page 103.
51. *Ibid.*, page 105.
52. *Ibid.*, page 106.
53. Noble Wilford, *Op. cit.*, pages 71ff.
54. Parry, *Op. cit.*, page 112.
55. Noble Wilford, *Op. cit.*, page 75.
56. At night the so-called 'guards' of the Pole Star describe a complete circle around the pole every twenty-four hours. 'A nocturnal' consisted of a circular disc with a central hole for sighting Polaris and a rotating pointer to be aligned on Kochab. Around the edge of the disc were a series of marks indicating the angle for midnight on various dates of the year. This gave a crude measure of midnight for every day of the year. Noble Wilford, *Op. cit.*, page 77.
57. *Ibid.*, page 79.
58. *Ibid.*, page 82.
59. Tidal races were also much more important in the Atlantic, where the tides rose and fell many feet, than in the Mediterranean, where they did not, and where the only dangerous tidal race was in the Straits of Messina. The relation of the tides to the moon now came into sharper focus, since they often affected access to Atlantic ports. Noble Wilford, *Op. cit.*, page 85.
60. Parry, *Op. cit.*, page 98. Phillips, *Op. cit.*, page 194, for the implications of the disappearance of the Pole Star.
61. Parry, *Op. cit.*, page 63.
62. *Ibid.*
63. For a vivid description of travel aboard a galley see: Chatterton, *Op. cit.*, page 139.
64. Parry, *Op. cit.*, page 58. See Chatterton, *Op. cit.*, page 144, for a description of the development of lateen rigging and the highpoint of its use at the battle of Lepanto in 1571. The format allowed a ship to sail 'two points nearer the wind'. And see the illustration facing page 142.
65. Ronald J. Watkins, *Unknown Seas: How Vasco da Gama Opened the East*, London: John Murray, 2003, page 118.
66. Parry, *Op. cit.*, page 140.
67. He also found Christians on the Malabar coast, whose liturgy was in Syriac. Moynahan, *Op. cit.*, page 553.
68. Parry, *Op. cit.*, page 149.
69. Bodmer, *Op. cit.*, page 10.
70. Parry, *Op. cit.*, page 151.

71. Felipe Fernández-Armesto, *Columbus and the Conquest of the Impossible*, London: Weidenfeld & Nicolson, 1974, pages 166–167.
72. Parry, *Op. cit.*, page 154 and ref. See also: Peter Martyr, *De Orbo Novo*, edited and translated by F. A. McNutt, New York 1912, volume 1, page 83, quoted in Parry, *Ibid.*
73. *Ibid.*, page 159.

CHAPTER 21: THE 'INDIAN' MIND: IDEAS IN THE NEW WORLD

1. Diamond, *Guns, Germs and Steel*, London: Cape, 1997.
2. *Ibid.*, page 140.
3. J. H. Elliott, *The Old World and the New*, Cambridge, England: Cambridge University Press/Canto, 1970/1992, page 7.
4. *Ibid.*, page 8.
5. *Ibid.*
6. Bodmer, *Op. cit.*, page 33.
7. Elliott, *Op. cit.*, page 9.
8. *Ibid.*, pages 9–10.
9. Bodmer, *Op. cit.*, pages 65–66 and 88. For Gómara, see: Michael D. Coe, *Breaking the Maya Code*, London and New York: Thames & Hudson, 1992, page 78.
10. Elliott, *Op. cit.*, page 10.
11. *Ibid.*, page 11.
12. *Ibid.*, page 12. But see: Jack P. Greene, *The Intellectual Construction of America*, Chapel Hill: University of North Carolina Press, 1993, page 15, for the expectations of Americans.
13. Bodmer, *Op. cit.*, page 12.
14. Elliott, *Op. cit.*, page 15.
15. There was a rougher side to the first explorers too. See Leithäuser, *Op. cit.*, pages 38ff, for the tricks Columbus used to keep his men pacific.
16. *Ibid.*, page 24.
17. Bodmer, *Op. cit.*, page 32.
18. Elliott, *Op. cit.*, page 25.
19. *Ibid.* See also: Moynahan, *Op. cit.*, page 510.
20. Elliott, *Op. cit.*, page 29.
21. On a different aspect of comparative science, despite the many wild animals in the New World, it was the bloodhounds of the Spanish which most terrified the Indians. These animals were sometimes instructed to tear the Indians to pieces. Leithäuser, *Op. cit.*, pages 160–161.
22. Bodmer, *Op. cit.*, pages 212–213.
23. Elliott, *Op. cit.*, page 34.
24. *Ibid.*, page 36.
25. *Ibid.*, page 37.
26. Leithäuser, *Op. cit.*, pages 165–166 for Indian drawings of these activities.
27. Bodmer, *Op. cit.*, pages 60–61.
28. Elliott, *Op. cit.*, page 38.
29. *Ibid.*, page 39.
30. Acosta had a theory that minerals 'grew' in the New World, like plants. Bodmer, *Op. cit.*, pages 144–145.
31. Elliott, *Op. cit.*, page 39.
32. *Ibid.*, pages 39–40.
33. Evgenii G. Kushnarev (edited and translated by E. A. P. Crownhart-Vaughan), *Bering's Search for the Strait*, Portland: Oregon Historical Society Press, 1990 (first published in Leningrad [now St Petersburg], 1968). For Cartier and Nicolet see Phillips, *The Medieval Expansion of Europe*, *Op. cit.*, page 259.
34. Elliott, *Op. cit.*, page 40.
35. Bodmer, *Op. cit.*, pages 209ff, for a discussion of the meaning of 'barbarity' in this context. See also: 'Savages

noble and ignoble: concepts of the North American Indian', chapter 7 (pages 187ff) of: P. J. Marshall and Glyndwr Williams, *The Great Map of Mankind: Perceptions of the World in the Age of Enlightenment*, London: Dent, 1982.

36. Leithäuser, *Op. cit.*, for a vivid description of Tenochtitlán, in Mexico, and its sophisticated engineering and art works.

37. Elliott, *Op. cit.*, pages 42–43.

38. Bodmer, *Op. cit.*, page 67.

39. Elliott, *Op. cit.*, page 43.

40. Anthony Pagden, *The Fall of Natural Man*, Cambridge, England: Cambridge University Press, 1982, page 39.

41. *Ibid.*, page 49. See Moynahan, *Op. cit.*, page 508, for the legalistic thinking behind this.

42. This view envisaged the Indian as one day becoming a free man but until that time arrived he must remain 'in just tutelage under the king of Spain'. Pagden, *Op. cit.*, page 104.

43. Wright, *Op. cit.*, page 23. Also: Bodmer, *Op. cit.*, pages 143–144. And Moynahan, *Op. cit.*, page 510.

44. Pagden, *Op. cit.*, page 45.

45. *Ibid.*, page 46.

46. Moynahan, *Op. cit.*, page 510. Bodmer, *Op. cit.*, page 144.

47. Pagden, *Op. cit.*, page 119.

48. Leithäuser, *Op. cit.*, pages 197ff, for the development of detailed maps of America.

49. Elliott, *Op. cit.*, page 49.

50. Pagden, *Op. cit.*, page 164.

51. *Ibid.*, page 174.

52. There was also a theory that the precious metals of the world were collected in a fabulous region near the equator, and that the American natives knew where this region was. Padre José de Acosta, *Historia Natural y Moral de las Indias*, Madrid, 1954, pages 88–89, quoted in Bodmer, *Op. cit.*, page 155.

53. Elliott, *Op. cit.*, pages 49–50.

54. *Ibid.*, page 51.

55. *Ibid.*, page 52.

56. Alvin M. Josephy Jr (editor), *America in 1492*, New York: Vintage, 1991/1993, page 6.

57. William McLeish, *The Day Before America*, Boston: Houghton Mifflin, 1994, page 168.

58. Moreover, the Sioux and many other tribes that became famous as Plains warriors were not yet living on the plains in 1492. Josephy (editor), *Op. cit.*, page 8.

59. *Ibid.*, page 34.

60. J. C. Furnas, *The Americas: A Social History of the United States, 1587–1914*, London: Longman, 1970, which includes details of the things Europeans tried to learn from the Indians.

61. Josephy (editor), *Op. cit.*, page 76.

62. *Ibid.*, pages 170–171.

63. McLeish, *Op. cit.*, page 131.

64. *Ibid.*, page 195.

65. *Ibid.*, page 196.

66. *Ibid.*, page 194.

67. Josephy (editor), *Op. cit.*, page 251. See Coe, *Op. cit.*, page 48, for a chart on the classification and time-depth of thirty-one Mayan languages.

68. Josephy (editor), *Op. cit.*, page 253.

69. *Ibid.*

70. *Ibid.*, page 254.

71. The central Alaskan Yupik Indians became famous for their many words for snow, distinguishing 'snow on the ground', 'light snow', 'deep, soft snow', 'snow about to

avalanche', 'drifting snow' and 'snow blocks'. Josephy (editor), *Op. cit.*, page 255.

72. *Ibid.*, page 262.

73. *Ibid.*, page 263.

74. Furnas, *Op. cit.*, page 366, says the Apaches were the least amenable to conversion by the Jesuits.

75. Josephy (editor), *Op. cit.*, page 278.

76. *Ibid.*, page 291. See Coe, *Op. cit.*, page 136, for the relation between Hopi grammar and their view of the world.

77. Josephy (editor), *Op. cit.*, page 294.

78. McLeish, *Op. cit.*, page 233.

79. Josephy (editor), *Op. cit.*, page 309.

80. The grave of a former shaman would be disinterred after a few years and the remains burned and turned into a special magic potion, consumed at a special ceremony, so that the men who came after him could acquire some of his wisdom. Josephy (editor), *Op. cit.*, page 312.

81. *Ibid.*, page 326.

82. *Ibid.*, page 329.

83. *Ibid.*

84. *Ibid.*, page 330.

85. Ronald Wright, *Stolen Continents: The 'New World' Through Indian Eyes*, Boston: Houghton Mifflin, 1992, examines five New World civilizations – Aztec, Inca, Maya, Cherokee and Iroquois – and their reactions to invasion. Wright describes, for example, the Incas' vast storage systems, their complex irrigation networks, their synthesis of earlier civilisations. It is a fascinating attempt to get inside the mind of the Indians and then goes on to explore their reactions, in the seventeenth, eighteenth and nineteenth centuries, to the takeover of their land. (See this chapter, pages 454–455.)

86. Josephy (editor), *Op. cit.*, page 343. But see Coe, *Op. cit.*, pages 59–60, for Aztec/Inca chronology.

87. Josephy (editor), *Op. cit.*, page 343.

88. *Ibid.*, page 367.

89. *Ibid.*, page 372.

90. *Ibid.*

91. Coe, *Op. cit.*, page 118, for a diagram of how Aztec writing could be built up.

92. Josephy (editor), *Op. cit.*, page 375.

93. *Ibid.*, page 375–376.

94. *Ibid.*, page 377.

95. *Ibid.*, page 381.

96. Furnas, *Op. cit.*, page 166, notes some instructive parallels between Aztec religion and Christianity, including the equivalent of Eve, the serpent and the Flood.

97. Josephy (editor), *Op. cit.*, page 389.

98. *Ibid.*, page 392.

99. *Ibid.*

100. Coe, *Op. cit.*, page 58, for Mayan attitudes to wildlife.

101. Josephy (editor), *Op. cit.*, pages 402–403.

102. *Ibid.*, pages 408–409.

103. *Ibid.*, page 409.

104. *Ibid.*, page 412.

105. Furnas, *Op. cit.*, pages 179ff, for the 'engineering marvels' of the Incas, gold-covered stones and weaving skills.

106. *Ibid.*, page 413.

107. *Ibid.*, See Coe, *Op. cit.*, pages 242–243, for a discussion of gods.

108. Josephy (editor), *Op. cit.*, page 413–414.

109. Other aspects of divinity lay in the fact that a creator of likenesses was believed to have some control over the person represented, and in the fact that the objects created were more important – more divine – than their creator. Josephy (editor), *Op. cit.*, page 416.

110. *Ibid.*, page 417.
111. *Ibid.*, page 419.
112. Terence Grieder, professor of art history at the University of Texas at Austin, has compared the early art of the Americas with that of Australia, Polynesia, Indonesia and south-east Asia and offers some fascinating observations. He finds in both realms that there are three basic types of civilisation and that the art of these three civilisations varies systematically in both form and symbolic content. He argues that this supports the idea that the Americas were peopled by three separate migrations. Grieder's main point is that there is a cultural gradient which shows parallels between the Americas and the Australian–south-east Asian landmass. For example, in Australia and the Atlantic coast of South America, furthest from the Eurasian landmass, were found the 'most primitive peoples', areas populated by bands of hunter-gatherers without permanent shelter, without agriculture or specialised techniques. Melanesian people, on the other hand, and the inhabitants of the Great Plains of North America, and some areas of South America, lived in settled villages and practised agriculture. Finally, in Indonesia, Malaysia and the Philippines, and on the Asian mainland, and in Central America, there were large populations who lived in towns, with temples of stone, and specialist occupations. In both locations (Australia to south-east Asia on the one hand, the Americas on the other), similar levels of civilisation had similar symbolic art.

The first wave, as Grieder calls it, was characterised by primitive vulva and phallus signs, cup-marked stones, face and body-painting. The second wave was typified by the holy tree or pole, masks and bark cloth. The third wave showed geometrical symbols (cross, checkerboard, swastika, S-design) and often represented the cosmos (celestial symbolism), which was also reflected in the use of caves and mountains as holy sites, including artificial mountains, or pyramids. Tattooing was introduced in the third wave, and bark paper books. Of course, in many areas the different waves came into contact and affected one another (Iroquois symbolism, in particular, is a mixture of all three waves, a conclusion supported by blood-type analysis). But Grieder finds that the three-wave symbolism is still strong and that it is unlikely to have been invented twice. He therefore concludes that not only were there three waves of migrants into the Americas, but that these three waves were paralleled in the migrations from south-east Asia to Australia, Tasmania and New Zealand. Grieder, *Origins of Pre-Columbian Art, Op. cit.*
113. Wright, *Op. cit.*, pages 53–54 and 165. See also Moynahan, *Op. cit.*, page 513 for 'Christian' forms of killing.
114. Elliott, *Op. cit.*, pages 81 and 86.
115. *Ibid.*, page 87.
116. Bernard Lewis and P. M. Holt, *Historians of the Middle East*, Oxford: Oxford University Press, 1962, page 184.
117. The whole process was underlined by an idea that had begun with the Church Fathers – that civilisation, and with it world power, moved steadily from east to west. On this account, civilisation had begun in Mesopotamia and Persia, and been replaced in turn by Egypt, Greece, Italy, France and now Spain. Here, it was said (by the Spanish of course), it would remain, 'checked by the sea, and so well-guarded that it cannot escape'. Elliott, *Op. cit.*, page 94 and Fernando Pérez de Oliva, *Las Obras*, Córdoba, 1586, 134f.

118. Elliott, *Op. cit.*, page 95.
119. *Ibid.*, page 96.
120. Earl J. Hamilton, *American Treasure and the Price Revolution in Spain, 1501–1650*, Cambridge, Massachusetts: Harvard University Press, 1934, page vii.
121. Walter Prescott Webb, *The Great Frontier*, London: Secker & Warburg, 1953. See pages 239ff for the role of the revolver and two new methods of farming. See also: Wilbur R. Jacobs, *Turner, Bolton and Webb: Three Historians of the American Frontier*, Seattle: University of Washington Press, 1965.
122. Though Michael Coe says that even today the population of, say, the Mayan Indians is unknown. *Op. cit.*, page 47.
123. Elliott, *Op. cit.*, page 65.
124. *Royal Commentaries*, translated by Livermore, part II, 'The conquest of Peru', pages 647–648. Quoted in Elliott, *Op. cit.*, page 64.
125. Elisabeth Armstrong, *Ronsard and the Age of Gold*, Cambridge, England: Cambridge University Press, 1968, pages 27–28.

## CHAPTER 22: HISTORY HEADS NORTH: THE INTELLECTUAL IMPACT OF PROTESTANTISM

1. Manchester, *A World Lit Only by Fire, Op. cit.*, page 132.
2. *Ibid.*, page 130.
3. *Ibid.,* page 131.
4. Manchester, *Op. cit.*, pages 134–135.
5. Moynahan, *The Faith, Op. cit.*, pages 346–347, for the rest of Tetzel's 'patter.'
6. Diarmaid MacCulloch, *Reformation: Europe's House Divided 1490–1700*, London: Allen Lane/Penguin Books, 2003, page 14.
7. *Ibid.*, page 17.
8. *Ibid.*, page 51.
9. *Ibid.*, page 73.
10. *Ibid.*, 88.
11. *Ibid.*, page 113.
12. Bronowski and Mazlish, *The Western Intellectual Tradition, Op. cit.*, page 80. Moynahan, *Op. cit.*, page 347.
13. Bronowski and Mazlish, *Op. cit.*, page 81.
14. Boorstin, *The Seekers, Op. cit.*, page 116, casts doubt on whether the theses were actually *nailed* to the doors.
15. Bronowski and Mazlish, *Op. cit.*, page 84.
16. MacCulloch, *Op. cit.*, page 123.
17. Bronowski and Mazlish, *Op. cit.*, page 76.
18. Moynahan, *Op. cit.*, pages 350–351, for Luther's battles with the church.
19. Manchester, *Op. cit.*, page 167.
20. MacCulloch, *Op. cit.*, page 134.
21. Bronowski and Mazlish, *Op. cit.*, page 85.
22. *Ibid.*
23. W. D. J. Cargill Thompson, *Luther's Political Thought*, Hassocks, Sussex: Harvester, 1984, page 28.
24. *Ibid.*, page 160.
25. Bronowski and Mazlish, *Op. cit.*, page 88.
26. See the discussion on *Innerlichkeit* in Chapter 33 and in the Conclusion.
27. Moynahan, *Op. cit.*, pages 352–353, for the ferocity – and popularity – of Luther's writings. Boorstin, *Op. cit.*, page 115, says these writings, and Luther's translations of the Bible, established German as a literary language.
28. Boorstin, *Op. cit.*, page 119.
29. Bronowski and Mazlish, *Op. cit.*, page 92. Moynahan, *Op. cit.*, pages 384–385.
30. Bronowski and Mazlish, *Op. cit.*, page 93.
31. Moynahan, *Op. cit.*, page 386.

32. Boorstin, *Op. cit.*, page 120.
33. Bronowski and Mazlish, *Op. cit.*, page 94. Moynahan, *Op. cit.*, pages 386–387, for the operation of the Consistory.
34. Boorstin, *Op. cit.*, page 121.
35. See Harro Höpfl (editor and translator), *Luther and Calvin on Secular Authority*, Cambridge, England: Cambridge University Press, 1991.
36. Bronowski and Mazlish, *Op. cit.*, pages 96–97.
37. It was the artisans who flocked to Geneva at this time who created the watchmaking business for which Switzerland is still known. Moynahan, *Op. cit.*, page 396.
38. In Geneva no deviation was tolerated. But foreigners who came to Switzerland to learn from Calvin – John Knox, for example – had to return to their own countries, where they were very much in a minority and therefore often had to ask for religious toleration. In general then the Calvinists became 'anti-absolutists', supporting the rights of minorities. In a sense this made them proto-democrats. It was another half-step towards modern political thinking. Bronowski and Mazlish, *Op. cit.*, page 99.
39. *Ibid.*, pages 105–106.
40. Manchester, *Op. cit.*, page 193.
41. *Ibid.*, page 195.
42. For the background, see: M. Creighton, *A History of the Papacy from the Great Schism to the Sack of Rome*, London: Longman, Greene & Co., 1919, pages 309ff.
43. *Ibid.*, pages 322–323.
44. *Ibid.*, pages 340ff.
45. Moynahan, *Op. cit.*, page 421.
46. Manchester, *Op. cit.*, page 199.
47. *Ibid.*
48. *Ibid.*, page 201. A papal reform commission was installed in 1536 but the differences with the Protestants were too large. Moynahan, *Op. cit.*, pages 422–423.
49. Manchester, *Op. cit.*, pages 201–202.
50. Jardine, *Worldly Goods*, *Op. cit.*, page 172.
51. Moynahan, *Op. cit.*, page 432.
52. *Ibid.*, page 440.
53. Sir Thomas More went so far as to say that Henry had more learning 'than any English monarch ever possessed before him'. Manchester, *Op. cit.*, page 203.
54. *Ibid.*, page 203.
55. McGrath, *In the Beginning: The Story of the King James Bible*, *Op. cit.*, page 72, for the exact dates of the translation.
56. Manchester, *Op. cit.*, page 204.
57. *Ibid.* McGrath, *Op. cit.*, page 72, for the rediscovery of the Cologne sheets.
58. McGrath, *Op. cit.*, pages 75–76, for the quality of the English.
59. Manchester, *Op. cit.*, page 205.
60. Bamber Gascoigne, *The Christians*, London: Jonathan Cape, 1977, page 186.
61. *Ibid.*, page 186. Volterra was always known afterwards as 'the breeches maker'.
62. MacCulloch, *Op. cit.*, page 226.
63. Michael A. Mullet, *The Catholic Reformation*, London: Routledge, 1999, page 38.
64. *Ibid.*, pages 38–39.
65. *Ibid.*, page 40.
66. *Ibid.*, page 45.
67. *Ibid.*, page 47.
68. *Ibid.*, page 68. See Jacque le Goff, 'The time of Purgatory', in *The Medieval Imagination*, *Op. cit.*, pages 67–77.
69. The effects of Trent: to begin with, the struggle against Protestantism was viewed by the church as a fight with heretics, with break-away sects, as had happened with the Cathars in the twelfth century. For example, the Duke of Alva, who led the reign of terror deemed necessary to keep the Low Countries safe for Catholic Spain, had his portrait painted showing him as a Crusader. No less a figure than Vasari was commissioned to paint two pictures in the Vatican, depicting two episodes of the 1570s, 'as if they were equally important Catholic victories'. They were the battle of Lepanto, where the Turkish navy was defeated; and the St Bartholomew's Day massacre, where 'numberless' Protestants in Paris were snatched from their beds and murdered in the streets. Such was the Catholic joy at this grisly 'victory' that a commemorative medal was struck, which actually showed the Huguenots being slaughtered. Gascoigne, *Op. cit.*, page 187.
70. *Ibid.*, page 185. Moynahan, *Op. cit.*, page 419.
71. *Gascoigne, Op. cit.*, page 419.
72. *Ibid.*, page 186.
73. *Ibid.*, page 189.
74. Moynahan, *Op. cit.*, pages 558ff, for Xavier in Japan.
75. Gascoigne, *Op. cit.*, pages 192–193; and Moynahan, *Op. cit.*, pages 560–561 for the crucifixions.
76. MacCulloch, *Op. cit.*, page 586.
77. *Ibid.*, page 587.
78. *Ibid.*, page 589.
79. *Ibid.*, page 651.
80. Rudolf Wittkower, *Art and Architecture in Italy: 1600–1750*, London: Penguin, 1958/1972, page 1.
81. *Ibid.*
82. Germain Bazin, *The Baroque*, London and New York: Thames & Hudson, 1968, page 36, for the religiosity of famous artists.
83. Wittkower, *Op. cit.*, page 12.
84. Much of the coloured marble for St Peter's was taken from ancient buildings. Wittkower, *Op. cit.*, page 10.
85. Peter and Linda Murray, *Penguin Dictionary of Art and Artists*, *Op. cit.*, page 38.
86. Wittkower, *Op. cit.*, page 17.
87. Bazin, *Op. cit.*, pages 104–105.
88. Wittkower, *Op. cit.*, page 18.

## CHAPTER 23: THE GENIUS OF THE EXPERIMENT

1. Herbert Butterfield, *The Origins of Modern Science, 1300–1800*, New York: Free Press, 1949, revised edition 1957.
2. Margaret J. Ostler (editor), *Rethinking the Scientific Revolution*, Cambridge, England: Cambridge University Press, 2000, page 25.
3. J. D. Bernal, *Science in History*, *Op. cit.*, page 132.
4. *Ibid.*, page 133. See also: MacCulloch, *Reformation*, *Op. cit.*, page 78. And: Richard H. Popkin, *The Third Force in Seventeenth-Century Thought*, Leiden: E. J. Brill, 1992, page 102.
5. Huff, *The Rise of Early Modern Science in Islam, China and the West*, *Op. cit.*, page 73.
6. *Ibid.*, pages 57ff.
7. *Ibid.*, page 226. See also: Ernst Cassirer, *The Philosophy of Symbolic Forms*, volume 1, *Language*, New Haven: Yale University Press, 1953, pages 230–243.
8. Bernal, *Op. cit.*, page 134.
9. Thomas Kuhn, *The Copernican Revolution: Planetary Astronomy and the Development of Western Thought*, Cambridge, Massachusetts: Harvard University Press, 1957/1976, page 156.
10. *Ibid.*, page 157.
11. *Ibid.*, page 159.

12. Though its introduction was suppressed by a fearful editor. Moynahan, *Op. cit.*, page 435.
13. Kuhn, *Op. cit.*, page 160.
14. *Ibid.*, page 166.
15. *Ibid.*, page 168.
16. Moynahan, *Op. cit.*, for Galileo's attitude to the Bible: 'Not a scientific manual.'
17. Leonardo had drawn the first musket in the West. Kuhn, *Op. cit.*, page 174.
18. *Ibid.*, page 183.
19. Boyer, *A History of Mathematics*, *Op. cit.*, pages 326–327.
20. Michael White, *Isaac Newton: The Last Sorcerer*, *Op. cit.*, page 11.
21. Kuhn, *Op. cit.*, page 189.
22. Boyer, *Op. cit.*, page 393. For Wordsworth see: Boorstin, *The Seekers*, *Op. cit.*, 296.
23. Boyer, *Op. cit.*, page 391.
24. Kuhn, *Op. cit.*, page 192.
25. Boyer, *Op. cit.*, page 333.
26. *Ibid.*, page 317; and Boorstin, *Op. cit.*, page 161.
27. Boyer, *Op. cit.*, pages 310–312.
28. *Ibid.*, page 314.
29. White, *Op. cit.*, page 205.
30. Boyer, *Op. cit.*, page 398.
31. J. D. Bernal, *The Extension of Man*, *Op. cit.*, page 207.
32. *Ibid.*, page 208. See Moynahan, *Op. cit.*, page 439, for the different attitudes to scripture as between Galileo and Newton. Unlike Galileo, Newton did not feel 'confined'.
33. J. D. Bernal, *Extension Op. cit.* page 209.
34. Schmuel Shanbursky (edited, introduced and selected by), *Physical Thought from the Presocratics to the Quantum Physicists*, London: Hutchinson, 1974, pages 310–213.
35. Bernal, *Extension*, *Op. cit.*, page 212.
36. Shanbursky (editor), *Op. cit.*, pages 269 and 302. G. MacDonald Ross, *Leibniz*, Cambridge, England: Cambridge University Press, 1984, page 31, for the division of the calculus into differentiation and integration.
37. Bernal, *Extension*, *Op. cit.*, page 217.
38. For an excellent, edited version of Newton's work on 'opticks', see Shanbursky (editor), *Op. cit.*, pages 172 and 248; see also R. E. Peierls, *The Laws of Nature*, London: Allen & Unwin, 1955, pages 24 and 43.
39. There was another – very different, rather more prosaic – reason for interest in the prism. The quality of cut glass was improving all the time and as a result there was a boom in chandeliers. Among their other attractions, they glittered in different colours. Alan Macfarlane says that the scientific revolution would not have happened as it did, but for the development of glass. Fifteen of the great experiments could not have been performed without glass. *Times Higher Educational Supplement*, 21 June 2002, page 19.
40. Bernal, *Extension*, *Op. cit.*, page 221.
41. Shanbursky (editor), *Op. cit.*, page 312.
42. Wightman, *The Growth of Scientific Ideas*, page 135. The next step forward was the realisation that light also travelled in waves. Christiaan Huygens, who made this particular breakthrough, was helped in his observations by means of a 'magic crystal', known as Iceland spar. Put a crystal of Iceland spar on the page of an open book, slide it over the paper, and you will observe that the print appears double. Moreover, as you slide the crystal around, the two images move relative to one another. Huygens was the first to grasp that the explanation lay in assuming that light is a wave. Bernal, *Extension*, *Op. cit.*, pages 225–227.
43. James Gleick, *Isaac Newton*, *Op. cit.*, page 15.
44. Bernal, *Extension*, *Op. cit.*, pages 235–236.
45. William A. Locy, *The Growth of Biology*, London: G. Bell, 1925, pages 153–154.
46. Carl Zimmer, *The Soul Made Flesh: The Discovery of the Brain and How It Changed the World*, London: Heinemann, 2004, page 19.
47. Locy, *Op. cit.*, page 155.
48. In the High Middle Ages, the church remained hostile to the dissection of human bodies, but this resistance was not always what it seemed. For example, in his bull, *De Sepultis*, issued by Pope Boniface in 1300, dissection of cadavers for scientific purposes was prohibited, but the primary purpose of the bull was to put a stop to the dismembering of Crusader bodies, which made them easier to carry home, but added to the risk of disease. Locy, *Op. cit.*, pages 156–157. For Vesalius' drawings, see Charles Singer, *A History of Biology*, London and New York: Abelard-Schuman, 1959, page 103.
49. *Ibid.*, pages 82ff.
50. Locy, *Op. cit.*, page 160
51. Zimmer, *Op. cit.*, page 20.
52. Locy, *Op. cit.*, page 168.
53. *Ibid.*, pages 169ff. See also William S. Beck, *Modern Science and the Nature of Life*, London: Macmillan, 1958, page 61, for the fall of Galenism.
54. Locy, *Op. cit.*, page 174. See also Zimmer, *Op. cit.*, page 21, for how all this changed ideas about the soul.
55. Locy, *Op. cit.*, pages 175–176.
56. Arthur Roch (editor), *The Origins and Growth of Biology*, London: Penguin, 1964, pages 178 and 185; and Zimmer, *Op. cit.*, page 66.
57. Locy, *Op. cit.*, page 184. Roch (editor), *Op. cit.*, page 175, has an extract on Harvey's motives in publishing his book.
58. He also refers twice to a magnifying glass.
59. Locy, *Op. cit.*, page 187.
60. *Ibid.*, page 188; and Zimmer, *Op. cit.*, page 69.
61. Though see Zimmer, *Op. cit.*, page 69, for some mistakes of Harvey.
62. Locy, *Op. cit.*, page 196.
63. *Ibid.*, page 197.
64. Roch (editor), *Op. cit.*, pages 100–101.
65. Locy, *Op. cit.*, page 201.
66. Ernst Mayr, *The Growth of Biological Thought*, Cambridge, Massachusetts: The Belknap Press of Harvard University Press, 1982, page 138.
67. Locy, *Op. cit.*, page 208.
68. *Ibid.*, page 211.
69. Mayr, *Op. cit.*, page 321.
70. Locy, *Op. cit.*, page 213.
71. Roch (editor), *Op. cit.*, pages 80ff.
72. Locy, *Op. cit.*, page 216.
73. *Ibid.*, page 217.
74. He later observed the same phenomenon in the webbing of a frog's foot, and in the tails of young fishes and eels.
75. Mayr, *Op. cit.*, page 138. Marcello Malpighi in Italy and Nehemiah Grew in England brought the microscope to bear not on animals but on plants. An interest in plants had been stimulated by the exotic species brought back from the New World (and Africa) by explorers. *Ibid.*, pages 100–101. Both men published superbly illustrated books on the anatomy of plants and, by an extraordinary coincidence, on the very day that Grew's book was delivered from the printer, Malpighi's manuscript was deposited at the Royal Society in London. *Ibid.*, page 387. In Malpighi's book *Anatome plantarum*, the cells which make up the various structures are named *utriculi*. He observed

different kinds of cells within plants – those that carry air, sap, and so on, and the same is broadly true of Grew in his book *The Anatomy of Plants. Ibid.*, page 385. But, although he observed cells, referring to them as 'bladders', Grew did not explore them any further either (others later called cells 'bubbles'). Neither man realised that the cell was the basic building block of life, from which all more complex organisms are constructed. The idea was not developed for more than two centuries.

76. Mayr, *Op. cit.*, pages 100 and 658–659.
77. Tarnas, *The Passion of the Western Mind, Op. cit.*, page 272.
78. *Ibid.*, page 273; see also Boorstin, *Op. cit.*, pages 155 and 158.
79. Tarnas, *Op. cit.*, page 274.
80. Robert Merton, *Science, Technology and Society in Seventeenth-Century England*, Bruges, 1938, chapter 15.
81. Boyer, *Op. cit.*, page 336.
82. *Ibid.*, page 337; and Boorstin, *Op. cit.*, pages 166–167.
83. Cartesian geometry is now synonymous with analytical geometry.
84. Tarnas, *Op. cit.*, page 277. Boorstin, *Op. cit.*, page 164. Popkin, *Op. cit.*, pages 237–238.
85. Tarnas, *Op. cit.*, pages 280–281.
86. Bronowski and Mazlish, *Op. cit.*, pages 183–184.
87. Bernal, *Science in History, Op. cit.*, page 462. Zimmer, *Op. cit.*, pages 183ff, for the very first meeting; he says that originally there was a list of forty potential members.
88. Bronowski and Mazlish, *Op. cit.*, page 182. Zimmer, *Op. cit.*, page 95, says there was another early Oxford group: the Oxford Experimental Philosophy Group.
89. Zimmer, *Op. cit.*, page 184.
90. Bronowski and Mazlish, *Op. cit.*, page 185; see also Zimmer, *Op. cit.*, pages 96 and 100.
91. Lisa Jardine, *Ingenious Pursuits: Building the Scientific Revolution*, New York: Doubleday, 1999; see also Zimmer, *Op. cit.*, pages 185–186. Lisa Jardine, *The Curious Life of Robert Hooke: The Man who Measured London*, London: HarperCollins, 2003.
92. Mordechai Feingold, *The Mathematicians' Apprenticeship: Science, Universities and Society in England: 1560–1640*, Cambridge, England: Cambridge University Press, 1984, pages 6, 122 and 215.
93. *Ibid.*, page 215.
94. Peter Burke, *A Social History of Knowledge: From Gutenberg to Diderot*, Cambridge, England: Polity Press, 2000, 45.
95. *Ibid.*, page 103.
96. *Ibid.*, page 135.
97. Ostler (editor), *Op. cit.*, page 43.
98. *Ibid.*, page 44.
99. *Ibid.*, page 45.
100. *Ibid.*, page 49. Carl Zimmer's point, about the Oxford Experimental Philosophy Group (note 88 above), underlines this aspect.
101. In Ostler (editor), *Op. cit.*, page 50.

CHAPTER 24: LIBERTY, PROPERTY AND COMMUNITY: THE ORIGINS OF CONSERVATISM AND LIBERALISM

1. Schulze, *States, Nations and Nationalism, Op. cit.*, page 17.
2. John Bowle, *Western Political Thought*, London: Cape, 1947/1954, page 288.
3. Schulze, *Op. cit.*, page 28.
4. Bronowski and Mazlish, *Op. cit.*, page 28.
5. Allan H. Gilbert, *The Prince and Other Works*, Chicago: University of Chicago Press, 1941, page 29.
6. Bronowski and Mazlish, *Op. cit.*, page 31.
7. In particular, for example, he thought that religion, by which he meant Christianity, hindered the development of a strong state, because it preached meekness. At the same time he thought that some form of religion was desirable, because it acted as a social 'glue' that kept people together. But this too was new, in that it was the first time anyone had (openly, at any rate) conceived religion as a coercive rather than as a spiritual force. Bronowski and Mazlish, *Op. cit.*, page 34; Boorstin, *Op. cit.*, page 178.
8. Schulze, *Op. cit.*, page 30.
9. *Ibid.*, page 31.
10. N. Machiavelli, *The Prince*, translated by Peter Whitshome (1560), reprinted 1905, chapter 18, page 323.
11. Boorstin, *Op. cit.*, page 178.
12. Bronowski and Mazlish, *Op. cit.*, page 36.
13. *Ibid.*, page 32.
14. Bowle, *Op. cit.*, pages 270–272.
15. Allied with its national character, Protestantism laid the spiritual/psychological basis for a political sovereignty based in the people. Calvin's insistence on the pre-eminence of individual conscience, which even allowed for tyrannicide against Catholic rulers on confessional grounds, became the forerunner of the right of rebellion, which was to become such a characteristic of later times. Taken together, these elements would lead eventually to the democratic theory of the state. The purpose of the state, for the early Protestants, was to protect the congregations within it, not in itself to provide the spiritual development of the people. 'The best things in life are not in the state's province at all.' Bowle, *Op. cit.*, pages 280–281.
16. *Ibid.*, pages 281–282.
17. Jonathan Wright, *The Jesuits: Mission, Myths and Historians*, London: HarperCollins, 2004, pages 148–149.
18. Bowle, *Op. cit.*, page 285.
19. *Ibid.*
20. Reinhard Bendix, *Kings or People: Power and the Mandate to Rule, Op. cit.*, pages 307ff; see also: John Dunn (editor), *Democracy: The Unfinished Journey: 508 BC to AD 1993*, Oxford: Oxford University Press, 1992, especially pages 71ff.
21. Schulze, *Op. cit.*, page 49.
22. Moynahan, *Op. cit.*, page 455, says the years 1562–1598 were the ones stained worst by massacres, murders and eight wars.
23. Schulze, *Op. cit.*, page 50.
24. Bowle, *Op. cit.*, page 290. Many (French) Huguenots emigrated to America after Louis XIV withdrew toleration in 1685. See: Moynahan, *Op. cit.*, page 576.
25. And in any case, Bodin was not himself a fanatic. Indeed, his thought anticipated the business-like outlook of Cardinal Richelieu, who was to put Bodin's ideas into practice on an ambitious scale.
26. Bowle, *Op. cit.*, page 291.
27. Schulze, *Op. cit.*, page 53.
28. *Ibid.*, pages 56–57.
29. Poland and the Netherlands were exceptions. Schulze, *Op. cit.*, page 57.
30. Bowle, *Op. cit.*, page 293.
31. *Ibid.*, page 317.
32. Bronowski and Mazlish, *Op. cit.*, page 198.
33. Bowle, *Op. cit.*, page 318. See also: Moynahan, *Op. cit.*, page 492.
34. One of its distinguishing features is the most vivid title

page of any book ever printed. The upper half shows a landscape which depicts a neatly planned town against a background of open country. Towering above this scene, however, there stands the crowned figure of a giant, a titan, shown from the waist up, his arms outstretched in a protective embrace, a great sword in one hand, a crozier in the other. Most poignant of all, the body of the figure is formed from a swarm of little people, their backs to the reader and their gaze fixed on the giant's face. It is one of the most eerie, and most powerful images in all history.

35. Ernst Cassirer, *The Philosophy of the Enlightenment*, Princeton, New Jersey: Princeton University Press, 1951, page 254.

36. Roger Smith, *The Fontana History of the Human Sciences*, London: Fontana Press, 1997, pages 105ff.

37. Bronowski and Mazlish, *Op. cit.*, page 205.

38. Bowle, *Op. cit.*, page 321.

39. *Ibid.*, page 329.

40. *Ibid.*, page 328.

41. Bronowski and Mazlish, *Op. cit.*, page 206.

42. *Ibid.*, page 207.

43. Bowle, *Op. cit.*, page 331.

44. *Ibid.*, page 361.

45. Boorstin, *Op. cit.*, page 180.

46. Bowle, *Op. cit.*, page 363.

47. *Ibid.*, page 364.

48. Schulze, *Op. cit.*, pages 70–71.

49. Bowle, *Op. cit.*, page 365.

50. Boorstin, *Op. cit.*, page 186, who says the works are 'labored' and that it is surprising they have been so inspiring.

51. Bronowski and Mazlish, *Op. cit.*, page 210.

52. Bowle, *Op. cit.*, page 378.

53. *Ibid.*, pages 379–381.

54. The *Tractatus* was originally published anonymously and, briefly, banned. The Jewish community of Amsterdam expelled him.

55. Bowle, *Op. cit.*, page 381. See: Richard H. Popkin, 'Spinoza and Bible scholarship', in: Don Garrett (editor), *The Cambridge Companion to Spinoza*, Cambridge, England: Cambridge University Press, 1996, pages 383ff, which has many of Spinoza's more pithy remarks on the scriptures.

56. R. H. Delahunty, *Spinoza*, London: Routledge & Kegan Paul, 1984, pages 211–212.

57. Bowle, *Op. cit.*, page 383.

58. Delahunty, *Op. cit.*, page 7.

59. Bowle, *Op. cit.*, page 386.

60. *Ibid.*, page 387.

61. Jonathan I. Israel, *Radical Enlightenment: Philosophy and the Making of Modernity 1650–1750*, Oxford: Oxford University Press, 2001, page 591.

62. Giuseppe Mazzitta, *The New Map of the World: The Poetic Philosophy of Giambattista Vico*, Princeton, New Jersey: Princeton University Press, 1999, pages 100–101.

63. Bowle, *Op. cit.*, page 389.

64. Joseph Mali, *The Rehabilitation of Myth: Vico's 'New Science'*, Cambridge, England: Cambridge University Press, 1992, page 48.

65. *Ibid.*, pages 99ff, for the role of providence and curiosity.

66. Bowle, *Op. cit.*, page 393.

67. Boorstin, *Op. cit.*, page 233, for the way some of these ideas are echoed by Oswald Spengler.

68. Bowle, *Op. cit.*, page 395.

69. T. C. W. Blanning, *The Culture of Power and the Power of Culture: Old Regime Europe 1660–1789*, Oxford: Oxford University Press, 2002, page 2.

70. *Ibid.*, page 137.

71. *Ibid.*, page 208.

72. *Ibid.*, page 151.

73. *Ibid.*, pages 156–159.

74. Israel, *Op. cit.*, page 150.

75. *Ibid.*, page 151.

76. Blanning, *Op. cit.*, page 169.

## CHAPTER 25: THE 'ATHEIST SCARE' AND THE ADVENT OF DOUBT

1. It was, as Thomas Kuhn puts it, in his monograph on the Copernican revolution, 'the first European astronomical text that could rival the Almagest in depth and completeness'. Kuhn, *The Copernican Revolution*, *Op. cit.*, page 185.

2. *Ibid.*, page 186.

3. Armstrong, *A History of God*, *Op. cit.*, page 330.

4. Popkin, *The Third Force in Seventeenth-Century Thought*, *Op. cit.*, pages 102–103. See also: Moynahan, *The Faith*, *Op. cit.*, page 354.

5. Moynahan, *Op. cit.*, page 357.

6. *Ibid.*, page 359.

7. *Ibid.*, page 360.

8. Simon Fish, *A Supplicacyion for the Beggars Rosa*, quoted in Menno Simons, *The Complete Writings*, Scotsdale: University of Arizona Press, 1956, pages 140–141.

9. Armstrong, *Op. cit.*, page 330.

10. Interestingly, Anaxagoras, an Ionian, and a pupil of Anaximenes of Miletus, held a number of views that anticipated Copernicus. He taught that the sun was not 'animated' in the way that the Athenians believed, and neither was it a god, but 'a red-hot mass many times larger than the Peloponnese'. He also insisted that the moon was a solid body with geographical features – plains and mountains and valleys – just like the earth. Anaxagoras also believed that the world was round. J. M. Robertson, *A History of Freethought*, volume 1, London: Dawsons of Pall Mall, 1969, page 166.

11. In fact there appears to have been something of a fashion for freethinking in Periclean Athens, where the aristocrats foreshadowed the thought in Voltaire's France, in believing that 'the common people' needed religion 'to restrain them', but that they themselves needed no such restriction.

12. Thrower, *The Alternative Tradition*, *Op. cit.*, pages 173 and 225–226.

13. Robertson, *Op. cit.*, page 181.

14. Thrower, *Op. cit.*, pages 204ff and 223.

15. *Ibid.*, pages 63–65.

16. *Ibid.*, page 84.

17. *Ibid.*, page 122.

18. Robertson, *Op. cit.*, pages 395–396.

19. Seznec, *The Survival of the Pagan Gods*, *Op. cit.*, page 25.

20. *Ibid.*, page 32.

21. *Ibid.*, page 70.

22. *Ibid.*, page 161.

23. Robertson, *Op. cit.*, pages 319–323.

24. Lucien Febvre, *The Problems of Unbelief in the Sixteenth Century*, Cambridge, Massachusetts: Harvard University Press, 1982, page 457.

25. Jim Herrick, *Against the Faith*, London: Glover Blair, 1985, page 29.

26. Barnes, *An Intellectual and Cultural History*, *Op. cit.*, page 712.

27. Though terrible for many people, it was at the same time liberating because, as Harry Elmer Barnes says, it freed man from 'the medieval hell-neurosis'.

28. Barnes, *Op. cit.*, page 714.

29. John Redwood, *Reason, Ridicule and Religion, 1660–1750*, London: Thames & Hudson, 1976, page 150.

30. Febvre, *Op. cit.*, page 340.

31. *Ibid.,* page 349.

32. Barnes, *Op. cit.*, page 715. As Febvre showed, a vernacular language such as French lacked both the vocabulary and the syntax for scepticism. Such words as 'absolute', 'relative', 'abstract' and 'concrete', 'occult' or 'sensitive', or 'intuition', were not yet in use. These were all words coined in the eighteenth century. As Lucien Febvre puts it, 'the sixteenth century was a century that wanted to believe'. Febvre, *Op. cit.*, page 355.

33. Redwood, *Op. cit.*, page 30.

34. Febvre, *Op. cit.*, page 332.

35. Kuhn quotes from a long cosmological poem, published in 1578 and very popular, which depicted Copernicans as

> Those clerks who think (think how absurd a jest)
> That neither heav'ns nor stars do turn at all,
> Nor dance about this great round earthly ball;
> But th'earth itself, this massy globe of ours,
> Turns round-about once every twice-twelve hours:
> And we resemble land-bred novices
> New brought aboard to venture on the seas;
> Who, at first launching from the shore, suppose
> The ship stands still, and that the ground it goes . . .

36. Kuhn, *Op. cit.*, page 190. Despite its views, even this book by Bodin was placed on the Index.

37. *Ibid.,* page 191. Luther's principal lieutenant, Philip Melanchthon, went further, quoting biblical passages that Copernican theory disagreed with, notably Ecclesiastes 1:4–5, which states that 'the earth abideth forever' and that 'The sun also ariseth, and the sun goeth down, and hasteth to his place where he arose.'

38. *Ibid.,* page 191; see Israel, *Radical Enlightenment, Op. cit.*, pages 27ff, for a different detailed discussion of heliocentrism and its reception. Peter Harrison, *The Bible, Protestantism, and the Rise of Natural Science*, Cambridge, England: Cambridge University Press, 2001.

39. Kuhn, *Op. cit.*, page 193.

40. Keith Thomas, *Religion and the Decline of Magic*, London: Penguin, 1971, page 4.

41. Kuhn, *Op. cit.*, page 197.

42. *Ibid.,* page 244.

43. Tycho Brahe did work out an alternative explanation to Copernicus, which kept the earth at the centre of the universe, and the moon and sun in their old Ptolemaic orbits. But even this, the so-called 'Tychonic' system, necessitated the sun's orbit intersecting with that of Venus and Mars. This meant that the traditional idea of the planets and stars orbiting around giant crystal balls could no longer be sustained.

44. Thomas, *Op. cit.*, page 416.

45. Next, the spots on the sun, also revealed by the telescope, conflicted with both the idea of the perfection of the upper realm, while the way the spots appeared and disappeared betrayed yet more the mutability in the heavens. Worse still, the movement of the sun-spots suggested that the sun rotated on its axis in just the same way that Copernicus claimed the earth did. Kuhn, *Op. cit.*, page 222.

46. People tried, of course. Some of Galileo's opponents refused even to look through a telescope, arguing that if God had meant man to see the heavens in that way he would have endowed him with telescopic eyes.

47. And in the universities, Ptolemaic, Copernican and Tychonic systems of astronomy (see note 43 above) were taught side-by-side, the Ptolemaic and the Tychonic not being dropped until the eighteenth century.

48. Kuhn, *Op. cit.*, page 198.

49. Popkin, *Op. cit.* Barnes, *Op. cit.*, page 784. People did not, at first, see any conflict between religion and reason. Redwood, *Op. cit.*, pages 214–215.

50. See: Israel, *Op. cit.*, chapter 12, 'Miracles denied', pages 218–229, for a fuller discussion of this subject; and Thomas, *Op. cit.*, pages 59–60.

51. Barnes, *Op. cit.*, page 785.

52. Herrick, *Op. cit.*, page 38.

53. The more you think about it, the harder it is to make this distinction.

54. Redwood, *Op. cit.*, page 140. The very concept of revelation took a knock at the end of the seventeenth century as the world of witches, apparitions, magical cures and charms suffered a near-fatal setback in the wake of the discoveries of science, which appeared to suggest an atomistic, determinist universe.

55. Barnes, *Op. cit.*, page 788.

56. Redwood, *Op. cit.*, page 179.

57. Israel, *Op. cit.*, page 519. Israel has a whole section on Collins, pages 614–619.

58. Barnes, *Op. cit.*, page 791.

59. Herrick, *Op. cit.*, page 58.

60. A. C. Giffert, *Protestant Thought Before Kant*, New York: Scribners, 1915, pages 208ff.

61. Roger Smith, *Op. cit.*, page 282.

62. Israel, *Op. cit.*, page 266.

63. Not that the deists were wholly negative in their views. A variant form of deism accepted the true Christianity of Jesus, but rejected the Christianity as it had grown up in the church.

64. Barnes, *Op. cit.*, page 794.

65. Preserved Smith, *History of Modern Culture, Op. cit.*, volume 2, page 522.

66. See in particular the sections on scepticism in Stephen Buckle, *Hume's Enlightenment Tract*, Oxford: Clarendon Press of Oxford University Press, 2001, for example, pages 111–118, 167–168, 270–280.

67. *Ibid.,* pages 289–294.

68. Herrick, *Op. cit.*, page 105.

69. Barnes, *Op. cit.*, page 805.

70. Herrick, *Op. cit.*, page 33. There are those who doubt that Bayle was a true sceptic, but see him instead as a 'fideist', a believer who thought it his Christian duty to air his doubts, as a way to encourage others to be stronger in their faith. Roy Porter, *The Enlightenment*, London: Palgrave, 2001, page 15. There were also many French sceptics grouped around Denis Diderot (1713–1784), and his *Encyclopédie*. Figures such as d'Alembert and Helvétius argued, as Hume did, that what people learn as infants tends to stay with them all their lives, for good or ill.

71. Herrick, *Op. cit.*, page 29; Barnes, *Op. cit.*, page 813; and Redwood, *Op. cit.*, page 32.

72. Armstrong, *A History of God, Op. cit.*, page 350.

73. Redwood, *Op. cit.*, page 35.

74. Israel, *Op. cit.*, pages 41 and 60.

75. Redwood, *Op. cit.*, page 35.

76. *Ibid.,* page 181.

77. *Ibid.,* page 187.

78. Richard H. Popkin, *The History of Scepticism from Erasmus to Spinoza*, Berkeley and London: University of California

Press, 1979, pages 215–216. See also the same author's *The History of Scepticism from Savonarola to Bayle* (revised and expanded edition), Oxford: Oxford University Press, 2003. Redwood, *Op. cit.*, page 34.

79. Barnes, *Op. cit.*, page 816.
80. Redwood, *Op. cit.*, page 120.
81. Israel, *Op. cit.*, page 605.
82. In some geology departments in modern universities, 23 October is still 'celebrated', ironically, as the anniversary of the earth's birthday.
83. Mayr, *The Growth of Biological Thought, Op. cit.*, page 315.
84. Rosenberg and Bloom, *The Book of J, Op. cit.*
85. Israel, *Op. cit.*, page 142.
86. Redwood, *Op. cit.*, page 131.
87. Mayr, *Op. cit.*, page 316.
88. Boyle actually said that he believed in 'natural morality'. Herrick, *Op. cit.*, page 39.
89. Barnes, *Op. cit.*, page 821.

CHAPTER 26: FROM SOUL TO MIND: THE SEARCH FOR THE LAWS OF HUMAN NATURE

1. Bronowski and Mazlish, *Op. cit.*, pages 247ff.
2. Boorstin, *The Seekers, Op. cit.*, page 193 for Voltaire's flight to London, and its effects. Geoffrey Hawthorn, *Enlightenment and Despair: A History of Social Theory*, Cambridge, England: Cambridge University Press, 1976, page 11, for Voltaire's education and how it bred intellectual independence; and pages 10–11 for the English influence on the French Enlightenment (Locke and Newton).
3. Bronowski and Mazlish, *Op. cit.*, page 249.
4. *Ibid.*
5. Quoted *Ibid.*, page 250.
6. *Ibid.*, page 251.
7. Raymond Naves, *Voltaire et l'Encyclopédie*, Paris, 1938.
8. P. N. Furbank, *Diderot*, London: Secker & Warburg, 1992, page 73.
9. *Ibid.*, page 84. See also: Boorstin, *Op. cit.*, page 196.
10. Furbank, *Op. cit.*, page 87.
11. After many problems. See *Ibid.*, page 92.
12. Norman Hampson, *The Enlightenment*, page 53.
13. *Ibid.*, pages 53–54.
14. Alfred Ewert, *The French Language*, London: Faber & Faber, 1964, pages 1–2.
15. *Ibid.*, pages 8–9.
16. M. K. Pope, *From Latin to Modern French*, Manchester: Manchester University Press, 1952, page 49.
17. *Ibid.*, pages 51 and 558.
18. Joachim du Bellay, *The Defence and Illustration of the French Language*, translated by Gladys M. Turquet, London: Dent, 1939, pages 26ff and 80ff.
19. Ewert, *Op. cit.*, page 19. French was spoken in England, at the court, in Parliament, and in the law courts, from the twelfth century to the end of the thirteenth, though it remained a court language until the fifteenth century and was not displaced by English in the records of lawsuits until the eighteenth.
20. Arnold Hauser, *The Social History of Art*, volume 3, New York: Vintage/Knopf, n.d., page 52.
21. Q. D. Leavis, *Fiction and the Reading Public*, London: Bellew, 1932/1965, page 83.
22. *Ibid.*, pages 83–84 and William Chappell, *Popular Music of the Olden Time*, two volumes, London, 1855–1859.
23. Leavis, *Op. cit.*, page 106; and see part 2, chapter 2, for the wide range of people who read *Pilgrim's Progress* and *Robinson Crusoe*.
24. Hauser, *Op. cit.*, page 53.

25. *Ibid.*
26. Leavis, *Op. cit.*, pages 123 and 300.
27. *Ibid.*, page 130. Other periodicals arrived as part of the same trend: the *Gentleman's Magazine* was started in 1731, soon followed by the *London Magazine*, the *Monthly Review* in 1749, and the *Critical Review* in 1756.
28. Leavis, *Op. cit.*, page 132.
29. *Ibid.*, page 145.
30. Only Lucretius, with his early idea of evolution, can be said to have had an idea of progress.
31. Barnes, *Op. cit.*, page 714.
32. Hampson, *Op. cit.*, pages 80–82.
33. Roger Smith, *The Fontana History of the Human Sciences, Op. cit.*, page 162.
34. *Ibid.*, pages 158–159.
35. *Ibid.*, page 162 and ref.
36. Alfred Cobban, *In Search of Humanity: The Role of the Enlightenment in Modern History*, London: Cape, 1960, page 69.
37. Boorstin, *Op. cit.*, page 184.
38. Roger Smith, *Op. cit.*, page 175.
39. *Ibid.*, page 192.
40. *Ibid.*, page 196.
41. *Ibid.*, page 197; see Cobban, *Op. cit.*, page 38, for Leibniz' reluctance to accept some of Newton's ideas.
42. Israel, *Radical Enlightenment, Op. cit.*, especially pages 552ff.
43. *Ibid.*, pages 436–437.
44. Cobban, *Op. cit.*, page 210.
45. *Ibid.*, page 208.
46. *Ibid.*, page 211. Physiognomy became a craze in the late eighteenth century but a more enduring legacy of Kant's approach was the founding of two journals in 1783. These were the *Zeitschrift für empirische Psychologie* (Journal for Empirical Psychology) and the *Magazin für Erfahrungsseelenkunde* (Magazine for Empirical Knowledge of the Soul). With close links to medicine and physiology, this was another stage towards the founding of modern psychology.
47. Roger Smith, *Op. cit.*, page 216.
48. Cobban, *Op. cit.*, page 133.
49. L. G. Crocker, *Nature and Culture: Ethical Thought in the French Enlightenment*, Baltimore: Johns Hopkins University Press, 1963, pages 479ff.
50. Roger Smith, *Op. cit.*, page 221.
51. J. O. de La Mettrie, *Man a Machine*, La Salle: Open Court, 1961, page 117. (Translated by G. C. Bussey.)
52. Dror Wahrman, *The Making of the Modern Self: Identity and Culture in Eighteenth Century England*, New Haven: Yale, 2004, pages 182–184.
53. *Ibid.*, pages 275–286.
54. James Buchan, *Capital of the Mind*, London: John Murray, 2003, page 5.
55. *Ibid.*, pages 1–2.
56. *Ibid.*, pages 174–179. And also helped developed laws. Cobban, *Op. cit.*, page 99.
57. R. A. Houston, *Social Change in the Age of Enlightenment: Edinburgh 1660–1760*, Oxford: Clarendon Press of Oxford University Press, 1994, page 80.
58. *Ibid.*, pages 8–9.
59. Buchan, *Op. cit.*, page 243.
60. He was little read in the nineteenth century: as James Buchan puts it, 'it was in the dark twentieth ... that Hume was crowned the king of British philosophers'. He was dismissed from his first job for correcting his master's English. Buchan, *Op. cit.*, page 76.

61. *Ibid.*, page 247 and ref.
62. Buckle, *Hume's Enlightenment Tract, Op. cit.*, pages 149–168.
63. Buchan, *Op. cit.*, page 81.
64. Hawthorn, *Op. cit.*, pages 32–33.
65. Buchan, *Op. cit.*, page 247 and ref.
66. See Hawthorn, *Op. cit.*, page 32, for the echoes of Hume in William James.
67. Buchan, *Op. cit.*, page 81.
68. Buckle, *Op. cit.*, pages 14–15.
69. Buchan, *Op. cit.*, page 221.
70. Though Cobban, *Op. cit.*, page 172, details other French and Swiss authors who anticipated Ferguson.
71. Buchan, *Op. cit.*, page 222.
72. Frania Oz-Salzberger, *Translating the Enlightenment: Scottish Civic Discourse in Eighteenth-Century Germany*, Oxford: The Clarendon Press of Oxford University Press, 1995, especially chapter 4, 'Ferguson's Scottish contexts: life, ideas and interlocutors'.
73. Buchan, *Op. cit.*, page 224.
74. *Ibid.*, page 305.
75. Many eyes focused on the Dutch United Provinces, for here was a small country – which even had to create its own land – yet had established a leading place among nations due to its excellence in the arts and in commerce.
76. 'Vital statistics' is a Victorian term. Buchan, *Op. cit.*, page 309.
77. *Ibid.*, page 316.
78. Ian Simpson Ross, *The Life of Adam Smith*, Oxford: The Clarendon Press of Oxford University Press, 1995, page 17.
79. *Ibid.*, page 133.
80. *Ibid.*, chapter 11, pages 157ff, 'The making of the theory of moral sentiments'.
81. *Ibid.*, page 121.
82. Paul Langford, *A Polite and Commercial People*, Oxford: Oxford University Press, 1989, page 447.
83. *Ibid.*, page 3.
84. *Ibid.*, page 391.
85. Roger Smith, *Op. cit.*, page 317.
86. Langford, *Op. cit.*, page 70.
87. Roger Smith, *Op. cit.*, page 319.
88. *Ibid.*
89. Hawthorn, *Op. cit.*, page 56.
90. Bernal, *Science in History, Op. cit.*, volume 4, page 1052, says that for Adam Smith *laissez faire* was the natural order.
91. H. T. Buckle, *A History of Civilisation in England*, London: Longman's Green, 1871, three volumes, volume 1, page 194.
92. Roger Smith, *Op. cit.*, page 333.
93. This has remained an influential form of pessimism, very alive in the twentieth century in the ecology movement. It also helped account for Thomas Carlyle's description of economics as 'the dismal science'. See Kenneth Smith, *The Malthusian Controversy*, London: Routledge & Kegan Paul, 1951.
94. Roger Smith, *Op. cit.*, page 335; see also Hawthorn, *Op. cit.*, page 80.
95. Roger Smith, *Op. cit.*, page 251.
96. The main difference between then and now, in the understanding of what we may call, for shorthand, sociology, was that in the eighteenth century they were less concerned with biology and psychology than we are, and more concerned with morality (virtue) and politics.
97. Cobban, *Op. cit.*, page 147. Boorstin, *Op. cit.*, page 198, considers him a masochist, always seeking a *maman*.
98. J.-J. Rousseau, *The First and Second Discourses* (edited by R. D. Masters), New York: St Martin's Press, 1964, page 92f. Cobban, *Op. cit.*, page 149, for Rousseau's 'intellectual epiphany'.
99. Roger Smith, *Op. cit.*, page 278.
100. Boorstin, *Op. cit.*, page 199. In arguing that feelings should guide man on how to live, Rousseau may be seen as one of the originators of the romantic movement. This also led him to his theory of education: he believed in childhood innocence, rather than the then-prevalent view that the child is inherently sinful and needs it knocked out of him.
101. Hawthorn, *Op. cit.*, pages 14–15.
102. Roger Smith, *Op. cit.*, page 293.
103. Bronowski and Mazlish, *Op. cit.*, page 258.
104. Barnes, *Op. cit.*, page 826.
105. See Boorstin, *Op. cit.*, page 161, for Bacon's failure to recognise the advances of Napier, Vesalius and Harvey.
106. Cobban, *Op. cit.*, page 51.
107. F. J. Teggar, *The Idea of Progress*, Berkeley: University of California Press, 1925, pages 110ff.
108. Roger Smith, *Op. cit.*, page 259.
109. *Ibid.* See Boorstin, *Op. cit.*, pages 193ff, for the arguments over the use of the word and concept 'civilisation'.
110. Teggar, *Op. cit.*, page 142; Boorstin, *Op. cit*, page 219.
111. Barnes, *Op. cit.*, page 824; and James Bonar, *Philosophy and Political Economy*, London: Macmillan, 1893, pages 204–205.
112. 'Tom Paine was considered for a time as Tom Fool to him', said H. S. Salt. Deborah Manley, *Henry Salt: Artist, Traveller, Diplomat, Egyptologist*, London: Libri, 2001. See also: H. S. Salt, *Godwin's Inquiry Concerning Political Justice*, printed for G. G. and J. Robinson, Paternoster Row, London, 1796, pages 1–2.
113. As one observer put it, 'this is the apotheosis of individualism and in a sense of Protestantism'. Barnes, *Op. cit.*, page 836.
114. Barnes, *Op. cit.*, page 839; and Boorstin, *Op. cit.*, page 208.
115. Barnes, *Op. cit.*, page 840 and Louis, duc de Saint-Simon, *Mémoires de Saint-Simon*, edited by A. de Boislisle (41 volumes), Paris, 1923–1928; Boorstin, *Op. cit.*, pages 207–212; Hawthorn, *Op. cit.*, pages 72–79, who describes Saint-Simon as 'an opportunist'.

## CHAPTER 27: THE IDEA OF THE FACTORY AND ITS CONSEQUENCES

1. Charles Dickens, *Hard Times*, London: Penguin, 2003, with an introduction by Kate Flint, pages 27–28. *Hard Times* was originally published in 1854.
2. *Ibid.*, page xi.
3. Bronowski and Mazlish, *Op. cit.*, page 307. Depending on which scholar you listen to, there were many other 'revolutions' in the eighteenth century – for example, the demographic, the chemical and the agricultural among them.
4. David Landes, *The Wealth and Poverty of Nations*, New York: Norton/Abacus, 1998/1999, page 42.
5. Bernal, *Science and History, Op. cit.*, page 520.
6. *Ibid.*
7. Peter Hall, *Cities in Civilisation, Op. cit.*, page 310.
8. *Ibid.*, page 312.
9. Phyllis Deane, *The First Industrial Revolution*, Cambridge, England: Cambridge University Press, 1979, page 90.

10. Hall, *Op. cit.*, page 313.
11. David S. Landes, *The Unbound Prometheus: Technological Change and Industrial Development in Western Europe from 1750 to the Present Day*, Cambridge, England: Cambridge University Press, 1969, pages 302–303.
12. Peter Lane, *The Industrial Revolution*, London: Weidenfeld & Nicolson, 1978, page 231. See Samuel Smiles, *The Lives of Boulton and Watt*, London: John Murray, 1865, pages 182–198, for Watt's transfer to Birmingham.
13. Hall, *Op. cit.*, page 315.
14. Lane, *Op. cit.*, pages 68–69.
15. Hall, *Op. cit.*, page 316.
16. *Ibid.*, page 319.
17. *Ibid.*, page 308.
18. Landes, *The Wealth and Poverty of Nations*, *Op. cit.*, page 41.
19. *Ibid.*
20. *Ibid.*
21. Hall, *Op. cit.*, pages 311–312.
22. Deane, *Op. cit.*, page 22.
23. *Ibid.*
24. Landes, *The Wealth and Poverty of Nations*, *Op. cit.*, pages 64–65.
25. *Ibid.*, page 5.
26. *Ibid.*, page 7.
27. Eric Hobsbawm, *The Age of Revolution*, London: Weidenfeld & Nicolson, 1962, page 63.
28. Landes, *The Wealth and Poverty of Nations*, *Op. cit.*, page 7.
29. Hall, *Op. cit.*, page 308.
30. Landes, *The Wealth and Poverty of Nations*, *Op. cit.*, page 262.
31. *Ibid.*, page 282.
32. Bernal, *Science and History*, *Op. cit.*, page 600.
33. *Ibid.*, pages 286–287.
34. Kleist is ignored in many histories. See Michael Brian Schiffer, *Draw the Lightning Down: Benjamin Franklin and Electrical Technology in the Age of Enlightenment*, Berkeley: University of California Press, 2003, page 46.
35. In turn, in the hands of André-Marie Ampère (1775–1836), Karl Friedrich Gauss (1777–1855) and Georg Ohm (1787–1854), far more was learned about magnetic fields produced by currents and the way these flowed through conductors. Current electricity was now a quantitative science. Landes, *Unbound Prometheus*, *Op. cit.*, page 285.
36. Bernal, *Science and History*, *Op. cit.*, page 620.
37. *Ibid.*, page 621.
38. Jean-Pierre Poirier, *Lavoisier: Chemist, Biologist, Economist*, Philadelphia: University of Pennsylvania Press, 1996, pages 72ff, 'The Oxygen Dispute'. Nick Lane, *Oxygen: The Molecule that Made the World*, Oxford: Oxford University Press, 2003.
39. Poirier, *Op. cit.*, pages 72ff.
40. *Ibid.*, pages 102ff, for the new chemistry; pages 105ff for the formation of acids; page 107 for combustion; pages 61ff for the calcinations of metals; and page 150 for the analysis of water.
41. John Dalton, *A New System of Chemical Philosophy*, London: R. Bickerstaff, 1808–1827 (reprinted 1953), volume II, section 13, pages 1ff and volume I, pages 231ff. And see the diagrams facing page 218.
42. Barnes, *Op. cit.*, page 681.
43. Bernal, *Science and History*, *Op. cit.*, page 625.
44. Bronowski and Mazlish, *Op. cit.*, page 323.
45. *Ibid.*, page 324.
46. Robin Reilly, *Josiah Wedgwood, 1730–1795*, London: Macmillan, 1992, page 183.
47. Bronowski and Mazlish, *Op. cit.*, page 325.
48. Reilly, *Op. cit.*, page 314.
49. *Ibid.*, page 327. Samuel Galton, grandfather of Francis, the founder of eugenics, was yet another who moved on from the Warrington Academy to the Lunar Society: he formed one of the earliest collections of scientific instruments. Thomas Day was most famous for his children's stories; he wrote 'pompously and vapidly', according to one account, but he lent money to the other members to support their activities. Robert E. Schofield, *The Lunar Society of Birmingham: A Social History on Provincial Science and Industry in Eighteenth Century England*, Oxford: Clarendon Press, 1963, page 53. James Keir, a former professional soldier, tried his hand at extracting alkalis from kelp (his method worked but the yield was too small) and then, having fought in France, and being fluent in French, translated Macquer's *Dictionary of Chemistry*, a distinguished (and highly practical) work, which helped establish the reputation of the Lunar Society.
50. John Graham Gillam, *The Crucible: The Story of Joseph Priestley LLD, FRS*, London: Robert Hale, 1959, page 138.
51. Bronowski and Mazlish, *Op. cit.*, page 329.
52. *Ibid.*, page 330.
53. *Ibid.*, page 329.
54. See: Jenny Uglow, *The Lunar Men: The Friends Who Made the Future*, London: Faber & Faber, 2002, especially pages 210–221, 237, 370 and 501.
55. Schofield, *Op. cit.*, page 440.
56. When the state of Massachusetts made its famous protest in the 1760s, that the British government had no right to tax the colony because there was no representative of Massachusetts in Parliament, part of the British government's reply was that Manchester had no representation either. Henry Steel Commager, *The Empire of Reason: How Europe Imagined and America Realised the Enlightenment*, London: Weidenfeld & Nicolson, 1978/2000; but see also Gillam, *Op. cit.*, page 182, for the atmosphere in Birmingham.
57. Landes, *Unbound Prometheus*, *Op. cit.*, page 23.
58. *Ibid.*, pages 25–26.
59. *Ibid.*, pages 22–23, for a good discussion of the controversy.
60. E. P. Thompson, *The Making of the English Working Class*, London: Gollancz, 1963, page 807f.
61. *Ibid.*, chapter 16, pages 781ff.
62. Bronowski and Mazlish, *Op. cit.*, page 339.
63. Athol Fitzgibbons, *Adam Smith's System of Liberty, Wealth and Virtue: The Moral and Political Foundation of the Wealth of Nations*, Oxford: The Clarendon Press of Oxford University Press, 1995, pages 5ff.
64. Landes, *Unbound Prometheus*, *Op. cit.*, page 246.
65. David Weatherall, *David Ricardo*, The Hague: Martinus Nijhoff, 1976, page 27, for his break with religion.
66. *Ibid.*, page 147.
67. J. K. Galbraith, *A History of Economics*, London: Hamish Hamilton/Penguin Books, 1987/1991, page 84.
68. *Ibid.*, page 118.
69. R. W. Harris, *Romanticism and the Social Order*, London: Blandford, 1969, page 78.
70. Frank Podmore, *Robert Owen*, New York: Augustus M. Kelley, 1968, page 188.
71. A. L. Morton, *The Life and Ideas of Robert Owen*, London: Lawrence & Wishart, 1963, page 92.
72. *Ibid.*, pages 88ff.

73. Bronowski and Mazlish, *Op. cit.*, pages 450ff.

74. Harris, *Op. cit.*, page 80. Podmore, *Op. cit.*, page 88, and page 80 for a photograph of the New Lanark mills.

75. He also provided an institute where evening lectures were given for those who wanted to carry on learning after they left school. Morton. *Op. cit.*, page 106.

76. Bronowski and Mazlish, *Op. cit.*, page 456.

77. Another of his ideas was the so-called 'Owenite communities' (in London, Birmingham, Norwich and Sheffield) where he brought craftsmen together to manufacture their own wares without the involvement of capitalist employers. Owen always remained convinced that capitalism was 'an inherently evil system' and he wanted others to share his vision. This is the main reason why he was such a passionate advocate of trades unionism. It was Owen who had the idea of labour exchanges, a system whereby craftsmen were able to exchange their own products for 'labour notes' that, in turn, could be exchanged for goods (another device to sideline the capitalist system). Most of these other ideas failed too, at least in the form that Owen conceived them. But, as R. W. Harris has pointed out, Owen was a visionary rather than an organiser. Many of his ideas would eventually become important elements in labour politics in the latter half of the nineteenth century and throughout most of the twentieth. Harris, *Op. cit.*, page 84.

78. Landes, *Unbound Prometheus, Op. cit.*, pages 298–299, for the importance of lubrication in the industrial revolution.

79. Hobsbawm, *The Age of Revolution, Op. cit.*, page 69.

80. *Ibid.*, page 72.

81. *Ibid.*, page 73.

82. See also Engels' conversation on the subject with a Mancunian. Hobsbawm, *Op. cit.*, page 182.

83. David McLellan, *Karl Marx: His Life and Thought*, London: Macmillan, 1973, page 130.

84. Galbraith, *Op. cit.*, page 127.

85. *Ibid.*, page 128. Hawthorn, *Op. cit.*, page 53, for Marx's relations with Hegel.

86. Jews in France were hopeful of a better future. Hobsbawm, *Op. cit.*, page 197.

87. Terrell Carver (editor), *The Cambridge Companion to Marx*, Cambridge, England: Cambridge University Press, 1991, page 56.

88. Roger Smith, *Op. cit.*, page 435.

89. *Ibid.*, page 436.

90. McLellan, *Op. cit.*, page 299ff.

91. *Ibid.*, page 334.

92. Galbraith, *Op. cit.*, pages 128–129.

93. McLellan, *Op. cit.*, pages 299–300 and 349–350.

94. *Ibid.*, pages 433–442.

95. Roger Smith, *Op. cit.*, pages 433–442.

96. Karl Marx, *Capital*, volume 2, Chicago: E. Untermann, 1907, page 763. Hawthorn, *Op. cit.*, page 54.

97. McLellan, *Op. cit.*, page 447. The International lasted until 1972.

98. Raymond Williams, *Culture and Society, 1780–1950*, London: Chatto & Windus, 1958, Penguin, 1963.

99. In fact, Adam Smith was one of the first to use the word in this new way, in *The Wealth of Nations*.

100. Williams, *Op. cit.*, pages 13–14.

101. *Ibid.*, page 14.

102. *Ibid.*, page 15.

103. *Ibid.*, pages 15–16.

104. *Ibid.*, page 16.

105. *Ibid.*, page 124. See also: Nicholas Murray, *A Life of Matthew Arnold*, London: Hodder & Stoughton, 1996, pages 243–245.

106. Williams, *Op. cit.*, page 130; and Murray, *Op. cit.*, page 245.

107. Williams, *Op. cit.*, page 136 and Matthew Arnold, *Culture and Anarchy*, London: John Murray, 1869, page 28.

108. Kenneth Pomeranz, *The Great Divergence: China, Europe and the Making of the Modern World Economy*, Princeton, New Jersey, and London: Princeton University Press, 2000, *passim*.

109. Karl Polanyi, *The Great Transformation*, Boston: Beacon Press, 1944/2001, pages 3ff.

110. *Ibid.*, pages 5 and 7.

111. *Ibid.*, page 15. See also: Niall Ferguson, *The Cash Nexus*, London: Allen Lane/Penguin, 2001/2002, pages 28–29; and 295–296. See page 355 for a table on the growth of democracy. The irony, and paradox, that this period was also the high point of imperialism is not often explored.

## CHAPTER 28: THE INVENTION OF AMERICA

1. Elliott, *The Old World and the New, Op. cit.*, pages 54–55.

2. *Ibid.*, page 56.

3. *Ibid.*, page 57.

4. Samuel Eliot Morison, Henry Steel Commager and William E. Leuchtenberg, *The Growth of the American Republic*, Oxford and New York: Oxford University Press, 1980, volume 2, pages 4–5.

5. Elliott, *Op. cit.*, pages 58–59.

6. *Ibid.*, page 65.

7. See Greene, *The Intellectual Construction of America, Op. cit.*, pages 21–22, for the respect for antiquity in Europe at the time.

8. Elliott, *Op. cit.*, page 81.

9. *Ibid.*, page 82.

10. Greene, *Op. cit.*, pages 39–42.

11. *Ibid.*, page 84; and see Greene, *Op. cit.*, pages 28–29, for ideas about Paradise and utopia in early America.

12. Elliott, *Op. cit.*, page 86.

13. *Ibid.*, page 87. The virility of this new economic arrangement was sufficient even to interest the Muslims. Faced with a Spain buoyed by its successes in the Americas, and with vast reserves of silver now at its command, the Ottomans began to display some curiosity about the New World. Around 1580 a *History of the West Indies* was written and presented to the Sultan Murad III. Relying mainly on Italian and Spanish sources, the author wrote: 'Within twenty years, the Spanish people have conquered all the islands and captured forty thousand people, and killed thousands of them. Let us hope to God that some time these valuable lands will be conquered by the family of Islam, and will be inhabited by Muslims and become part of the Ottoman lands.' *Ibid.*, page 88. (Compare Chapter 29, note 47 below.)

14. Bodmer, *Armature of Conquest, Op. cit.*, page 212.

15. Elliott, *Op. cit.*, page 103.

16. *Ibid.*, pages 95–96.

17. Henry Steel Commager, *The Empire of Reason, Op. cit.*, page 83.

18. *Ibid.*, pages 83–84.

19. *Ibid.*, page 84.

20. Kushnarev (edited and translated by Crownhart-Vaughan), *Bering's Search for the Strait, Op. cit., c.* page 169.

21. Bodmer, *Op. cit.*, page 106.

22. Antonello Gerbi, *The Dispute of the New World: The History of a Polemic, 1750–1900*, revised and enlarged

edition, translated by Jeremy Moyle, Pittsburgh: University of Pittsburgh Press, 1973, page 61.

23. Greene, *Op. cit.*, page 128.
24. Gerbi, *Op. cit.*, page 7.
25. Greene, *Op. cit.*, page 129.
26. Bodmer, *Op. cit.*, page 111.
27. Gerbi, *Op. cit.*, pages 52ff.
28. Commager, *Op. cit.*, page 16; Gary Wills, *Inventing America*, Boston: Houghton Mifflin, 1978/2002, pages 99–100, for Franklin's meeting with Voltaire.
29. Commager, *Op. cit.*, page 17; Boorstin, *The Seekers*, *Op. cit.*, page 204; Hugh Brogan, *The Penguin History of the United States*, London: Penguin, 1985/1990, page 97.
30. Brogan, *Op. cit.*, page 93.
31. Commager, *Op. cit.*, page 20.
32. *Ibid.*, and Brogan, *Op. cit.*, page 98.
33. Commager, *Op. cit.*, page 21.
34. Wills, *Op. cit.*, page 172.
35. Commager, *Op. cit.*, page 23.
36. *Ibid.*, page 24.
37. Greene, *Op. cit.*, page 168; and John Ferling, *A Leap in the Dark*, Oxford: Oxford University Press, 2003, page 256.
38. Commager, *Op. cit.*, page 30.
39. *Ibid.*
40. Wills, *Op. cit.*, page 45.
41. Commager, *Op. cit.*, page 33.
42. *Ibid.*, page 39.
43. Greene, *Op. cit.*, pages 131–138.
44. Brogan, *Op. cit.*, page 178; Daniel Boorstin, *The Americans: The National Experience*, London: Weidenfeld & Nicolson, 1966, page 399.
45. Commager, *Op. cit.*, page 41.
46. *Ibid.*, page 94.
47. Merrill D. Peterson, *Thomas Jefferson and the New Nation*, Oxford: Oxford University Press, 1970, pages 159–160.
48. Wills, *Op. cit.*, pages 136–137.
49. Commager, *Op. cit.*, page 98.
50. *Ibid.*, page 106.
51. *Ibid.*, page 108.
52. Wills, *Op. cit.*, page 129; and page 99, for the gadgets at Monticello.
53. Commager, *Op. cit.*, page 114.
54. Peterson, *Op. cit.*, page 160.
55. Commager, *Op. cit.*, page 99.
56. *Ibid.*, page 100.
57. Wills, *Op. cit.*, page 287.
58. Commager, *Op. cit.*, page 146.
59. *Ibid.*
60. *Ibid.*, pages 149–150.
61. *Ibid.*, page 151.
62. Ferling, *Op. cit.*, page 315.
63. Commager, *Op. cit.*, page 153.
64. Wills, *Op. cit.*, page 6, for Pendleton, page 18, for Adams (whom John F. Kennedy features in his *Profiles in Courage*).
65. Morison *et al.*, *Op. cit.*, page 67; Brogan, *Op. cit.*, pages 94–95.
66. Commager, *Op. cit.*, page 173, quoting: Samuel Williams, *Natural and Civil History of Vermont*, 1794, pages 343–344.
67. *Ibid.*, page 176.
68. For the sheer abundance in America, see Greene, *Op. cit.*, page 99, and also for some aspects of marriage.
69. W. H. Auden, *City Without Walls*, London: Faber, 1969, page 58.
70. Commager, *Op. cit.*, page 181.
71. *Ibid.*, page 183.
72. Brogan, *Op. cit.*, page 216.
73. Commager, *Op. cit.*, page 187–188.
74. Ferling, *Op. cit.*, page 26.
75. Commager, *Op. cit.*, page 192.
76. *Ibid.*, pages 192–193.
77. Ferling, *Op. cit.*, page 150.
78. Commager, *Op. cit.*, page 201.
79. *Ibid.*, page 208.
80. For the effects of this thinking on Europe, see Greene, *Op. cit.*, pages 131ff.
81. *Ibid.*, page 177 for the background.
82. Ferling, *Op. cit.*, page 298.
83. Commager, *Op. cit.*, page 236.
84. *Ibid.*, page 238.
85. Ferling, *Op. cit.*, page 257.
86. Commager, *Op. cit.*, pages 240–241.
87. Wills, *Op. cit.*, page 249; Ferling, *Op. cit.*, page 434.
88. Commager, *Op. cit.*, page 245.
89. Tocqueville noted the difference between 'dissolute' French-speakers in New Orleans and the 'pious' French-Canadians.
90. André Jardin, *Tocqueville*, London: Peter Halban, 1988, page 149.
91. *Ibid.*
92. *Ibid.*, page 117. See also: James T. Schleifer, *The Making of Tocqueville's 'Democracy in America'*, Chapel Hill, North Carolina: University of North Carolina Press, 1980, especially pages 62ff, 191ff, and 263ff.
93. Jardin, *Op. cit.*, page 126.
94. *Ibid.*, page 158; Brogan, *Op. cit.*, page 319.
95. Jardin, *Op. cit.*, page 114. An alternative view is that de Tocqueville thought equality the most important factor in America, but that the revolution had been of little importance in producing that spirit. He also famously said that the two great powers of the future would be America and Russia. See Wills, *Op. cit.*, page 323.
96. Alexis de Tocqueville, *Oeuvres Complètes* (edited and selected by J. P. Mayer), Paris: Gallimard, 1951–, volume 1, page 236.
97. Jardin, *Op. cit.*, page 162.
98. Brogan, *Op. cit.*, page 75.
99. Jardin, *Op. cit.*, page 208.
100. *Ibid.*, page 216.
101. Parts of his argument, and some of his observations, were paradoxical or contradictory. He found life more private in America though at the same time he thought people were more envious of one another. The development of industry in America, he felt, would perhaps destroy the community spirit he so admired as it exacerbated the differences between people. See Jardin, *Op. cit.*, page 263.
102. Wills, *Op. cit.*, page 323.

## CHAPTER 29: THE ORIENTAL RENAISSANCE

1. Donald F. Lach, *Asia in the Making of Europe*, Chicago: University of Chicago Press, 1965, volume 1, book 1, page 152.
2. *Ibid.*
3. *Ibid.*, page 153.
4. *Ibid.*, page 155.
5. J. C. H. Aveling, *The Jesuits*, London: Blond & Briggs, 1981, page 157.
6. John W. O'Malley *et al.* (editors), *The Jesuits: Culture, Science and the Arts, 1540–1773*, Toronto: University of

Toronto Press, 1999, page 338, though this was also seen as a hindrance.

7. *Ibid.*, page 247.
8. Lach, *Op. cit.*, page 314.
9. *Ibid.*
10. *Ibid.*, page 316; O'Malley *et al.* (editors), *Op. cit.*, page 380.
11. The fundamental source is John Correia-Afonso SJ, *Jesuit Letters and Indian History*, Bombay, 1955.
12. *Ibid.*, page 319. For the use of art works to overcome language barriers, see: Anna Jackson and Amin Jaffer (editors), *Encounters: The meeting of Asia and Europe 1500–1800*, London: V & A Publications, 2004, especially the chapter by Gauvin Bailey.
13. See O'Malley *et al.* (editors), *Op. cit.*, pages 408ff for other Hindu customs reported by the Jesuits.
14. Lach, *Op. cit.*, page 359.
15. *Ibid.*, page 415.
16. There are scattered references throughout the letters to epidemics, coins, prices and the availability of certain foodstuffs. In general, politics were ignored, beyond personal descriptions of this or that ruler. Correia-Afonso, *Op. cit.*, *passim.*
17. Lach, *Op. cit.*, page 436.
18. *Ibid.*, page 439.
19. O'Malley *et al.* (editors), *Op. cit.*, page 405, discusses the idea that some Jesuits thought they understood Hinduism better than the Hindus themselves.
20. Lach, *Op. cit.*, page 442.
21. Gernet, *A History of Chinese Civilisation*, page 440.
22. O'Malley *et al.* (editors), *Op. cit.*, pages 343–349 for Jesuit missions to China.
23. Gernet, *Op. cit.*, page 441.
24. Hucker, *China's Imperial Past, Op. cit.*, page 376.
25. Gernet, *Op. cit.*, page 507.
26. *Ibid.*, page 508. In a particularly Chinese flourish, books were not allowed to Make use of any of the characters which comprised the emperor's name, lest they be disrespectful.
27. Gernet, *Op. cit.*, pages 521–522.
28. Commager, *Op. cit.*, page 62.
29. *Ibid.*
30. Peter Watson, *From Manet to Manhattan: The Rise of the Modern Art Market*, New York and London: Random House/Vintage, 1992/1993, pages 108–109.
31. Marshall G. S. Hodgson, *The Venture of Islam: Conscience and History in a World Civilisation*, volume 3, *The Gunpowder Empires and Modern Times*, Chicago and London: University of Chicago Press, 1958/1977, page 42.
32. *Ibid.*, page 50.
33. *Ibid.*, pages 73ff.
34. *Ibid.*, page 158.
35. Hourani, *A History of the Arab Peoples, Op. cit.*, pages 256ff; and Bernard Lewis, *What Went Wrong?*, London: Weidenfeld & Nicolson, 2002, page 7.
36. Lewis, *Op. cit.*, page 118.
37. Asli Çirakman, *From the 'Terror of the World' to the 'Sick Man of Europe': European Images of Ottoman Empire and Society from the Sixteenth Century to the Nineteenth Century*, New York: Peter Lang, 2002, page 51.
38. Ekmeleddin Ihsanoglu, *Science, Technology and Learning in the Ottoman Empire: Western Influence, Local Institutions and the Transfer of Knowledge*, Aldershot: Ashgate/Variorum, 2004, page II 10–15.
39. *Ibid.*, page II 20.
40. *Ibid.*, page III 15.
41. *Ibid.*, page IX 161ff.
42. Ibid., page II 20.
43. Fatma Müge Göçek, *East Encounters West: France and the Ottoman Empire in the Eighteenth Century*, Oxford: Oxford University Press, 1987, page 25.
44. *Ibid.*, page 58.
45. Lewis, *Op. cit.*, page 25.
46. See, for example: Gulfishan Khan, *Indian Muslim Perceptions of the West During the Eighteenth Century*, Oxford: Oxford University Press, 1988; and: Michael Fischer, *Counterflows to Colonialism: Indian Travellers and Settlers in Britain 1600–1857*, Oxford: Oxford University Press, 2004.
47. 'A Turkish book on the New World was written in the late sixteenth century, and was apparently based on information from European sources – oral rather than written. It describes the flora, fauna and inhabitants of the New World and expresses the hope that this blessed land would in due course be illuminated by the light of Islam. This book also remained unknown until it was printed in Istanbul in 1729 ... Knowledge was something to be acquired, stored, if necessary bought, rather than grown or developed.' Lewis, *Op. cit.*, pages 37–39.
48. *Ibid.*, page 46.
49. *Ibid.*, page 47.
50. *Ibid.*, page 66.
51. It would change: see Hourani, *Op. cit.*, pages 303ff, and Chapter 35 of this book.
52. Lewis, *Op. cit.*, page 79.
53. Hourani, *Op. cit.*, page 261, for changing patterns of trade.
54. Lewis, *Op. cit.*, page 158.
55. O'Malley *et al.* (editors), *Op. cit.*, pages 241ff.
56. Moynahan, *Op. cit.*, page 557, for the trial of Roberto de Nobili, who dressed as a Brahman ascetic.
57. Raymond Schwab, *The Oriental Renaissance: Europe's Rediscovery of India and the East, 1680–1880*, New York: Columbia University Press, 1984, page 11.
58. *Ibid.*, page 7.
59. Abraham Hyacinthe Anquetil-Duperron, translation of *Zenda Avesta: Ouvrage de Zoroastre*, Paris, 1771.
60. *Ibid.*, page xii.
61. Patrick Turnbull, *Warren Hastings*, London: New English Library, 1975, pages 199ff.
62. Schwab, *Op. cit.*, page 35.
63. Lesley and Roy Adkins, *The Keys of Egypt*, New York: HarperCollins, 2000, pages 180–181, which reproduces the actual hieroglyphics that Champollion worked on in his breakthrough.
64. Schwab, *Op. cit.*, page 86.
65. *Ibid.*, page 41 and ref.
66. *Ibid.*, page 21. On the wisdom of the Indians, see the translation by E. J. Millington of *The Aesthetic and Miscellaneous Works of Friedrich von Schlegel*, London, 1849.
67. Schwab, *Op. cit.*, page 21.
68. *Ibid.*, page 218.
69. H. G. Rawlinson, 'India in European literature and thought', in G. T. Garratt, *The Legacy of India*, Oxford: The Clarendon Press of Oxford University Press, 1937, pages 35–36.
70. *Ibid.*, pages 171ff.
71. Robert T. Clark Jr, *Herder: His Life and Thought*, Berkeley, University of California Press, 1955, page 362f.
72. Schwab, *Op. cit.*, page 59.
73. M. Von Hersfeld and C. MelvilSym, translators, *Letters from Goethe*, Edinburgh: Edinburgh University Press, 1957, page 316.

74. Alphonse de Lamartine, *Cours familier de litérature*, Paris: privately printed, 1856, volume 3, page 338.
75. Schwab, *Op. cit.*, page 161.
76. *Ibid.*, page 177.
77. *Ibid.*, page 179.
78. Paul R. Sweet, *Wilhelm von Humboldt*, Cincinnati: Ohio State University Press, volume 2, 1980, pages 398ff, which shows that Humboldt was just as interested in (American) Indian languages as in Sanskrit.
79. Schwab, *Op. cit.*, page 181.
80. *Ibid.*, page 217.
81. *Ibid.*, page 250.
82. Marc Citoleux, *Alfred de Vigny, persistences classiques et affinités étrangères*, Paris: Champion, 1924, page 321.
83. Schwab, *Op. cit.*, page 468.
84. Clark Jr, *Op. cit.*, pages 130ff.
85. Schwab, *Op. cit.*, pages 273ff.
86. *Ibid.*, page 217. Friedrich Wilhelm Schelling, *Philosophie der Mythologies*, Munich: C. H. Beck, 1842/1943.
87. Schwab, *Op. cit.*, page 201.
88. *Ibid.*, page 211.
89. Non-German-speaking readers should consult: Franz Bopp, *A Comparative Grammar of the Sanskrit, Zend, Greek, Latin, Lithuanian, Gothic, German and Slavonic Languages*. Translated from the German by Lieutenant Eastwick, conducted through the press by H. H. Wilson. Three volumes, London: Madden and Malcolm, 1845–1853.
90. Schwab, *Op. cit.*, page 213.
91. *Ibid.*, page 220.
92. *Ibid.*, page 219.
93. Rüdiger Safranski, *Schopenhauer*, London: Weidenfeld & Nicolson, 1989, page 63.
94. Schwab, *Op. cit.*, page 427.
95. *Ibid.*
96. Arthur Schopenhauer, *The World As Will and Idea* (translated by R. B. Haldane and J. Kemp), London: Trübner, three volumes, 1883–1886, volume 3, page 281.
97. Schwab, *Op. cit.*, page 359.
98. *Ibid.*, page 357.
99. *Ibid.*, page 361.
100. *Ibid.*
101. Joanna Richardson, *Victor Hugo*, London: Weidenfeld & Nicolson, 1976, pages 217ff.
102. Schwab, *Op. cit.*, page 373.
103. *Ibid.*, page 417.
104. Referred to in: Émile Carcassone, 'Leconte de Lisle et la philosophie indienne', *Revue de litérature comparée*, volume 11, 1931, pages 618–646.
105. Schwab, *Op cit.*, page 431.
106. Michael D. Biddiss, *The Father of Racist Ideology*, London: Weidenfeld & Nicolson, 1970, pages 175–176.
107. Schwab, *Op. cit.*, page 438.
108. Richard Wagner, *My Life*, two volumes, New York: Dodds Mead, 1911, volume 2, page 638. Schwab has a whole chapter on Wagner's Buddhism.
109. He also said that he 'hated' America. It was 'a horrible nightmare'. Wilhelm Altman (editor and selector), *Letters of Richard Wagner*, London: Dent, 1927, volume 1, page 293.
110. Schwab, *Op. cit.*, page 441.
111. Judith Gautier, *Auprès de Richard Wagner*, Paris: Mercure de France, 1943, page 229.

CHAPTER 30: THE GREAT REVERSAL OF VALUES – ROMANTICISM

1. Harold C. Schonberg, *Lives of the Composers*, London: Davis-Poynter/Macdonald Futura, 1970/1980, page 124.
2. See David Cairns, *Berlioz*, London: Allen Lane The Penguin Press, 1999, pages 263–278, *passim*, for Berlioz's friendship with Hiller.
3. Schonberg, *Op. cit.*, page 126.
4. Menuhin and Davis, *The Music of Man*, *Op. cit.*, page 163.
5. Schonberg, *Op. cit.*, page 126.
6. Jacques Barzun, *Classical, Romantic, Modern*, London: Secker & Warburg, 1962, page 5.
7. Schonberg, *Op. cit.*, page 124.
8. Berlin, *The Sense of Reality*, London: Chatto & Windus, 1996. page 168.
9. *Ibid.*, page 168.
10. *Ibid.*, pages 168–169.
11. *Ibid.*, page 168.
12. *Ibid.*, page 169.
13. See Howard Mumford Jones, *Revolution and Romanticism*, Cambridge, Massachusetts: The Belknap Press of Harvard University Press, 1974, page 368, for German nationalism in response to Napoleon. And see Gerald N. Izenberg, *Impossible Individuality: Romanticism, Revolution and the Origins of Modern Selfhood, 1787–1802*, Princeton, New Jersey, and London: Princeton University Press, 1992, pages 45–47 and 94 for the Berlin salons.
14. Berlin, *Op. cit.*, page 170.
15. *Ibid.*, page 171.
16. *Ibid.*
17. *Ibid.*, page 173.
18. *Ibid.*, page 175.
19. See Israel, *Radical Enlightenment*, *Op. cit.*, page 668, for a view that Vico was a philosophical opponent of naturalism.
20. *Ibid.*
21. *Ibid.*, page 666.
22. *Ibid.*, pages 665 and 344.
23. *Ibid.*, page 344.
24. Mumford Jones, *Op. cit.*, page 242; see also Hawthorn, *Enlightenment and Despair*, *Op. cit.*, pages 32–33.
25. Roger Smith, *Op. cit.*, page 337.
26. Berlin, *Op. cit.*, page 176.
27. Mumford Jones, *Op. cit.*, page 229.
28. Berlin, *Op. cit.*, page 178.
29. *Ibid.*, page 179.
30. Barzun, *Op. cit.*, pages 135ff, for a discussion of the development of ideas about the will.
31. Berlin, *Op. cit.*, page 179.
32. Hauser, *A Social History of Art*, *Op. cit.*, volume 3, page 174.
33. Roger Smith, *Op. cit.*, pages 346–347.
34. Mumford Jones, *Op. cit.*, page 66.
35. *Ibid.*
36. Roger Smith, *Op. cit.*, page 347.
37. As Ortega y Gasset was to say later: 'Man has no nature, what he has is his history.' Ortega y Gasset, 'History as a system', in *Philosophy and History, Essays Presented to Ernst Cassirer*, edited by R. Klibonsky and J. H. Paton, 1936, page 313.
38. Mumford Jones, *Op. cit.*, page 100.
39. *Ibid.*
40. Roger Smith, *Op. cit.*, page 350.
41. Berlin, *Op. cit.*, page 179.
42. Mumford Jones, *Op. cit.*, page 242, says that Fichte's idea

of the will may have been an early conception of the super-ego.

43. Berlin, *Op. cit.*, page 180.
44. *Ibid.*, pages 181–182; see also Hawthorn, *Op. cit.*, pages 238–239.
45. Berlin, *Op. cit.*, pages 182–183.
46. *Ibid.*, page 183.
47. Mumford Jones, in his chapter on the romantic genius, *Op. cit.*, page 274, says that it was part of the theory that one best helped society by realising oneself as completely as possible.
48. Berlin, *Op. cit.*, pages 185–186.
49. *Ibid.*, page 187.
50. Despite the nationalism of the Germans, romantics felt that heroes of other cultures might be nearer the 'invisible nature' that man shares with the creator. Mumford Jones, *Op. cit.*, page 279.
51. Berlin, *Op. cit.*, page 188.
52. Chapter XII of Mumford Jones' *Revolution and Romanticism, Op. cit.*, is entitled 'The Romantic rebels'.
53. Hauser, *Op. cit.*, page 166.
54. Roger Smith, *Op. cit.*, page 346.
55. Mumford Jones, *Op. cit.*, page 274.
56. Hauser, *Op. cit.*, page 192.
57. *Ibid.*, page 188.
58. *Ibid.*, page 208.
59. Izenberg, *Op. cit.*, pages 142–143.
60. *Ibid.*, page 144.
61. The phrase is Hauser's, *Op. cit.*, page 210.
62. Mumford Jones, *Op. cit.*, page 288.
63. Hauser, *Op. cit.*, page 212.
64. *Ibid.*, pages 213–214.
65. *Ibid.*, page 216.
66. *Ibid.*, page 181.
67. In his discussion 'Two concepts of individuality', Gerald Izenberg explores the romantics' view of the differences between males and females. *Op. cit.*, pages 18–53.
68. For poetry as purification see Nicholas Boyle, *Goethe: the Poet and the Age*, volume 1, *The Poetry of Desire*, Oxford: The Clarendon Press of Oxford University Press, 1991, pages 329–331.
69. Mumford Jones discusses aspects of this. *Op. cit.*, page 264.
70. *Ibid.*, page 394.
71. Schonberg, *Op. cit.*, page 83.
72. *Ibid.*
73. See, for example, Alfred Einstein, *A Short History of Music*, London: Cassell, 1953, page 143.
74. Schonberg, *Op. cit.*, page 86.
75. The *Eroica* was originally dedicated to Napoleon but, according to legend, Beethoven changed his mind after Bonaparte proclaimed himself emperor. George R. Marek, *Beethoven*, London: William Kimber, 1970, page 343.
76. Schonberg, *Op. cit.*, page 89.
77. Einstein, *Op. cit.*, page 146. Marek, *Op. cit.*, page 344.
78. Mumford Jones, *Op. cit.*, page 293.
79. Schonberg, *Op. cit.*, pages 93–94.
80. Mumford Jones, *Op. cit.*, page 394.
81. Einstein, *Op. cit.*, page 152.
82. *Ibid.*
83. *Ibid.*, page 154.
84. Schonberg, *Op. cit.*, page 98.
85. *Ibid.*, page 109.
86. Barzun, *Op. cit.*, pages 545–546. See also: Baines (editor), *Musical Instruments Through the Ages, Op. cit.*, page 260, for the development of the saxophone.

87. Menuhin and Davis, *Op. cit.*, page 165; Mumford Jones, *Op. cit.*, page 391; and see Baines (editor), *Op. cit.*, pages 124–125, for Paganini and the final evolutionary details about the violin; and page 91 for the differences between English and German (Viennese) pianos.
88. It was said he achieved such excellence because he had sold himself to the devil (he had a cadaverous appearance). He never sought to deny this charge. Menuhin and Davis, *Op. cit.*, page 165; and Mumford Jones, *Op. cit.*, page 410.
89. Schonberg, *Op. cit.*, page 110.
90. Edward Dent says that romanticism was established by the time Weber appeared on the scene. Winton Dean (editor), *The Rise of Romantic Opera*, Cambridge, England: Cambridge University Press, 1976, page 145.
91. Schonberg, *Op. cit.*, page 112.
92. Einstein, *Op. cit.*, page 152.
93. Schonberg, *Op. cit.*, page 119.
94. Mumford Jones, *Op. cit.*, page 410.
95. Einstein, *Op. cit.*, page 176.
96. Mumford Jones, *Op. cit.*, page 410.
97. Cairns, *Op. cit.*, volume 2, page 1.
98. Mumford Jones, *Op. cit.*, page 375.
99. Menuhin and Davis, *Op. cit.*, page 178.
100. Jeremy Siepmann, *Chopin: The Reluctant Romantic*, London: Gollancz, 1995, pages 132–138, *passim.*
101. *Ibid.*, page 103. Schonberg, *Op. cit.*, page 153.
102. Menuhin and Davis, *Op. cit.*, page 180.
103. Einstein, *Op. cit.*, page 199.
104. Eleanor Perényi, *Liszt*, London: Weidenfeld & Nicolson, 1974, page 56. See also Baines (editor), *Op. cit.*, page 100.
105. Menuhin and Davis, *Op. cit.*, page 165.
106. Though Alfred Einstein reminds us that Liszt rescued the music of the Catholic church in the nineteenth century. *Op. cit.*, page 180.
107. *Ibid.*
108. Perényi, *Op. cit.*, page 11.
109. Einstein, *Op. cit.*, pages 158 and 178.
110. *Ibid.*, page 179.
111. *Ibid.*, page 158.
112. *Ibid.*, page 160.
113. Schonberg, *Op. cit.*, page 183.
114. *Ibid.*, page 214.
115. Menuhin and Davis, *Op. cit.*, page 187.
116. Mumford Jones, *Op. cit.*, page 325n; and Menuhin and Davis, *Op. cit.*, pages 187–188.
117. Charles Osborne (selector, translator and editor), *The Letters of G. Verdi*, London: Gollancz, 1971, page 596.
118. Mumford Jones, *Op. cit.*, page 216.
119. Einstein. *Op. cit.*, page 172.
120. Mary-Jane Phillips-Matz, *Verdi*, Oxford: Oxford University Press, 1993, page 204.
121. *Ibid.*, page 715.
122. Einstein, *Op. cit.*, page 185.
123. Schonberg, *Op. cit.*, page 230 and ref.
124. *Ibid.*, page 232.
125. Einstein, *Op. cit.*, page 185.
126. *Ibid.*, page 187; but see also: Nike Wagner, *The Wagners*, London: Weidenfeld & Nicolson, 2000, page 25, for 'the Tannhäuser problem'.
127. *The Nibelungenlied* (new translation by A. T. Hatto), London: Penguin Books, 1965.
128. Einstein, *Op. cit.*, page 188.
129. Schonberg, *Op. cit.*, page 239.
130. John Louis Di Gaetani, *Penetrating Wagner's Ring*, New York and London: Associated Universities Press, 1978,

ges 206–207, for his views about the Rhine, for
example.

instein, *Op. cit.*, page 190; and see Baines (editor), *Op.
..., pages 258–259, for some of the new instruments
available at Bayreuth.

132. Schonberg, *Op. cit.*, page 244.
133. Einstein, *Op. cit.*, page 191.
134. Nike Wagner, *Op. cit.*, page 172.
135. Einstein, *Op. cit.*, page 192.
136. Di Gaetani, *Op. cit.*, pages 219–238. See also: Erik Levine, *Music in the Third Reich*, London: Macmillan, 1994, page 35, for Hitler's sponsorship of Wagner research.

## CHAPTER 31: THE RISE OF HISTORY, PRE-HISTORY AND DEEP TIME

1. Frank McLynn, *Napoleon*, London: Jonathan Cape, 1997, page 171.
2. Jacques Barzun, *From Dawn to Decadence, 500 Years of Western Cultural Life*, New York and London: Harper-Collins, 2000, pages 442–444.
3. *Ibid.*, page 442.
4. *Ibid.*, pages 395–396.
5. Roger Smith, *Op. cit.*, page 372.
6. *Ibid.*, page 373.
7. *Ibid.*, page 374.
8. Boorstin, *The Seekers*, *Op. cit.*, page 210, for Bertrand Russell's and Benjamin Franklin's criticism of Hegel.
9. Paul R. Sweet, *Wilhelm von Humboldt: A Biography*, volume 2, Columbus: Ohio University Press, 1980, pages 392ff.
10. Roger Smith, *Op. cit.*, page 379.
11. This was very modern in itself, but Humboldt went further, arguing that some languages – German inevitably, and despite Napoleon's successes – were more 'suited' to 'higher' purposes. This was the beginning of what would turn into a very dangerous idea.
12. Roger Smith, *Op. cit.*, page 382.
13. *Ibid.*, page 385.
14. *Ibid.*, page 387.
15. David Friedrich Strauss, *The Life of Jesus, Critically Examined*, edited and with an introduction by Peter C. Hodgson, London: SCM Press, 1972, page xx.
16. See John Hadley Brooke, *Science and Religion*, Cambridge, England: Cambridge University Press, 1991, page 266, for a discussion of Strauss and the difference between myth and falsehood. See also Strauss/Hodgson, *Op. cit.*, page xlix.
17. Vincent Cronin, *Napoleon*, London: Collins, 1971, page 145.
18. C. W. Ceram, *Gods, Graves and Scholars*, London: Gollancz, 1971 pages 207–208.
19. Ian Tattersall, *The Fossil Trail*, *Op cit.*, page 14. H. Schaafhausen, 'On the crania of the most ancient races of Man'. Translated, with an introduction by G. Bush, in *Natural History Review*, volume 1, 1861, pages 155–176.
20. Bowler, *Evolution: The History of an Idea*, *Op. cit.*, page 65.
21. *Ibid.*, page 65.
22. *Ibid.*, page 75.
23. *Ibid.*, page 26.
24. Suzanne Kelly, 'Theories of the earth in Renaissance cosmologies', in Cecil J. Schneer (editor), *Towards a History of Geology*, Cambridge, Massachusetts: MIT Press, 1969, pages 214–225.
25. Bowler, *Op. cit.*, page 31.
26. *Ibid.*, page 37.
27. *Ibid.*, page 40.
28. *Ibid.*, page 44.
29. Charles Gillispie, *Genesis and Geology*, Cambridge, Massachusetts: Harvard University Press, 1949; Harper Torchbook, 1959, page 48.
30. *Ibid.*, pages 41–42.
31. Nicholas Steno, *The Prodromus of Nicholas Steno's Dissertation concerning a Solid Body Enclosed by Process of Nature within a solid*. Original 1669, translated into English by J. G. Winter in 1916, as part of the University of Michigan Humanistic Studies, volume 1, part 2, reprinted by Hafner Publishing Company, New York, 1968. John Woodward, 'An Essay Toward a Natural History of the Earth and terrestrial Bodyes', originally London 1695, reprinted New York: Arno Press, 1977.
32. Gillispie, *Op. cit.*, page 42. Jack Repcheck, *The Man Who Found Time: James Hutton and the Discovery of the Earth's Antiquity*, London: Simon & Schuster, 2003, who says that Hutton's prose was 'impenetrable' and that, at the time, people were not very interested in the antiquity of the earth.
33. See, for example, Gillispie, *Op. cit.*, page 46.
34. *Ibid.*, page 68.
35. *Ibid.*, page 84.
36. Bowler, *Op. cit.*, page 110.
37. Gillispie, *Op. cit.*, page 99.
38. Bowler, *Op. cit.*, page 116.
39. Gillispie, *Op. cit.*, page 101.
40. Bowler, *Op. cit.*, page 116.
41. *Ibid.*, page 119.
42. Brooke, *Op. cit.*, page 203, says that on one occasion Buckland 'detained' the British Association for the Advancement of Science until midnight, 'expatiating' on the 'design' of the great sloth.
43. Gillispie, *Op. cit.*, page 107.
44. Bowler, *Op. cit.*, page 110.
45. *Ibid.*, page 124 for a table.
46. Gillispie, *Op. cit.*, pages 111–112 and 142.
47. Bowler, *Op. cit.*, page 130.
48. *Ibid.*, page 132.
49. *Ibid.*, pages 134ff.
50. Gillispie, *Op. cit.*, page 133.
51. Bowler, *Op. cit.*, page 138.
52. Gillispie, *Op. cit.*, page 210.
53. *Ibid.*, page 212.
54. *Ibid.*, page 214.
55. Secord, *Victorian Sensation*, *Op. cit.*, page 388.
56. *Ibid.*, chapter 3, pages 77ff.
57. *Ibid.*, page 526, for the publishing histories of *Vestiges* and the *Origin* compared.
58. Edward Lurie, *Louis Agassiz: A Life in Science*, Chicago: University of Chicago Press, 1960, pages 97ff, for Agassiz' development of the concept of the Ice Age.
59. J. D. Macdougall, *A Short History of Planet Earth*, New York and London: John Wiley & Sons, 1996, page 210.
60. But there was something else too. Among the moraines were found considerable quantities of diamonds. Diamonds are formed deep in the earth and are brought to the surface in the molten magma produced by volcanoes. Thus, here was further evidence of the continuous action of volcanoes, reinforcing the fact that the discovery of the great Ice Age(s) confirmed both the antiquity of the earth and the uniformitarian approach to geology. *Ibid.*, pages 206–210.
61. Peter J. Bowler, *The Non-Darwinian Revolution*, Baltimore and London: Johns Hopkins University Press, 1988, page 13.

62. Mayr, *The Growth of Biological Thought, Op. cit.*, page 349. See also: Moynahan, *Op. cit.*, page 651.
63. Pietro Corsi, *The Age of Lamarck: Evolutionary Theories in France 1790–1830*, Berkeley and London: University of California Press, 1988, pages 121ff. Ernst Mayr, the eminent historian of biology, says that Lamarck presented his view of evolution with far more courage than Darwin was to do fifty years later. Mayr, *Op. cit.*, page 352.
64. Corsi, *Op. cit.*, pages 157ff, for those who did and did not agree with Lamarck.
    The rise of the Great Chain of Being, which was discussed in the Introduction, also formed part of the intellectual climate of the mid-nineteenth century. It was an ancient idea, which gave it credibility to begin with, but it was not really a scientific idea and therefore did not long outlive Darwin's innovations. See Bowler, *Evolution: The History of an Idea, Op. cit.*, pages 59ff for nineteenth-century ideas about the Great Chain and page 61 for a diagram.
65. These other factors included industrial capitalism – the notion that people should be free to compete in business activities, because in that way the good of the community and the selfish interests of individuals coincide.
66. Bowler, *The Non-Darwinian Revolution, Op. cit.*, page 36.
67. *Ibid.*, page 41.
68. Barry Gale, 'Darwin and the concept of the struggle for existence: a study in the extra-scientific origins of scientific ideas', *Isis*, volume 63, 1972, pages 321–344.
69. Bowler, *The Non-Darwinian Revolution, Op. cit.*, page 57.
70. Secord, *Op. cit.*, page 431.
71. Bowler, *The Non-Darwinian Revolution, Op. cit.*, page 42. Martin Fichnan, 'Ideological factors in the dissemination of Darwinism', in Everett Mendelsohn (editor), *Transformation and Tradition in the Sciences*, Cambridge, Massachusetts: Harvard University Press, 1984, pages 471–485.
72. Bowler, *The Non-Darwinian Revolution, Op. cit.*, page 43.
73. Mayr, *Op. cit.*, page 950. Ross A. Slotten, *The Heretic in Darwin's Court: The Life of Alfred Russel Wallace*, New York: Columbia University Press, 2004.
74. Bowler, *The Non-Darwinian Revolution, Op. cit.*, page 152.
75. Mayr, *Op. cit.*, page 501.
76. Bowler, *The Non-Darwinian Revolution, Op. cit.*, page 162.
77. *Ibid.*, page 187.
78. *Ibid.*, page 67.
79. Secord, *Op. cit.*, page 526.
80. Mayr, *Op. cit.*, page 510.
81. Even T. H. Huxley, 'Darwin's bulldog', who did so much to advance the cause of evolution overall, never made much of natural selection.
82. Bowler, *Evolution: The History of an Idea, Op. cit.*, page 24.
83. See: Peter Watson, *A Terrible Beauty: The People and Ideas That Shaped the Modern Mind*, London: Weidenfeld & Nicolson, 2000/*The Modern Mind: An Intellectual History of the Twentieth Century*, New York: HarperCollins, 2001, page 371, for a summary of the evolutionary synthesis. See also: Ernst Mayr and William B. Provine (editors), *The Evolutionary Synthesis*, Cambridge, Massachusetts: Harvard University Press, 1990/1998.
84. Secord, *Op. cit.*, pages 224 and 230.
85. Mayr, *Op. cit.*, page 654.
86. Bowler, *Evolution: The History of an Idea, Op. cit.*, page 271.
87. Bowler, *The Non-Darwinian Revolution, Op. cit.*, page 132.
88. *Ibid.*, page 135.
89. *Ibid.*
90. Lewis Morgan, *Ancient Society*, London: Macmillan, 1877.
91. This whole debate, however, was coloured by racist thinking. For example, a new science of 'craniometry' emerged in which the brain sizes of different races were compared. The leading figures here were S. G. Morton in America and Paul Broca in France, who both thought they had demonstrated that the 'lower' races had smaller brains and that this accounted for their lower intelligence and their more primitive position on the ladder of cultural evolution.
92. Bowler, *The Non-Darwinian Revolution, Op. cit.*, page 144.
93. *Ibid.*, page 145.
94. *Ibid.*
95. See Brooke, *Op. cit.*, page 147 for the background to Dubois' trip to the Far East.
96. Bowler, *The Non-Darwinian Revolution, Op. cit.*, page 174.
97. *Ibid.*, page 175.

CHAPTER 32: NEW IDEAS ABOUT HUMAN ORDER: THE ORIGINS OF SOCIAL SCIENCE AND STATISTICS

1. D. Gerould, *The Guillotine: Its Legend and Lore*, New York: Blast Books, 1992, page 25.
2. *Ibid.*, page 33.
3. See Barzun, *From Dawn to Decadence, Op. cit.*, pages 519ff, for other reactions to the French Revolution.
4. *Ibid.*, page 428.
5. Ken Alder, *The Measure of All Things: The Seven-Year Odyssey That Transformed the World*, London: Little Brown/Abacus, 2002/2004, page 96.
6. *Ibid.*, pages 314–325.
7. Hawthorn, *Enlightenment and Despair, Op. cit.*, page 67.
8. Roger Smith, *Op. cit.*, page 423.
9. Hawthorn, *Op. cit.*, page 218.
10. Roger Smith, *Op. cit.*, pages 423–424.
11. Saint-Simon saw society as composed of nobles, *industriels*, and 'bastard classes'. In other words, he had a healthy dislike of the bourgeoisie. Hawthorn, *Op. cit.*, page 68.
12. John Marks, *Science and the Making of the Modern World*, London: Heinemann, 1983, page 196.
13. *Ibid.*, page 197.
14. *Ibid.*, pages 198–199.
15. *Ibid.*
16. Charlotte Roberts and Margaret Cox, *Health and Disease in Britain: From Pre-history to the Present Day*, Stroud, England: Sutton, 2003, pages 338–340. Roy Porter cautions that though we now equate tuberculosis with consumption, in fact the latter often included asthma, catarrh etc. Roy and Dorothy Porter, *In Sickness and in Health: The British Experience, 1650–1850*, London: Fourth Estate, 1988, page 146.
17. Roger Smith, *Op. cit.*, page 427. Boorstin, *The Seekers, Op. cit.*, page 222.
18. Roger Smith, *Op. cit.*, page 201.
19. Mary Pickering, *Auguste Comte: An Intellectual Biography*, Cambridge, England: Cambridge University Press, 1993, pages 192ff, for the rupture with Saint-Simon.
20. Roger Smith, *Op. cit.*, page 429.
21. *Ibid.*, page 430.
22. Pickering, *Op. cit.*, pages 612–613 and 615.
23. Roger Smith, *Op. cit.*, page 431.
24. Comte had a high opinion of his accomplishments and towards the end of his life signed himself: 'The founder of Universal Religion, Great Priest of Humanity.'
25. See 'The vogue for Spencer', in Richard Hofstadter, *Social*

...inism in American Thought, Boston: Beacon Books, 1992, pages 31ff.

... Smith, Op. cit., page 438.

...age 446.

...oser, Masters in Sociological Thought: Ideas in Historical and Sociological Context, New York: Harcourt Brace, 1971, page 281. Harold Perkin, The Rise of Professional Society: England Since 1880, London and New York: Routledge, 1989/1990, page 49.

29. Roger Smith, Op. cit., page 555.

30. Hawthorn, Op. cit., pages 147ff, for the disputes 'smouldering' at the Verein.

31. Roger Smith, Op. cit., page 556.

32. Ibid., pages 556–557.

33. Hawthorn, Op. cit., page 157.

34. Anthony Giddens, introduction to Max Weber, The Protestant Ethic and the Spirit of Capitalism, London and New York: Routledge, 1942 (reprint 1986), page ix.

35. Reinhard Bendix, Max Weber: An Intellectual Portrait, London: Heinemann, 1960, page 70. For Weber's political views, see Hawthorn, Op. cit., page 154f.

36. Roger Smith, Op. cit., pages 561–562.

37. Giddens, Op. cit., pages ixff.

38. Roger Smith, Op. cit., page 563.

39. Hawthorn, Op. cit., page 186.

40. David Frisby, Georg Simmel, London: Tavistock Publications, 1984, page 51.

41. Roger Smith, Op. cit., page 546.

42. Ibid. See Hawthorn, Op. cit., page 122, for the links to pragmatism (see Chapter 34 below).

43. Roger Smith, Op. cit., page 547.

44. Steven Lukes, Emile Durkheim: His Life and Work, London: Allen Lane The Penguin Press, 1973, pages 206ff.

45. Ibid., page 207, for the difference between egoism, anomie and altruism.

46. Marks, Op. cit., page 208.

47. Roberts and Cox, Op. cit., page 537. 'The germ theory of disease', Alexander Hellemans and Bryan Bunch, The Timetables of Science, New York: Simon & Schuster, 1991, page 356.

48. Roger Smith, Op. cit., page 535.

49. Bernal, Science and History, Op. cit., volume 4, page 1140.

50. Alder, Op. cit., page 322.

51. Alan Desrosières, The Politics of Large Numbers: A History of Statistical Reasoning, translated by Camille Naish, Cambridge, Massachusetts: Harvard University Press, 1998, page 75.

52. Ibid., pages 73–79 and 90–91.

53. Lisanne Radice, Beatrice and Sidney Webb, Fabian Socialists, London: Macmillan, 1984, page 55.

54. Not everyone was in favour of the new approach. In Britain the new register of births, marriages and deaths was criticised on all sides. Counting births irritated the Church of England, which thought that not counting baptisms showed too much respect for Nonconformists; Unitarians thought it somehow disrespectful to God to count people who were going to join their maker; and many people thought the size of their family was in any case a private matter. M. T. Cullen, The Statistical Movement in Early Victorian Britain, Hassocks, Sussex: Harvester, 1975, pages 29–30.

55. David Boyle, The Tyranny of Numbers, London: HarperCollins, 2000, pages 64–65.

56. Ibid., page 72.

57. Ibid., page 74.

58. Desrosières, Op. cit., pages 232ff.

## CHAPTER 33: THE USES AND ABUSES OF NATIONALISM AND IMPERIALISM

1. Schulze, States, Nations and Nationalism, Op. cit., page 69.

2. Anthony Pagden, People and Empires, London: Weidenfeld & Nicolson, 2001, page 89.

3. Niall Ferguson, Empire: How Britain Made the Modern World, London: Allen Lane/Penguin, 2003/2004, page 63. See also: Pagden, Op. cit., page 92.

4. Ibid., page 94.

5. Ibid., page 97.

6. Ibid., page 98. Ferguson, Op. cit., page 85, for the wealth of New Englanders.

7. The notion of 'protection', however, meant that the East India companies did need to involve themselves in politics. See Jürgen Osterhammel, Colonialism, Princeton, New Jersey, and London: Princeton University Press, 2003, page 32. See also: Ferguson, Op. cit., page 163.

8. Pagden, Op. cit., pages 100–101.

9. Jeremy Bernstein, Dawning of the Raj: The Life and Times of Warren Hastings, London: Aurum, 2001, pages 208ff. See also: Ferguson, Op. cit., page 38.

10. Pagden, Op. cit., page 104. Ferguson, Op. cit., pages xxiii and 260. David Armitage, in The Ideological Origins of the British Empire (Cambridge, England: Cambridge University Press, 2002) says that Protestant arguments about property were important in the idea of Empire.

11. Seymour Drescher, in From Freedom to Slavery: Comparative Studies in the Rise and Fall of Atlantic Slavery, London: Macmillan, 1999, page 344, notes that Jews took little part in slavery.

12. Pagden, Op. cit., page 111.

13. Ibid., page 112.

14. Ibid., page 113. And see Moynahan, Op. cit., pages 537ff, for other papal bulls on slavery.

15. Pagden, Op. cit., page 114.

16. Lawrence James, The Rise and Fall of the British Empire, London: Little Brown/Abacus, 1994/1998, page 185. Drescher, Op. cit., pages 69–71, for the anti-slavery campaign before and around Wilberforce.

17. Pagden, Op. cit., page 117.

18. Schulze, Op. cit., page 197.

19. Ibid., page 198.

20. Ibid.

21. Ibid., page 199.

22. Ibid., page 200.

23. Ibid., page 204.

24. Ibid., page 205.

25. Tony Smith, The Pattern of Imperialism, Cambridge, England: Cambridge University Press, 1981, page 41, which explores the way the trades unions began to interfere in imperial ideology.

26. Friedrich Meinecke, Cosmopolitanism and the National State, translated by Robert B. Kimber, Princeton, New Jersey: Princeton University Press, 1970, pages 25–26.

27. Ibid., page 136.

28. Michael Morton, Herder and the Poetics of Thought, Pittsburgh: Pennsylvania University Press, 1989, page 99.

29. Schulze, Op. cit., page 232.

30. Ibid., page 233.

31. Wolfgang J. Mommsen (editor), Imperialismus, Hamburg, 1977, page 371.

32. William J. Stead (editor), The Last Will and Testament of C. J. Rhodes, London: Review of Reviews Office, 1902, pages 57 and 97f. James, Op. cit., page 169.

33. Osterhammel, Op. cit., page 34.

34. Raoul Girardot, *Le nationalisme français, 1871–1914*, Paris, 1966, 179.

35. Schulze, *Op. cit.*, page 237.

36. Fritz Stern, *Einstein's German World*, Princeton, New Jersey, and London: Princeton University Press, 1999, page 3.

37. William R. Everdell, *The First Moderns: Profiles in the Origins of Twentieth-Century Thought*, Chicago: University of Chicago Press, 1997, page 166.

38. William Johnston, *The Austrian Mind: An Intellectual and Social History 1848–1938*, Berkeley, Los Angeles and London: University of California Press, 1972/1983, page 183.

39. Gordon A. Craig, *Germany: 1866–1945*, Oxford and New York: Oxford University Press, 1978/1981, pages 39ff. Eva Kolinsky and Wilfried van der Will (editors), *The Cambridge Companion to Modern German Culture*, Cambridge, England: Cambridge University Press, 1998, page 5.

40. *Ibid.*, pages 43ff. Kolinsky and van der Will, *Op. cit.*, page 21.

41. See, for instance: Giles Macdonogh, *The Last Kaiser*, London: Weidenfeld & Nicolson, 2000/Phoenix, 2001, page 3. Kolinsky and van der Will, *Op. cit.*, pages 22–23.

42. Craig, *Op. cit.*, page 56. Kolinsky and van der Will, *Op. cit.*, pages 4 and 50.

43. *Ibid.*, 218.

44. *Ibid.*, pages 218–219.

45. Schonberg, *Lives of the Composers*, *Op. cit.*, pages 239ff.

46. Craig, *Op. cit.*, page 218.

47. J. W. Burrow, *The Crisis of Reason: European Thought, 1848–1914*, New Haven and London: Yale University Press, 2000, page 158.

48. They were destroyed in 1945 when the Nazis burned Immendorf castle, where they were stored during the Second World War.

49. Carl E. Schorske, *Fin-de-Siècle Vienna: Politics and Culture*, London: Weidenfeld & Nicolson/New York: Knopf, 1980, pages 227–232.

50. Burrow, *Op. cit.*, pages 137–138.

51. See Craig, *Op. cit.*, page 188.

52. Burrow, *Op. cit.*, page 188.

53. Pagden, *Op. cit.*, page 147.

54. *Ibid.*, page 148.

55. Hofstadter, *Social Darwinism in American Thought*, *Op. cit.*, page 171.

56. See Tony Smith, *Op. cit.*, pages 63–65, for why Russia, at that point, could not have been a nation of the future.

57. Ivan Hannaford, *Race: The History of an Idea*, Washington, DC, and Baltimore: The Woodrow Wilson Center Press and Johns Hopkins University Press, 1996, page 292.

58. Mike Hawkins, *Social Darwinism in European and American Thought, 1860–1945*, Cambridge, England: Cambridge University Press, 1997, page 193.

59. *Ibid.*, page 196.

60. Hofstadter, *Op. cit.*, page 5.

61. *Ibid.*, pages 51–70.

62. *Ibid.*, pages 143ff.

63. Hannaford, *Op. cit.*, pages 291–292.

64. Hawkins, *Op. cit.*, page 132.

65. Hannaford, *Op. cit.*, pages 289–290.

66. Hawkins, *Op. cit.*, page 185.

67. *Ibid.*

68. Hannaford, *Op. cit.*, page 338.

69. *Ibid.*

70. Johnston, *Op. cit.*, page 364.

71. Hawkins, *Op. cit.*, pages 126–127.

72. *Ibid.*, page 178.

73. *Ibid.*, page 62.

74. *Ibid.*, page 201.

75. Hannaford, *Op. cit.*, page 330.

76. A. L. Macfie, *Orientalism*, London: Longman, 2002, page 179.

77. *Ibid.*, page 180.

78. *Ibid.*

79. *Ibid.*

80. Tony Smith says that pre-British India was some 500 years behind Europe, economically speaking, when the British arrived. Macfie, *Op. cit.*, page 75.

81. *Ibid.*, page 181.

82. *Ibid.*

83. *Ibid.*, page 182.

84. Quoted in Ferguson, *Op. cit.*, page 39. Bernstein, *Op. cit.*, page 89, says that Nathaniel Halhed (aged twenty-three in 1771) was the first to point out the relation between Bengali and Sanskrit.

85. Hastings also funded several expeditions: Bernstein, *Op. cit.*, pages 145ff.

86. Macfie, *Op. cit.*, page 53.

87. See Tony Smith, *Op. cit.*, page 74, for a discussion of what the British destroyed in India.

88. Macfie, *Op. cit.*, page 56.

89. Ferguson, *Op. cit.*, pages 365–371.

90. Edward Said, *Culture and Imperialism*, London and New York: Chatto & Windus/Vintage, 1993/1994, pages xiff.

91. *Ibid.*, page xxiv.

92. *Ibid.*, pages 8–12.

93. *Ibid.*, page 85.

94. For some of the weaknesses in Said's work, see: Valerie Kennedy, *Edward Said: A Critical Introduction*, Cambridge, England: Polity Press, 2000, pages 25 and 37. Said considers only novels: see Roger Benjamin, *Orientalist Aesthetics: Art, Colonialism and North Africa, 1880–1930*, Berkeley and London: University of California Press, 2003, especially pages 129ff, for travelling scholarships for artists. And see: Philippe Jullian, *The Orientalists: European Painters of Eastern Scenes*, Oxford: Phaidon, 1977, who, in his chapter on the influence of artists, says they helped launch the 'desolate East' (page 39).

95. Said, *Op. cit.*, page 75.

96. *Ibid.*, page 102.

97. *Ibid.*, page 104.

98. *Ibid.*, page 108.

99. Edmund Wilson, 'The Kipling that nobody read', in *The Wound and the Bow*, Oxford: Oxford University Press, 1947, pages 100–103.

100. A different view was advanced by Noel Annan in his essay 'Kipling's place in the history of ideas', where he presents the notion that Kipling's vision of society was similar to the new sociologists – Durkheim, Weber and Pareto – who 'saw society as a nexus of groups; and the pattern of behaviour which these groups unwittingly established, rather than men's wills or anything so vague as a class, cultural or national tradition, primarily determined men's actions. They asked how these groups promoted order or instability in society, whereas their predecessors had asked whether certain groups helped society to progress.' Said, *Op. cit.*, page 186 and Noel Annan, 'Kipling's place in the history of ideas', *Victorian Studies*, volume 3, number 4, June 1960, page 323.

101. Said, *Op. cit.*, page 187.

102. *Ibid.*, page 196.

103. Redmond O'Hanlon, *Joseph Conrad and Charles Darwin*, Edinburgh: Salamander Press, 1984, page 17.

104. D. C. R. A. Goonetilleke, *Joseph Conrad: Beyond Culture and Background*, London: Macmillan, 1990, pages 15ff.

105. Kingsley Widner, 'Joseph Conrad', in *Dictionary of Literary Biography*, Detroit: Bruccoli Clark, volume 34, 1988, pages 43–82.

106. Joseph Conrad, *Heart of Darkness*, Edinburgh and London: William Blackwood/Penguin, 1902/1995.

107. Goonetilleke, *Op. cit.*, pages 88–91.

108. Conrad, *Op. cit.*, page 20.

109. Goonetilleke, *Op. cit.*, page 168.

110. Richard Curle, *Joseph Conrad: A Study*, London: Kegan Paul, French, Trübner, 1914.

111. In *Occidentalism* (London: Atlantic Books, 2004) Ian Buruma and Avishai Margalit identify the opposite sentiment to Orientalism, 'the hostile stereotypes of the western world that fuel the hatred at the heart of such movements as al Qaeda'. They root this variously in pan-Germanic movements of the nineteenth century, which affected national feeling in the Arab world and in Japan in the twentieth century, in Persian Manicheanism, and in the differences between the Catholic and Greek orthodox churches, with the latter, in Russia, fuelling an anti-rationalistic mentality.

112. Melvyn Bragg, *The Adventure of English*, London: Hodder & Stoughton, 2003, page 1.

113. *Ibid.*, page 3. But see also Geoffrey Hughes, *A History of English Words*, Oxford: Blackwell, 2000, page 99.

114. Bragg, *Op. cit.*, page 28.

115. Hughes, *Op. cit.*, pages xvii–xviii, for a chronology of English; and see also: Barbara A. Fennell, *A History of English*, Oxford: Blackwell, 2001, pages 55–93.

116. Bragg, *Op. cit.*, page 23.

117. Osterhammel, *Op. cit.*, pages 103–104, for a discussion of how colonisers affect (and often destroy) the language of the colonised.

118. Bragg, *Op. cit.*, page 52.

119. *Ibid.*, page 58.

120. *Ibid.*, page 52.

121. *Ibid.*, page 67.

122. M. T. Clanchy, *England and Its Rulers* (second edition), Oxford: Blackwell, 1998.

123. Not all conquerors impose their languages: See Osterhammel, *Op. cit.*, page 95, for the different experiences of the Spanish and Dutch (in Indonesia) in this regard.

124. Bragg, *Op. cit.*, page 85.

125. *Ibid.*, page 101.

126. Hughes, *Op. cit.*, pages 153–158.

127. Bragg, *Op. cit.*, page 148.

128. Boorstin, *The Americans: Op. cit.*, pages 275ff, for American 'ways of talking'.

129. John Algeo (editor), *The Cambridge History of the English Language*, Cambridge, England: Cambridge University Press, volume VI, 2001, pages 92–93 and 163–168 *passim*. See also Bragg, *Op. cit.*, page 169.

130. Bragg, *Op. cit.*, page 178.

131. Boorstin, *Op. cit.*, page 287, says another derivation may have come from Old Kinderhook, the nickname for Martin van Buren, in his presidential campaign. He was supported by Democratic OK Clubs in New York.

132. Bragg, *Op. cit.*, page 241.

133. For English around the world, see: Robert Burchfield, *The Cambridge History of the English Language*, Cambridge, England: Cambridge University Press, volume V, 1994, especially chapter 10.

CHAPTER 34: THE AMERICAN MIND AND THE MODERN UNIVERSITY

1. Boris Ford (editor), *The New Pelican Guide to English Literature*, volume 9, *American Literature*, London: Penguin Books, 1967/1995, page 61.

2. Commager, *The Empire of Reason, Op. cit.*, page 16f.

3. Louis Menand, *The Metaphysical Club: A Story of Ideas in America*, London: HarperCollins/Flamingo, 2001.

4. Menand, *Op. cit.*, pages x–xii. See too Hofstadter, *Op. cit.*, page 168, who also identifies what he calls 'a renaissance' in American thought.

5. Morison *et al.*, *Growth of the American Republic, Op. cit.*, page 209.

6. Menand, *Op. cit.*, page 6. Harvey Wish, *Society and Thought in Modern America*, London: Longmans Green, 1952, adds Veblen, Sumner, Whitman, Dreiser and Pulitzer, Louis Sullivan and Winslow Homer to this list.

7. Brogan, *The Penguin History of the United States, Op. cit.*, page 300. See also Boorstin, *The Americans: The National Experience, Op. cit.*, page 251.

8. Menand, *Op. cit.*, page 19.

9. *Ibid.*, page 26. See also Luther S. Luedtke, *Making America: The Society and Culture of the United States*, Chapel Hill: University of North Carolina Press, 1992, page 225, for the pivotal role of Emerson for writers.

10. Menand, *Op. cit.*, page 46.

11. Mark DeWolfe Howe, *Justice Oliver Wendell Holmes: The Shaping Years*, volume 1, Cambridge, Massachusetts: The Belknap Press of Harvard University Press, 1957–1963, two volumes, page 100.

12. Menand, *Op. cit.*, page 61.

13. Brogan, *Op. cit.*, pages 325ff, for a good brief introduction to the weaponry and tactics of the Civil War.

14. Morison *et al.*, *Op. cit.*, page 209. See also Albert W. Alschuler, *Law Without Values: The Life, Work and Legacy of Justice Holmes*, Chicago: University of Chicago Press, 2000, pages 41ff, 'The battlefield conversion of Oliver Wendell Holmes'.

15. Hofstadter, *Op. cit.*, page 32, for the impact of Darwin on Holmes.

16. Holmes famously said that anyone who was anyone should have produced a noteworthy achievement by the time he or she was forty. He himself just made it: *The Common Law* appeared when he was 39.

17. Menand, *Op. cit.*, page 338.

18. Howe, *Op. cit.*, volume 2, page 137.

19. Menand, *Op. cit.*, page 339.

20. Morison *et al.*, *Op. cit.*, page 209.

21. Menand, *Op. cit.*, page 339.

22. *Ibid.*, page 340.

23. *Ibid.*, page 341.

24. Howe, *Op. cit.*, volume 2, page 140.

25. Morison *et al.*, *Op. cit.*, page 209.

26. Menand, *Op. cit.*, page 342.

27. Alschuler, *Op. cit.*, page 126.

28. Menand, *Op. cit.*, page 344.

29. He had, he said, a pessimistic view of humanity. Alschuler, *Op. cit.*, pages 65 and 207.

30. Morison *et al.*, *Op. cit.*, page 201–210.

31. Menand, *Op. cit.*, page 346.

32. *Ibid.*

33. Morison *et al.*, *Op. cit.*, page 209.

34. Menand, *Op. cit.*, page 79.

35. Hofstadter, *Op. cit.*, page 127. Morison *et al.*, *Op. cit.*, page 199.

36. See his self-portrait sketch on page 140 of: Gary Wilson

Allen, *William James: A Biography*, London: Rupert Hart-Davis, 1967.

37. Morison *et al.*, *Op. cit.*, page 297.

38. This, says Menand, 'marked the beginning of the professionalisation of American science'. *Op. cit.*, page 100.

39. Linda Simon, *Genuine Reality: A Life of William James*, New York: Harcourt Brace, 1998, page 90.

40. Menand, *Op. cit.*, page 127.

41. *Ibid.*, page 146.

42. Morison *et al.*, *Op. cit.*, page 199.

43. Allen, *Op. cit.*, page 25.

44. Menand, *Op. cit.*, page 154.

45. *Ibid.*

46. Morison *et al.*, *Op. cit.*, page 198.

47. Menand, *Op. cit.*, page 180.

48. *Ibid.*, page 186.

49. Joseph Brent, *C. S. Peirce: A Life*, Bloomington, Indiana: Indiana University Press, 1993, page 208.

50. Hofstadter, *Op. cit.*, pages 124ff, for the links between Herbert Spencer and pragmatism.

51. Menand, *Op. cit.*, page 196.

52. Brent, *Op. cit.*, page 96.

53. Menand, *Op. cit.*, page 197.

54. *Ibid.*, page 199.

55. *Ibid.*, page 200.

56. Brent, *Op. cit.*, page 274. See Hofstadter, *Op. cit.*, pages 128ff, for the influence of Peirce and Spencer on James. See also Boorstin, *The Americans*, *Op. cit.*, page 260.

57. Menand, *Op. cit.*, page 352.

58. *Ibid.*

59. Simon, *Op. cit.*, pages 348ff for James' debt to Peirce.

60. Morison *et al.*, *Op. cit.*, page 199.

61. Menand, *Op. cit.*, page 355.

62. *Ibid.*

63. *Ibid.*, page 357.

64. See Allen, *Op. cit.*, page 321, for his reservations.

65. Menand, *Op. cit.*, pages 357–358.

66. Lovejoy, *The Great Chain of Being*, *Op. cit.*

67. See for example: Ellen Key, *The Century of the Child*, New York: Putnam, 1909.

68. Boorstin, *Op. cit.*, page 201.

69. Morison *et al.*, *Op. cit.*, page 223.

70. This lack of structure ultimately backfired, producing children who were more conformist, precisely because they lacked hard knowledge or the independent judgement that the occasional failure helped to teach them. Liberating children from parental 'domination' was, without question, a form of freedom. But, in the twentieth century, it was to bring its own set of problems.

71. Morison *et al.*, *Op. cit.*, pages 198–199.

72. Menand, *Op. cit.*, page 360.

73. *Ibid.*, page 361. See also: Hofstadter, *Op. cit.*, page 136.

74. Menand, *Op. cit.*, page 361.

75. Robert B. Westbrook, *John Dewey and American Democracy*, New York: Cornell University Press, 1991, page 349.

76. Morison *et al.*, *Op. cit.*, pages 199–200.

77. Fergal McGrath, *The Consecration of Learning*, Dublin: Gill & Son, 1962, pages 3–4.

78. *Ibid.*, page 11.

79. Negley Harte, *The University of London: 1836–1986*, Dublin: Athlone Press, 1986, pages 67ff.

80. John Newman, *The Idea of a University*, London: Basil Montague Pickering, 1873/New Haven, Connecticut Yale University Press, 1996, page 88.

81. *Ibid.*, page 123.

82. *Ibid.*, page 133.

83. George M. Marsden, *The Soul of the American University*, New York and Oxford: Oxford University Press, 1994, page 80.

84. *Ibid.*, page 91. Daniel Boorstin says that a characteristic of American colleges was that they were less places of instruction than of worship – worship of the growing individual, and this is what links the two parts of this chapter: pragmatism and universities. See Boorstin, *The Americans: The Democratic Experience*, New York: Vintage, 1973, which also has a useful discussion of the shape of US education, including the many new degrees devised, pages 479–481.

85. Marsden, *Op. cit.*, pages 51–52.

86. Brooks Mather Kelley, *A History of Yale*, New Haven, Connecticut: Yale University Press, 1974, pages 162–165. Yet at Yale, as late as 1886, ancient languages occupied a third of the students' time. See Caroline Winterer, *The Culture of Classicism*, Baltimore and London: Johns Hopkins University Press, 2002, pages 101–102.

87. *Ibid.*, page 88. See Morison *et al.*, *Op. cit.*, pages 224–225, for statistics on the growth of American universities.

88. Marsden, *Op. cit.*, page 153.

89. Abraham Flexner, *Universities: American, English, German*, Oxford: Oxford University Press, 1930, page 124.

90. Samuel Eliot Morison (editor), *The Development of Harvard University*, Cambridge, Massachusetts: Harvard University Press, 1930, pages 11 and 158.

91. Thomas P. Hughes, *American Genesis*, London: Penguin, 1990, page 14.

92. *Ibid.*, page 241.

93. *Ibid.*, page 16. Morison *et al.*, *Op. cit.*, page 53.

94. Hughes, *Op. cit.*, page 105.

95. Gillian Cookson, *The Cable: The Wire That Changed the World*, Stroud, Gloucestershire: Tempus, 2003, page 152.

## CHAPTER 35: ENEMIES OF THE CROSS AND THE QUR'AN – THE END OF THE SOUL

1. A. N. Wilson, *God's Funeral*, London: John Murray, 1999, page 133.

2. *Ibid.*, page 160.

3. *Ibid.*, page 4.

4. *Ibid.*, page 189.

5. *Ibid.*, page 193.

6. This is confirmed by a survey of influential books among 'freethinkers' published in 1905. See Edward Royle, *Radicals, Secularists and Republicans*, Manchester: Manchester University Press, 1980, page 173.

7. Wilson, *Op. cit.*, page 20.

8. *Ibid.*, page 22.

9. *Ibid.*, page 35.

10. Owen Chadwick, *The Secularisation of European Thought in the Nineteenth Century*, Cambridge, England: Cambridge University Press/Canto, 1975/1985, page 21.

11. *Ibid.*, page 23.

12. *Ibid.*, page 27.

13. Alfred Cobban, *In Search of Humanity: The Role of the Enlightenment in Modern History*, London: Cape, 1966, page 236. See also Hawthorn, *Enlightenment and Despair*, *Op. cit.*, pages 82–84.

14. Chadwick, *Op. cit.*, page 28.

15. *Ibid.*, pages 29–30; and Hawthorn, *Op. cit.*, page 87.

16. Chadwick, *Op. cit.*, page 37.

17. *Ibid.*

18. *Ibid.*, page 38.

19. But polarisation cut both ways. 'The Pope of 1889 was far more influential than the Pope of 1839 because the later Pope was surrounded by the press [as] the earlier Pope was not.' *Ibid.*, page 41.

20. David Landes says the poor 'entered the market as little as possible'. *Unbound Prometheus, Op. cit.*, page 127.

21. Chadwick, *Op. cit.*, page 46.

22. *Ibid.*, page 47.

23. Again, Marx ranked highly with Gibbon on the list of influential books referred to earlier (see note 6 above). Royle, *Op. cit.*, page 174.

24. Chadwick, *Op. cit.*, page 57. Hawthorn, *Op. cit.*, page 85, discusses the differences between Protestantism and Catholicism and what this meant for Marxism.

25. Chadwick, *Op. cit.*, page 59.

26. *Ibid.*, page 89.

27. Hofstadter, *Op. cit.*, page 24, observes that Protestants were more likely to become atheists.

28. Chadwick, *Op. cit.*, page 92.

29. *Ibid.*, page 97.

30. *Ibid.*, page 144.

31. Cobban, *Op. cit.*, page 110. On Carlyle: Boorstin, *The Americans, Op. cit.*, pages 246–247.

32. Chadwick, *Op. cit.*, page 145.

33. *Ibid.*, page 151.

34. Royle, *Op. cit.*, page 220.

35. *Ibid.*, page 17.

36. Chadwick, *Op. cit.*, page 155. Boorstin, *The Americans, Op. cit.*, page 195.

37. For the general pessimism of the nineteenth century about the eighteenth century, see Cobban, *Op. cit.*, page 215.

38. Chadwick, *Op. cit.*, pages 158–159.

39. *Ibid.*, page 159.

40. See Royle, *Op. cit.*, for the organisation of secularisation in Britain and its revival in 1876. For France, see Jennifer Michael Hecht, *The End of the Soul: Scientific Modernity, Atheism and Anthropology in France*, New York: Columbia University Press, 2003.

41. *Ibid.*, page 177.

42. When, near the end of the century, Josef Bautz, a Catholic professor of theology in Münster, argued that volcanoes are a proof of the existence of purgatory, he was roundly mocked and lampooned as the 'professor of hell'. Chadwick. *Op. cit.*, page 179. Most parents no longer believed in hell, says Chadwick, but they told their children they did, as a convenient form of control.

43. Chadwick, *Op. cit.*, page 212.

44. *Ibid.*, page 215.

45. *Ibid.*, page 220. Like Comte, Renan thought positivism could be the basis for a new faith. Hawthorn. *Op. cit.*, pages 114–115.

46. Chadwick, *Op. cit.*, page 224.

47. Lester R. Kurtz, *The Politics of Heresy*, Berkeley: University of California Press, 1986, page 18.

48. Hecht, *Op. cit.*, page 182. See also: Kurtz, *Op. cit.*, page 18.

49. Chadwick, *Op. cit.*, page 123.

50. Kurtz, *Op. cit.*, page 25.

51. *Ibid.*, page 27.

52. Moynahan, *The Faith, Op. cit.*, page 655.

53. Kurtz, *Op. cit.*, page 30.

54. Moynahan, *Op. cit.*, page 655.

55. Kurtz, *Op. cit.*, page 30.

56. *Ibid.*, pages 30–31.

57. 'Liberals and intransigents in France, 1848–1878', Chapter III of Alec R. Vidler, *The Modernist Movement and the Roman Church*, New York: Garden Press, 1976, pages 25ff.

58. Kurtz, *Op. cit.*, page 33.

59. *Ibid.*

60. Vidler, *Op. cit.*, pages 42 and 96.

61. Kurtz, *Op. cit.*, page 34.

62. *Ibid.*, page 35.

63. *Ibid.*

64. Moynahan, *Op. cit.*, page 659, for a vivid account of that day (including extraordinary weather).

65. Kurtz, *Op. cit.*, page 37.

66. *Ibid.*, page 38.

67. Vidler, *Op. cit.*, pages 60–65 and 133f.

68. Kurtz, *Op. cit.*, page 41.

69. *Ibid.*, page 42.

70. 'The Biblical Question', Chapter X, in Vidler, *Op. cit.*, pages 81ff. Moynahan, *Op. cit.*, page 661, says Leo 'warmed' to democracy and freedom of conscience. But only by comparison with Pius.

71. Kurtz, *Op. cit.*, page 44.

72. *Ibid.*, page 45.

73. Moynahan, *Op. cit.*, page 661, for the *Kulturkampf* in Germany that left all the sees in Prussia vacant and more than a million Catholics without access to the sacraments.

74. Kurtz, *Op. cit.*, page 50.

75. *Ibid.*, page 148.

76. See Hourani, *History of the Arab Peoples, Op. cit.*, chapter 18, 'The culture of imperialism and reform', pages 299ff. And: Erik J. Zürcher, *Turkey: A Modern History*, London: I. B. Tauris, 1993, pages 52–74.

77. Ekmeleddin Ihsanoglu, *Science, Technology and Learning in the Ottoman Empire, Op. cit.*, especially chapters II, III, IV, V, VII, VIII, IX and X.

78. *The Times* (London), 29 April 2004. See also: Aziz Al-Azmeh, *Islams and Modernities* (second edition), London: Verso, 1996, especially chapter 4, pages 101–127.

79. Hourani, *Op. cit.*, page 307, and pages 346–347.

80. *The Times*, 29 April 2004. Al-Azmeh, *Op. cit.*, pages 107–117. See also: Francis Robinson, 'Other-worldly and This-Worldly Islam and the Islamic Revival', Cantwell Smith memorial Lecture, Royal Asiatic Society, 10 April 2003.

81. The study of Machiavelli became popular in the Islamic world, as a way to understand tyrants and despots.

82. *The Times*, 29 April 2004. Al-Azmeh, *Op. cit.*, pages 41ff. Hourani, *Op. cit.*, pages 254, 302 and 344–345. See also: Tariq Ramadan, *Western Muslims and the Future of Islam*, Oxford: Oxford University Press, 2003.

The reform movement ended, more or less, with the First World War, when so many lost faith with the culture of science and materialism. In the Islamic world, the post-war scenario saw two parallel strands. Modernism continued in many areas but, beginning in Egypt with the Muslim Brotherhood, a more militant strand of Islam began to take root. Throughout the 1920s, 1930s and 1940s, when Marxism and socialism became the official ruling doctrines, religion was downgraded and no accommodation was sought with Islam. This climaxed in the Six-Day War with Israel, in 1968, which the Muslim countries lost decisively. This was seen in the Islamic world as a great failure of socialism, and it was now that fundamental and militant Islam began to fill the political vacuum created.

## CHAPTER 36: MODERNISM AND THE DISCOVERY OF THE UNCONSCIOUS

1. Ronald Clark, *Freud: The Man and the Cause*, New York: Random House, 1980, pages 20 and 504.

2. Everdell, *The First Moderns, Op. cit.*, page 129.

3. Mark D. Altschule, *Origins of Concepts in Human Behavior: Social and Cultural Factors*, New York and London: John Wiley, 1977, page 199. Peter Gay, *Schnitzler's Century: The Making of Middle Class Culture 1815–1914*, New York and London: W. W. Norton, 2002, pages 132 and 137.

4. Guy Claxton, *The Wayward Mind: An Intimate History of the Unconscious*, London: Little, Brown, 2005, *passim*.

5. Henri F. Ellenberger, *The Discovery of the Unconscious*, London: Allen Lane The Penguin Press, 1970, pages 56–70.

6. *Ibid.*, pages 124–125.

7. *Ibid.*, page 142.

8. Reuben Fine, *A History of Psychoanalysis*, New York: Columbia University Press, 1979, pages 9–10.

9. Ellenberger, *Op. cit.*, page 145.

10. The work of the historian Peter Gay, especially his four-volume *The Bourgeois Experience: Victoria to Freud*, Oxford and New York: Oxford University Press, 1984, views the whole of the nineteenth century as in some way culminating in Freud. His book tackles sex, gender, taste, learning, privacy, changing notions of the self, and is much too wide-ranging to be sensibly distilled in a book like this one. Gustave Gely's book *From the Unconscious to the Conscious*, London: Collins, 1920, argues the opposite theory: that evolution has resulted in consciousness.

11. Ellenberger, *Op. cit.*, page 205.

12. *Ibid.*, page 212.

13. *Ibid.*, page 219.

14. *Ibid.*, pages 218–223.

15. An entirely different tradition, too tangential in the author's view, is David Bakan's *Sigmund Freud and the Jewish Mystical Tradition*, Princeton, New Jersey: D. Van Nostrand, 1958.

16. Ellenberger, *Op. cit.*, page 208.

17. *Ibid.*, page 209.

18. Quoted in: Bryan Magee, *The Philosophy of Schopenhauer*, Oxford: Oxford University Press, 1983, pages 132–133.

19. Ernest Gellner, *The Psychoanalytic Movement*, London: Paladin, 1985, pages 21ff.

20. Allen Esterson, *Seductive Mirage*, Chicago and La Salle, Illinois: Open Court, 1993, page 224.

21. Ernest Jones, *Sigmund Freud: Life and Work*, London: Hogarth Press, 1953/1980, volume 1, page 410.

22. Ellenberger, *Op. cit.*, page 358.

23. Elton Mayo, *The Psychology of Pierre Janet*, London: Routledge & Kegan Paul, 1951, pages 24ff, offers a succinct account.

24. Ellenberger, *Op. cit.*, page 296.

25. *Ibid.*

26. Giovanni Costigan, *Sigmund Freud: A Short Biography*, London: Robert Hale, 1967, page 100.

27. Johnston, *The Austrian Mind*, *Op. cit.*, page 235.

28. Esterson, *Op. cit.*, pages 2–3. Johnston, *Op. cit.*, page 236.

29. Johnston, *Op. cit.*, page 236.

30. Costigan, *Op. cit.*, page 42.

31. *Ibid.*, pages 68ff.

32. *Ibid.*, page 70.

33. Clark, *Op. cit.*, page 181.

34. *Ibid.*, page 185.

35. Gregory Zilboorg, 'Free association', *International Journal of Psychoanalysis*, volume 33, 1952, pages 492–494.

36. See also: Hannah Decker, 'The medical reception of psychoanalysis in Germany, 1894–1907: three brief studies', *Bulletin of the History of Medicine*, volume 45, 1971, pages 461–481.

37. Albrecht Hirschmüller, *The Life and Work of Josef Breuer*, New York and London: New York University Press, 1978/1989, page 131.

38. See: Mikkel Borch-Jacobsen (translated by Kirby Olson in collaboration with Xavier Callahan and the author), *Remembering Anna O. A Century of Mystification*, New York and London: Routledge, 1996, pages 29–48.

39. Morton Schatzman, 'Freud: who seduced whom?', *New Scientist*, 21 March 1992, pages 34–37.

40. Esterson, *Op. cit.*, page 52.

41. Anthony Clare, 'That shrinking feeling', *The Sunday Times*, 16 November 1997, page 8–10.

42. T. J. Clark, *The Painting of Modern Life*, Princeton, New Jersey, and London: Princeton University Press, 1984, page 25.

43. *Ibid.*, page 30.

44. *Ibid.*, pages 23ff.

45. Perkin, *The Rise of Professional Society*, *Op. cit.*, page 80, for a table. For the same thesis applied to Germany, see: Geoffrey Cocks and Konrad H. Jarausch (editors), *German Professions: 1800–1950*, New York and Oxford: Oxford University Press, 1990. Malcolm Bradbury and James McFarlane (editors), *Modernism: A Guide to European Literature, 1890–1930*, London: Penguin Books, 1976/1991, page 47.

46. *Ibid.*, page 68.

47. *Ibid.*, page 100.

48. Johnston, *The Austrian Mind*, *Op. cit.*, pages 23 and 32; and Schorske, *Fin-de-Siècle Vienna*, *Op. cit.*, page 19.

49. Schorske, *Op. cit.*, page 19.

50. Bradbury and McFarlane (editors), *Op. cit.*, page 37.

51. Robert Ferguson, *Henrik Ibsen*, London: Richard Cohen Books, 1996, page 321.

52. Everdell, *The First Moderns*, *Op. cit.*, page 290. Franz Servaes, 'Jung Berlin, I, II, III', in *Die Zeit* (Vienna), 21 and 28 November, 5 December 1896.

53. Bradbury and McFarland (editors), *Op. cit.*, page 499.

54. This was based on Ibsen's anger towards his own countrymen. Ferguson. *Op. cit.*, pages 269ff.

55. John Fletcher and James McFarlane, 'Modernist drama: origins and patterns', in Bradbury and McFarlane (editors), *Op. cit.*, page 502.

56. *Ibid.*, page 504.

57. Sandbach, *Op. cit.*, page viii.

58. *Ibid.*, page ix.

59. Frederich Marker and Lise-Lone Marker, *Strindberg and Modernist Theatre*, Cambridge, England: Cambridge University Press, 2002, page 31; James McFarlane, 'Intimate theatre: Maeterlinck to Strindberg', in Bradbury and McFarlane (editors), *Op. cit.*, pages 524–525.

60. Marker and Marker, *Op. cit.*, pages 23ff.

61. Bradbury and McFarlane (editors), *Op. cit.*, page 525.

62. André Malraux, *Picasso's Masks*, New York: Holt, Rinehart & Winston, 1976, pages 10–11.

63. Everdell, *Op. cit.*, page 252; Fletcher and McFarlane, *Op. cit.*, page 503.

64. Burrow, *The Crisis of Reason*, *Op. cit.*, page 148.

65. *Ibid.*

66. *Ibid.*, page 148.

67. *Ibid.*, page 149.

68. *Ibid.*

69. *Ibid.*, pages 162–163.

70. Roger Smith, *The Fontana History of the Human Sciences*, *Op. cit.*, page 851 and ref.

71. *Ibid.*, page 852 and ref.

72. *Ibid.*, page 853. Curtis Cate, Nietzsche's biographer, says

he anticipated Freud, Adler and Jung in realising that an individual's attitude to his or her past is essentially ambivalent. This can act as a stimulant, or the opposite. But the past can provide inspiration, a force for the will. Curtis Cate, *Friedrich Nietzsche*, London: Hutchinson, 2002, page 185.

73. Burrow, *Op. cit.*, pages 189–190.

74. See Everdell, *Op. cit.*, pages 1–12, for a discussion of what modernism is 'and what it probably isn't'. And page 63 for Seurat's *Sunday Afternoon on the Island of La Grande Jatte* as a candidate for the first modernist masterpiece. Malcolm Bradbury and James McFarlane, 'The name and nature of modernism', in Bradbury and McFarlane (editors), *Op. cit.*, page 28.

75. Bradbury and McFarlane (editors), *Op. cit.*, page 50.

76. James McFarlane, 'The Mind of Modernism', in Bradbury and McFarlane (editors), *Op. cit.*, page 85.

CONCLUSION: THE ELECTRON, THE ELEMENTS AND THE ELUSIVE SELF

1. The Cavendish prize-winners included J. J. Thomson (1906), Ernest Rutherford (1908), W. L. Bragg (1915), F. W. Aston (1922), James Chadwick (1935), E. V. Appleton (1947), P. M. S. Blackett (1948), Francis Crick and James Watson (1962), Anthony Hewish and Martin Ryle (1974), and Peter Kapitza (1978). See: Jeffrey Hughes, ' "Brains in their finger-tips": physics at the Cavendish Laboratory, 1880–1940', in Richard Mason (editor), *Cambridge Minds*, Cambridge, England: Cambridge University Press/Canto, 1994, pages 160ff.

2. See the photograph on page 243 of: J. G. Crowther, *The Cavendish Laboratory, 1874–1974*, London: Macmillan, 1974.

3. Mason (editor), *Op. cit.*, page 162.

4. Crowther, *Op. cit.*, page 48.

5. Steven Weinberg, *The Discovery of Subatomic Particles*, New York: W. H. Freeman, 1983/1990, page 7.

6. Mason (editor), *Op. cit.*, page 161.

7. Paul Strathern, *Mendeleyev's Dream: The Quest for the Elements*, London: Hamish Hamilton, 2000, pages 3 and 286. See also: Richard Rhodes, *The Making of the Atomic Bomb*, New York: Simon & Schuster, 1986, page 30.

8. *Ibid.*, page 31.

9. *Ibid.*, pages 41–42.

10. *Ibid.*, pages 38–40.

11. *Ibid.*, pages 50–51 and 83–85.

12. Roy Porter, *Flesh in the Age of Reason*, London: Allen Lane, The Penguin Press, 2003, pages 69ff.

13. *Ibid.*, page 30. Wahrman, *The Making of the Modern Self*, *Op. cit.*, pages 182–184.

14. Bradbury and McFarlane (editors) *Op. cit.*, page 86; and Arnold Hauser, *A Social History of Art*, *Op. cit.*, volume IV, page 224. In *Augustine's Invention of the Inner Self* (Cambridge, England: Cambridge University Press, 2003), Phillip Cary argues that Augustine invented the concept of the self as a private inner space and in so doing inaugurated the Western tradition of inwardness.

15. Burrow, *Op. cit.*, pages 137–138.

16. *Ibid.*, page 153.

17. Robinson, 'Symbols at an Exhibition', *Op. cit.*, page 12.

18. P. B. Medawar, *The Hope of Progress*, London: Methuen, 1972, page 68.

19. John Maddox, *What Remains to Be Discovered*, London: Macmillan, 1998, page 306.

20. John Cornwell (editor), *Consciousness and Human Identity*, Oxford and New York: Oxford University Press, 1998, page vii. See: Simon Blackburn, 'The world in your head', *New Scientist*, 11 September 2004, pages 42–45; and Jeffrey Gray, *Consciousness: Creeping Up on the Hard Problem*, Oxford: Oxford University Press, 2004. Benjamin Libet, *Mind Time: The Temporal Factor in Consciousness*, Cambridge, Massachusetts: Harvard University Press, 2004.

21. See, for example, J. R. Searle, *The Mystery of Consciousness*, London: Granta, 1996, pages 95ff.

22. Roger Penrose, *Shadows of the Mind: A Search for the Missing Science of Consciousness*, Oxford and New York: Oxford University Press, 1994.

23. *Ibid.*, page 87.

24. Cornwell (editor), *Op. cit.*, pages 11–12. Laura Spinney, 'Why we do what we do', *New Scientist*, 31 July 2004, pages 32–35; Emily Suiger, 'They know what you want', *Ibid.*, page 36.

25. Robert Wright, *The Moral Animal*, New York: Pantheon, 1994, page 321.

26. Olaf Sporns, 'Biological variability and brain function', in Cornwell (editor), *Op. cit.*, pages 38–53.

27. John Gray, *Straw Dogs*, London: Granta, 2002, page 151.

# Indexes

## NAMES AND PLACES

# IDEAS

# ALSO BY PETER WATSON

## THE MODERN MIND

### An Intellectual History of the 20th Century

ISBN 0-06-008438-3 (paperback)

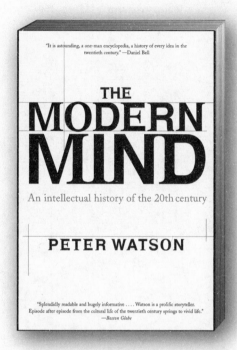

From Freud to Babbitt, from *Animal Farm* to Sartre to the Great Society, from the Theory of Relativity to counterculture to Kosovo, *The Modern Mind* is encyclopedic, covering the major writers, artists, scientists, and philosophers who produced the ideas by which we live. Peter Watson has produced a fluent and engaging narrative of the intellectual tradition of the twentieth century, and the men and women who created it.

"Splendidly readable and hugely informative. . . . Watson is a prolific storyteller. Episode after episode from the cultural life of the twentieth century springs to vivid life." —*Boston Globe*

"A remarkable narrative history of all the significant intellectual advances that made the century so glorious, so tragic, so revolutionary, so exciting. Watson's narrative style is so lucid and engaging that even the most complex and arcane thoughts and subjects are inviting." —*Indianapolis Times*

"[Watson] makes archaeology, history, and economics as scintillating as poetry, music, and astral theory. His inexhaustible interest is infectious." —Felipe Fernandez-Armstrong, *Sunday Times*